Arts & Ideas

		•		

Arts & Ideas Eighth Edition

William Fleming Syracuse University

Holt, Rinehart and Winston, Inc.

Fort Worth Chicago San Francisco Philadelphia Montreal Toronto London Sydney Tokyo Library of Congress Cataloging-in-Publication Data

Fleming, William, 1909-

Arts & ideas / William Fleming. — 8th ed.

p. cm.

Includes index.

1. Arts—History. I. Title. II. Title: Arts and ideas. NX440.F56 1990 90–41607 700'. —dc20 CIP

ISBN 0-03-054013-5

Copyright © 1991, 1986, 1980, 1974, 1963 by Holt, Rinehart and Winston, Inc.

Copyright 1955 by Holt, Rinehart and Winston, Inc.

Copyright renewed 1983 by Holt, Rinehart and Winston, Inc.

All rights reserved. No part of this publication may be reproduced or transmitted in any form or by any means, electronic or mechanical, including photocopy, recording or any information storage and retrieval system, without permission in writing from the publisher.

Requests for permission to make copies of any part of the work should be mailed to: Copyrights and Permissions Department, Holt, Rinehart and Winston, Inc., 6277 Sea Harbor Drive, Orlando, Florida 32887.

Address for editorial correspondence: Holt, Rinehart and Winston, Inc., 301 Commerce Street, Suite 3700, Fort Worth, Texas 76102

Address for orders: Holt, Rinehart and Winston, Inc., 6277 Sea Harbor Drive, Orlando, Florida 32887. 1-800-782-4479, or 1-800-433-0001 (in Florida)

Printed in the United States of America

1 2 3 4 048 9 8 7 6 5 4 3 2 1

Holt, Rinehart and Winston, Inc. The Dryden Press Saunders College Publishing

Composition and color by York Graphic Services, York, Pennsylvania. Printing and binding by R. R. Donnelley & Sons Company, Willard, Ohio.

Photographic credits appear on page 642.

Author's Preface

y aim in writing *Arts & Ideas* was to provide readers with a lively account of the arts through the ages. It began more than thirty-five years ago in answer to colleagues who asked for a volume that would treat, in depth, some typical works of art representative of their periods. By placing such works in their broader historical and humanistic contexts, it becomes possible to discover their interrelationships, what they meant to the people who produced them, and what they can mean to us today.

The book begins with the cave peoples and continues with the Mesopotamians, Israelis, Egyptians, and the Minoan and Mycenaean cultures. The final chapter comes to grips with postmodern styles as the contemporary period reaches out for continuity with the past and the cumulative momentum of historical developments in the pluralistic, relativistic, spatio—temporal continuum of the late 20th century. In between come the major periods and styles of the Western artistic tradition.

One of the most important features of Arts θ *Ideas* is the presentation of each major style in the city centers and social circumstances in which the work of art originally took shape. Works of art are not viewed as disembodied masterpieces hanging on museum walls but as living organisms in the lives of the people who produced them. Arts & Ideas illustrates the quality of life in ancient Athens with its confluence of eminent minds in the fields of architecture, sculpture, drama, and philosophy that met in the democracy of the city's thriving artistic and intellectual life. One can also feel this vitality in the Rome of Augustus, Trajan, and Hadrian; in the Ravenna of Theodoric and Maximian; in the early medieval monasteries; in the Chartres and Paris of the Gothic period; in the Renaissance Florence of the

Medicis; in the Rome of the high Renaissance when Leonardo, Michelangelo, and Raphael assembled at the papal court of Julius II; in the Venice of the Bellinis, Giorgione, Titian, and Tintoretto; in such baroque centers as Philip II's and Philip IV's Spain, when El Greco and Velázquez were active; at the French court, when Rubens and Poussin were painting and when Racine, Molière, and Lully were producing their plays and operas; in the Paris of the 1830s, when Géricault and Delacroix represented the visual aspects of romanticism, Victor Hugo the literary, and Berlioz, Chopin, and Liszt the musical; later in Paris, when the realists and impressionists were exploring new styles; in the birth of modern art from the paintings of Cézanne, Picasso, and Matisse and from the buildings of Labrouste and Le Corbusier; as well as in the New York of post-World War II, where abstract expressionism flourished. Such stimulating social, political, philosophical, and cultural surroundings bring works of art to life.

My heartfelt gratitude goes to the many colleagues at Syracuse University who have given me such wise counsel and thoughtful suggestions—most especially to Sidney Thomas, who shared his Shakespearean scholarship and vast learning with me; to Frank Macomber, who reviewed the music sections; to David Tatham, who recommended new illustrations; and to Wayne Franits, for his critical reading of the Dutch 17th-century chapter. I also acknowledge my debt to the many librarians, without whom no book could be written or revised—in particular to Randall Bond, Johanna Prins, and Donald Seibert of the Bird Library.

William Fleming August 1990

Contents

Preface	ν
Chapter 1 Onward into the Past	1
The Cro-Magnons	1
The Mesopotamians	3
The Egyptians	8
The Minoan and Mycenaean Cultures	12
Ideas: Dynamics of History	15
Arts and Society	15
Stylistic Unity and Diversity	16
Present and Past	19
Part 1 The Classical Period	20
Part 1 The Classical Period	20
Chapter 2 The Hellenic Style	22
Athens, 5th Century B.C.	23
Architecture	26
The Acropolis and the Propylaea	26
The Parthenon	26
The Erechtheum	31
Sculpture	33
The Parthenon Marbles	33
The Course of Hellenic Sculpture	39
Drama	42
Origins	43
Structure and Scope Music	43
Music and Literature	16 46
Music Theory	47
Music and Drama	48
Ideas	49
Humanism	49
Idealism	52
Rationalism	54
The Hellenic Heritage	57
Chapter 3 The Hellenistic Style	58
Pergamon, 2nd Century B.C.	59
Architecture	60
Upper Agora and Altar of Zeus	60
Athena Precinct and Theater	60
Royal Residence	61
Sculpture	63
First School of Pergamon	63
Second School: Altar of Zeus	65
Stylistic Differences	68
Paintings and Mosaics	69
Pergamene Painting and Roman Adaptations	69
Mosaics	71
Music Phrygian Music	72 73
PDTV(II 2D MILEIC	

75	
76	
78	
81	
82	
84	
86	
86	
87	
96	
97	
98	
100	
102	
103	
109	
110	
n	
133	
133	
134	
136	
136	
137	
140	
142	
143	
145	
145	
149	
149 149	
149 149 150	
149 149 150 152	
149 149 150 152 152	
149 149 150 152 152	
149 149 150 152 152 152 153	
149 149 150 152 152 152 153	
149 149 150 152 152 152 153 153	
149 149 150 152 152 152 153 153 154	
149 149 150 152 152 152 153 153	
149 149 150 152 152 153 153 154 154	
	78 81 82 84 86 86 87 96 97 98 100 102 103 103 104 105 105 108 109 110 111 112 115 116 117 122 130 131 133 133 134 136 136 137 140 142 143

	162	
The Bayeux Tapestry and the Norman Conquest	164	
Song of Roland	168	
The Art of Minstrelsy	170	
Norman Architecture	173	
The Tower of London	174	
Abbey Churches at Caen	176	
Ideas: Feudalism	177	
Feudal Virtues	177	
Ruggedness of Feudal Art	178	
Chapter 8 The Gothic Style	180	
Île-de-France, Late 12th and 13th Centuries	181	
Architecture of Chartres Cathedral	185	
West Façade	185	
Nave	185	
Transept, Choir, and Apse	189	
Interior Lighting	190	
Sculpture of Chartres Cathedral	190	
Iconography	191	
West Façade	192	
North and South Porches	194	
The Stained Glass of Chartres	194	
Iconography and Donors	195	
Rose Windows	196	
Music	199	
School of Notre Dame in Paris	199	
Ideas	201	
Gothic Dualism	201	
The Scholastic Synthesis	203	
Chapter 9 Late Medieval Styles	208	
Chapter 9 Late Medieval Styles	200	
	209	
English Gothic German Gothic		
English Gothic	209	
English Gothic German Gothic	209 214	
English Gothic German Gothic Italian Gothic	209 214 215	
English Gothic German Gothic Italian Gothic The Basilica of St. Francis at Assisi	209 214 215 215	
English Gothic German Gothic Italian Gothic The Basilica of St. Francis at Assisi The Life of St. Francis in Fresco	209 214 215 215 217	
English Gothic German Gothic Italian Gothic The Basilica of St. Francis at Assisi The Life of St. Francis in Fresco Before and After the Black Death	209 214 215 215 217 219	
English Gothic German Gothic Italian Gothic The Basilica of St. Francis at Assisi The Life of St. Francis in Fresco Before and After the Black Death Music and Literature Ideas	209 214 215 215 217 219 223 227	
English Gothic German Gothic Italian Gothic The Basilica of St. Francis at Assisi The Life of St. Francis in Fresco Before and After the Black Death Music and Literature	209 214 215 215 217 219 223 227 228	
English Gothic German Gothic Italian Gothic The Basilica of St. Francis at Assisi The Life of St. Francis in Fresco Before and After the Black Death Music and Literature Ideas Late Medieval Naturalism	209 214 215 215 217 219 223 227	
English Gothic German Gothic Italian Gothic The Basilica of St. Francis at Assisi The Life of St. Francis in Fresco Before and After the Black Death Music and Literature Ideas Late Medieval Naturalism	209 214 215 215 217 219 223 227 228	
English Gothic German Gothic Italian Gothic The Basilica of St. Francis at Assisi The Life of St. Francis in Fresco Before and After the Black Death Music and Literature Ideas Late Medieval Naturalism Franciscan Humanitarianism Part 3 The Renaissance	209 214 215 215 217 219 223 227 228 229	
English Gothic German Gothic Italian Gothic The Basilica of St. Francis at Assisi The Life of St. Francis in Fresco Before and After the Black Death Music and Literature Ideas Late Medieval Naturalism Franciscan Humanitarianism Part 3 The Renaissance Chapter 10 The Florentine Renaissance Style	209 214 215 215 217 219 223 227 228 229	
English Gothic German Gothic Italian Gothic The Basilica of St. Francis at Assisi The Life of St. Francis in Fresco Before and After the Black Death Music and Literature Ideas Late Medieval Naturalism Franciscan Humanitarianism Part 3 The Renaissance Chapter 10 The Florentine Renaissance Style Florence, 15th Century	209 214 215 215 217 219 223 227 228 229	
English Gothic German Gothic Italian Gothic The Basilica of St. Francis at Assisi The Life of St. Francis in Fresco Before and After the Black Death Music and Literature Ideas Late Medieval Naturalism Franciscan Humanitarianism Part 3 The Renaissance Chapter 10 The Florentine Renaissance Style Florence, 15th Century The Florentine City-State	209 214 215 215 217 219 223 227 228 229 234 235 235	
English Gothic German Gothic Italian Gothic The Basilica of St. Francis at Assisi The Life of St. Francis in Fresco Before and After the Black Death Music and Literature Ideas Late Medieval Naturalism Franciscan Humanitarianism Part 3 The Renaissance Chapter 10 The Florentine Renaissance Style Florence, 15th Century The Florentine City-State Brunelleschi's Dome	209 214 215 215 217 219 223 227 228 229 234 235 235 236	
English Gothic German Gothic Italian Gothic The Basilica of St. Francis at Assisi The Life of St. Francis in Fresco Before and After the Black Death Music and Literature Ideas Late Medieval Naturalism Franciscan Humanitarianism Part 3 The Renaissance Chapter 10 The Florentine Renaissance Style Florence, 15th Century The Florentine City-State Brunelleschi's Dome Dome and Dedication Motet	209 214 215 215 217 219 223 227 228 229 234 235 235 236 238	
English Gothic German Gothic Italian Gothic The Basilica of St. Francis at Assisi The Life of St. Francis in Fresco Before and After the Black Death Music and Literature Ideas Late Medieval Naturalism Franciscan Humanitarianism Part 3 The Renaissance Chapter 10 The Florentine Renaissance Style Florence, 15th Century The Florentine City-State Brunelleschi's Dome Dome and Dedication Motet Pazzi Chapel	209 214 215 215 217 219 223 227 228 229 234 235 235 236 238 238	
English Gothic German Gothic Italian Gothic The Basilica of St. Francis at Assisi The Life of St. Francis in Fresco Before and After the Black Death Music and Literature Ideas Late Medieval Naturalism Franciscan Humanitarianism Part 3 The Renaissance Chapter 10 The Florentine Renaissance Style Florence, 15th Century The Florentine City-State Brunelleschi's Dome Dome and Dedication Motet Pazzi Chapel Medici-Riccardi Palace	209 214 215 215 217 219 223 227 228 229 234 235 235 236 238 238 240	
English Gothic German Gothic Italian Gothic The Basilica of St. Francis at Assisi The Life of St. Francis in Fresco Before and After the Black Death Music and Literature Ideas Late Medieval Naturalism Franciscan Humanitarianism Part 3 The Renaissance Chapter 10 The Florentine Renaissance Style Florence, 15th Century The Florentine City-State Brunelleschi's Dome Dome and Dedication Motet Pazzi Chapel Medici-Riccardi Palace Sculpture	209 214 215 215 217 219 223 227 228 229 234 235 235 236 238 238 240 241	
English Gothic German Gothic Italian Gothic The Basilica of St. Francis at Assisi The Life of St. Francis in Fresco Before and After the Black Death Music and Literature Ideas Late Medieval Naturalism Franciscan Humanitarianism Part 3 The Renaissance Chapter 10 The Florentine Renaissance Style Florence, 15th Century The Florentine City-State Brunelleschi's Dome Dome and Dedication Motet Pazzi Chapel Medici-Riccardi Palace Sculpture Ghiberti's East Doors	209 214 215 215 217 219 223 227 228 229 234 235 235 236 238 238 240 241 242	
English Gothic German Gothic Italian Gothic The Basilica of St. Francis at Assisi The Life of St. Francis in Fresco Before and After the Black Death Music and Literature Ideas Late Medieval Naturalism Franciscan Humanitarianism Part 3 The Renaissance Chapter 10 The Florentine Renaissance Style Florence, 15th Century The Florentine City-State Brunelleschi's Dome Dome and Dedication Motet Pazzi Chapel Medici-Riccardi Palace Sculpture Ghiberti's East Doors Donatello	209 214 215 215 217 219 223 227 228 229 234 235 236 238 238 240 241 242 243	
English Gothic German Gothic Italian Gothic The Basilica of St. Francis at Assisi The Life of St. Francis in Fresco Before and After the Black Death Music and Literature Ideas Late Medieval Naturalism Franciscan Humanitarianism Part 3 The Renaissance Chapter 10 The Florentine Renaissance Style Florence, 15th Century The Florentine City-State Brunelleschi's Dome Dome and Dedication Motet Pazzi Chapel Medici-Riccardi Palace Sculpture Ghiberti's East Doors Donatello Pollaiuolo and Verrocchio	209 214 215 215 217 219 223 227 228 229 234 235 236 238 238 240 241 242 243 245	
English Gothic German Gothic Italian Gothic The Basilica of St. Francis at Assisi The Life of St. Francis in Fresco Before and After the Black Death Music and Literature Ideas Late Medieval Naturalism Franciscan Humanitarianism Part 3 The Renaissance Chapter 10 The Florentine Renaissance Style Florence, 15th Century The Florentine City-State Brunelleschi's Dome Dome and Dedication Motet Pazzi Chapel Medici-Riccardi Palace Sculpture Ghiberti's East Doors Donatello	209 214 215 215 217 219 223 227 228 229 234 235 236 238 238 240 241 242 243	

Fra Angelico	248
Benozzo Gozzoli and Filippo Lippi	249
Paolo Uccello	249
Piero della Francesca	250
Botticelli	250 254
Leonardo da Vinci	257
Poetry and Music Lorenzo as Poet and Patron	257
Carnival Songs	257
Collaboration with Heinrich Isaac	258
Ideas	258
Classical Humanism	259
Scientific Naturalism	260
Renaissance Individualism	261
Chapter 11 The Roman Renaissance Style	266
Rome, Early 16th Century	267
Sculpture: Michelangelo	269 269
The Pietà Tomb of Julius II	271
Painting	273
Michelangelo's Sistine Ceiling Frescoes	273
Raphael's Vatican Murals	278
The Dome of St. Peter's	279
Josquin Desprez and the Sistine Chapel Choir	280
Ideas: Humanism	282 282
Revival of Classical Forms	283
Pagan versus Christian Ideals	284
Chapter 12 Northern Renaissance Styles	285
The Northern Scene Commercial Revolution	286
Expanding Horizons	286
Art in the North	288
Flanders	289
The Germanies	296
England	300
Music	300 302
Orland Lassus	303
Tudor Composers Drama: Shakespeare	303
The Tempest	305
Ideas	306
Christian Humanism	306
Luther and the Reformation	307
Chapter 13 The Venetian Renaissance and	
International Mannerism	310
Renaissance Venice, 16th Century	311
Architecture	312
Painting	315 325
Music Mannerist Europe, 16th Century	327
International Mannerism	328
Painting: Pontormo, Parmagianino, Bronzino	329
Sculpture: Cellini and Bologna	333
Architecture: Romano, Scamozzi, Zuccari	335
Ideas	336 336
Time and Space Roads to the Baroque	338
Roads to the Daroque	,,,,

Part 4 The Baroque Period	340
Chanton 14. The Country Defended	
Chapter 14 The Counter-Reformation Baroque Style	342
2 1	
Rome, Late 16th and Early 17th Centuries Roman Counter-Reformation Art	343 346
Architecture	346
Painting and Sculpture	346
Spanish Counter-Reformation Art	352
Architecture	354
Painting	356
Music	363
Ideas: Militant Mysticism	363
St. Ignatius and the Jesuits	364
Mysticism and the Arts	364
Chapter 15 The Bourgeois Baroque Style	366
Amsterdam, 17th Century	367
Painting	370
Rembrandt	370
Hals, De Hooch, and Ruisdael	375
Vermeer	378
Music	380
Sweelinck Bach	380
Ideas: Domesticity	380 383
Domesticity and the Arts	384
•	
Chapter 16 The Aristocratic Baroque Style: France and England	386
France and Absolute Monarchy Architecture	387
Louvre Palace	389
Versailles Palace	389 390
Sculpture	393
Painting	394
Rubens	396
Poussin	398
Claude Lorrain	399
Music	400
Lully and French Opera	401
England and Limited Monarchy	403
Architecture	404
Banqueting House, Whitehall	404
St. Paul's Cathedral Wren's New Plan for London	404
Drama and Music	407 408
Dryden	408
Purcell and English Opera	409
Handel: Opera and Oratorio	411
Ideas	412
Absolutism	412
Academicism	413
Baroque Rationalism	414
Dynamics of the Baroque	415
Expansion of Time and Space	417

Part 5 The Revolutionary Period	418
Chapter 17 The 18th-Century Styles	420
The Rococo	421
Architecture and the Decorative Arts	422
Painting and Sculpture	425
Sensibility	426
Painting	428
Sculpture	431
Literature	432
Reactions to the Enlightenment	432
Storm and Stress	433
The Mozartian Synthesis	433
Don Giovanni	435
Ideas: 18th-Century Rationalism	437
Chapter 18 The Neoclassical Style	440
Paris, Early 19th Century	441
Architecture	443
Paris, the New Rome	443
Classic Revivals Elsewhere	446
Painting	446
David and Neoclassicism	446
Ingres and Academic Art	450
Sculpture: Canova	451
Music	452
Napoleon as Patron	452
Beethoven: The Heroic Ideal	453
The Archeological Idea	455
Faithfulness to Antique Models	456
Emancipation of Music	457
Chapter 19 The Romantic Style	458
The Romantic Revolution	460
Liberty Leading the People, 1830	460
Eugène Delacroix	462
Théodore Géricault	464
Francisco Goya	465
François Rude	467
Medieval Revival	469
Gothic Revival in England and America	469
Gothic Revival in Germany and France	471
Victor Hugo	472
Hector Berlioz	474
The Wagnerian Synthesis	476
Individualism and Nationalism	478
Exoticism	479
Back to Nature	483
Ideas: Romantic Historicism	486
Chapter 20 Realism, Impressionism, and Symbolism	490
Realism	491
Painterly Realism	492
Literary Realism	495
Sculptural Realism: Rodin	496
Architectural Realism	499
Impressionism	502
Postimpressionism	508

Symbolism Maeterlinck's Symbolist Drama	514 515
Debussy's Lyric Drama	515
Ideas	516
Alliance of Art and Science	516
Continuous Flux	517
Bergson's Theory of Time	518
Bergson and the Arts	518
Chapter 21 Early Modern Styles	520
The Age of Isms and Schisms Expressionism and Abstractionism	521
Neoprimitivism	522
Wild Beasts, The Bridge, Blue Rider, and Operatic Uproars	526 529
Cubism	534
Futurism and the Mechanical Style	537
Dadaism and Surrealism	539
Neoclassical Interlude	544
Social Realism	547
Nonobjectivism	550
Architecture	551
Organic Architecture: Sullivan and Wright	552
Art Deco	554
International Style: Gropius and Le Corbusier	557
Ideas: Relativism	558
Relativism and the Arts	559
-	
Chapter 22 Later Modern Styles	562
Revolutions and Evolutions	562 563
Revolutions and Evolutions Modernism	563 563
Revolutions and Evolutions Modernism The New York School	563 563
Revolutions and Evolutions Modernism The New York School Abstract Expressionism	563 563 563 566
Revolutions and Evolutions Modernism The New York School Abstract Expressionism Stylistic Fragments	563 563 563 566 579
Revolutions and Evolutions Modernism The New York School Abstract Expressionism Stylistic Fragments Modern Musical Developments	563 563 566 579 585
Revolutions and Evolutions Modernism The New York School Abstract Expressionism Stylistic Fragments Modern Musical Developments Modern Architectural Developments	563 563 566 579 585 589
Revolutions and Evolutions Modernism The New York School Abstract Expressionism Stylistic Fragments Modern Musical Developments	563 563 566 579 585
Revolutions and Evolutions Modernism The New York School Abstract Expressionism Stylistic Fragments Modern Musical Developments Modern Architectural Developments Ideas	563 563 566 579 585 589
Revolutions and Evolutions Modernism The New York School Abstract Expressionism Stylistic Fragments Modern Musical Developments Modern Architectural Developments Ideas The Scientific Worldview Chapter 23 Postmodern Styles Postmodernism	563 563 566 579 585 589 596
Revolutions and Evolutions Modernism The New York School Abstract Expressionism Stylistic Fragments Modern Musical Developments Modern Architectural Developments Ideas The Scientific Worldview Chapter 23 Postmodern Styles	563 563 566 579 585 589 596 596
Revolutions and Evolutions Modernism The New York School Abstract Expressionism Stylistic Fragments Modern Musical Developments Modern Architectural Developments Ideas The Scientific Worldview Chapter 23 Postmodern Styles Postmodernism Postmodern Painterly and Sculptural Developments The New Realism	563 563 566 579 585 589 596 596
Revolutions and Evolutions Modernism The New York School Abstract Expressionism Stylistic Fragments Modern Musical Developments Modern Architectural Developments Ideas The Scientific Worldview Chapter 23 Postmodern Styles Postmodernism Postmodern Painterly and Sculptural Developments The New Realism The New Historicism	563 563 566 579 585 589 596 598 599 600
Revolutions and Evolutions Modernism The New York School Abstract Expressionism Stylistic Fragments Modern Musical Developments Modern Architectural Developments Ideas The Scientific Worldview Chapter 23 Postmodern Styles Postmodernism Postmodern Painterly and Sculptural Developments The New Realism The New Historicism Postmodern Musical Developments	563 563 566 579 585 589 596 598 599 600 600 605 609
Revolutions and Evolutions Modernism The New York School Abstract Expressionism Stylistic Fragments Modern Musical Developments Modern Architectural Developments Ideas The Scientific Worldview Chapter 23 Postmodern Styles Postmodernism Postmodern Painterly and Sculptural Developments The New Realism The New Historicism Postmodern Musical Developments Postmodern Architectural Developments Postmodern Architectural Developments	563 563 563 566 579 585 589 596 598 599 600 600 605 609 611
Revolutions and Evolutions Modernism The New York School Abstract Expressionism Stylistic Fragments Modern Musical Developments Modern Architectural Developments Ideas The Scientific Worldview Chapter 23 Postmodern Styles Postmodernism Postmodern Painterly and Sculptural Developments The New Realism The New Historicism Postmodern Musical Developments Postmodern Architectural Developments Kahn and Venturi	563 563 563 566 579 585 589 596 596 598 600 600 605 609 611 611
Revolutions and Evolutions Modernism The New York School Abstract Expressionism Stylistic Fragments Modern Musical Developments Modern Architectural Developments Ideas The Scientific Worldview Chapter 23 Postmodern Styles Postmodernism Postmodern Painterly and Sculptural Developments The New Realism The New Historicism Postmodern Musical Developments Postmodern Architectural Developments Kahn and Venturi Graves, Beebe, and Moore	563 563 563 566 579 585 589 596 596 598 600 600 605 609 611 611
Revolutions and Evolutions Modernism The New York School Abstract Expressionism Stylistic Fragments Modern Musical Developments Modern Architectural Developments Ideas The Scientific Worldview Chapter 23 Postmodern Styles Postmodernism Postmodern Painterly and Sculptural Developments The New Realism The New Historicism Postmodern Musical Developments Postmodern Architectural Developments Kahn and Venturi Graves, Beebe, and Moore Ideas: Existentialism	563 563 563 566 579 585 589 596 596 598 600 600 605 609 611 611 614
Revolutions and Evolutions Modernism The New York School Abstract Expressionism Stylistic Fragments Modern Musical Developments Modern Architectural Developments Ideas The Scientific Worldview Chapter 23 Postmodern Styles Postmodernism Postmodern Painterly and Sculptural Developments The New Realism The New Historicism Postmodern Musical Developments Postmodern Architectural Developments Kahn and Venturi Graves, Beebe, and Moore Ideas: Existentialism Postmodern Horizons	563 563 563 566 579 585 589 596 598 599 600 600 605 609 611 611 614 616
Revolutions and Evolutions Modernism The New York School Abstract Expressionism Stylistic Fragments Modern Musical Developments Modern Architectural Developments Ideas The Scientific Worldview Chapter 23 Postmodern Styles Postmodernism Postmodern Painterly and Sculptural Developments The New Realism The New Historicism Postmodern Musical Developments Postmodern Architectural Developments Kahn and Venturi Graves, Beebe, and Moore Ideas: Existentialism	563 563 563 566 579 585 589 596 596 598 600 600 605 609 611 611 614

PREHISTORY, THE ANCIENT NEAR EAST, AND EGYPT (All dates are approximate)

	KEY EVENTS	ARCHITECTURE	VISUAL ARTS	WRITING	MUSIC
33,000 B.C. 4000 B.C.	33,000-10,000 Paleolithic Period (Old Stone Age) Cro- Magnon peoples. Culture of hunters and food gatherers 10,000-4,000 Neolithic Period (New Stone Age) Culture of food producers and animal husbandry	Houses of brick and mud, wattle and dab construction 7700-5700 first cities appear at Çatal Huyuk (Turkey), Jericho (Palestine)	15,000-10,000 Cave paintings and carvings in southwestern France (Lascaux) and northern Spain (Altamira) Stone carving (weapons and flint axes) Pottery, painted vases, weaving Woman of Willendorf carved		Bone whistles, primitive drums
		MES	OPOTAMIA	•	
4000 B.C. 333 B.C.	4,000-3,000 Sumerian Kingdom 3,000 Old Babylonian empire 1750 Hammurabi reigned 1400-1200 Hittite empire 1350-1200 Assyrian empire 612-539 Neo-Babylonian empire 605-562 Nebuchadnezzar II, king of Babylon 539-333 Persian empire of Cyrus, Darius, Xerxes 333 Conquest of Near East by Alexander	2100 Ziggur at Ur built 575 Ishtar Gate at Babylon built	Beginnings of Sumerian art: metal working, bronze casting 3300 Female head from Uruk carved 2100 Gudea from Tello carved 1760 Stele of Hammurabi carved	2400 Cuneiform writing invented 1750 Law Code of Hammurabi 1500 Alphabetic writing invented in Syria 1200 Epic of Gilgamesh recorded 650 King Ashurbanipal collected library of 22,000 clay tablets	2600 Sumerian harp from royal tombs at Ur 1800 Test for tuning system written on clay tablets 1400 Cult song from Ugarit written with notation on clay tablets
			EGYPT		
3000 B.C.	3000 Egypt united under one pharoah 2920-2575 Early dynastic period 2575-2134 Old Kingdom (4th to 8th dynasties) 2040-1640 Middle Kingdom (11th to 14th dynasties) 1550-1070 New Kingdom (18th to 20th dynasties) 1473-1458 Queen Hatshepsut reigned 1353-1335 Amenhotep IV reigned as Akhenaten 1333-1323 Tutankhamen reigned 1290-1224 Ramses II reigned 332-323 Conquest of Egypt by Alexander 323-30 Macedonian and Ptolemaic dynasties reigned 51-30 Reigns of Ptolemy and Cleopatra	2630 Imhotep, architect and physician built step pyramid for King Zoser 2551-2528 Pyramid of Khufu (Cheops) built 2520-2494 Pyramid of Khafre (Cheops) built 1473-1458 Temple of Amon at Karnak built 1390 Temple of Amon at Luxor built 1350 New capital at Tel-el-Amarna built 323 City of Alexandria built	2580 Statues of Prince Rahotep and wife Nofret carved and painted 2520-2494 Great Sphinx carved 2040-1640 Golden age of arts and crafts 1350 Bust of Queen Nefertiti carved and painted 1330 Tutankhamen's throne constructed 1260 Colossal statues of Ramses II carved	3100 Hieroglyphic writing invented 2600-2300 Collections of Egyptian religious literature carved in pyramids 1580-1350 Book of Dead existed in pyramid inscriptions 663-525 Book of Dead assumed present form 1350 Akhenaten's Hymn to the Sun written 320 Great library of Alexandria assembled	4000-3500 Harps and flutes played in Egypt 3500-300 Lyres and reed instruments added 1420 Musicians playing instruments painted for Tomb of Nakht
		CYCLADIC ISL	ANDS AND MYCE	NAE	
3000 B.C. 1000 B.C.	2500-1400 Minoan culture flourished on Crete and Cycladic Islands 1400-1100 Mycenaen culture flourished on Greek mainland 1230 Troy destroyed by Mycenaeans 1200 Iron in common use 1100 Dorian invasion of Greece 1100-750 Dark age	1750 Early palace built at Knossos, Crete 1250 Lion Gate of palace at Mycenae built	3000-2000 Cycladic Island idols carved Geometric Greek pottery	2000 Phoenician alphabet developed 750 Hesiod's Theogony, collection of stories about creation of world and gods of mythology 700 Homeric poems, Iliad and Odyssey composed	
			ISRAEL		
1025 B.C. 587 B.C.	1025-922 Kingdom of Israel united 1025-1000 Saul reigned 1000-968 David reigned 968-037 Solomon reigned 922-597 Two kingdoms: Israel to 793, Judah to 597 722 Israel conquered by Assyrians. Jerusalem destroyed 587 Judah fell to Babylonians. Period of Babylonian captivity	950 Temple of Solomon built	700 Frieze for Sennacherib's palace at Ninevah carved depicting procession of war prisoners including Palestinians	587 Early books of Old Testament assembled during Babylonian captivity	David's Psalms sung with lyre accompaniment

1

Onward into the Past

Many and varied are the faces of art, and together they reveal the basic urges and aspirations of humanity. The search for sights and sounds that delight the senses is only one of these many faces. The Cro-Magnon cave people in their vivid rendering of the animals that roamed the primeval forests were searching for the means of bringing their environment under control. The Mesopotamians constructed massive staged towers to reach upward into the abodes of their gods. The Egyptians built and embellished their tombs to provide for life beyond the grave. Minoan murals were painted to decorate their dwellings and delight the eye. Alone among the ancients, the Minoans had no priesthood and built no temples. The Greeks sought to find reality in the underlying mathematical and harmonic proportions of their temples and godlike figures. Through out history, art holds up a mirror to humanity. In it we behold the reflection of the past record, the present achievement, and the future aspirations of a people at a given time and in a given place.

THE CRO-MAGNONS

The first known human expressions in the arts, dating back some 30,000 years, are clouded over by the mists of prehistory. Whether people sought safety in the confines of the caves or built huts of mammoth bones and animal skins, early societies have from the first been involved with architecture. Making shelters for the body, refuges for the spirit, and sanctuaries for the gods were the earliest concerns. Ever since men and women saw their reflections in still pools, the desire to represent nature and human nature suggested itself to early peoples. The bone whistles, primitive flutes, and drumsticks found in caves and graves tell of the power of sound to evoke moods and echo the footsteps of man, woman, and beast in mysterious rites. Strange crisscross lines, Vshaped markings, and dots and circles on bone, ivory, and cave surfaces reveal that the Cro-Magnon

people created some sort of visual language that recorded a vast variety of observed detail, possibly notes of seasonal changes, records of births, and the like.

Through the magic of images, early people dealt with hunting and being hunted, with life and death, with existence and extinction (Fig. 1). Cave artists represented what they actually saw with such accuracy and immediacy that later literate societies have never excelled the sheer strength of the pictorial record left from prehistory. The herds of beasts and spirited specimens painted and carved on cave walls and ceilings capture the very essence of animality and tell of the precarious place of the cave people in a world dominated by brutish forces. The artists often took advantage of the natural contours of the cave surfaces so that the animal figures appear in low relief. It is as if the natural formations of the stone suggested the particular animal forms to the artist. The painters made these startling lifelike animals by incising, outlining, and shading them with charcoal, then adding colors mainly in reddish browns and yellow ochre shades. The pigments were natural minerals ground to powder, then applied to the damp limestone surfaces. Though horses and antelopes often appear in herds, the art of grouping figures or organizing images into complete compositions seems to have been of no importance. Anyway, since complete darkness prevailed, it was only by primitive lamps or fires that even a small part of the surface could have been seen at one time.

Why were they created? These animals may well have been symbols standing for the processes of nature, and the making of such lifelike images would then become the means of understanding the world they lived in. The caves may also have been sanctuaries for mysterious magical rituals or for initiation ceremonies for young hunters as they reached maturity and independence. Evidence that lances were hurled at the paintings also points to primitive hunting rites. For the cave people, art served life, art

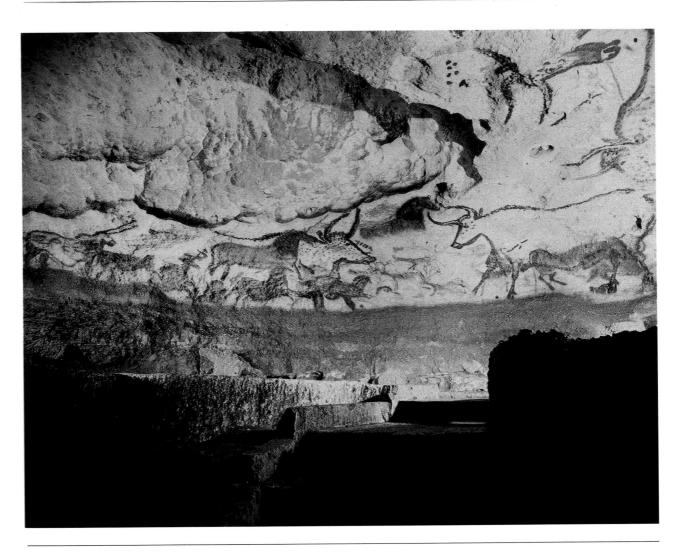

1. Paleolithic cave painting, c. 15,000–10,000 B.C. Approximately life-size. Lascaux (Dordogne), France.

and reality were one, and the image became the animal. By imitating their prey exactly, hunters could gain power over it. The idea was to create a double and then assault it, so that the hunters could bring their true quarry to bay. Other theories hold that the paintings may have constituted a record of the seasonal animal migrations or that the beasts may have been totemic figures of the various tribal families. Quite possibly these amazing images may have been created simply for the sheer pleasure of making a living likeness of the world the artists saw around them.

Strangely enough, human representations are rare. When they do appear, they are not treated naturalistically like the animals, but more often as geometric abstractions. Such a figure, less than 5 inches tall, is the Woman of Willendorf (Fig. 2). The head is crowned with small stylized curls over her feature-

less face. Exuding pride and contentment, she bends over her huge breasts, clasps them with tiny arms, and gazes downward at her pregnant belly. These exaggerated sex characteristics suggest a mother goddess of some fertility cult. The whole compact composition becomes a system of cones, curves, and spheres. Thus, many thousands of years before the beginnings of recorded history, the Stone Age people produced art that embraced naturalism and realism, abstraction and expressionistic distortion.

Over the millennia plant cultivation and animal husbandry gradually replaced hunting and food gathering so that people could live the year round in stable settlements. Such permanent communities as Jericho date continuously from around 8000 B.C. to the present. There the populace lived in mud-brick houses, and the community was surrounded by protective walls as referred to in the Bible.

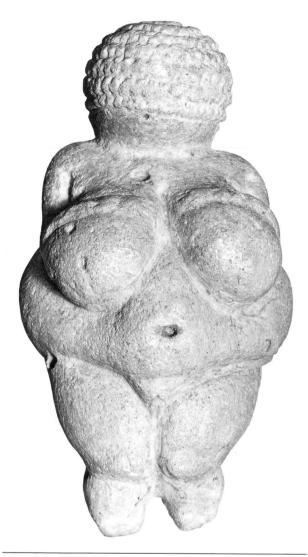

2. Woman of Willendorf, c. 30,000–25,000 B.C. Limestone, height $4_4^{3''}$ (11 cm). Naturhistorisches Museum, Vienna.

THE MESOPOTAMIANS

The earliest Near Eastern settlements were in the region known as Mesopotamia, a Greek word meaning "the land between rivers"—the Tigris and Euphrates, whose generous waters were brought under control by a system of dikes and irrigation canals. This prosperous area is also known as the Fertile Crescent. About 4000 B.C. the land of Sumer was inhabited by a people who developed a highly organized society. The Sumerians invented an early numerical system and also devised a form of writing on clay tablets with wedge-shaped characters called *cuneiform*.

The Sumerians believed in a pantheon of gods who personified the creative and destructive forces

of nature. Each city honored its special deity by erecting a ziggurat, which means "mountain" or "pinnacle." Architecturally, these towers were conceived as dwelling places of the god who watched over the fortunes of the town. They were also the center of the powerful priesthood, where scribes kept written records, accounts, and inventories of food and supplies. In the flat surrounding countryside these multistoried structures rose so high that they were thought, as recorded in the Bible (Gen. 11:3-4), to "reach unto heaven". The 270-foot (82.3-meter) ziggurat at Babylon was the legendary Tower of Babel, but now only the foundation remains. The ziggurat at Ur (Figs. 3 and 4), dating from about 2100 B.C., was also an imposing pile. Such Mesopotamian structures used a sun-dried mud-brick core faced with vellowish baked brick laid in bitumen, contrasting with the granite of the Egyptian pyramids. Approach was by three great stairways of a hundred steps each leading to the gatehouse some 40 feet above the ground level. The corners of the massive oblong base are oriented

Ziggurat at Ur, c. 2100 B.C.

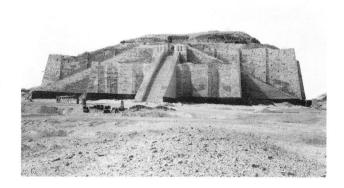

Reconstruction drawing of the Ziggurat at Ur (adapted from a drawing at the British Museum, London).

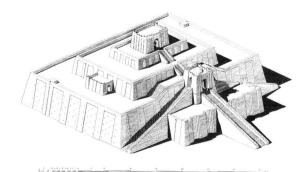

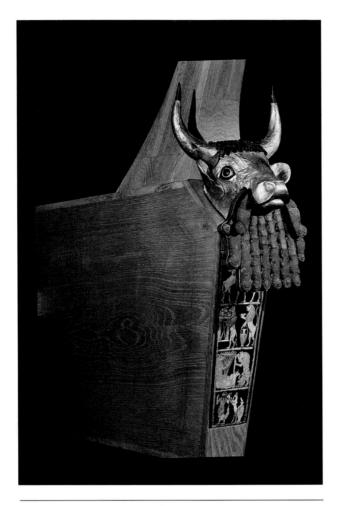

5. Soundbox of a harp, from Ur. c. 2685–2550 B.C. Wood with gold, lapis lazuli, and shell inlay; height 17" (43 cm). University Museum, University of Pennsylvania, Philadelphia.

toward the four points of the compass. Inward-sloping walls rise to make a platform for the second stage, which in turn supports the temple at the top.

Beginning in 1922 a rich treasure of art came to light in the diggings of the royal tombs at Ur, the biblical Ur of the Chaldees and traditional birthplace of Abraham. The jewelry, headdresses, musical instruments, and other found artifacts reveal an extraordinary quality of craftsmanship. The reconstructed harp (Fig. 5) has a marvelously wrought golden bull's head facing the soundbox. The tips of the horns, hair, eyes, and human beard are carved of lapis lazuli, a precious blue stone imported from distant Afghanistan. The four panels below are done in delicate inlay of shell and gold leaf. The fables told by these animals in human form illustrated some long-lost mythic lore (Fig. 6).

Other excavations have unearthed works of comparable quality. The strong yet sensitive female

head from Uruk (modern Warka) dates from around 3000 B.C. (Fig. 7). The soft modeling of the white marble and thoughtful expression reveal the warm countenance of a real personality. Was she goddess? priestess? queen? Originally the figure would have had a headdress, possibly of gold. The deep-cut eyebrows and large eyes would have been filled with shell or semiprecious stone. Gudea, the devout ruler of the city of Lagash, is shown in Figure 8, one of many such statues. The work is carved of diorite, a dark-colored stone that takes a high polish. From all

6. Detail of panel on soundbox under bull's head.

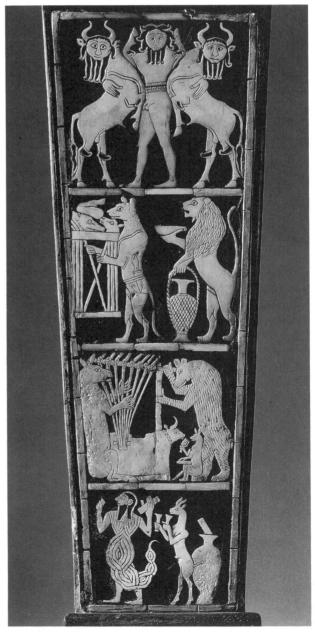

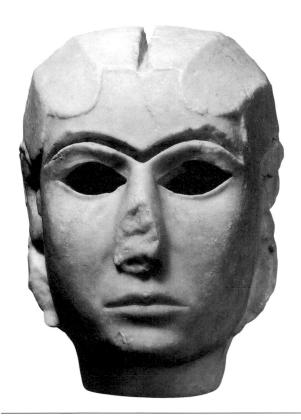

7. Female head from Uruk. c. 3500–3000 B.C. Marble, height 8" (20.3 cm). Iraq Museum, Baghdad.

accounts, Gudea was a serious but benevolent man who considered himself the "faithful shepherd" of his people. He is always shown as pensive or prayerful. In one version he is depicted with a building plan, probably the wall of a temple precinct, on his lap. Both here and in the female head (Fig. 7) the large eyes are a striking feature of Sumerian art. The allusion may be to the gift of sight and the mind's inner vision as the greatest boon that the gods can bestow.

Later, from about 1791 to 1750 B.C., Hammurabi ruled a kingdom that united most of Mesopotamia. He commands a secure place in history as the codifier of the influential body of laws that were inscribed on a tall stele of polished black stone (Fig. 9). The top is a sculptured relief of Hammurabi as "the favorite shepherd" of the enthroned, flame-shouldered sun-god Shamash, whose wishes were that "justice should prevail in the land" and that "the strong might not oppress the weak." Hammurabi's code, however, embraced the harsh retaliatory principle of an eye for an eye, a tooth for a tooth, and a limb for a limb. But it was also designed to protect widows and orphans, and to see that children supported their aged parents. Although a woman's first duty was to give her husband legitimate offspring,

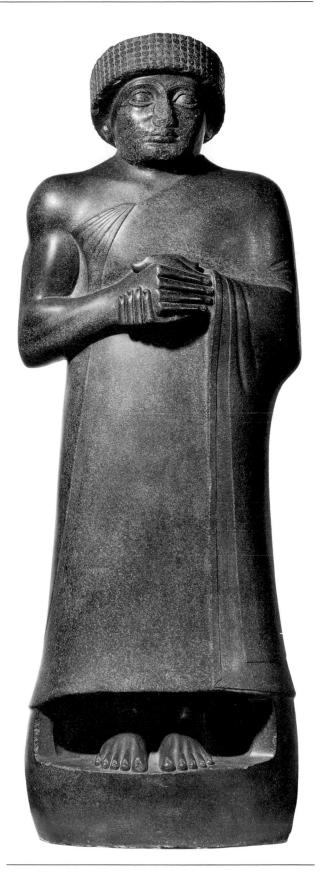

8. Gudea, from Tello. c. 2100 B.C. Diorite, height 38" (96.5 cm). Iraq Museum, Baghdad.

she was otherwise an independent person free to borrow and lend money as well as to own, buy, and sell land. Adulterous wives and their lovers, however, were to be sentenced to death by drowning.

In Sumerian literature the outstanding *Epic of* Gilgamesh predates Homer by some 1,500 years, and it still makes for compelling reading today. Gilgamesh was a legendary hero who ruled at Uruk, the biblical Erech, about 2700 B.C. The story has to do with the age-old human quest for the meaning of life in the face of death, the conflict between gods and mortals, and the consolations of love and friendship. In the search for his lost youth and immortality Gilgamesh encounters Utnapishtim, who has survived a mighty flood by building an ark and assembling all manner of birds and beasts within it. From him Gilgamesh receives a miraculous plant that magically restores youth, only to have a wily serpent snatch it from his grasp. The *Epic* ends with the words: "He was wise, he saw mysteries and knew secret things, he brought us a tale of the days before the flood. He went a long journey, was weary, worn out with labour, and returning engraved on a stone the whole story."

9. Hammurabi Stele (upper part). Susa, c. 1760 B.C. Basalt, height of entire stele 7'4" (2.23 m). Louvre, Paris.

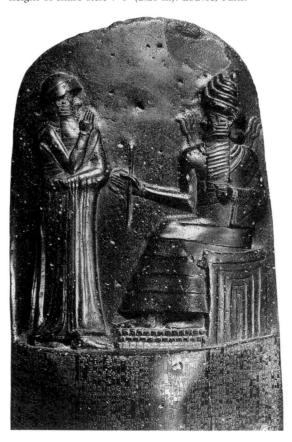

Thus, the journey ends tragically in death and disillusionment as Gilgamesh "goes back through the gate by which he came." The reader is left with the impression that the purpose of the journey may be the journey itself, and in such a quest for self-understanding it is perhaps better to ask questions than to receive answers. It is interesting to note that some of these tales and images would later find their way into the Book of Genesis.

Early Mesopotamian music is represented by a complete song dating from about 1400 B.C. that has been discovered in recent archeological excavations at ancient Ugarit (the modern Ras Shamra on the Mediterranean coast of Syria). Recorded in cuneiform script on clay tablets, the lyrics are in the dead Hurrian language, which is yet to be fully deciphered. Enough is known, however, to reveal that it is a cult hymn in praise of the mother goddess Nikkal, wife of the moon god. Texts on various tuning systems for musical instruments dating back to about 1800 B.C. that were found in the excavations at Ur proved helpful to the musicologists who reconstructed the melodic intervals of the song. Quite surprisingly, the scale closely approximates our modern major mode, and it is so notated in the version shown in the example. Even more astonishing was the discovery that there were two different pitches meant to be sounded simultaneously—one for the voice, with words, the other for an accompanying stringed instrument of the harp or lyre type (Fig. 10. See also Figs. 17 and 60). Until this discovery it had been assumed that all music before the medieval invention of counterpoint was monophonic, music consisting of a single line. The first part of the song is quoted in the example. The last bar, which calls for a repeat, appears at intervals throughout the whole hymn as a kind of refrain.

Hurrian Cult Song from Ancient Ugarit Transcribed by Anne D. Kilmer

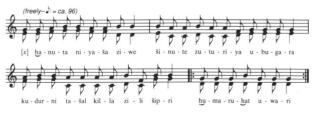

After the fall of the Sumerians, Mesopotamia was dominated in turn by the Akkadians and Assyrians. Meanwhile, nearer the Mediterranean coast, the Hebrew-speaking, nomadic tribe of Israel, a small but tenacious people, established a kingdom under Saul and his successors David and his son Solomon,

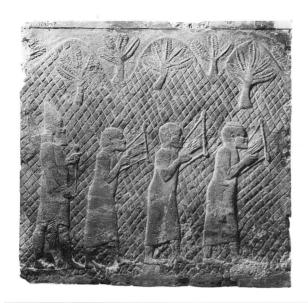

10. *Musicians Playing at Ashurbanipal's Banquet,* detail of a relief from the North Palace of Ashurbanipal at Ninevah. 668–627 B.C. Limestone, 23 × 55" (.58 × 1.4 m). British Museum.

who built a noted temple and impressive palace in Jerusalem. After Solomon's death the kingdom was divided in twain, the northern part called Israel and the southern, Judah. In 722 B.C. Israel was conquered by the Assyrians, while Judah fell in 586 B.C. to the Babylonians under Nebuchadnezzar: "And he burnt the house of the Lord, and the king's house, and all the houses of Jerusalem, and every great man's house burnt he with fire" (II Kings: 25–29). Among the captured Israelites was their king Jehoiachin and the prophet Ezekiel. Their lament is echoed eloquently in the words of Psalm 137:

By the rivers of Babylon, there we sat down, yea, we wept, when we remembered Zion.

We hanged our harps, upon the

willows in the midst thereof.

For there they that carried us away captive required of us a song; and they that wasted us required of us mirth, saying, Sing us one of the songs of Zion.

Music making under such circumstances can be seen in the carved panel from Sennacherib's palace depicting a procession of prisoners after that monarch defeated the kingdom of Israel (Fig. 10). Nebuchadnezzar's Babylon at this time had once again become a prosperous and resplendent city with its fabled Hanging Gardens. There were also a grand royal palace and an impressive temple complex surrounded by a magnificent wall and approached by spacious processional ways. The surviving Ishtar Gate (Fig. 11) was faced with enameled and molded brick that gleamed in the sun. The portal is decorated with fabulous beasts in white with yellow details, marching in solemn procession.

But pride as ever goes before a fall. As the prophet Daniel declaimed:

The king spake, and said, Is not this great Babylon, that I have built for the house of the Kingdom by the might of my power, and for the honour of my majesty?

While the words were in the king's mouth, there fell a voice from heaven, saying, O king Nebuchadnezzar, to thee it is spoken; The kingdom is departing from thee. (Dan. 4:30–31)

11. Ishtar Gate (restored), from Babylon. c. 575 B.C. Enameled baked brick, height 48'9" (15 m). Antikensammlung, Staatliche Museen, Berlin.

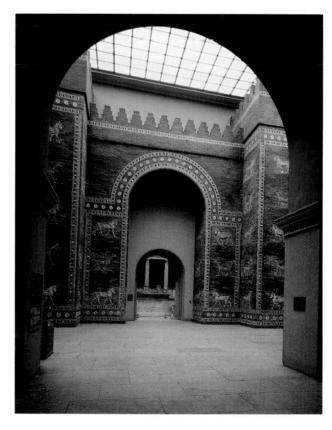

True enough, after the king's death the city was soon under siege, and the Neo-Babylonian empire fell this time to the Persians under Cyrus.

In the arts the Israelites were bound by the commandment from God to Moses: "Thou shalt not make unto thee any graven image, or any likeness of any thing that is in heaven above, or that is in earth beneath, or that is in the water under the earth" (Ex. 4:20). This effectively ruled out the representative arts of sculpture and painting. The Israelites did, however, build temples and palaces, all of which have perished in the course of time. So the primary direction of their creative thinking was then channeled into the world of letters with the compilation of the Old Testament, the first part of which, from the Book of Genesis to II Kings, achieved its present form in the late 5th century B.C.

THE EGYPTIANS

Egyptian artists, through monumental temples and spacious palaces, magnificent statues and murals,

representations of priestly ceremonies and royal processions, could give flesh and blood to the concepts of divinity, kingship, and priestly authority. Originality and innovation were discouraged, causing artists for the most part to concentrate on technique and skill of execution. Yet the paintings on the walls of Egyptian tombs show a keen eye for informal activities and naturalistic detail.

Egyptian society was like a pyramid with the Pharaoh at its apex. As a descendant of the sun he ruled with absolute authority and was responsible only to his gods and ancestors. The Pyramid of Khufu (*Cheops* in Greek) is the largest and grandest of funerary monuments, meant to last forever (Fig. 12). The statistics are staggering. Combining the basic geometrical forms of the square and triangle, it was built of 2.3 million blocks of stone, each weighing about 2.5 tons (2.3 metric tons). The stupendous structure covers more than 13 acres (5.2 hectares), encloses a volume of 85 million cubic feet (2.4 million cubic meters), and is completely solid except for two small burial chambers. To line it up

12. Sphinx (c. 2520–2494 B.C.) and Great Pyramid of Khufu (c. 2551–2528 B.C.), at Giza, Egypt. Original height of Great Pyramid 482′ (146.91 m), present height 449′ (136.86 m), base 775′ (230.12 m) square.

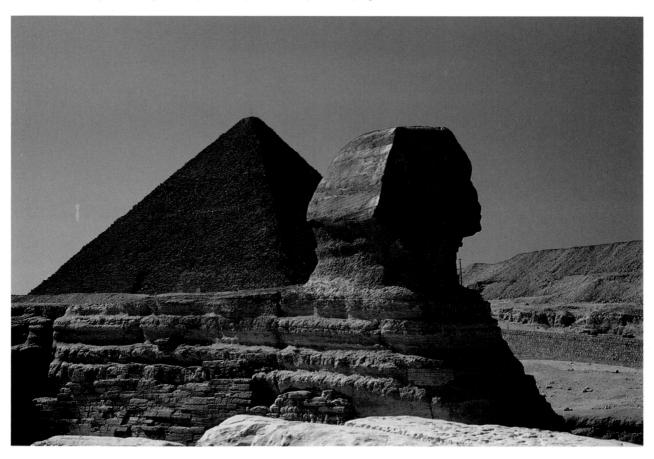

with the four corners of the world, it was surveyed so accurately that each of its 755-foot (299-meter) sides faces one of the cardinal points of the compass. So skillfully is the stone cut that joinings are scarcely visible. For centuries the pyramids have been convenient quarries, so that now the original smooth facing of varicolored sandstone and granite remains in only a few places. For sheer simplicity and endless durability, these masterly solids are likely to outlast anything human hands have ever produced.

The companions of this mighty monument are the pyramids of Khufu's dynastic successors and lesser members of the royal line. The guardian of this city of the dead is the inscrutable Sphinx (Fig. 12), which combines the crouching body of a lion with a human head. Facing the rising sun, the Sphinx's body symbolizes immortality (the Pharaohs were often buried in lionskins), while the face is thought to be a portrait of the deified King Khafre, son of Khufu.

The priestly caste made its architectural mark on the building of Egypt's temples. From its origins in the practice of occult magic, this group gradually gained in scientific knowledge and social influence. Cloaked in veils of secrecy, the priests were skilled in geometry and mathematics, knew the heavens and the movements of stars, and could predict the time when the Nile would overflow and bring renewed life to fields and gardens. At first, the priests had

13. Hypostyle Hall of Amenhotep III (c. 1390 B.C.) seen from Great Court with Colossi of Rameses II (c. 1260 B.C.). Temple of Amon, Luxor, Egypt.

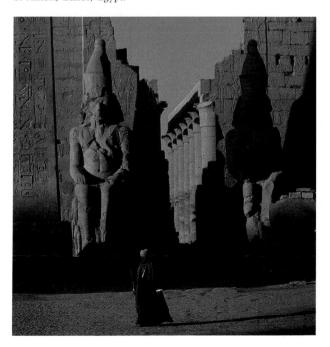

their temples carved out of rock, but gradually they caused them to assume stylized architectural forms. Worshipers approached the temples by broad avenues and entered through massive pylons, or gateways, into a forecourt. Beyond lay mysterious hypostyle halls and inner sanctums, where the roofs rested on forests of columns with carved hieroglyphic inscriptions, as in the Temple of Amon (Fig. 13). The colossal statues of Rameses II in this temple typify the aloof, rigid, unchangeable images of the pharaohs. These sculptured forms provide no suggestion of movement to disturb their majestic calm. Strict convention dictated the stance, with its severe frontality, stylized ceremonial beard, and hands placed upon the knees. As the direct descendant of Horus, god of the skies, Rameses appears as the absolute ruler and judge of his people.

The sole exception to these rigid and stylized representations of pharaohs occurred during the reign of Amenhotep IV, who rejected the many gods and rituals of his ancestors, adopted monotheism, and changed his name to Akhenaton ("Beneficial of the Aton," the universal and sole god of the sun). Akhenaton's vision is expressed in his eloquent Hymn to the Sun, which begins:

Thou appearest beautifully on the horizon of heaven, Thou living Aton, the beginning of life.

When thou art risen on the eastern horizon, Thou hast filled every land with thy beauty.

Thou art gracious, great, glistening, and high over every land; Thy rays encompass the lands to the limit of all thou hast made.

The unfinished bust of his beauteous queen, Nefertiti, was found at Tell el Amarna in the workshop of the sculptor Tuthmosis (Fig. 14). Despite the royal headdress, regal dignity, conventional elongated neck, and bright paint, the living likeness of a real personality with genuine human warmth shows through. On close examination, the queen can be seen as a woman well past the bloom of youth but not yet prey to the ravages of age. Breaking with formal conventions as well as with precedent, Akhenaton allowed himself to be portrayed informally as he offered his queen a flower and fondled his baby daughter, with Nefertiti holding two infant princesses on her lap.

Despite the restoration of polytheism, this informality carried over briefly into the reign of his successor, King Tutankhamen, famed because his is the only Pharaonic tomb found in modern times

almost intact and unplundered. On the back of Tutankhamen's throne (Fig. 15), the king is shown in a relaxed attitude talking with his wife while the sun god bestows his divine blessing with many ray-like hands.

The dominant fact of Egyptian life was death. And the art forms assume the shapes of mummy cases, stone sarcophagi, death masks, sculptured portraits, pyramids, tombs—all associated with death. The purpose was not to gladden the eye of the living, but to provide for the needs of the dead in the afterlife. Death for prominent Egyptians did not mean extinction but rather a continuation of life beyond the grave. To achieve immortality the body had to be preserved and the tomb elaborately fur-

14. Tuthmosis. *Queen Nefertiti*. c. 1340 B.C. Painted limestone with inlaid glass eye, height 20" (51 cm). Staatliche Museen, Berlin.

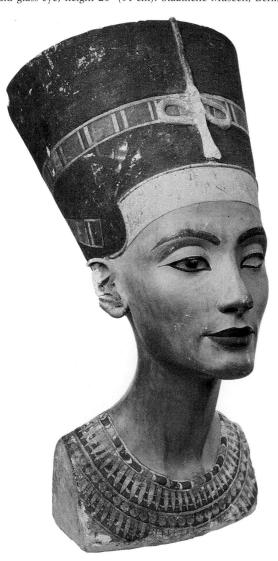

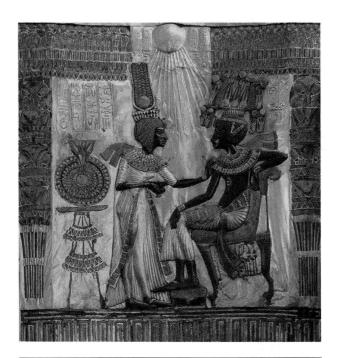

15.Back of Tutankhamen's throne, from Thebes. c. 1330 B.C.
Wood covered with gold leaf and colored inlays of faience, glass, and stone; back width 21" (53 cm). Egyptian Museum,

nished. The inner walls, floors, and ceilings were covered with hieroglyphic inscriptions that identified the deceased and recounted his or her titles and honors and with portrayals of the deceased surrounded by family and friends and occupied with his or her favorite pursuits.

After the mummy itself, the next most important object in the tomb was the lifelike representation of the deceased. Such a statue was considered to be the other self in which the *Ka*, or spirit of the person, would dwell. A pair of these speaking likenesses with all their original freshness are seen in the painted sculptures of Prince Rahotep and his wife Nofret (Fig. 16). Accuracy of portrayal including physical defects was paramount, and many have the annotation "carved from life" inscribed upon them. As always, these works were never intended for human eyes, their function intended only for the tomb.

Otherwise on the painted walls, the tomb's occupant was shown engaging in a favorite occupation such as sailing a boat, hunting or fishing, listening to music, playing games, and watching the dance. More serious pursuits included supervising work in the fields and making offerings to the gods. In such paintings and reliefs fruit and game were represented to provide for the table, and handmaidens and manservants were there to take care of all

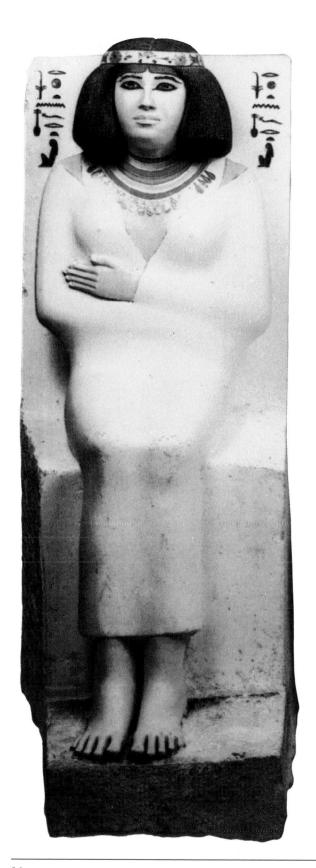

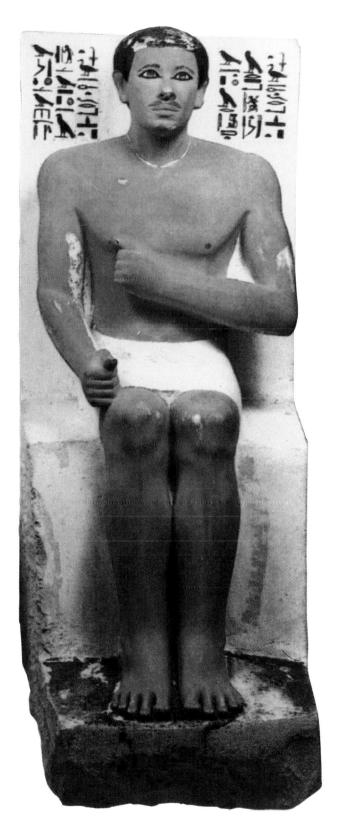

16. Prince Rahotep and His Wife Nofret. c. 2610 B.C. Painted limestone, height $47_4^{1\prime\prime}$ (1.2 m). Egyptian Museum, Cairo.

domestic needs. Everything was designed to make the deceased feel completely at home.

As seen in one of these tomb paintings (Fig. 17), the Egyptian artist was concerned only with the picture plane, not with creating illusions of depth, modeling the figures in three dimensions, or showing them against a background. According to the usual conventions, the heads are always drawn in profile, but the eyes (several thousand years before Picasso) are represented front face. The torsos are frontal, but the arms and legs offer a side view. And though the figures are shown from the right side, they have two left feet so that both big toes are toward the front. If a pool or river is included in a landscape, the view of it is from above, but fish, ducks, plants, and trees in and around it are shown sideways. Important personages always appear larger than their families, followers, or servants. Once these conventions are taken for granted, the scenes appear remarkably lifelike. Naturalistic detail is rendered so accurately that botanists and zoologists can recognize each separate species of plant and animal life. The Egyptian artist also knew how to portray the fur and feathers of animals and birds by breaking up the color surfaces with minute brushstrokes of various hues. Egyptian tomb art is thus a recreation of life as it was experienced in the flesh, and these still-vital, colorful murals provide an amazingly complete and comprehensive picture of how people behaved in an ancient civilization.

THE MINOAN AND MYCENAEAN CULTURES

Still other cultures arose in these times, with the Minoan on the eastern Mediterranean island of Crete and its surrounding islands and later with the Mycenaeans on the Peloponnesian peninsula of

17. Musicians with Double Aulos, Lute, and Harp, from Tomb of Nakht, Thebes. 18th Dynasty (c. 1420 B.c.). Height $15\frac{5}{8}$ " (40 cm).

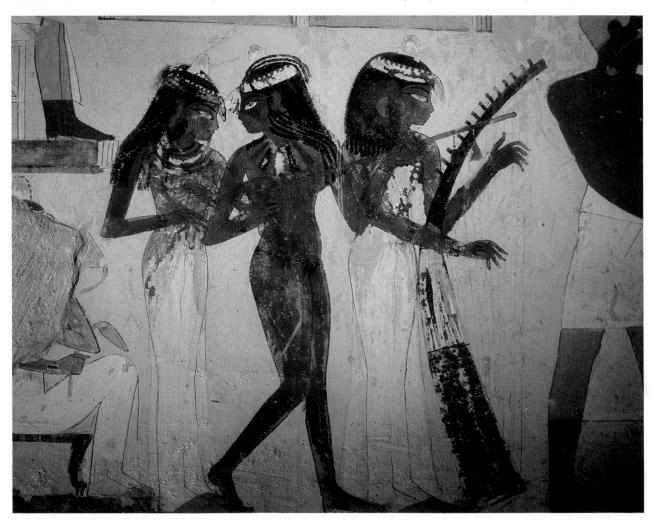

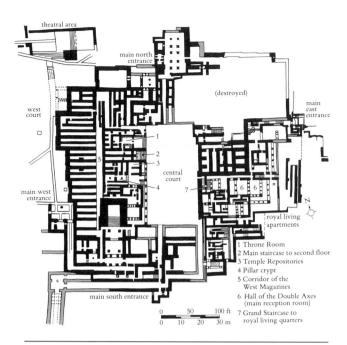

18. Plan of Palace at Knossos, Crete. c. 1600-1400 B.C.

mainland Greece. Unlike the landlocked powers of Mesopotamia and Egypt, who were dependent on rivers with their periodic floods and droughts, both the islanders and the Mycenaeans were mobile, seafaring peoples whose prosperity came from exporting their olive oil, grain, and wine, in addition to their splendid pottery and finely wrought crafts. The latter included such metalwork as gold and silver cups, jewelry, signet rings, precious metal vases, and bronze daggers.

For the people of Crete and the Cycladic Islands, the sea and their ships apparently provided all the protection they needed. They had no land fortifications, there are no records of wars, and their cities were without walls. They had no armies, no priestly caste, no temples. Only in caves or on mountaintops were there small shrines dedicated to local deities. Instead, palaces were built on their sloping hillsides with hundreds of rooms and meandering corridors (Fig. 18). These were built casually and haphazardly. Such a confusing lack of logical planning may well have given rise to the legend of the labyrinth that was thought to have contained an inner courtyard where the Minotaur, that half-man and halfbull monster who fed on hapless maidens, was found by the Athenian hero Theseus with the help of a thread spun by the Minoan princess, Ariadne.

An early example of this island art is seen in the elegant image at right (Fig. 19). Here the female form is simplified and abstracted into a compact, flattened shape. The purpose of these idols is not

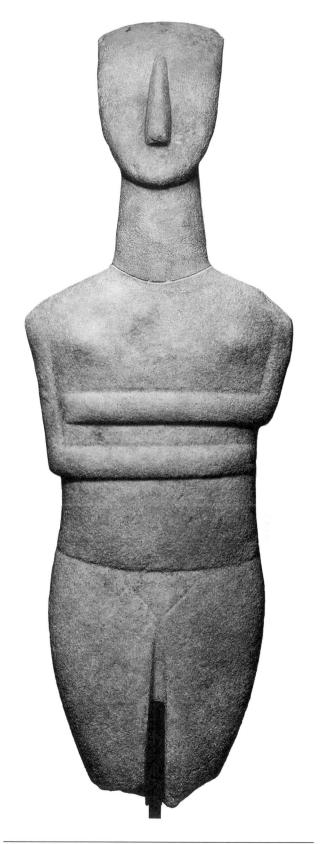

Female Figure from the Cyclades Islands. (c. 2500–2000 B.C.) Marble, $16\frac{1}{4}'' \times 55\frac{1}{8}''$ (41.2 cm). Kimbell Art Museum, Fort Worth, Texas.

known. Because they cannot stand upright, they are not statuettes. Found in tombs, where they were placed beside the body, these carved figures may be goddesses, fertility-cult forms, guides to the underworld, or spirits of the dead. The artist has stamped a preconceived geometrical outline on the material, which is the fine-grained white crystalline marble found in the Cycladic Islands north of Crete. The smooth surface treatment is broken by the sharp angular arrangement of the arms, the long, straight noses, and the conventional flat-topped heads devoid of other facial features.

The walls of the Minoan palaces and houses were lavishly decorated with lively fresco murals. The pictures reflect the happy temperament of a pleasure-loving people who looked to the natural world for their inspiration and decorative motifs. Entering a house on the island of Thera must have been like walking into a flower garden filled with songbirds on the wing (see Fig. 20). In some scenes one sees cats chasing ducks on riverbanks or lion and bull hunts in progress. In others, dancing figures in gauzy drapery are depicted. All are done with a

lightness of touch, a love of bright pastel colors, and a fondness for capturing the fleeting moment. Curiously, there are no instances of portraiture, storytelling, or heroic legends.

The decline of the Minoan culture was accompanied by the rise of the mainland Mycenaeans, who challenged the Minoan command of the seas and eventually took over Crete, apparently without a struggle. In many ways the two cultures are linked. They both spoke the same language, which has been identified as Linear-B, and the Mycenaeans had learned much from the older and more highly developed Minoan culture. The character of the Mycenaeans, however, was shaped by their harsher environment and the need for their rulers and warriors to defend themselves on land by the sword.

Stout fortifications enclosed their palace complexes, while the farming folk had to live outside the walls in mud-brick or wooden houses with earthen floors. Surviving is the renowned Lion Gate at Mycenae (Fig. 21), dating from about 1250 B.C. It was the entrance portal to the fortified citadel. Above the doorway appear twin rampant lions carved in bold

20. Mural from Thera. Room with landscape frescoes, House Delta, Thera. Minoan, c. 1500 B.C. National Archeological Museum, Athens.

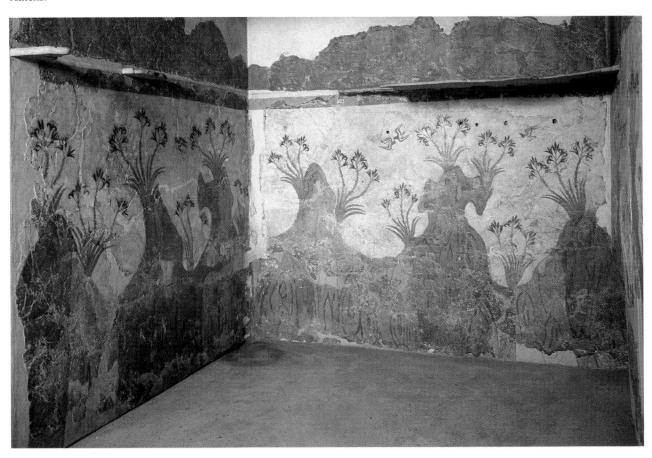

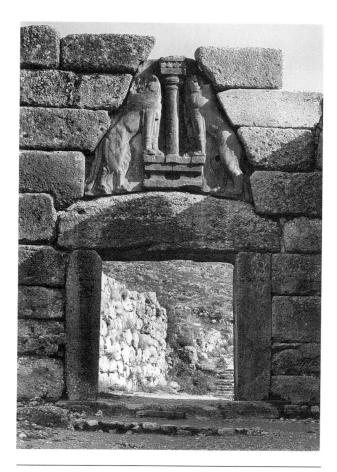

21. Lion Gate. c. 1250 B.c. Limestone high relief, height 9'6" (2.9 m). Mycenae, Greece.

high relief. The workmanship seems quite crude, but the heraldic role signifying power and strength undoubtedly outweighed the need for sculptural refinement. The nearby beehive-shaped royal tombs, however, with their 44-foot-high domes are marked by finely dressed and skillfully joined stone masonry, obviously built to last for the ages. The general effect is that of a monumental structure of stateliness and dignity.

Mycenae flourished at the time of the Trojan War, when Homer's heroes walked the earth. The legends and lore of the period also found their way into the plays by the major Athenian dramatists—Aeschylus, Sophocles, and Euripides. Even a brief genealogy rings out with the fabled names of King Atreus, founder of the royal house. One son, Agamemnon, married his cousin Clytemnestra and fathered Orestes, Electra, and Iphigenia. The other, Menelaus, espoused the beauteous Helen, who was abducted by the Trojan prince Paris, the act that became the reputed cause of the Trojan War as sung by the blind Homer in the *Iliad*.

With the migration of the Dorian Greeks from the north in the 12th century, the Mycenaean settlements were burnt and pillaged, thus bringing their culture to an abrupt end. In historical perspective, the Mycenaean civilization can be considered either as a postscript to the Minoan or as a transitional time pointing toward the Greeks of the classical period.

IDEAS: DYNAMICS OF HISTORY

Art history, like philosophy and science, is concerned with causes and effects. Thus, in reviewing the major styles of Western culture, one should keep in mind the mainstreams of influence. The dynamics of contact and conquest affect both the condition of life and the expression in art. But conquest is a double-edged sword. On one side the conquerors stamp their image on the conquered; on the other the overlords absorb many of the forms and expressions characteristic of the subjugated peoples.

Mesopotamia and Egypt developed as selfsufficient, landlocked powers and closed societies that, with little dependence on outside forces, were nurtured from inner reserves. But the islanders and Greeks were seafaring folk and, like the Romans after them, had to look beyond their shores for the maritime trade, commercial ventures, and colonization essential to their survival. The Greeks came in contact with Egyptian and Mesopotamian scientific and artistic traditions and then absorbed, refined, and transformed them into their own unparalleled achievements. Rome, as the cultural melting pot of antiquity, successfully merged the ideas, building methods, ornamental motifs, plastic and pictorial traditions, literary and musical expressions of the Greek, Near Eastern, Egyptian, North African, and Etruscan cultures, together with significant contributions of their own.

Arts and Society

Because artists must represent their world as they themselves see it, their work becomes a reflection of their time from a particular point of view. Their temples, statues, pictures, poems, or pieces of music are indications of the way sensitive members of that society imagine, dream, think, feel, and communicate. In this light, a building is not a mere pile of sticks and stones, steel and glass, no matter how interesting the shapes these materials may assume. Rather, it is a created environment, a form of action for some social activity. Masses and voids, solids and hollows, create rhythms in space. It could be said that the architect is the ballet master who writes the figure of a dance that all who enter the structure must

perform. From architectural engineering it is possible to tell how much a people knew about their environment, how advanced their scientific knowledge was, whether they were hunters or farmers, kings or commoners.

No art, however, is independent of its companion arts. Architecture finds its natural ally in sculpture as embellishment that relieves that strict functionalism of a structure. Sculpture can provide focal points of interest and give meaning to a building. In ancient times reliefs and freestanding statues were a visual reflection of the activity the architectural setting was designed to house. In a more exalted sense a statue becomes the image of the heroic or godlike ideal toward which a people is striving.

Paintings, frescoes, and mosaics supply the pictorial dimension. In them one discovers the profile of an age as well as the hopes and fears of the people who created them. Poetry and music crystallize the rhythms of human activity in songs and dances that reflect work and play, joy and sorrow, as well as the deepest longings and highest aspirations of the human heart.

Whether architect, sculptor, painter, poet, or musician, the artist begins the creative process with the vanishing point of the void—empty space and undefined time—then *composes* in the literal sense of selecting materials, placing them together, building them up. The procedure is from the singular toward the plural, from unrelatedness to relatedness, as the artist reaches out toward the order and unity of a particular style.

The *conventions* of a period are the inherited, invented, and prescribed formulas the people who formed its culture generally understood. The traditional arrangement of areas and rooms in a temple or dwelling, the larger-than-life representations and rigid postures of gods and rulers, the appearance of a masked deity or hero to pronounce the prologue and epilogue of a Greek drama, the required fourteen lines of a sonnet, the repeated rhythmic patterns of dances, the way characters speak in rhymed meters in poetic drama and sing their lines in opera—all are conveniences that became conventions through their acceptance by a representative number of people whose commonly held values and attitudes formed a culture.

The work of a period or particular artist is often criticized because it seems conventional or full of clichés. But all art is based on the observation of some rules. When everything is too much as expected, it tends to be repetitious and boring; however, if all is completely new or unanticipated, it becomes bewildering. Competent artisans of any time can master the basic media, the necessary techniques, the accepted conventions of their era. Only the true artist

knows how to depart from the rules meaningfully and how to break them brilliantly. Conventions are a body of habits, but a significant work is a product of genius. Conventions are perspiration; art is inspiration. Conventions are predictable; greatness is unpredictable. Conventions are the heritage of tradition; innovations are the mark of change.

The shift in prehistory from a nomadic to a communal life, from a food-hunting to a food-gathering society, from an animal-chasing to a cattlebreeding economy was reflected in the arts by the shift from naturalistic or direct imitation of nature to a more geometric art based on formal principles and traditional conventions. Concrete images yielded to abstract forms, naturalism to stylization, imitation to idealization, the actual to the metaphorical. In short, the rendering of reality was replaced by accepted conventions. These are the polar extremes in relation to which the art of all following periods tended to express itself—the faithful portrayal of the natural appearance and "speaking" likeness on the one hand and the conceptual, geometric, stylized conventions of the established formulas on the other.

Stylistic Unity and Diversity

The search for unity within historical style periods, or at least for a logical grouping of diversities, is crucial for both defining style and criticizing art. Cultural expressions, in the manner of the classical unities of Greek drama, usually occur within definite limits of time, place, and action. The search for the underlying ideas that motivate human activities can often reduce to simplicity what appears on the surface as a confusing multiplicity of directions. And because the arts are usually experienced simultaneously, not separately, it is often wiser to seek understanding from many directions rather than from one. If a common pattern of ideas can be found, then aspects that previously proved baffling may suddenly fall into place and acquire meaning.

Such ideas may be originated by artists themselves, either individually or as a group, or by single or collective patrons who have the insight, means, and energy to pursue complicated projects to completion. Such a patron might be a ruler with the vision of Pericles, who presided over the cultural climax of ancient Athens; an enterprising medieval abbot or bishop who envisaged a great monastery or cathedral complex; a family of merchant princes, such as the Medici, who brought Renaissance Florence to its creative peak; or a religious order like the Jesuits, who spread the Counter-Reformation baroque style in the wake of their missionary activities. The 20th century has witnessed the Commonwealth of India commissioning the Swiss-born architect Le

Corbusier to design and construct Chandigarh, an entirely new capital city for the East Punjab, complete with every public and private facility. In New York, the heirs of a modern industrialist sponsored an architectural complex in Rockefeller Center that compares in grandeur with the imperial forums of ancient Rome. And many public agencies and private contributors joined forces to erect in New York the Lincoln Center "acropolis" that embraces a group of opera houses, concert halls, repertory theaters, libraries, museums, and educational and cultural centers (Fig. 22).

Whenever a center has attained a degree of civilization, has developed a prosperous economy, has produced a number of promising individuals, has fostered an adequate educational system, has in its midst groups of artists and artisans, a significant cultural expression may occur. When this happens, it is

usually because some individuals with powerful convictions have reacted so strongly to the challenge of their time that they are catapulted into dominating positions.

Various explanations have been advanced for this phenomenon, such as the theory that outstanding persons stamp their image upon an age and that genius is the primary causal influence on history. Social realists, however, contend that environmental forces shape the characters and actions of the individuals involved. The truth probably lies somewhere between these extremes of nature and nurture. The interplay between powerful personalities and the social stimulus of their times usually brings about the explosion that is commonly described as genius.

Techniques of production are the private problems of particular artists. Composition, however, is common to them all. An architect puts together

22. Harrison and Abramowitz. Lincoln Center, New York, 1959–66. Metropolitan Opera House (center) 1962–66; Avery Fisher Hall (right) 1959–62. Philip Johnson. New York State Theater (left) 1964.

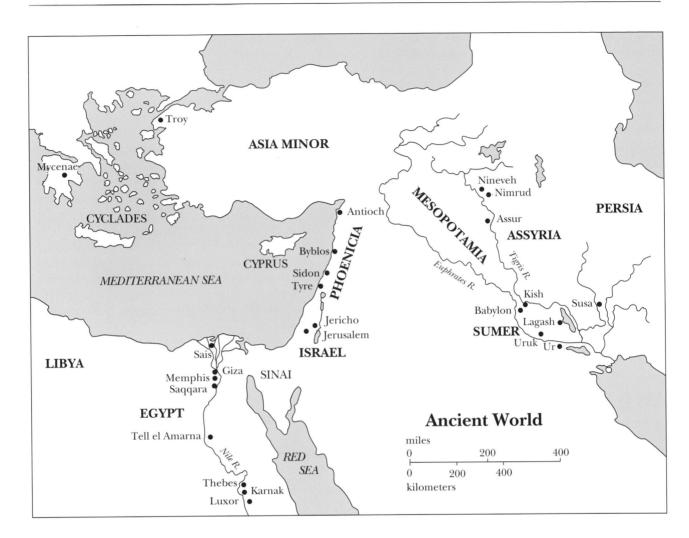

building materials, a poet words, a musician tones. But contrary to the views of some purists, they do not do so merely in order to express themselves but in order to communicate thoughts, fantasies, social comments, satirical observations, self-revelations, images of order, and the like. Their works—temples, statues, murals, odes, sonatas, symphonies—are addressed not to themselves but to their fellow human beings.

The choice of medium, the way of handling materials, the language used to express thoughts, personal idioms and idiosyncrasies, mode of vision, manner of representing the world, all add up to a vocabulary of symbols and images that define an artist's individual *style*. In a broader sense, however, a style must include similar expressions in many media, whether in visual, verbal, or tonal forms. Artists working within a given time and place share a common sociocultural heritage; therefore, it follows that each has a common point of departure. In the arts, as in politics, there are conservatives who try to preserve traditional values, liberals who are concerned with current trends, and progressives who point to coming developments. The individual artist

may accept or reject, endorse or protest, conform or reform, construct or destroy, dream of the past or prophesy the future, but the taking-off point must be the artist's own time. The accents with which artists and their contemporaries speak, the vocabularies they choose, the passion with which they champion ideas, all add up to the larger synthesis of a period style.

A positive approach in the search for stylistic unity, then, can be established on the coincidence of time, place, and idea. Artists, while working in separate fields, are a basic part of a society, living within a certain geographical and temporal center, and collaborating in varying degrees with each other and with the larger social group. The closer the coincidence of these factors, the closer the relationship will be. Composite works of art-forums, monasteries, cathedrals, operas—are always collaborative in nature and must be made to express the many interests and activities they are designed to serve. Liturgical needs, for instance, have to be taken into account in the design of a cathedral, and the sculptural and pictorial schemes must fit into an iconographic, or symbolic, program and the overall archi*tectonic*, or structural, plan. Hence in one *time* and in one *place*, the arts of architecture, sculpture, painting, music, literature, and liturgy share a common constellation of *ideas* in relation to the contemporary social order and its spiritual aspirations.

True history is no mere record of dates, treaties, battles, kings, and generals. Aristotle long ago recognized this vital fact when he placed poetic truth higher than historical truth. The political experience of a nation is but one phase of its whole life. If one desires to know the spirit and inner life of a people, one must look at its art, literature, dances, and music, where the spirit of the whole people is reflected. While kings, dynasties, and dictators rise and fall, and while political revolutions and battles seem abruptly to settle the affairs of nations, the arts, as the expression of the living unity of a people, reveal the continuity of life.

Present and Past

The past is now more than ever before a vital part of the present time, as the 20th century becomes the heir to the cumulative riches of all the ages. The continuous discoveries of archeologists, anthropologists, and historians are constantly bringing to light more precise knowledge of the remote past and thereby increasing our present-day cultural wealth. Before the late 18th century, for instance, Greek art was known principally through the adaptations and copies made by the ancient Romans. The Western world's first glimpse of the great Greek originals of the 5th century B.C. came in the early 19th century, when Lord Elgin transported many of the Parthenon sculptures from Athens to London. Ancient Greek works continue to come to light. Very recently a rare bronze statue was discovered from an ancient shipwreck off the southern Italian coast. It is discussed in the following chapter (see Fig. 65). Similarly, the Old Stone Age wall paintings of the cave people of Altamira in northern Spain were accidentally discovered in 1879. As a result, the frontiers of art and civilization were pushed back by some 30,000 years.

The foundations of Western civilization are to be found in the life and arts of ancient Mesopotamia and Egypt, yet our interest in and knowledge of the ancient Near East are quite recent. Egyptian art first influenced modern taste in the 18th century in the form of rococo fancies. Popular and scientific interest gained momentum with Napoleon's expeditions, grew steadily throughout the 19th century, and eventually produced the discovery in 1922 of Tutankhamen's tomb. Its rich yield of art works had remained hidden for well over 3,000 years. The Mesopotamian civilizations occupied scholars and collectors throughout the 19th century, but the high points of discovery came only with the early 20th-

century excavations of Babylon and the unearthing of the Sumerian royal tombs at Ur in 1922. Likewise, knowledge of the Minoan and Mycenaean cultures is based on digs that began in the mid-19th and continued on through the 20th century.

The past is thus constantly alive and ever present. In order to achieve a fuller understanding of the arts, therefore, we must view them within this expanded contemporary time framework. So to the question of what is old and what is new, the answer must inevitably be that everything is both old *and* new—all art is a kind of cumulative momentum of a past that permeates the present, a continuous mixture of ideas and motifs, media and techniques, shapes and forms.

Through the study of the arts in relation to the life and time out of which they spring, a richer, broader, deeper humanistic understanding can be achieved. The past, as reflected in the arts, exists as a continuous process, and any arbitrary separation from the present and future disappears in the presence of a living work. True critical judgment of art, or indeed of any other human activity, can never be a catalogue of minutiae, a record of isolated moments. Understanding can come only when one event is related to another, and when their sum total is absorbed into the growing stream of universal life from which each particular moment derives its significance. In their natural relationship, the arts become the study of people reflected in the everchanging images of men and women as they journey across historical time, search for reality, and strive to achieve the ideals that create meaning for life.

All creative activity begins in the mind's eye and ear of the artist, but a work of art that does not communicate meaning is stillborn. Art, then, is a two-way process involving both creator and recreator. The activity of the recreator, to be sure, may be less than that of the artist, but it is a dynamic activity nevertheless. The experience of responding to a work of art conjures up corresponding sets of perceptions, images, and impressions of one's own. To play this part in the creative act, the recreator must learn the visual, verbal, and auditory vocabularies that make communication possible and that distinguish the finer nuances of sight and sound. Imagination and knowledge must be summoned to supply the frame of reference and the aura that once surrounded the work of art in its original context. Hence it is necessary to know the period and style, the social and religious circumstances, the patronage system and personal situation within which the artist worked. These pages, then, have been written to guide the viewer, reader, and listener on the quest for enjoyment, knowledge, and understanding of the human experience.

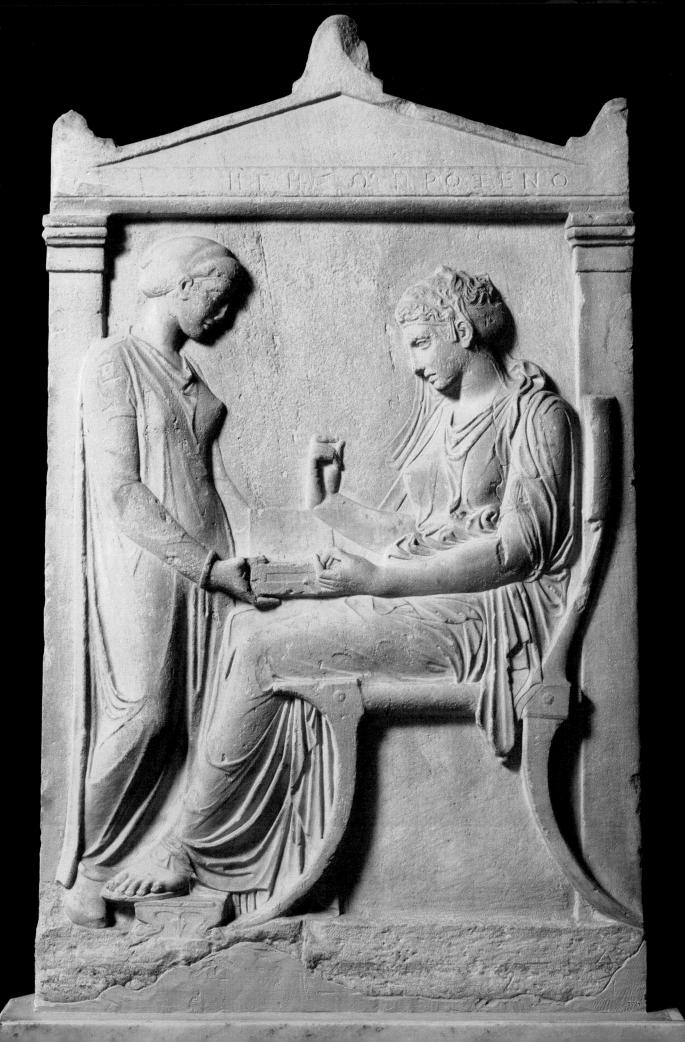

P A R T

The Classical

Period

he Greco-Roman classical period spanned about a thousand years. It extended from the glorious age of Pericles, when Greek culture reached its zenith: witnessed the expansion of Greek settlements far and wide under Alexander the Great; saw the rise of Roman power, the grandeur of the Roman empire, and its eventual decline and fall; and ultimately beheld the rise of Christianity as a social, political, and religious force. The period divides itself into a purely Hellenic phase, a more expansive and widespread Hellenistic continuation, the age of the late Roman republic and empire, and the early Christian period.

Instead of accepting mythological and religious explanations of their world, Greek philosophers examined the physical world for themselves. In the 6th century B.C., Pythagoras discovered a unity in nature based on numbers. As the heavenly bodies described their mathematically predictable orbits, they were thought to create a musical harmony of the spheres. Socrates' eloquent pursuit of the goals of

truth, goodness, and beauty inspired his pupil Plato, the supreme idealist for whom the world of ideas was preeminent. Aristotle's more down-to-earth approach brought together all current knowledge on logic, ethics, politics, poetics, physics, and metaphysics. His thinking was to remain influential for the next two thousand years.

The Romans in turn were adept at applying general principles to practical problems. They developed public-works projects, architecture, and the science of engineering. At the pinnacle of its power, Roman practicality and administrative genius succeeded in bringing the entire Western world under its dominion of law and order. In later antiquity, Roman forms and institutions found their way into the early Christian tradition as the empire was divided into the eastern Byzantine sector at Constantinople and a western section with its capital at Ravenna.

Throughout these phases and in various cultural centers, the arts flourished with unparalleled brilliance. In architecture, the Greeks carried the post-andlintel system to perfection in their gleaming temples. The Romans, building for larger cities and populations, brought the arch-and-vault method to its peak. Sculpture, based on the expressive power of the human body, achieved lifelike plasticity and fluidity, while vase painting, large-scale murals, and mosaics provided the pictorial dimension. Taught in the schools, music played a prominent role in ancient social and religious life. Greek musical theory laid the basis for all future musical development in the West. Greek and Roman epic, lyric, and dramatic writing mirrored the ancients' search for self-understanding and self-awareness. Drama especially provided insights into human character and its motivations. Greek tragedy scaled the heights and plumbed the depths of human potential and spirit.

Such a period has earned the title "classic" both for the perfection of its works of art and for creating models for future periods to emulate.

ATHENS, 5th CENTURY B.C.

	KEY EVENTS	ARCHITECTURE	VISUAL ARTS	WRITERS	MUSIC
	776 First Olympic games; beginning of Greek calendar c.650-c.500 Archaic period	c.650 Ionic temple of Artemis built at Ephesus c.530 Archaic Doric temples built at Athens, Delphi, Corinth, Olympia	c.600 Kouroi (youths) from Sounion carved c.550 Korai (maidens) from Samos carved	c.750 Hesiod ◆ c.700 Homer ◆ c.600 Sappho ◆ c.582-c.507 Pythagoras ○ 525-456 Aeschylus ★ 520-447 Pindar ◆	
500 - 400 -	c.494 Persians under Darius invaded Greece c.490 Athenians defeated Persians at Marathon 480 Persians under Xerxes defeated Spartans at Thermopylae. Athens sacked and burned. Athenians defeated Persian fleet at Salamis 477 Delian League against Persians set up under Athenian leadership 468- 450 Cimon (c.505-450), general leader of conservative aristocratic party, dominated Athenian politics 456 Athenian land empire reaches greatest extent 454 Delian League treasury moved to Athens 449- 429 Pericles (c. 490- 429), leader of popular party, ruled Athens 431- 404 Peloponnesian War between Athens and Sparta 413 Athenians defeated at Syracuse, Sicily 404 Athens fell to Sparta. End of Athenian Empire.	c.489 Doric treasury of Athenians built at Delphi c.480 Temple of Olympian Zeus built at Agrigentum, Sicily c.465-c.457 Temple of Zeus built at Olympia 450 Phidias appointed overseer of works on Athenian acropolis 448- 440 Temple of Hephaestus (Theseum) built 447- 432 Parthenon built by Ictinus 437- 432 Propylaea built by Mnesicles 427- 424 Temple of Athena Nike built by Callicrates 421- 409 Erechtheum built by Mnesicles	c.490-c.432 Phidias ● c.480-c.430 Polygnotus (noted for perspective drawing) ▲ c.475 Charioteer of Delphi cast in bronze c.460 Zeus (Poseidon?) cast in bronze c.460-c.450 Myron active ● c.460-c.440 Polyclitus active ● c.450 Myron cast Discobolus c.450 Phidias carved Athena Lemnia 447 Parthenon sculptures carved under Phidias: metopes 447-442; inner frieze 442-438; Phidias' cult statue dedicated 438; pediments 438-432 c.440 Apollodorus, the "shadow painter" (modeled figures in light and shade), flourished ▲	500-428 Anaxagoras ○ 496-406 Sophocles ★ c.495-425 Herodotus ■ 485-411 Protagoras ○ 480-406 Euripides ★ 469-399 Socrates ○ c.460-395 Thucydides ■ c.444-380 Aristophanes ★ c.434-c.355 Xenophon ■ 427-327 Plato ○	Principal instruments: Lyre (8 strings), aulos (woodwind), panpipes (reeds of various lengths and pitches) Plato's dialogues and Aristotle's treatises deal extensively with musical theory, practice, and ethical implications of music in education and life
	359- 336 Philip of Macedon gained control of Greek peninsula 336 Alexander the Great succeeded Philip as King of Greece 335 Aristotle founded Lyceum 335- 323 Alexander conquered Near East, Asia Minor, Persia; India reached 146 Corinth destroyed by Romans 86 Athens sacked by Romans under Sulla	334 Choragic monument of Lysicrates built. First external use of Corinthian order A.D. c.117 Temple of Olympian Zeus completed	c.390-c.330 Praxiteles C.350-c.300 Lysippus active c.340 Praxiteles carved Hermes and Infant Dionysus, and Aphrodite of Cnidos	A.D. c.100 Plutarch (c.46-c.115) wrote Parallel Lives A.D.c140-150 Pausanias visited Athens, later wrote description of Greece	c.321 Aristoxenus of Tarentum wrote treatise on Greek music c.300 Euclid wrote treatise on music

The Hellenic Style

ATHENS, 5TH CENTURY B.C.

In the land of Hellas, a small city-state dedicated to Athena, goddess of wisdom, saw the birth of a new spirit—a spirit destined to quicken the human heart and mind then, now, and for ages to come. Here in Athens for a brief span of time were concentrated the creative energies of many geniuses. There were leaders capable of securing Athens's victory in the struggle to dominate the Mediterranean world (see map, p. 55); statesmen with the perception to make Athens the first democracy in an era of tyrants; philosophers committed to search for an understanding of the physical, social, and spiritual nature of the environment they lived in; and artists who conceived daring expressions in stone, word, and tone.

In 480 $_{\rm B.C.}$ the Athenians had turned the tide against the powerful Persians, but only after their

city had been reduced to rubble. Without hereditary rulers, government rested on the shoulders of the citizen class, and the rule of the *demos*, the "people," became the order of the day. Here the statesman Pericles and the philosopher Socrates heard the wisdom of Anaxagoras, who taught that the universe was governed by a supreme mind that brought form out of the chaos of nature. He also taught that people, by thinking for themselves, could likewise bring order into human affairs.

After the destruction of their city, the Athenians boldly faced the future. They launched a new building program that surpassed anything the world had ever seen, one that would serve as a model for all future ages.

Like many other ancient cities, Athens had developed around an *acra*, or "hill," originally found suitable as a military vantage point. A long-

23. Acropolis, Athens, from northwest.

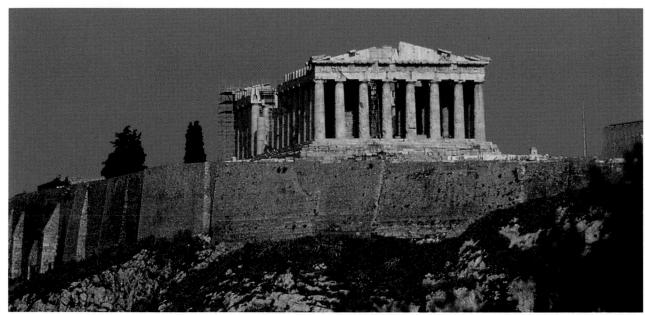

ago victory on this fortified hilltop, known as the *acropolis* (Fig. 23), had been attributed to the help of the gods. This caused the people to regard the acra as a sacred place, one to be crowned with an appropriate monument. Civic buildings, palaces, and temples were erected, and the people in the city below looked up with pride toward the acropolis that recorded their history, represented their aspirations, and had become the center of their religious, cultural, and civic ceremonies.

From the beginning, the Athenian acropolis was never static, and its successive buildings reflected the city's changing fortunes. Once it had been the site of a palace for the legendary king Erechtheus. Later it shifted from a military citadel and royal residence to a religious shrine, especially sacred to Athena as the city's protectress. This change is described by the poet Homer in the *Odyssey:* "Therewith gray-eyed Athene departed over the unharvested seas, left pleasant Scheria, and came to Marathon and wide-wayed Athens, and entered the house of Erechtheus."

Spreading out from the base of the acropolis was the *agora* (Fig. 24), a meeting and a market place, with rows of columns, public buildings, market stalls, gardens, and shade trees. This 10-acre (4-hectare) square was the center of the city's bustling business, social, and political life. Here could be found country folk selling their wares, citizens discussing the news, foreign visitors exchanging stories, and magistrates conducting routine city affairs.

On a typical day the philosopher Socrates could be heard arguing with the sophists, whom he called "retailers of knowledge," for as his pupil Plato was to point out, the merchandising in the agora was "partly concerned with food for the use of the body, and partly with food of the soul which is bartered and received in exchange for money." The sophists were concerned primarily with the art of persuasive speech, but some professed to teach wisdom as well. As manipulators of public opinion, they often became intellectual opportunists who would use any argument so long as it turned their trick. In his disputations, Socrates showed that sophistry was more a matter of quibbling on the surface over words than of penetrating deeply into the world of ideas. By pricking some of the sophists' pretensions with the sting of his wit, Socrates gained his immortal reputation as the "gadfly" of Athens.

On the southern slope of the acropolis was the theater of Dionysus (Fig. 25, upper right), the sanctuary dedicated to the god of wine and revelry and patron of the drama. Here, more than two thousand years before Shakespeare, the Athenians gathered to marvel at the plays that mirrored their world in dra-

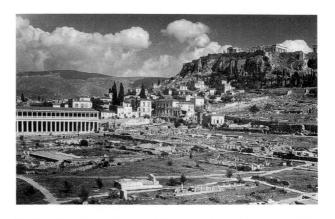

Agora, Athens. Reconstruction of Stoa of Attalus II of Pergamon, c. 150 B.c. (left). Acropolis is at upper right.

matic form. Annually, through their applause they chose the winner of the coveted poetry prize that had been won no less than thirteen times by Aeschylus, the founder of heroic tragedy. Sophocles, his successor and principal poet of the Periclean period, quickened the pace of Greek drama by adding more actors and action. Euripides, last of the great tragic poets, explored the full range of emotions, endowing his plays with such passion and pathos that they rose to the heights and plumbed the depths of the human spirit. After the great Periclean age was past, the comedies of Aristophanes proved that the Athenians still were able to see the humor of life.

Above the theater, on the rocky plateau of the acropolis, was a leveled site, about 1000 feet (304 meters) long and 445 feet (135.2 meters) wide, where the temples were constructed (Fig. 26). Under Cimon and his successor Pericles, this was a place of ceaseless activity by builders, sculptors, painters, and other craftsmen. Later Plutarch was to declare in his biography of Pericles that as the buildings rose, stately in size and fair in form, the craftsmen were "striving to outvie the material and the design with the beauty of their workmanship, yet the most wonderful thing of all was the rapidity of their execution. Undertakings, any one of which singly might have required, . . . for their completion, several successions and ages of men, were every one of them accomplished in the height and prime of one man's political service."

Pericles had the daring and wisdom to foresee that the unity of a people could rest on philosophical ideas and artistic leadership as well as on military might and material prosperity. A seafaring people, the Athenians had always looked beyond the horizon for ideas as well as goods to enrich their way of life. In the Delian League, once the Persian threats

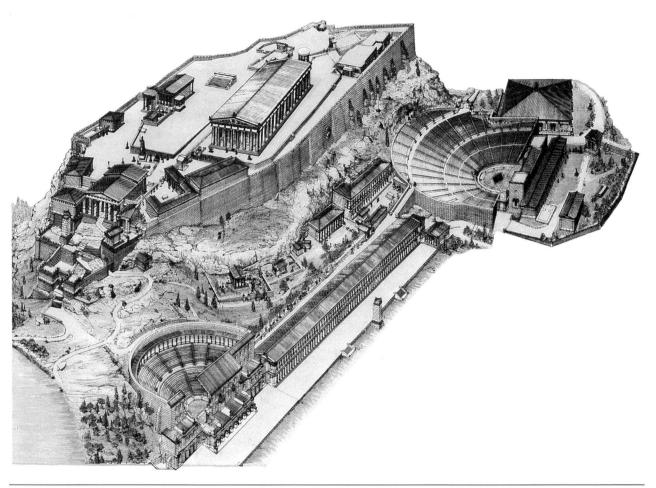

25. Acropolis, Athens. Reconstruction drawing as of end of A.D. 2nd century. Upper right, theater of Dionysus, 4th century B.C.; lower left, Odelon of Herodes Atticus, A.D. 2nd century. Reconstruction by Al. N. Oikonomides.

were ended, the Athenians joined with the broader community of Greek-speaking peoples of the mainland, the Aegean islands, and the coast of Asia Minor to defend themselves and to achieve cultural unity.

When the Delian treasury was brought to Athens and its ample funds became available for its building program, the city was assured leadership in the arts as well as in other practical and idealistic enterprises. Thus Athens became a city whose acknowledged wealth was in its dramatists Aeschylus, Sophocles, and Euripides; its architects Ictinus, Callicrates, and Mnesicles; its sculptors Myron and Phidias; and such painters and craftsmen as Polygnotus and Apollodorus.

The acropolis itself was both the material and spiritual treasury of the Athenians, the place that held both their worldly gold reserves and their religious and artistic monuments. Work continued with undimished enthusiasm until by the end of the 5th

26. Plan of Athenian acropolis, with Propylaea (a), Temple of Athena Nike (b), Parthenon (c), and Erechtheum (d).

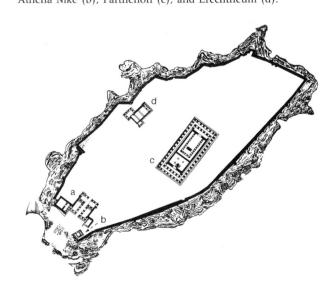

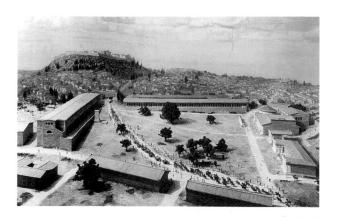

27. Athenian agora with Panathenaic Way. Reconstruction. Royal Ontario Museum, Toronto.

century B.C. the acropolis had become a sublime setting, worthy of the goddess of wisdom and beauty. It was also the pedestal that proudly bore the shining temples dedicated to her.

ARCHITECTURE

The Acropolis and the Propylaea

On festive occasions, the Athenians would leave their modest homes to walk along the Panathenaic Way (Fig. 27), the main avenue of their city, toward the acropolis. Towering above them was the supreme shrine—the acropolis where they worshiped their gods, commemorated their heroes, and recreated themselves. Accessible only by a single zigzag path up the western slope, the ascent was never easy. In Aristophanes' *Lysistrata*, a chorus of old men bearing olive branches to kindle the sacred fires chants as they mount the hill: "But look, to finish this toilsome climb only this last steep bit is left to mount. Truly, it's no easy job without beasts of burden and how these logs do bruise my shoulder!"

As the procession neared the top, the exquisite little Temple of Athena Nike appeared on a parapet to the right (see Fig. 37), and ahead was the mighty Propylaea, the imposing gateway to the acropolis (Fig. 28). This project, undertaken shortly after the completion of the Parthenon, was entrusted by Pericles to Mnesicles. The principal architect of the Parthenon, Ictinus, also probably had a hand in planning the Propylaea, whose further relationship to the Parthenon can be found in the proportions of its forms, in the presence of certain features of the Ionic order in a dominantly Doric structure, and in the main axis that the Propylaea shares with the larger monument.

The Propylaea was built mainly of Pentelic marble from nearby Mt. Pentelicus except for some dark contrasting Eleusinian stone. It was thus a spacious gateway with wings extending on either side to an overall width of about 156 feet (47.5 meters). An enclosure on the left was a picture gallery, and an open room on the right contained statues. In the center was the porch consisting of six Doric columns with the middle two spaced more widely apart, as if to invite entrance. Between the columns looking toward the city and the corresponding ones on the opposite side facing the acropolis plateau was an open vestibule with columns of the more slender Ionic order, which permitted greater height and space for exhibitions and the waiting crowds (Fig. 29).

Through the gateway of the Propylaea the procession entered the sacred area. Amid the revered monuments to the gods and heroes and looming above them was the colossal statue of Athena Promachus, said to have been fashioned by Phidias from the bronze shields of defeated Persian enemies. The tip of her spear is said to have gleamed brightly enough to guide homecoming sailors over the seas toward Athens. On the right was the majestic Parthenon, on the left the graceful Erechtheum.

The Parthenon

DORIC ORDER. At first glance, the Parthenon seems to be a typical Doric temple (Fig. 30). Such a shrine was originally conceived as an idealized dwelling to house the image of a deity. Under a low-pitched gabled roof, the interior was a windowless rectangular space called the cella, which sheltered the cult statue of the deity to whom the temple was dedicated. The portal, or doorway, to the cella was on one of the short ends, which extended outward in a portico, or porch, faced with columns to form the façade, or front. Sometimes columns were erected around the building in a series known as a colonnade. The construction was simple: a platform of three steps, the top one known as the *stylobate*, from which rose the upright posts that supported the lintels, or horizontal beams. When these columns and lintels were made of marble, the weight and size of the superstucture could be increased and the intercolumniation, or span between the supporting posts, widened. The history of Greek temple architecture was largely the refining of this post-and-lintel system of construction, which permitted the architects a steadily increasing freedom as time went on.

The *capital*, or crown, of the Doric column is in three parts: the necking, the echinus, and the abacus (Fig. 31). The purpose of any capital is to smooth the

passage between the vertical shaft of the column and the horizontal portion of the building above. The necking is the first break in the upward lines of the shafts, though the fluting continues up to the outward flare of the round, cushionlike echinus. This, in turn, leads to the abacus, a block of stone that squares the circle, so to speak, and makes the progression between the round lower and rectangular upper members.

entablature. Directly above the abacus is the architrave, a series of plain rectangular blocks. These stretch from the center of one column to that of its neighbor to constitute the lintels of the construction. They also support the upper parts of the entablature frieze, cornices, and pediment. At this point, sculpture is called into play for decorative purposes, beginning with a carved band known as a frieze.

Above the columns and below the roof is the

28. Mnesicles. Propylaea (view from east), Acropolis, Athens. 437-432 в.с.

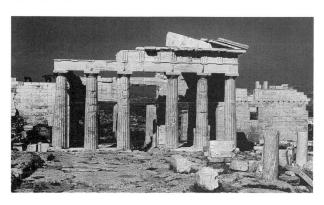

29. Propylaea, cross section (after H. D'Espouy).

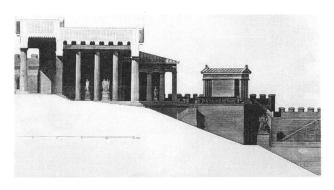

Ictinus and Callicrates. Parthenon, Athens. 447-432 B.C. Pentelic marble; height of columns 34' (10.36 m), length 228 × 104' $(69.5 \times 31.7 \text{ m}).$

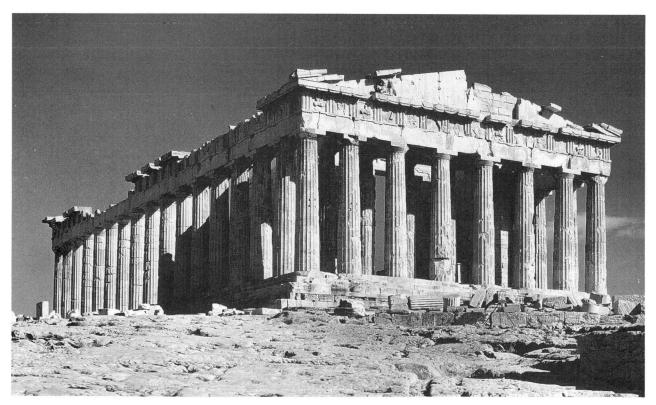

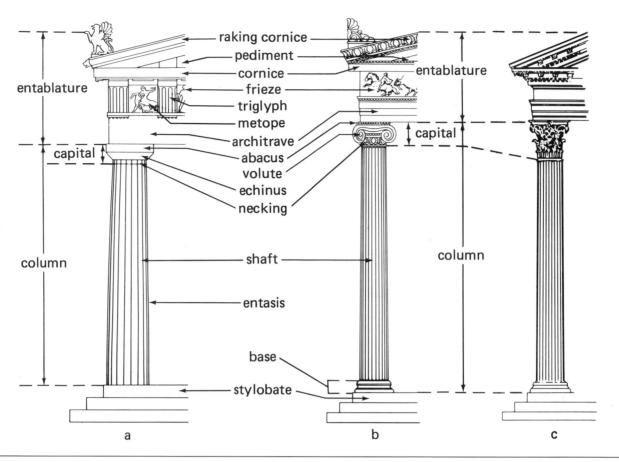

31. Comparison of Greek orders: Doric (a), Ionic (b), Corinthian (c).

In the Doric order, the frieze is made up of alternating triglyphs and metopes. The rectangular *triglyphs* are so named because of their three grooves (*glyphs*), two in the center and a half groove on either side. They are the weight-bearing members, and, by rule, one is placed above each column and another in the space between. The sameness of the triglyphs contrasts with the differently carved relief panels of the *metopes*. This alternation creates an interesting visual rhythm, which illustrates the classical principle of harmonizing the opposites of unity and variety.

The frieze is protected by the overhanging *cornice* (and enhanced by its shadow), and the *raking cornice* rises gablelike from the side angles to the apex in the center. The triangular space enclosed by the cornices is called the *pediment*, which is recessed or set back to create a shelf on which freestanding sculpture can be placed to climax the decorative scheme.

On closer inspection, the Parthenon is not so much a typical Doric temple as it is the culmination of the long evolution of the Doric order with adaptations conforming to the needs of its time and place. Since the Parthenon was to serve both as a shrine to Athena and as the treasury of the Delian League, the plan called for a double cella (Fig. 26). The larger room on the east was to house Phidias's magnificent gold-and-ivory cult statue of Athena, and that on the west was to be the treasury. It was this western cella that technically was the *parthenon*, or chamber of the virgin goddess. Later the name was given to the whole building. The outer four walls of the cella were embellished by a continuous frieze, a decorative device borrowed from the Ionic order.

A *peristyle*, or colonnade, of freestanding columns completely surrounded the temple. The columns were placed far enough from the cella walls to permit an *ambulatory*, or passageway. On each side, along its 228 feet (69.5 meters) of length, were seventeen columns, and along the 104-foot (31.7-meter) width in front and back were eight columns—hence the Parthenon is called *octastyle*. (The number of columns used on the porch of a Greek temple was determined by the size of the building rather than by any rigid rule. The usual number was six,

although some temples had as few as two, others as many as ten or twelve.) On both the east and west ends of the Parthenon, between the outer colonnade and the entrance portals to the cella, were six additional columns that formed the inner porches.

The outer surfaces of the columns have twenty grooves, or *flutes*, that form concave vertical channels from the bottom to the top of the shaft. Fluting serves several purposes, the first being to correct an optical illusion. When seen in bright sunlight, a series of ungrooved round columns appears flattened. In addition to maintaining the round appearance, the fluting makes a constant play of light and shadow and creates a number of graceful curves to please the eye. Also, the increased number of vertical lines quickens the visual rhythm, and the eye is led upward toward the sculpture of the entablature.

Except for such details as the wooden roof beneath the marble tiles and the wooden doors with their frames, the entire Parthenon was built of Pentelic marble. When freshly quarried, this finegrained stone was cream colored, but as it has weathered through the centuries, its minute veins of iron have oxidized, so that today the color varies from light beige to darker golden tones, depending on the light.

In the original design, bright colors played an important part. The triglyphs were tinted dark blue and parts of the molding were red, as is known from ancient sources. The sculptured parts of the metopes were left cream colored, but the backgrounds were painted. In the frieze along the cella walls, the reins of horses were bronze additions, and the draperies of figures here and on the pediments were painted. Such facial features as eyes, lips, and hair were done in natural tints.

For the sheer technical skill of its construction, the Parthenon is astonishing. No mortar was used anywhere; the stones were cut so exactly that when fitted together they form a single smooth surface. The columns, which appear to be monoliths of marble, actually are constructed of sections called *drums*, so tightly fitted by square plugs in the center that the joinings are scarcely visible.

The harmonious proportions of the Parthenon have long been attributed to some subtle system of mathematical ratios. But despite close study and analysis no geometrical formula has so far been found that fits all the evidence. However, there is a recurrence in several instances of the proportion of nine to four (9:4). This proportion has been noticed in the length of the building (228 feet [69.5 meters]) relative to its width (104 feet [31.7 meters]) when measured on the stylobate, or top step; in the width of the cornice contrasted to the height of the raking

cornice at the center; in the distance between the axial center of one column and the next (about 14 feet [4.2 meters]) as compared to the diameter of the column at its base; and in the bottom diameter of the columns relative to the width of the triglyphs.

DEVIATIONS FROM REGULARITY. At the same time, many irregularities defy mathematical logic. Any visitor to the Parthenon can observe that the columns stand somewhat closer together at the corners. Also apparent is the gentle arching of the stylobate from corner to corner—the center point on the short ends being about 23/4 inches (7 centimeters) higher than the corners and the long sides rising about 4 inches (10 centimeters) higher. Above the columns the architrave supporting the entablature echoes this curve. Noticeable too is the slight outward swelling of the column shafts as they rise (about 11/16 of an inch [1.7 centimeters]) and a tapering off toward the top, making a curved effect known as entasis. Entasis creates the impression of elasticity, as if the "muscles" of the columns bulged a bit in bearing the load imposed by the building's superstructure.

It has often been stated that not a single straight line is to be found in the Parthenon, though this is not quite true. If exaggerated and compressed, the lines of the façade would resemble the drawing reproduced in Figure 32, which suggests that the architect Ictinus intended the Parthenon to be more graceful and visually gratifying by virtue of the dominance of curved lines over straight.

Deviations from regularity exist elsewhere in the Parthenon. The thickness of the corner columns, for instance, is about 2 inches (5 centimeters) greater

32. Schematic rendering of the Parthenon exaggerating the curvature and irregularities in the scale.

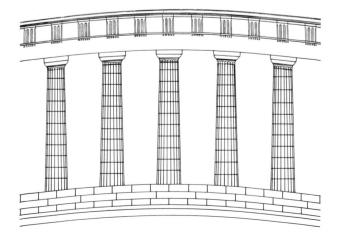

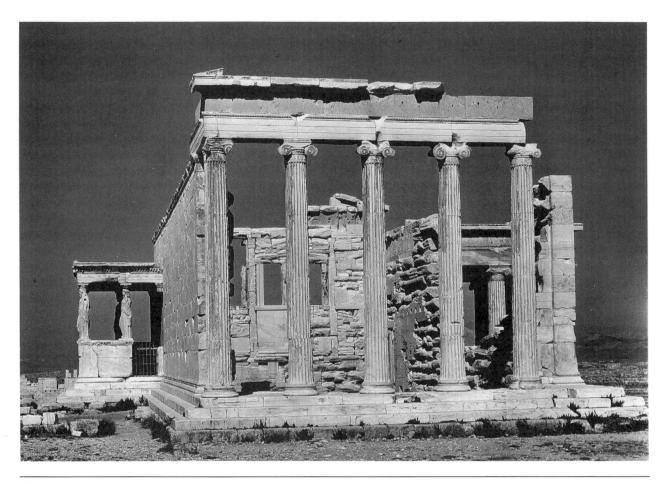

33. Mnesicles (?). Erechtheum (view from southeast), with Propylaea at left, Athens. c. 421–409 B.C. Pentelic marble; length 37′ (11.28 m), width 66′ (20.12 m).

than that of neighboring columns. This increased sturdiness and stability provides optical compensation for their being seen against light-filled, open space rather than against the solid mass of the cella wall and for their serving as final members of both lateral and longitudinal colonnades. In the spacing between columns, exact measurement reveals variations as great as $1\frac{1}{2}$ inches (3.8 centimeters). In addition, the columns lean inward to such an extent that they are some 3 inches (7.6 centimeters) off plumb. The deliberateness of this departure from exactitude is confirmed by the cella walls, which on the outside also tilt inward, while inside they are strictly perpendicular to the ground. It has been estimated that if continued upward, the lines of the Parthenon's columns would converge to meet at a point approximately 1 mile (1.6 kilometers) above.

The evidence is that the master builder Ictinus labored to avoid the rigidity and repetitiousness of the strict Doric order and to make the Parthenon organically coherent rather than merely mechanically consistent. The building can be thought of as a

monumental sculpture, compact and firmly structured but resilient and elastic in the relationships among its component parts. This invests the whole with an organic vital quality like that of life itself. Considered in this way, the Parthenon becomes more visual than logical, more the work of inspired stonemasons than of mathematicians. In short, the Parthenon is a work of art, far from being a cold abstraction.

In its time, the Parthenon stood out as a proud monument to Athena and her people and the attainment of Pericles' ideal of "beauty in simplicity." Begun in 447 B.C. as the first edifice in that great statesman's building program, it was dedicated during the Panathenaic festival ten years later, at a time when the star of Athens was still in ascendancy. It and its companion buildings on the acropolis would be standing today with only the usual deteriorations of time were it not for a disaster in the year 1687. At that time, a Turkish garrison was using the Parthenon as an ammunition dump, and during a siege by the Venetians a random bomb ignited the stored

gunpowder, blowing out the central section. From that time on, the Parthenon has been a noble ruin. Today, after numerous partial restorations, its outline is still clear. In its incomparable proportions and reserved poise it remains one of the imperishable achievements of the human mind.

The Erechtheum

IONIC ORDER. After Phidias's gold-and-ivory statue was so handsomely housed in the Parthenon, the city fathers wished to provide a place for the older wooden statue of Athena that was thought to have fallen miraculously from the sky. They also wished to venerate the other heroes and deities that formerly shared the acropolis with her. Hence a new building of the Ionic order (Fig. 33) was erected. The city records described it as "the temple in the acropolis for the ancient statue."

The site chosen was where Erechtheus, legendary founder of the city, had once dwelt. As recounted by Homer, Erechtheus was born from Earth, the grain giver, and was befriended and fostered by Athena, who "gave him a resting place in Athens in her own rich sanctuary; and there the sons of the Athenians worship him with bulls and rams as the years turn in their courses. . . ."

The Erechtheum, as the building was thus called, was also the spot where Athena and the sea god Poseidon were supposed to have held their contest for the patronage of the land of Attica and the honors of Athens. This story is depicted in the sculptures on the west pediment of the Parthenon. As the two deities asserted their claims, Poseidon brought down his trident on a rock, from which sprang a horse, his gift to humanity. A spring of salt water gushed forth to mark the event. When Athena's turn came, she produced the olive tree, and the gods awarded her the victory. Later, Erechtheus, whom she protected, tamed the horse and cultivated the olive that gave the Athenians oil for their cooking, a spread for their bread, ointment for their bodies, and fuel for their lamps.

Since the sacred olive tree, the salt spring, the mark of Poseidon's trident on the rock, and the tomb of Erechtheus were all in the same sacred precinct, the architect Mnesicles had to design the temple around them. Combining these separate functions makes the plan of the Erechtheum (Fig. 26) as complex as that of the Parthenon is simple. The rectangular interior, some 31 ½ feet (9.5 meters) wide and 61 1/4 feet (18.7 meters) long, had four rooms for the various shrines, on two different levels. One was 10³/₄ feet (3.3 meters) higher than the other. Projecting outward from three of the sides were porticoes,

each of different size and design. The east porch has a row of six Ionic columns almost 22 feet (6.7 meters) high. The north porch (Fig. 34) has a like number, but with four in front and two on the sides, while the smaller porch on the south (Fig. 35) is

34. Mnesicles (?). North porch of Erechtheum, Athens, Width 35'2" (10.72 m).

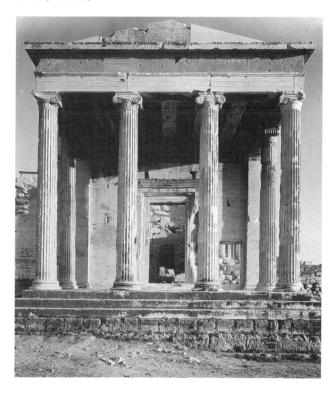

Mnesicles (?). South porch of Erechtheum, Athens. Height of caryatids 7'9" (2.36 m).

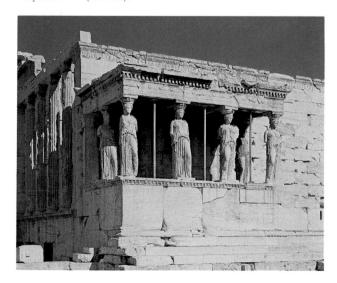

36. Decorative band from the Erechtheum showing (bottom to top) honeysuckle, bead-and-reel, egg-and-dart, bead-and-reel, and leaf-and-tongue motifs. c. 410 B.C. Staatliche Antikensammlung, Glyptothek, Munich.

famous for its six *caryatids*, the sculptured maidens who replace the customary columns.

Ionic columns (Fig. 31), unlike those of the Doric order, are more slender and have their greatest diameter at the bottom. Their shafts rest on a molded base instead of directly on the stylobate, and they have 24 instead of 20 flutings. Most striking, however, is the Ionic capital with its volutes, or scrolllike ornaments. The fine columns of the north porch (Fig. 34) rest on molded bases carved with a delicate design. The necking has a band decorated with a leaf pattern. Above this is a smaller band with the eggand-dart motif, followed by the volutes and then a thin abacus carved with eggs and darts. The columns support an architrave divided horizontally into three bands, each receding slightly inward. The architrave thus consists of a continuous carved frieze rather than the alternating Doric triglyphs and metopes. Above rises a shallow pediment without sculpture.

An admired and much-imitated doorway leads into the cella of the Erechtheum. The lintel above is framed with a series of receding planes and combines the decorative motifs that appear elsewhere in the building. As seen in the band that runs around the cella (Fig. 36), these include (from lower to upper) honeysuckle, bead-and-reel, egg-and-dart, another bead-and-reel, and leaf-and-tongue motifs.

SOUTH PORCH. Facing the Parthenon, the south porch of the Erechtheum, with its caryatids (Fig. 35), is smaller than the others, measuring only some 10 by 15 feet (3 by 4.6 meters). Above three steps rises a 6-foot (1.8-meter) parapet on which the six maidens, about one and a half times larger than life, are standing. In order to preserve the proportions of the building and not appear to overburden the figures, the frieze and pediment were omitted. Grouped as if in a procession, the figures seem engaged in a stately forward motion, with three on one side lifting their right legs and those on the other their left. The folds

of their draperies suggest the fluting of columns; and while the maidens seem solid enough to carry their loads, there is no stiffness in their stances.

On their acropolis, the Athenians brought to the highest point of development two distinct Greek building traditions—the Doric with the Parthenon, and the Ionic with the Erechtheum and the Temple of Athena Nike (Fig. 37). By combining the two architectural orders in the Propylaea and displaying them separately in the Parthenon and the Erechtheum, the Athenians made symbolic reference to their city as the place where the Dorian people of the western Greek mainland and the Ionian people of the coast of Asia Minor across the Aegean Sea had for centuries lived together in peace and harmony.

In the following century, another order was added: the Corinthian (Fig. 31). The columns of the Corinthian order are taller and more treelike than the Ionic. They are distinguished by their ornate capitals with double rows of acanthus leaves and fernlike fronds rising from each corner and terminating in miniature volutes. Too ornate for the generally restrained Hellenic taste, the Corinthian order had to wait for Hellenistic and Roman times to reach its full development, as seen in the ruins of the Temple of Olympian Zeus (Fig. 38).

37. Callicrates. Temple of Athena Nike, Athens. c. 427–424 B.C. Pentelic marble; length 17'9" (5.41 m), width 26'10" (8.18 m).

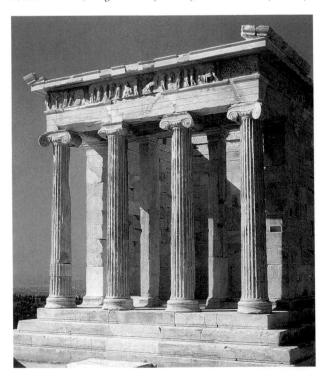

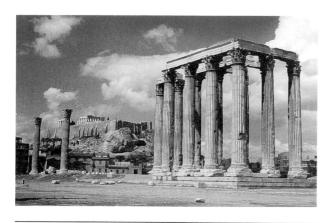

38. Temple of Olympian Zeus, Athens. 174 B.C.—A.D. 130. Pentelic marble, height of columns 56'6" (17.22 m).

SCULPTURE

The Parthenon Marbles

The Parthenon sculptures have a specific significance, because they rank high among the surviving originals of the 5th century B.C. The Parthenon statuary that has survived falls into three groups: the high-relief metopes of the Doric frieze, the low-relief cella frieze, and the free-standing pediment figures. Phidias's celebrated gold-and-ivory cult statue of Athena has long since disappeared, and inferior later

Lapith and Centaur, metope from Parthenon frieze. 447–441 B.c. Marble, $3'11'' \times 4'2''$ (1.19 × 1.27 m). British Museum, London (reproduced by courtesy of the Trustees).

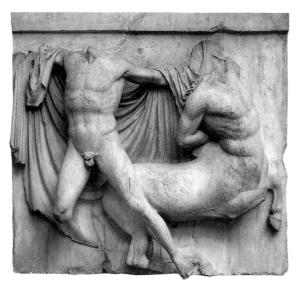

copies convey little of the splendor attributed to it by the ancients.

As architectural sculpture, the friezes and pediments should not be judged apart from the building they embellish. By providing curved and diagonal accents and irregular masses, as well as figures in motion, they offset the more immobile vertical and horizontal balances of the structural parts. The original location of these sculptures must also be kept in mind by the modern viewer. They were meant to be seen outdoors in the intense Greek sunlight and from the ground some 35 feet (10.6 meters) below. While some of the frieze work is still in place, most of it is now in museums, where it is seen in dim artificial light and at eye level.

The craftsmanship of the Parthenon marbles reveals the unevenness in quality common to all group projects. Some sculptures are obviously from the hand of a master; others seem the routine products of artisans. The metopes were completed first. These were in turn surpassed by the finer quality of the cella frieze, and then by the splendid pediment figures. This progressive growth in sculptural skills shows that the work on the Parthenon gathered momentum as it went along. Never satisfied with routine efforts, the sculptors strove constantly for the ideal of excellence in craftsmanship.

METOPES OF THE DORIC FRIEZE. The metopes of the Doric frieze play an important part in the architectural design of the Parthenon. They provide a welcome variety of figures to relieve the structural unity. Their predominantly diagonal lines contrast well with the alternating verticals of the triglyphs and the long horizontals of the architrave and cornice just below and above. In order to take full advantage of the bright sunlight, the sculptors chiseled these metopes in high relief, a technique by which the figures are deeply carved so as to project boldly outward from the background plane.

The subject of the figures in the south frieze is the battle of the Lapiths and centaurs after a centaur has kidnapped a Lapith bride at a wedding feast. In one of the most skillfully executed (Fig. 39), the rich spreading folds of the mantle form a fine unifying framework for the splendid human figure. In turn, both make a striking contrast with the awkward half-horse, half-human centaur.

CELLA FRIEZE. The inner frieze (Figs. 40–42) that ran along the outer walls of the cella was a continuous band about 3¾ feet (1 meter) high, over 500 feet (152 meters) in length; it included some six hundred figures. Since this frieze was placed behind the colonnade and directly below roof level, where it

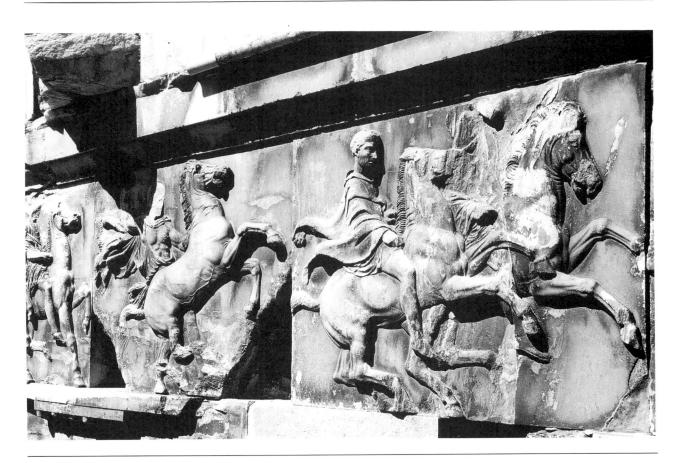

40. Horsemen, detail of Parthenon west cella frieze. c. 440 B.C. Marble, height 43" (109 cm).

had to be viewed from up close and at a steep upward angle, some sculptural adjustments were called for. The technique, of necessity, was *low relief*, in which the figures are shallowly carved. Because shadows in this indirect light are cast upward, the frieze had to be tilted slightly and cut so that the lower parts of the figures project only 1 ½ inches (3 centimeters) from the background plane, with the relief gradually becoming bolder toward the top where the figures extend outward about 2 ½ inches (5.7 centimeters). The handling of space, however, is so deft that as many as six horsemen are shown riding abreast without confusing the separate spatial planes.

Other adjustments can be observed. The horses, when seen at eye level, appear too small in comparison with their riders. When viewed from below and in indirect light, however, they would not seem out of proportion. The use of color and metal attachments for such details as reins and bridles also helped to accent parts and projected the clarity of the design. All the heads, whether the figures are afoot or on horseback, have been kept on the same level in order to preserve unity of design as well as to provide a parallel with the architectural line. (This prin-

ciple, known as *isocephaly*, will also be encountered later in Byzantine art [See Figs. 126, 136, 137]).

The cella frieze, unlike the traditional mythological subjects elsewhere in the Parthenon sculptures, depicts the Athenians themselves participating in the festival of their goddess. One of the oldest and most important festivals, the Panathenaea was held in mid-August. The scene depicted is the Greater Panathenaea, which took place every four years. Larger than the annual local procession as it included delegations from other Greek cities, the Greater Panathenaea was the prelude to poetical and oratorical contests, dramatic presentations, and games.

On the western side (Figs. 40 and 41), which is still in place, last-minute preparations for the parade are in progress as the riders ready their horses. The action, appropriately enough, starts just at the point where the live procession, after passing through the Propylaea, would have paused to regroup. The parade then splits in two, one file moving along the north and the other along the south side. After the bareback riders come the charioteers; and as the procession approaches the eastern corners, the marshals slacken the tempo to a more dignified pace.

Here are musicians playing lyres and flutes, youths bearing wine jugs for libations, and maidens walking with stately step. The two files then meet on the east side, where magistrates would be waiting to begin the ceremonies.

Even the immortal gods, as seen in the panel depicting Poseidon and Apollo (Fig. 42), are present to bestow their Olympian approval on the proceedings. The high point of the ritual comes in the center of the east side with the presentation of the *peplos*, the saffron and purple mantle woven by chosen maidens to drape the ancient image of Athena.

PEDIMENTAL SCULPTURES. The pedimental sculptures, in contrast to the friezes, are freestanding figures, carved in the round. The themes of both pediments have to do with Athena. That on the west, facing the city, depicts her triumph over Poseidon (see p. 31). That on the east pediment (Fig. 43) recounts the story of her miraculous birth, the event that was celebrated each summer at the Panathenaea. While only a few fragments of the western pediment remain, enough survives of its eastern counterpart to convey an idea of its original state.

From various sources it is known that the eastern scene is Mount Olympus, and that Zeus, father of the gods, was seated in the center. On one side stood the fire god Hephaestus, splitting open the head of Zeus to let Athena spring forth fully grown and fully armed. The sudden appearance of the goddess of wisdom, like a brilliant idea from the mind of its creator, disturbs the Olympian calm. As the news spreads from the center to the sides, each figure is in some way affected by the presence of divine wisdom in their midst. Iris, the messenger of the gods

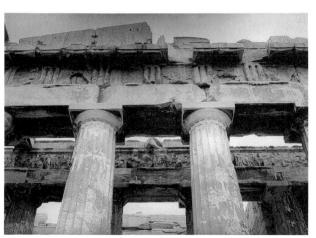

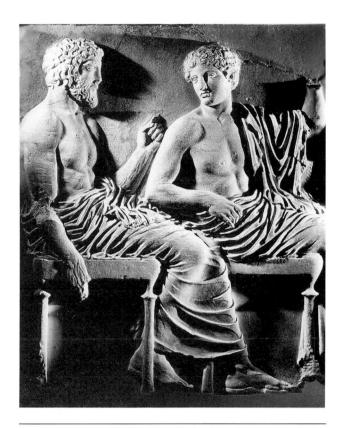

Poseidon and Apollo, detail of Parthenon east cella frieze. c. 440 B.C. Marble, height 43" (109 cm). Acropolis Museum, Athens.

(Fig. 44), rushes toward the left with a rapid motion revealed by her windswept drapery. Scated on a chest, Demeter and Persephone are turning toward her, and the rich folds of their costumes reflect their attitudes and interest. The reclining Dionysus, with his panther skin and mantle spread over a rock (Fig. 45), is awakening and looking toward the sun god Helios, the horses of whose chariot are just rising from the foaming sea at break of day.

Three goddesses (Fig. 46) on the opposite side have postures that bring out their relationship to the composition. The one nearest the center of the pediment, aware of what has happened, is about to rise. The middle figure is starting to turn toward her. The reclining figure at the right, still in repose, is unaware of the event, as is her counterpart Dionysus on the far left. Like the female group on the left, these figures form a unified episode in the composition, and their relation to the whole is made clear in the lush lines of their flowing robes. This undulating linear pattern and the way it transparently reveals the anatomy of the splendid bodies beneath mark a high point in the art of sculpture.

At the far right of this group the chariot of the moon goddess Selene was seen descending. Now

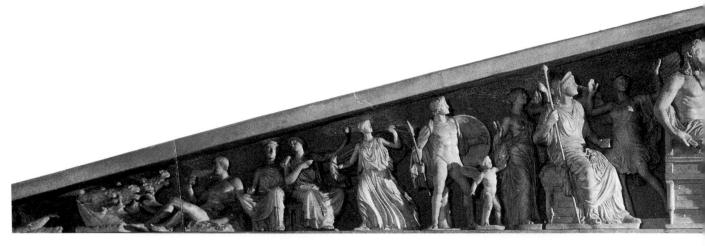

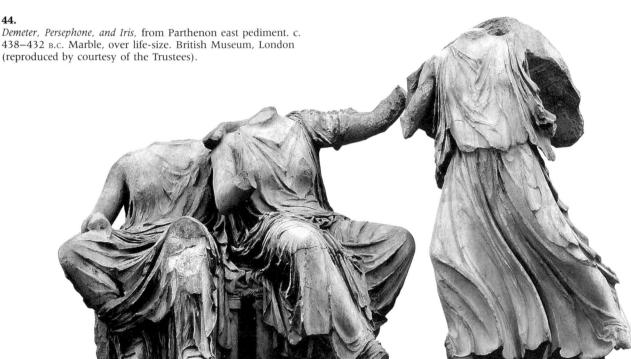

45. *Dionysus*, from Parthenon east pediment. c. 438–432 B.C.
Marble, over life-size. British Museum, London (reproduced by courtesy of the Trustees).

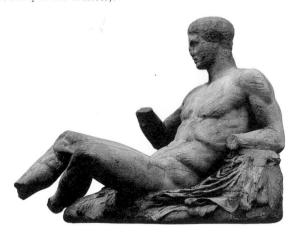

only the expressive downward-bending horse's head (Fig. 47) remains to show by his spent energies that it is the end of the journey.

Perhaps the most admirable aspect of the entire pediment composition is the ease and grace with which each piece fulfills its assigned space. Fitting suitable figures into a low isosceles triangle and at the same time maintaining an uncrowded yet unified appearance was a problem that long occupied Greek designers. An oversize standing figure usually dominated the center, with seated or crouching figures on either side and reclining ones in the acute side angles.

The pediment space of the Parthenon stretches about 90 feet (27.4 meters) and rises over 11 feet (3.4 meters) in the center. The chariots of the rising and setting sun and moon define the time span as that of a single day. Furthermore, the background of

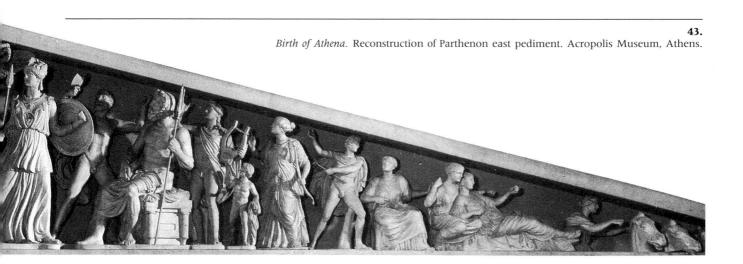

Three Goddesses, from Parthenon east pediment. c. 438–432 B.C. Marble, over life-size. British Museum, London (reproduced by courtesy of the Trustees).

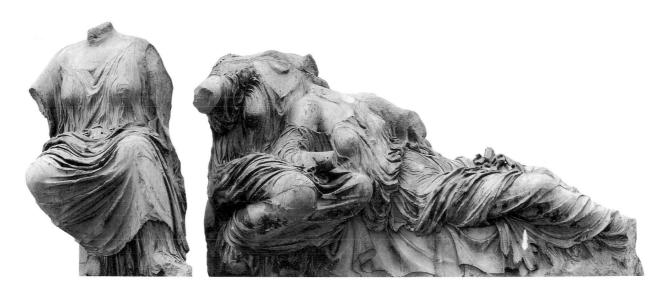

Mount Olympus and the single event identify time, place, and action in keeping with the classical unities (a principle that will be treated more fully in the section on drama).

The ascending and descending chariots give a contrasting upward and downward movement on the extreme ends, while the reclining and seated figures lead the eye to the apex, where the climax takes place.

OVERALL SCULPTURAL PROGRAM. Taken as a whole, the Parthenon marbles present a picture of the Greek past and present and of their aspirations for the future. The attempt of the Greek people to interpret their dark ancient myths in contemporary terms is found here in their sculptures as well as in their philosophy, poetry, and drama.

47. *Moon Goddess's Horse,* from Parthenon east pediment. c. 438–432 B.C. Marble, life-size. British Museum, London (reproduced by courtesy of the Trustees).

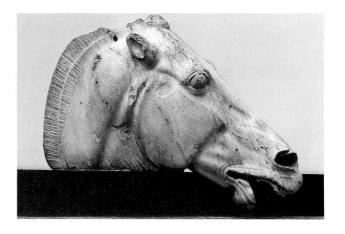

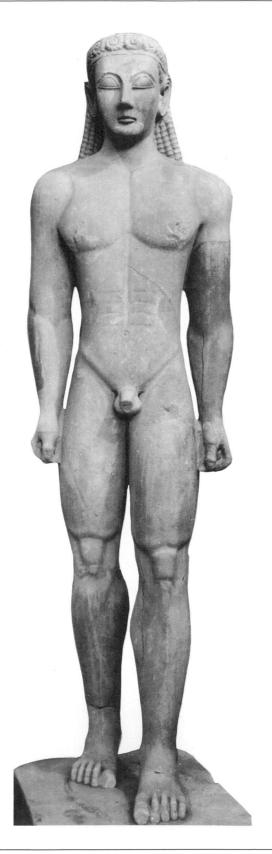

48. *Kouros,* from Sounion. c. 615–590 B.C. Marble, height 11' (3.35 m). National Museum, Athens.

The metopes on the east frieze portray the primeval battle of the gods and giants for control of the world, and the triumph of the Olympians hailed the coming of order out of chaos. The metopes on the south frieze show the oldest inhabitants of the Greek peninsula, the Lapiths, subduing the half-human centaurs with the aid of the Athenian hero Theseus. This victory signaled the ascendancy of human ideals over the animal side of human nature. In the north group, the Homeric epic of the Greek defeat of the Trojans is told, while in the west metopes the Greeks are seen overcoming the Amazons, those ferocious female warriors who symbolized the Asiatic enemies and, in this case, allude to the Athenian defeat of the Persians at Marathon. In the east pediment, the birth of the city's patroness, Athena, is seen; while the west pediment tells the story of the rivalry of Athena as goddess of the intellect and Poseidon as patron of maritime trade, suggesting the conflict of two ways of life—the pursuit of wisdom and of material wealth.

The Panathenaic procession of the cella walls brings history up to date by depicting a contemporary subject. Here the proud Athenians could look upward and see their own images carved on a sacred temple, an echo of the living procession that marched along the sides of the temple on feast days. The climax came after they had gathered at the east porch and the portals of the temple were opened to the rays of the rising sun, revealing the image of the goddess herself. Shining forth in all her gold-andivory glory, Athena was the personification of the eternal truth, goodness, and beauty for which her faithful followers were striving. With her help, Greek civilization had overcome the ignorance of the barbarians. The bonds between the goddess and the citizens of her city were thus periodically renewed, and the Parthenon as a whole glorified not only Athena but the Athenians as well.

Dark clouds, however, began to gather on the Athenian political horizon. Developing an empire and expending the funds of the Delian League on the acropolis buildings excited the wrath of some of the rival city-states. Their exaltation over their fellow Greeks and depiction of themselves in the very presence of the Olympian gods in the Parthenon frieze added further fuel to the flames. And when Phidias carved Pericles' and his own self-portrait on the sacred shield of the cult statue of Athena, he was going too far, even for an Athenian. Such demonstrations of Athenian military power and political dominance laid the foundation for the Peloponnesian War between Athens and Sparta, which broke out only one year after the Parthenon was completed.

The Course of Hellenic Sculpture

The tremendous distance encompassed by the art of sculpture from the archaic, or preclassical, phase prior to the 5th century B.C. to the end of the Hellenic style period in the mid-4th century can be seen clearly when examples are compared.

MALE FIGURES. The Kouros (Fig. 48) represents the archaic sculptural type of youthful athlete, victor in the games, moving toward the temple to dedicate himself. The advancing left foot provides the only suggestion of movement in the otherwise rigid posture. The anatomy of the torso is severely formal and close to the block of stone from which it was carved. The wide shoulders and long arms attached to the sides provide a rectangular framework. The long vertical line from the neck to the navel divides the chest, while the diamond-shaped abdomen is defined by four almost-straight lines, a heritage of the formalized geometrical conventions of the archaic period. About a century later, a similar figure (see Fig. 63) reveals how the rigid posture has softened, the muscles relaxed, and the spirit enlivened.

The *Doryphorus*, or *Spear Bearer*, by Polyclitus (Fig. 49), in contrast, moves with greater poise and freedom. Originally in bronze, it is now known only through routine marble copies. The sculptor won fame in ancient times for his attempts to formulate a *canon*, or body of rules, for the proportions of the human figure. The exact way Polyclitus's theory worked is not known, but the Roman architect Vitruvius mentions that beauty consists "in the proportions, not of the elements, but of the parts, that is to say, of finger to finger, and of all the fingers to the palm and wrist, and of these to the forearm, and of the forearm to the upper arm, and of all . . . to each other, as . . . set forth in the Canon of Polyclitus."

Whether the *module*, or unit of measure, was the head, the forearm, or the hand apparently varied from statue to statue. Yet once the module was adopted, the whole and all its parts were expressible in multiples or fractions of it. As Vitruvius illustrated the canon, the head would be one-eighth of the total height. The face would be one-tenth, subdivided, in turn, into three parts: forehead, nose, and mouth and chin. The forearm would be one-quarter the height, and the width of the chest equal to this length of forearm. Like the optical refinements of the Parthenon, however, Polyclitus's canon was not a mechanical formula. It allowed for some flexibility: the dimensions could be adjusted for a figure in movement or for one designed to be seen from a certain angle.

The Hermes and the Infant Dionysus (Fig. 50) attributed to Praxiteles, coming at the close of the Hellenic period, is the ultimate in poise and polish. Unlike the rather restrained *Doryphorus*, Hermes rests his weight easily on one foot. The relaxed stance throws the body into the familiar S-curve, a Praxitelean pose widely copied in later Hellenistic and Roman statuary. From the stiffness of the stolid

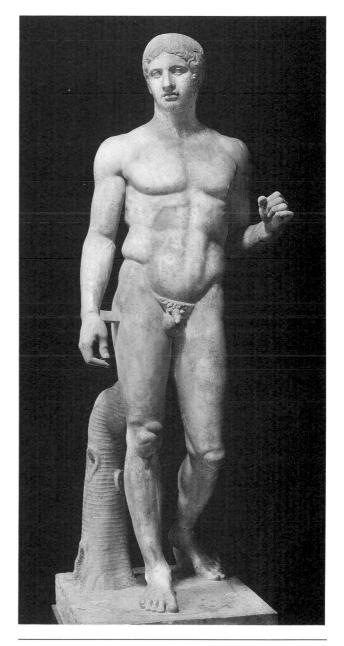

49. Polyclitus. *Doryphorus (Spear Bearer)*. Roman copy of original of c. 450–440 B.C. Marble, height 6'6" (1.98 m). Museo Nazionale, Naples.

archaic *Kouros* and the strength of the stocky *Doryphorus*, the sculptor Praxiteles has arrived at complete mastery of his material. Through the soft modeling and suave surface treatment, Praxiteles suggests the blood, bone, and muscles beneath the skin and gives his cold marble material the vibrancy and warmth of living flesh.

The *Charioteer* of Delphi (Fig. 51) and the *Zeus* found at Artemision (Fig. 52)—two of the rare Hel-

lenic bronze originals—and the Roman marble copy of Myron's lost bronze *Discobolus*, or *Discus Thrower*, (Fig. 53), reveal a transition in style from quiet monumentality to energetic action within a twenty-year span in the mid-5th century. The splendid *Charioteer* once was part of a larger group that included a chariot and several horses. Although in action, the figure has something of the monumentality and equilibrium of a fluted column due to the vertical folds of its

50.Praxiteles (?). Hermes and the Infant Dionysus.c. 340 B.C. Marble, height 7'1" (2.16 m). Archeological Museum, Olympia.

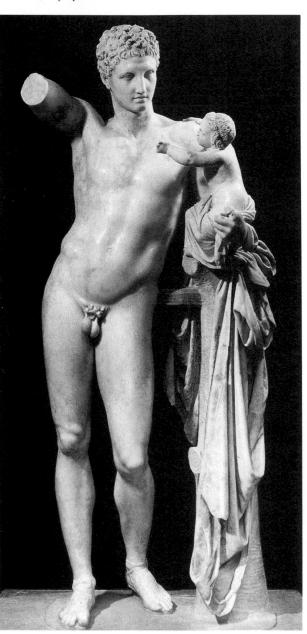

51. *Charioteer,* from Sanctuary of Apollo, Delphi. 475 B.C. Bronze, height 5'11" (1.8 m). Archeological Museum, Delphi.

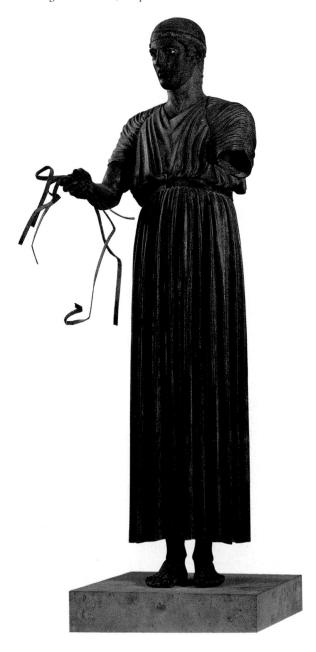

lower garment. The commanding figure of *Zeus*, poised to throw a thunderbolt, reveals in its powerful musculature the massive reserves of strength of a truly godlike physique. In his *Discobolus* Myron's challenge was to express movement in static terms. His inspired solution was to choose a pose where the taut yet elastic muscles of the athlete are poised momentarily after his backswing and before beginning his forward lunge. The whole backward-forward movement is thus captured in this one pregnant "Myronic moment." The vigorous motion is admirably contained by the curved arms that enclose the composition and confine the activity to a single plane.

FEMALE FIGURES. The archaic *Kore* from Samos (Fig. 54) is one of a file of maidens, originally in a temple courtyard, carrying small animals as votive offerings. Her severely cylindrical figure is quite abstract in that everything extraneous has been eliminated and only the essential formal and linear elements retained. The rhythmically repeated lines of

52. *Zeus (Poseidon?).* c. 460–450 B.C. Bronze, height 6'10" (2.08 m). National Museum, Athens.

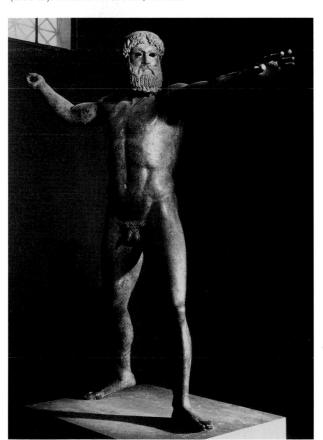

the skirt contrast with the curves of the upper drapery to create a pleasing linear design.

The Athena Lemnia (Fig. 55) is a superior marble copy of Phidias's original bronze statue that once stood on the Athenian acropolis. Phidias here created a mood that is more lyrical than epical, and in ancient sources the statue was referred to regularly as "the beautiful." The serene profile, softened by the subtle modeling, surely approaches the ideal of chaste classical beauty.

Praxiteles' Aphrodite of Cnidos was proclaimed by Greco-Roman critics as the finest statue in existence. It is now known only through such a routine copy as Figure 56. The "smile playing gently over her parted lips" and the "soft melting gaze of the eyes with their bright and joyous expression" that the Roman writer Lucian so admired in the original can now only be imagined. Praxiteles, however, departed from the draped goddesses of the previous century by boldly portraying the goddess of love in the nude. By so doing, he created a *prototype*, or original model, that influenced all subsequent treatment of the undraped female figure.

Myron. *Discobolus (Discus Thrower)*. Roman copy after bronze original of c. 450 B.C. Marble, life-size. Museo Nazionale, Rome.

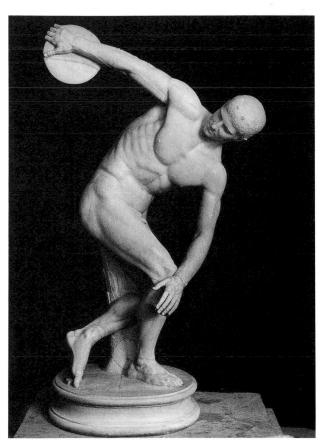

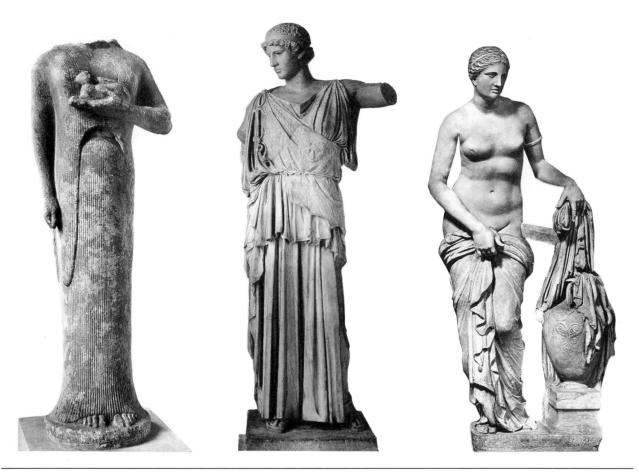

54. above left: *Kore,* from Samos. c. 550 B.c. Marble, height 5'3" (1.6 m). Antikensammlung, Staatliche Museen, Berlin.

55. above center:

Phidias (?). Athena Lemnia. Roman copy after original of c. 450 B.C. Marble, height 6'6" (1.98 m). Body, Albertinum, Dresden; head, Museo Civico, Bologna.

56. above right:

Praxiteles. Aphrodite of Cnidos. Roman copy after original of c. 340 B.C. Marble, height 6'8" (2.03 m). Vatican Museums, Rome.

DRAMA

Greek drama was a distillation of life in poetic form represented on the stage. In these vivid presentations, members of the audience through their representatives in the chorus became vicarious participants in events happening to a group of people at another time and in another place.

Like all great works of art, Greek drama can be approached on many different levels. At one level, it can be a thrilling story of violent action and bloody revenge. At another, it is a struggle between human ambition and divine retribution or a conflict of free will and predestined fate. At still another, it becomes a moving experience that ennobles through lofty language and inspired poetry.

Plots were always taken from mythology, heroic legends, or stories of royal houses. Since these age-old themes were forms of popular history, known in advance, the dramatist could concentrate more on purely poetic functions than on plot development, providing dramatic commentaries on old tales and reinterpreting them in the light of recent events. The playwright could thus inspire by conjuring up the heroic past, as did Aeschylus in The Persians; express individual sentiments in the light of universal experience, as did Sophocles in Antigone; invite reexamination of ancient superstitions, as did Euripides in *The Bacchae*; or place current problems in broader historical perspective by reminding the audience that present difficulties had parallels in times past.

Origins

The origins of Greek drama lay in the ancient tradition of heroic verse in which the storyteller might impersonate an epic hero. They were also associated with the worship of Dionysus (the Bacchus of Roman mythology). He was the god of wine and revelry, whose cult festivals coincided with spring planting and fall harvesting seasons (Fig. 57). From primitive magical practices the rituals gradually grew in refinement until they became a vehicle for powerful creative expression. When theaters came to be built, they were located in a precinct sacred to Dionysus. His altar occupied the center of the circular *orchestra*, where the chorus sang and danced. The audience that gathered paid their tribute to him by their presence.

The theater of Dionysus at Athens (Fig. 25), like the better-preserved one at Epidaurus (Fig. 58), had an auditorium hollowed out of a hillside to accommodate approximately eighteen thousand spectators. The semicircular tiers of seats half surrounded the orchestra and faced the skene, a scene building or raised platform on which the actors played their roles. The skene had a permanent architectural facade with three doors for the actors. The chorus entered and exited at the corners below. The stylized façade of the skene, suggesting a temple or palace, was suitable for most dramatic situations, since the action almost always took place in the open. The chorus, for example, usually represented worshipers at a shrine, townspeople or petitioners before a palace, a mob, or a group of prisoners. The actors moving in and out of the portals above took the parts of priests, heroes, or members of royal families. When the situation demanded another setting, the chorus or an actor would "paint" the scene with a few words, so that other sets were unnecessary.

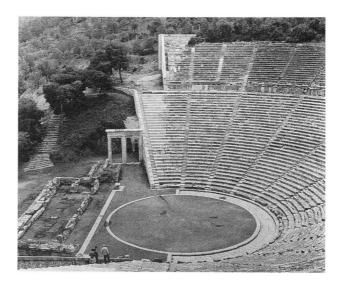

58. Polyclitus the Younger. Theater, Epidaurus. c. 350 B.C. Diameter 373' (113.69 m), orchestra 66' (20.12 m) across.

Structure and Scope

A typical Greek play opens with a *prologue*, spoken by one of the actors. The prologue sets the scene, outlines the plot, and provides a taking-off point for the action that is to follow. The substance of the drama then unfolds in a sequence of alternating choruses and episodes (usually five episodes enclosed by six choruses) and concludes with the *exodus* of the chorus and an *epilogue*. Actors wore masks (Fig. 59) of general types that could be recognized instantly by the audience. The size and outdoor location of the theaters made facial expressions ineffective, and the swift pace of Greek drama required the player of a king or shepherd to establish immediately a type and character. Masks also proved useful when an actor took more than one part, bringing him immediate acceptance in either role.

Restraint and simplicity were the rule in Greek staging. As with the later Elizabethan theater, scenery was conspicuous by its absence. The only visual illusion seems to have been the *mechane*, a crane that lowered to the stage those actors portraying gods. This *deus ex machina*, or "god from the machine," in later times became a convenient way of solving dramatic problems that were too complex to be worked out by normal means.

Direct action never occurred on stage. Any violent deed took place elsewhere and was reported by a messenger or another character. The plays proceeded by narration, commentary, speculation, dialogue, and discussion. All these devices—plot

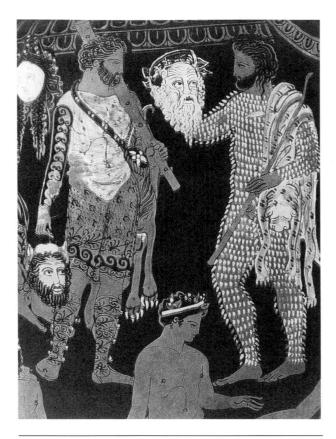

59. Pronomos Painter. *Actors Holding Their Masks*. Detail of redfigured painting showing the cast of a satyr play on exterior of volute krater. Ruvo, Italy. c. 410 B.C. Terra-cotta, height 29½" (75 cm). Museo Nazionale, Naples (from *Classical Greek Art, Arts of Mankind* series. Paris: Éditions Gallimard).

known in advance, permanent stage setting, use of masks, offstage action—served two principal purposes: to accent the poetry of the play and to give the freest possible scope to the spectator's imagination. Greek drama unfolds as a sequence of choral song, group dances, mimed action, and dialogue coordinated into a dramatic whole. Poetry, however, always remains the central dramatic agent.

The scope of Greek drama was tremendous. It extended from majestic tragedy of heroic proportions, through the pathos of *melodrama* (in its proper meaning of "drama with melody"), all the way to the riotous *comedies* of Aristophanes. Conflict, however, is always the basis for dramatic action, and the playwrights set up tensions between such forces as murder and revenge, crime and retribution, cowardice and courage, protest and resignation, pride and humility. When, for instance, a hero is confronted with his destiny, the obstacles he encounters are at once insurmountable and necessary to surmount. In the conflict that follows, the play

runs an entire range of emotions and explores the heights to which human life can soar and the depths to which it can sink. In Sophocles' *Oedipus Rex*, for instance, the hero starts at the peak of his kingly powers and ends in the abyss of human degradation, and in Euripides' *Bacchae* Pentheus, that pillar of respectability, is first made ridiculous and then destroyed. Each character in a true drama, moreover, is drawn three-dimensionally so as to reveal a typically human mixture of attractive and repulsive, good and bad traits.

The protagonist, or central character, of a Greek play can fulfill the requirements of tragedy only when portraying some noble figure—one "highly renowned or prosperous," as Aristotle argues—who is eventually brought to grief through a personal flaw in psychological makeup and by some inevitable stroke of fate. The reasons for this must be made apparent to the audience gradually through the process of "causal necessity." A common person's woes might bring about a pathetic situation but not a tragic one in the classical sense. When a virtuous hero is rewarded or the evil designs of a villain receive their just deserts, obviously there is no tragic situation. When a blameless person is brought from a fortunate to an unfortunate condition or when an evil person rises from misery to good fortune, there is likewise no tragedy because the moral sense of the audience is outraged.

AESCHYLUS. Under Aeschylus, its founder, Greek tragedy sought to comprehend the mystery of the divine will, so inscrutable to mortals—as in his *Agamemnon*. By establishing a working relationship between mortals and their gods, he tried to reconcile the conflict between the human and the divine and find a basis for personal as well as social justice. The implications of the early Aeschylean tragedy were thus strongly ethical, showing clearly that the drama was still identified in his mind with theological thought. The forms of Sophocles' plays were distinguished by their flawless construction, while their lofty content was based on the course of human destiny as seen in light of the moral law of the universe.

Sophocles. Aristotle hailed *Oedipus the King* as the greatest of Greek tragedies, both for the nobility of its conception and for the inexorable logic of its plot. Since everyone in Sophocles' audience knew the story, he was free to write a new play on an old theme. Unknown to himself at the time, Oedipus had violated two of the most basic taboos in any society—murdering his father and marrying his mother. Modern audiences may find this all the more shattering because of Freud's teaching that this

age-old dilemma mirrors our own secret desires and fears. "It is that fate of all of us," wrote Freud in his *Interpretation of Dreams*, "to direct our first sexual impulses towards our mother and our first hatred and . . . murderous wish against our father [the Oedipus complex]. Our dreams convince us that this is so."

Like Pericles, Oedipus was a master politician in full control of the state. Like Socrates, he was determined to seek the truth come what may and to shed some light on the dark corners of ignorance and superstition. The heroic aspect of Oedipus' character is not that his life is predestined by fate or by the will of the gods, but that he is his own man, free to pursue the truth wherever it might lead. Oedipus commands both admiration and sympathy as he brings the full force of his intelligence, courage, and relentless perseverance to the quest. In this progressive unmasking of himself the audience sees the hero as his own destroyer, as the detective who discovers the criminal to be himself. The closer he comes to his imminent downfall, the higher his stature rises. The true tragic grandeur then comes when he and the audience recognize that he must bear full moral responsibility for his life and acts. To expiate his crimes he first calls for his sword to kill himself. Then in a moment of bitter irony he seizes his wife Jocasta's golden pin and pierces his eyeballs, saying that when he could see he was blind, so only in blindness can he really see: "Be dark from now on, since you saw before what you should not, and knew not what you should."

The audience in 5th-century Athens would have seen Oedipus as one of themselves—reflecting their pride in their heritage, their resoluteness in action, and their willingness to examine their lives in the light of reality and reason. The spectators were inevitably caught up in the web of the plot, enthralled with its relentless progress while identifying themselves with the plight of the characters whose fate was unraveling. When the awful truth was revealed, Oedipus' catastrophe was perceived as the tragedy of the Athenians themselves as they in turn became aware of their own ignorance. Instead of man being the measure of all things, perhaps it was they who were being measured, tried in the balance, and found wanting. In short, as Bernard Knox writes in his perceptive preface to the play, Oedipus is the "dramatic embodiment of the creative vigor and intellectual daring of the fifth-century Athenian spirit."

EURIPIDES. Euripides, said the philosopher Aristotle, sought to show people as they are, while Sophocles had depicted them as they ought to be. In

some ways, the works of Euripides may not be so typical of the Hellenic style as those of Aeschylus or Sophocles, but his influence on the subsequent development of the drama, both in Hellenistic and later times, was incalculably greater.

The Bacchae, the last of Euripides' ninety-odd plays, was written at a time when the darkness of disillusionment was descending on Athenian intellectuals toward the end of the disastrous Peloponnesian War. In it he gives voice to some of the doubts and uncertainties of his time. The theme is the complex interplay between the human and divine wills, the known and the unknown. And what is the pale self-righteousness of Pentheus against the implacable, terrifying wrath of the god Bacchios? Agave, Pentheus's mother, is led to murder her own son because she voluntarily surrenders her reason to an irrational cult. His downfall comes because his reason was not strong enough to comprehend the emotional and irrational forces that motivated the mem bers of his family and his subjects. Since Pentheus could not understand these forces, he could not bring them under control and thus lacked the wisdom and tolerance necessary in a successful ruler.

Like most masterpieces, it is in some respects atypical, but in others it seems to stem from the deepest traditional roots of theater. Despite some inner inconsistencies and a certain elusiveness of meaning, the *Bacchae* has all the formal perfection and poetic grandeur of the loftiest tragedies. The strange, wild beauty of its choruses and the magic of its poetry supply this drama with all the necessary ingredients of theater at its best.

ARISTOTLE'S COMMENTARY. After the great days of Aeschylus, Sophocles, and Euripides had passed, Aristotle, with knowledge of their complete works instead of the relatively few examples known today, wrote a perceptive analysis of tragedy and more broadly of art in general in his treatise *Poetics*. According to him, true drama, indeed all other works of art, must have form in the sense of a beginning, a middle, and an end.

Unity of time, place, and action is also desirable. Sophocles' *Oedipus Rex*, for example, takes place in a single day (albeit a busy one); all the scenes are set in front of the palace at Thebes; and the action is direct and continuous without subplots. Other Greek plays encompass a longer span of time and have several settings. As Aristotle pointed out, these unities were useful but by no means hard-and-fast rules.

In the episodes, convention held that three actors on stage at one time was the maximum. If the play required six parts, the roles were usually appor-

tioned among three actors. As the action proceeds, the conflict between protagonist and antagonist emerges, and the play should rise to its climax in the middle episode. Through the proper tragic necessity, the hero's downfall comes because he carried the seeds of his own destruction within his breast. After this turning point, the well-planned anticlimax resolves the action into a state of equilibrium.

Tragedy, according to Aristotle, had to be composed of six necessary elements, which he ranked as follows: plot, "the arrangement of the incidents"; character, "that which reveals moral purpose"; thought, "where something is proved to be or not to be"; diction, "the metrical arrangements of the words"; song, which "holds the chief place among the embellishments"; and spectacle. Finally, Aristotle summed up his definition of tragedy as "an imitation of an action that is serious, complete, and of a certain magnitude; in language embellished with each kind of ornament, the several kinds being found in separate sections of the play; in the form of action, not of narrative; with incidents arousing pity and fear, wherewith to accomplish its *katharsis* ["purgation"] of the emotions."

MUSIC

The word *music* today carries the connotation of a fully mature and independent art. It must be remembered, however, that symphonies, chamber music, and solo instrumental compositions, where the focus is almost entirely on abstract sound, are relatively modern forms. The word *music* is still used to cover the union of sound with many other elements, as in the case of popular songs, dance music, military marches, and church music. It also describes the combination with lyric and narrative poetry, as in songs and ballads; with step and gesture, as in the dance; and with drama, as in opera.

In ancient Greece, *music* in its broadest sense meant any of the arts and sciences that came under the patronage of the Muses, those imaginary maidens who were the daughters of the heavenly Zeus and the earthly Mnemosyne. Since Zeus was the creator and Mnemosyne, as her name implies, the personification of memory, the Muses and their arts were thought to be the results of the union of the creative urge and memory, half divine, half human. This was simply a way of saying that the arts were remembered inspiration.

As Greek civilization progressed, the Muses gradually increased to nine under the patronage of Apollo, god of prophecy and enlightenment. The arts and sciences over which they presided came to include all the intellectual and inspirational disci-

plines that sprang from the fertile minds of this highly creative people—lyric poetry, tragic and comic drama, choral dancing, and song. Astronomy and history were also included. The visual arts and crafts, on the other hand, were protected by Athena and Hephaestus—symbolizing intellect tempered by fire. Plato and others placed music in opposition to gymnastic or physical pursuits, and its meaning in this sense was as broad as our use of the general terms *liberal arts* or *culture*.

The Greeks also used *music* more narrowly, in the sense of the tonal art. But music was always intimately bound up with poetry, drama, and the dance and was usually found in their company. At one place in the *Republic*, Socrates asks: "And when you speak of music, do you include literature or not?" The answer is yes. Thus, while it is known that the Greeks did have independent instrumental music apart from its combination with words, evidence suggests that the vast body of their music was connected with literary forms.

This does not imply, of course, that music lacked a distinct identity or that it was swallowed up by poetry, but rather that it had an important and honored part in poetry. Plato, for instance, remarks: "And I think that you must have observed again and again what a poor appearance the tales of the poets make when stripped of the colours which music puts upon them, and recited in simple prose. . . . They are like faces which were never really beautiful, but only blooming; and now the bloom of youth has passed away from them."

Music and Literature

Greek music must therefore be considered primarily in its union with literature, as illustrated in the vase painting *Instruction in Music and Grammar in an Attic School* by Douris (Fig. 60). The clearest statement of this is found in the *Republic*, where it is pointed out that "melody is composed of three things, the words, the harmony [the sequence of melodic intervals], and the rhythm." In discussing the relative importance of each, Plato states that "harmony and rhythm must follow the words." The two arts thus are united in the single one of *prosody*—that is, the melodic and rhythmic setting of a poetic text.

The Greek melodies and rhythms are known to have been associated with specific moods, or *modes*—scales constructed by adjusting the pitch of tones within the octave as with the more modern major and minor modes, from which they are descended. The modern major scale, or mode, can be found on the piano by playing the white keys from middle C to the next C above (eight tones, or an *octave*). Simi-

Douris. Instruction in Music and Grammar in an Attic School. Redfigured painting on exterior of kylix. c. 470 B.C. Staatliche Museen, Berlin,

larly, the minor scale, or mode, goes from A (two white keys below middle C) to the A above. The ancient Greek Dorian mode can be approximated by the white keys from E (2 white keys above middle C) to the E an octave above.

The great variety of Greek modes allowed poets and dramatists to elicit a gamut of emotional responses from their audiences. Although ethical and emotional orientations have changed over the centuries, the basic modal and metrical system of the Greeks has, in effect, continued through all subsequent periods of Western music and poetry.

Music, in both its broad and narrow senses, was closely woven into the fabric of the emotional, intellectual, and social life of the ancient Greeks. The art was also considered by them to have a fundamental connection with the health and well-being of individuals personally, as well as with their social and physical environment. There is no more eloquent tribute to the power of art in public affairs than that made by Socrates, who said, "When modes of music change, the fundamental laws of the State always change with them."

Education for young people in Greece consisted of a balanced curriculum of music for the soul and gymnastics for the body. The broad principle of building a sound mind in a sound body is still one of the ideals of education. Even the welfare of the soul after death had musical overtones, since immortality to many Greeks meant being somehow in tune with the cosmic forces and being at last able to hear the "music of the spheres."

All these notions had to do with the physical world being some way in harmony with the world of the spirit—the metaphysical world—and the soul being an attunement of the body. According to the

Greek myth of Orpheus, who is depicted in a fine red-figured vase of the early 5th century B.C. (Fig. 61), music even had the miraculous power to overcome death. This thought found an enduring place in Western literature, and no writer has expressed it more sensitively than Shakespeare in The Merchant of Venice (Act V, scene I):

. . . look, how the floor of heaven Is thick inlaid with patines of bright

There's not the smallest orb which thou behold'st

But in his motion like an angel sings, Still quiring to the young-eyed cherubins:

Such harmony is in immortal souls: But, whilst this muddy vesture of decay Doth grossly close it in, we cannot hear it.

Orpheus among the Thracians. Attic red-figured vase. c. 440 B.C. Staatliche Museen, Berlin.

Music Theory

The most important Greek contribution to music is without doubt a theoretical one—that of coordinating the mathematical ratios of melodic intervals with their scale system. The discovery, attributed to Pythagoras, showed that such intervals as the octave, fifth, and fourth have a mathematical relationship. This can easily be heard when a tuned string is stopped off exactly in the middle. The musical interval between the tone of an unstopped string and the one that is divided into two equal parts will then be the octave, and the mathematical ratio will be 1:2. Then if a segment of the string divided into two parts is compared with one of a string divided into three parts, the resulting interval will be the fifth, and the ratio, 2:3. If one compares the tone of the triply divided string with one divided into four parts, the interval will be the fourth, and the ratio 3:4. Hence, 1:2 mathematically equals the octave; 2:3, the fifth; 3:4, the fourth: 8:9, the whole tone; and so on.

Music to Pythagoras and his followers thus was synonymous with order and proportion and rested on a demonstrably rational basis.

Music and Drama

Knowledge of Greek music must be gleaned from a variety of sources, such as occasional literary references, poetry and drama, visual representations of musical instruments and music making in sculpture and painting, theoretical treatises, and some very fragmentary surviving examples of the music itself. When all the separate sources are combined, a faint notion of what Greek music actually was like can be had. From them, it is apparent that music's highest development undoubtedly was in its union with the drama. Athenian dramatists were by tradition responsible for the music, the training of the chorus, and the staging of their plays, as well as for the writing of the script. In addition, they often played some of the roles. So with all their other activities, the great dramatists had to be composers as well as poets, actors, playwrights, and producers.

In reconstructing the Greek drama, one must imagine a Greek audience to whom the drama was a lively aural and visual experience of choral singing and dancing, of vocal and instrumental music, as well as of dialogue and dramatic sequence. Today, with all the choruses and dances missing, such a play as The Suppliants of Aeschylus is like the text of an opera without the musical score. This play is so clearly a lyric drama that the music itself must have been a full partner in conveying the poet's meaning. Euripides' Bacchae, on the other hand, has far greater dramatic substance, but even here the emotional intensity of the individual scenes often rises to such a pitch that music had to take over where the words left off—just as when a person is so overcome with feeling that words fail and inarticulate sounds and gestures are all that remain.

THE CHORUS. The weight of the musical expression fell primarily on the chorus, which was the original basis of the dramatic form and from which all the other elements of the drama evolved. We have at last realized, said Nietzsche in his analysis of Greek drama, "that the scene, together with the action, was fundamentally and originally conceived only as a vision, that the only reality is just the chorus, which of itself generates the vision and speaks thereof with the entire symbolism of dancing, tone, and word." The chorus performed both in stationary positions and in motion. As the chorus circulated about the orchestra, where the choral songs, dances, and group recitatives took place around the altar of Dionysus, its song was accompanied with appropriate gestures. The forms of the choruses were metrically and musically very elaborate and were written with such variety and invention that repetitions either within a single play or in other plays by the same poet were very rare.

Interestingly enough, the sole surviving relic of Greek music from the 5th century B.C. is a fragment of a choral *stasimon*, or "stationary chorus," from Euripides' *Orestes* (Fig. 62). All ancient Greek manuscripts have come down through the ages from the hands of medieval scribes who omitted the musical notation of the earlier copies because it was no

62. Fragment of a choral stasimon from Euripides' *Orestes*. Beginning of 1st century B.C. Papyrus, $3\frac{1}{2} \times 3\frac{3}{8}''$ (9 × 8.5 cm). Austrian National Library, Vienna.

longer comprehensible to them. In the Euripides, the musical notation was included, but all that is left is a single sheet of poorly preserved papyrus.

Fragmentary though this scrap of evidence is. these few notes from Euripides' Orestes are enough to tell their own story. That the intervals called for are in half and quarter tones means that Euripidean choruses were musically complex enough to demand highly skilled singers. The mode is Mixolydian, which is described by Aristotle in his Politics as being "mournful and restrained." The words that accompany the fragment perfectly express this sentiment, and, when properly performed, the fragment still conveys this mood. Other than this single relic of choral recitative, the music of the 5th century must remain mute to our ears. So we can only echo the words of John Keats in his "Ode on a Grecian Urn": "Heard melodies are sweet, but those unheard / Are sweeter."

IDEAS

Each of the arts—architecture, sculpture, painting, poetry, drama, and music—is, of course, a distinct medium of expression. Each has its materials, whether of stone, bronze, pigments, words, or tones. Each has its skilled craftsmen who have disciplined themselves through years of study so they can mold their materials into meaningful forms. But every artist, whether architect, sculptor, painter, poet, dramatist, or musician, is also a child of a specific time and place, who in youthful years is influenced by the social, political, philosophical, and religious ideas of the period and who, in turn, on reaching maturity contributes creative leadership in a particular field.

No art exists apart from its fellows, and it is no accident that the Greeks thought of the arts as a family of sister Muses. Architecture, to complete itself, must rely on sculpture and painting for embellishments. Sculpture and painting, for their parts, must search for congenial architectural surroundings. Drama embraces poetry, song, and the dance in the setting of a theater.

This interdependence of the arts was all quite clear in ancient times, as Plutarch's quote of Simonides indicates: "Painting is silent poetry; poetry is painting that speaks." When the philosophers Plato and Aristotle examined the arts, they looked for common elements applicable to all. And they were just as keen in their search for unity here as they were for unity among all the other aspects of human experience.

Certain recurring themes appear in each of the arts of the Hellenic period as artists sought to bring their ideals to expression. Out of these themes

emerges a trio of ideas—humanism, idealism, and rationalism—that recur continually in Athenian thought and action. These three ideas, both separately and in their interaction, provide the framework that surrounds the arts and encloses them in such a way that they come together into a significant unity.

Humanism

"Man," said Protagoras, "is the measure of all things." And as Sophocles observed, "Many are the wonders of the world, and none so wonderful as man." This, in essence, is humanism. With the human being as yardstick, the Greeks conceived their gods and goddesses as idealized beings, immortal and free from physical infirmities but, like themselves, subject to human passions and ambitions. The gods, likewise, were personifications of human ideals: Zeus stood for masculine creative power, Hera for maternal womanliness, Athena for wisdom, Apollo for youthful brilliance, Aphrodite for feminine desirability. Because of this perceived resemblance to the gods, the Greeks gained greatly in selfesteem. When gods were more human, as the saying goes, men and women were more divine.

The principal concern of the Greeks was with human beings—their social relationships, their place in the natural environment, and their stake in the universal scheme of things. In such a small city-state as Athens, civic duties fell upon the individual. Every responsible person had to be concerned with politics, which Aristotle considered to be the highest social ethics. Participation in public affairs was based on the need to subordinate personal aspirations to the good of the whole state. A person endowed with great qualities of mind and body was honor-bound to exercise these gifts in the service of others. Aeschylus, Socrates, and Sophocles were men of action who served Athens on the battlefield as well as in public forums and theaters. One responsibility of a citizen was to foster the arts. Under Athenian democracy the state itself, meaning the people as a whole, became the principal patron of the arts.

Politically and socially, the life of the Athenians was balanced between aristocratic conservatism and liberal individualism, a balance maintained by the democratic institutions of their society. Their arts reflected a tension between this aristocratic tradition, which resisted change and emphasized austerity, restraint, and stylization in the arts, and the new dynamic liberalism, which put greater emphasis on emotion, the desire to cultivate ornateness, and a taste for naturalism. The genius of Phidias was his ability to achieve a golden mean between these op-

posites; the incomparable Parthenon was the result.

Humanism also expressed itself in kinship with nature. By personifying all things, animate and inanimate, the Greeks tried to come to terms with unpredictable natural phenomena and to explain the inexplicable. Their forests were populated with elusive nymphs and satyrs, their seas with energetic tritons, and their skies with capricious zephyrs. All were imaginative explanations and personifications of forces beyond their control.

These personifications, as well as the conception of the gods as idealized human beings, created a happy condition for the arts. By increasing their understanding of nature in all its aspects, the Hellenes also enhanced their own humanity. Even when the scientific philosophers sought to reduce the universe to basic matter—earth, air, fire, water—the body and soul were still identified with the basic stuff of the natural world. To create an imaginary world that is also a poetic image of the real world will always be one of the pursuits of the artist. And the Greeks thought of art as a *mimesis*—that is, an imitation or representation of nature. Since this also included human nature, it implied a recreation of life in the various mediums of art.

Particularly congenial to this humanistic mode of thought was the art of sculpture. With the human body as the point of departure, such divinities as Athena and Apollo appeared as idealized images of perfect feminine and masculine beauty. Equally imaginative were such deviations from the human norm as the goat-footed Pan, the half-human, half-horse centaurs, and the many fanciful creatures and monsters that symbolized the forces of nature.

The Greeks were more thoroughly at home in the physical world than the later Christian peoples, who believed in a separation of flesh and spirit. The Greeks greatly admired the beauty and agility of the human body at the peak of its development. In addition to studying literature and music, Greek youths were trained from childhood for competition in the Athenian and Olympic games. Since it was through the perfection of their bodies that human beings most resembled the gods, the culture of the body was a spiritual, as well as physical, activity.

The nude male body in action at gymnasiums was a fact of daily experience, and sculptors had ample opportunity to observe its proportions and musculature. The result is embodied in such well-known examples as the statues of athletes attributed to Polyclitus, such as the *Doryphorus* (Fig. 49), and the *Discobolus* (Fig. 53) by Myron. The *Kritios Boy* (Fig. 63), found on the acropolis, is one of the rare marble originals of this period. The slight turn of the head and the easy stance with the weight placed on

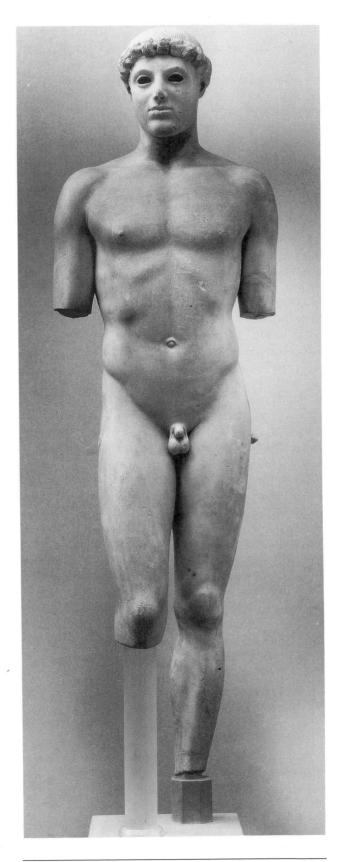

63.Kritios Boy. 480 B.C. Marble, height 34" (86 cm). Acropolis Museum, Athens.

one foot give the figure a supple grace and animation. As an instrument of expression, the male nude reached a high point in the 5th century B.C. The female form, however, had to wait for similar inspired treatment until the next century.

Any humanistic point of view assumes that life here and now is good and is meant to be enjoyed. This attitude is the opposite of medieval self-denial, which viewed the joys of this life as snares of the devil, believing that true good could be attained only in the unseen world beyond the grave. While the Greeks had no single belief about life after death, the usual one is found in the underworld scene of Homer's Odyssey when the spirit of the hero's mother explains that "when first the breath departs from the white bones, flutters the spirit away, and like to a dream it goes drifting." And the ghost of Achilles tells Odysseus that he would rather be the slave of the poorest living mortal than reign as king over the underworld. Greek steles, or gravestones, usually depicted the deceased in some characteristic worldly attitude—a warrior in battle, a hunter with his favorite horse or dog, or a lady choosing her jewelry for the day's adornment (Fig. 64, see also p. 20).

The spiritual kingdom of the Greeks was definitely of this world. They produced no major religious prophets, had no divinely imposed creeds, no sacred scriptures as final authority on religious matters, no single organized priesthood. Such mottoes inscribed on the sacred stones of Delphi as "Know thyself" and "Nothing in excess" were suggestions that bore no resemblance to the thunderous "Thou shalt nots" of Moses' earlier Ten Commandments.

Knowledge of their gods came to the Greeks from Homer's epics and Hesiod's book of myths. The character and action of these gods, however, were subject to a wide variety of interpretations, as is clear from the commentaries of the 5th-century drama. This nonconformity indicated a broad tolerance that allowed free speculation on the nature of the universe. Indeed, the Greeks had to work hard to penetrate the divine mind and to interpret its meaning in human affairs. Ultimately, their ethical principles were embodied in four virtues—courage, meaning physical and moral bravery; temperance, in the sense of nothing too much or, as Pericles put it, "our love of what is beautiful does not lead us to extravagance"; justice, which meant rendering to each person what was due; and wisdom, the pursuit of truth.

HUMANISM AND THE ARTS. Just as the Greek religion sought to capture the godlike image in human form, so also did the arts try to bring the experience of space and time within human grasp. Indefinite space and infinite time meant little to the Greeks.

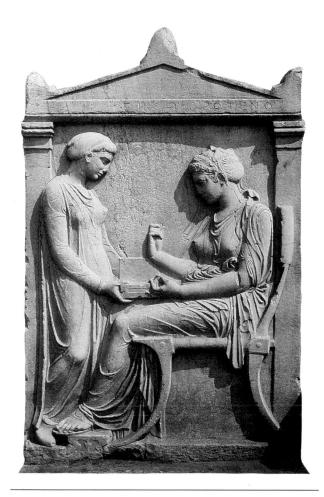

64. Grave stele of Hegeso. c. 410–400 B.C. Marble, height 4'11" (1.5 m). National Museum, Athens.

The modern concept of a nation as a territorial or spatial unit, for instance, did not exist for them. Expansion of their city-state had less to do with lines on a map than with a cultural unity of independent peoples sharing common language and ideals. The Greeks had little knowledge of or concern with an accurately dated historical past. This is seen in the imperfection of their calendar and in the fact that their historians, Herodotus and Thucydides, were really chroniclers of almost-contemporary events.

Greek geometry was designed to measure static rather than moving bodies, and their visual arts emphasized the abiding qualities of poise and calm. Greek architecture humanized the experience of space by organizing it so that it was neither too complex nor too grand to be fully comprehended. The Parthenon's success rests on its power to humanize the experience of space. Through its geometry, such visual facts as repeated patterns, spatial progressions, and distance intervals are made easy to see and to understand. The simplicity and clarity of Greek con-

struction were always evident to the eye, and by defining the indefinite and imposing a sense of clarity and order on the chaos of space, the architects of Greece made their conceptions of space both articulate and intelligible.

Just as architecture humanized the perception of space, so the arts of the dance, music, poetry, and drama humanized the experience of time. These arts fell within the broad meaning of *music*, and their humanistic connection was emphasized in the education of youth. For as Plato said, "rhythm and harmony find their way into the inward places of the soul, on which they mightily fasten, imparting grace, and making the soul of him who is rightly educated graceful."

The triple unities of time, place, and action observed by the dramatists brought the flow of time within definite limits and are in striking contrast to the shifting scenes and continuous narrative styles of later periods. The essential humanism of Greek drama is found in its creation of distinctive human types; in its making of the chorus a collective human commentary on individual actions of gods and heroes; in its treatment of human actions in such a way that they rise above individual limitations to the level of universal principles; and, above all, in the creation of tragedy, in which the great individual is shown rising to the highest estate and then plunging to the lowest depths, thereby spanning the limits of human experience.

In sum, all the arts of Greece became the generating force by which Athenians consciously or unconsciously identified with their fellow citizens and with the entire rhythm of life about them. Through the arts, human experience is raised to its highest level; refined by their fires, the individual is able to see the world in the light of universal values.

Idealism

When artists face the practical problem of representation, there are two main courses. They can choose to represent objects either as they appear to the physical eye or as they appear to the mind's eye. In one case, they would emphasize nature, in the other, imagination; the world of appearances as opposed to the world of essences; the real as opposed to the ideal. The avowed realist is more concerned with *concretion*—that is, with rendering the actual, tangible object with all its particular and peculiar characteristics. The idealist, on the other hand, accents *abstraction*, eliminating all extraneous accessories and concentrating on the essential qualities of things. A realist, in other words, tends to represent things as they are, an idealist, as they might or should be. Ide-

alism as a creative viewpoint gives precedence to the idea or mental image, tries to transcend physical limitations, aspires toward a fulfillment that goes beyond actual observation, and seeks a concept closer to perfection.

Both courses were followed in the Hellenic style. One of Myron's most celebrated works was a bronze cow said to be so natural that it aroused amorous reactions in bulls, and calves tried to suckle her. Such a work would certainly have been in line, in the literal sense at least, with the Greek definition of art as the imitation of nature. The striving to represent the world of natural appearances is well exemplified in the astonishing likeness of a warrior, a 5th-century-B.C. Greek original bronze recently found off the coast of southern Italy (Fig. 65). The

65.Warrior. 5th century B.C. Bronze with glass, bone, silver, and copper inlay, height 6'6" (2 m). Museo Nazionale, Reggio Calabria, Italy.

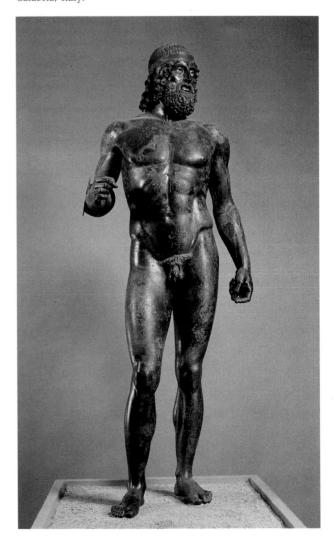

naturalistic representation is fortified by the use of bone and glass for the eyes; copper for the eyelashes, lips, and nipples; and silver for the teeth. The distance from stylization to realism can be measured by comparing this bronze with the earlier *Kouros* (Fig. 48). On the other hand, the difference between realism and idealism can also be seen when this warrior is compared with the godlike form of Figure 52.

PLATO'S IDEAL FORMS. The case for idealism is argued in Plato's dialogues. He assumes a world of eternal verities and transcendental truths but recognizes that perfect truth, beauty, and goodness can exist only in the world of forms and ideas. Phenomena observed in the visible world are but reflections of these invisible forms. By way of illustration, parallelism is a concept, and two exactly parallel lines will, in theory, never meet. It is impossible, however, to find anything approaching true parallelism in nature, and no matter how carefully a draftsman draws them, two lines will always be unparallel to a slight degree and, hence, will meet somewhere this side of infinity. But this does not destroy the concept of parallelism, which still exists in the ideal world.

Plato's *Republic*, to cite another example, is an intellectual exercise in projecting an ideal state. No one knew better than Plato that such a society did not exist in fact and probably never would. But this did not lessen the value of the activity. The important thing was to set up goals that would approach his utopian ideal more closely than did any existing situation. "Would a painter be any the worse," he asks, "because, after having delineated with consummate art an ideal of a perfectly beautiful man, he was unable to show that any such man could ever have existed? . . . And is our theory a worse theory because we are unable to prove the possibility of a city being ordered in the manner described?"

Plato's idealistic theory, however, leads him into a rather strange position regarding the activities of artists. When, for instance, they fashion a building, a statue, or a painting, they are imitating, or representing, specific things that, in turn, are imitations of the ideal forms, and hence their products are thrice removed from the truth. The clear implication is, of course, that art should try to get away from the accidental and accent the essential, to avoid the transitory and seek the permanent.

Aristotle, on the other hand, distinguished among various approaches in art. In his *Poetics*, he observes that "we must represent men either as better than in real life, or as worse, or as they are. It is the same in painting. Polygnotus depicted men as nobler than they are, Pauson as less noble, Dionysius drew them true to life. . . . So again in language,

whether prose or verse unaccompanied by music. Homer, for example, makes men better than they are; Cleophon as they are; Hegemon the Thasian, the inventor of parodies, . . . worse than they are." Aristotle applied the same standard to drama, pointing out that "Comedy aims at representing men as worse, Tragedy as better than in actual life." In the visual arts, the distinction, then, is between making an idealized image, a realistic image, or a caricature. Aristotle clearly implies that idealism as expressed in Homer's heroic poetry, Polygnotus's noble paintings, and Sophocles' moving tragedies constitutes the highest form of art.

IDEALISM AND THE ARTS. At its high point in the latter half of the 5th century B.C., the Hellenic style was dominated by the idealistic theory. The Greek temple was designed as an idealized dwelling place for a perfect being. By its logical interrelationship of lines, planes, and masses, it achieves something of permanence and stability in the face of the transitory and random state of nature.

In portraying an athlete, a statesman, or a deity, the Hellenic sculptor concentrated on typical or general qualities rather than on the unique or particular. This was in line with the Greek idea of personality, which it was felt was better expressed in the dominating traits than in individual oddities.

In sculpture, as well as in all the other arts, the object was to rise above transitory sensations to capture the permanent, the essential, the complete. Thus the sculptor avoided representing the human being in infancy or old age, since immaturity and postmaturity implied incompleteness or imperfection and hence were incompatible with the concept of ideal types. The range of representations extends from athletes in their late teens through images of Hermes, Apollo, and Athena, who are conceived in their early maturity, to Zeus, father of the gods, who appears as the fully developed patriarch in all the power of mature manhood. It must also be remembered that few of the Hellenic sculptor's subjects were intended to represent human beings as such. The majority were fashioned to represent gods, who, if cast in human form, must have bodies of transcendent beauty.

In some way, even the intangible tones of music participated also in the ideal world by way of the mathematical relationships on which they are based. A melody, then, might have something more permanent than its fleeting nature would indicate.

One of the main functions of the drama was to create ideal types, and while the typical was always opposed to the particular, somehow the one arose from the other. The interpretation of this interplay was assigned to the chorus, and the drama as a whole shared with the other arts the power of revealing how the permanent could be derived from the impermanent; how the formula could be extracted from the process of forming; how a permanent quality could be distilled from universal flux; how the type could be found in the many specific cases; and how the *archetype*, or highest type, could arise from the types.

In the extreme sense, the ideal and real worlds represent perfect order and blind chaos. Since the one was unattainable and the other intolerable, it was necessary to find a middle ground somewhere. Glimpses of truth, beauty, and goodness could be caught occasionally, and these intimations should help people to steer a course from the actual to the ideal. By exercising the faculties of reason, judgment, and moral sense, human beings can subdue the chaotic conditions of their existence and bring closer into view the seemingly far-off perfection.

The Socratic theory of education, expressed in the balance between gymnastic for the body and music for the soul, was designed as a curriculum leading toward this end. The Greek temple, the nobly proportioned sculptural figures, the hero of epic and tragedy, and the orderly relationships of the melodic intervals in music are all embodiments of this ideal. Politician, priest, philosopher, poet, artist, and teacher all shared a common responsibility in trying to bring the ideal closer to realization. As Socrates said, "Let our artists rather be those who are gifted to discern the true nature of the beautiful and graceful; then will our youth dwell in a land of health, amid fair sights and sounds, and receive the good in everything; and beauty, the effluence of fair works, shall flow into the eye and ear, like a healthgiving breeze from a purer region, and insensibly draw the soul from earliest years into likeness and sympathy with the beauty of reason."

Rationalism

Rationalism is a concept and a way of life that rests on the idea that the rule of reason should prevail in human affairs. In the *Republic* Plato sought to demonstrate that the mind could illuminate the ways and means of ordering human life as well as governing the state by the application of reason. He divided the human constitution into three parts—the appetitive, the emotional, and the rational—located in the abdomen, the chest, and the head, respectively. He also divided society into three classes—slaves, free men, and philosophers. Likewise human life could rise from its initial stage of ignorance, through a fluctuating period of constantly changing opinion, to the

final security and stability of knowledge together with the contemplation of the eternal verities—truth, goodness, and beauty. The clear implication is that the intellect is the highest human faculty, and that through education men and women can rise to the point where reason rules their lives.

Ever since Pythagoras had discovered the exact mathematical ratios of the musical intervals, Greek thinkers were convinced that the universe was knowable because it was founded on rational as well as harmonic principles. Plato recounts in the Republic the story of the fallen warrior, Er, who returned to life and told what he had seen in the otherworld. He said that he had beheld the heavenly bodies moving together to form one harmony, "and round about, at equal intervals, there is another band, three in number, each sitting upon her throne: these are the Fates, daughters of Necessity, . . . Lachesis and Clotho and Atropos, who accompany with their voices the harmony of the sirens—Lachesis singing of the past, Clotho of the present, Atropos of the future."

Following the Pythagorean theory that "all things are numbers," Socrates and Plato taught that human inquiries and endeavors could serve as a mirror of the cosmic order. It also followed that beyond the changing and shifting world of appearances, there was an underlying permanent and orderly continuity in both cosmic and human affairs and that it was based on logic and reason.

In the Hebraic and Christian traditions, original sin lay in breaking the moral law, but to the Greeks, the greatest error was a lack of knowledge. The tragedy of Oedipus in Sophocles' drama *Oedipus the King* is his ignorance, since it does not permit him to know he is murdering his father, marrying his mother, and begetting children who are also his own siblings. His downfall therefore comes through his ignorance, and his fate is the price he has to pay. The entire Greek philosophical tradition concurred in the assumption that without knowledge and the free exercise of the faculty of reason, there is no ultimate happiness for humanity.

By thinking for themselves in the spirit of free intellectual inquiry, the Greeks to a great extent succeeded in formulating reasonable rules for the conduct of life and its creative forces. This faith in reason also imparted to the arts an inner logic of their own, since when an artist's hands are guided by an alert mind, the work can penetrate the surface play of the senses and plunge to deeper levels of universal experience. For all later periods, this balance between the opposites of reason and emotion, form and content, reality and appearance becomes the basis for any classical style. For such subsequent classical move-

ments as those of the Renaissance and 19th-century neoclassicism, the guiding principles were symmetry, proportion, and unity based on the interrelationship of parts with one another and with the whole.

HARMONIC PROPORTIONS. In the Timaeus Plato theorized that God had created the world by making successive divisions of matter and by placing in space the seven heavenly bodies known to the Greeks. As the planets described their orbits, they were thought to create cosmic music in the manner of the division of the octave into the seven tones of the diatonic scale. All this accorded with the discoveries of Pythagoras and the doctrine of the music of the spheres. This doctrine continued to be held into the Middle Ages and the Renaissance through the writings of Galileo and Kepler, who still maintained that the planets created a music of the spheres in a kind of sonic counterpoint to the laws of planetary motion. Next, according to Plato, God created the human soul as the mirror image of this universal

soul and endowed human beings with the rationalintellective faculty so that they could then aspire to immortality "by learning the harmonies and revolutions of the universe."

So with God as the master builder composing the universe by musical and geometrical laws, it followed that architecture and sculpture as the framework of human activity must also mirror the cosmic order. At Agrigentum in Sicily the largest of all Doric temples was dedicated to the Olympian Zeus. Since Zeus was the lord of the skies, the two porches have seven columns each (an allusion to the seven planets), while the lateral columns number fourteen in the octaval proportion of 1:2. Near Athens on the island of Aegina a temple to a local goddess, Aphaia, is also in the Doric order and has six columns on the front and back and twelve on the sides, again 1:2. By the mid-5th century on the mainland, however, the proportions shifted to 1:2 plus 1, possibly for greater elegance and less rigid mathematical regularity. This is seen in the temple of Zeus at Olympia and the Hephaesteum in Athens. Both are framed by six

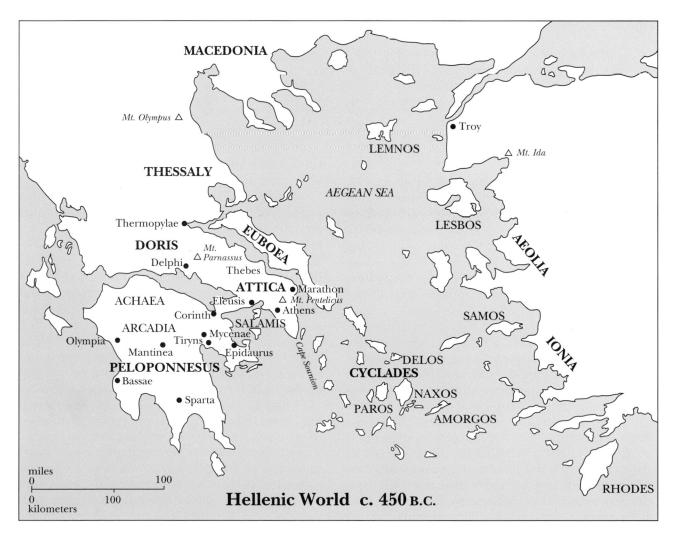

frontal and 13 lateral columns in the ratio of 6:13, and the Parthenon with 8:17. Later, in Rome, it will be seen that the geometry of the Pantheon is also based on exact harmonic proportions (see p. 99).

The sculptor Polyclitus thought along the same lines when he formulated a rational theory of the proportions of the human body. It was based on a modular system in which all parts become multiples or fractions of a basic common measure (see p. 39, pp. 99–100). His long-lost book was known to the Roman architectural theorist Vitruvius, who pointed out that since the head would be one eighth of the total height of an idealized figure, the human body itself would fit into the octave relationship of the musical intervals.

Vitruvius, for his own part, showed how the human body fits into the two most perfect geometrical forms, the circle and square. The drawing shown as Figure 66 is by Leonardo da Vinci after the theories of Vitruvius. Both hark back to Plato's *Timaeus*, where the cosmic soul is the macrocosm of the universe and the human soul the microcosm. This idea reverberated along the corridors of time, and as the poet John Dryden later wrote:

From harmony to heavenly harmony
This universal frame began;
From harmony to harmony
Thro' all the compass of the notes it
ran,
The diapason [octave] closing full in
man.

RATIONALISM AND THE ARTS. Hellenic artists were as much concerned as were Plato and Aristotle with the pursuit of an ideal order, which they felt could be grasped by the mind through the medium of the senses. Greek architecture, in retrospect, turns out to be a high point in the rational solution to building problems. The post-and-lintel system of construction, as far as it goes, is eminently reasonable and completely comprehensible. All structural members fulfill their logical purpose. Nothing is hidden or mysterious. The orderly principle of repetition on which Greek temple designs are based is as logical in its way as one of Euclid's geometry propositions or Plato's dialogues. It accomplishes for the eye what Plato tries to achieve for the mind.

The tight unity of the Greek temple met the Greek requirement that a work of art be complete in itself. Its carefully controlled but flexible relationships of verticals and horizontals, solids and voids, structural principles and decorative embellishments give it a relentless internal consistency. And the harmonic proportions of the Parthenon reflect the

66. Leonardo da Vinci. *Study of Human Proportions according to Vitruvius.* c. 1485–90. Pen and ink, $13\frac{1}{2} \times 9\frac{3^m}{4}$ (34 × 25 cm). Galleria dell' Accademia, Venice.

Greek image of a harmoniously proportioned universe quite as much as a logical system.

Sculpture likewise avoided the pitfalls of rigid mathematics and succeeded in working out principles adapted to its specific needs. When Polyclitus said "the beautiful comes about, little by little, through many numbers," he was stating a rational theory of art in which the parts and whole of a work could be expressed in mathematical proportions. But he also allowed for flexible application of the rule, depending on the pose or line of vision. By such a reconciliation of the opposites of order and freedom, he reveals the kinship of sculptors with their philosophical and political colleagues who were trying to do the same for other aspects of Athenian life.

Rational and irrational elements were present in both the form and content of Greek drama, just as they were in the architecture of the time. In the Parthenon, the structurally regular triglyphs were interspersed with panels showing centaurs and other mythological creatures. The theme of these sculptures was the struggle between the Greeks as champions of enlightenment and the forces of darkness

and barbarism. In the drama, the rational Apollonian dialogue existed alongside the inspired Dionysian chorus. However, even in the latter, the intricate metrical schemes and the complex arrangements of the parts partake of rationalism and convey the dramatic content in a highly ordered composition. In the dialogue of a Greek tragedy, the action of the episodes must by rule lead inevitably and inexorably toward the predestined end, just as the lines and groupings of the figures must do in a composition like that of the cella frieze or east pediment of the Parthenon.

In the union of mythological and rational elements, tragedy could mediate between intuition and rule, the irrational and rational, the Dionysian and Apollonian principles. Above all, it achieves a coherence that meets Aristotle's critical standard of "a single action, one that is a complete whole in itself with a beginning, middle, and end, so as to enable the work to produce its proper pleasure with all the organic unity of a living creature."

Just as the harmony of the Parthenon depended on the module taken from the Doric columns, so Polyclitus derived his proportions for the human body from the mathematical relationship of its parts. In similar fashion, melodic lines in music were based on the subdivisions of the perfect intervals derived from the mathematical ratios of the fourth, fifth, and octave. So also the choral sections of the Greek drama were constructed of intricate metrical units that added up to the larger parts on which the unity of the drama depended. In none of these cases, however, was a cold distillation the desired effect. In the architecture of the Hellenic style, in the statues of Polyclitus, in the dramas of Aeschylus, Sophocles, and Euripides, and in the dialogues of Plato, the rational approach was used principally as a dynamic process to suggest ways for solving a variety of human and aesthetic problems.

It was also the Greeks who first realized that music, like the drama and other arts, was a mean between the divine madness of an inspired musician, such as Orpheus, and the solid mathematical basis on which the art rested acoustically. The element of inspiration had to be tempered by an orderly theoretical system that could demonstrate mathemati-

cally the arrangement of its melodic intervals and metrical proportions.

Finally, it should always be remembered that the chief deity of Athens was the goddess of knowledge and wisdom. Even such a cult religion as that of Dionysus, through the Orphic and Pythagorean reforms, tended constantly toward increased rationalism and abstract thought. While Athena, Dionysus, and Apollo were all born out of a myth, their destinies found a common culmination in the supreme rationalism of Socrates and Plato, who eventually concluded that philosophy was the highest music.

THE HELLENIC HERITAGE

"We are all Greeks." So said Shelley in the preface to his play *Hellas*. "Our laws, our literature, our religion, our arts, have their roots in Greece." Merely the mention of such key words as *mythology*, *philosophy*, and *democracy* points immediately to their Greek source. So also do the familiar forms of architecture, sculpture, painting, poetry, drama, and music have their taproots in the age-old soil of Hellas, the land where the Hellenic style was nurtured and brought to fruition.

Such, then, was the remarkable configuration of historical, social, and artistic events that led to this unique flowering of culture. Although circumstances conspired to bring about a decline of political power, Athens was destined to remain the teacher of Greece, Rome, and all later peoples of Western civilization. And the words of Euripides still ring down the corridors of time:

Happy of old were the sons of
Erechtheus,
Sprung from the blessed gods, and
dwelling
In Athens' holy and untroubled land.
Their food is glorious wisdom, they
work
With springing step in the crystal air.
Here, so they say, golden Harmony first
Saw the light, the child of the Muses

nine.

HELLENISTIC PERIOD, 4th to 1st CENTURIES B.C.

	KEY EVENTS	ARCHITECTURE	VISUAL ARTS	WRITERS	MUSIC
	359-336 Philip of Macedon in control of Greece 352-350 Artemisia, queen of Caria, reigned 336 Philip assassinated; succeeded by son, Alexander the Great 334-323 Alexander's conquests in Near East, Asia Minor, India 333 Battle of Issus, conquest of Persia 331 City of Alexandria, Egypt, founded 323 Alexander the Great died in Babylon 323-275 Alexander's generals divided empire: Ptolemies in Egypt, Seleucids in Syria and Palestine, Attalids in Pergamon 323-31 Hellenistic period; 146-31 transitional Greco-Roman period; great centers of culture at Alexandria, Pergamon,	c.350 Mausoleum at Halicarnassus built under Queen Artemisia: Pythios, architect; frieze carved by Scopas and others	c.330 Apelles , court painter to Alexander, flourished c.310 Battle of Issus painted, now lost except for mosaic copy from Pompeii	c.341-c.270 Epicurus, founder of Epicureanism c.336-c.264 Zeno of Citium, founder of Stoicism c.321 Aristoxenus of Tarentum, musical theorist, flourished	Music important part of daily life and public entertainment
00 –	Antioch, and Rhodes				
10	241-197 Attalus I ruled as king of Pergamon. Defeated Gauls in Galatia; allied kingdom with Rome; erected monument commemorating victory over Gauls; patron of First School of Pergamene sculpture		c.280 Colossus of Rhodes cast in bronze by Chares c.228 First School of Pergamene sculpture. Attalus I's monument celebrating victory over Gauls	c.300 Euclid flourished c.287- 231 Archimedes	
) 0 —	197-159 Eumenes II, king of Pergamon. Defeated Gauls; founded Pergamene library; commissioned Altar of Zeus; patron of Second School of Pergamene sculpture. Power of kingdom at zenith 159-138 Attalus II, king of Pergamon, patron of painting 146 Roman conquest of Corinth	183-179 Eumenes II built Altar of Zeus at Pergamon. Menocrates of Rhodes, architect c.150 Stoa of Attalus built at Athens	c.200 Boethos active. Statue of Boy with Goose c.190 Winged Victory of Samothrace carved 183-174 Second School of Pergamene sculpture. Altar of Zeus frieze carved		
00 –	148-133 Attalus III, king of Pergamon; willed kingdom to Rome 129 Pergamon became a Roman province		c.120 <i>Venus of Milo</i> (<i>Aphrodite of Melos</i>) carved		
			c.100 <i>Laocoön Group</i> carved	c. A.D. 50-138 Epictetus	c.A.D. 50 Skolion of Seiklos , complete melody with Greek words carved on tombstone

The Hellenistic Style

PERGAMON, 2ND CENTURY B.C.

The commanding figure of the Hellenistic period was Alexander the Great (Fig. 67). Capitalizing on the conquests of his father, Philip of Macedon, he united the entire Greek peninsula into one kingdom and brought the rule of the independent city-states to an end. He then set out to conquer the entire known world from Egypt and Mesopotamia to Persia and India. Throughout subsequent history the name of Alexander became a legend. Tutored in his youth by the philosopher Aristotle, he received the education of a model prince. One of the greatest generals of all time, Alexander saw himself as the champion of Hellenism, bringing the influence of Greek culture wherever he went. When he died at Babylon in 323 B.C., his whole empire was divided among his generals—the Ptolemies in Egypt; the Seleucids in Syria; and in Asia Minor the Attalids, whose capital city was Pergamon.

The height of the Hellenistic period spans the time from the death of Alexander to the Roman conquest of Corinth in 146 B.C. During these two centuries, cultural leadership remained in the hands of the Greeks, but as they came in contact with such a variety of native influences, their culture became progressively more cosmopolitan. Hence the distinction between the earlier and purer Hellenic and the later, more diffused Hellenistic styles. Though in decline, the Hellenistic period continued through a transitional Greco-Roman era until 31 B.C., when Rome became master of the Western world.

Like the earlier city of Athens, Pergamon (or Pergamum) in Asia Minor developed around its acra, the fortified hilltop that became the residence of its rulers and a sanctuary. The Pergamene acropolis was a geographic site with even greater natural advantages than that of Athens. Thus it played a significant role in the growth of the city. Strategically

located on a plain near the Aegean Sea, Pergamon developed a prosperous export trade. The fertile plain, formed by the flowing together of three rivers, was easily defensible from the hill. The city itself,

Alexander the Great. Pergamon, c. 160 B.C. Marble, life-size. Archeological Museum, Istanbul.

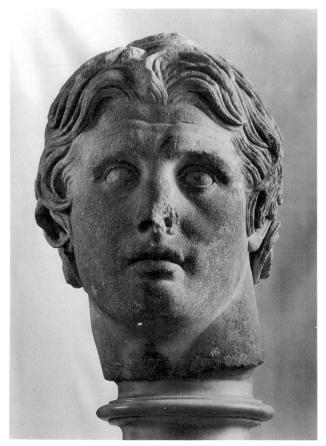

surrounded as it was by the sea, high mountains, and precipitous ravines, was unassailable except from its southern approach. Here, in a situation of unusual beauty, grew the city that was to play such an important role in the Hellenistic period.

The planning of Greek cities apparently goes back no further than the middle of the 5th century B.C. The fame of "wide-wayed Athens" rested on its Panathenaic Way, a street about 12 feet (3.66 meters) broad. Just wide enough for five or six persons to walk abreast, it made easier the processions to the acropolis, theaters, and marketplace. Otherwise, the streets of Athens were narrow alleys barely broad enough to permit the passage of a driver with a donkey cart. Unpaved in any way, they must have been as dry and dusty in summer as they were damp and muddy in winter and spring. The Athenian residential section was only a mass of mud-brick houses in which rich and poor lived side by side in relative squalor. Only in the agora and on the acropolis did spaciousness develop. But even here buildings were planned with more attention to their individual logic than to their relationship as a group. Each building thus existed more as an independent unit and less as part of a coherent whole.

Greek city plans, while a vast improvement on their haphazard predecessors, were based on the application of an inflexible crisscrossing grid pattern that paid little or no attention to the irregularities of the natural site. When a hill was within the city limits, the streets sometimes became so steep that they could be climbed only by difficult stairways. While the residential sections of the ancient city of Pergamon have only now begun to be excavated, it is known that they followed such a regular system. Under Eumenes II, the city reached its largest extent, and the thick wall he built around it enclosed over 200 acres (81 hectares) of ground—more than four times the territory included by his predecessor. Ducts brought in ample water from nearby mountain springs to supply a population of 120,000. The system was the greatest of its kind prior to the later Roman aqueducts.

The main entrance to Pergamon was from the south through an impressive arched gateway topped by a pediment with a triglyph frieze. Traffic was diverted through several vaulted portals that led into a square, where a fountain refreshed travelers. From here, the road led past the humbler dwelling places toward the lower marketplace, which bustled with the activities of peddlers and hucksters of all sorts. This market was a large open square surrounded on three sides by a two-story colonnade behind which were rows of rooms that served for shops. Moving onward, the road went past buildings that housed

the workshops and mills for pottery, tiles, and textiles. Homes of the wealthier citizens were located on higher positions off the main streets overlooking the rest of the city. At the foot of the acropolis another square opened up, which would boast of a large fountain and a fine view.

On a dramatic site almost 1000 feet (305 meters) above the surrounding countryside rose the Pergamene acropolis (Fig. 68), a stronghold that ranked among the most imposing in the Greek world. Up the slopes of the hill, on terraces supported by massive retaining walls and fortifications, were the buildings and artifacts that gave the city its reputation as a second Athens. By ingenious use of natural contours, the Pergamenes had developed settings for a number of buildings, which not only were outstanding as individual edifices but which, by means of connecting roadways, ramps, and open courtyards, were grouped into a harmonious whole. Here on a succession of rising levels were marketplaces, gymnasiums, athletic fields, temples, public squares, wooded groves, and an amphitheater. Above them all, flanked by watch towers, barracks, arsenals, storage houses, and gardens, stood the residence of the kings of Pergamon.

ARCHITECTURE

Upper Agora and Altar of Zeus

Approaching the acropolis was the highest of the marketplaces (Fig. 68, A), an open square that served both as an assembly place and as a market for such quality merchandise as the renowned Pergamene pottery and textiles. Above this agora spread the broad marble-paved terrace on which stood the Altar of Zeus (Fig. 68, B), with its famous frieze depicting in marble slabs the battle of the gods as personifications of light and order against the giants as representatives of darkness and chaos. Dating from about 180 B.C., this artistic triumph of the reign of Eumenes II was considered by some Hellenistic and Roman authorities one of the seven wonders of the ancient world. Since both its structure and sculptures are of major importance, this edifice will be discussed later.

Athena Precinct and Theater

Above the Altar of Zeus was the precinct dedicated to Athena Polias, or Athena, protectress of cities and guardian of laws and city life. Her shrine (Fig. 68, C) was a graceful Doric temple, smaller than the Parthenon, with six-columned porches on either end and ten columns on each side. This level was framed

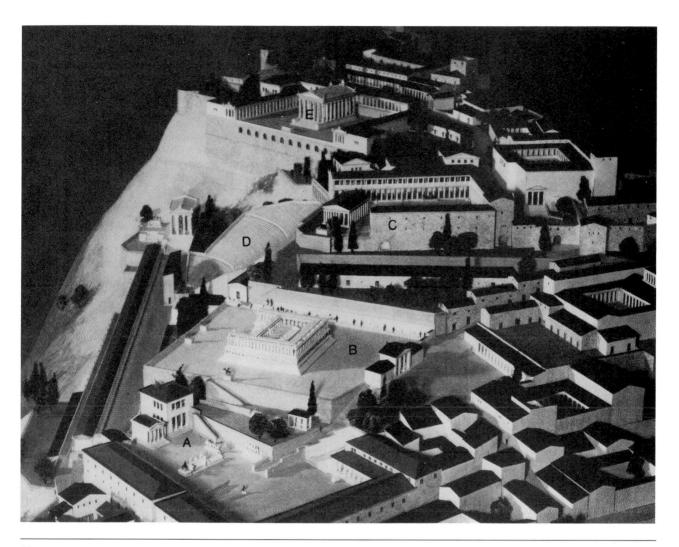

Acropolis, Pergamon. Reconstruction by H. Schlief. Antikensammlung, Staatliche Museen, Berlin. A. Upper agora; B. Altar of Zeus; C. Temple of Athena Polias, courtyard, and library; D. Theater; E. Temple of Trajan and palace precinct.

by an L-shaped, two-storied colonnade that formed an open courtyard in which stood the bronze monument that celebrated the victory of Attalus I, father of Eumenes, over the Gauls (Figs. 69 and 70). This colonnade served also as the façade of the great library of Pergamon, which appropriately was placed here in the precinct of Athena, goddess of reason, contemplation, and wisdom. The most precious part of the library was housed in four rooms on the secondstory level stretching about 145 feet (44 meters) in length and 47 feet (14.2 meters) in width. On their stone shelves, some of which still exist, rested the ancient scrolls, estimated to have numbered about 200,000 at the time of the Attalids. The Pergamon library ranked with that of Alexandria as one of the two greatest libraries of antiquity. Later, after the major portion of the Alexandrine collection of half a million volumes had been burned in an uprising

against Caesar, Mark Antony made a gift to Cleopatra of the entire library of Pergamon.

Below the Athena precinct was the theater (Fig. 68, D), constructed under Eumenes II about 170 B.C. The auditorium with its 78 semicircular tiers of stone seats could hold ten thousand spectators and was carved out of the hillside. Below was the circular section of the orchestra, where the chorus performed around a small altar dedicated to Dionysus, and the rectangular scene building for the actors.

Royal Residence

Just as the Attalid kings dominated the life of their city and constituted the apex of the social pyramid of their kingdom, so the royal residence crowned the highest point in their capital city. Later, after the

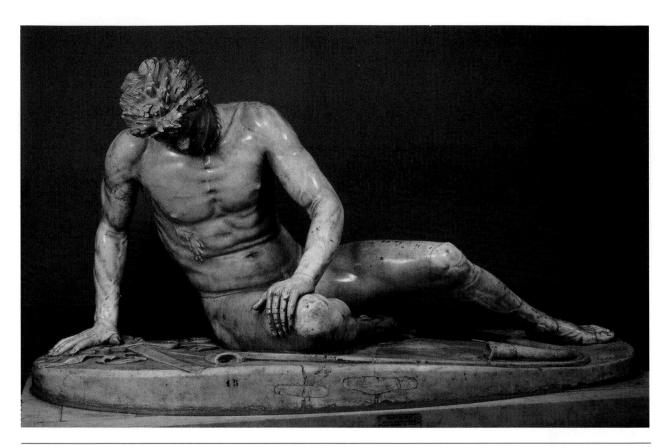

69.Dying Gaul. Roman copy after bronze original of c. 225 B.C. Marble; height 3' (.91 m), length 6'3" (1.91 m). Museo Capitolino, Rome

realm came under the domination of Rome, part of the palace was then destroyed to make way for the large Corinthian temple honoring Emperor Trajan (Fig. 68, E).

From their hilltop residence the kings of Pergamon could survey much of their rich domain. From the mountains to the north came the silver and copper that furnished the metal for their coins—so necessary in promoting trade and paying soldiers. From the same region came also supplies of pitch, tar, and timber—greatly in demand for the building of ships—as well as marble for buildings and sculptures. A panorama thus unfolded around them, starting with the heights of Mount Ida and the surrounding range (down whose slopes flowed the streams that watered the fertile valleys and broad plains), all the way to the bright waters of the Aegean, beyond which lay the shores of the Greek motherland.

The planning of Pergamon thus cleverly promoted the idea of the monarchy towering above it. There, topographically as well as politically, stood the king, aloof from his people and associated by them with the gods. Even while living, he was ac-

corded such divine prerogatives as a cult statue, with perfumed grain burning on an altar before it, and an annual celebration in his honor. This semidivine status, connected with the king's right to rule, served the practical social purposes of commanding obedience to his laws, facilitating the collection of taxes (often under the guise of offerings to the deities), and uniting the peoples and factions who lived under him. Assisting in this deification were the scholars and artists the king attracted to his court, whose works were regarded with awe by native and foreigner alike.

The pomp and display that marked Hellenistic life was a distinct departure from the simplicity and nobility of the more austere 5th century B.C. Grandeur became the grandiose, and many monuments were erected not to revere the gods but to honor kings who, even in their own lifetimes, assumed semidivine status. The accent was no longer on abstract ideals but on the glorification of individuals.

With the changing times, however, definite advances in the art of building were taking place. Domestic architecture was emphasized, and Pergamene architects went beyond the simple post-

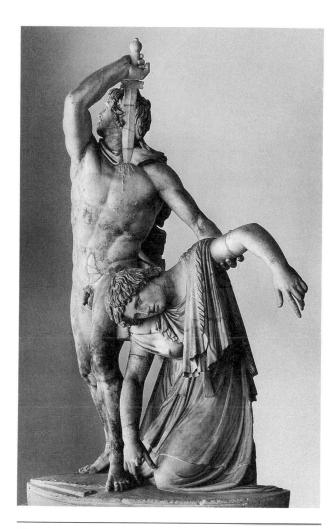

70. Gaul and His Wife. Roman copy after bronze original of c. 225 B.c. Marble, height 6'11" (2.11 m). Museo Nazionale, Rome.

and-lintel method of the Hellenic period by employing the arch and vault in city gates and in underground water and sewer systems. Architecturally as well as culturally, Pergamon forged an important link between the Greek and Roman periods.

SCULPTURE

While sculptural works of all kinds are known to have existed in profusion throughout the city of Pergamon, the examples that claim the attention of posterity were located on two of the terraces of the acropolis. In the Athena precinct just below the royal residence, bounded by the temple on one side and the L-shaped colonnades of the library on two others, was a spacious courtyard in which Attalus I erected the sculptural monuments commemorating his victories. The groups he commissioned were in place during the last quarter of the 3rd century B.C.

On the terrace below, in the first quarter of the 2nd century B.C., his son and successor Eumenes II built the Altar of Zeus (see Fig. 71) with its famous frieze.

Historically, the two periods have been distinguished as the First and Second schools of Pergamon. Since they were separated by less than half a century, however, some sculptors possibly worked on both projects, and if not, they must have had a hand in training their successors. All the bronze originals of the First School have disappeared and can be studied only in the marble copies made by later Hellenistic or Roman artists. Most of the sculptures from the Second School survive, because of the fortunate results of the late 19th-century German excavations and may be seen today in the Pergamon Museum in Berlin.

First School of Pergamon

The principal works of the First School were two large monuments in bronze, each of which was composed of many figures. One commemorated the victories of Attalus over the neighboring Seleucid kingdom. Only a few details of this group survive. The other honored his earlier and greater victory over the nomadic tribes of Gauls, which swept down from Europe across the Hellespont into the region north of Pergamon. From this province, called Galatia after them, the Gauls were a constant threat to the Greek cities lying to the south. While his predecessor had bought them off by paying tribute, Attalus I refused to do so. He met their subsequent invasion with an army, and the outcome of the battle, fought about 30 miles (48 kilometers) to the east of Pergamon, was decisive enough to repel the Gauls for a generation. Its consequences were felt far and wide, and all the cities and kingdoms of the Greek world breathed a little easier.

The fierce Gauls had inspired such general terror that their defeat was associated in the popular mind with something of a supernatural character. The name of Attalus was everywhere acclaimed as *Soter* ("Savior," the victor), and after incorporating the lands he had gained, he assumed the title of king. Thereafter, as King Attalus the Savior, he continued to capitalize on his fortunes by embarking on a program of beautifying his city with the services of the best available Greek artists. Sharing the same patroness, Athena, Pergamon began to acquire the status of a second Athens, and its ruler that of a political and cultural champion of Hellenism.

Parts of the monument that Attalus erected to the memory of his victory over the Gauls can be seen in numerous museums. The *Dying Gaul* (Fig. 69) and the *Gaul and His Wife* (Fig. 70) are the most famous of the individual units to survive from antiquity. The Dying Gaul is a fine example of Hellenistic emotional expression. He is the trumpeter who sounded the call for relief. Mortally wounded, the warrior has agonizingly dragged himself out of the thick of the battle to struggle alone against death. His eyes are fixed on the ground where his sword, the trumpet, and other pieces of his equipment are lying. He supports himself weakly with one arm, proud and defiant to the end, while his life's blood flows out of the gaping wound in his side. The anguished expression in the face has an intensity not encountered before in Greek art. The strong but rough musculature of his powerful body, so different from that of the supple Greek athletes, marks him as a barbarian. Further contrast is found in his hair, which is greased so heavily that it is almost as thick as a horse's mane, and in the collar of twisted gold worn around his neck.

All these carefully recorded details show the interest of the period in individuals as such, in the features that distinguish one person or group from another, and in the portrayal of non-Greek types as heroic in size and fearsome in battle. The very strength and bravery the Pergamenes attributed to

their enemies made their victory seem all the more impressive, a point certainly not lost on the ancient spectator. In addition there was the artist's desire to awaken the sympathies of the observer. By the process of empathy, the sculptor involves the observer in the situation. The contemporary audience would have felt both attraction and repulsion toward such a subject and hence would have experienced a strong emotional reaction. The litter of the battlefield beside the Gaul, as well as other realistic details, is not used so much for its own sake as to convey a sense of immediacy in the experience of the beholder. At the same time, the viewer was invited to look beyond the physical wounds and behold the spiritual anguish of the proud but defeated warrior, so reluctant to accept his fate.

The expressive impact of the *Gaul and His Wife* (Fig. 70) is no less powerful. The custom of the Gauls was to take their women and children with them on their campaigns. Realizing his defeat and too proud to be taken a slave, this Gaul has just killed his wife and looks apprehensively over his shoulder at the approaching enemy as he plunges his sword into his own neck. The mood of despair is heightened by the sweeping lines of the woman's

71. Altar of Zeus, Pergamon (restored). Begun c. 180 B.C. Marble. Antikensammlung, Staatliche Museen, Berlin.

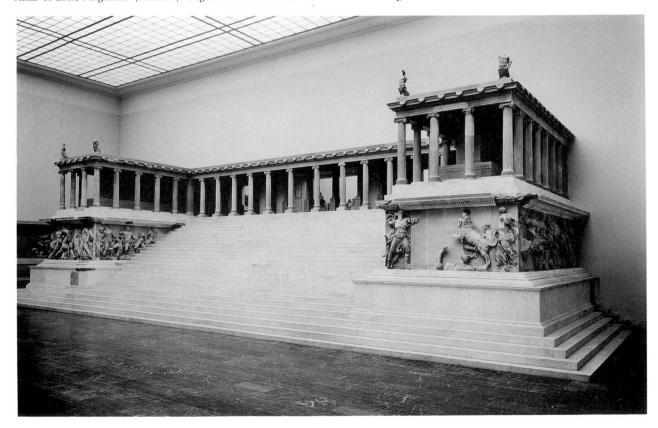

drapery, which droops downward in deep folds, casting dark shadows. In both these surviving representations, strong feeling is aroused in the observer by the noble figures who stare death so directly and courageously in the face.

Second School: Altar of Zeus

To the Second School of Pergamon are assigned all the works that fall within the reign of Eumenes II, the patron under whom Pergamon achieved the highest point of its power and glory. Like his father before him, Eumenes II had his victories over the Gauls, and in the Altar of Zeus (Fig. 71) he continued the tradition of erecting votive works. It was at once the greatest single monument of the city and one of the few top-ranking architectural and sculptural works of the Hellenistic period. It, too, was intended to glorify the position of the king and to impress the entire Greek world with Eumenes' contribution to Hellenism in the struggle against the barbarians.

Beginning in 1873, piece by piece each fragment was painstakingly unearthed, and after a half-century of study, the entire monument was reconstructed in the Pergamon Museum in Berlin. Famed throughout the ancient world, the altar was described in the early years of the Christian era by St. John as "Satan's seat" (Rev. 2:13). The reference seems to have been prompted by the resemblance of the structure to an immense throne and by the pagan gods and demons depicted in the frieze. While the principal interest is focused on the sculpture, the building itself also commands attention.

72. Plan of Altar of Zeus.

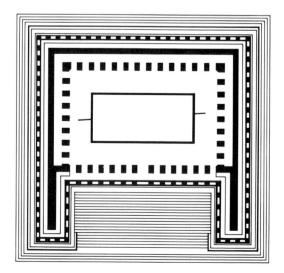

STRUCTURE. The actual altar on which animal sacrifices and other offerings were burned was a large stone podium standing in the inner courtyard. The altar was surrounded by a U-shaped enclosure known as a temenos (Fig. 72). The building rested on a podium, or platform, with five steps, above which was the great frieze more than 7 feet (2 meters) in height and 450 feet (137 meters) in length. It ran continuously around the entire podium, bending inward on either side of the stairway and diminishing in size as the steps rose. Below, the frieze was framed by a molding and, above, by a dentil range (see Figs. 73 and 74), a series of small projecting rectangular blocks. These bricklike blocks served also to support an Ionic colonnade that surrounded the structure and paralleled the frieze. Above the colonnade appeared a friezeless entablature with a second dentil range supporting the roof. Crowning the whole was a series of freestanding statues of deitics and mythological animals placed at various points along the outer edges of the roof.

The concept of space that underlies the Altar of Zeus differs from that of the 5th century. In the earlier period, the altar was placed outside the temple, and rituals took place against the exterior colonnades. In the Hellenistic period, the concept of space included an interest in depth. Thus, in the Altar of Zeus, the spectator looked into a courtyard that enclosed the altar, and not toward a background plane. The wider space between the columns also invited the eye toward the interior, whereas the closer-spaced columns of the 5th century promoted the continuity of the plane.

The general effect produced by the Altar of Zeus as a whole is that of a traditional Greek temple turned upside down. The simple dignity of the older Doric temple—the Parthenon, for example depended upon its structural integrity. The columns served the logical purpose of supporting the upper members, and the sculptured sections were high above where they embellished but did not dominate the design. At Pergamon, the traditional order was inverted. Considered more important than the columns, the decorative frieze was put below, only a little above eye level, in order to be seen more easily. For the sake of tradition, the colonnade was included, but placed above the frieze, where it had no structural purpose. Structurality as a guiding principle had yielded to decoration for its own sake, and the art of architecture, in effect, had given way to the art of sculpture. In the case of the Parthenon, the decorative frieze was included to give some variety to what might otherwise have been monotonous unity. In that of the Altar of Zeus, on the other hand, the variety of the frieze was so overwhelming that

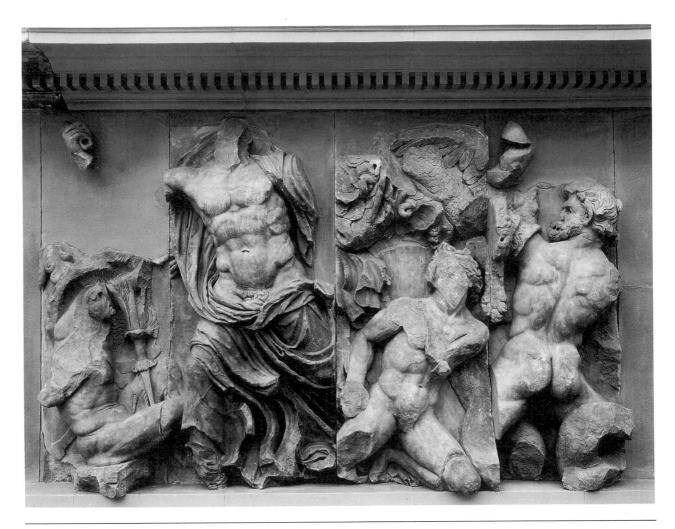

73. *Zeus Hurling Thunderbolts,* detail of Altar of Zeus frieze. c. 180 B.C. Marble, height 7'6" (2.29 m). Antikensammlung, Staatliche Museen, Berlin.

the regularity of a colonnade was needed to preserve the unity. The quiet Hellenic architectural drama, in other words, had become a Hellenistic architectonic melodrama.

FRIEZE. The subject of the frieze is the familiar battle of the gods and giants. In the typical depiction of this scene, it was customary to include the twelve Olympians and an equal number of opponents, but here the unprecedented length of available space demanded more participants. Almost certainly scholars of the library were called upon to compile a catalogue of divinities, together with their attendants and attributes, in order to have enough figures to go around. Lettered inscriptions were liberally used to identify the less familiar figures and to make the narrative more vivid. These program notes supplied many associational meanings and made it possible to read the frieze as well as view it.

Further scholarly influence is found in the allegorical treatment of the ancient battle theme. Literal belief in the gods was largely a thing of the past, and the local scholars interpreted gods as personifications of the forces of nature. Thus the gods represented orderly and benign phenomena, and the giants represented such calamities as earthquakes, hurricanes, and floods.

The narrative begins on the inner part of the right podium, facing the stairs. Moving parallel with the descending stairs, it proceeds along the south side and around the corner to the east. Along the way are introduced the principal characters in the drama—Zeus and his fellow gods, whose mortal combat is with Chronos, father of Zeus, and his supporters, the wicked titans and giants. There are also Helios, the sun god; Hemera, the winged goddess of day; her brother Aether, the spirit of air; and the moon goddess. Such others as Hecate, goddess of the

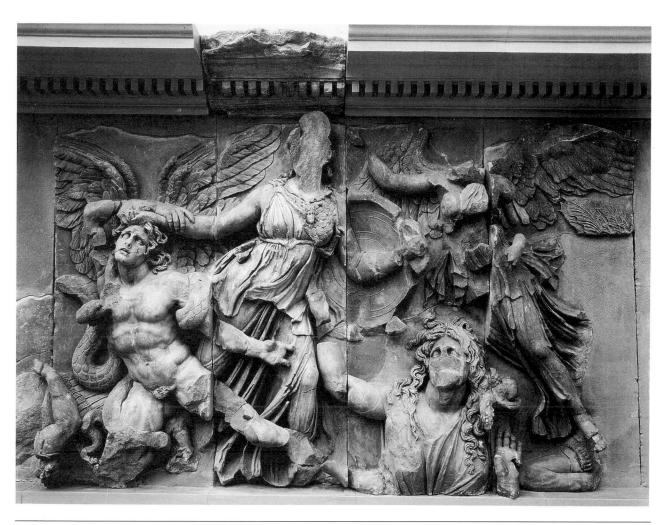

74.Athena Slaying Giant, detail of Altar of Zeus frieze. Marble, height 7'6" (2.29 m). Antikensammlung, Staatliche Museen, Berlin.

underworld; Artemis, the heavenly huntress; and Heracles, father of Telephus, the legendary founder of Pergamon, are included as well. The struggle is between the forces of darkness—the giants—and the spirits of light.

In the four panels reproduced in Figure 73, Zeus is seen, appropriately, in combat with no less than three titans at once. His powerful figure, wrapped in a swirling mantle, is rearing back to smite the giants with his spear and thunderbolts. While most of Zeus's right arm is missing, his hand is seen in the upper left corner of the panel. The titan in the lower left has already been overcome by a thunderbolt, which is shown as a pointed spear with a handle of acanthus leaves. The second giant is on the other side, his body tense with terror before the blow falls. In the slab to the right, Porphyrion, king of the titans, is shown from the back. From his animal ears to his serpent legs, he is a fearsome sight as

he shields himself with a lion skin from both Zeus's eagle above and the thunderbolts that the mighty god is about to hurl.

Next comes the fine group depicting the part played by Athena, protectress of the city (Fig. 74). Her figure is shown in the second slab. Bearing a shield on her left arm, she grasps a winged giant by the hair with her right and forces him to earth, where her sacred serpent can inflict the mortal wound. A moment of pathos is provided by the giant's mother, the earth goddess Gaea, who is seen as a torso rising from the ground. Though she is on the side of the gods, the earth mother implores Athena with her eyes to spare the life of her rebellious son. Gaea's attributes are seen in the horn of plenty she carries in her left hand, a cornucopia filled with the rich fruits of the earth—apples, pomegranates, and grapes with vine leaves and a pine cone. Over her hovers the goddess Nike, symbolizing the victory of Athena.

From this climax in the sky, the action on the shadowy north side of the frieze gradually descends into the realm of the water spirits. They drive the fleeing giants around the other corner of the stairway into the sea, where they drown. Here are the representations of the rivers of Greece. Around the face of the west side and up the stairs are other creatures of the sea. The tumultuous action opens on the right side with the divinities of the land and ends on the left with those of the sea. They are separated by the wide stairs as well as by their placement at the beginning and the end of the dramatic conflict between the forces of good and of evil.

The frieze as a whole is a technical feat of the first magnitude and was executed by a school of sculptors, many of whose names are inscribed below as signatures for their work. In addition to the figures, such details as swords and belt buckles, saddles and sandals, and the cloth for costumes are carved and polished to simulate the textures of metal, leather, and textiles, respectively. The bold high-relief carving, deep undercutting that allows the figures to stand out almost in the round, and rich modeling effects that make full use of light and shadow reveal complete mastery of material.

To sustain such a swirl of struggling forms and violent movement over such a vast space is a minor miracle. The traditional Doric frieze could depend for unity on the momentary action in the metopes regularly interrupted by the static triglyphs. Here at Pergamon the unity relies on the continuity of the motion itself. The slashing diagonal lines and sharp contrasts of movement are grouped into separate episodes by the device of coiling snakes. Winding in and out, they are at once the visual punctuation marks that separate the scenes and the connecting links of the composition. They lead the eye from one group to another and promote a sense of constant writhing motion. The posture of Athena was taken directly from that on the Parthenon east pediment; that of Zeus is derived from the Poseidon of the west pediment. There the Athenians had defeated the Persians, while here the Pergamenes had vanquished the Gauls. In both instances the cities and their rulers had become the champions of Greek culture against barbarian invasions. And here for everyone to see, Pergamon was pictured as the new Athens, directly under the protection of the goddess Athena.

Stylistic Differences

Comparing the great frieze with the *Dying Gaul* and *Gaul and His Wife*, one can note a style trend from the First to the Second school. Both allude to the

constant wars between the Pergamenes and Gauls. But, in contrast to the almost morbid preoccupation with pain of the earlier monument, the gods on the Altar of Zeus slay the giants with something approaching gaiety and abandon. Thus instead of having sympathy for the victims, the viewer wonders at the many ingenious ways the gods dispatch their enemies.

Both monuments accent pathos, but whereas in the earlier examples the compassion of the observer is awakened simply and directly, the great frieze deals with its subject, the battle of the gods and giants, as a thinly disguised allegory of the war between the Pergamenes and Gauls. The Pergamenes, in the guise of the gods, have become superhuman figures, while the giants, whose features closely resemble earlier Gallic and other non-Greek types, are now monsters.

Instead of the frank realism of the previous generation, then, the tale is told in the language of melodrama accompanied by visual bombast. It is put on the stage, so to speak, and done with theatrical gestures and histrionic postures. The emotional range is, correspondingly, enormous, beginning with the stark horror of monsters with enormous wings, animal heads, snaky locks, long tails, and serpentine legs, which recall grotesque prehistoric creatures that might have inhabited the primordial world. After being terrorized by the sight of such bestial forms, the then-contemporary audience must have melted into sympathy for the earth mother pleading mercy for her monstrous offspring and then gone from tears to laughter at the inept antics of some of the clumsy giants. And after hissing the villains, the viewers must have applauded the gods coming to the rescue.

This theatrical exaggeration of reality extends to the representation of bodily types. The functional physique of the *Dying Gaul* has become the Herculean power of the professional strongman who finds himself more at home in the arena than he does on the battlefield.

The perception of deeper space entered into the sculptural composition of the Altar of Zeus as well as into its architectural composition. Just as with the architectural composition the eye is being drawn into an enclosed interior, so with the sculpture, the eye does not move only from side to side, as in a plane, but is constantly led back and forth into spatial depth. To escape the plane, some of the figures of the great frieze project outward in such high relief as to be almost in the round; others even step outward from the frieze and support themselves by kneeling on the edge of the steps. The heavy shadows cast by the high-relief carving further intensify this effect.

Thus the two-dimensional plane of the Hellenic style was expanded here to suggest some recession in depth.

A general comparison of Hellenistic art with the Athenian art of the 5th century B.C. leaves one with the impression of discord rather than harmony; an overwhelming magnitude rather than dimensions constrained within limited bounds; a wild emotionalism in the place of a rational presentation; virtuosity triumphing over dignified refinement; melodrama superseding drama; variety ascending over unity. The Athenian culture, in short, placed its trust in human beings, the Hellenistic, in superbeings. No longer the masters of their fate, Hellenistic people were engulfed in the storms and stresses of grim circumstances beyond their control.

PAINTINGS AND MOSAICS

As a consequence of the enduring qualities of stone, more ancient sculpture has survived than have art works in any other form. Buildings were torn down for their materials and replaced by others. Statues in bronze, precious metals, and ivory were too valuable in their essential material to survive as such. Libraries either were burned or had their volumes disintegrate in the course of time, so that their books survive only in imperfect copies made by medieval scribes or as fragmentary quotations in other volumes. The musical notation contained in ancient manuscripts could not be understood by these copyists, who eventually omitted it. Mosaics and pottery have fared better, but for the most part they, too, were either broken up or carried off by conquerors and collectors.

Pergamene Painting and Roman Adaptations

Of all the major visual arts in antiquity painting has suffered most from the ravages of time. The number of surviving examples is sufficient to give only a hint of what this art must have been at its best. The impression is thus easily gained that sculpture was the most important of all the arts. Literary sources, however, verify the effectiveness of painting and the high esteem in which it was held by the ancients. The fame of individual painters and the critical praise for their works make it clear that painting actually ranked higher than either architecture or sculpture.

Pausanias, a writer of Roman times, described the works of the legendary 5th-century-B.C. Athenian painters Polygnotus and Apollodorus. The former worked out the principles of perspective drawing, and the latter was renowned for his use of light and shade and the finer gradations of color. Pausanias also mentioned many paintings at Pergamon. The excavated fragments there reveal that the interior walls of temples and public buildings frequently were painted with pictorial panels and had streaks of color that imitated the texture of marble. Other scattered fragments of paintings show that the Pergamenes loved bright colors, such as yellows, pinks, and greens, that contrasted with deep reds, blues, and browns.

The palace paintings used motifs of actual animals, such as lions and charging bulls, and imaginary ones, such as tritons and griffins. Interiors of rooms were often decorated with painted friezes similar to sculptural ones; and walls, especially of small rooms, were painted with panels and columns that cast realistic shadows in order to create the illusion of spaciousness. The writers of antiquity mention that the subjects of paintings were often drawn from mythology or literary sources, such as the *Odyssey*. It is also known that Hellenistic painting frequently dealt in *genre scenes*, that is, casual, informal subjects from daily life.

Although the original paintings no longer exist and only fragments of mosaics and vase painting survive, well-preserved copies of Pergamene work have been found in the Greek cities of southern Italy, notably Herculaneum. This city supposedly was founded by Hercules, whose son Telephus founded Pergamon. A "family" relationship thus existed between the two centers. Herculaneum, in fact, became a later middle-class version of the earlier richer and aristocratic Pergamon.

Both Herculaneum and nearby Pompeii were suddenly buried in a rain of cinders and a hail of volcanic stone that accompanied the eruption of Mount Vesuvius in A.D. 79. When rediscovered in the 18th century, the two cities yielded many paintings and mosaics preserved almost intact. The prevailing taste was Hellenistic, and the well-to-do patrons, preferring traditional subjects, usually commissioned copies of famous paintings rather than original works of art.

Hercules Finding His Infant Son Telephus (Fig. 75) is an adaptation of a Pergamene original. The winged figure in the upper right is pointing out to Hercules his son Telephus, who is seen in the lower left among wild animals and suckling from a doe. The place is the legendary fertile land of Arcadia, personified by the stately seated figure. Beside her are the fruits of the land, and at her back a playful faun is holding a shepherd's crook and blowing the panpipes. The coloring for the most part is sepia and reddish brown, relieved by lighter blue, green, and whitish tints. The figures appear against the back-

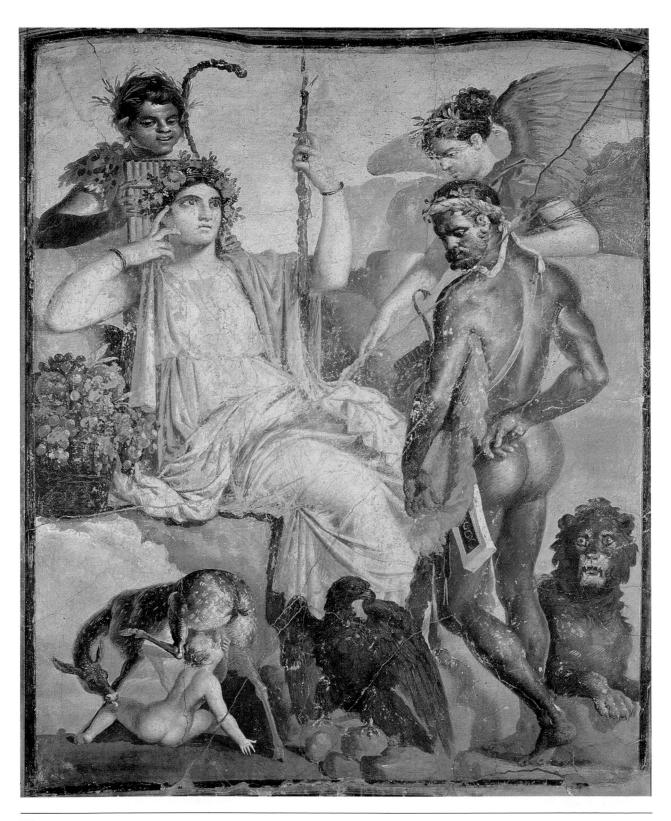

75.Hercules Finding His Infant Son Telephus. c. A.D. 70. Fresco from Herculaneum, probably a copy after a Pergamene original of 2nd century B.C. Museo Nazionale, Naples.

ground plane of the sky that projects them forward in the manner of relief sculpture. The drapery and modeling of the flower-crowned Arcadia recall the carving of a marble relief, while the powerful musculature of Hercules' body is cast in the manner of a bronze statue in the round.

Since ancient sculpture usually was painted in vivid colors, and reliefs sometimes had landscapes painted in the backgrounds, the arts of painting and sculpture obviously were closely identified in the Hellenistic mind, and they should perhaps be thought of more as complementary arts than as independent media. Paintings were more adaptable to interiors, while weather-resistant stone made marble reliefs better for the open air. From the existing evidence it is clear that the visual intention and expressive effect of both arts were closely associated and that neither could claim aesthetic supremacy over the other.

Mosaics

Mosaic, the art of which goes back to remote antiquity, was highly favored at Pergamon for the flooring of interiors and for wall paneling. As with later Roman work, geometrical patterns were preferred for floors, while representations of mythological subjects, landscapes, and genre scenes were used for

murals. Such compositions are formed of small cubes or pieces of stone, marble, or ceramic known as *tesserae* that are set in cement.

One mosaic (Fig. 76) by the artist Hephaistion covered the entire floor of a room. It has a blank center surrounded first by a colorful geometrical design of black, gray, red, yellow, and white marble tesserae. Beyond this is a wavelike pattern of black and white. Then enclosing the whole is a border about a yard (0.9 meter) wide with a foliated, or leaflike, design of such rich variety that in its 44-foot (13.3-meter) expanse there is no repetition. Against a dark background are intertwined colored flowers, exotic lilies, vine leaves and various fruits, all with delicate shadings. In some places grasshoppers are feeding on acanthus leaves; in others small winged *putti*, or Cupidlike boys symbolizing love, are playing among the vines.

According to the Roman writer Pliny the Elder, the most famous mosaicist of antiquity was Sosus, who worked at Pergamon. Among his most widely copied designs was one of doves drinking from a silver dish. A favorite design of his for the floors of dining rooms showed vegetables, fruit, fish, a chicken leg, and a mouse gnawing on a nut (Fig. 77).

A fine mosaic copy of an earlier Hellenistic painting was found at Pompeii. It depicts the youthful Alexander's triumph in the *Battle of Issus*

76. Hephaistion. Mosaic from Palace of Attalus II at Pergamon. c. 150 p.c. 28′ (8.53 m) square. Antikensammlung, Staatliche Museen, Berlin.

(Fig. 78), a scene of epic sweep and unprecedented vividness. Shown is the climactic moment, when the Persians realize their imminent defeat and are about to turn and flee. The dauntless Alexander advances on horseback from the left into the phalanx of bending spears. Darius, the king of kings, faces Alexander with a helpless gesture and apprehensive expression while his charioteer's whip gives the signal for retreat. The brilliant lighting allows the swords and armor to gleam and the skillfully modeled figures to cast shadows on the ground. Note also the fallen

Persian warrior cowering between the two horses on the right, staring at his own face as reflected in his polished bronze shield.

MUSIC

Pergamon was identified with the musical tradition of the nearby northern Asia Minor region known as Phrygia, which had its own characteristic idioms, modes, rhythms, scales, and instruments. As early as the 5th century B.C., the Greeks in Athens were di-

77. Sosus. *Unswept Dining Room Floor*, detail of later Roman copy of original Pergamene mosaic of 2nd century B.C. Vatican Museums, Rome.

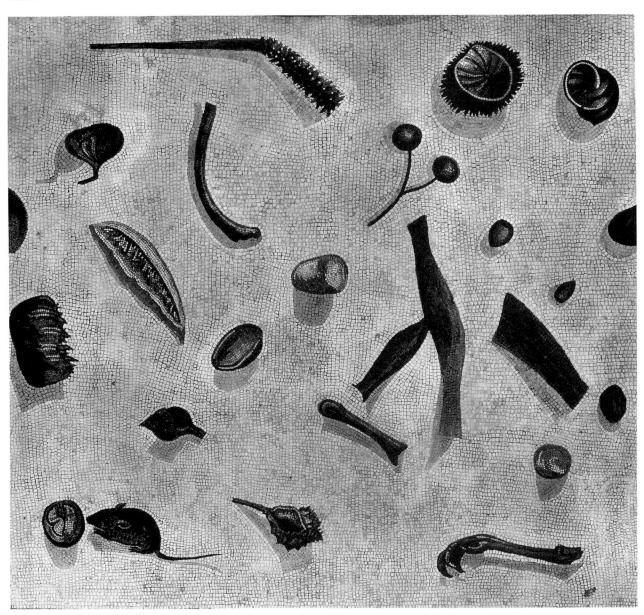

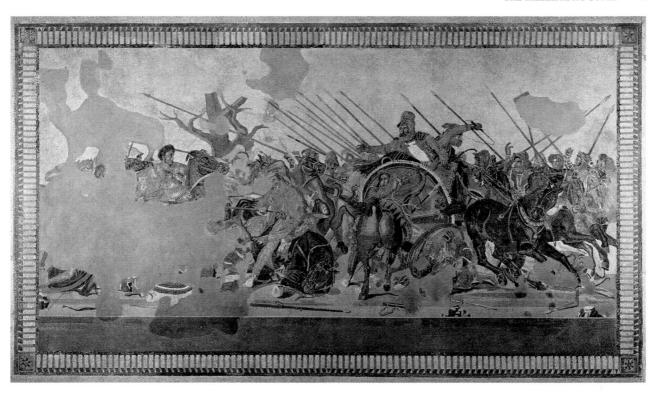

78. Battle of Issus, from House of the Faun, Pompeii. 2nd century B.c. Mosaic, $8'10'' \times 16'9''$ (2.69 \times 5.11 m). Mosaic copy of painting from c. 320 311 B.c. Museo Nazionale, Naples.

vided in their views as to the relative merits and propriety of the native Dorian musical tradition of the Greek mainland and of the increasing influence from foreign centers. In particular, the wild and exciting music of Phrygia was now gaining in popular favor.

Phrygian Music

Melodies in the Phrygian mode apparently induced strong emotional reactions, and the introduction of a musical instrument called the Phrygian pipe had a similar effect in inflaming the senses. This pipe was a double-reed instrument with a peculiarly penetrating sound, somewhat like the modern oboe. Properly, the single version of the pipe is known as the *aulos* and the double version (shown in Fig. 79, right) as the *auloi*. In many English translations from the ancient Greek both are often incorrectly rendered "flute." Dorian music, on the other hand, was associated with such stringed instruments as the lyre and the cithara (Fig. 79, left), the latter often mistranslated as "harp."

Both the lyre and the cithara in the Dorian music and the aulos in the Phrygian were used principally to accompany the songs, melodies, and choruses of the two modes and only to a much lesser **79.**Contest of Apollo and Marsyas. Relief from Mantineia, Greece. c. 350 B.C. Marble. height 38½" (97 cm). National Museum, Athens.

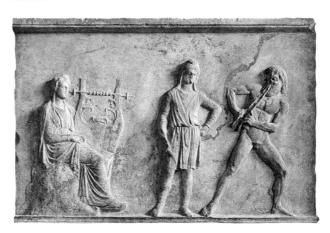

extent were played as solo instruments by skilled performers. Lyre playing was especially associated in the Dorian tradition with the Apollo cult. The Greeks attributed to this body of music the quality of *ethos*, or ethical character. The aulos, as the instrument of Dionysus, was associated with *pathos*, or

strong emotional feeling, and had a sensuous quality conducive to enthusiasm. To the Athenians, this meant a division in their aspirations and ideals—one instrument and mode of singing were associated with clarity, restraint, and moderation, the other with emotional excitement and aroused passions.

Musical Contests. The resultant division of opinion was expressed in the many sculptural representations of the musical contest between the Olympian Apollo and the Phrygian satyr Marsyas. According to an ancient myth, Athena was the inventor of the aulos. One day as she was playing, however, Athena caught sight of her reflection in a pool of water. So displeased was she with the facial grimaces the aulos caused her to make that she threw it away in disgust. Marsyas, happening along, found it and was so enchanted by its sounds that he challenged Apollo, the immortal patron of the Muses, to a contest. The god chose to play on the dignified lyre, won the contest easily, and proved once again that mortals are no match for the gods. As a punishment Apollo had his challenger skinned alive.

A relief from Mantineia of the school of Praxiteles represents the contest in progress (Fig. 79). On one side, calmly awaiting his turn, is the seated Apollo with his lyre; on the other, Marsyas is ecstatically blowing on the aulos. Between them is the judge, or music critic, standing patiently but with knife in hand. The Pergamene versions left out the contest and showed the victorious Apollo, the unfortunate Marsyas strung up by the wrists to a tree (Fig. 81), and the crouching figure of a Scythian slave, whetting a knife with keen anticipation (Fig. 80). The choice of the punishment as the part of the myth to be represented—and the evident enjoyment with which this Hellenistic artist tackled the gruesome subject—were designed to tear the emotions to shreds.

Music in Hellenistic Life. While historical facts about the actual musical life of Pergamon are few, it is known that here, as in other Hellenistic centers, the practice of music was given a high place in the arts. Both boys and girls received musical instruction in their educational institutions and sang hymns as they marched in processions or participated in religious observances. The curriculum included musical notation and the chanting of poetry to the accompaniment of the cithara. The chief educator of the city, the gymnasiarch, was also expected, among his other duties, to arrange for the appearances of visiting poets and musicians.

Skolion of Seikilos 1st century a.d.

Tralles, a city of the Pergamene kingdom, provides some general information and one of the best musical examples of antiquity. Gymnastic and musical festivals in honor of the Pergamene kings were held annually. One of these was the Panathenaea, which honored Athena as the protectress of Pergamon; another was the Eumenaia, which honored the monarch himself. From inscriptions it appears that the Eumenaia was a musical contest.

At Tralles a tombstone that bears an inscription of some four lines of poetry accompanied by clear musical notation has been unearthed. It was an epi-

80. *Knife Sharpener.* Roman copy after Pergamene original. Marble, life-size. Galleria degli Uffizi, Florence.

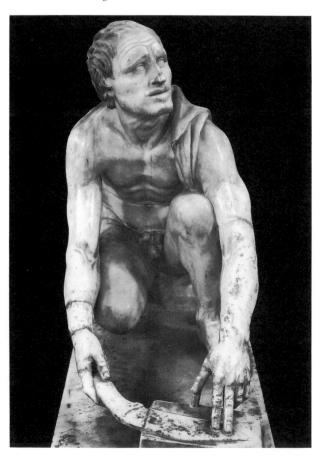

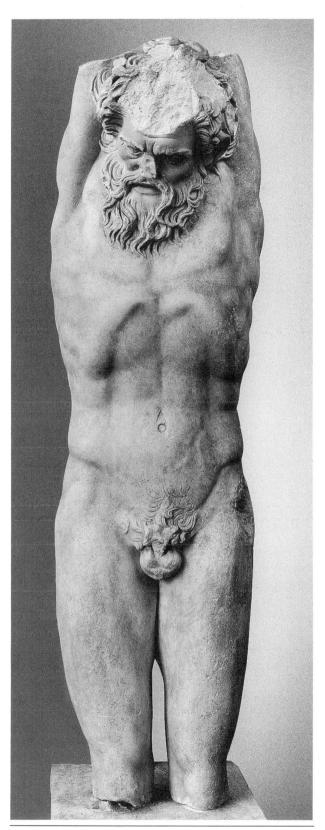

81. *Marsyas.* c. 200–190 B.C. Roman copy after Pergamene original. Marble, life-size. Staatliche Antikensammlungen, Glyptothek, Munich.

taph inscribed on a slab of stone by a man named Seikilos for the grave of the departed Euterpe. On transcription it turned out to be the words and music of a short but intact tune in the Phrygian mode from the 1st century B.C. After hearing about the wild and orgiastic character of Phrygian music, the listener will find this short song a model of sobriety. The mood, in fact, is more melancholy than intoxicating and, since it was carved on a tombstone, the elegiac character is altogether appropriate.

This little song, almost two thousand years old, was of a popular type known as a *skolion*, or drinking song. It was sung after dinner by the guests as the cup was passed around for toasts and sacrificial drinks to the gods. The word *skolion* is derived from the Greek meaning "zigzag." It referred to the manner in which the lyre and cup were passed back and forth, crisscrossing the table as each of the reclining guests sang in turn.

The simplicity of this example marks it as the type of tune expected in the repertory of every acceptable guest rather than as one of the more elaborate ballads intended to be sung by professional entertainers. In spirit and mood it is not unlike "Auld Lang Syne," and the occasions on which it was sung would parallel those when we sing the venerable Scottish tune. The substance of the words is the universal one of eat, drink, and be merry for tomorrow we die, which expresses a convivial philosophy of the Epicurean type. Technically, it is in the Phrygian mode with the upper and lower extremes falling on the E above middle C and the E an octave above. This spans a full octave. The tone most often stressed is A. It thus becomes the mean between the higher and lower reaches of the melody and consequently functions as its tonal center.

IDEAS

Many striking differences have been noted between the Hellenistic and earlier Hellenic styles. Although both styles are Greek, the Hellenic was a more concentrated development in the small city-states of the Greek mainland, whereas the Hellenistic is a combination of native Greek and such regional influences as those of the Near East, North Africa, Sicily, and Italy. The spread of Hellenistic art over several centuries and the entire Mediterranean world makes any quest for stylistic unity difficult.

In addition, the contrast between Hellenic and Hellenistic styles is never extreme but rather like a tilting of the cultural scale in one direction or another. The generalized social humanism of Athens becomes the particularized personal *individualism*

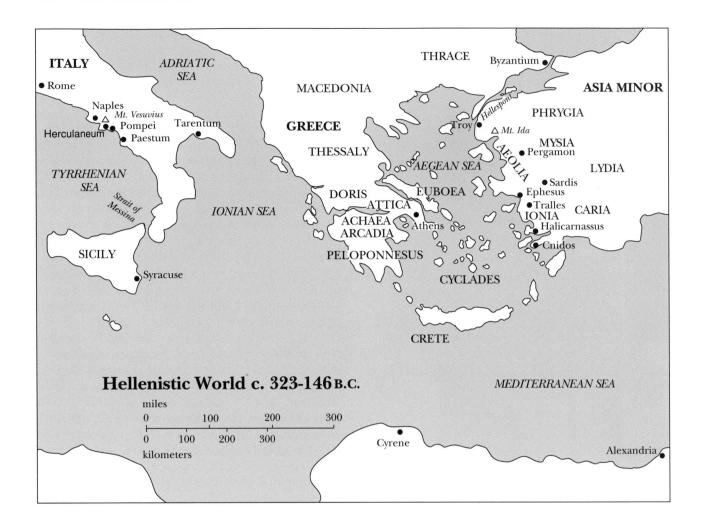

of Pergamon and other centers. The noble Hellenic idealism breaks down into a *realism* that looks at the world more in terms of immediate experience than under the aspect of eternity. The uncompromising rationalism of Socrates and Plato yields to an *empiricism* of scientists, scholars, and artists interested more in the development of methods and techniques and in the application of scientifically acquired knowledge to practical affairs than in the spirit of free inquiry. The tendencies that underlie the various art enterprises at Pergamon in particular and the Hellenistic period in general, then, are to be found in a pattern of interrelated ideas, of which individualism, realism, and empiricism are parts.

Individualism

The individualistic bias of Hellenistic life, thought, and art was an aspect of humanism, but it contrasted strongly with the broader outgoing social accent of the Hellenic period. In politics, the rough-and-tumble public discussions of free citizens and deci-

sions arrived at by voice vote were superseded by the rule of a small group headed by a king who enjoyed semidivine status. Another evidence of individualism was the cult of personal hero worship that started with Alexander the Great and continued with the kings who succeeded him in the various parts of his far-flung empire. It was reflected in the popular biographies of great men and in the building of lavish temples and monuments glorifying not the ancient gods but monarchs and military heroes. The famous Mausoleum (Fig. 82) for King Mausolus of Halicarnassus is a good example. It was also reflected in the sculptor's accent on individual characteristics, personality traits, and racial differences.

In the earlier Hellenic centers, poets, playwrights, and musicians were mainly skilled amateurs; even in sports the emphasis was on active participation. In the Hellenistic period, however, a rising spirit of professionalism is noted in the fame of individual writers, actors, musical performers, and athletes. As a result people became passive spectators rather than active participants.

STOICISM AND EPICUREANISM. Two contrasting philosophies—Stoicism, with its emphasis on world order and determinism, and Epicureanism, with its accent on chance and personal freedom dominated Hellenistic thought. The founder of Stoicism was Zeno, who taught in the stoa of the Athenian agora (see Fig. 24) and whose thought took the greatly expanded world of Alexander's empire into account. Hellenistic Greece was no longer a collection of city-states with a common language and geography, but the ruler of the known parts of western Asia, North Africa, and Mediterranean Europe. Like Plato in the Timaeus (see p. 56), Zeno believed that the human race was fashioned by the creator in the image of the world soul. He envisaged humanity as one people, citizens of one state, with each individual as part of the world soul observing universal laws and living in harmony with fellow beings. As his follower, the Phrygian philosopher Epictetus, observed, every person is like an actor in a play in which God has assigned the parts, and it is our duty to perform our parts worthily, whatever they may be.

82. Pythios. Mausoleum at Halicarnassus. 359–351 B.C. Length 106' (32.31 m), width 86' (26.21 m). Reconstruction drawing.

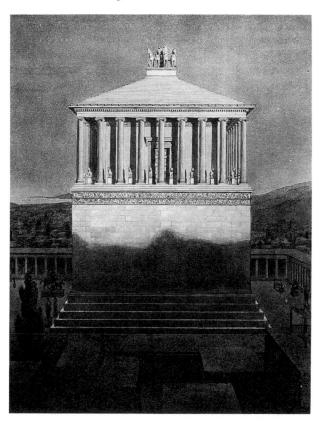

With a world empire to be taken into account, the Stoic ideal of kinship with nature, universal brotherhood, and world citizenship found fertile soil in later Roman thought. Seneca, the dramatist, politician, and philosopher, counseled that a wise man cannot meet with misfortune since all experience of evil is only an instrument to train the mind. Evil is also a challenge to exercise the powers of endurance and a means of showing the world a person's indifference to external conditions. Later the Emperor Marcus Aurelius, whose Meditations was the last great book on Stoicism, had to rationalize his philosophy with his exalted position by declaring that he was in the world, not of it. His thought embraced recognition of the interdependence of all people and the cultivation of fortitude and endurance. In sum, the Stoics believed that the true good lies within oneself. Only by cultivating virtue, accepting duty, and maintaining human dignity in the face of adversity can true freedom and mastery of life be attained.

Epicurus's theory that pleasure was the highest good found ready acceptance in the rich cities of Asia Minor. His materialistic worldview was based on atomism—the belief that all is brought about by the haphazard collision and conjunction of tiny particles. Everything is perpetually changing as the atoms come together, then separate to form new patterns. There is, then, no afterlife, no future reward or punishment, since death is simply the dissolution of a person's collection of atoms. The life here and now should thus be lived to the fullest, and the object is "freedom from trouble in the mind and from pain in the body." The lofty idealism and rigorous logic of Socrates gave way to a tendency toward a comfortable *hedonism*, the belief that pleasure is the chief goal in life. But since too much physical pleasure can lead to pain, moderation should prevail. And since some pleasures exceed others, the mind and critical faculties are needed to distinguish among those that give more lasting satisfaction. Epicurus also held that happiness for the individual lay in the direction of the simple life, self-sufficiency, and withdrawal from public affairs. This in effect denied the social responsibilities of citizenship and encouraged escapism and extreme individualism. The viewpoints of these different philosophies had considerable influence on the various modes and manners of depicting both gods and men and their expressive attitudes.

INDIVIDUALISM AND THE ARTS. Since the state was so wealthy, Hellenistic people took their enjoyment in personal and home life. Poverty had been thought honorable in ancient Athens, where rich and poor lived as neighbors in modest homes. Helle-

nistic prosperity, however, allowed a more luxurious standard of living for a larger percentage of the population. Hellenistic architects took special interest in domestic dwellings. Painters and mosaicists were called upon to decorate the houses of the well-to-do. Sculptors created figurines with informal, sometimes humorous, subjects, because they were more adaptable to the home than the monumental formal works in public places. Together with potters and other craftsmen, all artisans contributed to the life of luxury and ease of a frankly pleasure-loving people.

Hellenistic artists were more interested in exceptions than rules, in the abnormal than the normal, in diversity than unity. In portraiture, they noted more the physical peculiarities that set an individual apart than those that united an individual with others. Even the gods were personalized rather than generalized, and the choice of subjects from daily life showed the artists' increased preoccupation with informal, casual, everyday events. They were also more concerned with environmental influences on the human condition than with the ability to rise above one's limitations. Hellenistic artists, by recognizing the complexity of life, gave their attention to shades of feeling and to representing the infinite variety of the world of appearances.

Hellenistic thought entered on a new and more emotional orientation. Instead of looking for the universal aspects of experience that could be shared by all, Hellenistic philosophers held that each person has feelings, ideas, and opinions that are entirely different from those of others. Thus each must decide what is good and evil, true and false. Instead of seeking a golden mean between such opposites as harmony and discord, as did their Hellenic predecessors, Hellenistic philosophers became psychologists, analyzing the self and laying bare the causes of inner conflict. The joy, serenity, and contentment of the Hellenic gods and athletes were social emotions that could be shared by all. The sorrow, anguish, and suffering of Hellenistic wounded warriors and defeated giants were private, personal feelings that separated a person from the group and invited inward reflection. It was an old variation on the theme—laugh and the world laughs with you, weep and you weep alone.

Reflecting this new orientation, artists turned from the ideal of self-mastery to that of self-expression, from the concealment of inner impulse to outbursts of feeling—in short from ethos to pathos. It was said of Pericles that he was never seen laughing and that even the news of his son's death did not alter his dignified calm. A strong contrast to this Olympian attitude is provided by the late Hellenistic

Laocoön Group (Fig. 83), where the balance of reason and emotion is replaced by a reveling in feeling for its own sake. What is lacking in self-restraint and regard for the limitations of the sculptural medium, however, is amply made up for by the vigor of treatment and virtuosity of execution.

The preoccupation of Pergamene artists with such painful and agonizing subjects as the defeated Gauls, the punishment of Marsyas, the battle of gods and giants, and the hapless struggle of Laocoön reveals the deliberate intention to involve the spectator in a kind of emotional orgy. Misfortune becomes something that can be enjoyed by the fortunate, who participate in the situation with a kind of morbid satisfaction. The French writer and moralist La Rochefoucauld said: "We all have the strength to endure the misfortunes of others." Aldous Huxley similarly observed that when the belly is full, men can afford to grieve, and "sorrow after supper is almost a luxury."

In the spirit of Stoic philosophy, life and suffering were to be endured with a benign resignation and acceptance of misfortunes that one can do nothing about. The artists of the frieze of the Altar of Zeus, for instance, were incredibly inventive in the ways they found for the gods to inflict pain and death. The composition approaches encyclopedic inclusiveness in the various modes of combat by the gods and the capacity for suffering by the giants. Nothing like it appears again until the Romanesque Last Judgments (see Fig. 163) and Dante's *Inferno*.

Realism

The increasing complexity and quicker pulse of Hellenistic life weakened the belief in the underlying unity of knowledge and abiding values that produced the poise of Hellenic figures and the unemotional calm of their facial expressions. The world of concrete experience was more real to the Hellenistic mind than one of remote abstract ideals. Taking a more relativistic view of things, people now looked to variety rather than unity and took into account individual experiences and various differences.

Hellenistic artists sought to present nature as they saw it, to depict minute details and ever finer shades of meaning. The decline of idealism was not so much the result of decadence as it was a matter of placing human activities in a new frame of reference, reexamining the goals and redefining the basic values of humanity. Confronted with the variety and multiplicity of this world, Hellenistic artists made no attempt to reduce its many manifestations to the artificial simplicity of types and archetypes.

Hellenic artists portrayed their subjects standing aloof and rising above their environmental limitations, but in Hellenistic art men and women find themselves beset on all sides by natural and social forces and are inevitably conditioned by them. The writhing forms on the great frieze reveal some of the conflicts and contradictions of Hellenistic thought.

The gods in this work became projections of human psychological problems. The earlier Hellenic gods appeared to have the world well under control, and the calm, poised Zeus in Figure 52 exhibits no sign of strain as he hurls his thunderbolt. The deities of the Altar of Zeus, however, are fighting furiously, and the struggle verges on getting out of hand.

83. Agesander, Athenodorus, and Polydorus of Rhodes. *Laocoön Group*. Late 2nd century B.C. Marble, height 8' (2.44 m). Vatican Museums, Rome.

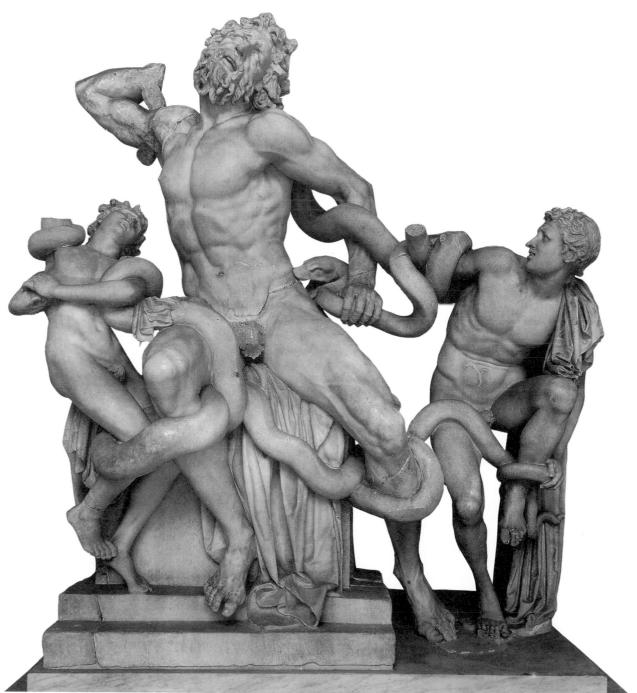

REALISM AND ARCHITECTURE. In the Athenian architecture of the 5th century B.C., each building, however well in harmony with its site, was an independent unit, and the architects were little concerned with any precise relationship to nearby buildings. Indeed, to have admitted that one structure was dependent upon another in a group would have diminished its status as a self-contained whole and thus rendered it incomplete by Hellenic standards. On the Athenian acropolis, each temple had its own axis and its independent formal existence—in keeping with the conception that each separate work of art must be a logical whole made up of the sum of its

84. *Old Market Woman.* 2nd century B.C. Marble, height $4'1\frac{1}{2}''$ (1.26 m). Metropolitan Museum of Art, New York (Rogers Fund, 1909).

own parts. Only such concessions to nature as were necessary for structural integrity were made. To the artist alone belonged the power of creating symmetrical form and balanced proportion, and the perfection of each building had to stand as a monument to the human mind and, as such, to rise above its material environment rather than be bound by it.

Hellenistic architecture moved away from the isolated building as a self-contained unit and toward a realistic recognition that nothing is complete in itself but must always exist as part of an interrelated pattern. City planning is in this sense a form of realism, and Hellenistic buildings were considered as part of the community as a whole. In the case of the Pergamene acropolis, the relationship of each building was carefully calculated not only in regard to its surroundings but also to its place in the group.

REALISM AND SCULPTURE. In sculpture, the members of each group were likewise subject to their environment, and the individual is portrayed as an essential part of the surroundings. By painting in backgrounds and by using higher relief, Hellenistic sculpture becomes more dependent on changing light and shade for its expressive effect, allows for movement in more than one plane, and suggests greater depth in space. In earlier sculpture, a figure always bore the stamp of a type, and personality was subordinate to the individual's place in society. A warrior, for example, had a well-developed physique, but his face and body bore no resemblance to a specific person. He could be identified by a spear or shield and was more a member of a class than a person in his own right.

The Hellenistic desire to render human beings as unique personalities and not as types required a masterly technique capable of reproducing such particular characteristics as the twist of a mouth, wrinkles of the skin, physical blemishes, and individualized facial expressions. Faces, furthermore, had to appear animated and lifelike, so that the subject of a realistic portrait could be distinguished from all others. Faithfulness to nature also meant the accurate rendering of anatomical detail. Like a scientist, the sculptor carefully observed the musculature of the human body so as to render every nuance of the flesh. The Old Market Woman (Fig. 84), for example, reveals the body of a person worn down by toil. The bent back, sagging breasts, and knotty limbs are the results of the physical conditions under which she has had to live. A portrayal such as this would have been unthinkable to an earlier artist.

In the handling of materials, the older Hellenic sculptors never forgot that stone was stone. But their realistic zeal often led later Hellenistic craftsmen to force stone to simulate the softness and warmth of living flesh. The story of the legendary sculptor Pygmalion, who chiseled his marble maiden so realistically that she came to life, could have happened only in the Hellenistic period, and the sensuous figure of the *Aphrodite of Cyrene* (Fig. 85) surely bears this out. The easy grace with which Praxiteles had rendered his gods and goddesses (Figs. 50 and 56) reach a climax in such elegant and polished figures as this Aphrodite and the famous *Apollo Belvedere* (Fig. 86).

Hellenistic emphasis on realism appealed greatly to the forthright Roman conquerors of Greece. Its appeal was largely responsible for the survival of the Pergamene art now known to us.

Empiricism

The rationalism of Hellenic thought as developed by Socrates, Plato, and Aristotle had emphasized the

85. *Aphrodite of Cyrene.* Roman copy of c. 100 B.C. after Praxitelean original, found at Cyrene, North Africa. Marble, height 5' (1.52 m). Museo Nazionale, Rome.

spirit of free intellectual inquiry in a quest for universal truth. Epicureanism and Stoicism, by contrast, were practical philosophies for living. The abstract logic of the earlier period yielded to an empiricism that was concerned more with science than wisdom. It focused on bringing together the results of isolated experimentation and on applying scientific knowledge to the solution of practical problems. More broadly, it stressed fact gathering, cataloguing source materials, research, collecting art works, and developing criteria for judging the arts.

Epicurus, by eliminating the notion of divine intervention in human affairs, and by his physical explanations of natural phenomena, led the way toward a scientific materialism. The scientific achievements of the period are truly impressive. Hellenistic mathematics extended as far as conic sections and trigonometry, and such astronomers and physicists as Archimedes and Hero of Alexandria

86. *Apollo Belvedere.* Roman copy after Greek original of late 4th century B.C. Marble, height 7'4" (2.24 m). Vatican Museums,

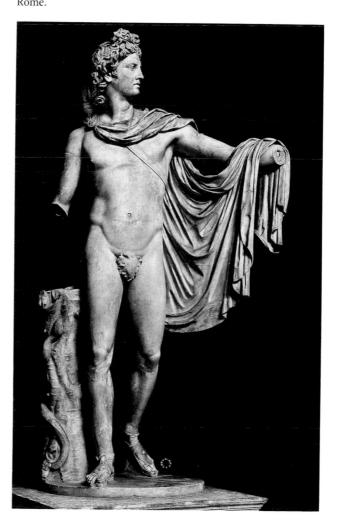

knew the world was round and also knew its approximate circumference and diameter. Hellenistic scientists had a solar calendar of 365¼ days, invented a type of steam engine, and worked out the principles of steam power and force pumps. Indeed, the modern mechanical and industrial revolutions might well have taken place in Hellenistic times had not slave labor been so cheap and abundant. The progressiveness of the period is also seen in its commercial developments that led to new sources of wealth.

The scientific attitude of Hellenistic thought found brilliant expression in the musical field by the development of the theoretical basis of that art. While philosophers and mathematicians of the earlier period had made many discoveries and had had brilliant insights into the nature of music, it remained for the Hellenistic mind to systematize them and construct a full and coherent science of music. Under Aristoxenos of Tarentum, a disciple of Aristotle, and under the great geometrician Euclid, the theory of music reached a formulation so complete and comprehensive that it became the foundation for Western music. While it is impossible to go into the intricacies of the Greek musical system here, one should keep in mind that it was in this theoretical field more than in any other that a lasting musical contribution was made.

RISE OF ANTIQUARIANISM. After establishing his great library, Eumenes II gathered about him many of the outstanding Greek scholars of his day. They were dedicated to the task of preserving the literary masterpieces of former days, making critical editions of the works of ancient poets and dramatists, selecting material for anthologies, cataloguing collections, copying manuscripts, writing grammatical treatises, and compiling dictionaries. In their scholarly endeavors, they held the works of the ancients above those of their own time. As a consequence their literary production began to be addressed more to other scholars than to the general populace.

This was a period of *antiquarianism*, or concern with things old and rare, of scholarly rather than creative writing, of book learning instead of inspiration. Only systematic, exhaustive research, for instance, could have produced the program of the great frieze encircling the Altar of Zeus, which is a veritable catalogue of Greek mythology, complete with footnotes and annotations. The Attalids not only collected art but actually engaged in archeological excavations, another antiquarian activity, and for the first time the living sculptor and painter were confronted with a museum filled with noted works from the glorious past. As a result, copying the masterpieces of Myron, Phidias, and others be-

came an industry that thrived throughout antiquity until the coming of organized Christianity. The age raised the social position of the artist. As in literature and music, it established the history of art and formulated aesthetic standards, so that now art was worthy of attention in intellectual and social circles.

THE ROAD TO ROME

A reputation for learning had direct bearing on the political purposes of the Pergamene government. The more famous their capital became for its intellectual and cultural enterprises, the higher its prestige in the Greek world would be. The career of Eumenes II's brother, who eventually succeeded him as Attalus II, is a case in point. As a skillful general, he was invaluable to the Pergamene regime, yet at the conclusion of a successful war he took five years off to study philosophy at the academy in Athens. Furthermore, the proudest boast of the Attalids after their military victories was that they were the saviors of Hellenism from the barbarians. This claim, of course, had to be fortified by the development of their capital as a center of arts and letters.

To advertise the cultural achievements of his realm, Eumenes II chose his librarian, the famed grammarian Crates of Mallus, as his ambassador to Rome. By defending humanistic learning, and by stimulating Roman desire for more knowledge about Greek philosophy, literature, and art, Crates made a lasting impression on the future world capital.

With literary talents being diverted into the editing of manuscripts, scholars delving into the history of the past, art collectors digging for buried treasure, and musicians writing theoretical treatises, Pergamon was well on its way toward becoming an archive and a museum. In time, this antiquarianism was bound to reduce artistic developments to a system of academic formulas and rules—all of which is symptomatic of a hardening of the artistic arteries and the eventual decline of the creative powers. When Attalus III willed his kingdom to Rome in 133 B.C., he was actually presenting that city with a living museum. The vast art holdings of the Attalids soon were on their way to Italy, where the interest and admiration they commanded, when shown in public exhibitions, were destined to have a powerful effect on the taste of the Romans. With them went the Hellenistic craftsmen who would embellish the new world capital with a wealth of public buildings, carvings, murals, and mosaics.

Southern Italy and Sicily had long been the site of important Greek settlements. In the 6th and 5th centuries B.C. there were thriving settlements on the mainland such as Naples, Paestum, and Tarentum, as well as on the adjacent island at Syracuse and

Agrigentum. Greek influence still prevailed in late Hellenistic times in these places and also at Pompeii and Herculaneum. So when Greece came under Roman political control, Greece in turn took over Rome with its philosophy, literature, and art. One could well ask the age-old question: Who really conquered whom? The emperor Trajan's Arch at Beneventum (Fig. 87), which celebrated the completion of a highway from Rome to the seaport that linked it with the main centers of the east—Athens, Pergamon, Alexandria, Ephesus, and Antioch—is a reminder of the route by which the heritage of the classical Mediterranean world became a part of the Western cultural tradition. The road between Greece and Rome was thus smoothly paved, both literally and figuratively.

Arch of Trajan, Benevento. A.D. 114.

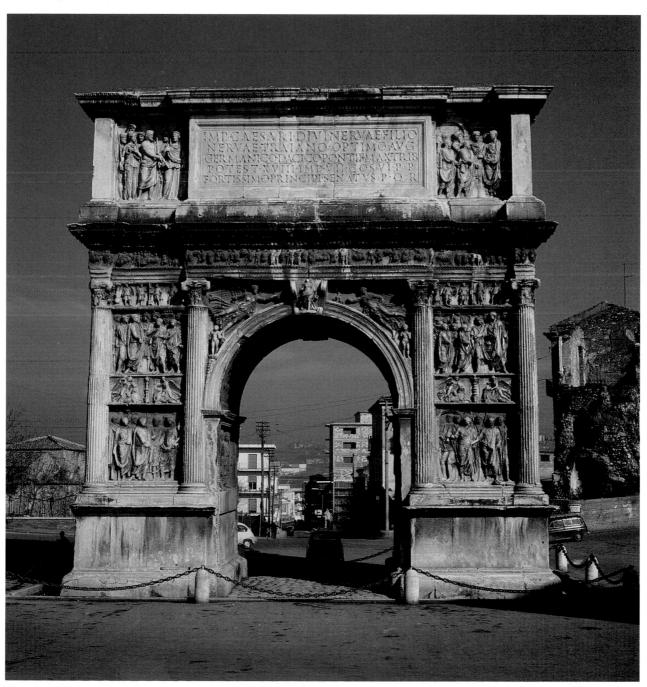

ROMAN PERIOD REPUBLIC AND EARLY EMPIRE

	KEY EVENTS	ARCHITECTURE	WRITERS
-00	753 Legendary date of Rome's founding 616-c.509 Etruscan period. Tarquin kings reigned c.509 Roman Republic founded; Tarquins dethroned		
200 -	c.450 Romans colonized Italy 390 Gauls sacked Rome 280-275 Greek power in Italy weakened 264-241 First Punic War; Rome annexed Sicily, Corsica, Sardinia 218-201 Second Punic War; Hannibal invaded Italy; Carthage ceded Spain to Rome		c.254-184 Plautus , comic poet and dramatist
	150-146 Third Punic War ; Carthage destroyed; African province created 133 Pergamon bequeathed to Rome		c.185- 159 Terrence , Roman senator and writer of comedies 106-43 Cicero , statesman, orator, essayist c.102-44 Julius Caesar, historian, wrote <i>Gallic Wars</i>
100 -	100-44 Julius Caesar. Conquered Gaul (58-51); crossed Rubicon, occupied Rome, became dictator (49); founded Julian family dynasty of future emperors; campaigned in Egypt, Asia Minor, Africa, Spain (48-45); Julian calendar (45); assassinated (44) 43 Second Triumvirate formed—Anthony, Octavian, Lepidus 31 Naval battle at Actium; Anthony and Cleopatra defeated. Octavian master of Rome 27 B.CA.D.14 Octavian reigned as Caesar Augustus 4 B.C. Birth of Jesus	c.48 B.C. Forum of Julius Caesar begun 27 B.CA.D.14 Augustus built new forum, Ara Pacis, Mausoleum of Augustus, Baths of Agrippa, Theater of Marcellus, Basilica Julia	c.96-55 Lucretius, poet, philosopher, wrote On Nature of Things 87-57 Catullus, lyric poet 70-19 Vergil, wrote Aeneid, Eclogues, Georgics 65-8 Horace, Odes 59 B.C A.D. 17 Livy, History of Rome c.50-c.10B.C. Vitruvius active, wrote treatise De architectura 43 B.CA.D. 17 Ovid, wrote Art of Love, Metamorphoses 3 B.CA.D. 65 Seneca, philosopher, dramatist
D	54-68 Nero reigned 70 Titus took Jerusalem; temple destroyed 79 Vesuvius erupted; destroyed Pompeii, Herculaneum 79-81 Titus reigned 96-180 Antonine Age, or "Era of Five Good Emperors." Roman Empire at height of power 98-117 Trajan reigned. Dacian campaigns (101-106); conquered Armenia, Parthia; Empire extended to Persian Gulf and Caspian Sea (113-117)	c.60 Nero built Domus Aureus, Baths of Nero c.80 Titus finished Colosseum; built Temple of Vespasian, Arch of Titus	c.20-66 Petronius, Satyricon 23-79 Pliny the Elder, naturalist, encyclopedist c.50-c. 90 Epictetus, Stoic philosopher 35-95 Quintilian, Institutes of Oratory 40-c.102 Martial, epigrammatist c.46-120 Plutarch, Parallel Lives 55-c.117 Tacitus, historian, Annals, Germania c.60-c.135 Juvenal, Satires 62-113 Pliny the Younger, writer, administrator; delivered Panegyric to Trajan before Roman Senate (100) 75-c.150 Suetonius, Lives of the Caesars
.00	117-138 Hadrian reigned 138-161 Antoninus Pius reigned 161-180 Marcus Aurelius reigned	c.100-c.120 Apollodorus of Damascus, architect, active 103 Harbor at Ostia constructed 105 Apollodorus of Damascus constructed bridge over Danube River 110 Trajan constructed Via Traiana from Benevento to Brindisi; Baths of Trajan built; Forum and Column of Trajan erected 113 Arch of Trajan at Benevento begun 117 Temple of Olympian Zeus at Athens completed under Hadrian 120-127 Villa of Hadrian at Tivoli built 135 Hadrian's Tomb, Rome built 211-217 Baths of Caracalla built c.298-306 Baths of Diocletian built	c.160 Apuleius flourished, philosopher, Golden Ass

The Roman Style

When Octavian, later to become Augustus Caesar, defeated the combined forces of Anthony and Cleopatra at the Battle of Actium in 31 B.C., he became sole ruler of the Roman world. His early life had of necessity been that of a warrior, and he is so portrayed in the standing statue found at Prima Porta (Fig. 88). His posture is in the imposing attitude of an imperator, or commander-in-chief, addressing his troops. Carved on the cuirass, or metal breastplate of his armor, are scenes in low relief recounting the outstanding achievements of his reign together with pictures of gods and goddesses who conferred favors upon him. Below is a cupid astride a dolphin, a dual allusion to the goddess Venus, mother of Aeneas, the legendary founder of Rome to whom Augustus traced his ancestry. The dolphin is a reminder that Venus was born of the sea, and the Cupid symbolizes her status as the goddess of love.

After the victory at Actium, Augustus now made as his mission the establishment of the Pax Romana, a lasting peace after almost a century of civil and foreign wars. Assuming the title of Augustus Caesar (he was the grand nephew of Julius Caesar), he turned his energies to restoring civilian morale and rebuilding the city of Rome. By fostering a literature in their own Latin tongue, he reawakened the pride of his people in their own historical past and present. One such work was Vergil's Aeneid, an epic poem in the manner of Homer's Odyssey that will be discussed later. Augustus also undertook an ambitious building plan that included a new forum and numerous other public edifices, the gem among them being the Ara pacis Augustae, dedicated to the spirit of peace.

The *Ara pacis* (Fig. 89) is a smaller version of the Altar of Zeus at Pergamon (see Fig. 71). The inner and outer walls are embellished by elegantly wrought, high-relief sculptured panels that picture the original dedicatory ceremony (Fig. 90). The fig-

ures are framed by the Greek *meander*, or key pattern. Reading from left to right, the imperial procession is led by the high priest, assisted by the sacrificer holding an axe. Next comes Augustus himself, clad

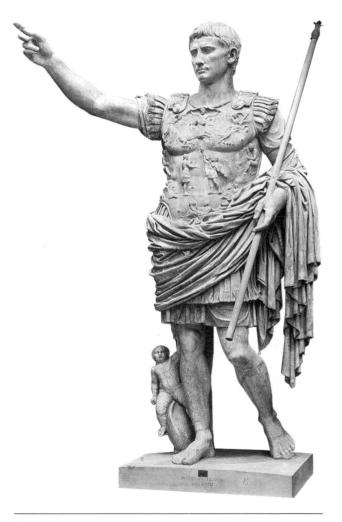

88.Augustus of Prima Porta. c. 20 B.C. Marble, height 6'8" (2.03 m). Vatican Museums, Rome.

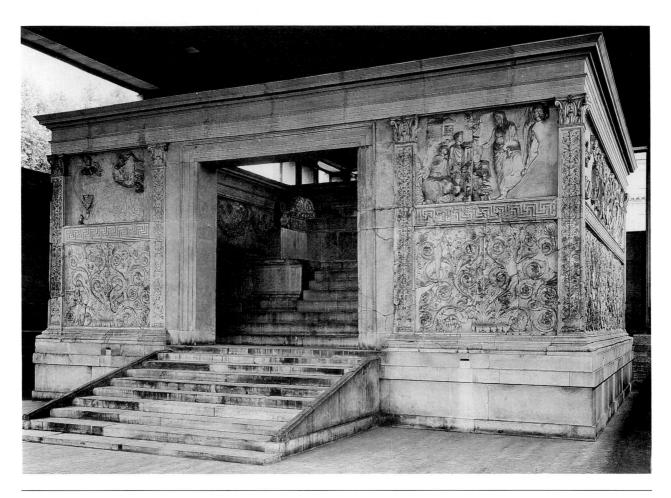

89. Ara Pacis Augustae. c. 13 B.c. Marble, height $36 \times 33'$ (11×10 m).

in prayer robes and followed by his empress. Between them is their small son. The interior features a rhythmically repeated motif of undulating festoons and garlands made of clustered oak leaves and flowers. The climax of the handsome design comes with the panel showing the seated earth-goddess, Tellus, from whose name Italy is derived (Fig. 91). She is shown in the midst of sheaves of grain, flocks of sheep, and all the bountiful yields that go with the good earth. At her breast are two infants, possibly Romulus and Remus, the legendary founders of the city of Rome. At the left above the bird is a female figure symbolizing the sky, and on the right above a gushing spring is a river god. Together they represent three of the four basic elements of matter-earth, air, and water.

THE 2ND CENTURY A.D.

In the next century, when Rome had a sequence of five good emperors including Trajan, Hadrian, and Marcus Aurelius, the 18th-century historian Edward Gibbon in his classic book *The Decline and Fall of the Roman Empire* could declare that Rome had at last experienced a "period in the history of the world during which the condition of the human race was most happy and prosperous." At this time, he continues, "the empire of Rome comprehended the fairest part of the earth and the most civilized portion of mankind." This favorable state of affairs he attributed to the Romans' genius for law and order, their cultivation of the tolerance and justice, and their capacity for wise government.

ARCHITECTURE AND SCULPTURE

By Trajan's time Rome had departed from Hellenistic precedents in addition to absorbing all the useful arts and ideas from the entire Mediterranean world, including Rome's own Etruscan and early heritage. When all these influences and devices had been taken into account, a special synthesis was developed by which the architects, sculptors, and writers achieved a unique Roman style.

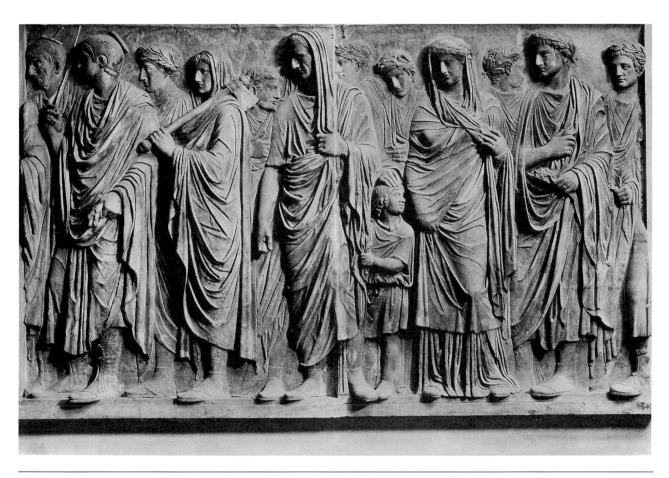

90. *Imperial Procession,* detail of Ara Pacis Augustae (Augustus's Altar of Peace), Rome. c. 13 B.C. Marble, height 5'3" (1.6 m).

Forum of Trajan

Following his accession as emperor in A.D. 98, Trajan began a grandiose project in Rome: the construction of a new forum (Figs. 92 and 93). Just as the Empire had grown in his time to its greatest extent, so the population of Rome had risen to over a million, creating a need for larger and more imposing public buildings. The old Roman forum of the Republic and that of Augustus had long been inadequate. Trajan's project, however, was so ambitious that it equaled all previous forums combined, bringing the total area covered by such structures to over 25 acres (10 hectares).

The magnificence of the new forum was in every way comparable to its size. Trajan entrusted the project to Apollodorus, a Greek architect-engineer from Damascus, famous for the construction of a stone bridge over the widest part of the Danube before Trajan's second Dacian campaign.

Typically Roman in conception, a forum combined a system of open courtyards and buildings all

grouped in a specific relationship. The reconstruction drawing of the Athenian acropolis (see Fig. 25) shows the Parthenon and Erechtheum had little more in common than the site on which they stood. But no part of a forum existed in isolation, and in the case of Trajan's forum everything was conceived organically from the beginning. All is on a grand scale and with an eye to symmetry and proportion. The whole, as seen in the groundplan (Fig. 93), was divided by a central axis running from the center of an arched gateway, through the middle of the open square, through the entrance to the basilica (whose axis is at right angles to that of the whole forum), then to the base of the monumental column (Fig. 94), and finally up the steps of the temple to the altar at the back.

Entrance to the forum was made through a majestic triple archway into the large paved rectangular courtyard, enclosed on three sides by a wall and colonnade and on the fourth by the Basilica Ulpia, whose entrances stood opposite those of the archway. Standing in the exact center of the open

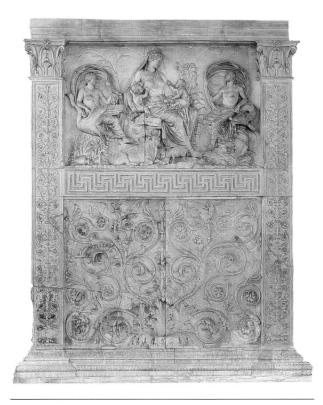

91. Tellus. Relief panel from Ara Pacis Augustae.

92. below left:

Apollodorus of Damascus. Forum of Trajan, Rome. c. A.D. 113–117. Length 920' (280.42 m), width 620' (188.98 m). Reconstruction by Bender. Museo della Civiltà Romana, Rome.

93. below right: Plan of Forum of Trajan.

square was an impressive bronze statue of Trajan on horseback. Though no longer in existence, it is known to have resembled the surviving bronze equestrian portrait of Marcus Aurelius (Fig. 95), who sits astride his splendid mount with a sense of balance and a thoughtful appearance worthy of the patient Stoic philosopher and author of the widely read *Meditations* (see p. 77).

Flanking the square on the east and west were semicircular recesses known as *exedrae* outlined by tall Doric columns. On one side, cut into the Quirinal hill, was a market complex constructed of brick that rose some six stories high (Fig. 96). On the forum floor were stalls for fresh produce; above were large vaulted halls where wine and oil were stored. Spices and imported delicacies were sold on the third and fourth floors. The fifth was used to distribute food and money from the imperial treasury. And on top were tanks supplied with fresh water from an aqueduct where live fish could be bought.

Basilica Ulpia. Adjacent to the open square was the Basilica Ulpia (Fig. 94), of which only the rows of broken columns remain. The term *basilica* was applied rather generally to large public buildings and is approximately equivalent to the modern word *hall* used for meeting places. Since the court sessions were also held in a basilica, the term *hall of justice* is likewise related to one of its functions. As an architectural form, the Roman basilica is one link in the long chain of Mediterranean structures that began with domestic dwellings, Egyptian hypostyle halls, and Greek temples, and that continued later with Christian basilicas.

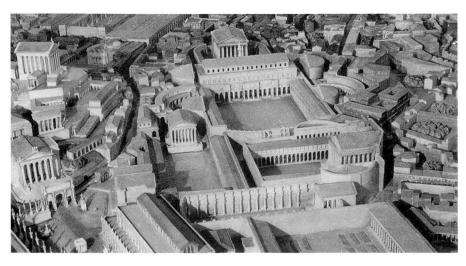

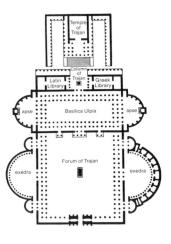

The large rectangular interior of the Basilica Ulpia, named for Trajan's family, was marked by a double colonnade in the Corinthian order that ran completely around the building. It supported a balcony and a second tier of columns that, in turn, supported the beams of the timbered roof (Fig. 97). This large central hall served as a general meeting place as well as a business center. The semicircular interior recesses called *apses* housed the courts of law. They were probably roofed over with hemispherical vaults

as seen in the reconstruction and set apart from the central hall by screens or curtains.

Trajan's Column. Beyond the basilica were two libraries, one for Greek, the other for Latin scrolls. They were separated by a courtyard that enclosed the base of Trajan's Column. To commemorate Trajan's victories in the two campaigns to subdue the Dacian people of the lower Danube region, this monumental column was erected in the emperor's

94. Apollodorus of Damascus. Column of Trajan and ruins of Basilica Ulpia, Rome. Column of Trajan, A.D. 106–113. Marble; height of base 18' (5.49 m), height of column 97' (29.57 m).

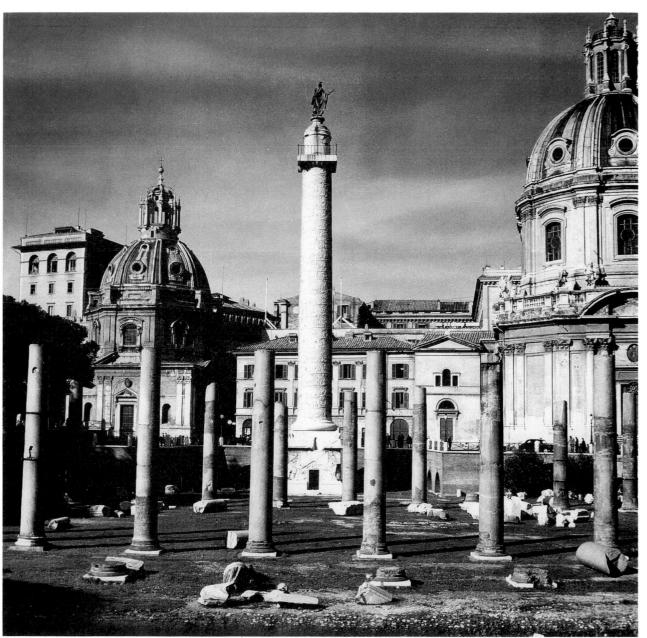

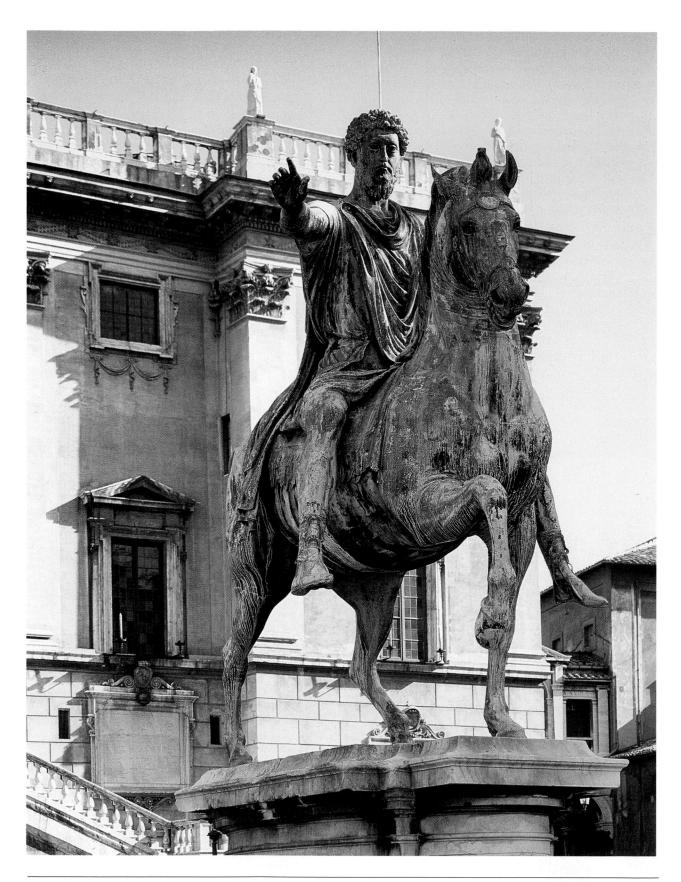

95. *Marcus Aurelius*. A.D. 161–181. Gilt bronze, height 9'10" (3 m). Piazza del Campidoglio, Rome.

forum by the Senate and people of Rome. Its base was originally surrounded by a colonnade that supported an upper gallery from which better views of the sculptures could be obtained. As a whole it rose to a full height of 128 feet (39 meters), including the 18-foot (5.5-meter) base, the 97-foot (29.5-meter) shaft, and a 13-foot (4-meter) colossal statue of Trajan that originally stood at the top. The latter disappeared long ago and has since been replaced by a standing figure of St. Peter. Inside the column is a circular staircase that winds upward to the top and is lighted by small windowlike slits cut into the frieze. According to tradition, Trajan chose the monument as the site of his burial, and his ashes were placed in a chamber under the column.

The column is constructed in several sections of white marble. Its surface is entirely covered by a spiral band, carved in low relief. Reading from left to right, the story of the two Dacian campaigns unfolds in a continuous strip about 50 inches (127 centimeters) wide and 218 yards (199 meters) long. More

than 2,500 human figures make their appearance in this visual narrative, in addition to horses, boats, vehicles, and equipment of all kinds.

The hero of the story is, of course, the soldierly Trajan, who is shown fulfilling his imperial mission as the defender of Rome against the advances of the barbarians. The Empire was always willing to include any people who accepted the values of Mediterranean civilization, but it could tolerate no challenge. When an important barbarian kingdom was founded in Dacia, Trajan regarded it as a threat and set out to bring it under Roman control. While it took two campaigns to do the job, the lasting result of this Romanizing process is seen in the name of one of the nations of the region—modern Romania.

Trajan's brilliance as a commander was well known, and on this column and other similar monuments his reputation certainly did not suffer for lack of public advertisement. In the frieze, he seems to be everywhere at once and is portrayed as a bold and steady figure in complete command of the situa-

96. Apollodorus of Damascus. Forum of Trajan, Rome. Northeast exedra and market hall. c. A.D. 113–117.

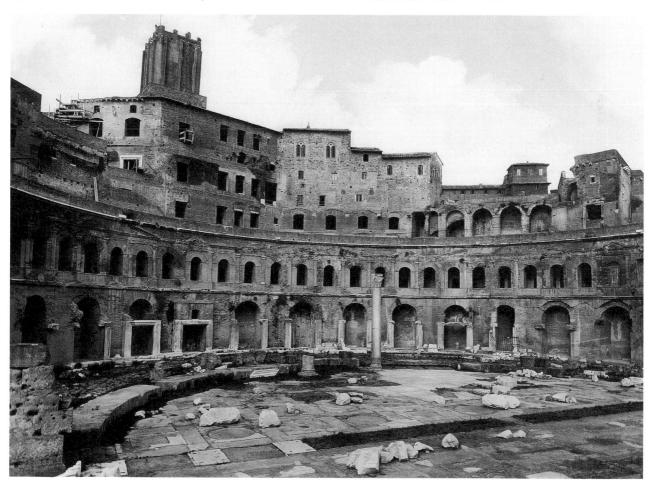

tion, whatever its nature. Sharing top billing with their general are the Roman soldiers. Their opposite numbers are Trajan's antagonists, the Dacian king Decebalus and his barbarian hordes.

The beginning of the campaign is placed on the banks of the Danube in a Roman camp guarded by sentries and supplied by boats (Fig. 98). As the Romans set forth across a pontoon bridge, a river god personifying the Danube rises from a grotto and lends his support by holding up the bridge. From this point the action moves with singular directness toward the inevitable climax: the triumph of Roman arms. The scenes show Trajan holding a council of war, clad in a toga pouring a sacrificial drink to the gods, and standing on a platform as he addresses his troops (Fig. 99). The army is shown pitching a camp on enemy soil, burning a Dacian village, and in the midst of battle. At this psychological moment Jupiter appears in the sky, throwing thunderbolts at the enemy to disperse them in all directions. The aftermath is then shown with the victorious soldiers crowding around the Emperor and holding up the severed heads of the enemy; surgeons are seen caring for the wounded, and winged Victory makes her appearance.

The scenes are designed to promote the continuous flow of action as smoothly as possible. For reasons of clarity the episodes have to be differentiated. The artist does this through some ninety separate appearances of Trajan, each of which signals a new activity. Other devices employed are an occasional tree to set off one scene from another and new backgrounds, indicated in some places by a mountain, in others by a group of buildings, and so on.

The comparison of this type of spiral relief has aptly been made with the form of the unfolding papyrus and parchment scrolls that the educated Ro-

97. Apollodorus of Damascus. Basilica Ulpia, Forum of Trajan, Rome. A.D. 113. Reconstruction drawing of interior.

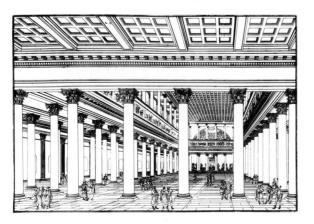

mans were accustomed to read. Trajan is known to have written an account of his Dacian campaigns, much as Julius Caesar had done in the case of the Gallic wars, but the document is lost. Since commentaries on this bit of history are so fragmentary, the column has become one of the principal sources of information about it. The impression viewers receive is so vivid that they feel almost as if they were experiencing the campaign with Trajan.

The reliefs have a definite likeness to literature in their manner of telling a story by the process of visual narration. The methods the Romans used in such cases have been distinguished as "the simultaneous" and "the continuous." The simultaneous method is the same as that used by the Greeks in the east pediment and frieze of the Parthenon, for example, where all the action takes place at a given moment that is frozen into sculptural form. It thus observes the classical unities of time, place, and action. The continuous, or cyclic, method was developed by the Romans for just such a series of scenes as Trajan's wars. Unity of action is obtained by the telling of a life story, or it can be broadened to include a couple of military campaigns, as in this instance. The unities of time and place are sacrificed as far as the whole composition is concerned but are preserved in the separate scenes. While the origin of this continuous style is still a matter of scholarly dispute, no one has challenged the effective use the Romans made of it. Its spirit is close to their keen interest in historical and current events, and its value for the purposes of state propaganda is obvious.

Despite the direct narrative content of the spiral frieze, the style is not realistic. For effects, the artist depended upon a set of symbols as carefully worked out as the words used by writers of epics. The use of a series of undulating lines, for example, indicates water. A jagged outline on the horizon stands for a mountain. A large figure rising up out of the water represents a river. A wall can mean either a city or a camp. A female figure whose draperies are folded in the shape of a crescent moon informs the observer that it is night.

With such symbolism, liberties with perspective inevitably occur, and it is quite usual to find a man taller than a wall and an important figure, such as the emperor, much greater in size than those around him. This technique does not rule out such clearly recognizable things as the banners of certain Roman legions as well as the details of their shields and armor. The Trajan frieze points unmistakably in the direction of the pictorial symbolism used later by early Christian and medieval artists, who doubtless were influenced by it.

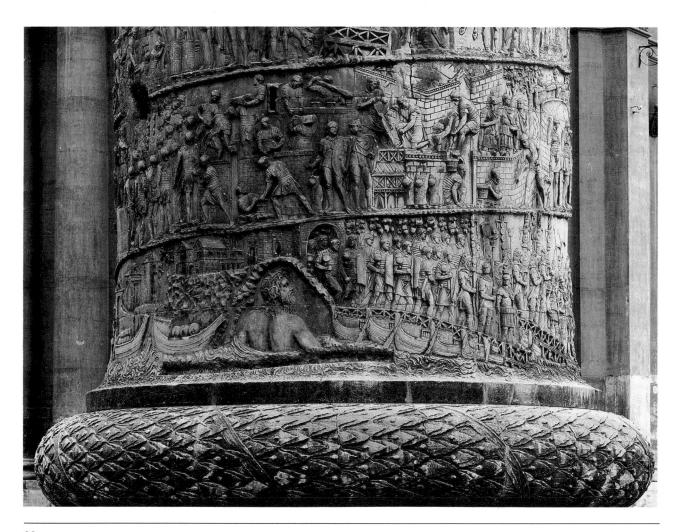

98.Trajan's Campaign against the Dacians, detail of Trajan's Column. A.D. 106–113. Marble, height of frieze band 4'2" (1.27 m).

Much of the work will seem crude if placed beside the sculptures of Hellenistic artists who were still active in Rome. But this belief is clearly and intentionally an example of Roman popular art, and as such it was addressed to that large segment of the populace not accustomed to getting its information and enjoyment from books. Its location between two libraries also indicates a recognition that history could come from pictorial sources as well as from Greek and Latin scrolls.

The elegant and placid forms of Greek gods were not apt to arouse the emotions of those Romans who sought amusement in the gladiatorial contests held in the Colosseum. While the educated minority could admire dignity and restraint in their sculpture, the vast majority had to be aroused by just such an energetic action-filled story as this, involving people like themselves. Thus viewed, Trajan's frieze is fresh, original, and astonishingly alive.

The artist who designed the frieze was clearly a master of relief sculpture, able to depict with ease, in extremely low relief, whole armies, pitched battles, and the surrounding landscapes and sky. The care in execution is consistent, and even though the reliefs at the top were almost certainly out of view, the quality remains the same.

Standing in its prominent location from Trajan's time to the present, this column and the similar one of Marcus Aurelius have had incalculable influence on later art. The continuous mode of visual narration was taken over directly into the catacomb paintings of the early Roman Christians. It was continued in illuminated manuscripts, religious sculptures, and the stained glass of the medieval period. And it can still be found going strong in the comic strips of daily newspapers. Even modern films owe a certain debt to the technique worked out here in the 2nd century A.D. In this book, examples of the

direct influence of this narrative mode include the Roman Christian tomb of Junius Bassus (Fig. 116); the mosaics relating the story of Christ in the church of Sant' Apollinare Nuovo in Ravenna (Figs. 124, 125); the Bayeux Tapestry, which tells the story of the Norman conquest of England (Figs. 168–170); and the studious duplication of Trajan's Column made under Napoleon for the Palace Vendôme in Paris (Fig. 416).

TEMPLE OF TRAJAN. After Trajan's death his adopted son and successor, Hadrian, built at the end of the main axis of the forum the Corinthian temple that climaxed the grand design. Architecturally, it was a version of the Maison Carrée at Nîmes in southern France (Fig.100). Like other Roman temples, this one honoring Trajan and the Maison Carrée rested on **podiums**, or masonry platforms, and had porches only in the front. These porches were much more prominently featured than those in Greek temples. The well-preserved example at Nîmes likewise shows only the columns of the porch

99. *Trajan Addressing Assembly of Troops,* detail of Trajan's Column.

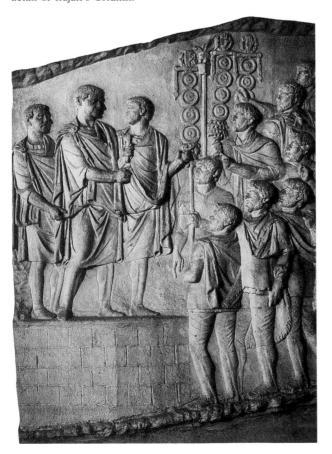

standing free, while the rest are attached to the cella. This indicates that columns were needed less for structural strength than for embellishment.

The practice of deifying rulers and erecting temples to them was widespread in Hellenistic times and began in Rome as early as the reign of Augustus. The type of statue that stood in such a temple can be seen in the portrait of Augustus that was found near Prima Porta (Fig. 88).

Much of Roman religion was a family affair, honoring the living *pater familias*, or "father of the family," as well as the nearer and more remote ancestors. A room in every residence was set aside for this purpose, and the custom was responsible for a uniquely Roman type of portrait sculpture. Examples range from the elegantly poised, fashionable young Roman matron (Fig. 101) to the calm gravity and dignity of the patrician couple who are the honored elders of their family (Fig. 102). In contrast to the generalized and idealized image of Augustus as statesman and imperator, these living likenesses of everyday Roman personalities are remarkably vivid and realistic. Both kinds of sculpture, however, served the same purpose, that of family portraits to be honored with reverence and respect. The emperor was felt to deserve the universal reverence of the whole Roman family, since he was considered pater patriae, or "father of his country." Erecting a temple to a distinguished Roman emperor was done in much the same spirit as building the Washington Monument or the Lincoln Memorial in Washington,

100. *Maison Carée*, Nîmes, France. 16 B.C. Marble; base $117 \times 59'$ (35.66 \times 17.98 m), height of podium 11' (3.35 m), height of columns 30'6'' (9.3 m).

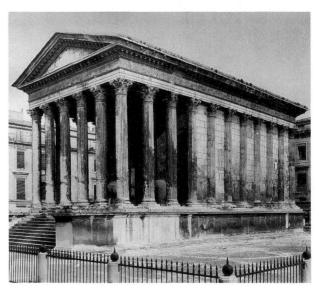

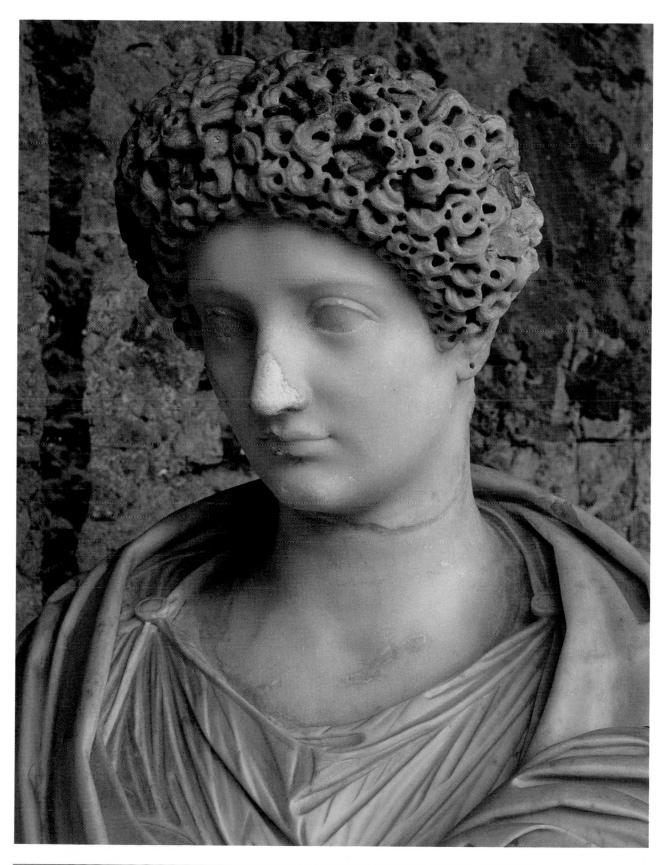

101.Portrait of a Roman Lady. c. A.D. 90. Marble, life-size. Museo Capitolino, Rome.

D.C. In ancient Rome certain days were set aside for the offering of food and drink in simple family ceremonies. On the day for honoring the emperor, the rites at his temple were more formal, occasionally including animal sacrifice, a procession, festivities, and amusements. Religion to the Romans was the tradition and continuity of the family and, in the larger sense, the history and destiny of Rome itself.

With the exception of the temple, the Forum of Trajan was completed during his lifetime and was dedicated by him for the use of the people of Rome in A.D. 113. Its many parts—the triumphal entrance archway, the courtyard and its equestrian statue, the market buildings, the Basilica Ulpia, two libraries, a monumental column, and the temple—add up to an architectural composition on a grand scale, designed to accommodate activities on many levels. Beginning with a shopping center and place to transact business, the forum continued with a general meet-

ing place and the halls of justice, moved on to places for quiet contemplation, study in the libraries and the reading of history in visual form on the column, and, finally, came to rest in the precinct for honoring the emperor and worshiping the Roman gods.

Imperial Baths

While the forums took care of the more serious pursuits of his people, Trajan never forgot that circuses often were as important as bread in promoting the happiness of his subjects. One of every emperor's duties, in fact, was to provide for public amusement out of his private purse. Only the very wealthy could afford entertainment in their own homes, so the people as a whole had to look for their recreation outside. To this end many baths, theaters, and stadiums had been built all over the city. The variety of architectural forms and human activities they encompassed has never been surpassed. To this day the

102. Porcia and Cato (?), portrait of a Roman couple. c. 1st century B.C. Marble, height 27" (69 cm). Vatican Museums, Rome.

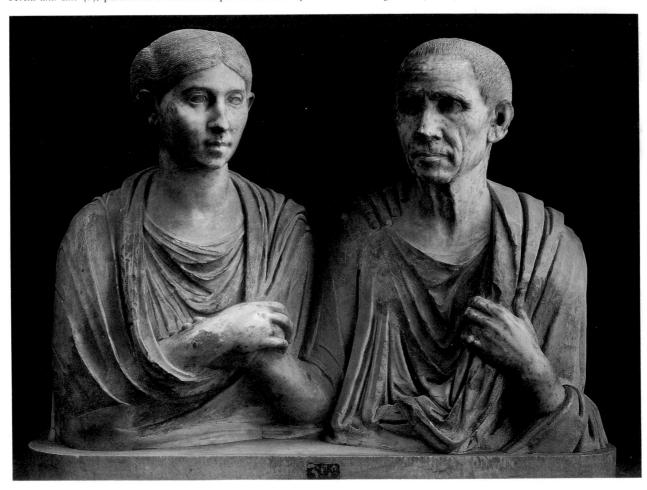

highest praise that can be given an elaborate public festival is to call it a "Roman holiday."

Imperial baths provided the people with far more than hot, cold, and tepid swimming pools. They offered such other facilities as dressing rooms, gymnasiums, restaurants, bars, and shady walks. Guests also could attend plays, witness athletic contests, listen to public lectures, read in one of the libraries, or stroll about the galleries or gardens where paintings and statues were exhibited. The baths were, in short, the people's palaces where citizens could enjoy together what only the rich could afford separately. Favored also as places to show the booty and souvenirs from foreign conquests, they are the sites where much ancient statuary has been found. These baths also had important hygienic advantages. With the habit of frequent bathing established, the people of Rome seem to have been cleaner than those of any other city before or since.

Trajan added to the already existing public baths a large establishment also built by Apollodorus. Although the ruins of his thermae ("baths") are not so well preserved as the later Baths of Caracalla and Diocletian, enough is known to establish a clear picture of what they were like. The large central hall was the earliest known use of concrete cross vaulting, the principle of which can be studied in Figure 111 and in the similar central hall of the Baths of Caracalla (Figs. 103 and 104). It measured 183 feet (55.7 meters) in length with an open space between the walls of 79 feet (24 meters). From the illustration, it can be seen that the barrel vault that runs lengthwise is three times intersected at right angles by shorter vaults extending across the width of the hall. Besides spanning larger interior spaces without the obstruction of supporting piers and columns, this type of construction offered the advantage of ample lighting through a clerestory, a row of windows in the upper part of a wall, which used thin strips of translucent yellow marble in place of glass. Modern architects, when erecting such huge edifices as the Union Station in Washington, D.C., and Grand Central Terminal in New York City, found no better models among large secular structures than these Roman baths.

Colosseum and Aqueducts

The Colosseum (Fig. 105), which dates from the late 1st century, was the scene of rather garish forms of mass entertainment, including gory gladiatorial contests between men and wild beasts. The oval form of the Colosseum covers about 6 acres (2.4 hectares) and could seat about 50,000 spectators at one time: Around its circumference run some eight archways,

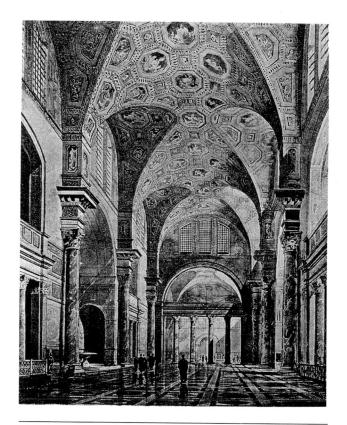

Tepidarium (heated central hall), Baths of Caracalla. A.D. 211–217. Reconstruction drawing by Spiers.

104. Plan of Baths of Caracalla, Rome. Length 750' (228.6 m), width 380' (115.82 m).

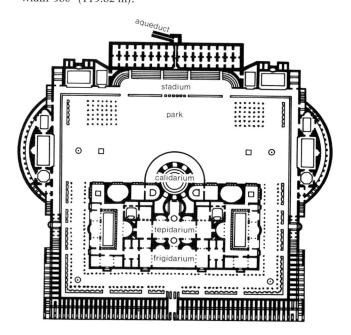

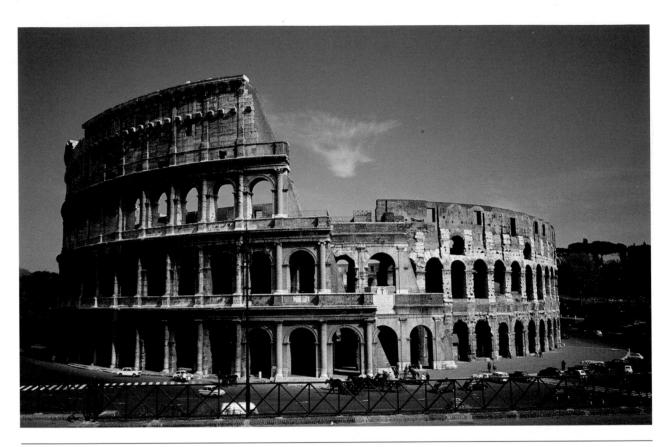

105. Colosseum, Rome. A.D. 72–80. Long axis 620' (188.98 m), short axis 513' (156.36 m), height 160' (48.77 m).

which served so efficiently as entrances and exits that the entire bowl could be emptied in a matter of minutes. The Roman talent for organization is not only evidenced here in such practical respects but also extends to the structure and decorative design. Three architectural orders are combined in the successive stories of the same building. The attached columns on the lower range are the "home-grown" variation of the Doric, known as the Tuscan. Those on the second tier are Ionic, those on the third, Corinthian. On the fourth, which rises to a height of 157 feet (47.7 meters), are found shallow, flat Corinthian piers known as pilasters between which runs a row of sockets for the poles over which a canvas awning was stretched to protect the spectators from sun and rain.

The building material of the Colosseum was a concrete made from broken pieces of brick, small rocks, volcanic dust, lime, and water. It could be poured into molds of any desired shape, including channels for use in aqueducts. The exterior was originally covered with marble facing; the structure would be in good condition today had it not been used later as a quarry for building materials right up to the 18th century. Still, the Colosseum is one of the

most impressive ruins to survive from Roman times. Its popularity as a model can be seen in the numerous football stadiums on college campuses.

In order to assure enough water for his public bathing establishments, Trajan found it necessary to improve the old system of aqueducts and to add a new one, 35 miles (56 kilometers) long, that is still in use today. A fine example of a Roman aqueduct is the Pont du Gard at Nîmes (Fig. 106), which survives from the 1st century A.D. A system of underground and open concrete channels was constructed to bring water from mountain sources to the town 25 miles (40 kilometers) away. Functioning on the principle of gravity, the ducts were sloped in the desired direction. In this instance the water was carried almost 300 yards (274.2 meters) across the valley at a height of more than 160 feet (48.8 meters). The graceful lower range of arches supports a bridge that is still in use, while the upper series of large and small arches carry the water channel.

The Pantheon

The Roman sense of social organization extended into the field of religion with the Pantheon

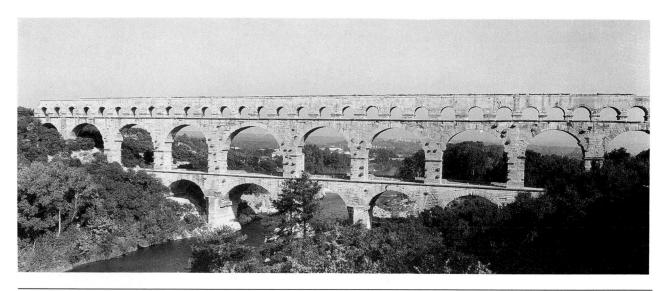

106. Pont du Gard, Nîmes, France. A.D. early 1st century. Length 902' (274.93 m), height 161' (49.07 m).

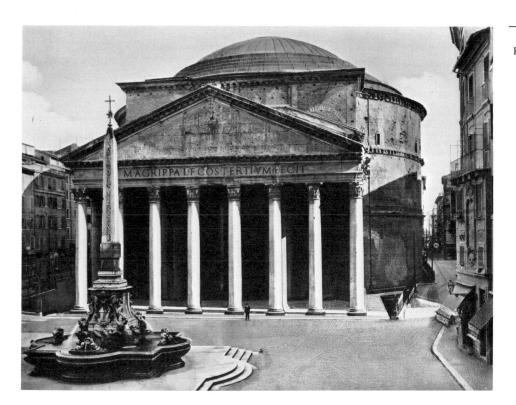

Pantheon, Rome. c. a.d. 120. Height of portico 59' (17.98 m).

(Fig. 107). While the name might imply a temple to all the gods, in effect the Pantheon became a mirror of the world order, with statues placed in niches to personify the planetary deities—Jupiter, Saturn, Venus, Mars, Mercury, the sun, and the moon. The emperor Hadrian himself is said to have had a hand in the design of this distinguished edifice, and he occasionally presided over meetings of the Roman senate held in its splendid interior.

The Pantheon's geometry is based on the conjunction of the circle, cylinder, and sphere. The cylindrical base is a circle 144 feet (44 meters) in diameter, and the height of the whole structure is the same, thus creating the closest of all harmonic proportions, 1:1, the unison. The cylindrical base is also the height of its own radius, 72 feet (22 meters) in the proportion of 2:1, thus yielding the octave. Remember that these two musical intervals are the

most closely related of all harmonies (see pp. 46–48, 56). The dome is an exact hemisphere. If completed, the whole sphere would fit precisely into the allotted interior space (Figs. 108 and 109).

The inner surface of the dome is indented with *coffers*, panels that serve the dual purpose of diminishing the weight of the concrete and furnishing the basis for its decorative scheme. In the center of each coffer was a gilded bronze rosette or star, a motif that related the dome to the sky. A column of light descends through the *oculus*, or eye of the dome (Fig. 110). Like a searchlight beam signifying the all-seeing eye of heaven, it moves around the interior, varying with time of day and season. With the seven planetary deities on their altars singing their cosmic diatonic chorus, the proportions of the Pantheon echo the musical aspect of Plato's universe (see p. 56) as interpreted by the influential Roman author Vitruvius.

After the fall of the Roman empire, the Pantheon was converted into a Christian church, which accounts for its fine state of preservation. Much of the once-elegant interior, with its marbles of glowing ochre with red, green, and black contrasts, is still in place. Gone, however, are the gilt-bronze rosettes that once spread across the coffered inner dome like an expanse of stars. The exterior marble veneer, the bronze plates of the portico ceiling, and the giltbronze sheath that once covered the dome's exterior have long since disappeared. The Pantheon's appropriateness for a place of worship, whether pagan or Christian, is clear to all who enter. The worshiper is free to ponder on the nature of the seen and the unseen and to contemplate the dome as an image of heaven. Indeed, the dome and half-dome became symbols of the universe, and the forms were incorporated into countless later Christian churches.

Despite the vicissitudes of time, the Pantheon is the best-preserved single building from the ancient world and the oldest structure of large proportions with its original roof intact. It still holds its own as one of the world's most impressive domed buildings, despite such outstanding competition as Hagia Sophia in Constantinople (Fig. 135), the Cathedral in Florence (Fig. 222), St. Peter's in Rome (Fig. 254), and St. Paul's in London (Fig. 383). Its descendants are numberless—the Villa Rotonda (Fig. 293), Thomas Jefferson's home at Monticello, the rotunda he designed for the University of Virginia (Fig. 417), the Pantheon in Paris, certain features of the Capitol rotunda in Washington, D.C., and the Low Memorial Library at Columbia University in New York, to name only a few of the buildings inspired by the Pantheon.

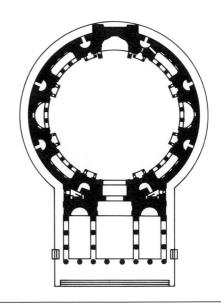

108. Plan of Pantheon.

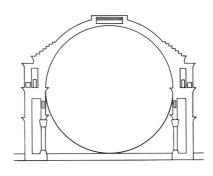

109. Cross section of Pantheon.

The Roman Architectural Contribution

The Roman contribution to architecture was fourfold: (1) building for use, (2) development of the arch and vault as a structural principle, (3) emphasis on verticality, and (4) design of significant interiors. In the first case, Roman architecture was marked by a shift in emphasis from religious buildings to the civil-engineering projects that had such an important bearing on the solution of the practical problems of the day. This did not mean that the Romans neglected their shrines and temples or that they lacked religious feeling. As in the 19th and 20th centuries, however, the main architectural expression was to be found in secular rather than religious structures. In this category come the basilicas, aqueducts, roads, bridges, even the sewer systems, which so admirably served the practical purposes of the Romans.

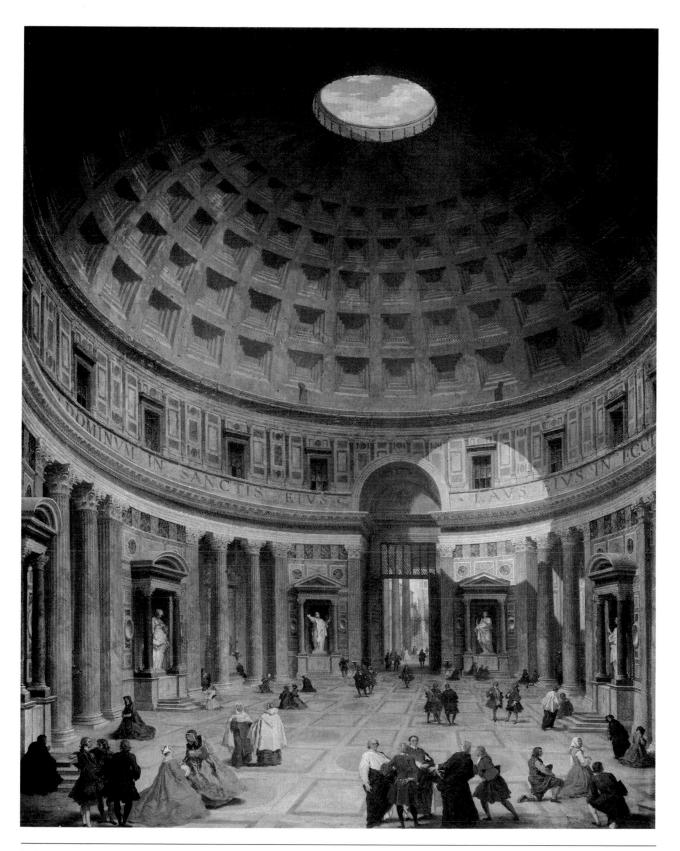

110. Giovanni Paolo Pannini. *Interior of the Pantheon, Rome.* c. 1740. Oil on canvas, $4'2\frac{1}{2}'' \times 3'3''$ (1.28 × .99 m). National Gallery of Art, Washington, D.C. (Samuel H. Kress Collection, 1939).

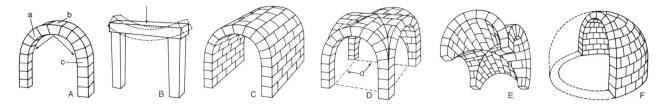

The *arch* is a curved structural member used to span a space between two vertical elements, such as posts (piers) or walls (A). Wedge-shaped blocks, called *voussoirs* (a), give the arch its form and stability by virtue of their compressed relationship to each other and to the *keystone* (b) at the apex of the semicircle. The curve of the arch rises from the *springing* on either side of the opening (c). The *compression* of its stone is better able than the *tensile* strength of a *lintel* on posts (B) to resist the downward thrust of the load above. It does this by directing the weight in a lateral direction and by transmitting the load to the ground through the arch and the vertical elements supporting it. Placed one after the other, a series of arches make a *tunnel vault* (C). Two tunnel vaults intersecting each other at right angles (D) create a *cross vault*, also known as a *groin vault* (so called for the groin line (E) along which the vaults join). The square or rectangular space they define is called a *bay* (d). Intersecting each other around a central axis, a series of arches would form a *dome* (F).

Second—and perhaps most important of all was the Roman exploitation of the possibilities inherent in the arch as a building principle to achieve the previously mentioned objectives. The construction of a true arch by means of the wedge-shaped blocks known as voussoirs, as well as some of the implications of the system, can be seen more easily in Figure 111 than explained in words. When such arches are placed side by side in a series, the resulting arcade can be used for such structures as aqueducts and bridges, as seen in the Pont du Gard (Fig. 106). When placed in a series, from front to back, the result is a *barrel vault* (also called a *tunnel* vault), which can be seen in the Arch of Trajan at Benevento (Fig. 87) and which was useful for roofing interiors. When two barrel vaults intersect each other at right angles, as seen in Figure 103, the result is a cross vault (or groin vault). When a series of arches span a given space by intersecting each other around a central axis, the result is a dome, as exemplified in the Pantheon (Fig. 110). In greatly oversimplified form, these constitute the technical principles behind the Roman architectural achievement.

Third, by their technical advances the Romans were able to increase the height of their buildings in proportion to the growing size of their large structures. The six-story market buildings of Trajan's Forum were an impressive demonstration of the practical advantages of such verticality, which allowed the combination of many small shops into a single structure in a crowded city location. The multifamily, multistory apartment houses in Ostia and Rome were also cases in point. The trend was to be seen, too, in the great height of the halls in the Baths of Trajan and Caracalla and of the Pantheon. The pleasing proportions resulting from such height were made possible by cross vaulting and the dome.

Last, the enclosing of large units of interior space was made necessary by the expansion of the city's population. The direction of architectural thought in meeting this need can easily be seen by contrasting a Greek agora (see Fig. 27) with the Forum of Trajan, a Hellenistic theater (see Figs. 58 and 68), with the Colosseum, or the Parthenon with the Pantheon. Special attention to space composition and the problems of lighting are evident in the planning of such interiors as those of the Basilica Ulpia, the Pantheon, and the halls of the great baths. In all instances, the Romans treated space as a tangible reality to be molded into significant designs.

MUSIC

The practice of poetry and music enjoyed higher favor among educated Roman amateurs than did dabbling in the visual arts. Suggesting a plan for a building or some of its decorative details was all right for a member of the patrician, or upper, class, but from there on it was the architect's and carpenter's business. Women of the patrician class achieved prominence in Roman times and may also have participated in such activities. With sculpture and painting wealthy people could make an impression as collectors, but the actual chiseling and painting were for artisans and slaves. When it came to writing verse or singing to the accompaniment of the lyre, however, amateurs were plentiful in the highest ranks of Roman society.

The emperors themselves were included in the ranks of skillful amateurs. While Trajan's recreations seem to have been as strenuous as some of his military activities, those of his immediate successors included literary and musical pursuits. Hadrian wrote poetry in both Greek and Latin, but it remained for

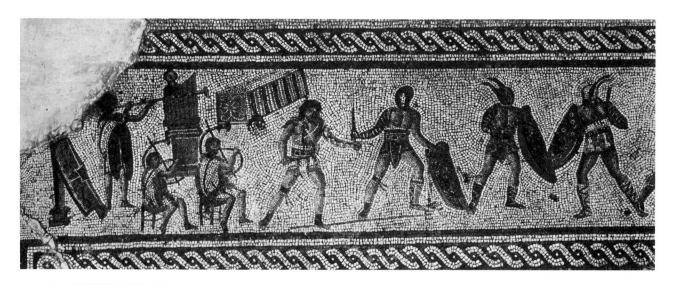

112. *Gladiatorial Contest,* showing orchestra with hydraulic organ, trumpet, and horn players. Mosaic from Zliten, North Africa. c. a.d. 70. Courtesy Salvatore Aurigemma.

Marcus Aurelius to make an enduring reputation as a writer and philosopher. The emperors Hadrian, Antoninus Pius, and Caracalla were proficient on the cithara and hydraulic organ. Their musical ability, however, was not destined to put that of their predecessor, Nero, into the shade.

Instruments and Performing Groups

While much is known about Roman literature, no actual examples of Roman music survive. All knowledge of it must be gathered from occasional literary references, from sculptures, mosaics, and wall paintings that show music-making situations and from some of the musical instruments themselves. From these sources, it is clear that the Romans heard much music and that no occasion, public or private, was complete without it.

A mosaic showing a small Roman instrumental ensemble performing in an amphitheater during a gladiatorial contest has been found in excavations in North Africa (Fig. 112). One musician is shown playing the long, straight brass instrument known as the *tuba*, or "trumpet." Two others are playing the circular *cornu*, or "horn." Still another is seated at the *hydraulus*, or "water organ." Equipped with a rudimentary keyboard and stops, this highly ingenious instrument produced sounds by forcing air compressed by two water tanks through a set of bronze pipes. Some of these instruments were 10 feet (3 meters) high. They were used mainly in open-air arenas where their tone must have resembled that of the calliopes once so popular in circus parades.

In keeping with the Roman idea of grandeur, the size of their musical instruments was greatly increased. The writer Marcellinus described an openair performance in which hundreds of players took part, some of whom were said to have performed on "lyres as big as chariots." An ever-increasing volume of sound was demanded of wind instruments owing to their usefulness in warfare. Battle signals were relayed by means of trumpet calls, and the more the legions, the bigger and brassier became the sound. This is verified by the philosopher and teacher Quintilian, who asks a typical rhetorical question, then proceeds to answer it with a characteristic flourish: "And what else is the function of the horns and trumpets attached to our legions? The louder the concert of their notes, the greater is the glorious supremacy of our arms over all the nations of the earth."

Music in Speech and Drama

Quintilian also points out some of the practical applications of music to the art of oratory. He particularly emphasizes the development of the voice because "it is by raising, lowering, or inflexion of the voice that the orator stirs the emotions of his hearers." He then cites the example of one of the great speakers of the past who had a musician standing behind him while making his speeches, "whose duty it was to give him the tones in which his voice was to be pitched. Such was the attention which he paid to this point even in the midst of his most turbulent speeches, when he was terrifying the patrician party."

Music was also a part of every theatrical performance. While the Roman drama omitted the chorus that the Greeks had stressed, its dialogue was interspersed with songs accompanied by the *tibia*, an ancient wind instrument originally fashioned from the leg bone of an animal. Such musical portions, however, were not directed by the dramatists, as they had been in the Athenian tradition, but were delegated to specialists in this field. The importance of choruses and bands for military morale was not overlooked, and a functional type of military music existed in addition to the trumpet calls to battle. Popular groups played music at games and contests, and strolling street musicians were part of the everyday scene.

The fact that not a single note of any of this music exists today testifies that Roman music was primarily a performing art. While the practicing musicians may very well have composed their own songs and pieces or made variations on traditional tunes, none seem to have been concerned with writing them down—and if they had done so, the later Church fathers would very likely have had these pagan melodies committed to the flames. So, like much folk music that existed only in oral tradition until the coming of modern notation and recording devices, the art of Roman music died with the people who practiced it.

LITERATURE

Roman expression in literature was slow in gaining momentum during the Republic since the educated classes preferred Greek writers. Before Augustus there were such early playwrights as Plautus and Terence, who wrote plays in the Greek tradition for their Latin-speaking audiences. The outstanding dramatist of the Empire was Seneca. After the invention of printing, these three playwrights received wide popularity. English translations were made in the Elizabethan era, and Shakespeare, for instance, paid tribute to Plautus by borrowing from him material for an early play, The Comedy of Errors. Then there were such philosophical authors as Cicero, with his expansive orations and penetrating essays, and Lucretius, with his masterly On the Nature of Things that explored the scientific world in poetic meters and lordly language.

Historians abound, with Julius Caesar's account of the Gallic wars, and Livy with his lifework, the *History of Rome*. Tacitus provided posterity with his insights into Roman life and customs in the early years of the Empire, and Suetonius scored with his anecdotal biographies in the *Lives of the Twelve Cae-*

sars. On the poetic plane, there are Horace's odes and epodes; Catullus's sensuous love lyrics; and Ovid's *Metamorphoses*, ardent love poems, and his erotic *Art of Love* that informs his readers how to attract and keep a lover.

A special Roman development is found in the art of satire as exemplified in the witty twists of Martial's epigrams and in the pungent verses of Juvenal. Satire, with its ironic bite and neat turns of phrase, makes for lively and amusing reading. It also became a potent weapon for writing disguised social and political criticism. Satiric wit and wisdom continued in prose with the brilliantly written romance, the Satyricon, of Petronius that contains the hilarious scene of Trimalchio's feast. Then came Apuleius's popular Golden Ass, the only Latin novel to survive intact. Both works were commentaries on the follies and foibles of Nero's reign. Later picaresque novels such as Cervantes' Don Quixote and John Fielding's Tom Jones owed much to the techniques developed by Petronius and Apuleius.

The climactic figure of Latin letters, however, was one Publius Vergilius Maro, known to history as Vergil. His elegant *Eclogues* were cast in the form of songs sung by idyllic shepherds dwelling in Arcadian landscapes, which became classic models for all future pastoral poetry. The *Georgics* were paeans of praise for the beauties of nature, the joy of living and working with the soil, and the importance of the farmer in the social scheme of things. Their visual counterpart can be found in the Tellus panel of the *Ara pacis* (Fig. 91). Both the *Georgics* and his masterpiece, the *Aeneid*, were commissioned by Augustus, who was seeking to establish a national literature in the native tongue that would rival that of Greece.

The Aeneid conjures up a legendary past for Rome through the exploits and adventures of its reputed founder, the Trojan prince Aeneas. As the myth has it, his father Anchises was so handsome that he attracted the attention of the goddess Venus herself, and Aeneas was the fruit of their union. After the fall of Troy, the gods commanded Aeneas to abandon the flaming ruins of his city and set forth over the seas to Italy, where he was destined to found a great empire that would one day rule the world. Vergil, who was educated by Greek tutors, found his model in Homer's Odyssey, and similarly the Aeneid may be read as a voyage of the spirit. Like Homer's hero, Ulysses, Aeneas is beset on his journey by all manner of ogres and temptresses. Despite such distractions, however, Aeneas never loses sight of his stern duty.

The epic opens with the stirring words: *Arma virumque cano*:

I tell about war and the hero who first from Troy's frontier,

Displaced by destiny, came to Lavinian shores.

To Italy—a man much travailed on sea and land

By the powers above, because of the brooding anger of Juno,

Suffering much in war until he could found a city

And march his gods into Latium. whence rose the Latin race,

The royal line of Alba and the high walls of Rome.

Aeneas is telling his tale at a feast given by Dido, founder of Carthage, where he has been driven by the raging storm stirred up by the jealous goddess Juno. Here, after finding the love of his life, he is once more called upon by Jupiter to bear the burden of his destiny and sail ever onward. Dido then tragically takes her own life, and his ship is lighted out of the harbor by the flames of her funeral pyre. Later he makes his descent into the underworld, where he learns from the shade of his dead father the shape of Rome's future:

Let others fashion from bronze more lifelike breathing images— For so they shall—and evoke living faces from marble: Others excel as orators, others track with their instruments The planets circling in heaven and predict when stars will appear. But, Romans, never forget that government is your medium! Be this your art:—to practice man in the habit of peace, Generosity to the conquered, and firmness against agressors.

At last Aeneas lands on Latium's shore near the mouth of the Tiber to fulfill his mission as an empire builder.

Topical allusions to Augustan times abound. Aeneas would have been seen by Roman readers as the ancestor of the first emperor, who played the role of pater patriae, father of his country (Fig. 88), while his people by proxy became the new Trojans. Dido has been portrayed sympathetically in many later plays and operas (see pp. 409–11) as the tragic queen, abandoned by her faithless lover. But to the Romans she was the temptress who had tried and

failed to seduce a Roman hero and divert him from his imperial destiny. In her farewell to her people, Dido had cursed Aeneas and called for someone to rise up and avenge her. The Romans had only to recall Hannibal, the fearsome Carthaginian warrior, who later was to cross the seas and Alps with his armies and elephants on the way to laying siege to Rome. They would also have recalled Cato's thunderous words to the Roman senate—Carthago delenda est, "Carthage must be destroyed." The Romans would have interpreted the burning of the city when Aeneas left as a prophecy of their ultimate victory in the Punic wars when Carthage was once more laid in ruins. Dido could also have been seen as a more ancient Cleopatra, who had seduced another Roman hero, Anthony. And Aeneas's exploits could have been read as an allusion to Augustus's campaign in the east with his triumph over Cleopatra at the Battle of Actium. Some critics have pointed out the part the poem played as imperial propaganda. This is true only to a limited extent, since the sheer grandeur of the conception and the magnificence of the writing rise well above such considerations. In the Latin original, Vergil's majestic hexameters create haunting rhythms that make a mystic music akin to magical incantations. The Aeneid has aptly been hailed by the modern poet T. S. Eliot as the supreme classic of Western literature.

IDEAS

As a part of the mainstream of classical culture, Roman civilization shared many of the basic ideas that produced the Hellenic and Hellenistic styles. In fact the prevailing philosophy of the Roman patrician class was that of Stoicism and, to a lesser extent, Epicureanism (see p. 77). Here, however, the discussion will center on how Roman thought affected the arts. Significantly, the Romans widened the scope of the arts to include not only works that were aimed at the expert but also those that carried broad mass appeal. The two ideas that differentiate the Roman style from earlier classical styles are the genius for organization and the frank spirit of utilitarianism. Both conceived the arts as a means to popular enjoyment and the solution for practical problems.

Organization

The Roman ability to organize is shown in the building up of a systematic world order, which embraced a unified religion, a unified body of laws, and a unified civilization. Military conquest was, to be sure,

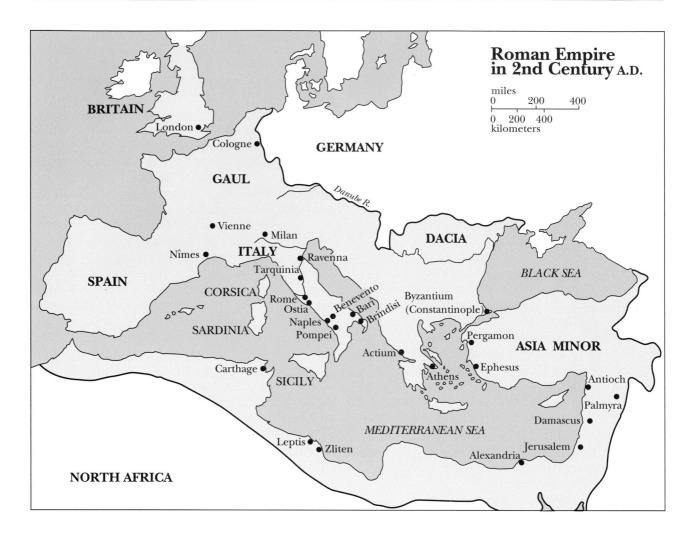

one of the means employed. However, the allowance of a maximum of self-government to subject peoples and the latitude given to local customs, even to tribal and cult religions, are proof of the Romans' realistic approach to governing. Their desire for external unity did not imply internal uniformity, and their frank recognition of this fact was at the root of their success as administrators.

ARCHITECTURE. With this ability to organize religious, legal, social, and governmental institutions, the Romans' greatest contribution in the arts clearly would lie in the direction of architecture. This organizational spirit, moreover, is revealed most decisively in their undertaking of large public-works projects, such as the building of roads, ports, aqueducts, and the like. It is also seen in their manner of grouping buildings on a common axis, as in the Forum of Trajan, which was so directly in contrast to the Hellenic idea of isolated perfection. It appears, similarly, in the organization of business activities in common centers and in the various forms of recreation in the baths. The technical application and de-

velopment of all the possibilities of construction by means of the arch and vault is another example. The combination of the Ionic and Corinthian capitals to form the Composite order, the only distinctive Roman contribution to the classical orders, is yet a further example. So is their combination of three orders on the exterior of the same building, as in the Colosseum, where the Tuscan-Doric order is used on the first story, Ionic on the second, and Corinthian on the third and fourth. Equally impressive in this regard are the development of the multifamily apartment house, the attention given to the efficient assembling and dispersing of large numbers of people in such buildings as the Colosseum, and the invention of a supermarket, such as the six-storied example in Trajan's Forum. A final example is in the erection of a supertemple for the principal gods, as in the Pantheon.

EXPANSION OF INTERIOR SPACE. The same organizational spirit is reflected in the gradual expansion of interior space, as in the Basilica Ulpia, the Pantheon, and the great halls of the baths, in order to

accommodate ever-larger numbers of people. The Greek idea had been to define space in planes. Thus, the exteriors of their temples were designed as backdrops for processions and religious ceremonies. Those who worshiped Athena at the Parthenon were concerned primarily with its external colonnades, not the interior. Space in this sense was defined but not organized. In the Pantheon, however, interior space was enveloped and made real. To the Greeks, space always remained a formless void to be controlled and humanized, but the Romans recognized the possibilities of molding three-dimensional space, enclosing it and giving it significant form.

The Romans sought to enhance this spatial feeling in many ways. They showed a sensitivity to scale and a tendency to design buildings in related structural units. They exploited color by the use of *polychrome*, or many-colored marbles, which enlivened interiors and which added to the perception of depth. They used illusionistic wall paintings to suggest the third dimension (Fig. 113). They also gave increased attention to lighting problems. All this the Romans accomplished without sacrificing the classical clarity of form.

The same feeling, furthermore, is carried over into sculpture, where the tangibility of the spatial environment is reflected in the backgrounds of reliefs by means of buildings and landscapes that suggest depth. The 5th-century B.C. Grecian style, by contrast, consciously omitted any such frame of reference. In addition to this, the organization of time into a continuum, as in the spiral series on the Col-

umn of Trajan, shows a new concept of sequential order translated into the pictorial medium.

Broadening Appeal of the Arts. Still another facet of this Roman organizational ability is found in the allowance for a wide range of taste in the arts. There were styles that appealed to the educated few and those that held the attention of the middle and lower classes. In one case it was directed to the eye and ear of the expert; in the other it was frankly popular in its appeal. The conservative tastes of the first group embraced the tried-and-true values of Greek art; hence they either collected antique statues and paintings, or they commissioned new works to be executed in the older style. Exquisite Greek craftsmanship held little interest for the majority. who needed a large bronze equestrian statue or a monumental triumphal arch to capture their attention. In Trajan's Forum, due allowance was made for this variety of taste, with the Greek and Latin libraries placed on either side of a court and a column in between, where the story of Trajan's campaigns was related in a carefully worked-out popular language of symbols designed to awaken the curiosity of the multitude.

The disdain of the conservative group for popular art was well stated by Athenaeus, a Greek scholar and teacher who lived in Rome around A.D. 200. He defended the virtues of the older cultural tradition and frequently made unflattering comparisons between the higher standards of past times and those that prevailed in his own day. "In

113. View of a Garden. c. 20 B.C. Wall painting from Villa of Livia at Prima Porta. Museo Nazionale, Rome.

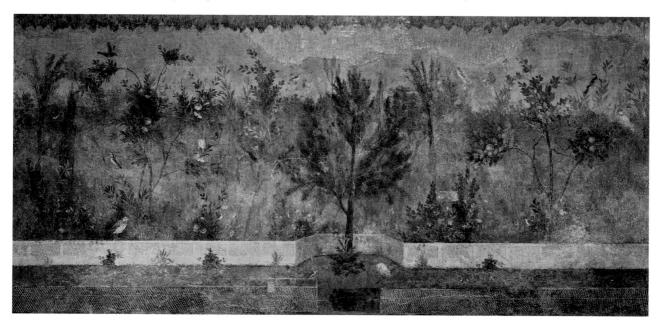

early times," he wrote, "popularity with the masses was a sign of bad art; hence, when a certain aulosplayer once received loud applause, Asopodorus of Phlius, who was himself still waiting in the wings, said 'What's this? Something awful must have happened!' The player evidently could not have won approval with the crowds otherwise. . . . And yet the musicians of our day set as the goal of their art success with their audiences."

Just as in the case of architecture, sculpture, and painting, the Romans were heirs to the Greek musical tradition. The ancient theories survived in philosophical speculation, and Greek music teachers were employed by preference in the homes of the wealthy. The only musical compositions to survive from this period, for instance, are three hymns by Mesomedes, a Greek musician attached to Hadrian's court. Those who cultivated this more austere style felt that music was meant primarily to educate and elevate the mind, but the popular taste lay in quite another direction.

The music making that Athenaeus and his conservative group scorned was obviously the very kind that the majority of Romans enjoyed at their public festivals, military parades, games, sporting contests, races, and to some extent the theater. The modern parallel would be the split that exists between audiences interested in chamber music, symphony concerts, and the opera, and those attracted by bands at football games, Broadway musicals, jazz, and rock. What the Romans' diversity accomplished was to broaden the base of the appeal of the arts and gear them to different types of audiences. They thus succeeded in providing for the entertainment of a large city population, just as their buildings and civilengineering projects took care of the physical needs of the populace.

Utilitarianism

In referring to the administrations of Antoninus Pius and Marcus Aurelius, Gibbon declared that "their united reigns are possibly the only period of history in which the happiness of a great people was the sole object of government." The basis of this claim is to be found in the way the Romans managed to steer a middle course between Scylla and Charybdis, which in this case involved Greek theoretical abstractions about the nature of an ideal state versus religious speculation on the joys of the world to come, which was to characterize the subsequent Christian phases of the Empire. Speculation on the eternal verities could uplift the mind, but the understanding of human behavior was rewarded by more immediate advantages.

At this time, Rome had reached a balance based on an acceptance of the Stoic doctrine of "live and let live" and the Epicurean idea of pleasure as an index to the highest good. The transfer of these doctrines of individualism to the forms and policies of a government meant a high degree of tolerance and a recognition that the standard of excellence in either a law or a work of art was the greatest good for the greatest number.

The construction of elegantly proportioned temples was therefore not so important as the building of bridges (Fig. 114). Maintaining a luxurious private palace was secondary to providing people's palaces, such as the public baths and theaters. A private collection of sculpture was subordinate to public exhibitions in city squares and galleries, where the statues could be seen and enjoyed by many. A play, poem, or piece of music that awakened only the sensibilities of the cultured minority did not rank so high on this scale as those that were applauded by the multitude. In short, the practical arts were favored over the decorative arts, material goods superseded more remote spiritual blessings, and utility was valued over abstract beauty (though the two are by no means mutually exclusive).

Since the Romans were little concerned with ideal forms, it was not an accident that their greatest successes occurred in the arts of government rather than in the fine arts. As was said earlier, the art which proved most congenial to Roman aspirations

114. Bridge (Pons Aelius), Rome. A.D. 134. Hadrian's Tomb (Castel Sant' Angelo), A.D. 135–139.

was that of architecture, especially in its utilitarian aspects, as found in the field of civil-engineering. Building a 200-mile (320-kilometer) highway over the mountains, moving part of a hill over 100 feet (30.5 meters) high to make way for a forum, providing a sewer system for a city of over a million inhabitants, bridging the Danube at its widest point, perfecting such a new building material as concrete—all these were taken in stride.

When it came to sculpture, the Romans saw that subject matter served the purposes of the state by praising the virtues and deeds of the emperors. Such epic poems as Vergil's *Aeneid* performed a similar service in the literary medium; and, as Quintilian said, the loud sounds of the brass instruments proclaimed the glory of Roman arms.

Other applications of this utilitarianism arc found in the brilliant exploitation of such technical devices as the arch and vault. Their success in solving practical problems is proved by the number of roads, aqueducts, and bridges that are still serving their purpose today. In sculpture the application of the continuous-narrative method was more psychologically practical. This way of telling a tale promoted a sense of continuity in time and anticipated later Christian and secular pictorial forms.

Effective as utilitarianism was, it was purchased at the price of conflict between structure and decoration, external and internal values, and functional and nonfunctional aspects of art. The Romans built and decorated well, but the two activities somehow failed to achieve a harmonious coexistence. This is well illustrated by the somewhat hollow claim of Augustus, who had boasted that he found Rome a city of brick and left it a city of marble. Actually, Rome was still a city of brick, stone, and concrete under an Augustan marble veneer. None of these materials needs a disguise, or even an apology, as proved by the rhythmical grace of the functional arches of the Pont du Gard. Hence Augustus had no need to imply that Roman structures were solid marble like the Parthenon. As a whole, then, Roman architecture was at its best when it stuck to its frank utilitarianism, undertook vast engineering projects,

and successfully solved the practical problems of construction.

The Eternal City

Older cultural centers, such as Athens and Pergamon, were so far off the beaten track that their more restrained classical purity did not exert any appreciable influence on the forms of Western art until the archeological discoveries of the 18th and 19th centuries. All intervening phases of classicism were, in effect, revivals of the Roman style. With the establishment of the Roman building methods, Western architecture was firmly set on its course, and it steered in substantially the same direction until the technological discoveries of the 19th and 20th centuries. Consequently, it must be emphasized once more that Rome was the gateway through which all the styles, forms, and ideas of Mediterranean civilization passed in review. After being transformed by the process of selectivity—and by flashes of genuine originality—into a uniquely Roman expression, they proceeded by way of the new Roman imperial capitals of Byzantium in the East and Ravenna in the West.

Rome in imperial times was also the western center of Christendom from the first century. Because Christianity was at first an underground religion, the art had to be hidden in underground passages known as *catacombs*. Later, when Constantine legalized Christianity, large churches known as basilicas were built. Surviving from this time are many elaborately carved marble tombs, or *sarcophagi*, depicting biblical subjects (Fig. 116).

When Rome declined as the center of world empire, it still remained the capital of Christendom. As the object of pilgrimages, its architectural, sculptural, and literary monuments were bound to exert a massive influence on those who were drawn at one time or another toward the city. Because of this enduring preeminence, no important Western city exists without a bit of Rome in it. It is therefore with full justification that Rome has been and still continues to be called the Eternal City.

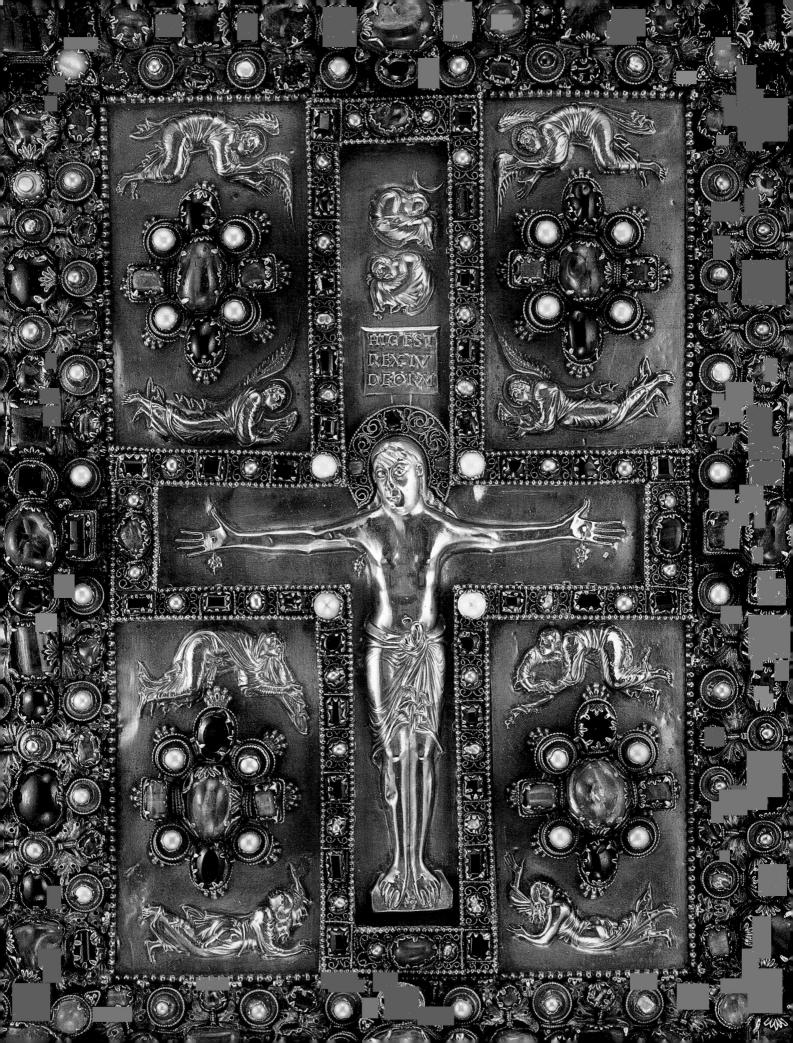

P A R T

2

The Medieval Period

he medieval period, or Middle Ages, was so named by later historians to account for the thousand-year span between the fall of Rome and the revival of classical learning in the 15th century. The era is divided into the Dark Ages (550–750), the Carolingian and Ottonian empires (750–1000), the Romanesque phase (1000–1150), and the Gothic period (1150–1400).

The East Roman Empire remained a powerful force until its capital, Constantinople, fell to the Ottoman Turks in 1453. In the West a new Roman power, the Christian Church, was restoring order and imposing a new code of law. Medieval thought turned from the scientific and materialistic worldview of the ancients and created a system based on faith, spiritual values, and miracles. Art was almost exclusively under the patronage of the Church, with the clergy in control of the forms and iconography, although artists had a free hand in the execution of their work. In music plainsong melodies were dictated by the Church. Yet new voices could be

woven around the traditional tunes, a practice that allowed musicians a wide latitude.

Medieval society witnessed the rise of monasticism, feudalism, the building of cities, and the emergence of national monarchies. The monastic movement kept the torch of knowledge alight by copying ancient books and establishing libraries and schools. Feudalism established an economy based on the ownership and productivity of land. From the nobles to the peasants and serfs, everyone's place was fixed by birth. The only path to upward mobility was the Church. The Romanesque period saw people embarking on pilgrimages to shrines at Rome, Jerusalem, and Santiago de Compostela. Gothic times witnessed the rise of cities in northern Europe. Here the merchants and artisans became distinct social groups, organizing into guilds, similar to trade unions, that regulated prices, set forth codes for business practices, and assured quality of production. The beginnings of nationhood were to be seen in the

growth of monarchies. In England King John signed the Magna Carta in 1215, recognizing that laws applied even to kings, who had to share power with the nobles. This event marked the beginning of a representative form of government known as the parliamentary system.

This colorful period mirrors the inventive power and inspired spirit of the people who participated in it. The creation of such marvels as the immense abbey churches, the imaginative sculptures that reflected the medieval world in stone, the organization of the crusades that brought the peoples of the Christian West and Moslem East together, the building of the soaring Gothic cathedrals, the intricate logic of scholastic summas that systematized the articles of faith into monumental edifices, the founding of universities, the invention of liturgical dramas and miracle plays, the fiery magic of stained glass that transformed natural light into supernatural visions, the otherworldly sounds of plainchant—all combine into a magnificent panorama.

EARLY CHRISTIAN CENTURIES

[ROME			
ŀ	KEY EVENTS	ARCHITECTURE	LITERATURE	MUSIC
975	281-305 Diocletian, emperor. last persecution of Christians 306-337 Constantine, emperor 313 Edict of Milan legalized Christianity 325 First Council of Nicaea. Arian heresy condemned c.340-397 St. Ambrose, bishop of Milan from 374 402 Rome abandoned by Emperor Honorius as capital of West Roman Empire 410 Visigoths under Alaric sacked Rome 455 Vandals sacked Rome 455 Vandals sacked Rome; fall of West Roman Empire 590-604 Gregory the Great, pope; Roman Catholic liturgy codified c.742-814 Charlemagne, King of Franks from 768, crowned Holy Roman Emperor, 800 912-973 Otto the Great, Holy	c.313 Lateran Basilica begun on site of present San Giovanni in Laterano c.324-c.333 Old St. Peter's Basilica begun on Vatican Hill c.330-c.350 Tomb of Santa Costanza, daughter of Constantine. Later rededicated as church 385 San Paolo fuori le Mura ("St Paul's outside the Walls") Basilica built. (Destroyed by fire 1823 and rebuilt.) c.432-c.440 Santa Maria Maggiore Basilica begun	340- 420 St. Jerome ; translated Latin Vulgate Bible 354- 430 St. Augustine ; bishop of Hippo (North Africa); author of Confessions (c.400), City of God (c.412)	c.524 Boethius wrote authoritative treatise <i>De musica</i> c.600 Pope Gregory the Great organized church liturgy. Reputed founder of Schola Cantorum in Rome
913	Roman Emperor, 962-973 RAVENNA			
380		· · · · · · · · · · · · · · · · · · ·	20.00113	c.386 Bishop Ambrose of
640	395-423 Honorius, West Roman emperor 402 Ravenna, under Emperor Honorius, became capital of West Roman Empire 476 Odoacer conquered Ravenna; fall of West Roman Empire 476-493 Odoacer established Ostrogothic kingdom in Ravenna, also ruled Italy 493-526 Theodoric the Great reigned as king of Ostrogothis, also ruled West Roman Empire 495-540 Cassiodorus served as minister to Theodoric and successors 535 Belisarius invaded Italy in name of Emperor Justinian 546 Maximian appointed archbishop of Ravenna; ruled as Byzantine exarch	c.402- 405 "Neonian" Baptistry for Roman Christians c.425-c.440 Mausoleum of Galla Placidia 493 Church of Sant' Apollinare Nuovo begun c.520 "Arian" Baptistry c.526 Mausoleum of Theodoric built c.527 Church of San Vitale begun c.527 Church of San Vitale begun at Ravenna c.530- 539 Church of Sant' Apollinare in Classe 547 San Vitale completed 556 Ivory throne of Maximian finished at Ravenna	524 Boethius wrote Consolations of Philosophy c.540 Cassiodorus founded monastery at Vivarium, Italy, for preserving and copying manuscripts. Wrote History of Goths 560- 636 Isadore of Seville collected Greek and Latin writings	Milan arranged hymns and psalms for antiphonal congregational singing. Body of choral music, Ambrosian chant (plainsong) is attributed to him.
	BYZANTIUM (CONSTANTINOPLE)			
320 570	c.324-c.330 Constantine made Byzantium capital of East Roman Empire 325 First Council of Nicaea 518-527 Justin, East Roman emperor 527-565 Justinian the Great, East Roman emperor	c.527 Church of Sts. Sergius and Bacchus begun 532- 537 Church of Hagia Sophia built by architects Anthemius of Tralles and Isidorus of Miletus	529 Justinian issued <i>Code of Civil Law</i> c.564 Byzantine historian Procopius died. Wrote <i>On Building</i> , detailing works built by Justinian's time; <i>History of his own Time</i> ; and <i>Secret History</i> about scandals at court	329- 379 St. Basil , bishop of Caesarea, liturgist of Eastern Orthodox Church c.345- 407 St. John Chrysostom , patriarch of Constantinople and liturgist of Eastern Orthodox Church

Late Antiquity: Early Roman Christian and Byzantine Styles

Christianity in the early days of the Empire was to the Romans but one of many mysterious cults that promised a better life beyond the grave. Eventually, it was the only one to survive. In the West it spread gradually beyond Italy into Spain, France, and Britain. Early converts were mainly from the dispossessed and downtrodden masses though some were drawn from the patrician and educated classes. With the acceptance of slaves and women into their communities, Christians gained momentum until their religion became a force to be reckoned with in Roman officialdom. Since Christians believed in peace and good will toward men, most refused to pay obeisance to the emperor and likewise to serve in the imperial armies. Consequently, they were periodically persecuted under various emperors according to prevailing political conditions. Trying to stem the rising tide of their ranks, the emperor Diocletian launched the final official suppression in the year 303. Just ten years later his successor, Constantine, issued the Edict of Milan recognizing Christianity as one of the official state religions. It was now possible for the Christians to worship openly; and with Constantine's support, an extensive building program was undertaken in Rome that included the basilicas of St. Peter in the Vatican (Figs. 121-122), Santa Maria Maggiore, and "St. Paul's Outside-the-Walls."

At first Christianity was of necessity an underground religion, both literally and figuratively. Believing in the resurrection of the body, Christians departed from the Roman practice of cremation and, with permission of the authorities, dug burial chambers for their members in catacombs. These catacombs also served as meeting places for their secret communal meals and early celebrations of the mass. Such settings for their religious rites were grim indeed. Decorative art as such was not only beyond

their means but was ruled out as being too worldly. Some slave converts, however, had certain skills, and they were allowed to paint the walls with Christian symbols and visual versions of the Old and New Testament stories that illustrated the teachings of the church for those who could not read (Fig. 115).

Favorite subjects were Christ as the good shepherd leading his flock as in the 23rd Psalm, vineyard scenes that referred to the communion wine, and Old Testament stories that were reinterpreted with new meaning. Isaac being sacrificed by Abraham now was seen as a prophecy of Christ's sacrificial mission. The tale of Jonah being thrown overboard, spending three days in the belly of the great fish, and finding himself on a peaceful shore under the shade of a green gourd vine became the journey of the soul after death toward refuge in heaven. Daniel's rescue from the lion's den, like that of the three youths from the fiery furnace, meant redemption through suffering and deliverance by the power of faith.

Some of the sarcophagi, the marble tombs carved after Christianity became legal, show a consummate craftsmanship that set them apart from the catacomb paintings and forged a link between pagan Roman and early Christian art. That of Junius Bassus, a Roman prefect, provides a prime example (Fig. 116). Above, reading from left to right, are the high relief panels showing Abraham sacrificing Isaac as his hand is stayed by a messenger from God, the arrest of Peter, and Christ enthroned in majesty between Saints Peter and Paul. Under his feet is a canopied classical figure signifying the firmament, and in Christian terms the heavenly realm. Then follow two scenes depicting Jesus being judged by Pontius Pilate. Lower on the left are panels showing Job's sufferings; Adam and Eve with the tree of knowledge and serpent between them, the scene a reference to original sin; Christ's triumphal entrance into

115. The Good Shepherd, c. A.D. 4th century. Painted ceiling, Catacomb of Saints Pietro and Marcellino, Rome.

Jerusalem; Daniel in the lions' den; and finally, St. Paul being led to execution. For clarity, the scenes are framed by classical colonnettes. All figures are draped in Roman togas with the exception of Adam and Eve, who are naked. Christ, however, is accorded the honor of the Greek pallium, a robe associated in classical times with teachers and philosophers. The youthful representation of Jesus also recalls images of the young Apollo.

A decisive event in early Christian history was the convening of the Council of Nicaea by Constantine in 325. Here the basic tenets of the Christian faith were debated and coordinated by leaders from both West and East. The most controversial issues were the nature of the godhead and the doctrine of the Trinity. Was Jesus, as the only begotten son of God, of one substance with the Father and hence purely divine? Or, since he was begotten, was he both divine and human? Or was he all human? As professed in the Nicene Creed, Jesus was believed to be "of one substance with the Father, by whom all things were made." The major dissenter was Arius of Alexandria, who held that Jesus was the most perfect of men, but not of one substance with the Father. Arius was then excommunicated and his followers declared heretics. The Arians, however, continued to make converts, especially with the peoples of the Danube Valley including the Ostrogoths. Their leaders at this time were Odoacer and Theodoric, who finally brought about the fall of the West Roman Empire by capturing its capital city, Ravenna.

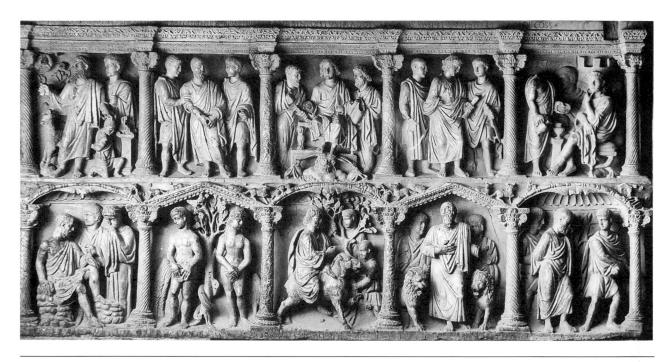

116. Sarcophagus of Junius Bassus. c. a.d. 359. Marble, $3'10\frac{1}{2}'' \times 8'$ (1.17 × 2.44 m). Vatican Grottos, Rome.

RAVENNA, LATE 5TH AND EARLY 6TH CENTURIES

Many an old Roman coin bears the inscription *Ravenna Felix*—"Happy Ravenna." By a felicitous stroke of fate, this previously unimportant little town on Italy's Adriatic coast became the stage on which the great political, religious, and artistic dramas of a century and a half of world history were enacted.

Ravenna was, in turn, the seat of the last Roman emperors of the West, the capital of a barbarian Ostrogothic kingdom, and the western center of the East Roman Empire. A more forbidding site could hardly be imagined. To the east lay the Adriatic Sea; to the north and south, wide deltas of the river Po; and the only land approach was through marshes and swamps. Yet when the barbarian hordes had Rome in a state of almost constant siege, it was this very isolation that led Emperor Honorius to abandon Rome in A.D. 402 and seek in Ravenna a fortress where his hard-pressed legions could be supplied by the East Roman Empire through the nearby port of Classe (see map p. 136).

Even with all its natural advantages, Ravenna could hold out against the barbarians only until the year 476. Odoacer then succeeded in entering the all-but-impregnable city and put an end to the West Roman Empire. The Ostrogothic kingdom of Theodoric, Odoacer's successor, was even more

short-lived, and Ravenna fell once more in 540, when Justinian's armies of the East Roman Empire conquered the Italian peninsula and for a brief time reunited the old Empire. Meanwhile a third force, the more enduring power of the Roman papacy, was becoming increasingly influential.

Diverse historical traditions as well as wide geographical distances separated Rome in the west, Byzantium in the east, and the nomadic Ostrogoths in the north. Early in the 4th century, after he had made Christianity an official state religion, Emperor Constantine had moved his court to Byzantium, christening the city the "new Rome." Later, this second capital was called Constantinople in his honor, and soon the East and West Roman empires were going their separate courses. With the encroachments of northern barbarians, a three-way struggle for power began among Justinian, Theodoric, and the pope.

More than the sea stretched between Ravenna and Constantinople, higher mountains than the Alps stood between it and the restless northern barbarians, and greater obstacles than the Apennines separated it from Rome. Theological barriers, in fact, proved more impassable than seas or mountains, because this was the age that was laying the foundations of basic Christian beliefs. The controversies in Ravenna foreshadowed the later separations of Christianity into Eastern Orthodox and Roman Catholic.

Paralleling the political and religious controversies, a conflict of art styles took place within Ravenna as successive rulers built and embellished the city. In the 6th century, Ostrogothic Arian heretics, Byzantine patriarchs, and members of the Roman hierarchy, together with the schools of artists each

117. Mausoleum of Galla Placidia, Ravenna. c. 425.

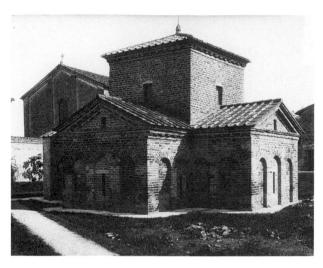

patronized, had different cultural heritages, aesthetic goals, and ways of looking at the world.

During the days when the Roman Empire was united, cultural influences came from all parts of the Mediterranean world, and with due allowance for regional diversity, Roman art achieved a recognizable unity. But with the disintegration of Roman power, the adoption of Christianity as an official religion, and the separation of the Empire into eastern and western centers, a reorientation in the arts took place. Though there were many overlapping elements, owing to a common heritage, two distinct styles began to emerge. Hence, when reference is to all the art of this period, the designation will be Early Christian. The term Early Roman Christian will be used to distinguish the Western style from the declining old pagan Roman arts, on the one hand, and from the subsequent Romanesque and Gothic styles of the later medieval period on the other. Byzantine will designate the parallel Eastern style.

ARCHITECTURE AND MOSAICS

Ravenna's replacement of Rome as a capital city demanded successive building programs that would

118. *Christ as the Good Shepherd,* mosaic above entrance portal, interior of mausoleum of Galla Placidia, Ravenna. A.D. 425–450.

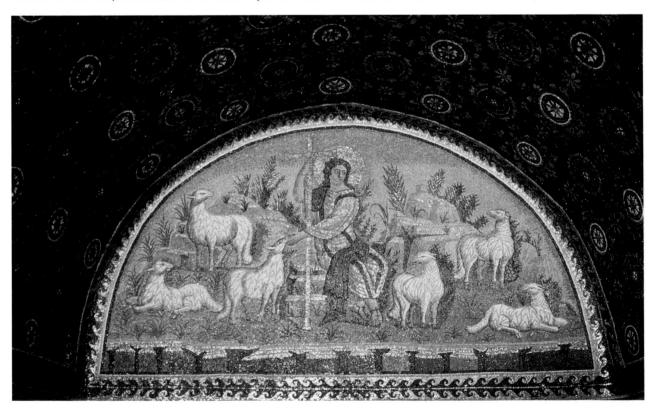

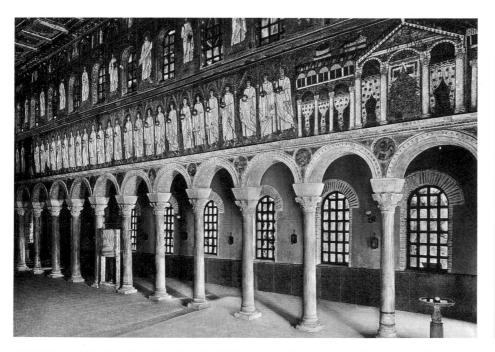

119. above left: Interior, Sant' Apollinare Nuovo, Ravenna. c. 493–526.

120. above right: Plan of Sant' Apollinare Nuovo.

transform a minor provincial town into a major metropolis. No ruler could afford to be outdone by predecessors. Therefore the West Roman emperors and the Empress Galla Placidia, whose tomb is seen in Figure 117, erected significant secular and religious structures. The interior of this architectural gem is completely lined with mosaic work of surpassing brilliance. Over the entrance portal one finds a portrayal of the youthful Christ as the Good Shepherd in the midst of his flock (Fig. 118). Later, when the northern barbarian king Theodoric came to power, he sought to be more Roman than the Romans. As he wrote to an official in Rome, he wished his age to "match the preceding ones in the beauty of its buildings." And the great Justinian, after the Byzantine conquest, made architectural contributions corresponding to his imperial dignity.

Rectangular Basilicas: Sant' Apollinare Nuovo

Theodoric included in his building program a church to serve his own Arian sect. Originally dedicated by him to "Our Lord Jesus Christ," this church (Fig. 119) today bears the name of Sant' Apollinare Nuovo, honoring Apollinaris, patron saint of Ravenna and, by tradition, the disciple and friend of St. Peter. The floor plan is a severely simple one (Fig.

120). There is a division of space into a vestibule entrance, known as the *narthex;* a central area for the congregation to assemble, known as the *nave*, separated from the side aisles by two rows of columns; and a semicircular *apse*, which framed the altar and provided seats for the clergy.

Older pagan temples, with their small, dark interiors, were not suitable models for Christian churches that had to house large congregations. Ancient Greek ceremonies had taken place outdoors around an altar with the temple as a backdrop. The principal architectural and decorative elements of the classic temples—colonnades, friezes, pediments—faced outward. The Christian basilica turned the Greek temple outside in, leaving the exterior quite plain, and concentrated attention on the interior colonnades and the painted or mosaic embellishments of the walls and semidomed apse.

The most complete of these Early Christian basilicas was Old St. Peter's (Figs. 121 and 122), so called because it was destroyed in the 16th century to make way for the present basilica of Bramante, Michelangelo, and Maderno (see Fig. 254). Planned from the year 324, when it was dedicated by Constantine, built over the presumed tomb of the Apostle, and as the largest church of the period, Old St. Peter's, until its demolition, ranked as the key monument of Western Christendom.

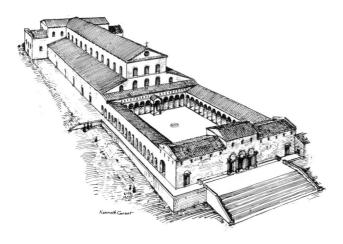

121. Reconstruction of Old St. Peter's Basilica, Rome. c. 333. Length of grand axis 835′ (254.5 m), width of transept 295′ (86.87 m). Restoration study by Kenneth J. Conant.

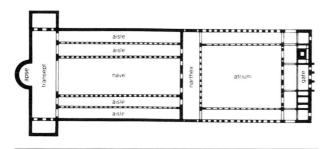

122. Plan of Old St. Peter's.

To provide for all Christian activities, Old St. Peter's brought together elements of Roman domestic, civic, and temple architecture into a new harmonious composition. Approached by a flight of steps, entrance to the open atrium was made through an arched gateway. This courtyard, derived from old Roman country villas, was surrounded by roofed arcades, or series of arches, supported by columns. It provided space for congregations to gather, facilities for the instruction of converts, and offices for church officials. In its center was a fountain for the ceremonial washing of hands. The side of the atrium toward the church became the *narthex* that serves as a frontispiece to the church proper. Through the portals of the narthex, entrance was made into the nave and the side aisles (Fig. 122). This spacious nave was 80 feet (24.4 meters) wide and resembled the rectangular law courts of Roman public basilicas (see Fig. 97). It was flanked on either side by two aisles 30 feet (9.1 meters) wide and a procession of columns that led the eye along its 295-foot (89.9-meter)

length to the *triumphal arch* (so called because of its derivation from similar Roman imperial structures, such as that in Fig. 87). Beyond this was the wide *transept*, the "arms" set at right angles to the nave and an area that functions as a second nave, followed by the semicircular apse.

The ground plan (Fig. 122), then, was roughly T-shaped or cruciform, resembling a long Latin cross with short arms. From beginning to end, the design of Old St. Peter's swept along a horizontal axis of 835 feet (254.5 meters) and opened out at its widest point in the 295-foot (89.9 meter) transept.

Vertically, a basilica (Fig. 123) rises above the nave colonnades through an intermediate area called the *triforium*. Above this is the *clerestory* with its rows of windows that light the interior and with its masonry that supports the wooden beams of the shed roof. In keeping with the sheltered and inward orientation of these early basilicas, no windows gave view on the outside world. Those at the clerestory were too high and too deeply set to allow even a glimpse of the sky. It was inner radiance of the spirit rather than natural light that was sought.

ROMAN AND BYZANTINE Mosaics. Sant' Apollinare Nuovo (Fig. 119), unlike Old St. Peter's, which had to accommodate a standing congregation of forty thousand or more, was designed as the private chapel of Theodoric's palace. Only the nave now remains intact, all other parts being restorations or later additions. As such, its modest architecture would attract only passing attention. However, the magnificent mosaics that decorate its nave wall are of major importance in art history. Although they present a harmonious design, the mosaics actually were made in two different periods and styles.

123. Section view of a typical Early Roman Christian basilica.

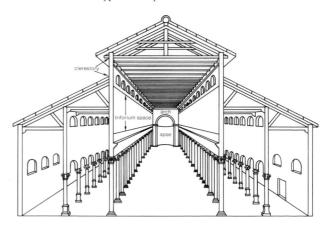

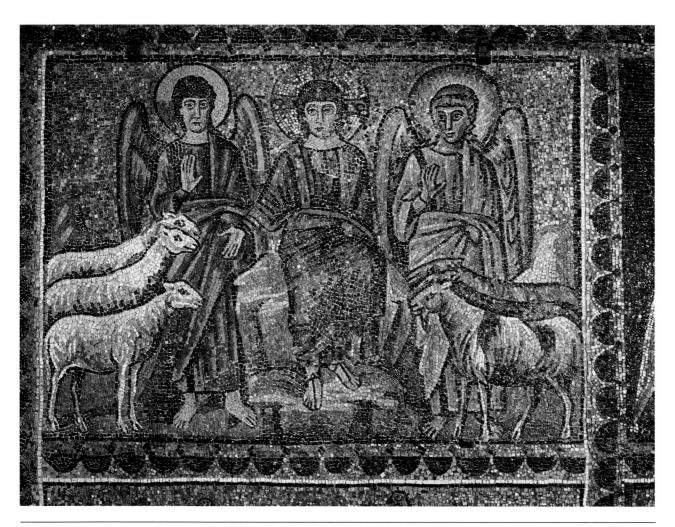

124.

Good Shepherd Separating the Sheep from the Goats. c. 520. Mosaic, Sant' Apollinare Nuovo, Ravenna.

The mosaics of the earlier period were commissioned by Theodoric and are Early Roman Christian craftsmanship. "Send us from your city," Theodoric had written through his secretary Cassiodorus to an official in Rome, "some of your most skilled marble workers, who may join together those pieces which have been exquisitely divided, and connecting together their different veins of color, may admirably represent the natural appearance." After Justinian's conquest, the church was rededicated and all references to Arian beliefs and Theodoric's reign were removed. Half a century later, part of the frieze above the nave arcade was replaced by mosaics in the Byzantine style.

Completely covering both walls of the nave, the mosaic work is divided into three bands (Fig. 119). Above the nave arcade and below the clerestory windows, a wide and continuous mosaic strip runs the entire length of the nave in the manner of a

frieze. It depicts two long files of saints (the Byzantine part) moving in a majestic procession from representations of Ravenna on one side and Classe on the other (the Early Roman Christian part). The second band fills the space on either side of the clerestory windows with a series of standing toga-clad figures.

At the top level, panels depicting incidents in the life of Christ alternate with simulated canopylike niches over the figures standing below. The middle and upper bands are of Roman craftsmanship. The scenes in the upper band constitute the most complete representation of the life of Christ in Early Christian art. On one side, the story of the parables and miracles is told, among them the *Good Shepherd Separating the Sheep from the Goats* (Fig. 124), an allusion to the Last Judgment. In this and other scenes Christ appears youthful, unbearded, with blue eyes and brown hair. On the opposite side, scenes of the

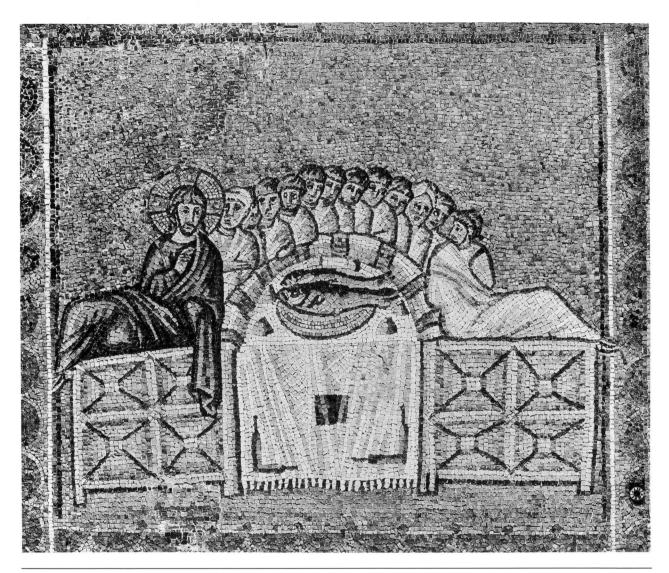

125.
Last Supper. c. 520. Mosaic, Sant' Apollinare Nuovo, Ravenna.

Passion and Resurrection are presented. In the *Last Supper* (Fig. 125), showing Christ and the disciples reclining in the manner of a Roman banquet, he is seen as a more mature and bearded figure. In all instances he has the cruciform halo with a jewel on each arm of the cross to distinguish him from the attending saints and angels. His dignified demeanor and purple cloak also tend to show him in the light of royal majesty.

Standing like statues on their pedestals, the figures in the middle band are modeled three-dimensionally in light and shade and cast diagonal shadows. They apparently were once identified by inscriptions over their heads. The removal of their names suggests they may have been prophets and saints revered by the Arian Christians.

The great mosaic frieze above the nave arcade starts on the left and right of the entrance with representations of the ports of Classe and Ravenna, respectively. In the crescent-shaped harbor with three Roman galleys riding at anchor, Classe is seen between two lighthouses. Above the city walls some of the ancient buildings are discernible, and from the gate issues the procession of virgin martyrs.

On the opposite side is Ravenna, with Theodoric's Palace in the foreground (see Fig. 119). Under the word *Palatium* is the central arch where once was a portrait of Theodoric on horseback. Under the other arches, outlines and traces of heads and hands indicate that members of his court were also portrayed, and Theodoric was again depicted in the city gate at the right. But when the Ostrogothic

kingdom came to its abrupt end, these personages were replaced by simulated Byzantine textile-curtains. Above the palace are several of Theodric's buildings with the Church of Sant' Apollinare Nuovo itself on the left.

As with the cella frieze of the Parthenon, this procession reflects the ritual that regularly took place in the church. According to the early custom, the congregation gathered in the side aisles, with women on one side and men on the other. At the offertory they went forward through the nave to the altar carrying with them their gifts of bread and wine for the consecration. In a stylized way, the procession frieze reenacts this part of the service on a heavenly level. On the left (Fig. 126), 22 virgins are led forward by the Three Wise Men to the throne of the Virgin Mary, who holds the Christ child on her lap. Arrayed in white tunics with richly jeweled mantles, the virgins carry their crowns of martyrdom in their hands as offerings.

In a similar manner, 25 male martyrs on the right are escorted by St. Martin of Tours into the

presence of Christ, who is seated on a lyre-backed throne. The eye is led along by the upward folds and curves of their costumes as they step along a flowered path lined with date palms that symbolize both Paradise and their martyrdom. All is serene and no trace of their earthly suffering is seen. Their heads, though tilted differently to vary the design somewhat, are all on the same level in keeping with the Greco-Byzantine convention of isocephaly. (See Chapter 2, p. 33, for a Hellenic example.)

In the procession only St. Agnes is accompanied by her attribute, the lamb. Otherwise the faces reveal so little individuality that they could not be identified without the inscriptions above their heads.

A completely different artistic feeling is revealed when these Byzantine figures are compared with the earlier Roman work in the bands above. The lines of the Byzantine design form a frankly two-dimensional pattern, while the garments of the Roman personages fall in natural folds that model the forms they cover in three-dimensional fashion.

126. Procession of Virgin Martyrs. c. 560. Mosaic, Sant' Apollinare Nuovo, Ravenna.

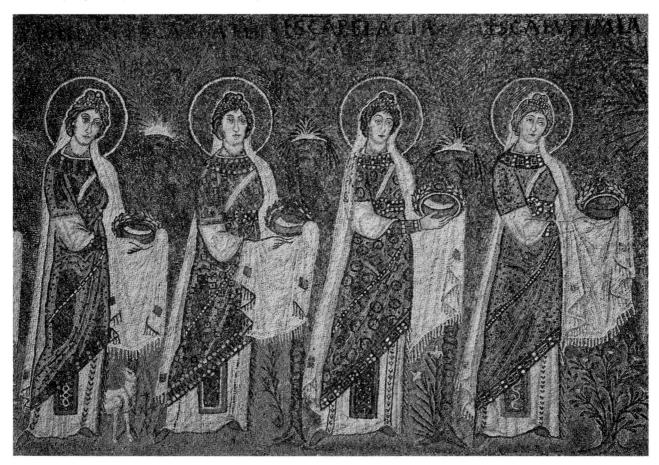

All the figures in the upper two bands wear simple unadorned Roman togas, while the saints below are clad in luxurious, ornate Byzantine textiles decorated with rare gems. The Roman figures appear against such natural three-dimensional backgrounds as the green Sea of Galilee, hills, or a blue sky. The Byzantine virgins and martyrs, however, are set against a shimmering gold backdrop with uniformly spaced stylized palms. The candor, directness, and simplicity with which the Roman scenes are depicted likewise contrast strikingly with the impersonal, aloof, and symbolic Byzantine treatment of the nave frieze. Differences of theological as well as stylistic viewpoints are thus involved, since the Arian-Roman panels accent the Redeemer's worldly life and human suffering, while the Byzantine frieze accents his divinity and remoteness from worldly matters.

The art of mosaic, in general, depends for its effectiveness on directing the flow of light from

many tiny reflectors. After the placement of the panels, the design, and the colors have been determined, the mosaicist must take into account both the natural source of light from windows and artificial sources from lamps or candles. Accordingly, the mosaicist fits each *tessera*, or small cube made of glass, marble, shell, or ceramic, onto an adhesive surface, tilting some this way, others that, so that a shimmering luminous effect is obtained.

Central-Type Churches: San Vitale

Little more than a year's time elapsed between the death of Theodoric and the accession of Justinian as emperor in Constantinople. In the politics of that day, the building of a church that would surpass anything undertaken by Theodoric would serve both as an assertion of Justinian's authority in Italy and as evidence of the weakening power of Theodoric's Ostrogothic successors. Almost immediately, there-

127. Exterior of apse, San Vitale, Ravenna, c. 527–547. Diameter 112′ (34.24 m).

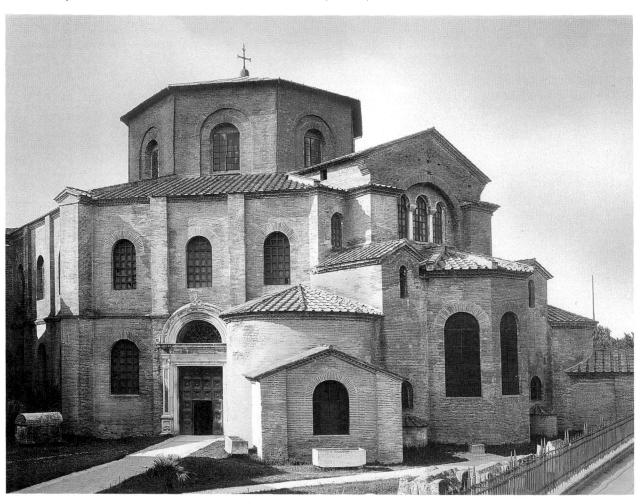

fore, Justinian decided to build the church of San Vitale at Ravenna (Fig. 127).

At first Justinian's position in the capital of the West Roman Empire was anything but certain, and the project languished. Eventually, the use of force was needed to assert his Italian claims, and his armies entered the city in the year 540. Thereafter, construction of San Vitale proceeded swiftly, and seven years later the church was ready for its dedication by Archbishop Maximian. Its plain red-brick exterior is proof that as little attention was paid to the outside of San Vitale as to that of any other church of the period. But with its rich multicolored marble walls, carved alabaster columns, pierced marble screens, and, above all, its sanctuary mosaics, the Church of San Vitale is a veritable jewel box.

Architecturally, San Vitale is a highly developed example of the central-type church (Fig. 128), differing radically from Sant' Apollinare Nuovo. Yet it has all the usual features of the basilica, including a narthex entrance, circular nave, surrounding side aisles, and a triumphal arch leading into a sanctuary with an apse and two side chambers. The striking difference, however, between an oblong basilica and a centralized church is the direction of its axis. In the former, the axis runs horizontally through the center of the building, dividing the church lengthwise into equal halves, the eye being led toward the apse. In the central-type building the axis is vertical, leading

128. Plan of San Vitale.

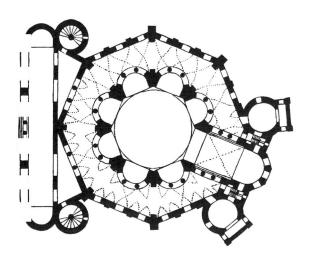

the eye upward from the central floor space to the dome. Were it not for the addition of the oblong narthex on the west and the apse and side chapels on the east, the ground plan of San Vitale would be a simple octagon.

The two side chambers of the apse are usually associated with Eastern Orthodox churches. Their presence here points to the fact that San Vitale was designed as a theater for the Byzantine liturgy. The northern chamber was designated the *prothesis*, to indicate its use as the place where the communion bread and wine were prepared for the altar. In Eastern Orthodox usage, the sacrificial aspect of the mass assumed a dramatic character, and the sacramental bread was "wounded, killed, and buried" on the table of the prothesis before it appeared on the altar, where it symbolized the resurrection of the body. The southern chamber is called the *diakonikon* and served as the vestry and as a place to store the sacred objects used in the orthodox service.

STRUCTURAL COUNTERPARTS. In order to understand San Vitale and central-type churches, one must look at similar buildings at Ravenna and elsewhere. While the ancestors of the rectangular basilica were Roman domestic and public buildings, the centralized church derives from ancient circular tombs such as Hadrian's colossal monument on the banks of the Tiber (see Fig. 114). The ancient preference for the circular mausoleum can be explained partly by its symbolism. Immortality was frequently represented by the image of a serpent biting its tail that is, a living creature whose end was joined to its beginning. Another ancestor is the round classical temple, such as the Pantheon (see Figs. 107–110).

The idea of a church built in the same form as a tomb is by no means as somber as it might seem. In the Christian sense, a church symbolized the Easter tomb, reminding all of the resurrection of Christ. In his memory, churches were dedicated to martyrs and saints who were believed to be partaking of the heavenly life with him, just as the faithful hoped that they themselves would one day be doing. The ancient Orphic cult had stressed the idea of the body being the tomb of the spirit. Hence, death and resurrection were aspects of one and the same idea, and the martyr's death was a mystical union with Christ. Indeed, the altar itself was a tomb or repository for the sacred relics of the saint to whom the church was dedicated. Early altars in the catacombs actually were sarcophagi that served also as communion tables. Thus, in the rites of the church, the earthly past of Christ, his apostles, saints, and martyrs was commemorated, and, at the same time, the glorious heavenly future was anticipated.

The eight-sided Christian baptistry was taken over directly from the octagonal bathhouses found in ancient Roman villas. There the pool was usually octagonal and the structure around it assumed that shape. Early Christian baptisms involved total immersion, and the transition from bathhouse to baptistry was easy and natural. Since baptism is a personal and family affair, not calling for the presence of a congregation, baptistries usually are small.

The Arian Baptistry was built in Theodoric's time in the same style as the earlier "Neonian" Baptistry for the Roman Christians. Both are domed structures with the chief interest centered on the fine interior mosaics. Both have similar representations of the baptism of Christ on the interior surfaces of their *cupolas*, or domes. That of the Arian Baptistry (Fig. 129) shows the ceremony being performed by St. John the Baptist, while the river Jordan is personified as an old man in the manner of the ancient pagan river gods (see Fig. 98, lower left).

Around the central scene are the twelve apostles, who move processionally toward the throne of Christ. Just as the virgins and martyrs reenacted the offertory procession above the nave arcade of Sant' Apollinare Nuovo, so the apostles here mirror the baptismal rites on a more heavenly level. They group themselves around the center above where Christ is being baptized, just as the clergy, family, and sponsors gathered about the font below for the baptism of

129.Baptism of Christ and Procession of Twelve Apostles. c. 520. Dome mosaic. Arian Baptistry, Ravenna.

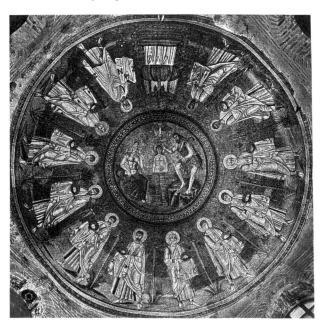

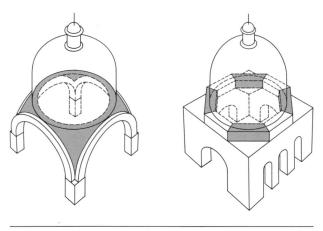

Pendentives (shaded area) supporting a dome.

Squinches (shaded area) supporting a dome.

130-131.

Circular domes can be raised over rectangular buildings by *pendentives* or *squinches*. Pendentives are vaults in the form of spherical triangles that connect arches springing from corner piers and unite at the apex of the arches to form a circular base upon which the dome rests. Squinches are stone lintels placed diagonally across corners to form a continuous base for the dome. Often the squinch is supported from below by masonry built up in wedge or arch formation.

some Ravenna Christian. Here is yet another example of the *iconography*, or subject matter, of the decorative scheme reflecting the liturgical activity that took place within the walls of the building.

Balancing domes over square or octagonal supporting structures was a preoccupation of 6thcentury architects. The Romans had found one solution in the case of the Pantheon—resting the dome on supporting cylindrical walls—but in Ravenna later builders found two other solutions. The exquisite little mausoleum of Galla Placidia (Fig. 117), which dates from about A.D. 425, was built in the form of an equal-winged Greek cross. Its dome rests on pendentives—that is, on four concave spherical triangles of masonry rising from the square corners and bending inward to form the circular base of the dome (Fig. 130). The role of the pendentives is to encircle the square understructure and make the transition to the round domed superstructure. The Ravenna baptistries exemplify the same pendentive solution, but in their cases the domes rest directly on octagonal understructures.

Another solution stemming from the same early period is based upon a system of *squinches*, or pieces of construction placed diagonally across the angles of the square or octagonal walls of the understructure so as to form a proper base for a dome (Fig. 131). This was the method employed for the doming

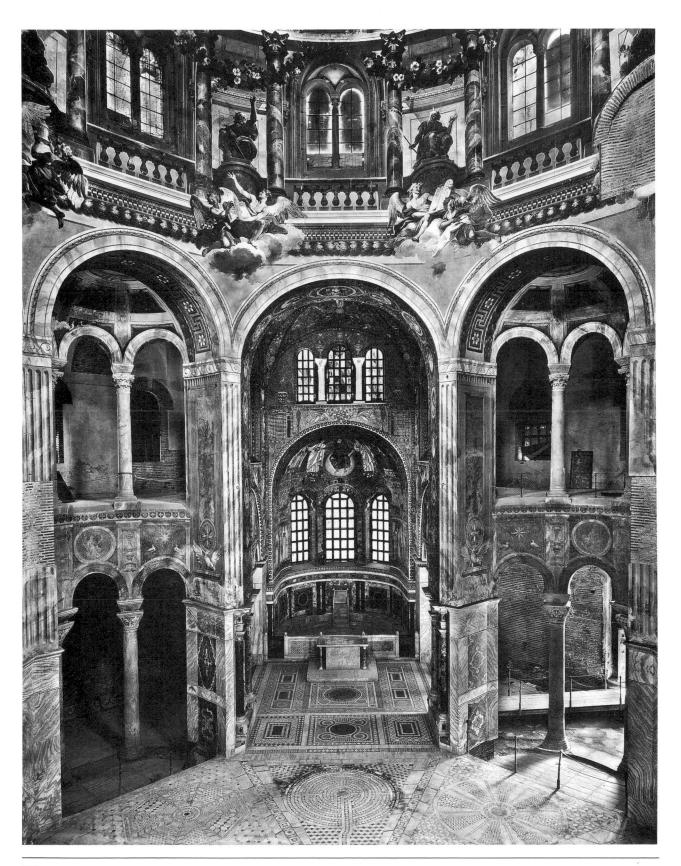

132. Interior, San Vitale, Ravenna. 527–547 (clerestory decorations, 18th century).

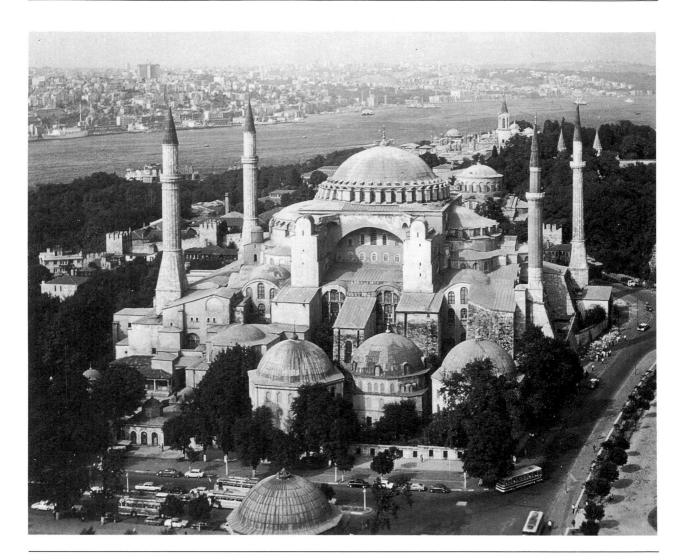

133. Anthemias of Tralles and Isidorus of Miletus. Hagia Sophia, Istanbul (Constantinople). 532-537 (minarets after 1453). $308 \times 236'$ (93.9×71.9 m).

of San Vitale. The eight piers of the arcaded central room below rise and culminate in an octagonal drum on which, by means of squinches, the dome rests.

Above the nave arcade and beneath the dome, the builders of San Vitale included a vaulted triforium gallery running around the church and opening into the nave (Fig. 132). This gallery, which was called the *matroneum*, was for the use of women, who were strictly segregated in the Byzantine rites.

The Eastern parallels of San Vitale are found in Justinian's churches at Constantinople—Sts. Sergius and Bacchus, among others. The great Hagia Sophia ("Sancta Sophia," or "Holy Wisdom"), however, is the foremost monument of the Byzantine style. As a combination of great art and daring engineering, Hagia Sophia has never been surpassed (Figs. 133, 134). Externally it is practically square with bulging

134. Plan of Hagia Sophia.

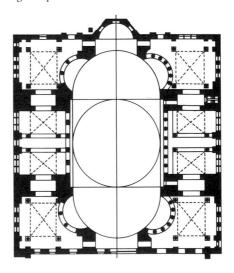

buttresses, or masonry supports, and swelling half-domes mounting, by means of pendentives, to a full dome on top. Internally, from the narthex entrance on the west, the space opens into a large nave, and the eye is led horizontally to the apse in the east (Fig.

135). While the most ambitious Gothic cathedral nave never spanned a width of more than 55 feet (16.8 meters), the architects of Hagia Sophia achieved an open space 100 feet (30.5 meters) wide and 200 feet (61 meters) long.

135. Interior, Hagia Sophia. Height of dome 183' (55.78 m).

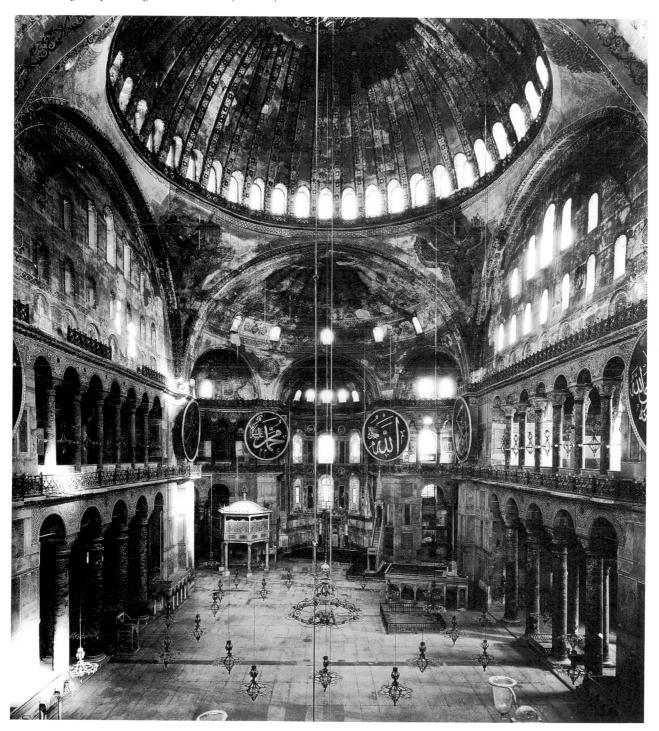

Both the structural and the psychological effects of the dome in central-type churches is to bring the separate parts into a unified whole. In the interiors of both Hagia Sophia and San Vitale the dome and its supports are clearly visible and the structure is therefore self-explanatory. Psychologically, this equilibrium is important, for it produces a restful effect that is in direct contrast with the restless interiors of later Gothic cathedrals (see Fig. 183). There the dynamic surge depends partly on the fact that the exterior buttressing is not apparent. Indeed, the dome of San Vitale is an interior fact only, because on the outside its octagonal base has been continued upward and roofed over.

DECORATIVE DESIGN. In the apse of San Vitale, facing the altar from opposite sides, are two panels in mosaic that portray the leading figures of the early Byzantine rule in Ravenna. On one, Emperor Justin-

ian appears in the midst of his courtiers (Fig. 136). On the other, facing him as an equal, is Empress Theodora in all her sovereign splendor (Fig. 137). It is significant that the finest existing portrait of the great emperor should be in mosaic rather than in the form of a sculptured bust, a bronze figure on horseback, or a colossal statue. It is just this medium that could best capture the unique spirit of his life and times. Concerned with the codification of Roman law, presiding at religious councils, and reconciling different political points of view, Justinian based his rule on the skillful use of legal and theological formulas as well as on naked military might. He is, then, represented as a symbol of unity between the spiritual force of the Church on one hand and the temporal power of the state on the other.

Preceding Justinian in the procession are the clergymen, among whom only Archbishop Maximian is identified by name. His crucifix is held up as

136. *Emperor Justinian and Courtiers.* c. 547. Mosaic. San Vitale, Ravenna.

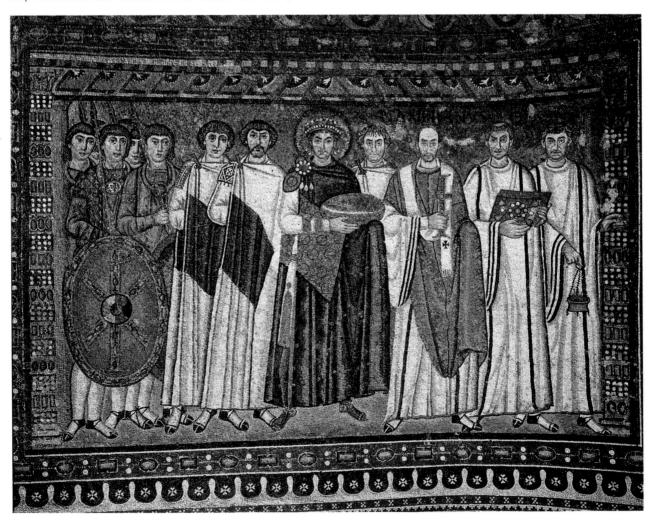

an assertion of his power as the spiritual and temporal lord of Ravenna. On the emperor's other side are his courtiers and honor guard holding their jeweled swords aloft. The shield with its Chrismon insignia points to the status of the soldiers as defenders of the faith. The Chrismon was a widely used monogram of the time, made up of the Greek letters *Chi* (X) and *Rho* (P), which together form the abbreviation of Christ. Somewhat more allegorically, the letters become a combination of the Cross and the shepherd's crook, which symbolize the Savior's death and pastoral mission.

In the center of the procession stands Justinian, clothed in all his magnificence and crowned with the imperial diadem. The observer knows immediately that this is no ordinary royal personage but rather one who could sign his name as the Emperor Caesar Flavius, Justinianus, Alamanicus, Francicus, Germanicus, Anticus, Alanicus, Van-

dalicus, Africanus, Pious, Happy, Renowned, Conqueror and Triumpher, ever Augustus. Great as Justinian's military exploits were, however, it is his works of peace that have endured. In addition to a vast building program, the Byzantine Emperor is remembered for his monumental code, the *Digest of Laws*, which prevailed for centuries throughout the Western world.

On her side, the Empress Theodora (Fig. 137), richly jeweled and clad in the imperial purple, is seen as she is about to make her entry into the church from the narthex. Possibly because of her humble origin as the daughter of the feeder of the bears at the circus of Constantinople and her stage career as an actress, Theodora appears more royal than the king. Her offering recalls a remark by Procopius, the chronicler of Justinian's reign. He said that she fed the geese of the devil while on the stage and the sheep of Christ when she sat on the

137. Empress Theodora and Retinue. c. 547. Mosaic. San Vitale, Ravenna.

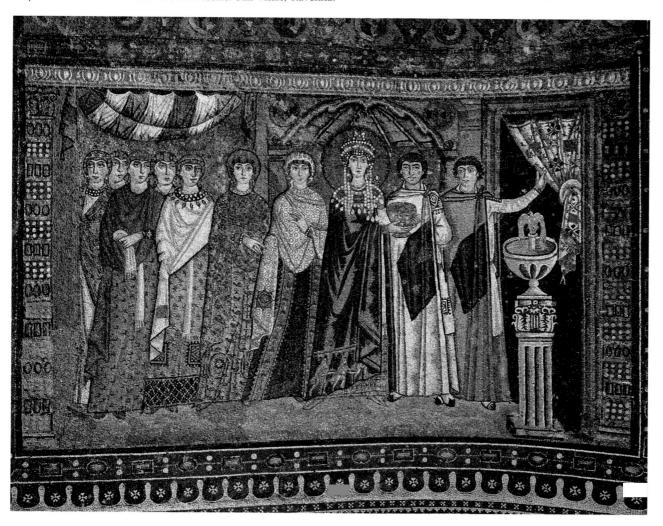

throne. On the hem of her robe the offertory motif is carried out by the embroidered figures of the Three Wise Men, the first bearers of gifts to Christ. Since the Wise Men of old as well as Justinian and Theodora came from the East, this motif served as reminder to the people of Ravenna that the source of wisdom and power lay in that direction.

These two mosaic portraits are especially precious because they are among the few surviving visual representations of the vanished glories of Byzantine courtly ceremonies. The regal pair appear as if participating in the offertory procession at the dedication of the church, which took place in the year 547—though neither was actually present on that occasion. Such ceremonial entries were a part of the elaborate Byzantine liturgy, and both the emperor and empress are shown as the bearers of gifts. On his side, Justinian is carrying the gold *paten*, which was used to hold the communion bread at the altar, while Theodora is presenting the chalice that contains the wine. Since their generosity was responsible for the building, decoration, and endowment of San Vitale, the allusion is to gifts of gold as well.

In keeping with the rigid conventions of Byzantine art, all the heads appear in one plane. Those of Justinian and Theodora are distinguished by their halos, which in this case not only refer to their awe-

138. Byzantine capital. San Vitale, Ravenna. c. 547.

some power but also are a carry-over of the semidivine status assumed by the earlier Roman emperors. Even though they are moving in a procession, they are portrayed frontally in the manner of imperial personages accustomed to receiving the homage of their subjects. In spite of the stylized medium, the eye can follow the solemn procession as it moves in dignified measure, carried forward by the linear pattern in the folds of garments. The elegant costumes add to the richness of the scene, emphasizing by their designs the luxury of their Oriental origins.

In addition to the mosaics, the decorative design of San Vitale includes carved alabaster columns, *polychrome*, or multicolored marble wall panels, pierced marble choir screens, and many other details. The capitals of the columns are carved with intricate patterns, such as that in Figure 138. When the harmonious proportions of the building as a whole are combined with the rich optical effects of the mosaics, polychrome marble, and ornamental sculptures, San Vitale, as the counterpart of Hagia Sophia, is the high point of Byzantine art in the West.

SCULPTURE

From its status as a major art in Greco-Roman times, sculpture declined to a relatively modest place in the ranks of Early Christian arts. Instead of constituting a free and independent medium, it became primarily the servant of the architectural and liturgical forms of the Church. Even its classical three-dimensionality was in eclipse, and sculpture tended to become increasingly pictorial and symbolic as it assumed a teaching role in Early Christian usage.

When sculpture moved indoors, it underwent a radical change in relation to light and shade. A statue in the round, for instance, was either placed against a wall or stood in a niche, which prevented its being seen from all sides. The closeness in time and place to the pagan religions also served to channel Christian visual expression in other directions. With one of the Ten Commandments expressly forbidding the making of "graven images," it is remarkable that the art survived as well as it did.

A rare surviving example of three-dimensional Early Roman Christian sculpture is the *Good Shepherd* (Fig. 139). Figures of peasants carrying calves or sheep to market are frequently found in ancient Greek and Roman genre sculpture. In the Christian interpretation, however, the shepherd is Christ, the sheep the congregation of the faithful, and, when a jug of milk is included, the whole image refers to the Eucharist.

139. *Good Shepherd.* c. 300. Marble, height 39" (99 cm). Vatican Museums, Rome.

Characteristic Forms and Representations

Sculpture, in general, proved adaptable to the new demands and purposes. In the new frame of reference, architectural sculpture—capitals of columns, decorative relief panels, carved wooden doors, and, to some extent, statues in niches—continued with

appropriate modifications. The principal emphasis, however, shifted toward objects associated with the new form of worship, such as altars, pulpits, pierced marble screens, and carved ivory reliefs. Smaller items, such as precious metal boxes for relics, lamps, incense pots, communion chalices, jeweled book covers, and patens, all with delicately worked designs, began to ally the former grand classical art more closely with that of the jeweler.

One of the strongest influences on Early Christian design was the new orientation of thought toward symbolism. As long as the religions of Greece and Rome were oriented toward the human form, sculptors could represent the gods as idealized human beings. But in Christian terms, how could they represent in concrete form such abstractions as the Trinity, the Holy Spirit, the salvation of the soul. or the idea of redemption through participation in the Eucharistic sacrifice? The solution could come only through use of parables and symbols. Thus the Christian idea of immortality could be rendered through biblical scenes of deliverance—Noah from the flood, Moses from the land of Egypt, Job from his sufferings, Daniel from the lions' den, the youths from the fiery furnace, and Lazarus from his tomb.

In Early Christian relief panels, plant and animal motifs were included less for naturalistic reasons than to convey symbolic meaning. The dove represented the Holy Spirit, the peacock stood for Paradise, and so on. The cross is seldom found in Early Christian art, since it recalled a punishment used for the lowest type of criminal. Instead, the Chrismon symbol already seen on the shield of Justinian's soldiers (see Fig. 136) was used. A fish, or the Greek word for it, ichthys, is often found as a reference to Jesus' making his disciples fishers of men. The letters of the word also constituted an abbreviation for Jesus Christ Son of God, Savior, Such symbols and lettered inscriptions caused sculpture to assume the aspect of engraved designs on stone surfaces, which carried special meaning and mystical significance to the initiated worshipers.

Carved Stone Tombs. One of the chief forms of early Roman Christian sculpture is the carved stone sarcophagus (Fig. 118). The custom of burial above ground was carried over from late Roman times, and a special Christian incentive came from the desire for interment within the sacred precincts of the church. The relics of saints reposed in the altar. Tombs of bishops and other dignitaries were housed in the church. Those of the laity were usually placed out in the atrium. Survivals of this latter custom continue well into modern times with burials taking place in churchyards.

140. Sarcophagus of Archbishop Theodore. 6th century. Marble, $3'3\frac{1}{2}'' \times 6'9''$ (1 × 2.06 m). Sant' Apollinare in Classe, Ravenna.

A fine example is provided by the sarcophagus of Archbishop Theodore (Fig. 140). The front panel shows the combination of the Chrismon symbol with that of the first and last letters of the Greek alphabet, Alpha and Omega, another reference to Christ, taken from his statement that he was both the beginning and the end. Their inclusion here on a tomb indicates the end of earthly life and the beginning of the heavenly one. Flanking the symbols are two peacocks symbolizing Paradise and, on either side, a graceful vine pattern in which the small birds feeding on grapes refer symbolically to communion. The inscription reads in translation, "Here rests in peace Archbishop Theodore." On the lid are repetitions of the Chrismon monogram, here surrounded by the conventional laurel wreath symbolizing immortality. The end of the sarcophagus that shows in Figure 140 is carved to symbolize the Trinity. From the urn at the bottom springs the tree of life indicating the Father. Above it appear the cross for the Son and the descending dove as the Holy Spirit. The cross is repeated above on the end panel of the lid.

MAXIMIAN'S CATHEDRA. By far the most impressive single example of sculpture of this period is the chair which is thought to be that of Archbishop Maximian (Fig. 141), Justinian's viceroy who is portrayed beside him in the mosaic panel in San Vitale (Fig. 136). Such an episcopal throne is called a cathedra, and the church in which it is housed is termed a cathedral. When a bishop addresses his congregation from it, he is said to be speaking ex cathedra. A cathedra may also be called a sedes (the Latin word for "seat"), from which word is derived the noun see, which once meant the seat of a bishop but now meant the territory in the charge of a bishop. Originally sedes meant a chair denoting high position. Roman senators used such chairs on public occasions, and modern politicians still campaign for a "seat" in the senate or legislature. Both Jewish rabbis and Greek philosophers taught from a seated position, hence the reference in modern colleges to a "chair" of philosophy or history.

Maximian's cathedra consists of a composition of ivory panels, carefully joined together and deli-

cately carved. Originally, there were 39 different pictorial panels, some of which told the Old Testament story of Joseph and his brethren, and the others, the story of Jesus. The chair is thought to have been presented to Maximian by Justinian, and the different techniques employed in the various panels indicate collaboration of craftsmen from Anatolia, Syria, and Alexandria. On the front panel, below Maximian's monogram, is a representation of St. John the Baptist flanked on either side by the Evangelists (Fig. 141). The Baptist holds a medallion on which a lamb is carved in relief, while the Evangelists hold their traditional books.

The elegant Byzantine carving of the front panel—with its complex grapevine motif intertwined with birds and animals denoting the tree of eternal life, the peacocks symbolizing heaven, the symmetrically arranged saints, and the luxuriant linear pattern of their classical drapery—lends itself best to just such a static, formal, stylized design. In the Joseph story illustrated in the side panels, however, the overriding concern is with an active narrative as related in a series of episodes. Content and vivid detail then rise above formal considerations.

While sculpture is not the outstanding Byzantine art, such intricate tracery and arabesque patterns become highly important. Since ivory does not make monumentality either possible or desirable, such details as these, handled with precision, are richer and more satisfying than the work as a whole.

MUSIC

From the writings of Theodoric's learned ministers Boethius and Cassiodorus, some knowledge about the status of musical thought in 6th-century Ravenna can be gained. Like the writings of the Church fathers and other literary figures of the day, however, these reveal much about the theory of the art and little about its practice.

Theoretical Discussions

Boethius was a tireless translator of Greek philosophical and scientific treatises into Latin, among which were no less than thirty books by Aristotle alone. When he fell from favor and was imprisoned, Boethius wrote *The Consolation of Philosophy*, which became one of the most influential medieval books. Called by Gibbon "a golden volume not unworthy of the leisure of Plato or Tully [Cicero]," the *Consolation* later found its way into English via translations by Alfred the Great and Chaucer. Boethius's was a universal mind, capable of discoursing on anything

141. Cathedra of Maximian. c. 546-556. Ivory panels on wood frame, $4'11'' \times 1'11\frac{5}{8}''$ (1.5 × 0.6 m). Museo dell' Arcivescovado, Ravenna.

from the mechanics of water clocks to the science of astronomy.

Boethius's treatise on music became the common source of most medieval essays on the subject. In transmitting the best of ancient Greek musical theory, it became the foundation stone of Western musical thinking. Like the ancients before him, Boethius believed that "all music is reasoning and speculation," and hence more closely allied with mathematics than with the auditory art that music is today.

Boethius divided music into three classes, the first of which was the "Music of the universe," by which he meant the unheard astronomical "music" of planetary motion. The second was "human music," which referred to the attunement of the mind and body, or the rational and irrational elements of the human constitution, in the manner of a Greek harmony of opposites. The third was instrumental music and song, of which he had the philosopher's usual low opinion, considering only the the-

oretical aspects of the art as pursuits worthy of a gentleman and scholar. The only true "musician" in his opinion was one "who possesses the faculty of judging, according to speculation or reason, appropriate and suitable to music, of modes and rhythms and of the classes of melodies and their mixtures . . . and of the songs of the poets."

Cassiodorus wrote in a similarly learned vein after he had retired from public life to the haven of his monastery at Vivarium. But while he was still involved in the affairs of Theodoric's kingdom, he was constantly called upon to solve every conceivable administrative problem. Among these was a request from Clovis, king of the Franks, for a *citharoedus* that is, a singer who accompanied himself on the stringed instrument of the classical lyre type known as the cithara (see Figs. 79 and 144). In search for such a musician, Cassiodorus turned to his fellow senator Boethius, who was in Rome at the time. His letter first launches into a flowery discourse on the nature of music, which he describes as the "Oueen of the senses." It continues with endless discussions of its curative powers, how David cast out the evil spirit from Saul, the nature of the modes, the structure of the Greek scale system, and the history of the art. Then he comes to the lyre, which he calls "the loom of the Muses," and after going off on a few more tangents, he finally gets to the point. "We have indulged ourselves in a pleasant digression," he says, making the understatement of the millennium, "because it is always agreeable to talk of learning with the learned; but be sure to get us that Citharoedus, who will go forth like another Orpheus to charm the beast-like hearts of the Barbarians. You will thus obey us and render vourself famous."

Church Music

Knowledge about the church music of Ravenna at this time is based on conjecture and must be gathered from a variety of sources. From the writings of the Church fathers it is evident that great importance was attached to music in connection with divine worship. The problem was how to separate a proper body of church music from the crude idioms of popular music on one hand and from the highly developed but pagan art music of Rome on the other. From St. Paul and the Roman writer Pliny the Younger, in the 1st and 2nd centuries, respectively, it is known that the earliest Christian music sounded very much like the ancient Jewish singing of psalms.

Hebrew, Greek, and Latin sources thus provided the basis for Early Christian music, just as they had done in the cases of theology and the visual arts. Out of these diverse elements and with original ideas

of their own, the Christians of the Eastern and Western churches over the centuries gradually worked out a synthesis that resulted in a musical art of great power and beauty. The 6th century witnessed the culmination of many early experimental phases. At its close, the Western form of the art found official formulation in the body of music known as *plainsong* or *plainchant*. In its various changes and restorations, as well as in its theoretical aspects, this system has remained the official basis of Roman Church music up to the Second Vatican Council, which ended in 1965. Closely related forms are still in use throughout the Christian world, where free adaptations of its melodies have enriched the hymn books and liturgies of nearly every denomination.

ARIAN LITURGY. Knowledge about the Arian liturgy, such as that which was practiced at Sant' Apollinare Nuovo during Theodoric's reign, is very obscure, because all sources were destroyed when the orthodox Christians gained the upper hand and stamped out the Arian heresy. From a few negative comments, however, it is known that hymn and psalm singing by the congregation as a whole was among the practices.

Arius, the founder of the Arian sect, was accused of insinuating his religious ideas into the minds of his followers by means of hymns that were sung to melodies derived from drinking songs and theatrical tunes. Such hymns were frowned upon in orthodox circles because they were too closely allied with popular music. Furthermore, the Arian way of singing them was described as loud and raucous, indicating that they must have grated on the sensitive ears of the more civilized Roman Christians.

Ambrosian Liturgy. The popularity of these musical practices, however, was such that the Arians were making too many converts. So in the spirit of fighting fire with fire, St. Ambrose, bishop of Milan, where the Arians were strong, compromised by introducing hymn and psalm singing into the Milanese church service.

A firsthand account of this practice is contained in a passage from St. Augustine's *Confessions*. In the 4th century, when Bishop Ambrose was engaged in one of his doctrinal disputes with the Byzantine Empress Justina, he and his followers at one point had to barricade themselves in a church for protection. "The pious people kept guard in the church, prepared to die with their bishop," wrote St. Augustine. "At the same time," he continues, "was it here first instituted after the manner of the eastern churches, that hymns and psalms should be sung, lest the people should wax faint through the tedi-

ousness of sorrow: which custom being retained from that day to this, is still imitated by divers, yea, almost by all thy congregations throughout other parts of the world."

Aeterne rerum Conditor (Hymn of St. Ambrose)

Ae - ter - ne re - rum Con - di - tor, No-ctem di - em que qui _ re - gis,

Et tem - po-rum das tem - po - ra, Ut al - le - ves fa - sti - di - um _

The practice spread widely and was incorporated into the Roman liturgy during the following century. Since Ravenna was the neighboring see to that of Milan, the musical practices there must have been quite similar.

Some half-dozen hymns can be attributed to the authorship of St. Ambrose. Whether he also composed the melodies is not so certain, but they at least date from his time. From the example of *Aeterne rerum Conditor* (above), it can be seen that the extreme simplicity and metrical regularity of these vigorous Ambrosian hymns made them especially suitable for congregational singing. The mosaics of Sant' Apollinare Nuovo show files of male and female saints on opposite sides of the nave arcade (Fig. 119). Below them, the men of the congregation were grouped on one side, while the women and children gathered on the other, thus forming two choirs.

The psalms were sung in two ways: antiphonally and responsorially. When the two choruses sing alternate verses, then join together in a refrain on the word *alleluia* after each verse, the practice is referred to as *antiphonal psalmody*. When the priest or leader chants one verse as a solo, and the choirs perform the next verse as a choral response, it is called *responsorial psalmody*. Both were widespread practices in the Western church, including Ravenna.

BYZANTINE LITURGY. Since Sant' Apollinare Nuovo and San Vitale were designed for different purposes, it follows that their music must also have differed. As a part of the Byzantine liturgy, the music heard at San Vitale would have been like that of the cathedral in Constantinople. As in the West, congregational singing was included there at first, but with the abandonment of the offertory procession, congregational singing was gradually replaced by that of a professional choir. Music for congregational singing must always be kept relatively simple, but with a

truly professional group all the rich potentialities of the art can be explored and developed.

Since San Vitale, like Hagia Sophia, was under the direct patronage of the emperor, and since both formed a part of Justinian's grand design, provision for a group capable of performing the music of the Byzantine liturgy could hardly have been overlooked. The principal difference between the music of the Eastern and Western churches is that between a contemplative and an active attitude. The contemplative aspect of the Eastern liturgy is illustrated by a remark of St. John Chrysostom, who said that "one may also sing without voice, the mind resounding inwardly, for we sing not to men, but to God, who can hear our hearts and enter into the silences of the mind." This attitude contrasts strongly with that of St. Ambrose, who said in connection with the participation of the congregation in song: "If you praise the Lord and do not sing, you do not utter a hymn. . . . A hymn, therefore, has these three things: song and praise and the Lord."

In a static form of worship, greater rhythmic freedom is possible, while the chant that accompanies a procession must have more metrical regularity. The singing of a professional choir, furthermore, implies an elaborate and highly developed art, while the practice of congregational singing means the avoidance of technical difficulties. The difference, then, is the difference between the sturdy Ambrosian *syllabic* hymn (see above)—that is, with a syllable allotted to each note—and the more elaborate *melismatic* alleluia of Byzantine origin—that is, with each single syllable prolonged over many notes in the manner of a *cadenza* (below).

Byzantine music had a distinctive style of its own, comparable in this respect to that of the visual arts. The elaborate melismas of the latter example would have been heard in San Vitale and in other Byzantine churches at the end of the 6th century. It was precisely such excessively florid alleluias that were ruled out by the Gregorian reform which was to occur in the early 7th century.

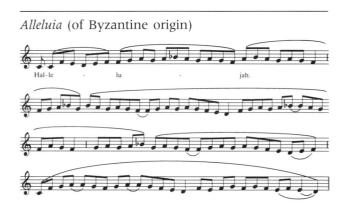

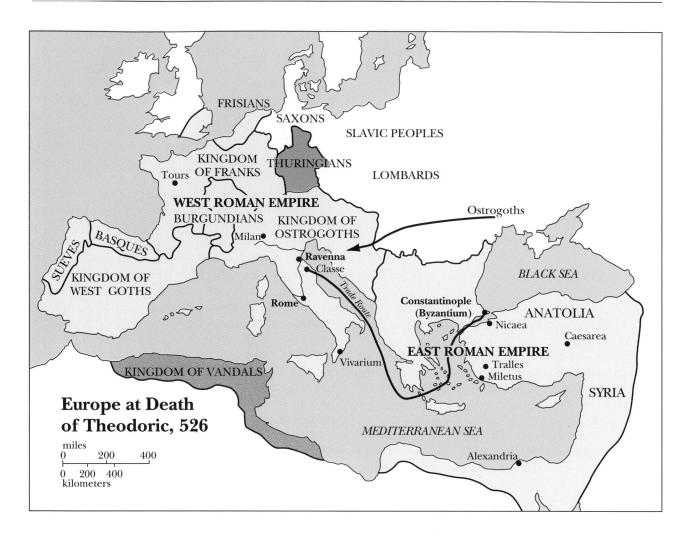

IDEAS

Since all the surviving monuments of Early Christian art are religiously oriented, it follows that the various sources of patronage, the geographical locations, and the liturgical purposes are the factors that determine the forms of architecture, the iconography of mosaics, the designs of sculpture, and the performance practices of music.

The Early Roman Christian and Byzantine styles were both Christian, and all the arts of the time lived, moved, and had their being within the all-embracing arms of Mother Church. But her Western and Eastern arms pointed in different stylistic directions. The disintegrating Roman power in the West led to decentralization of authority and allowed a wide range in local and regional styles, while the Byzantine emperors kept tight autocratic control of all phases of secular and religious life. Early Roman Christian art was more an expression of the people. It involved all social levels, its quality varied from crude to excellent, and it was more sim-

ple and direct in its approach. Byzantine art, however, was under the personal patronage of a prosperous emperor who ruled both as a Caesar and a religious patriarch. Only the finest artists were employed; and the arts, like the vertical axis of a centralized church, directed attention to the highest level and tended to become more removed from the people and more purely symbolic. As the arts of both West and East pass by in review, two ideas seem to be the clues to their understanding: authoritarianism and mysticism.

Authoritarianism

Ravenna in the 6th century was the scene of a three-way struggle among a barbarian king who was a champion of Roman culture, a Byzantine emperor who claimed the prerogatives of the past golden age, and a Roman pope who had little military might but a powerful influence based on the succession of spiritual authority derived from Christ's apostles. As the conflict shaped up, it was among an enlightened

worldly liberalism, a traditionalism based on a divinely ordered social system, and a new spiritual institution with a genius for compromise.

In the course of the century, the Ostrogothic kingdom was vanquished by the Byzantine Empire. However, after a brief period of domination, Byzantine power in the West crumbled, and the political and military weakness that followed became the soil that nurtured the growth of the new Rome. By the end of the century, Gregory the Great had succeeded in establishing the papacy as the authority that eventually was to dominate the medieval period in the West, while the Eastern Empire continued in its traditional Byzantine forms of organization.

The principle of authority was by no means foreign to Christianity, which grew to maturity in the later days of the Roman Empire. With Christianity an official state religion under the protection of the emperors, Christian organization increasingly reflected the authoritarian character of the imperial government. Theologians accepted the authority of the divinely inspired Scriptures and the commentaries on them by the early Church fathers.

Authoritarianism also colored the educational picture. Both Cassiodorus and Boethius were major classical scholars, who also served as principal ministers in Theodoric's government. Both were key figures in the transition from Greco-Roman paganism to Christianity. Boethius was especially influential with his lucid Latin translations of such treatises as Nichomachus's on arithmetic, Ptolemy's on astronomy, and Archimedes' on physics and mechanics. All became basic texts in the schools and universities of the Middle Ages. Especially important were his translation and commentaries on Aristotle's Organon that set the tone for logical argumentation for succeeding centuries. His own Consolation of Philosophy, called by Gibbon a "golden volume," unfolds like a Platonic dialogue in prose and poetry. In it the author seeks to reconcile the capricious turns of fortune and misfortune with the benevolent role of Providence in human affairs.

The thought of the period was expressed in constant quotations and requotations, interpretations and reinterpretations of ancient Hebrew, Greek, Latin, and early Christian authors. No one was willing or able to assume complete and independent authority for a position; on all issues one had to cite ancient precedents. The intellectual climate produced by these Church fathers paved the way for the mighty struggle for political and spiritual authority. The only remaining questions were what form the authority was to assume and who would exercise it.

AUTHORITARIANISM AND THE ARTS. Justinian, who claimed the authority and semidivine status of the old Roman emperors, lived in an atmosphere so unchanging and conservative that the words *originality* and *innovation* were used at his court only as terms of reproach. Despite the high price, Byzantine civilization purchased only a blanket uniformity. The principal creative energies of the period were channeled into aesthetic expression, largely because there was no other direction in which to move.

Only in the arts were any variety and freedom to be found. Here again the art of both Church and state was under the sole patronage of the emperor. It was then all the more remarkable that such a flowering as that which produced Hagia Sophia in Constantinople and San Vitale in Ravenna could have taken place. In both of these instances, the methods of construction were experimental, and the solution developed in response to the architectural and decorative problems was uninhibited and daring.

The Byzantine concept of authority was embodied in the architectural and decorative plans of both Hagia Sophia and San Vitale. The central-plan church, with its sharp hierarchical, or ranked, divisions that set aside places for men and women, clergy and laity, aristocrat and commoner, was admirably suited to convey the principle of imperial authority. The vertical axis culminated in a dome that overwhelmed Byzantine subjects by reminding them, when they were in the presence of the Supreme Authority, of their humble place in the scheme of things. The august imperial portraits in the sanctuary showed them that, outside the clergy, only the emperor and empress and those who occupied the top rungs of the social ladder might approach the altar of God.

On the other hand, as typical forms of the basilica, Sant' Apollinare Nuovo and its companion, Sant' Apollinare in Classe (Figs. 142 and 143), indicated a contrasting conception of both God and humanity. As the twin rows of columns on either side of the nave marched forward, they carried the eyes and footsteps of the faithful with them. The appproach to the sacred precincts was encouraged rather than forbidden, and even the gift of the poor widow's pittance (Mark 12:41–42; Luke 21:2) was acknowledged in one of the mosaic panels above.

Mysticism

The art of the 6th century in Ravenna, like that of such other important centers as Constantinople and Rome, makes the transition from the classical Greco-Roman to the medieval world. While some of the

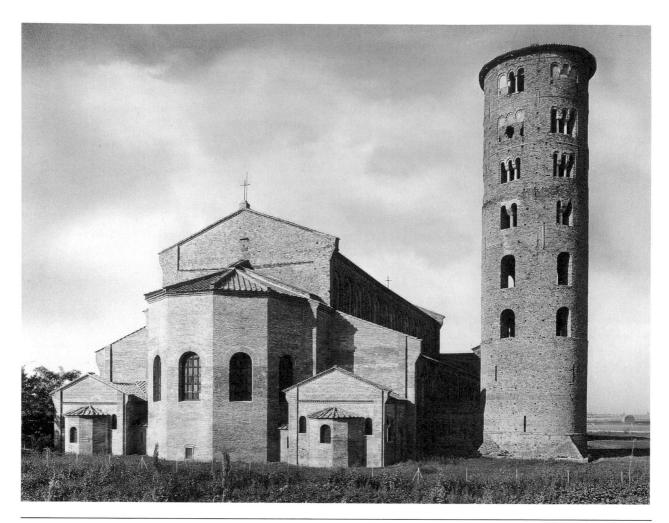

142. Exterior of apse, Sant' Apollinare in Classe. c. 530.

ancient grandeur remained, the accent on symbolism laid the foundation for the coming medieval styles. The physical was replaced by the psychical, the outer world of reality by the inner world of the spirit, and the rational road to knowledge by intuitive revelation.

World of Symbols. Many of the older art forms were carried over and reinterpreted in a new light. The Roman bathhouse became the Christian baptistry, where the soul was cleansed of original sin, and the public basilica was redesigned for church mysteries. Mosaics, formerly used for Hellenistic and Roman floors and pavements, became the mural medium for mystical visions. The shepherd of classical genre sculpture became symbolically the Good Shepherd. Classical bird and animal motifs became symbols for the soul and the spiritual realm. Music became a reflection of the divine unity of God and mortals, and the classical lyre, because of its stretched strings on a wooden frame, was reinter-

preted by St. Augustine as a symbol of the crucified flesh of Christ. Orpheus, by means of the lyre's sounds, had descended into the underworld and overcome death. Christ as the new Orpheus is therefore frequently represented as playing on the lyre (Fig. 144), and at Sant' Apollinare Nuovo he is seated on a lyre-backed throne.

The concept of space turned from the limited classical three-dimensional representation of the natural world to an infinite Christian two-dimensional symbolic world. Invisible things rose in importance above those that could be seen with the eyes. While the classical mind had regarded the world objectively from without, the Early Christian mind contemplated the soul subjectively from within. Socrates once asked an artist whether he could represent the soul. The reply was: "How can it be imitated, since it has neither shape nor colour. . . . and is not visible at all?" St. Augustine also observed that "beauty cannot be beheld in any bodily matter."

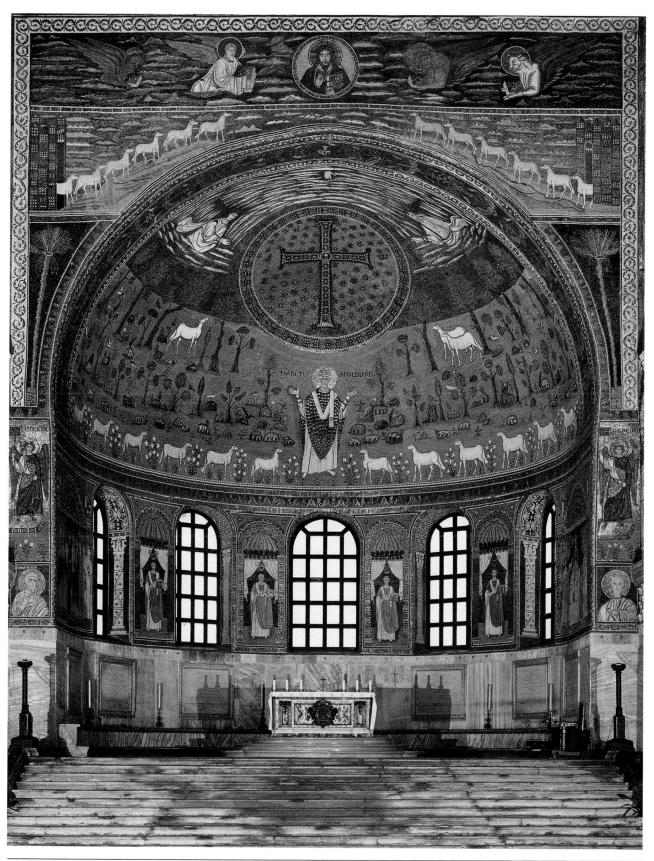

143. Interior of apse, Sant' Apollinare in Classe. c. 530.

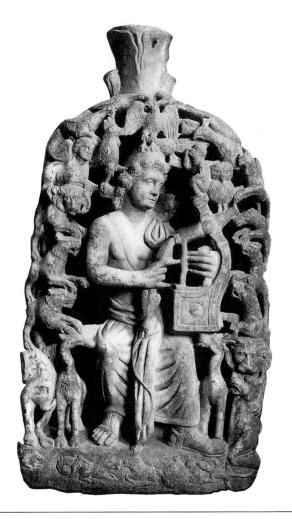

144. Christ as Orpheus. 4th century. Marble, height $40_4^{1\prime\prime}$ (102 cm). Byzantine Museum, Athens.

Such mystical visions could be represented only through symbolism. While natural science had been the foundation stone of ancient philosophy, symbolic theology became the basis of Christian philosophy. Whereas Greek drama (which was a form of religious experience) had reached its climax step by step with remorseless logic, the Christian drama (as expressed in the liturgy) kindled the fires of faith and arrived at its mystical climax by intuitive means. The denial of the flesh and the conviction that only the soul can be beautiful doomed classical bodiliness and exalted bodilessness. Instead of capturing and clothing the godlike image with flesh and blood, the new concern was with releasing the spirit from the bondage of the flesh.

LITURGY AS EMBODIMENT OF MYSTICISM. The liturgy was the great creation and the all-inclusive medium shaped during this period to convey the otherworldly vision. The thought, action, and sequence of rites of Constantinople, Ravenna, Rome,

and other centers determined to a large extent the architectural plans of churches, the symbolism of the mosaics, and the forms of the sculpture and music. At this time, the fruits of generations of contemplative and active lives gradually ripened into mature structures. The content of centuries of theoretical speculation united with the practical efforts of countless generations of writers, builders, decorators, and musicians to produce the Byzantine liturgy in the East and the synthesis of Gregory the Great in the West. Removed from its primary religious association and seen in a more detached aesthetic light, the liturgy as a work of art embodies a profound and dramatic insight into the deepest longings and highest aspirations of the human spirit.

The Early Roman Christian and Byzantine styles were responses to the need for new verbal, visual, and auditory modes of expression. In both cases, there was a shift from the forms designed to represent this world to those capable of conjuring up otherworldly visions. Through the poetry of language, the dancelike patterns of step and gesture, and the exalted melodies of the chant, the gripping drama of humanity embodied in the liturgy was enacted in awe-inspiring theaters. Such theaters were furnished with an impressive array of stage settings, decor, costumes, and props created by the inspired hands of the finest craftsmen and artists of the time. The liturgy is, moreover, a continuous pageant. It lasts not only for a few hours but unfolds with constant variation during the continuous sequence of solemn and joyful feasts through the weeks, months, and seasons of the calendar year, the decades, centuries, and millennia.

THE ROAD NORTHWARD

After the fall of Ravenna and Rome, the center of gravity gradually shifted northward, and a period known as the Dark Ages descended on Europe. The spread of Christianity was accompanied by a time of struggle and strife among contending migratory tribes and local factions, which resulted in a power vacuum. One of the first lights to shine through the prevailing darkness was in the form of a kingdom of the Franks in the Rhine valley. The Franks, who later gave their name to the whole of France, were Christians faithful to the bishops of Rome, and they took over much of the Roman system of government.

The riches of Ravenna and the fame of San Vitale reached the court of the Frankish King, Charles the Great, known to history as Charlemagne. During his prodigious lifetime, he conquered most of western Europe and in the year 800 was crowned Holy Roman Emperor by the pope in St.

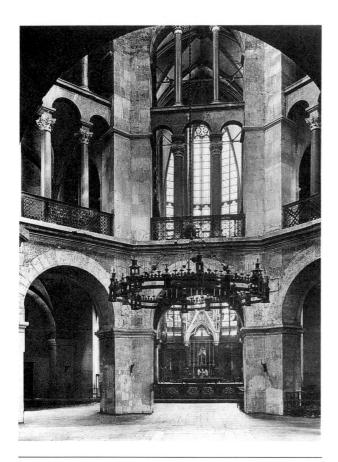

145. Capella Palatina (Charlemagne's Chapel). 792–805. Aachen (Aix-la-Chapelle), West Germany.

Peter's basilica. Thereafter his eyes turned eastward, where he established more or less friendly relations with the East Roman Empire. He even sent embassies on elephant back as far afield as Baghdad to the court of Harun-al-Rashid, the famed caliph of the *Arabian Nights*. On his way back north from Rome, he carried off many of San Vitale's carved marble panels and all of the mosaics except those in the sanctuary. In his capital city of Aachen (Aix-la-Chapelle), he built a sumptuous palace that included the Imperial Chapel (Fig. 145), now included in a larger cathedral complex. The plan was based on the octagonal contours of San Vitale, and its marbles and mosaics found a new home.

In addition to his military conquests and the building of palaces and churches, Charlemagne took pleasure in the company of scholars. He gathered around him some of the wisest and most eminent minds of his time, including his personal tutor and advisor, the Anglo-Saxon Alcuin of York. He also established schools, restored a purified Latin as the primary literary language and founded bishoprics, monasteries, and libraries for the production and illumination of manuscripts (see page 111). Charlemagne's long and productive reign has gone down in history as the Carolingian Renaissance. His accomplishments and those of Otto the Great in the succeeding century, who also reigned as Holy Roman Emperor, did much to pave the way for the future florescence of the Romanesque period.

MONASTIC ROMANESQUE PERIOD

	KEY EVENTS	ARCHITECTURE AND SCULPTURE	LITERATURE AND MUSICAL THEORY
500	c.480-c.547 St. Benedict. Founder Western monasticism; c.540 formulated monastic rule		
500 -	590- 604 Pope Gregory the Great united western Church under Roman papacy 711 Moslems (Moors) took Seville, Cordoba, and Toledo in Spain	c.529 St. Benedict built abbey at Monte Cassino, Italy	c.635 Mohammed wrote <i>Koran</i>
700 -	732 Charles Martel defeated Moslems in battles of Tours and Poitiers, France 768- 814 Charlemagne ruled at Aix-la-Chapelle (Aachen); Carolingian Period initiated	c.792-800 Centula monastery built by Charlemagne c.796-804 Palatine Chapel at Aix-la-Chapelle built	730 Venerable Bede wrote Historia Ecclesiastica Gentis Anglorum (Ecclesiastic History of the English People) 735 Alcuin of York active; from 782 at Charlemagne's court c.750 Wind organs replaced water organs 760 Book of Kells (Latin Gospels) illuminated in Ireland 790 Schools for Church music founded at Paris, Cologne, Soisson, and Metz 790 Musica enchiriadis, a treatise using Latin letters for musical notation
800 -	800 Charlemagne crowned Holy Roman Emperor by pope in Rome 910 Abbey of Cluny in Burgundy, France, founded 962 Otto the Great (936-973) crowned Holy Roman Emperor	c.800 St. Gall (Switzerland) monastery begun	840-912 Notker Balbulus , poet and hymn writer 927-942 Odo , abbot of Cluny, reputed author of musical treatises c.995-c.1050 Guido of Arezzo , author of musical treatises; inventor of staff notation
1100 -	1000- 1150 Romanesque Period at height 1049-1109 Hugh of Semur abbot of Cluny 1066 William, Duke of Normandy, conquered England; reigned as king of England 1066-1087 1077 Emperor Henry IV bowed to Pope Gregory VII at Canossa; Abbot Hugh of Cluny mediated 1088- 1099 Urban II of Cluny became pope; 1095 preached First Crusade 1098 Cistercian order founded by St. Bernard of Clairvaux; principal opposition to Cluniac order	1063 Pisa Cathedral begun; 1153 Baptistry added 1071-1112 Pilgrimage church at Santiago de Compostela, Spain, built c.1080 Church of Sant' Ambrogio begun at Milan c.1088- 1160 Church of St. Sernin built at Toulouse, France 1088- 1130 Great Third Church at Cluny built under Hugh of Semur by architect Hezelo; 1088-1095 capitals depicting tones of plainsong carved; 1095 apse dedicated by Pope Urban II 1096-1120 Abbey Church of La Madelaine at Vézelay built (1096 church begun; 1104 Romanesque choir and transept dedicated; 1110 nave finished; 1120 narthex begun and nave revaulted after fire; c.1130 tympanum over central portal of narthex carved; 1132 dedicated	
1100 -		c.1130-1135 Gislebertus carved sculptures at St. Lazare, Autun 1168-1188 Matteo carved Portico de la Gloria at Cathedral of Santiago de la Compostela, Spain	

The Monastic Romanesque Style

The most typical expression of the Romanesque period was the monastery. The life of ancient Athens and Pergamon had culminated in the clusters of their acropolis buildings, that of Rome had been realized in its forums and civil-engineering projects, while Constantinople and Ravenna had evolved the basilica and palace as the Church and state sides of a divinely ordered social system. In the Gothic period that succeeded the Romanesque the symbolic structure was to be the cathedral.

As Christianity had spread northward after the fall of the West Roman Empire, southern classical forms had met and merged with those of the northern barbarian peoples. This union of the older, settled Roman civilization, with its ideals of reason, restraint, and repose, and the newly awakened spirit of the north, with its restless energy and brooding imagination, resulted in the Romanesque style. Previously, monasticism as a way of spiritual life dated from the early Christian period. After the end of Theodoric's Ostrogothic kingdom, his prime minister, Cassiodorus, retired to Vivarium, where he founded a monastery noted for preserving and copying classical as well as Christian manuscripts. Even before that, the basic rules of monasticism had been codified by St. Benedict. The movement gradually gained momentum and eventually reached its climax in Romanesque times, and with it came the development of a typical style of its own that reached maturity between the years 1000 and 1150.

Lacking the security of strong central governments and without the advantages of flourishing cities and towns, the monastic movement sought peace of mind in the abbey as a haven from the stormtossed seas of the chaotic social surroundings. In these centers off the beaten path were built miniature worlds that contained a cross section of Romanesque life. Besides serving as a religious shrine where pilgrims could gather to revere sacred relics, the monastery was the manufacturing and agricultural center of its region as well as a seat of learning and

a source for civilization where the only libraries, schools, and hospitals of the time were to be found.

THE MONASTERY AT CLUNY

The largest and grandest of all Romanesque monasteries was the abbey at Cluny. Kenneth J. Conant has reconstructed its appearance at the pinnacle of its power and fame (Fig. 146). Within these walls, men of contemplation were to be found beside men of action; those who were world-weary dwelled side by side with those who knew little of life beyond the cloister; saints brushed shoulders with criminals who sought refuge from the prosecution of secular authorities.

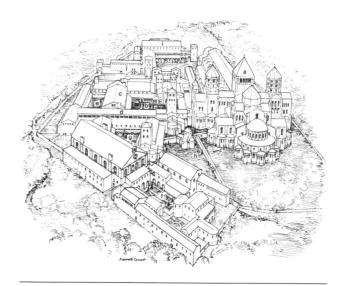

146. Abbey of Cluny, from southeast, c. 1157. Reconstruction by Kenneth J. Conant. Third Abbey Church, with lantern tower over crossing of nave and major transept (a); Cloister of Pontius, main cloister (b); refectory (c); monks' dormitory (d); novices' cloister (e); visitors' cloister (f); Cloister of Notre Dame (g); monks' cemetery (h); hospice (i); craftsmen's quarters and stables (j).

Those who were drawn to the vocation of monk were firm believers in the seeming paradox in Christ's words: "For whosoever will save his life shall lose it: but whosoever will lose his life for my sake, the same shall save it" (Luke 9:24). By taking the triple vows of poverty, chastity, and obedience, the monk automatically renounced such worldly pursuits as individual material rewards, the pleasures of the senses, the personal satisfactions of family life, and even the exercise of his own free will. According to the Rule of St. Benedict, the founder of Western European monasticism, a monk "should have absolutely not anything; neither a book, nor tablets, nor a pen-nothing at all . . . it is not allowed to the monks to have their own bodies or wills in their power."

In order to provide such a life, a monastery had to be planned so that the monks would have all that was necessary for both their bodily existence and their spiritual nourishment. The objective was to be as independent of Caesar as possible so as to render

their all unto God. The Benedictine Rule did not prescribe the exact form that a monastic building should take, and, nominally, each abbey was free to solve its problems according to its needs, the contours of its site, and the extent of its resources. But tradition often operated as rigidly as rules, and with local variations most monasteries followed a common pattern. If one allows for the exceptional size and complexity due to its status as mother house of a great order, the plan of Cluny can be accepted as reasonably typical.

Since the life of a Cluniac monk was one of almost continuous religious duties alternating with periods for contemplation, the soul of the monastery was in its abbey church, and its heart was in its cloister (Fig. 147). The church served primarily as the scene of the constant devotional activities of the monks day and night throughout the year. Only secondarily was it a shrine for the streams of pilgrims who arrived from near and far to revere relics of saints.

147. Cloister, Abbey of St. Trophîme, Arles. c. 1100.

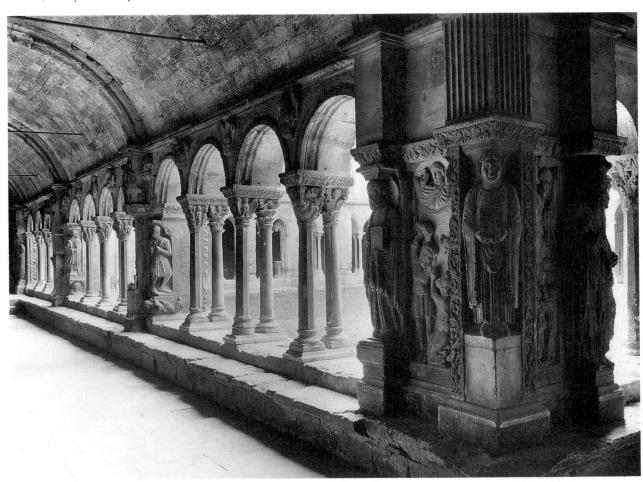

Cluny was rich in relics, and on the feastdays of the saints, pilgrims flocked there as they did to other famous shrines, such as that of the Apostle James at Santiago de Compostela in Spain (see map, p. 157). European pilgrimage routes were traveled mainly by foot. Hospices at 20-mile (32-kilometer) intervals afforded places where travelers could eat and sleep after a day's journey. Pilgrims from England had to cross the Channel. Those from Germany traveled south by way of the Alpine passes. Pilgrims to the Holy Land went by ship from Genoa, Venice, or Sicily with stops at Cyprus, Constantinople, or Rhodes.

Next in importance to facilities for the church services was the provision for the contemplative life that centered on the cloister. The cloister is found, typically, in the center of the abbey and south of the nave of the church. The other monastic buildings cluster around it. The usual cloister was an open quadrangular garden plot enclosed by a covered arcade on all four sides. The somewhat irregular shape of the cloister at Cluny in the 12th century resulted from the ambitious building program required by the rapid growth of the monastery. Since this renowned marble-columned cloister no longer exists, the one of St. Trophîme at Arles will serve as an example (Fig. 147).

Such a complete abbey at Cluny had to provide for many other functions. The daily life of the monks demanded a refectory where they could eat their meals in common, plus kitchens, bakeries, and storage space. There were also a chapter hall, where they could transact their communal business and a dormitory adjacent to the church, for services were held during the night as well as by day. Three small cloisters were included—one for the education of novices (young future members of the order), another for visiting monks and religiously inclined laymen who sought refuge from the world, and a third, near a cemetery, for the aged and infirm brothers. The hospice, or guesthouse, provided accommodations for visitors who flocked in during the pilgrimage season. There were also quarters for blacksmiths, carpenters, cobblers, and the like, as well as stables for dairy cattle and other domestic animals.

The plan of Cluny was thus a coherent system of adjoining quadrangles that embraced courts and cloisters whose variation in size and importance accommodated the differing activities they were designed to serve. Altogether, it was a highly complex and at the same time logical plan for a complete community. It took into account the ideals, aspirations, practices, and everyday activities of a group that gathered to work physically and spiritually toward a common end.

ARCHITECTURE

Hugh of Semur, greatest of the Cluniac abbots, succeeded Odilo in the year 1049. Under Hugh, Cluny was destined to attain a period of such splendor that it could be described by an enthusiastic chronicler as "shining on the earth like a second sun." Taking as his model the accepted feudal organization of society, in which smaller and more dependent landowners swore allegiance to the larger and more powerful landlords in return for protection, Hugh began to bring many of the traditionally independent Benedictine monasteries into the Cluniac orbit. With the express approval of the popes, Hugh gradually concentrated the power of the whole order in his hands and transformed Cluny into a vast monastic empire that extended from Scotland in the north to Portugal in the west, Jerusalem in the east, and Rome in the south. In the Church hierarchy he was outranked only by the pope. In the secular world he was the peer of kings.

Hugh figured prominently in most of the historical events of his day. He even acted as intermediary between an emperor and a pope on the famous occasion at Canossa when Henry IV came on bended knee to beseech Gregory VII for forgiveness. Hugh's greatest moment, however, came when Pope Urban II, who had received training as a monk at Cluny under Hugh's personal guidance, was present to dedicate the high altar of his great new abbey church. Honor after honor was bestowed upon the monastery by this Cluniac pope, who was also the preacher of the First Crusade. By attempting to wrest the Holy Land from Moslem control, the Crusaders were destined to break the prevailing isolation of the West by bringing Europeans into contact with Islamic culture, often with mutually beneficial results.

Third Abbey Church at Cluny

With such a rapidly expanding monastic order Hugh had to undertake a massive building program. The ever-increasing number of Cluniac monks and the growing importance of Cluny as a pilgrimage center made the older second church inadequate. So to rival the legendary temple of Solomon and to eclipse all other churches in Western Christendom, Hugh and his architect Hezelo began the immense Third Abbey Church.

In contrast to the simpler Early Christian basilicas (compare Figs. 119 and 120), Romanesque abbey churches show remarkable extensions before and beyond the nave (Fig. 148). The three-aisled narthex entrance has grown to the size of a large church in itself. It was, in fact, called variously the

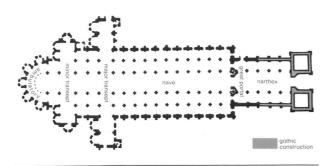

148. Plan of Third Abbey Church of Cluny. c. 1120.

"church of the pilgrims" and the "minor nave." Besides accommodating these devout visitors, the narthex was the assembly place for the clergy who marched in the grand processions on high holidays such as feastdays of saints.

The spacious five-aisled nave itself allowed pilgrims and townspeople to gather for religious services, while the space beyond was expanded for the large monastic community. Instead of a single transept there were now two. Extending outward from both the major and minor transepts were chapels dedicated to various saints, each the size of a small church. The apse was enlarged to accommodate the huge high altar, and an *ambulatory*, or passage for pilgrims and processions, was provided to reach the *apsidal chapels* that radiated outward from the apse, as the term implies. An exterior view of these apsidals can be seen in Figure 149.

On entering the nave (Fig. 150), one noticed at once the mighty proportions of the huge basilica. From the entrance portal to the end of the apse, it extended a distance of 415 feet (126.5 meters). The entire horizontal axis from front to back, including the narthex, reached an overall length of 615 feet (187 meters). The nave itself had eleven bays, or arched units between the supporting columns, that stretched forward a distance of 260 feet (79 meters). Each bay was separated by a group of columns clustered around supporting piers. As the architectural counterpart of the monks, they marched in solemn procession toward the climax of the building at the high altar. In width, the nave spread outward 118 feet (35.9 meters) and was divided into five aisles. This division responded in part to the need to provide extra space for altars, since it was now the custom for each monk to celebrate mass once each day.

It can be seen in Figure 150 that a stone screen was placed across the nave to close off the space set aside for the monks' choir. The height of the church was such that the screen did not break the impression of a unified whole. The eye was drawn aloft to

the tall columns around the high altar and above them, in turn, to the towering figure of Christ gazing downward as if in a vision, painted in the fresco technique on the interior of the half-dome of the apse.

Whereas the Early Roman Christian basilicas basically were horizontally directed, the Romanesque examples, because of the northern influence, raised the levels of the nave upward vertically. Gradually this resulted in more and more accent being placed on the parts of the building above the nave arcade. At Cluny, a double row of windows was found, the lower of which was filled in with masonry, while the upper remained open and served as the clerestory for illumination. Though it had numerous windows, the church drew criticism from later Gothic builders as being too dark. Its thick walls and massive proportions allowed little direct sunlight to penetrate into the church itself. This was not of great importance, because so much of the monastic liturgy took place at night, when the interior was illuminated by candlelight. Churches designed for city people who worshiped by day naturally had to pay more attention to lighting problems.

150. Hezelo. Nave, Third Abbey Church of Cluny. 1088–1130. Reconstruction by Kenneth J. Conant.

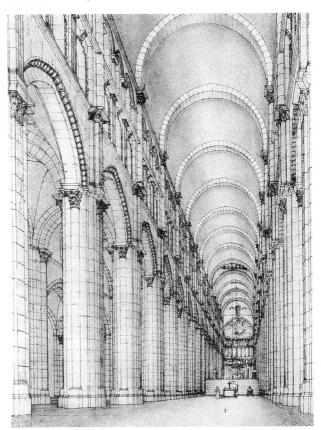

The nave at Cluny was spanned by ribbed barrel vaulting, 32 feet (9.8 meters) wide, supported by slightly pointed arches. Rising a full 98 feet (29.8 meters) above the pavement, the vaults were the highest achieved up to this time. But the emotional exuberance of attaining such height outran the engi-

neering knowledge needed to maintain it, and a part of the Cluny vaulting soon collapsed. Out of this accident came experimentation with external buttressing, so when the vaults were rebuilt, a range of supports with open round arches was placed outside on the aisle roofs. Cluny thus achieved the distinction of

149. Exterior of apse, St. Sernin, Toulouse. c. 1080. Height of lantern tower 215' (65.53 m).

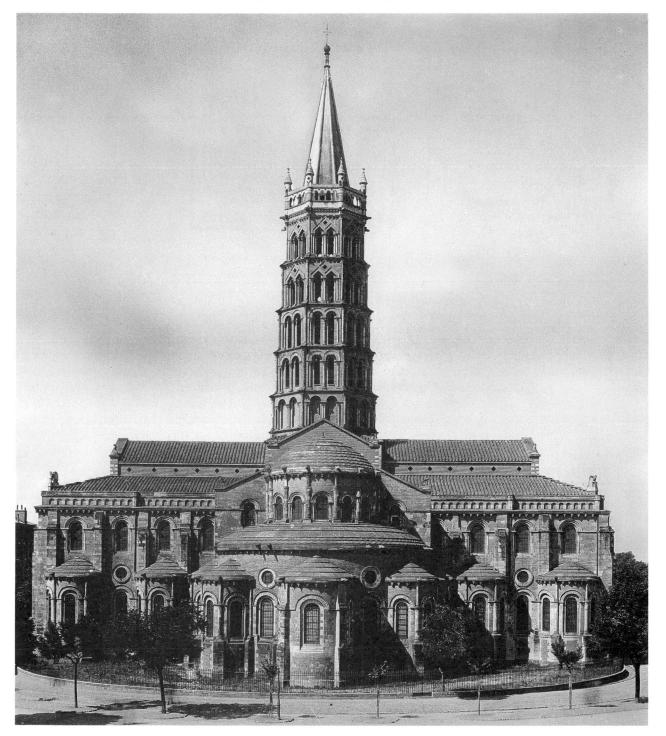

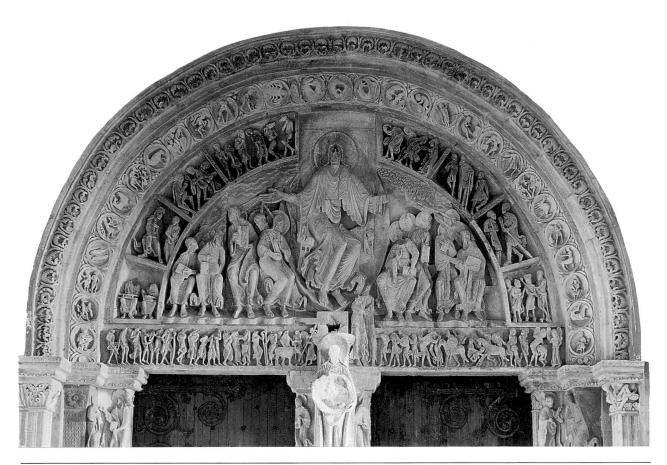

151. Tympanum, Abbey Church of La Madeleine, Vézelay. c. 1120–32.

being the first church to have external buttresses supporting its nave vaults. With its pointed arches and high vaulting in addition to external buttresses, Cluny combined for the first time three of the features that future builders would employ to make the unified system characteristic of the great Gothic cathedrals: high ribbed vaulting, pointed arches, and flying buttresses.

The decorative plan of the church was carried out on a scale comparable in quality to the grandeur of its spatial dimensions. More than 1200 sculptured capitals surmounted the columns of the structure, while carved moldings outlined the graceful pointed arches of the nave arcade. Most of the sculpture was painted in rich colors that gave an added glow to the splendor of the interior, and the whole church was paved with mosaic floors inlaid with images of saints and angels or with abstract designs.

All this magnificence did not go unchallenged. St. Bernard, the vigorous opponent of the Cluniac order, disapproved violently of such extravagances. By doing so in writing, he inadvertently left a first-hand account of the glory of Hugh's church soon after it was finished. In a letter to one of the Cluniac

abbots, Bernard deplored (with Cluny in mind) "the vast height of your churches, their immoderate length, their superfluous breadth, the costly polishings, the curious carvings and paintings which attract the worshiper's gaze and hinder his attentions." His feeling was that "at the very sight of these costly yet marvelous vanities men are more kindled to offer gifts than to pray. . . . Hence the church is adorned with gemmed crowns of light-nay, with lustres like cart-wheels, girt all round with lamps, but no less brilliant with precious stones that stud them. Moreover we see candelabra standing like trees of massive bronze, fashioned with marvelous subtlety of art, and glistening no less brightly with gems than with the lights they carry. What, think you, is the purpose of all this? The compunction of penitents, or the admiration of beholders?"

Cluny Abbey stood proudly until the year 1798, when a wave of anticlericalism swept France in the wake of the Revolution, causing the abbey to be sacked and burned. All the buildings except a single transept wing were blown up by gunpowder, and the rubble was sold as common building stone. Some sculptural fragments survive, and the spirit of

the great monastery lives on in the influence it exerted on such related structures as St. Trophîme at Arles (Fig. 147), St. Sernin in Toulouse (Fig. 149), and La Madeleine at Vézelay (Figs. 151–153).

SCULPTURE

Some of the first sculpture that dates from the period of Cluny's grandeur is in the abbey church of La Madeleine at Vézelay. The nave and narthex are contemporary with Hugh's church at Cluny, and the intelligent restoration in the 19th century by the French medieval archeologist Viollet-le-Duc accounts for their present good condition. While its proportions are considerably smaller than those of the great basilica at Cluny, La Madeleine today is the largest Romanesque abbey church in France. Rich in historical associations, it derived its principal fame in medieval times as the repository of the relics of St. Mary Magdalene.

The chief interests at Vézelay, however, are the seemingly endless wealth of sculptured capitals and, above all, the relief compositions over its three portals leading from the narthex into the nave and side aisles.

Tympanum at Vézelay

The splendid semicircular tympanum over the central portal at Vézelay (Fig. 151) is from the first quarter of the 12th century. In its iconography and design, it is by far the most complex Romanesque tympanum, yet the logical division of space keeps the composition from seeming cluttered or confused. Here, as elsewhere, Romanesque designers and sculptors looked for their subjects and models in the drawings and miniature paintings that illustrated the texts of the Scriptures in monastic libraries. Such illuminated manuscripts provided convenient models that the monks could show to the sculptors who were to carry out the projects. At Vézelay, the robe of Christ, as well as those of the apostles, reveals a pattern of clear, sharp, swirling lines that stems from pen drawings in manuscripts of the time.

The interpretation and iconography of the tympanum scene may be discovered in the vision of St. John as recorded in Revelation (22:1–2): "And he showed me a pure river of water of life, clear as crystal, proceeding out of the throne of God and of the Lamb. In the midst of the street of it, and on either side of the river, was there the tree of life, which bare twelve manner of fruits, and yielded her fruit every month: and the leaves of the tree were for the healing of the nations."

The figure of Christ dominates the composition, seated, as St. John says, on "a great white throne," but not so much to judge mortals as to redeem them. While the figure is supremely majestic, Christ is not crowned. The streams issuing from his fingers descend upon the barefoot apostles, who bring spiritual understanding through the books they hold in their hands and physical healing through the divine mercy which they transmit to humanity. On one side of Christ's head, the water referred to in the quotation flows forth, while on the other are the branches of the tree.

The twelve fruits, one of each month of each year, are found among the twenty-nine medallions in the middle band of archivolts, the series of arches that frames the tympanum. A figure treading grapes, for example, represents September; October is symbolized by a man gathering acorns for his pigs. The months themselves, besides being connected with such labors, are also symbolized by the signs of the zodiac that, in turn, remind Christians of the very limited time they have in which to attain salvation. A few of the other medallions picture strange beasts taken from the bestiaries, those curious books of the time that recounted the lore about animals actual and fabulous. A survival from antiquity can be noted in the medallion (lower right) that depicts a centaur.

The inner band of the archivolt is divided into eight irregular compartments that contain figures representing the nations which the leaves of the tree of life are intended to heal. The one on the top left, next to the head of Christ, contains two dog-headed men, called by the Spanish prelate and scholar Isidore of Seville in his *Etymologies* the "Cynocephaloi," a tribe supposed to have inhabited India. The corresponding compartment on the right side shows the crippled and bent figure of a man and that of a blind woman taking a few halting steps as she is led forward. In the other compartments, the lame supported on crutches are found along with lepers, who point toward their sores.

Along the lintel below, a parade of the nations converges toward the center. While the compartments above picture those in physical distress, here are the pagans and heathens who need spiritual aid. Among these strange peoples who populate the remote regions of the earth are a man and woman (in the far right corner) with enormous ears and feathered bodies. Next to them is a group of dwarfs or pygmies so small they have to mount a horse by means of a ladder. On the far left, half-naked savages are hunting with bows and arrows, while toward the left center some heathens are shown leading a bull to sacrifice.

In the center stands St. John the Baptist holding a medallion with the image of the lamb on it, a reference to Christ as the lamb of God (John 1:29). This is doubtless intended to convey the explanation that the "river of water of life" is baptism, the way to salvation that all must take if they want to enter into eternal life. It is an appropriate symbol to adorn the portal leading into the nave, for the interior of the church with its glowing colors and jeweled decorations was often likened to the heavenly city, the New Jerusalem so eloquently described by St. John: "And the gates of it shall not be shut at all by day: for there shall be no night there. And they shall bring the glory and honour of the nations into it" (Rev. 21:25–26).

The open books of the apostles seated next to St. Peter on the left recall the following verse, which states that all who enter it are the ones "which are written in the Lamb's book of life" (Rev. 21:27). Furthermore, in a monastic church especially, the monks would have been conscious of the final reference to these gates: "Blessed are they that do his commandments, that they may have right to the tree of life, and may enter in through the gates into the

city" (Rev. 22:14). The awakened interest in foreign countries and peoples was doubtless due to the influence of the early Crusades, which were then being preached.

Capitals at Vézelay

At Vézelay, the imaginative scope displayed in the abundance of sculptured capitals is breathtaking. Biblical scenes, incidents from the lives of the saints, allegorical commentaries, and the play of pure fantasy are found throughout the narthex and the nave. One of the capitals shows the angel of death striking down the eldest son of Pharaoh (Fig. 152). Another shows a bearded figure pouring grain into a handmill that a barefoot man is turning (Fig. 153). The real meaning of this scene would be lost to posterity were it not for a chance remark in the writings of Suger, the abbot of St. Denis near Paris, who visited Cluny and Vézelay before beginning to rebuild his own abbey church. He noted that the corn is the old law, which is poured into the mystic mill by an ancient Hebrew prophet, probably Moses, and is being ground into the meal of the new law by St. Paul.

152–153. Nave capital sculptures, Church of La Madeleine, Vézelay. c. 1130.

Angel of Death Killing Eldest Son of Pharaoh.

Mystic Mill: Moses and St. Paul Grinding Corn.

154. Gospel Book Cover, England. c. 1050–65. Gilt silver and bejeweled. $11\frac{5}{8}'' \times 7\frac{7}{8}'' \times 2\frac{1}{8}''$ (29.5 × 20 × 5.5 cm). Pierpont Morgan Library, New York.

Unlike the statuary of antiquity that was made of marble or bronze, French Romanesque capitals are usually of soft sandstone and limestone. This malleable material was well adapted to the pictorial forms of Romanesque sculpture. Its plasticity responded more quickly to the imaginative demands made on it than a harder stone could have done.

Works in Metal

While the examples discussed are stone carvings, the general category of Romanesque sculpture in this period should be broadened to include works in metal. Only a few examples of this kind have survived, because they were made of such precious materials as gold, silver, and copper, adorned with enamel work and studded with precious gems.

Cluny, according to an early inventory, had a golden statue of the Virgin seated on a silver throne and wearing a jeweled crown. Churches also needed chalices, plates, and pitchers for the sacred services. On important feast days, books with ivory or metal

155. Initial page with letter Q, from Evangelistary of Abbey at St. Omer. c. 1000. Manuscript illumination. Pierpont Morgan Library, New York.

covers encrusted with jewels (Fig. 154) were used on the high altar, where also rested reliquaries fashioned to contain the relics of saints. Candelabra, incense burners, and metal choir screens added their beauty to the sacred precincts.

Romanesque sculpture always remained an integral part of the architectural design and is inseparable from the whole. The walls, ceiling, portals, columns, and capitals were not merely mute structural necessities. They were places where carved images communicated messages and meanings—where stones spoke to monk and pilgrim alike in the eloquent language of form, line, and color.

PAINTING AND OTHER MONASTIC CRAFTS

Miniatures of modest proportions on the parchment pages of books and monumental murals in the apses of abbey churches were the two extremes of the art of painting in the Romanesque period. The one craft known definitely to have been consistently practiced by the monks themselves was the copying, illustrating, and binding of books, activities that took place in a large communal room called the *scriptorium*. This tradition, which dates from the time of Cassiodorus, was followed by all Benedictine houses, and those in the Cluniac order fostered it with both diligence and enthusiasm.

Manuscript Illumination and Murals

While the Cluniac copyists were known for the beauty of their lettering and the accuracy of their texts, a monk skilled in his craft would certainly not have been content merely to copy letters all his life. A blank place in the manuscript provided him with both the space and the challenge to fill it in. At first, these spaces were filled with nothing more than fanciful little pen drawings or an elaborate initial letter at the beginning of a paragraph. Gradually, the drawings grew into miniature paintings, and the initial letters became highly complex designs.

The luxurious development of this art of illuminating manuscripts seems to have been one compensation for the austerity of Benedictine life. As the practice became more widely accepted, specialists in the various phases began to be designated. A painter of small illuminated scenes was called a *miniator*, while one who did initial letters was known as a *rubricator*.

Cluniac manuscripts were done with the utmost delicacy. Miniatures were painted in many colors, and halos of saints or crowns of kings were made with thin gold leaf. The letter Q in an evan-

geliary from St. Omer is an intricate example of the illuminator's art (Fig. 155).

Such flourishes of the pen by expert copyists on their parchment pages and the gradual refinement of the painstaking miniature art of illumination had effects far beyond the medium for which either was intended originally. They became the models for the large murals that decorated the walls and apses of churches and for the sculpture that embellished the spaces above portals and columns. Later, they were the prototypes of designs for stained glass windows in Gothic cathedrals.

Contrasting with the diminutive illuminations in manuscripts were the huge frescoes painted on the surfaces of barrel-vaulted ceilings, arches, and semidomed apses of churches of the Romanesque period. Except for a few fragments, all the large paintings at Cluny itself have disappeared. Notable examples, however, are found elsewhere. In a chapel at nearby Berzé-la-Ville, a residence built for Hugh's last years, there is an apse mural modeled after that in the Third Abbey Church (Fig. 156). Christ is clothed in a robe of white, over which is draped a red mantle. While blessing the sixteen surrounding apostles and saints with his right hand, he gives St. Peter a scroll containing the law with his left. The heavenly setting is suggested by the dark blue background of the mandorla, an almondshaped contour, which is studded with golden stars, and by the hand of God the Father, which hovers above Christ holding a crown.

MUSIC

Odo of Cluny, abbot from 927 to 942, brought the monastery its earliest musical distinction through actively fostering choral music. Documents tell of more than a hundred psalms being sung at Cluny daily in his time; and on his tours of inspection to other monasteries he devoted much of his energies to the instruction of choirs. His great success made it necessary for his teaching methods to be written down, and from this circumstance something about the early status of music at Cluny can be ascertained.

Development of Notation

Odo's great accomplishments include the arranging of the tones of the scale into an orderly progression from A to G. By thus assigning to them a system of letters, he was responsible for an early effective system of Western musical notation. Odo's method, as expounded in the treatise often ascribed to him, also included the mathematical measurement of intervals, the difference in pitch between tones, on the

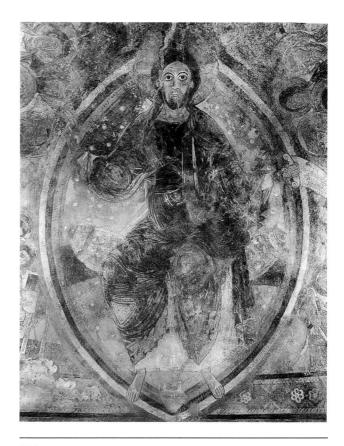

156. Christ in Glory. c. 1103. Fresco (apse mural), height 13' (3.96 m). Cluniac Chapel, Berzé-la-Ville, France.

monochord. This instrument, consisting of a single string stretched over a long wooden box with frets for varying the length of the string, made it possible to demonstrate the relationships between string lengths and intervals.

Before Odo's time, the chants used in the sacred service had to be learned laboriously by rote; and if any degree of authenticity was to be achieved, they had to be taught by a graduate of the Schola Cantorum that Gregory the Great had established in Rome. Odo's treatise declares that by teaching the singers to perform by reading notes, they soon "were singing at first sight and extempore and without a fault anything written in music, something which until now ordinary singers had never been able to do, many continuing to . . . study for fifty years without profit."

Refinements on Odo's method were made in the 11th century by another monk, Guido of Arezzo. His treatise, which was in the library of Cluny, made it clear that he embraced the Cluniac musical reforms. He also freely acknowledged his debt to the work of his great predecessor, the Abbot Odo, "from whose example," he said, "I have departed only in

the forms of the notes." This slight departure by Guido was actually the invention of the basis for modern musical notation on a staff of lines where tones of the same pitch always appear on the same line or space.

Odo's work also led to Guido's system of *sol-mization*, which assigned certain syllables, derived from a hymn to St. John, to each degree of the scale:

C D F DE D Ut que -ant la -xis D C D E E re - so -na -re fe -bris **E**FG E D EC Mi - ra ge -sto -rum G A G **FED** fa - mu -li tu - orum. FE F G D **G**AG **Sol** - ve pol -lu -ti G A F GA la - bi -i re -a -tum, ED C F D San - cte Io -an -nes.

Later the syllable *si*, compounded from the first two letters of the Latin form of "St. John" (*Sancte Ioannes*), was added as the seventh scale degree. In France, these syllables are still used as in Guido's time. In Italy and elsewhere, the first note *ut* is replaced by the more singable *do*.

The most remarkable fact about Odo's and Guido's treatises is that both champion music as an art designed to be performed in the praise of the Creator and to enhance the beauty and meaning of prayer. Previously, Boethius, along with most early writers on music, had considered music a branch of mathematics that could reveal the secrets of the universe. Guido, however, made a point of stating that the writings of Boethius were "useful to philosophers, but not to singers," and both Odo and he intentionally omitted heavenly speculations. Cluny, therefore, emerged as a center of practical music making rather than as a place where scholars pondered on music only as a theoretical science.

Music Pictured in Sculpture

The story of music at Cluny was also told visually with compelling beauty in two sculptured capitals that survive from the apse of Hugh's great church. In the sanctuary, the architectural climax of the whole edifice, was a series of columns grouped in a semicir-

cle around the high altar, and the capitals of these pillars constituted the high point of late-11th-century sculptural skill. One capital presented on its four faces the theological virtues, another the cardinal virtues. On a third were pictured the cycles and labors of the monk's year in terms of the four seasons. His hopes for the hereafter were portrayed by the four rivers and trees of Paradise. Finally, his praise for the Creator was expressed with figures to symbolize the eight tones of sacred psalmody.

On the first of the eight faces of these twin capitals (Fig. 157) is inscribed: "This tone is the first in the order of musical intonations." The figure is that of a solemn-faced youth playing on a lute. Here the symbolism of the stringed instrument stems from the belief in the power of music to banish evil, as David had cast out Saul's evil spirit when he played to him.

The second tone (Fig. 158) is represented by the figure of a young woman dancing and beating a small drum. The inscription reads, "There follows the tone which by a number and law is second." Such percussion instruments are known to have been used to accompany medieval processions on joyful feast days in the manner described in Psalm 68:25: "The singers went before, the players on instruments followed after; among them were the damsels playing with timbrels."

The next inscription (Fig. 159) says: "The third strikes, and represents the resurrection of Christ." The instrument here is of the lyre type with a sounding board added, which is one of the 11th-century forms of the psaltery, the legendary instrument with which David accompanied himself as he sang the psalms. This instrument with its gut strings stretched over the wooden frame roughly resembles a cross and was used as a symbolic reference to Christ stretched on the Cross.

The fourth figure (Fig. 160) is that of a young man playing a set of chime bells. The accompanying inscription reads: "The fourth follows, representing a lament in song." The Latin word *planctus* denotes a funeral dirge. The practice of ringing bells at burials is pictured in the contemporary representation of the burial procession of Edward the Confessor in the Bayeux Tapestry (see Fig. 169), where the figures accompanying the bier carry small bells.

Early Forms of Polyphony

While Gregorian plainsong was a purely melodic style and continued to be practiced as such, during the Romanesque period the choral responses began to show variations in the direction of singing in several parts at different levels of pitch. The 9th, 10th, and 11th centuries thus saw the tentative beginnings

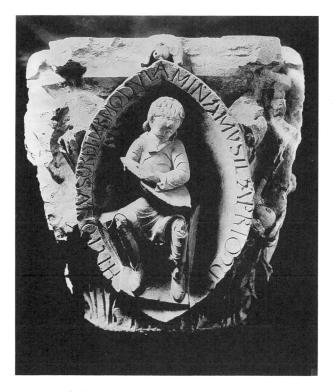

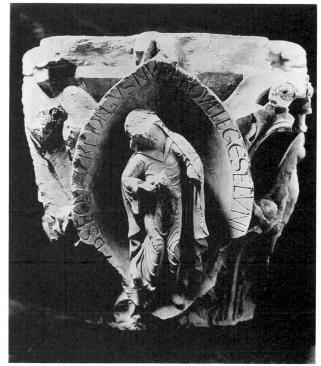

Second Tone.

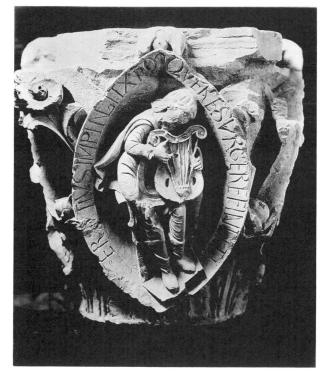

Third Tone.

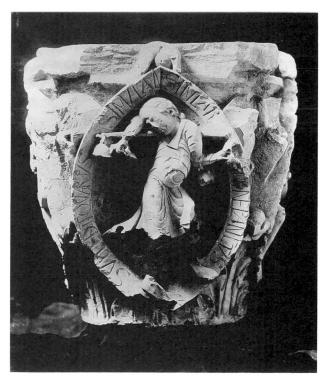

Fourth Tone.

of the *polyphonic*, or "many-voiced," style that was to flourish in the Gothic period and in that of the Renaissance.

Unfortunately, the polyphonic practice of the pre-Gothic period is known only through theoretical treatises. From the rules they give for the addition of voices to the traditional chant, however, some idea of the early forms of polyphony can be determined. As might be expected, the influence of mathematics and the Pythagorean number theory was found in the musical usages of the time (see Chap. 2, pp. 47–48). The perfect intervals of the octave, fifth, and fourth were preferred over all others, since their mathematical ratios indicated a closer correspondence with the divine order of the universe.

Parallel Organum (10th century)

In a treatise dating from the beginning of the 10th century, the type of choral response known as *parallel organum* (above) is discussed. The original Gregorian melody was maintained intact. However, at pitch levels of the fourth, fifth, and octave above and below, the principal voice was paralleled by these so-called organal voices. Parallel organum, in effect, built a mighty fortress of choral sound around the traditional Gregorian line of plainsong. By thus enclosing it within the stark and gaunt but strong perfect intervals, parallel organum achieved a massive and solid style quite in the spirit of the other Romanesque arts.

The music of this time was yet another expression of the praise of God. When related to the great buildings, the richly carved sculpture, the illuminated manuscripts and painted murals, it fits into the picture as a whole. Consequently, when the choir section of a monastic church was being planned, every effort was made to provide a resonant, acoustically vibrant setting for the perpetual chant. Hugh's great church was especially famous for its acoustics. The curved ceiling vaults and the great variety of angles in the wall surfaces of the broad transepts and cavernous nave gave the chant there a characteristic tone color that can be reproduced only in a similar setting. The effect of a monastic choir of several hun-

dred voices performing joyous songs with all its heart and soul must have been overwhelming.

Cluny's sculptured capitals depicting the tones of plainsong represent an obvious synthesis of the arts of sculpture, music, and literature into an appropriate architectural setting. Their expressive intensity, moreover, bespeaks both the motion and emotion typical of the Romanesque style in general. As such, they are representative products of a people capable of the long and difficult pilgrimages and the fantastic effort associated with the organization of the First Crusade. These sculptures reveal something of that unconquerable energy, and especially of a vigorous attitude toward the act of worship, that must have been channeled into a performance style which was emphatic in feeling. They are, in fact, the embodiment of the spirit expressed by St. Augustine, who called upon the faithful to "Sing with your voices, and with your hearts, and with all your moral convictions, sing the new songs, not only with your tongue but with your life."

IDEAS

The key to the understanding of the Romanesque as a living and active art style is a knowledge of the opposing forces that created it. As the Roman Christian influence spread northward, it encountered the restless surging energies of the former barbarian tribes. In effect, a Church that respected and admired tradition and encouraged an unchanging order was absorbing peoples with an urge for experimentation and action. The resulting innovations gave ancient forms new twists and turns.

When builders combined the horizontal Early Roman Christian basilica, for example, with northern towers and spires, they took the first step toward Romanesque architecture. Further development of the style was the direct result of this union of southern horizontality and northern verticality, reflecting as it did the broad spirit of the late Roman humanism and the soaring northern aspirations.

The musical counterpart is found in the joining together of southern monophony and northern polyphony, which occurred when the Mediterranean tradition of singing one melody in unison met the northern custom of singing in several parts. The result was the experimentation with primitive forms of counterpoint and harmony that characterized the music of the Romanesque period.

This meeting of southern unity with northern variety, and its slow maturation over the centuries, was thus responsible for the first truly European art style: the Romanesque. The ideas that underlie the

monastic aspect of the style are an outgrowth of those motivating the earlier period in Ravenna. The mysticism of the previous period moved into an otherworldly phase; and early Christian authoritarianism resulted in the rigid stratification of society into strict hierarchies. The two basic ideas, then, crystallize as asceticism and hierarchism.

Asceticism

The monastic way of life demanded the seclusion of the countryside as an escape from the distractions of the world. Since the monk conceived earthly life to be but a stepping-stone to life beyond, living required only the barest essentials. The very absence of physical luxury led to the development of a rich inner life, and the barren soil of rural isolation almost miraculously produced an important art movement. Poverty, chastity, and humility became virtues as the result of moral rather than aesthetic impulses, but the very severity of monastic life stimulated

imaginative experience, and individual self-denial reinforced communal energies.

The attitude of turning away from the world found its architectural expression in the plain exteriors and rich interiors of monastic churches. Thus the net effect of asceticism was to increase the fervor of the spirit and to express this with great intensity. Two favorite Cluniac saints were the same Paul and Anthony who, in early Christian times, had gone farthest into the forbidding African desert; it was they who had the most fantastic visions and the most dreadful and horrifying temptations.

The spread of social centers into widely scattered monastic communities likewise lent a peculiar intensity and a wide variety to the expressive forms of the Romanesque. The arts, consequently, were not intended to mirror the natural world or to decorate the dwelling place of an earthly ruler but, rather, to conjure up otherworldly visions of divine majesty. Hence, all the arts found a common ground in their desire to depict aspects of the world beyond.

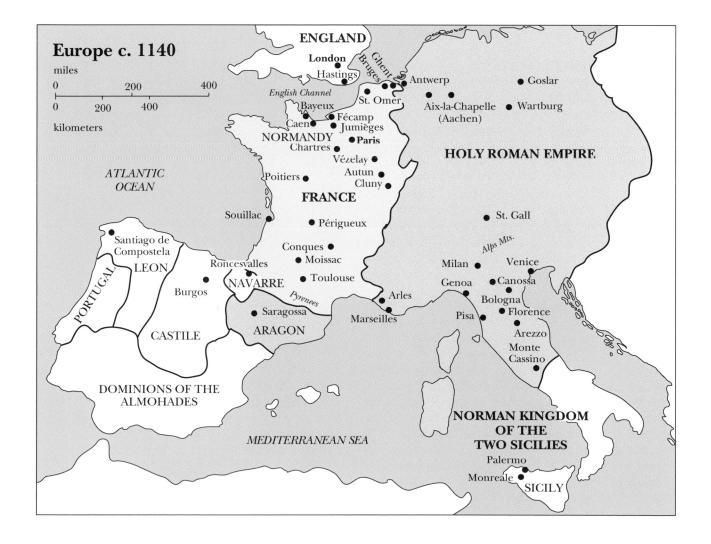

Symbolism and Otherworldliness. The monks developed an art of elaborate symbolism addressed to an educated cloistered community familiar with sophisticated allegories. The growth of such a symbolic language—whether in architecture, sculpture, painting, or music—could only have been promoted by an abbot like Hugh, whose learning was so universal that he succeeded in adding "philosophy to ornament and a meaning to beauty." By contrast, the later Gothic arts were directed more toward the unlettered people beyond the cloister. While the sculpture and stained glass of the Gothic cathedral were destined to become the Bible in stone and glass for the poor, in a monastic church the comparable forms were always aloof and aristocratic and at times intentionally subtle and enigmatic. This does not mean that Romanesque art was overly intellectualized and remote from the experience of those to whom it was addressed. On the contrary, it was very directly related to the intensity of the inner life and the visionary otherworldly focus of the religious communities that developed it.

Greco-Roman sculpture was successful in its way precisely because the classical mind had conceived the gods in human form. As such they could be rendered so well in marble. When godhood was conceived as an abstract principle, a realistic representation of it became essentially impossible. Rational proportions were of no help to the Romanesque mind, since it was considered impossible to understand God intellectually. God had to be felt through faith rather than comprehended by the mind. Only through the intuitive eye of faith could his essence be grasped. Hence he had to be portrayed symbolically, not represented literally, since a symbol could stand for something intangible. Physical substance was secondary, and soul stuff primary; but the latter could be depicted only in the imagination.

A life so abstractly oriented and motivated by such deep religious convictions could never have found its models in the natural world. The fantastic proportions of Romanesque architecture, the eccentric treatment and distortions of the human body in its sculpture, the unnecessarily elaborated initials in the manuscript illuminations, and the ornate melismas added to the syllables of the chant all signified a rejection of the natural order of things and its replacement by the supernatural. The book of the Bible most admired was Revelation, containing as it did the apocalyptical visions of St. John. It is not surprising, then, that the pictorial element in sculpture and painting in both large and small forms reflected Romanesque emotions with such intensity that the human figures seem to be consumed by the inner fires of their faith. Reason seeks to persuade by

calm or serene attitudes, but such animated figures as those of the prophets at Souillac (Fig. 161) and Moissac seem to be performing spiritual dances in which their slender forms stretch to unnatural lengths with gestures more convulsive than graceful.

The Romanesque monk thus dwelt in a dream world where the trees that grew in Paradise, the angels who populated the heavens, and the demons of hell were more real than anything or anybody he beheld in everyday life. Even though he had never seen such creatures, he never doubted their existence. Indeed, the monsters whose fearsome characteristics were described in the bestiaries, and which were represented in the manuscripts and sculptures, had a moral and symbolic function far more real to the monks than any animals of mere physical existence. All these imaginary creatures existed together in a rich jungle of the imagination where the abnormal was the normal and the fabulous became the commonplace (Fig. 162).

161. *Isaiah*, west portal, Church of Notre Dame, Souillac. c. 1110.

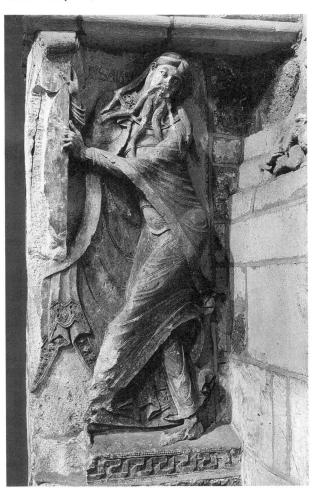

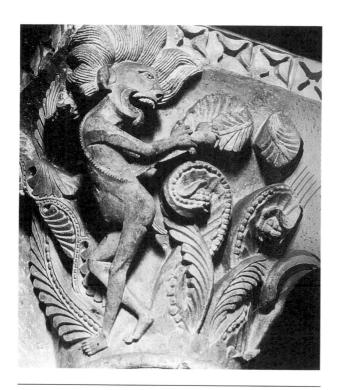

162. *Demon of Luxury,* nave capital sculpture, Church of La Madeleine, Vézelay. c. 1130.

Hierarchism

A strict hierarchical structure of society prevailed throughout the Romanesque period. It was as rigid in its way inside the monastery as was the feudalism outside the cloistered walls. The thought of the time was based on the assumption of a divinely established order of the universe, and the authority to interpret it was vested in the Church. The majestic figure of Christ in Glory carved over the entrance portals of the Cluniac abbey churches, and echoed in the mural compositions painted on the interiors of their half-domed apses, proclaimed this concept.

Christ was no longer the Good Shepherd of early Christian times but a mighty king, crowned and enthroned in the midst of his heavenly courtiers, sitting in judgment on the entire world (Fig. 163). The keys to his heavenly kingdom, as seen in the Vézelay tympanum and the apse painting at Berzéla-Ville, rest firmly in the grasp of St. Peter, the first of the popes according to the Roman tradition. As if to lend additional emphasis to this doctrine, Peter at Berzé-la-Ville is seen receiving a scroll containing the divine laws from the hands of Christ. The papacy of medieval days always found its most powerful

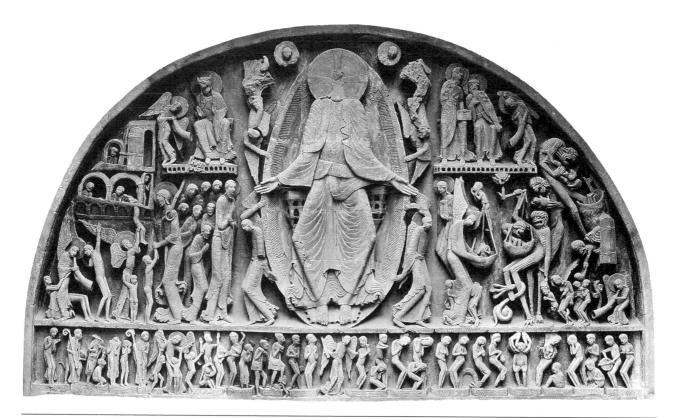

163. Gislebertus. *Last Judgment*, west tympanum, Autun Cathedral. c. 1130–35.

support in the Cluniac order, and through such aid succeeded in establishing a social order based on this mandate from on high.

The authority of the Church was nowhere better expressed than in these monumental sculptural and mural compositions, which from their place of prominence warned those who beheld them of their position on the road either to salvation or to damnation. The milestones marking the path were placed there by the Church, whose clergy alone could interpret them and assure the penitent that he or she was on the way to the streets of gold instead of the caldrons of fire. The frequency with which the apocalyptic vision of St. John was represented, with apostles and elders surrounding the throne of Christ, was evidence of the reverential respect for the protective-father image in the form of the venerable bearded patriarch.

In such a divine order, nothing could be left to chance. All life had to be brought into an organizational plan that would conform to this cosmic scheme of things. The stream of authority, descending from Christ through Peter to his papal successors, flowed out from Rome in three main directions. The Holy Roman emperor received his crown from the hands of the pope; in turn, all the kings of the Western world owed him homage, as did all on downward, from the great lords to the humblest serf, for all had a preordained place in this great cosmic plan. Next, the archbishops and bishops received their miters in Rome, and in their bishoprics they were feudal lords in their own right. Under them, the so-called secular clergy, from the parish priest to the deacon, owed their allegiance to the superiors from whom they received their orders. Finally, the monastic communities under their abbots also owed allegiance to the pope; through loyal support of the papacy the Cluniac order grew so strong that its abbot was, except for the pope, the most powerful cleric in Christendom.

The Romanesque abbey church was organized according to a rigid hierarchical plan that mirrored the strict order of precedence in the processionals of the liturgy for which it was the setting. By its insistence on visible proportions, it signified the invisible plan of a divinely ordered world. The monastic buildings that surrounded it were similarly significant in their regularity. They were designed to enclose those persons who expressed their willingness to conform to such a regulated life and thus to constitute a reflection of the divinely established plan for salvation

The very spaciousness of the abbey church was far in excess of anything that was needed to accommodate the few hundreds who normally worshiped there. It was, however, the monument that mirrored the unshakable religious convictions of the Romanesque mind; and, as the house of the Lord and Ruler of the universe, it became a palace surpassing the dreams of glory of any king on the face of the earth. In the insecurity of the feudalistic world, Romanesque people built fortresses for their faith and for their God designed to withstand the attacks of heretics and heathens as well as the more elemental forces of wind, weather, and fire. Furthermore, the abbey church was the place where the heavenly Monarch held court; it was where his subjects could pay him their homage in the divine services that went on day and night, year in and year out.

This hierarchical principle, moreover, applied not only to the social and ecclesiastical levels but also to the basic thought processes. Authority for all things rested firmly on the Scriptures and the interpretations of them by the early Church fathers. Rightness and fitness were determined by how ancient the tradition was, and scholarship consisted not so much in exploring new intellectual paths as in interpreting traditional sources. To the educated, this process took the form of learned commentaries; to the uneducated, it was expressed in the cult of relics. Thousands traveled the dusty pilgrimage roads across France and Spain to touch the revered tomb of the Apostle James at Compostela. In the arts, this veneration of the past made mandatory the continuance of such traditional forms as the Early Roman Christian basilica and the music of the plainchant.

Tradition and Innovation

This traditionalism, curiously enough, never led to stagnation or uniformity. In making learned commentaries on the Scriptures, the writers unconsciously, and sometimes quite consciously, interpreted them in the light of contemporary views. And as the untaught populace traveled about Europe on pilgrimages and later went to the Near East on the Crusades, it absorbed new ideas that eventually were to transform the provincialism of feudal times into a more dynamic social structure.

All the arts, however, exhibited an extraordinary inventiveness and such a rich variety as to make the Romanesque one of the most spontaneous and original periods in history. Diversity rather than unity was the rule of Romanesque architecture. Regional building traditions and the availability of craftsmen and materials contributed to the varied pattern. At St. Mark's in Venice (Fig. 290) there is a combination of the multidomed Byzantine style with Greek-cross ground plans. In Spain, the Moorish influence is felt; in northern Italy, Sant'

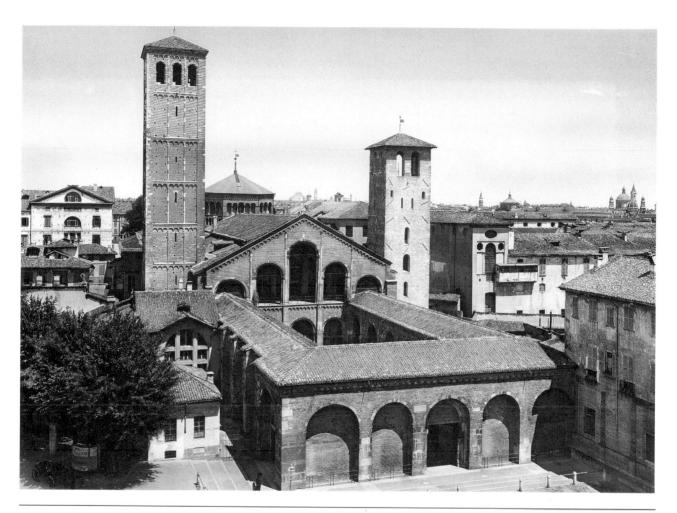

164. Sant' Ambrogio, Milan, from west. c. 1181. Length, including atrium, 390' (118.87 m); width 92' (28.04 m).

Ambrogio at Milan (Fig. 164) has the rich red brickwork and square belfry towers typical of Lombardy; while in central Italy, the Romanesque is characterized by zebra-striped exteriors composed of alternating strips of dark green and cream-colored marbles, as at the Baptistry of Florence (see Fig. 222) and the Cathedral of Pisa.

Romanesque structures never became types as Greek temples, Byzantine churches, and the later Gothic cathedrals did. Each building and each region sought its own solutions. Through constant experimentation, Romanesque architects found the key to new structural principles, such as their vaulting techniques. By gradually achieving command of their medium, they progressed in their building techniques from the earlier heavy fortresslike structures to the later edifices of considerable elegance.

Meanwhile, the decorators groped toward the revival of monumental sculpture and mural painting. The need for larger and better choirs likewise led to the invention of notational systems, and the emo-

tional exuberance in worship made many modifications of the traditional chant, which eventually culminated in the art of counterpoint. In all, the creative vitality exhibited in each art medium is a constant source of astonishment.

Within the formal framework provided by the abbey church, architectural detail, sculpture and other decorative arts, music, and liturgy combined as integral parts of the overall architectonic design. The nave and transepts were designed as a resonant hall for the chant, just as the tympanum over the entrance portal and the semidomed interior of the apse were designed as settings for sculptural and painted mural embellishments. The sculptural representations of plainsong on the ambulatory capitals in the Third Abbey Church at Cluny show a union of music and sculpture, while their inscriptions add a literary dimension. All the arts converge into the unified structure of the liturgy, since all were created, in the monastic concept, for service in the greater glorification of God.

FEUDAL ROMANESQUE PERIOD

	KEY EVENTS	ARCHITECTURE AND ARTWORK	LITERATURE AND MUSIC
	841 Vikings invaded and colonized northern France		
1100	911 Dukedom of Normandy ceded to Northmen by King Charles of France c.1000 Leif Eriksen, Viking navigator reached North America? 1035 William (c.1027-87) succeeded as Duke of Normandy after father's death on pilgrimage to Jerusalem 1042-1066 Edward the Confessor, king of England 1051 Duke William visited England; probably received promise of English succession from Edward the Confessor 1053 William married Matilda, daughter of Count of Flanders, who traced lineage from Alfred the Great 1057 Normans arrive in southern Italy 1059 Pope granted dispensation for marriage of William to cousin Matilda 1061 Duke Harold of England visited Normandy; presumably upheld William's claim to English throne 1061-1091 Norman conquest of Sicily under Roger I (1031-1101) 1066 Death of Edward the Confessor; coronation of Harold as successor; invasion of England by William the Conqueror; Battle of Hastings; Harold killed; William crowned king of England 1085 Domesday Survey, census and land survey of England ordered by William as basis for taxation 1095 First Crusade	1037-1066 Abbey Church of Notre Dame at Jumiège built in early Norman Romanesque style 1043 Imperial Palace of Holy Roman emperors built near Goslar 1056 Westminster Abbey in Norman style dedicated by Edward the Confessor. Later rebuilt in Gothic style c.1064 Church of St. Étienne (Abbaye-aux-hommes) begun under patronage of William. Church of Ste. Trinité (Abbaye-aux-Dames) begun at Caen under patronage of Matilda c.1073-1088 Bayeux Tapestry embroidered in English workshop 1078 Tower of London begun by William 1093 Durham Cathedral begun; Norman style with high ribbed vaulting	980 Organ with 400 pipes constructed at Winchester, England 1000 Minstrels convened during Lenten season at Fecamp, Normandy c.1000 Beowulf, epic poem, written in Old English c.1010 Song of Roland, epic poem, written in Old French c.1050 Beginnings of polyphonic singing
	1101-1154 Roger II ruled Sicily 1147-1149 Second Crusade	c.1100 Sculptures of Abbey of St. Trophîme carved	c.1100 Music school of St. Martial at Limoges founded; developed polyphonic style 1110 Earliest record of miracle play being performed c.1200 Nibelungenlied, German epic poem, written c.1237-1288 Adam de la Halle, author and composer of Le Jeu de Robin et Marion (c.1280), pastoral play with sole surviving example of chanson de geste melody

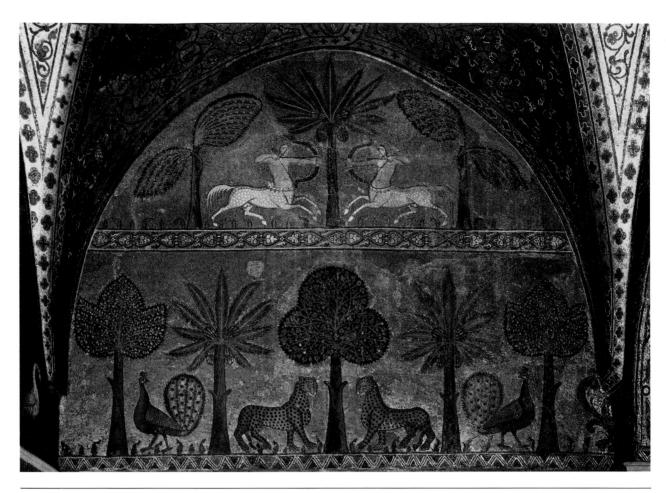

166. Mosaic of centaurs, leopards, and peacocks from Dining Hall of Roger II. Palace of Norman Kings, Palermo. c. 1132.

sades, the *Song of Roland*, owes its present existence to some monastic scribe who happened to write it down either for a minstrel with a poor memory or because he wanted to preserve it after it had ceased to be sung. The one authentic melody to which such poetry was chanted is extant because it was included as a jest in a 13th-century musical play. And the so-called Tower of London, a *keep* or fortress, that William the Conqueror constructed, is still intact because of its later use as a royal residence and prison and because it housed an important chapel.

THE BAYEUX TAPESTRY AND THE NORMAN CONQUEST

The most complete example of pictorial art is the so-called Bayeux Tapestry, one of the most eloquent documents of the time. Here, in visual form, the story of the winning of England by William the Conqueror is told. It presents a vivid picture of the life and attitudes of the feudal period. The term *tapestry*

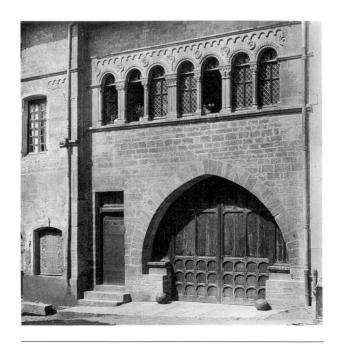

167. Romanesque house, Cluny. c. 1159.

is not quite accurate, though it is somewhat justified in this case because the cloth did function as a wall hanging. Since the design is applied in woolen yarn to a coarse linen surface rather than woven into the cloth itself, the work is more correctly described as an embroidery.

Such cloth decorations were used to cover the bare stone walls of castles, but in this case the extraordinary dimensions—20 inches (51 centimeters) high and 231 feet (70.4 meters) long—and its possession over the centuries by the Bayeux Cathedral indicate that this tapestry or embroidery was intended to cover the plain strip of masonry over the nave arcade of that building. It was probably the product of one of the many renowned English embroidery workshops and apparently was completed about twenty years after the great battle it so vividly describes.

On the English side of the Channel, Harold's claim to the throne was based on the recommendation of Edward the Confessor and his election by the Saxon barons. Besieged in the north by the Danes, he had won a complete victory near York less than three weeks before he had to face William in the south at Hastings. The long forced march had tired his men, but they fought the good fight from dawn to dusk on that fateful day. The Saxon footsoldiers were both outnumbered and outmaneuvered by the swift Norman cavalry. In the course of the battle Harold's two brothers were killed, then Harold himself was struck by a chance arrow, leaving the English side leaderless. By nightfall the English had retreated, and William had won one of the most momentous battles in history.

The Tapestry tells the story from the Norman point of view. The central figure is, of course, William the Conqueror, who indelibly stamped his powerful personality on the north European scene throughout the latter half of the 11th century. The span of time is from the closing months of the reign of Edward the Confessor to that decisive day in 1066 when the Conqueror made good his claim to the throne by putting the English forces to rout at the Battle of Hastings.

In its surviving state the Bayeux Tapestry is divided into 79 panels, or scenes. The first part (panels 1–34) is concerned with William's reception of Harold, an English duke, whose mission to Normandy allegedly was to tell William that he would succeed Edward the Confessor as king of England. In one of these scenes, William and Harold are seen at Bayeux (Fig. 168), where Harold took an oath to Duke William. (The italics here and later are literal translations of the Latin inscriptions that run along the top of the Tapestry above the scenes they describe.) Plac-

ing his hands on the reliquaries that repose on the two altars, Harold apparently swears to uphold William's claim, although the exact nature of the oath is left vague. This is, however, the episode that later became the justification for the English campaign—because Harold, false to his supposed sworn word, had had himself crowned king.

In the upper and lower borders of these early panels a running commentary on the action continues a tradition begun in manuscript illuminations. Here the commentary is in the form of animal figures that were familiar to the people of the time from bestiaries and sculpture. Others allude to certain fables of Aesop. The choice of the fox and crow, the wolf and stork, and the ewe, goat, and cow in the presence of the lion all have to do with treachery and violence and serve to point out the supposedly treacherous character of Harold.

William is seated serenely on his ducal throne, foreshadowing his future dignity as king. The scene, furthermore, truly is located in the Bayeux Cathedral, the exterior of which is shown in the curious representation to the left of the seated William. Bayeux's bishop was none other than Odo, William's half-brother, who in all probability commissioned the tapestry. Odo possibly intended that the tapestry be exhibited each year on the anniversary of William's conquest and that it would forever commemorate the glory of that occasion—and, of course, the bravery of the bishop and builder of the church.

The main course of the action in the Bayeux Tapestry moves like the words on a printed page—that is, from left to right. At times, however, it was necessary to represent a pertinent episode apart from the principal action. In these instances the pictorial narrator simply reversed the usual order and moved the scene from right to left, thus, in effect, achieving a kind of visual parenthesis and avoiding any confusion with the flow of the main story.

Such a reversal is used in the scene depicting the death and burial of the Confessor (Fig. 169). On the right near the top is *King Edward in his bed as he addresses his faithful retainers*. On one side of him is a priest; Harold is on the other, while the queen and her lady-in-waiting are mourning at the foot of the bed. Below, under the words *here he had died*, the body is being prepared for burial. Moving toward the left, the funeral procession approaches *the church of St. Peter the Apostle*, the Romanesque predecessor of Westminster Abbey in London, which Edward had built and dedicated only ten years before. Note the hand of God descending in blessing. The procession includes monks reading prayers and two assistants ringing the funeral bells.

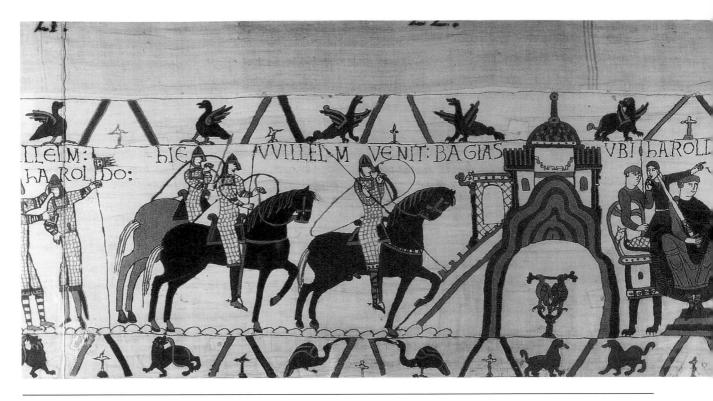

168. Harold Swearing Oath, detail of Bayeux Tapestry. c. 1073–88. Wool embroidery on linen; height 1'8" (.51 m), entire length 231' (70.41 m). Town Hall, Bayeux.

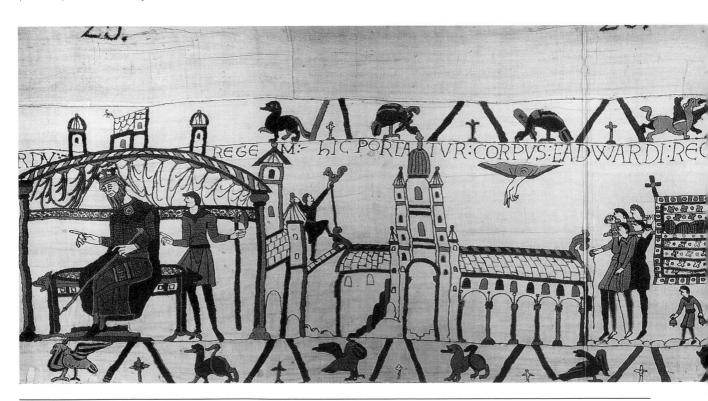

169.Death and Burial of Edward the Confessor, detail of Bayeux Tapestry.

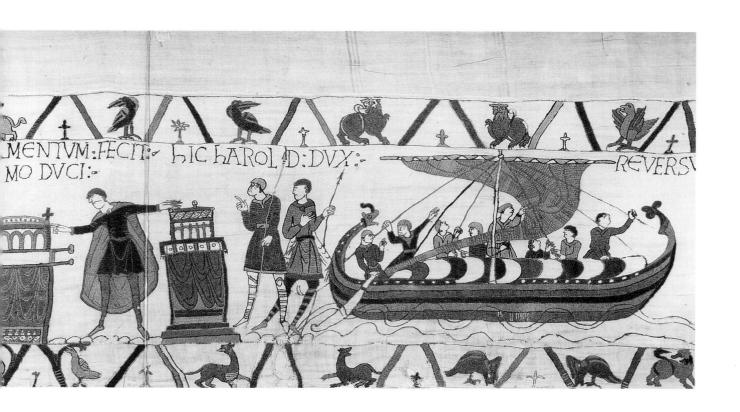

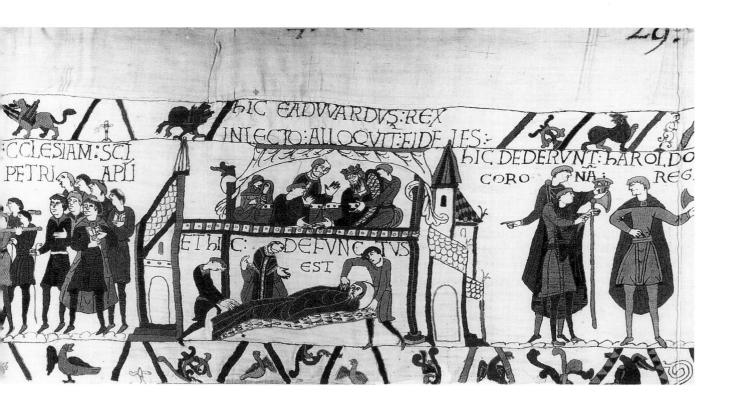

When William received word that Harold had been crowned, he immediately resolved to invade, and the second part of the Tapestry (panels 35–53) is concerned with the preparations for his revenge, up to the eve of the battle. After all was in readiness, he set sail. The ships seen in the Tapestry are similar to those in which William's restless Viking ancestors invaded the French coast two centuries before. It was in just such ships that Leif Eriksson and his fellow mariners apparently reached the eastern coast of North America earlier in the same century.

After the landing, the grand finale begins with the assembling of forces for the great battle (panels 54–79). The Norman side has both archers on foot and knights on horseback, while the English infantry fight to close formation with immense battleaxes, small spears, and clubs with stone heads. The Normans move in from left to right and the English from the opposite direction. The climax of the battle is reached in a wild scene at a ravine, where men and horses are tumbling about while the English and French fall together in battle. Shortly after, Harold is killed, and the fighting concludes with English turned in flight. The lower border in these scenes spares none of the horrors of warfare. Dismembered limbs are strewn about, scavengers strip coats of mail from the bodies of the fallen, and naked corpses are left on the field.

The design of the Bayeux Tapestry is dominantly linear and, like the illuminated manuscripts of the time, is rendered in two dimensions, with no suggestion of spatial depth. The coarseness of the linen and the thickness of the wool, however, create interesting textural contrasts. The eight shades of woolen yarn—three blues, light and dark green, red, buff yellow, and gray—make for a vivid feeling of color, which is not used for natural representation but to enliven the design. Some men have blue hair, others green, and horses often have two blue and two red legs. Faces are merely outlines, though some attempt at portraiture is made in the various likenesses of William (Fig. 170).

Details, such as costumes, armor, mode of combat, and deployment of troops in battle, are by contrast done with great accuracy. For this reason, the Tapestry is a never-ending source of amazement and one of the most important historical documents on the manner of life in the 11th century—so much so that its historical value is often allowed to overshadow its quality as a work of art. Admittedly crude and at times naïve, the Bayeux Tapestry does not elaborate details. It concentrates on telling its story, and the sweeping effect of the whole takes precedence over any of its parts.

The Bayeux Tapestry is a work of infinite variety. In the handling of the narration, after a slow beginning with frequent digressions, the designer went on in the middle panels to the rather feverish preparations that culminated in the breathless climax of the battle. In both tempo and organization, the Tapestry can stand comparison with the best works in narrative form, visual or verbal. The details, whether in the main panels or in the upper or lower borders, are handled so imaginatively that they not only embellish the design but add visual accents, comment on the action, and further the flow of the plot. Scenes are separated one from another by buildings that figure in the story and by such devices as the stylized trees that are mere conventions. So skillfully are these arranged that the continuity of the whole is never halted, and the observer is hardly aware of their presence. All in all, a successful work of art designed for such a long and narrow space is a feat of impressive visual virtuosity, and it leaves no doubt that it is the product of a master designer.

SONG OF ROLAND

Epic poetry is still another feature of the Romanesque picture—sagas based on the mighty deeds of legendary heroes, replete with blood feuds, gory vengeance, and black magic. The Anglo-Saxon Beowulf and the Germanic Nibelungenlied (Song of the Nibelungs), which Richard Wagner revived for his Ring cycle of music dramas in the 19th century, were set in dark forests populated with lurking dragons and bloodthirsty monsters. Their French counterpart, the Chanson de Roland, or Song of Roland, is cast in the mold of a *chanson de geste*, or song of deeds, an action story in poetic form sung by a minstrel to the accompaniment of a viol or lyre. It is an epic poem in Old French, the medieval language of the French people, rather than in the scholarly Latin. Narrated in an abrupt, direct manner, the transitions between episodes are sudden and unexpected. A warlike atmosphere surrounds the characters, including the fighting Archbishop Turpin as well as the Archangels Gabriel and Michael who, like the Valkyries in the Song of the Nibelungs, swoop down onto the battlefield to bear the souls of fallen warriors to heaven.

Though set in an earlier time (the actual event took place in 778), the *Song of Roland* is, both in form and spirit, the product of the warlike feudalistic 11th century, and various recorders of historical events of that time mention it in connection with the Battle of Hastings. Guy of Amiens, one of William and Matil-

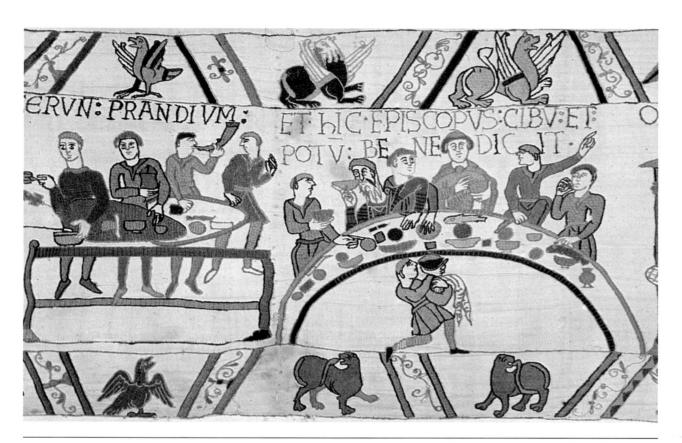

170. William's Feast, detail of Bayeux Tapestry.

da's courtiers, who died ten years after the battle, was the author of a Latin poem about a *jongleur*, or singing actor, by the name of Taillefer. This "minstrel whom a very brave heart ennobled," Guy relates, led William's forces into the battle throwing his sword in the air, catching it again, and singing a song of Roland. The English historian William of Malmesbury, writing about fifty years after the battle, tells that William began to sing the *Song of Roland* "in order that the warlike example of that hero might stimulate the soldiers."

The *Song of Roland* is thus an action-filled story, set in the time of Charlemagne and the Carolingian period. It relates incidents from the campaign in northern Spain where that emperor had been battling the pagan Islamic armies and the troublesome Basques for seven years. Roland, Charlemagne's favorite nephew, and the twelve peers, the flower of French knighthood, had been left in charge of the rear guard, while Charles and the main body of the army were crossing the Pyrenees back into France. Roland is betrayed by his own stepfather, the wicked Ganelon, who has violated his vow of fidelity to Charlemagne and loyalty to his own family. The situation would have been read by the Normans as

William's betrayal by Harold. Roland is attacked near Roncesvalles by overwhelming pagan forces. The outnumbered rear guard is cut to pieces, and Roland, before dying a hero's death, sounds his ivory horn, summoning his uncle and his army from afar.

The latter part of the poem has to do with the vengeance of Charlemagne, just as the corresponding section of the Bayeux Tapestry relates that of William. All is action and heroism, with swords flashing, helmets gleaming, drums beating, horns blowing, banners snapping, and steeds prancing. The story of the battle proceeds in what amounts to a blow-by-blow account, echoing frequently with such statements as "fierce is the battle and wondrous grim the fight."*

First one hears the preparations in the camp of Charles. The poet, using a cumulative technique, describes the ten battalions one by one. Knight is added to knight, battle group to battle group, weapon to weapon, in order to build up the full

^{*} All quotations from *The Song of Roland* translated by Dorothy L. Sayers, published by Penguin Books. © Executors of Dorothy L. Sayers, 1937, 1957.

monumentality of the occasion in the listeners' minds and imaginations. All the forces of Western Christendom are eventually drawn up on Charlemagne's side—the French, Normans, Bavarians, Germans, Bretons, and so on. The virtues of the men invariably are those of bravery, valor, and hardiness. They have no fear of death; never do they flee the battlefield; and their horses are swift and good.

Then quite suddenly and without any transition the reader is in the midst of the pagan hordes. Twenty Saracen battalions are described, and in order to show how the Christians were outnumbered, still another ten are added. The fearsomeness of the enemy, however, is due not to their numbers alone but to their ferocious character as well. The only admirable quality allowed them is that of being good fighters; otherwise they are hideous to behold, fierce and cruel, and lovers of evil. Yet in spite of this the poet can say of both Christian and pagan forces, "Goodly the armies."

The physical appearance of the people from these strange lands is fantastically exaggerated. The Myconians, for instance, are men with "huge and hairy polls, / Upon whose backs all down the spine in rows, / As on wild boars, enormous bristles grow." Of the warriors of the desert of Occian, it is said, "Harder than iron their hide on head and flanks, / So that they scorn or harness or steel cap." Later, during the battle, these same men of Occian "whinny and bray and squall," while the men of Arguille "like dogs are yelping all."

The religious life of the enemy is just as much misunderstood as their appearance. The pagans are represented as polytheists who worship as strange an assortment of gods as was ever assembled-Apollyon, Termagant, and Mahound. When things are not going well from their point of view, they upbraid these gods. The statue of Apollyon is trampled underfoot; Termagant is robbed of his carbuncle, a precious stone; and Mahound is cast "into a ditch . . . For pigs and dogs to mangle and befoul." Later, when Marsilion, the king of Spain, dies, the listener hears that he "yields his soul to the infernal powers." Such descriptions could not have been written after the Crusades had brought Western warriors into contact with Moslem culture. Like the foreigners depicted on the Vézelay tympanum (Fig. 151), then, the imagery of the Song of Roland is filled with naïve wonder.

With the lines of battle thus drawn, the setting is described in a single line: "Large is the plain and widely spread the wold." Then as the conflict begins, battalion falls on battalion, hewing and hacking. Christian knights hurtle against pagan knights the whole day until the battle is reduced to a personal

encounter between Charlemagne and his opposite, Baligant the Emir:

At the Emir he drives his good French blade.

He carves the helm with jewel-stones ablaze,

He splits the skull, he dashes out the brains,

Down to the beard he cleaves him through the face,

And past all healing, he flings him down, clean slain.

After this the pagans flee, and the day is won.

The lines of the original Old French proceed according to a crude rhyming scheme of assonance in which the final syllables of each line correspond roughly in sound. The last words of each line of one of the stanzas will suffice to illustrate this principle of assonance: *magne*, *Espaigne*, *altaigne*, *remaigne*, *fraindre*, *muntaigne*, *m'enaimet*, *reclaimet*, *ataignet*.

Much of the direct character and rugged strength of the poem is due to rigid avoidance of literary embellishment. This is observable in such single lines as the forward motion within such minute details as: So sent Rollanz de tun tens ni ad plus. Nothing is allowed to block the progress of these sturdy military monosyllables. So consistent is this quality of starkness throughout the poem that it even extends to the portrayal of the characters themselves. Each is the embodiment of a single ideal and human type: Ganelon is all treachery and hatred; Roland is bravery to the point of rashness; Oliver, Roland's close companion, is reason and caution; and Charlemagne, outstanding in his solitary grandeur, represents the majesty of both Church and state. Through each one of these devices separately and through all of them together, the poem as a whole rises to the heights of epic art. Its language, style, and form thus will fit the brave deeds of the heroic men with whom its narrative is concerned.

THE ART OF MINSTRELSY

"A verse without music is a mill without water," said Folquet of Marseilles, the *troubadour* (a lyric poet or poet-musician, of noble rank) whom Dante immortalized in his *Divine Comedy*. Poetry in medieval times was a popular art form in which verses were chanted by a jongleur, or *minstrel*, to the accompaniment of a viol or lyre. No festive occasion was complete without these performers who sang *chansons de geste* and lays, told tales and fables, played on a variety of musical instruments, per-

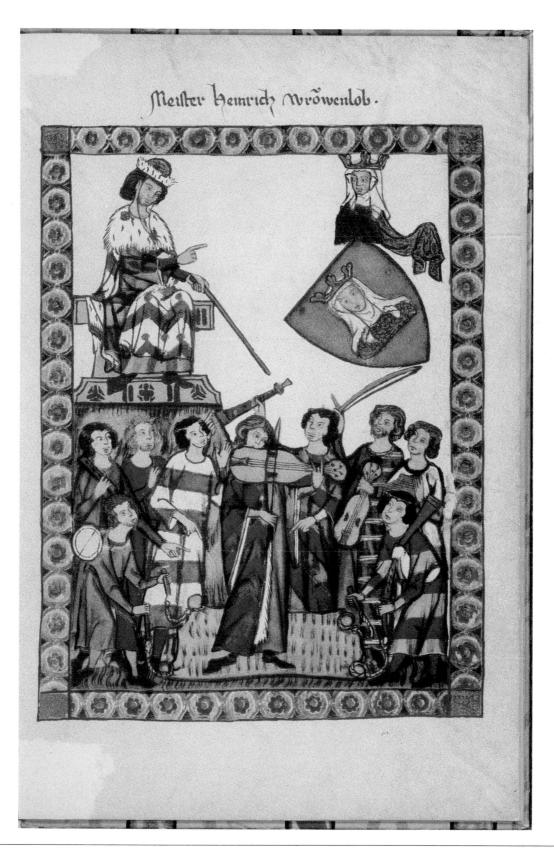

171.

Heinrich Frauenlob Directing a Minstrel Performance, from the Manesse Manuscript of German minnesingers. 14th century. University Library, Heidelberg.

formed dances, and astonished and delighted the audience with juggling and sleight-of-hand tricks.

Records of these jongleurs go back many centuries. It is known that jongleurs gathered at Fécamp in Normandy in the year 1000. It is also known that they met together regularly during the slack season of Lent, when the Church forbade their public performances, to learn one another's tricks and techniques and increase their repertories with new tales and songs. A lively account of their place in medieval society is contained in a description of a wedding feast in Provence, which says: "Then the joglars stood up, each one anxious to make himself heard: then you could hear instruments resounding in many a key. . . . One played the Lay of the Honeysuckle, another that of Tintagel, another that of the Faithful Lovers, another the lay that Ivan made. . . . Everyone performed at his best and the noise of the instrumentalists and the voices of the narrators made a considerable uproar in the hall."

The jongleurs of the 11th century were not of noble birth as were most of the later troubadours and their northern French and German counterparts, the *trouvères* and *minnesingers*, but they were welcomed in every castle and abbey. Records reveal that some women were included in the ranks of jongleurs and troubadours. Under the patronage of the feudal nobility, lyrical poetry and music were to bloom in the 12th and 13th centuries into the full-fledged art of the troubadours, trouvères, and minnesingers. Courtly tournaments, brave knights winning fair ladies, and aristocratic poets making music with minstrels enlivened the nobles' entertainments in the Gothic period (Fig. 171). The practice of holding songfests also began at this time.

Since 11th-century secular music forms were just emerging, the models undoubtedly were derived from certain formulas used in the performance of church music. The simple repetitive melodies of the *chansons de geste*, together with the assonanced stanzas and insistent rhythms of the poetry, had much in common with the litany—though, of course, the subject matter differed radically. It is greatly to be regretted that the musical setting of the *Song of Roland* has not been preserved. While jongleurs could refresh their memories of longer epics from the manuscripts they carried in the leather pouches that they wore, these manuscripts included no musical parts. Hence it is assumed that the melodies were so simple there was little need to write them down.

The music of the *chansons de geste*, according to medieval sources, consisted of a short melody with one note to a syllable, repeated over and over for each verse in the manner of a litany or folk song. At the end of each stanza was a melodic appendage,

which served as a refrain much like the *alleluias* between the verses of psalms and hymns. In the manuscript of the *Chanson de Roland* the puzzling letters AOI appear after each of the 321 stanzas, while in the songs of troubadours and minnesingers the letters are EUOUAE or some variant. EUOUAE is an abbreviation of *sa-e-c-u-lor-u-m-a-m-e-n*, the last two words of the Latin version of the lesser Doxology (the full text of which is "Glory be unto the Father, the Son, and the Holy Spirit, as it was in the beginning, is now, and ever shall be, world without end. Amen"). Thus there is a link between the troubadour's refrain and some Gregorian melody.

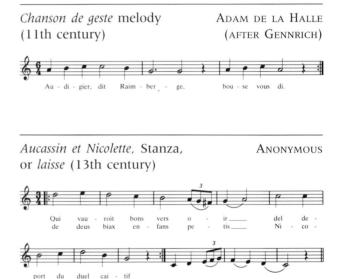

The single authentic example of a chanson de geste melody that survives was quoted in a pastoral play by Adam de la Halle to poke fun at its old-fashioned character (above). The short melody is repeated for each line of the stanza, following which there would have been a short cadenza, or refrain, for either the voice or an instrument. The operation of this refrain principle is also found in a song from Aucassin et Nicolette, a French chantefable (above). Written about a century later, it is similar in style to a chanson de geste. The melody of the first eight measures is repeated for each line of the stanza, each time to different words. The refrain in the final three bars is then either sung or played between each of the verses and again at the end. The extreme simplicity of these melodies indicates that the music alone would not have held an audience. The dominant interests were epic poetry and the minstrel's performance of it with appropriate action, gestures, and vocal inflection.

NORMAN ARCHITECTURE

The architecture of the Normans was sufficiently important to give one aspect of the Romanesque style the name Norman. The building done in 11th-century Normandy not only had a lasting effect on that region of France but also reached a logical conclusion in the fortresses, castles, abbeys, and cathedrals that the Normans later built in England. Since the Romanesque style in England dates from the Norman Conquest, it is still referred to there as the Norman style.

Norman architecture, like many other facets of Norman culture, resulted from the union of the rugged pagan spirit of the Vikings and the Gallic Christian remnants of the disintegrated Carolingian empire. As a representative product of these people, their architecture reflects blunt strength and forthright character. Both the Carolingian and Viking societies were nomadic. Charlemagne and his successors, as well as the dukes of Normandy down to William's time, frequently shifted their residences, and the insecurity of the times discouraged building in general. But as the feudal system reached its mature stage and a more settled order became possible, the Norman conquerors turned to the assimilation and development of the vast new lands they had acquired instead of seeking further conquests. William's policy thus shifted from offensive to defensive. Earlier he had discouraged the construction of cas-

172. Tower of London, aerial view. 1078–97.

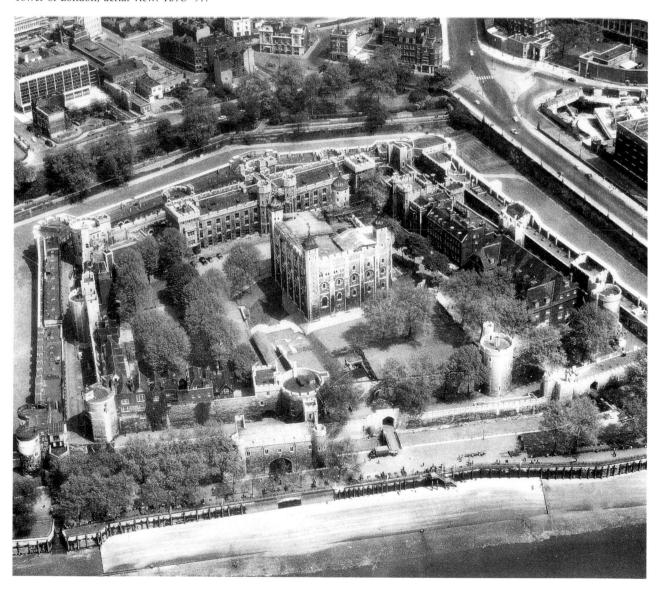

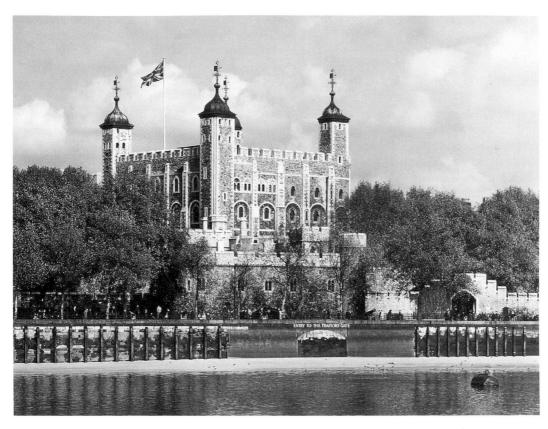

173. above left: White Tower, London. c. 1078–97. Height 92' (28.04 m).

174. above right: Plan of the White Tower. A. Banqueting hall; B. Presence chamber; C. Chapel.

tles and sanctioned only monasteries; now he proposed to impress his new subjects with solid and unconquerable fortresses, as well as feats of arms.

The Tower of London

The Tower of London (Fig. 172), or more specifically the White Tower (Fig. 173), was begun by the Conqueror about 1078 and finished by his successor in order to defend and dominate the town. Its form was that of a Norman keep, and as such it was something new to England. The Tower is simply a massive, square, compact stone building, divided into four stories that rise 92 feet (28 meters) with a turret at each corner. A glance at the plan (Fig. 174) will show some of its many irregularities. Its four sides, for instance, are unequal in length, and its corners are therefore not exactly right angles. Three of its turrets are square, while one is round. The one on the west rises 107 feet (32.6 meters), while that on the south is 118 feet (36 meters) high. The walls vary from 11 to 15 feet (3.4 to 4.6 meters) in thickness. In addition, the interior is divided from top to bottom in two unequal parts by a wall running through from north to south.

The bareness of its original exterior (it has been changed over the centuries) was well suited to the White Tower's function as a fortress, but the austerity, or severity, of the interior was a commentary on the bleakness and general lack of physical comforts of medieval life. The Tower was divided into four stories by means of wooden floors, and its darkness was relieved only by narrow, slitted, glassless windows. They were more important as launching sites for arrows than as sources of light and air.

After Norman times, other buildings were added until the whole became a system of outward-spreading fortification, with the old Norman keep as its heart. From William's time on, the Tower has been in continuous use as fortress, palace, or prison.

The main floor of the White Tower has three divisions: a large council chamber, which also doubled as a banqueting hall, a smaller presence chamber, and the well-preserved St. John's Chapel (Fig. 175). Like a miniature church, this chapel has a barrel-vaulted nave of four bays. On either side are

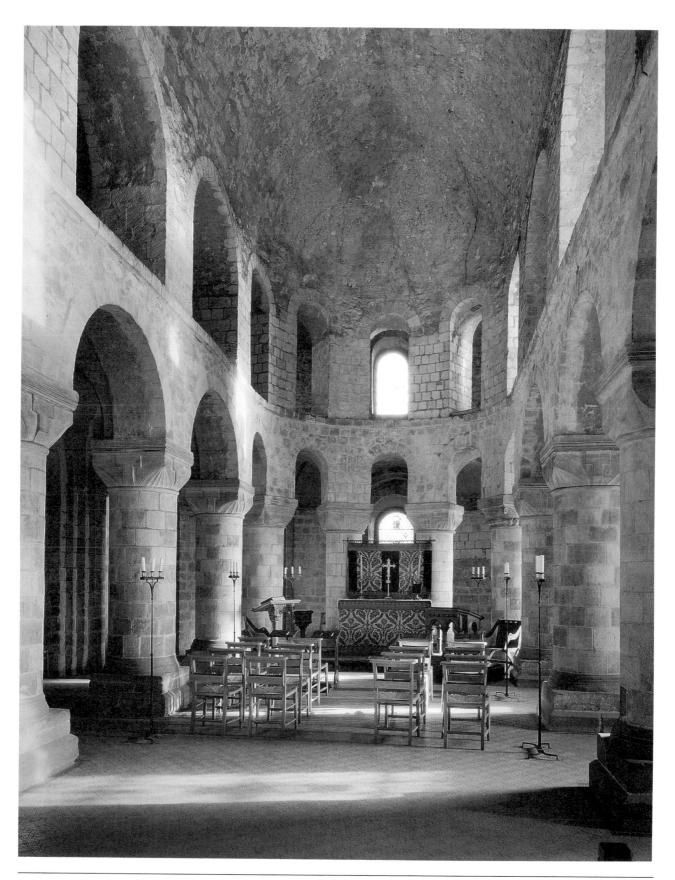

175. St. John's Chapel, White Tower, London. 1078–97.

The Feudal Romanesque Style

While a monastery was a haven of peace, a feudal manor was an armed fortress. While the cloistered brothers were laying up treasures in heaven, the feudal lords were harvesting theirs on earth. And while the monk was a man of prayer, the landed baron was a man of war.

Surviving examples of secular art from the Romanesque period are so rare that each is practically unique. The treasures of a monastery or cathedral were under the watchful eye of the clergy, and religious restraints against raiding Church property usually were strong enough to prevent wanton destruction. The same cannot be said for secular property. Feudal castles constantly were subject to siege, and those that survived frequently were remodeled in later centuries with the changing fortunes of their successive owners. Among the best preserved of these Romanesque residences are the Imperial Palace near Goslar, Germany (Fig. 165); the Wartburg Castle, where Tannhäuser's famous songfest took place; and parts of the Palace of the Normans in Si-

cily, notably the Dining Hall of Roger II, with its emblematic animals and traditional symbols of feudal heraldry (Fig. 166).

Towns did grow up in the protective shadows of a castle, a monastery, or a cathedral, but only a few urban dwellings remain, such as those at Cluny (Fig. 167). Their arched doorways facing the street sometimes were decorated by sculptured hunting scenes or representations of an artisan's trade—a cobbler bending over his workbench, for example, or a merchant showing cloth to a client. Of interior decorations—mural paintings, wall hangings, furniture, and the like—almost nothing is left. And since poctry and music were intended to be heard rather than read by these feudal people, little of either was written down.

History, however, is filled with accidents. For example, the single large-scale example of secular pictorial art, the famous Bayeux Tapestry, survives because it was designed for a church instead of a castle. The only French epic poem before the Cru-

165. Imperial Palace at Goslar, Lower Saxony, Germany. Begun 1043, rebuilt 1132. Chapel of St. Ulrich (far left), 11th century.

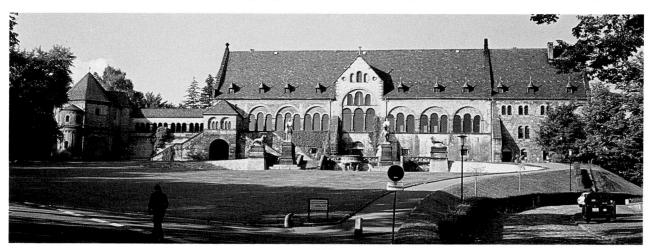

aisles that command interest because of their early use of cross vaulting. The columns of the nave arcade are thick and stubby, and the cushion-like capitals have only the most simple scalloped carving by way of decoration. Above is a triforium gallery, which was used by the queen and her ladies, with slitlike windows that serve as a clerestory.

Abbey Churches at Caen

At Caen in Normandy, two buildings were under the personal protection of William and Queen Matilda and designated as their respective burial places: St. Étienne, or Abbaye-aux-Hommes (Fig. 176), and Ste. Trinité, or Abbaye-aux-Dames. Since both were abbey churches, they properly belong in a discussion of the monastic Romanesque style. They were, however, not commissioned by the Church itself, but by two worldly donors. Here they serve to complete the picture of the Norman style.

Begun just prior to the conquest, St. Étienne has a well-proportioned west façade. Four prominent buttresses divide the section below the towers into three parts that correspond to the central nave and two side aisles of the interior. Vertically, the façade rises in three stories, with the portals matching

176. Façade, St. Étienne (Abbaye-aux-Hommes), Caen. c. 1064–1135. Nave 157'6" × 32'10" (48.01 × 10.01 m), height of towers 295' (89.92 m).

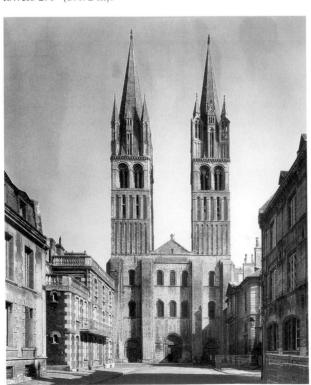

the level of the nave arcade inside, while the two rows of windows above are at the gallery and clerestory levels, respectively. The windows are mere openings and in themselves are quite undistinguished. But the functional honesty in this correspondence of exterior design and interior plan was a Norman innovation that came into general use in the Gothic period.

The twin towers belong to the original design, but their spires are later additions. As with the usual Norman church, the towers are square and in three stories. Thus they repeat on a higher level the triple division of the façade below. The first story is of solid masonry. The second has alternate blind (that is, blank) and open arches. The greater open space of the third story contributes to its function as a belfry and relieves the general heaviness. Otherwise the bareness and heaviness of the façade in general is a fitting prelude to the gloomy grandeur of the interior (Fig. 177). The church as a whole is as thoroughly rugged and masculine in character as its founder and typifies the spirit of the Norman people and their forceful leader.

When the bare façade of St. Étienne is compared to the exterior of the Tower of London, it becomes apparent that the lack of decoration was a

177. Interior, St. Étienne.

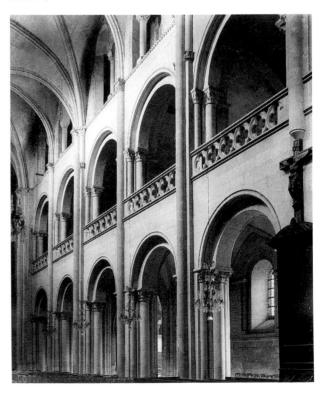

conscious part of the design of both. One façade impresses by its bold outlines, sturdiness, and straightforward honesty, the other by its strength and bluntness.

Though the Norman accent on structure rather than embellishment was to be replaced soon after the Crusades by Saracen innovations, it did lead to advances in the art of building. In their churches, although the clerestory windows were small, the Normans achieved more adequate lighting than in previous Romanesque structures. More unified interiors were attained by connecting the three levels of the nave arcade, gallery, and clerestory by single vertical shafts between the bays that run from floor to ceiling. Both these features, as well as the harmonious spatial divisions of such a façade as that of St. Étienne, were incorporated into the Gothic style.

Still, when the work of the Normans is placed alongside that of their Burgundian contemporaries, it seems crude by comparison. The Normans were as blunt and brash as the Cluniacs were ingenious and subtle. The difference, in short, is that between men of action and men of contemplation.

IDEAS: FEUDALISM

The Bayeux Tapestry, the *Song of Roland*, the abbey churches at Caen, and the White Tower in London are representative of the Romanesque style, and all are related in time, place, and intent. Each was a high point in the development of Norman culture, falling between the dates of the Battle of Hastings in 1066 and the First Crusade in 1095. The *Song* was sung at the battle; the Tapestry was designed soon after the battle whose tale it tells (and both reveal the same form and spirit); and the abbey churches and the Tower were built when William's success and prosperity after the conquest were at their height. This relationship coincided with the climax of feudalism, and it is in the terms of this all-embracing concept that the individual works have their unity.

All the separate concepts of the Norman world were contained in the overpowering central idea of feudalism. Like the concentric rings of the inner and outer fortifications of the Tower of London, individuals in a feudal society were but tiny circles in an expanding cosmic scheme of things that determined their relations to their superiors, their peers, and their inferiors. The feudal system provided a proper place for every person in a strict hierarchy, with barons holding their power from their overlords, ecclesiastical or secular; dukes holding their realms from their king; and the king, emperor, and pope holding the earth as a *fief*, or feudal estate, from God.

Feudal Virtues

The feudal virtues were faith, courage, and loyalty to peer and superior. Feudalism, as a system of government, was based on the possession of land. Whatever the station in life, everybody was a vassal of some lord, a relationship that involved mutual obligations. As the vassal one was bound to swear an oath of *fealty*, or fidelity, that promised loyalty to the immediate superior. Central governments were weak, and the main function of kings was to raise armies in order to defend their realms against foreign invaders. Local governments were powerful in enforcing laws, raising taxes, and settling disputes.

Factional and regional confrontations involving treachery and defection from the feudal code had to be decided by personal combat or on the field of battle, with God awarding victory to the righteous cause. Enemies, however, were granted the distinctions of honor and bravery, provided their lineage was in order; otherwise it would have been socially impossible to do battle with them. In the *Song of Roland*, no one below the rank of baron figures with any degree of prominence; similarly, the abbeys of William and Matilda were intended primarily for persons of rank, and by the foundation of these churches the royal pair pledged their feudal oath to God.

In their subject matter, the *Song of Roland* and the Bayeux Tapestry have many points in common. As the *Song* opens:

Carlon the King, our Emperor Charlemayn,

Full seven years long has been abroad in Spain.

He's won the highlands as far as to the main:

No castle more can stand before his face.

City nor wall is left for him to break, Save Saragossa in its high mountain place;

Marsilion holds it, the king who hates God's name,

Mahound he serves, and to Apollyon prays:

He'll not escape the ruin that awaits.

If the simple substitutions of William for Charles, England for Saragossa in Spain, the barrier of the sea for that of the mountain, and Harold for Marsilion are made, the situation becomes the contemporary one that the Tapestry so vividly portrays. Later, at the battle of Roncesvalles, the dominant trio is Roland, Oliver, and the fighting Archbishop Turpin, in whom it is not difficult to recognize their parallels at Hastings: William and his half brothers, Robert of Mortain and the irrepressible Bishop Odo.

Both Tapestry and poem are set in a masculine world of clear-cut loyalties and moral and physical certainties. Chivalry in each is based on the ways of fighting men. The code of Roland and Oliver, and of William and Odo, was clearly "My soul to God, my life to the king, and honor for myself." It remained for the Gothic period to add "My heart to the ladies." Roland's dying thoughts, for instance, are occupied with his family and lineage; his king, Charlemagne; his country, the fair land of France; and his sword, Durendal. Surprisingly, he makes no mention of the woman he has promised to marry, the Lady Aude.

Earlier, the exasperated Oliver had reproached Roland for his rashness in not summoning aid sooner, and at that time he swore:

Now by my beard . . . if e'er mine eyes Again behold my sister Aude the bright, Between her arms never you think to lie.

No true or courtly love is this, only the feudal baron bestowing his female relatives like his goods and property on those whose faith and courage he has cause to admire. Later, after Charles returns to France, the poor Lady Aude inquires about the fate of her fiancé. The King tells her of his death and as a consolation prize offers her the hand of his son, Louis, whereupon the lady falls dead at his feet. Whether she dies of grief for Roland or from the indelicacy of Charlemagne's suggestion is left open to conjecture. Since scarcely more than a dozen of the 4,000-odd lines of the poem are devoted to her, the historian Henry Adams was fully justified in observing: "Never after the first crusade did any great poem rise to such heroism as to sustain itself without a heroine."

Curiously enough, on the Saracen side Marsilion's queen takes an important part in the affairs of state after her husband is incapacitated. Nowhere on the Christian side is a woman given anything like a similar status. And in the Bayeux Tapestry, the only place where a woman is mentioned by name is the enigmatic inscription *Where a cleric and Aelfgyva*, apparently introduced to give a motive for the minor episode describing an invasion of Brittany. While a few female figures are found in the borders and in

attendance at the death of the Confessor (Fig. 169), none has any prominence. Both works are thus as bold and direct as the poetry and art of the coming Gothic period was delicate and subtle. Roland and his counterparts in the Tapestry fought for king and country, while the knightly hero of the later period entered the lists for a loving glance from his lady fair's blue eyes, a fleeting smile, or a fragrant rose tossed from his lady's chamber.

Ruggedness of Feudal Art

Formal considerations of the *Song of Roland* and the Bayeux Tapestry are in keeping with their rugged character. The emphasis everywhere is on the concrete rather than the abstract, content rather than form, and separate narrative episode over structure.

Symmetry in the *Song* and the Tapestry is seldom considered. The lines of the poem, for example, are rough-hewn but heroic pentameters that group themselves into irregular stanzas (known as *laisses*) averaging fourteen lines in length. Similarly, the space given to individual scenes in the Bayeux Tapestry, like the irregular size of the compartments in the archivolt of the Vézelay tympanum (Fig. 151) and the unequal height of the arches in a Romanesque cathedral wall, takes no account of proportion and balance in a unified design.

Details in the *Chanson*, the Tapestry, St. Étienne, and the Tower of London thus remain crude and unpolished. The Romanesque in general and the Norman period in particular are characterized by forming, the art of building, experimenting, and reaching out toward new modes of expression.

In architecture, the process of building was more important than what was built. The emphasis in the Tapestry on representations of castles, fortifications, and specific buildings, like the Bayeux Cathedral and the abbey churches at Caen, suggests the image of a builder's world and a century of architectural activity and progress. The forthright, direct narration of deeds in the Song and Tapestry finds its architectural counterpart in the functional honesty of the Tower style and William's church at Caen. Just as the action-filled stories of the Chanson and Tapestry take precedence over literary form and decorative flourish, so the structural honesty of the building process, as exemplified in the Tower and St. Etienne, becomes the leading characteristic. The process of lengthening balladlike poetry into the epic chanson de geste, capable of sustaining attention through the long Norman winter evenings or of extending a few pictorial panels into a heroic tapestry depicting a major historical episode in its entirety, was essentially the same as that of piling up tall towers that could pierce the gloomy northern skies.

The image of the Norman world as it thus builds up through the various arts is not essentially a complex one. There was little of the mystical about these clear-headed Viking adventurers. They caught on quickly to any progressive development of the time, whether it was the discarding of their rather inflexible mother tongue in favor of the more expressive French or the adopting of many of the Cluniac moral and architectural reforms.

Whatever the Normans did, they did always with characteristic determination and energy. Thus the rugged man of action in William unites with the military monosyllables of the Chanson, the frank, almost comicstrip directness of the Bayeux Tapestry, and the rough-hewn stones of the Tower and abbeys to make a single monolithic structure. Each was concerned with forms of action, and whether in picture, word, or stone, the epic spirit is present. Deed on deed, syllable on syllable, stitch on stitch, image on image, stone on stone—each builds up into the great personality, heroic epic, impressive tapestry, or gaunt tower. In the process a Norman feudal structure of monumental proportions is revealed.

GOTHIC PERIOD IN FRANCE

	KEY EVENTS	ARCHITECTURE	LITERATURE AND MUSIC
1100 -	1095-1291 Crusade period . Christians and Moslems fought over Holy Land; trade routes opened		
1100	1116 University of Bologna founded 1137 Louis VII King of France ; married Eleanor of Aquitaine		c.1130 Abelard (1079-1142) wrote <i>Sic et non</i> , taught at School of Notre Dame, Paris
1140 -	c.1150 University of Paris founded	1140 Abbey Church of St. Denis , prototype of Gothic Cathedrals, begun by Abbot Suger	c.1149 Abbot Suger (1081-1151) wrote account of building and decoration of St. Denis c.1150 Adam of St. Victor wrote hymns with St. Bernard of Clairvaux c.1150 Troubadours flourished c.1150 Léonin active as composer at Cathedral of Notre Dame, Paris
1160 -	c.1163 Oxford University founded	1163-1235 Cathedral of Notre Dame in Paris built	1160 <i>Tristan et Iseult</i> , Celtic epic, written 1170 <i>Lancelot and Perçeval</i> , romance of courtly love, by Chrétien de Troyes
1180 -	1180-1223 Philip Augustus reigned as king of France; enclosed Paris with walls; Paris became capital city	1194-1260 Chartres Cathedral built after fire destroyed earlier Romanesque cathedral. 1260 new cathedral dedicated by Louis IX	c. 1183 Perotin active as composer at Cathedral of Notre Dame, Paris
1200 -	1200 Cambridge University founded 1215 Magna Carta signed by King John in England 1223 Louis VIII crowned king of France 1226 Louis IX king of France under regency of mother, Blanche of Castile, until 1236	1210 Rheims Cathedral rebuilt 1220 Amiens and Rouen cathedrals begun 1225 Beauvais Cathedral begun; choir finished 1272 1243 Ste. Chapelle, royal chapel of French kings, begun in Paris	1236 Roman de la Rose written c.1250 Vincent of Beauvais (died 1264) wrote encyclopedic Speculum Naturale, Historiale, Doctrinale 1250 Albertus Magnus (c.1193-1280), scholastic philosopher taught at University of Paris 1273 Summa theologiae written by Thomas Aquinas (1225-1274) 1275 Scholastic philosophy at height c.1280 Adam de la Halle (c.1237-1288) author and composer of Le Jeu de Robin et Marion, pastoral play with music
1300 -		1334-1362 Palace of pope s built at Avignon	

The Gothic Style

ÎLE-DE-FRANCE, LATE 12TH AND 13TH CENTURIES

In contrast to the shores of the Mediterranean, where such splendid centers of culture as Athens, Alexandria, Antioch, Constantinople, and Rome flourished for centuries, northern Europe had been little more than a rural region with a few Roman provincial outposts and, later, a scattering of castles, monasteries, and villages. Before the 13th century not one medieval center north of the Alps could properly have been described as a city.

Toward the end of the 12th century, however, Philip Augustus as king of France was promoting the destiny of Paris as his capital, enclosing it with walls and paving some of its streets with stone. The work was continued under his successors, and by the end of the 13th century Paris was the capital of a kingdom of growing importance. With its splendid Cathedral of Notre Dame; its university famed for the teaching of Abelard, Albertus Magnus, Thomas Aquinas, and Bonaventura; and with its flourishing mercantile trade capable of supporting about 150,000 inhabitants, Paris could well claim the sta-

• Cambridge Malmesbury Oxford London • Bruges Salisbury Ghent Cologne Lille Beauvais J. Rheims • St. Denis BRITTANY Strasbourg • **ILE-DE-FRANCE** Bourges miles 100 **BURGUNDY** 100 200

tus of a capital city. When it is remembered, however, that Constantinople was the hub of the rich East Roman Empire and had been a city of over a million since Justinian's time, the status of this first northern urban center is seen in proper perspective.

The growth of Paris, while more rapid than that of other northern centers, was far from an isolated instance. For a full century, the town as a social unit had been gaining importance over the manorial estate, and the literature of the time mentions Ghent with its turreted houses, Lille and its cloth, Tours and its grain, and how all were carrying on commerce with distant lands. With the exception of such occasional references, however, the life of medieval French towns would have remained a closed book had it not been for the visual record preserved in the castles of their feudal lords and in the monasteries. Above all, it is seen in the building and decoration of Gothic cathedrals.

The loftiest expression of the medieval period is seen in these miracles of soaring stone—the crystal-lized expressions of community effort, religious exaltation, and emotional and intellectual forces of the people who created them. Gothic architecture, moreover, is a struggling, striving, dynamic urge that reaches upward to embrace infinity. Though the building process often spanned several centuries, there are no finished Gothic cathedrals.

The prototype of the Gothic cathedral has been recognized in the abbey church of St. Denis (Figs. 178, 179) just outside Paris. This monastery was under the direct patronage of the French kings and was their traditional burial place. Around the middle of the 12th century its abbot was Suger, a man whose talents were as remarkable as his origin was humble. The trusted confidant of two kings, he ruled France as regent while Louis VII was away on a crusade. When he undertook the rebuilding of his abbey church, his great personal prestige, as well as its importance as the royal monastery and burial place, enabled him to call together the most expert

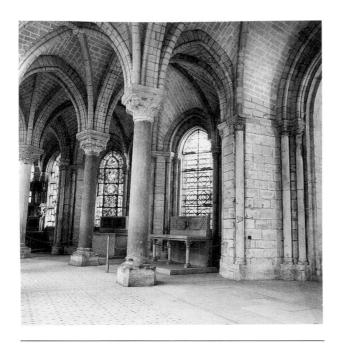

178. Choir (including ambulatory) of Abbey Church of St. Denis, near Paris. 1140–44.

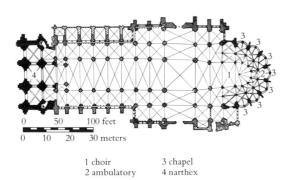

179. Plan of the Abbey Church of Saint Denis. (Abbot Suger was responsible for those parts of the existing church shaded black.) 1. Choir; 2. ambulatory; 3. chapel; 4. narthex.

craftsmen from all parts of the kingdom. Suger's church thus became a synthesis of all the ideas that had been tried and found successful by the Romanesque builders.

Posterity has had reason to rejoice that the abbot's enthusiasm for his project caused him to write extensively about it, for his book is an invaluable source of information about the architectural thought of the time. In 1130, when St. Denis was in the planning stage, Abbot Suger had made a prolonged visit to Cluny to learn from firsthand observation about its recently completed church. His commentary on the iconography of the windows and

sculpture of St. Denis suggests that he took a personal hand in this part of the project, but of the architect who carried out the building no mention is made. St. Denis is notable not so much for its innovations as for its successful combining of such late Romanesque devices as the pointed arch, ribbed stone vaulting, and radiating apsidal chapels.

Many late Cluniac Romanesque churches had used these features separately, but not before Suger's church had they been brought into a dynamic system of structural relationships. The abbot's position at the French court, as well as the proximity of his church to Paris, assured the widest possible circulation of his ideas. Hence, St. Denis became the model for many of the Gothic cathedrals that were built in the region shortly afterward.

The Île-de-France (see map. p. 181), the royal domain with Paris as its center, was the setting in which the Gothic style originated and where, over a period extending approximately from 1150 to 1300, it reached the climax of its development. The name of this region referred to the royal lands under the direct control of the French king. The rest of what is now France was still under the dominion of various feudal lords. By heredity, marriage, conquest, and purchase, the Île-de-France gradually had grown over the years into the nucleus of the future French nation. Like a wheel with Paris as its hub, it radiated outward about 100 miles (161 kilometers), with spokes extending toward the cathedral towns of Amiens, Beauvais, Rheims, Bourges, Rouen, and Chartres.

Cathedrals as such were city-oriented churches. Unlike an abbey church, a cathedral is located in a populated area where it comes under the administration of a bishop, whose official seat it is. A cathedral cannot rise from a plain like a monastic church; it needs the setting of a town where it can soar above the roofs and gables of the buildings that cluster around it. The barren exterior of an abbey forbids, while the intricate carving on the outside of a cathedral awakens curiosity and invites entrance. As the center of a cloistered life, a monastic church is richest in its dim interior, while the most elaborate decoration of a cathedral points toward the dwelling places of the people.

The tall towers of a Gothic cathedral need space from which to spring and room to cast their shadows. Their spires beckon the distant traveler to the shrine beneath and direct the weary steps of the toiling peasant homeward after a day in the fields. The bells they enclose peal out to regulate the life of a whole town and its surrounding countryside. They tell of weddings and funerals and of the time for work and rest and prayer.

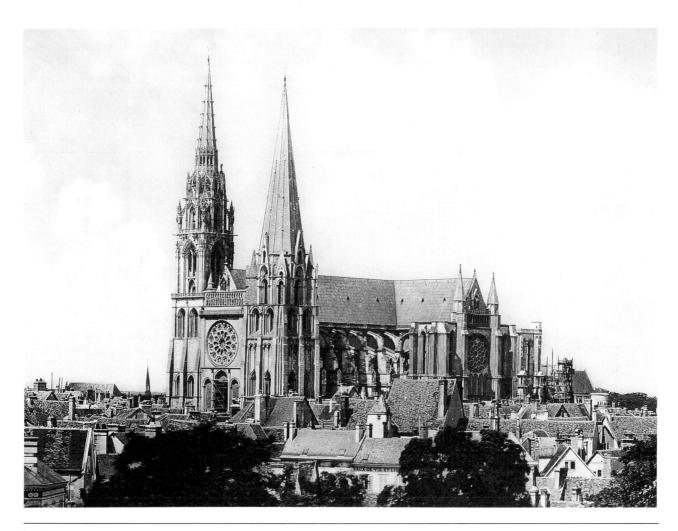

180. Chartres Cathedral, from south. c. 1194–1260.

A cathedral is, of course, primarily a religious center, but in a time when spiritual and worldly affairs were closely interwoven, the religious and secular functions of a cathedral were intermingled. Its nave was not only the place for religious services but on occasion a town hall where the entire populace could gather for a meeting. The rich decorations that clothe the body of the cathedral told not only the story of Christianity but also the history of the town and of the activities of its people. The cathedral was thus a municipal museum on whose walls the living record of the town was carved.

Inside, the iconography of a cathedral dedicated to Notre Dame (Our Lady) was concerned mainly with religious subjects. Since the Virgin Mary was also the patron of the liberal arts, her cathedral often constituted a visual encyclopedia whose subjects ranged over the entire field of human knowledge. The pulpit was not only the place from which sermons were preached but also a podium for lec-

tures and instruction. The sanctuary became a theater in which the constantly changing sequence of religious drama was enacted. The choir was not only the setting for liturgical song but, like a concert hall or opera house, it was the place where intricate polyphonic choral works could be performed and the melodies of the religious dramas chanted.

Outside, the deep-set portals provided stage sets for the mystery plays appropriate to the season, and the porches became platforms from which minstrels and jugglers could entertain their audiences. The stone statues and stained glass were useful not only as illustrations for sermons but also as picture galleries to stimulate the imagination.

Chartres (Fig. 180), unlike Paris, was never a center of commerce but a small town of fewer than 10,000 in the midst of a rural district well off the beaten path. Its greatest distinction came from its shrine of the Virgin Mary, where annually thousands congregated from far and wide to celebrate the

feasts of the Virgin, the grand celebrations that were unique to the Cathedral of Chartres.

Here as elsewhere, the cathedral was not only the spiritual center of the lives of the townsfolk but also the geographical center of the medieval town. Towering over all, its great shadow fell upon the clustering church buildings that included the bishop's palace, the cathedral school, a cloister, a hospice or lodging for travelers, and an almshouse for help to the poor. Its west façade faced one side of the mar-

181. below left:

West facade, Chartres Cathedral. Portals and lance windows c. 1145; south tower (right) c. 1180, height 344′ (104.85 m); north spire (left) 1507–13, height 377′ (114.91 m). Length of cathedral 427′ (130.15 m), width of facade 157′ (47.85 m).

182. below right: Plan of Chartres Cathedral.

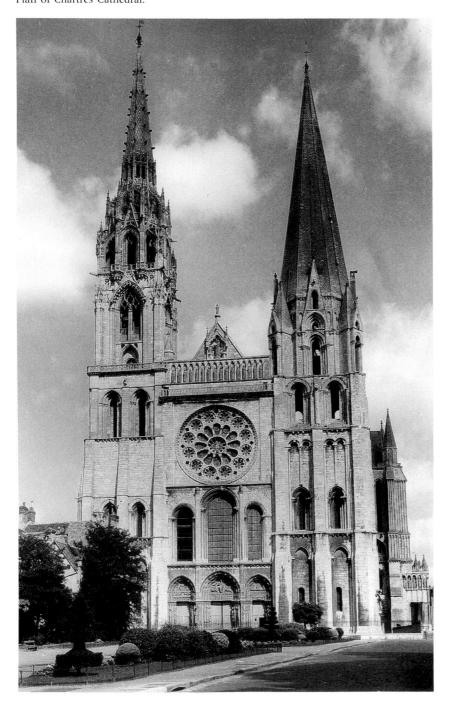

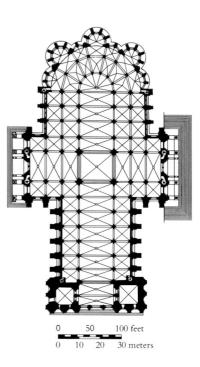

ketplace, and from the cathedral square radiated the narrow streets on which were located the houses and shops of the townspeople. As members of guilds (associations of craftsmen), the people of the town contributed their labor and products to the cathedral when it was being built and through their guilds donated windows and statuary. They also undertook to fill such continuing needs as candles for the altars and bread for the communion service.

The cathedral itself, toward which all eyes and steps were drawn, represented a group effort of the stonecutters, masons, carpenters, and metalworkers, all of whom gave of their time, skill, and treasure to build it. It thus was the greatest single product a town could produce.

As a great civic monument the cathedral was the pride of the community, and the ambitions and aspirations of citizens determined its character and contours. In those days, the importance of a town could be measured by the size and height of its cathedral as well as by the significance of the religious relics its cathedral housed. Civic rivalry was thus involved when the vaulting of Chartres rose 122 feet (37.2 meters) above the ground. Next came the cathedral at Amiens, which achieved a height of 140 feet (42.6 meters). Finally Beauvais became the loftiest of all with the crowns of its high vaults soaring more than 157 feet (47.9 meters).

The extraordinary religious enthusiasm that prompted the undertaking and construction of these immense projects is well brought out by several medieval writers. Allowing for the enthusiasm of a religious zealot, as well as for the probably symbolic participation of the nobles in manual labor, Abbot Haimon's words reflect the spirit of these times:

> Who has ever heard tell, in times past, that powerful princes of the world, that men brought up in honor and wealth, that nobles, men and women, have bent their proud and haughty necks to the harness of carts, and that, like beasts of burden, they have dragged to the abode of Christ these waggons, loaded with wines, grains, oil, stone, wood, and all that is necessary for the wants of life, or for the construction of the church? . . . When they have reached the church, they arrange the waggons about it like a spiritual camp, and during the whole night they celebrate the watch by hymns and canticles. On each waggon they light tapers and lamps; they place there the infirm and sick, and bring them the precious relics of the Saints for their relief.

ARCHITECTURE OF CHARTRES **CATHEDRAL**

West Façade

When the harmonious proportions of the west facade of the Cathedral of Notre Dame at Chartres (Fig. 181) are first observed, everything appears as right as an eternal truth. Yet what seems so certain, so solid, so monumental is actually the end result of fire salvage, a long process of growth, and a goodly amount of improvisation. Four centuries, in fact, separate the earliest parts from the latest, and the interval between saw rapid construction in time of prosperity, slower progress in time of poverty, work inspired with religious ardor, and cruel destruction by fire.

The stylistic difference between the two spires is one of the most striking features of the Chartres façade. The supporting towers, part of the previous church, are approximately contemporary. The upper part and the spire of the one on the right, however, date from the time the later parts of the Romanesque abbey church at Cluny were being finished. Their counterparts on the left are contemporary with the laying of the foundations for St. Peter's basilica in Rome in the early 16th century.

Close inspection will reveal such minor flaws as the discrepancy between the proportions of the portals and the scale of the façade as a whole, the rosc window being set slightly off center, and the awkward joining of the gallery and arcade of kings above it with the tower on the right. In spite of these differences, the facade bears out the initial impression of unity surprisingly well. Its space is so logically divided as to become an external promise of the interior plan (Fig. 182). Horizontally, the three entrance portals lead into the nave, while the flanking towers face the aisles. Vertically, the portals correspond to the nave, arcade within, the lancets to the triforium gallery, and the rose window to the clerestory level. By this means, the spatial composition maintains a close relationship between the inner and outer aspects of the structure.

Rising above the twin towers are the tall, tapering spires that seem both a logical and necessary continuation of the vertical lines of the supporting buttresses below and a fitting expression of the Gothic spirit of aspiration generally.

Nave

When one enters Chartres Cathedral through the central portal, the broad nave (Fig. 183) spreads out to a width of 53 feet (16 meters), making it one of

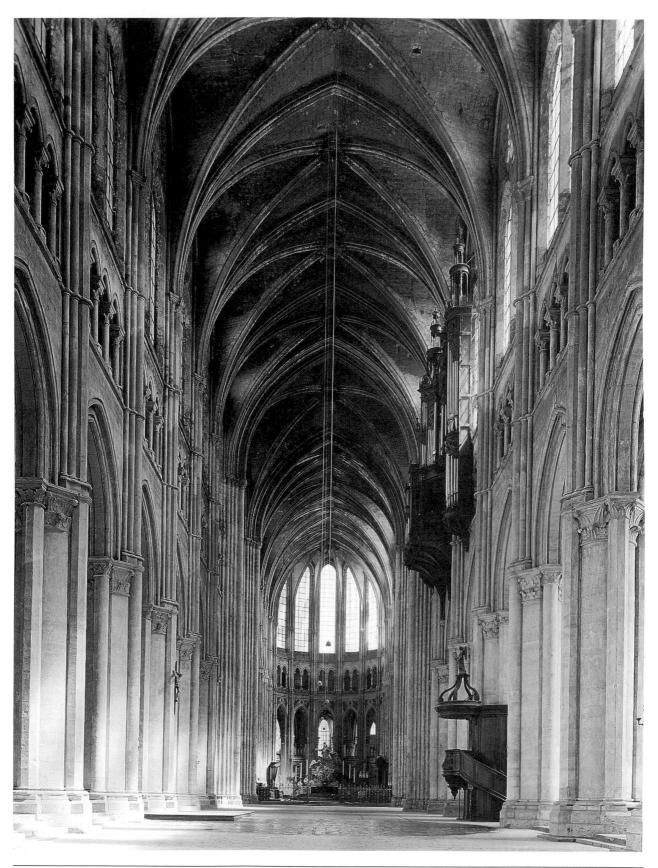

183. Nave and choir, Chartres Cathedral, c. 1194–1260. Length of nave 130' (39.62 m), width 53' (16.15 m), height 122' (37.19 m).

the most spacious of all Gothic naves. On either side are amply proportioned aisles with their stained glass windows that allow a rich flood of light to enter.

INTERIOR CONSTRUCTION. The plan reveals that in comparison with the abbey church at Cluny (Fig. 148), the Gothic architect has practically dispensed with walls. Instead of running parallel to the nave, the buttresses are now at right angles to it, and the area between is bridged over with vaults. This allows open space for glass to light the interior at both ground and clerestory levels. The walls, instead of serving to bear the weight of the superstructure, now exist mainly to enclose the interior and as a framework for the glass.

Through the language of form and color, in representations of religious subjects, the wall space communicates with the worshipers. On a sunny day the beams of filtered light transform the floor and walls into a constantly changing mosaic of color. Together with the clerestory windows, the shafts of mysterious light serve also to accent the structural system of arches, piers, and vaults in such a way as to contribute to the illusion of infinite size and height. And since the eye is naturally drawn to light, the interior gives the impression of being composed entirely of windows (Fig. 184).

From the center of the nave, attention is drawn next to the arcade of six bays marching majestically toward the crossing of the transept and to the choir beyond. Each immense *pier* consists of a strong central column with four attached colonnettes of more slender proportions clustered around it. As Figure 184 shows, piers with cylindrical cores and attached octagonal colonnettes alternate with piers with octagonal cores and attached cylindrical colonnettes. An interesting rhythm of procession and recession is set up, and a further variation is provided by the play of light on the alternating round and angular surfaces of the piers.

The space above the graceful pointed arches of the nave arcade is filled by a series of smaller open arches that span the space between the bays (see Fig. 185). Behind them runs the triforium gallery, a passage using the space above the internal roofing over the aisles and under the slanting external roof that extends outward from the base of the clerestory. Above the triforium runs the clerestory level, which now fully accomplishes its purpose. The triple pattern of two tall, pointed *lancet windows* below and a circular one above allows a maximum of open space for the glass and a minimum for the masonry.

Covering the span of the nave is the triumph of the Gothic builders, the broad quadripartite or four-

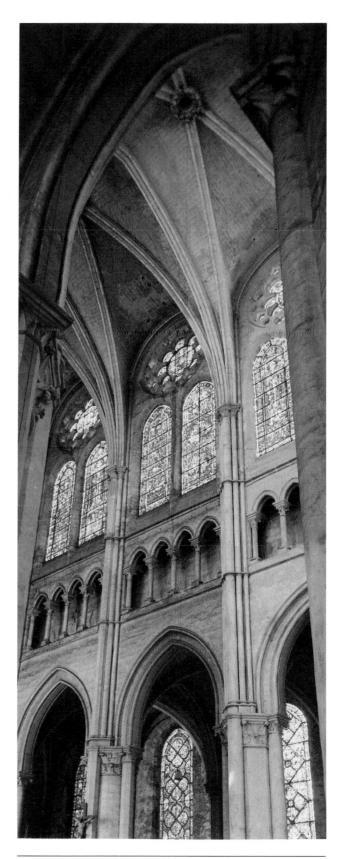

184. North clerestory wall of nave, Chartres Cathedral. c. 1194–1260

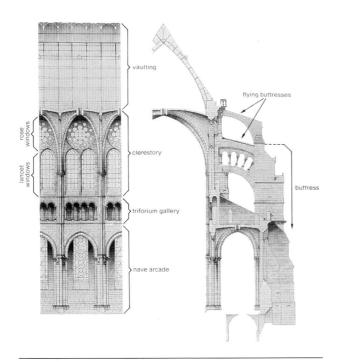

185.Transverse section of nave (left) and diagram of vaulting (right), Chartres Cathedral. Drawing by Goubert.

part vaulting (Figs. 183 and 185) that at Chartres rises 122 feet (37 meters) above the ground level. It is this principle of vaulting that underlies all Gothic thinking and, in turn, explains all the supporting facts of shafts, colonnettes, clustered columns, buttresses, and pointed arches. Each of these comes into play to direct the desending weight of the intersecting ribs of the vaults toward the ground as efficiently as possible. The heavier transverse ribbing is carried past the clerestory and triforium levels by the large central shaft, while the smaller cross ribs are borne by the groups of slender colonnettes that extend downward and cluster around the massive central piers of the nave arcade below.

Chartres is about midway in the cumulative trial-and-error process by which the Gothic system was eventually perfected. The central piers of the nave arcade are still somewhat bulky, as though the architect did not feel entirely free to be daring. Greater slenderness was achieved at Rheims and Amiens. The tendency toward slimness and height continued until its limit was achieved at Beauvais.

EXTERIOR SUPPORTS. Externally, there is an opposite number to each of these interior members (Fig. 186). The purpose of the flying buttress is to carry the thrust of the vaulting at specific points over the aisles to the outer buttresses that are set at right angles to the length of the nave. The function of the flying

buttress and exterior buttressing is now clarified. From the observer's point of view, just as in the interior of the cathedral the eye is drawn irresistibly upward by the rising vertical lines, so on the outside it follows the rising vertical piers to the pinnacles, along the procession of the flying buttresses toward the roof of the transept, and on to infinity.

The purpose of the pointed arch also becomes clear now. The Romanesque architects of Burgundy had used it at Cluny mainly as a decorative motif to promote a feeling of height and elegance (see Fig. 150). Gothic architects, however, pointed their arches to raise the crowns of the intersecting ribs of the vaulting to a uniform height to achieve greater structural stability. The tendency of the round arch is to spread sideways under the gravitational force of the weight it bears. A pointed arch, being steeper, directs the thrust of its load downward and onto the upright supporting members (Fig. 187). By the everincreasing skill with which they used the device of the pointed arch, Gothic builders were able to achieve a constantly increasing height. This in turn led to loftier vaults and more ethereal effects.

When all these various devices—pointed arch, rib vault, flying buttress, triforium gallery, walls

186. South nave exterior, Chartres Cathedral. c. 1194–1260.

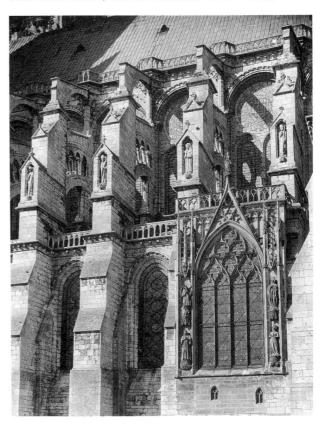

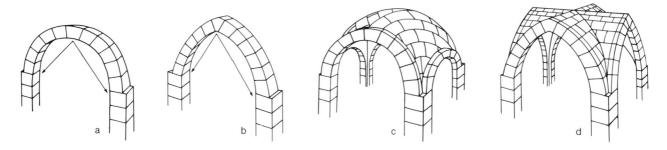

187.

The *pointed arch* and *ribbed groin vault* are fundamental to Gothic architecture, making it a light and flexible building system that permits generous openings in walls for large, high windows. The result is well-illuminated interior spaces. Whereas the less stable, lower round arches spread the load laterally (a), pointed arches, being more vertical, thrust their load more directly toward the ground (b). Too, pointed arches can rise to any height, but the height of semicircular arches is governed by the space they span. In (c) and (d) the space, or *bay*, that has been vaulted is rectangular in shape, rather than square. In (c) the round arches create a dome-shaped vault whose forms and openings are irregular and restricted. In (d) the pointed arches rise to a uniform height and form a four-part Gothic vault with ample openings.

maintained by spacious arcades, window spaces maximized at all levels—came together in a working relationship, Gothic architects were able to bring the dead masses of masonry into an equilibrium of weights and balances. Gothic architecture is thus a complex system of opposing thrusts and counterthrusts (Fig. 186) in which all parts exist in a logical relation to the whole.

Transept, Choir, and Apse

At Chartres, the wings of the transept terminate in triple portals (Fig. 188) that in size and magnificence surpass those of the western façade, parts of which had survived from the previous church. The north and south portals in the 13th-century style, however, are framed by row upon row of richly sculptured receding archivolts that bring a maximum of light and shadow into play. The shape of such sections was partly determined by the tastes of individual donors. The north transept, with its portals, porch, and stained glass, was the gift of the royal family of France, primarily Blanche of Castile and her son Louis IX, while its southern counterpart was donated by their archrival, the Duke of Brittany. When the cathedral was dedicated in the year 1260, Louis IX was present with such an assembly of bishops, canons, princes, and peasants as had rarely been seen.

Beyond the transepts extend the spacious choir and sanctuary, surrounded by a double-aisled ambulatory that gives easy access to the apse and its necklace of radiating chapels. The increasingly elaborate Gothic liturgy demanded the participation of more and more clerics, and the cavernous recesses of the huge structure were needed to accommodate an ever-growing number of choristers. The apsidal

chapels are also a distinctive feature of a developed Gothic plan, so that pilgrims could have access to the various altars where the revered relics of saints were kept in reliquaries.

The Cathedral of Notre Dame at Chartres, as well as earlier churches that stood on the same site, was closely associated with the cult of the Virgin Mary. Its most famous relic was the legendary veil of the Virgin, which, by tradition, had been presented to Charlemagne by the Byzantine Empress Irene. Another chapel enshrined the skull of St. Anne, the Virgin's mother, which was brought back by Crusaders and given to the church in 1205. This relic explains the many representations of St. Anne in statuary and stained glass and the pilgrimages in her honor, which were second only to those of the Virgin herself.

The most important chapel in Gothic cathedrals was the *Notre Dame*, Lady Chapel, devoted to

188. South porch, Chartres Cathedral. c. 1210–15.

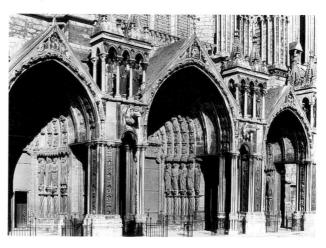

Mary. It was usually placed on the main axis of the nave beyond the center of the apse, with chapels of other saints grouped on either side. All these considerations caused the parts beyond the transepts to expand to unprecedented proportions.

Interior Lighting

Gothic interiors need little more decorative detail than the vertical lines of the structural members, the variety of representations in stained glass, and above all, the flow of light. At Chartres, the lighting is so organized as to achieve a gradual crescendo. It proceeds from the dark violet and blue lancets and rose window in the west through the brighter tones of the aisle and clerestory windows of the nave, past the flaming reds of the transept rose windows to the high intensity of the five red and orange lancets, the tall pointed windows in the apse. These apsidal windows soar above the altar and capture the rays of the morning sun.

Romanesque abbey churches were lighted mainly from within by lamps and candles, while Gothic interiors are illuminated by sunlight transformed through stained glass into a myriad of mysterious prismatic colors. The interior masses and voids become activated and etherealized by the directional flow of light, and material and immaterial elements fuse into a flowing harmonious whole.

SCULPTURE OF CHARTRES CATHEDRAL

As important to the medieval mind as the structure of the cathedral itself were the choice and location of the sculptural and pictorial representations that were to give the church its significance and meaning. In a Romanesque monastic church, these were found in the carved tympanums over the narthex portals, on the capitals of the columns throughout the interior, and in wall paintings, especially in the apsidal end. Since such representations were designed for those leading cloistered lives, they were placed inside, and the variety and subtlety of their subjects make it clear they were meant to be pondered upon and carefully studied.

Gothic sculpture was more popularly oriented and faced the outside world, where it clustered around and over the porches and entrance portals to form an integral part of the architectural design. Both the large number of figures and the quality of their execution testify to the importance of sculpture in the art of the period. The exterior of Chartres has more than two thousand carved figures about evenly

distributed among the west façade and the north and south porches of the transepts.

Gothic sculpture, like the Romanesque, was done by itinerant craftsmen who gathered wherever a church was being built. From the enormous productivity of the period, it seems clear that the ranks of these craftsmen must have been numerous and that the strokes of the sculptor's chisel on stone must have been a familiar sound. Gothic sculptors had the advantage of excellent stone models to follow, whereas their Romanesque predecessors had had to translate the lines of illuminated manuscripts into the stone medium. While Romanesque sculptors thought more in linear terms (see Figs. 151 and 163), their Gothic counterparts were more concerned with carving in depth; and the placement of the Gothic sculpture out of doors also made the play of light and shade more important. While the technique of the Gothic sculptor undoubtedly was superior, the iconography had become standardized in this time and did not allow quite so much imaginative freedom as the Romanesque sculptor had enjoyed. Both Romanesque and Gothic sculpture, however, show the unevenness of workmanship associated with "school sculpture," because some freelance carvers were more skillful than others.

The profusion of sculpture in a Gothic cathedral might lead to considerable confusion were it not for the close relationship of the sculptured forms to the architectural framework. The Gothic structure was so complete, so overwhelming, that no amount of decorative license would have been able to overshadow it. Nevertheless, the Gothic carvers had no intention of going their separate ways, and their work was always conceived and executed in terms of the architectural frame of reference. Even so, the enormous number of examples would be bewildering were it not for some attempt to unify the iconography. Since it is a people's church, the cathedral could not follow so consistent a system as that of an abbey, which was designed for a small group of people following a common ideal of life. Instead of single unified compositions, therefore, the designer of the Gothic cathedral sought to provide enough variety for every level of taste.

A Gothic cathedral, with the all-embracing activities it housed and the all-encompassing subject matter of its sculpture and stained glass, has often been likened to a *summa*, a comprehensive summary of law, philosophy, and theology written by medieval scholars. Cathedrals have also been described as the Bible in stone and glass, or the books of the illiterate; but they should not be overlooked as visual encyclopedias for the educated as well.

Iconography

The key to the iconography of Chartres is the encyclopedic character of medieval thought as found in the Speculum Majus of the French Dominican scholar Vincent of Beauvais, who divided all learning into Mirrors of Nature, Instruction, History, and Morality. The Mirror of Nature is seen in the plant and animal forms that are represented in comprehensive fashion. Instruction is present in the personifications of the seven liberal arts and the branches of learning taught in the universities. History is found in the story of humanity from Adam and Eve to the Last Judgment. Finally, Morality can be seen in the figures depicting virtue and vice, the wise and foolish virgins, the saved and the damned in the Last Judgment, and in the hovering saints and angels and fleeing gargoyles and devils.

There is also a logical sequence of presentation. The beginning is on the west façade, where the story of Christ from his ancestors to his ascension is told. The middle is on the north porch, where the history of Mary is traced along Old Testament lines from the creation of Adam to her death and heavenly corona-

tion. And the end is on the south porch, which takes up the drama of redemption from the New Testament, through the work of the Church, its saints, popes, abbots, and bishops, to the climax of the final day of the universe at the Last Judgment.

Each of the three porches has some seven hundred carved figures clustered in the three tympanums over the portals, the archivolts that frame them, and the columns below and galleries above. In addition to the scriptural scenes and lives of the saints, the designers found a place for ancient lore and contemporary history, for prophecy and fact, for fabulous animals and the latest scientific knowledge, for portraits of princes and those of merchants, for beautiful angels and grotesque gargoyles (some of which function as water spouts to drain the roof, others as decorative motifs symbolizing demons fleeing from the sacred precincts of the church).

The iconography at Chartres thus stems from three principal sources: the dedication of the cathedral to Our Lady, an honor that was shared with such other Notre Dame cathedrals as those at Paris, Rheims, Rouen, and Amiens; the presence of a cathedral school, an important center of learning, for

189. Royal Portal, west façade, Chartres Cathedral. Right, Virgin Portal. c. 1145–70.

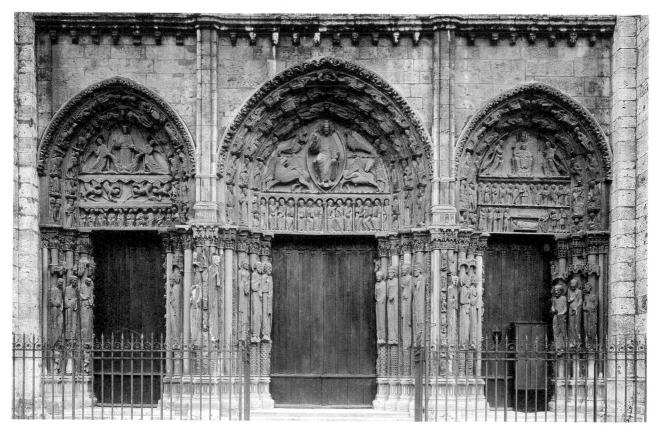

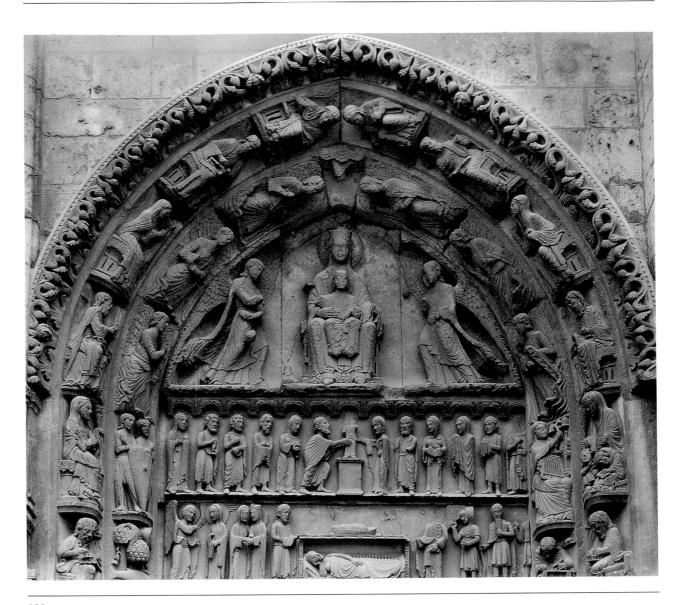

190. Life of the Virgin Mary, tympanum of the Virgin Portal, west façade, Chartres Cathedral. c. 1145–70.

Mary was also the patron of the liberal arts; and the preferences of such patrons as the royal family, lesser nobility, clergy, and local guilds who donated so many of the sculptures and windows.

It must also be borne in mind that sacred and secular elements in a medieval town and manor were so closely interwoven that every spiritual manifestation had a worldly counterpart. So the cathedral, as the court of Mary, Queen of Heaven, had to surpass in magnificence the grandeur that surrounded any mere earthly queen.

West Façade

The sculptures and doorways of the west façade at Chartres are called the Royal Portal (Fig. 189). The central tympanum encloses the figure of Christ in Majesty surrounded by the four symbolic beasts of the Evangelists and the twenty-four elders of the Apocalypse. The tympanum over the left portal depicts the close of Christ's days on earth and his ascension. On the right is the tympanum of the Virgin Portal (Fig. 190), depicting the beginning of the Savior's earthly life.

In the simplest terms, the story is told in three rising panels. Starting in the lower left is the Annunciation, with just the figures of the Angel Gabriel and Mary. The next pair shows the Visitation. The Nativity is in the center. The shepherds in the midst of their sheep are coming from the right for the Adoration, just as their successors came in from the fields near Chartres to worship at Mary's shrine. The mid-

dle panel depicts the presentation of the young Jesus in the temple. His position on the altar foreshadows his later sacrifice. Friends approach from both sides bearing gifts. In the top panel, the Virgin sits crowned and enthroned, holding her divine son and attended by a pair of archangels. She is shown frontally as a queen accepting the homage of the humble, who enter her court through the portal below.

SEVEN LIBERAL ARTS. Of great interest are the figures in the archivolts that frame the tympanum. These symbolize Mary's attributes. Like Athena of old, the Virgin was the patroness of the arts and sciences. The German philosopher Albertus Magnus in his *Mariale* declared that the Virgin was perfect in the arts; and in his *Summa*, the Italian theologian Thomas Aquinas included among his propositions the question of "Whether the Blessed Virgin Mary

possessed perfectly the seven liberal arts"—which, of course, was triumphantly affirmed. These representations are also reminders that this was an age which produced great scholars and that intellectual understanding as well as faith was now among the paths to salvation. The fact that Chartres was the location of one of the great cathedral schools is also important. Before the founding of the University of Paris, it shared with Rheims the distinction of being one of the best-known centers of learning in Europe.

The curriculum of the cathedral school was, of course, the seven liberal arts. These were divided into the *trivium*, which dealt with the science of words in the three subjects of grammar, rhetoric (speech), and dialectic (logic), and into the higher faculty of the *quadrivium*, which was concerned with the science of numbers through the study of arithmetic, geometry, astronomy, and music.

191–192. Details, Virgin Portal tympanum, west façade, Chartres Cathedral. c. 1145–70.

Grammar.

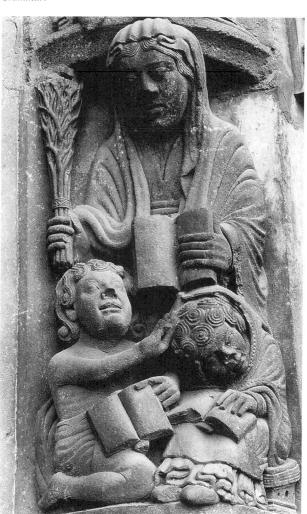

Music.

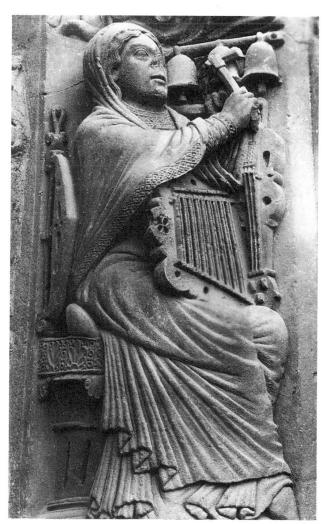

On the archivolt, these seven arts are symbolized abstractly by female figures somewhat akin to the ancient Muses, while below them are found their most famous human representatives. Beginning with the lower left corner of the outside archivolt, Aristotle is seen dipping his pen into the inkwell. Above him is the thoughtful figure of Dialectic. In one hand she holds a dragon-headed serpent symbolizing subtlety of thought and in the other, the torch of knowledge. Then comes Cicero as the great orator and over him the figure of Rhetoric making a characteristic oratorical gesture. The next pair are Euclid and Geometry, both of whom are deep in their calculations. In the same band, moving now from the top downward, are Arithmetic, probably personified by Boethius. Below them is the stargazing figure of Astronomy, who holds a bushel basket that signifies the relationship of her science to the calendar, so important in a farming district like Chartres. Ptolemy, to whom the medievalists ascribed the invention of the calendar and clock, is her human representative.

The figures on the lowest level are Grammar and Donatus, the ancient Roman grammarian. Grammar (Fig. 191) holds an open book in one hand and the disciplinary switch in the other over two young pupils, one laughing and pulling the other's hair.

The last pair in the series of seven are adjacent to those in the inner archivolt. Below is Pythagoras, the reputed founder of music theory, who is shown writing in medieval fashion with a desk over his knees. Above him is the figure of Music (Fig. 192), surrounded by instruments. At her back is a monochord, used to calculate musical intervals and to determine accuracy of pitch. On her lap is a psaltery. On the wall hangs a three-stringed viol. She is striking the set of three chime bells, an allusion to the Pythagorean discovery of the mathematical ratios of the perfect intervals—the octave, the fifth, and the fourth. Both Gerbert of Rheims and his pupil Bishop Fulbert of Chartres are known to have taken an active interest not only in the theory of music but in its performance as well. The two figures, showing Pythagoras as the thinker and Music as the performer, signify that Chartres was an important center for theoretical and practical aspects of music.

North and South Porches

Far more elaborate in scope and less restrained in decorative detail than the west façade is the incomparable north porch. With its three portals it stretches out to a width of 120 feet (36.6 meters), thus spanning the transept completely. A gift of the

royal family of France, its construction and decoration extended from the reign of Louis VIII and the regency of his queen, Blanche of Castile, through the reign of their son St. Louis (Louis IX), about the first three quarters of the 13th century. The north porch is dedicated to the Virgin and expands the theme of the Virgin Portal on the west façade to encyclopedic proportions. Her history from the annunciation and nativity through the childhood of Jesus is found on the left portal. The scenes of her death and assumption are depicted on the lintel over the central door, while those of her enthronement and coronation are in the tympanum above.

Mary's attributes are revealed in the archivolts through series after series of cyclical representations, such as those of the fourteen heavenly beatitudes and twelve feminine personifications of the active and contemplative lives. Especially fine is the single figure of her mother, St. Anne, holding the infant Mary in her arms (Fig. 193), which adorns the *trumeau*, the post or pillar that supports the lintel and tympanum of the central portal. From the harmonious lines of the folds of her drapery to the dignified and matronly face, the work is one of the most satisfying realizations of the mature Gothic sculptural style.

It will be noted from the contours of the south porch (see Fig. 188) that the arches of the portals are now more highly pointed, and their enclosure by triangular gables further emphasizes their verticality. The deep recession of the porch allows for a much greater play of light and shade in the statuary that covers every available space from the bases of the columns to the peak of the gable.

The figures on both the north and south porches, in comparison with the earlier ones on the west façade, have bodies more naturally proportioned; their postures show greater variety and informality; and their facial expressions have far more mobility. The representations of plants and animals are considerably closer to nature; and in comparison with the impersonality of those on the west front, many of the human figures are so individualized that they seem like portraits of living persons. In the change of style, however, something of the previous symbolic meaning and monumentality has been lost, as well as the closer identity with architecture.

THE STAINED GLASS OF CHARTRES

Time has taken its inevitable toll of the exterior sculptures of Chartres. The flow of carved lines remains, and the varied play of light and shade relieves the present browns and grays. But only traces of the

original colors and gilt are left to remind the observer that here was once a feast of color with an effect that can now only be imagined. In the interior, however, where the stained glass remains undimmed, the full color of medieval pageantry still exists. The wealth of pure color in the 175 surviving glass panels hypnotizes the senses. Through the medium of multicolored light something of the emotional exaltation that inspired medieval people to create such a temple to the Queen of Heaven can still be felt.

Here, as elsewhere, the structural and decorative elements are closely tied together. Just as with

193. *St. Anne with the Virgin,* trumeau of center portal, north porch, Chartres Cathedral. c. 1250.

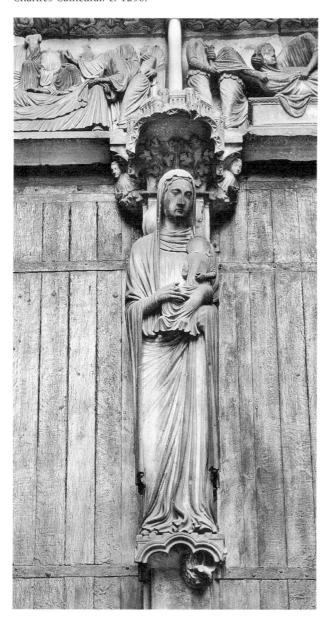

the sculpture, the glass does not exist separately but only as a related part of the whole. The designer was always aware of the size, proportion, and placement of the window in relation to the architectural setting.

Glass is not usually thought of as a building material until the 19th and 20th centuries, but in medieval times and later it did have to fill a large architectural void while taking into account the pressure of wind and weather. This the designer accomplished mainly by dividing the space geometrically into smaller parts by use of *mullions*, the vertical posts that divide the windows; by stone tracery to frame smaller glass panels, as in the great rose windows; by parallel iron bars across the open expanse; and, more minutely, by the fine strips of lead that hold the small pieces of glass in place.

While Chartres must divide architectural and sculptural honors with its neighboring cities, the town was especially well known as the center of glass making. With the highest achievements of its glaziers exemplified in their own cathedral, Chartres is unsurpassed in this respect. The great variety of jewel-like color was achieved chemically by the addition of certain minerals to the glass while it was in a molten state. When cool, the sheets were cut into smaller sections, and the designer fitted these into a previously prepared outline. Details, such as the features in the faces, were applied in the form of metal oxides and made permanent by firing in a kiln. Next, the glass pieces of various sizes were joined together by lead strips. Finally, the individual panels making up the pattern of the whole window were fastened to the iron bars already imbedded in the masonry. When seen against the light, the glass appears translucent, while the lead and iron become opaque black lines that outline the figures and separate the colors to prevent blurring at a distance.

The artists of stained glass shared with mosaicists and manuscript illuminators a distinct preference for two-dimensional designs. The dignified formality of their figures and the abstract patterns of the borders blended their work admirably into the architectural setting. By thus avoiding any hint of naturalistic effects, such as landscape backgrounds, and by concentrating on patterns of pure color and geometrical forms, they helped to promote the illusion of infinite space.

Iconography and Donors

The iconographical plan of the glass at Chartres, like that of the exterior sculptures, is held together mainly by the dedication of the church as a shrine of the Virgin. There is never any doubt on the part of those who enter that they are in the presence of the Queen of Heaven, who sits enthroned in majesty in the central panel of the apse over the high altar. Grouped around her in neighboring panels are the archangels, saints, and prophets, emblems of the noble donors, and symbols of the craftsmen and tradespeople, almost four thousand figures in all, who honor her and make up her court. Below, on her feast days, were the crowds of living pilgrims who gathered in the nave and chapels, aspiring to enter her eternal presence one day as they had entered her shrine.

An interesting commentary on the changing social conditions of the 13th century can be read in the records of the donors of the windows. In the lowest part of each one is a "signature" indicating the individual, family, or group who bore the expense of the glass. Only a royal purse was equal to a large rose window, as evidenced by the fleur-de-lys insignia so prominent in the north rose (see Fig. 195). Within the means of members of the aristocracy and the Church hierarchy, such as bishops and canons, were the lancet windows of the nave and choir. The status and prosperity of the guilds of craftsmen and merchants, however, was such that most of the windows were donated by them.

While the royal family of France and the Duke of Brittany were content with windows in the transepts, the most prominent windows of all, the 47-foot (14.3-meter) high center lancets of the apse, were given by the guilds. The one over the high altar, toward which all eyes are drawn, was the gift of the bakers. Each guild had a patron saint, and a window under a guild's patronage was concerned with the life and miracles of its special saint. In the case of the nobility, the family coat of arms was sufficient to identify the donor; with a guild, the "signature" took the form of a craftsman engaged in some typical phase of work. In the windows of Chartres some nineteen different guilds are shown, including that of the bakers (Fig. 194).

Rose Windows

The great rose window of the west façade dates from the early 13th century and thus is contemporary with the majority of examples in the rest of the church. The three lancets below it, however, like the portals and surrounding masonry on the exterior, originally were part of the previous church. Besides being the earliest of all the windows, they are, possibly, also the best. Their origin has been traced to the school that did the windows for Suger's church at St. Denis, and their work was on the whole much finer grained and more jewel-like, with infinite care lavished on the geometrical and arabesque patterns in

194. *Bakers,* detail of stained glass window, Chartres Cathedral. c. 1250.

the borders. They are dominated by their vibrant blue background, while the figures and abstract patterns have been done in several shades of red, emerald green, yellow, sapphire, and white.

The great rose window of the north transept (Fig. 195), like the sculpture on the porch outside, glorifies the Virgin Mary. Together with its lancets, the composition shares with the other glass of the 13th century a preference for red backgrounds instead of the earlier blue. The individual panes are larger, and the borders are more conventionalized. Its greatest effect comes from the large splashes of warm color that contrast with the cool tones of the lancet windows of the west façade, as well as that of the earlier regal and glowing panel known by the name of *Notre Dame de Belle Verrière (Our Lady of the Beautiful Window)* (Fig. 196).

In the Gothic period the art of stained glass replaced the mosaics and mural paintings of the early Christian and Romanesque churches and is the ultimate stage in the etherealization of interior space. Because it gives form and meaning to light, the art of the glazier is perhaps better adapted to the expression of transcendental concepts than any other artistic medium.

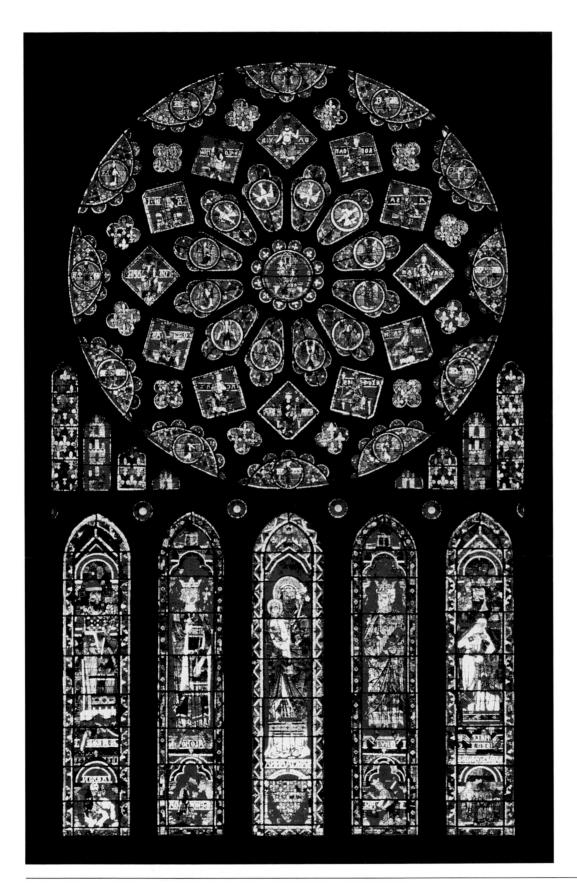

195.North rose window, Chartres Cathedral. 1223–26. Diameter 44' (13.41 m).

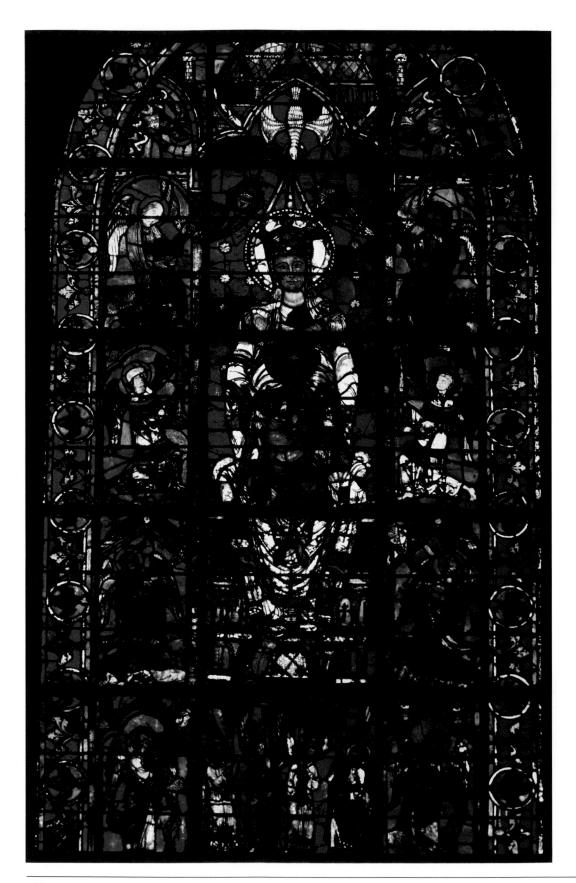

196. Notre Dame de Belle Verrière. 12th century. Stained glass window. Chartres Cathedral.

By the transformation of raw sunlight into a spectrum of brilliant prismatic color, the architect gained complete control over interior lighting. It could be caused to flow in any manner the architect willed. This material control over an immaterial medium could then be placed at the disposal of the architects and iconographers to shape light to their structural, pictorial, and expressive needs.

Something of the ecstasy felt by medieval men and women in the contemplation of the precious stones that adorned the altar and the jeweled glass of the windows is expressed in these words of the Abbot Suger:

Thus, when—out of my delight in the beauty of the house of God—the loveliness of the many-colored gems has called me away from eternal cares, and worthy meditation has induced me to reflect, transferring that which is material to that which is immaterial, on the diversity of the sacred virtues: then it seems to me that I see myself dwelling, as it were, in some strange region of the universe which neither exists entirely in the slime of the earth nor entirely in the purity of Heaven; and that, by the grace of God, I can be transported from this inferior to that higher world in an anagogical manner.

MUSIC

Massive and magnificent as the Gothic cathedral is, it can be considered the highest achievement of its time only if associated with the various activities it was designed to house. Most important, of course, is the liturgy. As the enclosed space increased, the cathedral grew into a vast auditorium that hummed with collective voices at communal prayer, resounded with readings and the spoken word from the pulpit, and reverberated with the chanting of solo and choral song from the choir.

The Île-de-France, site of the most significant developments in architecture of the 12th and 13th centuries, was also the scene of the most important musical innovations of the Gothic period. Specifically, these were the more sophisticated practices of *polyphonic*, or "many-voiced," music and their relation with the still universally practiced *monophonic*, or unison, art of plainchant. Singing in parts was of northern origin in contrast to the prevailing Mediterranean style of singing in unison, and part singing in folk music apparently predates by several centuries its incorporation into church music. Just as the Gothic cathedral was the culmination in the long

process of reconciling the northern urge for verticality with the southern horizontal basilica form, so Gothic music was the union of the northern tradition of multivoiced singing with the southern one-voice tradition to form a new style of church music.

School of Notre Dame in Paris

It has already been noted that in the construction of the first Gothic church the builder of St. Denis brought together many principles that had been developed separately elsewhere and for the first time used them in a systematic whole. The same was true of music, and Paris, as the growing capital of the French kingdom, was the logical place for the pieces to be fitted into a whole. The contrapuntal, or polyphonic, forms and textures developed in such monasteries as Cluny and in such cathedral schools as Rheims and Chartres, as well as the tradition of folk singing in several parts, were organized systemati cally for the first time at the School of Notre Dame in Paris. Again, as in the case of architecture, the man and the time can be fixed with certainty. The first great monument of Gothic music was the Magnus Liber Organi by Léonin, dating from c. 1163. As its name implies, it was a great book bringing together a collection of music in two parts, arranged cyclically so as to provide appropriate music for all the feast days and seasons of the calendar year.

TENOR, OR CANTUS FIRMUS. In the traditional rendering of the plainchant some parts were sung by a soloist and answered responsorially by a chorus singing in unison (see p. 135 and examples). In the Gothic period, the choir still chanted in the way it had done for centuries, but the solo parts began to be performed simultaneously by two or more individual singers. Notre Dame in Paris, for example, employed four such singers. The distinction between solo voice and choir hence was replaced by the opposition of a group of individual singers and a massed chorus. With several skilled soloists available, the way was open for an art of much greater complexity than had ever been developed before.

Since the music, however, was still intended for church performance, it was required that one of the traditional sacred melodies be used. A special part called the *tenor*, a term derived from the Latin *tenere*, meaning "to hold," was reserved for it. This melody was also known as the *cantus firmus*, or "fixed song," implying that it could not be changed. The development of Gothic music was that of taking the *cantus firmus* as an established basis and adding one by one the voices called, in ascending order, the *duplum*, *triplum*, and *quadruplum*. Since these

voices were superimposed one above the other, a definite concept of verticality is implied, which contrasted strongly with the horizontal succession of tones that characterized the older monophonic chant. The growing complexity of singing in several parts led of necessity to a new type of mensural notation to define the rhythmic ratios and hold the various polyphonic voices together.

The earliest forms of Gothic polyphony are almost as rigid in their way as the old parallel organum of the Romanesque period, but they are based on the new principle of punctus contra punctum literally "note against note," or point counter point. Mira Lege (below) illustrates one of the strictest applications of this idea. The plainchant melody is in the lower part, while the counterpoint above moves as much in opposition to it as possible. Though parallel movement is not against the rule, and from time to time does occur, contrary motion is preferred. A treatise written at the beginning of the 12th century declares, "If the main voice is ascending, the accompanying part should descend, and vice versa." The name given to this newly created melodic line was the discantus, or "descant," referring to the idea of singing against the established melody, a practice that has continued in religious and secular music.

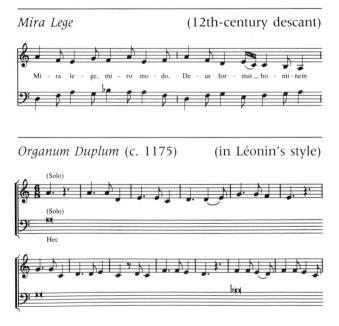

Two-Part Chant. In addition to such examples, Léonin's *Magnus Liber* contains another type of counterpoint known as the *organum duplum* (above). The *plainsong cantus firmus* is found in the lower voice, but the individual tones are stretched out to extraordinary lengths. The descanting, or

duplum, voice moves now in free counterpoint consisting of ornate melismas over what has in effect become a relatively fixed base.

The greater melodic and rhythmic freedom that the descant assumed called for expert solo singers, and much of the descanting of Gothic times is known to have been improvised. The practice of such a freely flowing melodic line over a relatively fixed bass points to a possible origin in one of the old types of folk singing. Survivals are found in the instrumental music of the Scottish bagpipers, where such a tune as "The Campbells Are Coming" is heard over a droning bass note.

In performance, the slowly moving tenor, or *cantus firmus*, may have been sung by the choir, while the soloist sang a freely moving duplum part over it; or the tenor may have been played on the organ, as the instrument is known to have been in use at this time. The organ keyboard was a 13th-century Gothic innovation, and the many manuscript illustrations from the period point to the wide usage of organs. The term *organ point*, furthermore, continues to be used to refer to a musical passage in which the bass tone remains fixed, while the other parts move freely over it.

THREE-PART MOTET. Another significant development was the addition of a third part above the other two, which was known as the triplum, from which the term "treble" is derived. This step was taken by Pérotin, who was active in Paris in the late 12th, and probably in the early 13th, century. In his revision of the work of his predecessor, Léonin, Pérotin moved away from polyphonic improvisational practices toward an art based on stricter melodic control and clearer rhythmic definition. By thus achieving a surer command of his materials and evolving a logical technique for manipulating them, he was able to add a third voice to the original two (see below), and in two known instances there is even a fourth part. These compositions were known as *motets*, independent works designed for performance in the liturgy but not a part of the regular mass.

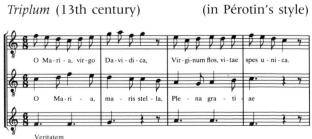

The three-part motet, like its predecessors, still had its *cantus firmus* in the tenor, which was the lowest part and held the *mot* (word), from which the term *motet* is probably derived. Over it the contrapuntal voices wove a web of two different strands, singing their independent melodic lines. In the hands of Pérotin the three-part motet became the most favored and characteristic practice of 13th-century Gothic music.

Besides achieving ever-greater melodic independence, the two contrapuntal voices even had their own separate texts. A three-part motet thus had three distinct sets of words—the tenor, with its traditional line, and usually two contemporary hymnlike verses over and above it—which were sung simultaneously. Intended as they were for church performance, the words customarily were in Latin. However, around the middle of the 13th century, it was not uncommon for one of the voices to have its verses sung in French.

With the entrance of the *vernacular*, or local language, came also popular melodies. So above the stately tenor, it was possible to have a hymn to the Virgin in Latin and a secular love song in French going on at the same time. By the simple expedient of replacing the sacred melodies with secular tunes, a fully developed musical art independent of the Church was not only possible but by the end of the 13th century had become an accomplished fact.

Gothic music exists in such close unity with other manifestations of the Gothic style that it can scarcely be understood as a thing apart. The subjects of the new hymns, especially those with the words of St. Bernard and the melodies of Adam of St. Victor, were mainly devoted to the Virgin, as were most of the cathedrals and the iconography of the sculpture and stained glass. Instead of a monolithic choir chanting in unison or in parallel organum, Gothic listeners now heard a small group of professional singers. In the case of a three-part motet, they could choose, according to their temperament or mood, to follow either the solemn traditional melody, the Latin commentary above it, or the French triplum in their own everyday mode of speech. This allowance for diversity of musical taste is a part of the general shift from the homogeneity of monastic life in the abbey to the heterogeneity of city life, of which the cathedral is the expression. The new melodic, rhythmic, and textural variety implies a congregation of people from all walks of life, just as had been the case with the diversified imagery of the sculpture and stained glass.

Since the individual voices were superimposed one above the other, a concept of verticality, similar to the architectural developments, is realized. The ear, like the eye, needs fixed points to measure rises and falls. In the *Mira Lege* example, the intervals of the lower part established the point over which the descant moved in contrary motion. In the case of the *organum duplum*, it was the long sustained tone in the tenor against which the soaring upward and plunging downward movement of the melody could be heard.

In addition to this linear impulse, all types of counterpoint achieve a sense of rhythmical progress by having a relatively static, or stable, point against which the more rapid movement of the other voices could be measured. Together with the several opposing melodies, the clash of dissonant intervals, the simultaneous singing of separate texts, as well as the progress of several independent rhythms. Gothic music was able to build a sense of mounting tension that set it apart as a distinctive new style.

IDEAS

In the century between the dedication of the great Romanesque abbey church at Cluny (1095) and the beginning of Chartres Cathedral (1194), much more than a change in artistic styles had occurred. A mighty shift in social and political institutions and in basic modes of thought had taken place. The resulting changes in church, secular, and artistic life brought into the open sharp divisions of opinion. Old conflicts, long restrained by the power of the medieval divinely ordered social structure, now burst into flames, and new ones broke out, fanned by the breath of new voices clamoring to be heard. Intellectual disputes grew hot and bitter as emotional tensions deepened.

In this critical situation, rational processes of scholastic philosophy were brought to bear on these divisive forces, and the Gothic is best understood as a clashing and dissonant style in which opposite elements were maintained momentarily in a state of uneasy equilibrium. With the eventual dissolution of the Gothic synthesis in the following century, the basic oppositions, or the dualisms, became so impossible to reconcile that they led in some cases to the battlefield, in others to schisms, or divisions, within the Church, and generally to growing philosophical and artistic conflicts.

Gothic Dualism

Politically, the age-old struggle of Church and state, evident in Romanesque times in the endless quarrels between popes and Holy Roman emperors, now shaped up as the conflict between traditional ecclesiastical authority and the growing power of northern

European kingdoms, especially France and England. Simultaneously came the beginning of a split between the internationalism of the church and Holy Roman Empire and rising nationalism that produced centuries of rivalry between the south and north for the domination of Europe.

The prevailing monastic and feudal organizations of Romanesque times had tended to separate society into widely scattered units of cloister and manor, thereby isolating many of the causes of social strains. But as the towns began to grow into cities, the different elements were brought together in a common center where confrontation made problems more immediate.

Tensions mounted between the landed aristocrats on the one hand and the volatile urban groups on the other, between the monastic orders and the growing secular clergy. And towns witnessed at close range the bitter rivalries between abbot and bishop, lord and burgher, clergy and laity.

For the common people there was always the contrast between the squalor in which they existed and the luxury of their lords, bishops, and abbots; between the poverty of their daily lives and promises of heavenly glory in the beyond; between the strife of their world and the visions of serenity and peace in Paradise.

GOTHIC DUALISM AND THE ARTS. The arts were torn between expressing the aspirations of this world and those of the next, and artists between accepting a relatively anonymous status in the service of God and competing actively with their fellows in search of worldly recognition and rewards. Instead of the comparative unity of artistic patronage in the aristocratically oriented Romanesque period, patronage in the city was now divided between the aristocrats and clergy on the one hand and the increasingly important middle class and guilds on the other. The rising power of the middle class is well illustrated by such dwelling places as one of the surviving Gothic halftimbered houses at Rouen (Fig. 197) and the splendid residence of the banker Jacques Coeur at Bourges (Fig. 198).

In architecture, be it the interior or exterior of the Gothic cathedral, there is an opposition between the masses and voids and an interplay of thrust and counterthrust and of attraction and repulsion that awaken dead weights into dynamic forces.

In sculpture, the conflict of the particular and universal is seen in the remarkable feeling for human individuality in some of the separate figures. It is apparent as well in the iconographic necessity of molding them into the dignified impersonality required of a row of prophets and saints.

In literature, the cleavage between Latin and the vernacular languages becomes as evident as the growing distinction between the sacred and secular musical styles. Within the province of the tonal art are found such external disparities as the fruitless academic discussions about the hypothetical nature of the music of the spheres and the increasing importance of the actual sounds heard in the choirs of the churches, the abstract study of theoretical acoustics in the universities and the practical art of writing and making music.

In music also there are such internal differences as the singing of monophonic choruses alternately with groups singing polyphonically, the contrast between voices and instruments, the flow of

197. Gothic half-timbered house, Rouen, 15th century.

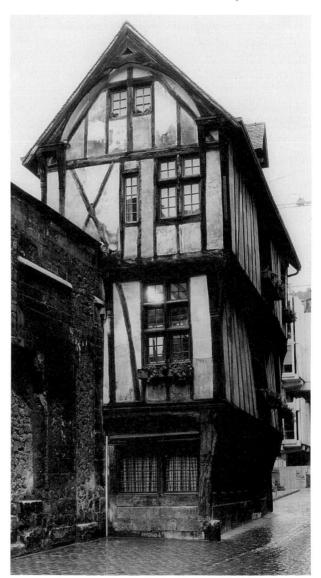

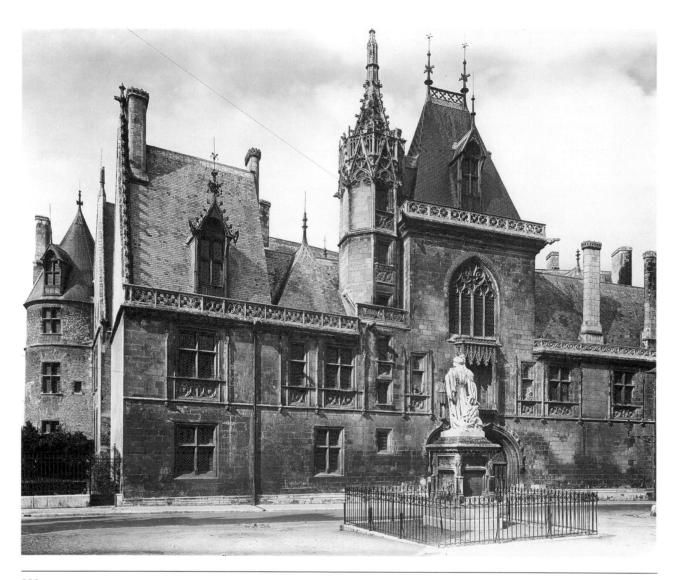

House of Jacques Coeur, Bourges. 1443-51.

horizontally moving melodic lines versus their simultaneous vertical aspects, the opposition of consonance and dissonance, and the rhythmical contrast between the independent voices within a polyphonic motet, line against line, cantus versus discantus. In short, Gothic music displays all the inherent oppositions of an art based on the principle of punctus contra punctum, or point counter point.

The Scholastic Synthesis

In the face of so many differences, it seems only a step short of the miraculous that the Gothic style was able to effect a synthesis at all. Such dualities, however, generated the need for some sort of coexistence. That this was achieved is yet another proof of the remarkable intellectual ingenuity and creative vitality of the Gothic period. The method for achieving this coexistence was devised by scholasticism: a kind of pro-and-con dialogue followed by a resolution. The results of this dialectic shaped up in the form of the Gothic monarchy, university, encyclopedia, summa, and cathedral.

On entering Chartres Cathedral through the Virgin Portal, the worshiper was reminded by the personification of the seven liberal arts that faith needed to be enlightened by reason and knowledge. Architecture had to be a kind of logic in stone; sculpture and glass had to be encyclopedic in scope; and music had to be a form of mathematics in sound. All experience, in fact, had to be interpreted intellectually rather than emotionally, as in the Romanesque.

To the scholastic philosopher, God, as the Creator of a world based on principles of reason, was approachable through the logical power of the mind. Hence the key to understanding the universe was in the exercise of the rational faculties. Philosophical truth or artistic value was determined by how well an idea fitted into a logically ordered system.

Abelard's *Sic et Non (Pro and Con)* was an early manifesto of Gothic dualistic thinking. With unprecedented daring, Abelard posed one pertinent question after another, then lined up unquestionable authorities from the Scriptures and Church fathers for and against. His purpose was to bring out into the open some of the wide cleavages of thought among sanctioned authorities, and he made no attempt at reconciling them.

AQUINAS'S SUMMA. The scholastic successors of Abelard debated whether ultimate truth was to be found through faith or reason, blind acceptance of hallowed authorities or evidence of the senses, universals or particulars, determinism or freedom of the will, intuition or reason. Thomas Aguinas and his fellow scholastics in their search for synthesis found the answer in the dialectical, or logical, method of argument. Aquinas's synthesis, as found in his Summa Theologiae (Summation of Theology), was a comprehensive attempt to bring together all Christian articles of faith into a rational system. The problems Thomas faced were how to adapt Aristotle's philosophy to Christian theology and how to harmonize such differences as truth revealed by God in the Scriptures and truth arrived at by human learning, the biblical and Greco-Roman heritage, the classical and Christian tradition, the mystery of faith and the light of reason. Abelard's pros and cons and the divergent views of the previous thousand years of speculation were reconciled by a subtlety of intellect that has never been surpassed.

Such a *summa* was as intricately constructed as a Gothic cathedral and had to embrace the totality of a subject, systematically divided into propositions and subpropositions, with inclusions deduced from major and minor premises. Every logical preposition was fitted exactly into place like each stone in a Gothic vault. If one of the premises were disproved, the whole structure would fall like an arch without its keystone.

AESTHETICS AND NUMBER THEORY. From Aquinas's highly rationalistic viewpoint followed the scholastic definition of beauty, which, according to St. Thomas, rested on the criteria of completeness, proportion, harmony, and clarity—because, he said, the mind needed order and demanded unity above all other considerations. Mathematical calculation and symbolism therefore played an important part in the thought of the time.

In the cathedral schools and later in the universities, music was studied mainly as a branch of mathematics. Bishop Fulbert of Chartres emphasized theory in the training of singers, saying that without it "the songs are worthless." His view was generally held throughout the Gothic period. As one theorist put it, a singer who is ignorant of theory is like "a drunkard who, while he is able to find his home, is completely ignorant of the way that took him home." Mathematical considerations, in fact, led composers to emphasize the perfect intervals of the octave, fifth, and fourth for theoretical reasons more than for the agreeableness of sound. The tendency was to suppress sensuous beauty of tone and emphasize the mathematical, theoretical, and symbolic aspects of the musician's art.

At Chartres (as at other cathedral schools) arithmetic, geometry, music, and astronomy, as the quadrivium of the seven liberal arts, were carefully and closely studied. Plato's theory of the correspondences between visual proportions and musical harmony (see pp. 47-48, 55-56) was kept alive in early Christian times by both St. Augustine and Boethius in their books on music. In his De Musica Augustine wrote that both architecture and music are the children of numbers. For him, architecture was the mirror of the cosmos, while the tonal art was the echo of the music of the spheres. These two books, along with parts of Plato's Timaeus, were widely studied in medieval monasteries and universities. In the geometry of Chartres abstract ideas are everywhere expressed in numbers, which in turn shaped the forms and proportions of its architecture.

The mystical number 3 plays a major role. Since antiquity uneven numbers had been considered male and even numbers female. The number 1 was the symbol of the progenitive force and creative principle, and the number 2 was the female equivalent. The two joined together to form the first whole—or complete—number, 3. Note the musical implications of 1 is to 2 (the octave), and 2 is to 3 (the fifth). Three was also considered as the first and divine whole number since it contained the beginning, middle, and end. It is also associated with Plato's trinity of truth, goodness, and beauty, and its Christian trinitarian symbolism is obvious. It also referred to the three parts of creation: hell below, the earth, and the heavens above.

In the plan and cross section of Chartres Cathedral (Figs. 182 and 185) the number 3 is all-pervasive. There are the triple entrance portals. The façade rises in three steps from the level of the doorways, through the intermediate story, to the rising towers intended to elevate the thoughts of the worshipers

and direct their aspirations heavenward. In the interior there are the three corresponding levels, beginning with the nave arcade, the triforium gallery, and the windowed clerestory. In the clerestory itself each bay has two lancets and one rose window. Then there is the tripartite division of the ground space into the nave, transepts, and choir sections; the three semicircular chapels in the apse; and so on indefinitely. In philosophy the encyclopedias and the *sum*mas were divided into three parts. The triple rhyming plan of the Latin poetry, as in the *Dies Irae* (p. 225) and in the terza rima that Dante wrote in the Divine Comedy (p. 226), will serve as literary examples. In music, Gothic composition favored the three-part motet and the ternary, or three-beat, rhythm that was called the tempus perfectum because of its Trinity symbolism. (Binary rhythms, since they recalled marching steps, were considered too worldly.)

Six was also a favored number in the Chartres plan; it was the first of the perfect numbers whose factors (1, 2, and 3) add up to the number itself. In the pavement of the nave at Chartres is a large circular mosaic in stone containing a mysterious labyrinth pattern with a six-petaled rose at its center (Fig. 199). The circle is, of course, the perfect form without beginning or end, and the rose refers to Mary. A hexagon forms the basis for the proportions of the center and heart of the plan at the crossing of the nave and transept. Again, the hexagon is the perfect geometric figure, contained as it is in a circle any radius of which will be equal to one of the hexagon's sides.

While the number 3 designated the spirit, 4 stood for matter, since the material elements composing the universe were considered to be fire, earth, air, and water. The sum of the two numbers is 7, which symbolized the human being-whose dual nature was made up of both spirit and matter, soul and body. The product of these two numbers pointed to the twelve tribes of Israel, the twelve apostles, the twelve lesser prophets, and so on. At Chartres, 7 also referred to Mary as the patron of the seven liberal arts. Nine was also a Marian symbol, since the Virgin was considered the seat of wisdom and by analogy knowledge was the root of power (3 being the square root of 9). As Dante wrote, "The Blessed Virgin is nine, for she is the root of the Trinity." Chartres has nine entrance portals, three in the façade and three in each of the transepts. According to the original plan the cathedral was to have had nine towers—pairs on the west façade, on each of the transepts, two flanking the apse, and a climactic one over the crossing of the nave and transepts. Thus it was that numbers were thought to be the key to

199. Labyrinth pattern in the nave pavement at Chartres Cathedral.

the divine plan and the link between the seen and the unseen. It is clear also that they are the clue to the understanding of the forms and shapes that underlie the geometry and iconography at Chartres.

Hovering above all these earthly concerns and holding her court in all the Notre Dame cathedrals and Lady Chapels was the motherly figure of Mary. The worship of Mary also had its worldly reflection, as Gothic chivalry and courtliness were rapidly replacing the might-makes-right code of Romanesque feudalism. And just as the clergy sang the praises of Notre Dame, so the knights of the castles praised their ladies in particular and Our Lady in general. The high place of womanhood in secular circles is thus the courtly parallel of the religious cult of the Virgin.

In the poetry of the time, a knight's lady love is always the paragon of feminine virtue and charm. To woo and win her, he who aspired to her favor had to storm the fortress of her heart by techniques far more intricate and subtle than those needed to take a castle. When successful, he became the vassal of his mistress and she his liege lady to command him as she would. As one of the troubadours sang: "To my lady I am vassal, lover, and servant. I seek no other friendship but the secret one shown me by her beautiful eyes." The concept of romantic love originated here in the Gothic period and came to full flower in the complex code of chivalry. With its exaltation of the position of women and its concern with the defense of the weak against the strong, chivalry established the Western code of manners that has remained the ideal well into modern times.

Broader Resolutions. The rise of national monarchies in France and England began to limit the international authority of the papacy, as well as to curb the provincial powers of the feudal lords do-

mestically by increasing centralization of civil authority. In England, a political resolution between king and nobles and between nobles and commoners, was made in the Magna Carta that became the basis for parliamentary government. In France, the establishment of a working relationship between the king and the urban middle class accomplished a similar purpose. King Louis IX of France was so skillful in strengthening his own kingdom, while maintaining such good relations with the popes, that he became a saint. In the cities the guilds brought patrons and craftsmen together; meanwhile, the system of apprenticeships and examinations ensured a high standard of quality and workmanship.

The undertaking of the fantastic Crusades was found to be a way of uniting many opposing European factions in a cause against a common enemy. The code of chivalry was an attempt to reconcile the opposition between idealistic love and the gratification of the senses and, more broadly, to establish a standard of behavior between strong and weak, lord and peasant, rich and poor, the oppressor and the oppressed.

The Gothic universities were set up as institutions to bring together all the diverse disciplines and controversial personalities and to fit all the various intellectual activities into a single universal framework. Scholasticism became the common mode of thought and its dialectic the common method of solving all intellectual problems.

The structural uniformity of Gothic vaulting and buttressing was, in effect, the Gothic builder's answer to Romanesque experimentalism. Ample allowance for urban diversity was made in the iconography of the individual cathedral and in the differences of cathedrals from town to town and from country to country, where each was distinctive.

Both internally and externally, Gothic architecture tried to synthesize the building with the space surrounding it. Externally, the eye follows the numerous rising vertical lines to the spires and pinnacles and then to the sky. Inside, the experience is similar; the vertical lines rise to the window levels and from these through the glass to the space beyond. In contrast to the monastic church that was based on the notion of excluding the outside world, the Gothic cathedral attempted an architectural union of the inner and outer world as the exterior and interior flowed together through the glasscurtained walls. The thrust and counterthrust of the interior vaulting was paralleled on the outside by that of pier and flying buttress; the sculptural embellishments of the exterior were repeated in the iconography of the glass in the interior. Through the medium of stained glass, the iconographers endowed light with meaning by transforming physical light into metaphysical and mystical illumination.

The various European languages and dialects found a place for themselves in secular literature, but Latin was championed by the Church and universities as the universal language of scholarship. In music, Latin and the language spoken by the common people were reconciled in the multiple texts of the motet. When only one language was used, the same form provided a highly ingenious method by which an authoritative text was sung, while at the same time one or more running commentaries upon it could be presented. Gothic music also represented a synthesis of theory and practice functioning together as equals. Through all these separate manifestations the Gothic spirit was revealed, whether in the systematic logic of St. Thomas, in the heightened sense of time achieved by the musicians, or in the visual aspirations and linear tensions of the builders.

200. Eugène Viollet-le-Duc. Drawing of a Gothic cathedral with full set of seven spires.

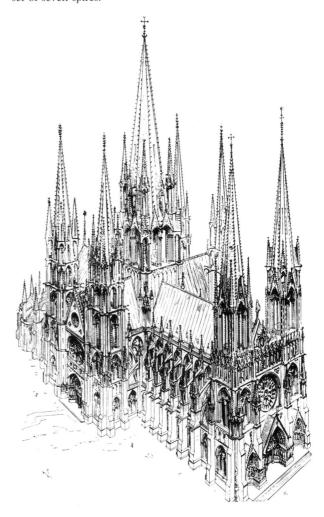

No one of these resolutions was in any sense final, and the Gothic style must, in the last analysis, be viewed as a dynamic process rather than an end result. By contrast, a Greek temple or even a Romanesque abbey is a completed whole, and in both the observer's eye eventually can come to rest. The appeal of the Gothic lies in the very restlessness that prevents this sense of completion. The observer is caught and swept up in the general stream of movement and from the initial impulse gets the desire to continue it. The completion, however, can only be in the imagination, since there were, in fact, no finished cathedrals. Each lacked something, from a set of spires in some cases to a nave, as at Beauvais. The 19th-century French medieval archeologist Violletle-Duc once projected such a complete cathedral with seven spires—one pair on the west facade, others on the north and on the south transepts, and a climactic spire over the crossing of the nave and transept (Fig. 200). This quality was not limited to

architecture. Vincent's encyclopedia and Thomas Aquinas's *Summa* were likewise never completed.

Gothic unity is therefore to be found mainly in such methods and procedures as its dialectic in philosophy, structural principles in architecture, and techniques of writing in literature and music. No more effective processes could have been devised to deal with the specific inconsistencies with which the Gothic mind had to contend. They were, in fact, the only ways to reconcile the seemingly irreconcilable, to arrive at the irrational by ingenious rational arguments, and to achieve the utmost in immateriality through material manifestations.

The object of Gothic thought was thus to work out a method for comprehending the incomprehensible, for pondering on the imponderables, for dividing the indivisible. Gothic art as a whole was designed to bridge the impossible gap between matter and spirit, mass and void, natural and supernatural, inspiration and aspiration, the finite and the infinite.

LATE MEDIEVAL PERIOD

	KEY EVENTS	ARCHITECTURE	VISUAL ARTS	LITERATURE AND MUSIC
1200	c.1140 Guelph and Ghibelline wars began 1182-1226 St. Francis of Assisi; founded Franciscan order, 1210; confirmed by pope, 1223; declared saint 1228 1198-1216 Innocent III, pope; Church reached pinnacle of power	1174-1184 Canterbury choir built by William of Sens		1172-1220 Wolfram von Eschenbach, poet, Minnesinger □ 1172-1230 Walther von der Vogelweide, poet, Minnesinger □
1200		1220-1258 Salisbury Cathedral built 1228-1253 Basilica of St. Francis built at Assisi 1248 Cologne Cathedral begun, finished in 19th century 1278-1283 Campo Santo at Pisa built by Giovanni di Simone	c.1205-1278 Nicola (d'Apulia) Pisano ● 1230-1240 Bamberg Rider carved 1240-c.1302 Giovanni Cimabue ▲ 1250-1260 Ekkehard and Uta carved at Naumburg Cathedral c.1250-c.1317 Giovanni Pisano ● c.1255- 1319 Duccio di Buoninsegna ▲ c.1260 Pulpit in Pisa Baptistry carved by Nicola Pisano c.1266-c.1336 Giotto di Bondone ▲ c.1270-1349 Andrea Pisano ● c.1285-1344 Simone Martini ▲ c.1296 Frescoes on life of St. Francis painted at Assisi	1203 Wolfram von Eschenbach wrote Parzifal c.1214-1294 Roger Bacon, Franciscan monk and scientist ○ c.1225-1274 Thomas Aquinas, scholastic philosopher ○ 1225 St. Francis wrote Canticle of the Sun 1229 Thomas of Celano wrote Life of St. Francis 1262 St. Bonaventura wrote Life of St. Francis 1265-1321 Dante Alighieri ◆ c.1270-1347 William of Occam, Franciscan monk and nominalist philosopher ○ 1291-1361 Philippe de Vitry □
1300			2007 2000 GL W	1304-1374 Petrarch (Francesco
	1309-1376 Popes in residence at Avignon 1348 Black Death swept Europe 1378-1417 Great Schism between rival popes	c.1350 Haddon Hall built	c.1305-1309 Giotto painted frescoes on life of Virgin at Padua 1305-1348 Pietro Lorenzetti active ▲ 1308-1311 Duccio painted Maestà altarpiece, Siena Cathedral c.1320 Giotto painted Bardi Chapel frescoes in Santa Croce, Florence 1321-1363 Francesco Traini active ▲ 1323- 1348 Ambrogio Lorenzetti active ▲ 1330-1339 Bronze doors of Florence Baptistry cast by Andrea Pisano c.1334 Andrea Pisano and Giotto collaborated on sculpture for Florence Cathedral c.1350 Triumph of Death painted in Campo Santo, Pisa, by Traini	Petrarca) ◆ 1306 Jacopone da Todi died □ 1313-1375 Giovanni Boccaccio ◆ 1314-1321 Dante wrote Divine Comedy 1316 Ars nova, treatise on new music written by Philippe de Vitry 1325-1397 Francesco Landini, organist-composer at Florence □ 1332 Little Flowers of St. Francis compiled c.1340-1400 Geoffrey Chaucer ◆ 1341 Petrarch crowned poet laureate in Rome 1348-1352 Decameron written by Boccaccio 1354 Triumph of Death written by Petrarch

Late Medieval Styles

The great building wave that engulfed central France soon swept all before it, and Gothic quickly became an international style. Some of the French schools of stonemasons crossed the Channel into England, where great cathedral complexes were begun at Canterbury and Salisbury while Chartres and other Île-de-France cathedrals were still being built. Thereafter the Gothic moved across the Rhine into Germany, over the Alps into Italy, and across the Pyrenees into Spain. As the Gothic style spread, it encountered new social, political, religious, and cultural forces that were destined to give all the arts new shapes and directions. The oppositions previously maintained in a state of uneasy equilibrium by the application of scholastic logic and strict structurality were to break out in the 14th century into open conflicts.

Gothic cathedrals were still being built in the north while the sleeping beauty of classical art was being awakened in the south. Thunderous threats of fire and brimstone and fear of the Lord were hurled from church pulpits one day to be followed the next by comforting Franciscan parables and assurances of divine love and mercy. Professors in universities still argued with the icy logic of scholastic philosophy, while the followers of St. Francis were persuading people by simple human truths. Some painters designed images of doomsday filled with warring angels and demons while others portrayed biblical stories as seen through the eyes of simple folk. And people wondered whether the world they lived in was a moral trap set by the devil to ensnare the unwary or a pleasant place a loving Creator designed for their enjoyment.

For a drama of such sweeping scope, no single city or center could serve as the stage. All Europe, in fact, was the theater for this many-faceted performance in which people and their arts were in a state of creative ferment. The old Ghibelline and Guelph wars, which had started as a struggle between the forces loyal to the Holy Roman Empire and the sup-

porters of the popes, assumed a new shape in the 14th century. People were moving from the country to the towns, leaving the entrenched landowning aristocrats to rally around the Ghibelline banner, while the growing ranks of the craft guilds and merchants in the cities raised the Guelph flag.

The new Franciscan and Dominican monastic orders rarely kept to their cloisters. Instead they took to the highways and byways as preachers to all who would gather and listen. The great Italian writers Dante and Petrarch became exiles from their native cities, and their words were written during extended stays in half a dozen centers. Like them, the great painters were journeymen, traveling to wherever their work called them. Giotto, the leader of the Florentine school, did fresco cycles that occupied him several years each in Rome, Assisi, and Padua, as well as in his home city. Simone Martini of Siena was active in Pisa and Naples before he painted a chapel in St. Francis's church at Assisi. Then he spent his last years at Avignon. Internal Church dissensions were such that even the popes had to flee from their traditional seat in Rome to hold court in widely scattered residences, most notably at Avignon in southern France. Here the glittering papal court attracted the best and most progressive writers, artists, and musicians from all Europe, and Avignon became one of the main centers of the International Gothic style in the 14th century.

ENGLISH GOTHIC

Salisbury (Figs. 201, 202) is unique among English cathedrals because it was substantially finished within a short period from its beginning in 1220 to its consecration in 1258. All others were in a constant state of construction and alteration depending on the changing fortunes and needs of their constituent cities. Set in a magnificent park on the banks of a river, the structure gives the impression of unity from every angle. This is partly due to its coherent

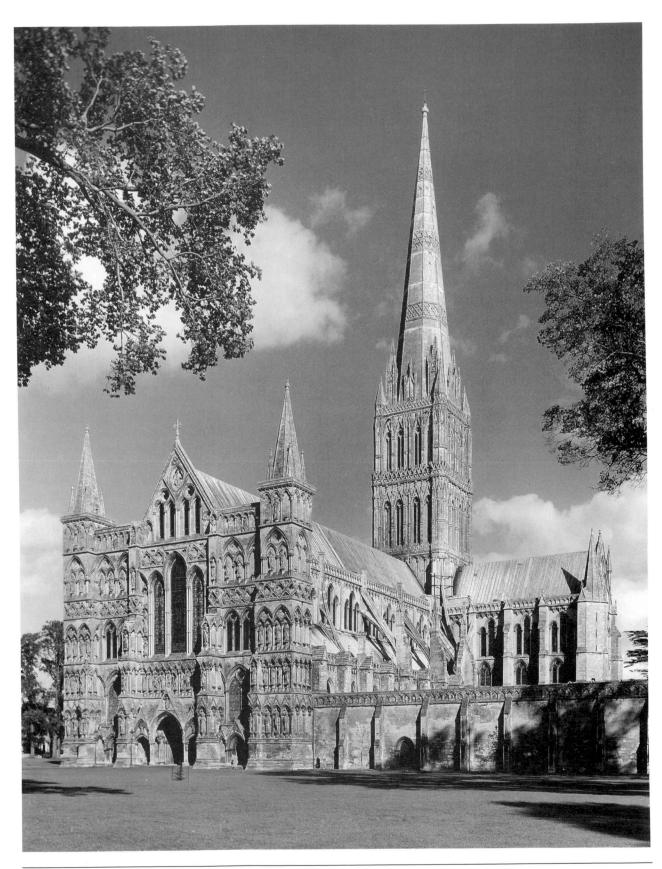

201. Salisbury Cathedral. 1220–58. Length 473' (144.17 m), width 230' (71.1 m), height of spire 404' (123.14 m).

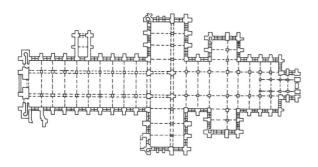

202. Plan of Salisbury Cathedral.

design and partly to the grand tower, which has a centralizing effect on the composition. This splendid spire, soaring some 404 feet (123.2 meters), was added in the 14th century and is the loftiest in England. The plan of Salisbury is a model of geometrical clarity. The English liturgy favored stately processions, and the long nave has ten bays (compared to Chartres's six). Two extensive transepts and a long choir add to the feeling of immense interior space. The church terminates in a handsome Lady Chapel on the main axis—which is dedicated to Mary, as is the entire edifice. Like many English cathedrals, Salisbury also has an attached cloister and chapter house to serve a monastic community.

The Gothic style became so completely acclimatized on British soil that it became known there as English architecture, partly because it was so popular and partly to distinguish it from the earlier Norman style. With various mutations (known as the Early English, the Decorated, the Perpendicular, and the Tudor), the Gothic continued as the dominant mode of construction that permeated every aspect of English life into the 17th century. There were all manner of Gothic chapels, parish churches, castles, manor houses, schools, colleges such as those at Oxford and Cambridge, guildhalls, market halls, inns, hospitals, townhouses, country cottages, bridges, fortifications, castles, and even barns, stables, and furniture.

Haddon Hall in Derbyshire is a manor house in the grand Gothic tradition. Set on the side of a hill amid pastoral surroundings, the house overlooks verdant fields where sheep and cattle graze (Fig. 203). Its spacious banqueting room (Fig. 204), with its timbered ceiling, large arched windows, and huge fireplace, is particularly impressive. The rest of the stately structure includes a long gallery, a chapel the size of a small church, ample living and sleeping quarters, and exterior terraces and extensive gardens. A glimpse of the entertainments in the banqueting halls of this period on the most elegant courtly level is provided on the January page in the richly illustrated *Book of Hours* created by the Limbourg Brothers for the Duke of Berry, brother to the King of France (Fig. 205). The feast in progress is in celebration of Epiphany, or Twelfth Night, the day the three Wise Men, following the star of Bethlehem

203. Exterior view of Haddon Hall.

204. Haddon Hall Banqueting Hall, 14th century.

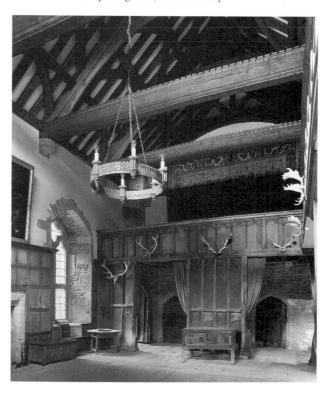

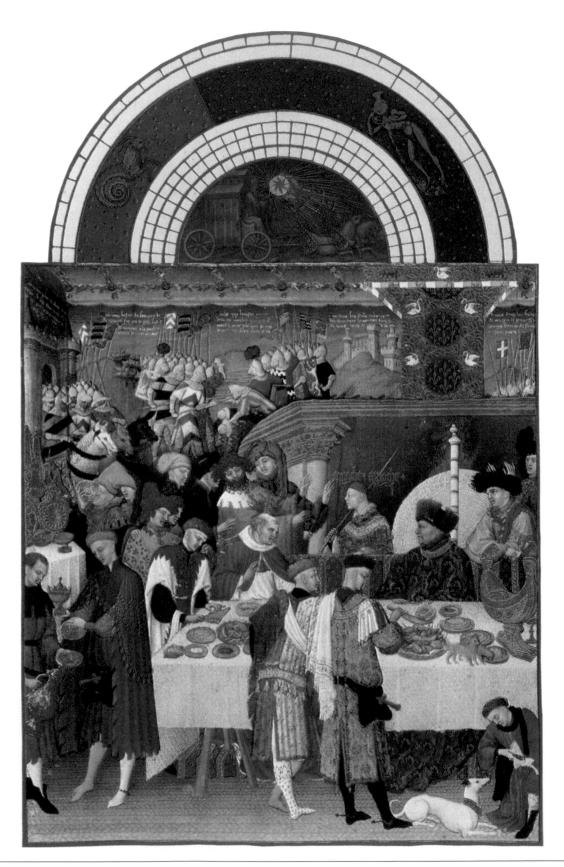

205.January page of Duke of Berry's *Book of Hours*. Victoria and Albert Museum, London.

(Fig. 205), found the infant Jesus in the manger and brought gifts of gold, frankincense, and myrrh. Here the Duke of Berry is sitting at the table receiving various gifts. The central figure with the monk's tonsured head is considered to be a self-portrait of the artist, Paul de Limbourg.

In the English countryside, where trees were plentiful, a modest type of wooden domestic dwelling developed along Gothic lines. These houses, with raftered ceilings and steep-pitched Gothic gabled roofs, traveled to America with the early colonists—who built the kinds of home they knew and remembered best.

The arts of sculpture and stained glass were also incorporated into English architecture, but never to the extent of their French counterparts. Both arts suffered in the break from Roman Catholicism in the time of Henry VIII, and most of what remained was destroyed under Cromwell's Puritan revolution in the 17th century. The fragments that survive show that these arts were similar in quality and character to those in 13th-century France. In the case of sculpture, some French craftsmen may have had a hand in its carving—for as historian Nicholas Pevsner observes, "The English are not a sculptural race." English architecture and literature, however, remain unrivaled.

A vivid verbal picture of this period was painted by Geoffrey Chaucer, who caught the spirit of these times in the sparkling verses of his *Canterbury Tales*. The time is spring and the place a London tavern where a motley group of people ranging from a knight to a ploughman is gathered before setting out on a pilgrimage to honor the martyred saint Thomas à Becket, the archbishop who had been murdered in the cathedral at Canterbury.

And specially from every shire's end Of England they to Canterbury wend, The holy blessed martyr there to seek Who helped them when they lay so ill and weak.

Pilgrims, according to tradition, were tellers of tall tales, and Chaucer lets them talk in the conversational tones of the English as its was spoken in his day. The stories range from moral tales and fables to lively storytelling and outright farce. Religious beliefs are treated with a worldly slant and goodhumored irony. One by one in the General Prologue, he introduces this amiable cross section of medieval society. The group includes the bawdy wife of Bath, who has buried five husbands and is still looking around; a poor Oxford student; an earthy miller; a fraudulent, "quack" doctor; a flamboyant young

squire with a roving eye for the ladies; a rich, busybody lawyer; a fastidious prioress whose inclinations are far more worldly than a nun's should be; and finally a knight, who draws the shortest straw and thus gets to tell the first tale:

He said: "Since I must then begin the game,

Why welcome be the cut, and in God

Why, welcome be the cut, and in God's name!

Now let us ride, and hearken what I say."

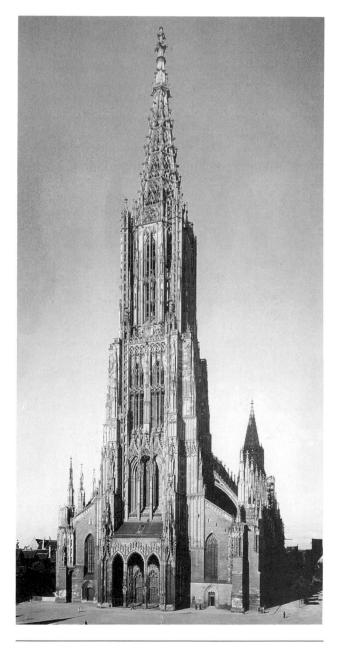

206. Ulm Cathedral, west façade. Begun 1377; tower designed 1482; spire 19th century.

GERMAN GOTHIC

In Germany the new Gothic style had to do battle for acceptance with the traditional Romanesque style that was so thoroughly entrenched under the Holy Roman Empire. Slow in evolving, it eventually acquired a distinctly national character of its own.

The Cathedral at Ulm (Fig. 206) carried to a climax the Gothic urge toward height. The single western tower and spire rise to the unprecedented height of 529 feet (140 meters), but the projected spire had to wait until the 19th century for its final flourish, when its builders could use cast-iron construction. The great cathedral complex at Cologne also had a tortuously slow history. Begun in 1248, its 150-foot (45.6-meter) choir and transept stood for centuries at one end with the stubs of the two

207. Ekkehard and Uta. c. 1250-60. Naumburg Cathedral, Germany. Limestone, life-size.

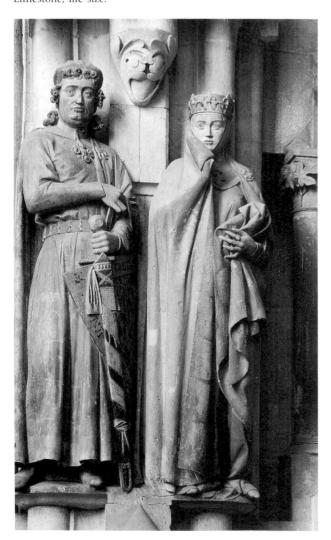

façade towers at the other and a yawning chasm between. So it was for almost six hundred years, when the interest of the Romantic period in medieval architecture led to the discovery of the original building plan. The new wealth of Cologne during the industrial revolution finally provided the funds for its completion.

German Gothic sculpture also shows a distinctive national character. In the choir of the Naumburg Cathedral the donors and founders are depicted in solemn procession (Fig. 207). The figures portrayed

208. Bamberg Rider. c. 1230-40. Bamberg Cathedral, Germany. Limestone, life-size.

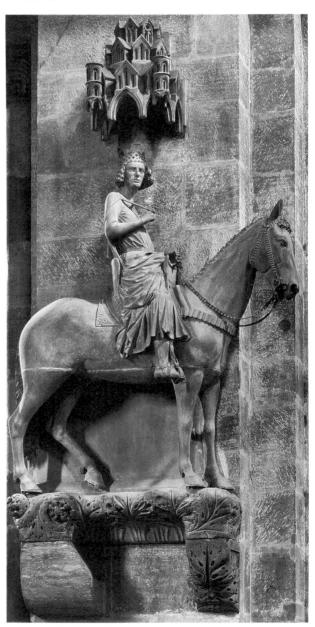

were from the historical past, but the skillful sculptor creates them in almost living likenesses. The stocky Margrave Ekkehard appears as a self-confident, haughty aristocrat whose hand is never far from his sword. Uta, his beautiful wife, is regally poised. With graceful gestures she draws her collar across her face with one hand while gathering the ample folds of her gown with the other. As with classical sculpture, the curves of the arm and modeling of the breast reveal how the artist distinguishes the drapery from the body beneath.

Splendidly carved and lifelike is the majestic figure of the *Bamberg Rider*, placed in a niche on the exterior of the Bamberg Cathedral (Fig. 208). Sitting high in his saddle on his impatient horse, this Gothic knight might well be preparing to participate in some medieval tournament or leading his victorious soldiers into some vanquished city.

ITALIAN GOTHIC

When the Gothic reached Italy, it underwent radical transformation. Tall spires and the urge to pierce the skies did not harmonize with either the Italian temperament or landscape. Churches were conceived as cool retreats from the southern sun, so the need for illuminated interiors was less of a pressing problem than in the North. The mural arts of mosaic making and fresco painting still flourished in the decoration of Italian churches and public buildings, so stained glass never played a major role. Northern influence on sculpture and the handling of pictorial space is evident in many instances. But with the remains of classical civilization all around them, Italian artists always had models of high quality from antiquity to inspire them.

In this era of change, the little village of Assisi in the Umbrian hills of central Italy became more representative than a large center like Rome. A town of such small size would, of course, have been too insignificant to support a major art movement, and no important artist could have survived in this provincial location had Assisi not been the birthplace of Francis, one of the most beloved medieval saints. Consequently, after the completion in the mid-13th century of Assisi's great pilgrimage basilica, many of the outstanding artists of the age came to decorate its walls.

The town of Assisi was built upon a rocky hill in the midst of a countryside both gentle and lush. A truly mountainous terrain might have nourished a rugged spirit capable of bringing down some new commandments from above, but the gentle rolling green hills instead brought forth the most humble of Christian saints. A large city might have produced a

great organizer, capable of moving the minds of the many with clever speeches to bring about a new social order. Francis of Assisi, however, recognized the dangers of bombastic oratory and the short-lived nature of all forms of social organization. He accomplished his pastoral mission with the sweet persuasion of simple parables and the eloquence of his own exemplary life.

While the mature life of Francis fell within the 13th century, the collection of tales that made him a living legend, as well as the full development of the Franciscan movement, belongs to the 14th. The clergy who received their training in the universities and the scholarly orders of monks had never influenced a broad segment of society. The Franciscans, however, found a way into the hearts and minds of the multitudes by preaching to them in their own language and in the simplest terms, and Franciscan voices were heard more often in village squares than in the pulpits of the churches

The essence of the Franciscan idea is contained in the mystical marriage of the saint to Lady Poverty, the subject of one of the Assisi frescoes. When a young man had approached Christ and asked what he should do in order to have eternal life, the answer came, ". . . go and sell that thou hast, and give to the poor, and thou shalt have treasure in heaven: and come and follow me" (Matt. 19:21). Francis took this commandment literally, and in his last will and testament described his early life and that of his first followers. "They contented themselves," he wrote, "with a tunic, patched within and without, with the cord and breeches, and we desired to have nothing more. . . . We loved to live in poor and abandoned churches, and we were ignorant and submissive to all." He then asked his followers to "appropriate nothing to themselves, neither a house, nor a place, nor anything; but as pilgrims and strangers in this world, in poverty and humility serving God, they shall confidently go seeking for alms."

The Basilica of St. Francis at Assisi

Had St. Francis's vow of complete poverty been followed strictly, no great art movement would have developed at Assisi. A building program involved the accumulation and expenditure of large sums, and immediately after Francis's death this matter created dissension among those who had been closest to him. Brother Elias wanted to build a great church as a fitting monument to his friend and master, while others felt that Francis should be honored by the closest possible adherence to his simple life pattern. The monument Brother Elias had in mind would take a vast treasure to erect, and many of his fellow

friars were shocked when Elias set up a marble vase to collect offerings from pilgrims who came to Assisi to honor Francis. Yet only two years later, at the very time he was made saint, a great basilica and monastery were begun on the hill where Francis had wished to be buried.

Taking advantage of the natural contours of the site, the architects designed a structure that included two churches, a large one above for pilgrims and a smaller one below for the Franciscan monks. In spite of their comparatively large size, both churches are without side aisles, having just central naves terminating beyond transepts in apses. The large interior areas are spanned by spacious quadripartite ribbed vaults, which are partially supported by rows of columns set against the walls. Italian Gothic, contrary to the northern style, did not accent well-lighted in-

teriors in which the walls were almost completely replaced with stained glass windows. The southern sun made shade more welcome, and the interiors took on the character of cool retreats from the burning brightness of the world outside.

The absence of a nave arcade and side aisles and the small number of stained glass windows allowed ample wall space in both the upper and lower churches at Assisi for the brightly colored fresco paintings that cover them. Lighted principally by the clerestory, the walls of the upper church glow in the dim interior with a mild inner light all their own, illuminated as they are by scenes from the life of St. Francis. More than anything else, it is these murals that bring the twin churches their most special distinction, and the names of the artists who worked on them read like a roster of the major painters of the

209. Nave, Upper church of St. Francis, Assisi. 1228–53.

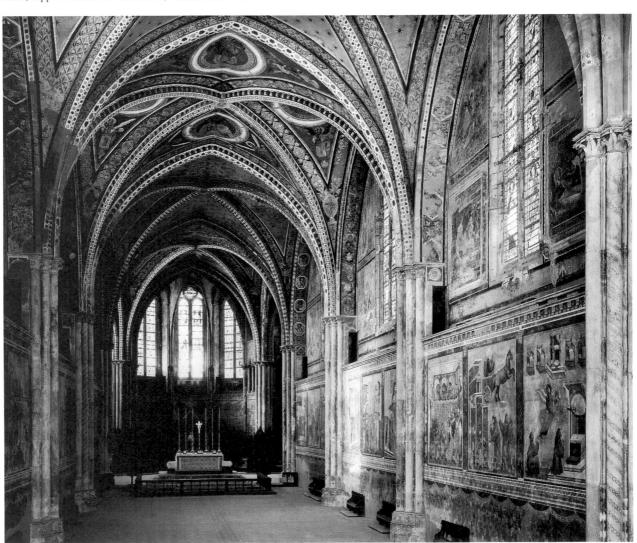

period: Cimabue and Giotto of Florence and Simone Martini and Pietro Lorenzetti of the Sienese school.

The Life of St. Francis in Fresco

On the walls of the nave of the upper church at Assisi are the series of frescoes on the life of Francis that tradition attributes to Giotto (Fig. 209). His actual role as principal painter or designer is still a matter of scholarly debate. The date generally assigned to the work is the four-year span just before the jubilee year of 1300. Knowing that more pilgrims than ever before would be traveling to Rome for the celebrations, the artists at Assisi made every effort to cover the bare walls of the upper church in time. The frescoes for the friars' own lower church had to wait until the mid-14th century for completion.

Giotto, like other master artists of his period, had learned to work in a variety of techniques. In addition to frescoes, he did mosaics, painted altarpieces in tempera on wood, and was a sculptor. Several years before his death, he was named the chief architect of Florence, and in this capacity he designed the *campanile*, or bell tower, of the cathedral (see Fig. 222), still popularly called "Giotto's Tower." Giotto's greatest and most enduring fame, however, rests most securely on the three fresco cycles in Assisi, Padua, and Florence.

The fresco medium calls for the rapid and sure strokes of a steady hand and for designs that harmonize with the architectural scheme and awaken walls into a vibrant and colorful life. After first covering the entire wall with a layer of rough plaster and allowing it to dry thoroughly, the artist makes a *cartoon*, a preliminary drawing in charcoal, on the surface. Then, taking an area that can be finished in a single day, the artist smooths on a thin layer of wet plaster and, if necessary, may retrace the original drawing. Next, earth pigments (colors) are mixed with water, combined with white of egg as a binder, and applied directly to the fresh plaster—hence the term *fresco*.

The pigments and wet plaster combine chemically to produce a surface as permanent as that of any medium in painting. Artists sometimes paint over the surface after it is dry, but this repainting usually flakes off in time. If corrections are necessary, the entire section must be knocked out and redone. Fresco, then, is a medium that does not encourage overly subtle types of expression; and it is best adapted to a certain boldness of design and simplicity of composition. The emotional depth, the communicative value, and the masterly execution of Giotto's cycles rank them among the highest achievements in world art.

Assisi and Padua Series. The first two panels of the series at Assisi are worthy of Giotto himself, but since Giotto worked with a group of assistants, it is impossible to be completely certain how much of these are actually his work. On the right, after one passes through the entrance portals, is the Miracle of the Spring (Fig. 210), while on the left is the well-known Sermon to the Birds. The order of the scenes is psychological rather than chronological. These two were placed on either side of the entrance, probably to impress pilgrims at the outset with the most popular Franciscan legends—those showing the saint ministering to the poor and humble on one side and his kinship with all God's creatures, including his brothers the birds, on the other.

The literary source for the *Miracle of the Spring* is in the *Legend of the Three Companions*, which tells of Francis's journey to the monastery of Monte la Verna. A fellow friar, a peasant, and his donkey accompanied him, but the way was steep and the day hot. Overcome by thirst, the peasant cried out for water. Kneeling in prayer, the saint turned to him,

210. Giotto (?). *Miracle of the Spring.* c. 1296–1300. Fresco, Upper church of St. Francis, Assisi.

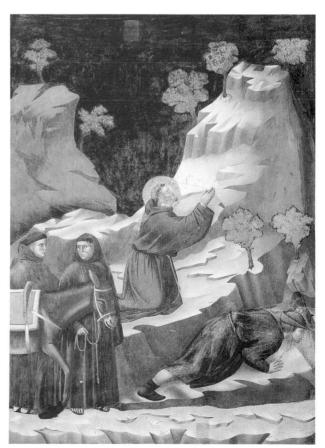

saying, "Hasten to that rock and thou shalt find a living water which in pity Christ has sent thee from the stone to drink." Pilgrims entering the church were thirsty for spiritual refreshment, and the placement of this picture assured them that they had arrived at a spiritual spring.

The composition is as simple as it is masterly. St. Francis is the focal center of two crisscrossing diagonal lines like the letter X. The descending light from the rocky peak in the upper right reveals the contours of the mountain in a series of planes. It reaches its greatest intensity in its union with Francis's halo, diminishing in his shadow where his two companions and the donkey stand. The dark moun-

tain at the upper left moves downward toward the shadowy figure of the drinking peasant at the lower right, as if to say he is still in spiritual darkness. But since Francis is also on this diagonal line, the way to enlightenment is suggested.

Giotto's marvelous mountains are found in many of his major compositions, such as *Joachim Returning to the Sheepfold* (see Fig. 221), the *Flight into Egypt*, and the great *Pietá* (Fig. 211), all in the Arena Chapel at Padua. Structurally, the mountains advance and recede to form niches for his figures, and their hardness and heaviness are complementary to the compassion and expressiveness of his human types. The mountains, or architectural back-

211. Giotto. *Pietà (Lamentation)*. 1305–06. Fresco, 7'7" × 7'9" (2.31 × 2.36 m). Arena Chapel, Padua.

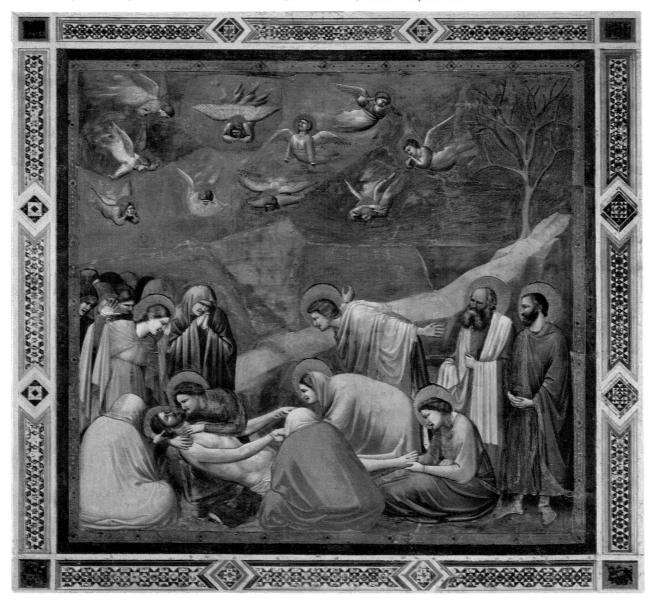

grounds, do not exist in their own right but become volumes and masses in Giotto's pictorial designs as well as inanimate extensions of human nature. Giotto's spatial proportions, furthermore, are psychologically rather than actually correct. Human beings, in keeping with their greater expressive importance, loom large against their mountain backgrounds; and his scattered trees serve mainly as spatial accents.

Perhaps the most dramatic of the series at Assisi is *St. Francis Renouncing His Father* (Fig. 212), after a controversy involving worldly goods. In his haste to abandon the material world, Francis casts off his garments and stands naked before the townspeople, saying, "Until this hour I have called thee my father upon earth; from henceforth, I may say confidently, my Father who art in Heaven, in whose hands I have laid up all my treasure, all my trust, and all my hope." The bishop covers Francis with his own cloak and receives him into the Church.

The expressions of the various figures as revealed in their gestures and facial expressions make this fresco an interesting study of human attitudes. The angry father has to be physically restrained from violence by a fellow townsman, yet his face shows the puzzled concern of a parent who cannot understand his son's actions. His counterpart on the other side is the bishop, who becomes the new father of the saint in the Church. Disliking such a scene, his glance shows both embarrassment and sympathy. These opposing figures are supported respectively by the group of townspeople, behind whom is an apartment house, and by the clergymen, behind whom are church buildings. An interesting pictorial geometry is used to unify the picture and resolve the tension. The two opposing groups, symbolizing material pursuits and spiritual aspirations, become the base of a triangle. Between them the hand of Francis points upward toward the apex, where the hand of God is coming through the clouds.

Before and after the Black Death

All went well in Italy during the first third of the 14th century. Townspeople prospered, life was good, the arts flourished. Beginning in 1340, however, a series of disasters befell Italy, starting with local crop failures and continuing with the miseries of famine and disease. The climax came in an outbreak of bubonic plague in the catastrophic year of 1348. In this so-called Black Death, more than half the populations of such cities as Florence, Siena, and Pisa perished. A chronicler of Siena, after burying five of his children, said quite simply: "No one wept for the dead, because everyone expected death himself."

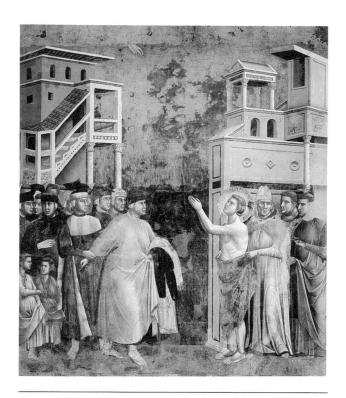

212. GIOTTO (?). *St. Francis Renouncing His Father.* c. 1296–1300. Fresco. Upper church of St. Francis, Assisi.

An event so catastrophic, and one that spread over the entire European continent, was bound to have a deep effect upon social and cultural trends. Many survivors found themselves suddenly made poor or, through unexpected inheritances, vastly enriched. Thousands of residents in the relatively safe countryside flocked into the cities to take the places of those who had died. The lives of individuals underwent radical changes that quickened their normal instincts. For some, it was the "eat, drink, and be merry" philosophy, exemplified in Boccaccio's *Decameron*; for others, it was moral self-accusation and repentance, as seen in the purgatorial vision of the same author's later *Corbaccio*.

Driven by fear and a sense of guilt, people felt that something had gone disastrously wrong and that the Black Death, like the biblical plagues of old, must have been sent by an angry God to chastise humanity and turn people from their wicked ways. Both Boccaccio and Petrarch in the literary world adopted this view after their earlier, more worldly writings, and what was true of literature was true also of painting.

SCULPTURE AT **PISA.** Giovanni Pisano and his father, Nicola, were the two outstanding sculptors of their time. Nicola Pisano, also known as Nicola

d'Apulia from his southern Italian origin, designed a handsome pulpit with six religious panels for the Baptistry at Pisa, and some years later Giovanni did one for the cathedral. The panels of both depict scenes from the New Testament. The differing attitudes of the father's generation and of the son's are revealed when panels dealing with the same subject are compared. Together, their work represents the trend of sculpture before the Black Death.

Nicola's panel of the *Annunciation and Nativity* (Fig. 213) clearly was influenced by the relief sculpture he knew so well from his formative years spent near Rome (see Figs. 90, 98, 99, 116). The Virgin appears as a dignified Roman matron reclining in a characteristic classical pose. The angel at the left in the Annunciation section is seen against a classical temple and is dressed in a Roman toga, as are many of the other figures. Nicola employs the old simultaneous mode of narration, with the Virgin making three appearances on the same panel. The relief as a whole projects a mood of monumental calm.

Giovanni's work, as seen in his *Nativity and Annunciation to the Shepherds* (Fig. 214), moved away from his father's classicism into the French Gothic orbit. His figures are smaller in scale and more naturally proportioned to their surrounding space. Greater animation and agitation of line replace the serene repose of his father's style. The works of both father and son, however, display a sense of human warmth that closely resembles the spirit of Giotto's frescoes on the life of St. Francis.

SIENESE AND FLORENTINE SCHOOLS OF PAINT-ING. Nearby Siena, prior to the Black Death, was also enjoying a period of prosperity. Unlike its rival city Florence, which was a Guelph stronghold where power was held by the guilds and rich merchants, Siena was a faithful Ghibelline town dominated by the landed aristocracy. These oppositions led Florence in a progressive direction and kept Siena as a stronghold of tradition. Cimabue, the leading Florentine artist of the late 13th century who brought

213. NICOLA PISANO. *Annunciation and Nativity,* detail of pulpit. 1259–60. Marble. Baptistry, Pisa.

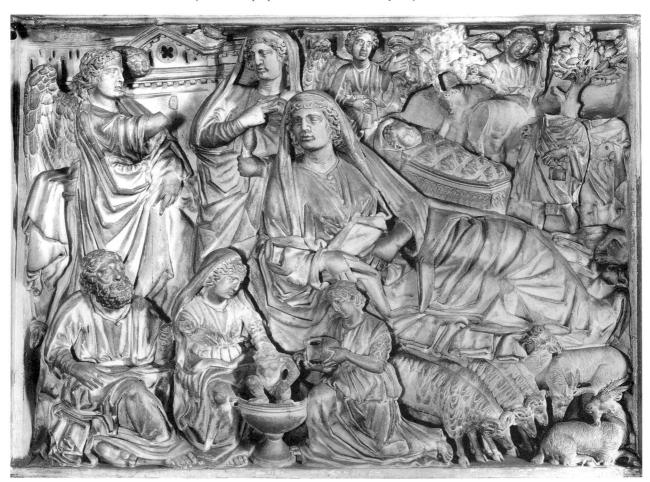

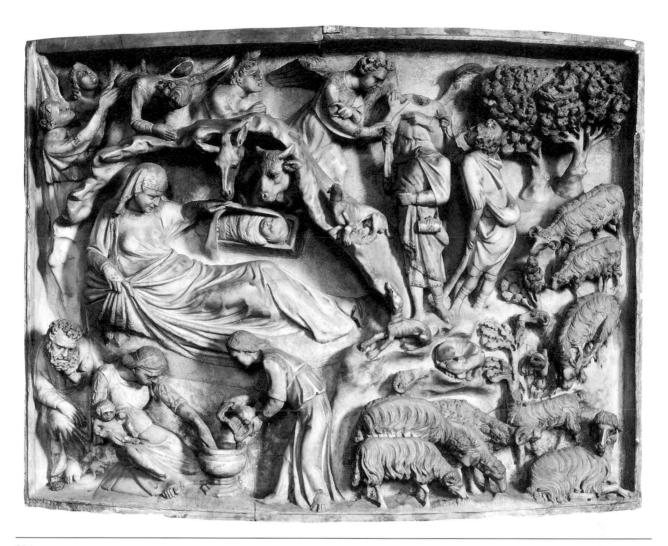

214. GIOVANNI PISANO. *Nativity and Annunciation to the Shepherds,* detail of pulpit. 1302–10. Marble. Cathedral, Pisa.

the Gothic style to its peak in his city, was succeeded by the formidable figure of Giotto, whose painting points clearly to the coming Renaissance. In Siena, however, the great Duccio was followed by Simone Martini and the Lorenzetti brothers, who continued in the Byzantine tradition that had been introduced into Italy via such centers as Ravenna and Venice many centuries earlier. Despite this continuing traditionalism, the Sienese school poured enough late Gothic wine into the old medieval wineskins to bring about a brilliant, but final, flowering of Italo-Byzantine painting.

Four altarpieces for Florentine churches—similar in purpose, theme, and form but different in style—will illustrate this painterly trend. Cimabue's *Madonna Enthroned* (Fig. 215), designed for the high altar of Santa Trinità, has all the feeling of medieval majesty and monumentality. Gothic verticality governs the two-story composition with four solemn

prophets below displaying their scrolls and the ascending ranks of the eight angles above. The Madonna sits frontally on a solid architectural throne of complexly inlaid wood. Her dark blue mantle and rose-red robe are flecked with highlights of gold that combine with the rich folds to create a rhythmic linear pattern. The Christ child conforms to the theological image of the miniature patriarch born knowing all things.

Duccio's altarpiece called the "Rucellai" Madonna (Fig. 216), from the Church of Santa Maria Novella, is in a lighter, more buoyant and decorative vein. While Duccio undoubtedly knew Cimabue's monumental style, his kneeling angels are airier, as if gently settling down after a heavenly flight. The folds of the background drapery, the liberal use of gold, Byzantine richness of line, the surpassing linear delicacy of the undulating edges of the Madonna's robe, the slight off-center angle of the throne,

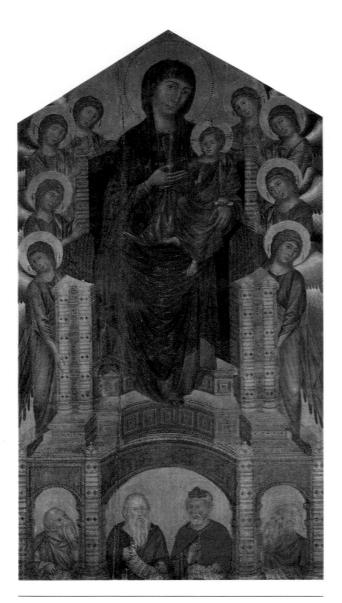

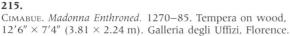

The new direction of the early Renaissance, however, is manifest in Giotto's *Madonna Enthroned* (Fig. 217), painted for the Church of Ognissanti about twenty years later than those of Cimabue and Duccio. Two angels kneel in the foreground, while the angels of the heavenly choir are placed one in front of the other so as to expand the sense of space and to create a recession in depth toward the back row, where six grave saints are depicted. The drawing is simplified, thus parting company with its predecessors. Among other differences, the Madonna's gaze meets that of her beholders; her figure is heav-

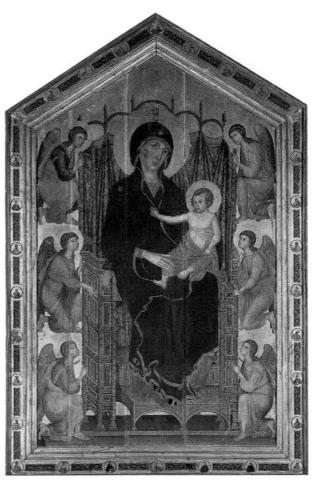

216. Duccio. "Rucellai" Madonna. 1285. Tempera on wood, $14'9'' \times 9'6''$ (4.5 \times 2.9 m). Galleria degli Uffizi, Florence.

ier, the breasts prominent; the Child is in a more natural posture; and the Madonna's robe is modeled in light and shadow to delineate the flesh beneath.

In the *Annunciation* (Fig. 218) by Duccio's Sienese disciple and Giotto's contemporary Simone Martini, aristocratic aloofness prevails. The Gothic setting is courtly with the elegant vase of lilies and the regal Madonna draped in a French-style blue gown rendered in pigment made from the powdered semiprecious blue stone, lapis lazuli. Disturbed in her reading by the sudden appearance of the Archangel Gabriel, his robes and wings aflutter, the startled Virgin recoils in fear and astonishment as she hears the words that appear in relief: "Hail Mary . . . the Lord is with thee." The composition is a masterly

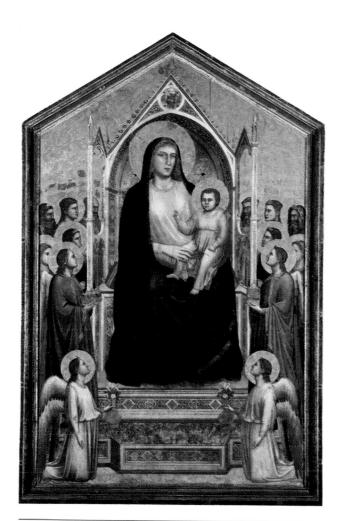

Giotto. Madonna Enthroned. c. 1310. Tempera on wood, $10'8'' \times 6'8''$ (3.25 × 2.03 m). Galleria degli Uffizi, Florence.

combination of vivid colors and curvilinear design as revealed in the folds of the costumes, the vase of flowers, the spiraling columns, and the arched niches that frame the figures.

REACTION TO THE PLAGUE. As a result of the black Death of 1348, Sienese art declined. The reaction to the great plague is well illustrated in the series of frescoes on the inner walls of the Campo Santo at Pisa. The theme is the Last Judgment, and the Triumph of Death (Fig. 219) took its name from a poem by Petrarch. While no direct cause-and-effect relationship between picture and poem can be proved, both were reactions to the plague, both shared common attitudes of the time, and both were based on a similar theme.

Triumph of Death is a grandiose statement, with so much detail crowded into every bit of space that something in it was bound to appeal to everybody. Like the sermons of the time, each part warned of the closeness of death, the terrors of hell if the soul were claimed by the devil, or, conversely, the bliss of being carried off by the angels.

In the fresco attributed to Francesco Traini a group of mounted nobles is shown equipped for the hunt, but instead of the quarry they were pursuing, they find only the prey of death. Inside the three open coffins serpents are consuming the corpses of the onetime great of the earth. Petrarch also speaks of death as the great leveler when he notes in his poem that neither "the Popes, Emperors, nor Kings, no enseigns wore of their past hight but naked show'd and poor," and then asks, "Where be their riches, where their precious gems? Their miters, scepters, robes and diadems?" Nearby is a bearded anchorite monk unfolding a prophetic scroll that warns them to repent before it is too late. The only relief from the scene of horror and desolation is found in the upper left, where some monks are gathered around a chapel busying themselves with the usual monastic duties. Apparently only those who renounce the world can find relief from its general turmoil and terror of death. The sheer horror and desolation of this scene hark back to the carved Last Judgments in earlier medieval churches.

Music and Literature

The contrast between the gloomy, threatening medieval worldview and the kind, joyful Franciscan spirit is illustrated by two 13th-century songs. The facts behind their composition alone are sufficient to point out the split in thought of the period. The Dies irae, which so admirably reflects the prevailing medieval spirit, is traditionally attributed to the great Latin stylist Thomas of Celano a few years before he met St. Francis and became one of his friars. The second, the Canticle of the Sun, is by St. Francis himself. Thomas of Celano entered the Franciscan order about the year 1215, enjoyed the friendship of St. Francis for several years, and was entrusted by Pope Gregory IX with the official biography that was written shortly after Francis was declared saint in 1228.

THE DIES IRAE. In the triple stanzas and 57 lines of the Dies irae, the medieval Latin poetic style reaches a high point. Its content invokes the vision of the final dissolution of the universe, the sounding of the angelic trumpets calling forth the dead from their tombs, and the overwhelming majesty of the coming of Christ as king to judge the living and the dead.

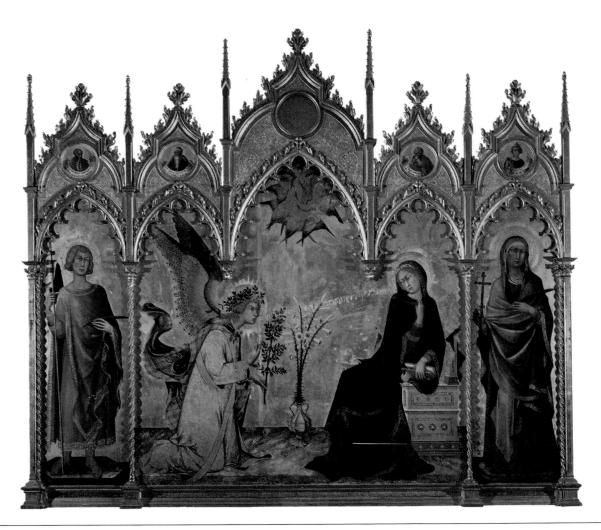

218. Simone Martini. Annunciation (saints in side panels by Lippo Memmi). 1333. Tempera on wood, $8'8'' \times 10'$ (2.64 \times 3.05 m). Galleria degli Uffizi, Florence.

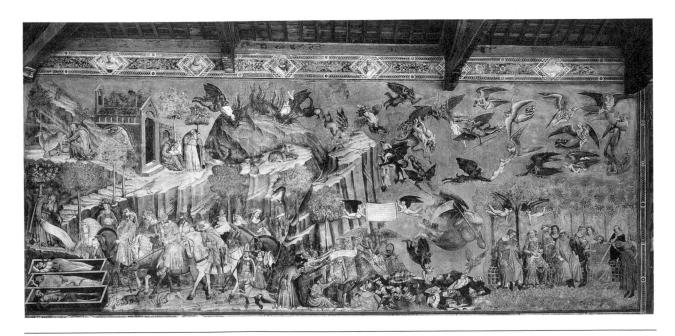

The grandeur of its language and the perfection of its poetic form are in every way equal to this solemn and awesome theme. The images and moods run from anger and terror to hope and bliss before coming to a close with a final plea for eternal rest. A sampling of its vivid verses can be gained from the following stanzas:

> Day of Wrath! O day of mourning! See fulfilled the prophets' warning, Heaven and earth in ashes burning!

Wondrous sound the trumpet flingeth; Through earth's sepulchres it ringeth; All before the Throne it bringeth.

Guilty, now I pour my moaning, All my shame with anguish owning; Spare, O God, Thy suppliant groaning!

While the wicked are confounded. Doomed to flames of woe unbounded. Call me, with Thy saints surrounded.

Dies irae (early 13th century) Thomas of Celano (?)

Although the colorful language and verbal rhythms of the Latin original have a music all their own, the Dies irae is inseparable from a melodic setting in the mixed Dorian mode (above). Both the poem and its melody found their way into the liturgy as important parts of the mass for the dead. Later this melody was to become famous as a symbol of medieval hellfire and brimstone in the 19th-century romantic movement (see pp. 474-476).

LAUDS AND THE CANTICLE OF THE SUN. The most characteristic Franciscan contribution to poetry and music is found in a body of informal hymns called laudi spirituali—songs of praise or simply "lauds"-traceable directly to St. Francis and his immediate circle. The practice of spontaneous hymn singing continued from his time onward and in the 14th century was firmly established as the most popular form of religious music.

In music, as in his religious work, Francis drew together the sacred, courtly, and popular traditions.

The lauds were thus a poetic bridge between the traditional music of the Church, the music of the castle, and the music of the streets. The words always had a religious theme. Often they were mere variations of psalms and prayers sung to popular airs. Above all. they were music and poetry that the people could both sing and feel with their hearts.

Contrapuntal choral music, whether it was in the form of a church motet or a secular madrigal, was a sophisticated musical medium that needed the voices of skilled professionals. By contrast, the lauds were folklike in spirit, simple and direct in their appeal, and sung either as solos or with others in unison. Just as the skilled monastic choir was characteristic of the Cluniac movement and the contrapuntal chorus the musical counterpart of the northern Gothic spirit, the lauds became the special and characteristic expression of the Franciscans.

The Canticle of the Sun by St. Francis is at once the most sublime of all the lauds and the most original. The legend goes that when St. Francis was recovering from an illness in a hut outside the convent of St. Clare, the nuns heard from his lips this rapturous new song. The informality, even casualness, of its composition and its rambling rhythms and rhymes make it as simple and unaffected in its form as the Umbrian dialect in which it is written. Sincerity and deep human feeling dominate the unequal stanzas of St. Francis's songs of praise, rather than any attempt at learned communication or poetic elegance. It goes in part:

> Praised be my Lord God with all his creatures, and especially our brother the sun, who brings us the day and who brings us the light; fair is he and shines with very great splendor; O Lord, he signifies to us Thee!

Praised be my Lord for our sister the moon, and for the stars, the which He has set clear and lovely in heaven.

Praised be my Lord for our sister water, who is very serviceable unto us and humble and precious and clean.

Praised be my Lord for our brother fire, through whom thou givest us light in the darkness; and he is bright and pleasant and very mighty and strong.

While the original melody of the Canticle of the Sun is now lost forever, countless lauds do survive, some of which date back to shortly after St. Francis's time. A Franciscan monk by the name of Jacopone da Todi, who died in 1306, was one of the greatest writers of lauds. His most famous hymn is the Stabat Mater Dolorosa, which was officially incorporated in the liturgy in the 18th century to be sung on the Feast of Seven Sorrows. This remarkable man, like St. Francis before him, was of Umbrian origin, and, after a succession of such diverse careers as lawyer, hermit, and Franciscan preacher, he turned poet and composer. His hymns readily found their way into the texts of the early miracle plays, which dramatized episodes in the life of a miracle-working saint or martyr, and his music became the foundation of the laudistic tradition. The example (below) is a part of one of his lauds. Its rhythmic complexity, emotional intensity, and stylistic character mark it as typical of the early Franciscan movement.

DANTE'S DIVINE COMEDY. At the summit of the Middle Ages, Dante Alighieri built a poetic cathedral of architectural grandeur in the soaring verses of his Divine Comedy. This summa of diverse philosophical, theological, and political worldviews became at once a great human document, the outstanding book of the medieval period, and a prophecy of Renaissance things to come. In one stroke, Dante established the Italian spoken by the common people as an expressive language and endowed his country with its most enduring literary masterpiece. The work is not only a synthesis of scholastic and Franciscan philosophy, but a summation of the entire thought of the medieval period and of Greco-Roman antiquity as its author knew it. Classical figures such as Aristotle, Cicero, Ovid, and Vergil rub shoulders across its pages with Boethius, Thomas Aquinas, St. Francis, and Giotto-who, tradition has it, portrayed Dante in a Paradiso of his own, painted in the Chapel of the Bargello at Florence (Fig. 220).

While the poem is elaborately allegorical, replete with all manner of symbolism, and meant to be read on more than one level, the reader should not be initimidated. For Dante tells a broad, compelling

story, as well as stories within stories. Allegory, after all, is simply a matter of interpreting experience by means of images; it may be thought of as an extended metaphor. Symbols are just generally agreedupon signs that stand for something else—as \$ stands for the dollar. The form of the poem is divided into a three-part structure—Hell, Purgatory, and Heaven—and one of his building blocks is the medieval mystical number 3. Each stanza has three lines; the rhyming scheme is the melodious terza rimaaba, bcb, etc. In turn, Dante is terrified by three animal personifying the three sins he must overcome to progress upward. Each time he is saved by the mediation of three holy women. To enter the three realms he must pass through three gates. Each section contains 33 cantos, the number of Christ's years on earth. Finally, the introductory canto, added to the three times 33 others, brings the total to an even 100, that number having the quality of wholeness and perfection. Nine as the multiple of three also plays its part. Hell and Purgatory each have nine circles, while in Paradise there are nine categories of angels in their nine different spheres, plus Empyrean above all, which is the abode of God.

The allegorical journey through these vast spaces symbolizes the soul in its quest for self-knowledge and spiritual illumination. The path runs the gamut from despair to hope, from sin to grace, from hate to love, from ignorance to enlightenment. His vision is not concerned only with life after death, but with the course of human life from birth in original sin, through the purgation process of experience, to the knowledge of ideal goodness, truth, and beauty. As Dante says in the opening lines:

Midway in our life's journey, I went astray from the straight road and woke to find myself alone in a dark wood.

From the dark and sunless woods, he plunges into the depths of the Inferno, where he encounters the fearsome inscription: *Abandon All Hope Ye Who Enter Here*.

Here sighs and cries and wails coiled and recoiled

on the starless air, spilling my soul to tears.

A confusion of tongues and monstrous accents toiled.

In the lowest pit of Hell he encounters the monstrous body of Lucifer who, as his name implies, is the fallen angel of light now dwelling in eternal

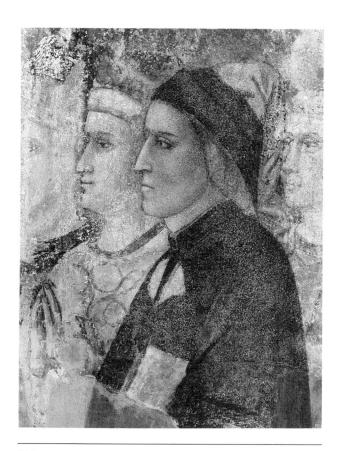

220. Giotto (?). Portrait of Dante, detail of fresco. c. 1325. Chapel of Palazzo del Podestà, Bargello, Florence.

darkness. From this point onward, Dante's progress begins the ascent from darkness to light, from ignorance to knowledge, from unawareness to enlightenment. The next state is Purgatory, where light begins to dawn:

Now shall I sing of that second kingdom given the soul of man wherein to purge its guilt and so grow worthy to ascend to Heaven.

Here he glimpses the pure radiance of the eastern star while encountering a strange shade who asks:

Who led you? or what served you as a light in your dark flight from the eternal valley, which lies forever blind in darkest night?

Until now he has been guided by the classical Roman poet Vergil, who must leave him at this

point, since only Christians may enter the sacred precincts of Paradise. From here onward his guide will be Beatrice, who had from afar been his lifelong beatific love, inspiration, and spiritual ideal. In real life Dante had met her socially only a few times, but she instantly became for him his "blessed and glorious Beatrice." Now she appears as the personification of divine grace. He then climbs the mount of Purgatory where the sunrise and sunset are the transitory phases before progressing into the ultimate realm, where sunlight never fades in the presence of God, the source who controls the star-studded spheres.

The glory of Him who moves all things rays forth through all the universe, and is reflected from each thing in proportion to its worth.

I have been in that Heaven of His most and what I saw, those who descend from there lack both the knowledge and the power to write.

Dante does indeed have the power to write. He has the true musician's ear for sound, and his verses have a music all their own. He also has the painter's eye for the smallest detail of appearances, and his images are a feast for the inner eye of the imagination as well. Primarily it is a spiritual light that concerns him, but he conjures up its vision in familiar everyday impressions filtered through the mind's eye of a true poet. He sings of sunlight, firelight, starlight; the sparkle of precious stones; the gleaming rays of a lamp in the darkness; the translucent effects of light filtered through water, wine, glass, and jewels; rainbows and the colored reflections from clouds; the ruddy glow of infernal flames and the pure radiance of Paradise; the light of the human eye and that of halos surrounding the heads of saints. Light then becomes the divine spark that leads from reason to revelation. Finally, soaring toward the firmament, each of the three cantos of the poem end on the word stelle (stars). The last words of the Paradise mirror the ultimate, ineffable vision of divinity as "The love that moves the sun and other stars."

IDEAS

While English and German thought and action were still firmly rooted in the Middle Ages, Italy had one foot in medieval times and the other in the emerging Renaissance. The opposing worldviews are reflected in a number of situations. Among them are the great Church schism, the social struggle between the landed aristocracy and growing cities, the incompatibility of Gothic architecture and the sunny landscape of Italy, the presence of medieval devils and genuine human types in Giotto's frescoes, the opposing visions of the Inferno and Paradise in Dante's *Divine Comedy*, and the attitudes expressed in poetry and painting before and after the Black Death.

The backward and forward directions are illustrated also in the struggle within the minds and consciences of individual persons. The life of St. Francis, to cite one example, combined an otherworldly self-denial with an obvious worldly love of natural beauty. Fire for him was not created so much for roasting the souls of sinners in Hell as to give light in the darkness and warmth on a cold night.

The Romanesque St. Peter Damian had said: "The world is so filthy with vices, the holy mind is befouled by even thinking of it." In contrast, the Gothic encyclopedist Vincent of Beauvais exclaimed: "How great is even the humblest beauty of this world!" St. Francis in his *Canticle of the Sun* found evidence of God's goodness everywhere—in the radiance of the sun, in the eternal miracle of springtime. He saw all nature as a revelation of divinity, and his thought foreshadowed a departure from the divisive medieval dualism based on opposition of flesh and spirit. After a lifetime of self-denial and self-inflicted pain, he humbly begged pardon of his brother the body for the suffering he had caused it to endure.

Late Medieval Naturalism

In both north and south the abstractions of the scholastic mind found a new challenge in the down-to-earth reasoning of the philosophers who called themselves *nominalists*. Later scholasticism had, in fact, become more and more a strained exercise in logical gymnastics. Its forms all too often disregarded the real world and the facts necessary to give substance to thought.

On their road to knowledge the nominalists simply turned the scholastic ways upside down. They insisted that generalities must be built from the bottom up, first by gathering the data and sorting out particular things and events, then by putting like with like. Only in this way, they said, was it possible to classify things and give a *name* to those that grouped themselves together (hence the term "nominalists"). The question was whether to start with an

assumption determined beforehand and then look for the supporting data as did the scholastic thinkers or whether to assemble the facts first. These two methods approximate the difference between deductive and inductive thought, the latter pointing toward the experimental method of modern science.

The nominalist viewpoint, as it gained a foothold, weakened medieval authoritarianism, in which the word of Aristotle and the Church fathers was accepted without question. Correspondingly, it initiated the modern practice of finding facts from firsthand observation. Particular things became more important than universal forms. A plant, now, was a vegetable or flower that grew in a garden rather than the manifestation of a universal idea of a plant existing in the mind of God.

The result of this new mental orientation was a renewed interest in a tangible reality that would have as important consequences in art as it did in the realm of scientific inquiry. In the 15th century it was to lead to the representation of figures in natural surroundings, the rendering of the body with anatomical accuracy, the modeling of figures three dimensionally by means of light and shadow, and the working out of laws of linear perspective for foreground and background effects.

While these systems of logic were being argued in the universities, the friars of St. Francis were bringing his message to town and country folk. With them, religious devotion became a voluntary, spontaneous relationship between human beings and God rather than an imposed obligation, an act based on love rather than on fear. The Franciscans also sought to establish a common bond between individuals, whatever their station in life, and their neighbors, thus implementing the golden rule, "Love thy neighbor as thyself." This was an important shift from the vertical feudal organization of society, in which individuals were related to those above and below them by a hierarchical authority, to a horizontally oriented ethical relationship that bound people to their fellows.

Nominalism AND THE ARTS. St. Francis saw evidence of God's love in everything, from the fruits and flowers of the earth to the winds and the clouds in the sky—a concept that was to have great consequences for the course of art. The birds to which St. Francis preached, for instance, were the birds that were heard chirping and singing every day, not the symbolic dove of the Holy Spirit or the apocalyptic eagle of St. John.

While this tendency toward naturalism was already noticeable in the 13th-century sculpture of Chartres and elsewhere, it became widespread in the 14th century. As this view of the natural world gained ascendance over the supernatural, based as it was on concrete observation rather than on metaphysical speculation, it released the visual arts from the perplexing problems of how to represent the unseen. The love of St. Francis for his fellows and for such simple things as grass and trees, which could be represented as seen in nature, opened up new vistas for artists to explore.

St. Francis's message was taught in parables and simple images of life that all could understand, and Giotto succeeded in translating these into pictorial form. In this favorable naturalistic climate, he found his balance between the abstract and the concrete, between divine essence and human reality.

Giotto, by refraining from placing his accent on symbolism, moved away from medieval mysticism and in his pictures portrayed understandable human situations. To him, the saints were not remote ethereal spirits but human beings, who felt all the usual emotions from joy to despair—just as did the people in the Italian towns he knew so well. Now that he no longer had to be concerned mainly with allegories but could reproduce the world of objects and actions as he saw it, a new pathway was opened.

Even his contemporaries could see that Giotto was blazing new trails. Yet their admiration for his faithfulness to nature must be measured by the art that had preceded his time rather than by 15thcentury or later standards. While Giotto undoubtedly showed a love of nature as such, he never accented it to the point where it might overshadow or weaken his primary human emphasis. His interest was less in nature for its own sake than in its meaning in the lives of his subjects.

In viewing a picture by Giotto, one does well to begin with his people and be concerned only secondarily with their natural surroundings, because his pictures are in psychological, rather than linear, perspective. His subjects seem to create their own environment by their expressive attitudes and dramatic placement. While his work shows an increasing concern with problems of natural space, his space then becomes less important than his expressive intentions. His use of color and shading gives his human figures the sense of depth and volume that brings them to life. In this way, both human nature and nature as such achieve an intimate and distinctive identity in Giotto's art.

Franciscan Humanitarianism

Long before the trend to naturalism, Cluny had changed the character of monasticism by uniting cloistered life with feudalism. Now the new orienta-

tion of the Franciscan order was no less revolutionary. St. Francis did not confine his monks in cloisters but sent them forth as fishers of men. The idea of evangelical poverty, humility, and love for humanity expressed through living and working with simple people resulted in a union with, rather than a withdrawal from, society. The Franciscans did not avoid the world so much as they avoided worldly pursuits. As the English writer G. K. Chesterton remarked, what St. Benedict had stored, St. Francis scattered. The Cluniacs were, in the proper sense of the word, an order—that is, their discipline required a strict hierarchical organization. The Franciscans were, in every sense of the word, a movement.

The icy intellectualism of the medieval universities was bound to thaw in the warmth of Franciscan emotionalism. Self-denial held little appeal for an increasingly prosperous urban middle class. The mathematical elegance of Gothic structures began to yield to more informal types of buildings. The logical linear patterns of the surviving Byzantine pictorial style gave way to the expressive warmth of Giotto's figures, and the empty, stylized faces of Byzantine saints pale in the light of the human tenderness found in a smiling mouth or tearful eve in a Giotto picture. The formal architectural sculpture and abstract patterns of Gothic stained glass were replaced by the colorful informality of mural paintings in fresco. St. Francis in his music, as in his religious work, drew the sacred and popular traditions closer together, and in the lauds, he encouraged people to sing. He gave people a music to feel in their hearts without having to understand it with their brains.

HUMANITARIANISM AND THE ARTS. When Dante declared that Giotto's fame outshone that of Cimabue, and when Boccaccio proclaimed that Giotto revived painting after it had "been in the grave" for centuries, they were recognizing in his art a new spirit and style. These are also apparent in the Decameron, which mocks the manners and ways of Gothic knights, abbots, and monks and the outmoded feudal ideal to which they clung.

The new feeling was also apparent in music. In France, Philippe de Vitry published a musical treatise in 1316 with the title Ars Nova, or New Art, which he opposed to the ars antiqua, or "old art," of the Gothic 13th century. He was the ardent champion of bringing some lively new dancelike rhythms into church music. His book gained such popularity that it brought down upon it the anger of conservative Church leaders in the form of a papal criticism issued by Pope John XXII in the year 1325.

A new spirit of freedom was in the air, a freedom from tradition. St. Francis earlier had struck out in a new religious direction, and Giotto, by translating the saint's life into pictures, avoided the traditional biblical subjects and their traditional stylized treatment. Actually he was working on an almost contemporary subject, as well as rendering it in a new manner. Giotto rendered subjects that came within the iconographical tradition, such as *Joachim Returning to the Sheepfold* (Fig. 221) and the *Pietà* or *Lamentation* (see Fig. 211), far more dramatically than had others before. In general, his figures moved about in the space he created for them with greater suppleness than in earlier pictures. His world was

marked by a new, warm, and compatible relationship between human beings, their natural environment, and their God.

Representations of Christ as an infant in arms began to replace the mature image in divine majesty of the Gothic period. Along with the growing interest in the cycle of Christ's infancy, legends of Mary's life became increasingly prominent. The emotional element in the Passion was largely conveyed through compassion for the Virgin as the mother of sorrows. This was as true for Giotto's cycle in Padua as for Jacopone da Todi's *Stabat Mater Dolorosa*.

221. Giotto. *Joachim Returning to the Sheepfold*. 1305–06. Fresco. Arena Chapel, Padua.

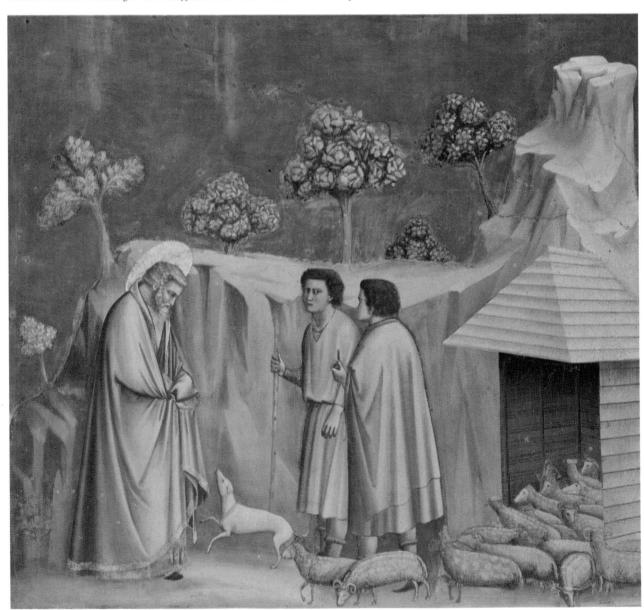

The adoption of the language of ordinary people in literature, the informal treatment of fresco painting, and the folk spirit in music—all make it apparent that works of art were being addressed to a new group of patrons. Furthermore, one of Giotto's recorded sayings reveals the artist's new conception of himself. Each man, he said, "should save his soul as best he can. As for me, I intend to serve painting in my own way and only so far as it serves me, for the sake of the lovely moments it gives at the price of an agreeable fatigue." Even the Black Death had some beneficial effects for artists after Giotto's time, because the younger masters could assert their independence and develop ideas and techniques with fewer restrictions from conservative guilds.

Survival of Classicism. What appears to be a renewed interest in classical antiquity began to be seen, heard, and read in the works of the artists and writers of the 14th century. The panels of Nicola Pisano's pulpit show the classical Roman influence of such narrative reliefs as Trajan's Column. However, what seems to be a revival of Roman classical forms is also something in the nature of a survival. For if Nicola's sculpture is placed chronologically after a group of French Gothic examples, it certainly seems to be closer to the art of ancient Rome than to the Gothic. But since Roman sculpture was present everywhere in Italy, any Italian sculptor with open eyes could not miss seeing it. Simple as it may sound, the explanation is a geographical rather than a chronological or psychological one—central Italy is closer to Rome than to northern France. Likewise, since Dante was writing an epic poem, the obvious model was Vergil's Aeneid, which had never ceased to be read.

While a growing consciousness of the classical in the works of Dante and his contemporaries is not

to be overlooked, it must be seen from the 14th-century point of view as a continuation of a cultural tradition rather than as a sudden rebirth of classicism. The influence of the classic authors and classical art had never been quite so neglected or dead as many historians have supposed. Vergil, Cicero, and certain works of Aristotle were as widely read and written about in medieval times as they were in the 14th and 15th centuries.

This is not to deny that a new spirit of curiosity enlivened the search, begun by Petrarch and Boccaccio, in monastic libraries for manuscripts by other Greek and Roman authors than those who bore the sacred approval of Church tradition. This probing also went hand in hand with the discovery in Rome of some long-buried antique sculpture and with the study of Roman building methods.

Even though Petrarch amid much classical fanfare was crowned in Rome with the laurel wreath, that ancient token of immortal fame, and even though he wrote his cycle of Triumphs with the Roman triumphal arch form in mind, it is doubtful that he or Dante or Boccaccio did more than bring the ancient world a little closer to their own time. They certainly had no such admiration for pagan antiquity for its own sake as did the 15th-century Florentines. Even though Giotto spent some time in Rome, the joyous humanistic spirit that permeates his work is much closer to the new Franciscan outlook and the continuous tradition of Roman relief sculpture and fresco painting than to any conscious reappraisal of classical culture as such. It is necessary, then, to disassociate the spontaneous 14thcentury Franciscan humanitarianism from the more self-conscious revival of Greco-Roman antiquity for its own sake that characterized developments in the 15th-century Florentine and early 16th-century Roman humanism.

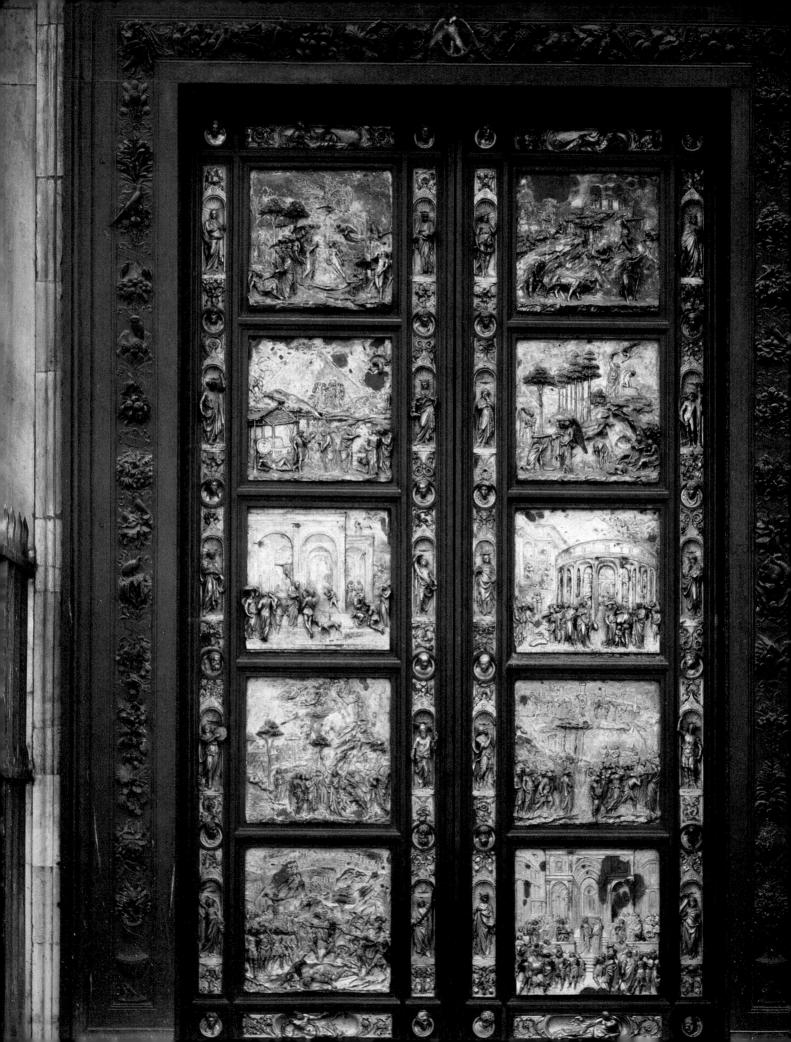

P A R T

3

The Renaissance

he Renaissance was a period of exploration in many new directions—the advancement of humanistic and scientific knowledge; the discovery of new worlds by navigating the globe; the continued growth of cities, with wealth in the hands of the merchant class and expanding national states; and an unparalleled outburst of productivity in the arts.

Humanistic scholars saw the Renaissance as an intellectual awakening after a long medieval night. They searched the monasteries for neglected volumes and studied the Greco-Roman classics from a new viewpoint. After the fall of Constantinople, many Greek scholars found refuge in Italy, bringing with them their learning and ancient manuscripts. The humanists rediscovered the beauties of life in the here and now rather than in the hereafter, and they reaffirmed the ancient belief that "nothing is more wonderful than man." The invention of printing made books more readily available, aiding in the spread of knowledge. In the fifty years after Gutenberg first published his Bible in 1456, more books were printed than had been copied by

hand in the previous thousand years

More broadly, humanism promoted a revival of interest in the affairs of the everyday world, reasserted the faith of men and women in themselves, and reinforced the role of individuals in all spheres. Writers, dramatists, visual artists, and musicians flourished. Architects were inspired by the geometrical clarity and harmonious proportions of the ancient Roman style. Sculptors and painters studied geometry, optics, and anatomy in order to represent the world, objects, and the human figure in three dimensions as the eye beholds them.

In northern Europe, Renaissance humanism expressed itself less in terms of the revival of antiquity and more in scientific observation and careful study of natural phenomena. In the arts this meant a shift away from medieval symbolism and heavenly visions toward a more careful description and accurate representation of forms as seen in the natural world.

The position of the Church, both as a powerful political force and as an institution increasingly concerned with worldly affairs,

came under close scrutiny. Abuses among the clergy in amassing worldly goods set the stage for the Reformation, as did the papal interest in winning victories on the battlefield rather than caring for human souls. Reformers rejected the central authority of the Church and the mediation of the priesthood. They held that by reading the scriptures individuals could interpret the word of God for themselves and arrive at truths independent of traditional religious doctrines.

During the Renaissance the merchant and artisan classes rose to challenge the entrenched position of the landed nobility. This progress of the new urban middle class was fortified by the expansion of trade in the wake of geographical explorations and by a broader spread of political power among city officials and councils. Some merchant princes became important patrons of the arts and letters.

With these momentous developments in thought, science, religion, exploration, statecraft, and the arts, the Renaissance was truly a rebirth for humanity at the dawn of the modern era.

15th CENTURY FLORENCE

	KEY EVENTS	ARCHITECTURE	VISUAL ARTS	LITERATURE AND MUSIC
		1377-1446 Filippo Brunelleschi 1391-1473 Michelozzo di Bartolommeo	1370-1427 Gentile da Fabriano 1371-1438 Jacopo della Quercia 1378-1455 Lorenzo Ghiberti 1386-1466 Donatello 1387-1455 Fra Angelico 1397-1475 Paolo Uccello c.1400-1461 Domenico Veneziano	1304-1374 Petrarch (Francesco Petrarca) 1313-1375 Giovanni Boccaccio
1400 -	1406 Pisa comes under Florentine rule 1421 Giovanni de' Medici elected magistrate 1434 Pro-Medici government elected; Cosimo de' Medici began rule 1434-1444 Pope Eugene IV resided in Florenece 1439-1442 Council of Florence nominally united Eastern and Western churches 1447 Parentucelli, Florentine humanist elected as Pope Nicolas V	c.1402 Brunelleschi studied ancient architecture in Rome 1404-1472 Leone Battista Alberti 1420-1436 Brunelleschi built dome of Florence Cathedral c.1429 Pazzi Chapel begun by Brunelleschi 1436 Florence Cathedral dedicated by Pope Eugene IV (begun 1298; dome by Brunnelleschi) 1444-1459 Medici-Riccardi Palace built by Michelozzo	1400-1482 Luca della Robbia 1401-1428 Masaccio 1401 Competition for Florence Bapistry north doors held c.1402 Donatello studied ancient sculpture in Rome 1403-1424 Ghiberti worked on Bapistry north doors c.1406-1469 Filippo Lippi c.1416-1492 Piero della Francesca 1420-1497 Benozzo Gozzoli 1423-1457 Andrea del Castagno 1425-1452 Ghiberti worked on Florence Bapistry east doors ("Gates of Paradise") c.1429-1498 Antonio Pollaiuolo 1435-1488 Andrea del Verrocchio 1444-1510 Sandro Botticelli 1449-1494 Domenico Ghirlandaio	1400-1474 Guillaume Dufay 1430-1495 Jean de Ockeghem 1433-1499 Marsilio Ficino 1436-1475 Antonio Squarcialupi 1436 Dufay wrote choral motet for dedication of Florence Cathedral 1449-1492 Lorenzo de' Medici
1450 -	,			
	1453 Constantinople falls to Ottoman Turks. End of East Roman empire 1464-1469 Piero de' Medici ruled after Cosimo's death 1469-1492 Lorenzo de' Medici ruled 1478 Pazzi family's unsuccessful revolt against Medici; Giuliano de' Medici died, Lorenzo consolidated power 1489 Savonarola (1452-1498) preached moral reform 1490 Aldine Press in Venice began printing works of Plato and Aristotle 1492 Lorenzo de' Medici died 1494 Medicis exiled from Florence; government dominated by Savonarola 1498 Savonarola burnt at stake	c.1485 Alberti's treatise on architecture printed	c.1450-1523 Perugino 1452-1519 Leonardo da Vinci 1458-1504 Filippino Lippi 1475-1564 Michelangelo Buonarroti c.1485 Alberti's treatises On Painting (1436), On Sculpture (1464). Both printed c.1485 1489 Michelangelo apprenticed to Ghirlandaio	1450-1505 Jacob Obrecht c.1450-1517 Heinrich Issac c.1460-1521 Josquin Desprez 1463-1494 Pico della Mirandola 1466-1482 Marsilio Ficino's translations of Plato's dialogues 1467 Squarcialupi organist in Florence and music teacher to Medici household 1469-1527 Niccolò Machiavelli 1478-1529 Baldassare Castiglione c.1480 Heinrich Issac succeeded Squarcialupi as organist at Florence Cathedral; also served as court composer for Lorenzo de' Medici and teacher of his children

10

The Florentine Renaissance Style

FLORENCE, 15TH CENTURY

Colorful festivals were the delight of all Florentines, but March 25, 1436, was a special occasion that would linger long in the memory of these prosperous and pleasure-loving people. The dedication of Florence's newly completed cathedral (Fig. 222) brought together an unprecedented number of Church dignitaries, statesmen, and diplomats, and in their wake were famous artists, poets, scholars, and musicians. The white-robed Pope Eugene IV, crowned with the triple tiara, attended by 7 cardinals in bright red and no fewer than 37 bishops and archbishops in purple vestments, made a triumphal progress through the banner-lined streets, accompanied by city officials and heads of the guilds with their honor guards.

Appropriately enough, the cathedral was christened Santa Maria del Fiore (Holy Mary of the Flower), since Florence (derived from *flora*) was indeed the city of flowers. March 25 was also the Feast of the Annunciation, the beginning of new life nine months before Christ's birth, and both the Annunciation and the Nativity were favorite subjects of Florentine art.

The Florentine City-State

Lining the streets for the grand procession and crowding their way into the vast nave of the cathedral were the colorfully costumed citizens of this prosperous Tuscan town. In contrast with that of northern countries, city life in this region had come of age. At a time when many feudal aristocrats still lived in their cold fortresslike castles, the Florentine patrician families lived in a style that could well have been the envy of kings.

The working members of the population belonged to the various guilds and trade organizations, the most important of which were those dealing with the carding, weaving, and dyeing of wool and silk for the famous Florentine textile industry. Metalcrafts and stonework followed in importance, and so on down to the butchers and bakers. The masters of the principal guilds were the influential citizens from whose ranks the members of the Signory, or city council, were chosen and from which the merchant and banking families emerged.

The most renowned of these families was the Medici, whose head at this time was Cosimo. By a combination of political understanding and keen financial ability, he dominated the government of the city. Knowing his fellow townspeople's passion for equality, Cosimo never assumed a title or other outward sign of authority. Instead, he was the political boss, ruling from behind the scenes with the support of the guilds, which knew that a stable government and peaceful relations with their neighbors (see map, p. 262) were the best safeguards of their prosperity.

The Medici were also the papal bankers who received on deposit Church funds from England, France, and Flanders. From their branch offices in London, Lyon, and Antwerp they lent this money at fantastic rates of interest to foreign heads of state. With the papal revenues they also bought English wool, had it processed in the Netherlands, shipped it to Florence to be woven into fine fabrics, and exported these at a handsome profit. It was Cosimo who made the florin the soundest currency in Europe. But political power and high finance were not the only pursuits of this ambitious banker.

Cosimo's other accomplishments were unusual for a Renaissance merchant capitalist. As a seri-

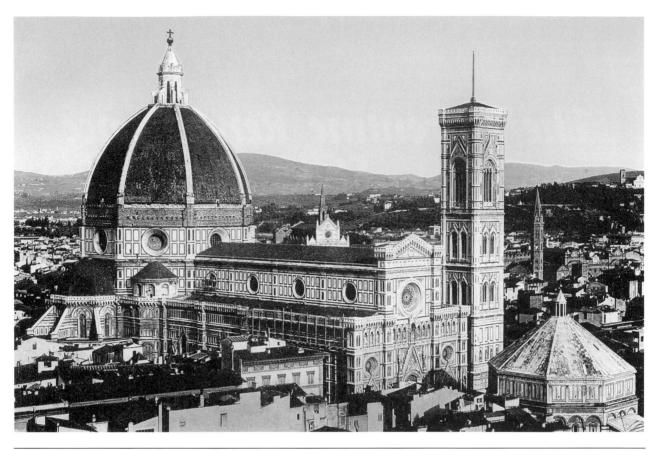

222. Florence Cathedral group. Cathedral begun by Arnolfo di Cambio, 1296; dome by Filippo Brunelleschi, 1420–36; present façade 1875–87. Length of cathedral 508′ (154.84 m), height of dome 367′ (111.86 m). Campanile begun 1334 by Giotto, continued by Andrea Pisano, 1336–48; height 269′ (81.99 m). Baptistry (lower right) 1060–1150.

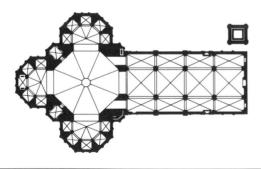

223. Plan of Florence Cathedral.

ous student of Plato, he became one of the founders of the Neoplatonic Academy, an institution that had enormous intellectual influence. From all the parts of Europe where his financial interests extended, he commissioned works of art. At home he gathered a library of rare manuscripts for study and translation.

Through Cosimo's generosity, a group of Dominican monks had just moved into the monastery of San Marco, which was being rebuilt for them by his personal architect, Michelozzo. Among the

monks was Fra Angelico, whom Cosimo encouraged to decorate the monastery walls with his famous frescoes. Although Masaccio, one of the century's most original painters, had been dead for six years. Filippo Lippi, the future teacher of Botticelli, was active and looking to Cosimo for commissions. Cosimo took Donatello's advice, collected antique statuary, placed it in his gardens, and encouraged young sculptors to work there. Small wonder, then, that the Signory voted him the posthumous title *Pater Patriae*—"Father of His Country."

Brunelleschi's Dome

The eyes and thoughts of all Florentines on the day of the Feast were directed upward to the mighty *cupola*, or dome, that crowned the crossing of their cathedral and gave their city its characteristic profile. Though begun in the late 13th century, the building's construction had long been delayed because no architect possessed the necessary knowledge to span such an enormous, gaping (140-foot [42.7-meter]-wide) octagonal space (Fig. 224).

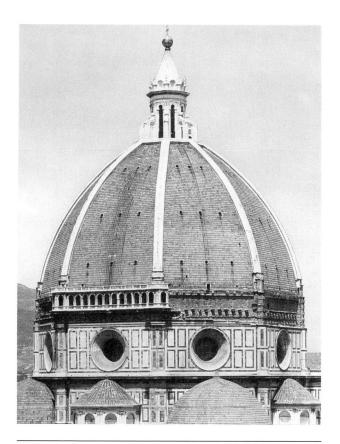

Filippo Brunelleschi, however, after studying the Pantheon and other ancient monuments in Rome, had returned and undertaken the gigantic task now at the point of completion. Starting at a level some 180 feet (54.9 meters) above ground, he sent eight massive ribs soaring skyward from the angles of the supporting octagon to a point almost 100 feet (30.5 meters) higher, where they converged at the base of a lantern tower. Concealing them from external view, he added two minor radial ribs between each major rib, twenty-four in all, to make his inner shell. Reinforcing these by wooden beams and iron clasps at key points, he then had the necessary support for the masonry of his inner and outer shells. The structure is, in effect, an eight-sided Gothic vault. But by concealing the functional elements and shaping a smooth external silhouette, Brunelleschi crossed the bridge into Renaissance architecture.

Opposite the façade of the cathedral is the old Romanesque baptistry (Fig. 222, lower right), which was feeling new Renaissance life with Ghiberti's gilded bronze doors. Already in place were the handsome north doors, and the sculptor was well on his way to completing the east doors

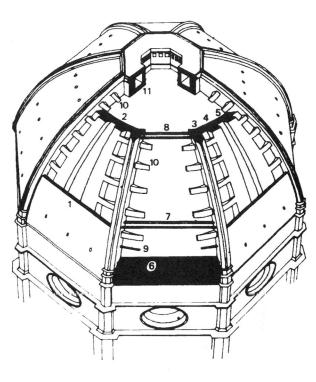

225. Internal structure of Brunelleschi's Dome, Florence Cathedral.

(see p. 232), which Michelangelo was later to hail as worthy of being the "Gates of Paradise." Helping him cast these doors in his workshop at various times were the architect Michelozzo, the sculptor Donatello, and the painters Paolo Uccello and Benozzo Gozzoli. Donatello, at the same time, was working on a series of statues of prophets for niches on the exterior of both the cathedral and the campanile, traditionally known as "Giotto's Tower."

In Popc Eugene's company were some of the leading Florentine humanists, including the artistscholar Leone Battista Alberti, who had just completed his book *On Painting* and was at work on his influential study *On Architecture*. On hand to provide music for the occasion was the papal choir, whose ranks included the foremost musician of his generation, Guillaume Dufay, who composed the commemorative motet for the occasion. Antonio Squarcialupi, regular organist of the cathedral and private master of music in the Medici household, is thought to have composed the solemn high Mass.

An eyewitness account noted the perfume of the flowers and incense, the bright-robed company of viol players and trumpeters, "each carrying his instrument in hand and arrayed in gorgeous cloth of gold garments." Continuing in appropriately flowery language, he writes that "the whole space of the temple was filled with such choruses of harmony, and such a concert of divers instruments, that it seemed (not without reason) as though the symphonies and songs of the angels and of divine paradise had been sent forth from Heaven to whisper in our ears an unbelievable celestial sweetness."

Dome and Dedication Motet

The chronicler was referring in part to the dedicatory motet *Nuper rosarum flores* (Flowers of roses), written for the occasion by the great composer Guillaume Dufay. In this choral work the architecture of Brunelleschi's dome finds its exact musical counterpart. In the text the cathedral is praised as "this mighty temple" and the dome as a "magnificent artifice" and a "marvel of art."

Both Brunelleschi and Dufay were the most important representatives of their crafts in the Florence of the first half of the 15th century. Both were liberally educated, and Brunelleschi's first biographer, Manetti, states specifically that he had studied Vitruvius and that he thought in terms of the ancient musical proportions. Both the dome and motet were constructed by late medieval methods, in one case by Gothic vaults, in the other by isorhythmic symmetries incorporating strict rhythmic progressions and formal proportions. Such isorhythmic motets are built of sections that are unified by the use of identical rhythmic relationships but not necessarily the same melodic patterns. Such music was never intended primarily to please the ear or stir the emotions but to mirror the hidden harmonies of the universe and thus to constitute a worthy offering to its Creator. In Dufay's conception, however, the universe is no mere empty structure but is populated with shapely melodies, warm harmonic colors, and a rich variety of rhythmic forms. Dufay's special contribution was in clothing the austere skeletal structure of such a composition with smooth melodic lines and a fluency of sound that made it a joy to the ear as well as to the mind.

Both the dome and the motet have the same modular scheme, thus relating the architecture and music solidly and convincingly (Fig. 225). In Brunelleschi's case, he takes the pre-existing octagonal base of the dome, then describes a square inside to derive the basic module so that the dimensions can be precisely stated in terms of the ratios of 6:4:2:3. Note the symbolism of the numbers. The first two, 6:4, can be reduced to 3:2, and the last two are 2:3. Both, then, are based on the interval of the fifth. The cupola has two shells, an inner and outer,

separated by intervening space. This, according to Brunelleschi himself, was to allow for the outer visible shell to "vault it in a more magnificent and swelling form." This double dome arrangement is closely paralleled by the double tenor voices that constitute the two lower parts of Dufay's four-part motet. The two "tenors" refer, of course, to the parts that hold (tenere in Latin) the same basic cantus firmus, a fifth apart. The general effect is to amplify the sonority so as to harmonize in the manner of Brunelleschi's "magnificent and swelling form." And the mensurations of the two tenors are the counterpart of the thickness of the two cupolas in the proportions of 2:3, while the upper two parts of Dufay's motet soar freely in the musical space that the composer provides for them.

The correspondences between the numerical proportions of the dome and the motet can be seen in the following chart. Modern bar lines did not exist in the 15th century. It is possible, however, to measure out the rhythmic pulses by their correspondence with the metrical patterns of the text. In this way Dufay's motet can be seen as containing 168 measures that divided into four sections as follows:

Proportional scheme of Catheral dome	Number of measures per section		Beats per measure		Total beats	Proportion of total beats
6:4:2:3	Sec. 1: 56	X	6	=	336	6
	Sec. 2: 56	X	4	=	224	4
	Sec. 3: 28	X	4	=	112	2
	Sec. 4: 28	X	6	=	168	3
	168					

Pazzi Chapel

The analogy that Renaissance theorists made between audible and visual proportions ran as an undercurrent in all their designs. It bore witness to the profound belief in the harmonic-mathematical basis of creation. Music also had a strong attraction for Renaissance architects since it had always been considered a mathematical science and had been studied as such in antiquity and in the medieval universities. These proportions are much more easily seen in Brunelleschi's Pazzi Chapel where, unlike the Cathedral situation, he had complete control of the whole design (Fig. 226). The central axis, as seen in the ground plan (Fig. 227), is based on three circles signifying the domed spaces above, and the relationship of the two smaller to the larger is in the ratio of 2:1. Similarly, the two smaller squares above form

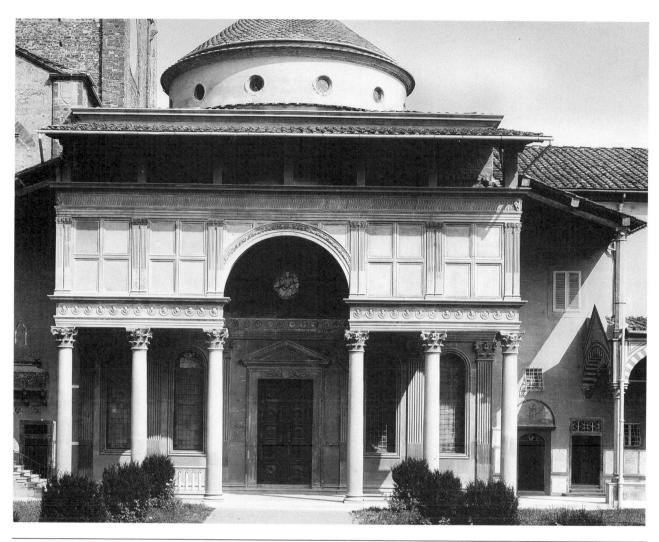

226. FILIPPO Brunelleschi. Façade, Pazzi Chapel, Cloister of the Church of Santa Croce, Florence. c. 1429–33.

an octaval relationship to the large square surrounding the central dome.

The fruits of Brunelleschi's studies of ancient Roman buildings are more in evidence here in the façade, and the break with the Gothic tradition is complete. The harmonious spacing of the columns of the porch, the treatment of the walls as flat surfaces, and the balance of horizontal and vertical elements make his design the prototype of the Renaissance architectural style. The entablature above the columns and below the roof gives further evidence still of the classical influence. The curved pattern above comes directly from ancient Roman sarcophagi, while the elegant carving of the Corinthian capitals, the Composite pilasters, and other design details reveal Brunelleschi's early training as a silversmith and his interest in authentic Roman originals.

The interior bears out the promise of the façade and shows a Roman classical concern with the logi-

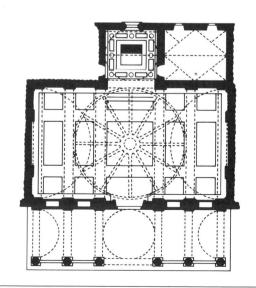

227. Plan of Pazzi Chapel.

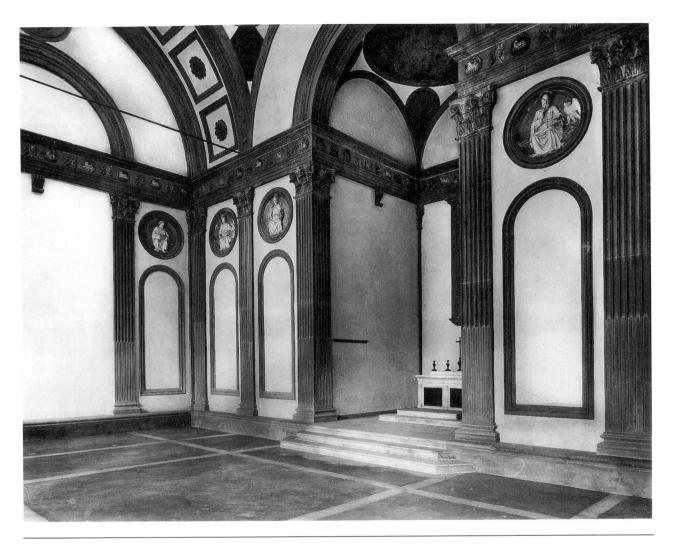

228. FILIPPO BRUNELLESCHI. Interior, Pazzi Chapel, Cloister of the Church of Santa Croce, Florence. c. 1429–33. Length 59'9" (18.21 m), width 35'8" (10.87 m).

cal molding of interior space (Fig. 228). Lacking Gothic mystery and indefiniteness, the pilastered walls give a cool, crisp impression. Frames of darkcolored stone divide the surfaces into geometric forms easily understood by the eye. Mystery and infinity have yielded to geometrical clarity. The rectangular room is covered by barrel vaults, with a low dome on pendentives (see Fig. 130) rising in the center at the point of intersection. Albeit hesitantly, this interior indicated a new concept of space without, however, realizing its full implications. The clear-cut simplicity of its design made the Pazzi Chapel a highly influential model throughout the Renaissance, and the unity of its centralized organization under a unifying dome became the point of departure for the later church plans of Alberti, Bramante, and Michelangelo.

Medici-Riccardi Palace

When Cosimo de' Medici decided to build himself a new house, he is said to have rejected a magnificent plan submitted by Brunelleschi with the observation that envy is a plant that should not be watered. For the Medici-Riccardi Palace (Fig. 229) he chose instead a less pretentious design submitted by Brunelleschi's disciple Michelozzo. (The palace has a dual name because it was bought from the Medicis in the 17th century by the Riccardi family.)

As the palace design materialized, the building turned out to be an appropriately solid structure, eminently suited to the taste of a man of such considerable substance as Cosimo. As a type, such buildings were actually a continuation, rather than a revival, of the multistoried Roman city apartment

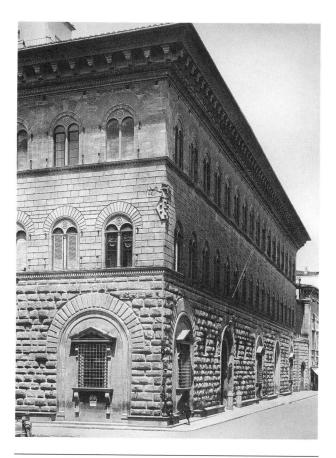

229.MICHELOZZO. Façade, Medici-Riccardi Palace, Florence. 1444–59. Length 225' (68.58 m), height 80' (24.38 m).

house. Here the dominance of solid mass over the space allowed for the windows, and the heavily rusticated masonry of the first story (many of the rough-cut stones protrude more than a foot) still has something of the forbidding aspect of a medieval fortress. But as the eye moves upward, the second and third floors present an increasingly urbane appearance. The accent on horizontal lines, seen in the molding strips that separate the three stories and in the boldly projecting cornice at the roof level, are quite unmedieval. A classical allusion can be seen in the semicircular arches that frame the windows (the pediments over those on the lower story are a somewhat later addition). Details, such as the colonnettes of the windows on the second and third floors, as well as the egg-and-dart pattern and the dentil range that appear in the cornice frieze, just under the roof, are definitely Renaissance in style.

Cosimo's sense of modesty stopped with the palace's exterior; inside the doors everything was on a princely scale. With the frescoes of Benozzo Gozzoli and an altarpiece by Filippo Lippi decorating its

second-floor chapel, easel paintings by Uccello and Botticelli hanging on salon walls, antique and contemporary bronze and marble statues standing in the courtyard and gardens, collections of ancient and medieval carved gems and coins in its cabinets, precious metal vessels and figurines standing on its tables, and priceless manuscripts, including the works of Dante, Petrarch, and Boccaccio in its library, the Medici-Riccardi Palace was, in fact, one of the first and richest museums in Europe.

SCULPTURE

Ghiberti versus Brunelleschi

In the year 1401, the Signory of Florence together with the Guild of Merchants had held a competition to determine who should be awarded the contract for the projected north doors of the baptistry. As in the earlier pair by Andrea Pisano, the material was to be bronze, and the individual panels were to be enclosed in the *quatrefoil*, or four-lobed, pattern. The subject, for the purpose of the contest, was to be the Sacrifice of Isaac. Some half-dozen sculptors were invited to submit models, among them Brunelleschi and Lorenzo Ghiberti.

Both men were in their early twenties and were skilled workers in metal and members in good standing of the Goldsmiths' Guild; however, a comparison of their panels reveals many significant differences of viewpoint and technique (Figs. 230 and 231). Brunelleschi's composition shows the influence of Gothic verticality in the way the design is built in three rising planes. Ghiberti's composition is almost horizontal, and his two scenes are divided diagonally by a mountain in the manner of Giotto. Brunelleschi's panel is crowded, and his figures spill out over their frame. Ghiberti's is uncluttered, and all his figures and details converge toward a center of interest in the upper right formed by the heads of the principal figures. Brunelleschi accents dramatic tension, with Abraham seizing the screaming Isaac by the neck and the angel staying his hand at the last moment. Ghiberti sacrifices intensity for poise and decorative elegance. Brunelleschi shapes Isaac's awkward body with Gothic angularity. Ghiberti models it with the smooth lines and impersonal grace of a Hellenistic statue. (Ghiberti's Commentaries mention the discovery near Florence of the torso of an ancient classical statue on which he modeled his Isaac.) Finally, Brunelleschi cast his relief in separate sections, mounting these on the bronze background plate. Ghiberti, with greater technical command, cast his in a single mold.

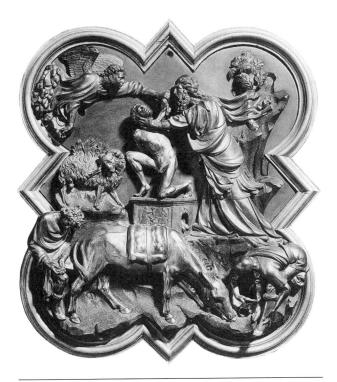

Ghiberti's East Doors

Ghiberti's north doors were no sooner in place than he was commissioned, this time without competition, to execute another set. The famous east doors (see p. 232), on which he worked from 1425 to 1452, tell their own tale. The Gothic quatrefoil frames of the competition panels were now a thing of the past, and, while his north doors were conceived in terms of their architectural function, the east doors served as a convenient framework for decoration. They even disregard techniques appropriate to the three-dimensional medium of relief sculpture and become like pictures painted in gilded bronze.

Ghiberti attempts daring perspectives far in advance of the painting of the period. Some figures, such as those in the center panel of the left door, are in such high relief as to be almost completely in the round. In the Adam and Eve panel at the top of the

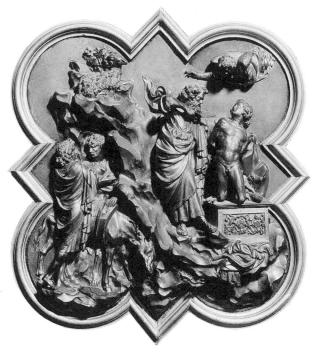

231. LORENZO GHIBERTI. *Sacrifice of Isaac.* 1401. Gilt bronze, $21 \times 17\frac{1}{2}$ " (53 × 44 cm). Museo Nazionale, Florence.

left door (Fig. 232), he uses three receding planes. The high relief in the lower foreground is used to tell of the creation of Adam (left) and Eve (center) and the expulsion (right) in the present tense. The immediate past is seen in the half relief of the middle ground showing the Garden of Eden. And in the low relief of the background God and his accompanying cloud of angels seem to be dissolving into the thin air of the remote past.

On either side of the pictorial panels, Ghiberti included a series of full-length figurines that alternate with heads that recall Roman portrait busts. Hebrew prophets on the outer sides are set opposite pagan sibyls, all of whom were supposed to have foretold the coming of Christ. The figure beside the second panel from the top on the right door is that of the biblical strong man Samson, but his stance and musculature are those of a Hellenistic Hercules. Ghiberti mentions in his *Commentaries* how he sought to imitate nature in the manner of the ancient Greeks when molding the plant and animal forms of these door frames.

The care and delicate craftsmanship Ghiberti lavished on these and other details make the east doors a high point in the metalworker's art. Ghiberti, as was said, belonged to the Goldsmiths' Guild, and its influence is felt in many aspects of Florentine art. It is to be seen not only in such door moldings but in

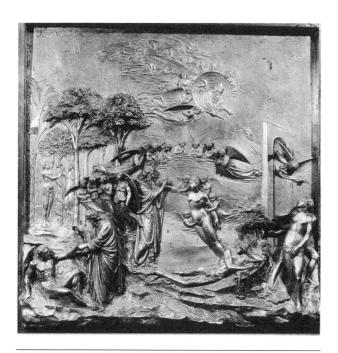

LORENZO GHIBERTI. Story of Adam and Eve, detail of east doors, Baptistry, Florence. c. 1435. Gilt bronze, $31\frac{1}{4}$ " (79 cm) square.

pulpits, wall panels, window brackets, columns, pilasters, and cornices—all of which were executed with a wealth of fine detail lovingly dwelt upon.

Donatello

Donatello's personality and career contrast strongly with Ghiberti's. A man of fiery temperament and bold imagination, Donatello scorned the fussy details which allied Ghiberti's work with that of the jeweler. His sculpture has a rugged grandeur that makes Ghiberti's appear precious by comparison. While Ghiberti studied local examples of antique sculpture and read Vitruvius's books, Donatello journeyed to Rome with Brunelleschi to study the finest surviving classical statuary.

Ghiberti remained a specialist in bronze, while Donatello was at home with all materials—marble, wood, painted terra-cotta, and gilded bronze. He was equally comfortable in all mediums—relief and in the round, small scale and heroic size, architectural embellishment and independent figure—and in all subjects—sacred and secular, historical scenes and portraiture. While Ghiberti had a single personal style, Donatello had many. His tremendous power of epic expression, enormous energies, sweeping passion, and impetuosity make him the representative sculptor of his period and the immediate artistic ancestor of Michelangelo.

The Prophet (Fig. 233), also known as Lo Zuccone, which means "pumpkin head" or "baldpate,"

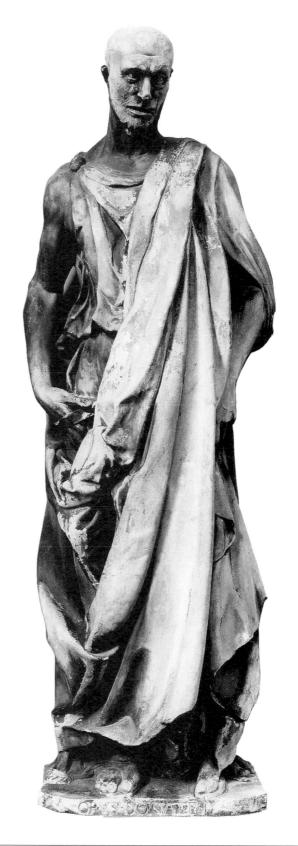

233. Donatello. Prophet (Lo Zuccone), from campanile, Florence Cathedral. 1423-25. Marble, height 6'5" (1.96 m). Original in Museo dell' Opere del Duomo, Florence.

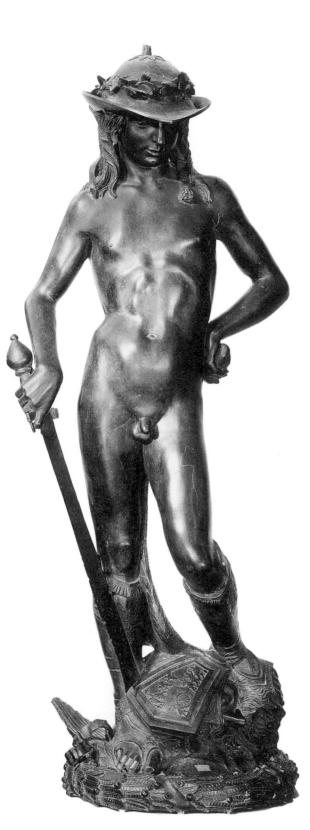

234. Donatello. *David.* c. 1430–32. Bronze, height $5'2_4'''$ (1.58 m). Museo Nazionale, Florence.

235.Donatello. *Repentant Magdalene*. 1454–55. Wood, height 6'2" (1.88 m). Museo dell' Opere del Duomo, Florence.

is one of a series of marble statues Donatello was commissioned to do for the Florence Cathedral and its campanile in 1424. Designed for a third-story niche of the campanile, it was intended to be seen about 55 feet (16.8 meters) above ground level. The deep-cut drapery and lines of the face consequently took into account this angle of vision and lighting. By the boniness of the huge frame, the powerful musculature of the arms, the convulsive gesture of the right wrist, the tension of the muscles of the neck, and the intensity of the face, Donatello sought to produce a powerfully expressive rather than a handsome figure.

Donatello is representing an Old Testament prophet (either Habakkuk or Jeremiah). The figure is full of inner fire and fear of the Lord, a seer capable of fasting in the desert, dwelling alone on a mountaintop, or passionately preaching to an unheeding multitude from his niche, urging them to repent. The classical influence is seen in the drapery, an adaptation of the toga, and in the rugged features and baldness, which recall realistic Roman portraiture. With Lo Zuccone, Donatello created a unique figure of

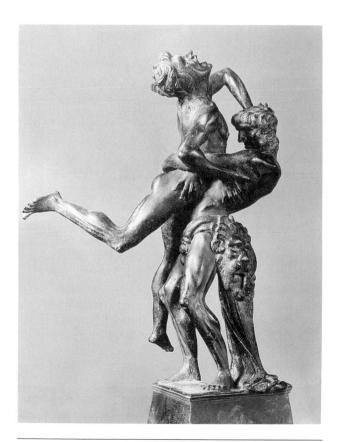

236. Antonio Pollaiuolo. *Hercules Strangling Antaeus*. c. 1475. Bronze, height $17\frac{3}{4}$ " (45 cm). Museo Nazionale, Florence.

strong individuality, not one of the traditional iconographical types. The nickname given the statue shows that it was accepted as such.

In his bronze *David* (Fig. 234) Donatello works in a more lyrical vein. As a figure meant to be seen from all angles, the *David* is definitely a departure from the Gothic tradition of sculpture in niches and as architectural embellishment. As the first life-size bronze nude in the round since antiquity, it marks the revival of classical nude statuary.

David stands alone in the confident attitude of the victor over the vanquished, a sword in his right hand, a stone in his left. His weight rests on his right foot, while the left is on the severed head of the conquered Goliath. The posture is that of the hip-shot curve familiar from Greco-Roman antiquity (see Fig. 50). The serenity of the classical profile and the stance and modeling of the youthful body show Hellenistic influence. A local touch is provided by the Tuscan shepherd's hat, which throws the smooth, delicate-featured face into strong shadow and serves to accent the somewhat gawky lines of the adolescent body. The opposite end of Donatello's emotional range is seen in the ghostly Repentant Magdalene (Fig. 235). The emaciated, cadaverous figure originally stood in the Florence Baptistry as a reminder to the participants in the baptismal ceremony of the original sin that is washed away and of the universal presence of death among the living.

Pollaiuolo and Verrocchio

Quite another attitude is revealed in the work of the next generation, of which Antonio Pollaiuolo and Andrea del Verrocchio are the leading exponents. The work of Pollaiuolo is dominated by scientific curiosity, especially in regard to human anatomy. (He is known to have dissected corpses in order to study the musculature and bone structure at first hand.) Trained with his brothers in his father's gold-smith shop, he specialized in such athletic figures as the cast-bronze *Hercules Strangling Antaeus* (Fig. 236), of which he made both painted and sculptural versions.

The legends of the strong man of antiquity were excellent subjects that permitted the artist to bring out the musculature of the male figure in action. In this instance, Hercules overcomes his enemy, the Lybian giant, by raising him off the earth which is the source of his strength while Antaeus struggles desperately to release the stranglehold Hercules has upon him. The muscles in Hercules' legs as they bear the weight of both bodies should be noted. Pollaiuolo also painted a series of pictures on the Labors of Hercules. Like his work in bronze, they are

studies of muscular tension, full of athletic energy and quite unrelieved by gracefulness.

Verrocchio, a contemporary of Pollaiuolo, was the official sculptor of the Medici. For this powerful and prolific family he designed everything from tournament trophies and parade gear to portraits and tombs.

Like Pollaiuolo, Verrocchio was also a painter at a time when sculpture led the field in experiments with perspective, anatomy, and light and shadow. While Ghiberti and Donatello had been more classically oriented, Pollaiuolo and Verrocchio were primarily scientifically minded, and it was in Verrocchio's workshop that Leonardo da Vinci got his training. It was Leonardo who carried on the searching scientific curiosity of his master, while it remained for Michelangelo, under the stimulus of Donatello's art, to carry on the humanistic ideal into the next century.

PAINTING

Masaccio

With Brunelleschi and Donatello, the third member of the trio of early 15th-century innovators was Masaccio, the only one born within the century. The importance of his series of frescoes in the Brancacci Chapel of the Church of Santa Maria del Carmine (where he worked with his older and more conservative colleague Masolino) can hardly be overestimated. In the *Expulsion from the Garden* (Fig. 237), he chose one of the few subjects in the iconographical tradition in which the nude human body could be portrayed in churches without raising ecclesiastical eyebrows.

By defining the source of light as coming diagonally from the right and by having Adam and Eve approach it, Masaccio was able to represent them as casting natural shadows. In addition, by surrounding his figures with light and air, by relating them to the space they occupy, by modeling them in light and shadow as a sculptor would, so that they appear as if seen in the round with all the weight and volume of living forms, Masaccio thus achieved one of the most important innovations in painting—atmospheric perspective.

Masaccio, moreover, was well aware of the drama of the situation. The full force of this first moral crisis in human history is expressed by the body alone, with almost no reliance on surrounding details. Eve, aware of her nakedness, cries aloud, while Adam, ashamed to face the light, expresses his remorse by covering his face. Even the avenging

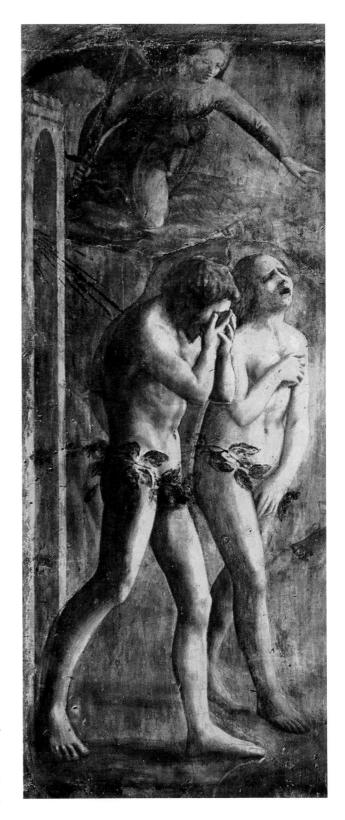

237. MASACCIO. *Expulsion from the Garden.* c. 1427. Fresco, $6'6'' \times 2'9''$ (1.98 × .84 m). Brancacci Chapel, Santa Maria del Carmine, Florence.

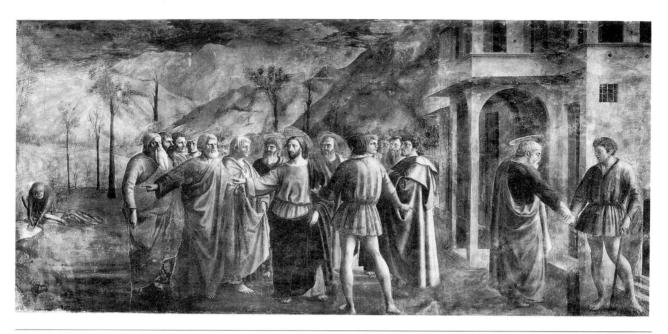

238. Masaccio. Tribute Money. c. 1427. Fresco, 8'4" × 19'8" (2.54 × 5.9 m). Brancacci Chapel, Santa Maria del Carmine, Florence.

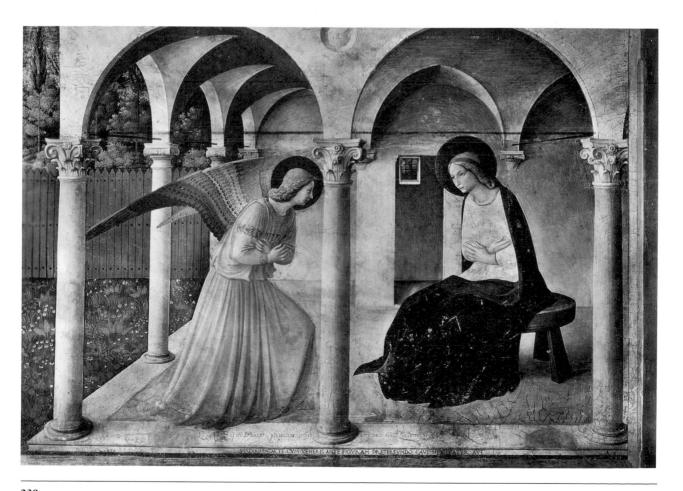

239. Fra Angelico. Annunciation. c. 1445–50. Fresco, $7'6'' \times 10'5''$ (2.29 \times 3.18 m). Monastery of San Marco, Florence.

angel who drives them out of the garden reflects the tragedy of the fall from grace by an expression of human concern and compassion. The curved line of Adam's right leg was apparently so drawn to show the hurried motion of the expulsion; but the proportions of his arms and the drawing of Eve's lower hand are anatomically incorrect. Such flaws, however, are minor in comparison with the momentous step in painting that puts figures in an entirely new relationship to their spatial environment.

The *Tribute Money* (Fig. 238), another of the Brancacci Chapel frescoes, illustrates still further the principle of atmospheric perspective. The figures are well modeled in light and shade, and each occupies his appointed space in the front and middle planes with ease and assurance. Approached by the tax collector, Peter and his fellow Apostles question the propriety of Christian believers paying tribute to the Roman authorities, whereupon Jesus responds,

"Render therefore unto Caesar the things that are Caesar's; and unto God the things that are God's" (Matt. 22:21). Jesus then tells Peter that the first fish he catches will have a coin in its mouth. The old simultaneous mode of presentation is employed, with St. Peter appearing first in the center, then at the left fishing, and finally at the right paying the debt. Masaccio's death at the age of twenty-seven prevented a more complete realization of his discoveries and innovations.

Fra Angelico

Spiritually, Fra Angelico was in many respects a late Gothic artist who never painted anything but religious subjects. While he dwelt lovingly on the older forms, he did, however, often treat them within the new frame of reference. The *Annunciation* (Fig. 239) that he painted for the upper corridor of his own

240.Benozzo Gozzoli. *Journey of the Magi*, detail. c. 1459–63. Fresco, length 12'4^{1"}₄ (3.77 m). Chapel, Medici-Riccardi Palace, Florence.

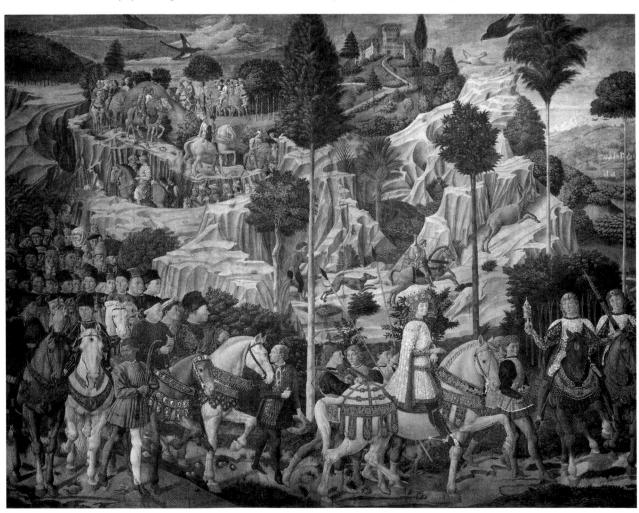

monastery of San Marco is a blend of these old and new elements.

A mystic by temperament, Fra Angelico found angels as real as his fellow human beings. But while he always paints with the deepest religious sentiment, his figures in this case appear within the new conception of space. The perspective and the 15th-century architectural details are so exact that the event could well be taking place in a corner of the San Marco cloister that Michelozzo recently had rebuilt. Furthermore, the native Tuscan flowers seen in garden are observed well enough to satisfy a botanical expert. The lighting, however, is far from the natural illumination of Masaccio. Fra Angelico makes it seem that the figure of Gabriel and the serene purity of Mary are beheld as if in a vision.

Benozzo Gozzoli and Filippo Lippi

Unlike the eyes of Fra Angelico, those of his favorite pupil, Benozzo Gozzoli, were focused firmly on this world. With Cosimo's son Piero as his patron, Benozzo painted the *Journey of the Magi*, a favorite subject for pomp and pageantry. Here, his talents were more than equal to their task—a fresco cycle on three walls of the chapel in the Medici Palace.

In the detail (Fig. 240), a richly costumed young Wise Man sits astride his splendid horse. At the head of the retinue that follows in his wake Benozzo portrays three generations of the Medici family. At the far right, Piero de' Medici (in profile) appears at the head of the procession. Displayed on the lower part of the harness of his white horse is the motto Semper ("Forever"), a part of the Medici coat of arms, each letter being in the center of one of the jeweled rings that make a continuous chain. Beside him is the elderly Cosimo (also in profile) on a gray mule with a black groom at his side. The youthful Giuliano and his older brother, the future Lorenzo the Magnificent, are at the extreme left. Bringing up the rear are various intimates and retainers of the Medici court, with the artist himself in the second row back, identified by a cap band that reads Opus Benotii (Work of Benozzo). Other faces may represent the philosopher Pico della Mirandola, the poet Poliziano, and Fra Angelico.

The procession winds around through the mountains and valleys of the lovely Tuscan land-scape punctuated by tall parasol pines and needle cypresses. It terminates at the fourth wall of the chapel where Fra Filippo Lippi's altarpiece, the *Adoration* (Fig. 241), could be seen. His Madonnas are slim and girlish, his babies plump and childlike, his saints kindly and paternal. The linear emphasis of Lippi's drawing, softened by his lush palette of pastel

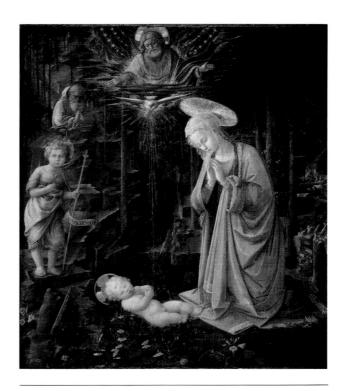

241. Fra Filippo Lippi. *Adoration.* c. 1459. Tempera on wood, $4'2'' \times 3'10''$ (1.27 × 1.17 m). Staatliche Museen, Berlin.

hues, had a decisive influence on the art of his pupil Botticelli. In this *Adoration*, the pictorial space is divided symmetrically by the Trinity, with God the Father imparting a blessing on his Son through the descending rays of the Holy Spirit. The rays find an earthly echo in the vertical lines of the tree trunks that rise by steps in the background, thus creating niches for the figures of the Madonna on the right and the youthful St. John and paternal St. Bernard of Clairvaux on the left. It is the latter's Nativity sermons that provide the keys that unlock the picture's complex iconography.

Paolo Uccello

To decorate one of the rooms of the Medici Palace, Cosimo called upon Paolo Uccello. As a student of spatial science, Uccello was trying to solve the problem of *linear perspective*—the formula of arranging lines on a two-dimensional surface so that they converge at a vanishing point on the horizon and promote the illusion of recession in depth. One of his three scenes depicting the *Battle of San Romano* (Fig. 242), a skirmish of 1432 in which the Florentines put the Sienese army to flight, shows his pioneering effort in applying Euclidean geometry to pictorial mechanics.

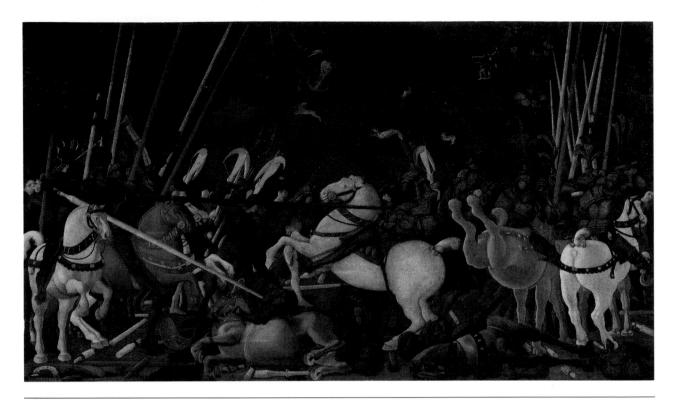

242. PAOLO UCCELLO. *Battle of San Romano*. c. 1455. Tempera on wood, $6' \times 10'5''$ (1.83 \times 3.18 m). Galleria degli Uffizi, Florence.

As a scientific experiment, Uccello lays his lances and banners out on the ground as if on a chess board. He was evidently so absorbed with his lines that his bloodless battle is staged more in the manner of a dress parade than a clashing conflict. He also did not develop the element of light and shade, so that his merry-go-roundlike horses, despite the variety of their postures, remain as flat as cardboard. For all this intellectual effort, the solution of the linear problem eluded him, and in this respect he was always a pupil and never a master.

Piero della Francesca

Present in Florence during the 1440s was Piero della Francesca. As an assistant to Domenico Veneziano, he absorbed the richness of Venetian color. Studying Masaccio, he learned about atmospheric perspective and how to model figures in light and shade. Associating with Ghiberti, Brunelleschi, Alberti, and Paolo Uccello, he eventually became a master of linear perspective and later wrote an essay on the subject.

Piero's *Resurrection* (Fig. 243), painted for the chapel of the town hall of his native Umbrian town of Borgo San Sepolcro, is one of his most sophisticated works. His geometrical clarity of design is seen at once in the compact pyramidal composition that

builds up from the sleeping soldiers (the second from the left is generally thought to be a self-portrait) and sarcophagus to the figure of Christ, modeled like a classical statue and holding the triumphant banner.

Color contrasts, as well as light and shade, play important roles both in the pictorial mechanics and in the symbolism of this *Resurrection*. The somber tones of the soldiers' costumes are offset by the radiant pink of Christ's robe. Furthermore, the dark-clad soldiers, paralleled by the shadowy earth, set up an alternating rhythm with the flowing figure of Jesus against the Easter dawn. The barren earth on the left yields to the springtime rebirth of the fields on the right. The effect of the brightening sky above, together with the radiant spirit of Christ with his piercing, almost hypnotic gaze, is reflected in the disturbed soldiers below, who though still asleep, are just beginning to be aware of the dawn.

Botticelli

Painting in the first part of the 15th century had to reckon with many different trends and diverse personalities. Sandro Botticelli, however, rose above the majority of his contemporaries. He became the most representative artist of the humanistic thought that dominated the latter half of the century.

Botticelli enjoyed the patronage of the Medici family, and in his Adoration of the Magi (Fig. 244) he portrays the clan, as had his predecessor, Benozzo Gozzoli (Fig. 240). Among the admirably arranged figures one finds the elderly Cosimo kneeling at the

feet of the Christ Child. Also kneeling are his two sons, Piero and Giovanni. To their right, standing against the ruined wall, is the profiled figure of Giuliano, the handsome grandson of Cosimo and the younger brother of Lorenzo the Magnificent, who is

243. Piero della Francesca. Resurrection. c. 1460. Fresco, 9'6" × 8'4" (2.9 × 2.54 m). Pinacoteca, Palazzo Comunale, Borgo San Sepolcro.

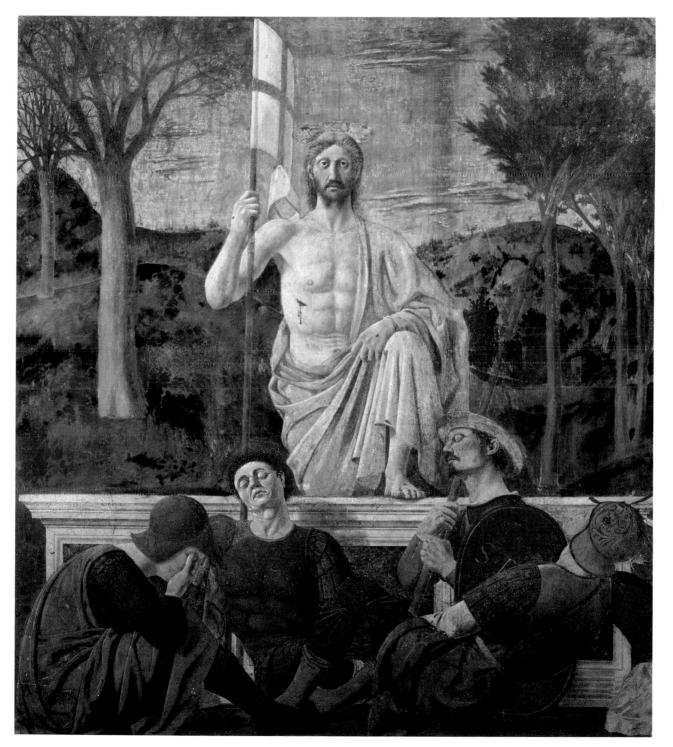

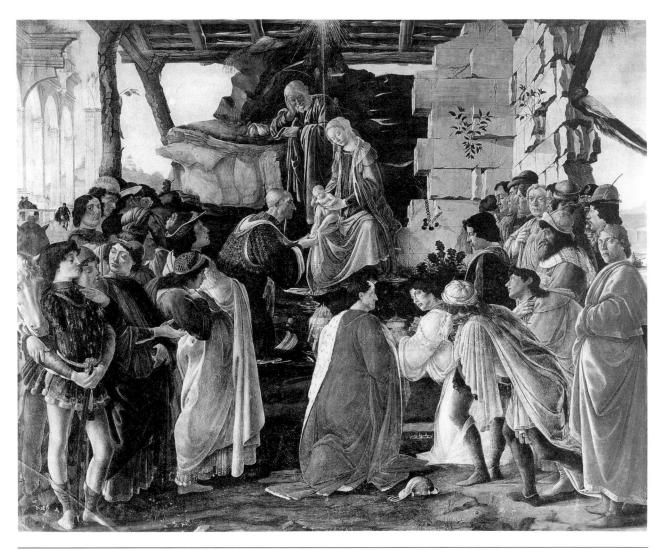

244. Sandro Botticelli. *Adoration of the Magi.* c. 1475. Tempera on wood, $3'7\frac{1}{2}'' \times 4'4\frac{3}{4}''$ (1.1 × 1.34 m). Galleria degli Uffizi, Florence.

to be found in the extreme left foreground. His opposite number at the right usually is identified as Botticelli himself. Though the coloring is bright—ranging from the cool sky blue of the Virgin's robe and the dark green and gold embroidery of Cosimo's costume to the ermine-lined crimson cloak of the kneeling Piero and the bright orange of Botticelli's mantle—it falls into a harmonious pattern. Attention should also be called to the classical touch provided by the Roman ruin in the left background.

Botticelli was not a popular painter of pageants like Benozzo Gozzoli and his contemporary Ghirlandaio but a member of the sophisticated group of humanists who gathered around his Medici patrons. In this circle, which included the poet Angelo Poliziano and the philosophers Marsilio Ficino and Pico della Mirandola, as well as Lorenzo the Magnificent and his cousin Pierfrancesco di Lorenzo de'

Medici, classical myths were constantly discussed and interpreted. The dialogues of Plato, the *Enneads* of the Roman philosopher Plotinus, and Greek musical theory were all thoroughly explored. With the Florentine interest in the pictorial arts, the ancient references to sculpture and painting were not neglected. This neopagan atmosphere with Christian parallels is seen in many of Botticelli's paintings.

Botticelli's *Primavera*, or *Allegory of Spring* (Fig. 245), is one of the most eloquent expressions of Renaissance thought. It was painted for the instruction of a young cousin of Lorenzo de' Medici who numbered among his tutors the poet Poliziano and the Neoplatonic philosopher Marsilio Ficino. The eight figures, with Venus in the center, form an octaval relationship, and together they run a gamut of myth and metaphor. The drama reads from right to left. The gentle south wind, Zephyr, is pursuing the

shy nymph of springtime, Chloris. As he impregnates her, flowers spring from her lips, and she is transformed into Flora in an appropriately flowery robe. As told by the Roman poet Ovid, "I was once Chloris, who am now called Flora." This figure also refers to Florence, an allusion not lost on the citizens of the city of flowers. The blind Cupid is shooting an arrow toward Castitas (Chastity), the youthful central dancer of the three graces. Her partners are the bejeweled Pulchritudo (Beauty) and Voluptas (Passion). Their transparent, gauzy drapery vibrates with the figures of their dance to create a ballet of rhythmic flowing lines. (In his Pagan Mysteries of the Renaissance, historian Edgar Wind sees the dance as the initiation rites of the virginal Castitas into the fullness of beauty and passion.) At the far left stands Mercury, both the leader of the three graces and the fleet-footed god of the winds. As Vergil wrote, "With his staff he drives the winds and skims the turbid clouds." Lifting his magic staff, the Caduceus, he completes the circle by directing his opposite number, Zephyr, to drive away the wintry clouds and make way for spring. On the philosophical plane, Mercury is dispelling the clouds that veil the intellect so that the light of reason can shine through. Presiding over the entire scene is the mediating and ameliorating figure of the goddess of love. Pico della Mirandola observed that the "unity of Venus is unfolded in the trinity of the three graces." She also reminds the viewer that love is the tie that binds both the picture and the world together.

Botticelli reveals here his close connection with the Florentine Renaissance humanists who were concerned with the revival of classical forms, figures, and imagery. Botticelli's break with the past, however, is not quite complete, since the composition of his picture is still that of the traditional Christian iconography of the Madonna surrounded by saints and angels.

Another aspect of the goddess of love is found in the *Birth of Venus* (Fig. 246), a composition inspired by ancient descriptions of a lost masterpiece, *Venus Anadyomene*, by Apelles, court painter to Alexander the Great. Here there are four figures instead of eight, a triad grouped around Venus. Her presence and modest posture express the dual nature of love,

245. Sandro Botticelli. *Allegory of Spring (Primavera)*. c. 1478. Tempera on wood, $6'8'' \times 10'4''$ (2.03 × 3.15 m). Galleria degli Uffizi, Florence.

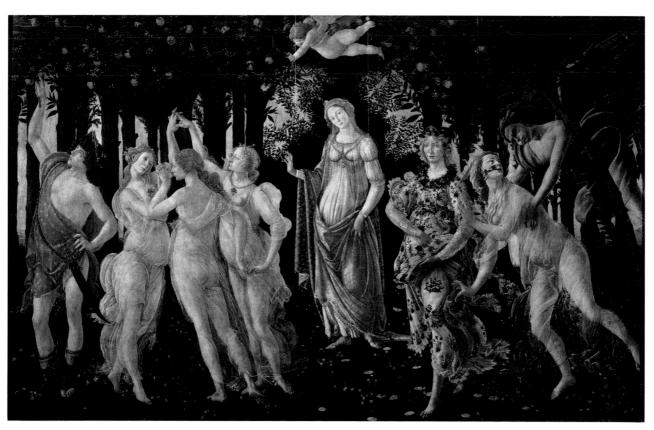

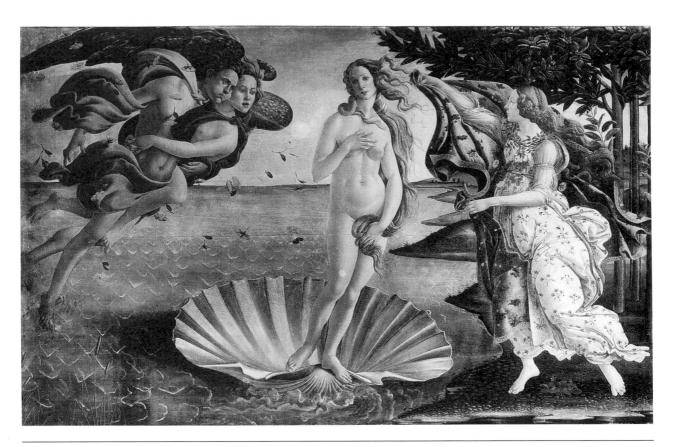

246. Sandro Botticelli. Birth of Venus. c. 1480. Tempera on canvas, $6'7'' \times 9'2''$ (2 \times 2.79 m). Galleria degli Uffizi, Florence.

the sensuous and the chaste. These motifs are carried out on the left by the blowing winds, which Poliziano called amorous zephyrs, and the chaste Hora on the right (one of the Hours present at classical births), who is rushing in with the robe. Botticelli's achievement is to produce a picture of great lucidity and freshness. Venus seems to be floating gently across the green sea on her pink shell. The fluttering drapery of the side figures creates a sense of lightness and movement and leads the eye toward the head of Venus, which is surrounded by an aura of golden hair. The clarity of outline, the balletlike choreography of lines, and the pattern of linear rhythms recall the technique of relief sculpture. In spite of the pagan subject matter, Botticelli's iconographical source is once more that of the traditional baptism of Christ as he stands in the river Jordan with St. John on one side and an angel on the other.

Leonardo da Vinci

Trained in Verrochio's workshop, Leonardo rejected the classical humanistic scholarship that prevailed in the Florence of his time in favor of firsthand investigation, observation of nature, and constant experimentation. In the process his restless intelligence roamed the entire field of human knowledge. Many of his theories and speculations pushed the frontiers of knowledge far beyond his time. A music lover all his life, it was as a lute player and singer that he was first received at the court of Milan. But in a letter to the duke he said that he could "vie successfully with any in the designing of public and private buildings, and in conducting water from one place to another . . . I can carry out sculpture in marble, bronze, or clay. . . . " And then he casually mentions that "in painting I can do as well as any man." The voluminous notebooks he kept throughout his long life testify to his wide-ranging interests-including the flight of birds, the flow of water, the force of winds, the movement of clouds, and the invention of machines. His precisely observed, elegant drawings in all these fields and in human anatomy qualify him as the founder of modern scientific illustration.

Leonardo's point of departure in painting is found not in the graceful linear approach of Botticelli, but in the natural lighting, atmospheric perspective, and sculpturesque modeling of Masaccio (see pp. 246–48). His treatise on painting advises

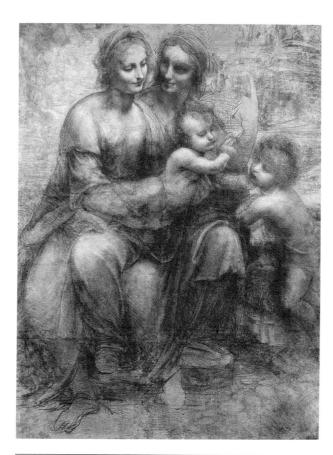

247. LEONARDO DA VINCI. Cartoon for *Madonna and Child with St. Anne.* 1497–99. Charcoal and white chalk on paper, $4'6_4^{3\prime\prime} \times 3'3_4^{3\prime\prime}$ (1.39 × 1.01 m). National Gallery, London (reproduced by courtesy of the Trustees).

artists to observe faces and figures in the softer light of dawn, dusk, and cloudy weather rather than in full daylight. This, he felt, yielded more delicacy of expression and a special quality of warmth and intimacy. In his masterly cartoon for Madonna and Child with St. Anne (Fig. 247) all sharp lines are eliminated. Through his subtle chiaroscuro he is able to penetrate those unfathomable depths that give visual shape to intuitions and states of mind, thereby revealing true character and personality. In this portrayal of three generations, the grandmotherly St. Anne becomes the personification of benign tranquility and Mary the image of grace and maternal concern while the Christ child and St. John reveal the thoughtful gravity of those on whom the salvation of the world will depend.

In the *Madonna of the Rocks* (Fig. 248) the forms seem to emerge out of the surrounding darkness. The light appears in diffused rays that model the bodies three dimensionally and illuminate the landscape background. More important than mere physical light, however, is the spiritual illumination that

shines from each face. Here Leonardo carries chiaroscuro one step further, into what is called *sfumato*, whereby all hard lines disappear and the figures are revealed in a hazy, almost smoky atmosphere. The central part of the picture is built three dimensionally like a pyramid, one of Leonardo's most significant contributions to pictorial form. The Madonna's head becomes the apex, while the two children give just the right weight and volume to the base. The hands play an expressive part as Mary embraces the young St. John, the representative of humanity in need of protection. Her other hand seems to hover in space as it forms a halo for the infant Jesus. The hand of the angel points to St. John as the forerunner of Christ, while that of the infant Jesus is raised in blessing.

Leonardo's great interest in nature also plays a prominent role in this painting. Around the pool in

248. LEONARDO DA VINCI. *Madonna of the Rocks*. Begun 1483. Oil on panel (transferred to canvas), $78\frac{1}{2} \times 48''$ (1.99 × 1.22 m). Louvre. Paris.

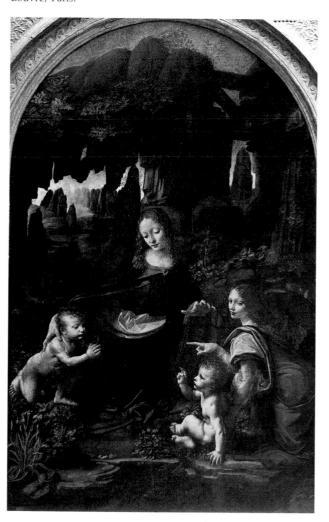

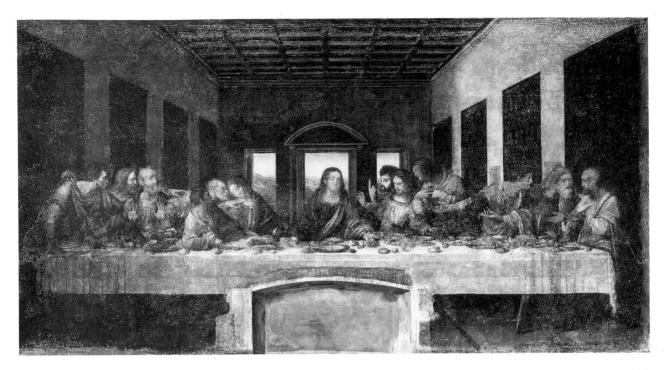

249. above:

LEONARDO DA VINCI. Last Supper. 1495–98. Oil and tempera on plaster, $14'5'' \times 28'\frac{1}{4}''$ (4.39 \times 8.54 m). Refectory, Santa Maria della Grazia, Milan.

250. right:

Diagram of Figure 249 showing vanishing point (one-point) perspective.

the foreground and throughout the cave are the flowers, grasses, and plants that are observed with minute accuracy and painted with a loving hand. The stalagmites, stalactites, and other rock formations are rendered with the precision of an expert in geology. The overall tone of the grotto setting is melancholy, seeming to foreshadow the tomb that awaits the Savior at the end of his earthly mission.

The Last Supper, a fresco on the wall of the monks' refectory in Santa Maria delle Grazie in Milan (Fig. 249), is a masterpiece of dramatic power and pictorial logic. Leonardo has chosen to depict the moment when Jesus said: "Verily I say unto you, that one of you shall betray me." And the apostles "were exceeding sorrowful, and began every one of them to say unto him, Lord is it I?" (Matt. 26:21-22). The reactions run the gamut of human feeling from fear, outrage, and doubt to loyalty and love. As each responds, his mental and emotional state is reflected in the searching facial expressions and eloquent gestures that plumb the psychological depths of each character (Fig. 251). In the process the defiant Judas is isolated as the only one who really knows. He is drawing back, his face in deep shadow, his hand clutching the moneybag containing the fatal 30 pieces of silver. Of him Jesus said: "Behold,

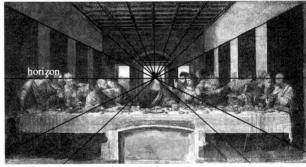

the hand of him that betrayeth me is with me on the table" (Luke 22:21).

To contain this highly charged scene Leonardo devised a setting of spaciousness and stability. All the lines of the walls and ceiling beams converge in the exact middle, directly behind the head of Christ in perfectly realized linear perspective (Fig. 250). The light from the center window with the curved pediment above functions as a halo around his head. At the table the revealing gestures of the hands also focus attention toward the center. As an underlying motif Leonardo draws on his Florentine heritage of harmony as expressed in numbers, in this case the symbolism and properties of the number 12. The twelve apostles appear in four groups of three on either side of the lonely central figure. There are four wall hangings on each side and three windows, alluding to the four gospels and the Trinity. Twelve also refers to the passage of time—the hours of the day and months of the year—in which human salvation is to be sought.

Always thoughtful and deliberate in his working methods, Leonardo found the usual fresco technique of rapid painting on wet plaster uncongenial. Instead, he experimented by mixing oil pigments with tempera in order to lengthen the painting time, get deeper colors, and work in more shadow effects. Unfortunately, the paint soon began to flake off the damp wall. Over the years it has been so often restored and repainted that only a shadow of its original splendor remains. It is still possible, however, to admire the overall design, the dramatic deployment of gestures of the figures, and some of the color tones. All the heads have been repainted so that the intensity of the facial expressions can only be recaptured through the few preparatory drawings that have survived. A particularly poignant one is the profile of Philip, who is standing third to the right of Christ (Fig. 251).

Leonardo's ambitions, conceptions, and projections far exceeded his capacity to realize them In tangible form. None of his buildings progressed beyond the planning stage, his sculptures have all perished, and only about 17 generally accepted paintings remain. These include four that are unfinished, while the others exist in varying states of preservation, restoration, and repainting.

POETRY AND MUSIC

Lorenzo as Poet and Patron

The principal poets of the Florentine Renaissance were Lorenzo de' Medici and Poliziano. Lorenzo's title *Il Magnifico*, in retrospect, seems fitting in recognition of his activities as poet, humanist, philosopher, discoverer of genius, patron of the arts and sciences, and adviser to writers, sculptors, painters, and musicians.

Under the wise guidance of his grandfather Cosimo, *Pater Patriae*, Lorenzo had been educated by Pico della Mirandola and other Latin and Greek scholars of the highest repute to be the type of philosopher-ruler Plato had described in the *Republic*. Social conditions, however, had changed considerably since Cosimo's time, and while his grandfather had been a banker with intellectual and artistic tastes, Lorenzo became a prince whose power rested on philosophical prestige and leadership in matters of taste as well as on his formidable banking fortune.

Lorenzo maintained embassies at all the principal courts to which he made loans. He was willing to finance foreign conflicts, provided he saw a substantial profit for himself, but he preferred to fight his own wars with words. By having the services of the greatest humanists under his command, he ensured

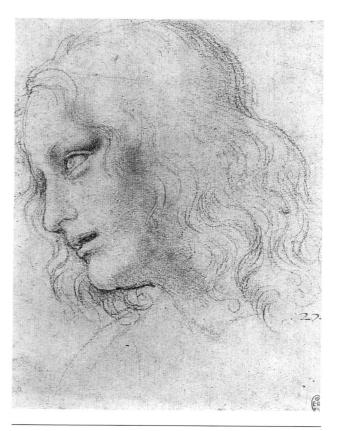

251.LEONARDO DA VINCI. Study of St. Philip for the *Last Supper*. Black chalk on paper, c. 1495–96. Copyright reserved. Reproduced by gracious permission of Her Majesty Queen Elizabeth II. Royal Library, Windsor Castle.

that he would not run out of ammunition in the form of elegantly turned phrases, veiled threats, and verbal thunderbolts.

Changes in the status of the arts had also come about as the 15th century progressed. In the early decades Ghiberti had been employed by the Signory, and his work was intended for public view. Later the major commissions came from a few wealthy families. Under Lorenzo the arts took on a more courtly character, and the audiences grew correspondingly smaller and more elite. Some painters were able to remain outside the charmed circle and to make careers depicting social scenes of births and marriages for an upper-middle-class clientele. Botticelli's pictures, however, were meant mainly for the humanistic intellectuals of the time.

Carnival Songs

Lorenzo himself, though the leader of this exclusive group, had the instincts of a popular ruler and did not neglect the common touch. He participated actively in the Florentine festivals by composing new verses for the traditional folk tunes, by encouraging

others in his circle to do the same, and by holding competitions among composers for better musical settings of the songs.

Lorenzo thus gave new impetus to popular literature in the native dialect. In a commentary on four of his own sonnets, he went to considerable lengths to defend the expressive possibilities of Tuscan Italian. After comparing it with Hebrew, Greek, and Latin, he found that its harmoniousness and sweetness outdid all the others. While he continued to write sophisticated sonnets, Lorenzo also wrote popular verses that have, in addition to their beauty and literary polish, all the spontaneous freshness, humor, and charm of folk poetry. In some of his pastoral poems he even uses the rustic dialogue of true country folk. Few poets could rival the lyricism of his *canti carnascialeschi*, or "carnival songs," one of which contains the oft-quoted lines:

Fair is youth and free of sorrow, Yet how soon its joys we bury! Let who would be, now be merry: Sure is no one of tomorrow.

In order to flourish, popular poetry needed appropriate musical settings. A young man of eighteen, Lorenzo was in search of a composer to set his lyrics, and a letter he wrote in 1467 requests the "venerable Gugliemo Dufay," who by this time was approaching seventy, to compose music for his verses. This was the same Guilaume Dufay who some thirty years earlier had composed the dedicatory motet for the cathedral.

Collaboration with Heinrich Isaac

Popular music making in Florence and other Italian cities was as much a part of the good life as any of the other arts. But it was mainly an art of performance, and little music was ever written down. When the time came to appoint a successor to Squarcialupi as private master of music in the Medici household after his death in 1475, Lorenzo's choice fell on Heinrich Isaac, a native of Flanders and a rapid and productive composer. Florence immediately became a second home to this truly cosmopolitan figure, and native Italian idioms soon were combined with those of his own background and training.

Isaac's duties included those of organist and choirmaster at the Florence Cathedral as well as at the Medici Palace, where Lorenzo is known to have had no fewer than five organs. Together with the poet Angelo Poliziano, he was also the teacher of

Lorenzo's sons, one of whom was destined to be the music- and art-loving Pope Leo X. But most important, Isaac collaborated with Lorenzo on the songs written for popular festivals. He thus became cocreator of one of the popular kinds of secular music that eventually led to the 16th-century madrigal. The madrigal was a popular type of vocal chamber music in the polyphonic style, usually of amorous character and designed for home performance and entertainment.

Dufay's settings of Lorenzo's verses are now lost, but many by Isaac still exist. In one of these, he shows the tendency away from complex counterpoint and toward simple harmonic texture. Its style is that of a Florentine *frottola*, a carnival song for dancing as well as singing, and its lilting rhythm freely shifts its meter. As the setting stands (below), it could be performed by a three-part chorus. It could also be performed as a solo song with the two lower parts taken by the lute or two viols or other instruments, or as a vocal duet with the soprano and either one of the two other voices.

Un di lieto

LORENZO DE' MEDICI and HEINRICH ISAAC

The collaboration of Lorenzo and Isaac thus resulted in both a meeting of minds and a merging of poetic and musical forms. Lorenzo's verses were a union of the courtly *ballata* and popular poetry, while Isaac succeeded in Italianizing the Burgundian *chanson*, or "song." *Italianizing* in this case means simplifying, omitting all artificiality, and enlivening a rather stiff form with the graceful Florentine folk melodies and rhythm. It can be seen that such a movement worked both ways by raising the level of popular poetry on the one hand and at the same time giving new life to more sophisticated poetic and musical forms through popular idioms.

IDEAS

The dominating ideas of the Florentine Renaissance cluster around three concepts—classical humanism, scientific naturalism, and Renaissance individualism. In their broadest meaning, humanism, naturalism and individualism were far from new. When classical humanism took shape in Italy, it was very

likely as much a survival from ancient times—Roman architecture and sculpture were always present on Italian territory—as a true revival in the sense of a reinterpretation and new adaptation of the older Greco-Roman forms.

Naturalism, in the sense of faithfulness to nature, appears in a well-developed form both in the northern Gothic sculpture and in the poetry of St. Francis, who had died as long before as 1226. By the 14th century, representations of people and nature alike had pretty well lost their value as otherworldly symbols. But rather than being content with describing the world as seen by the eye alone, Florentine 15th-century naturalism took a noticeably scientific turn. Careful observation of natural events and the will to reproduce objects as the eye sees them was evidence of an empirical attitude; dissection of corpses in order to see the structure of the human body revealed a spirit of free inquiry; and the study of mathematics so as to put objects into proper perspective involved a new concept of space. Clearly a new scientific spirit was now afoot.

While individualism as such is practically universal, the distinctive feature of its Florentine expression was that conditions in this small city-state were almost ideal for artists to come into immediate and fruitful contact with their patrons and audience. Competition was keen; desire for personal fame was intense; and a high regard for personality is seen in the portraiture, biographies, and autobiographies.

Humanism in the humanitarian Franciscan sense was a carryover from the 13th and 14th centuries. Naturalism stemmed from late Gothic times. And some form of individualism is always present in any period. It should therefore be clear that the Florentine Renaissance was characterized by no sharp division from the past and that its special flavor lies in the quality of its humanism, in the tendency of its naturalism, and in its particular regard for the nature of its individualism.

Classical Humanism

The term *Renaissance*, implying as it does a rebirth, is a source of some confusion. To the early 16th-century historian it meant an awakening to the values of ancient classical arts and letters after the long medieval night. But just what, it anything, was *reborn* has never been satisfactorily explained. Since all the principal ideas were present in the Gothic period, one might do better to speak of the maturing of certain tendencies present in late medieval times. Yet there was a specific drive that gave an extraordinary stimulus and color to the creative life and

thought of this small Tuscan city-state in the 15th century. It is important to discover what it was, and what it was not, that gave humanism in Florence its special flavor.

Though Florentine humanism evolved from the Franciscan spirit, it did take on a consciously classical coloration. Here again, however, a word of caution is necessary when speaking of a "rebirth" of the spirit of antiquity. In Italy, much more than in northern Europe, the classical tradition had been more or less continuous. Roman remains were everywhere in evidence. Many Roman arches, aqueducts, bridges, and roads were still in use, while fragments of ancient buildings were reused as building materials.

In the late 13th century, Nicola Pisano's sculptural models were the Roman remains he saw all around him, and by the 15th century the revival of the classical male nude as an instrument of expression is seen in the work of Ghiberti, Donatello, Pollaiuolo, and Verrocchio. At the beginning of the 16th century, Michelangelo had developed such a formidable sculptural technique that his *David* (Fig. 252) not only rivaled the work of such ancient sculptors as Praxiteles (see Fig. 50) but surpassed it.

Aristotle was still studied in university and theological circles, and ancient musical theory continued to be taught. What was new to Florence was the study of the Greek language, the setting up of Ciceronian rather than medieval Latin as a standard, and a passionate interest in Plato. In spite of a certain concern for antique books and works of art, however, the net result was less a revival of things past than a step forward. It was a search for past examples to justify new practices.

Much has been said also about the pagan aspect of this interest in antiquity. Here again it was less anti-Christian than appears on the surface. Florentine interest in Plato was a conscious departure from scholastic thought, but it was mainly a substitution of the authority of Plato for that of Aristotle. Marsilio Ficino, as the high priest of the movement, in his interpretation of the *Republic* and *Laws*, speaks of Plato as the Athenian Moses. He is also known to have added "Saint" Socrates to his litany and to have burned a candle before a bust of Plato. In this light, his thought appears more as a reinterpretation of Christianity in Platonic terms than a revival of paganism as such.

When the Florentine philosopher Pico della Mirandola said that "there is nothing to be seen more wonderful than man," he was picking up exactly where the ancient Greek thinkers left off (see p. 49). No more exalted conception of human dig-

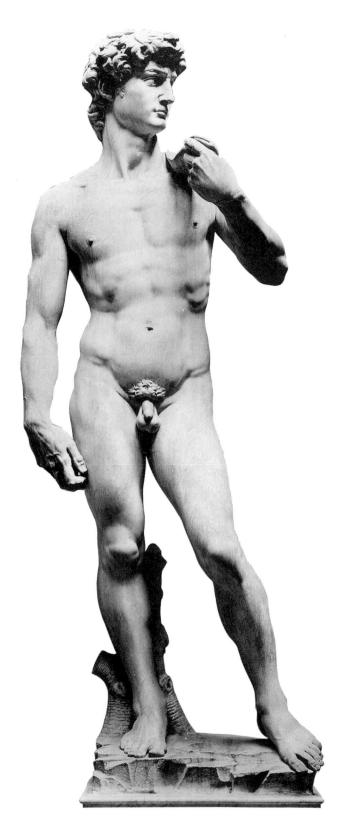

252. MICHELANGELO. *David.* 1501–04. Marble, height 18' (5.49 m). Galleria dell' Accademia, Florence.

nity has ever been uttered than that in Pico's famous Oration. He placed humanity at the center of the universe and considered man "the intermediary between creatures, the intimate of higher beings and the king of lower beings, the interpreter of nature by the sharpness of his senses, by the questing curiosity of his reason, and by the light of his intelligence, the interval between eternity and the flow of time. . . . " Man, according to Pico, has the possibility of descending to the level of brute beasts or the power to rise to the status of higher beings, which are divine. This confident picture of the human potential and destiny animates the spirit of the great humanistic artists Botticelli, Michelangelo, and Raphael, and it is one of the most important keys to the interpretation of their works.

Scientific Naturalism

The two basic directions taken by the naturalism of the 15th century led to a new experimental attitude and a new concept of space. A close partnership between art and science developed, with architects becoming mathematicians, sculptors anatomists, painters geometricians, and musicians acousticians.

The spirit of free inquiry was by no means confined to the arts alone. It penetrated all the progressive aspects of the life of the time from a reexamination of the forms of secular government to Machiavelli's observations on how people behave in a certain set of political circumstances. This searching curiosity reached its full fruition in the early years of the 16th century in Machiavelli's political handbook *The Prince* and in the same author's attempt to apply the Thucydidean method of rational historical analysis in his *History of Florence*. The scientific observations in Leonardo's notebooks, which cover everything from astronomy to zoology, show similar searching curiosity.

Well within the 15th century, however, the same spirit manifested itself. Ghiberti's *Commentaries* took up the mathematical proportions of the human body as the basis of its beauty, and he wrote the first essay in Italian on optics. Brunelleschi, as a diligent student of the Roman architect Vitruvius, was concerned with the mathematical and harmonic proportions of his buildings. Alberti, in his books on painting, sculpture, and architecture, stressed the study of mathematics as the underlying principle of all the arts. Leonardo also took up this theme by demonstrating the geometrical proportions of the human body in his well-known drawing (see Fig. 66).

The sculptors and painters who followed the leadership of Antonio Pollaiuolo and Verrocchio

were animated by the desire to express the structural forms of the body beneath its external appearance. Their anatomical studies opened the way to the modeling of the movements and gestures of the human body. The result was the reaffirmation of the expressive power of the nude.

In painting, naturalism meant a more faithful representation of the world of appearances, one based on detailed and accurate observation. Even Fra Angelico showed an interest in the exact reproduction of Tuscan botanical specimens in the garden of his *Annunciation*. Botticelli, too, under the influence of Pollaiuolo and Verrocchio, combined objective techniques with imaginative subjects.

The culmination of this line of thought was reached in Verrocchio's pupil Leonardo da Vinci, who considered painting a science and sculpture a mechanical art. Leonardo's scientific probing went beyond the physical and anatomical into the metaphysical and psychological aspects of human nature.

In music there was a continued interest in Greek theory, coupled, however, with attempts to experiment with acoustical problems. The compositions of Dufay and others of the northern school were characterized by extreme learning. For instance, mathematical laws were strictly applied to such aspects of composition as rhythmical progressions, formal proportions, and the development of technical devices.

Highly dramatic was the conquest of geographical space that began with the voyages of Columbus, leading to the development of trade routes and commerce and the tapping of new and distant sources of wealth. In architecture, this breakthrough in space is reflected in the raising of Brunelleschi's cupola almost 370 feet (112.7 meters) into the air. In painting, it is seen in a number of advances. Among them are the placing of figures in a more normal relationship to the space they occupy and the use of landscape settings. Others are Masaccio's development of atmospheric perspective, in which figures are modeled in light and shade, and the working out of rules for linear perspective, whereby the illusion of depth on a two-dimensional surface is achieved by defining a point at which lines converge. Foreshortening, the reduction in the size of figures and objects in direct ratio to their distance from the picture plane, is vet another.

Since the subject matter of medieval art was drawn from the other world, it fell outside the scope of naturalistic representation and had to be shown symbolically. Art now entered a new phase of self-awareness as Renaissance artists began to think less in terms of allegory, symbolism, and moral lessons

and more in terms of aesthetic problems, modes of presentation, and pictorial mechanics. In medieval music, the emphasis had been on perfect intervals and mathematical rhythmic ratios in order to please the ear of God. Renaissance musicians now reversed the process by concentrating on sounds that would delight the human ear. The new spirit was also heard in the extension of the range of musical instruments in both higher and lower registers, to broaden the scope of tonal space. Thus, the development of pleasant harmonic textures, the softening of dissonances, and the writing of singable melodies and danceable rhythms are all related developments giving style to the period.

In this trend toward scientific naturalism, the arts of painting and sculpture became firmly allied with geometrical and scientific laws, a union that lasted until 20th-century expressionism and abstract art. The 15th-century Florentine artists literally reveled in the perspective, optical, and anatomical discoveries of their day. And when all the basic research, experiments, and discoveries had been made, it was left for their successors—Leonardo da Vinci, Michelangelo, and Raphael—to explore their full expressive possibilities.

Renaissance Individualism

In the Renaissance, the desire for personal prestige through art became of prime importance. Wealthy families and individuals commissioned artists to build memorial churches and chapels as well as create statues and paintings. The high regard for individual personality is also mirrored in the number and quality of portraits painted at this time. Since artists were so eagerly sought after, their social status rose accordingly, and sculptors and painters became important personalities in their own right.

The religious nature of the vast majority of the works of art has already been pointed out, but personal patronage was in the ascendancy. Brunelleschi built the Pazzi Chapel, Masolino and Masaccio decorated the Brancacci Chapel, and Benozzo Gozzoli and Fra Filippo Lippi did the paintings for the Medici Chapel, all on commission from private donors as memorials to themselves and their families. San Lorenzo, the parish church of the Medici, was rebuilt and redecorated by Brunelleschi and Donatellobut the money came from Cosimo and not from the Church. Fra Angelico decorated the corridors of the monastery of San Marco, which was under the protection of the Medici family, and Squarcialupi and Isaac were on the payroll of the Medici when they played the organ in the cathedral, in a church, or in

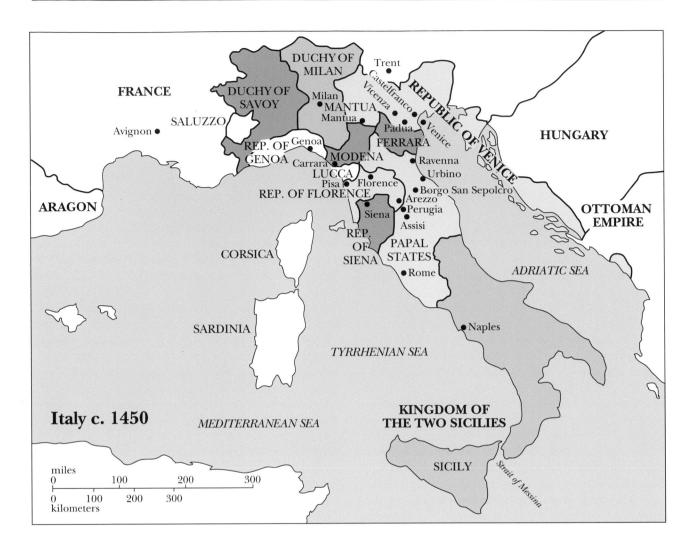

the family palace. Piousness and the desire for spiritual salvation were not the only motives for such generosity. More important was the knowledge that the donor's present and future fame depended on building monuments and choosing artists to decorate them.

In addition to the circumstances of patronage, certain technical considerations within the arts of themselves point in the same individualistic direction. The development of perspective drawing, for example, implied that the subject in the picture—whether a Madonna, a saint, or an angel—was definitely placed in this world rather than symbolically in the next. Hence the figure was more on a basis of equality with the observer. The unification of space through the convergence of all the lines at one point on the horizon tended to flatter the spectator. By clear organization of lines and planes, linear perspective assumes that everything is seen from a single optical vantage point. While the point of view is actually that of the artist, it is made to seem as if it

were also that of the observer. By closing the form, the artist further implies that nothing of importance lies outside the painting, and the whole of the picture can then be taken in at a glance. Since nothing, then, is beyond the grasp of the viewer, and all can be understood with relatively little effort, the eye and mind of the onlooker are reassured.

Human figures, whether rendered as prophets or portraits, tended to become more personal and individual. Each statue by Donatello, be it *Lo Zuccone* or his *David*, was an individual person who made a powerful, unique impression. Even Fra Angelico's Madonna is a personality more than an abstraction, and his figure of the Angel Gabriel possessed genuine human dignity. Whether the medium was marble, terra-cotta, paint, words, or tones, there was evidence of the new value placed on human individuality. Whether the picture was a disguised family group, like Botticelli's *Adoration of the Magi*, or a personal portrait, like Verrocchio's bust of Lorenzo, the figures were authentic personages rather than styl-

ized abstractions; even though Lorenzo de' Medici was the most powerful political figure of Florence, Verrocchio saw him as a man, not as an institution.

The higher social status given to Florentine artists was evident in the inclusion of self-portraits in such paintings as that of Benozzo Gozzoli in his *Journey of the Magi* and the prominent position Botticelli allowed himself in his *Adoration of the Magi*. Ghiberti's personal reminiscences in his *Commentaries* were probably the first autobiography of an artist in history. His inclusion of the lives and legends of his famous 14th-century predecessors were the first biographies of individual artists. He also included a self-portrait in one of the round medallions in the center of his famous doors.

Signatures of artists on their works became the rule, not the exception. The culmination came when Michelangelo realized his work was so highly individual that he no longer needed to sign it. The desire for personal fame grew to such an extent that Benvenuto Cellini no longer was content to let his works speak for him but wrote a lengthy autobiography filled with self-praise. The painter Giorgio Vasari likewise took up the pen to record the lives of the artists he knew personally and by reputation.

In late medieval and early Renaissance times, artists were content with their status as craftsmen. They were trained as apprentices to grind pigments, carve wooden chests, make engravings, and prepare wall surfaces for frescoes, as well as to carve marble reliefs and paint pictures. In the late 15th and early 16th centuries, however, it was not enough for artists to create works of art. They had to know the theory of art and the place of art and the artist in the intellectual and social atmosphere of their period.

Two Italian literary works of the following century round out the picture of Renaissance humanism and individualism—Machiavelli's The Prince (1513) and Castiglione's Book of the Courtier (1518). One is a handbook for achieving success as a political leader, the other a manual of courtly manners and etiquette. Niccolò Machiavelli's very name has become a part of our language. One who misbehaves is said to be "full of the Old Nick," and to act in a "Machiavellian" manner denotes devious and unscrupulous behavior. This negative ascription, however, overlooks Machiavelli's monumental intellectual honesty and his status as one of the founders of modern political science. Reading The Prince has been obligatory for every would-be politician and political observer from the 14th century to the present.

Machiavelli declared that "a prince must not keep faith when by doing so it would be against his self-interest." But he also pointed out that "the voice

of the people is the voice of God." Like a good scientist he simply isolated his subject from extraneous considerations to study and describe it more precisely. In practice this meant divorcing politics from ethics and religion. Primarily a pragmatist, Machiavelli held that whatever works in the power-political game is good, and whatever fails is bad. Well-versed in the classics, Machiavelli had as a starting point Aristotle's dictum that "man is a political animal." From his own experience as a diplomat for his native Florence and from his keen powers of observation he concluded that people are primarily self-seeking and basically evil. In matters of statecraft, he held that the end justifies the means and that what is morally right or wrong is beside the question. He believed that a ruler must be cunning as a fox and fierce as a lion: "The one who knows best how to play the fox comes out best, but he must understand well how to disguise the animal's nature and must be a great simulator and dissimulator. So simpleminded are men and so controlled by immediate necessities that a prince who deceives always finds men who let themselves be deceived." Machiavelli counseled that "it is much safer for a prince to be feared than loved, if he is to fail in one of the two."

In any state the rights of the people are important if domestic peace and stability are to be maintained. However, when dissenters appear, the people can be managed only by a hard-headed ruler who knows how to utilize factions to his own best advantage. Divide and conquer was his guiding principle. Machiavelli also felt that princes need to surround themselves in a style befitting their position. He saw the arts as useful to propaganda, and writers, painters, and musicians as valuable instruments to impress a ruler's rivals as well as his own subjects.

Baldassare Castiglione's Courtier was written at the glittering court of Urbino. In the form of a lively dialogue recalling Plato's Symposium, the Courtier's subject is the deportment and accomplishments expected of the lords and ladies who participated in courtly life. Courtiers, he wrote, should be persons of wide humanistic learning with high ethical standards. In addition to mastery of martial arts and physical skills, a courtier should be a connoisseur of the arts, a wise and witty conversationalist, a poet, a graceful dancer, singer, and musician. Some of these qualities shine through Raphael's dignified portrait of the author (Fig. 253). Castiglione also explored the role of women in high social circles. He held that women should be equally educated except in the arts of war, be able to lift their voices in song, participate in discussions, and be knowledgeable about literature and painting.

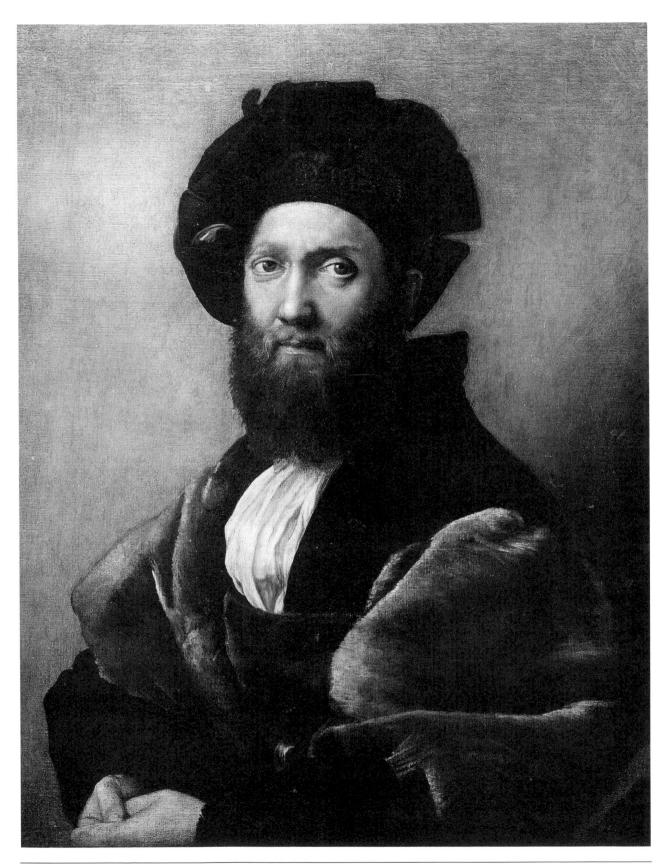

253. Raphael. *Baldassare Castiglione*. 1515–16. Oil on panel (transferred to canvas), $29\frac{1}{2} \times 25\frac{1}{2}$ " (75 × 65 cm). Louvre, Paris.

One of the qualities most admired by Castiglione and other Renaissance writers was *virtù* (the word comes closer in the modern sense to "virtuoso" than "virtuous"). *Virtù* revealed itself in the boundless vitality and extraordinary ability that led to the achievements of a Lorenzo the Magnificent or the breathtaking conceptions of a Michelangelo. Also with *virtù*, Renaissance artists could no longer be completely satisfied with a single speciality but sought to become universal in their activities. Brunelleschi was a goldsmith, sculptor, engineer, and mathematician as well as one of the leading lights of Renaissance architecture.

Castiglione articulated the Renaissance ideal of the *uomo universale*, the universal man, who embodied all the aspects of Renaissance humanism and individualism in one person. An artist who approached this ideal was Leon Battista Alberti, who in his youth excelled in feats of athletic strength and extraordinary horsemanship. In maturity he mastered mathematical skills and scientific knowledge.

He was a noted Latin stylist, a practicing musician, painter, sculptor, architectural designer, and city planner. His work was summed up in three influential treatises on painting, sculpture, and architecture which provided the foundation of the Renaissance theory of art. Alberti believed all persons can do all things if they have the will to do so. He was not only a universal man himself, but the prototype for his high Renaissance successors, Leonardo da Vinci and Michelangelo. In Leonardo, Renaissance universality reached a peak; it is more difficult to find a field in which he was not proficient than one where he greatly excelled. Michelangelo shunned the blandishments of courtly life in favor of his studio, preferring to deal with popes and princes as equals and rejecting all offers of noble titles. He realized his potential by becoming the ranking sculptor, painter, poet, and architect of his day. Moreover, when people began calling Michelangelo "the divine," the cycle was complete.

LATE 15th- AND EARLY 16th-CENTURY ROME

	KEY EVENTS	ARCHITECTURE	VISUAL ARTS	LITERATURE AND MUSIC
1500 -	1471-1527 Roman Renaissance: art and humanism at climax 1471-1484 Sixtus IV (della Rovere) pope 1484-1492 Innocent VII (Cibò) pope 1492-1503 Alexander VI (Borgia) pope	c.1444-1514 Donato Bramante 1473-1480 Sistine Chapel built 1475-1564 Michelangelo Buonarroti	c.1441-1523 Luca Signorelli ▲ 1452-1519 Leonardo da Vinci ▲ 1454-1513 Bernardino Pinturicchio ▲ 1460-1429 Andrea Sansovino ● 1475-1564 Michelangelo Buonarroti ● ▲ 1481-1482 Side-wall frescoes painted by Rosselli Ghirlandaio, Botticelli, Perugino, Signorelli, Piero di Cosimo 1483-1520 Raphael (Raffaelo Sanzio) ▲ 1493-1506 Ancient Roman frescoes and statues uncovered: Apollo Belvedere, Laocoön Group excavated 1496-1501 Michelangelo in Rome working on Bacchus and Pietà	c.1440-1521 Josquin Desprez □ 1469-1527 Niccolò Machiavelli ◆ 1474-1533 Ludovico Ariosto ◆ 1478-1529 Baldassare Castiglione ◆ 1483-1531 Martin Luther ◆ 1486-1492 Josquin Desprez in Sistine Chapel choir
	1503-1513 Julius II (della Rovere) pope 1513-1521 Leo X (Medici) pope 1517 Protestant Reformation began in Germany with Luther's Theses 1521 Luther excommunicated 1523-1534 Clement VII (Medici) pope 1527 Rome sacked by Emperor Charles V; pope Clement VII imprisoned 1534-1549 Paul III (Farnese) pope 1534 Church of England separated from Rome. Reaction to Renaissance humanism began	1506 New Basilica of St. Peter begun by Bramante; Old St. Peter's razed 1547 Michelangelo named architect of St. Peter's 1556-1629 Carlo Maderno 1558-1560 Apse and dome of St. Peter's built	1500-1571 Benvenuto Cellini ● 1505 Michelangelo began Julius II's tomb 1508-1512 Michelangelo painted Sistine Chapel ceiling. Raphael painted frescoes in Vatican Palace 1523 Michelangelo worked on Medici tombs in Florence 1535 Michelangelo painted Last Judgment in Sistine Chapel 1542 Michelangelo painted frescoes in Pauline Chapel	1511-1574 Giorgio Vasari ◆ 1512 Capella Giulia founded to perform in St. Peter's 1515 Ariosto wrote Orlando Furioso (Madness of Roland) 1515-1564 Michelangelo wrote sonnets and other poems c.1521-1603 Philippe de Monte □ 1525-1594 Giovanni da Palestrina □ 1528 Castiglione's The Courtier published 1532 Machiavelli's The Prince published c.1532-1594 Orland Lassus □ 1544-1595 Torquato Tasso ◆ 1548-1600 Giordano Bruno ◆ 1550 Vasari's Lives of the Most Eminent Painters, Sculptors, and Architects published c.1550 Philippe de Monte in Rome; first book of madrigals published 1554 1562 Tasso wrote Rinaldo 1575 Tasso wrote Jerusalem Delivered

 \square - Musician \blacktriangle - Painter \multimap - Sculptor \spadesuit - Writer

11

The Roman Renaissance Style

ROME, EARLY 16TH CENTURY

On April 18, 1506, when the foundation stone of the new Basilica of St. Peter was laid (Fig. 254), Rome was well on its way to becoming the undisputed artistic and intellectual capital of the Western world. Pope Julius II was gathering about him the foremost living artists in all fields, and together they continued the transformation of the Eternal City from its medieval past into the brilliant Rome of today.

Donato Bramante, originally from Umbria but educated in Lombardy, was the architect at work on the plans for the new St. Peter's, the central church of the Christian world at that time. Michelangelo Buonarroti from Florence was collecting the marble for a monumental tomb for Julius and was about to begin the painting of the Sistine ceiling. Raffaelo (Raphael) Sanzio of Umbria would soon be summoned from Florence to decorate the rooms of the Vatican Palace. The Florentine Andrea Sansovino was carving a cardinal's tomb in one of Julius II's favorite Roman churches, Santa Maria del Popolo, where the Umbrian Pinturicchio was covering its choir vaults with a series of frescoes. The singercomposer Josquin Desprez, already a member of the papal choir for eight years, had left to become choirmaster to the king of France.

The papal court under Julius II and his successor, Leo X, was such a powerful magnet that for three years the three greatest figures of the Renaissance—Leonardo da Vinci, Michelangelo, and Raphael—found themselves at the Vatican. In 1517, however, the aged Leonardo abandoned the artistic field of honor there to join the court of Francis I of France.

The flight of the Medici from Florence in 1494 had signaled a general exodus of artists. Many found temporary havens in the ducal courts of Italy, but Rome proved an irresistible attraction. Hence, during the days of the two great Renaissance popes, Julius II and Leo X, the cultural capital shifted from Florence to Rome. And, since Leonardo, Andrea

Sansovino, Michelangelo, and Pope Leo were from Florence, and since Bramante and Raphael had absorbed the Florentine style and ideas in extended visits there, the cultural continuity was unbroken. It was, in fact, like a smooth transplantation from the confines of a nursery to an open field—a move that led artists to branch out from local styles into the universal air of Rome.

Such projects as the building of the world's largest church, the construction of Julius II's tomb, the painting of the Sistine ceiling, and the Vatican Palace murals could be found only in Rome. Nowhere else were monuments of such proportions or commissions of such magnitude possible. In Rome also resided the cardinals, who maintained palaces that rivaled the brilliance of the papal court.

The interest in antiquity had animated many other Italian centers, but when the Renaissance got under way in Rome, it was, so to speak, on home soil. When antique statues were excavated elsewhere, they caused a considerable stir. In Rome, however, many of the ancient monuments were still standing, and when the archeological shovels probed the proper places, a veritable treasure trove was waiting. One by one the Apollo Belvedere (Fig. 86), the Venus of the Vatican, and the Laocoon Group (Fig. 83) came to light to stimulate the work of Michelangelo and other sculptors. The frescoes from Nero's Domus Aurea and the Baths of Titus provided the first important specimens of ancient painting. While the art of painting on fresh plaster had never died out, these ancient Roman fragments gave fresco painting a new impetus.

Julius II had received most of his training in diplomacy and statecraft from his uncle, Pope Sixtus IV. Fortunately, a passionate love of the arts was included in this education. It was Sixtus who had built the chapel that has subsequently carried his name, and who had installed there the group of papal singers that have ever since been known as the *Cappella Sistina*, or Sistine Chapel Choir. It remained

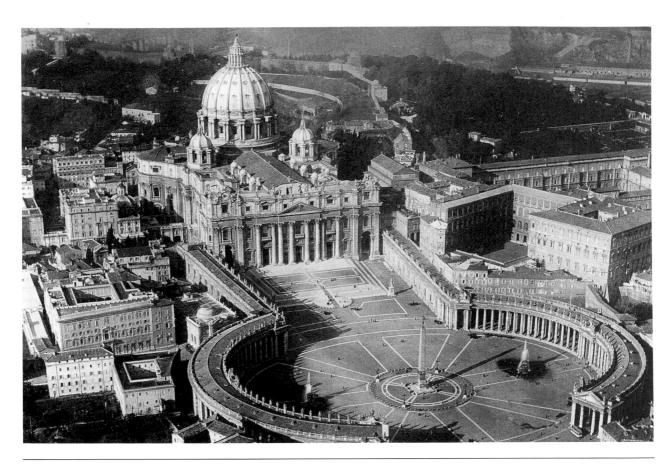

254. St. Peter's Basilica and the Vatican, Rome. Apse and dome by Michelangelo, 1547–64; dome completed by Giacomo della Porta, 1588–92; nave and façade by Carlo Maderno, 1601–26; colonnades by Gianlorenzo Bernini, 1656–63. Height of façade 147′ (44.81 m), width 374′ (114 m), height of dome 452′ (137.77 m).

for Julius to establish a chorus to perform in St. Peter's—one that still bears his name, the *Cappella Giulia*, or Julian Choir. This latter group corresponded to the ancient Schola Cantorum and prepared the singers for the Sistine Choir. Both have always received strong papal support.

Essentially a man of action, Julius II was an expert with the soldier's sword as well as the bishop's staff. He met his age on its own terms, and the spectacle of the pope riding a fiery horse into the smoke of battle had a remarkably demoralizing effect on his enemies. As one of the principal architects of the modern papacy, he also saw the need of a setting on a scale with the importance of the Church founded by St. Peter and made it a matter of policy to command artists as well as soldiers. At the end of his career, Julius II became the subject of one of Raphael's most penetrating portraits (Fig. 255).

When Leo X ascended the papal throne, one of the sayings went: "Venus has had her day, and Mars his, now comes the turn of Minerva." Venus symbolized the reign of the Borgia pope, Alexander VI; Mars, of course, referred to Julius II; and Minerva, the Roman equivalent of Athena, was Leo. As the son of Lorenzo the Magnificent, he brought with him to Rome the intellectual spirit of Florence, that latter-day Athens. Michelangelo, whom Leo had known since his childhood at the Medici palace, was unfortunately bound by the terms of his contract to serve the heirs of Pope Julius, but the suave and worldly Raphael was available—and more congenial to the personal taste of Pope Leo than was the gruff titan Michelangelo. Once again Raphael served as papal portraitist in an unusually fine study (Fig. 256).

Heinrich Isaac, Leo's old music teacher, wrote the six-part motet that commemorated his accession, and Isaac's pupil became one of the most liberal of all Renaissance patrons of music. Other princes of Europe had difficulty in keeping their best musicians, because the Pope's love of the tonal art was so well known. Leo collected lute and viol players, organists, and the finest singers; chamber music was avidly cultivated at the papal palace; and a wind ensemble performed at papal dinners. Leo's encouragement of music, to the point of putting it on a par with literary pursuits, caused considerable murmurings among poets and writers. As a competent com-

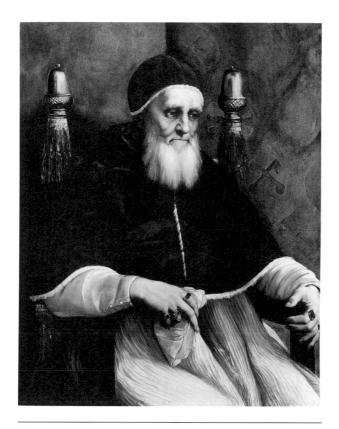

255. RAPHAEL. *Julius II.* 1511–12. Oil on wood, $42\frac{1}{2} \times 31\frac{1}{2}''$ (108 × 80 cm). National Gallery, London (reproduced by courtesy of the Trustees).

poser in his own right, he knew the art from the inside as few patrons have ever known it. As a philosopher, writer, and collector, his patronage, like that of his father, Lorenzo the Magnificent, was accompanied by an active participation in many of the pursuits that he sponsored. The Renaissance historian Jacob Burkhardt wrote that Rome "possessed in the unique court of Leo X a society to which the history of the world offers no parallel."

SCULPTURE: MICHELANGELO

Despite his many masterpieces in other media, Michelangelo always thought of himself first and foremost as a sculptor. Other projects were undertaken reluctantly. On the contract for the painting of the Sistine Chapel ceiling, for example, he pointedly signed *Michelangelo scultore*—"Michelangelo the sculptor"—as a protest. His first visit to Rome at the age of twenty-one coincided with the discovery of some ancient statuary, including the *Apollo Belvedere*, that proved a powerful stimulant to his own productivity. His most important statues from this early period illustrate the conflicting pagan and Christian ideals that were to affect his aesthetic thought throughout a long career.

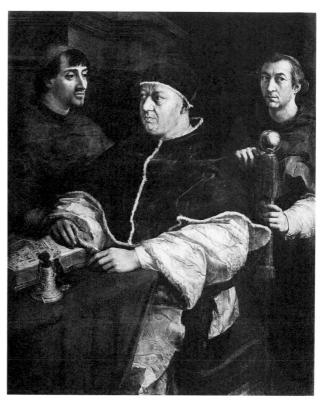

RAPHAEL. Leo X with Two Cardinals. c. 1518. Oil on wood, $5^{1}8^{m} \times 3^{9}88^{m}$ (1.54 × 1.14 m). Galleria degli Uffizi, Florence.

The Pietà

The *Pietà* (Fig. 257), now in St. Peter's, was commissioned in 1498 by Cardinal Villiers, the French ambassador to the Vatican. Its beauty of execution, delicacy of detail, and poignancy of expression reveal that Michelangelo was still under the spell of the Florentine Renaissance. Its pyramidal composition follows a type worked out by Piero della Francesca (Fig. 243) and by Leonardo da Vinci, seen in his drawing for *Madonna and Child with St. Anne* (Fig. 247). Michelangelo uses the voluminous folds of the Virgin's drapery as the base of the pyramid and her head as the apex.

The figure of Christ is cast in the perfect form of a Greek god, while the Madonna, though overwhelmed by grief, maintains a classical composure. No tears, no outcry, no gesture mar this conception of Mary as the matronly mother of sorrows. Yet Michelangelo allows himself many liberties with the proportions of his figures in order to heighten their expressive effect and enhance the harmony of his design. The excessive drapery exists to increase the number of folds and sweeping lines. The horizontal body of Christ is far shorter than that of the vertical Madonna, but the disproportion serves to make the

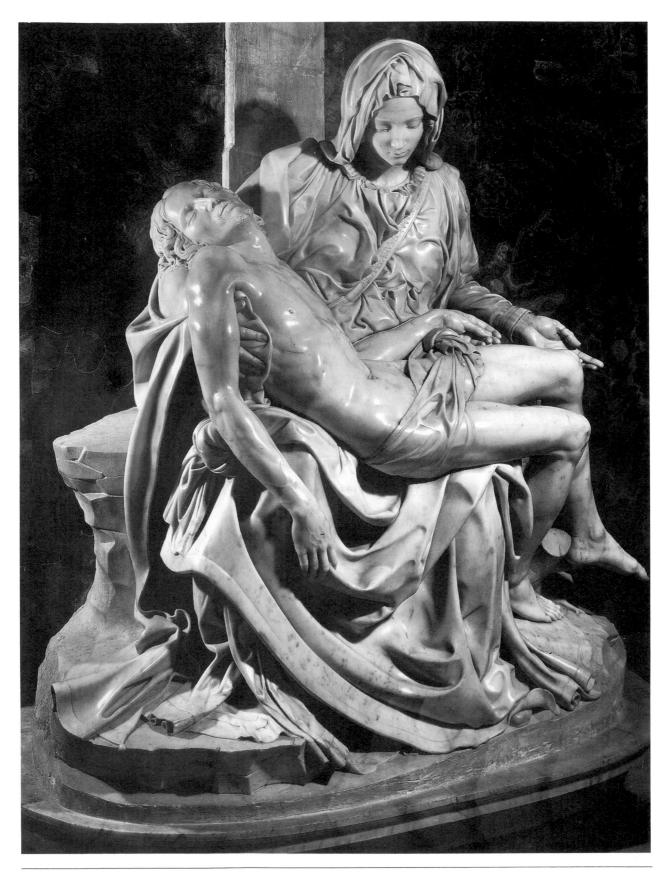

257. MICHELANGELO. *Pietà*. 1498–99. Marble, height 5'9" (1.75 m). St. Peter's, Rome.

composition more compact. The triangular shape, as a self-sufficient form, holds the attention within the composition and makes unnecessary such external considerations as niches or architectural backgrounds. As such, the *Pietà* is a sculptural declaration of independence, and it bears the distinction of being the only work Michelangelo ever signed.

Tomb of Julius II

After finishing the *Pietà*, Michelangelo went home to Florence, where he worked on the *Bruges Madonna* and his *David* (Fig. 252). In 1505, however, he was summoned back to Rome by the imperious Julius to discuss a project for a colossal tomb. In the original conception of this gigantic composition, the artist's imagination for once met its match in his patron's ambitions. Julius's monument was conceived as a small temple within the great new temple—St. Peter's—that was being built. It was to rise pyramidally from a massive quadrangular base visible from all four sides, and it was to include more than forty statues (Fig. 258).

When Julius died in 1513, only parts of the project had been finished, and a new contract with his heirs had to be negotiated. Further revisions were made later, each reducing the proportions of the project and eliminating more of the unfinished statues. In its final form of 1545, the monument had shrunk to the relatively modest wall tomb now in the aisle of the church of San Pietro in Vincoli.

Tombs of the popes, like the triple tiaras with which they were crowned, were traditionally in three rising zones, symbolizing earthly existence, death, and salvation. For the original project, Michelangelo translated these divisions into Neoplatonic terms representing the successive stages of the liberation of the soul from its bodily prison (see p. 54). For the final project, the monument lapsed into more traditional stages. In the original scheme, the lowest level was to have figures symbolizing those who are crushed by the burden of life and those who rise above the bonds of matter. This idea was retained in some of the later revisions, and six of the so-called Slaves or Captives and one so-called Victory survive in various stages of completion.

On the second level of the original project were to have been placed heroic figures of the leaders of humanity, those individuals who pointed the way toward the divine goal of reunion with God. Moses and St. Paul were to represent the old and new law, while Rachel and Leah would personify the active and contemplative ways of life. Of these, only the Moses was finished by Michelangelo himself.

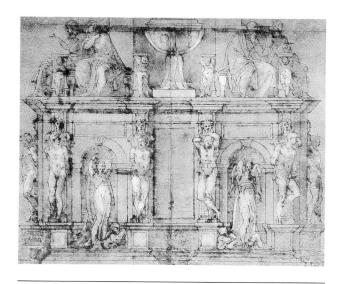

258. Michelangelo. *Projected Tomb of Julius II*. Drawing. Galleria degli Uffizi, Florence.

The three figures that date from the years 1513 to 1516, when Leo X was pope, are the two "Slaves" now in the Louvre and the Moses. The "Bound Slave" (Fig. 259) is the more nearly finished of the two, and it seems to represent a sleeping adolescent tormented by a dream rather than the "dying captive" it is sometimes called. The imprisoned soul, tortured by the memory of its divine origin, has found momentary peace in sleep. The cloth bands by which the figure is bound are only symbolic, since Michelangelo is not concerned with the external aspect of captivity but rather with the internal torment. It is the tragedy of the human race, limited by time but troubled by the knowledge of eternity; mortal but with a vision of immortality; bound by the weight of the body yet dreaming of a boundless freedom.

This tragedy of the tomb was understood only too well by Michelangelo himself, who had the conception of his great project in mind but was doomed to see only a few fragments of his dream completed. Figures such as the "Slaves" and the "Victory" that he planned were associated with the triumphal arches as well as with the mausoleums and sarcophagi of ancient Rome. The similarity between the "Bound Slave" and the younger son in the 2nd century B.C. Laocoön Group (Fig. 83) has aptly been pointed out.

The Platonic idea of the human soul confined in the bonds of flesh was continued in a later version of the tomb (Fig. 260). The imprisonment of the spirit by matter in these "Captives" is all but complete. Unconscious, locked in their stone wombs, they struggle and writhe to emerge from their material bondage. Their unfinished state gives an interest-

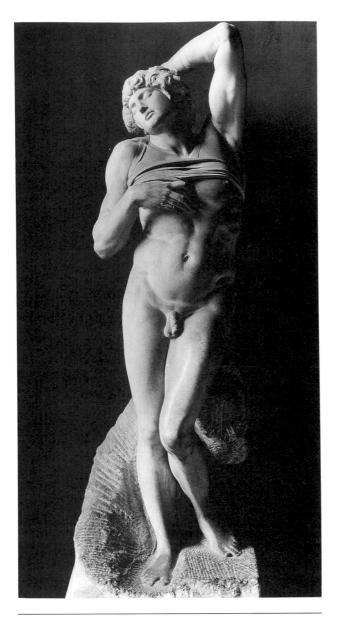

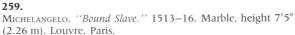

ing glimpse into Michelangelo's methods, which were similar to those of relief sculpture. The statue, to Michelangelo, was a potential form hidden in the block of marble awaiting the hand of the master sculptor in order to be born. "The greatest artist has no single concept which a rough marble block does not contain already in its core. . . ," wrote Michelangelo in a sonnet. The artist-creator, he continues, must discover, "concealed in the hard marble of the North, the living figure one has to bring forth. (The less of stone remains, the more that grows.)" The Neoplatonic implication is that the soul is still en-

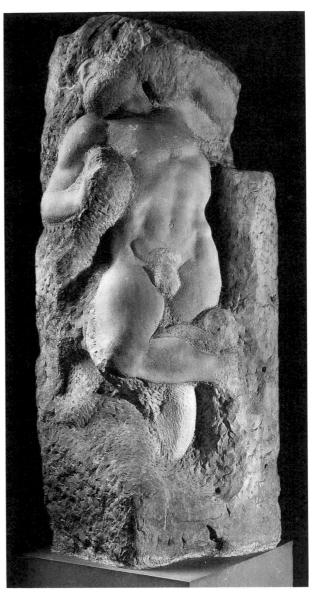

260. MICHELANGELO. "Boboli Captive." c. 1530–34. Marble, height 7'6½" (2.3 m). Galleria dell' Accademia, Florence.

tombed in the body and can only be perfected into pure being by the hand of a higher creative power.

Moses (Fig. 261) is the only statue completed entirely by Michelangelo's hand to find its place in the finished tomb. Both Julius II and Michelangelo possessed the quality of *terribilità*, or "awesomeness," that is embodied in this figure. Julius was known as *il papa terribile*, meaning the "forceful" or "powerful pope," imbued with the fear of the Lord. Michelangelo conceived his *Moses* as the personification of a powerful will, and partially as an idealized portrait of the determined Julius who, as the formu-

lator of a code of Church laws, had something in common with the ancient Hebrew law-giver. Moses is further portrayed as the personification of the elemental forces. He is the human volcano about to erupt with righteous wrath, the calm before a storm of moral indignation, the dead center of a hurricane of emotional fury, the messenger of those thunderous "Thou Shalt Nots" of the Ten Commandments, the man capable of ascending Mt. Sinai to talk with God and coming back down to review all humanity from the seat of judgment. The smoldering agitation revealed through the drapery, the powerful musculature of the arms, the dominating intelligence of the face, the fiery mood, and the twisting of the body in the act of rising are characteristic of Michelangelo's

261. MICHELANGELO. *Moses*. 1513–15. Marble, height 8'4" (2.54 m). San Pictro in Vincoli, Rome.

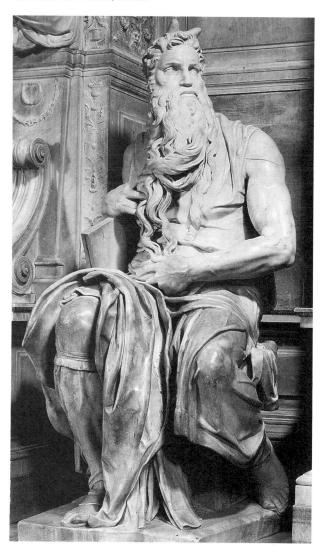

style. An interesting detail is the carved irises of the eyes, found earlier in his *David* (Fig. 252), which Michelangelo did to express a look of fixed determination. When he wanted to convey the qualities of dreaminess, gentleness, and resignation, as in his Madonnas, he left the eyes untouched. The curious horns on Moses' head were an iconographical tradition from medieval days. They stem from a mistranslation in St. Jerome's Latin version of the Old Testament, which should have read "rays of light."

Michelangelo worked at the time when many of the most outstanding examples of antique statuary were being unearthed and admired. Inevitably this led to critical comparisons. Michelangelo, like the Greco-Roman artists, saw men and women as the lords of creation, but their natural environment was always a matter of indifference to him. His early art especially was an affirmation of the supreme place of humanity in the universal scheme of things. That world was populated by godlike beings at the peak of their physical power, full of vitality, creatively active, and affirmatively self-confident.

As Michelangelo's art matured, his men and women were beset with quite unclassical tensions, doubts, and conflicts. Unlike the statues of antiquity, his figures, when they come to grips with fate, are armed with mental and moral powers that imply the hope of ultimate victory. Having thus surpassed the art of the ancients as well as that of his own time, not only by his technical mastery but by his expressive power, he came to be regarded by his contemporaries with awe. Vasari, his biographer, wrote: "The man who bears the palm of all the ages, transcending and eclipsing all the rest, is the divine M. Buonarroti, who is supreme not in one art only but in all three at once." History has since had no reason to reverse this judgment.

PAINTING

Michelangelo's Sistine Ceiling Frescoes

When Michelangelo fled from Rome because of numerous frustrations with plans for Julius II's tomb, the pope resorted to every means from force to diplomacy to get him to return. Knowing he had a restless genius on his hands, Julius conceived some interim projects to keep Michelangelo busy until all the problems with his tomb were solved. Thinking it soon to be done, he set Michelangelo to painting the Sistine Chapel ceiling.

The building itself, the roof of which can be seen paralleling the nave on the right of St. Peter's in Figure 254, was built by and named by Julius's uncle, Pope Sixtus IV, as the private chapel of the popes. The interior consists of a single rectangular room 44 by 132 feet (13.4 by 40.2 meters) (Fig. 262). Around the walls were frescoes painted by the foremost 15th-century artists, including the Florentines Ghirlandaio (one of Michelangelo's teachers), Botticelli, and Perugino, teacher of Raphael. Above the frescoes were six windows in the side walls, and overhead was a barrel-vaulted ceiling 68 feet (20.7 meters) above the floor with 700 square yards (585.3 square meters) of surface stretching before the artist's eye. Using the traditional fresco technique (see p. 217), Michelangelo set to work.

The entire Sistine ceiling was conceived as an organic composition motivated by a single unifying philosophical as well as artistic design (Fig. 263). The iconography is a fusion of traditional Hebrew-Christian theology and Neoplatonic philosophy that Michelangelo knew from his days in the Medici household. The space is divided into geometric forms, such as the triangle, circle, and square, which were regarded in Plato's philosophy as the eternal forms that furnish clues to the true nature of the universe. Next is a three-way division into zones, the lowest consisting of eight concave triangular spaces

above the windows and four pendentive-shaped corner spaces. The intermediate zone includes all the surrounding space except that given to the nine center panels, which in turn form the third zone.

Symbolically these divisions correspond to the three Platonic stages—the world of matter, the world of becoming, and the world of being. Analogies to such triple divisions run as an undercurrent through all aspects of Plato's thought. Plato divided society, for instance, into three classes: workers, free citizens, and philosophers, which he symbolized by the metals brass, silver, and gold. Each stratum had its characteristic goal: the love of gain, the development of ambition, and the pursuit of truth. Learning was similarly broken down into the three stages of ignorance, opinion, and knowledge. Plato's theory of the human soul was also tripartite in nature, consisting of the appetitive, emotional, and rational faculties, located in the abdomen, breast, and head, respectively. Of these only the rational or intellective part could aspire to immortality (see p. 47).

On the lower outside level Michelangelo placed the unenlightened men and women imprisoned by their physical appetites and unaware of the divine word. In the intermediate area are the in-

262. Sistine Chapel, view toward Michelangelo's *Last Judgment* over the altar. 1473–80. Height of ceiling 68' (20.73 m). Vatican Palace, Rome.

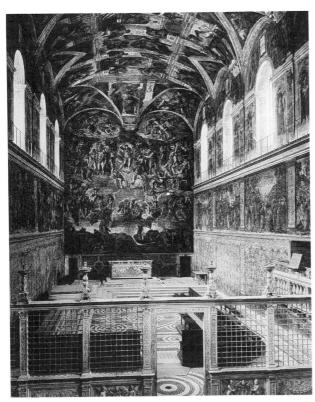

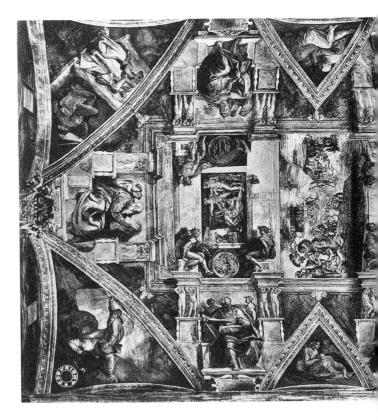

spired Old Testament prophets and pagan sibyls who through their writings and prophecies impart knowledge of the divine will and act as intermediaries between humanity and God. In the central section are the panels that tell the story of men and women in their direct relationship to God. They are seen through the architectural divisions as if they were beyond on a more cosmic plane.

Lower and Intermediate Area. The eight border triangles tell the dismal tale of people without vision, who, as St. Luke says, "sit in darkness and in the shadow of death," awaiting the light that will come when the Savior is born. In the four corners are the heroic men and women whose active deeds secured temporary deliverance for their people: David's slaving of Goliath, Judith's beheading of Holofernes, Haman's punishment through Esther, and Moses' transformation of his rod into a serpent that devoured the similarly transformed rods of the Egyptian priests.

This serves as an introduction to the representations of the seven Hebrew prophets, who alternate with five pagan sibyls like a chorus prophesying salvation. The *Delphic Sibyl* is the first of the series (Fig.

264). In the Greek tradition and in Plato, she was the priestess of Apollo at Delphi. In Vergil's Aeneid, Book VI, she is described as a young woman possessed by the spirit of prophecy. In the grip of divine fury, she turns her head toward the voice of her inspiration. Though clothed in classical Greek garments, her beauty recalls that of Michelangelo's early Madonnas.

Above each of the prophets and sibyls and framing the central panels are *ignudi* (nude youths), seen in Figure 263. In the Christian tradition, these figures would have been represented as angels. In the Platonic theory, however, they personify the rational faculties of the sibyls and prophets by means of which they contemplate divine truth and by which they are able to bridge the gap between the physical and spiritual, or earthly and heavenly, regions. Thus, all the prophets and sibyls have a single figure below to denote the body, a pair of nudes behind them to signify the will, and a heroic ignudo to personify the immortal soul. These three levels correspond to Plato's tripartite conception of the soul the appetitive, the emotional, and the intellective faculties. These symbolic figures also serve to soften the contours of the architectural design.

263. Michelangelo. Ceiling, Sistine Chapel. 1508–12. Fresco, 44 × 128' (13.41 × 39.01 m). Vatican Palace, Rome.

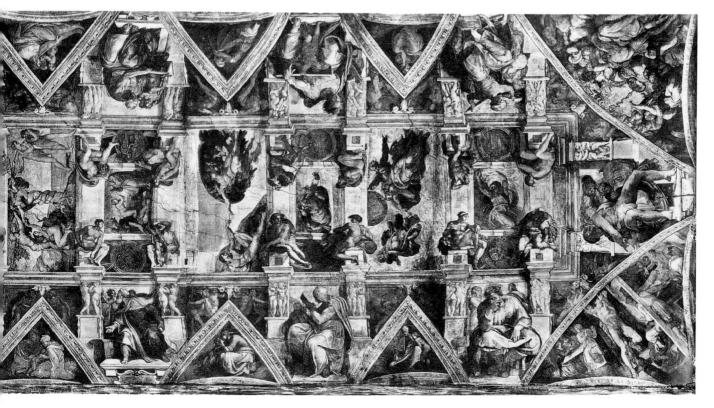

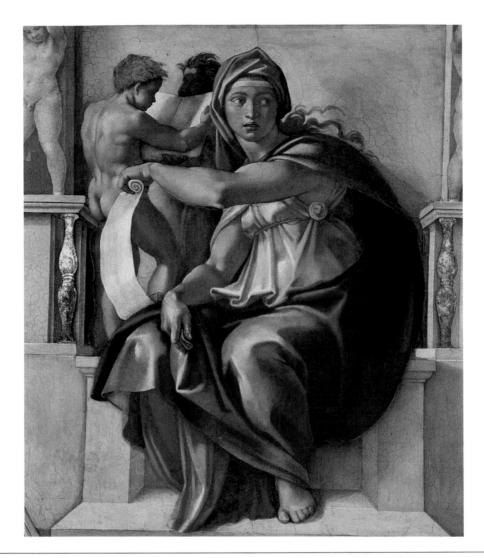

264. Michelangelo. *Delphic Sibyl*, detail of Sistine Chapel ceiling. 1509. Fresco. Vatican Palace, Rome.

CENTER PANELS. In the center panels of the Sistine Chapel ceiling, instead of starting at the beginning and proceeding chronologically as in Genesis, Michelangelo conceives the story of creation in reverse order, or as the Platonic ascent of humanity from its lowest estate back to its divine origin. In this return to God, the soul in its bodily prison gradually becomes aware of God and moves from finiteness to infinity, from material bondage to spiritual freedom. Immortality, in this sense, is not the reward for a passive and pious existence but the result of a tremendous effort of the soul struggling out of the darkness of ignorance into the light of truth.

The first of the histories in the nine central panels is the *Drunkenness of Noah*. As in the "Slave" figures of the Julius monument, the picture of Noah shows a mortal man in his most abysmal condition, the victim of bodily appetites. Noah's servitude is

symbolized at the left, where he is seen tilling the parched soil. He is still strong physically, but his spirit is overwhelmed by the flesh. His sons, bluff adolescents in their physical prime, do not seem to be discovering their father's nakedness, as related in the Bible, but the tragic fate of all mortals, who must work, grow old, and die. Noah's reclining posture recalls that of the ancient Roman river gods, and in this case the head has sunk forward on his chest in what seems to be a premonition of death. After this picture of Noah as the prisoner of his own baser nature, the next panel represents the Deluge, which shows the plight of men and women when beset by the elemental forces of nature beyond their control. In the third panel, Noah's Sacrifice, human dependence on God is implied for the first time.

The Fall and Expulsion from Paradise follows. Then the last five panels are concerned with various

aspects of God's divine nature. In the Creation of Eve he appears as a benign paternal figure closed within the folds of his mantle. In the Creation of Adam (Fig. 265), God is seen in the skies, with his mantle surrounding him like a cloud, as he moves downward toward the earth and the inert body of Adam. The creative force is here likened to the divine fire that flashes like lightning from the cloud to the earth. Adam's body is one with the rock on which he lies, not unlike the unfinished "Slaves" of the Julius tomb. In keeping with the Platonic idea of life as a burden and imprisonment, Adam is awakening to life reluctantly rather than eagerly. With his other arm. God embraces Eve. who exists at this moment as an idea in the mind of God. She resembles Michelangelo's Madonna types and looks with fear and awe on this act of creation. God's fingers point to the

coming Christ Child, while behind him are the heads of unborn future generations of human beings.

After the Gathering of the Waters comes the Creation of the Sun and Moon (Fig. 263, right). Here the figure of God becomes a personification of the creative principle, while in God Dividing the Light from Darkness (Fig. 263, far right), the final panel of the series, the climax and the realm of pure being are attained. Here is clarity from chaos, order from the void, existence from nothingness. Light here is the symbol for enlightenment and the knowledge that gives freedom from the darkness of ignorance and bondage. Only through the light of wisdom can an individual attain the highest human and divine status. "You shall know the truth and the truth shall make you free," say the scriptures (John 8:32); "Know thyself," the Delphic oracle told Socrates.

265. MICHELANGELO. Creation of Adam, detail of Sistine Chapel ceiling. 1511. Fresco. Vatican Palace, Rome.

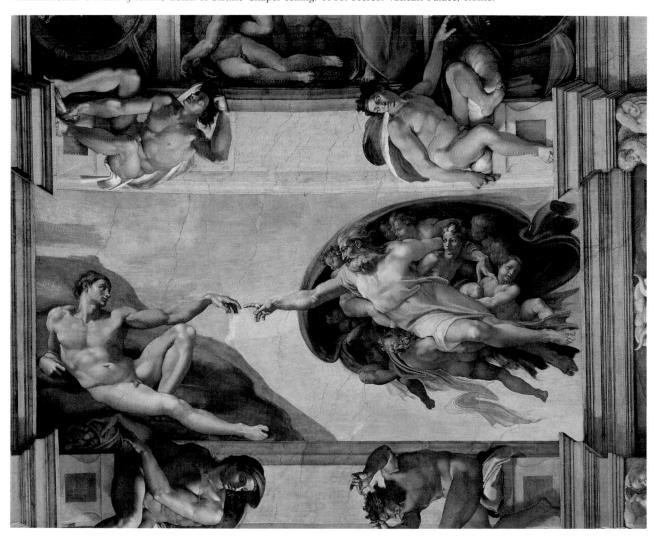

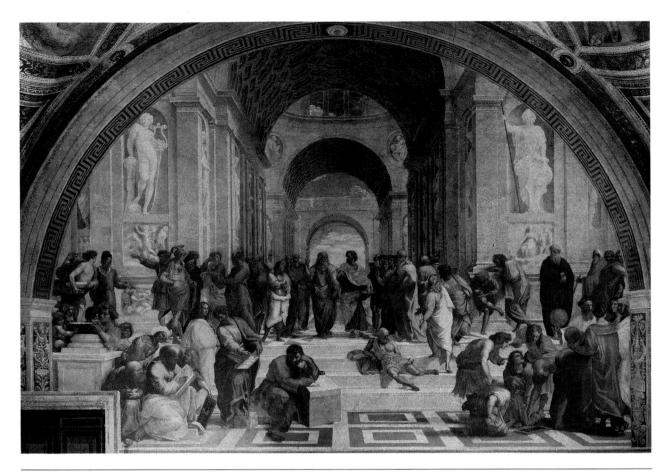

266. RAPHAEL. School of Athens. 1501–11. Fresco, $26 \times 18'$ (7.92 \times 5.49 m). Stanza della Segnatura, Vatican Palace, Rome.

The conception of God has progressed from the paternal human figure of the *Creation of Eve* to a cosmic spirit in the intervening panels, and now to a swirling abstraction in the realm of pure being. The Neoplatonic goal of the union of the soul with God has been achieved by the gradual progress from the bondage of blind humanity, through the prophetic visions of the seers, and, finally, by ascending the ladder of the histories into the pure light of knowledge, to the point of dissolving into the freedom of infinity. In the words of Pico della Mirandola, the human being "withdraws into the center of his own oneness, his spirit made one with God."

The weight of expression, story content, and philosophical meaning are carried entirely by Michelangelo's placement and treatment of the more than three hundred human figures in a seemingly infinite variety of postures.

Though he later returned to the Sistine Chapel to paint the *Last Judgment* on the altar wall (Fig. 262) and worked on another group for the Pauline Chapel in the Vatican, Michelangelo never suc-

ceeded in recapturing the optimism and creative force of the earlier series.

Raphael's Vatican Murals

At the same time as Michelangelo was painting the Sistine ceiling, his younger contemporary Raphael was at work on the murals of the Vatican Palace. In School of Athens (Fig. 266), Raphael presents such a complete visual philosophy that it places him, along with Michelangelo, in the select ranks of artistscholars. Raphael's fresco is full of intellectual as well as pictorial complexities. Yet by the expanding space of the setting and the skillful arrangement of the figures, as well as their relationships to each other and to the architecture, it is clear and uncluttered. As members of a philosophical circle intent on reconciling the views of Plato and Aristotle, Raphael and his friends held that any point in Plato could be equated with and translated into a proposition of Aristotle and vice versa—the principal difference being that Plato wrote in poetic images, while Aristotle used the language of rational analysis. The two philosophers, "who agree in substance while they disagree in words," are placed on either side of the central axis of the fresco with the vanishing point between them. The book Plato holds in his hands is his Timaeus, and he points skyward to indicate his idealistic worldview. Aristotle carries his Ethics and indicates by his earthward gesture his greater concern with the real world.

In the spacious hall, which recalls the Roman poet Lucretius's remark on "temples raised by philosophy," the various schools of thought argue or ponder the ideas put forth by the two central figures. On Plato's side a niche contains a statue of Apollo, patron of poetry. On Aristotle's side is one of Athena, goddess of reason. This division of the central figures balances the picture, with the metaphysical philosophers ranked on Plato's side and the physical scientists pursuing their researches on Aristotle's.

Spreading outward on either side are groups corresponding to the separate schools of thought within the two major divisions, each carrying on the philosophical arguments for which they were famous. The figure of Plato is thought to be an idealized portrait of Leonardo da Vinci. In the group at the lower right Raphael portrayed his architect friend Bramante as Archimedes demonstrating on his slate a geometrical proposition. At the extreme right, Raphael paints a self-portrait in profile next to his friend the painter Sodoma.

In School of Athens as a whole, Raphael captured the intellectual atmosphere and the zest with which Renaissance ideas were argued. By his grouping and placement of figures and by their attitudes, attributes, and gestures, he provides a far clearer commentary on the thought of his time than did the more complex and lengthy philosophical treatises of the period. To paint such metaphysical abstractions at all, and clothe them with plastic form, is a triumph of clear thinking and logical organization. Posterity is fortunate to have this summation of Renaissance humanism as seen through the eye of such a profound artist as was Raphael.

THE DOME OF ST. PETER'S

The foundations of the new St. Peter's (Fig. 254) had been laid as early as 1506, when Michelangelo was starting plans for Pope Julius's tomb. Comparatively little progress had been made in the stormy years that followed, in spite of the succession of brilliant architects. Michelangelo favored the centralized church plans of Brunelleschi and Alberti just as his predecessor Bramante had done. The latter's design, however, was to have culminated in a low dome, modeled after that of the Pantheon but with a series of columns at the base and a lantern tower on top.

Michelangelo accepted Bramante's Greekcross ground plan with a few alterations of his own (Fig. 267), but he projected a loftier dome rising over the legendary site of St. Peter's tomb. This cupola was to be of such monumental proportions that it would not only unify the interior spaces and exterior masses of the building but would serve also as the climax of the liturgical, religious, and artistic forces of the Roman Catholic world and also as a symbol of Christendom.

Michelangelo's first problem was an engineering one—to find out whether the masonry was strong enough to support such a dome. It was not, and he had to reinforce the four main piers until each was a massive 60 feet (18.3 meters) square. Pendentives became the means by which the square understructure was encircled, and then the cylindri cal drum was ready to rise. Meanwhile he made a large model of the dome itself, so that it could be built by others in case of his death. All the preparatory work was thus completed, and Michelangelo lived just long enough to see the drum finished. The dome (Fig. 268) was completed after his death by two of his associates without substantial alterations.

Michelangelo's centralized plan might well have been finished as he had envisaged it except for forces beyond his control. After his death there were calls for reforms within the Church itself, along with a new spirit of conservatism that frowned on anything that might be considered as a pagan form. A new wave that favored a return to the traditional Latin-cross planning was begun. In the early 17th century, then, Carlo Maderno undertook the lengthening of the nave and the design of the façade (Figs. 269 and 254).

Liturgically, the new nave provided more space for the grandiose processions. Practically, it afforded room for larger congregations. Historically, it absorbed all the area formerly occupied by Constantine's basilica, demolished to make way for the new structure. Aesthetically, however, the proportions suffered, and the climactic effect of the great dome was lessened. The scale of the interior, however, had been set by Michelangelo's huge piers beneath the dome, and Maderno had to continue the same proportions. The vaulting thus rises a little over 150 feet (45.7 meters) above the pavement, while the enormous interior covers more than 25,000 square yards (20,903 square meters) in area.

The exterior of the church Michelangelo planned can best be seen from the apse and the inte-

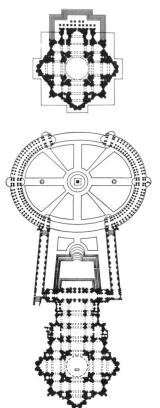

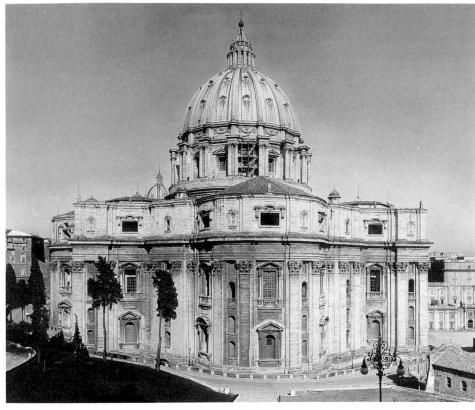

267. top left:

MICHELANGELO. Plan of St. Peter's.

268. right:

Michelangelo. Apse and dome, St. Peter's. Begun 1547. Height of dome 452' (137.77 m).

269. bottom left:

St. Peter's. Plan of present complex.

rior from beneath the dome, where it appears as the compact unified structure he wanted. From the apse of the completed church (Fig. 268), where the lengthened nave does not detract, the effect is still substantially as Michelangelo intended it to be. From this vantage point the building itself appears as a great podium for the support of the vast superstructure; and from the ground level to the base of the dome there is a rise of about 250 feet (76 meters). The cupola then continues upward to the top of the lantern tower, where an ultimate height of 452 feet (137.8 meters) above ground level is attained.

JOSQUIN DESPREZ AND THE SISTINE CHAPEL CHOIR

A Florentine literary historian in a book on Dante published in 1567 wrote:

I am well aware that in his day Ockeghem was as it were the first to rediscover music, then as good as dead, just as Donatello discovered sculpture in his; and that of Josquin, Ockeghem's pupil, one might say that he was a natural prodigy in music, just as our own Michelangelo Buonarroti has been in architecture, painting, and sculpture; for just as Josquin has still to be surpassed in his compositions, so Michelangelo stands alone and without a peer among all who have practiced his arts; and the one and the other have opened the eyes of all who delight in these arts, now and in the future.

Josquin Desprez was thus still regarded almost half a century after his death as a figure comparable to Michelangelo. A Florentine could bestow no higher praise. This opinion, moreover, was also held by musicians. The distinguished theorist Glareanus wrote that the work of Josquin was "the perfect art to which nothing can be added, after which nothing but decline can be expected."

The so-called *ars perfecta*, or "perfect art," rested on the typical Renaissance historical assumption of the development of the arts in antiquity, which had been lost in medieval days and subsequently rediscovered in the then-modern times. The previous quotation is a critical application of this doctrine of regained perfection to the art of music.

Italians, whether at home or abroad, took the greatest pride in the achievements of their own architects, sculptors, and painters, but universally they acknowledged the supremacy of the northern composers. The spread of the northern polyphonic art dated from the time the popes had become acquainted with it at Avignon. Later, it led to the establishment of the *Cappella Sistina* in 1473, which was dominated by Flemish, Burgundian, and French musicians, whose influence from there spread over the entire Christian world. From this time forward, the mastery of these artists in contrapuntal writing became the standard of perfection

Under Pope Sixtus IV, church music had moved from its status as the modest servant of the liturgy to a position of major importance. The grandeur of the Roman liturgical displays called for music of comparable magnificence. Owing to the prevailing taste of the time, musicians from the great singing centers of Antwerp, Liège, and Cambrai thus flocked to Rome to seek their fortunes. The highest honor of all was an appointment to the Sistine Choir, whose privilege it was to perform on the occasions when the pope himself officiated.

Membership in the Sistine Choir was highly selective, totaling from 16 to 24 singers except during the time of the musical Leo, who increased it to 36. These singers were divided into four parts: boy sopranos, male altos, tenors, and basses. Normally they sang *a cappella*—that is, "in the chapel manner," without instrumental accompaniment—a practice that was considered exceptional rather than usual at the time.

The quality of this choir can be deduced from the list of distinguished men who made their reputations in its ranks. In the archives are numerous masses, motets, and psalm settings composed by Josquin Desprez during his service there from 1486 to 1494. Giovanni Palestrina, who had studied Josquin's contrapuntal technique, became a member in 1551 and later brought the organization to a pinnacle of technical perfection.

In Josquin's compositions, the stark, barren intervals of Gothic polyphony and all traces of harshness in the harmonies are eliminated. He allows dissonances to occur only on weak beats or as suspensions on the stronger ones. His rhythms and forms are based on strict symmetry and mathemati-

cally regular proportions. His writing is characterized by the usual northern fondness for imitation of a melody by successive voice parts, in the manner of a *canon*, and other complicated contrapuntal constructions. Such devices, however, are managed with complete mastery, and his tremendous technique in composition never intrudes upon the expressive content.

Josquin was at home in all Renaissance musical forms, excelling perhaps in his motets and in his solo and choral songs. In Rome, where his unique abilities were combined with the warmth and liquid smoothness of Italian lyricism, Josquin mellowed in his music until it achieved a style of incomparable beauty, formal clarity, and the purest expressivity.

Josquin's four-part motet *Ave Maria* will serve as an admirable illustration of his art. Like Michelangelo's early *Pietà* (Fig. 257), it is in a perfectly selfcontained form, emotionally restrained, and full of luxuriantly flowing lines. Even such a short excerpt as that reproduced on the following page shows his love of canonic imitation between the voices and the smoothness of contour that comes with stepwise melodic motion. These imitations can be seen when the melody in the top line is imitated exactly a fifth below by the next lower line. Later the same thing occurs, beginning with the words *Nostra fuit* and also with those starting *Ut lucifer lux*.

Josquin treats all four voices with balanced impartiality but prefers to group them in pairs, as in this example, in order to achieve a transparency of texture and purity of sound. Darker sides of Josquin's emotional spectrum can be found in his requiem masses and in his setting of the psalm *De Profundis*.

Later periods saw in Michelangelo both a summing up of the Renaissance and the beginning of the baroque style. Josquin's place was more limited. While he enjoyed universal acclaim as the greatest musical mind of the early 16th century, the very perfection of his art implied that it was on the verge of becoming archaic. Josquin's mantle was inherited by a number of composers in the succeeding generation, who carried his art to its logical conclusion. Palestrina's music is, perhaps, better adapted to religious purposes, though he remains Josquin's inferior in invention, inspiration, and depth of expression. Victoria carried the style to Spain, William Byrd to England; and through Philippe de Monte and Orland Lassus, it spread throughout France and Germany. In the 17th century, though the art was still studied, it became known as the "antique style," in contrast to the baroque music, which was called the "modern style." Within its limitations the art has never been surpassed.

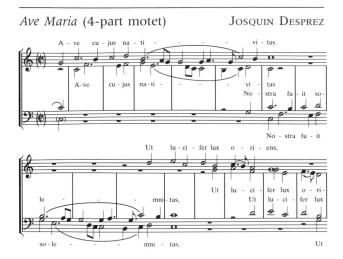

IDEAS: HUMANISM

Revival of Classical Forms

Florentine humanism and its Roman aftermath were motivated by a reappraisal of the values of Greco-Roman antiquity, by an attempt to reconcile pagan forms with Christian practices, by a desire to reinstate the philosophy of Plato and reinterpret that of Aristotle, and, above all, by a rediscovery of this world and human values. Renaissance humanists were not primarily religious- or scientific-minded. They tended to substitute the authority of respected classical writers for that of the Bible and Church dogma. In looking forward, they found more convenient and convincing precedents in the civilizations of Greece and Rome than in the immediate medieval past. Lorenzo de' Medici, for instance, saw a new orientation for secular government in Plato's Republic. Machiavelli found a new method for writing history in Thucydides' writings. And Bramante made a new adaptation of the Greco-Roman temple for Christian worship.

Bramante's Tempietto (Fig. 270) was a conscious revival of the rounded commemorative structures of antiquity (see Figs. 107, 108, 114). This temple in miniature, coming as it did at the outset of the 16th century, became the architectural manifesto of the Roman Renaissance, just as Brunelleschi's Pazzi Chapel (Figs. 226–228) had been in the 15th-century Florentine Renaissance. Placed in the cloistered courtyard of the Church of San Pietro in Montorio, the little temple rests on the site where St. Peter is supposed to have been crucified.

For his architectural order Bramante chose the simple yet monumental Doric order. He held to the

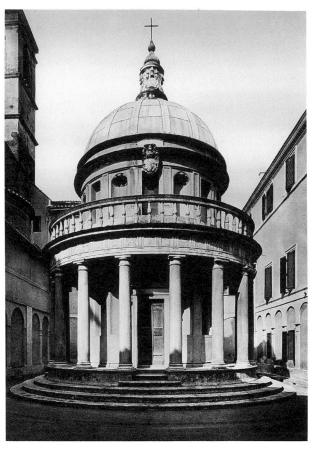

270.Donato Bramante. Tempietto, San Pietro in Montorio, Rome. 1504. Marble; height 46' (14.02 m), diameter of colonnade 29' (8.84 m).

classical principle of the module whereby all parts of the building are either multiples or fractions of the basic unit of measure. He also promoted the feeling of balance and proportion by making the height and width of the lower floor equal to that of the upper story. Spare of ornament, the only formal decorative element is in the Doric frieze with the regular triglyphs alternating with metopes that employ a shell motif.

Above all, Bramante wished to demonstrate the cohesiveness and compactness of the centralized plan under the unifying crown of a cupola. Later, when Pope Julius entrusted him with the design of the new St. Peter's, Bramante had his chance to build on a monumental scale. Here again he turned to antiquity for inspiration and is reputed to have declared: "I shall place the Pantheon on top of the Basilica of Constantine."

The humanists preferred purer versions of classical art forms to the adaptations that had been made in the thousand-year period between the fall of

Rome and their own time. The members of the Florentine humanistic circle learned to read and speak ancient Greek under native tutors. Ficino translated the dialogues of Plato, while Poliziano translated Homer from the original Greek into Italian and wrote essays in Latin on Greek poetic and musical theory. Other scholars catalogued and edited books for the Medici library, while Squarcialupi compiled the musical compositions of the preceding century.

The interest in cataloguing, editing, translating, and commenting was pursued with such enthusiasm that it all but blotted out the production of live literature. The Latin of Renaissance scholars was Ciceronian rather than medieval Latin, which they considered corrupt. The architects read Vitruvius and preferred central-type churches modeled on the Pantheon to the rectangular basilica form that had evolved over the centuries. They revived the classical orders and architectural proportions in a more authentic form. Decorative motifs were derived directly from ancient sarcophagi, reliefs, and carved gems. Sculptors reaffirmed the possibilities of the nude, and with Michelangelo it became the chief expressive vehicle of his art. Painters, lacking major models from antiquity, used mythological subjects and the literary descriptions of ancient works.

Musicians reinterpreted Greek musical thought, and some actually made attempts to put into practice the theories expounded by Euclid's musical essay. The Greek assertion that art imitates nature was universally acknowledged, but in architecture and music this had to be applied in the general sense of nature as an orderly and regular system conforming to mathematical proportions and laws. Josquin Desprez was hailed as a modern Orpheus who had regained the lost perfect art of the ancients though the Greeks would have been bewildered by his musical style. Josquin's less enthusiastic admirers pointed out that the trees and stones still showed some reluctance to follow him as they had not in the case of the original Orpheus. His art, however, like that of Michelangelo, was thought by the humanists to be a path back to a classical paradise.

Pagan versus Christian Ideals

Both Botticelli and Michelangelo set out to produce works in the classical spirit. The literary ancestry of Botticelli's *Allegory of Spring (Primavera)* and *Birth of Venus* (Figs. 245, 246) has been traced through the poetry of his contemporary Poliziano back to the Roman poets Lucretius and Horace. Their philosophical ancestor, however, is the Plato of the *Symposium*, which deals with the nature of love and beauty. Human beings, according to Plato's theory,

have drunk of the waters of oblivion and forgotten their divine origin. Falling in love with a beautiful person reminds them of their natural affinity for beauty. From physical attraction and fleeting loveliness, they are led to thoughts of the lasting beauty of truth and, finally, to the contemplation of the eternal verities of absolute beauty, truth, and goodness. Venus is, of course, the image of this transcendent beauty, and the way to approach it is through love. The eternal feminine, as Goethe was later to say in his *Faust*, draws us ever onward.

Michelangelo's Plato, however, was the Plato of the *Timaeus*, which dwells on the creation of the world, the spiritual nature of the human soul, and the return to God. Unlike Botticelli, who had a fragile dream of beauty, Michelangelo had a vigorous vision of the creative process itself. When Botticelli came under the influence of the fiery moralist Savonarola, with his resurgence of medievalism, he repented of his paganism and painted only religious pictures.

Botticelli never tried to combine paganism and Christianity as did Michelangelo, and for him they remained in separate compartments and on an either/or basis. Michelangelo, however, had the mind to assimilate Platonic abstractions, the overwhelming urge to express his ideas, and the technical equipment to translate them into dramatic visual form. But the voice of Savonarola spoke loudly to him, too, and in his rugged mind Michelangelo was destined to wrestle with the two essentially irreconcilable philosophies for the rest of his life. Leonardo da Vinci, by contrast, kept the religious themes of his painting and his scientific inquires in separate intellectual compartments.

Michelangelo's Madonnas reveal the unity between mortal beauty and eternal beauty; his Moses links human moral power with eternal goodness; and his organic compositions connect the truth of historical time with eternal truth. His triple divisions symbolizing the Platonic stages of the soul as it progresses from its bodily tomb to its liberation and reunion with God are a constantly recurring preoccupation. Even in the abstract architectural forms of St. Peter's this concern with the progress of the soul is apparent. The pilasters, like imprisoned columns, are the "slaves" held down by the weight of the heavy burden they must carry. Overhead soars the lofty dome in the geometrical perfection of the circular form, symbolizing the paradise that humanity has lost and must somehow regain. The whole building is thus conceived as an organic system of upward pressures and tensions, reaching its highest point in a cupola that ascends toward the divine realm and finally dissolves into the freedom of infinity.

THE NORTHERN RENAISSANCE

	KEY EVENTS	VISUAL ARTS	LITERATURE AND MUSIC
	1337-1453 Hundred Years' War between England and France	c.1324- 1327 Jean Pucelle active ▲ c.1370- 1426 Hubert van Eyck ▲	c.1328- 1384 John Wyclif + c.1340- 1400 Geoffrey Chaucer ♦
	1384 Philip of Burgundy acquired Flanders	c.1375-c.1425 Limbourg Brothers: Pol, Herman, and Jehanequin ▲	1369- 1415 John Huss +
		c.1378- 1444 Robert Campin (Master of Flemalle) ▲	1379- 1471 Thomas à Kempis + c.1390- 1453 John Dunstable □
		c.1379- 1406 Claus Sluter active ● c.1390- 1441 Jan van Eyck ▲	
1400 -	1414 Council of Constance began Church	c.1400- 1464 Roger van der Weyden ▲	1400-1474 Guillaume Dufay
	reform; declared Church councils as supreme authority, not pope; condemned John Huss as heretic	c.1405-c.1445 Conrad Witz ▲ c.1415- 1475 Dirk Bouts ▲	1427 Thomas à Kempis wrote Imitation of Christ c.1430- 1495 Johannes Ockeghem □
	1420-1436 Philip the Good of Burgundy made Bruges his capital	c.1420- 1481 Jean Fouquet ▲	c.1440- 1521 Josquin Desprez □ c.1446- 1506 Alexander Agricola □
	1429 Joan of Arc defeated English at Orleans; Charles VII crowned at Rheims	c.1435- 1498 Michael Pacher ▲ c.1440- 1482 Hugo van der Goes ▲	1450- 1505 Jacob Obrecht □ c.1450- 1517 Heinrich Isaac □
	1440 Gutenberg developed press with movable type; 1456 Gutenberg Bible printed	c.1440- 1494 Hans Memling ▲ c.1450- 1491 Martin Schongauer ▲	1466- 1536 Erasmus of Rotterdam + 1470 Varagine's Golden Legend (Lives of saints)
	1455-1485 Wars of Roses in England; 1485 Henry VII (Tudor) ascends throne	c.1450- 1516 Hieronymus Bosch ▲ c.1460- 1523 Gerard David ▲	first printed in Cologne 1473- 1543 Nicholas Copernicus ◆
	1474 Caxton printed first book in English	c.1460- 1531 Tilman Riemenschneider ●	1478- 1536 Thomas More ◆
	(Histories of Troy) at Bruges 1488 Diaz rounded Cape of Good Hope	c.1465- 1530 Quentin Metsys ▲	1483- 1546 Martin Luther + 1484- 1531 Ulrich Zwingli +
	1492 Columbus reached America	c.1465- 1524 Hans Holbein the	1489- 1556 Thomas Cranmer +
	1493-1519 Holy Roman Emperor Maximilian I	Elder ▲	1497- 1560 Philip Melanchthon +
	ruled; patron of Dürer	c.1470- 1528 Mathias Grünewald ▲	1500- 1553 François Rabelais ◆
	1498 Vasco da Gama voyaged to India	1471- 1528 Albrecht Dürer ▲	1509 Erasmus wrote In Praise of Folly
	1500-1700 Overseas empires created by Spain,	1472- 1553 Lucas Cranach the Elder ▲	1509- 1564 John Calvin +
	Portugal, Holland, England, and France	c.1480- 1538 Albrecht Altdorfer ▲	c.1510- 1585 Thomas Tallis □
	1517 Luther posted 95 Theses condemning Church practices	c.1485-c.1540 Jean Clouet ▲	1514- 1564 Andreas Vesalius ◆
	1519 Charles I of Spain elected emperor; until	c.1497- 1543 Hans Holbein the	c.1515- 1572 John Knox +
	1555 ruled Spain, Low Countries, Germany,	Younger ▲	c.1521- 1603 Philippe de Monte □
	Austria, Italy as Charles V	c.1508- 1575 Pieter Aertsen ▲	c.1522- 1599 Edmund Spenser ◆
	1519-1522 Magellan's expedition circumnavi-	c.1510-c.1565 Jean Goujon ●	1521- 1531 Luther translated Bible into German
	gates globe 1521 Diet of Worms ; Luther refuses to retract	c.1527- 1569 Pieter Bruegel the	c.1532- 1594 Orland Lassus □
	teachings, declared outlaw by Charles V's	Elder▲	1533- 1592 Montaigne ◆
	Council. Luther excommunicated by Pope Leo X, burns papal bull, translates new Testament into German	c.1535- 1590 Germain Pilon ●	1536 John Calvin published <i>Institutes of Christian Religion</i> ; founded Protestant church at Geneva 1541
	1524-1525 Peasants' revolts in Germany		1543-c.1622 William Byrd □
	1534 Church of England founded under Henry VIII		1543 Copernicus published <i>On the Revolution of the Celestial Bodies.</i> Vesalius wrote <i>Structure of the Human Body</i>
	1545-1563 Council of Trent called to reform		1546- 1601 Tycho Brahe ◆
1550	begun; Inquisition established to try and condemn heretics		1549 Cranmer compiled first book of Common Prayer, revised 1552
	1555 Diet of Augsburg convened by Charles V;		1554- 1586 Philip Sidney ◆
	ordered Protestants to state beliefs; Augsburg Confession became Lutheran creed; each ruler		c.1557-c.1622 Thomas Morley □
	could decide faith of his people		1561- 1626 Francis Bacon ♦
	1555 Charles V abdicates; son Philip II ruled Spain, Low Countries, Mexico, Peru; brother		1561 John Knox's Book of Discipline established church constitution for Scotland
	Ferdinand ruled Austria, the Germanies		c.1562-1638 Francis Pilkington □
	1572 Dutch war of liberation begun. 1576		c.1563- 1626 John Dowland
	Provinces of Netherlands united		1564-1593 Christopher Marlowe ♦ 1564-1616 William Shakespeare ♦
	1572 St. Bartholomew Day Massacre of Huguenots (French-Calvinists)		c.1565- 1640 Giles Farnaby □
	1577-1580 Drake sailed around world		1567- 1620 Thomas Campion □
	1583 William of Orange became ruler of		1571- 1630 Johannes Kepler ◆
	northern Netherlands		1572- 1637 Ben Jonson ◆
	1588 Spanish Armada defeated by British		1583- 1625 Orlando Gibbons □
	1598 Edict of Nantes gave Huguenots freedom of		1594- 1613 Shakespeare wrote plays
	conscience, private worship, and civil rights 1603 Elizabeth I succeeded by James I		1604 Francis Bacon published Advancement of Learning
			1611 Bible appears in King James Version

12

Northern Renaissance Styles

THE NORTHERN SCENE

The Renaissance developed more gradually and diffusely in the northern countries than in the South. There were no sudden outbursts of creative energy and clear-cut manifestations of a new style, as there had been in Florence. Nor did the North have the revival of classical antiquity for a catalytic agent, as Italy did. Renaissance thought and action in the North was essentially a maturation and selection of ideas present in the late Middle Ages. Most particularly it was the trend toward an increased awareness of the natural environment, an acute observation of the visible world, and a fascination with what the human eye could see, the mind comprehend, and the human heart feel.

The geographic scene was also widely diffused. No convenient centers of convergence such as Florence, Rome, and Venice can be cited. And the countries-Germany, France, England, and the Lowlands—were far from being the centralized nations one knows today. Germany was such a loose collection of principalities, duchies, bishoprics, and citystates that it can only be referred to in the plural: the Germanies. The one overall political authority recognized by these localities was that of the Holy Roman Emperor, whose principal duty was to defend their territorial integrity and to settle disputes between them. The French kings at this time were weakened by wars and the power of the feudal duchies, particularly that of Burgundy. In England the Hundred Years' War, fought on French soil, had

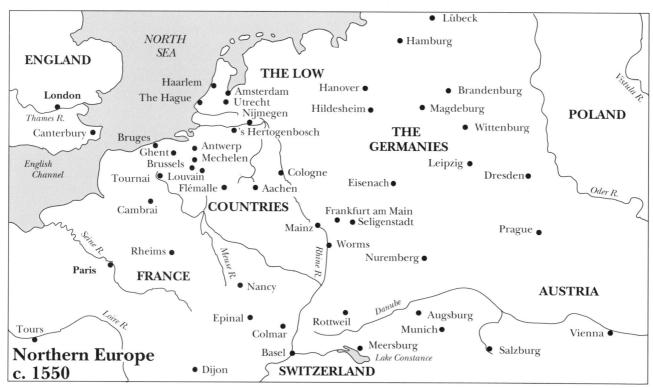

taken its toll—as had the domestic Wars of the Roses, in which the royal house of York was overthrown. The Tudors emerged as victors and the astute, wily Henry VII began to lay the foundations of the modern British state.

The area covered by modern Belgium, Holland, and Luxembourg must be referred to at this period as the Low Countries. At the beginning of the 15th century Philip the Good, Duke of Burgundy, by fortuitous circumstances and political skill brought under his rule the counties of Flanders and Artois; the duchies of Brabant, Limburg, and Luxembourg; and the counties of Hainaut, Holland, Zeeland, and Friesland. Much local autonomy still prevailed, but there were some centralizing institutions and a legal system. Since Philip established his court and capital in Flanders, the term Flemish came into common usage as describing all the peoples of the Low Countries, including the schools of painters and musicians for which the region was so famous. In the early 16th century, by a combination of dynastic marriages and territorial consolidations, the Low Countries came under the dominion of the formidable Emperor Charles V, who was also the king of Spain, lord of the Spanish overseas empire, ruler of Germany and Austria, and conqueror of Italy.

Northern artists and composers lived in a restless age. As journeymen seeking commissions, they traveled all over Europe. The Flemish painter Jan van Eyck was active at the courts of both John of Holland and Philip of Burgundy. The German artist Albrecht Dürer's home was in Nuremberg, but he traveled extensively in Italy and the Low Countries. His countryman Hans Holbein the Younger, who was born in Augsburg, made his career in Switzerland and at the court of Henry VIII in England. John Dowland, the English lutenist and foremost songwriter of his time, worked mainly in London, but he traveled widely in Italy and Germany and held posts at the courts of the Duke of Brunswick and the King of Denmark. The great Flemish-born composer Orland Lassus was the complete cosmopolitan, active in Sicily, Naples, Rome, and Antwerp before settling at the ducal court at Bavaria.

Commercial Revolution

The importance and prosperity of the Low Countries stood on two main pillars. First came the flourishing textile trade, evidenced by the fine wool and linen cloth that was sent all over Europe. On a more limited and luxurious level, the region was also renowned for its tapestries, lace, rugs, cloth of gold, and costly glazed pottery and dishes. Next, its seaand riverports were the busy scenes of shipping as

well as bartering for goods from all over the known world. With the rapid growth of the northern cities the commercial center of gravity was gradually shifting from the Mediterranean ports of Venice, Genoa, Marseilles, and Barcelona to those of the North Sea. Dutch merchant ships, for instance, carried their cargoes south to Lisbon, where they picked up Portuguese imports of spices and goods from India and Africa and transported them north. The cities of Bruges, Antwerp, and Cologne were the main marketplaces for the exchange of goods and became the principal financial centers of northern Europe. The accumulation of wealth by the merchant class was accompanied by a corresponding decline in the importance of land ownership as the primary source of wealth. The land continued to produce the food supply and raw materials, but the commercial revolution favored the merchants. The large fortunes amassed by some families gave them both increasing political importance and the means to become patrons of the arts.

In his portrait of Georg Gisze, a German merchant at work in his London office, Hans Holbein the Younger caught the spirit of the commercial revolution that brought the new middle class into such prominence (Fig. 271). An amazing amount of information is communicated in the various written memos. The letter that is being opened is addressed: "For the hands of the worthy Georg Gisze, my brother, at London in England." From the sheet of paper at the top of the wall it is learned that the subject is thirty-four years old and the date is 1532. The Latin motto painted on the wall over the signature of the sitter contributes a philosophical note: "No pleasure without pain."

The painterly eye of the artist obviously delighted in the rich variety of textures. He dwells lovingly on the contrast of the black cap and the locks of light hair, the rich folds of the red silk sleeves, the pattern of the tablecloth, the woods of the wall and shelves, and all the objects of daily use that surround the subject. The shapely Venetian glass vase with carnations, the parchment-bound account book, the metal scales, the feather pens, the open change box, and all the other minute details are delineated with extraordinary clarity and dexterity.

Expanding Horizons

In the northern universities scientists and humanistic scholars were much more free in their inquiries and speculations than their counterparts in Italy and Spain, where the Church imposed closer controls. The beginnings of scientific geography, for instance, received great impetus from the expansion of north-

ern commerce, the opening of new trade routes to far-off places and particularly from the discoveries of the great navigators. Observing the winds and sea currents, mapping shorelines and landmarks, studying the stars and developing mathematics, and in-

venting mariners' instruments were all related to a vastly expanding view of the world. The spread of such learning by means of new printing presses that sprang up in southern Germany, Bruges, Amsterdam, and London became one of the crowning

271. Hans Holbein the Younger. *Georg Gisze, Merchant.* 1532. Oil on wood, $37\frac{3}{4} \times 33''$ (95.88 \times 83.82 cm). Gemäldegalerie, Staatliche Museen, Berlin.

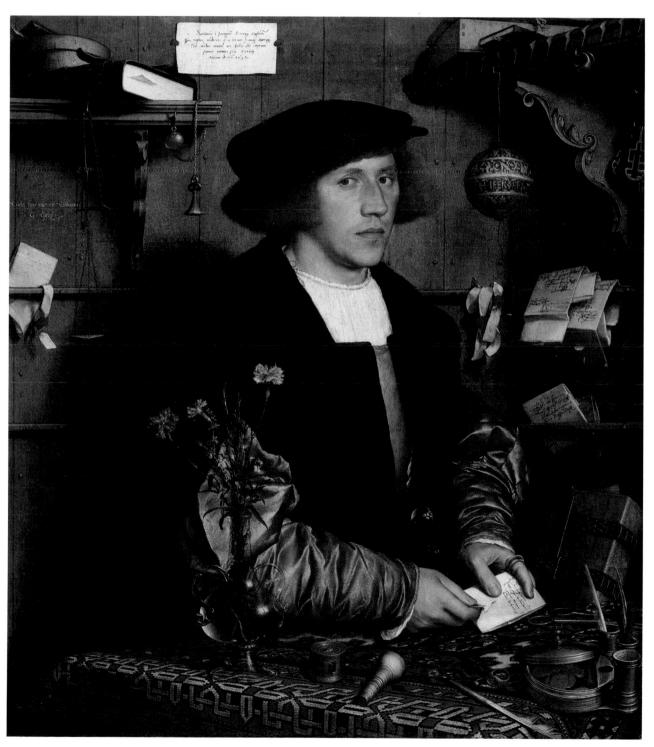

achievements of the Northern Renaissance. The production of books soon became an industry. To cite just a few examples, there was the printing of Gutenberg's beautiful Bible about 1456. The English printer John Caxton published the first book in English at Bruges in 1474. The Flemish scientist Vesalius revolutionized the study of anatomy in 1543 with his book *On the Structure of the Human Body*. In the same year the astronomer Copernicus turned the world upside down and inside out by showing in his book on the *Revolution of the Celestial Bodies* that the earth was but one planet revolving around the sun instead of vice versa.

The Northern Renaissance took place in turbulent times. The movement was partly a declaration of cultural independence from the long dominance of the Mediterranean South that had begun in Greco-Roman times and continued through the Middle Ages with the power of the Church of Rome. In the commercial field it meant wresting control of shipping and trade from the southern ports. Socially there were the tensions between the growing towns and the feudal landholding nobles. In political life there was the struggle between the international outlook of the Church of Rome (and its secular arm, the Holy Roman Empire) and the rising tide of national movements in the Low Countries and England. In religion there was the split in the 16th century between the various protestant movements in Germany, the Low Countries, and England and those loyal to Rome. Whether in spite of or because of all these tensions and conflicts, the arts flourished as seldom before. The Flemish and German painters Jan van Eyck, Hugo van der Goes, and Albrecht Dürer and the Flemish composers Guillaume Dufay, Josquin Desprez, and Orland Lassus became powerful influences all over Europe, including France, Italy, and Spain.

Architecture continued to develop along late Gothic lines with none of the striking innovations associated with the Italian Renaissance. Painting flourished in a unique way with acute and accurate observations of nature. Except in the case of Dürer, there were few traces of southern classicism. The important technical breakthrough of painting in the oil medium, however, swept all before it. Productivity in literature, except in England, was more restricted. The struggle between the reformers and Roman Catholics led to tight censorship under the Spaniards and Holy Roman emperors. Humanistic learning with a particularly northern character, however, continued unabated. In music the Flemish composers were the acknowledged leaders throughout Europe.

ART IN THE NORTH

When Philip the Bold, Duke of Burgundy, founded a Carthusian monastery outside his capital city of Dijon, he summoned skilled craftsmen from all over Europe. Among them was Claus Sluter from Haarlem in Holland, who was destined to bring the carver's art to new heights of expression. His works include a group of lifesize figures surrounding a well in the middle of a courtyard (Fig. 272). This so-called Well of Moses consists of a group of Old Testament prophets who carry scrolls that foretell the Passion of Christ. The carving reveals an extraordinary feeling for naturalistic detail, and the voluminous deep-cut

272.CLAUS SLUTER. "Well of Moses." Detail: Zechariah and Daniel. 1395–1403. Height 10'6" (3.2 m), height of figures c. 6' (1.83 m). Chartreuse de Champmol, Dijon, France.

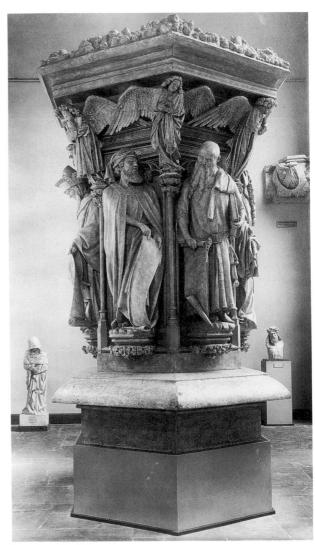

drapery creates a rhythm of curved lines that seem to activate the space that surrounds them. The prophets' grave, expressive faces are almost speaking likenesses of living persons. When originally painted in lifelike colors (one of them had actual goldframed eyeglasses), they must have created an overwhelming impression. Sluter's style stems from the late Gothic, but the monumentality and grandeur of his work sets him apart as a figure comparable to Donatello (see Figs. 233–235). His work was known throughout the Low Countries, and his influence on painting was as profound as it was on sculpture.

Flanders

JAN VAN EYCK. The art of Jan van Eyck "challenges nature itself," according to the painter father of Raphael, Giovanni Sanzio. That judgment has been confirmed by history, as Jan's art is truly a mir-

ror of the visible world. His fame rests securely on his painterly sensitivity to color, his jeweler's eye for precision, his exquisite description of the minutest detail, and his technical innovations in the oil medium. He was fortunate in enjoying the patronage and friendship of the Burgundian Duke Philip the Good, for whom he executed delicate diplomatic missions as well as painting commissions; the wealthy Jodoc Vyt, who sponsored the Ghent altarpiece; and the Medici representative in Bruges, whose marriage portrait he painted.

The acknowledged masterpiece of Flemish art is the magnificent altarpiece by Hubert and Jan van Eyck at the Cathedral of St. Bavo in Ghent (Fig. 273). The genesis of the work is still a matter of scholarly controversy, but the evidence seems to point to Hubert as the sculptor of the sumptuous Gothic tabernacle that once surrounded it, while Jan painted the twenty panels. Hubert's framework was

273. Hubert and Jan van Eyck. *Ghent Altarpiece* (open), "Adoration of the Lamb," detail. Completed 1432. Oil on wood, c. $11' \times 15'1''$ (3.35 \times 4.6 m). Cathedral of St. Bavo, Ghent.

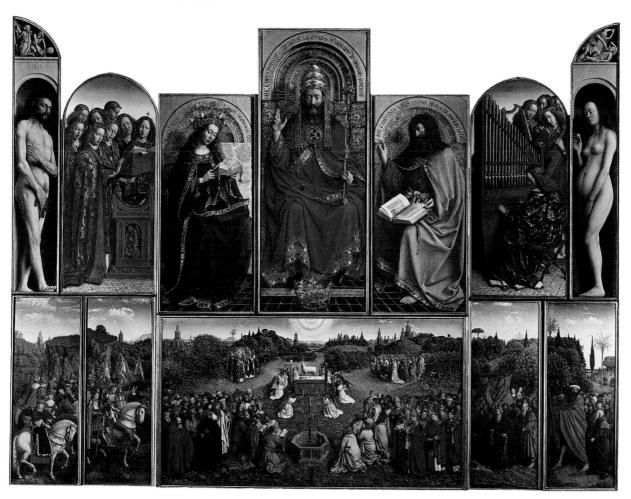

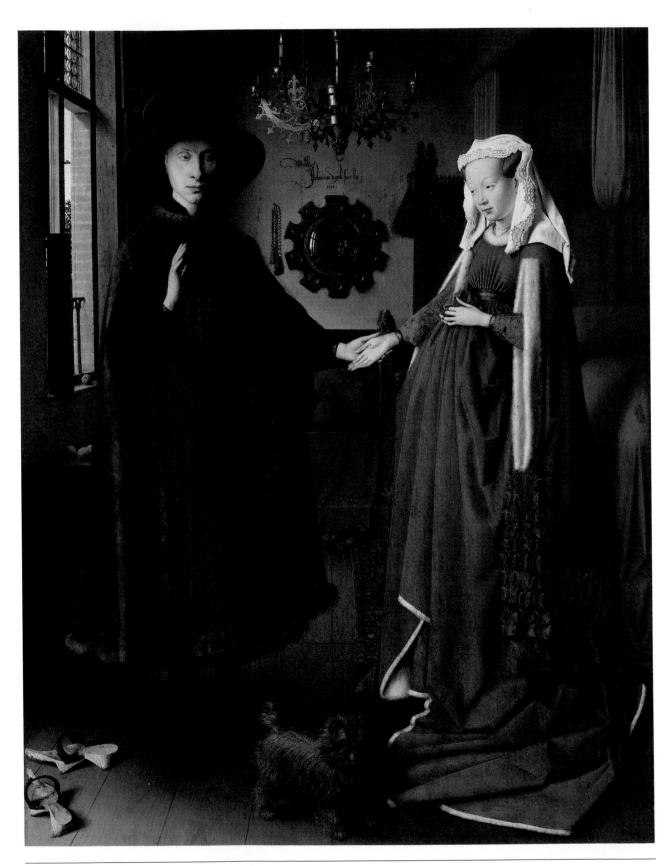

274. Jan van Eyck. *Marriage of Giovanni Arnolfini and Giovanna Cenami*. 1434. Oil on wood, $33 \times 22\frac{17}{2}$ " (84 × 57 cm). National Gallery, London (reproduced by courtesy of the Trustees).

demolished in the religious strife of the latter part of the 16th century. Forewarned, the clergy hid the painted panels, which have survived. Shorn of its frame, the work still stands in its original place, the memorial chapel sponsored by its donor, Jodoc Vyt. The form is that of a multipanel *polyptych* with hinged panels that open and close like the pages of a book. The glowing luminosity and technical brilliance of the painting is undiminished by time.

When the great altarpiece is open, a rainbow of radiant hues greets the viewer's eye with the "Adoration of the Lamb" in the lower middle section (Fig. 273). The grandeur of the conception and the majesty of the forms are overwhelming. The overall theme is the union of God and humanity as in the apocalyptic vision of St. John: "Behold, the tabernacle of God is with men, and he will dwell with them, and they shall be his people . . . " (Rev. 21:3). The upper level is on the heavenly plane, while the lower represents the new Jerusalem of the book of Revelation. The dominating figure above is that of God the Father in the guise of Christ. Robed in rich scarlet with gold trim and sparkling jewels, he wears the triple tiara telling of his Trinitarian nature and his dominion over heaven, earth, and the underworld. At his feet is a golden crown signifying that he is lord of lords and king of kings. The Virgin Mary is enthroned at his right, clothed in bright blue with a crown of twelve stars from which spring lilies and roses, symbols of purity and love. John the Baptist is at his left with an emerald-green cloak over his camelhair undergarment. Spreading outward on both sides are choirs of angels in brocaded velvet gowns, singing and playing the organ, harp, and other instruments. It is unusual to find Adam and Eve on the heavenly level, but here, splendidly modeled, they represent redeemed humanity and God's love for mankind.

On the central axis, reading downward from God the Father, is the dove of the Holy Spirit in the sky below; then the Lamb on the altar, connoting the redeeming sacrifice of Jesus, completes the Trinity. Then come the Fountain of Living Waters and the stream that flows through the green, flower-bedecked meadow. "And I John saw the holy city, new Jerusalem, coming down from God out of heaven . . ." (Rev. 21:2). And the angel showed me "a pure river of water of life, clear as crystal, proceeding out of the throne of God and of the Lamb" (Rev. 22:1).

From the four corners of the earth come the faithful, moving toward the altar of the Lamb. In the side panels are the delegations symbolizing the four cardinal virtues—the judges for Justice: the knights on horseback, Fortitude; the pilgrims, Prudence; the

hermits, Temperance. Around the Fountain of Life on the left are the kneeling apostles and a group of red-robed martyrs, on the right the evangelists with their gospel books and a group of prophets. The holy virgins come from the right background, the holy confessors from the left, while a chorus of angels encircles the altar. Taken as a whole, Jan van Eyck's realization of the new Jerusalem is the summation of Christian aspirations and one of the miracles of art.

Van Eyck's *Marriage of Giovanni Arnolfini and Giovanna Cenami* (Fig. 274) is a reminder of the close ties between North and South. The shrewd and calculating Arnolfini, the Bruges agent of the Medici of Florence, was active in business and banking circles. He had risen to the rank of counselor to the Duke of Burgundy, who was also Van Eyck's patron. Both he and his bride were from the Tuscan town of Lucca. The picture is a record of their marriage vows. Before the Council of Trent made it one of the seven sacraments, marriage could be contracted in private by joining hands and pledging faith. The artist himself was a witness, as his beautifully lettered signature on the wall testifies: *Jan de Eyck fuit hic. 1434* (Jan van Eyck has been here, 1434).

At first glance the picture seems to be a straightforward double portrait of almost photographic realism. The meticulous rendering of every detail; the deft handling of perspective; the contrasting textures of cloth, wood, fur, metal are all handled with naturalistic precision. Above all, the warm light coming from the open window accents the faces and hands of the subjects, the black velvet and apple-green of their fashionable Burgundian costumes, the polished brass candelabrum and the mirror. It then gradually fades into the shadowy background. Van Eyck seems to draw the spectator right into the room by the device of the convex mirror that reflects the backs of the figures, two witnesses (one perhaps a self-portrait of the artist), and the doorway and wall behind that complete the intimacy of the cubically enclosed space.

Beyond this surface play, however, is an intricate and intriguing program of symbolism where nothing is as it first seems. The dog, for instance, stands for fidelity (fides in Latin, hence the popular name Fido). The apples refer to Adam and Eve in the Garden of Eden, the fall of man, and original sin. The ten miniature scenes surrounding the mirror tell of Christ's Passion, his death, and human salvation. The whisk broom represents domestic care. The statuette above the chair at the back is of Margaret, patron saint of child-bearing women—note that Giovanna's left hand is over her womb. The single lighted candle signifies the all-seeing eye of God, the light of the world.

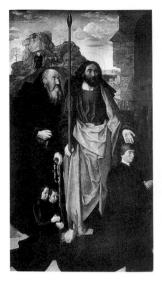

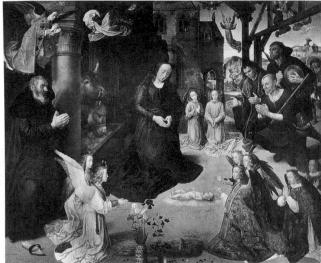

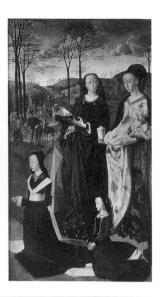

275. Hugo van der Goes. *Portinari Altarpiece*. c. 1476. Oil on wood, $9'2\frac{1}{2}'' \times 21'8\frac{1}{2}''$ (2.81 × 6.62 m). Galleria degli Uffizi, Florence.

Hugo van der Goes. In the latter half of the 15th century Tommaso Portinari, another Medici representative in Bruges and a shipowner, commissioned an altarpiece for the Portinari Chapel in St. Egidio, Florence. Hugo van der Goes, the artistic heir of Van Eyck, painted it in the form of a three-paneled triptych (Fig. 275). In the left wing he portrays the donor and his two sons kneeling and praying. Over them loom the large-scale figures of their patron saints, Anthony and Thomas, in melancholy and brooding attitudes. On the right side in similar postures are his wife and daughter with their saints, Margaret and Mary Magdelene.

The central panel depicts the adoration of the shepherds. As with Van Eyck, there is the same close observation of naturalistic detail—from the weatherbeaten faces of the shepherds to the rich brocaded cloth of the angels' robes. The artist, however, allows himself some spatial discrepancies to achieve dramatic effect: the floor tips slightly upward to project the figures forward; the figures in relation to the picture plane, with Joseph, Mary, and the shepherds in the middle ground, loom larger than the angels in the foreground.

With Hugo too every detail has symbolic significance. The building behind Mary is the palace of David, identified by the harp carved in the tympanum over the doorway, thus referring to Mary and Jesus stemming from the house of David. The presence of spring flowers in the dead of winter casts a miraculous atmosphere over the event. The sheaf of wheat alludes to Bethlehem, which means "house of bread" in Hebrew. The reference is also to the

bread of the Eucharist, while the jar refers to the wine. The white lilies symbolize Mary's purity, the red refer to blood and suffering, and the irises ("swordflowers" in northern parlance) point to the pierced heart of the Madonna as the mother of sorrows. A psychological intensity characterizes the picture as a whole, but the joyousness of Christ's birth is overshadowed by a sense of foreboding in that it foreshadows his coming sacrifice on the cross.

HIERONYMUS BOSCH. Hieronymus Bosch took his name from the last syllable of S'Hertogenbosch, the Flemish town where he was born and worked all of his life. His was a time of social tension and religious unrest, a period that still believed in witchcraft, sorcery, the pseudoscience of alchemy, and the coming of the Antichrist. Unlike Jan van Eyck's, Bosch's art does not hold up a mirror to nature but a mirror to man. It is a reflection not of the visible world but of the invisible realm of subconscious desires and drives that motivate human behavior. For the sources of his bizarre imagery scholars have ransacked the Bible; lives of the saints as told in Varagine's Golden Legend; bestiaries, mystery plays, and writings of the mystics; Flemish proverbs and folklore; books on alchemy; drawings in manuscripts; the fiery blood-and-thunder sermons and moralistic tracts of his time. Any interpretation of his work must be many-sided and multilayered. His pictures have been read as pre-Freudian psychoanalytic dreams, as premonitions of surrealism and fantastic art, as satiric commentaries on the vanities and follies of his time, as mysteries inside enigmas. They

can also be enjoyed just as images that delight the eye and challenge the imagination.

In the triptych Garden of Earthly Delights (Fig. 276) the viewer enters a world of magic and mystery conjured up by Bosch's inexhaustible imaginative invention. When the wings are closed, one sees a giant sphere enclosing the world as it was on the third day of creation, when the dry land had been divided from the waters and the earth had brought forth grass, herbs, and trees. The colors are neutral grays and greens. In the upper left-hand corner God is seen uttering the words: "For he spake and it was done" (Ps. 33:9). When the triptych is open, the spectator beholds a bright-colored vision—a phantasmagoria of fascinating forms. In the left panel God has created Eve and brings her to the awakening Adam with the words "Be fruitful, and multiply, and replenish the earth" (Gen. 1:28). Around them is a Noah's ark of animals, some natural, others fabulous A spiraling flock of blackbirds flies out of a strange hollow rock; a dragon fights with a wild boar. The Fountain of Life, shaped like an intricately carved tabernacle, yields its waters while a wise owl peers out from the pupil of the eye below. Nearby is a palm tree encircled by a serpent.

In the center panel is the garden of love that gives the triptych its name. God's command to

Adam and Eve for fruitfulness and multiplication has been abundantly realized. Nude young men and women disport themselves in the crystal-clear light, making love with gay abandon in the alluring pastel-tinted spring landscape. They eat luscious fruits and gigantic strawberries such as might have existed at the beginning of the world. In the center, as on a carousel, male riders, mounted on exotic animals, circle a pool filled with maidens who await their amorous advances. Strange, hornlike rock structures are silhouetted against the sky. Crustaceans, birds, and fish of normal and monstrous size abound. Curiously enough, there are no children.

A grim and awesome day of reckoning is discovered in the right panel, depicting Hell, where the lush dreams have now become nightmares. Here all nature is dead, and the spectral barkless trees accent the lifeless atmosphere. Below are the objects of sin—dice, cards, a backgammon board, a brothel scene, a drunken brawl. Above are enormous musical instruments, an allusion to the seductive power of music and the dance, but here they have become objects of torture. One naked soul is tied to a lute, another is enmeshed in the strings of a harp, still another is crammed into the bell of a large horn. Terrifying is the image of a man with an egg-shaped torso with decaying tree trunks for legs and boats for shoes. On

276. Hieronymus Bosch. Garden of Earthly Delights (open). c. 1500. Oil on wood, $86\frac{5}{8} \times 76\frac{3}{4}$ " (2.2 × 1.95 m) center, $86\frac{5}{8} \times 38\frac{1}{4}$ " (2.2 × .97 m) each wing. Museo del Prado, Madrid.

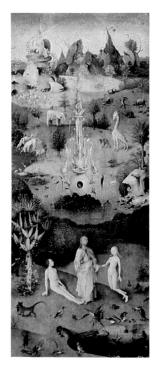

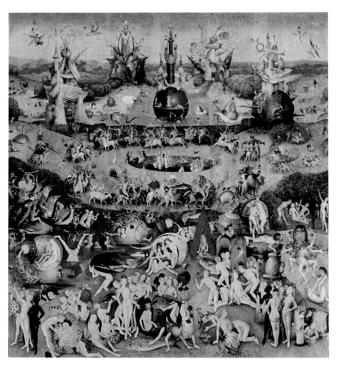

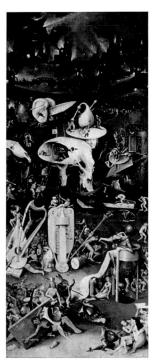

his head is a bagpipe, an obvious sexual symbol. Horrors are myriad. Note the devil on the far right making a pact with a man who is goaded on by a monster whose legs are attached to his helmet and the man tempted by a sow clothed in a nun's veil. Above are two huge ears pierced by a lance with a projecting knife blade.

Though its format recalls that of a church altarpiece, the picture was obviously intended for a sophisticated lay patron, much as Botticelli's pagan classical allegories were in Florence (Figs. 245 and 246). Philip II of Spain was one of Bosch's greatest admirers, and in 1593 this work was added to the royal collection.

What is the meaning of it all? No one key can unlock the door to complete understanding. Bosch's *Haywain* is a similar but far less complicated picture. Like the *Garden*, it is flanked by Paradise and Hell, and the key in this case lies in an old Flemish proverb: "The world is a heap of hay, and everyone takes from it what he can grab." So it is an allegory of

human greed and the deadly sin of Avarice. Bosch's Garden, then, can be read as an allegory of human folly and the deadly sin of Lust. From the innocence of Paradise on the left, humanity passes through the Garden of Delights on its way to the fire and brimstone of Hell. Men and women are seen as the victims of their carnal desires, heedless of the word of the Lord. It is a kind of Last Judgment. But in Bosch's pessimistic worldview there are no virtues, only vices; no saved, only damned. Thus one beholds a world of dreams and nightmares, surrendering to the mystery of the puzzle, wondering at the tangled thicket of metaphors and images, reveling in the brilliant colors, shuddering at the horrors of Hell, and above all admiring the inventive fantasy of forms and images.

PIETER BRUEGEL THE ELDER. Pieter Bruegel the Elder was the heir to Bosch's style, and many of his early paintings were directly inspired by the older master. Bruegel's main fame, however, rests solidly

277. PIETER BRUEGHEL THE ELDER. Peasant Wedding Feast. c. 1567. Oil on wood, $3'8_8^{7''} \times 5'4_8^{1''}$ (1.14 × 1.63 m). Kunsthistoriches Museum, Vienna.

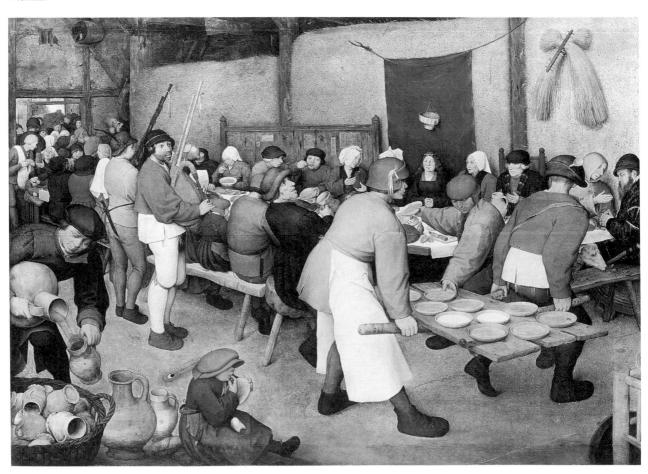

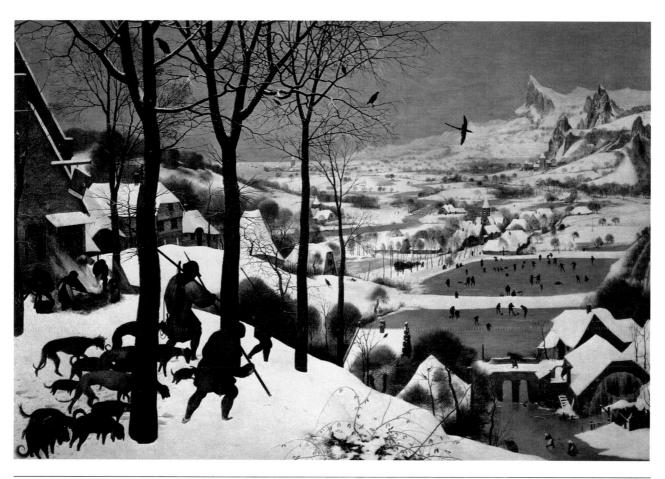

278. PIETER BRUEGHEL THE ELDER. *Hunters in the Snow.* 1565. Oil and tempera on panel, c. $46\frac{1}{8} \times 63\frac{1}{4}$ " (1.17 × 1.6 m). Kunsthistoriches Museum, Vienna.

on the vivid scenes of rustic life that gave him his nickname, "Peasant Bruegel." Far from a peasant himself, he was a well-educated prosperous painter who was welcome at the imperial court and who numbered the cardinal-archbishop of Malines among his many patrons. His pictures depicting the pleasures and activities of the farming people helped establish genre scenes as an important category of painting, one that carried over into the Dutch School of the 17th century.

The *Peasant Wedding Feast* (Fig. 277) is set in a hay-stacked barn. The bride sits on the right under a paper crown against an improvised cloth of honor that is hung from a rope and fastened on the left by a pitchfork stuck in the hay. Grooms at such Flemish weddings were less important, and this bridegroom could be the figure stuffing himself in the center background. More likely he is the seated young man at the end of the table serving bowls of cereal from the unhinged door that serves as a tray. It was the custom at the time for the groom to wait on the bride's family on such occasions. The entertainers are playing the bagpipes, the typical peasant instru-

ment. Note the unforgettable expression of the one who is looking at the food with hungry eyes. At the far right the bearded man in the black costume with a sword at his side has been identified as a self-portrait of the artist, based on resemblance to an earlier engraving. The crowded scene with its deep diagonal accent captures all the sturdy, stolid, and earthy qualities of people who live close to the soil.

Peasant life, however, was only one aspect of Bruegel's complex painterly personality. He also devoted much attention to intricately constructed landscapes such as the *Hunters in the Snow* (Fig. 278), one of a projected series depicting the months. The bleak open spaces are enlivened by the interplay of sporting activities, with the tired hunters and their dogs in the foreground and skaters on the frozen ponds in the background. In addition, Bruegel painted penetrating religious and moral allegories such as the *Fall of the Rebel Angels*, the *Deadly Sins*, and the grim *Triumph of Death*, as well as fantastic scenes dwelling on human folly such as *The Blind Leading the Blind*. He also pioneered the field of printmaking with many etchings and engravings.

The Germanies

Meanwhile, in southern Germany there were painters of great originality, imaginative invention, and strong individual character who rose above their isolated city cultures to command international acclaim. Among them were Albrecht Dürer from Nuremberg; Matthias Grünewald, who was active in Mainz and other centers; and Hans Holbein the Younger, who worked in Switzerland and England.

ALBRECHT DÜRER. Many German artists were attracted to the twin centers of Bruges and Ghent, but Dürer blazed the trail over the Alps into Italy and became the mediator and arbiter of the classical Renaissance South in the northern countries. His enormous productivity after his return from Italy is reflected in the woodcuts and engravings that poured prolifically from his own presses and led him to international fame.

Dürer's *Self-Portrait* (Fig. 279) bears the legend *I made this according to my appearance when I was 26*. The long curly hair and elegant costume are accents of visual enrichment, while the serious, searching

expression provides a thoughtful note. He divides the pictorial space so that he is shown against a closed background on one side, while the other opens out into a landscape with menacing mountains that loom over a Germany that was facing a tortured century of peasant wars, internal dissents, and religious reformation. Here Dürer reveals himself not only as a confident young master but also as a thinker.

Dürer's lifelong preoccupation with the accurate rendering of nature is seen in his *Madonna and Child with a Multitude of Animals* (Fig. 280). His beasts show no affinity with medieval bestiaries but are true-to-life animals from field and forest. Dürer's lambs leap and graze, his foxes stalk their prey, his birds take wing. Such minute and accurate observations were gained not only from his eager eye but also from the long and hard study of essays on geological formations, the structure of plants, and the anatomy of animals and birds.

Dürer's mature masterpiece *Four Apostles* (Fig. 281) is a visual manifesto of the Reformation. The artist revered Luther as "that Christian man who has helped me out of great anxieties." Several quota-

279. Albrecht Dürer. *Self-Portrait.* 1498. Oil on wood, $20\frac{1}{2} \times 16\frac{1}{8}$ " (52 × 41 cm). Museo del Prado, Madrid.

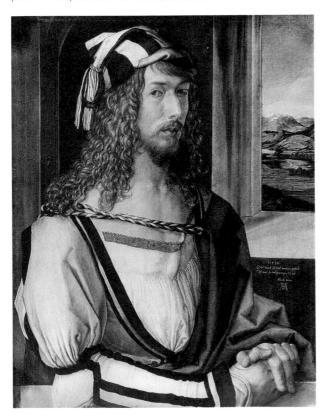

280.

Albrecht Dürer. *Madonna and Child with a Multitude of Animals*. c. 1503. Pen and ink with watercolor, $12\frac{5}{8} \times 9\frac{5}{8}$ " (32 × 24 cm). Graphische Sammlung Albertina, Vienna.

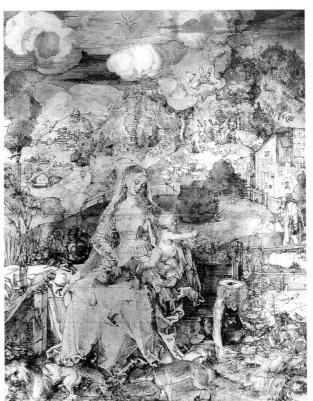

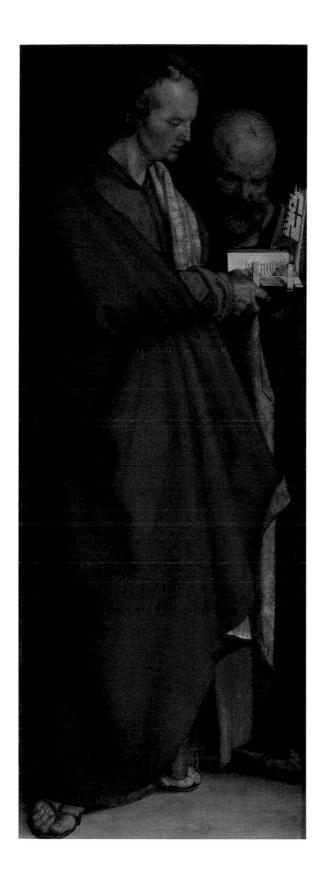

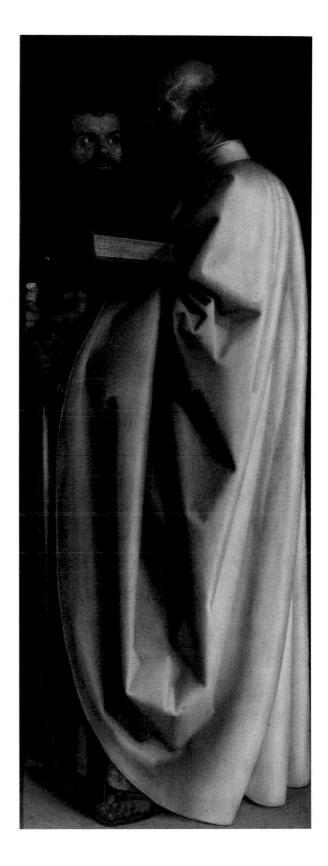

281. ALBRECHT Dürer. Four Apostles. 1526. Oil on wood, 2 panels, each $85 \times 30''$ (2.16 \times .76 m). Alte Pinakothek, Munich.

tions from Luther's German translation of the New Testament are found beneath the figures. When the governing board of Nuremberg had resolved the religious crisis by adopting Lutheranism, Dürer presented the two panels to be hung in the city hall as his legacy to his native town and as a memorial to himself.

Dürer once told Melanchthon, the Protestant humanist and close associate of Luther: "When I was young I craved variety and novelty; now, in my advanced years, I have come to see . . . that simplicity is the ultimate goal of art." All extraneous detail and superfluous ornamentation are eliminated so that the individuality and integrity of the characters can shine through with utmost clarity and complete conviction.

The over-life-size figures represent John the Evangelist and St. Peter on the left, with Mark and Paul on the right. St. John was Luther's favorite evangelist, and St. Paul was the spiritual father of the whole Protestant movement, so much so that the Catholic theologians referred to the reformationists as the Paulines. Peter with his keys to the Kingdom, the oldest of the apostles, is still present though now in the background.

The perfectly balanced composition is replete with naturalistic detail down to the stitches and layers of leather in the sandals. But far more important is the powerful psychological portrayal of these religious leaders. Dürer's friend, colleague, and early biographer noted that the four apostles stand for the four temperaments. The ruddy-complected St. John

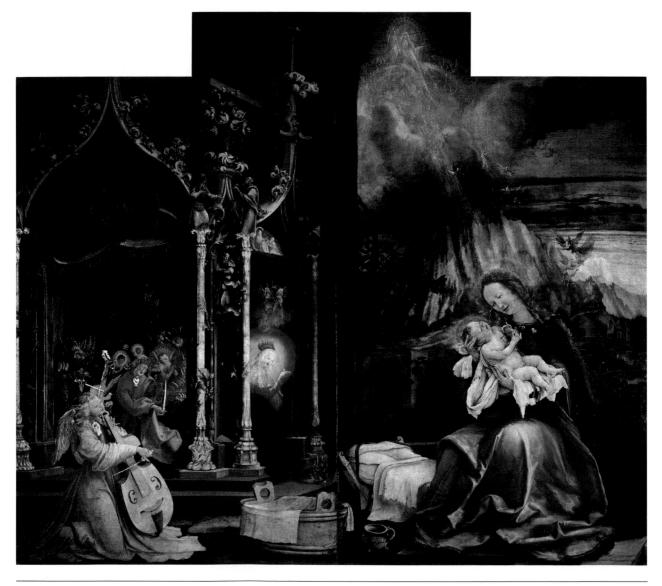

282. MATTHIAS GRÜNEWALD. *Nativity*, center panel, front opening of *Isenheim Altarpiece*. Completed 1515. Oil on wood, $8'9_8^{7''} \times 10'_8^{7''} \times 10'_$

in his glowing red robe is the warm, outgoing *sanguine* type. The white-robed St. Paul, with his symbolic sword as soldier of Christ, stands as his opposite number in the psychological as well as in the pictorial sense. He represents the *melancholic* side with his piercing hypnotic eye and stern unyielding demeanor. The bowed head and downcast eyes of Peter and his withdrawn and resigned attitude bespeak the *phlegmatic* character. St. Mark, with his rolling eyes and fiery visionary look, represents the *choleric* temperament. Together they constitute the four basic aspects of religious experience, and the picture itself becomes a monument to Reformation thought.

MATTHIAS GRÜNEWALD. Matthias Grünewald's celebrated *Isenheim Altarpiece* (Figs. 282, 283) was painted for the monks of St. Anthony, a religious order that maintained hospitals for the needy, sick, and poor. The work consists of a cycle of scenes painted on the front and back of two sets of folding

panels, with immovable side wings, paired one behind the other. This intricate form shows a likeness to the northern art of the book, opening leaf after leaf to allow the stories of the Christian calendar to pass by in review. Earthly, heavenly, and infernal beings alike are present to worship, to witness, to horrify, and to tempt. The moods run from the ecstatic joy of the music-making angels in the *Nativity* panel to the depths of despair in the *Crucifixion*. The details range from the Annunciation and Nativity, through the Passion and Entombment of Jesus, to the fantastic ordeals of St. Anthony, the legendary prophet of Christian monasticism.

The unusual and obscure iconography derives from a number of sources, including the scriptures, the mystical writings of St. Bridget of Sweden, and the pictures of Grünewald's contemporaries, not the least of whom was Dürer. The strange *Nativity* (Fig. 282) omits the traditional St. Joseph, the crib, the animals and shepherds. The *Crucifixion* scene (Fig. 283) includes St. John the Baptist, rare in this con-

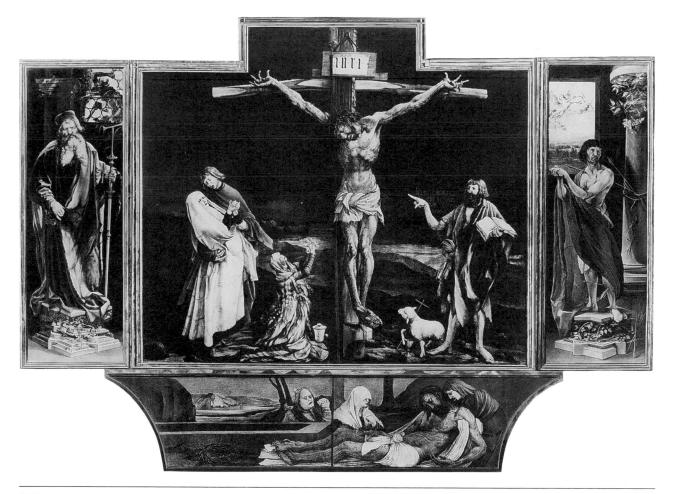

text. In this *Nativity* Mary appears twice, on the right as the more familiar Madonna with Child, and on the left kneeling in prayer in a Gothic temple—like chapel, her head surrounded by heavenly light. Such a vision is described by St. Bridget in her *Revelations*, and the allusion also suggests the *Magnificat* in St. Luke (1:46–55), in which the Virgin prays: "My soul doth magnify the Lord, and my spirit hath rejoiced in God my Saviour." The images of the prophets, musicians, and the Venetian glass pitcher at her feet may point to the Revelation of St. John, where the 24 elders of the Apocalypse appear with jars to symbolize their prayers and with musical instruments to signify their praises given to the Lord.

In the Crucifixion (Fig. 283) Grünewald depicts the Baptist on the right side of the cross, St. John the Evangelist on the left, and Sts. Sebastian and Anthony on the side wings. He thus includes the interceders for the principal maladies treated at the hospital: St. Sebastian for the plague, the two Johns for epilepsy, and St. Anthony for St. Anthony's fire (often thought to be the feverish, infectious inflammation of the skin known as ergotism, a disease caused by eating contaminated grain). No Italian harmony softens the grim agony of the crucified Christ. Festering sores and dried blood cover the ghastly green flesh. Such details are naturalistic, but the unnatural dimensions of the figures bear no relation to southern Renaissance practice. Is Grünewald following the medieval way of proportioning his figures according to their religious or dramatic importance? Compare the size of the kneeling Magdalene's hands with those of the Savior. Or is he emphasizing graphically the inscribed prophecy of the Baptist: "He must increase, but I must decrease" (John 3:30)? In either case "correct" proportions yield to the design and expressive intent.

The *Temptation of St. Anthony*, with its ghoulish and monstrous apparitions, reminded the suffering patients of the horrible ordeals endured by their patron saint. With its all-encompassing range of human feeling, Grünewald's altarpiece becomes one of the most moving documents in art history. In the 20th century its imagery has inspired the expressionist movement, as well as Paul Hindemith's opera and symphony *Mathis der Maler (Mathias the Painter)*.

England

HANS HOLBEIN THE YOUNGER. With Hans Holbein the Younger the scene shifts to Tudor England; here he served as painter at the glittering court of Henry VIII, where poetry, drama, and music flourished. Among Holbein's surviving portraits are those of Henry's son, the future Edward VI, and three of

Henry's wives—Jane Seymour, Anne of Cleves, and Catherine Howard.

The Allegorical Portrait of Jean de Dinteville and Georges de Selve (Fig. 284) is one of Holbein's most courtly, subtle, and intriguing statements. The pair of envoys are bringing a letter from the French king to Henry VIII. Beyond the surface play of elegant costumes, rich drapery, and the complex panoply of still-life objects, all rendered with meticulous clarity, lies a profound interplay of signs and symbols. Reading from bottom upward, each figure stands on the tiled marble pavement with one foot in a circle, signifying his spiritual aspirations, and the other foot in the central square, denoting the worldly realm and man's physical nature. The objects in the middle are arranged on two levels. On the terrestrial plane one discovers a globe of the world, a compass, some flutes, a lute, and a hymnal open to Luther's translation of Veni creator spiritus. Above them are a spherical map of the skies, some navigational instruments, a pyramidal Pythagorean solid geometrical form with a square, and a circle echoing the pattern on the floor below. Together they signify the various attributes of the seven liberal arts, particularly the subjects of the quadrivium—mathematics, geometry, music, and astronomy, which were the humanistic pursuits of the scholarly gentlemen represented.

There is, however, a more somber side, since all these things are but vanities when viewed under the aspect of eternity. The theme seems to be sic transit gloria mundi (thus passeth worldly glory). The richly costumed subjects and their attributes represent the wealth and power of the state and Church, while the sundial and lute with its broken string indicate the brevity of life and the inevitability of death. To confirm this interpretation, there are a medallion with a skull in the left figure's cap and a strangely distorted image of a skull on the floor, which can be seen only when viewed from the extreme lower right of the picture. This, of course, is the traditional memento mori (remember you must die). Such a reference to death as the great leveler comes as a chilling footnote to the overall splendor of the human dignity and achievement that are depicted above.

MUSIC

"The man that hath no music in himself, nor is not mov'd with concord of sweet sounds, is fit for treasons, stratagems, and spoils . . . let no such man be trusted.—Mark the music." Shakespeare's words testify to the high esteem in which the tonal art was held in the northern countries. Music, in fact, was closely woven into the fabric of daily life for all social

classes, from the rustic bagpipers in Bruegel's *Peasant Wedding Feast* (Fig. 277) and the wind players in town bands available for civic occasions, through middle-class house music to courtly entertainments. Very little was actually written down, and most of that has been lost over the years. The great impetus to the spread of music came with the development of printed anthologies that made songs and dances readily accessible. It also stimulated composers to write for a wider audience outside their own circles.

The greatest body of surviving music still is, of course, that for churches, performed in those people's concert halls where everyone from commoner to king could hear it. Outside the church, however, printed collections of solo and group songs with lute accompaniment (Fig. 285), madrigals, rondos, and motets for special celebrations such as state visits, military victories, births, marriages, and other ceremonies became available. These works were mainly for professional performers or educated amateurs.

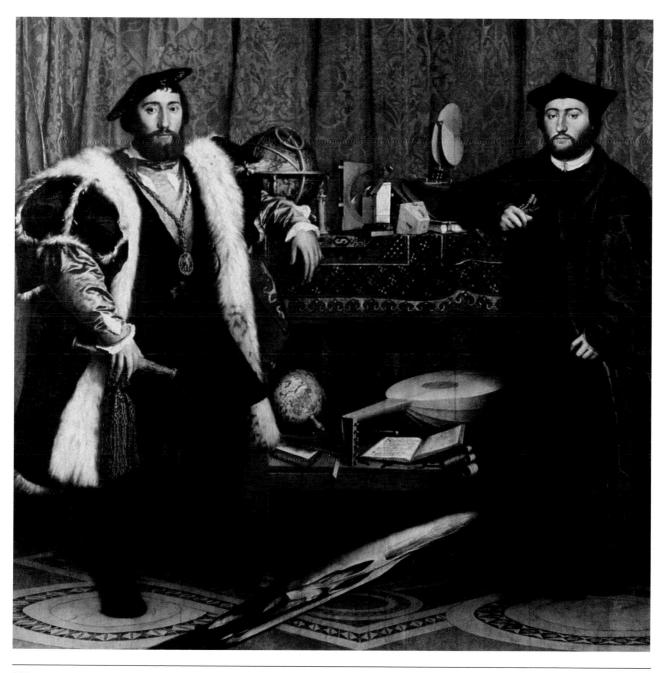

284.

The Courtier, Castiglione's popular etiquette book published in English in 1561, makes the point that "music is not only an ornament, but also necessary for a courtier." Besides knowing how to read music at sight, Castiglione advised that every gentleman should also be a musician and "have skill on sundry instruments." Gradually the pleasures of such music making were adopted in middle-class households, where music after dinner became a popular form of entertainment. Each household could have its own printed or hand-copied scores, and music masters were called upon for instruction in reading notes or playing on the lute, recorder, keyboard, and viols. The Elizabethan madrigal composer Thomas Morley told the story of a young man at a social gathering who was called upon to sing a part. When he protested he could not, everyone started wondering how he had been brought up.

Orland Lassus

The great fame of the Flemish composers of this period spread throughout Europe in church and courtly circles. Among others, Guillaume Dufay was the dominating force in the earlier 15th-century Italian scene (see p. 238), as was Josquin Desprez in the later (see pp. 280–82). Orland Lassus completed the illustrious line that practiced what was called the "perfect art" of polyphony in the 16th century. Trained in his native Flanders and in Italy, he was active all over the Continent. Eventually he settled in Munich for the last four decades of his life, where he was ennobled by the Emperor Maximilian II and enjoyed every honor fame could bestow—including such accolades as "prince of musicians" and "the divine Orland." Lassus was adept at writing in any style and set texts in French, Italian, and German. He

285.John Dowland. "I Saw My Lady Weepe," from *Second Book of Songs or Ayres*. Solo voice with lute accompaniment in tablature (left), optional arrangement for voices (right). Printed in 1600. Facsimile edition. Library of Congress, Washington, D.C.

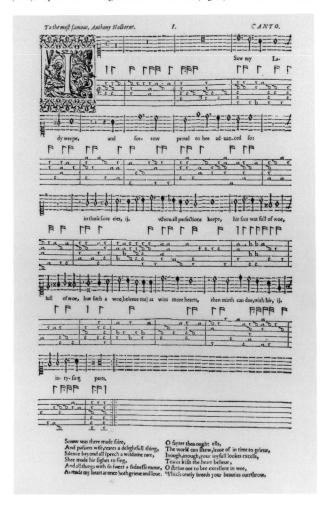

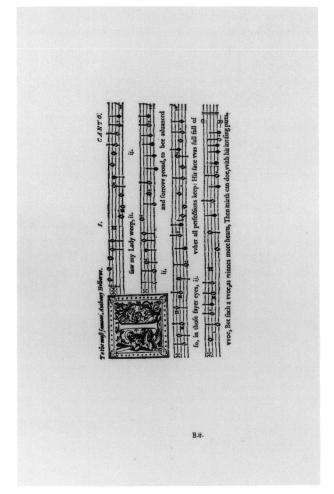

took special delight in the sounds of particular words and was sensitive to every nuance of the text. Musically his writing is characterized by ineffable purity of sound, close knitting together of the various voices, perceptive motivic imitations, and clarity of texture. In his *chansons* the moods range from bawdy burlesque to profoundly moving serious sentiments. *Susanne un jour* and *Bonjour mon coeur*, the one deriving from the Old Testament story of Susanna and the Elders, the other a touching love song, were the most popular of his many-voice songs during his lifetime. They have been arranged in every way from solo lute and voice settings to madrigals and full choruses.

Tudor Composers

Tudor England also enjoyed a flourishing musical life. Henry VIII—himself a composer—attracted the best Flemish, Italian, and English composer performers to his court. His son Edward VI played the lute, while his daughter Elizabeth I was an expert performer on the virginal, a small harpsichordlike instrument. England also had its share of great contrapuntal composers, chief among them Thomas Tallis and William Byrd. But the crowning achievement of the period was in the madrigal, a type of part-song for several individual voices, and the *ayre*, or solo song, in which lyric poetry and melody combined to create a delicate and appealing art form.

The time was distinguished by an extraordinary coincidence of poets and composers of exceptional quality that made this art unique. Outstanding among them was John Dowland, who most fully expressed and realized the potential of the solo song. His ayres range in mood from plaintive laments to those of passionate intensity and dramatic power. The published arrangement of Dowland's *I Saw My Lady Weepe* (Fig. 285), one of his most characteristic works, shows how they were printed for home music making.

The book opened so that the performers could be seated at a table. In this case the principal singer and lute player would sit together, as shown in the left-hand score. It can also be sung by two voices, with the second singer seated around the table at the right. Many such songs were arranged for vocal quartet with a lute accompaniment that duplicated the three lower parts, allowing great flexibility in performance. Depending on the number of available singers, these arrangements could be done as solos with lute accompaniment; a cappella (that is, for four voices without accompaniment), as a duet, as a lute solo, as an instrumental piece with viols instead

of voices, as a combination of voices and viols, as an instrumental ensemble with doublings of the parts, with wind instruments substituting for the voices and viols, and so on practically indefinitely. The music had to be adaptable to the size, skill, and instrumental capabilities of any group that might gather together for an evening of musical pleasure in the home. Such works were the genuinely popular music of the period.

DRAMA: SHAKESPEARE

The towering achievement of the Renaissance in England was in the field of drama. By the mid-16th century plays had become a popular form of entertainment for the nobility and for the general public. The growing demand led to the formation of traveling troupes of actors who played in the provinces as well as in London. The usual place of performance was in the courtyard of an inn. When more permanent theaters, such as the old Globe Playhouse in London (Fig. 286), were built, their design still recalled the layout of a courtyard inn with its open-air center surrounded by roofed galleries. People of all classes attended these performances; the more prosperous were seated in the galleries with a view of the stage, while the others stood in what was called the pit or ground. The stage itself had doorways for the entrances and exits of the players. Otherwise it was quite barren of scenery; the poetry of the text described the setting and carried on the action of the play. The Globe was the playhouse of William Shakespeare and others until it burned down in 1613 during a performance of Shakespeare's Henry VIII. Its site has recently been discovered under a parking lot and is currently being excavated.

Born in the provincial town of Stratford-on-Avon, Shakespeare led an early life clouded in obscurity. Like that of most great artists, however, his biography is to be found in his life's work—nearly 40 plays and some 150 sonnets. He was associated at the end of Queen Elizabeth I's reign with a group of players known as the Lord Chamberlain's Men. Such a group not only performed in public places but also in aristocratic households, including the royal court itself. A number of Shakespeare's plays were performed before Queen Elizabeth, whom he gracefully referred to in A Midsummer Night's Dream as "a fair vestal throned by the west." Queen Elizabeth is said to have been so delighted with the character of Sir John Falstaff in the Henry IV dramas that she expressed the wish to see a play with Falstaff in love. The result was The Merry Wives of Windsor. After 1603 Shakespeare's plays were frequently performed at the court of James I, who was flattered by

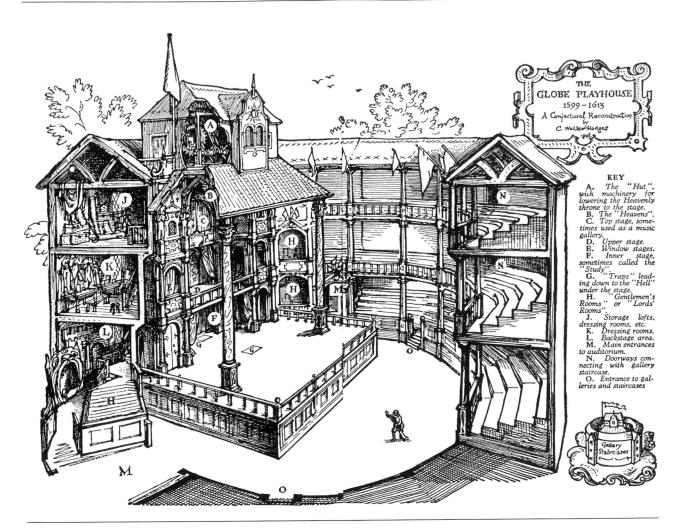

286. Globe Playhouse, London. Conjectural reconstruction by C. Walter Hodges.

Macbeth's allusions to his writings on witchcraft. Under James I, Shakespeare's actors were designated as the King's Men with the honorary title of Grooms of the Chamber.

The scope of the early plays runs a gamut from the rollicking *Comedy of Errors* and *Taming of the Shrew*, through the tragedy *Romeo and Juliet*, to such great comedies as *Much Ado about Nothing* and *Twelfth Night*. The historical dramas range from ancient Roman times with *Julius Caesar* to the reigns of various English monarchs. The climax of Shakespeare's prodigious output was attained in his mature years with the tragedies *Hamlet*, *Othello*, *Macbeth*, and *King Lear*, all poetically profound works that examine the perennial questions of life and death, love and hate, sanity and madness, ambition and human error. His later plays find him still seeking new dramatic directions and exploring the borderline between comedy and tragedy.

Shakespeare's stage can be seen as a mirror of the Elizabethan era. So universal is his humanity that his appeal has extended to all subsequent generations. Since his works can be read on so many different levels, new meanings and interpretations are constantly brought to light. There are as many Shakespeares as there are actors, directors, scholars, critics, historians, and audiences, as each interprets, appraises, and enjoys the plays in his or her own way. The ancient Greek philosopher Heraclitus once said that one can never step into the same river twice. Likewise, one can never experience the same Shakespeare play a second time, for each reading brings new discoveries. He expresses the gamut of human emotion from ecstasy to despair, the range of human understanding from profound insight to abysmal ignorance. His characters represent human society from the lords of the earth to its fools and knaves. Above all, Shakespeare was the lover of all things human. His scintillating wit and profound insights into the psychological conflicts, passions, and ambitions of his characters are unparalleled in literature. As his contemporary and fellow dramatist Ben Jonson summed it up: "He was not of an age, but for all time."

The Tempest

The Tempest is one of Shakespeare's last plays, and its construction borders on technical perfection. The airiness and transparency of its textures have a Mozartian elegance. The classical unities of time, place, and action are observed, and it follows the five-act form of ancient Roman drama. Essentially a pastoral play, it is concerned with the opposition of nature and art. Prospero's art includes all the graces and wisdom of civilization. He is the man of learning with power over the environment and over himself. In Shakespeare's time Prospero's magic would have been understood as knowledge derived from books such as Francis Bacon's Advancement of Learning of 1603. This even Caliban realizes as he tries to burn them. Caliban, like the shepherds in classical pastoral plays, is the man of nature. Here he is portrayed as akin to the beasts of the field, ignorant and savage. It is Caliban, however, who becomes the core of the play against whom all the other figures are measured. He is portrayed at the simple level of the senses—pleasure without knowledge, lust without love, incapable of distinguishing good and evil. However, the civilized characters, beneath their polished exteriors, still have within themselves in varying degrees some of the baser instincts of Caliban.

Very briefly, the fairy-tale plot tells of Prospero, the rightful Duke of Milan, who is exiled with his lovely daughter Miranda on a tropical island. The only other inhabitants are Caliban, "a freckled whelp... not honor'd with a human shape" and the "ayric spirit" Ariel. Learning through his magic powers that his old enemies are sailing past, Prospero conjures up a tempest that shipwrecks their boat and scatters the survivors about the island. Ferdinand, the handsome young prince of Naples, finds Miranda. After many trials, plots, and subplots, the lovers are united, their marriage celebrated. Prospero regains his dukedom while forgiveness and reconciliation prevail.

Interpretations abound, and mythic qualities are everywhere apparent. In recent years there have been productions playing up the adversary relationship between Prospero and Caliban as representing the rapacious colonial powers exploiting the sullen natives of distant lands. This view, surprisingly

enough, is not without some justification. Elizabethan England was already a major rival of Spain in the colonization of the New World. Walter Raleigh's and Francis Drake's accounts of their voyages had already been published. And just at the time of *The Tempest*'s first performance in 1611, topical interest had turned to the adventures of a group of colonists who had been shipwrecked in Bermuda on their way to Virginia. The religious and ethical implications of the meeting of settlers and natives were the subject of hot debate. Shakespeare certainly knew about these developments. The name *Caliban*, for instance, is an anagram for cannibal, which at the time referred to the natives of the Caribbean, not to eaters of human flesh.

In other views the drama has been seen as symbolizing the four elements, with Caliban as earth and brute force, Prospero as the fire of imagination, Ariel as the fancy-free spirit of air, and the sea as the environmental waters that surround them. It can also be interpreted as an allegory of fall and redemption, revenge and resolution.

The sheer musicality of Shakespeare's verse has been an open invitation and challenge to composers from his time to the present. Such lyrics in the plays as the touching "Willow Song" in Othello were intended to be sung rather than spoken. There is an anonymous setting from the time, but there is no way of knowing whether it was actually performed in a Shakespeare production. The first known setting of a Shakespeare lyric is Robert Morley's "It was a lover and his lasse" from As You Like It, but again there is no record of its performance in the play. Shakespeare's contemporary Robert Johnson's settings of two lyrics from The Tempest-"Full fathom five" and "Where the bee sucks"—survive and are generally thought to have been composed for the production of 1611, although they were not printed until 1660.

The Tempest's alliance with music is secured by the inclusion in Act IV of a full-scale *masque*. These spectacles that predate opera were designed for courtly entertainment, and in this case its second known performance was in 1613 for the betrothal of James I's daughter Elizabeth and the Elector Palatine. It was performed by the King's Men, the royal acting troupe of which Shakespeare was a member. This play within a play begins with a prologue to set the theme, in this case reconciliation and forgiveness. It continues with songs, dances, and instrumental interludes, and finally come the revels in which the audience participates. The reconciliation is then completed in the last act, where Miranda speaks the oft-quoted lines: "O brave new world, /

That has such people in't." Even Caliban joins in with the words: "I'll be wise hereafter / And seek for grace."

One of the most intriguing interpretations of the play is that Prospero is Shakespeare himself, and that his lines toward the end of the masque are his farewell to the theater when he was leaving London for retirement at Stratford:

Our revels now are ended. These our actors.

As I foretold you, were all spirits and Are melted into air, into thin air:

And, like the baseless fabric of this vision,

The cloud-capp'd towers, the gorgeous palaces,

The solemn temples, the great globe itself,

Yea, all which it inherit, shall dissolve And, like this insubstantial pageant faded,

Leave not a rack behind. We are such

As dreams are made on, and our little life

Is rounded with a sleep. . . .

IDEAS

Christian Humanism

The new learning in England, France, and the Low Countries, as seen in the books of Thomas More, Rabelais, and Erasmus, was pursued vigorously in the early 16th century. It flourished best before it became entangled in the thicket of Reformation theological controversies. Their Italian counterparts, too close to Rome for comfort, had to veil some of their criticism of the Church by projecting a past golden age in antiquity and reviving Plato in their opposition to Aristotelian scholasticism. From their vantage point, however, northern scholars could view Church and social abuses more objectively. They also tended to look more at nature and the world about them. In their works criticism of the Church and the inherited social order assumed two main directions. One way led to the projection of imaginary idealized societies on the model of Plato's Republic, the other to holding up the mirror of satire and ridicule to the outmoded medieval heritage.

Thomas More, a lawyer by profession, rose to become Lord Chancellor of England under Henry VIII. When he refused to recognize Henry as head of the English church, he was tried and executed for treason. His widely read Utopia was a disguised exposé of the social absurdities and injustices of his time; it is the picture of a society founded entirely on reason. All property is held in common, since only without personal property can there be social equality. All towns have the same plan, all houses are exactly alike, all men and women dress alike, each family makes its own clothing, and all religions are tolerated. A chosen few are called to pursue learning, and those who govern are picked from this group. There is a representative democracy modeled on the parliamentary system, and the ruler is chosen by indirect election. He serves for life but may be deposed if he turns to tyranny. Life in More's Utopia may have been ideal, but it certainly was dull.

Far more lively reading is provided by the satirists. In France, François Rabelais was a professed monk of broad humanistic learning who took up the pen to ridicule the medieval outlook of his period and human folly in general. In his *Gargantua* and its sequel, *Pantagruel*, the bawdiness and ribaldry of his tales and his unbridled zest for living all too often obscure his essentially serious concerns with politics, education, and philosophy. His real purpose was to liberate men and women from their foolishness so that they could realize their higher potentialities as human beings.

Most influential of all was Erasmus of Rotterdam, universally admired for his great knowledge, sharp wit, brilliant writing style, and for the breadth of his humanistic worldview. He was also a connoisseur of art and a personal friend of Holbein the Younger, who painted several portraits of him and illustrated many of his books.

In "The Godly Feast," one of his *Colloquies*, Erasmus discusses how nature and art complement each other in two gardens—one real, the other painted. "In one we admire the cleverness of nature, in the other the inventiveness of the painter. . . . Finally, a garden isn't always green nor flowers always blooming. *This* garden grows and pleases even in midwinter."

In *Praise of Folly*, Erasmus's biting wit cuts most into the pretensions and hypocrisies of his time. Folly narrates the book; her satire targets people in all walks of life, from the high and mighty to those who live at the brute level. All are dependent on her, for who can marry or mate without Folly? Held up to ridicule are the monks who "compute the time of each soul's residence in purgatory," the theologians with their endless disputes about the Trinity and incarnation, and the friars who calculate "the precise number of knots to the tying of their sandals." Bish-

287.Hans Holbein the Younger. Marginal drawing for last page of Erasmus's 1515 Basel printing of *In Praise of Folly,* facsimile edition. The George Arents Research Library at Syracuse University.

ops, cardinals, popes are castigated for having little religion in them, and it is suggested that even religion is a form of folly.

Visual artists also took up the cudgel of satire. Holbein's *Dance of Death*, a series of woodcuts portraying humanity from the Creation to the Last Judgment, is really the comedy of life. Everyone from popes and emperors to common sailors and peasants is eventually leveled off by Death, who appears as a skeleton. Holbein also did a series of marginal drawings for the 1515 printing of Erasmus's *In Praise of Folly* (Fig. 287). Here on the last page Folly, in the joker's cap and bells, has been preaching to her audience of fools. She now descends from the pulpit, saying: "And now fare ye well, applaud, live, and drink, ye votaries of Folly."

In his other writings Erasmus opposed pilgrimages, papal indulgences, the mediation of saints, the power of the clergy, the sacramental system, and the literal interpretation of the Bible. Thus the road to the Reformation was paved by the northern humanists, whose articulation and advocacy of reason in human affairs pruned away so much medieval superstition. Erasmus had hoped that his reforms would lead to a new golden age of the arts, and it has been said that he laid the egg that Luther hatched. But when he beheld the chick, Erasmus remarked bitterly that "wherever Lutheranism reigns there is the death of letters." He resolved (as did More and Rabelais) to stay with the Church of Rome, and it

remained for Luther to sharpen the issues and bring the Reformation to a head.

Luther and the Reformation

The towering figure of Martin Luther and his reforms became the dominating force of the 16th century. He not only changed the map of Europe, he also redirected the way people thought of themselves, their fellows, and the world about them. During the dark days of his mighty inner struggle to clarify his beliefs, he was struck by the lightning flash of St. Paul's words: "The just shall live by faith." Justification by faith became Luther's motto, but it was a faith that every person had to find for himself or herself. Luther also held that the individual conscience was the ultimate moral authority and proclaimed the priesthood of all believers. Through prayer, each believer could address God directly without the mediation of priestly authority or the intercession of the saints.

The word of God, Luther taught, was not necessarily to be found in the maze of writings by the Church fathers or in Roman Catholic doctrine, but in the Bible itself. It then became imperative to translate the Scriptures into the languages the people could understand. Again printing played a major role in spreading both the Gospel and the writings of the reformers. No longer were the Bible and other books the preserve of the clergy, the learned, or the

well-to-do, but the common property of all. Learning to read and understand, then, became the necessary prelude to faith and salvation. The psychological impact of Lutheranism lay in shifting the burden of thinking from the authority of the priesthood to the individual. Brushing off the accumulated dust of centuries, Luther held that the Bible spoke directly and clearly. Though Luther himself wrote many commentaries, he allowed ample scope for individual opinion and interpretation.

EFFECT ON THE ARTS. This fundamental shift of direction had an enormous impact on the arts. At first there was a disruption in the sources of patronage. The resources of the Roman Church for architectural projects complete with sculptural and decorative programs were no longer forthcoming in the Reformation countries. However, with the rise of nation-states and the growing power of the merchant and shipping families, a reorientation of the patronage system gradually took place.

Architecture now had to take the new religious direction into account. The Church of England, for the most part, retained elaborate liturgies, so the heritage of the Gothic structures continued to suffice. On the Continent, however, the Protestants were against ceremonial pomp, and their services were now sermon-centered. At first they simply took over and adapted existing Roman Catholic churches, tearing out the sculpture and paintings, whitewashing the walls, and holding all decorative detail to a minimum. The new emphasis was on communion, baptism, confession, and preaching. When new churches were built, they tended to resemble university lecture halls. Lutheranism recognized only two sacraments, so the communion altar was retained, but no longer with relics of the saints and no longer as the center of attention. The baptismal font also remained, but no longer in a separate chapel. The new order focused on the pulpit, with appropriate seating for the congregation, and a prominent place for the choir and organ loft.

In the representational arts sculpture suffered the most because its three-dimensionality was felt to be too close to idol worship and the graven images forbidden by the second commandment. Painted altarpieces were also out of the question. One of the darkest chapters in 16th-century history has to do with the wholesale destruction of church art. The Protestant extremists in England, France, and Germany took to smashing stained glass windows, destroying statuary, decapitating sculptured figures on Gothic porches and façades, and destroying the ornate choir screens that were felt to separate the faithful from the altar. Paintings were ripped out and

burned. Fortunately, Luther disapproved of this wanton destruction, and with a marvelous metaphor warned his more zealous followers that it was not necessary "to swallow the Holy Ghost feathers and all."

The positions of the Reformation leaders on the proper place for the arts varied from partial acceptance to total exclusion. John Calvin first said, "I approached the task of destroying images by first tearing them out of my heart. . . ." Then he modified his position somewhat by saying that crucifixes and images of the saints were "praiseworthy and to be respected," but for memorial purposes only. Calvin, however, remained rigid in his disapproval of works of art and the worship of images.

Luther naturally was against the worship of icons and images, but he was not an iconoclast. "If it is . . . a good thing for me to bear the image of Christ in my heart," he asked, "why should it be a sin to have it before my eyes?" He sat for innumerable portraits (Fig. 288) and numbered the painter Lucas

288. Lucas Cranach the Elder. *Luther as Augustinian Friar.* 1520. Copper engraving, $5\frac{78}{8}$ " $\times 4\frac{58}{8}$ " (14.8 \times 11.8 cm). British Museum, London (reproduced by courtesy of the Trustees).

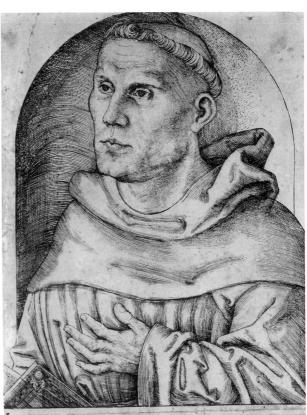

EXPRIMITAT VVITVS CERA LYCAE OCCIDVOS

M.D.X.X.

Cranach the Elder among his friends and Dürer and Bruegel among his admirers. In general Luther was more sensitive to the spoken word and music than to the visual arts. Revelation for him came more through the sense of hearing than sight.

As for the pictorial artists, new themes and a new iconographic tradition gradually emerged. Until now the great emphasis had been on history painting with mainly biblical and mythological subjects. The Reformation, however, brought the other categories to the fore. The iconographic shift was from universals to particulars. Luther's reorientation of religion toward the more subjective, personal, and individual side favored the development of portraiture. Genre scenes telling of everyday experiences, personal feelings, and reactions received new impetus with the Reformation. Dürer's engravings and Bruegel's paintings of peasant life are cases in point. More attention was also given to landscape (Fig. 289), not as mere background for figures but as a category in its own right. For the Reformationists, landscape was a reflection of increasing interest in the exploration of nature as such, an expression of God's bounteous creation, and a confirmation of the existence of a rational universe. Still life also began to come into its own, not as a mere component of large-scale works. The new middle class took special delight in the tangible objects that represented the good life, but their consciences demanded a moral message. Thus representations of crockery, mirrors, jewelry, and the like were considered vanitas vanitatum, or worldly vanity, while flowers, fruit, dead animals, and skulls were classed as memento mori, reminders of the passage of time and the brevity of life. Above all, a lively market developed for prints, both alone and as illustrations in books new media that had never before been associated with idolatry or popery. Indeed, book illustration soon became an art in its own right, one that was acceptable in both Protestant and Catholic circles, and one of great future importance.

The Reformation also opened up boundless possibilities for music. Luther himself wrote the stirring words and perhaps the music for *A Mighty Fortress Is Our God*, the anthem that has been called the *Marseillaise* of the Reformation. His reorganization of the German Mass opened the doors to new directions.

289. Albrecht Altdorfer. *Danube Landscape Near Regensburg.* c. 1522–25. Panel, $11\times 8\frac{5''}{8}$ (27.9 × 21.7 cm). Alte Pinakothek, Munich.

tions in choral and organ music and to the forms of the cantata and oratorio (see pp. 382–83, 411–12). Both congregational and professional singing were woven into the Mass.

In this conflict between North and South, the Germanic and the Latin cultures, nationalism and internationalism, personal conviction and hierarchically organized religion, no one side could be declared the winner. The principal casualty, however, was the Renaissance style in both North and South. The stage was now set for an artistic renewal that first reflected the era of spiritual conflict and mannerism, then confidently set forth on a new course all its own, the baroque.

16th-CENTURY VENICE AND INTERNATIONAL MANNERISM

	KEY EVENTS	ARCHITECTURE	MUSIC AND PAINTING	MANNERISTS
1450			c.1427- 1516 Giovanni Bellini ▲ 1429- 1507 Gentile Bellini ▲	
1450 -	1453 Turks conquered Constantinople; Venetian commerce challenged 1492 Geographical discoveries by Spanish and Portuguese navigators weakened Venetian maritime trade 1495 Aldine Press began publishing inexpensive editions of Greco-Roman classics	1486-1570 Sansovino (Jacopo Tatti)	c.1455-c.1526 Vittore Carpaccio ▲ 1478- 1510 Giorgione (Giorgio da Castelfranco) ▲ c.1480- 1562 Adrian Willaert □ c.1490- 1576 Titian (Tiziano Vecelli) ▲	c.1492- 1546 Giulio Romano (Pippi) 1494- 1540 Rosso Fiorentino (Giovanni Battista di Jacopo) 1494- 1556 Pontormo (Jacopo Carucci)
1500 - 1550 -	1517 Protestant Reformation began 1527 Sack of Rome by Charles V; artists flee. Beginning of mannerist style 1545-1563 Council of Trent initiated Counter- Reformation	1508-1580 Palladio (Andrea di Pietro) 1536 Library of St. Mark built by Sansovino 1540 Loggietta at base of campanile built by Sansovino 1546-1549 Basilica at Vicenza built by Palladio	1501 Oahecaton, anthology of vocal and instrumental works by Josquin Desprez, Obrecht, Isaac, and others printed in Venice by Petrucci 1510-1586 Andrea Gabrieli □ 1510-1592 Bassano (Jacopo da Ponte) ▲ 1516-1565 Cipriano de Rore □ 1517-1590 Gioseffo Zarlino □ 1518-1594 Tintoretto (Jacopo Robusti) ▲ 1527-1562 Willaert choirmaster of St. Mark's 1528-1588 Veronese (Paolo Cagliari) ▲	1500- 1571 Benvenuto Cellini 1503- 1540 Parmagianino (Francesco Mazzola) 1503- 1572 Bronzino (Angelo de Cosimo di Mariano) 1511- 1574 Giorgio Vasari 1529- 1600 Giovanni Bologna (Giambologna) c.1540- 1609 Federico Zuccari
	1571 Naval Battle of Lepanto; Venice and Spain defeated Turks 1573 Veronese called before Inquisition	1550 Villa Rotonda near Vicenza begun by Palladio 1552-1616 Vincenzo Scamozzi 1565 Church of San Giorgio Maggiore, Venice, built by Palladio 1570 Palladio published Four Books of Architecture 1576-1578 Church of II Redentore, Venice, built by Palladio 1579-1580 Olympic Theater, Vicenza, built by Palladio 1584 Procuratie Nuove, continuation of Sansovino's design of St. Mark's Library built by Scamozzi 1589 Olympic Theater, Vicenza, dedicated with performance of Sophocles' Oedipus (music by A. Gabrieli)	1557- 1612 Giovanni Gabrieli □ 1567- 1643 Claudio Monteverdi □ 1585- 1612 Giovanni Gabrieli choirmaster of St. Mark's	1555- 1619 Ludovico Carracci 1560- 1609 Annibale Carracci
1600 -		1604-1675 Baldassare Longhena 1631 Santa Maria della Salute begun	1602- 1676 Francesco Cavalli □ 1613- 1643 Monteverdi choirmaster of St. Mark's	

13

The Venetian Renaissance and International Mannerism

RENAISSANCE VENICE, 16TH CENTURY

A glimpse of Venice as it was at the threshold of the 16th century can be seen through the eyes of the painter Gentile Bellini. His faithful reporting in *Procession in St. Mark's Square* (Fig. 290) is so accurate that architectural historians can make reconstructions of buildings long since destroyed, researchers can study the mosaics and sculptures of St. Mark's Basilica as they were before later restorations, and historians of liturgy, musical performances, and costume find it prime source material.

St. Mark's Basilica at once proclaims Venice the meeting place of Orient and Occident, the East and the West. Begun in the 10th century, it is the product of centuries of community effort. Indeed, an early law required every Venetian ship to bring back materials for the construction or decoration of the church. As a result, fragments from every Mediterranean country can be found somewhere in its fabric—from the Greco-Roman bronze horses of the 1st century A.D. over the central portal (Fig. 291) and the Alexandrian many-colored marble columns and Greek alabaster windows to present-day changes. The plan is that of a Greek cross with smaller domes

290. Gentile Bellini. *Procession in St. Mark's Square.* 1496. Oil on canvas, $12 \times 24'$ (3.66 \times 7.32 m). Galleria dell' Accademia, Venice.

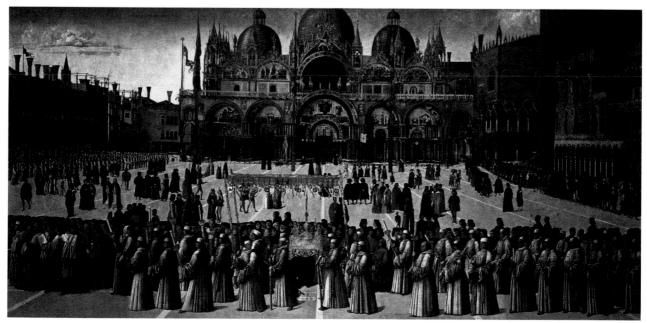

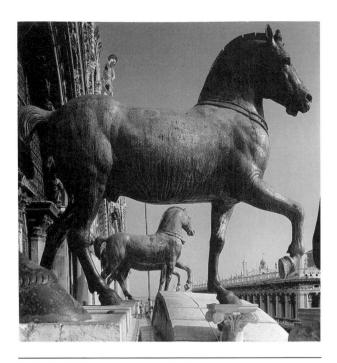

291. Four horses of Greek origin. A.D. 1st century. Gilt bronze, lifesize. St. Mark's Basilica, Venice.

covering each of the four wings and a large cupola 42 feet (12.7 meters) in diameter at the center.

To the right is a corner of the Doge's Palace where the doge—the chief official of Venice—and his guests are seated on the second-story arcade. This striking variation of a Gothic town hall rises in two stories of open pointed arches surmounted by a third story notable for its diamond-shaped design in bright pink marble tiling. Across the square on the left is the old library from which many spectators are watching the activities. This building with its curious chimney pots also dates from medieval times.

More remarkable than its architecture, however, is the institution of the library itself. Venice treasured the great collections of books that had been left her by the poet Petrarch, the Greek scholar Cardinal Bessarion, and other donors because in this watery city the danger of fire was less than elsewhere. In addition to these collections, the library housed all the specimens of the city's elegant printing and bookmaking industry. These included fine but inexpensive editions of classics published here for the first time by the famous Aldine Press, which gave great momentum to the spread of learning throughout the educated world. In the 16th century, these collections were transferred to the handsome building across the square designed by Sansovino especially to house them (Fig. 292).

In the procession scene, a feeling of open public life and freedom of social movement can be

sensed in both the participants and the bystanders. The independence of Venice and the prosperity of its citizenry were due in many respects to the city's unusual situation. Built on a group of island lagoons at the head of the Adriatic Sea, Venice was truly what a Florentine poet described as "a city in the water without walls." Secure from attack by land and by sea as a result of its possessing the largest navy then in existence, Venice carried on an active commerce between East and West that afforded her citizens a manner of life unrivaled in its time for comfort and luxury.

The fall of Constantinople to the Turks in 1453 and the rising power of the Ottoman Empire spelled competition for Venice's commercial empire, and naval warfare had already begun. While Venice had given birth to one great explorer, Marco Polo, the voyages of the 16th-century Spanish, Portuguese, Dutch, and English navigators were being exploited to enrich rival countries, thereby upsetting the traditional economy in which Venice flourished. In spite of the unsettled world situation, the Venetians were preparing to reassert their economic supremacy. So in the 16th century they embarked on an ambitious program of building and decorating with a lavish hand to enrich their city as well as to impress their rivals.

Architecture

Sansovino. Jacopo Sansovino was awarded the commission to build the new Library of St. Mark (Fig. 292). Trained in both sculpture and architecture in his native Florence, he had been active in both Tuscany and Rome before settling in Venice in 1527. Here the finest marble, building materials, and skilled craftsmen were at his command. His library design recalls such Renaissance city palaces as those built for the wealthy families of Florence and Rome (Fig. 229), but with a difference. Instead of staying with the flat surfaces, rusticated masonry, and fortresslike façades, he proceeds to mold his masses and voids in sculpturesque fashion. The structure has two stories with a spacious foyer below and a great staircase leading to a well-lighted reading room above.

This projection in depth creates an effective play of light and shadow, an element normally associated more with sculpture and painting than with architecture. The dignified Doric arcade of the lower story serves as a base for the increasingly rich adornment of the upper parts. The deeply set arched windows of the second floor are unified by the regularity of the Ionic columns, while the poses of the sculptured nudes in the spandrels provide variety. Above

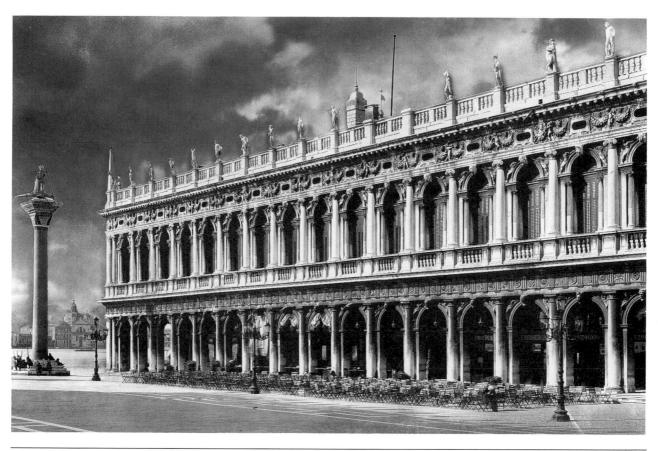

292.Jacopo Sansovino, Library of St. Mark, Venice, Begun 1536, Length 290' (88,39 m), height 60' (18,29 m).

runs a frieze of cherubs in high relief holding garlands that alternate with small, deep-set windows. Over this rises a *balustrade*, a row of short posts topped by a rail, that encircles the roof and supports a row of statues silhouetted against the skyline. The overall impression is one of spaciousness and openness that invites entrance and promises an equally significant interior.

PALLADIO. Sansovino's designs influenced Andrea Palladio, the greatest architect associated with the Venetian style. As the author of the highly influential Four Books of Architecture, first published in Venice in 1570, Palladio has left a detailed discussion of his philosophy. In the preface to this work, Palladio paid eloquent tribute to his ancient Roman guide Vitruvius, whose writings stimulated his study of the classical buildings in Rome. "Finding that they deserved a much more diligent Observation than I thought at first Sight," he noted, "I began with the utmost Accuracy to measure every minutest part by itself."

Palladio's ideas were thus based on the background of Roman classical architecture as well as some of the more progressive trends of his Renaissance contemporaries. He also saluted his immediate predecessor Sansovino, whose library he praised as "perhaps the most sumptuous and the most beautiful edifice . . . since the time of the Ancients."

Palladio's architecture can be studied more fully in nearby Vicenza, then a part of the Venetian Republic's holdings on the mainland. Just outside Vicenza is the Villa Rotonda (Fig. 293), a country house in the grand style and the prototype of many later buildings. The plan is a cube enclosing a cylindrical core surmounted by a low saucer dome (Fig. 294).

On four sides grand flights of steps lead to Ionic porches that project 14 feet (4.3 meters) forward and are 40 feet (12.2 meters) wide. The pediments are those of a classical temple, with statues on either side and above. Each porch provides entrance into the imposing round reception room that gives the villa the name *rotonda*. This central salon is as high as the house itself and rises to the cupola above. Alcoves left over from the parts between the round central hall and the square sides of the building allow space for four winding staircases and for no less than 32 rooms in the adjoining corners—all excellently

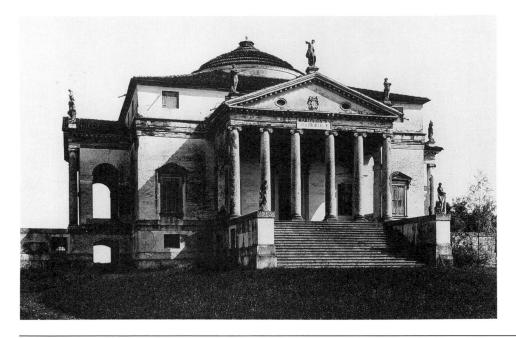

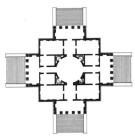

293. above left:Andrea Palladio. Villa Rotonda, Vicenza. Begun 1550. 80' (24.38 m) square, height of dome 70' (21.34 m).

294. above right: Plan of Villa Rotonda.

lighted both from the outside and from the eight round windows at the base of the cupola.

Below, a basement includes ample storerooms, servants' quarters, and kitchens. Palladio's achievement here is a house that is spacious but simple in plan.

As with Brunelleschi and Alberti in Florence, musical proportions play a major role in Palladio's spatial thinking. The ground plan (Fig. 294) is a marvel of geometric clarity, with the central circle signifying the dome. Grouped around it are reception rooms, and those on the corners are rectangular, measuring some 18 by 30 feet (5.49 by 9.14 m). Palladio insisted that the harmonic ratios be preserved not only in each single room but also in the relationships of each room to the others, plus the additional concordance between length, width, and height. Palladio was thoroughly conversant with the musical ideas of his contemporary Gioseffo Zarlino, the Venetian theorist who synthesized all knowledge of music in his famous 16th-century compendium. Since this was the great age of counterpoint, Zarlino's system was based on the hexachord, or sixnote scale from do to la. So in Palladio's thought the number 6 comes to the fore as the basic module. If a room, for instance, is 6 feet wide (or some multiple thereof), then the length would be 12 feet and the height the mean between, or 9 feet. Palladio also favored rooms measuring 18 by 30 (divisible by 6),

or 12 by 20 (divisible by 4), each making a ratio of 3:5. Musically, 3:5 comes out as the interval of the major sixth. "Such harmonies," wrote Palladio, "usually please very much without anyone knowing why, apart from those who study their causes."

When advancing years limited Sansovino's activities, Palladio was called to Venice to construct several buildings, among them the Church of Il Redentore, "the Redeemer" (Fig. 295). Palladio set himself the problem of reconciling the Greco-Roman temple with the traditional oblong Christian basilica plan (Fig. 296). Since a classical temple is of uniform height with a simple shed roof, and a Christian basilica has a Latin-cross ground plan with a central nave rising high above two side aisles, his solution to this age-old problem shows great ingenuity.

The central part of the façade of Il Redentore becomes the portico of a classical temple complete with columns and pediment to face the high central nave within, while the acute angles of a fragmentary second pediment face the side aisles. The pediment idea is repeated in the small triangle above the entrance and in the side angles at the roof level, to make in all two complete and two incomplete pediments. This *broken-pediment* motif was later incorporated into the baroque vocabulary. To create the feeling of deep space, Palladio alternated square pilasters with round columns and arranged the pediments in a complex intersecting design.

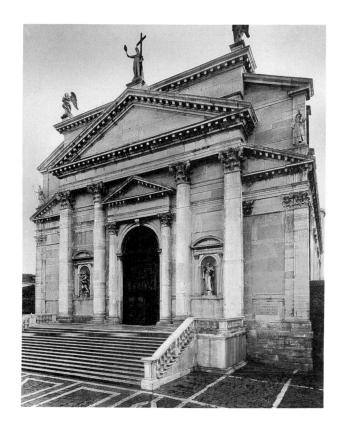

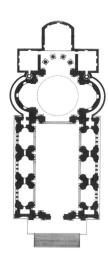

295. left: Andrea Palladio. Il Redentore, Venice. 1576–92.

296. above: Plan of Il Redentore.

The interior of Il Redentore is a model of geometric clarity (Fig. 297). In order to create the impression of spatial depth, Palladio eliminated the traditional solid-walled apse that usually closes the space around the altar. In its place he used a semicircular open colonnade against clear glass windows. The effect is to lead the viewer's eye past the altar and on into the distance.

The last building Palladio undertook was the Olympic Theater at Vicenza (Fig. 298). It was begun the year of his death and finished later from his designs by Scamozzi. An ingenious device to create the feeling of deep space is seen through the central arch from which actors made their entrances—a rising ramp flanked by building façades, which recedes only about 50 feet (15.2 meters) but creates the illusion of a long avenue leading to an open city square in the distance. Clearly inspired by ancient Roman amphitheaters, the Olympic has, in turn, been the inspiration for many later theaters, including one of London's largest, the Palladium.

Palladio emerges as the most influential architect of his period. His thought as he expressed it in *Four Books of Architecture*, with their sketches and drawings, had an even wider influence in France, England, Ireland, and America than did his buildings. The English translation, published with notes by his disciple Inigo Jones, helped establish the Georgian tradition in both England (see Fig. 381)

and America, where it was carried on by Thomas Jefferson. The latter's loyal Palladianism is seen in the designs he prepared for his residence at Monticello and the Rotunda of the University of Virginia (Fig. 417), both of which are adaptations of the Villa Rotonda. Jefferson also wanted to build the White House at Washington, D.C., on the same plan, but his proposal, submitted anonymously, was not the one chosen. However, even in its present form the White House has a typical Palladian design with a classical Ionic entrance portico in the center and two equal wings spreading outward.

Painting

Venice has always been a painters' paradise. Palaces seem to rise like lace out of the waters. The mercurial movements of the winds and clouds cast constantly changing reflections and colors on the canals. There seems to be no borderline between dream and reality. For its fulfillment as a major art, however, the Venetians had to wait for the right medium to come along. Mosaics had served well in medieval times but were not adaptable to the more subtle Renaissance modes of representation. Fresco murals painted on plaster were too impermanent in the damp climate. Tempera on wood panels also proved fugitive, and the pale pastel water-based colors did not suit the Venetian temperament. When the tech-

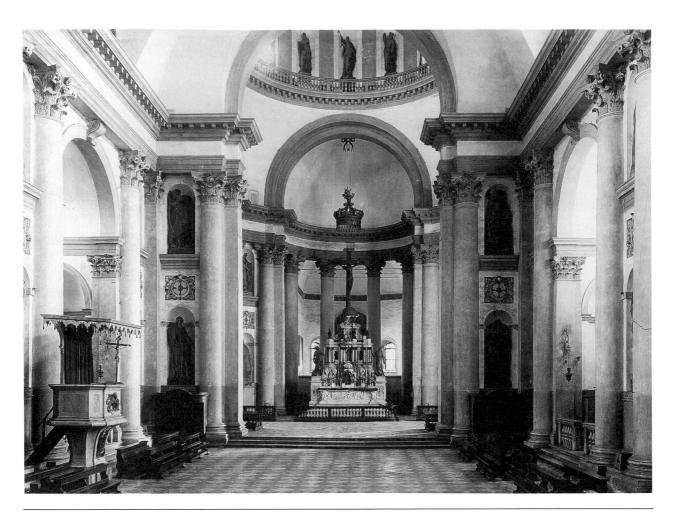

297. Interior, Il Redentore, Venice. 1576–92.

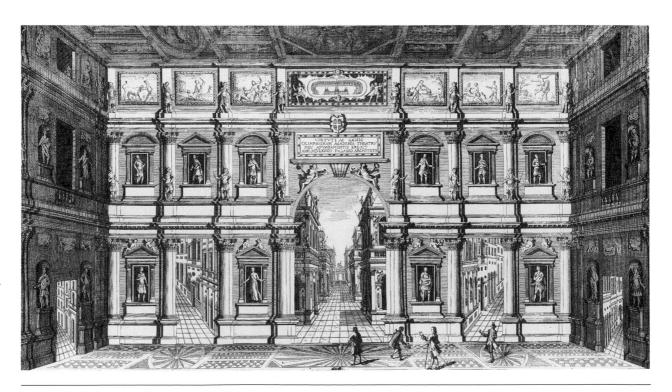

298. Andrea Palladio. Interior, Teatro Olimpico, Vicenza. 1580–84.

nique of oil on canvas was developed elsewhere in the middle and late 15th century, the Venetians quickly took it up and made it their own.

The oil medium opened up many new possibilities. In contrast to the hard resins used by the Flemish painters, the Venetians mixed their pigments with oil and flexible resins, giving themselves greater freedom of brushwork. This new technique also allowed them to work directly on canvas without preliminary drawings either on paper or on the canvas itself. The color range was vastly increased. Dramatic use of high intensities to spotlight principal figures and deeper shadow for subordinate ones became possible. More subtle modeling of figures, softness of contours, and various atmospheric effects also came under the control of the artist. The Venetian mode of painting, in fact, became universal. After it spread throughout Italy, El Greco carried it with him to Spain. Rubens brought it to northern Europe; both Rubens and Van Dyck introduced the technique to England; and from there it traveled to America.

GIOVANNI BELLINI. When the young German painter Albrecht Dürer first visited Venice in 1495, Gentile Bellini was working on his *Procession in*

St. Mark's Square. His brother Giovanni was doing a series of altarpieces for Venetian churches. Of all the painters, Giovanni Bellini's work commanded Dürer's highest admiration. This first impression was confirmed on a later trip in 1506 when he wrote of Giovanni as "still the supreme master."

The root of Giovanni Bellini's art was a harmonious, familial blend of his father Jacopo's early-Renaissance heritage and the special contributions of his brother Gentile and his brother-in-law Andrea Mantegna of Mantua. But the beautiful branches of this family tree were Giovanni's own paintings that embraced an emotional range from the silent suffering of his pietàs through the melancholy meditations of saints and hermits (Fig. 299) to the lyrical grace and joyous maternity of his Madonnas (Fig. 300). All are set in poetic landscapes filled with the soft, mellow, golden light that brought all of nature into a warmly glowing unity. Bellini's special handling of pictorial space by dividing interest between the closed setting for foreground figures and open, receding landscape backgrounds also became a part of the full Venetian vocabulary. For later painters it was to become practically a cliché for religious subjects and portraiture.

299. GIOVANNI BELLINI. *Saint Jerome Reading*. c. 1480–90. Oil on wood, $19\frac{1}{4} \times 15\frac{1}{2}$ " (49 × 39 cm). National Gallery of Art, Washington, D.C. (Samuel H. Kress Collection).

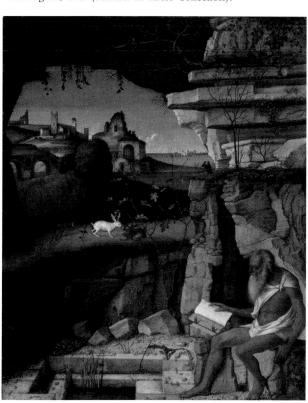

300. GIOVANNI BELLINI. *Madonna and Child.* 1505. Oil on wood, $19\frac{5}{8}\times16\frac{8}{8}''$ (50 \times 41 cm). Galleria Borghese, Rome.

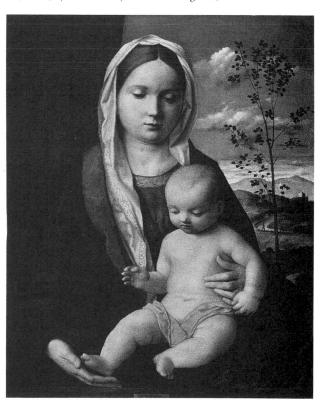

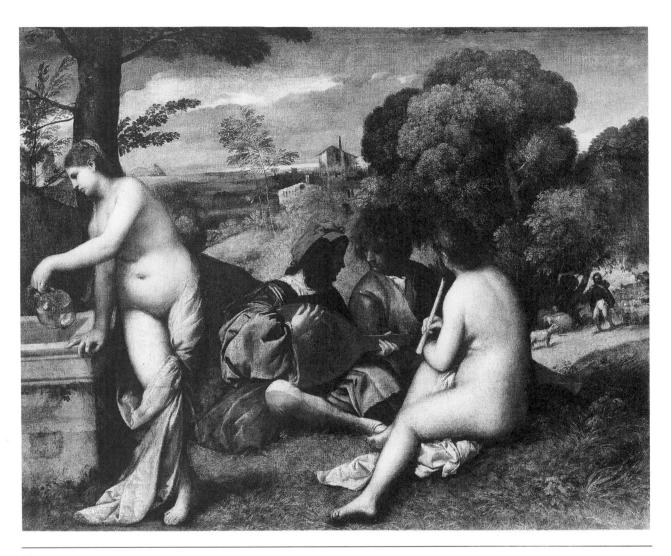

301. GIORGIONE. Concert Champêtre (Pastoral Concert). c. 1510. Oil on canvas, $3'7\frac{1}{4}'' \times 4'6\frac{3}{8}''$ (1.1 × 1.38 m). Louvre, Paris.

GIORGIONE. The full stride of Venetian painting and the High Renaissance is felt in Giorgione's poetic pictures and in those of his close associate, Titian. Giorgione's Concert Champêtre, or Pastoral Concert (Fig. 301), impresses with its spaciousness and its distribution of interest from foreground to background. The eye first is attracted to the four figures of the picture plane, then is led leisurely toward the middle ground where the shepherd is tending his flock, and finally comes to rest on the gleaming water of the distant horizon. This pastoral idyll, or interlude, is enlivened by several oppositions. Among them are the clothed male figures and female nudes; the pairing of the polished courtier and stately lady at the left with the rustic shepherd and shepherdess on the right; the attitudes of the two women—one gazing intently upon her lover, the other turning gracefully away; and the lute symbolizing lyric poetry and the flute, pastoral poetry.

Giorgione's *Tempest* (Fig. 302) is even less concerned with storytelling and more with pictorial construction than his *Concert Champêtre*. The sunny foreground and human figures define the picture plane. Iconographically, a soldier usually personifies fortitude, while a seated mother nursing her child represents love or charity. But the main interest becomes the landscape as the eye is led in receding planes into deep space and the threatening sky in the distance. Stability is maintained by the careful balance of vertical (standing figure, broken columns, trees, buildings) and horizontal (unfinished wall, bridge) lines.

In both the *Pastoral Concert* and the *Tempest*, Giorgione creates a mood rather than tells a story, builds a picture rather than communicates specific meaning. A puzzle to his contemporaries who were accustomed to the usual iconographic subjects, Giorgione is understandable to the modern observer,

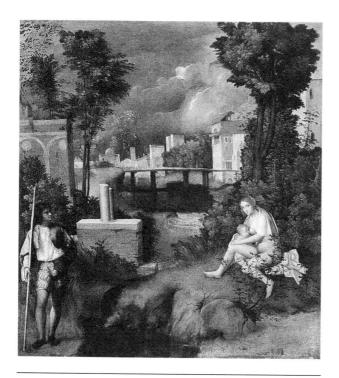

302. GIORGIONE. *Tempest.* c. 1505. Oil on canvas, $32\frac{1}{4} \times 28\frac{3}{4}$ " (82 × 73 cm). Galleria dell' Accademia, Venice.

who is used to separating subject matter from pictorial form and to seeing a picture as a composition complete within itself rather than as an illustration of a religious or literary theme.

TITIAN. Titian's large altarpiece Assumption of the Virgin (Fig. 303) for the church of Santa Maria dei Frari, with its heroic-sized figures, was intended to catch the attention of those entering by the nave portal about 100 yards (91.4 meters) away. Its dynamic vertical movement fits well into the Gothic style of the church. In this dramatic composition, heavenly and earthly spheres converge momentarily. Below, in deep shadow, are grouped the apostles, their arms raised toward the intermediate zone and the ascending Madonna, whose gesture in turn directs the eye to the dazzling brightness above. The upward motion then is arrested by the descending figure of God the Father surrounded by his angels. Linear movement and gradations of light, as well as transitions of color from somber shades to light pastel hues, are skillfully adapted by Titian to carry out his theme of the soaring human spirit triumphant over the gravitational pull of earthly considerations. Titian herewith created a new pictorial type that was to have a profound influence on the mannerist El Greco (Fig. 341), the baroque sculptor Bernini (Fig. 335), and a number of 17th-century painters.

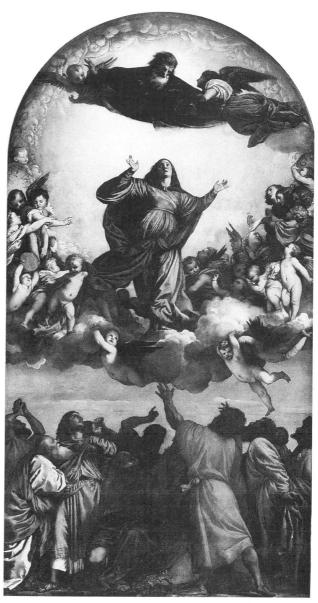

303. TITIAN. Assumption of the Virgin. 1516–18. Oil on canvas, $22'6'' \times 11'8''$ (6.86 \times 3.56 m). Santa Maria dei Frari, Venice.

Titian's sumptuous coloring also became the model for such later Venetians as Tintoretto and for such baroque masters as Rubens and Velázquez. The extraordinary brilliance and bright tonality of the master's palette have been startlingly revealed by recent cleanings of some of his paintings. In his *Bacchus and Ariadne* (Fig. 304) Titian depicts the god's return from India accompanied by his mixed band of revelers. On seeing the lovelorn Ariadne, who has been deserted by her lover Theseus, Bacchus leaps from his panther-drawn chariot, his pink drapery aflutter, to embrace her in wedlock. A fascinating visual rhythm based on the repetition of the V-

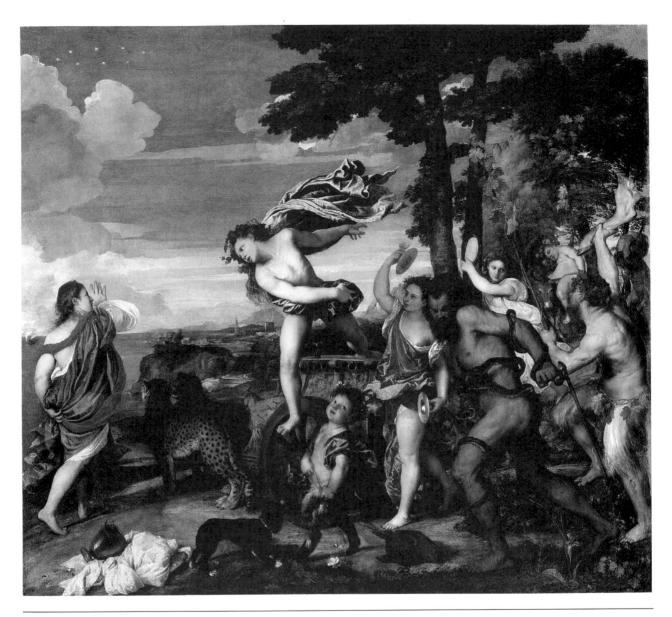

304. Titian. *Bacchus and Ariadne*. c. 1520. Oil on canvas, $5'8'' \times 6'\frac{7}{8}''$ (1.73 × 1.85 m). National Gallery, London (reproduced by courtesy of the Trustees).

shaped tree pervades the composition. In inverted form it is echoed in the limbs of Bacchus and Ariadne. Then it continues across the canvas with the legs of the leopard, the dog, the young faun, and each of the dancing bacchantes.

Titian devises a slashing diagonal direction for the sharp downward plunge of Bacchus. A subtle touch of visual counterpoint can be seen in the sky, where the incident is reenacted by the clouds whose shapes echo the drapery and gestures of the principals, and where the starry crown of immortality awaits Ariadne.

In spite of Titian's compositional innovations and great influence on later periods, his art as a

whole remains within the scope of the Renaissance. The painting of his younger colleague Tintoretto, however, crosses the stylistic bridge and penetrates deep into the expressive possibilities developed in Venetian mannerism.

TINTORETTO. The drawing of Michelangelo and the color of Titian were the twin ideals of Tintoretto. His violent contrasts of light and dark; his off-center diagonal directions; his interplay of the natural and supernatural, earthly and unearthly light, human and divine figures; and his placement of principal figures on the edge of the action, from where he created lines that lead the eye in several different direc-

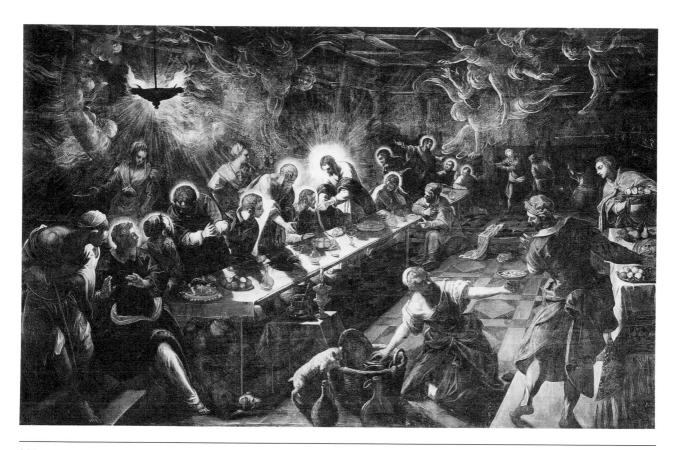

305. Tintoretto. *Last Supper*. 1592–94. Oil on canvas, $12' \times 18'8''$ (3.66 \times 5.69 m). San Giorgio Maggiore, Venice.

tions—all these elements combine to make his art both dynamic and dramatic.

In his *Last Supper* (Fig. 305), Tintoretto represents the miraculous moment when Jesus offers the bread and wine as the sacrificial body and blood of human redemption. To throw light on this unfathomable mystery of faith, Tintoretto bathes his canvas in a supernatural glow that seems to come partly from the figure of Christ and partly from the flickering flames of the oil lamp. The smoke is then transformed into an angelic choir hovering to form a burst of glorious light around the head of Christ. The drastic diagonals of the floor are paralleled by those of the table, but instead of directing the eye to the head of Christ, they lead to an indefinite point in the upper right and to space beyond the picture.

In a more lyrical vein, Tintoretto designs his *Marriage of Bacchus and Ariadne* (Fig. 306) with a rotary movement in which the figures seem to be floating weightlessly in space. This is one of four panels originally painted for the ambassadorial waiting room in the Doge's Palace, each with a political message. One depicts Vulcan in his forge producing armor to signify Venice's industrial might. In another Minerva with her wisdom is repulsing the war

god Mars to proclaim Venice's love of peace. A third shows the doge between figures symbolizing Peace and Justice. And here the seated Ariadne personifies Venice, crowned with the stars of immortality. Bacchus represents the good life providing the fruits of the earth that flow in with the prosperous maritime trade. The hovering Venus as the goddess of love binds both together. The ship on the horizon recalls the grand aquatic ceremony that took place each year when the doge cast a golden ring into the water to symbolize Venice's marriage to the sea.

VERONESE. Paolo Cagliari, known as Veronese, did not scale the heights and plumb the depths as did his colleagues Titian and Tintoretto. Instead, his searching eye sought out the rich and varied surface play of the Venetian scene he saw around him. A painter's painter, Veronese is known for his bravura with the brush, the sensuousness of his surfaces, and the tactile strength of his drawing. In his *Dream of Saint Helen* (Fig. 307), he is not so much concerned with her inner vision as he is with the colorful splendor of his canvas. Helen was the mother of the Emperor Constantine, who became a Christian convert in 313. According to tradition, it was she who first

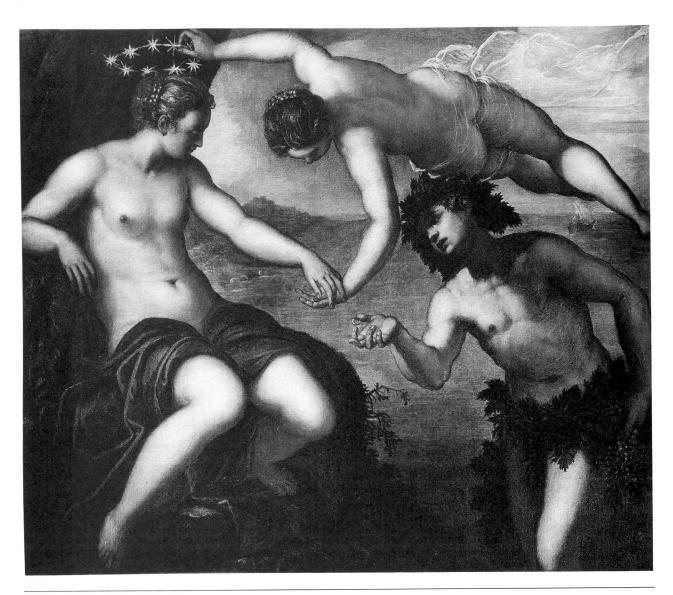

306. Tintoretto. Marriage of Bacchus and Ariadne. 1577–88. Oil on canvas, $4'9'' \times 5'5''$ (1.45 × 1.65 m). Doge's Palace, Venice.

found a relic of the true cross of Christ, and in a vision beheld the location of the Holy Sepulchre. As Veronese portrays her, she is clad in a queenly robe of satin brocade and wearing a bejeweled crown. Veronese revels in the play of light and shade around the rich folds of the drapery, the glow of the gold crown, the shimmer of the pearls. He further excels in rendering the contrasting textures of the marble column, the wood of the cross, and the nude flesh of the angel.

Of all subjects, however, the most congenial to Veronese's art was festivity. Painted with the primary object of delighting the eye, his canvases in this category succeeded in capturing an important part of Venetian life—the pleasure and amusement of large

social gatherings and the love of rich surroundings embellished with fruits, flowers, animals, furniture, draperies, and jesters. The *Feast in the House of Levi* (Fig. 308) was originally painted as a *Last Supper* for the refectory of a Venetian monastery. His composition is held in tight control by the three arches of the loggia setting, which Veronese adapted from the designs Sansovino had made for the interior of the library and the Loggietta at the base of the campanile in St. Mark's Square (Fig. 290). Questions were soon raised, however, about the propriety of its content. By tradition a *Last Supper* portrayed only Christ and the twelve apostles, but Veronese had included some fifty figures, and this departure from tradition brought him before the Inquisition court.

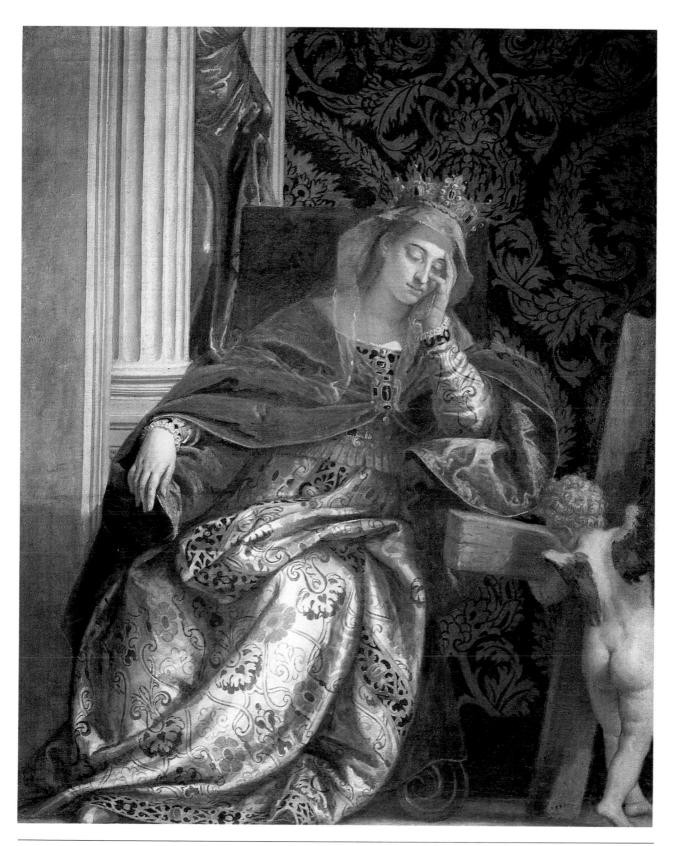

307. Paolo Veronese. *Dream of St. Helen.* c. 1580. Oil on canvas, $5'5\frac{1}{3}'' \times 4'4\frac{3}{4}''$ (166 \times 134 cm). Vatican, Pinacoteca.

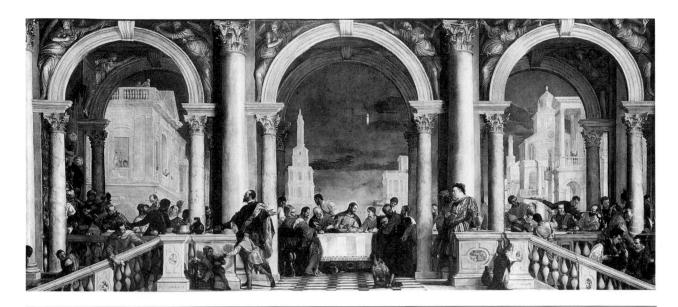

308. PAOLO VERONESE. Feast in the House of Levi. 1573. Oil on canvas, $18'2'' \times 42'$ (5.54 × 12.8 m). Galleria dell' Accademia, Venice.

In one of the most remarkable documents in the history of painting—a summary of the painter's actual testimony—much about this picture in particular and about Veronese's conception of art in general is revealed. The inquisitors were disturbed not only by the number of figures but by the presence of a dog and cat, which Veronese had painted in the foreground. Even more disturbing was the inclusion of German soldiers sitting on the staircase at the very time when the Roman Catholic Church was experiencing a theological confrontation with the Lutheran Reformation in Germany.

QUESTION. Did anyone commission you to paint Germans, buffoons, and similar things in that picture?

ANSWER. No, milords, but I received the commission to decorate the picture as I saw fit. It is large and, it seemed to me, it could hold many figures.

- Q. Are not the decorations which you painters are accustomed to add to paintings or pictures supposed to be suitable and proper to the subject and the principal figures or are they just for pleasure—simply what comes to your imagination without any discretion or judiciousness?
- A. I paint pictures as I see fit and as well as my talent permits.

- Q. Does it seem fitting at the Last Supper of the Lord to paint buffoons, drunkards, Germans, dwarfs and similar vulgarities?
- A. No, milords.
- Q. Do you not know that in Germany and in other places infected with heresy it is customary with various pictures full of scurrilousness and similar inventions to mock, vituperate, and scorn the things of the Holy Catholic Church in order to teach bad doctrines to foolish and ignorant people?
- A. Yes, that is wrong; but I return to what I have said, that I am obliged to follow what my superiors have done.
- Q. What have your superiors done? Have they perhaps done similar things?
- A. Michelangelo in Rome in the Pontifical Chapel painted Our Lord, Jesus Christ, His Mother, St. John, St. Peter, and the Heavenly Host. These are all represented in the nude—even the Virgin Mary—and in poses with little reverence.*

^{*}Literary Sources of Art History: An Anthology of Texts from Theophilus to Goethe, ed. Elizabeth G. Holt (copyright © 1947, 1975 by Princeton University Press), reprinted by permission of Princeton University Press.

The figures seated with Jesus at the damask-covered table should be the twelve apostles, but only two could be specifically identified by the artist—St. Peter, on his right, in robes of rose and gray, who according to the painter is "carving the lamb in order to pass it to the other end of the table"; and St. John, on his left. When questioned about the other figures, Veronese was evasive and pleaded that he could not recall them as he had "painted the picture some months ago." Since but ten months had passed, this was his way of avoiding explanation of the portraits of Titian and Michelangelo seated at the table under the left and right arches, respectively.

The verdict required Veronese to make certain changes in the picture. Rather than comply, he simply changed the title to *Feast in the House of Levi*, thereby placing it outside the iconographic tradition. The controversy with the Inquisition is a landmark in art history. By defending his work, Veronese raised aesthetic and formal values above those of subject matter.

Music

The high peak of Renaissance musical development was the polyphonic style of the Netherland composers. The general admiration for this art at the beginning of the 16th century was summed up by the Venetian ambassador to the court of Burgundy, who, in effect, said that three things were of the highest excellence: first, the finest, most exquisite linen of Holland; second, the tapestries of Brabant, most beautiful in design; and third, the music, which certainly could be said to be perfect. With such sentiments being expressed in official circles, it is not surprising to find that a Netherlander, Adrian Willaert, was appointed in 1527 to the highest musical position in Venice—choirmaster of St. Mark's.

Adoption of the northern musical idea is but another instance of the internationalism of the Venctians. Under Willaert, a leading representative of the polyphonic art, and his successors, Venice became a center of musical progress, while Rome remained the fortress of tradition. The measure of its religious freedom also predisposed Venice to new developments, and a number of new musical forms and radical changes of older ones were the results. In vocal music, this meant the development of the madrigal, the modification of the church motet, and the development of the *polychoral style* that made simultaneous use of two, three, and sometimes four choirs.

Instrumental music found new forms in the organ *intonazione* (short prelude), *ricercare* (contrapuntal composition), and *toccata* (brilliant showpiece) for keyboard solo, and in the *sinfonia* and

early *concertato* and *concerto* forms for orchestra. Here the Venetian school spoke in a new voice and in tones of individual character.

During the late 16th century, as it gradually lost favor, the old *ars perfecta* became known as the *stile antico*, in contrast to the *stile moderno*. This "modern style" was associated in Venice with Giovanni Gabrieli and his organ music, early orchestral writing, and the development of the polychoral style. In Florence it was associated with Vincenzo Galilei, Peri, and Caccini and their solo songs and early opera experiments. In Rome, Frescobaldi and his virtuoso organ works were linked to the modern style. And in Mantua and Venice, Claudio Monteverdi, whose madrigals and operas became the cornerstone of baroque music, was another leader in this new style.

Gabrieli. The culmination of the musical development that Willaert began was reached in the work of Giovanni Gabrieli, who held the position of first organist at St. Mark's from the year 1585 until his death. His principal works were published under the title of *Symphoniae Sacrae* in 1597 and 1615.

The domed Greek-cross plan of St. Mark's, with its choir lofts placed in the transept wings, seems to have suggested some unusual acoustical possibilities to composers. When a choir is concentrated in the more compact space beyond the transept, as in the traditional Latin-cross church, the body of sound is more unified. When placed in two or more widely separated groups, as at St. Mark's, the interplay of sound led to experiments that resulted in the so-called polychoral style. In effect, it dissolved the traditional choruses and heralded a new development in the choral art.

These *chori spezzati*—literally, "broken choruses"—as they were called, added the element of spatial contrast to Venetian music, and new color effects were created. These included the echo device, so important in the entire baroque tradition; the alternation of two contrasting bodies of sound, such as chorus against chorus, single line versus a full choir, solo voice opposing full choir, instruments pitted against voices, and contrasting instrumental groups; the alternation of high and low voices; a soft level of sound alternated with a loud one; the fragmentary versus the continuous; and blocked chords contrasting with flowing counterpoint.

The resultant principle of duality, based on opposing elements, is the basis for the *concertato* or *concerting* style. The word appears in the title of some works Giovanni published jointly with his uncle Andrea Gabrieli in 1587: *Concerti . . . per voci et stromenti* ("Concertos . . . for voices and instru-

ments"). The term later came to be widely used, with such titles as *Concerti Ecclesiastici (Church Concertos)* appearing frequently.

The motet *In ecclesiis* (below), written as the second part of the *Symphoniae Sacrae*, is an example of Gabrieli's mature style. Though the specific occasion for which it was intended is unknown, Gabrieli's motet is of the processional type and as such appropriate music for ceremonies similar to that depicted in Bellini's picture (Fig. 290). And the choirs he arranged in groups, as well as a brass ensemble, are similar to Bellini's details (Fig. 309).

In ecclesiis (processional motet)

Giovanni Gabrieli

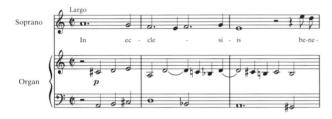

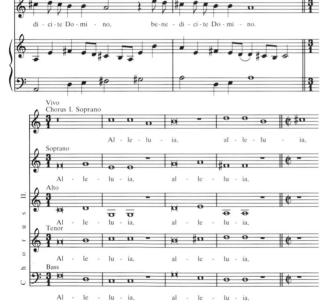

Since Bellini's setting was St. Mark's Square, all the Venetian love of civic pomp and splendor are in evidence, and Gabrieli's music was in every respect quite able to fulfill the similar demands of any such later outdoor ceremony. His art was as typical of its time and place as that of his colleagues in other arts—Titian, Veronese, Sansovino, Palladio.

The structure of Gabrieli's motet is based on the word *alleluia*, which functions as a *refrain*, or recurring section, and acts as a divider between the verses. The alleluias also are set in the more stationary triple meter suggesting a pause in the procession,

309. Gentile Bellini. *Brass Ensemble*. Detail of Figure 290.

while the stanzas have the more active beat of footsteps as in march time.

The gradual buildup of volume can be heard in the sequence of sopranos and full chorus; tenors and full chorus; the instrumental sinfonia first alone, then in combination with tenors and altos; and the instrumental color against the chorus with organ support. The cumulative climax is then brought about by the final grandiose union of all vocal and instrumental forces, ending in a solid cadence radiating with musical color and producing the huge sonority necessary to bring the mighty work to its close. The magnificence of these massive sounds seems to fill the out-of-doors, just as it filled the vast interior of St. Mark's.

Giovanni Gabrieli's music foreshadows the baroque by setting up such oppositions as chorus against chorus, solo and choir, voices versus instruments, strings alternating with wind ensembles; the interplay of harmonic and contrapuntal textures; diatonic and chromatic harmony; the oppositions of soprano and bass lines, loud and soft dynamics; and the distinction of sacred and secular styles.

Monteveror. While Gabrieli's vast tonal murals became the precedent for the later "colossal baroque," it remained for his great successor, Claudio Monteverdi, to probe the inner spirit of the new style. With Monteverdi in music, as with Longhena in architecture, the transition to the baroque is evident. Appointed master of music of the Most Serene Republic of Venice in 1613 after serving as court composer at Mantua for 23 years, Monteverdi achieved a working combination of Renaissance counterpoint and all the experimental techniques of his own time.

At Mantua, Monteverdi had already written his *Orfeo* (1607), a complete opera in the modern sense with overture, choruses, vocal solos and ensembles, instrumental interludes, and ballet sequences. At Venice, where the first public opera house was established in 1637, he continued with a series of lyrical dramas of which only the last two survive: *Return of Ulysses* (1641) and the *Coronation of Poppea* (1642). Both operas are heard today in concert performance and international opera houses with increasing frequency.

In addition, Monteverdi gave a new twist to the Renaissance *madrigal*, a type of nonchoral vocal music for two or more singers, each of whom has a separate part. The madrigal with lyrics devoted to the delights of love and the beauties of nature reached a high point of popularity in 16th-century Italy and also in the England of Queen Elizabeth. With Monteverdi, however, the madrigal took on a special emotional and dramatic character that paralleled the developments in visual mannerism.

The new emotional orientation is stated in Monteverdi's Eighth Book of Madrigals (1638): "I have reflected that the principal passions or affections of our mind are three, namely, anger, moderation, and humility or supplication; so the best philosophers declare, and the very nature of our voice indicates this in having high, low, and middle registers. The art of music also points clearly to these three in its terms 'agitated,' 'soft,' and 'moderate' [concitato, molle, and temperato]." The collection has the significant subtitle "Madrigals of War and Love," and Monteverdi says he intends to depict anger, warfare, entreaty, and death as well as the accents of brave men engaged in battle. According to Monteverdi, vocal music of this type should be "a simulation of the passions of the words." Descriptive melodies in this representative style reflected the imagery of the poetic text. In Monteverdi's madrigal Zefiro torna ("Return, O Zephyr"), the word l'onde ("waves") is expressed by a rippling melody, while da monti e da valli ime e profonde ("from mountains and valleys high and deep") is rendered by sharply rising and falling lines.

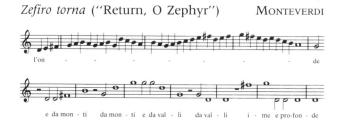

MANNERIST EUROPE, 16TH CENTURY

In the 16th century Europe was in a state of acute crisis. A series of catastrophic events both worldly and spiritual awakened the major centers of power from Renaissance dreams of harmony and confronted them with the realities of contradiction and conflict. Every aspect of life—religious, scientific, political, social, economic, personal, aesthetic—was destined to undergo reexamination and radical change.

In Britain Henry VIII broke with Rome and established the Church of England. On the Continent the moral zeal and desire for reform of Martin Luther, John Calvin, and others divided Europe into Reformation and Counter-Reformation camps. Territorial ambitions and the lust for conquest brought a clash of wills between Emperor Charles V and King Francis I of France. Feeling his country caught up in a giant squeeze play, Francis tried to fortify his position by invading northern Italy. But the king was no match for the powerful Holy Roman Emperor. Previously, the voyages of the great navigators and the exploits of the colonizers who followed in their wake had brought most of North, Central, and South America under the Spanish crown. With the monopoly of the spice trade of the Orient and with the gold and silver mines of the New World pouring fabulous riches into its treasury, Spain was rapidly becoming the most powerful country in the world. With the Spanish crown and the lordship of Holland, Flanders, the Germanies, and Austria firmly in his grasp, Charles next turned his attention to Italy. One by one the formerly independent Italian duchies and city-states came under his domination. Opposition from any quarter was intolerable, and in 1527 His Catholic Majesty's mercenaries marched on Rome, sacking and plundering. Eight days later the eternal city was a smoking ruin, the Vatican a barracks, St. Peter's a stable, and Pope Clement VII a prisoner at Castel Sant' Angelo. Among the resident artists who fled the scene were Sansovino (to Venice), Parmagianino (to Parma), and Benvenuto Cellini (to France).

Thereafter the papacy had no choice but to submit to Spanish policy. A Spanish viceroy ruled in Naples, and a Spanish government was installed in Milan. Through the Gonzagas in Mantua, the Estes in Ferrara, and the Medici in Florence the Spaniards controlled all important centers, and with Spanish rule came Spanish austerity and religiosity, etiquette and courtly elegance.

The new scientific theories and discoveries were equally unsettling. In 1543 the astronomer

Copernicus brought out his book *On the Revolution of the Planets in Their Orbits*, a work destined to change the conception of the cosmos from an earth-centered to a sun-centered universe. A shock reaction followed as Renaissance people began to realize they inhabited a minor planet whirling through space, that they were no longer at the center of creation. Later, when his observations tended to prove the Copernican theory, Galileo was tried for heresy, sentenced to prison, and released only when he disavowed his teachings and writings. The combined effect of these and other scientific discoveries, however, began to weaken general belief in miracles and divine intervention in human affairs.

Peasant revolts, invasions by the Ottoman Turks, piracy at sea, trials by the dreaded Universal Inquisition followed by the burning of heretics, and religious and civil wars completed the turbulent picture. Such a seething of currents and crosscurrents, new and old directions, inner anxieties and contradictions was bound to find expression in the arts.

INTERNATIONAL MANNERISM

As a historical phenomenon, mannerism runs its erratic course from about 1530 to 1590, sandwiched between the dying Renaissance and the forthcoming baroque style. Like the crisis it reflects, mannerism points in many directions. Any discussion of mannerism should probably refer to mannerisms, since so many different centers, conflicting trends, varieties of patrons and personalities, and individual idioms are involved. The word itself admits of several meanings. Maniera in Italian denotes manner or style. In English "mannered" indicates, somewhat derogatorially, a highly personal, idiosyncratic, affected, exaggerated mode of behavior. In the arts all forms of mannerism imply fluency, virtuosity of execution, a high degree of sophistication, a sense of stylishness, often leading to a certain over-refinement and self-consciously contrived attitudes.

Living in the shadow of such unrivaled masters of the immediate past as Leonardo da Vinci, Michelangelo, and Raphael created a dilemma for the younger generation of painters. They were very much aware that a golden age had preceded them and that there was no possibility of their improving on the craftsmanship of their famous predecessors. These young artists therefore found themselves at a crossroads. Following the old paths would mean selecting certain ideas and techniques of their predecessors and reducing them to workable formulas. Striking out in new directions would imply taking for granted such perfected technical achievements as linear and atmospheric perspective, mathematically

correct foreshortening, and anatomically correct renderings—if only to deliberately break these rules with telling and dramatic effects.

The first course meant working "in the manner" of the giants of the past, and academies sprang up to transmit the traditional techniques to young artists. When Vasari, the disciple of Michelangelo, used the term *de maniera*, he meant working in the manner of Leonardo, Michelangelo, and Raphael. By reducing their art to a system of rules, he could work fast and efficiently. His fondest boast was that while it took Michelangelo six years to finish one work, he could do six works in one year.

The experimental stage was over; the era of fulfillment was at hand. This was not a time of eccentric genius or soul-searching prophecy, only a period of competent craftsmanship. Such was the course that was followed by Vasari, Palladio, and Veronese. In Florence, Vasari was instrumental in founding an academy of design in 1561. At Bologna in 1585, the Carracci family established an institute with the significant word *academy* in its name, and courses in art theory and practice were offered.

Such academic mannerist artists did not go to nature for their models, as Leonardo had done, but studied great works with the thought of mastering systematically the artistic vocabularies of the late Renaissance geniuses. Art, in other words, did not hold up a mirror to nature but rather to art. At the lowest level, this implied well-schooled technicians and a style based on conventions—a free borrowing and reassembling without the birth pangs of the original creative synthesis. At its highest, this approach could lead to virtuosity of execution. In no way did it rule out that intangible essence inspiration. So it was with the Florentine mannerist Rosso Fiorentino, who followed in the footsteps of Michelangelo. Rosso's tumultuous canvas (Fig. 310), with its muscular Michelangelesque male nudes, is a typical example of this aspect of mannerism.

With Palladio, academic mannerism came to terms with the classical orders of his ancient Roman guide Vitruvius. By adapting Roman architectural forms to his contemporary needs, he held in check the Venetian love of lavishness and curbed the excesses of overdecoration. Veronese, by the symmetry of his designs, his closed forms, and the organizing function of his architectural backgrounds, was able to handle large crowds and bustling movement without injury to his pictorial unity, as in the *Feast in the House of Levi* (Fig. 308). And while Gabrieli's music broke up the unity of the Renaissance choir—encompassing and increasing the scope of musical space—his support of the traditional Renaissance polyphony kept his work under strict control.

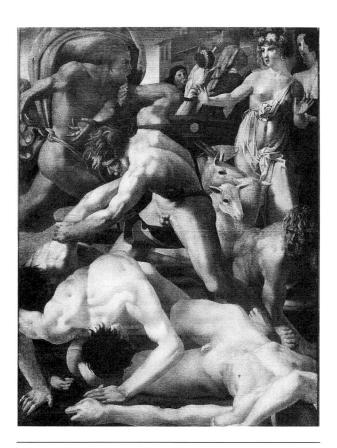

310. Rosso Fiorentino. *Moses Defending the Daughters of Jethro.* 1523. Oil on canvas, $5 \times 4'$ (1.52 \times 1.22 m). Galleria degli Uffizi, Florence.

Thus in one instance mannerism can be considered as the extension, codification, and academic adaptation of the ideals of the High Renaissance. The more striking aspect of mannerism, however, lies in the violent reactions to and bold, dramatic departures from Renaissance rules and decorum. It was this trend that loyal followers of the Renaissance saw as the collapse of an ideal order and the adoption of an "affected manner" by highly idiosyncratic artists.

This generation of painters could no longer be thrilled by the mathematics of linear perspective or by finding the proper size and relationship of figures to their surrounding space. Instead, they found excitement in breaking established rules with dash and daring and in violating Renaissance assumptions for the sheer shock effect. Under such conditions, a number of changes occurred. Naturalism gave way to the free play of the imagination. Classical composure yielded to nervous movement. Clear definition of space became a jumble of picture planes crowded with twisted figures. Symmetry and focus on the central figure were replaced by off-balance diagonals that made it difficult to find the protagonist of the drama amid the numerous directional lines. Back-

grounds no longer contained the picture but were vaguely defined or nonexistent. The norms of body proportion were distorted by the unnatural elongation of figures. *Chiaroscuro*, the art of light and shade, served no more to model figures but to create optical illusions, violent contrasts, and theatrical lighting effects. Finally, strong deep color and rich costumes faded to pastel hues and gauzy, fluttering drapery. In short, the Renaissance dream of clarity and order became the mannerist nightmare of haunted space, art was in danger of becoming artifice, and the natural gave way to the artificial.

Some of these tendencies were already present in the High Renaissance. Giorgione's puzzling pictures that broke with the iconographic tradition confused his contemporaries. In Leonardo's *Madonna and Child with St. Anne* (see Fig. 247) the figures are uncomfortably superimposed on each other; how St. Anne supports the weight of the Madonna and what they are sitting on is left to the imagination. In the black terror and bleak despair of Michelangelo's *Last Judgment* (see Fig. 322), clarity of space no longer exists—there are crowded parts and bare spaces; the size of figures is out of proportion; and one cannot even be sure who are the saved and who the damned.

The exception in the High Renaissance, however, became the rule under mannerism, which quickly, though briefly, emerged as an international style. Such Florentine mannerists as Rosso Fiorentino and Benvenuto Cellini were summoned to Paris to become court artists of Francis I, and Raphael's pupil Giulio Romano was the official architect of the Duke of Mantua.

In spite of their desire to dazzle and their whimsically contrived tricks, these men had no intention to deceive, since their art was addressed to the sophisticated few. Only those well aware of the rules could enjoy the witty turns and startling twists by which they were broken. This courtly phase of the mannerist style, however, was too much restricted to a single class and too refined and self-conscious in its aestheticism to endure for long.

Painting: Pontormo, Parmagianino, Bronzino

Pontormo's *Joseph in Egypt* (Fig. 311) was painted on commission for a bedroom in a Florentine palace. This appropriately dreamlike canvas is like a picture puzzle, the parts of which do not quite fit. The story is told in three scenes, with Pharaoh's dream in the upper right, the finding of the cup in Benjamin's sack in the center, and Joseph's reconciliation with his brothers at the left. The unified space of the Ren-

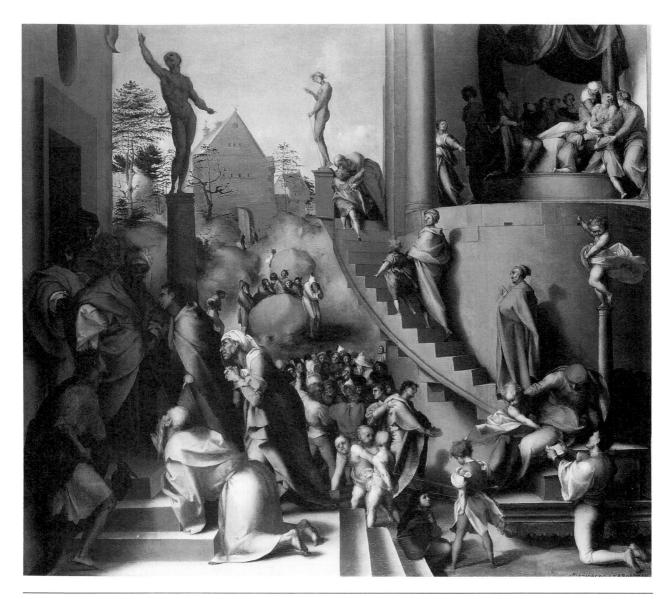

311. Jacopo Pontormo. *Joseph in Egypt.* 1518. Oil on canvas, $38 \times 43\frac{1}{8}$ " (96.52 × 109.47 cm). National Gallery, London (reproduced by courtesy of the Trustees).

aissance and the logical diminution of figures as they recede from the picture plane are deliberately violated. The kneeling figure in the right foreground is half the size of his counterpart on the left. The winding staircase that goes nowhere, the statues that gesticulate like stage actors, and the capricious flickering of light and shadow over the surface of the picture all add to the strange, enigmatic atmosphere.

Gracefulness, elegance, and extreme refinement characterize Parmagianino's picture called the *Madonna with the Long Neck* (Fig. 312). To approach his ideal of beauty the artist deliberately distorts human anatomy for expressive purposes. The swanlike neck is paralleled by the strange rising column that supports nothing. The length of her hand, the

delicate tapering of her fingers, and the elongated body of the child provide balancing horizontal accents. The serpentine posture of Mary terminates in the unnatural elongation of her right foot and left leg. The prophet on the right (Isaiah?) in a calculated violation of normal perspective completes this amazing excursion into artistic license.

Back in Florence, Bronzino came by his mannerism naturally, since he was a pupil of Pontormo, who portrays him as the boy sitting on the steps of the middle foreground of Figure 311. He is best known for the icy formalism of his elegant court portraits of the local aristocracy. In his *Allegory of Venus* (Fig. 313) Bronzino makes one of his excursions into mythological metaphor. The number of figures is

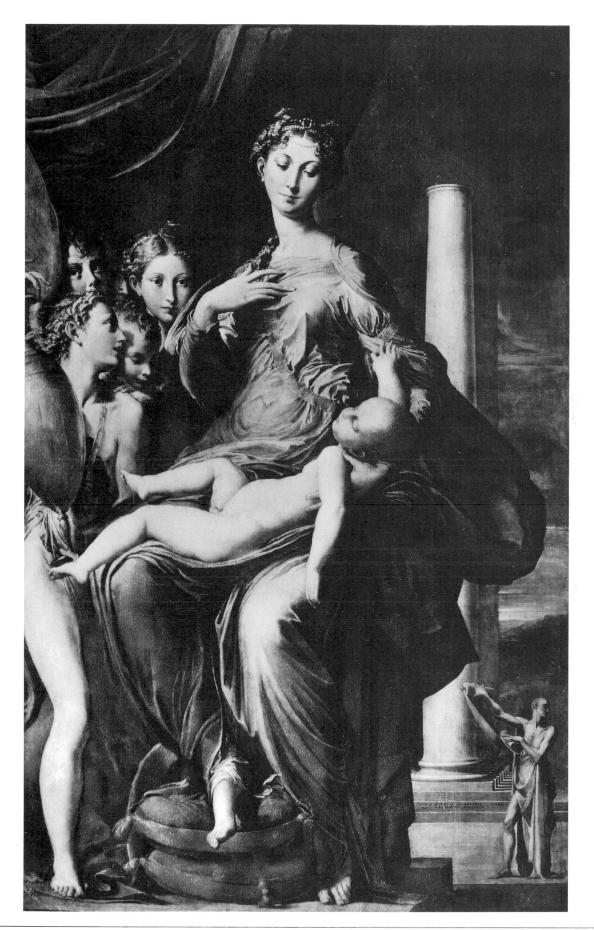

312. Parmingianino. Madonna with the Long Neck. 1534–40. Oil on wood, $85 \times 52''$ (216 \times 132 cm). Galleria degli Uffizi, Florence.

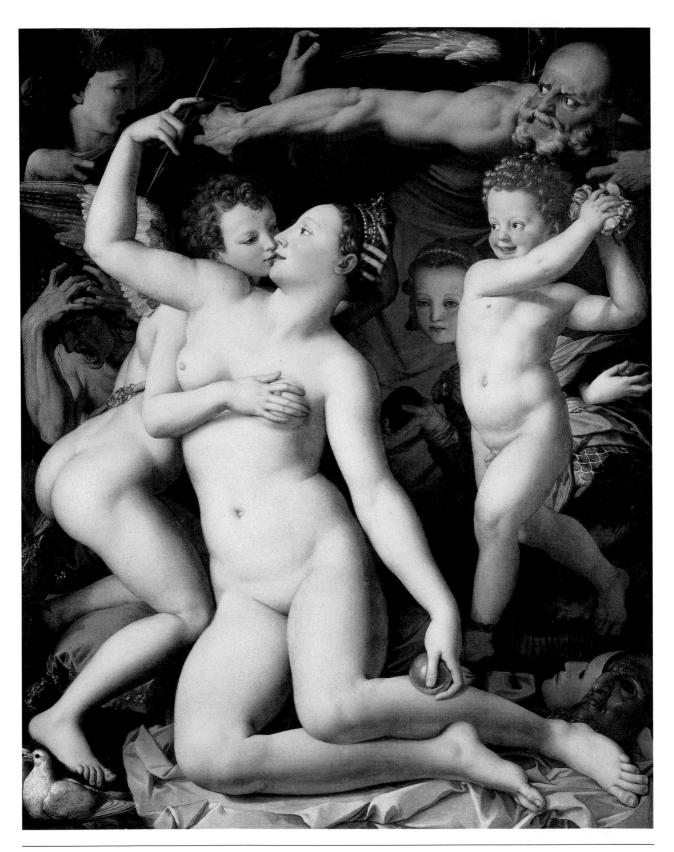

313. Bronzino. *Allegory of Venus.* c. 1550. Oil on wood, $4'9'' \times 3'9''$ (1.45 \times 1.14 m). National Gallery, London (reproduced by courtesy of the Trustees).

enough to fill a large-scale mural, but here they are intertwined and crowded into a cramped, claustrophobic space. The muscular, Michelangelesque arm of Time aided by Truth at the top is drawing a curtain to expose the tableau vivant below. This arm, coupled with Venus's legs below and the standing figures of Cupid and Folly, frames the picture. The ardent caresses of Cupid certainly exceed the usual demonstrations of affection by a son for his mother. Behind them the old hag Envy clutches her hair despairingly while turtledoves bill and coo below. The innocent face of the figure identified as Fraud or Inconstancy lurks in the right background. She holds a honeycomb in a left hand that is grafted onto her right arm. Further deception is seen in her lion's legs and her coiling, scaly serpent's tail. The masks in the lower right cast the whole scene as a theater piece.

The last and perhaps greatest of mannerist painters, El Greco, carried the style to Spain, where he transformed mannerism into an art of burning religious fervor and spiritual incandescence (see pp. 356–360).

Sculpture: Cellini and Bologna

Today Benvenuto Cellini's reputation rests more on his flamboyant, swaggering autobiography than on his surviving works. Probably as much fiction as fact, the autobiography portrays Cellini as a soldier of fortune, a statesman, an ardent lover, as well as a sculptor. He provides an eyewitness account of Charles V's sack of Rome, and he was imprisoned there because of his involvement in a violent crime. After a spectacular escape, he fled to France. Although he was first and foremost a goldsmith, only one such work survives that can be attributed to him, the saltcellar executed for Francis I (Fig. 314). The workmanship shows the over-refined and pre-

314. Benvenuto Cellini. Saltcellar of Francis I. 1540–43. Gold, chased and partially enameled; base made of ebony; $10\frac{1}{4} \times 13''$ (26 × 33 cm). Kunsthistorisches Museum, Vienna.

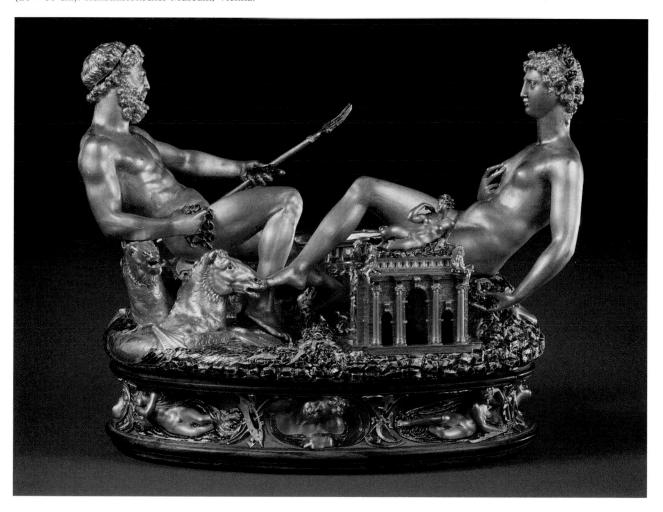

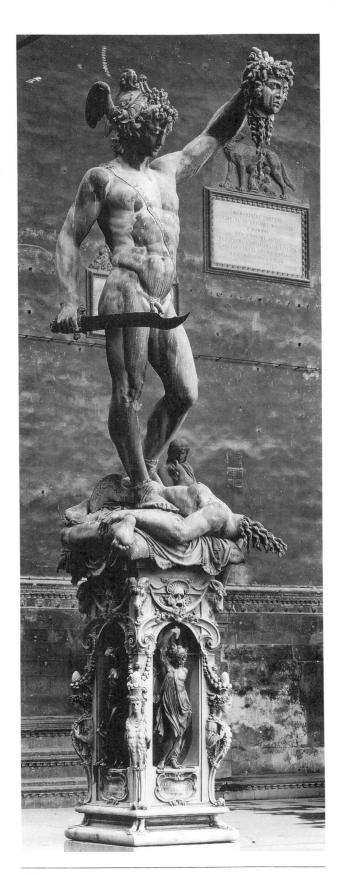

315.Benvenuto Cellini. *Perseus and Medusa.* 1545–54. Bronze, height 18' (5.49 m). Loggia dei Lanzi, Florence.

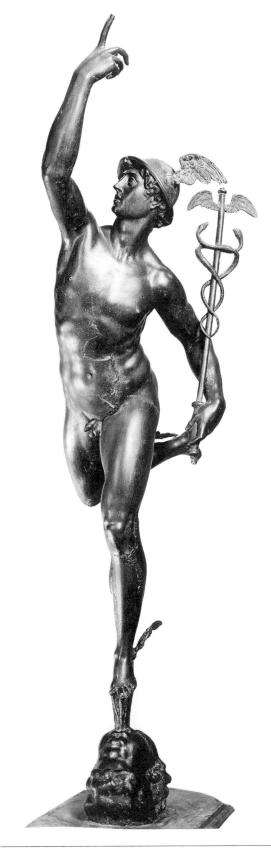

316. GIOVANNI BOLOGNA. *Winged Mercury*. c. 1574. Bronze, height 5'9" (1.75 m). Bargello, Florence.

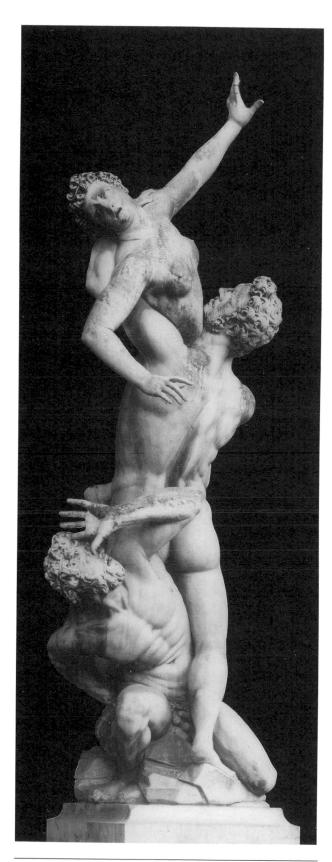

317.GIOVANNI BOLOGNA. *Rape of the Sabine Women*. 1583. Marble, height 13'6" (4.11 m). Loggia dei Lanzi, Florence.

cious side of manneristic art. Referring to the two figures, he writes that Earth is "fashioned like a woman with all the beauty of form, the grace and charm, of which my art was capable." As Earth's limbs become erotically entwined with her opposite, Water, the two meet and merge with a promise of future fertility. He also describes the large-scale bronze-casting methods he used in the over-life-sized, free-standing statue of *Perseus with the Head of Medusa* (Fig. 315). Here he chooses the moment just after the decapitation as Perseus holds high the head with its coiling, snaky locks while blood gushes forth in intricate patterns.

Elegance of design, polished craftsmanship, and fluency of line mark the sculpture of Giovanni Bologna. *Winged Mercury* (Fig. 316) with its delicate balance and extraordinary technical dexterity has with justification become the gleaming symbol of the modern communications industry.

For his group that was later called Rape of the Sabine Women (Fig. 317), Giovanni Bologna set himself the task of probing the limits of motion and emotion that could be expressed in marble. The writhing, rotary serpentine movement spirals upward from the crouching elderly male figure through the twisting tension of the young man's muscular body to the wildly outflung arms of the girl. In spite of the violent centrifugal motion, the action is contained within an open cylindrical space. The obvious precedent is the ancient Laocoon Group (Fig. 83). But, unlike this classical model, which is frontally oriented, Giovanni's design was meant for an outdoor setting where it could provide variety and interest when seen from any angle. Born in Flanders and trained in northern Europe, Giovanni Bologna worked mainly in Florence, where he became a dominating force in Italian sculpture. He was, in fact, the link between Michelangelo and Bernini, between the Renaissance and the baroque styles.

Architecture: Romano, Scamozzi, Zuccari

The shapes mannerism assumed in architecture are many and varied. Giulio Romano built the Palazzo del Tè, or "Tea Palace" (Fig. 318), outside Mantua in northern Italy for the pleasure of the ducal family. To enclose the formal garden he constructed a wall of heavily rusticated masonry far too massive for its function. Strong Doric columns rise upward only to support the frieze. This dramatic overstatement, however, pales in comparison with the somewhat unnerving effect of the frieze itself, in which every third triglyph slips downward a notch, thus creating a lively syncopated visual rhythm. Small frameless windows are crowded between the closely spaced

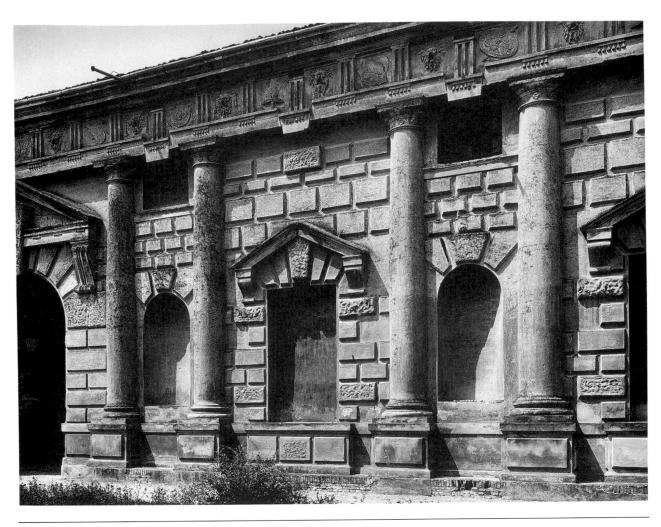

318.GIULIO ROMANO. Detail of courtyard, Palazzo del Tè, Mantua. 1525–35.

columns at the top, while the heavily pedimented windows below are blind. The intent was obviously to make an architectural caprice for the delight of his sophisticated clients. Giulio Romano's handling of the classical orders and detail recalls an aphorism in a letter to him from the witty Venetian writer Pietro Aretino, who said of his style, "Always modern in the antique way and antique in the modern way."

In Venice, meanwhile, Scamozzi, the younger collaborator of both Sansovino and Palladio, was commissioned in 1584 to add a wing to Sansovino's Library. Extending the side toward St. Mark's Square, the wing would house the Procuratie Nuove, the new civic agencies (Fig. 319). His design shows the usual Palladian sharp angularity, but he turned to Michelangelo for the alternation of semicircular and angular window brackets. A touch of manneristic whimsy is found in the insecurely perched nudes on top of the third-story window

brackets, which he borrows directly from Michelangelo's tombs for the Medici dukes in Florence.

In Rome, Federico Zuccari built himself a house he described as a poetic caprice, one that carries mannerism into the realm of the grotesque. The windows, doors, and the monstrous entrance portal (Fig. 320) seem to come right out of Dante's *Inferno*.

IDEAS

Dynamic Space and Time

In both Venetian Renaissance art and mannerism a quickening of pace and an increased sense of action in space and time are apparent. Venetian space is never in repose but is restless and teeming with action. Sansovino's and Palladio's buildings, with their open *loggias*, or galleries, recessed entrances and windows, and pierced, deep-cut masonry, invite

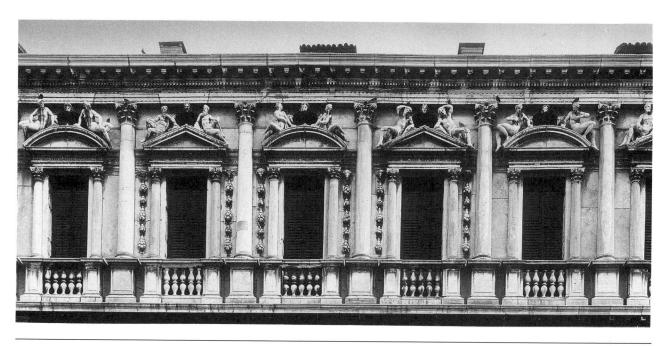

319. VINCENZO SCAMOZZI. Detail of façade, Procuratie Nuove, Venice. 1584.

entrance. Inside, their spacious interiors allow for freedom of movement. Action is also felt in the lively contrasts of structural elements and decorative details, rectangularity side by side with roundness, and complete and broken intersecting pediments. Palladio's churches, with their open semicircular colonnades around the altar and windows in the apse, allow the eye to continue into deep space beyond. The reflection of façades in the rippling waters of the canals and the use of mirrored interior walls serve to activate the heavy masses of masonry and to increase the perception of light and space.

The breaking up of Renaissance unity in the composition of Venetian paintings is a similar instance in two dimensions. Dynamic rather than stable space is felt in the winged balance of opposite forms and figures on the picture plane and in the receding planes of a composition in depth that let the eye travel from foreground to middle ground and background with points of interest in each succeeding plane. Both devices can be seen in Giorgione's Concert Champêtre and Tempest (Figs. 301, 302). Similarly, active space is achieved by the rising planes of a vertical organization, as in Titian's Assumption, and by the wheel-like rotary movement Tintoretto sets up in his Marriage of Bacchus and Ariadne (Fig. 306). The diagonal accent is found in the slashing movement from upper right to lower left in Titian's Bacchus and Ariadne (Fig. 304). In the pictures of Tintoretto and Veronese, breaking up the unity of

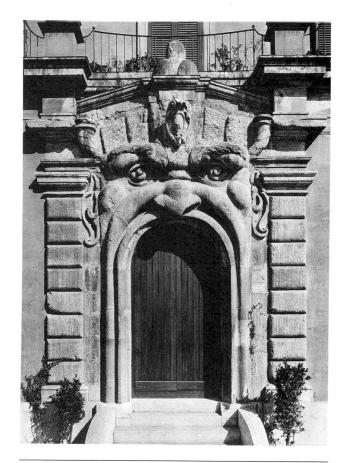

320. FEDERICO ZUCCARI. Palazzetto Zuccari, Rome. c. 1593. Detail, entrance portal.

central perspective produces a fragmentation that leads the eye simultaneously in several directions.

A similar expression is heard in music. In Gabrieli's "broken" choirs, parts of one group are contrasted with the full sound of a whole chorus, and the sequence of contrasting sound progressively builds up ever-larger volumes until the climax is reached in the union of them all. The tossing back and forth of contrasting, unequal sound masses in the concerting style; the alternation of loud and soft dynamic levels of opposing groups as well as in the Venetian echo effect; and the contrast of high and low parts—all intensify the motional and emotional effects of music.

The increase in spatial and temporal dimensions in all the arts is also striking. Palladio's villa interiors are designed for large gatherings and to impress visitors by their spaciousness, so necessary to the grand manner of living to which his clients aspired. His preference for central plans in such private dwellings as the Villa Rotonda and for church buildings as well is, he says, because "none is more capacious than the round." The growth in the size of paintings by Titian, Veronese, and Tintoretto is a phenomenon in itself. The dimensions alone predispose them to the monumental. (The finished version of Tintoretto's colossal Paradise mural in the Doge's Palace has more than 500 figures and measures about 72 by 23 feet [21.9 by 7 meters].) The grandeur of sound produced by the vast musical resources Gabrieli marshaled for his impressive polychoral motets also exceeded anything before their time. The Venetian ideal of the human figure is likewise large and ample. Womanhood, draped and undraped, approaches the monumentality of the spacious façades, the large canvases, and the huge sonorities of polychoruses. All point in the direction of the grandiose.

The sense of dynamism is all-pervasive in the work of the mannerists, completely upsetting Renaissance equilibrium. The canvases of Pontormo teem with activity, and the figures seem to be moving in all directions at once. In the crowded compression of Bronzino's allegory the characters almost burst their bonds. Giovanni Bologna's Mercury speeds along with lightning swiftness, while his *Rape of the Sabine Women* writhes and turns. The very space around his statues seems to be in vibrant motion.

ROADS TO THE BAROQUE

From Venice, as well as from Rome and the centers where international mannerism flourished, the roads to the baroque fanned out in all directions. The

thriving painting industry assured the circulation of Venetian ideas in every civilized country. The writings of Palladio, as translated in English with commentary by Inigo Jones, led to the architecture of Christopher Wren and the Georgian styles and from there to the colonial and federal styles in America. The printing of musical scores assured Venetian composers of general prominence. Venetian diplomacy, by avoiding commitments to either extreme, paved the way for the acceptance of certain aspects of the Venetian style in both Reformation and Counter-Reformation countries.

Venetian innovations in architecture and painting were eagerly adopted in the Church and court circles of Spain and France. Both the Church hierarchy and the aristocracy needed the impressive splendor of the arts to enhance their exalted positions. The more monumental the buildings, the more lavish the decorations, the more grandiose the musical entertainments, the better the arts served their purpose of impressiveness and magnificence. Hence, it was natural for both to seek out the richest expression of this ideal, which in Venice was to be found in abundance.

El Greco absorbed the Venetian and Florentine versions of mannerism in his journeyman's travels and was eventually accepted by the Church and court in Spain, where his art made a deep impression. Rubens spent eight years in Italy, much of the time making copies of Titian's pictures, then took the Venetian techniques with him to his native Flanders and later to France. Rubens and his pupil van Dyck in turn transmitted them to England, and eventually they reached America.

In the Counter-Reformation countries—Italy, Spain, France, and Austria—church music remained more constant to the Roman tradition, but Venetian music was readily accepted in secular circles. However, for the Reformation centers—Holland, Scandinavia, and northern Germany—the greater liturgical freedom of Venetian musical forms proved more adaptable to Protestant church purposes precisely because of their departure from Roman models.

Sweelinck, who studied the works of both Andrea Gabrieli and Zarlino, carried the Venetian keyboard style to Amsterdam, where his great reputation brought him organ students from Germany who later taught the generation of Pachelbel and Buxtehude, both major influences on the style of Bach and Handel. Cavalli, Monteverdi's successor at the Venetian opera, was called to Paris to write the music for the wedding festivities of Louis XIV. Heinrich Schütz, the greatest German composer before Bach and Handel, was a pupil of both Giovanni

Gabrieli and Monteverdi. In sum, the Venetian style became a part of the basic vocabulary of the baroque artistic language.

It remained for Longhena in the early years of the 17th century to make the break from the brittle rectilinear style of Palladio and Scamozzi and carry Venetian architecture over into the exuberant baroque spirit with his Church of Santa Maria della Salute (Fig. 321). The ground plan is an octagon. The main entrance (right) is like a Roman triumphal arch with a classical triangular pediment rising above. Each of the other seven sides echoes this idea. Supporting the high-pitched dome are buttresses in the form of ornamental scrolls, a motif that was to achieve wide use throughout the baroque period. The elaborately decorated exterior is held together by the good composition of the design as a whole. This building was far more to the taste of the Venetians than the restrained Palladian style, and it is one of the finest examples of the early baroque

Venice at this time was the stylistic clearing-house for currents of thought flowing from the Italian South, the Mediterranean East, and the European North. Flemish and German merchants established trade connections and resident communities in the city of canals, while commerce prospered. Equally active was the traffic in artists and musicians. Thus Venice moved slowly and consistently from the glow of its Byzantine dawn through a Renaissance high noon and the brief thunderstorm of mannerism to its florid baroque sunset.

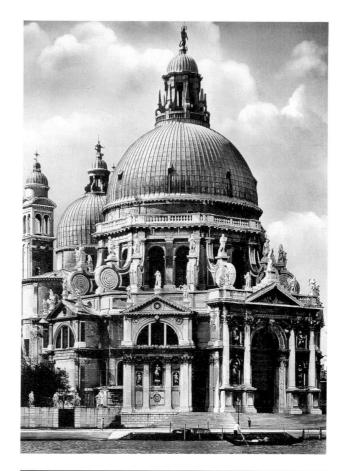

321.Baldassare Longhena. Santa Maria della Salute, Venice. 1631–56. Length 200′ (60.96 m), width 155′ (47.24 m).

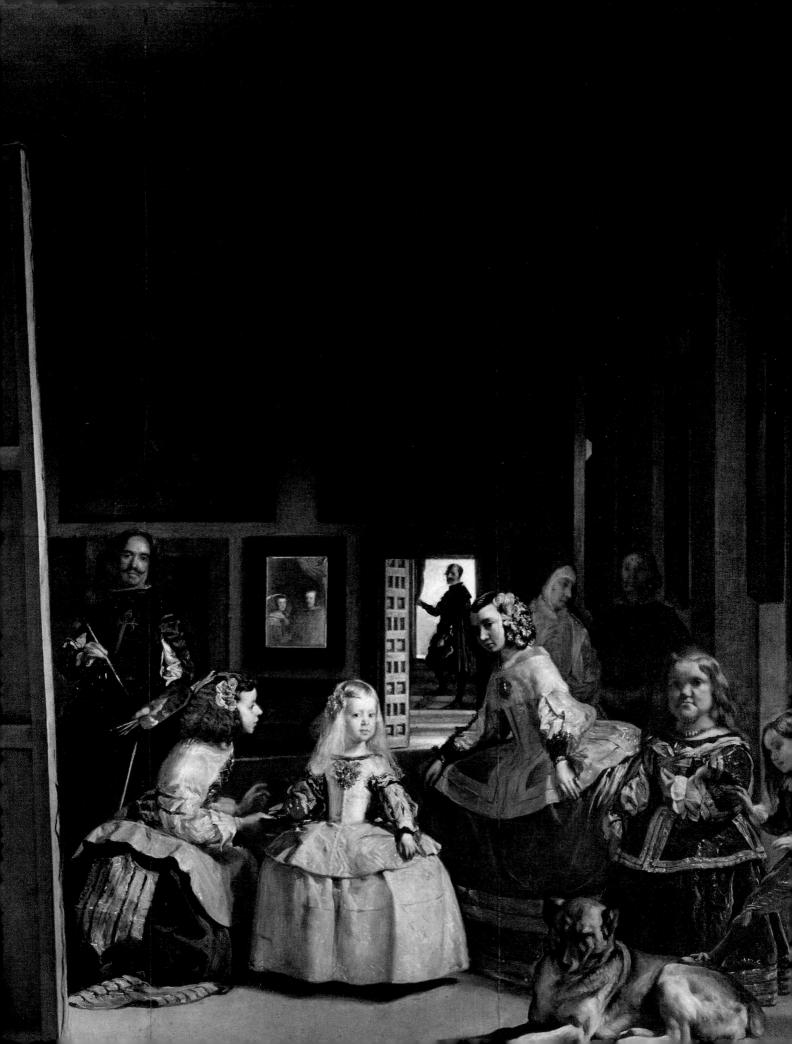

4

The Baroque Period

he baroque period coincided with a time of expansion and empire building when great wealth was pouring into European coffers from the Americas, Africa, India, the East and West Indies, and China. The arts played a major role in religion, in statecraft, and in the enhancement of the good life.

The Reformation had elicited a major movement for reform within Roman Catholicism itself, and the Counter-Reformation undertook vast building programs in the countries that remained loyal to the Church. The Church rededicated itself to religious work. New orders were founded to carry on missionary work all over the world, while the Roman social worker Philip Neri and his Oratian Fathers brought religious inspiration to the poor and oppressed people of such cities as Rome, Madrid. Paris, and Vienna.

Grandeur and magnificence prevailed in the baroque period. Emperors, kings, popes, and princes vied with one another to attract great artists to their courts by offering large commissions. The arts were caught up in the service of church and state, becoming involved in the creation of the myths of the miraculous and the majestic. The new wealth of the bourgeois merchants and bankers became an important source for commissioning and collecting art.

In literature the baroque is expressed in the lofty poetry and stylized tragedies of Corneille and Racine as well as in the rich imagery and grandiloquent language of Dryden and Pope. In music the baroque is heard in the tonal murals of the Venetian and Roman schools with monumental choral and instrumental sonorities vying with one another. On a smaller scale the baroque is heard in the interplay of large and small volumes of sound in the concerto-grosso form and in the intricate vocalisms of Italian and French opera.

The baroque was the age of reason when minds and imaginations opened up new worlds of scientific knowledge as well as artistic creativity. The astronomer Copernicus had literally turned the world upside down and inside out by establishing that the sun was the center of the solar system and that the earth was but one of the planets revolving around it. Newton's speculations on celestial mechanics led to the formulation of the laws of gravity and motion. Such a dynamic world called for a new mathematics capable of dealing with infinity and a universe of matter in motion. With Leibniz came the development of the infinitesimal, or differential calculus.

The philosopher Descartes sounded the call of reason with the declaration, "I think; therefore I am." His skepticism is revealed in his remark that the only thing that cannot be doubted is doubt itself. His attitude is revealed in his statement that only the things the mind perceives clearly are true.

Baroque art became the aesthetic reflection of a new conception of the world and the exuberant affirmation of a modern dynamic attitude toward life.

ROME AND SPAIN—16th AND EARLY 17th CENTURIES

	KEY EVENTS ROME	KEY EVENTS SPAIN	VISUAL ARTS	LITERATURE AND MUSIC
1500		1474-1516 Ferdinand and Isabella reigned; West Indies discovered by Columbus (1492); South America (1498); expulsion of Moors and Jews from Spain	1498-1578 Giulio Clovio ▲ ?-1567 Juan Bautista de Toledo ●	1491-1556 Ignatius Loyola ♦
1500 -		1516-1556 Charles I , king of Spain; became Holy Roman Emperor Charles V in 1519	1507-1573 Giacomo Vignola ●	c.1500-1553 Cristobal Morales □ c.1500-1566 Antonio de Cabezón □ 1515-1582 Teresa of Ávila ♦ 1524-1594 Giovanni da Palestrina □
1525 - 1550 -	1527 Charles V's mercenaries sacked Rome. Protestant Reformation in progress under Luther in Germany, Zwingli and Calvin in Switzerland. Reaction to Renaissance humanism began. 1534 Counter-Reformation began 1540 Society of Jesus (Jesuit Order) founded by Ignatius Loyola 1542 Universal Inquisition established. Censorship of printed matter began 1543 Copernicus's On the Revolution of the Heavenly Orbs published 1545 Council of Trent (1545-63) undertook reform within Church; reaffirmed dogma		1530-1597 Juan de Herrera ● 1531-1621 Juan Bautista Monegro ● c.1540-1604 Giacomo della Porta ● c.1541-1614 El Greco ▲ (Domenicos Theotocopoulos)	1538-1584 Charles Borromeo ◆ 1542-1591 John of the Cross ◆ 1547-1616 Miguel de Cervantes ◆ c.1548-1611 Tomás Luis de Victoria □
	c.1562 Teresa of Ávila and John of the Cross reformed Carmelite orders	1556-1598 Philip II, king of Spain; Spanish empire reached greatest extent 1561 Madrid chosen as capital	1556-1629 Carlo Maderno ● 1573-1610 Michelangelo Merisi da Caravaggio ▲	1562-1635 Lope de Vega ◆
1575 -	1575 Congregation of the Oratory (founded by Philip Neri) approved	1588 English navy sank Spanish Armada 1598-1621 Philip III, king of Spain; decline of Spanish power	c.1580-1648 Juan Gomez de Mora ● 1593-1652 Artemisia Gentileschi ▲ 1598-1680 Gianlorenzo Bernini ● 1599-1660 Diego Velázquez ▲ 1599-1667 Francesco Borromini ●	1583 Victoria published <i>Missarum Libri Duo</i> , books of masses dedicated to Philip II
1600	1616 Galileo enjoined by pope not to "teach or defend" researches confirming Copernican theory; called before Inquisition in 1633 1622 Canonization of Ignatius Loyola, Teresa of Avila, Philip Neri, Francis Xavier	1621-1665 Philip IV, king of Spain 1623 Velázquez appointed court painter 1648 Treaty of Westphalia; Spanish power in Europe checked	1617-1682 Bartolomé Murillo ▲ 1642-1709 Fra Andrea Pozzo ▲ 1665-1725 José de Churriguera ● c.1683-1742 Pedro de Ribera ●	1600 Victoria published collection of masses, motets, psalms, hymns, dedicated to Philip II 1600-1681 Pedro Calderón ◆ 1604 Cervantes' Don Quixote, Part I, published in Madrid (Part II, 1615)

14

The Counter-Reformation Baroque Style

ROME, LATE 16TH AND EARLY 17TH CENTURIES

At the threshold of the 17th century Rome was caught up in a swirl of stylistic trends associated with the late Renaissance and mannerism. However, new forces were emerging that pointed in the direction of a new stylistic synthesis—the baroque. Within the Church decisive action had to be undertaken to meet the challenge of the Reformation and a host of other difficulties that had arisen. The Council of Trent, which met intermittently from 1545 to 1563, was called by the pope to deliberate these matters and to undertake the reform of the Church from within.

As a result of the Council's recommendations, bold humanistic thinking was replaced by violent reaction. Neoplatonic philosophy was succeeded by a return to Aristotelian scholasticism. The distant but seductive voices of pagan antiquity were drowned out by the roar of rekindled medieval fire and brimstone. The reveling in sensuous beauty was followed by bitter self-reproach. Promises of liberal religious attitudes were broken in a return to strict Church doctrines. New access to literature and knowledge through the printing press and scientific discoveries was suppressed through the Universal Inquisition and the *Index Expurgatorius*. God appeared not as the Loving Father but as a terrifying Judge, Christ not as the Good Shepherd but as the Great Avenger.

The founders of the new Counter-Reformation religious orders, which were to shape the course of Roman Catholicism in the 17th century, were in Rome at various times. Philip Neri brought together, for informal meetings in his Congregation of the Oratory, people of all classes, from aristocrats to street urchins, and encouraged them to pray or preach as the spirit moved them. By dramatizing and

setting to music familiar biblical stories and parables (the origin of the baroque oratorios), he generated a cheerful devotional spirit that stirred the hearts of the poor and humble.

Ignatius Loyola came from Spain to obtain papal sanction for his Society of Jesus, a militant order generally known as the "Jesuits" and dedicated to foreign missionary work, education, and active participation in worldly affairs. There were also the mystics Teresa of Ávila and John of the Cross, whose abilities to combine the contemplative and active ways of life resulted in a significant literary expression of the period and in the reorganization and redirection of the Carmelite orders. In Rome too was Carlo Borromeo, the young, energetic archbishop of Milan, who gave voice to the new Church doctrines and wrote manuals for architects and artists, as well as for the students and teachers in the many seminaries he founded.

At a single grand ceremony in the newly completed Basilica of St. Peter on May 22, 1622, Ignatius Loyola, Francis Xavier, Teresa of Ávila, and Philip Neri were canonized and admitted to the honors of the altar. Thereupon the architects Giacomo Vignola, Giacomo della Porta, Carlo Maderno, Gianlorenzo Bernini, and Francesco Borromini were called upon to build churches and chapels dedicated to them.

In this floodtide of reform, the classical harmony, stability, and poise of Renaissance art were not hardy enough to survive, nor could the overrefined, overly dramatic art of mannerism adapt itself to the new religious climate. Gaiety gave way to sobriety, Venuses reverted to Virgins, Bacchuses and Apollos to bearded Christs. The organic form and unity of Michelangelo's Sistine ceiling were succeeded by the calculated shapelessness of his awesome *Last Judgment* (Fig. 322); see also Fig. 262).

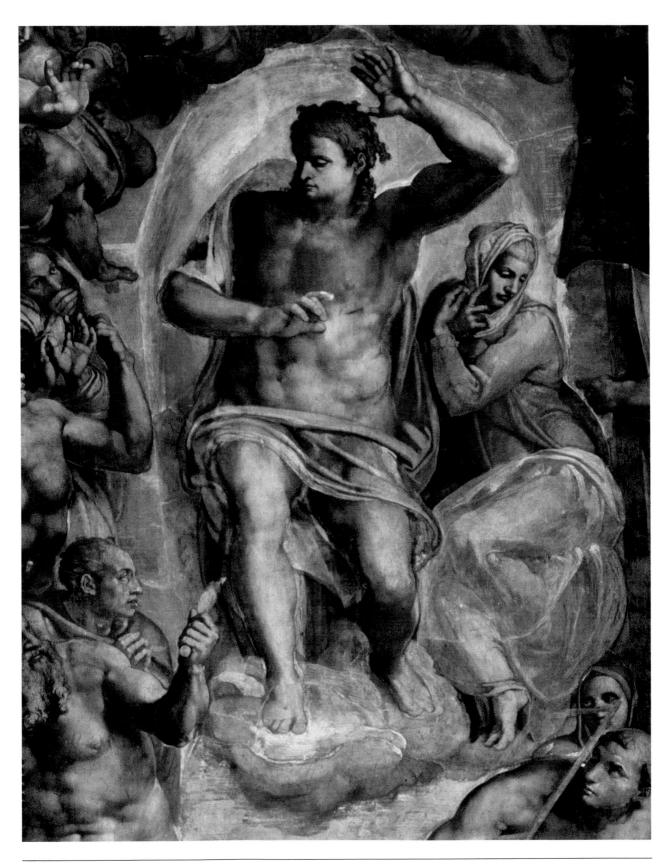

322. MICHELANGELO. *Last Judgment,* detail with self-portrait on flayed skin at lower right. 1534–41. Fresco, $48 \times 44'$ (14.63×13.41 m). Sistine Chapel, Vatican Palace, Rome.

Palestrina was conscience-stricken for having written madrigals and thenceforth wrote only masses. Under the rulings of the Council of Trent, Church art was firmly reunited with religion, and the clergy had to assume responsibility for the way artists treated religious subjects.

The lives and attitudes of Counter-Reformation artists were deeply affected by the new religious climate. Michelangelo's Last Judgment reveals the new spirit in the serious, soul-searching attitudes of each of the figures. But the heritage of the Renaissance was seen in the Apollo-like Christ, the mythological Charon rowing the souls of the dead over the River Styx, and other pagan classical details. Later in the century, Michelangelo's nudes were judged offensive by the stricter reformers, and drapery was ordered to cover them. Only the timely intervention of a group of artists saved the Last Judgment from complete destruction.

Michelangelo became a recluse in his last years, gave up figurative art for the abstractions of architecture, and devoted himself to the building of St. Peter's, a project for which he would accept no fee. In the privacy of his own studio, he worked periodically at sculpture and brooded over his last Pietàs, one of them intended for his own tomb. Palestrina was banished from his post as leader of the Sistine Choir because he refused to take the priestly vow of celibacy and give up his wife. Later he was reinstated and asked to reform Church music.

Gianlorenzo Bernini, busiest and most successful sculptor-architect of the Counter-Reformation baroque style, was closely associated with the Jesuits and regularly practiced St. Ignatius's Spiritual Exercises. Andrea Pozzo, who painted the illusionistic ceiling of the Church of Sant' Ignazio (Fig. 332), was a member of the Society of Jesus. El Greco, Spain's greatest representative of Counter-Reformation art, was a religious mystic in whose last visionary canvases physical matter practically ceases to exist. His

324. Plan of Il Gesù.

325. Andrea Sacchi and Jan Miel. Urban VIII Visiting Il Gesù. 1639-41. Galleria Nazionale, Rome.

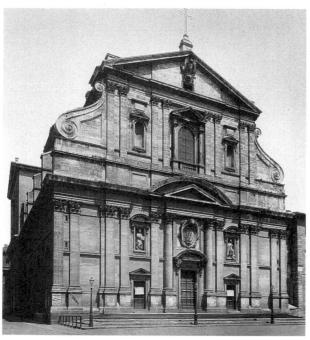

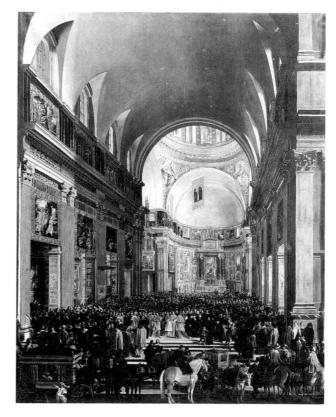

tall, slender figures are more spirit than flesh, his settings more of the realm of heaven than of earth.

As matters shaped up, the Counter-Reformation baroque style had its beginning in Rome, where it reached its climax in the fifty-year period from about 1620 to 1670. Its consequences were felt simultaneously in Spain, the strong secular arm of the Church militant. Thereafter the style spread throughout the Roman Catholic countries of Europe and traveled with the missionary orders to the Americas and everywhere in the far-flung colonies established by Spain and Portugal.

ROMAN COUNTER-REFORMATION ART

Architecture

As the central monument of the Jesuit order, the Church of Il Gesù in Rome (Figs. 323-325) became the prototype for many Counter-Reformation churches (Figs. 326-328). Indeed, so many different versions and variants have since appeared that with justification it has been called the most influential church design of the past four centuries. Commissioned in 1564, Il Gesù combines classical motifs from the Renaissance heritage, correct in every detail but combined in a quite unclassical and original way. Giacomo Vignola's design for the façade, somewhat revised after his death by his successor Giacomo della Porta, recalls a Roman triumphal arch on the ground floor, but the lean-to roofing over the side chapels is masked with graceful scrolls that swirl upward toward the triangular templelike pediment. The heart of the structure—the domed crossing of the nave and short transepts—is derived from Michelangelo's and Palladio's centralized plans, like those reproduced in Figures 267 and 294. The spacious 60-foot (18.3 meters) wide nave with no side aisles allows for a large congregation to gather within sight of the high altar and within earshot of the pulpit.

Borromini's San Carlo alle Quattro Fontane (Fig. 326) is one of the most original expressions of the period. Turning to full advantage the small site at the intersection of two streets with a fountain at each of the four corners, the architect devised a plan that embraced a complex interplay of geometrical shapes. The plan is formed by two equal-sided triangles joined at their bases to make a diamond-shaped rhombus, which was then softened with curved lines (Fig. 327). The façade, with its walls rippling like a stage curtain, rises upward toward an oval dome. The inner surface of the dome is a geometrical triangle with its play of octagons and elongated hexagons

that join to produce Greek crosses in the intervening spaces (Fig. 328). These shapes diminish in size toward the top to suggest greater height, though it is actually quite shallow. Partially concealed openings allow light to filter in and give the honeycomblike pattern a gleaming brightness. The façade (Fig. 323) is set into swaying motion by the alternating concave and convex walls and the flow of curved lines and forms, which allow a maximum play of light and shade over the irregular surface.

Painting and Sculpture

Of all the painters and sculptors active in post-Renaissance Rome, two tower above all the others—Caravaggio and Bernini. Taking his name from his native town, Caravaggio brought the northern Italian tradition of mannerism and the Venetian drama of light and shade with him to Rome. But he struck out in the bold new direction of a graphic naturalism. Departing from the artificiality of mannerism, he found his inspiration in nature, especially human nature. The sculptor-architect-designer-painter Bernini, for his part, succeeded in synthesizing Renaissance, Michelangelesque, mannerist, and baroque elements and brought the baroque to its expressive climax in the Eternal City.

Restless and rebellious, Caravaggio was always at odds with society and his patrons, while Bernini, despite his passionate temperament, was nevertheless a polished courtier. "It is your good luck," Bernini was told by the newly elected Pope Urban VIII, "to see Maffeo Barberini pope; but we are even luckier that Cavaliere Bernini lives at the time of our pontificate." Caravaggio's life and career proved brief, solitary, and meteoric; Bernini's was long, social, and prodigiously productive. Both artists were destined to have far-reaching effects on future developments. Caravaggio with his bold chiaroscuro influenced later Italian and French baroque painters, as well as Rubens and Rembrandt. Bernini with his twisted columns and visionary illusionism had a major impact on baroque sculpture and architecture.

CARAVAGGIO. Caravaggio, who painted in Rome from about 1590 to 1606, scorned Renaissance correctness, dignity, and elegance and set out to depict religious subjects in a vivid, down-to-earth way. His Calling of St. Matthew (Fig. 329) shows the future Evangelist among a group at a public tavern. A significant darkness hovers over the table, where tax money is being counted. As Jesus enters, a shaft of light illuminates the bearded face of St. Matthew and the faces of the young men in the center. As the light strikes each figure and object with varying degrees of

intensity, it becomes the means by which Caravaggio penetrates the surface of events and reveals the inner spirit of the subjects he depicts. Note the hand of the Savior, which is taken directly from that of God in Michelangelo's *Creation of Adam* (Fig. 265), now a symbol for the divine spark. The *Calling of St. Matthew* was at first refused by the church for which it had been painted, because it showed the saint in a too-worldly situation, even though the story is told by the Evangelist himself.

In the *Conversion of St. Paul* (Fig. 330), Caravaggio creates a blinding lightning flash to highlight the saint's inner illumination. "And suddenly there shined round about him a light from heaven," reads the New Testament passage, "and he fell to the earth, and heard a voice saying unto him, Saul, Saul, why persecutest thou me?" (Acts 9:3–4).

As observers behold St. Paul's prone body from an extremely foreshortened angle, with arms flung

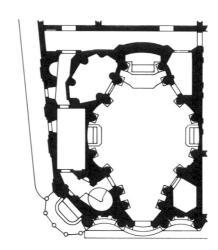

327. Francesco Borromini. Plan of San Carlo alle Quattro Fontane.

326.

Francesco Borromini. Façade, San Carlo alle Quattro Fontane, Rome. Begun 1635, façade 1667. Length 52' (15.86 m), width 34' (10.36 m), width of façade 38' (11.58 m).

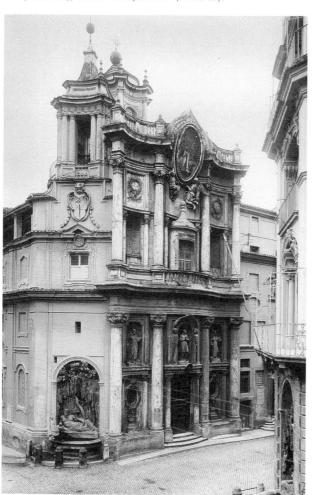

328. Francesco Borromini. Interior of dome, San Carlo alle Quattro Fontane, Rome. c. 1638.

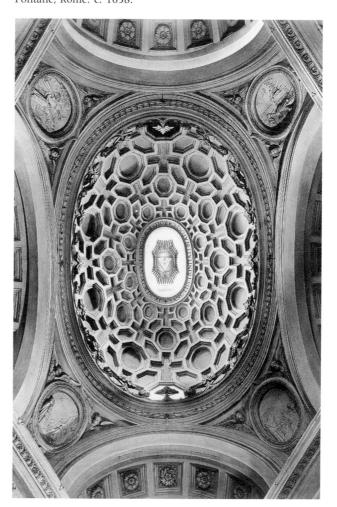

out as if to embrace the new light, they are caught up in the event and share the wonderment and concern of the attendant and the huge horse. One fascination of the picture is the way Caravaggio creates a tense vertical rhythm with the alternation of horse's shanks and human arms and legs. Manneristic freedom can be seen in the artist's moving the head and shoulders of the groom over to the right. This keeps the design below undisturbed, but there is no natural way for the man's limbs to be joined to his trunk and shoulders. Pictorial construction, not naturalism, was for Caravaggio the first consideration.

The echoes of Caravaggio's breakthrough were soon heard in all parts of Europe. Among his many followers was Artemisia Gentileschi, who was active in both Rome and Naples. Her powerful *Judith Slaying Holofernes* (Fig. 331) depicts the heroic daughter of Israel saving her people by beheading the invading general whose cohorts were sweeping down on her city. Like Caravaggio, she employs the technique of *tenebrism* to carry chiaroscuro into the menacing darkness—thus creating the perfect setting for her gruesome subject. The stark realism is brought home as Judith holds back to avoid the spurting blood. She

329. Caravaggio. Calling of St. Matthew. c. 1597–98. Oil on canvas, $11'1'' \times 11'5''$ (3.38 \times 3.48 m). Contarelli Chapel, San Luigi dei Francesi, Rome.

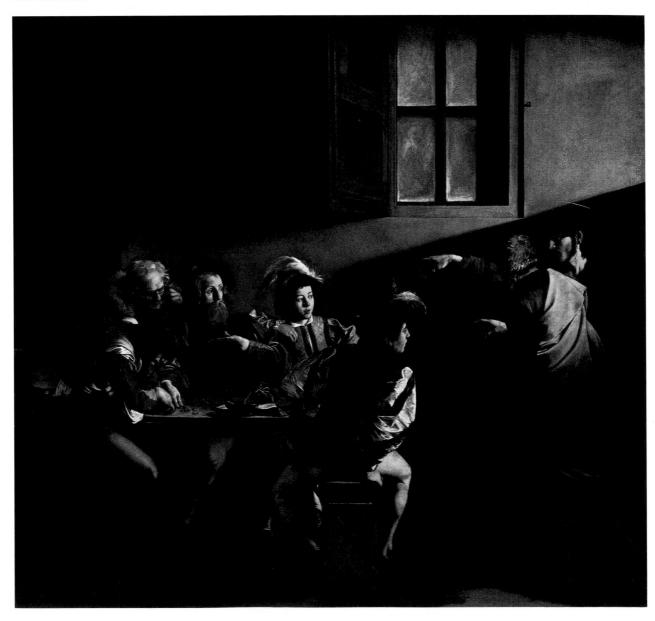

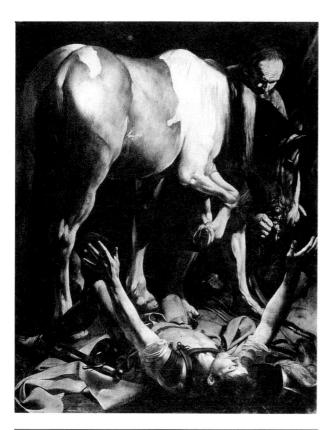

330. Caravaggio. *Conversion of St. Paul.* 1601–02. Oil on canvas, $7'6\frac{1}{2}'' \times 5'9''$ (2.3 × 1.75 m). Cerasi Chapel, Santa Maria del Popolo. Rome.

In Rome Caravaggio's efforts to create a truly popular religious art as seen through the eyes of the common people met with a mixed reception. Paradoxically, only the sophisticated few grasped its originality and significance. The Roman priests and public both preferred more conventional elegance and illusionism. It was in the illusionistic virtuosity of such ceiling murals as those of Annibale Carracci in the Farnese Palace, Pietro Cortona in the Barberini Palace, and Pozzo in the church of Sant' Ignazio, and especially in the work of Bernini that the mainstream of the baroque is to be found.

Pozzo. Andrea Pozzo succeeded in capturing the new spirit in his extraordinary painting on the barrel-vaulted ceiling of the Church of Sant' Ignazio (Fig. 332), a sister church in Rome of Il Gesù (Fig. 325) dedicated to the founder of the Jesuit order. Above the clerestory windows, the walls of the building seem to soar upward so that the vaulting of the nave becomes that of heaven itself. In a series of remarkable foreshortenings, St. Ignatius,

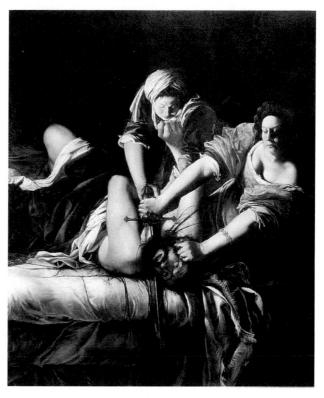

331. Artemisia Gentileschi. *Judith Slaying Holofernes.* c. 1620. Oil on canvas, $78\frac{1}{3} \times 64''$ (1.99 × 1.62 m). Galleria degli Uffizi, Florence.

accompanied by a heavenly host, ascends in a winding spiral toward figures symbolizing the Trinity. Here all the lines converge, and beams of lights radiate outward to illuminate the four corners of the world—personified by allegorical representations of Europe, Asia, Africa, and America—where missionary work of the Society of Jesus was carried on. Pozzo was also the author of a definitive book on perspective, in which he advised artists "to draw all points thereof to that true point, the Glory of God."

Bernini. In Gianlorenzo Bernini, the fiery and versatile architect, sculptor, and painter, the Roman Counter-Reformation baroque found its most representative and productive champion. Notably, he designed the Piazza of St. Peter's that begins with the trapezoidal plaza in front of the basilica's façade and opens out into the mighty oval area framed by massive fourfold Doric colonnades (see Figs. 254 and 269). As a sculptor he created many of the basilica's chapels, notably the one in the apse containing the Chair of St. Peter. His designs can readily be seen in public monuments such as the Fountain of Four Rivers in Piazza Navona (Fig. 333). Bernini, even more

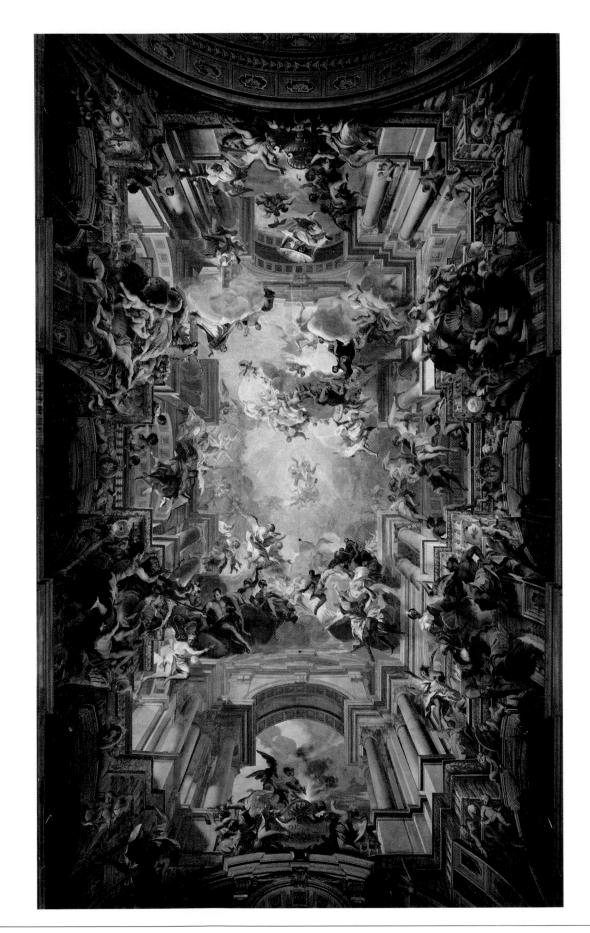

332. Andrea Pozzo. *St. Ignatius in Glory.* c. 1691. Fresco, nave ceiling. Sant' Ignazio, Rome.

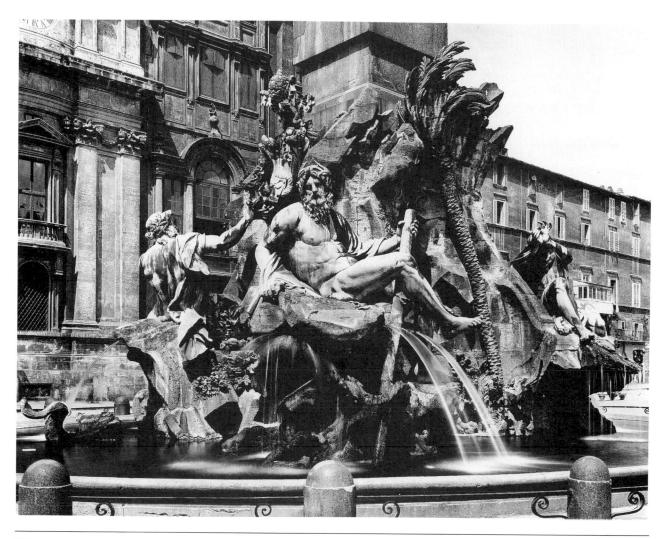

333.
GIANLORENZO BERNINI. Fountain of Four Rivers, Piazza Navona, Rome. 1648–51.

than Michelangelo, is responsible for lifting the face of Rome and for giving the city the appearance it has today.

One of the essential features of baroque art is the manner in which all parts of a composition are brought into a convincing unity by some single structural, linear, painterly, rhythmic, or plastic device. While Renaissance compositions tended toward the isolated perfection of each part, in the baroque all components are brought together into one interpenetrating, interdependent, and indissoluble whole. Then, looking beyond a single painting, all the separate arts and media are brought into play so that they melt and merge with one another to form new and fascinating possibilities. An outstanding example is Bernini's chapel in the Roman Church of Santa Maria della Vittoria.

St. Teresa in Ecstasy is at once Bernini's undoubted masterpiece and the work that most com-

pletely captures the Counter-Reformation baroque spirit. The composition fills one transept of Carlo Maderno's church of Santa Maria della Vittoria, where space makes it impossible to photograph it as a whole. A painting made with the help of Bernini's drawing shows the chapel as it appeared in the 18th century (Fig. 334). First there is the literary allusion to St. Teresa's description of her vision in vivid images. Then all the visual arts are called upon—architecture, sculpture, scenic design, and fresco—and a rich array of materials is assembled: varicolored marbles, gilt bronze, stucco, and tinted glass. All are so artfully combined that the dividing line between media and materials disappears, and one grand total effect emerges that defies classification.

In the central group (Fig. 335) Bernini portrays Teresa in a state of ecstasy. In her autobiography she describes a bright angel, face aflame, who appeared to her in a vision. As she describes it, In his hands I saw a great golden spear, and at the iron tip there appeared to be a point of fire. This he plunged into my heart several times so that it penetrated to my entrails. When he pulled it out, I felt he took them with it, and left me utterly consumed by the great love of God. The pain was so severe that it made me utter several moans. The sweetness caused by this intense pain is so extreme that one cannot possibly wish it to cease, nor is one's soul then content with anything but God. . . . So gentle is this wooing which takes place between God and the soul. . . .*

In the composition as a whole, warm color and luminosity play a leading role. From a concealed window beams descend along darting gilded shafts and bathe the saint's figure in a miraculous golden glow. Marble paneling of agate and dark green frame the picture. On either side kneeling cardinals and members of the Cornaro family, who donated the chapel, behold the vision as if from stage boxes, though they actually are kneeling at prayer desks. In the central niche floats the figure of the mistica dottora herself, suspended weightlessly in a state of voluptuous ecstasy torn between earthly emotion and divine love, rising and falling on gales of passion. An angel, the iconographic cousin of the pagan Cupid, is about to pierce her heart with his dart. High above, a ceiling fresco, augmented by three-dimensional painted stucco additions, depicts an angelic choir grouped around the dove of the Holy Spirit.

The chapel begs the questions "Is it architecture, sculpture, painting, stage design? Is it sculpture in the round, in relief?" The answer in each case must be yes—but combined not separated, in fusion not isolation. The sculpture group is surrounded by actual and illusionary architecture; the painted sky and the theatrical lighting form part of a single conception in which real and visionary elements blend into one, in which metal, marble, forms, colors, and light harmonize as a multimedia concert of the arts.

SPANISH COUNTER-REFORMATION ART

The close alliance of Italy and Spain that had begun with the invasion of Charles V continued throughout the baroque period. Politically and economically the Spanish crown controlled all major Italian re-

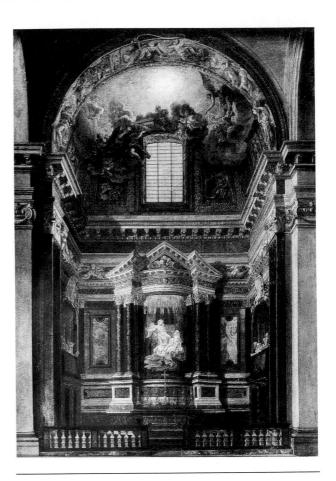

334.Anonymous. *Cornaro Chapel, Santa Maria della Vittoria, Rome*. c. 1644. Oil on canvas. Staatliches Museum, Schwerin, Germany.

gions by viceroys and puppet regimes. Papal approval of the Jesuit order made the influence of its militant missionaries worldwide and brought sainthood to two of its Spanish founding members, Ignatius Loyola and Francis Xavier. And the words of two great Spaniards, St. Teresa of Ávila and St. John of the Cross, perhaps most completely captured the Counter-Reformation spirit in literature and became the most widely read in the Roman Catholic world.

The personal tastes of that melancholy monarch Philip II, who succeeded his father, Charles V, were austere to the point of severity. His worldly position and ambitions, however, made it necessary that he surround himself with sufficient magnificence to command awe and respect. To unify his kingdom, take local authority away from his feudal lords, and give himself all the power of an absolute monarch, Philip selected as his capital the thenobscure but centrally located town of Madrid. There, an enormous building program had to be undertaken to house the court and provide city palaces for the aristocracy (see map, p. 354).

^{*}Life of St. Theresa. Tr. by J. M. Cohen. Harmondsworth, Eng.: Penguin, 1957, p. 210.

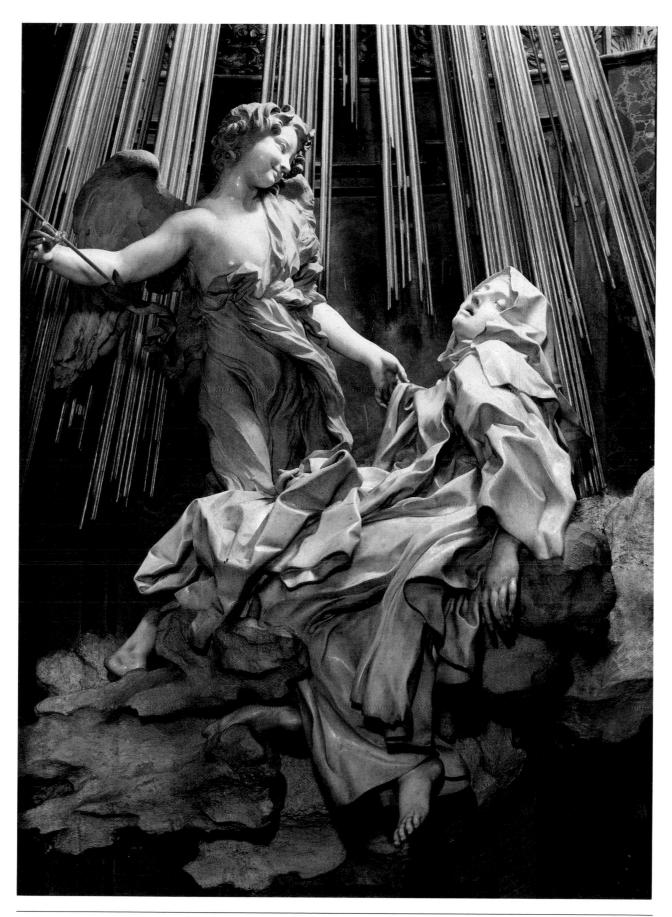

335.

GIANLORENZO BERNINI. St. Teresa in Ecstasy. 1645–52. Marble and gilt bronze, life-size. Cornaro Chapel, Santa Maria della Vittoria, Rome.

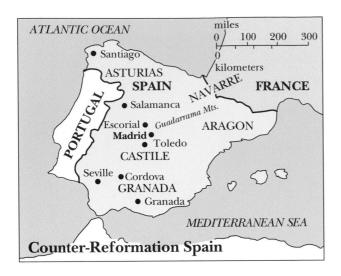

With the riches of the Old World and the unlimited resources of the New at his command, Philip summoned the leading artists of Europe to help build and embellish his chosen capital, and his ambassadors were under instruction to buy any available masterpiece of painting and sculpture. While they remained in their native cities, Titian and other Italian artists continued to paint for Philip as they had for his father. But Domenicos Theotocopoulos, the Greek-born artist who had been trained in the Venetian mannerist style and had studied the work of Michelangelo and Raphael in Rome, settled in Spain, where he became known as the foreigner El Greco ("the Greek"). The Spanish composer Victoria, though he was fully established in Rome, dedicated a book of Masses to Philip in the hope of receiving a court commission. Attracted by the glitter of Spanish gold, other artists from all parts of Europe, known and unknown, flocked to Madrid in search of fame and fortune. Thus, while Spain's power and prestige were to decline in the 17th century, the precedent set by Charles V and Philip II as patrons of the arts was continued by Philip III and Philip IV to round out a full century of brilliant artistic activity.

Architecture

THE ESCORIAL. In planning the Escorial, Philip II was bound by his father's will to build Charles V a tomb, bound by his own solemn oath to found a monastery dedicated to St. Lawrence, on whose day he gained his great military victory over the French, and bound also by his own religious fervor and royal position. Philip II envisioned a vast architectural project that would coordinate these different objectives and resolve some of his own inner conflicts. As the plan matured in the king's mind this monument

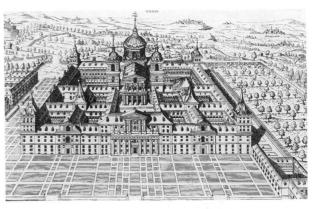

336.JUAN BAUTISTA DE TOLEDO and JUAN DE HERRERA. Escorial Palace, near Madrid. 1553–84. Engraving after Herrera.

was to be at once a temple to God, a mausoleum for his ancestors and descendants, a national archive of arts and letters, a dwelling place for the monks of St. Jerome, a college and seminary, a place of pilgrimage with a lodging for strangers, a royal residence, and, in general, a symbol of the glory of the Spanish monarchy.

A site in the barren foothills of the Guadarrama Mountains about 30 miles (48 kilometers) from Madrid was chosen for the undertaking, which took its name from the nearby village of Escorial. The original plans were drawn up by Juan Bautista de Toledo, who had studied with Jacopo Sansovino and Palladio in Venice and worked on St. Peter's in Rome under the direction of Michelangelo. After his death, the work was completed by Juan Bautista's collaborator, Juan de Herrera.

According to Philip's instructions, the monument had to embody the ideals of "nobility without arrogance, majesty without ostentation." As it stands, the Escorial is a vast quadrangle of almost 500,000 square feet (46,500 square meters), which is subdivided into a symmetrical system of courts and cloisters (Fig. 336). The form symbolically refers to the gridiron on which St. Lawrence was roasted alive. The corner towers can be said to represent the legs of the iron grill, while the palace, which projects from the east end, forms its handle. Elsewhere in the building the grill is widely used as a decorative motif.

The Escorial strikes a note of gloomy grandeur and stark magnificence in keeping at once with the Spanish spirit as well as with the somber personality of Philip II. Each side presents a long expanse of wall, entirely lacking in decoration, its monotony broken only by the endless rows of windows (Fig. 337). The principal entrance (Fig. 336), which is found on the west front, is carried out in the strict

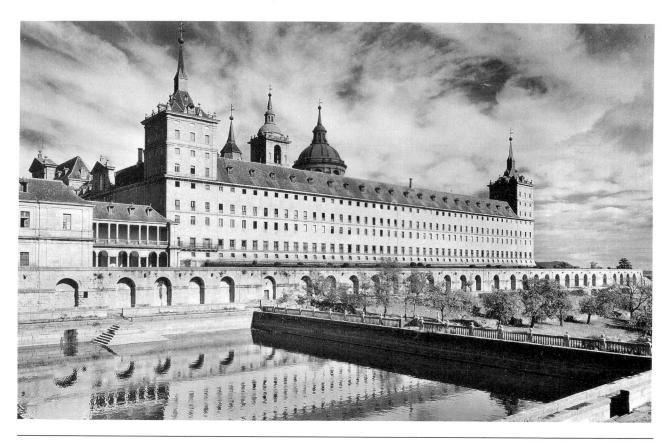

337. Escorial Palace, side view.

Doric order with only the royal coat of arms and a colossal statue of St. Lawrence holding his gridiron to relieve the general austerity. The portal leads into the Patio of the Kings, which occupies the central place in the design. The Patio takes its name from the statues of David, Solomon, and the other kings of Israel over the entrance to the imposing church.

The Escorial, by reaching out to bring all the functions of an absolute monarch within a single structure, is baroque in the grandeur of its conception. However, the restraint of Philip's taste, as well as the discipline of his architects, kept the urge to decorate well within academic bounds. Exercising the privilege of an absolute monarch, Philip insisted on the right to pass on the suitability and style of every public building that was undertaken during his reign. Herrera, the court architect, was commissioned to inspect all such plans and, as a consequence, became an artistic dictator who enforced the severe tastes of his royal master on the nation.

PLATERESQUE AND CHURRIGUERESQUE STYLES. Not until after Philip's death did Spain have the freedom to develop the richly elaborated style that is now such a prominent feature of its large cities. Indeed, some of the florid baroque's emotional enthu-

siasm and excesses came as a direct reaction to the formal severity of Philip's time. Daring designs, fantastic forms, curved lines, and the spiral twist of corkscrew columns replaced the austere façades and classical orders enforced by Herrera.

Architectural developments at Salamanca and Madrid will dramatize the situation. The Casa de las Conchas (Fig. 338, right), or "House of the Shells," is a Renaissance structure built in 1514, well before Philip's time. It nevertheless shows the tendency toward applied decoration that was popularly known as *plateresque*, an ornamental style resembling silver plating.

Across the street is the church of the Jesuit college of La Clérica (Fig. 338, left), which was begun after the period of Philip and Herrera. The lower part dates from the early 17th century and was designed by Juan Gómez de Mora. Even though it still adheres nominally to the classical orders, the decorative urge is seen clearly in the attached Composite columns and in the baroque frieze above them, as well as in many of the other details. The towers and gable belong to the latter part of the 17th century and were executed by Churriguera, whose name is associated with the more florid aspects of Spanish baroque, the *Churrigueresque* style.

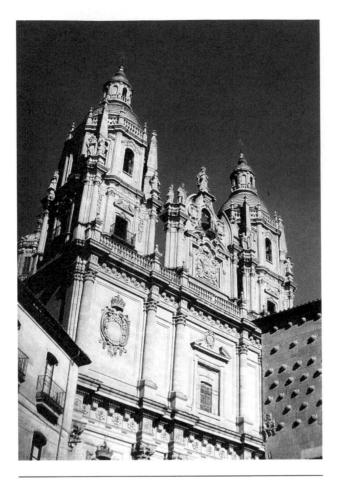

Painting

EL GRECO. While the Escorial was still under construction, Philip II commissioned El Greco to paint an alterpiece for the Chapel of St. Maurice. The subject of El Greco's early masterpiece, the Martyrdom of St. Maurice and Theban Legion (Fig. 340), is typical of the Counter-Reformation in that it has to do with the dilemma of the individual who is caught between conflicting loyalties. St. Maurice, the figure in the right foreground, was the commander of the Theban Legion, a unit of Christians serving in the Roman imperial army. An order has just arrived commanding all members of the unit to acknowl-

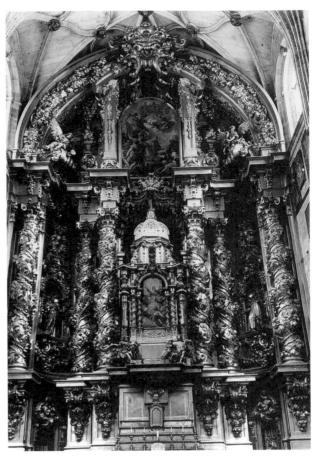

339. José de Churriguera. Altarpiece, San Esteban, Salamanca. 1693.

edge the traditional Roman deities or else be put to death. In the expressive gestures of their hands, St. Maurice and his staff officers reveal their positions. Christ, it is true, had approved by his own example the rendering unto Caesar the material things that are Caesar's, but the spiritual worship of false idols is another matter. The line is thus clearly drawn, and a choice has to be made between duty to the state and duty to the Church, between the earthly city and the city of God. St. Maurice points upward, expressively indicating his decision.

El Greco's spiral composition is well adapted to convey the tension between the material and spiritual realms, the natural and supernatural, the earthly and heavenly. It can be sensed in the twitching muscles, flamelike fingers, taut faces, and swirling upward motion of the composition itself. In coiled snakelike fashion, it winds around to the left middle ground where St. Maurice is seen again, this time giving comfort to the men as they await their turns for beheading. The tempo is increased toward the background where the nude figures of the sol-

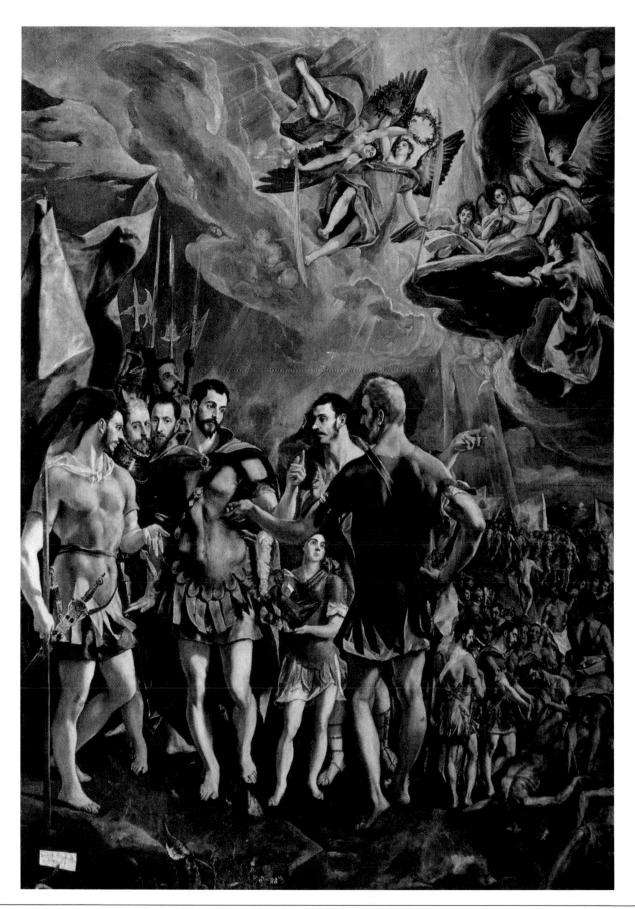

340. Et Greco. Martyrdom of St. Maurice and Theban Legion. 1581–84. Oil on canvas, $14'6'' \times 9'10''$ (4.42 \times 3 m). Escorial Palace.

diers seem already to have parted company with their bodies and are drawn into the center of a Dantesque spiritual whirlwind that bears their souls aloft. The eye is led upward by the constantly increasing light and the transition of color from the darker hues below to the vaporous pink and white clouds above. There a visionary vista in the heavens is beheld, where some of the angelic figures hover and hold crowns of martyrdom for those who suffer and die below, while others produce the sounds of celestial harmony.

Despite the grimness of the subject, the light, transparent palette that El Greco employs gives the work an almost festive air, with the rose-colored banners and steel blue and lemon yellow costumes set against a background of silvery gray. The originality of the work, with its daring color dissonances, the manneristic elongation of the figures, and the lavish use of costly ultramarine blue, lost for El Greco the favor of King Philip, whose tastes ran to the more conservative Italian style. Thereafter, El Greco painted almost exclusively for Church circles. One of the earliest and most renowned of these was the *Assumption of the Virgin* altarpiece (Fig. 341).

El Greco's model for the *Assumption* was the picture Titian had painted on the same subject some sixty years earlier (see Fig. 303). El Greco's version, however, reveals both manneristic agitation and the baroque preference for open space, while Titian contains all action within his picture. By dividing his composition into three planes, Titian starts a vertical ascending motion in the lower two but arrests it by the descending figure of God above. By combining the acute receding diagonal lines of the apostles, El Greco in his *Assumption* forms a conelike base from which the Madonna soars in a spiraling movement, leading the eye upward out of the picture into the open space above.

For his own parish church of San Tomé in Toledo, his adopted city, El Greco painted his masterpiece, the *Burial of Count Orgaz* (Fig. 342). The count, who rebuilt and endowed the church, was legendarily honored in 1323 by the miraculous appearance of St. Stephen and St. Augustine, who gently lower him into his tomb, which is in the wall just below the picture. The vivid earthly and visionary heavenly spheres are separated by the flickering torches and swirling draperies as the soul of the count is borne heavenward on angelic wings to be received by the radiant figure of Christ.

The row of mourners includes portraits of the Toledo clergy and gentry, among them a self-portrait of the artist with his hand raised directly above the head of St. Stephen. A note of subtle humor is struck

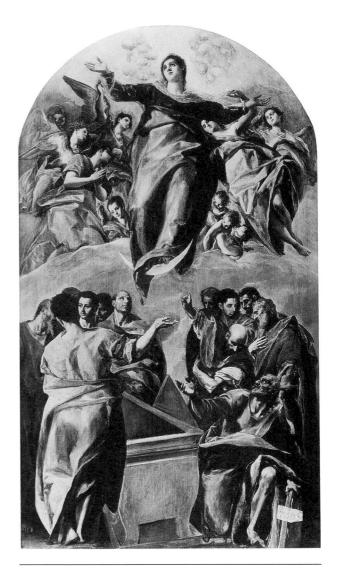

341. EL GRECO. *Assumption of the Virgin*. c. 1577. Oil on canvas, $13'2'' \times 7'6''$ (4.01 \times 2.29 m). Art Institute of Chicago (gift of Nancy Atwood Sprague in memory of Albert Arnold Sprague).

in the portrait of El Greco's eight-year-old son Jorge Manuel as the attendant in the lower left. The boy points to the encircled white-and-gold rose embroidered on St. Stephen's vestment—the circle being the symbol of immortality, the rose of love. On his son's pocket handkerchief El Greco signed in Greek: "Domenicos Theotocopoulos made me, 1578." However, the date is not that of the picture but of his son's birth.

In *Christ Driving the Money Changers from the Temple* (Fig. 343) Jesus appears in the role of the refining fire as prophesied by Isaiah. Together, the painting and the subject are a manifesto of Counter-Reformation thought. Jesus himself is seen here as a reformer fighting the commercialization of religion.

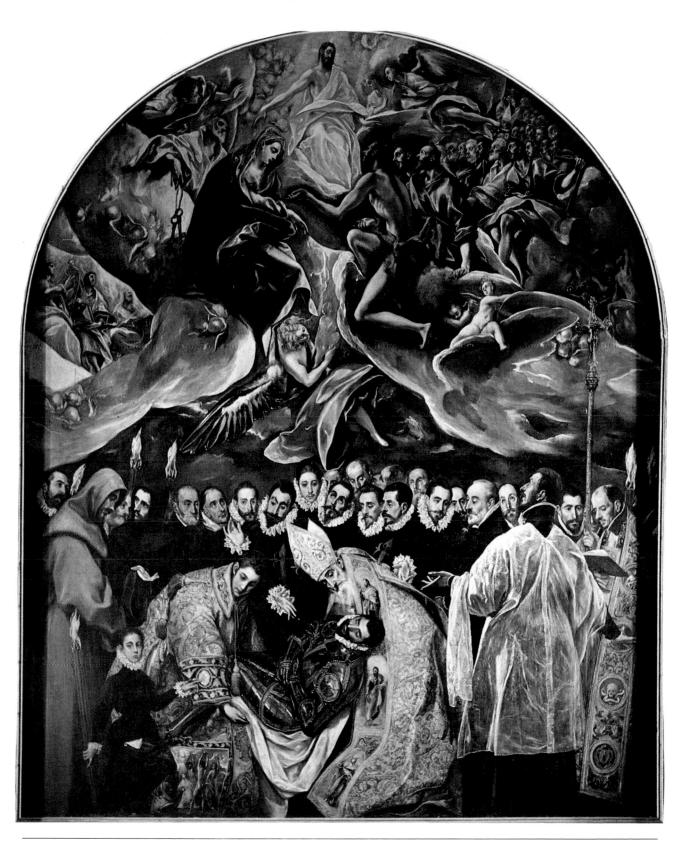

342. EL Greco. Burial of Count Orgaz. 1586. Oil on canvas, $16' \times 11'10''$ (4.88 \times 3.61 m). Santo Tomé, Toledo, Spain.

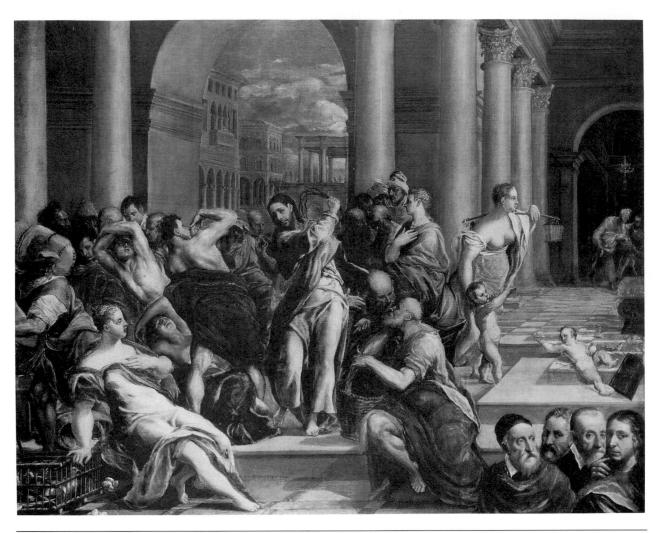

343. EL Greco. *Christ Driving the Moneychangers from the Temple.* c. 1572–74. Oil on canvas, $3'8'' \times 4'9''$ (1.12 × 1.45 m). The Minneapolis Institute of Arts (Dunwoody Fund).

As St. John's Gospel records the event, he "found in the temple those that sold oxen and sheep and doves, and the changers of money sitting: And when he had made a scourge of small cords, he drove them all out of the temple. . . . And said unto them that sold doves, Take these things hence; make not my Father's house an house of merchandise" (John 2: 14-16). The mood of fiery anger is reflected in El Greco's clashing colors of crimson red, pink, orange, and greenish yellow. The pictorial organization recalls Last Judgment scenes with Christ in the center as judge, the sinners on the left, and the saints on the right. On one side all is turbulence and confusion, on the other all is calm as the disciples reflect on the meaning of the event. The picture is also a personal document, as the four heads in the lower right are those the painter held to be his artistic mentors. From left to right they are Titian, Michelangelo, Giulio Clovio, and Raphael, each of whom he greatly admired.

VELÁZQUEZ. Spain's other great master, Diego Velázquez, had spent his early years in his native Seville painting naturalistic genre pictures such as the *Water Carrier of Seville* (Fig. 344). Less than a decade after El Greco's death, the new monarch, Philip IV, appointed Velázquez his court painter. Velázquez's art consequently comes within the category of the aristocratic baroque, which is treated in a later chapter, but as a complete contrast to El Greco and as an equally great contribution to the high Spanish period, it is more appropriately discussed here.

While El Greco concerned himself almost exclusively with religious subjects, Velázquez, with few exceptions, painted scenes of courtly life. In contrast to El Greco's personal involvement in his pictorial

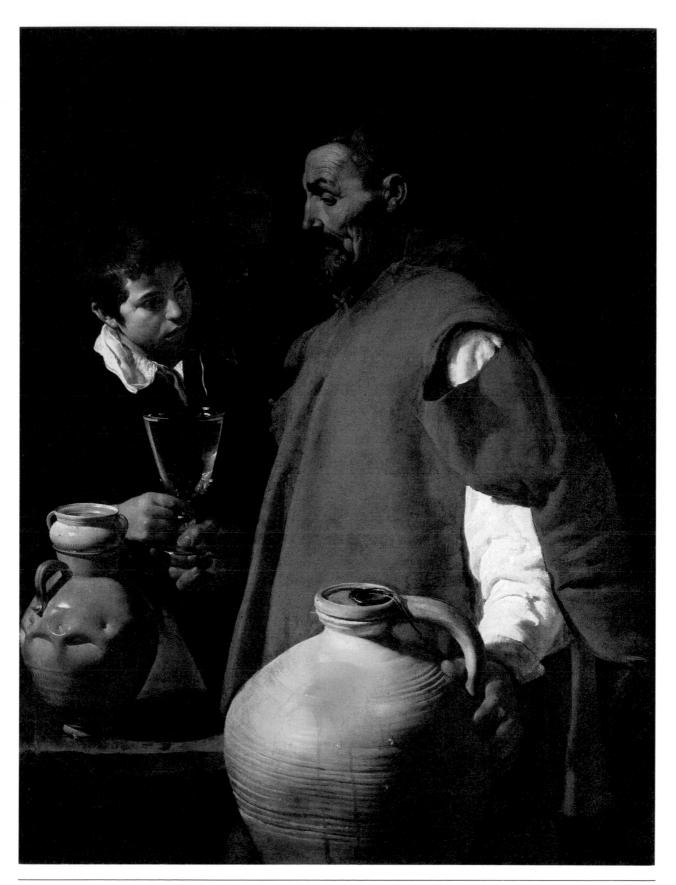

344. Diego Velázquez. Water Carrier of Seville. c. 1619–21. Oil on canvas, $41\frac{1}{2} \times 31\frac{1}{2}$ " (105 × 80 cm). Victoria and Albert Museum, London (Crown copyright reserved).

content, Velázquez sees his world with cool detachment and an objective eye. His work is admirably summed up in his masterpiece *Las Meninas*, or the *The Maids of Honor* (see p. 340). With it, the painter combines the formality of a royal group portrait with the informality of a more casual genre scene in his studio. In the picture attention is about evenly distributed among the various groups. In the foreground, the Infanta Margarita, dressed in a gown of white satin, is standing in the center. On the left, a maid of honor is offering her a drink from a red cup on a gold tray. At the right is a group made up of a second maid of honor and two of the court dwarfs, one of whom is poking the sleepy dog with his foot.

In the middle ground, on the left, is Velázquez standing before a canvas which, by reason of its large dimensions, must be for Las Meninas itself. The presence of the painter practicing his profession and the pictures within the picture are like the amusing passages in Cervantes's picaresque novel where Don Quixote and Sancho Panza talk to the author about the book in which they are the principal characters. Here Velázquez is looking at King Philip IV and Queen Mariana, whose faces are reflected in the mirror at the back of the room. As a balance for his own figure, Velázquez paints the conversing lady-inwaiting and courtier in the right middle ground. In the rear of the room, a court attendant stands in the open doorway pulling back a curtain, possibly to adjust the light.

Velázquez is a virtuoso in the handling of space and light. With the utmost precision, he has organized the picture into a series of receding planes, and by so doing he gives the figures their spatial relationships. The first plane is in front of the picture itself where the king and queen and, by inference, the observer are standing. In this way the spectator becomes part of the picture itself, just as the king and queen do. Next comes that in which the principal group stands in the light of the window at the right, which again is outside the picture but which provides the brilliant illumination that falls on the blond hair of the princess. The light here is balanced by that from the door at the rear, which defines the plane in the background. In between is the intermediate plane with the figures of Velázquez and the attendants, who are shown in more subdued light. Five receding planes can thus be distinguished. Otherwise the space is broken up geometrically into a pattern of rectangles, such as the floor, ceiling, the window, the easel, the pictures hanging on the wall, the mirror on the wall, and the door at the back.

On another level Velázquez's picture becomes a painting about the art of painting. At the time the

work was in progress, the artist was seeking membership in the order of the Knights of Santiago. His candidacy had the powerful support of the king himself, and that of the great dramatist Lope de Vega. The ancient rules, however, forbade admission of manual workers. In his pictorial manifesto Velázquez is attempting to raise the status of painting to that of a liberal rather than a mechanical art. On the wall in back he includes copies of works by Sir Peter Paul Rubens, who had been ennobled by King Charles I of England. The subjects are those in which gods and goddesses themselves take part in the arts. In his self-portrait Velázquez appears not in an ordinary painting smock but in his costume as court chamberlain with the keys of his office on his belt. Later, when he was finally admitted, he painted in the cross of the noble order at the request of the king himself.

In such a precise analytical study of space and light, which lacks both the spiritual mysticism of El Greco and the worldly grandeur of the Venetian

345. Bartolomé Murillo. *Immaculate Conception.* c. 1666–70. Oil on canvas, $6'9'' \times 4'8^{5''}_8$ (2.06 \times 1.44 m). Museo del Prado, Madrid.

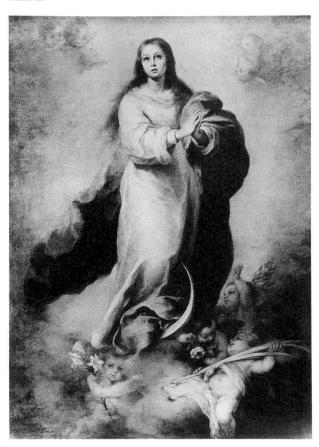

painters, the baroque qualities are not immediately apparent. Velázquez, however, is a master of external rather than internal vision, and therefore his baroque qualities are found in such things as the intricate play of light and shadow, the complex spatial arrangements, the fact that much of what is happening lies outside the picture space itself, and the subtle relationships of the subjects to each other.

Just as Spanish architecture showed a reaction when the restraints of the earlier period were lifted, Spanish painting moved away from the austerity and intensity of the previous century. No painter could sustain the spiritual insight and emotional power of El Greco. The relaxation into sentimentality is clearly seen in Murillo's Immaculate Conception (Fig. 345). The subject was in particular favor with the Spanish Church, and Murillo and his workshop are known to have turned out some twenty versions of it. According to Roman Catholic belief, Mary was conceived miraculously and without original sin. Artistically she is represented as recorded in St. John's vision: "And there appeared a great wonder in heaven; a woman clothed with the sun, and the moon under her feet, and upon her head a crown of twelve stars" (Rev. 12:1). In this instance she is born aloft by cherubs holding the lily, rose, olive branch, and palm leaf-symbols of purity, love, peace, and martyrdom, respectively.

Music

The Roman urge for reform predisposed church music to look more to the past than the future, to traditional rather than experimental forms. "The Antiphonals, Graduals, and Psalters have been filled to overflowing with barbarisms, obscurities, contrarieties, and superfluities as the result of clumsiness or negligence or even wickedness of the composers, scribes, and printers," reads the papal brief authorizing Giovanni da Palestrina to undertake the reform of Church music along lines laid down by the Council of Trent. An ardent advocate of the Flemish contrapuntal style of Josquin Desprez and Heinrich Isaac, Palestrina, together with his great contemporaries Orland Lassus and Tomás Luis de Victoria, brought that art to its final fruition.

Palestrina's prayers in song achieved a fluidity and transparency of texture, a balance of melody and harmony, a spiritual and organic unity worthy of the closing years of the *ars perfecta*, or "perfect art." The music of his younger colleague, Victoria, however, has a darker mood, a brooding emotional fervor, and a deeper concern with the dramatic meaning of his texts.

O vos omnes
(4-part motet)

Tomás Luis de Victoria

(4-part motet)

Victoria's settings of the *Offices for Holy Week* have become an established tradition for performance in the Sistine Chapel. One of these is the four-part motet *O vos omnes* (above), its text coming from Jeremiah and its mood one of lamentation. The passage shows the characteristic grieving motif in the descending tenor voice in measure 4, as well as the dissonance created by the dip of the minor second by the same voice in measure 5, so as to intensify the significance of the word *dolor*, or "sorrow."

Victoria never wrote a single note of secular music. As he stated in one of his dedications, he was led by some inner impulse to devote himself solely to church music. In his motets and masses, he even avoided the secular *cantus firmus* themes that were customarily employed by his contemporaries. Instead, he chose his motifs and melodies from his own religious works or from the traditional plainsong. In later compositions after his return to Spain, Victoria's work took on an even greater passion and intensity. With its religious ardor and devotional spirit, his music rises in its way to the same heights of mystical grandeur as the writings of Teresa of Ávila, the architecture of Herrera, and the pictures of El Greco.

IDEAS: MILITANT MYSTICISM

The Counter-Reformation was accompanied by a vigorous reassertion of the mystical worldview. In keeping with the spirit of the times, however, it was a practical mysticism of this world as well as the next, a realistic blending of the active as well as the contemplative life, a religious experience not limited to future saints but broadened to include all those faithful to the Church as the mystical body of Christ.

The new mysticism was socially oriented to enlist laity as well as clergy, those active in worldly affairs as well as those behind convent walls. It was a rekindling of the fires of faith at a time when the foundations of faith were threatened by new scientific discoveries; a call to arms for all those willing to fight for their convictions against doctrines the

Roman Catholic Church considered to be heresy. This was a military mysticism of a Church on the march.

The enemy was made up of the various Protestant movements at home; the pagan religions of Africa, Asia, and the Americas abroad; the materialistic worldview that went with growing nationalism and colonial expansion; and the forces of rationalism unleashed by free scientific inquiry.

The Counter-Reformation was just as much a reassertion of spiritual and moral values in the face of growing scientific materialism as it was an anti-Protestant movement. The Church plainly saw that if the mechanical image of the world as "matter in motion" were generally accepted, the belief in miracles would be undermined, the notion of divine intervention in worldly affairs would be destroyed, and the sense of mystery would be drained out of the cosmos.

The new psychology was not so much concerned with abstract theological notions as with concrete religious experience through vivid imagery. The mysticism of St. Teresa and St. John of the Cross differed from medieval mysticism in its rational control and written documentation of each stage of the soul's ascent from the depths of temptation and sin to the ecstasy of union with the divine.

St. Ignatius and the Jesuits

The most typical expression of the Church militant, however, was the Society of Jesus, founded by that soldier and man of action St. Ignatius Loyola. His Jesuits helped adapt Church doctrine to modern conditions, faced the moral and political realities of the century, and took an active part in education, public affairs, and missionary work. Under the director general, a Jesuit enlisted as a "warrior of God under the banner of the Cross" and stood ready to go for the "propagation of the faith to the Turks or other infidels even in India or to heretics, schismatics or some of the faithful." The whole world, for missionary purposes, was divided into Jesuit provinces, and the priestly army of occupation followed in the wake of the navigators and colonizers.

The spiritual side of the Jesuit military organization is reflected in St. Ignatius's *Spiritual Exercises*, a precise, disciplined exploration of the mysteries of faith through the medium of the senses. As part of the Jesuit system of education, St. Ignatius worked out a four-week series of meditations leading to a cleansing and purifying of the soul. All faculties are brought into play so that the experience becomes a vividly personal one.

Sin is the subject of the first week, and its consequences are felt through each of the senses in turn. In the "Torment of Sight," the student visualizes the terrible words engraved on the gates of Hell—Ever, Never—and sees the flames spring up around. In the "Torment of Sound," the sinner listens to the groans of millions of the damned, the howls of demons, the crackle of flames that devour the victims. With the "Torment of Smell," he or she is reminded that the bodies of the doomed retain in Hell the corruption of the grave. Their "stink shall come up out of their carcasses," prophesied Isaiah (Isa. 34:3). For the "Torment of Taste," the condemned shall suffer hunger like dogs; "they shall eat every man the flesh of his own arm" (Isa. 9:20), and their wine shall be the "poison of dragons and the cruel venom of asps" (Deut. 32:33). And in the "Torment of Touch," the damned will be enveloped in flames that boil the blood in the veins and the marrow in the bones but do not consume the victim. Both flames and flesh are forever renewed so that pain is eternal.

In the final phases, the progress leads up to the suffering, resurrection, and ascension of Christ, and it closes with the contemplation of heavenly bliss. The exercises were, of course, merely the preparation for and prelude to the mystical experience itself. By proclaiming that human beings could influence their own spiritual destiny, Jesuit optimism held a ready appeal for people of action.

Mysticism and the Arts

Such a strong accent on sensory experience as the means to excite religious feeling was bound to find expression in the arts. Through architectural, sculptural, pictorial, literary, and musical illusions, miracles and transcendental ideas could be made to seem real to the senses, and the mystical worldview could be reasserted through aesthetic imagery. The increasing complexity of life, the rapid growth of new knowledge, the deepening of psychological insights all shaped the course of baroque art. As religious, social, and economic pressures mounted, people were increasingly inclined to resolve their insecurities by turning to the cults of visionary saints or to the power of the absolute state. Artists were enthusiastically enlisted to enhance the full power and glory of both Church and state. Counter-Reformation churches were spacious, light, and cheerful; and visual artists, dramatists, and composers joined forces to make them like theaters where a concert of the arts played a prelude to future heavenly bliss.

Renaissance clarity of definition and the division of space into clearly understood patterns gave way to an intricate baroque geometry that took fluidity of movement into account. Neat Renaissance lines, circles, triangles, and rectangles became the intertwining spirals, curves, ovals, elongated diamond shapes, rhombuses, and irregular polygons of the baroque. With Borromini, horizontal and vertical surfaces were set into waves of rippling rhythms; balance and symmetry yielded to restless, unsettled movement; walls were molded sculpturally, surfaces were treated with a rich play of color, light, and shadow. Pictures escaped from their vertical walls and settled upon spherical triangular pendentives and spandrels, concave and convex moldings, and the inner surfaces of ceilings, vaults, and domes.

With Pozzo's paintings, solid walls, vaulted ceilings, and domes dissolved into cloudy, illusionistic vistas of the great beyond. With Bernini, marble saints and angels floated freely in space. With El Greco, bodily being almost ceased to exist, and his

figures are more spirit than flesh, his landscape backgrounds more heavenly than earthly. St. Teresa recorded and published her ecstatic visions in sparkling Spanish prose and poetry so that a wide public could experience them vicariously. Palestrina and Victoria illuminated the hymns of the liturgical year with the clarity of their counterpoint, and their melodies made them glow with new meaning.

By adopting the baroque styles as their own and helping shape the artistic vocabulary of the time, the Jesuits not only brought baroque art down from the exclusive aristocratic level but also carried the new ideas with them wherever they went, thus broadening the baroque into an international style. Counter-Reformation baroque churches are found as far afield as Mexico (Fig. 346), South America, and the Philippines. The extraordinary vigor of the Church militant thus succeeded in tapping new spiritual sources and vitalizing Roman Catholicism to such an extent that it re-emerged as a popular religious movement.

346. Mexico City Cathedral. 1656–71.

17th-CENTURY HOLLAND

	KEY EVENTS	PHILOSOPHY, SCIENCE, LITERATURE	PAINTING AND MUSIC
		1466-1536 Desiderius Erasmus	
1500 -	1517 Protestant Reformation began in Germany 1536 <i>Institutes of Christian Religion</i> published by John Calvin (1509-64); Dutch Reformed Church established later along Calvinist lines		c.1542-1623 William Byrd (English School) 🗆
1550			
1600 -	1566 Revolt of Netherlands against Spain began 1575 University of Leyden, first Dutch university, founded by William the Silent, prince of Orange	1583-1645 Hugo Grotius , founder of international law 1587-1679 Joost van den Vondel , Dutch dramatist, author of <i>Lucifer</i> , poem similar to Milton's <i>Paradise Lost</i> 1596-1650 René Descartes 1596-1687 Constantijn Huygens , poet, humanist, diplomat	1562-1628 John Bull (English School), organist at Antwerp (1617-28), friend of Sweelinck □ c.1562-1638 Francis Pilkington (English School), author, First Booke of Ayres □ c.1576-1643 Henry Peacham (English School), author of Compleat Gentleman, teacher and composer □ c.1580-1666 Frans Hals ▲ 1583-1625 Orlando Gibbons (English School) □ 1585-1672 Heinrich Schütz (German School) □ 1587-1654 Samuel Scheidt (German School), pupil of Sweelinck □ 1596-1663 Heinrich Scheidemann (German School), pupil of Sweelinck □
1000	1602 Dutch East India Company organized 1609 Holland and Flanders given virtual independence in truce with Spain 1618-1648 Thirty Years' War; full independence given to Holland under Treaty of Westphalia (1648) 1621 Dutch West India Company founded		1606-1669 Rembrandt van Rijn ▲ 1610-1660 Judith Leyster ▲ c.1617-1681 Gerhardt Terborch ▲ 1623-1722 J. A. Reinken (German School), successor of Scheidemann at Hamburg, and influencer of J. S. Bach □
1625			c.1628-1682 Jakob van Ruisdael ▲
	1630-1687 Limited public art partonage dispensed through Constantijn Huygens 1642 Dutch explorer Tasman discovered New Zealand 1648 Independence of Netherlands recognized by Treaty of Westphalia	1629-1648 René Descartes resided in Holland 1629-1695 Christian Huygens 1632-1677 Baruch Spinoza 1637 <i>Discourse on Method</i> published in Leyden by Descartes 1644 <i>Principles of Philosophy</i> published by Descartes in Amsterdam	c.1629-1679 Jan Steen ▲ c.1629-1683 Pieter de Hooch ▲ 1630-1693 Maria van Oosterwyck ▲ 1632-1675 Jan Vermeer van Delft ▲
1650	1652-1674 Anglo-Dutch commercial wars	1670 Spinoza published <i>Tractatus Theologico-</i> Politicus	1685-1750 Johann Sebastian Bach (German School) □ 1685-1759 George Frideric Handel (German School) □

15

The Bourgeois Baroque Style

AMSTERDAM, 17TH CENTURY

If visitors to 17th-century Amsterdam—or any of the other sturdy Dutch towns, for that matter—looked about for triumphal arches, pretentious palaces, or military monuments, they were doomed to disappointment. In fact, if there was anything grand at all about life in Holland and Flanders, it was its complete down-to-earth commonplaceness.

After they had achieved their cherished independence by winning back their country town by town and province by province from the grasp of the Spanish despots, the people organized their government with a minimum of unity and a maximum of diversity. They had no intention of substituting one brand of tyranny for another, much less a domestic variety; and so the land became the United Provinces under a *stadtholder*, or "governor." Let their English rivals call them the "united bogs"; their muddy swamps and marshlands were poor things, but at least they were their own (see map, p. 383).

The Dutch wars of independence, geographic isolation, constant struggle against the advances of the sea, harsh climate, seafaring economy, Calvinist Protestantism, and individualistic temperaments conspired with the other circumstances of Dutch life to focus the center of interest on the home.

When Jakob van Ruisdael painted the *Quay at Amsterdam* (Fig. 347), he was showing more than just a view of the old fish market at the end of the broad canal known as the Damrak. In this local variant of the international academic style (compare Fig. 379), he was in fact picturing the bourgeois, or middle-class, way of life. The scene depicts thrifty housewives gathering up provisions for their dinner tables. A part of the moored fishing fleet is seen at the left. Anchored in the distance are the merchant vessels used by the Dutch to create an efficient modern commerce. Sailing the seven seas, such merchants traded their clay pipes, glazed tiles, and Delft pottery for sugar, spices, fabrics, and other wares.

In such a situation, some families inevitably accumulated more than others, and by means of the wealth that was concentrated in their hands, they became a ruling class. These so-called regent families were the ones from whose ranks the members of the town councils and mayors were selected. They were, however, an upper-middle-class group rather than an aristocracy, and there was safety in their numbers. Their power, together with that of the professional and merchant societies known as guilds, depended upon exercising a maximum of local authority.

This decentralization favored the growth of universities—those at Leyden and Utrecht became the most distinguished in Europe—and promoted the careers of such noted native humanists as Constantijn Huygens, friend and patron of Rembrandt, and Hugo Grotius, founder of the new discipline of international law. The freedom to think and work attracted such foreigners as the French philosopher René Descartes, who resided in Holland for almost twenty years, and the parents of Baruch Spinoza—one of the most profound human intellects of all time—who found refuge in Amsterdam after the persecution of the Jews had made life intolerable for them in their native Portugal.

The architectural expression of this bourgeois way of life is found in the various town halls, in such commercial structures as warehouses, countinghouses, and the market building, seen on the extreme right in Figure 347, and, above all, in the long rows of gabled brick houses like those seen on either side of the canal in the same picture. Dating from earlier times were such ecclesiastical buildings as the Oudekerk, or "Old Church," whose Gothic tower is silhouetted against the sky in the right background. Originally Roman Catholic, the building had been taken over by the Dutch Reformed Church after the Reformation.

As organized under the precepts of John Calvin, the Reformed Church held that religious truth

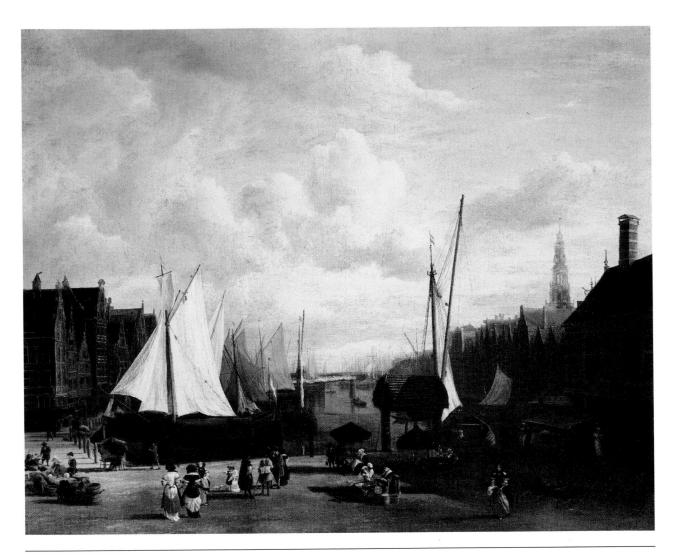

347. Jakob van Ruisdael. *Quay at Amsterdam.* c. 1670. Oil on canvas, $20\frac{3}{4} \times 26''$ (53 × 66 cm). Frick Collection, New York.

was not the exclusive possession of any individual or any group and that the word of God was available to each person without the mediation of priestly authority. Following the development of the printing press, every family could have its own Bible, and the high degree of literacy meant almost everyone could read it.

As in government, the Dutch people were wary of authority in religion; and as confirmed Protestants, they took rather literally the words of Christ to go into their closets and pray. Thus, through family devotions, hymn singing, and Bible reading, much of the important religious activity took place in the home. According to the teaching of Calvin, the reason for going to church was to hear a sermon and sing the praises of the Lord. No architectural embellishments, statuary, paintings, and professional choirs or orchestras should distract the wor-

shipers' attention. Since commissions no longer came from Church and aristocratic sources, artists had to seek an outlet for their work in family circles.

The prosperous Dutch families fortunately felt the need of an art that would reflect their healthy materialism and reveal their outlook, their institutions, and their country just as they were—solid, matter-of-fact, and without airs. In this happy state of affairs, patronage was spread on a sufficiently broad basis so that almost every home had at least a small collection of pictures.

All categories of painting were represented, but always with a characteristic national and personal touch and twist. In *history scenes*, Greco-Roman mythological allegories were avoided because they recalled aristocratic court life under which the Dutch had been suppressed for so long. Also shunned were the traditional Roman Catholic subjects, such as the

life of the Virgin Mary and representations of Christ's suffering, death, and resurrection. Instead, the Protestant accent was upon the stories and parables of the New Testament and Jesus' teaching and preaching (see Fig. 352).

Landscape had a strong attraction since the Dutch had fought for every inch of their soil, and paintings of fields, mills, and cottages appealed to their sense of ownership. Typically horizontal in orientation, these flat landscapes were seen under mercurially windswept skies. They also included human figures tilling the soil to emphasize that these precious acres had been wrested from the ravages of the sea and were now under cultivation to contribute to the good life of their hard-won country.

Genre scenes were particularly popular because such casualness, informality, and human interest harmonized with Dutch domestic surroundings. Such pictures portrayed unpretentious people going about their daily activities within intimately defined spaces. The subjects covered ranged from the tranquil atmosphere of well-ordered home life, peasants at their farming chores, and young musicians playing or singing at the family hearthside, all the way to roguish and ribald tavern scenes. Such studies were rendered with meticulous visual description of even the minutest details.

348. JUDITH LEYSTER. *Self-Portrait.* c. 1635. Oil on canvas, $29\frac{8}{8} \times 25\frac{8}{8}$ " (72 × 65 cm). National Gallery of Art, Washington, D.C. Gift of Mr. and Mrs. Robert Woods Bliss.

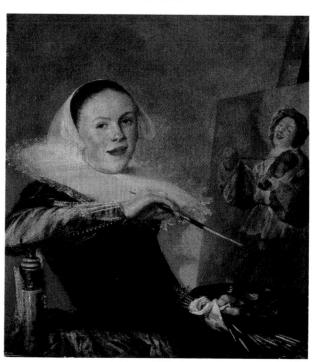

The severe simplicity of *still-life* compositions also found favor, since quiet arrangements of fruit, flowers, oysters, herrings, ceramics, drinking glasses, and textiles were visible evidences of the good life. In these studies, objects were rendered with almost scientific precision as seen in the picture by William Claes (Fig. 349). Often a somber note was sounded in these representations of the joys of possession, since worldly goods were also symbols of life's vanities. The inclusion of these *memento mori*, or reminders of death, were introduced by such objects as a trumpet, an allusion to Judgment Day; a lute with a broken string, signifying the transitoriness of time; and playing cards with the ace of spades that told of death (See Fig. 284 and p. 300).

Above all, portraiture was the most popular. The good Dutch burghers and burgesses wanted family portraits for their living rooms. These might be commemorative pictures of such events as christenings and weddings; paintings of quiet interiors with the wife and daughter performing some household chore; or paintings of a talented family member playing a musical instrument (see Fig. 363). A piquant example is found in Judith Leyster's Self-Portrait (Fig. 348). Leyster enjoyed a high reputation in her native Haarlem, where she was the only woman member of the painter's guild. Here, with brush in hand and palette beside her, she is painting one of her musical genre scenes. Her sensitivity to the nuances of interior lighting and her command of lustrous coloring combine to make her pictures memorable.

For their part, Dutch men liked to be portrayed along with their co-workers in what are called *corporation pictures*. In these group portraits, the men were seen in the company of their fellow directors or board members in panels designed to hang on the walls of some guild hall, professional society, officer's club, or charitable trust.

Under Calvinistic austerity, only three groups of professional musicians survived: the church organists, the hired singers and instrumentalists who performed for weddings, banquets, and parades, and the music teachers who taught the younger members of the family to sing and to play the lute (see Fig. 357), viols, and keyboard instruments such as the virginal and spinet (see Fig. 363). Music, therefore, like all the other aspects of Dutch life, was centered largely in the home. During the Renaissance, Holland and Flanders had dominated European music with the polyphonic glories of their distinguished composers. Only one musical genius of universal stature was left in the Amsterdam of the early 17th century: Jan Pieterszoon Sweelinck, whose

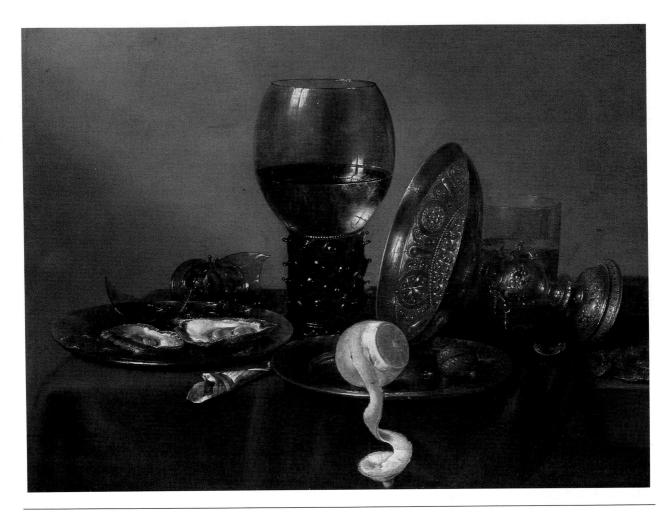

349. WILLEM CLAES HEDA. Still Life with Oysters, Rum Glass and Silver Cup. 1634. Panel, $17 \times 22\frac{1}{8}$ " (43 × 57 cm). Museum Boymans-van Beuningren, Rotterdam.

career brought to a brilliant close the radiant chapter of Dutch music that had dominated the Renaissance.

All the arts were thus centered in the home. The simple and unpretentious Dutch dwelling with its polished tiled floors, tidy interiors, and window boxes for the tulips was the modest framework for this bourgeois way of life. Unless ceramics are included, there was little sculpture other than a few figurines on the mantelpiece and an occasional statuette. Domestic pictures and music making provided the primary aesthetic pleasures of the Dutch, while such objects as Delft pottery jugs, tablecloths, laces, and draperies enriched their world of qualities.

The reality of daily life was made up of the routine of the business establishment, the marketplace, and the household. It was a reality of simple truths in which nothing was too small to be noticed and appreciated. All things, even the most insignificant, were considered gifts of God. As such, they were studied in the Holland of the 17th century in the smallest detail.

PAINTING

Rembrandt

Towering above all other Dutch painters because of the breadth of his vision, the power of his characterizations, and the uncompromising integrity of his ideals, stands the figure of Rembrandt van Rijn in lonely eminence. Like his contemporaries, Rembrandt painted portraits, genre scenes, historical subjects, and landscapes; but unlike them, he refused to specialize and succeeded magnificently in all. Furthermore, he brought a new psychological depth to his portraiture, an unaccustomed liveliness to his genre scenes, a greater dramatic intensity to his religious pictures, and a broader sweep to his landscapes than had been achieved before in the northern tradition.

Above all, Rembrandt's discoveries of the power of light, in all its varying degrees, to illumi-

nate character both from without and from within. to define space by varying degrees of brightness, and to give life to that space by the flowing movement of shadows identify him as a prime mover in the establishment of the northern baroque pictorial style. Rembrandt's art as a whole shows a steady growth from his early to his late years in the capacity to penetrate appearances, to discover and reveal the spiritual forces that lie beneath.

Soon after he settled in Amsterdam, the twenty-six-year-old painter received his first important assignment from the local Guild of Surgeons and Physicians. The result was Dr. Tulp's Anatomy Lesson (Fig. 350), a composition that combines group portraiture of the so-called corporation type with the anatomy pictures of the medieval and Renaissance tradition. The subjects in this case were the heads of the guild and other prominent citizens. whose names are recorded on the sheet of paper held by the figure in the center

In his painting, Rembrandt's grouping of figures and placement of the heads on different levels give a certain freedom and informality to the composition. By the use of light, the artist develops the essential drama of the situation, and by the expression on each of the faces shows reactions that vary from intense concentration to casual indifference. The fullest light is focused on the corpse and on the hands of Dr. Nicholas Tulp, the professor of anatomy who is giving the lecture. The large open book at the feet of the corpse is quite possibly an edition of Vesalius's Anatomy. This universally recognized authority was the work of the Dutch scientist Andries van Wesel (1514–1564), who had taught and held just such demonstrations at the University of Padua. Since Dr. Tulp styled himself Vesalius redivivus ("Vesalius revived"), the reference is appropriate. In sum, Rembrandt's dramatization of the spirit of scientific inquiry is a vivid product of a period that has been aptly called the Age of Observation.

350. Rembrandt. Dr. Tulp's Anatomy Lesson. 1632. Oil on canvas, $5'3\frac{8}{8}'' \times 7'1\frac{1}{4}''$ (1.16 × 2.17 m). Mauritshuis, The Hague.

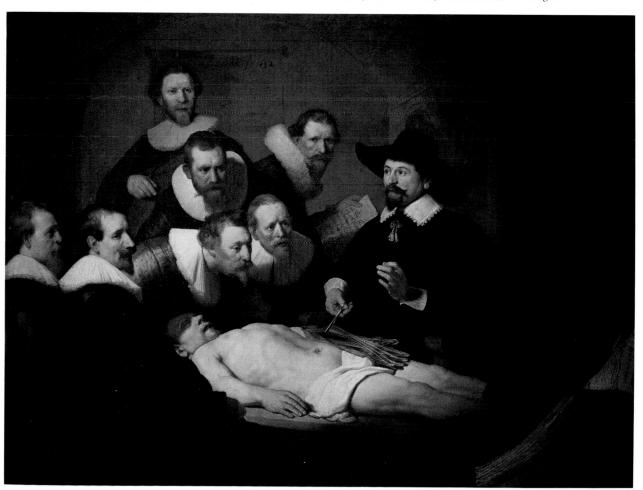

Exactly a decade elapsed between the *Anatomy* Lesson and the Sortie of Captain Banning Cocq's Company of the Civic Guard (Fig. 351), Rembrandt's masterpiece of the corporation type. Group portraits of such military units that had fought against the Spaniards were common enough at the time to have the designation musketeer pictures. Once their original purpose in the struggle for independence was gone, many of these companies continued as parts of the civic guard and as officers' clubs, available as the occasion warranted for anything from emergency duty to a parade. By 1642, most members had become prosperous shopkeepers who hugely enjoyed dressing up now and then in their dashing uniforms, polishing their shooting irons, and posing as warriors in holiday processions or civic celebrations.

In the so-called musketeer pictures, these military units were usually shown in convivial situations, for example, gathered around a banquet table. However, to get life and movement into his picture, Rembrandt discarded this rather stilted pose and chose to show Captain Cocq's company in action, as if responding to a call to duty. The life-size figures are therefore seen moving outside the city gate.

The free flow of light can be seen moving throughout the whole composition, filling every corner with dynamic gradations from dark to bright. The light becomes most intense in the center, where Captain Cocq is explaining the plans to his lieutenant, whose uniform catches the rays of the morning sun. As a counterbalance, Rembrandt places the whimsical figure of a young girl in gleaming cream-

351. Rembrandt. Sortie of Captain Banning Cocq's Company of the Civic Guard. 1642. Oil on canvas, 12'2" × 14'7" (3.71 × 4.45 m). Rijksmuseum, Amsterdam.

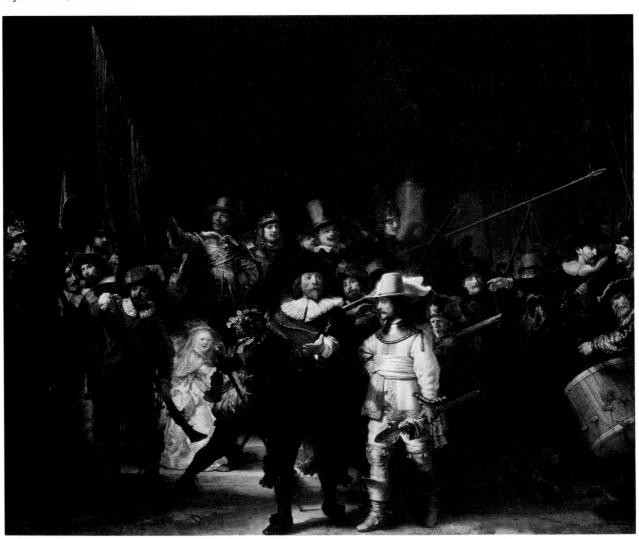

colored satin at the captain's other side. Strung from her belt are a powder horn and a white cockerel. possibly a pun by Rembrandt on the captain's name. The shadow of Captain Cocq's hand falling across the lieutenant's uniform defines the source of light that, in turn, blends together and relates all the other figures to the central pair by the intensity with which it illuminates them. Such skill in the handling of light and shadow was one of Rembrandt's unique achievements, and it was also evident in his prints.

The etching Christ Healing the Sick (Fig. 352), familiarly known as the Hundred Guilder Print, is an example of Rembrandt's several hundred works in what was then a popular medium in the visual arts. Financially, the relatively modest price of an etching assured Rembrandt of some income—and a fairly wide distribution of his work—at those times when his paintings piled up unsold in his studio. (The price in the case of this etching was a record high rather than a rule.)

Technically, the etching medium gave Rembrandt the opportunity to explore the qualities of

light in simple line patterns independent of colors. By scratching a coated metal plate with a sharp, penlike stylus, an artist makes a linear pattern that is etched, or bitten, into the metal upon being plunged into an acid solution. When the coating is removed and the plate inked, an etching is made by transferring the inked impression on the metal plate to paper. In this example, the gradations of light and dark run from such inky blackness as that behind the figure of Christ to the whiteness of the untouched paper, like that of the large rock in the extreme left. Rembrandt's true artistic stature is revealed in the way his art scales the heights of moral grandeur within severe limitations. The expressive power of this print is as great as the medium is small.

Rembrandt was brought up in a family of Anabaptists who tried to live according to strict biblical teachings. His religious subjects are seen from a Protestant point of view and, as such, show an intimate personal knowledge of the scriptures. Since he was not painting for churches, and thus was under no compulsion to conform to the usual iconographic

Rembrandt. Christ Healing the Sick (Hundred Guilder Print). c. 1649. Etching, $10\frac{7}{8} \times 15\frac{8}{8}$ " (28 × 39 cm). Metropolitan Museum of Art, New York (H. O. Havemeyer Collection, 1929).

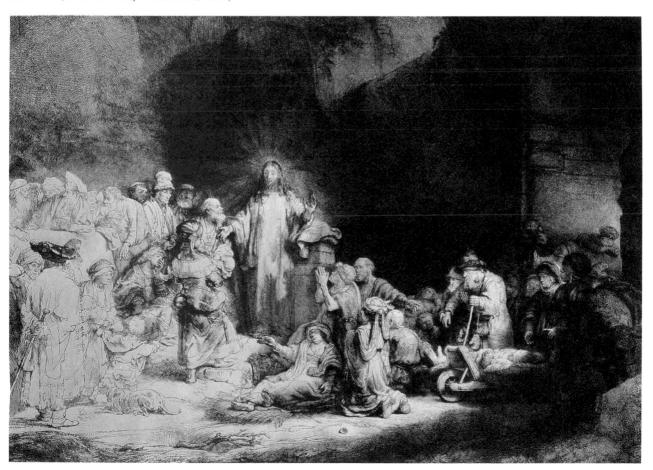

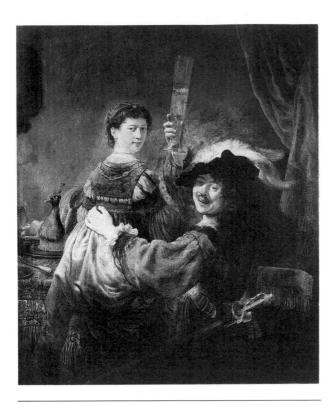

353. Rembrandt. *Self-Portrait with Saskia.* c. 1634. Oil on canvas, $5'3\frac{1}{2}'' \times 4'3\frac{1}{2}''$ (1.16 × 1.31 m). Gemäldegalerie Alte Meister, Dresden.

tradition of Madonna and Child, the Crucifixion, and so on, he was free to develop new themes and new points of view. Much of the intimacy and effectiveness of such free works is due to the fact that they were not conceived as public showpieces. Rembrandt also loved to explore the Amsterdam ghetto, and it was there that he found subjects for his art among the Jewish descendants of the people who created the Old Testament.

SELF-PORTRAITS. Rembrandt is known to have painted at least sixty-two self-portraits, surely a record number. The motivation, however, came more from a strong tendency to look inward than from personal vanity. Besides, no model was more quickly available. Extending from young manhood to his last year, his likenesses of himself read like a pictorial autobiography. After successfully establishing himself in Amsterdam and after his marriage to Saskia van Uylenburgh, daughter of a wealthy family, Rembrandt enjoyed a period of material prosperity. In cavalier costume and enthusiastic mood, he paints himself with his young wife sitting on his knee as he lifts his glass in a toast (Fig. 353). Beyond the joyous personal note here, the iconographical

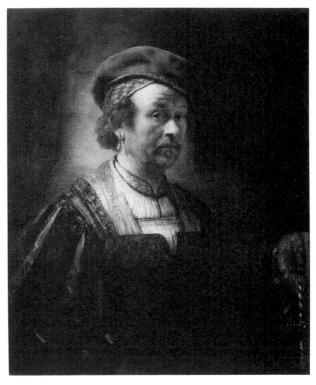

354. Rembrandt. *Self-Portrait.* 1650. Oil on canvas, $36\frac{1}{4} \times 29\frac{3}{4}$ " (92 × 75 cm). National Gallery of Art, Washington, D.C. (Widener Collection, 1942).

precedent for such a picture is that of the prodigal son who "wasted his substance with riotous living" (Luke 15:13).

From 1640 on, Rembrandt sustained a series of tragedies, beginning with his mother's death, which was followed two years later by that of his wife, Saskia, shortly after the birth of their son Titus. By 1650 artistic tastes had changed, but Rembrandt firmly followed his own genius, making no bow to fickle fashions.

The penetrating look in the self-image reproduced in Figure 354, glowing with an internal light, peers into the depths of his own character and seems to be asking "Which way now?" From this time onward, Rembrandt realized more and more that his mission was to explore the world of the imagination and leave the world of appearances to others. Consequently his face shows the serenity of a man who, having chosen his course, knows there is no longer any turning back.

Financial troubles increased as debts piled up, and from 1656 to 1660 the artist went through bankruptcy. His fine house, with its furnishings, his personal collections of paintings, prints, armor, and artistic props, all were sold to satisfy creditors. At this

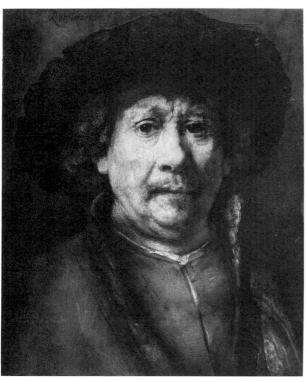

REMBRANDT. Self-Portrait. 1656-58. Oil on wood, 20 × 16" $(51 \times 41 \text{ cm})$. Kunsthistorisches Museum, Vienna.

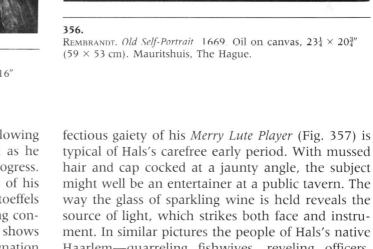

point (Fig. 355), the searching gaze of the glowing eyes begins to turn inward in self-appraisal as he forthrightly evaluates his moral and artistic progress. The last years were saddened by the deaths of his faithful friend and housekeeper Hendrickje Stoeffels (1662) and his son Titus (1668). Still working continuously, Rembrandt in his last self-portrait shows the familiar face marked by illness and resignation but still full of the deep human compassion that characterized his life and art (Fig. 356).

Hals, De Hooch, and Ruisdael

Between the polar extremes of the introspective Rembrandt and the calculated detachment of his younger colleague Vermeer (see Figs. 360-363) is the range of subjects and moods projected by their contemporaries. While Rembrandt sought to portray the spirit of the whole person, Frans Hals was content to capture human individuality in a fleeting glance or a casual gesture. In his early work he was more interested in appearances than essences. Later, when he came under the influence of Rembrandt's soul-searching, he gave up his vivid colors and light touch for somber hues and serious subjects. The in-

REMBRANDT, Old Self-Portrait 1669. Oil on canvas, $23\frac{1}{4} \times 20\frac{3}{4}$

typical of Hals's carefree early period. With mussed hair and cap cocked at a jaunty angle, the subject might well be an entertainer at a public tavern. The way the glass of sparkling wine is held reveals the source of light, which strikes both face and instrument. In similar pictures the people of Hals's native Haarlem—quarreling fishwives, reveling officers, and tipsy merrymakers—live again with all their boundless vitality.

Pieter de Hooch's Mother and Child (Fig. 358) is a quiet study of domestic life in a proper household. Like his fellow painters, de Hooch knew that light was the magnet which attracted the eye and that its vibrations gave such an interior its share of life and movement. But de Hooch works with a softer light that matches the calm of his subject matter. Sunlight streams inward from the open Dutch door at the back and the window at the upper right. By this means the artist separates his space into three receding planes; explores the contrasting textures of the tile flooring, transparent glass, varnished wood surfaces, soft textiles, and metallic brilliance of the copper bedwarmer; as well as models the figures of mother, daughter, and dog.

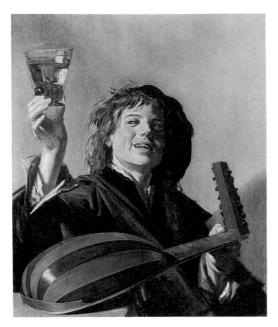

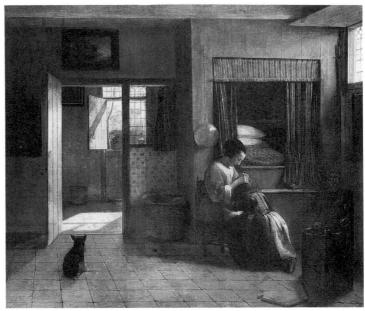

357. above left: Frans Hals. Merry Lute Player. c. 1627. Oil on canvas, $35\frac{1}{2} \times 29\frac{1}{2}$ " (90 × 75 cm). Private collection.

358. above right: Pieter de Hooch. Mother and Child. c. 1660. Oil on canvas, $20\frac{3}{4} \times 24''$ (52.5 × 61 cm). Rijksmuseum, Amsterdam.

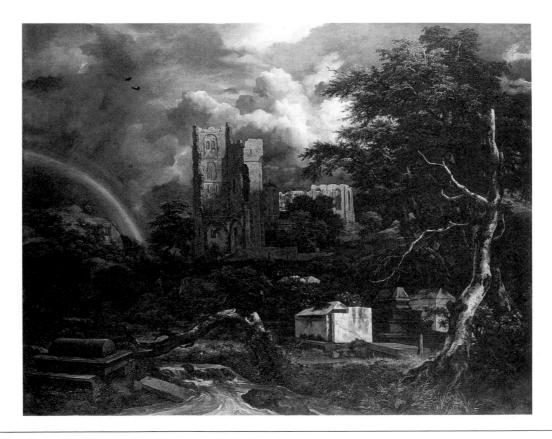

359. Jakob van Ruisdael. The Cemetery. c. 1655–60. Oil on canvas, $4'8'' \times 6'2_4^{1''}$ (1.42 \times 1.89 m). Detroit Institute of Arts (gift of Julius H. Haass, in memory of his brother Dr. Ernest W. Haass).

De Hooch's world is more stable than Rembrandt's, his figures less animated than Hals's, and his pictorial geometry more casual than Vermeer's. Yet each of his interiors has the timeless essence of a still life, with figures and objects blending together to make a compositional whole.

Jakob van Ruisdael's somber study of a cemetery belongs to the category of the landscapes that meant so much to the Dutch people who had fought persistently for their country against the Spanish oppressors. While his Quay at Amsterdam (Fig. 347) is a forthright cityscape, exact in its descriptive detail, Ruisdael, in The Cemetery (Fig. 359), seems to be searching for deeper symbolic values. The setting was the Jewish graveyard near the Oudekerk in Amsterdam, but to heighten the mood of his picture the painter invents many imaginary picturesque details that contribute here to the somber feelings, loneliness, and desolation of mortals when confronted with forces beyond their control. The abandoned ruins of the old castle and the skeletonlike trunks of two dead trees, which were not in the actual scene, unite with the white stone slabs of the tombs to haunt the picture with thoughts of death.

The inscriptions on the headstones—several of which are still there—remind the viewer that the religious toleration of the Netherlands made the country the haven for the Jewish refugees from the Spanish and Portuguese inquisitions. Ruisdael projects a depth of feeling as well as of space into this landscape. With the waterfall and knotted, twisted trees groping toward the threatening sky, he cap-

360. Jan Vermeer. View of Delft. c. 1658. Oil on canvas, $38\frac{3}{4} \times 46\frac{1}{4}$ " (98 × 117 cm). Mauritshuis, The Hague.

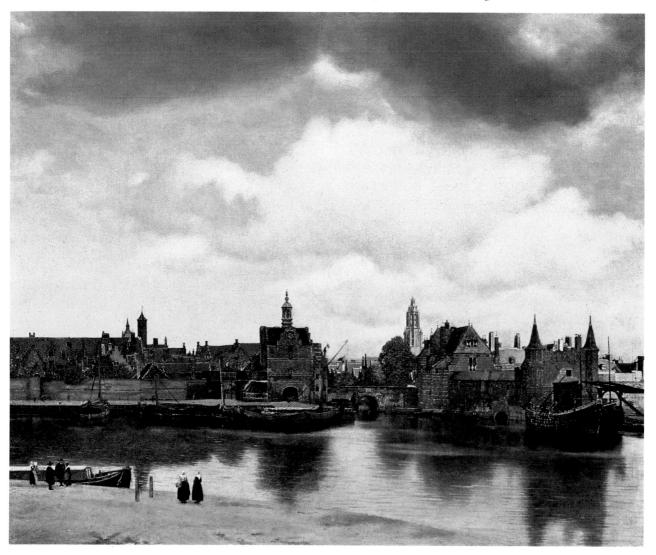

tures something of the sublimity of nature that sweeps mere mortals and all their works before it. His art with its flights of imagination, rugged grandeur, and eye for the picturesque anticipates certain similar aspects of 19th-century romantic landscape painting (see Figs. 449, 450).

Vermeer

In his *View of Delft* (Fig. 360) Jan Vermeer van Delft painted the profile of his native city. From the people strolling in the lower left foreground, the artist carries the eye across the canal, along the line of commercial buildings and houses behind the city wall on the left, past the stone bridge in the center with the steeple of the church rising in the background, to the moored boats and drawbridge on the extreme right. Vermeer's unusual and inventive handling of pictorial space is seen in this horizontal sweep, which makes no attempt to draw the eye into the deep background space based on a single vanishing point.

The effectiveness of the *View of Delft* is greatly increased by the subtle treatment of light and color. As the sunshine filters through the broken clouds, the light falls unevenly over the landscape, varying from the shadowy foreground and the dull red of the brick buildings, through the flame and orange tones in the sunny distance, to the brilliant gleam of the

361. Jan Vermeer. *Officer and Laughing Girl.* 1655–60. Oil on canvas, 20×18 " (51 \times 46 cm). Frick Collection, New York.

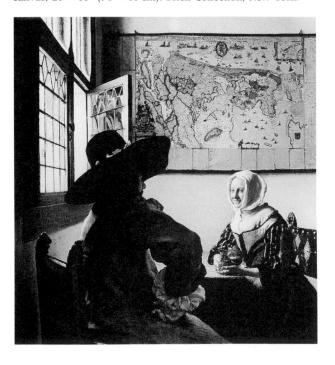

church tower in the distance. More than half the area of the picture is given to the ever-changing Dutch sky, where patches of blue alternate with the silvery and leaden grays of the clouds, while the waters below reflect the mirror image of the town.

With utmost economy of means, Jan Vermeer also painted a group of interior scenes, such as Officer and Laughing Girl (Fig. 361). Here Vermeer's logical organization of rectangles and intersecting surfaces is somewhat softened by the importance given to the conversing couple. The daring cameralike perspective projects the figure of the officer forward and gives greater size to his large slouch hat and head than to the figure of the girl. His red coat and sash also contrast noticeably with the cooler colors of the girl's white cap, black and yellow bodice, and blue apron that allow her figure to recede. The map on the wall is painted with the greatest care in relation to the light and angle of the wall. Its Latin title is quite clear and reads: "New and Accurate Map of all Holland and West Friesland." The warm, rich, natural light that streams in from the open window gives both unity and life to the severe division of planes. It bathes every object and fills every corner of the room, starting with the maximum intensity of the area around the source and tapering off by degrees into the cool bluish tones of the shadows in the lower right.

The *Art of Painting* (Fig. 362) is a work that must have had deep personal significance for Vermeer, as he kept it in his studio during his lifetime. After his death, his wife also made every effort to keep it in her possession. The 16th-century costume of the painter places the action in the past, while the lovely model, crowned with laurels, represents Clio, the muse of history. The large volume she holds is thought to be the *Schilderboeck*, a work on the lives of the Dutch painters by Karel van Mander, while the trumpet signifies Fame. The map of Holland, the trumpet, the book, and the death mask on the table all add geographical, musical, and sculptural dimensions to this allegory of the arts.

The contrast between Rembrandt's restless, searching spirit and Vermeer's sober, objective detachment is fully as great as that between El Greco and Velázquez or Rubens and Poussin. Rembrandt's light is the glow of the burning human spirit, Vermeer's that from the open window. While Rembrandt tries to penetrate the world of appearances, Vermeer is content with the visual image. With his warm personal quality, Rembrandt embraces humanity just as Vermeer, with his cool impersonality, encompasses space. Rembrandt is concerned at all times with moral beauty, Vermeer with physical per-

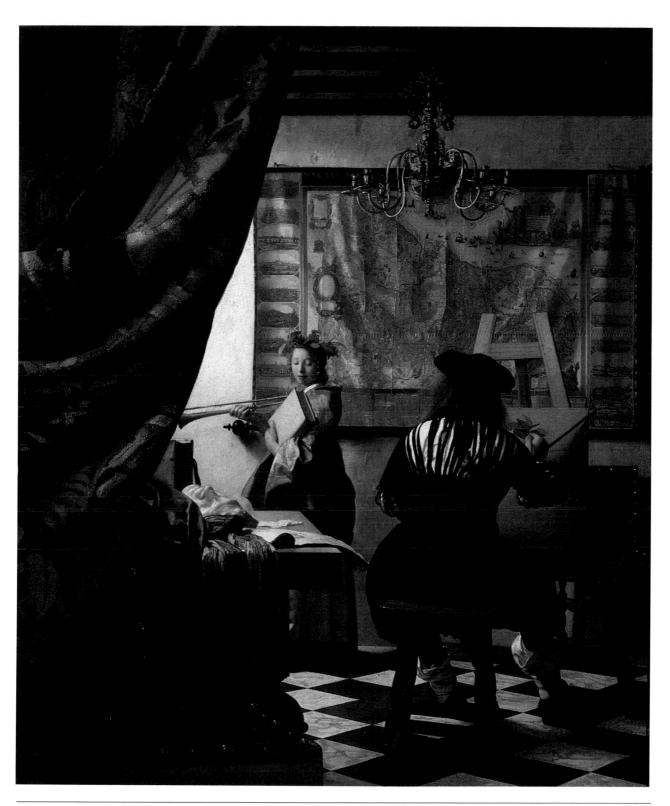

362. Jan Vermeer. The Art of Painting. c. 1665–70. Oil on canvas, $4' \times 3'8''$ (1.32 \times 1.12 m). Kunsthistorisches Museum, Vienna.

fection. Rembrandt's inner dramas need only the crescendo of a single color from deep brown to golden yellow or in an etching, from black to white; Vermeer's absence of drama demands the entire spectrum of colors.

Like a philosopher, Rembrandt lays the soul bare in his moving characterizations, while Vermeer, like a jeweler, delights the eye with his unique perception of the quality and texture of things. Thus, in Holland, as well as in both Spain and France, the 17th century, like a stormy March, had been swept in on the leonine gusts of the free florid baroque and had gone out on a gentle lamblike academic breeze.

MUSIC

Sweelinck

Jan Pieterszoon Sweelinck was the last great representative of that brilliant period when Dutch and Flemish composers dominated the European musical scene. Unlike Heinrich Isaac, Josquin Desprez, and so many of his earlier fellow composers, Sweelinck remained a lifelong resident of Amsterdam, where he held the post of organist at the Oudekerk for more than forty years. Under the strict rules of Calvinism church music consisted mainly of the congregational singing of psalms and hymns. The development of music as an art, then, would have been ruled out were it not for the fact that Dutch tradition favored the organ, and the organist was allowed to play preludes and postludes before and after the service. On special occasions, choral settings of the psalms with some elaboration were performed during the service.

Sweelinck's viewpoint was international in scope. He knew the work of the great organists and choirmasters of Venice, including the Gabrielis, and was thoroughly familiar with the English keyboard school. His official title was Organist of Amsterdam, and as such his duties included the giving of public concerts. The Oudekerk, according to contemporary accounts, was always crowded on these occasions, and large audiences took delight in his improvisations and variations on sacred and secular themes; the baroque flourishes of his Venetian toccatas; his fantasies "in the manner of an echo," a keyboard adaptation of the Venetian double-choral style; and the choral preludes and fugues that he built on Protestant hymn tunes.

The other public Dutch music was of the occasional type, given by choral groups and instrumental ensembles that, for a modest price, would furnish anything from the madrigals sung at weddings to the

dances played at receptions. The home, however, was the center of the major part of the musical life of the time. Most of the surviving compositions from this period are found in the numerous manuscript copies that were made for home use. Printed scores, however, were obtainable from Venice and London, and early in the 17th century music printing began to flourish in Antwerp, Leyden, and Amsterdam. Holland also became noted as a center for the manufacture of musical instruments. The musical practices of the times can be vividly reconstructed by combining the surviving scores and musical instruments with the rich visual evidence in paintings of the period.

Vermeer's *The Concert* (Fig. 363), for one, shows a typical musical situation in the home. The trio is made up of a young woman, who reads her song part from the score she holds in her hand; a seated man, who supplies the harmonic background on his theorbo, a type of lute; and a girl at the spinet, the winged version of the virginal, who plays the keyboard part. On the floor is a viola da gamba, an instrument somewhat like the modern cello. Had it a player, this instrument would duplicate the bass line of the keyboard part in a combination known as the *continuo*.

The widespread custom of domestic music making resulted in a large body of literature that was designed for the home rather than for public performance. An example of this type of music is seen in John Dowland's song in several parts (see Fig. 285 and p. 302), where the score is laid out for the participants to gather around a table.

Sweelinck's fame attracted to Amsterdam students from all over northern Europe. Through them his influence spread, especially over the Protestant parts of Germany. His most noted pupil here was Samuel Scheidt of Halle, whose *Tablatura Nova*, published in 1624, did much to crystallize the German Protestant organ and choral style. A direct line thus extended from Sweelinck, who coordinated the Venetian and English schools, through such pupils as Scheidt, who transmitted the tradition to northern Germany, where Johann Sebastian Bach and George Frideric Handel were born in the year 1685.

Bach

The warm, human, all-embracing art of Johann Sebastian Bach is deeply rooted in the soil of the German Reformation. Though he wrote chamber music, instrumental dance suites, and concertos for the pleasure of aristocratic patrons, and though he composed his monumental B-minor Mass for a Roman

Catholic prince, the vast quantity of his artistic output consists of the cantatas, oratorios, and organ pieces he wrote for the faithful congregations of St. Thomas's Lutheran Church in Leipzig. While the Reformation put restrictions on the visual arts and some rigorous sects even disapproved of professional musicians generally, the Lutherans in the main were far more liberal than the Calvinists concerning music.

Bach's duties included not only playing the organ, directing the choir, and on special occasions

363. Jan Vermeer. The Concert. c. 1660. Oil on canvas, $28 \times 24_4^{3''}$ (71 × 63 cm). Isabella Stewart Gardner Museum, Boston.

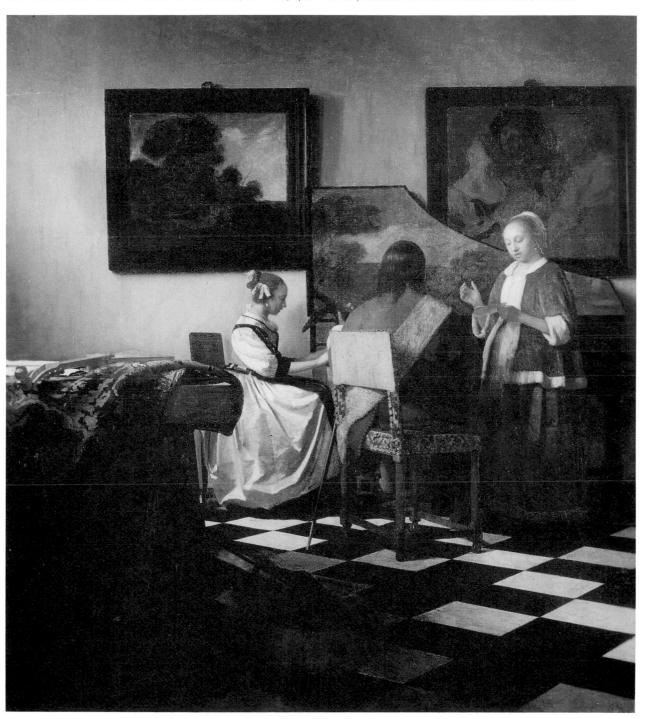

conducting the small orchestra but also writing most of the music for church services. This meant a cantata for Sundays; large-scale oratorios for Christmas, Passion Week, and Easter; and occasional music for marriages, funerals, the installation of a pastor, important civic occasions, and the like. Bach's fertile musical imagination and inexhaustible industry led to his completing no less than five series of cantatas for each Sunday and feast day of the church calendar—some three hundred in all, of which about two hundred still exist.

Chorale from Johann Sebastian Bach Cantata No. 140 (Wachet auf, ruft uns die Stimme)

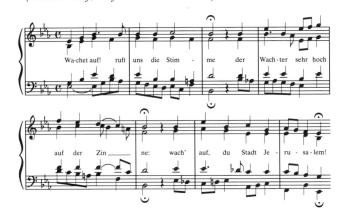

The *cantata* is a form of incidental music for voices and instruments, woven directly into the Sunday service—the Protestant counterpart of the Roman Catholic sung mass. After the reading of the scriptural lesson the first half of the cantata was performed. Then came the sermon and the second half of the cantata, ending with the chorale, or hymn of the day, with the whole congregation participating. Just as the sermon was an interpretation of the scriptures, the cantata was a musical commentary on the text of the day.

Sleepers Awake, the Watchman's Calling (Wachet auf, ruft uns die Stimme), Bach's Cantata No. 140, was written for the 27th Sunday after Trinity. It is scored for solo soprano, tenor, and bass; four-part chorus; an orchestra of strings plus two oboes, English horn, French horn; and a continuo of organ or harpsichord supported by a cello or double bass. The text of the chorale is a 16th-century hymn based on the parable of the wise and foolish virgins (Matt. 25:1–13), who go forth to meet their heavenly Bridegroom. The love motif of the recitatives and two duets comes from the same source, with embellishments from the Song of Solomon (3:1–5). The

theme is that of the Bride (the individual soul) awaiting the coming of the Bridegroom (Jesus). The first part expresses longing and the last, fulfillment.

The sturdy chorale, the words of which give the cantata its name, provides the basic musical material and in whole or part is present in all sections of the cantata's fabric (left). A short recitative follows for tenor with continuo accompaniment. This leads up to a duet for soprano and bass, also with continuo accompaniment, but with the addition of an obbligato, or embellishing, part for solo violin that embroiders garlands around and over the voice parts. In the exact center of the design the chorale again appears—this time with the tenors carrying the melody, supported by the continuo below and the violins and violas above. This number is a typical chorale prelude, confirmed by Bach's own arrangement of it for organ solo. These organ compositions based on a chorale were played during the service and before the chorale was sung by the congregation. Now follows another recitative written for bass voice, continuo, and strings. The next-to-last number is a duet for soprano and bass with oboe obbligato and continuo accompaniment. Finally comes the chorale once more, this time as a harmonized hymn in which the choir, orchestra, and congregation all join.

For the great church festivals Bach provided special music on a much larger scale. The tradition for such presentations goes all the way back to the mystery, miracle, and passion plays of the Middle Ages when, for instance, at Christmastime a manger scene, or crèche, was set up in the church for the reenactment of the story of the Nativity. In such a liturgical drama the choirboys would represent angels, adult choristers the shepherds, and members of the clergy Joseph and the Three Wise Men. Bach's famous 17th-century predecessor, Heinrich Schütz, wrote a notable example called the Christmas Story; and Bach himself composed a Christmas Oratorio, consisting of a series of six cantatas for weekly presentations during Advent, a period of anticipation beginning four weeks before Christmas, with the last one scheduled for the day after Christmas.

The Passion oratorios, similarly, grew out of the liturgical dramas performed during the week preceding Easter, particularly on Good Friday. They are the epic counterparts of the more lyrical and intimate Sunday cantatas. Here Bach again had, among others, the precedent of Schütz's St. Matthew Passion.

In keeping with established tradition, the scriptural passages in Bach's *St. Matthew Passion* are delivered by the Evangelist, who is represented by a tenor singing in recitative style. In the course of the work, the recitatives, solos, and ensembles represent

the dramatic action, which is balanced by the more thoughtful choral sections. The solo passages thus represent individual reactions, while the chorus symbolizes at various times the crowd or mob, and ultimately the body of faithful Christians. The congregation joins in for the chorales. Thus they gain a sense of participation in the events in the life of the Lord. Bach's *St. Matthew Passion* and B-minor Mass represent his supreme achievement in choral music.

A certain domestic intimacy associated with family festivals characterizes the Protestant musical treatment of these biblical stories, so that the Christmas story and Passion become in turn the counterparts of the events in family life—birth, marriage, suffering, death. In Bach, however, the Protestant Reformation reaches its highest musical fulfillment.

IDEAS: DOMESTICITY

The various aspects of the bourgeois baroque style find a common undercurrent in the idea of domesticity. Many related ideas, such as commercialism, Protestantism, antiauthoritarianism, nationalism, individualism, the passionate championship of personal rights and liberties, and the practical application of scientific discoveries, come together in this central concept. But the unity lies in the cult of the home. Bourgeois house comforts, for instance, were never so highly cultivated in the warmer, friendlier south, where recreational activity can occur in the open air. The northern climate, however, contributed to the concentration of family pleasures in the home.

The spirit of commerce led to navigational adventure on the high seas and to the exploration of distant lands. The conquests of the Dutch, however, were mainly those of the business people. Their empire was based on corporate enterprise, and their personal kingdoms were those of the banking houses and holding companies. Hard work and industriousness coupled with thrift led to a widespread accumulation of wealth in the hands of the middle class.

No riotous living or public displays of luxury were possible when the Protestant church permitted no embellishment in its buildings and little musical elaboration in its services. While both the Anglican and Lutheran reform movements preserved much of the beauty of the traditional Roman Catholic liturgy in a modified form, Calvinistic Protestantism was marked by its extreme austerity. A strict interpretation of Calvinism would lead directly to a gloomy form of asceticism, but the natural good sense and honest enjoyment of material pleasures saved the Dutch from the bleaker aspects of this doctrine. So

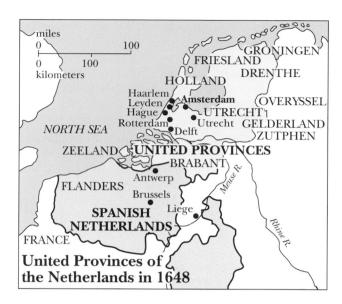

the principal outlet for their prosperity and desire for aesthetic enjoyment was in their homes.

Wealthy burghers, however, did not build palaces—though they certainly had the means to do so. They were content with comfortable houses that were functionally suited to their needs. Fighting the Spanish crown for their independence and resisting the growing menace of Louis XIV's absolute state made the Dutch look with disfavor on any form of courtly pomp and display.

The Protestant movement also fortified Dutch hostility to authority and intensified nationalist consciousness. Middle-class merchants particularly resented the draining off of their provinces' wealth in the direction of Rome. The resentment was equally strong against the secular arm of the Roman Catholic Church: the Holy Roman Empire. Protestantism thus took root and became identified in the Dutch mind with patriotism. Protection of their national rights and individual freedoms further focused attention on their homes, where they were lords.

Philosophy, social theory, and the natural sciences flourished in the Dutch universities. These intellectual pursuits theorized on the existence of an ordered and regulated universe in which everything could be measured and understood. Solid citizens instinctively distrusted the physical and emotional forces that could render their world chaotic and unpredictable. Hence, an ideal universe had appeal for a middle class whose security and comforts could be perpetuated by it.

Descartes' rational theory of the universe, his equally rational psychology, and Spinoza's mathematically provable ethical system paralleled the concept of art as a form of reasoned organization. It took a Rembrandt, however, to illuminate this age of rea-

son with an inner glow and to warm this rational world with the fire of human feeling.

Human anatomy was of consuming interest and, with Vesalius's *Anatomy* as a point of departure, dissection was carried over into other fields. Books had titles like *Anatomy of Melancholy, Anatomy of Wit, Anatomy of Abuses,* and *Anatomy of the World.*

In this Age of Observation, the restless human eye extended by the lens could explore many worlds, and more things were seen in heaven and earth than were ever dreamed of before. Optical instruments were developed by the skilled lens makers of Holland, whose ranks included Spinoza. An astronomical observatory was built at the University of Leyden, where the telescope could scan the skies. Conversely, the microscope opened up a new world in miniature.

Though their eyes were on the heavens, Dutch scientists did not neglect earthly applications of their

discoveries. Astronomical calculations led to the discovery of triangulation and the spiral balance, both of vast value to navigation. The pendulum was applied to the keeping of time, and the pocket watch gave punctuality to daily life.

Domesticity and the Arts

The circumstances of the Dutch state of mind and material prosperity led to the placement of artistic patronage in the hands of a well-to-do middle class. Outside such necessary public buildings as the town halls, churches, and commercial structures, Dutch architecture was, for all intents and purposes, domestic architecture. Since the houses were about the same size as middle-class homes today, they provided neither room nor opportunity for monumental sculpture. The major domestic aesthetic expressions occurred, therefore, in painting and music, together

364. Jan Steen. *Merry Family*. 1668. Oil on canvas, $3'7\frac{1}{4}'' \times 4'7\frac{1}{2}''$ (1.1 × 1.41 m). Rijksmuseum, Amsterdam.

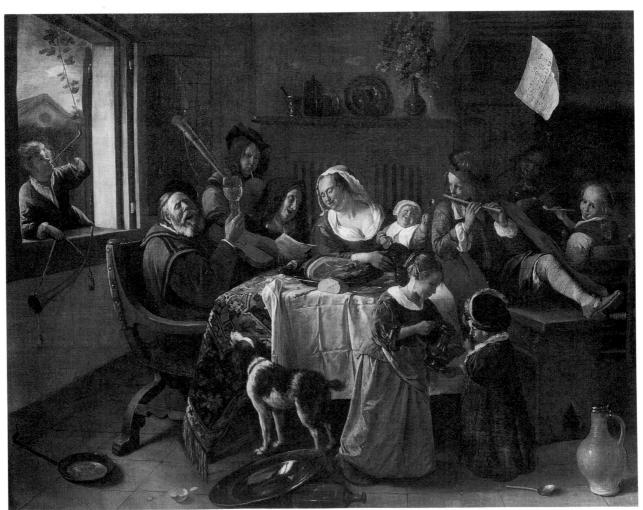

with all the minor decorative arts that added to the comfort and beauty of the home.

Destined for living room walls, pictures were correspondingly smaller than those painted for palaces and public halls. There was a seemingly inexhaustible demand for pictures, and the output was enormous. The number of professional artists multiplied with the demand and led to a corresponding degree of specialization. In portraiture there were the painters of the proper family types, of the drinkers in public taverns, and of corporation pictures. There were landscapists, seascapists, skyscapists, and even those whose specialty was cows. Painters also were drawn to the various social levels, with Jan Steen painting coarse tavern scenes and boisterous domestic interiors (Fig. 364); Frans Hals finding his subjects among fishwives and fruit peddlers; de Hooch and Vermeer depicting scenes in proper middle-class homes; and Terborch delighting in subtle narrative scenes and elegant society portraits.

The home was thus the factor that determined the art forms and gave them such an intimate character and quality. Dutch domestic architecture, painting, and music were all designed to be lived with and enjoyed by middle-class people who frankly took delight in their physical comforts and the arts that enriched their lives.

Large canvases designed for altarpieces or to cover palace ceilings, colossal choral compositions for cathedrals, and operatic performances for palaces could produce grandiose utterances but had no place in the home. The more modest dimensions of a painting or an etching intended for the wall of a living room or of a chamber sonata or solo keyboard piece meant to be played in the same room succeeded in encouraging a more intimate and personal form of communication.

The home was the dominant architectural form as well as the place where the pictures were hung, the books read, and the music played. In Holland and the northern countries generally, the baroque style was adapted both to Protestantism and to the tastes of the middle class. The bourgeois aspect of baroque art finds its unity in the cult of the home, and domesticity is the key to its understanding.

17TH CENTURY FRANCE AND ENGLAND

	KEY EVENTS	ARCHITECTURE	VISUAL ARTS	LITERATURE AND MUSIC, FRANCE	LITERATURE AND MUSIC, ENGLAND
4.600	1598-1610 Henry IV , king of France	1552-1626 Salomon de Brosse 1573-1652 Inigo Jones 1598-1680 Gianlorenzo Bernini	1577-1640 Peter Paul Rubens ▲ 1594-1665 Nicolas Poussin ▲ 1598-1680 Gianlorenzo Bernini ●	1596-1650 René Descartes ◆	1561-1626 Francis Bacon ♦ 1563-1593 Christopher Marlowe ♦ 1564-1616 William Shakespeare ♦ 1572-1631John Donne ♦ 1573-1637 Ben Jonson ♦ 1588-1679 Thomas Hobbes ♦
1700	1603-1625 James I (Stuart) reigned 1610-1643 Louis XIII, king of France with his mother Maria de' Medici (1573- 1642) as regent during his minority 1618-1648 Thirty Years' War. Spain and Austria defeated, France became dominant European nation 1624-1642 Cardinal Richelieu (1548-1642), prime minister 1625-1649 Charles I reigned; after 1629 ruled without Parliament 1642-1660 English Civil War 1643 Theaters closed by Parliament 1643-1661 Cardinal Mazarin (1602-61), prime minister 1643-1715 Louis XIV, king of France; ruled without prime minister 1643-1715 Louis XIV, king of France; ruled without prime minister from 1661 1649 Charles I executed; England proclaimed Commonwealth 1653-1658 Oliver Cromwell (1599-1658) ruled 1660-1685 Charles II reigned 1664-1665 Black Death (bubonic plague) swept London 1665-1683 Colbert (1619- 83), minister of finance 1666 Great Fire of London 1683 Government and ministries of France installed at Versailles 1685-1688 James II reigned 1688 Glorious Revolu- tion; James II deposed; William of Orange and Mary (Stuart) became limited monarchs 1689-1702 William and Mary reigned 1702-1714 Queen Anne reigned	1612-1670 Louis Le Vau 1613-1688 Claude Perrault 1613-1700 André Le Nôtre 1615-1624 Luxembourg Palace built for Queen Mother by Salomon de Brosse 1619-1621 Banqueting House, Whitehall, built by Inigo Jones 1632-1723 Christopher Wren 1661-1688 Versailles Palace built by Le Vau and Mansart; chapel added 1699-1708 1662 Christopher Wren appointed deputy surveyor-general to king; 1665 in Paris to observe remodeling of Louvre; met Bernini, Perrault, Mansart 1665 Bernini came to Paris to rebuild the Louvre Palace. French Academy in Rome established 1667-1674 East façade of the Louvre Palace built by Perrault 1669 Wren appointed royal surveyor-general 1671 Academy of Architecture established 1671-1680 St. Mary-le- Bow and other London parish churches built by Wren 1675-1710 St. Paul's Cathedral built 1682-1754 James Gibbs 1690 Wing of Hampton Court Palace built by Wren	1600-1682 Claude Lorrain (Claude Gellée) ▲ 1619-1690 Charles Lebrun ▲ 1621 Rubens commissioned to paint murals in Luxembourg Palace 1622-1694 Pierre Puget ● 1628-1715 François Girardon ● 1640 Poussin returned from Rome to decorate the Louvre Palace 1640-1720 Antoine Coysevox ● 1648 Royal Academy of Painting and Sculpture founded 1659-1743 Hyacinthe Rigaud ▲	1602-1676 Francesco Cavalli, Venetian opera composer □ c.1602-1672 Jacques de Chambonniéres, organist and clavecinist □ 1606-1684 Pierre Corneille ◆ 1621-1695 Jean de La Fontaine ◆ 1622-1673 Molière (J.B. Poquelin) ◆ 1623-1662 Blaise Pascal ◆ 1632-1687 Jean Baptiste Lully □ 1635 French Academy of Language and Literature established 1635-1688 Phillipe Quinault ◆ 1636-1711 Nicolas Boileau ◆ 1639-1699 Jean Racine ◆ 1666 Academy of Sciences established 1668-1687 François Couperin le Grand, clavecinist □ 1669 Royal Academy of Music (Paris Opera) established under Lully 1674 Alceste, lyrical tragedy by Quinalt and Lully, performed at Versailles. Boileau's Art of Poetry published	1604 Advancement of Learning by Francis Bacon 1606-1668 William Davenant □ 1608-1674 John Milton ◆ 1611 King James's authorized English translation of Bible completed 1620 Novum Organum by Francis Bacon 1628 Treatise on Terrestrial Magnetism and Electricity by William Gilbert (1540-1603) published in English edition. Circulation of blood discovered by William Harvey (1578-1657) 1628-1688 John Bunyan ◆ 1631-1700 John Dryden ◆ 1632-1704 John Locke ◆ 1633-1703 Samuel Pepys ◆ c.1647-1674 Pelham Humfrey □ c.1648-1708 John Blow □ 1651 Leviathan by Hobbes 1652-1715 Nahum Tate ◆ 1659-1695 Henry Purcell □ 1661 The Sceptical Chymist by Robert Boyle (1627-91) 1662 Royal Society of London for Improving Natural Knowledge founded; Isaac Newton, Christopher Wren, Robert Boyle, John Dryden, charter members 1667 Paradise Lost by Milton 1670 John Dryden named poet laureate and royal historian 1678 Pilgrim's Progress, Part I, by Bunyan; Part II, 1684 1680 Purcell appointed organist at Westminster Abbey; named composer-in-ordinary to king (1683) 1682 Venus and Adonis, chamber opera by John Blow, performed at court 1685 Albion and Albanius, opera by Dryden and Purcell, performed in London 1685-1759 George Frideric Handel□ 1687 Mathematical Principles of Natural Philosophy by Newton (1642-1727) c.1689 Dido and Aeneas, opera, by Purcell 1690 Essay concerning Human Understanding by John Locke 1691 King Arthur A Dramatick Opera by Dryden and Purcell 1692 Nahum Tate named poet laureate

16

The Aristocratic Baroque Style: France and England

Philip II's austere tastes and Dutch common sense held baroque expression within tight controls in Spain and Holland. In France, however, the aristocratic baroque style burst the bonds with ruffles, flourishes, and all manner of extravagance. Royal pomp and circumstance started in England with the Stuart kings but was temporarily overthrown by Cromwell's puritanical revolution. After the restoration of the monarchy, however, the baroque resumed its opulent course but in a much more limited fashion under Charles II and his successors.

FRANCE AND ABSOLUTE MONARCHY

With Louis XIV the aristocratic phase of the baroque became state policy, as everything about the king was calculated to suggest grandeur. His concept of kingship assured him the title le grand roi, or "great king"; his code of etiquette created the grand manner and made him in every sense the grand seigneur, or "great gentleman"; and his reign gave his century the name le grand siècle, "great century." At the time of his portrait by Hyacinthe Rigaud in 1701 (Fig. 365), Louis had been king in name for well over half a century and a king in fact for a full forty of those years. Dressed in his ermine-lined coronation robes. with the collar of the Grand Master of the Order of the Holy Spirit draped about his regal neck, Louis XIV might actually be uttering the words attributed to him: L 'Etat, c'est moi—"I am the state." Since he was in fact the personification of France, his portrait, appropriately, was that of an institution; his figure was as much a pillar holding up the state as is the column that supports the building in the background. Pompous and pretentious though the portrait may be, it formed part of the illusionism of a period that strove to make such abstractions as the

divine right of kings, absolutism, and the politically centralized state seem real to the senses.

The success of this system of centralization is seen in the list of positive accomplishments of Louis XIV's reign. In the course of his kingship the feudal power of the provincial nobles was broken, the Church became a part of the state instead of the state a part of the Church, Paris became the intellectual and artistic capital of the world, and France attained the dominant position among European nations. For the arts, the alliance with absolutism meant that they were of value as instruments of propaganda, as factors in the assertion of national power and prestige, and as the means of glorifying the state, impressing visiting dignitaries, and stimulating export trade. All this led, of course, to the concept of the arts as important aids to the cult of majesty and as the creator of the myth that by divine right the king could do no wrong.

With the king as principal patron, art inevitably became a department of the government, and Louis was surrounded with a system of cultural satellites, each of whom was supreme in a specific field. The foundation of the Academy of Language and Literature in 1635, the Royal Academy of Painting and Sculpture in 1648, and the others that followed made it possible for Boileau to dominate the field of letters, Lebrun the visual arts, and Lully music.

Absolutism also meant standardization, since no artist could receive commissions or employment except through official channels. Louis, however, knew what he was about, and in an address to the academy he once remarked, "Gentlemen, I entrust to you the most precious thing on earth, my fame." Consequently, he defended his writers and artists, supported them generously, and above all exercised that most noble trait any patron can possess—good taste.

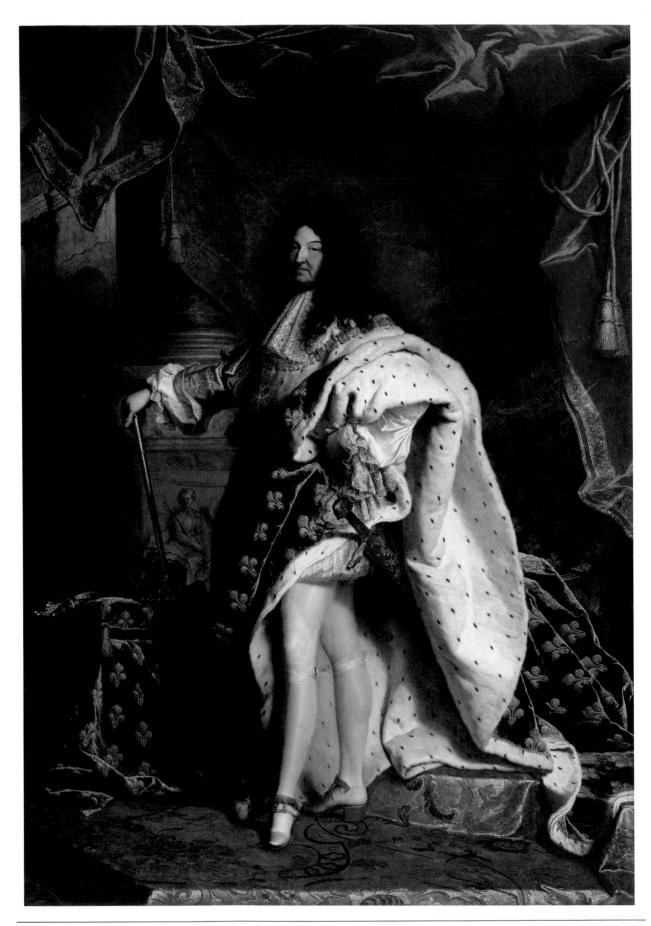

365. Hyacinthe Rigaud. *Louis XIV.* 1701. Oil on canvas, $9'1\frac{1}{2}'' \times 6'2\frac{5}{8}''$ (2.78 × 1.9 m). Louvre, Paris.

The outward and visible sign of this absolutism was to be seen in the dramatization of the personal and social life of this Roi Soleil, or "Sun King." The adoption of the sun as his symbol was natural enough, and such motifs as the sunburst were widely used in the decor of his palaces. As patron of the arts, Louis could identify himself freely with Apollo, the sun god, who was also the Olympian protector of the Muses. In the morning, when it was time for the Sun King to rise and shine, the lever du roi was as dazzling in its way as a second sunrise. This special dawn was accompanied by a cloud of attendants who flocked into the royal bedchamber precisely at 8 A.M. in order to hand the king the various parts of his royal apparel. A similarly colorful ceremony accompanied the coucher du roi, when the Sun King in a golden glow of candlelight finally set at precisely 10 P.M.

In the present day of dull cabinet officers and drah parliamentary hodies, it is difficult to imagine the overwhelming effect of the formal pomp and circumstance surrounding an absolute monarch's court. If his peers and subjects beheld a sufficiently majestic spectacle, a ruler apparently could get away with anything.

Throughout a reign of 72 years, Louis XIV played the leading role in this constant court drama with all the effortless technique and perfect self-assurance of an accomplished actor. Such a great actor needed, of course, a great audience; and such a dramatic spectacle demanded an appropriate stage setting. Architects therefore were called upon to plan

the endless series of connecting salons as impressive backdrops for the triumphal entries. Landscape designers were summoned to fashion the grand avenues for the open-air processions. Painters were commissioned to decorate the ceilings with pink clouds and classical deities so that the monarch could descend the long flights of stairs as if from the Olympian skies. Musicians, too, were brought in to sound the ruffles and flourishes that accompanied the grand entrances.

It was thus no accident that the Louvre and Versailles palaces resembled vast theaters, that the paintings and tapestries of Lebrun seemed like curtains and backdrops, and that Bernini's, Puget's, and Coysevox's sculptural adornments took on the aspect of stage props. Nor was it by chance that the most important literary expression should be the tragedies of Racine and the comedies of Molière, and that the characteristic musical forms should be Lully's court ballets and operas.

ARCHITECTURE

Louvre Palace

Colbert, Louis' astute finance minister, counseled him that "apart from striking actions in warfare, nothing is so well able to show the greatness and spirit of princes than buildings; and all posterity will judge them by the measure of those superb habitations which they have built during their lives." In 1665, at Colbert's insistence, the king requested the

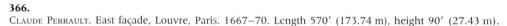

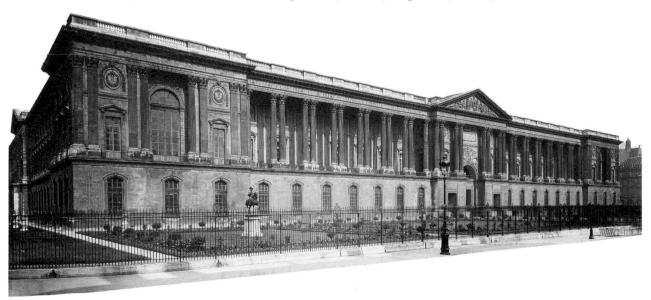

pope to permit his principal architect, Gianlorenzo Bernini, to come to Paris to supervise the rebuilding of the Louvre Palace. When he arrived on French soil, Bernini was received with all the honor due him as the ranking artist of his day. The design he made for the Louvre was radical in many ways. It would have required the replacement of the existing parts of the building by a grandiose baroque city palace of the Italian type. Colbert admitted that Bernini's palace was truly grand in style, but felt it left the king housed no better than before.

After a round of festivities, Bernini returned to Rome. His plan was scrapped, and a French architect, Claude Perrault, was appointed to finish the job. This little episode proved to be a turning point in cultural history. It marked the weakening of Italian artistic influence in France. It also indicated that Louis XIV had plans of his own.

Perrault's façade (Fig. 366) incorporated some parts of Bernini's project, such as the flat roof concealed behind a Palladian balustrade and the long straight front with the wings extending toward the sides instead of projecting forward to enclose a court in the traditional French manner. Perrault's own contributions can be seen in the solid ground floor, which is relieved only by the series of windows. This story functions as a platform for the classically proportioned Corinthian colonnade, with its rhythmic

row of paired columns marching majestically across the broad expanse of the façade. The space between the colonnade and the wall of the building allows for the rich play of light and shadow that was so much a part of the baroque ideal. The frieze of garlands adds an ornate touch, while the central pediment, as well as the classical orders of the columns and pilasters, act as a restraining influence.

Versailles Palace

Even before Bernini came to Paris and long before the Louvre was completed, Louis XIV had conceived the idea of a royal residence outside Paris where he could escape from the restrictions of the city, take nature into partnership, and design a new way of life. Colbert, who felt that a king's place was in his capital, advised against it, and Louis allowed the Louvre to be completed as a gesture to Paris. But his real capital was destined to be Versailles. This project was sufficiently awesome to serve as a symbol of the supremacy of the young absolute monarch. With such a center he could assert his power over rival nations, the landed aristocracy of his own country, the parliament, the provincial governments, the town councils, and the middle-class merchants. Away from Paris there would be a minimum of distraction and a maximum of concentration on his

367. Versailles Palace, aerial view. 1661–88. Width of palace 1935′ (589.79 m).

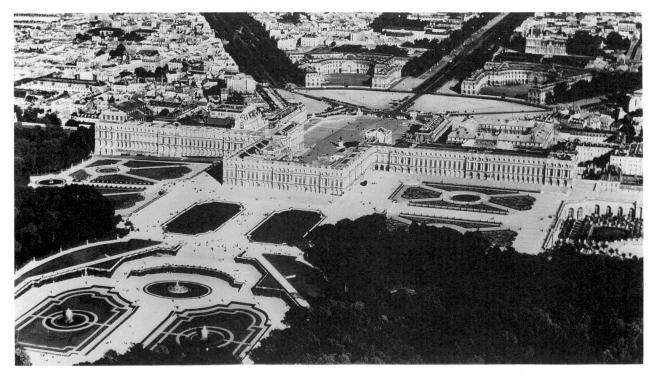

368.Louis Le Vau and Jules Hardouin-Mansart. Garden façade, Versailles Palace. 1669–85.

own royal person. In a wooded site almost half the size of Paris, which belonged entirely to the crown, everything could be planned from the beginning, and a completely new manner of living could then be organized.

The grand axis, or main line of direction, of the Versailles Palace starts with Avenue de Paris (Fig. 367, top right), continues through the center of the palace building itself, and runs along the grand canal toward the horizon, where it trails off into infinity. As the avenue enters the palace grounds, the barracks for the honor guard, coach houses, stables, kennels, and orangeries are found on either side. The latter building caused an ambassador from a foreign country to remark that Louis XIV must indeed be the most magnificent of beings since he had a palace for his orange trees more beautiful than the residences of other monarchs.

The wide avenue narrows progressively with the parade grounds toward the marble court of honor (see Fig. 380), above which is found the heart of the plan—the state bedroom of Louis XIV. The whole grand design is so logical, so symmetrical, that it becomes a study in absolute space composition. It makes Versailles an all-embracing universal structure which incorporates a vast segment of external as well as internal space. No one building or any part of it is a law unto itself, and together they are inconceivable without their natural environment. The gardens, parks, avenues, and radiating pathways are just as much an essential part of the whole as the halls, salons, and corridors of the palace itself.

Jules Hardouin-Mansart was the architect of the two wings that extend the main building to a width of about a third of a mile (about half a kilometer) (Fig. 367). His design is noteworthy for the horizontal accent attained by the uniform level of the roof line, broken only by the roof of the chapel, which was added in the early 18th century. The simplicity and elegance of these long, straight lines, in contrast to the irregular profile of a medieval building, proclaim the new feeling for space. From every room vistas of the garden are a part of the interior design and tell of a new awareness of nature. A detail of the garden facade (Fig. 368) reveals how freely Mansart treated the classical orders and how the levels become increasingly ornate from the podiumlike base below to the attic story and balustrade above with its file of silhouetted statuary. As a whole the building is a commanding example of baroque luxuriance and grandeur modified by academic discretion and restraint.

Some of the interior rooms have been preserved or restored in the style of Louis XIV. The grandest room of the palace is the famous Hall of Mirrors stretching across the main axis of the building and looking out toward the spacious gardens (Fig. 369). Designed by Mansart and decorated by Lebrun, it was the scene of the most important state ceremonies and a kind of glorification of the absolute monarchy. Corinthian pilasters of green marble support the ornate vault that is covered with paintings by Lebrun and inscriptions by Boileau and Racine—all to the greater glorification of the Sun King.

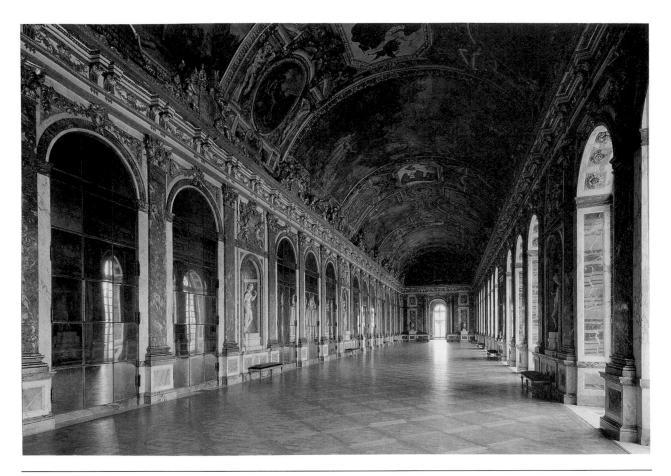

369.JULES HARDOUIN-MANSART and CHARLES LEBRUN. Hall of Mirrors, Versailles Palace. Begun 1676. Length 240' (73.15 m), width 34' (10.36 m), height 43' (13.11 m).

370. André Le Nôtre. Plan of Gardens of Versailles. 1662–88.

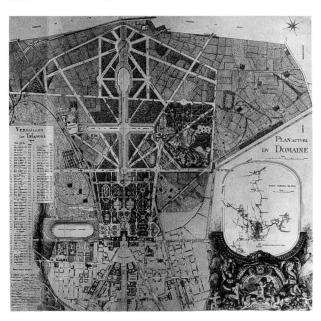

The gardens, which were laid out by André Le Nôtre, are not just a frame for the building but are part of the whole spatial design (Fig. 370). Their formality and geometrical organization symbolized human dominance over nature, but with the idea of embracing nature rather than keeping it at arm's length. The square pools across the garden side, so liberally populated with goldfish and swans, reflect the contours of the building with an external echo of the mirrored chambers within. The statues of river gods and nymphs at the angles, designed by Lebrun, personify the rivers and streams of France.

The gardens and park form a logical system of terraces, broad avenues, and pathways radiating outward from clearings. They are lavishly embellished by fountains, pools, canals, pavilions, and grottos, all of which are richly decorated with statuary. More than 1,200 fountains were installed by skilled engineers of waterworks, and with their jets spouting water into the air in many patterns, they were marvels of their craft. Each had its name, and each was adorned with an appropriate sculptural group.

The Versailles Palace, in the broader political sense, was not so much a monument to the vanity of Louis XIV as it was a symbol of the absolute monarchy and the outstanding example of aristocratic baroque architecture. It represented a movement away from a feudal, decentralized government toward a modern, centralized state. As a vast advertising project it was also a highly influential factor in the international diplomacy of the time. By urbanizing the country aristocracy and promoting court activities, Versailles built up for the arts a larger and more knowledgeable audience. It assured the shift of the artistic center of gravity from Italy to France. The French court was also a center of style and dress, and as a school for the training of craftsmen, it assured France leadership in fashion and elegance.

By combining all the activities of a court into a single structure, Versailles pointed the way toward the concept of architecture as a means of creating a new pattern of life. The design of Versailles also be came a model for later city planning. A large housing development the size of a town was constructed so as to envelop rather than escape from nature. Details of Le Nôtre's garden plan, such as the radiating pathways, were the acknowledged bases for the laying out of new sections of Paris; and the city plan of Washington, D.C., for instance, was a direct descendant of the parks of Versailles. Modern city planners and housing developers have hailed Versailles as the origin of the contemporary ideal of placing large residential units in close contact with nature. Finally, by starting with a grand design, Versailles pointed the way to the planning of whole cities from the start without the usual haphazard growth and change. In this light, Versailles is one of the earliest examples of modern urbanism and city planning on a large scale.

SCULPTURE

While Gianlorenzo Bernini was working on the Louvre plans, he was besieged by requests from would-be patrons to design everything from fountains for their gardens to tombs for their ancestors. The king as usual came first in such matters, and Bernini received a commission from Louis XIV for a portrait bust (Fig. 371). This minor by-product of the artist's visit to Paris ultimately turned out to be far more successful than his major mission.

Dispensing with the usual formal sittings, Bernini made rapid pencil sketches while Louis was playing tennis or presiding at cabinet meetings, so that he could observe his subject in action. He was convinced that movement was the medium that best defined the personality and brought out the unique characteristics of his subjects. The informal sketches

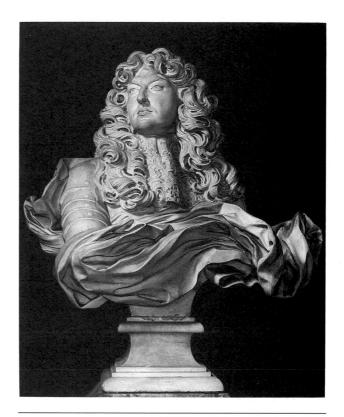

371. GIANLORENZO BERNINI. *Louis XIV.* 1665. Marble, height 33\frac{1}{8}" (84 cm). Versailles Palace.

were made, as he said, "to steep myself in, and imbue myself with, the King's features."

After Bernini had captured the individuality he was to portray, his next step was to decide on the general ideas—nobility, majesty, and the optimistic pride of youth. Here all the accessories, such as the costume, drapery, position of the head, and so on, would play their part. After the preliminaries were over and the particular as well as the general aspects were settled, the king sat thirteen times while Bernini made finishing touches directly on the marble.

In addition to such portraits, Bernini's fame as a sculptor rested more broadly on religious statues, such as his *St. Teresa in Ecstasy* (see Fig. 335), on the many fountains he designed for Rome (see Fig. 333), and on mythological groups such as his *Apollo and Daphne* (Fig. 372), designed to embellish aristocratic residences.

This youthful work is full of motion and tense excitement. According to the myth, Apollo, as the patron of the Muses, was in pursuit of ideal beauty, symbolized here by the nymph Daphne. The sculptor chose to make permanent the pregnant moment from which the previous and forthcoming action may be perceived. As Daphne flees from Apollo's ardent embrace, she cries aloud to the gods, who

hear her plea and change her into a laurel tree. Though rootbound and with bark already enclosing her limbs, she seems to be in quivering motion. The diagonal line running from Apollo's left leg and right hand to Daphne's leafy fingers leads the eye upward and outward.

The complex surfaces of the sculpture are handled so as to give maximum play to light and shadow. Bernini has carefully carved the various textures, such as the smooth flesh, flowing drapery, floating hair, the bark, leaves, and branches, in keeping with is objective of painting in marble. But above all the sculptor has accomplished his express intention, which as to achieve emotion and movement at all costs and to make marble seem to float in space.

The Versailles gardens provided French sculptors with an inexhaustible outlet for their wares.

372. GIANLORENZO BERNINI. *Apollo and Daphne*. 1622–25. Marble, lifesize. Galleria Borghese, Rome.

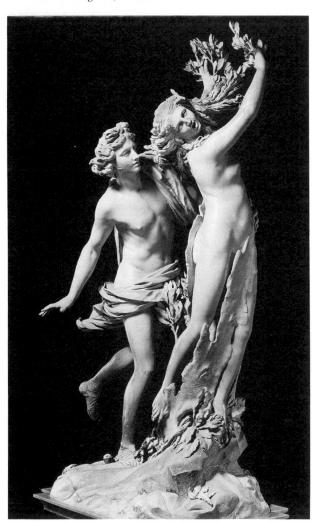

Many went to Italy to copy such admired antiques as the *Laocoön Group* (see Fig. 83). These replicas were then sent back and placed on pedestals along the various walks at Versailles. Notable among these sculptures were such works of Pierre Puget as his *Milo of Crotona* (Fig. 373). This statue shows the ancient Olympic wrestling champion, who had challenged Apollo himself to a match. He was, of course, given the punishment due a mortal who dares to compete with a god—death.

PAINTING

Patronage of the arts on a lavish and international scale had been a royal privilege ever since the time of Francis I. The procession of major figures to the French court beginning in the 16th century with Leonardo da Vinci and Benvenuto Cellini had never ceased. Foremost among the newcomers was that great internationally celebrated Fleming, Peter Paul Rubens. Though loyal to Flanders and Antwerp, where he maintained his studio, Rubens had studied the works of Titian and Tintoretto in Venice, as well as those of Michelangelo and Raphael in Rome.

373. PIERRE PUGET. *Milo of Crotona*. 1671–83. Marble, height $8'10\frac{1}{2}''$ (2.71 m), width 4'7'' (1.4 m). Louvre, Paris.

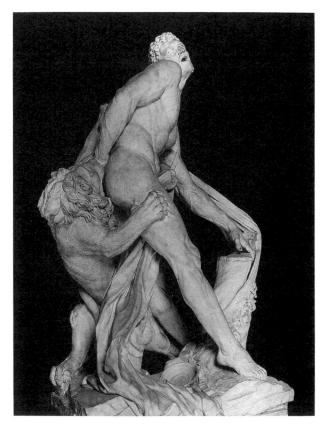

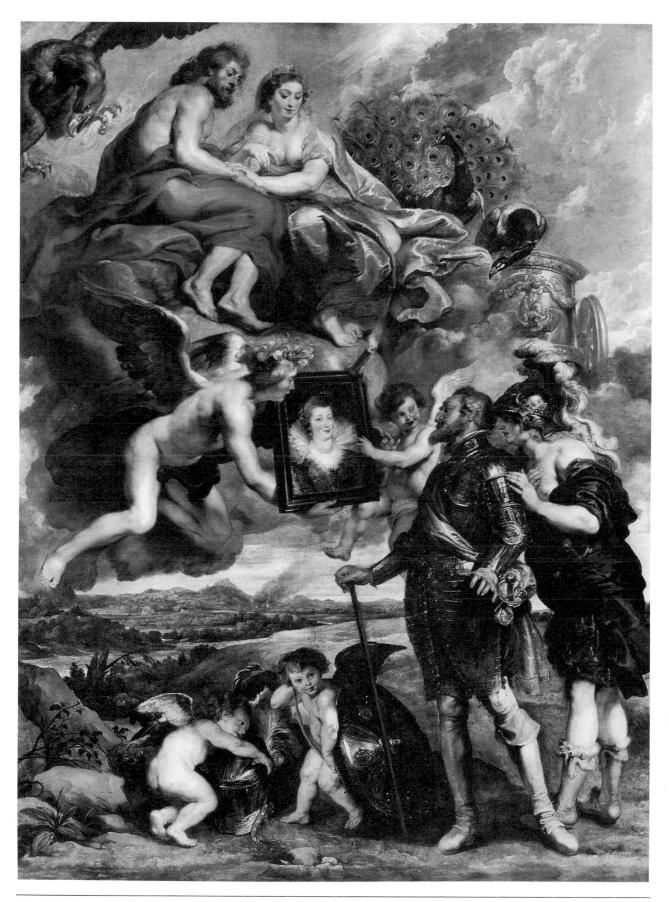

374. Peter Paul Rubens. Henry IV Receiving the Portrait of Maria de' Medici. 1622–25. Oil on canvas, $13' \times 9'8''$ (3.96 \times 2.95 m). Louvre, Paris.

Never lacking aristocratic favor, he passed long periods in Spain and in Italy, particularly at Mantua and Venice.

Rubens

During the reign of Louis XIII, when the Luxembourg Palace was being completed for the Queen Mother, Maria de' Medici, her express desire was for a painter who could decorate the walls of its Festival Gallery in a manner matching the Italian baroque style of its architecture. Maria's career as Henry IV's queen and as Louis XIII's regent was as lacking in luster as her own mediocre talents could possibly have made it. Nevertheless, as the direct descendant of Lorenzo the Magnificent, she seemed to sense that the immortal reputations of princes often depended more on their choice of artists than on their skill in statecraft. Maria's choice for the Festival Gallery murals was Rubens.

Rubens's cycle of twenty-one large canvases gave the needed imaginary glorification to Maria's unimaginative life. The success of this visual biography, however, belonged more truly to the man who painted it than to the lady who lived it. The remarkable thing was how Rubens could exercise so much individual freedom within the limits of courtly officialdom and succeed so well in pleasing both himself and his royal mistress.

As Rubens portrays her, when Maria reached the age of grace and beauty, the Capitoline Triad themselves—Jupiter, Juno, and Minerva—presided over the scene of *Henry IV Receiving the Portrait of Maria de' Medici* (Fig. 374). Minerva, goddess of peace and war, whispers words of wisdom into the king's ear. The celestial scene above assures everyone concerned that marriages are indeed made in heaven, where Jupiter and his eagle and Juno with her peacocks are seen bestowing their Olympian blessing.

The baroque ideal of richness and lavishness is seen once again in a picture from Rubens's later years, the *Garden of Love* (Fig. 375). The actual setting for this allegory was the garden of his magnificent home at Antwerp, and the ornate doorway in the background still exists. The scene of amorous

375. Peter Paul Rubens. Garden of Love. c. 1632–34. Oil on canvas, $6'6'' \times 9'3\frac{1}{2}''$ (1.98 × 2.83 m). Museo del Prado, Madrid.

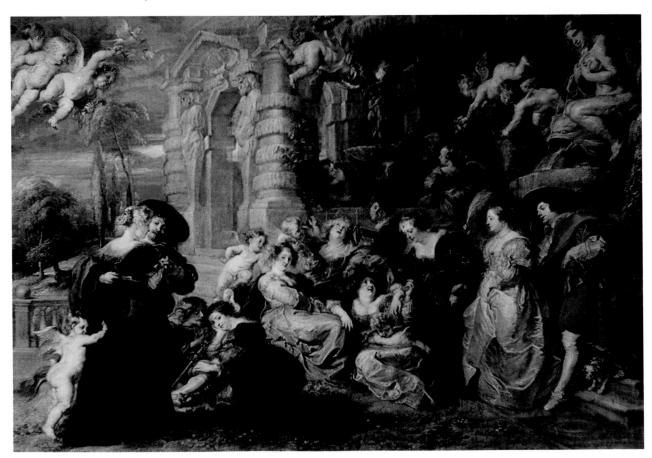

revelry unfolds in a diagonal line beginning with the chubby cherub in the lower left. Rubens himself is seen urging his second wife, Helena Fourment, who appeared in so many of his later pictures, to join the others in the garden of love. The rest of the picture expands in a series of spirals mounting upward toward the figure of Venus who, as a part of the foun-

tain, presides over the festivities. The use of large areas of strong primary colors—reds, blues, yellows—enlivens the scene and strengthens the pictorial structure.

Rubens succeeded in combining the rich color of Titian and the dramatic tension of Tintoretto with an unbounded energy and physical power of his

376. Peter Paul Rubens. Rape of the Daughters of Leucippus. c. 1618. Oil on canvas, $7'3'' \times 6'10''$ (2.21 \times 2.08 m). Alte Pinakothek, Munich.

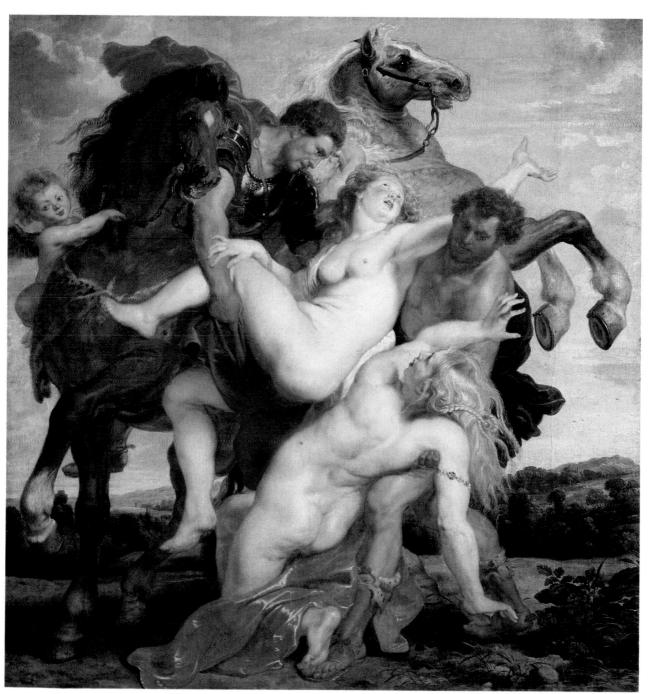

own. His conceptions have something of the heroic sweep of Michelangelo, though they lack the latter's thoughtfulness and restraint. His complex organization of space and freedom of movement recall El Greco, but his figures are as round and robust as the latter's were tall and thin. His success in religious pictures, hunting scenes, and landscapes, as well as the mythological paintings that suited his temperament so well, shows the enormous sweep of his pictorial powers. For sheer imaginative invention and brilliant handling of the brush he has rarely, if ever, been equaled.

Poussin

While Rubens was executing his murals for the Festival Hall, a then obscure French painter named Nicolas Poussin, who had been working on minor deco-

rations, left the Luxembourg Palace for the less confining atmosphere of Rome. There he soon built a solid reputation that came to the attention of Cardinal Richelieu, who bought many of Poussin's paintings and determined to bring the artist back to Paris. In 1640, Poussin did return to decorate the Grand Gallery of the Louvre—and received from Louis XIII a shower of favors and the much-desired title of First Painter to the King. The inevitable courtly intrigues that followed such marked attention made Poussin so miserable that after two years he returned to Rome. There he acted as the artistic ambassador of France and supervised the French painters sent under government subsidies to study and copy Italian masterpieces for the decoration of the Louvre. And there, for the rest of his life, Poussin had the freedom to pursue his classical studies, the independence to work out his own principles and

377. NICOLAS POUSSIN. Rape of the Sabine Women. c. 1636–37. Oil on canvas, $5'1'' \times 6'10_2^{1''}$ (1.55 × 2.1 m). Metropolitan Museum of Art, New York (Harris Brisbane Dick Fund, 1946).

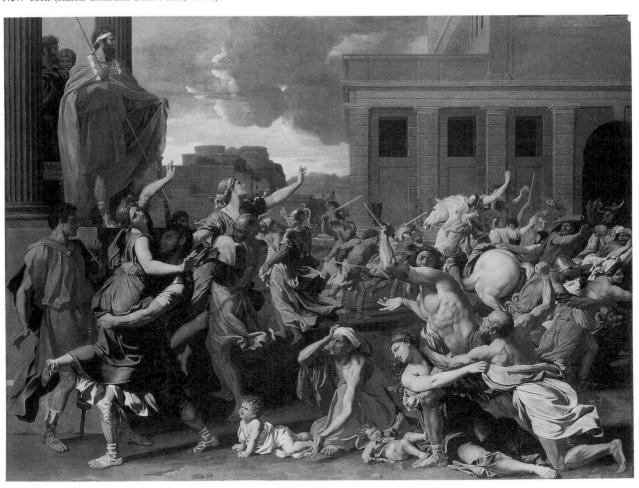

ideals, and the time to paint pictures ranging from mythological and religious subjects to historical canvases and architectural landscapes.

Two truly superb paintings depicting baroque attitudes toward sex reflect the differences in temperament between Rubens and his younger French colleague (Figs. 376 and 377). Poussin's scene, Rape of the Sabine Women, refers to the legendary founding of Rome according to the historians Livy and Plutarch. Romulus, having been unsuccessful in negotiating marriages for his warriors, has arranged a religious celebration with games and festivities as a plan to bring families from the neighboring town of Sabina to the Roman Forum. For Rubens, the Rape of the Daughters of Leucippus is an affair of robust personal passion in which Castor and Pollux "fairly dived into the sea of female flesh that splashed and wildly undulated around them," as the English writer Aldous Huxley has described it.

The more studious Poussin, in his efforts to recreate the classical past, turned to Roman museums for models of many of his figures and to Vitruvius for his architectural setting. Romulus, from his position of prominence on the porch of the temple at the left. is giving the prearranged signal of unfolding his mantle, whereupon every Roman seizes a Sabine maiden and makes off with her. Though the subject is one of sexual violence, Poussin manages to balance his picture by a careful arrangement of opposites. The anger of the outraged victims contrasts with the purposive calm of Romulus and his attendants; for, as a ruler, Romulus believed that the future of his city rested on the foundation of families. and that here the end justified the means. The turbulent human action is counterbalanced also by the ordered repose of the architectural and landscape background. The smooth marblelike flesh of the women contrasts with the bulging muscles beneath the bronzed skins of the Romans, and the contours of the figures generally are as clearly defined as if they had been chiseled out of stone.

Poussin's obsession with antique sculpture is readily seen when the group in the right foreground is compared with the Hellenistic *Gaul and His Wife* (see Fig. 70). Poussin's male figure is an exact copy of the ancient statue, but the position of the left arm and right hand are reconstructions as he thought they ought to be. While such direct copies are comparatively rare, this group reveals the close study the artist made of ancient architecture and statuary in Rome's libraries and museums. The building at the right, for instance, is taken from a description of a Roman basilica in Vitruvius's book on architecture. Both the reconstruction of the statue and the shape

of the basilica turn out to be quite wrong in the light of later, more exact archeology.

Et in Arcadia Ego (Fig. 378) shows Poussin in a quieter and more lyrical mood. The rustic figures of the shepherds might well have stepped out of one of Vergil's pastoral poems, while the shepherdess could be the tragic Muse in one of Corneille's dramas. As they trace out the letters of the Latin inscription on the sarcophagus, "I Too Once Dwelled in Arcady," their mood becomes thoughtful. That the shepherd in the tomb once lived and loved as they do casts a spell of gentle melancholy over the group. The words can also be rendered as "I, Death, also dwell in Arcady." In this meditative study in the composition of space, the female figure parallels the trunk of the tree to define the vertical axis, while the arm of the shepherd on the left rests on the tomb to supply the horizontal balance. Each gesture, each line, follows inevitably from the initial spatial statement that progresses with all the cool logic of a geometrical theorem.

The subject is obviously a sympathetic one to Poussin, for he had found his own Arcadia in Italy and took a lifelong delight in the monuments of antiquity and the voices from the past that spoke through just such inscriptions. Like the ancients, he tried to conduct his own search for truth and beauty in a stately tempo and with a graceful gesture. Like them, too, he sought for the permanent in the momentary, the type in the individual, the universal in the particular, and the one in the many.

Claude Lorrain

Claude Gellée, better known as Claude Lorrain, like his countryman Poussin, also preferred life in Italy to that in his native France. His lifelong interest was landscape, but the convention of the time demanded that pictures contain personages and also have titles. Claude solved the problem by painting his landscapes, letting his assistants put in a few incidental figures, and giving the pictures obscure names, such as *Embarkation of the Queen of Sheba, Expulsion of Hagar*, or *David at the Cave of Adullam*—subjects no other artist had ever painted. With tongue in cheek, he once remarked that he sold his figures and gave away his landscapes.

Harbor scenes like the one entitled *Disembarkation of Cleopatra at Tarsus* (Fig. 379) were his special delight. In them, he could concentrate on limitless space and the soft atmospheric effect of sunlight on misty air. His usual procedure was to balance his compositions on either side of the foreground with buildings or trees, which are treated in considerable

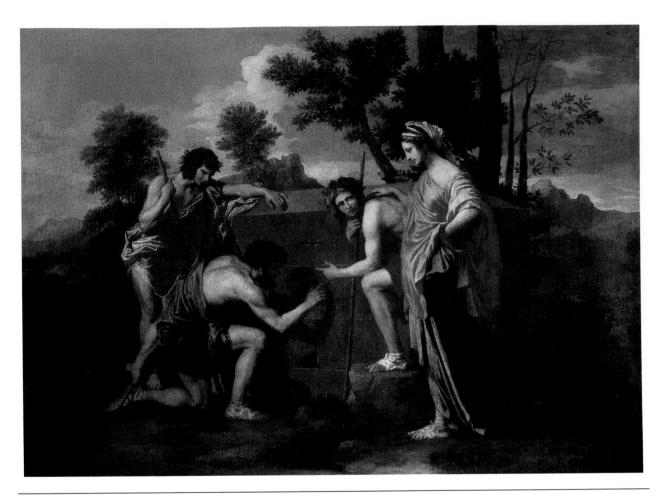

378. Nicolas Poussin. Et in Arcadia Ego (I Too Once Dwelled in Arcady). 1638–39. Oil on canvas, $33\frac{1}{2} \times 47\frac{5}{8}$ " (85 × 121 cm). Louvre, Paris.

detail. Then the eye is drawn deeper into the intervening space with long vistas over land or sea toward the indefinite horizon. Formal values based on geometrical principles dominate. The stylistic differences of Rubens and Poussin admirably illustrate the free and academic sides of the baroque coin. Both painters were well versed in the classics, both reflected the spirit of the Counter-Reformation, and both in their way represented the aristocratic tradition. But while Rubens's emotionalism knew no bounds, Poussin remained aloof and reserved; while Rubens cast restraint to the winds and filled his pictures with violent movement, Poussin was quietly pursuing his formal values; while Rubens's figures are soft and fleshy, Poussin's are hard and statuesque; while Rubens sweeps up his spectators in the tidal wave of his volcanic energy, Poussin encourages quiet meditation. The Academy's championship of Poussin made clear the distinction between academic and free baroque. In the late 17th and 18th centuries, painters were divided into camps labeling themselves either "Poussinist" or "Rubenist," and well into the 19th century echoes were still to be heard in the controversy of classic versus romantic.

MUSIC

The musical and dramatic productions at the court of Louis XIV were as lavish as those of the other arts. Three groups of musicians were maintained, the first of which was the *chambre* group, which included the famous *Vingt-quatre Violons* ("Twenty-four String Players"), the first permanent orchestra in Europe. This was the string ensemble that played for balls, dinners, concerts, and the opera. Lutenists and keyboard players also were found in this group. Next came the *chapelle*, the choirs that sang for religious

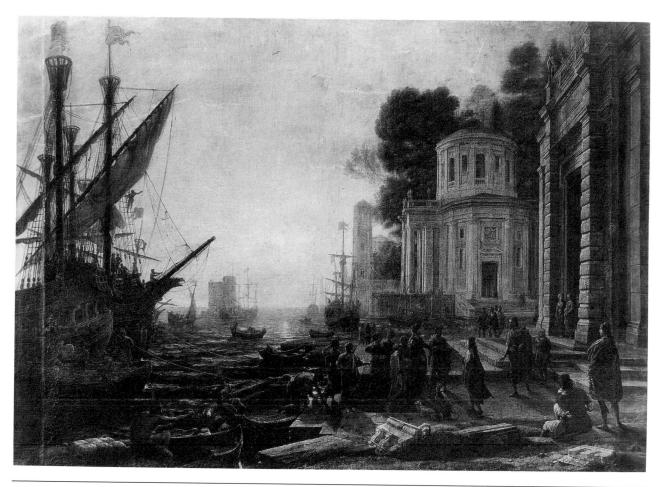

379. CLAUDE LORRAIN. Disembarkation of Cleopatra at Tarsus. c. 1647. Oil on canvas, $3'10_4^{3''} \times 5'6_2^{1''}$ (1.19 × 1.69 m). Louvre, Paris.

services, and the organists. The *Grande Écurie*, or military band, formed the third category, which consisted mainly of the wind ensemble, available for parades, outdoor festivities, and hunting parties.

Lully and French Opera

During Louis' youthful years his Italian prime minister Cardinal Mazarin sought to bring the new Italian opera, "the spectacle of princes" as it was known, into French courtly life. Cavalli, the pupil and successor of Monteverdi, who had brought the Venetian lyric drama to a high point of development, was invited to Paris in 1660 to write and produce an opera. It met with a mixed reception, but two years later Cavalli was again on hand to write another, this time for Louis' wedding celebration. Another challenge to the court ballet came from Molière, who united the elements of comedy, music, and the

dance into a form he called *comédie-ballet*. The best known of these is the popular *Le Bourgeois Gentilhomme (The Would-be Gentleman)*, which included incidental music by Lully and was first performed at the court in 1670.

The ever-resourceful Jean-Baptiste Lully, however, was biding his time on the sidelines until he could spring some surprises of his own. Florentine by birth and French by education, he was fiddling away at the early age of seventeen as a violinist in the *Vingt-quatre Violons*. When Cavalli produced his two operas, it was Lully who wrote the ballet sequences that, incidentally, proved more popular than the operas themselves. It was Lully again who collaborated with Molière by supplying the musical portions of the *comédie-ballets*. And when the right moment arrived, it was Lully who came up with a French form of opera that he called *tragédie lyrique*, or "lyrical tragedy."

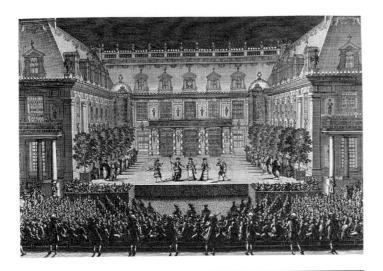

380.Louis Le Vau. Marble Court, Versailles Palace. Engraving by Lepautre showing a performance of Lully's *Alceste*, 1674. Metropolitan Museum of Art, New York (Harris Brisbane Dick Fund, 1930).

One of the earliest of these operas was *Alceste*, performed in the Marble Court at Versailles on July 4, 1674 (Fig. 380). With a genius for organization, Lully used the *Vingt-quatre Violons* as the nucleus of his orchestra, supplementing them with wind instruments from the *Grand Écurie* for fanfares as well as for the hunting, battle, and climactic transformation scenes. The *chapelle* was also drafted into the operatic service for the choruses, and the generous dance sequences that Lully included assured the ballet group plenty of activity.

FORM. The form of lyrical tragedies crystallized early and changed little in the following years. Each begins with an instrumental number of the type known as the "French overture." The first part is a march with dotted notes, massive sonorities, and resolving dissonances as in the first example on the right. The second half is livelier and contrapuntal.

Next came the prologue, and that of *Alceste* is quite typical. The setting is the garden of the Tuileries, the palace in Paris that was still the official royal residence at this time, where the Nymph of the Seine is discovered. Singing her lines in *recitative* style, she makes some topical references to the current war in flowery and mythological terms. (Recitative is a kind of free vocal delivery of lines that sets the scene, describes the action, or carries on the dialogue. It is usually sung to the accompaniment of a keyboard instrument supported by a string bass. Recitative is opposed to the more formally organized and melodic *arias* or *airs* that are accompanied by the orchestra.)

Glory now enters to the tune of a triumphal march, and a duet and solo are then sung. The two are joined eventually by a chorus of water nymphs and pastoral divinities, whose songs and dances give assurance that France will be ever victorious under the leadership of a great hero, whose identity is never for a moment in doubt. The overture is repeated, and the five acts of a classical tragedy follow with much the same formal pattern as the prologue.

STYLE. Two excerpts from Act III, scene 5 of *Alceste* will illustrate Lully's style. After the death of Alceste, a long instrumental *ritornel* provides the pompous funereal strains for the entrance of the mourning chorus. One of the grief-stricken women approaches, indicating sorrow by her gestures and facial expressions. Her air (below) is in the recitative style, which Jean-Jacques Rousseau considered Lully's chief "title to glory." The composer always insisted that the music and all other elements of the opera were the servants of drama and poetry, and he counseled singers to follow the noble and expansive intonations of the actors trained by Racine. Thus, a Lully air is never so set as an Italian aria but follows the elastic, fluid speech rhythms and the natural recitation of French baroque poetry and prose. The mourning chorus takes up where the air leaves off with a variant of the opening ritornel, and the scene closes with a long passage alternately for orchestra and chorus based on a continuation of the ritornel.

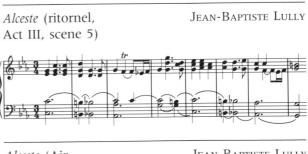

Alceste (Air, Jean-Baptiste Lully Act III, scene 5)

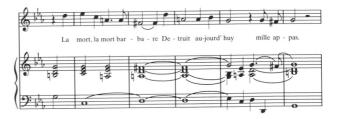

Since the hero was so closely identified with the monarch, a tragic ending was quite impossible. A *deus ex machina*—usually Apollo, Mercury, or Mi-

nerva—descended just when all seemed darkest. After everything had been put right, the final act brought the tragedy to a glorious conclusion.

Practically singlehandedly, Lully brought the ballet into a unified, organic form and founded French opera. His standardization of the sequence of dances became known as the "French suite," his form of the overture was called the "French overture," and his organization of the opera remained standard practice for almost two centuries. Even though Quinault wrote the texts, Lully's operas may be considered the musical reflection of Racine's tragedies. In them are found the same observance of classical rules of drama, the same dignified prosody, the same polished correctness.

The limitations of Lully's operas were the inevitable outgrowth of the circumstances of their creation. By being addressed so exclusively to a single social group, they neglected to provide the more resonant human sounding board needed for survival in the repertory. Like Poussin's paintings, Lully's operas remained aloof, restrained, and aristocratic. The concept of opera, however, by its combination of elevated language, emotional appeal, sonorous splendor, majestic movement, and visual elegance, emerges as one of the most magnificent creations of the baroque era.

ENGLAND AND LIMITED MONARCHY

London in the 17th century had a character all its own. The substantial middle-class citizenry had been on a collision course with the absolute monarchical ideas of Charles I. When he attempted to assert the divine right of kings by dissolving parliament and ruling by royal decree, he plunged his country into a bitter civil war.

Charles was brought to trial and condemned to death. Parliamentary rule was established under the Commonwealth, but the uncompromising Oliver Cromwell continued to alienate the still-powerful aristocracy. Eventually a compromise was reached with the Restoration regime of Charles II as a limited monarch.

The political and social struggle also actively involved the arts, as poets, playwrights, architects, and painters contended for patronage and audiences in both aristocratic and middle-class circles. The French aristocratic baroque, just like the absolute monarchy, was too rich for the English diet. When it came time to build a new cathedral after the Great Fire of London, Charles and his principal architect, Christopher Wren, thought in terms of the richly

embellished classical orders, the splendor and spaciousness of the Louvre and Versailles, and the central-type churches of Palladio and Michelangelo. The Church of England clergy and their parishioners, however, still thought of a cathedral as a tall, imposing Gothic structure. Wren wanted it to be crowned with a dome; the church leaders thought it should have a spire. So Wren built his dome and put a high lantern tower on top of it. Charles wanted the London parish churches to be free of Gothic gauntness and gloom, but the parishioners insisted on belfries with tall-spired steeples. So Wren gave them their steeples, but with classical geometrical flourishes.

A similar compromise was achieved in music. Charles wanted Lullian opera, but London theatergoers showed remarkable resistance toward sung recitative. So they got a hybrid form of spoken dialogue with songs and instrumental interludes inserted at intervals.

A comparison among the three great figures of the Restoration style—Wren, Dryden, and Purcell—can be illuminating. Each in his way was trying to bring his country up to date on the latest Continental developments, just as each was trying to inject something of the grandeur of the baroque style into an English art form. To do so, each was willing to make the necessary compromises in order to avoid parting company with English audiences.

When Wren was designing his preferred models on his drawing board, when Dryden was writing solely for a small circle of readers, and when Purcell was composing experimentally for amateurs, each could be as free as he chose. But when it came to building a cathedral, mounting a play, and composing music for the theater, many subtle and even drastic adjustments had to be made. Each man had sufficient mastery in his field and each was sufficiently versatile and inventive to make those adjustments. Each preferred and developed an aristocratic style but never neglected the common touch. Each in his turn had an influence that lasted well into the next century. Wren's buildings became the backbone of the Georgian style, Dryden's works the background for 18th-century Augustan classicism in English literature, and Purcell's works were absorbed directly into the sacred and secular music of later generations.

With political authority divided between the monarch and Parliament, literary tastes between the classical and Elizabethan traditions, architectural ideas between the French baroque and English Gothic, and musical expression between the Continental developments and native preferences, the British genius for compromise was able to combine

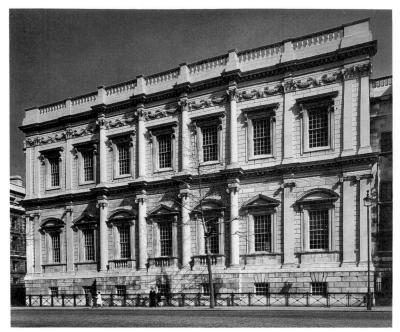

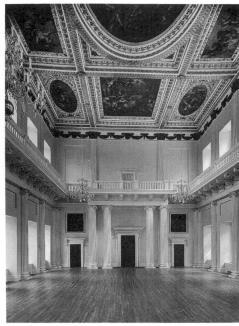

381. above left:

INIGO JONES. Banqueting House, Whitehall, London. 1619-22. Length 120' (36.58 m), height 75' (22.86 m).

382. above right:

INIGO JONES. Interior, Banqueting House, Whitehall, London. Ceiling paintings by Peter Paul Rubens, 1629-34.

opposing elements into a whole. Remarkably, the British achieved a synthesis of aristocratic and middle-class institutions, Roman Catholicism and Protestantism, as well as the Continental and English traditions. Through the efforts and genius of Wren in architecture, Dryden in literature, and Purcell in music, the Continental influences were merged with native traditions and transformed into a distinctive Restoration style.

ARCHITECTURE

Banqueting House, Whitehall

London had caught a brief glimpse of Continental elegance under James I, Charles II's grandfather, who had commissioned Inigo Jones to build the Banqueting House at Whitehall (Fig. 381) as the first unit of a projected royal palace. An enthusiastic admirer of Palladio, Jones had brought his theories to England with a translation of the *Four Books on Architecture* for which he wrote an introduction. The interior dimensions of the Banqueting House are 55 feet in height, 55 feet in width, and 110 feet in length $(16.8 \times 16.8 \times 33.5 \text{ meters})$, thus forming two equal cubes. This is still another use of musical proportions, with the double cubes forming the 1:1 and 2:1 relationship of the unison and octave.

The harmonious room (Fig. 382), its ceiling murals done entirely by the hand of Peter Paul Rubens, was the frequent scene of major musical activites. The Jacobean court masques were often performed here. These "compleat entertainments" involved dancing, singing, instrumental and choral interludes, spoken dialogue, all woven around some mythological plot. The elaborate and intricate "scenes and machines" were usually designed by Inigo Jones himself, and the writers included such luminaries as John Milton, Francis Bacon, and Ben Jonson.

St. Paul's Cathedral

In the crypt beneath St. Paul's Cathedral in London a Latin inscription on a stone slab reads: "Beneath is laid the builder of this church and city, Christopher Wren, who lived more than 90 years, not for himself but for the good of the state. If you seek a monument, look around you." The most striking feature of St. Paul's (Fig. 383) is its structural unity, for this is the only major cathedral in Europe to be built by one architect, by one master mason, and during the episcopate of one bishop. In contrast, it took thirteen architects, twenty popes, and more than a century to build St. Peter's in Rome (Fig. 254). The last stone on the lantern tower above the dome of St. Paul's

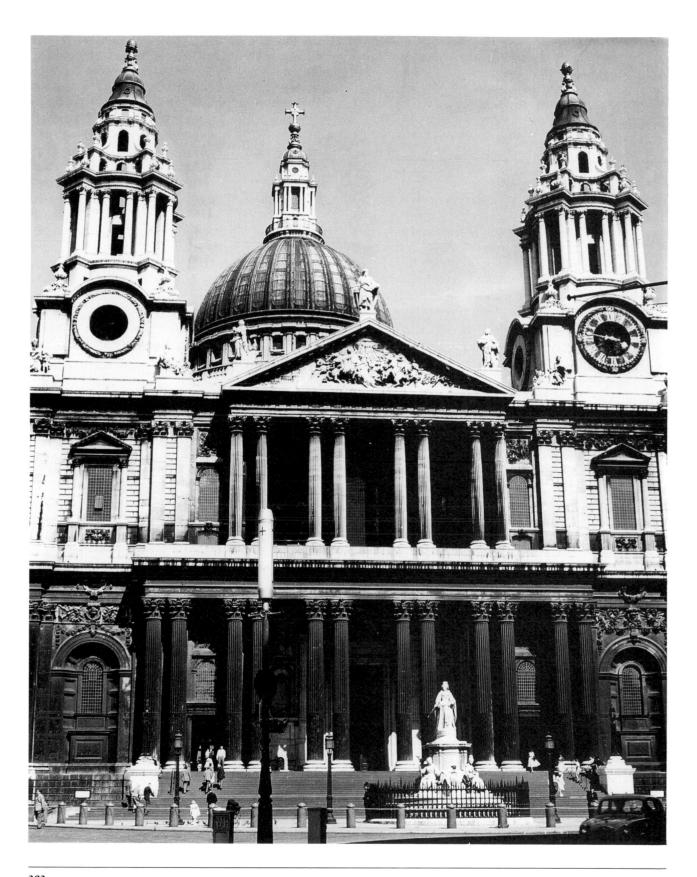

383. Christopher Wren. Façade, St. Paul's Cathedral, London. 1675–1710. Length 514' (156.67 m), width 250' (76.2 m), height of dome 366' (111.56 m).

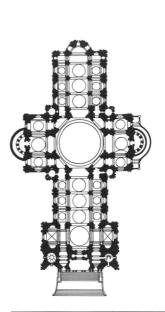

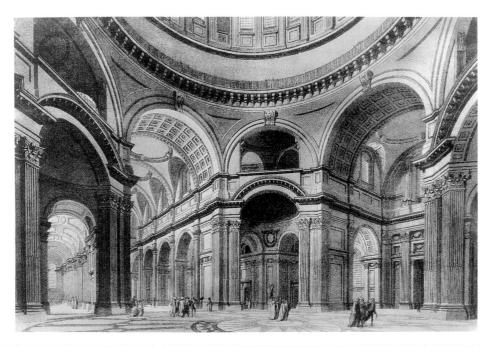

384. above left: Plan of St. Paul's Cathedral as executed.

385. above right:

CHRISTOPHER WREN. Rotunda, St. Paul's Cathedral. Aquatint by Thomas Malton, 1798.

was put in place in 1710 by one of Wren's sons in the presence of the 78-year-old builder, and for another eight years Wren continued to supervise the completion of the last decorative details.

Even before the Great Fire, Wren was a member of a commission charged with the remodeling of Old St. Paul's. The plan had to be scrapped when a survey after the fire showed the building beyond repair, giving Wren his great opportunity.

Like Bramante and Michelangelo before him (see Fig. 267), Wren projected a spacious centralized area from which radiated subsidiary units of space. Like his famous predecessors, he too preferred a central-type church based on the Greek cross. In this way a building of such monumental proportions could have both its exterior mass and interior space dominated by the all-embracing, unifying force of a dome. From a practical point of view, Wren was also aware he was designing a Protestant cathedral that should permit as many people as possible to be within earshot of the pulpit to hear the sermoncentered service of the Anglican Church.

The conservative members of the clergy, with thoughts of the ancient Catholic processional liturgy in mind, wanted a long nave with aisles on either side. Wren therefore, without sacrificing the heart of his plan, lengthened the edifice by adding an apse in the east and a domed *vestibule*, or lobby, with an

extended porch in the west. His model, however, brought further objections from the clergy, necessitating still other revisions. All Wren's diplomacy, versatility, cleverness, and, above all, patience were called into play in order to create a workable compromise that would satisfy his difficult clients and yet at the same time save the essential elements of his cherished conception.

Wren gave the clergy their aisled nave and transepts and their deep choir, but he grouped them around the central plan of his original design (Fig. 384). In this way he could still concentrate great space under the dome. Wren thus was actually building two churches, the clergy's and his own, a procedure that was bound to produce some architectural dissonances but for which he succeeded in finding a satisfactory, if somewhat uneasy, resolution in the cathedral that was finally completed.

Another problem had developed when no quarry could supply stone of the necessary lengths for the great columns of his original façade. To solve this Wren had had to divide the façade into two separate stories of the Corinthian and Composite orders. His use of paired columns recalls Perrault's colonnade on the east front of the Louvre (Fig. 366). The side *turrets*, or ornamental towers, were designed after 1700, and it is of more than passing interest that for some time one of them was left hollow ex-

cept for a circular staircase for Wren and his fellow astronomers to use as an observatory.

The effect of Wren's preferred plan is felt most strongly in the rotunda beneath the dome (Fig. 385). Geometrically, the space is bounded by a gigantic octagon, accented at the angles by the eight piers on which the cupola rests. These are bridged over by a ring of connecting Roman triumphal arches, which in turn are crowned by the great dome, the culmination of the entire composition.

From this central area the arches open outward into eight spatial subdivisions that give the interior such constant variety and interest. The centralization under the lofty dome, the complex divisions and subdivisions of space, the imaginative design and Roman detail reveal Wren's fondness for the baroque. The restraining influences of the conservative clergy, the lack of unlimited funds, and Wren's rationalistic viewpoint demonstrate his remarkable feat in making the style acceptable to British taste.

Wren's New Plan for London

Wren's plan for the rebuilding of London met with even stiffer resistance than his project for St. Paul's. It included the laying out of a series of new streets that extended outward starlike from central squares and that took the main traffic routes into consideration. Certain public buildings were to be situated on an axis involving the new cathedral and the Royal Exchange. The spires of the various parish churches were to point up the silhouette at certain points and lead up to the climax of St. Paul's dome.

The plan, if it had been carried out, would have gone far beyond that of Versailles. But Wren's king was not an absolute monarch with the power to condemn property and the money to buy it. Time also ran against Wren, because the shopkeepers throughout London were in a hurry to rebuild and start their business concerns again. About all he could rescue were the church steeples he was called upon to design.

As London's principal architect, Wren was commissioned to build more than fifty of these new parish churches. Discussions had to be held with the churchwardens on the problems and needs of each church. For monetary reasons the churches had to be modest affairs. Wren, in keeping with the spirit of the time, wanted to build them in the restrained baroque style based on the classical orders. His clients, however, still demanded the Gothic spires that not only had the force of symbols but also the practical purpose of housing the bell towers, which were still functional units of churches. Wren's problem, therefore, was to balance the vertical tendency of the stee-

Christopher Wren. St. Mary-le-Bow, London. 1671–80. Total height 216′1″ (65.86 m), steeple 104′6″ (31.85 m).

ple with the horizontality of his classical temple façades—once more, the reconciliation of northern and southern building traditions. Wren's solution, among his minor miracles, can only be understood through an actual example.

The steeple of St. Mary-le-Bow (Fig. 386), where the famous Bow Bells once rang out, shows the mathematician's obvious delight in a free play of geometrical forms. From a solid square base it moves through several circular phases and terminates finally in an octagonal pyramid. The wise use of baroque scrolls and twists at various points prevented any hint of abruptness. Because the churches themselves would be hidden by the surrounding buildings, Wren lavished most of his skill on their spires.

The continuation of the Wren tradition into the next century is seen in James Gibbs's Church of St. Martin-in-the-Fields (Fig. 387). Wren had always planted his steeples firmly in the ground, so to speak,

387. James Gibbs. St. Martin-in-the-Fields, London. 1721–26.

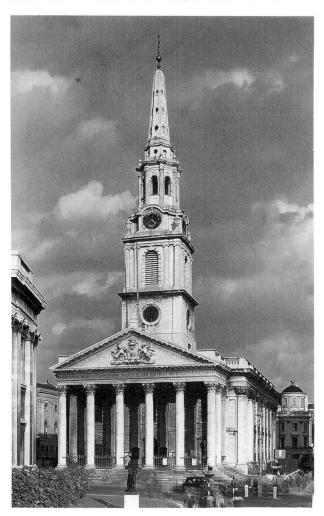

so that they seemed to grow in an organic relation to the whole composition. Gibbs's spire, by contrast, appears to sprout unexpectedly out of the roof. The memory of these churches and their steeples was carried to the American colonies by the founding fathers; and when they came to build their own churches in new cities, it was to the designs of Wren and Gibbs that they turned for their models.

Despite his many responsibilities, Wren found the time to design some spacious and impressive houses for well-to-do middle-class clients. During the reign of William and Mary, he was also commissioned to complete the unfinished Royal Hospital at Greenwich, begun earlier by Inigo Jones, and to add a new wing to Hampton Court Palace. His patron, William of Orange, remembered the good red brick of his native Holland, while Wren recalled the grandeur of the Louvre and Versailles palaces. Another of Wren's famous compromises is found in his design for the Fountain Court and the garden façade at Hampton Court Palace (Fig. 388).

Thus it was that Wren, the professor of astronomy at London and Oxford, left off probing the mysteries of the heavens with his telescope and equations and became a leading engineer and architect. Wren penetrated that segment of the sky above London with the majestic spires and domes that gave the city its characteristic profile and skyline.

DRAMA AND MUSIC

Dryden

On the gala occasion of the formal opening of the King's Theatre in 1674, His Majesty and London's most distinguished audience gathered there for the evening's entertainment. John Dryden, that cold, aristocratic but brilliant author, took advantage of the situation offered by the prologue to express his sentiments in some well-chosen words:

'Twere folly now a stately pile to raise, To build a playhouse while you throw down plays;

Whilst scenes, machines and empty Operas reign,

And for the Pencil you the Pen disdain; While Troops of famished Frenchmen hither drive,

And laugh at those upon whose Alms they live;

Our English Authors vanish, and give place

To these new Conquerors of the Norman race.

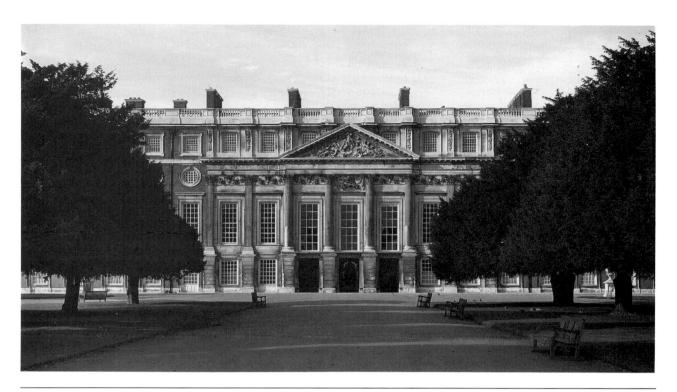

388. Christopher Wren. Garden façade, Hampton Court Palace. c. 1690.

Dryden was thus making the brave effort of a dedicated poet and playwright to stem the tide of foreign forms of opera, which, in his opinion, threatened to engulf reason with rhymc. Dryden, of course, felt that the dramatic logic of plot development would be arrested and overwhelmed by the music and that the high art of poetry would have to yield to jingling rhymes for the convenience of singers. The course of events, however, was flowing far too strongly, and Dryden soon was collaborating with one of those fashionable Frenchmen and writing some fancy "scenes and machines" himself.

With all the adaptability of a thoroughly professional writer, Dryden honestly tried to squeeze some content into those "empty Operas." In his preface to *Albion and Albanius*, for instance, he was more than a little apologetic about having to write so as "to please the hearing rather than gratify the understanding"; and, he continued, "it appears, indeed, preposterous at first sight, that rhyme, on any consideration, should take the place of reason."

Purcell and English Opera

Meanwhile, Henry Purcell, England's greatest composer, was trying to bring some of the new Venetian and French techniques into an English form of opera. The London stage, however, was not yet

ready for such Continental extravaganzas. To introduce and demonstrate the new style, he wrote and staged his miniature operatic masterpiece, *Dido and Aeneas*, for a school for young gentlewomen at Chelsea, where he was music master. For the text he had to get along with a rather ordinary book by Nahum Tate, who later became poet laureate under William and Mary. The work is a true *chamber opera*, one designed for a limited space, restricted to a few characters, and employing a small orchestra. Though small in scale, it is large in emotional scope; and while it falls within the province of amateur performance, it is filled with the most surprising invention and sophistication.

Dido and Aeneas opens with a dignified overture in the Lully style, marked by the halting rhythms and constantly resolving chains of dissonances of a slow beginning and the contrapuntal imitations of a lively conclusion. All the orchestral sections seem to have been scored only for strings with the usual keyboard support.

For his recitatives and airs, Purcell turns to the models developed by Monteverdi and his successor at the Venetian opera, Cavalli. Purcell makes particularly bold use of the "representative style," a type of word painting by which the descriptive imagery of the text is reflected in the shape and turn of the melodic line (p. 410). This can be illustrated by the first

word in the opera, "Shake" (a), and the menacing movement of the line for "storms" (b). In a comment on Aeneas's parentage, the valor of his father, Anchises, is characterized by a warlike rhythm (c); while immediately afterward a modulation to the minor mode and a caressing melody express the sensuousness of Venus's charms (d). Also, when Aeneas's entrance is announced, Belinda's words take on the shape of a trumpet fanfare (e).

The airs show a considerable variety of type. Dido's opening and closing songs are built over a short repeated bass pattern as in the Italian *ostinato aria*. The melody of "Oft She Visits" is written over a continuously flowing bass line in the manner of an Italian *continuo aria*, while the three-part melodic form of "Pursue Thy Conquest, Love," the final section of which repeats the beginning, identifies it as a *da capo aria*.

Dido and Aeneas
(recitative excerpts)

Shake what storms, An-chi-ses' va

d)
e)
lour mix'd with Ve-nus' charms, See, see your roy-al guest ap-pears;

The emphasis on the choruses and dances is in the English court masque tradition, but both are handled by Purcell with a highly original blend of native and Continental elements. In the palace scenes, the courtiers function as a true Greek chorus by making solemn comments in unison on the action. The final number, "With Drooping Wings," is a typical French mourning chorus straight out of Lullian opera. The witches, however, sing in the English madrigal style with the amusing substitution of some malicious "Ho, ho, ho's" for the jollier "Fa la la's," to signify their sinister purposes.

Highly interesting is Purcell's introduction of a Venetian echo chorus in these solemn surroundings. While the witches sing "In Our Deep Vaulted Cell," an offstage chorus softly echoes "-ed cell." By thus increasing the perception of space, Purcell is able to add the necessary eerie touch as the witches start to prepare their mysterious charms. The spell is further carried out in the "Echo Dance of Furies," in which an offstage instrumental group echoes the principal orchestra to enhance the feeling of mystery and deep space.

The dances show much of the same stylistic mixture as the choruses. Scene 1 concludes with the courtiers doing a "Triumphing Dance," which is a vigorous version of a Lully *chaconne*, a composition consisting of continuous variations on a short theme in slow triple meter, treated in this instance as a set of instrumental variations over a repeated ground bass. During Act III, when Aeneas is preparing to sail away from Carthage, Purcell paints a typical English seaport scene in which the sailors' dances mingle with the salty comments of a chorus of common people. The angularity of such native rhythms as the hornpipe is a distinct contrast to the more formal *courantes* and chaconnes danced by the courtiers.

Purcell's logic and fine dramatic perception do not permit him to soften his opera toward the end by allowing a *deus ex machina* to bring it to a happy ending in the manner of the French court style of Lully. The human will when battling with the gods is always doomed, and the plot must move inevitably onward. The tragedy is therefore carried through to its predetermined conclusion with growing eloquence and mounting emotion.

As a consequence, "Dido's Farewell" (p. 411) becomes one of the most moving moments in all music, combining as it does the most passionate feeling with the dignified restraint demanded of a tragic heroine out of Vergil's Aeneid. It is cast in the form of an ostinato aria with an obstinately repetitive bass pattern, which descends chromatically to the rhythm of the stately passacaglia, a dance tune similar to the chaconne. Dido's inner struggle is expressed by the tension between the obbligato, or ornate melodic line, that she sings and the inflexible bass. She contends with this *ground bass* as with her tragic fate. Vainly she tries to bend it to her will, as seen in some of the asymmetrical diagonal shifts of her phrases off their center. In the end, however, she must resign herself to it while the orchestra carries the aria onward to its tragic conclusion.

Within the limitations of this short opera, which takes only about an hour to perform, Purcell produced a major work of art. It reveals the sure touch of one who knows every aspect of the dramatic business. The extensive emotional range and the variety of technical devices are all the more astonishing in view of the few resources he had at his disposal. Purcell possesses, first of all, the rare power to create believable human characters by musical means, a gift he shares with Gluck and Mozart. He is also one of the few composers who know how to convert the dry academic techniques of counterpoint into lively dramatic devices, a characteristic he shares with Bach and Handel.

These traits can be illustrated in Dido's first air. "Ah, Belinda." Her melody is like a series of descending sighs over a ground bass that, like destiny, is relentless and unyielding. At the words "Peace and I are strangers grown," the parting of the two lovers' ways is depicted by a canon at the octave; and on the word "strangers," the predominant fourbar pattern begins to wander and is stretched out into five bars. Again, after Aeneas declares he will defy destiny itself in order to remain with Dido, the chorus makes contrapuntal comments that graphically give expression to its disturbed and conflicting emotions. When Purcell wants to depict the hustle and bustle around the departing ships in the scene at the dockside in Act III, the independent introduction in the form of a fugue, literally meaning "flight," with its imitative thematic entries and exits, humorously describes the coming and going of the people.

When such skillful means as these are combined with Purcell's deft handling of the orchestra, colorful use of chromaticism, and deep poetic feeling, they are certain to result in significant ends—as indeed, in this case, they did.

Dido and Aeneas Henry Purcell ("When I Am Laid in Earth")

Handel: Opera and Oratorio

Early in the 18th century another great composer, George Frideric Handel (Fig. 389), was to have a try at bringing English audiences around to the delights of Italian opera. In his native Germany, Handel had been music director at the court of the Elector of Hanover, who succeeded Queen Anne on the British throne as George I. Coming just after the newly

crowned king, he was assured of his position in London. Like Bach, Handel also wrote all forms of keyboard and chamber music, concertos, and other orchestral works. Vocal music took first place, however, as it did for all major baroque composers.

Italian opera was Handel's first love, but in spite of the beauty of such masterpieces as Giulio Cesare (Julius Caesar), these operas in Italian enjoyed only limited success in the London of their day. When that door was closed, Handel turned to largescale oratorios with English texts. Like operas, oratorios had instrumental overtures and interludes, recitatives, solo arias, and choruses. However, they were usually presented in concert form without scenery, costumes, and dramatic action. Handel's oratorios were written to both sacred and secular texts and were primarily intended for public performances in theaters and large halls rather than in church. They were, in fact, promoted as "Grand Musical Entertainments." Such immortal works as Semele, the Messiah, and Israel in Egypt have won an assured place in the international repertory.

Handel's *Semele*, though technically described as a secular oratorio, is nonetheless an excellent example of his operatic writing. It has, moreover, the

389. Thomas Hudson. *George Frideric Handel.* c. 1742. Oil on canvas, $47\frac{1}{8}\times39''$ (121 \times 100 cm). Staats- und Universitätsbibliothek, Hamburg.

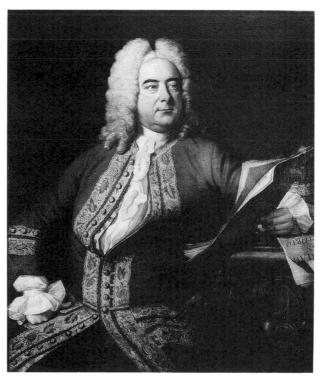

advantage of an English text of considerable literary quality by the distinguished playwright William Congreve. Act II opens with Juno venting her jealous fury in an impassioned recitative passage. Semele, by way of contrast, sings a serene solo aria, "Oh Sleep, Why Dost Thou Leave Me?" The eloquent melody rises over a lullabylike continuo accompaniment by harpsichord and cello revealing the sleepless state of a woman in love and longing for her lover—none other than the divine Jupiter himself. When Jupiter appears, their dialogue is carried on in a recitative that leads up to one of Handel's most eloquent arias, "Where'er You Walk."

After lavishing two such masterpieces on a single scene, Handel has still further lyrical surprises in store, such as Semele's aria, "Myself I Shall Adore." Semele's vanity, which is to be her downfall, has been cleverly prodded by Juno in disguise, and the aria is sung as she gazes fondly into her mirror. Handel chooses the concerted aria, in which the voice alternates with instruments, for this situation, and Semele's mirror image is graphically described by the violins, which reflect her phrases in echolike imitations of the vocal line. With his constant flow of melodic invention and by matching such technical devices as the concerted aria with significant insights into human character, Handel succeeds in drawing dramatic sparks from the stately lines of Congreve's text and in writing convincingly for the lyric stage.

The inward direction and lyrical qualities of the Messiah contrast strongly with the sweep of such biblical epics as Israel in Egypt. In this mighty oratorio the chorus represents the collective image of the children of Israel and is both the dramatic protagonist and the group narrator. Free use is made of the representative, or word-painting, style, notably in such passages as those depicting the plagues. A leaping pattern that accompanies a solo aria, for instance, neatly describes the frogs mentioned in the text (No. 5).* Further graphic realism is found in the buzzing "Chorus of Flies" (No. 6), as well as in the "Hailstone Chorus" (No. 7). The mournful harmonics of "He Sent a Thick Darkness over the Land" (No. 8) paint a vivid picture of nightfall with the singers groping their way through a maze of remote harmonic centers, while the driving rhythms of "The Lord Is a Man of War' (No. 22) proceed in powerful, hammerlike strokes.

It is, of course, the chorus, not the solo aria, that dominates a Handel oratorio, and the power and breadth of the expressive sounds that never fail to make an unforgettable impression.

Comparison with Bach. The two towering figures of the late baroque—Handel and Bach—invite comparison since, though they were fellow Germans and exact contemporaries, they were products of different social environments and different individual temperaments. Handel, for instance, was a sophisticated figure, at home in great capital cities. Bach, in spite of his formidable reputation, was content to pursue his career in German provincial centers. Bach's post at Leipzig was an important one, and Leipzig itself was a university town of some standing in Germany. But Handel in 18th-century London found himself in a city that competed with Paris for the position of the cultural and intellectual capital of Europe.

Handel, as a robust man of the world, had a straightforward, vigorous mind, while Bach was more disposed to brooding and self-searching contemplation. Handel was more concerned with the joy and beauty of this life, while Bach beheld blissful visions of ultimate truth in the next. Both were perceptive students of the Bible, but Handel favored the Old Testament and the inevitable victory of the righteous cause, while Bach preferred the New Testament and the problems of death and redemption. Handel, in his choral music, approached a text much more directly and concretely than Bach, whose thought ran in a more abstract vein, even at times to the complete disregard of the text's metrical rhythm.

It has often been observed, too, that Handel was essentially a vocal composer, while Bach was primarily instrumentally minded. Both, however, were masters of external forms as well as inner expression, and in the end they must be considered complementary rather than contrasting figures. Both also, in any final evaluation, must be given equal importance in their respective spheres. Together these bright musical suns of the baroque period sum up two centuries of accumulated creative experience and expression.

IDEAS

The many aspects of the aristocratic baroque style cluster mainly around three distinct but interrelated ideas—absolutism, academicism, and rationalism.

Absolutism

The concept of the modern unified state, which first emerged in the Spain of Philip II, was adapted to French political purposes by Cardinal Richelieu and ultimately reached its triumphant realization under Louis XIV. "It is the respect which absolute power demands, that none should question when a king

^{*}The numbers follow the order given in the Mendelssohn edition of the score published by G. Schirmer, Inc., New York.

commands"; this was how Corneille stated the doctrine in 1637 in his heroic drama *The Cid.* As the principal personification of monarchical absolutism and the centralized state, Louis XIV, the Sun King, assumed the authority to replace natural and human disorderliness with a reasonable facsimile of cosmic law and order. All human and social activities came under his protectorship, and by taking the arts under his paternal wing, he saw that they served the cult of majesty. Versailles became the symbol of absolutism, the seat of absolute monarchy, and the personal glorification of the king.

Unification of the Arts. Just as political absolutism meant the unification of all social and governmental institutions under one head, its aesthetic counterpart implied the bringing together of all the separate arts into a single rational plan. While Louis' reign produced some buildings, statuary, paintings, literature, and music that command attention in their own right, they spoke out most impressively in their combined forms.

It is impossible to think of Versailles except as a combination of all art forms woven together into a unified pattern and as a reflection of the life and institutions of the absolute monarchy. The parks, gardens, fountains, statuary, buildings, courtyards, halls, murals, tapestries, furnishings, and recreational activities are all parts of a single coordinated design. As such, Versailles accomplished the daring feat of unifying all visible space and all units of time into a spatial-temporal setting for the aristocratic way of life. Indoor and outdoor space are inseparable; even music and the theater went outdoors at Versailles and at London in the public parks. Sculpture was an embellishment of the landscape; painting was allied with interior design, comedy with ballet, and tragedy with opera.

All the arts, in fact, were mirrored in the operatic form with its literary lyricism, orchestral rhetoric, dramatic recitation, instrumental interludes, statuesque dancing, architectural stage settings, mechanical marvels, and picturesque posturings. In Lully's hands opera became a kind of microcosm of court life, an absolute art form in which all the separate parts related closely to the whole.

The spirit of absolutism was also directly revealed in the drama surrounding the life of the monarch. All the arts took the cue, became theatrical, and sought to surprise and astonish. The purely human element was buried under an avalanche of palatial scenery, pompous wigs, props, and protocol.

Only in Molière's satires, La Fontaine's fables, and the secret memoirs of the period is it possible to catch glimpses of a more truthful version of the actu-

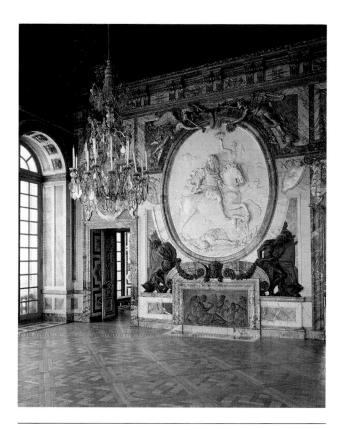

390.JULES HARDOUIN-MANSART and CHARLES LEBRUN. Salon de la Guerre, Versailles Palace. Begun 1678. Relief of Louis XIV on horseback by Antoine Coysevox.

alities behind the scenes of courtly life. Otherwise the architecture of Versailles, the statuary of Bernini and Coysevox, the murals of Lebrun (Figs. 369, 390), the tragedies of Racine, and the operas of Lully were all designed to promote the illusion that Louis XIV and his courtiers were beings of heroic stature, powerful will, and grandiose utterance.

Academicism

While the academic movement began formally with the first French academy during the reign of Louis XIII, it was not until later in the century that the implications of academicism were completely realized and its force fully mobilized. Both Louis XIV and his minister Colbert believed that art was much too important to be left exclusively in the hands of artists. The various academies, therefore, became branches of the government and the arts a part of the civil service. An administrative organization was instituted, topped by the king and director on down to professors, members, associates, and the students. Approved principles were taught and theoretical and practical knowledge communicated by lectures, demonstrations, and discussions.

Boileau as the head of the Academy of Language and Literature, Lebrun of the Academy of Painting and Sculpture, Mansart of the Academy of Architecture, and Lully of the Academy of Music were subject directly to the king and were absolute dictators in their respective fields. As such, they were the principal advisers to the king and his ministers, and, in turn, they were responsible for carrying out the royal will. Control of patronage was centered in their hands. Theirs was the final word in determining who would receive commissions, appointments, titles, licenses, degrees, pensions, prizes, entrance to art schools, and the privilege of exhibiting in the salons.

The academies were thus the means of transmitting the absolute idea into the aesthetic sphere. Academicism invariably implied an authoritarian principle, whereby regularly constituted judges of taste placed their stamp of approval on the products in the various art media. These interpreters of the official point of view inevitably tended to become highly conservative.

One example will show how academicism worked. Under Lebrun, the Academy of Painting and Sculpture favored the restrained style of Poussin over the passionate emotionalism of Rubens. It thereby set up an academic subdivision of the baroque style as opposed to the expression of the free baroque. Many reasons for the choice can, of course, be advanced. Poussin's pictorialism, for instance, may—quickly and easily—be reduced to a system of formal values based on geometrical principles. Rubens's style, however, is so personal, fiery, sensuous, and violently emotional that it always remains a bit beyond the grasp. Academicism in this case was trying to tame baroque enthusiasm and reduce it to formulas and rules. Nothing eccentric, nothing unpredictable was allowed to creep in and destroy the general impression of orderliness. The Academy always remained somewhat skeptical of emotion and color, since neither was subject to scientific laws.

The pictorial standards of the Academy were therefore based on formal purity, clear mathematical relationships, logical definition, and rational analysis. These were the qualities that brought academic art the designation of *classic*, a term that was defined at the time as "belonging to the highest class" and hence approved as a model. Since similar standards were generally to be found in Roman antiquity, classic and Roman art became accepted models.

French academicism was from the start an unqualified practical success. Under the academies, the artistic dominance of Europe passed from Italy to France, where it has effectively remained up to re-

cent times. The hundreds of skilled artists and artisians who were trained on the vast projects of Louis XIV became the founders and teachers of a tradition of high technical excellence. French painting alone, to use the most obvious example, continued its unbroken supremacy until well into the 20th century.

In Spain, by way of contrast, the only successor to El Greco, Velázquez, and Murillo was the lonely figure of Goya. In Flanders there were no outstanding followers of Rubens and van Dyck except Watteau, who made his entire career in France. In Holland there was no one to take up where Rembrandt and Vermeer had left off until Van Gogh in the late 19th century.

In France, however, painting continued on a high level throughout the 18th and 19th centuries; and, by setting rigorous technical standards, academicism was a determining force even in nonacademic circles. The work of Perrault and Mansart in architecture, Boileau in criticism, Molière in comedy, Racine in tragedy, and Lully in opera was also absorbed directly into a tradition that succeeded in setting up measuring rods of symmetry, order, regularity, dignity, reserve, and clarity. To this day these measures still have a certain validity, even if only as points of departure.

In England, academies were founded under royal charter and supported by state subsidies. The oldest of these was the Royal Society for Improving Natural Knowledge, founded about 1660. Its interests were mainly scientific, and it numbered Isaac Newton, Christopher Wren, and Robert Boyle among its founding members. Later, in 1768, came the Royal Academy of Arts "for the purpose of cultivating and improving the arts of painting, sculpture, and architecture." This was followed by the Royal Academy of Music in 1822. Its function was to support opera and concerts as well as to instruct young musicians. Then, there are the various learned societies—scientific, archeological, literary, and so on, that were founded and carried on by private collective effort. These served as supplements to the state-supported institutions and are devoted to the gathering, collating, and disseminating of scholarly research and knowledge.

Baroque Rationalism

Stimulated by the explorations of navigators of the globe, the scanning of the skies by astronomers, and the advances of inventors, the baroque mind reassessed the world and the place of human beings in the universe. Galileo's telescopes confirmed Copernicus's theory of a solar system in which the earth revolved around the sun rather than vice versa. The

concept of the unmoving Aristotelian universe thus had to yield to one that was full of whirling motion. Since the earth was no longer considered as a fixed point located at the nerve center of the cosmos, human beings could hardly be regarded any longer as the sole purpose of creation. It was some consolation, however, to know that this strange, new, moving universe at least was subject to mechanical and mathematical laws, and therefore to a considerable extent predictable. Copernicus and Kepler, as well as the other scientists, were convinced of its unity, proportion, and harmony; and the fact that the human mind had the privilege of probing into the innermost secrets of nature—if the intellect proved equal to the task—was a great challenge.

The rationalism of the 17th century, then, was based on the view that the universe could at last be understood in logical, mathematical, and mechanical terms. As a philosophy and semireligion, this worldview had far reaching consequences; it pre pared for the theories of positivism and materialism, the doctrines of deism and atheism, and the mechanical and industrial revolutions.

While Greek rationalism had been based on the perception and measurement of a stable, immobile world, baroque rationalism had to come to terms with a dynamic universe. Scientific thought was concerned with movement in space and time. The need for a mathematics capable of understanding a world of matter in motion led Descartes to his analytical geometry, Pascal to a study of cycloid curves, and both Leibniz and Newton to the simultaneous but independent discovery of integral and differential calculus.

Baroque invention also led to refinements in navigation, to improvements in the telescope and microscope for the exploration of distant and extremely small regions of space, the barometer for the measurement of air pressure, the thermometer for the recording of temperature changes, and the anemometer for the calculation of the force of winds. Astronomers were occupied with the study of planetary motion; William Harvey discovered the circulation of the blood; and physicists were experimenting with the laws of thermodynamics and gravitation.

Newton's concern with mass, force, and momentum, his speculations on the principles of attraction and repulsion, and his calculations on earthly and heavenly mechanics led him to a monumental synthesis that he presented to the British Royal Society in 1686 and published in London a year later. Newton's *Principia*, as it was called, embraced a complete and systematic view of an orderly world based on mechanical principles, capable of mathematical proof, and evident by accurate prediction.

His work was, in fact, a scientific *summa*, or summation, that established the intellectual architecture of the new view of the universe.

Such a changed worldview was bound to have important consequences for the arts, which responded in this case with a ringing reassertion of human supremacy and a joyous acceptance of this new understanding of the universe. The application of rationalistic principles to aesthetic expression is by no means accidental or casual. Before he became an architect, Christopher Wren was a mechanical inventor, an experimental scientist, and a professor of astronomy at London and Oxford. As a founder of the Royal Society, he was in close contact with such men as Robert Boyle and Isaac Newton.

The fellows of the Royal Society appointed John Dryden to a committee, the purpose of which was to study the English language with a view toward linguistic reforms. They recommended that English prose should have both purity and brevity, so that verbal communication could be brought as close to mathematical plainness and precision as possible. Dryden's embarrassment in writing an opera that was designed to please the ear rather than gratify the intellect was therefore understandable.

The music of Bach, Lully, Purcell, and Handel was based on a system of complex contrapuntal principles and tonal logic in which given premises, such as sequences or repeated ground basses, are followed by predictable conclusions. Moreover, it is characterized by intellectual discipline, symmetry, clarity, and a sure sense of direction. Their forms are models of brevity in which each part has its place, no loose ends are left dangling, and the cadences bring everything to a positive finish.

Like the architecture of Perrault and Hardouin-Mansart in France and that of Wren in England, the musical art of Lully, Purcell, and Handel reflects an assured self-confidence. Theirs was an inventive spirit that gave birth to new forms, an exploration of novel optical and acoustical ideas, and a conviction that a work of art should be a reflection of an orderly and lawful universe.

DYNAMICS OF THE BAROQUE

The baroque period was one in which irresistible modern forces met immovable traditional objects. Out of all the theological conflicts, philosophical discussions, scientific arguments, social tensions, political strife, warfare, and artistic creation came both the baroque style and the modern age.

The baroque world was one in which oppositions that were impossible to reconcile had to find a way to coexist. The rise of rationalism was accompa-

nied by the march of militant mysticism. The aristocratic cult of majesty was echoed by the bourgeois cult of domesticity. The internationalism of Roman Catholicism was in conflict with the nationalism of the Protestant sects and rising monarchies. Religious orthodoxy had to contend with freedom of thought. The Jesuits brought all the arts into their churches, while Calvin did his best to exclude the arts as vanities. Philip II built a magnificent mausoleum and monastery, while Louis XIV erected a pleasure palace and theater. Charles I tried to force an absolute monarchy on England, and Cromwell's answer was a republican commonwealth. The printing press made books available, while suppression by censorship took them away. The boldest scientific thinking took place alongside a reassertion of the belief in miracles and a renewal of traditional religious beliefs. Newton's *Principia* and the final part of John Bunyan's Pilgrim's Progress appeared in London within two years of each other. The arts demonstrated similar oppositions. In Spain, the emotional involvement of El Greco was succeeded by the optical detachment of Velázquez. In France the spontaneity of Rubens was followed by the academic formalism of Poussin. In Holland, the broad humanity of Rembrandt led to the specialization and precision of Vermeer.

Such oppositions could hardly be expected to resolve themselves into a single uniform style. At best, they could achieve only a temporary resolution and a fusion of forms, such as those found in a Counter-Reformation church, the Versailles Palace, Rembrandt's visual dramatization of the Bible, and Purcell's operatic synthesis. In them, forceful striving and restless motion are more characteristic than calm and repose. Baroque art thus emerges from these tensions and speaks in eloquent accents of the expanding range of human activities, grandiose achievements, and a ceaseless search for more powerful means of expression.

391. Antonio Gherardi. Cupola, Ávila Chapel, Santa Maria in Trastevere, Rome. c. 1686.

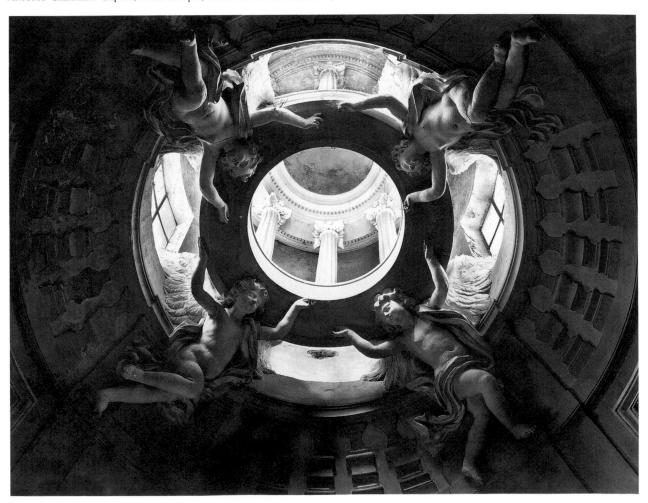

Expansion of Space and Time

The conflicts of the baroque world took place within a tremendously enlarged sense of space and time. The astronomers told of remote regions populated by an infinite number of stars. Pascal speculated on the mathematical implications of infinity. The gardens and avenues of Versailles were laid out in keeping with this vastly extended concept of space. The vistas led the eye toward the horizon and invited the imagination to continue beyond. The unification of the vast buildings and gardens into a single, allembracing design brought baroque society wholly within the scope of nature and declared it to be a part of the new measurable universe.

Wren's attempt to bring his cathedral, parish churches, and public buildings into one all-embracing scheme was also in keeping with this image of the comprehensive baroque universe. Painters likewise delighted in leading the eye outside their pic tures and attempted to convey the impression of infinity through the bold use of light and exaggerated perspective effects. The Dutch landscapists tried to capture atmospheric perspective, and Rembrandt was concerned with the infinite gradations of light. Through use of illusionistic effects, ceilings of Counter-Reformation churches opened the skies and tried to promote the feeling of a world without end (see Fig. 332).

In music there was a corresponding expansion of tonal space. The organs and other keyboard instruments were built to include a wider range from bass to soprano. Both the wind and the stringed instruments were constructed in families, ranging all the way from what the English organist and composer Orlando Gibbons called the "Great Dooble Base" to the high soprano register of the violin. Louis XIV and Charles II incorporated this string

family into groups of twenty-four players, thus increasing both resonance and volume of sound through the doubling process. The use of chromatic harmony with all the half-tone, or half-step, divisions of the octave was the internal extension of the same idea. Purcell's opposition of ground basses and soprano melodies emphasized the baroque love of a spacious distribution of resonances. His adoption of the Venetian double chorus and his dramatic use of the echo effect in *Dido and Aeneas* were still further evidence of the desire of baroque composers to increase the perception of space through sound.

Above all, the baroque universe was in ceaseless movement. Whether a rationalist thought of it in terms of whirling particles or a mystic as full of swirling spirits, both saw their world as a whirlpool of spheres and spirals making infinitely complex patterns of motion. Kepler's planets revolved in elliptical orbits. Counter-Reformation churches were built over seemingly undulating floor plans. Their walls rippled like stage curtains. The decorative lavishness of their façades further activated the heavy masses of masonry and increased their rhythmic pulsation. Under their domes terra-cotta angels flew in orbits. The unyielding stone of the statuary finally rose off the ground and melted into a myriad of fluid forms (Fig. 391). Paintings escaped from flat wall spaces and took flight to concave surfaces of the ceilings. where they could soar skyward and where more daring perspective effects were possible.

Baroque music also mirrored a moving universe. Its restless forms took on the color of this dynamic age, and its sound patterns floated freely through their tonal spaces, freed from gravitational laws. No longer in bondage to religious ritual, to the dance, or to poetry, music was not completely emancipated. Of such ideas and materials was the image of this brave new baroque world constructed.

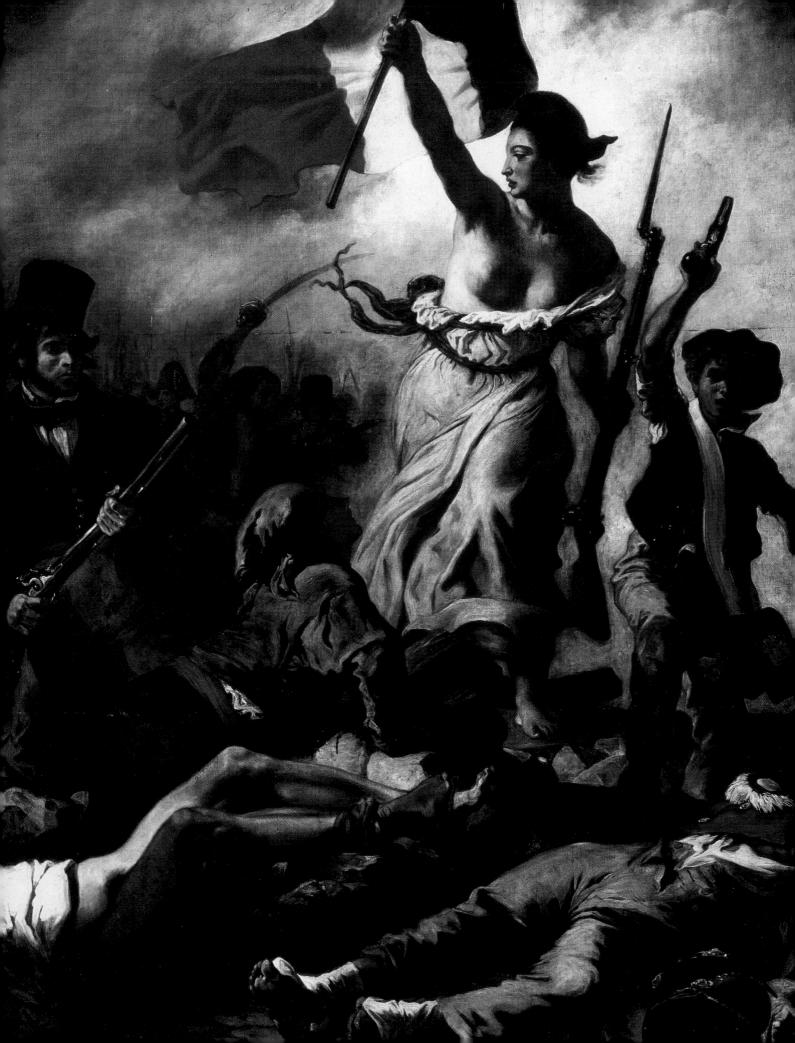

P A R T

5

The Revolutionary Period

he modern age was swept in on a tidal wave of revolution—industrial, social, political, technological, scientific, and cultural. Fundamental beliefs were washed away. Ideas of society, the processes of nature, and the structure of the universe were changed. In the age of reason, scientific knowledge had been greatly expanded but remained largely theoretical. When scientific principles were applied to practical problems, the invention of machinery revolutionized agriculture, manufacturing, communications, mining, and warfare, altering forever the Western world.

"Man is born free and is everywhere in chains," wrote Rousseau in his Social Contract. The slogan was echoed in the mid-19th century in the words of Karl Marx: "Workers of the world, unite. You have nothing to lose but your chains." The fetters were those of ignorance, superstition, poverty, and a social structure based on hereditary privilege, class distinction, and the divine right of kings. Rousseau and his fellow philosophers were heartened by events in the New World. The American colonies had shown that political freedom, religious toleration, and the goals of life, liberty, and the pursuit of happiness could coexist. By achieving independence, the American Revolution led the way. The French Revolution with its ideals of liberty, equality, and fraternity soon followed.

A swift sequence of inventions throughout the 19th century sped up the production and marketing of manufactured and raw goods. In the 20th century the natural outgrowths of this Industrial Revolution were technological and electronic revolutions. Such initial advances as the railroad and the steamboat were followed by the automobile and airplane. The harnessing of electricity, which had produced the telegraph, telephone, and radio, added totally new dimensions to communications through recordings, motion pictures, and television. Mass production, automation, laser beams, satellites, space exploration, and the development of the computer changed the conditions of human life.

Even more awesome than the consequences of the Industrial Revolution were the effects of the scientific revolution on the understanding of nature. Darwin in the mid 19th century had revolutionalized the life sciences by demonstrating that creation was a continuous evolutionary process. In the struggle for existence species have the constant need to adapt to their environment, he wrote. Natural selection leads to the survival of the fittest.

In the 20th century Einstein's theory of relativity and the development of quantum theory produced a similar revolution in physics. Einstein created the picture of the universe as a four-dimensional, spacetime continuum. Space and time as separate absolutes were replaced by space-time in the light of relativity; light was joined to time, and time to space, opening up a whole new concept of nature, not only for the starry cosmos but also for the ultimate tiny particles that are the basic building blocks of the universe.

Twentieth-century artists have been constantly producing revolutions of their own. As in all previous periods, the arts have reflected emotional and intellectual trends, continuing to give voice to the eternal hopes and fears of humanity.

18TH CENTURY

	KEY EVENTS	ARCHITECTURE	VISUAL ARTS	LITERATURE AND
	REI EVENIS	AMCINIECTORE		MUSIC
1700		1656-1723 Johann Fischer von Erlach 1664-1720 John Vanbrugh 1667-1754 Germain Boffrand 1668-1745 Lukas von Hildebrandt 1685-1766 Dominikus Zimmerman 1687-1753 Balthasar Neumann 1698-1782 Ange-Jacques Gabriel	1684-1721 Antoine Watteau ▲ 1696-1770 Giovanni Battista Tiepolo ▲ 1697-1764 William Hogarth ▲ 1699-1779 J. B. S. Chardin ▲	1667-1745 Jonathan Swift ♦ 1668-1733 François Couperin □ 1683-1764 Jean Phillipe Rameau □ 1689-1761 Samuel Richardson ♦ 1694-1778 Voltaire (François Marie Arouet) ♦ 1698-1782 Pietro Metastasio ♦
1700 -	1704 Marlborough defeats		1703-1770 François	1707-1754 Henry Fielding ◆
1725 -	Louis XIV in Battle of Blenheim 1705 Blenheim Palace begun by Vanbrugh 1715 Louis XIV died 1715-1774 Louis XV , king of France	172 4 Belvedere Palace , Vienna, finished; Hildebrandt architect	Boucher ▲ 1714-1785 Jean Baptiste Pigalle ● 1716-1791 Étienne Falconet ●	1712-1778 Jean-Jacques Rousseau ◆ 1713-1784 Denis Diderot ◆ 1714-1787 Christoph Willibald von Gluck □ 1714-1788 C. P. E. Bach □ 1717-1768 Johann Winckelmann ◆ 1724-1804 Immanuel Kant ◆
1725 -	1740-1780 Maria Theresa, empress of Austria 1740-1786 Frederick the Great, king of Prussia 1748 Excavations at Pompeii begun	1732 Hôtel de Soubise, Paris, begun; Boffrand, architect 1744 Schönbrunn Palace built in Vienna (begun in 1696 by Fischer von Erlach) 1745-1754 Wieskirche built near Steingaden	1725-1805 Jean Baptiste Greuze ▲ 1732-1806 Jean Honoré Fragonard ▲ 1738-1814 Clodion (Claude Michel) ● 1741-1825 Henry Fuseli ▲ 1741-1828 Jean Antoine Houdon ●	1726 Gulliver's Travels by Swift 1728 Beggar's Opera by John Gay (1685-1732) performed in London 1728-1774 Oliver Goldsmith ◆ 1729-1781 Gotthold Ephraim Lessing ◆ 1732-1809 Joseph Haydn □ 1732-1799 Caron de Beaumarchais ◆ 1744-1803 Johann Gottfried von Herder ◆ 1748 Spirit of Laws by Montesquieu 1749-1832 Wolfgang von Goethe ◆
1750 -				1749-1838 Lorenzo da Ponte ◆
1775 -	1762-1796 Catherine the Great, empress of Russia 1774-1792 Louis XVI, king of France	1762-1768 Petit Trianon , Versailles, built by Louis XV for Mme. Dubarry; Gabriel, architect	1755-1842 Élisabeth Vigée-Lebrun ▲	1751-1772 Encyclopédie, or A Classified Dictionary of the Sciences, Arts, and Trades, published by Diderot 1752 Pergolesi's Serva Padrona performed in Paris. Guerre des Bouffons, "war" in Paris over serious versus comic opera 1756-1791 Wolfgang Amadeus Mozart □ 1759 Candide by Voltaire 1759-1805 Friedrich von Schiller ◆ 1762 Social Contract by Rousseau. Gluck's Orpheus performed in Vienna 1774 Gluck's Orpheus and Iphigenia in Aulis performed in Paris
1113	1776 American Declaration of Independence 1780-1790 Joseph II, emperor of Austria 1789 French Revolution begun 1789 Washington elected president 1793 Louis XVI executed; France declared republic			1775 Beaumarchais' Barber of Seville presented in Paris 1775-1817 Jane Austen ◆ 1776 Storm and Stress, play by Maximilian Klinger (1752-1831), gave name to art movement 1781 Mozart settled in Vienna. Critique of Pure Reason by Kant 1784 Beaumarchais' play Marriage of Figaro presented; 1786 Mozart's Marriage of Figaro performed in Vienna 1787 Mozart's Don Giovanni performed in Prague; in Vienna 1788 1790 Faust, A Fragment, by Goethe published in Leipzig 1794 Progress of the Human Spirit by Condorcet 1797 Sense and Sensibility by Jane Austen; published in 1811

17

The 18th-Century Styles

In the 18th century new ideas, social theories, and styles in the arts were all contending for a place in the sun. The century began and continued with a period of relative calm that was favorable to productivity in the arts. The beginnings of the industrial era and accompanying migration of people from the country to the cities presaged a time of radical social change that eventually culminated in the late 18th century's revolutionary upheavals. The rise of the middle class to wealth and social prominence was accompanied by a corresponding decline in aristocratic dominance. In 1776 the world heard the ringing words of the American Declaration of Independence, that "all men are created equal, that they are endowed by their Creator with certain inalienable Rights, that among these are Life, Liberty and the pursuit of Happiness." Later, in 1789, these sentiments were echoed in the French Declaration of Human Rights with its ideals of liberty, equality, and fraternity.

The dominant trend in intellectual life was that of the Enlightenment. In 1784 the German philosopher Immanuel Kant gave voice to the new worldview with the challenge: "Dare to know! Have courage to use your understanding! That is the motto of enlightenment." For artists and theorists the Enlightenment meant setting up rational rules of expression that would guarantee excellence. For members of the audience it meant the cultivation of taste and judgment. Taste, as the French savant Voltaire defined it, meant "attaining a quick discernment, a sudden perception which, like the sensations of the palate, anticipates reflection; like the palate it relishes what is good with an exquisite and voluptuous sensibility, and rejects the contrary with loathing and disgust." Without a knowledge of the rules, the person of taste could not appreciate the subtle and often inspired deviations from the norm. and for such discernment one needed education.

Art activity in this productive century moved in several stylistic directions. There was the aristocratically oriented rococo, or gallant, style. Then came sensibility, which reflected middle-class sentiments and aspirations. This was followed in the 1770s by the Storm and Stress movement, an outburst by angry artists who chafed at the artificial restraints of both academic rules and the restrictive codes of polite society. They sought to liberate artistic expression and to broaden the scope of emotional responses. Eventually these competing styles were to meet and merge into the syntheses of classicism and romanticism.

THE ROCOCO

With the death of Louis XIV in 1715, the aristocratic baroque style moved into its final rococo phase. The regent for his young successor closed the majestic Versailles Palace and re-established the royal residence in Paris. Artistic patronage was no longer the monopoly of the court, and the painter Watteau, arriving in Paris the year the Sun King died, had to look for his patrons among a broad group drawn from both the nobility and the upper middle class. Throughout the century, the operas of Rameau, Gluck, and Mozart were composed for public opera houses where aristocrats rubbed shoulders with the bourgeoisie. The arts, in effect, moved out of the marble halls into the elegant salons (Fig. 392), where subtlety and charm were considered higher aesthetic virtues than impressiveness and grandeur.

The rococo, that late version of the aristocratic baroque style, was by no means confined to Paris. All European courts took on in some degree the character of cultural suburbs of Versailles. French fashions in architecture, painting, furniture, costume, and manners were echoed in such far-off corners as the courts of Catherine of Russia and of Maria Theresa in Vienna. Whether a prince ruled a province in Poland or a duchy in Denmark, French was spoken in his household more naturally than

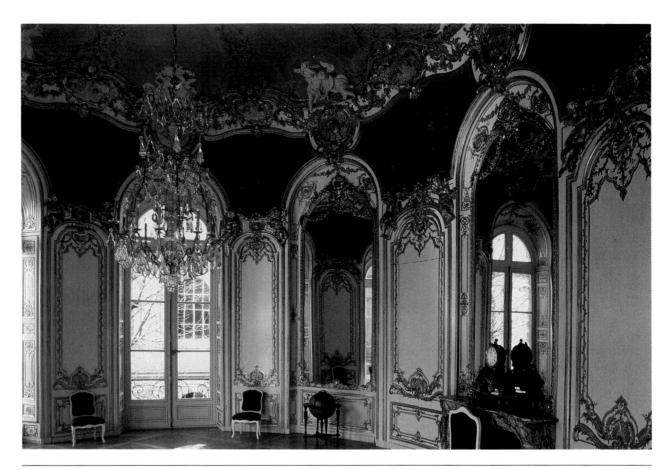

392.GERMAIN BOFFRAND. Salon de la Princesse, Hôtel de Soubise, Paris. c. 1740. Oval, 33 × 26' (10.06 × 7.92 m).

the language of his native country. In Prussia, Frederick the Great built a rococo palace at Potsdam and called it *Sans-souci* ("Carefree"); the king of Saxony commissioned the jewel-like Zwinger pleasure pavilion in Dresden; and the prince-bishop erected a handsome residence in Würzburg (see Fig. 397 and p. 424). Such French authors as Voltaire and Jean-Jacques Rousseau found an international reading public; French dances dominated the balls and French plays the theaters.

In southern Germany and Austria, however, Italian influence was still strong. At the court in Vienna an Italian architect finished the Schönbrunn Palace for Maria Theresa; Italian paintings decorated its walls. Metastasio was the poet laureate, playwright, and opera librettist; and only plays and operas in Italian could be performed in the royal theaters. The missionary energy of the Jesuits working outward from Rome spread and popularized the religious counterpart of the aristocratic style throughout the Counter-Reformation countries.

The word *rococo* apparently was a pun on *barocco*, the Italian word for "baroque," and on *rocailles* and *coquilles*, the French words for "rocks"

and "shells," which were so widely used as decorative motifs in the rococo style. As such the rococo must be considered a modification or variation of the baroque rather than a style in opposition to baroque. Its effect is of a domesticated baroque, better suited to fashionable townhouses than palace halls, but used in both.

Architecture and the Decorative Arts

The rococo suited the intimate salon life of wit and subtle conversation. The style affected both the major art forms and the decorative arts. Typical of the time is an engraved drawing by Watteau that makes the shell a prominent motif (Fig. 393). Such a design could have been applied to furniture, paneling, stage curtains, ceramics, fabrics, and so on. In relation to a Louis XIV interior (see Figs. 369 and 390) the rococo rooms of Vienna's Hofburg Palace (Fig. 394) are delicate, light, and charming. Monumentality, stateliness, and pompous purples are replaced by refinement, elegance, and pastel shades.

At the Belvedere Palace in Vienna, the decorative impulse can be seen as the rococo bursts out-of-

doors into a lavish exterior design (Fig. 395). Details that the French architects had for the most part confined to interiors are found here on the garden façade of a summer palace begun in 1713 by Lukas von Hildebrandt for Prince Eugene of Savoy. Pal-

393. Antoine Watteau. *Garden of Bacchus*. Engraving by Huquier, $10\frac{1}{4}\times15''$ (26 \times 38 cm). Cooper-Hewitt Museum, New York.

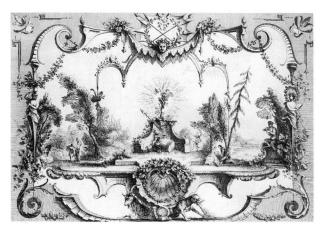

ladian academic restraint has been cast to the winds. On either side of the windows, highly ornate double Composite pilasters can be found, and over the entrance struggling Atlas-like figures are grouped in balletic formation. Otherwise the architectural orders as points of reference have all but disappeared. The sense of repose created by the triangular temple pediments and window brackets of the academic style has dissolved into flowing curves and broken decorative rhythms.

The fusion of the arts to produce mystical-emotional excitement comes to a climax in the churches of Austria and Bavaria. The Roman baroque extravaganzas of Pozzo, Borromini, and Bernini (see pp. 349–52) had by this time reached the popular level of rococo fancies. Such churches as Dominikus Zimmermann's Wieskirche (Church in the Meadow) appear in rural surroundings where the faithful believed some saint or angel had come to minister to those in distress or deliver the local people from some impending evil. Hence they became known as *pilgrimage churches*, since they attracted visitors from far and near.

394. Salon, Hofburg Palace, Vienna. c. 1760–80.

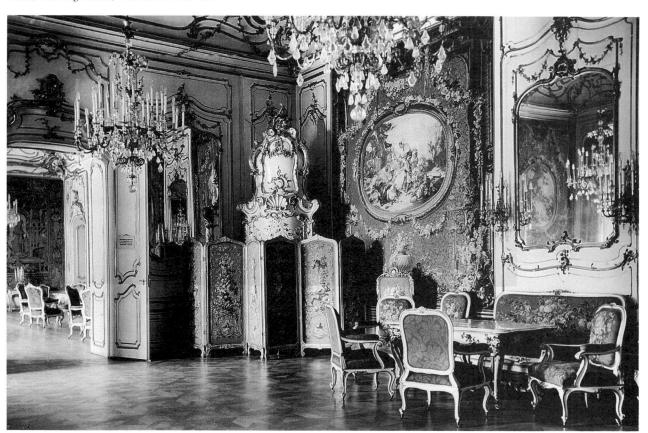

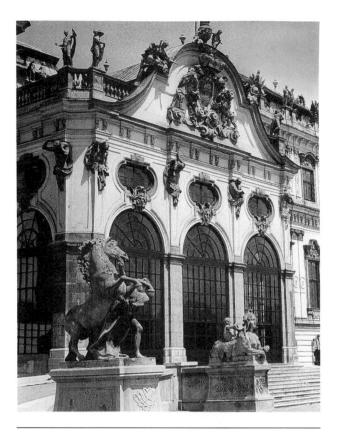

395.LUKAS VON HILDEBRANDT. Detail of façade, Belvedere Palace, Vienna. 1724.

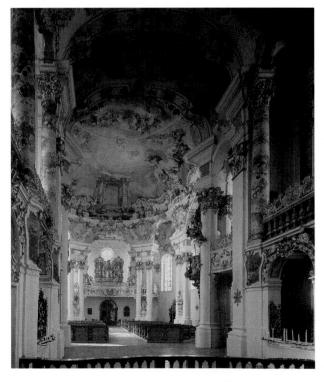

396.Dominikus Zimmermann. Wieskirche, Upper Bavaria. View of Nave toward Entrance Portal. 1745–54.

On entering the oval nave, the pilgrim is swept up in swirls of curvilinear forms and crescendos of brilliant color as if borne aloft on the whirring wings of smiling cherubs and dancing angels (Fig. 396). The high point is reached in the choir loft and ceiling, where the tones of the organ mingle with the concealed chorus and float upward past the terracotta angels perching gracefully on stucco clouds to where the vanishing point is reached in the vast atmospheric perspective of the painted vaulting. Quite airily and effortlessly, all the arts—including liturgy and music—fuse harmoniously to produce a complete work of art where architecture, sculpture, and painting mirrored a unified worldview. And colors, lights, sounds, surfaces, lines, and shapes all melted and merged into a single whole impression.

Elsewhere in southern Germany aristocrats built themselves pleasure palaces such as that of the Prince-Bishop of Würzburg. His architect, Balthasar Neumann, created in the Kaisersaal (Imperial Room) a complex synthesis of the arts (Fig. 397). The soft undulating movement of the decorative details leads the eye upward toward the flowing lines, wavy curves, and visionary vistas of the illusionistic ceiling mural by the Venetian painter Giovanni Battista Tiepolo. In such a stately, aristocratic room, where Mozart once played, rococo and gallant-style music were both at home.

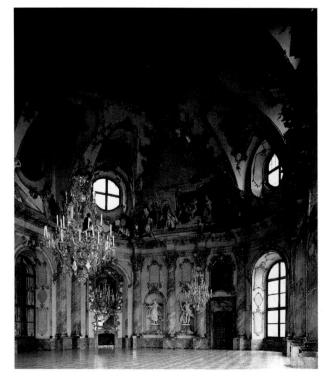

397.
Balthasar Neumann. Kaisersaal (Imperial Room), Residenz (Bishop's Palace), Würzburg. 1719–44.

Painting and Sculpture

The rococo painter without rival was Antoine Watteau. His Music Party (Fig. 398) is an example of his fête galant, or "elegant entertainment," style. Such canvases depicted imaginary visions of well-dressed young people enjoying themselves in idyllic gardens and spacious landscapes. A comparison of this picture with the sensuous baroque Garden of Love by Rubens (Fig. 375) reveals the hallmarks of the new style. The dimensions of the pictures alone tell their story, since Watteau did small easel paintings for the drawing room rather than murals for a grand gallery. Watteau, like Rubens, was Flemish, and he was an ardent admirer of the monumental art produced by his older countryman. In Watteau's pictures, however, Rubens's massive figures are reduced to graceful and slender proportions. They have animation, but Rubens's lusty revelers now dance the graceful minuet. With Watteau the effect is whimsical rather than monumental, and the mood spirited rather than sensuous.

In the *Music Party*, a group has gathered on a terrace for a pleasant afternoon of musical instruction. The cello has been laid aside, the score is still open, and the lady who has just had her lesson lets her elbow rest on her guitar. The music master is tuning his theorbo before beginning to play, and a soft mood of melancholy anticipation prevails.

Beginning as a genre painter specializing in scenes of Flemish village life, Watteau became associated in Paris with decorators and designers of theater scenery and took an interest in the world of elegance found in the world of fashion. With extraordinary poetic intuition, he combined these elements to create a new style in which the fantasy of the stage and the reality of everyday life mixed to play out a comedy of love and desire.

Antoine Watteau's generation was the first in more than seventy years to experience life without

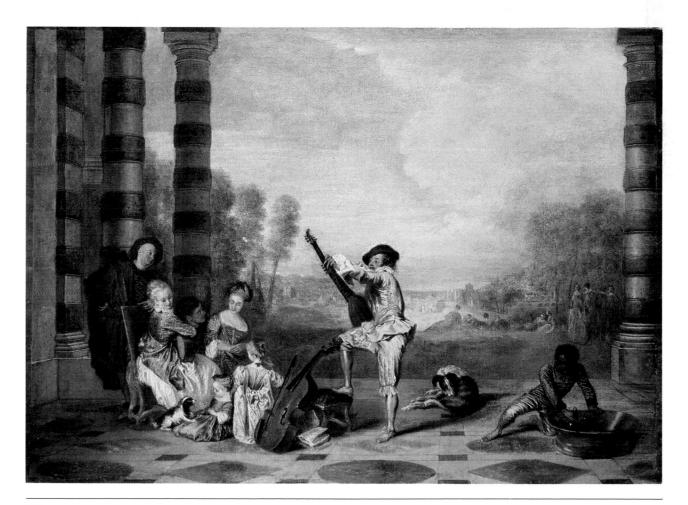

398. Antoine Watteau. *Music Party.* c. 1719. Oil on canvas, $25\frac{1}{2} \times 36\frac{1}{4}$ " (68.6 × 90.5 cm). Wallace Collection, London (reproduced by permission of the Trustees).

the absolutist rule and style of grandiose public rhetoric upheld by Louis XIV. The averted gazes, turned backs, dreaminess, and personal isolation of Watteau's characters—like the theorbo player in the *Music Party* struggling alone to tune a temperamental instrument—suggest something of the loss of identity, the alienation, even anonymity felt by an aristocratic society no longer subject to the arbitrary commands of a powerful authoritarian personality.

Sparkling with skillful brushwork, delicious in color, charming in imagery and conception, Watteau's art achieved a freedom and fantasy new in Western painting. A deep poetic feeling, gentle irony, and elusiveness of precious moments lifts these scenes of social frivolity to the level of great art. As in *Music Party*, misty, vaporous landscapes are important in conveying his subtle moods. Like characters in the pastoral novels of the time, ladies and lovers of equal elegance stroll through lush gardens like the Arcadian shepherds of old. Watteau handled such scenes with a characteristic lightness of touch and delicacy of sensation that set the tone for the later phases of the rococo style.

399. François Boucher. *Toilet of Venus.* 1740. Oil on canvas, $42\frac{5}{8} \times 33\frac{1}{2}$ " (108×85 cm). Metropolitan Museum of Art, New York (bequest of William K. Vanderbilt, 1920).

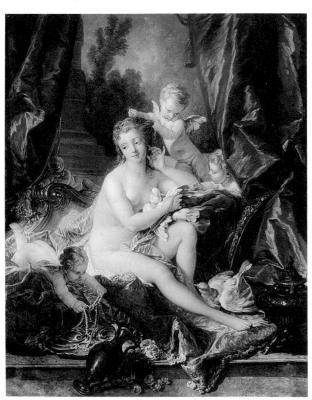

François Boucher, the favorite painter of Louis XV's mistress, Madame de Pompadour, worked in a lighter vein than Watteau. The *Toilet of Venus* (Fig. 399) shows the 18th-century ideal of feminine charm in all its artificiality. Love is no longer the robust passion it was with Rubens but a sophisticated flirtation. Full, mature womanhood is replaced by slender girlish forms.

Jean Honoré Fragonard was Boucher's successor as the leading painter of the French rococo. *The Swing* (Fig. 400), which was commissioned by the young aristocrat shown in the lower left, portrays the frivolous, pleasure-seeking pursuits of his class. He has bribed the servant (lower right) to conceal him in the shrubbery while his lady love swings herself. As her skirts and petticoats billow on the breeze, her silken slipper flies off toward the statue of Cupid, who enters the conspiracy by putting a finger to his lips. The artist's fine feeling for color and the masterly draftsmanship with which he handles his diagonal composition save the picture from the twin perils of overrefinement and triviality.

Much of the same spirit of elegance and charm animates the sculpture of Falconet and Clodion. Clay can be modeled quickly, and so terra-cotta, or ceramic, was a fine medium to capture the fleeting rhythms of Clodion's *Intoxication of Wine* (Fig. 401), a Bacchic dance honoring the god of wine and revelry. These rococo figurines based on classical themes were sometimes even franker in their eroticism than the paintings of the period.

SENSIBILITY

To the sturdy, hard-working, socially responsible members of the middle class, the frills and furbelows of the rococo were too frivolous. The heroic attitudes of mythological gods and goddesses and the rustic loves of charming shepherds and shepherdesses might be fine for the titled nobility. In their own pictures and novels, however, the populace wanted something more down-to-earth that reflected their own experience. The style known as sensibility sprang up as an answer to this demand in England; in France it was known as sensibilité, and in Germany as Empfindsamkeit. The key words here were nature and natural. In the 18th-century sense, nature was the opposite of the artificial, a departure from affectation, a liberation from the affected manners and life-styles of a frivolous class, a reflection of an ordered universe in which all things had their proper place. It found expression in the painting, literature, and music of the period.

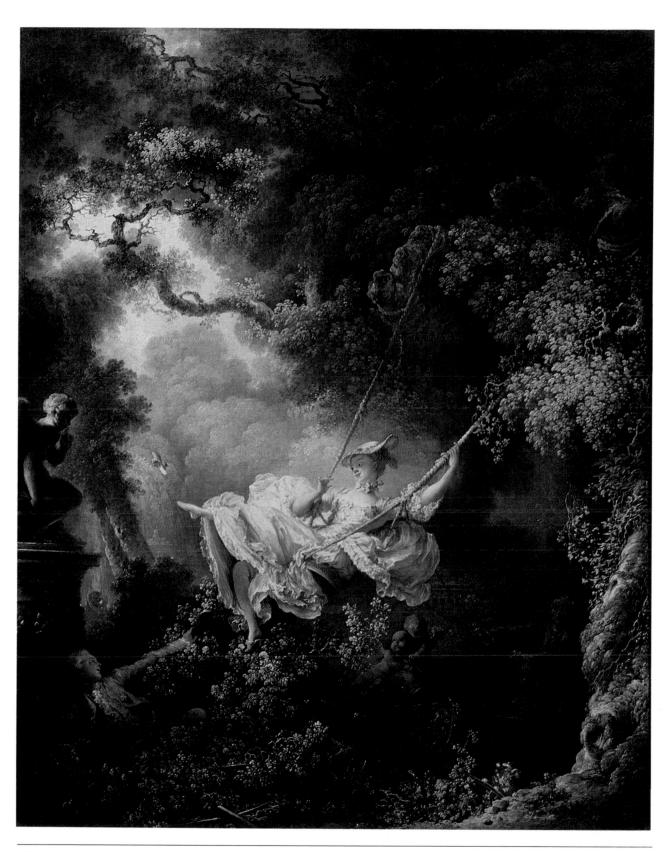

400. Jean Honoré Fragonard. *The Swing.* c. 1768–69. Oil on canvas, $32 \times 25\frac{1}{2}$ " (83 × 66 cm). Wallace Collection, London (reproduced by permission of the Trustees).

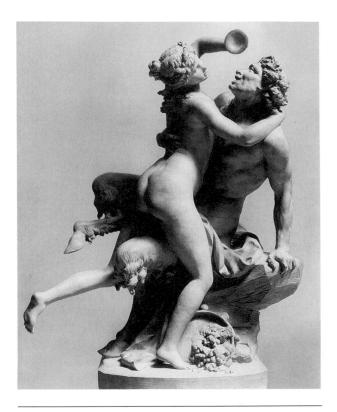

401. CLODION. *Intoxication of Wine (Nymph and Satyr)*. c. 1775. Terracotta, height $23\frac{1}{4}$ " (59 cm). Metropolitan Museum of Art, New York (bequest of Benjamin Altman, 1913).

In France the painters Watteau, Chardin, and Greuze drew their clientele mainly from middleclass ranks, as was the case in England with Hogarth. In literature the novels of Richardson, Fielding, and Goldsmith in England were aimed at this growing middle-class readership. In Germany such plays as Lessing's Miss Sara Sampson (1755) and in France Diderot's Natural Son (1757) established what came to be known as the bourgeois drama. A similar shift occurred in musical life. The collective patronage of the newly opened public concert halls replaced music making exclusively in courtly and church circles. Instead of aiming to please one patron, composers and performers now tried to win the favor of the many. Mozart, for one, felt strong enough to break with his tyrannical archbishop and strike out as an independent composer. It is far from an accident that his operatic masterpiece Don Giovanni was commissioned by the municipality of Prague rather than by the royal capital of Vienna.

Painting

One of Watteau's most significant pictures (Fig. 402) was painted as a signboard for a Paris art dealer by the name of Gersaint. The project was proposed by the artist himself, who was dying of tuberculosis and

wanted for a brief period, as he put it, "to get the stiffness out of my fingers." Watteau idealized his sponsor to the extent of showing him as the owner of a gallerylike showroom filled with the fashionable elite of Parisian society—though this was more wish fulfillment than reality. On the right, Gersaint is praising the virtues of an oval painting in the manner of Watteau to a lady and gentleman who view it through their lorgnettes. On the left, the picture being packed away is the portrait of Louis XIV. This implies farewell to the old regime and a salute both to the new age and style and to the name of Gersaint's shop, Au Grand Monarque. The scene (cut in half sometime after 1750) constitutes an elegant stage setting where real characters act out the drama of everyday life in 18th-century Paris.

Genre pictures with casual everyday subjects are among the 18th-century middle-class reactions to aristocratic posturing. As such they parallel those in Holland a century before (see Figs. 357-363). A master in this category was Chardin, whose sensitive painting revealed visual poetry in the lives of ordinary people going about their daily routines or indulging in quiet pleasures (Fig. 403). His many stilllife compositions are glorifications of commonplace things familiar in every household—bottles, cups, jugs, fruit and vegetables for the dinner table (Fig. 404). But beyond Chardin's modest subject matter and deceptive simplicity, a thoughtful relationship between these objects is noticeable. By his careful arrangements, contrasts of textures, and subtle choice of colors, these became symbols of the good life. The French philosopher and critic Diderot, one of his ardent admirers, wrote that Chardin "is the one who understands the harmony of colors and reflections." Diderot pointed out that it was not the colors he mixed: "it is the very substance of objects, it is the air and light you take with the tip of your brush and fix on the canvas." Chardin's geometrical clarity and pictorial harmony became the model for many modern masters, notably Manet, Cézanne, and Matisse (see Figs. 468, 478, 489).

The English painter William Hogarth must be considered among the distinguished company of 18th-century social satirists. Like Swift's *Gulliver's Travels*, John Gay's *Beggar's Opera*, and Voltaire's *Candide*, Hogarth's series of six pictures entitled *Marriage à la Mode* is a merciless exposé of the conditions and customs of his time, modified by the saving grace of a brilliant wit. As Dickens and Zola, Goya and Daumier were to do in the less humorous 19th century, Hogarth dramatized the conditions he saw and issued a challenge to society to do something about them. In this case it is the evil of putting young men and women on the auction block of marriage.

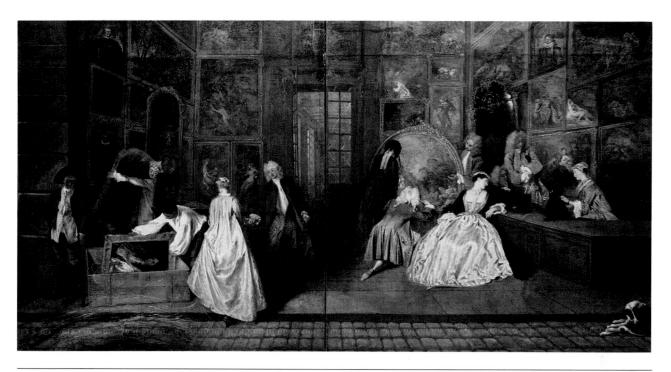

402. Antoine Watteau. *Gersaint's Signboard*. 1720–21. Oil on canvas, $5'3\frac{7}{8}'' \times 10'1''$ (1.62 × 3.07 m). Staatliche Museen, Berlin.

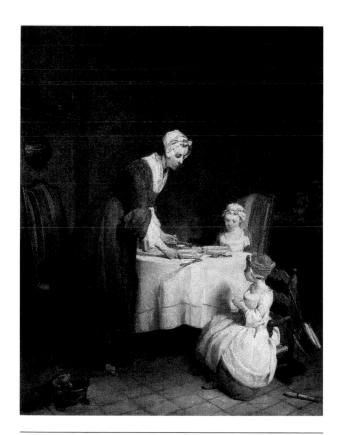

403. Jean-Baptiste Siméon Chardin. *Grace at Table.* 1740. Oil on canvas, $19 \times 15''$ (48.3 \times 38.1 cm). Louvre, Paris.

Hogarth's *Marriage Contract* (Fig. 405) introduces the characters as in the first scene of a play. The gouty nobleman points with pride to the family pedigree as he is about to sell his social standing, in the person of his son, to pay off the mortgage on his ancestral estate. The merchant who is marrying off his daughter carefully inspects the dowry settlement through his spectacles, just as he would in any other hard-driven business bargain. The pawns in this game, the ill-matched bride and groom, sit with their backs to each other. The lawyer, Counselor Silvertongue, beginning a flirtation, flatters the future Lady Squanderfield while her fiancé takes a pinch of snuff. "Marriages of convenience" was the polite name for these loveless matches.

The other five scenes show the unhappy consequences of this doomed union as it progresses from boredom and frivolity to infidelities, a duel, and death. In the *Countess's Levée* (Fig. 406), Lady Squanderfield entertains some of her fine-feathered friends as she makes her morning toilette. Counselor Silvertongue, now her lover, shows her tickets for a masked ball that evening. A French barber dresses her hair, a servant passes cups of chocolate, while a little black pageboy points gleefully to the horns of a doll, indicating she is cuckholding her husband. The corpulent singer may be Farinelli, the famous castrato, who was then doing soprano roles in London opera. The infatuated fan beside him has been

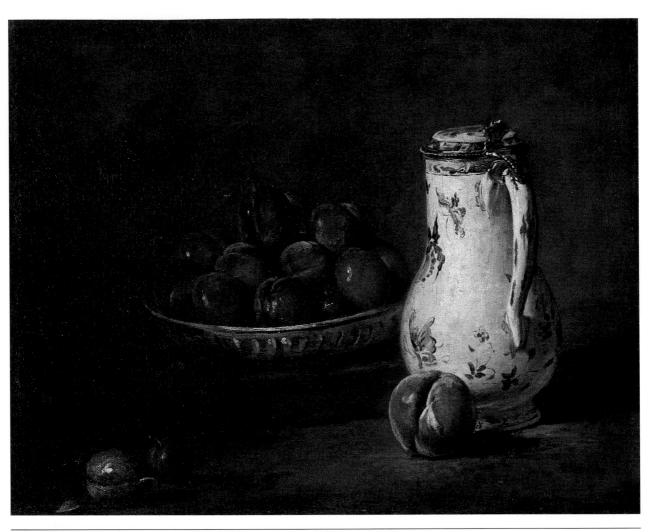

404. Jean-Baptiste Siméon Chardin. *Still Life: Bowl of Plums, a Peach, and Water Pitcher.* c. 1728. Oil on canvas, $17\frac{3}{4} \times 22\frac{3''}{8}$ (45 × 57 cm). Phillips Collection, Washington, D.C.

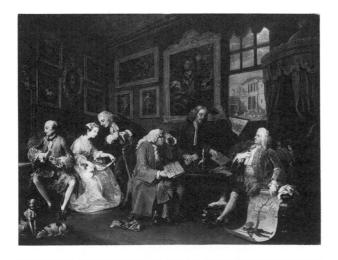

405. William Hogarth. *Marriage Contract (Marriage à la Mode,* Scene I). 1744. Oil on canvas, $27 \times 35''$ (69×90 cm). National Gallery, London (reproduced by courtesy of the Trustees).

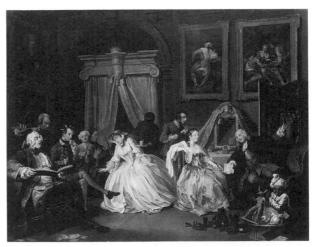

406. WILLIAM HOGARTH. *Countess's Levée (Marriage à la Mode, Scene IV)*. 1744. Oil on canvas $27 \times 35''$ (69 \times 90 cm). National Gallery, London (reproduced by courtesy of the Trustees).

identified as a socialite who once exclaimed, "One God, one Farinelli!"

This and such other series as the *Harlot's Progress* and the *Rake's Progress* were first made as paintings and then copied in the form of copper engravings. The prints were widely sold by subscription, and this type of group patronage made them financially successful. Every detail in Hogarth's crowded rooms is a commentary on both the action and the taste of his time. Beyond their biting satire, his pictures became great works of art by virtue of their superb draftsmanship and tightly knit composition.

Back in France, sensibilité upheld moral standards. According to Diderot, the arts should celebrate the victory of virtue and the defeat of vice. This view is explored in the paintings of Jean-Baptiste Greuze, who entitled some of his pictorial sermons The Paralytic Cared for by His Children, Young Girl Weeping over Her Dead Bird, and The Father's Curse.

Typical is his *Village Bride* (Fig. 407), depicting the moment when the father of the bride hands over her dowry to the groom. Such pictures are like stage scenes. Sensibility here, however, comes close to sentimentality.

Sculpture

As might be expected, bourgeois sculptural expression was at home in the domain of portraiture. Houdon's fine feeling for characterization assures him a place among the foremost portraitists of Western art. His bust of Voltaire (Fig. 408) is one of several likenesses he did of the famous French philosopher and dramatist. By the tilt of the head and the humorous gleam of the eye, Houdon captures the amused look of the philosopher as he ponders and comments on the foibles and follies of his fellow mortals. To chisel a glance of amiable skepticism in

407. Jean Baptiste Greuze. *Village Bride*. 1761. Oil on canvas, $36 \times 46^{17}_2$ (91.4 × 118.1 cm). Louvre, Paris.

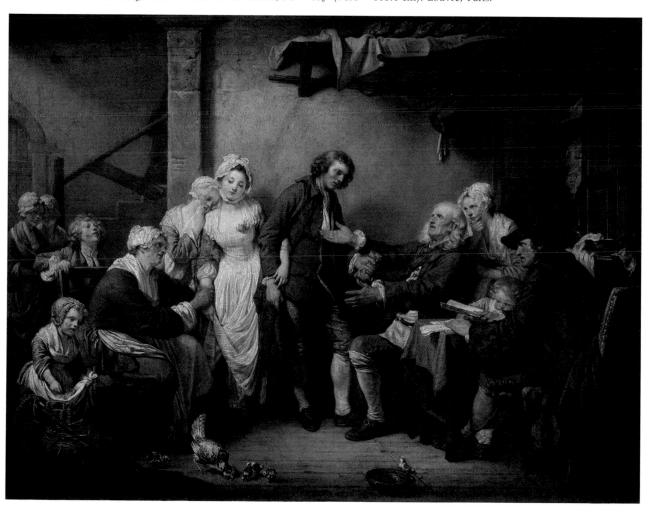

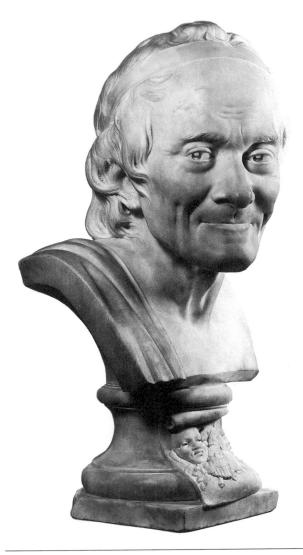

408.Jean Antoine Houdon. *Voltaire*. 1781. Marble, height 20" (51 cm). Victoria and Albert Museum, London (Crown copyright).

marble is no small feat. Leaving a rough edge in the outline of the pupil of the eye, the artist is able to produce a special glint that gives just the desired effect. By such means Houdon achieved a speaking image in which, during a fleeting moment of animated conversation, the philosopher might just have coined one of his famous epigrams.

Houdon's subjects also included many Americans, including Thomas Jefferson, John Paul Jones, Robert Fulton, and Benjamin Franklin, carved while Franklin was ambassador to the court of Louis XVI. In 1785, on the invitation of Jefferson, Houdon crossed the Atlantic with Franklin and spent several weeks at Mount Vernon making studies for the statue of George Washington now at the Virginia state capitol at Richmond.

Literature

In English novels, sensibility explored personal feelings and a spectrum of emotional reactions to familiar social situations. Samuel Richardson's 1740 novel Pamela portrayed a poor but proud young woman who had to seek her fortune by working in the residence of a well-to-do bachelor. She takes his fancy but resists his overtures resolutely until frustration provokes him into a proposal of marriage. This triumph of virtue over vice was celebrated in the press and pulpit, winning wide popularity for the author. In Oliver Goldsmith's Vicar of Wakefield, the trials and troubles of a saintly country parson push him nearly to the breaking point. First he loses his modest capital to a rascally traveling salesman, next his beloved daughter is ravished by a villain's strategem, and then his son's career is ruined by false accusations. After suffering every possible mortification and calamity, he still manages to hold his head high. In the end, of course, all comes out well.

Jane Austen toward the end of the century had the woman's last word in her *Sense and Sensibility*. This witty comedy of middle-class manners portrays two sisters. Elinor is the one who has good sense, "strength and understanding. . . . Her feelings are strong, but she knew how to govern them." Marianne, however, "was eager in everything; her sorrows, her joys, could have no moderation . . . she was everything but prudent." In an ironic twist, Elinor marries for love, and Marianne learns that prudence and common sense are the proper foundation for family happiness.

REACTIONS TO THE ENLIGHTENMENT

For intellectuals Enlightenment thought was the taking-off point. Those who believed the exercise of reason could solve all political, social, religious, and personal problems took the optimistic view. Those who looked at the dismal conditions that surrounded them took the pessimistic line. Jonathan Swift, for instance, questioned the assumption that human nature was essentially good. For him men and women were animals capable of reason, but more often than not they used their faculties "to aggravate man's natural corruptions." Coining the phrase "man's inhumanity to man," his sharp pen exposed in such satires as Gulliver's Travels the social evils and inequalities he beheld all around him. He carried his convictions to the grave that bears his self-written epitaph: "He has gone where savage indignation can tear his heart no more."

Voltaire, a central figure of the French Enlightenment, believed like his colleagues in the power of reason, as well as in freedom of thought. His incisive critical intelligence, however, led him to satirize the pursuit of pure reason. If, as the 17th-century rationalist Baron Leibnitz believed, the human race was all good and its progress inevitable, then human beings must inhabit the best of all possible worlds. In his masterpiece, Candide, Voltaire satirizes Leibnitz as Dr. Pangloss, the tutor of the naïve Candide, whom he escorts on a grand tour. Along their way they experience one social and natural disaster after another-rape, murder, slavery, shipwrecks, and earthquakes. Total pessimism, on the other hand, is equally untenable, so some middle ground had to be found. Like his colleague Rousseau, Voltaire held that "the only book that needs to be read is the great book of nature." So Candide returns to his farm and heeds the advice of his friend Martin: "Let us work without theorizing, it is the only way to make life endurable." Voltaire's parting words are: "We must cultivate our gardens."

Storm and Stress

By far the most tempestuous reaction to the Enlightenment took place in Germany with the Sturm und Drang movement. Its central figure was the poet and dramatist Johann von Goethe. In his university days, Goethe was greatly attracted to the philosopher Gottfried Herder, who had studied with Kant and was conversant with all the ideas of Enlightenment rationalism. Under the spell of Rousseau, however, Herder concluded that reason was not the key that unlocked the universe. Throwing off the restraints of academic rules, he felt that only nature could provide the answers. He found nature in folklore as the voice of the people, in Gothic architecture with its myriad imaginative forms, in Shakespeare's plays, and in the sublime. The latter was a concept the English philosopher Edmund Burke had projected as a counterbalance to beauty. Beauty was achieved through order, clarity, symmetry, and the judicious balancing of opposites. But the sublime was to be found in the wild and awesome aspects of nature tempests and torrents, impenetrable forests, mountain avalanches, and Alpine scenery. The terrifying, the fearsome, the mysterious, and even the ugly could become the material of art. In the canon of Storm and Stress, rules were not made to be broken elegantly and politely as with the rococo, but with shattering and shocking effect.

Herder then became Goethe's model for the characterization of Faust, the title figure in the

drama that occupied him much of his life. Faust was based on a medieval legend of the philosopher who sold his soul to the devil for magical knowledge that would unlock the secrets of the universe. Goethe's Mephistopheles, however, is a very sophisticated devil with a cynical sense of humor and an ironic eye for human follies and foibles. Faust in Goethe's original version of the 1770s has concluded that the world cannot be known through theory alone but only through experience, feeling, and emotion. Faust's tragedy is that in the fulfillment of his love for Margaret, he has brought about the destruction of the woman he loves. Margaret's tragedy is that when she experiences love with all its tender feeling, and when she achieves the fulfillment of her womanhood in childbirth, she is condemned as an unwed mother by the customs and laws of a strict society. Faust's constant search for new experiences and emotional involvements, however, is also the tragedy of life, since only by seeking for the unattainable can the divine spark ignite and illuminate the course of human existence. For both Faust and Margaret. the road to salvation and redemption lies in continuous striving and struggling. After his Storm and Stress period had waned, Goethe wrote a philosophical sequel in which Faust finally finds redemption through the prayers and love of Margaret and in his service to humanity.

The visual aspect of the Storm and Stress rationale is reflected in the pictures of the Swiss-born artist Henry Fuseli. Trained for the ministry and ordained at the age of 20, he made a rebellious escape into the world of art. Shakespeare and Michelangelo were hailed as his "twin gods," and his psychological insights into the dark, irrational realm of dreams added a nightmarish dimension to Storm and Stress expression. His pictures are populated with witches, goblins, ghosts, and ghouls. His drawing of Theseus and the Minotaur (Fig. 409) shows his antiheroic, manneristic treatment of traditional mythological themes. Instead of a glamorous classical portrayal of a heroic Theseus slaying the mighty Minotaur, Fuseli pictures a frenzied struggle to escape from the terrifying confines of the spectral labyrinth.

THE MOZARTIAN SYNTHESIS

Wolfgang Amadeus Mozart's most mature music was written during the last decade of his life, as a resident of Vienna. While he continued to compose chamber music for aristocratic salons, an occasional chamber opera for the Schönbrunn Palace, and German comic operas for the popular musical theater, his art attains its most universal expression in the

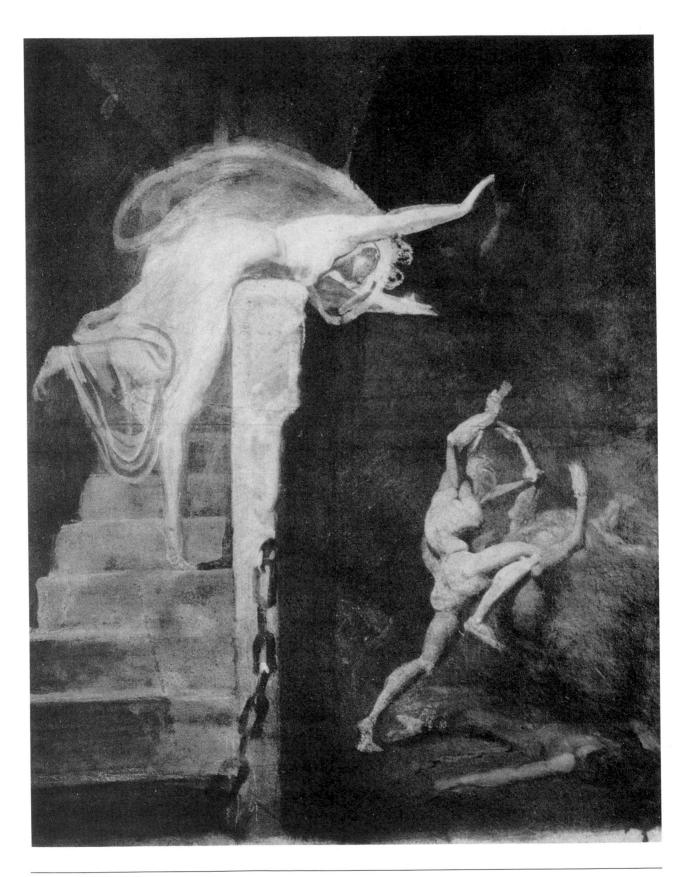

409. Henry Fusell. Ariadne Watching the Fight between Theseus and the Minotaur. 1794. Preparatory drawing for a painting. $23\frac{1}{2} \times 18\frac{1}{2}$ " (59.7 × 47 cm). Mellon Collection, Upperville, Virginia.

works he created for the public opera houses and concert halls, where nobles and commoners gathered together for their mutual recreation. It was here that Mozart's musical genius found its widest scope, here that he could explore the endless variety of tragic and comic situations that give his operas their boundless humanity, and here that his dramatic power could make its greatest impact. It is also these qualities that were carried over into the less direct and more abstract form of his symphonies and concertos and that give these compositions their dramatic intensity.

The spirit of the Enlightenment can be seen in the logical clarity and unified structure of Mozart's music and dramatic forms: his letters show his enthusiasm for Rousseauian naturalness; and the explosive energy of Mozart's music displays his knowledge of Storm and Stress literature. Indeed, everything in his epoch was processed in the laboratory of his brilliant mind, sifted through his creative consciousness, and eventually refined into pure musical gold. In opera, he found the form in which he could combine all these ideas and styles into one grand endlessly changing yet well-ordered pattern. For him the lyric theater was always his most natural medium of expression.

Mozart's power of characterization is akin to that of Shakespeare, though his dramas are made with musical materials. No composer understood better than Mozart that an opera is not a drama with music but a drama in music, or knew better that a character has no existence apart from the melody that is sung. The character simply is the melody. As the supreme musical dramatist, Mozart can awaken characters to life by a phrase or a rhythmical pattern, carry them through living situations by the direction of a melodic line, and develop the most intricate interactions with the others in a scene by harmonic modulation and contrapuntal complexity.

Mozart's emotional range is enormous. Within a short span of time, his music can be both spirited and profound, serene and agitated, ethical and diabolical. Yet all takes place within an ordered framework, and nothing ever gets out of hand.

For example, Mozart's *Marriage of Figaro*, an adaptation of Beaumarchais' play, is really a vast human panorama in which all the characters, whether master or servant, noble or knave, appear as equal partners in the dance of life. Every amorous situation is explored with objectivity, psychological insight, good humor, and warm understanding. The opera progresses from Cherubino's adolescent fascinations with the opposite sex to the more mature love of Figaro and Susanna. It moves on to a portrayal of the Count and Countess as the unfaithful

husband and neglected wife, and finally to a pair of scheming blackmailers. The situations meanwhile run a range from intrigue, flirtation, and lust to infidelity, forgiveness, and tender reconciliation. Much of Beaumarchais' political satire is missing, but every shade of human feeling is explored to the utmost.

Don Giovanni

For *Don Giovanni*, Mozart was fortunate in having the collaboration of Lorenzo da Ponte, a skillful writer and adapter with a real theatrical flair. On hand at the final rehearsals of this saga of the world's greatest lover, and helping to put a few finishing touches on the text, was none other than Giacomo Casanova, a man who had done enough research on the subject to qualify him as an authority. The Don Juan story was far from new, and like the Faust legend, it went all the way back to the medieval morality drama.

INTERPRETATIONS. Both the subject matter and Mozart's sparkling music led to the acceptance of *Don Giovanni* by the following generation as the ideal type of the romantic opera. In one of his late conversations, Goethe remarked rather ruefully that Mozart should have composed a *Faust*. What the great poet overlooked was that Mozart had already done so, since the Faustian concept completely parallels the character of Don Giovanni, who was a Mephistopheles and Faust rolled into one.

Mozart called his opera a *dramma giocosa* (comic drama), but he also referred to it as an "opera buffa in two acts." So it materializes as a subtle mixture of both comic and dramatic elements. The best approach to this unique masterpiece is to consider it a high-spirited 18th-century comedy of manners in which Molièrian satire is blended with Storm and Stress demonology.

PLOT AND CHARACTERS. The pace of the opera is breathtaking. In the first scene alone there are an attempted rape, a challenge and duel, the dying gasps of an outraged father, blasphemy, the escape of the culprit, and oaths of vengeance. In all this the absolute dramatic center is Don Giovanni, who, in Storm and Stress fashion, bursts the bonds of civilized restraint, defies all social conventions, sweeps aside every barrier in his way, and stands alone against the world. In Mozart's other operas, such as the *Marriage of Figaro*, all the characters interact with each other. Here the figures, like the spokes of a wheel, exist only in their relation to the hub, Don Giovanni himself. Opposite him are the three female

leads, each of equal importance—Donna Anna, Donna Elvira, and the peasant girl Zerlina.

Chronologically, Donna Elvira comes first, since she has been seduced and deserted before the curtain rises. Hers is the fury of a woman scorned, joined with the desire to forgive and forget and to save Don Giovanni from damnation. Her character is most clearly revealed in Aria No. 8, "In qual eccessi," where she advises the lightheaded young Zerlina of the pitfalls of life with the dashing Don. Mozart writes it as a typical baroque rage aria in the manner of Handel. By so doing, he implies that Elvira's moral sermons are old-fashioned, and the dignified form makes it an effective contrast to the general frivolity.

The emotional life of Donna Anna, whose screams when Don Giovanni tries to seduce her are heard at the beginning of the opera, is no less complicated. Full of righteous wrath, possibly mixed with some unconscious admiration for Don Giovanni, and fixed with filial affection for her murdered father, she swears vengeance on his assassin. She is joined in this resolve by her gentlemanly fiancé, Don Ottavio. Together they constitute the serious couple usual in Italian opera buffa. Since Don Ottavio is the lonely champion of lawful love versus dissoluteness, he is bound to appear somewhat pale and conventional in these highly charged surroundings. His two tenor arias, "Dalla sua pace" and "Il mio tesoro'' (Nos. 10B and 21), feature lovely lyricism and an appropriately aristocratic gallant style. Donna Anna, on the contrary, rises to tragic stature in "Or sai chi l'onore" (Aria No. 10), in which, outraged but also attracted to Don Giovanni, she intermingles hatred with fury and passion.

Third in this list is the naïve but flirtatious Zerlina, torn between loyalty to her rustic bridegroom Masetto and the flattering attentions of the glamorous Don. Zerlina and the Don's duet "Là ci darem la mano" (No. 7) is a perceptive piece of musical characterization in which the division of the melody between the voices and the subtle melodic variants point up their respective attitudes. The Don is tender yet still the lordly aristocrat; Zerlina is feminine and doubtful of his intentions, but enjoying every moment. Later, the aria "Vedrai carino" (No. 18) reconciles Zerlina to her young peasant husband and reveals her maternal feelings toward him.

On the male side, Don Giovanni has no romantic competition, only a very substantial shadow in the form of Leporello, the comic servant who plays Sancho Panza to his Don Quixote. Leporello is a stock opera-buffa character who expresses his rather earthy cynicism in some chattering patter songs based on a series of rapidly repeated syllables

and notes. He introduces himself in the first aria of the opera; and in the famous "Catalogue Aria" (No. 4), he lists the master's amorous conquests—1,003 thus far—in what must surely be the most hilarious set of statistics ever enumerated.

FINALES TO ACTS I AND II. The two scenes in which all the characters are on stage are the finales to Acts I and II. In the first, Don Giovanni is entertaining a lively peasant wedding party in the hope of winning the bride, Zerlina, to add to his list of conquests. Fine dramatic contrast is provided in Don Giovanni's joyous drinking song (No. 11), which sparkles like the wine he is ordering, and the sullen resentment of Masetto when he senses that his bride's head is being turned by this glamorous member of the privileged class.

Don Giovanni Wolfgang Amadeus Mozart (dance scene, finale, Act I)

The scene reaches its brilliant climax when the dance music strikes up. There are no less than three instrumental groups on stage in addition to the main orchestra in the pit. Everyone at the time would have recognized this as a scene in a typical Viennese public ballroom, for which Mozart frequently composed music. So that there would be dances that appealed to everybody, minuets were customarily played in one room, waltzes in another, and so on. Here the three groups also play different dances (above). The first group, consisting of two oboes, two horns, and strings, plays one of the best-known of all minuets. On the repetition of the last part, the second stage orchestra, made up of violins and a bass, does a type of square dance known as a contredanse; while a third ensemble, also of stringed instruments, plays a type of old-fashioned German waltz known as a Ländler. An obvious separation of social levels is implied, with the masked figures of Donna Anna and Don Ottavio doing the aristocratic minuet; the peasants stamping out the vigorous, Ländler-like meter of the waltz, with strong accents on the fist and third beats; while Don Giovanni and Zerlina meet on the middle-class ground of the bourgeois contredanse. Each social group is thus expressed through a characteristic rhythm. With the stage bands playing against the main orchestra below, all the plots and subplots boiling merrily away, and all the characters conversing and commenting on the action, the resulting rhythmic complexity and dramatic tension make this scene one of the major miracles of musical literature.

In the cemetery scene, which precedes the finale to Act II, Don Giovanni as a fugitive from justice is confronted with the equestrian statue of the Commendatore, Donna Anna's father, whom he has killed in the duel at the beginning of the opera. The ominous tones of the voice from the tomb reproach him for his wickedness; and Don Giovanni, as a lark, responds by inviting the statue to a midnight meal.

The final scene opens with the preparations for the banquet, while the trumpets and drums sound the proper note of aristocratic hospitality. Like many nobles of his time, Don Giovanni has his own house orchestra standing by to play dinner music. This wind group plays snatches from two popular Italian operas by Mozart's rivals; and a delightful bit of humor is introduced when they quote the 'Non più andrai' from his own Marriage of Figaro, which happened to be a hit tune of that season, not a classic as now.

Donna Elvira, ever the killjoy, now enters to play her trump card, which is the announcement that she is returning to her convent, where life under the veil will presumably be more peaceful. As she reaches the door, her shriek announces the arrival of the statue. With fatefully heavy footsteps, the monument sings a long melodic line as rigid as rigor mortis itself, reinforced by the funereal sounds of trombones—instruments which were then associated with solemn church festivals and burial services. The contrast between the living and the dead is brought out by the statue's stiff melody, around which all the other characters react in ways that vary from farce to frustration and tragedy.

When Don Giovanni takes the hand of his marble guest, the Storm and Stress horror music that had been foreshadowed in the overture is heard. Strings play spine-tingling scale figures upward and downward, alternately soft and loud. Thunder roars, demons shout, and flames rise upward. The Don, unrepentant to the last, goes to his doom on a descending D-major scale. Breathlessly, the other char-

acters arrive too late for the excitement but in time to sing a final quintet to these words: "Sinner, pause, and ponder well / Mark the end of Don Juan! / Are you going to Heaven or Hell?"

IDEAS: 18TH-CENTURY RATIONALISM

Baroque rationalism had been the province of a few outstanding minds. Newton had projected his image of a universe in which all phenomena obeyed certain predictable cosmic laws. John Locke had taught that all knowledge comes through sense experience, including common sense. Descartes had made his famous pronouncement, "I think; therefore I am," while pointing out that only the things he observed clearly and distinctly could be true. In the 18th century, as scientific knowledge became the common property of the educated classes, rationalism broadened its base into the movement known as the Enlightenment. The Enlightenment flourished concurrently with the rococo and sensibility styles as still another divergence within the broad 18th-century cultural-historical picture. It became an intellectual movement that embraced the 18th-century version of rationalism, scientific inquiry, encyclopedic development, the inventive spirit, the optimistic worldview, and the belief in progress.

As the streams of rationalism and academicism met, one of the most characteristic expressions of the Enlightenment became the 35-volume Encyclopédie edited by Denis Diderot. In this Classified Dictionary of the Sciences, Arts, and Trades, some 180 outstanding minds made available in clear language all the knowledge that had existed previously only in obscure scientific treatises. Most of the outstanding French intellectuals contributed their expertise, with Voltaire writing the historical parts, Montesquieu those on political science, Rousseau the sections on music, and Diderot himself the philosophical and critical articles, and so on down the list. The encyclopedists were convinced that the world was knowable if only knowledge could be gathered, classified, and collated. To them men and women were rational beings, held down only by political oppression and religious superstition.

The Enlightenment spirit of free scientific inquiry was so opposed to the clergy as purveyors of age-old superstitions that it came close to becoming a substitute religion. *Deism* then became the rational substitute for traditional Catholicism. To the deists, God was a kind of cosmic clockmaker who created a mechanical universe, wound it up for all eternity, and let it go. The experimental method of laboratory science became the liturgy of this new orientation,

the encyclopedia its Bible, nature its church, and all human beings of reason the congregation.

The Enlightenment was also accompanied by a healthy spirit of optimism and by a belief in progress and human perfectibility. Theologically, the Hebraic and Christian viewpoints were based on the fall of humanity and the doctrine of original sin dating from the expulsion of Adam and Eve from the Garden of Eden. Philosophically, Plato's theory of knowledge was also founded on a doctrine of perfection prior to birth and the subsequent acquisition of knowledge by the process of remembrance. Humanists, such as the historians Gibbon and Winckelmann, believed in the intellectual and artistic paradise of ancient Greece and Rome and as a consequence wrote books analyzing their declines and falls.

Without denying the greatness of Greece, the champions of the Enlightenment were well aware that they had gone far beyond classical science and believed that, if the rational processes could be properly applied, they would eventually surpass the ancients in all fields. Kant, for instance, enthusiastically hailed Rousseau as the Newton of the moral world, and Condorcet in his Progress of the Human Spirit listed the ten stages by which humanity had raised itself from ignorance and savagery to the threshold of perfection. Material progress was certainly an observable fact; and since the many secrets held by nature could be unlocked by reason, eventually rational humans could control their environment. If all mental and moral powers were used to their fullest extent, the argument ran, human development could go in one direction only, onward and upward.

While the fruits of rationalism became the common property of the middle class, *reason*, in the vocabulary of the 18th century, by no means implied only cold intellectuality. Reason was considered a mental faculty shared by all who chose to cultivate it. Among its implications were common sense, exercise of good judgment, and the development of taste—all of which were accompanied by a healthy involvement in active human pursuits.

As applied to the arts, reason meant the search for expressive forms and sentiments sufficiently universal and valid to be accepted by all who supported the principles of good taste and judgment. With the broadening of the bases of wealth and education, the middle class was able to rise and challenge the ancient authority and privileges of the aristocracy. Through the power of knowledge released by the Enlightenment, the age-old chains of superstition, intolerance, and fear began to be thrown off. The ideals of freedom championed by reasonable people were eventually written into the American Declara-

tion of Independence and Bill of Rights and became the moving force behind the French Revolution. Increasingly, it was now the middle class who wrote and read the books, who constructed and lived in the buildings, who painted and bought the pictures, and who composed and listened to the music.

The philosophy of the Enlightenment did not, however, go unchallenged. Undercurrents of irrationalism were found in movements that anticipated 19th-century romanticism. Rousseau, for example, gave sensibility a deeper emotional tone. In France, England, and Germany sensibility meant tugging at the heartstrings of readers, observers, and listeners. This tendency also became the background for the Storm and Stress movement. While the Enlightenment was trying to tame nature and bring it under human control, the Sturm und Drang authors were reveling in how nature imposed its obscure and mysterious will on humanity. During the height of the Enlightenment, for instance, the Storm and Stress artist Henry Fuseli powerfully portrayed the blinded mythological giant Polyphemus in a pose modeled on one of the damned souls in Michelangelo's Last Judgment, as Rodin was later to do for his Thinker (Fig. 460). Here the image represents a helpless humanity struggling vainly to realize its strength and potential. Blinded by ignorance, it cannot see the light of self-knowledge. In Goethe's early drama Faust was the rebel against all accepted forms of wisdom, especially those arrived at through mathematical or scientific formulas. Both Faust and Don Giovanni were engaged in a quest for emotional truth and succeeded in unleashing the infernal forces that eventually consumed them. The "Stormers and Stressers" made a personal interpretation of Rousseau's initial statement in his Social Contract: "Man is born free, and everywhere he is in chains." Goethe's characterizations of Faust and Prometheus and Mozart's Don Giovanni were independent human beings. They defied the gods of convention and demanded a range of inner and outer experience, even if they had to pay the penalty of eternal torment.

The truth such figures sought was one of feeling rather than logic, and their curiosity was boundless. By bursting the bonds of civilized restraints, they were in full rebellion against hereditary aristocratic privilege as well as stern middle-class morality. Their freedom was far from that of the Enlightenment. It was, in fact, an antirationalistic, antiuniversal, powerfully pro-individualistic freedom that bordered on self-destruction and anarchy.

The 18th century as a whole was marked by a quickening of the pulse of human affairs. The flood of material from the printing presses alone made it

all but impossible to keep up with the pace set in philosophy, literature, and music. The spread of wealth led to the development of urban centers and widespread building projects. Writers, painters, and musicians no longer aimed their output exclusively at one social group.

While it is often called the Age of Reason, the 18th century gave birth to some of the most bizarre and irrational beings, real or imaginary, ever conceived by the mind or imagination. The passionate disputes begun in the 17th century continued, but

on the surface at least the divisions did not appear to be so sharp. The unresolvable oppositions of the baroque were softened in subtle satires, gentle ironies, witty verbal dueling, and nostalgic melancholies. What appeared as a period of comparative quiet, however, was but the calm before the storm, the prelude to a social explosion that brought the aristocratic rococo to a violent, revolutionary end, and hurled into the next century the forces of reason and emotion it had generated.

EARLY 19TH CENTURY

	KEY EVENTS	ARCHITECTURE	VISUAL ARTS	LITERATURE AND MUSIC
4.5.0		1733-1808 Carl Gotthard Langhans 1739-1811 Jean François Thérèse Chalgrin 1743-1826 Thomas Jefferson 1748 Excavations begun at Pompeii and Herculaneum	1716-1809 Joseph Marie Vien ▲ 1741-1807 Angelica Kauffmann ▲ 1746-1828 Francisco Goya ▲ 1748-1825 Jacques-Louis David ▲	1714-1787 Christoph Wilibald von Gluck □ 1741-1813 André Ernest Modeste Grétry □ 1741-1816 Giovanni Paisiello □
1750 -		1753-1837 John Soane 1762-1820 Pierre Alexandre Vignon 1762-1853 Pierre F. L. Fontaine 1764-1838 Charles Percier	1757-1822 Antonio Canova ●	1760-1837 Jean François Lesueur □ 1760-1842 Salvatore Cherubini □ 1762 Antiquities of Athens published by Stuart and Revett 1764 History of Ancient Art published by Winckelman (1717-68)
			1770-1844 Bertel Thorvaldsen ● 1771-1835 Antoine-Jean Gros ▲	1766 <i>Laocoön</i> published by Lessing (1729-81) 1770-1827 Ludwig van Beethoven □ 1774-1851 Gasparo Spontini □ 1774 Gluck's <i>Orfeo</i> produced at Paris Opera
1775 -	1789 French Revolution began 1792-1794 First French Republic 1796 Napoleon's first Italian campaign	1781-1867 Robert Smirke 1784-1864 Leo von Klenze 1785-1820 Federal style in the United States 1788-1791 Brandenburg Gate in Berlin built by Langhans	1780-1867 Jean-Auguste- Dominique Ingres ▲	
1000	1798 Napoleon's campaign in Egypt. Battle of the Pyramids 1799 Napoleon became First Consul		1791-1824 Théodore Géricault ▲ 1798-1880 Phillippe-Joseph- Henri Lemaire ●	1797-1828 Franz Schubert □
1800 -	1802 Napoleon made Consul for life 1803 Napoleonic Code of Laws issued 1804 Napoleon crowned emperor 1814 Napoleon abicated; Bourbons restored to French throne 1814-1821 Louis XVIII, king of France 1815 Napoleon defeated in Battle of Waterloo 1821 Napoleon died 1824-1830 Charles X, king of France 1830 July Revolution 1830-1848 Louis Phillipe, king of France, constitutional monarch	1806 Temple of Glory (later La Madeleine) begun by Vignon. Arc de Triomphe du Carrousel begun by Percier and Fontaine. Arc de Triomphe de l'Étoile begun by Chalgrin	1805-1852 Horatio Greenough ● 1810 Elgin Marbles first exhibited in London 1816 Elgin Marbles purchased by Parliament, placed in British Museum	1804 Beethoven finished <i>Eroica</i> Symphony

18

The Neoclassical Style

PARIS, EARLY 19TH CENTURY

Some books, some archeological discoveries, and some social upheavals brought to Paris many sweeping changes in political thought, in styles of art, in forms of government, and in the structure of society during the latter part of the 18th and early part of the 19th centuries.

Stuart and Revett, two Englishmen who had visited Greece, published in 1762 Antiquities of Athens, which made a clear differentiation between Greek and Roman architecture. Two years later, Johann Joachim Winckelmann's highly influential History of Ancient Art, a landmark in art history, similarly distinguished between Greek and Roman sculpture. "The principal and universal characteristic of the masterpieces of Greek art is a noble simplicity and a quiet grandeur," it declared. "As the depth of the sea remains always at rest, however, the surface may be agitated, so the expression in the figures of the Greeks reveals in the midst of passion a great and steadfast soul."

Winckelmann's words provided the critics of the rococo style with the needed aesthetic ammunition to fire at Boucher and Fragonard because of the frivolous content of their paintings (see Figs. 399 and 400). During revolutionary times, the voice of Diderot, moral philosopher and apostle of the Enlightenment, continued to be heard, especially his opinion that the function of art was to make "virtue adorable and vice repugnant."

Ancient Rome now became a symbol for the revolutionary protest. In politics, this at first meant a republican instead of a monarchical form of government. In religion, the protest was associated with a tolerant paganism, as opposed to Christianity. (For a brief time, in fact, the Cathedral of Notre Dame in Paris was rededicated to the "Goddess of Reason.") In political and economic life it mean championing the weak against the strong and equalizing the possession of wealth. This spirit is nobly captured in

Angelica Kauffmann's *Cornelia Pointing to Her Children as Her Treasures* (Fig. 410). The severe simplicity of the composition is in keeping with neoclassical ideals. Cornelia is pointing to her two sons, who were to become social reformers in the days of the ancient Roman republic. They eventually led the efforts to repossess public lands which had been taken over by the rich in order to redistribute them to the poor. Kauffmann was a Swiss-born, Italian-trained painter who became one of the leading figures of neoclassicism and one of the founding members of Royal Academy of Arts in London.

Heroism and self-sacrifice, rugged resolve and Spartan simplicity became hallmarks of the revolutionary spirit, and reflections of these qualities were easily found in Roman literature and art. The political writings of Cicero and Seneca were widely read and quoted to confirm the principle that sovereignty resided in the people and that government should be based on a voluntary agreement among citizens. Political pamphlets came to be studded with quotations from the Romans Tacitus, Sallust, and Horace, and the oratory of the period was modeled on that of Cicero.

The convention hall where the revolutionary legislators met was lined with laurel-crowned statues of Solon, Camillus, and other ancient statesmen, and in debates the speakers relied on apt phrases from Cicero to clinch important points. They referred to their followers as Brutuses and Catos and to their opponents as Catalines; their postures and gestures were studied imitations of Roman statues, and their oaths were sworn on the head of Brutus or by the immortal gods.

All those who could read became biography-conscious and spoke like living characters out of Plutarch's *Parallel Lives*. (On the day she murdered Marat, Charlotte Corday had spent her time reading Plutarch.) Never before had public personalities seemed so obviously to have walked straight out of books. Surely Oscar Wilde must have had this revo-

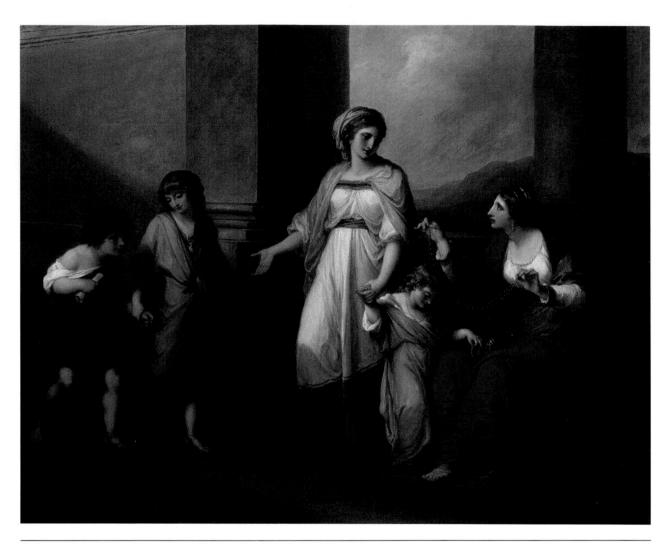

410. Angelica Kaufmann. *Cornelia Pointing to Her Children as Her Treasures.* 1785. Oil on canvas, $40 \times 50''$ (101.6×127 cm). Virginia Museum, Richmond (The Williams Fund, 1975).

lutionary period in mind when he wittily twisted the old Greek aesthetic doctrine by saying that nature, in this case human nature, imitates art.

Many of the symbols of the French Revolution too were borrowed directly from the ancients. The cap of liberty was a copy of the Phrygian cap worn by the liberated slaves in Rome. The *fasces*, or bundle of sticks with the protruding ax tied together with a common bond, was once again the symbol of power.

When Napoleon Bonaparte rose to political power, he shared the popular enthusiasm for antiquity. His chosen models were Alexander the Great and Julius Caesar, especially the latter since Caesar's career and Napoleon's had so many parallels. Napoleon became first a republican consul. Later he ruled France through a tribune. Then, after a plebiscite, he emerged a Roman emperor. The *fasces* became his emblem of authority. The eagles of the old Roman

legions he made into the insignia of the French battalions. Such a manipulation of the forms and images of ancient glory had a vast appeal to this man of modest birth

During his brief period of strutting on the stage of history, Napoleon envisaged France as the leader of a new Roman empire. His vainglorious proclamation to the Italian people on the eve of his invasion of their country points up his pompous rhetoric. "We are the friends of all nations," he protested, perhaps too much, "especially the descendants of Brutus, the Scipios, and of the great men we have chosen for our own model." And he took frequent pains to point out that he was embarking on a cultural as well as a military mission. Here was no barbarian Attila the Hun storming the citadel, but a conqueror who came to sack Rome in the company of a group of art experts who were well aware of the value of everything they took.

A petition signed by all the important French artists actually had been sent to the Directory government in 1796, pointing out how much the Romans had become civilized by confiscating the art of ancient Greece and how France would likewise flourish by bringing original works to Paris to serve as models. While this returning would-be Caesar brought back with him no human captives, his victory celebration was livened by the presence of such distinguished prisoners of war as the *Apollo Belvedere* (see Fig. 86), many paintings by Raphael, and the rare treasures Napoleon plundered from the Vatican and other Italian collections.

The invasion of Italy, however, did have a valid rationale, since the northern provinces were under Austrian control. The reactionary monarchists there had been threatening the invasion of France not only to avenge the execution of their princess, Marie Antoinette, but to combat the spread of French revolutionary ideas in their territories.

ARCHITECTURE

With the reorganization of the government, the remaking of the constitution, and the rewriting of the

laws on the model of the Roman Empire, Napoleon was determined that Paris should be replanned as a new Rome. He therefore undertook the ordering and commissioning of buildings with the same incredible vigor that marked his activities in other fields.

Paris, the New Rome

The heart of the new city was still to be the spacious center designed around the old Place Louis XV, which under the Directory had been renamed the Place de la Concorde (Fig. 411). Its axis began on the left bank of the Seine River with the old Palais Bourbon, now the Chamber of Deputies, which was to have its face lifted by a Corinthian colonnade. It continued across the river, by the bridge that had been begun in early revolutionary days (lower center), to the center of the Place, where some statuary was to cover the spot where the guillotine had done its grim work. The end of the axis was to be the unfinished Church of La Madeleine at the end of the Rue Royale, scheduled to be rebuilt in the form of a Roman temple (upper center).

To complete his scheme. Napoleon commissioned Percier and Fontaine, his favorite architects,

411. Place de la Concorde, Paris, aerial view.

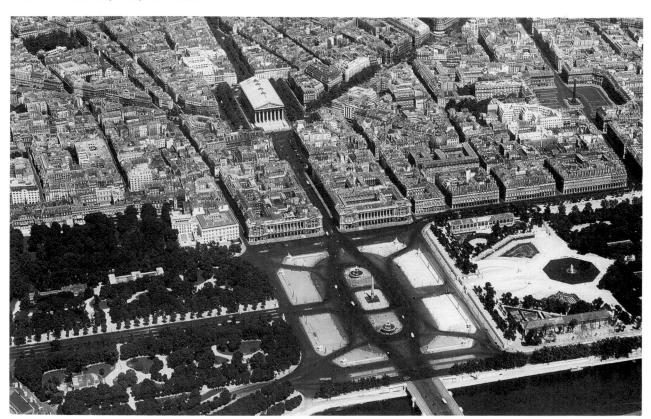

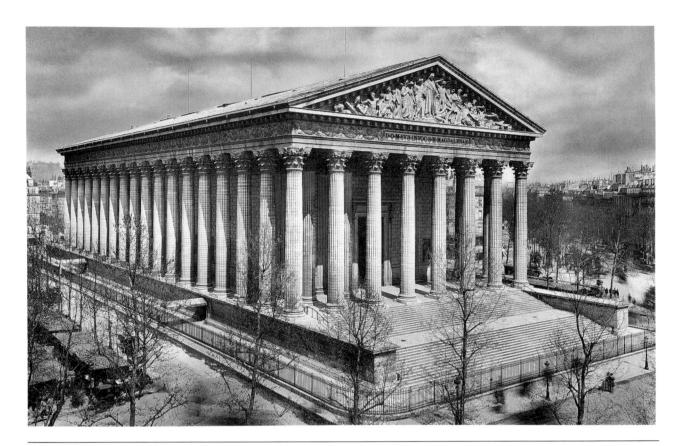

412. PIERRE-ALEXANDRE VIGNON. La Madeleine, Paris. 1762–1829. Length 350' (106.68 m), width 147' (44.81 m), height of podium 23' (7.01 m).

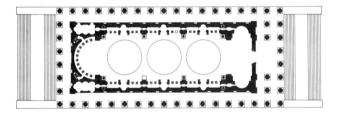

413. Plan of La Madeleine.

to redesign the Rue de Rivoli, which intersected the axis at right angles and ran parallel to the Seine River (middle right). Elsewhere throughout Paris, triumphal arches and monumental columns were erected to fortify the image of Paris as the New Rome.

LA MADELEINE. The church that had been started under Louis XVI was now to be completed as a pagan Temple of Glory with a dedicatory inscription: "From the Emperor to the soldiers of the Great Army." For this project Napoleon chose a plan by Pierre-Alexandre Vignon that was to be a large-scale Roman temple of the Corinthian order (Fig. 100).

After Napoleon's downfall, it was completed as a Christian church, but the structure itself was finished according to Vignon's design (Figs. 412 and 413). In the Roman manner, La Madeleine stands on a podium 23 feet (7 meters) high and is approached by a flight of steps in the front. Running completely around the building is a series of Corinthian columns about 63 feet (19.2 meters) high, eighteen on each side, eight on each end, and an additional row of four in front that supports the cornice.

The interior cella of an ancient temple was never intended as a gathering place and always remained dark and mysterious. Hence, of necessity, Vignon had to depart from precedent and come up with something new. The surprise that awaits the visitor who passes through the massive bronze doors is complete, for the interior and exterior actually amount to two different buildings.

The aisleless nave is divided into three long bays and a choir (Fig. 414), which are not roofed in timber as in a Greek temple or vaulted in the Roman manner but are crowned with three low saucershaped domes on pendentives. The nave ends in a semicircular apse that is roofed over by a semidome. Chapels are located in the recesses created by the

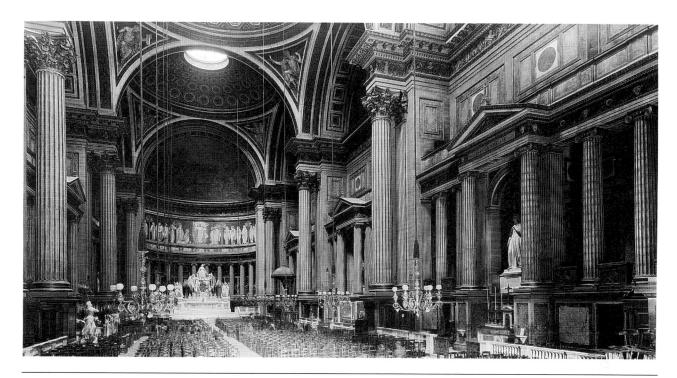

414. Interior, La Madeleine.

buttresses that support the domes, and two classical orders—the Corinthian and Ionic—form the basis of the decorative scheme.

ARCHES OF TRIUMPH. In 1806, after winning military victories in Germany and Austria, Napoleon entrusted to Percier and Fontaine the building of a triumphal arch. Now known as the Arc de Triomphe du Carrousel (Fig. 415), it was designed as a gate of honor to the Tuileries Palace. It turned out to be a rather slavish imitation of the Arch of Septimius Severus in Rome (compare Fig. 87), though of more modest proportions. Standing on the platform above it, however, was one of Napoleon's proudest battle trophies—the group of four bronze horses taken from St. Mark's in Venice (Fig. 291). Owing to the shifting fortunes of war, Venice later got back the horses as a result of a peace treaty, and a triumphal chariot drawn by horses of a considerably later vintage was installed in their place to celebrate, somewhat ironically, the restoration of the old line of Bourbons in the person of Louis XVIII. The face of the triumphal arch is decorated with rather undistinguished carvings in low relief depicting such scenes as the Battle of Austerlitz, the surrender of Ulm, the Peace of Tilsit, and Napoleon's triumphal entries into Munich and Vienna.

When finished, the result was insufficient to measure up to Napoleon's imperial ambitions, and

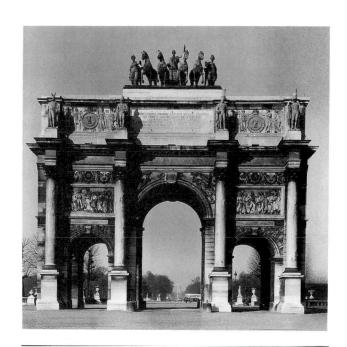

415. CHARLES PERCIER and PIERRE F. L. FONTAINE. Arc de Triomphe du Carrousel, Paris. 1806. Width 63'6" (19.35 m), height 48' (14.63 m).

so another and still grander arch was commissioned for the Place de l'Étoile (now Place De Gaulle). In this familiar Paris landmark, the architect Jean-François Chalgrin achieved more life and elasticity by freely adapting rather than copying a known model.

In it, French baroque precedents, Roman classical inspiration, and academic correctness of execution are combined in a harmonious manner. For his monumental effect, Chalgrin relied on bold proportions and a grand scale. Later, after Napoleonic times the severity of the general outline was relieved by the skillful placement of high-relief sculptures by Cortot and Rude (Fig. 433) on a scale comparable to the immense size of the arch.

Still not content, Napoleon ordered a monumental Doric column to be erected in the Place Vendôme (Fig. 416). In size and style of ornamentation,

416. Charles Percier and Pierre F. L. Fontaine. Vendôme Column, Paris. 1810. Marble with bronze spiral frieze, height 140' (43.2 m), diameter 13' (3.96 m).

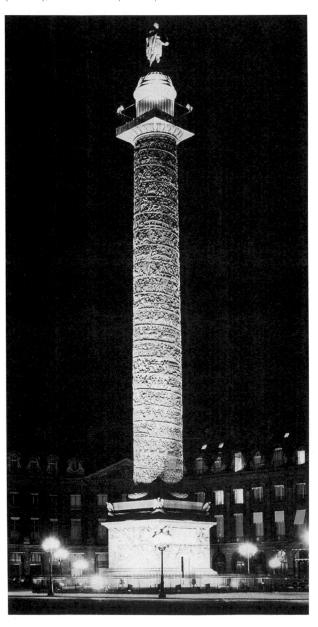

it was a conscious copy of Trajan's Column in Rome (Fig. 94). The principal difference was that its spiral relief images were done on a bronze strip made from the guns and cannons captured from the defeated Prussian and Austrian armies. The sculpture recounts the story of the campaign of 1805 in scenes such as Napoleon's address to his troops, the meeting of the three emperors, and the conquests of Istria and Dalmatia.

Classic Revivals Elsewhere

The wave of enthusiasm for classical architecture was by no means confined to Paris. Germany, England, and the United States had each experienced classic revivals in the 18th century. During the early 19th century, the Roman revival was strongest in the countries identified with Napoleon's Empire, while the Greek revival was accented in the anti-Napoleonic nations, notably England and Germany.

In England, such a public building as the British Museum was strongly Greek in character. In Berlin, an early example is the Brandenburg Gate, modeled after the Athenian Propylaea. In the United States, the classical revival period corresponded generally to the federal style, which flourished from about 1785 to 1820. Buildings that show the Roman influence are the Virginia state capitol, which Thomas Jefferson designed after the Maison Carrée (Fig. 100), and the Rotunda (Fig. 417), the original library of the University of Virginia, which Jefferson modeled after the Pantheon in Rome (Fig. 107).

PAINTING

David and Neoclassicism

The most articulate artistic champion of this stern world of revolutionary fervor and ancient Roman heroism was destined to be Jacques-Louis David, a painter whose temperament and technique were ideally suited to the spirit of the times. A reformer by nature and a classical enthusiast by nurture, David painted pictures whose austerity was a conscious reaction to the rococo extravagances exemplified in the work of his great-uncle, François Boucher (see Fig. 399). By virtue of his studies in Rome, David had absorbed all that was necessary for the exploitation of the classical enthusiasms of the readers of Plutarch's Parallel Lives and Winckelmann's History of Ancient Art. Harkening to Diderot and other earnest moralists, David never thought of a picture as a mere painting. It had to have a manifestolike message pointing to political and social action.

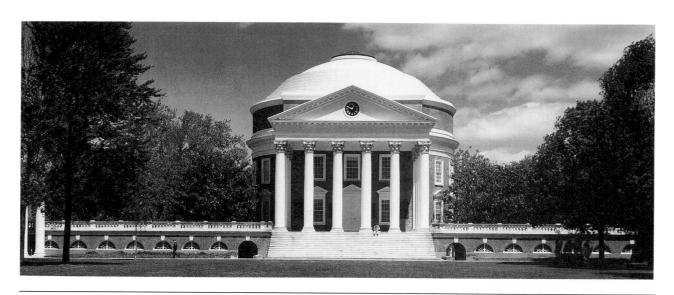

417. Thomas Jefferson. Rotunda, University of Virginia, Charlottesville. 1819–26.

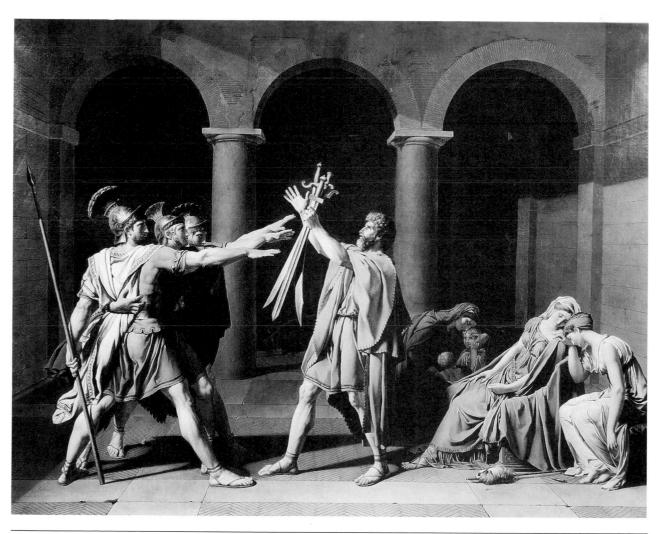

418. Jacques-Louis David. *Oath of the Horatii*. 1784. Oil on canvas, $10'10'' \times 14'$ (3.3 \times 4.27 m). The Toledo Museum of Art (gift of Edward Drummond Libbey, 1950).

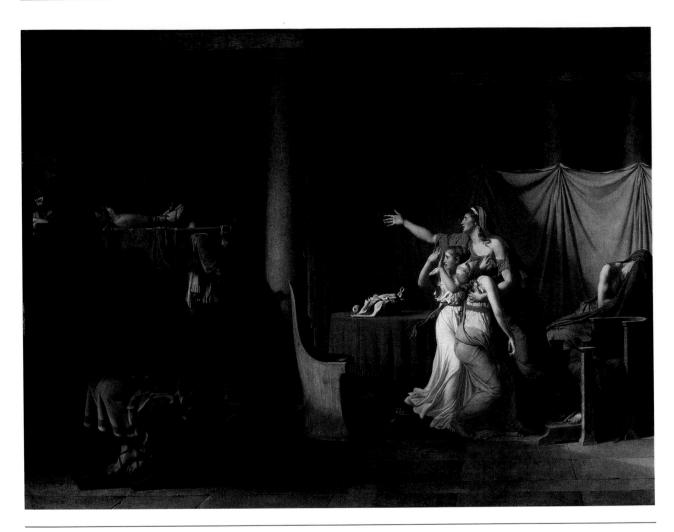

419. Jacques-Louis David. Lictors Bringing Back to Brutus the Bodies of His Sons. 1789. Oil on canvas, $10'8'' \times 13'10_2^{10}''$ (3.25 × 4.23 m). Louvre, Paris.

It was inevitable that the high moral purposes of the French Revolution would be reflected in art. Indeed, David's immediate success can be attributed to the fact that his style caught the same strong spirit that the revolutionists espoused. Bourgeois by birth and upbringing. David frankly addressed his art to the newly established middle-class social order.

ANCIENT ROMAN SUBJECTS. David's first great success was the *Oath of the Horatii* (Fig. 418), finished in Rome while Louis XVI was still on the French throne. The subject, one of the legends of the founding of the ancient Roman republic, was suggested by Corneille's ballet *Les Horaces (The Horatii)*. The three arches of the severely simple setting separate the figures like niches for statuary. In the center stands Horatius Proclus dedicating the swords of his three sons, who swear to defend the Roman republic against the plotting Curiatii, one of whom was the

fiancé of their grief-stricken sister on the right. Baroque precedents can be cited for this important painting. "If I owe my subject to Corneille," said David, "I owe my picture to Poussin." Clarity of contour, sculpturesque sharpness of modeling, and harsh but clear handling of light and shadow characterize this stark but heroic canvas.

Over and beyond his work as a painter and the genuine value of his painting, David took on the role of power politician in the field of art with far-reaching effects. More academic than the former academicians, he succeeded in laying the foundations of official art that endured for the rest of the 19th century. While his theories and subject matter are still a matter of controversy, David's craftsmanship was on a par with that of any of the master painters of the past, and many distinguished painters of the present have been well aware of his style and manner of execution. The technique of Salvador Dali and the

20th-century neoclassicism of Picasso, for instance, owe much to the cool objective art of their 19th-century predecessor.

David's picture of the Lictors Bringing Back to Brutus the Bodies of His Sons (Fig. 419) bears the date of the fateful year 1789. It is both a reminder that his career began during the latter days of the monarchy and that he was attempting to continue the subject and substance of his earlier spectacular success, Oath of the Horatii. In it one finds the same stern spirit of self-sacrifice, the same severity of style that had appealed so much to the eyes that were weary of the fussy rococo, the same somber type of setting that had interested those who were reading about the archeological discoveries at Pompeii and Herculaneum. With remarkable boldness, David was able to flaunt the stern, do-or-die virtues of Roman republicanism right under the noses of his aristocratic patrons. These two pictures were not only the manifesto of a new style in art but of a new image of society as well. Their unparalleled success was due in no small measure to the fact that they appeared at precisely the right moment.

For his subject David again chose an incident from the days soon after the founding of the ancient Roman republic. Lucius Junius Brutus (foreground left), one of the consuls, had discovered that his own sons were involved in a plot to restore the recently overthrown monarchy. Having ordered their executions, he is shown as an isolated figure in the statuesque shadow of the goddess Roma. Behind him are the lictors, Roman officers, bearing the dead bodies of his sons, while a third group is formed by his grieving wife and daughters. Many who were living through the trying times of the Revolution could see something of themselves in that figure of stoic resolution, torn between public duty to the state and private grief.

PORTRAITS. In his portraiture, David reveals himself an expert judge of personality, and his viewers find in this category a certain relief from his more heroic efforts. A sensitive example is the unfinished portrait of *Madame Récamier* (Fig. 420), one of the most fascinating and intelligent women of the period. In her, David found a promising subject who furnished her salon in the fashionable Pompeian style that had become so popular. Here she reclines in the classical manner on an Empire chaise longue just as she might have done on the days she received her guests. Her flowing white gown is draped with deep folds reminiscent of antique statuary. The only

420. Jacques-Louis David. *Madame Récamier*. 1800. Oil on canvas, $5'8'' \times 7'11\frac{3}{4}''$ (1.73 × 2.43 m). Louvre, Paris.

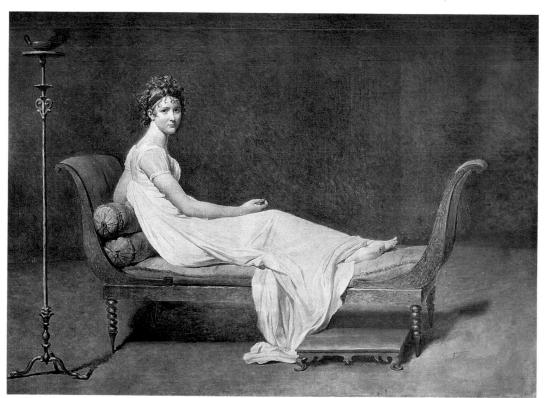

other pieces of furniture are the footstool and bronze lamp, which were drawn from Pompeian originals. The clarity with which David handles the outlines of the figure and the silhouette of the head combine with the austere setting for an orderly, elegant effect.

Ingres and Academic Art

After David, the leading figure of the academic art world was his pupil Jean-Auguste-Dominique Ingres. Like his teacher, Ingres realized the importance of championing the arts in official circles; eventually he became a senator of France. The Academy had been re-established after Napoleon's downfall, and the idea of placing the official stamp of approval on writers and painters finds full expression in the *Apotheosis of Homer* (Fig. 421). Commissioned as a ceiling mural in the newly established Charles X Museum in the Louvre, the painting is well adapted to its setting, impressive in content and in its large proportions.

Ingres treats his subject, the deification of Homer, as some supreme session of an academy of arts and letters for the immortals. In their midst sits the enthroned Homer, the father of poetry. Behind him is the façade of an Ionic temple. Winged Victory

holds the laurel wreath above his brow; at his feet are the personifications of his brainchildren, the *Iliad* and the Odyssey; and about him are his successors who have carried the torch for poetry and art throughout the ages. In this exclusive society, Aeschylus is seen unfolding a scroll listing his tragedies; the poet Pindar holds up his lyre in tribute; Vergil and Dante (extreme left) represent epic poetry. Longinus is standing up for philosophy, Boileau for criticism. At the lower right Racine and Molière, in the courtly wigs of the time of Louis XIV, make an offering of tragic and comic masks; and Raphael, the profiled figure in the upper left, represents Renaissance painting. Below him in the foreground is Poussin, and behind him, William Shakespeare. Ingres's composition exemplifies the neoclassical ideals of clarity, order, and symmetry, while its content calls upon the artists of his day to carry on the achievements of their counterparts in past golden ages.

Ingres's great technical skill in drawing is seen in the sharply defined figures. Like his contemporaries, he accepted the Greek aesthetic of art as a representation of nature, with the reservation that it was the artist's function to endow nature with orderliness through the process of rearrangement and editorial selection. In this case, he builds his compo-

421. Jean-Auguste-Dominique Ingres. *Apotheosis of Homer.* 1827. Oil on canvas, $12'8'' \times 16'10_4^{3''}$ (3.86 \times 5.15 m). Louvre, Paris.

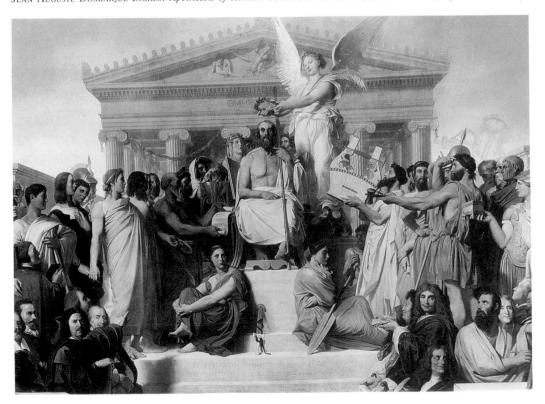

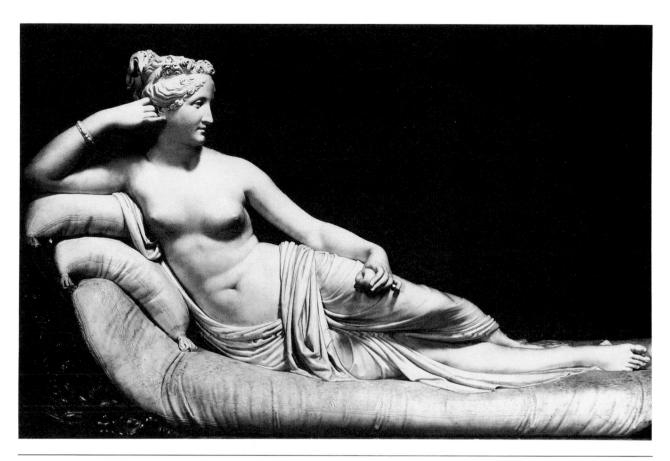

422. Antonio Canova. *Pauline Bonaparte as Venus*. 1808. Marble, life-size. Galleria Borghese, Rome.

sition by means of precise lines, which he then organizes into a series of receding planes. Color for him, as for David, was secondary.

SCULPTURE: CANOVA

The sculptor Antonio Canova, who in his day enjoyed a reputation second to none, was summoned from Rome to Paris by Napoleon to execute statues of the emperor and his family. Through his neoclassical eyes, the Italian artist saw Napoleon's mother as the matronly Agrippina of old, Napoleon's sister Pauline—not without some justification—as Venus Victorious (Fig. 422), and Napoleon himself, most obligingly, as a Roman emperor (Fig. 423).

Canova was accompanied to Paris by his brother, who recorded the conversations between artist and patron, from which one learns that Napoleon had a few qualms about being portrayed in the "heroic altogether" and suggested an appropriate costume. To this Canova grandiosely replied: "We, like the poets, have our own language. If a poet introduced into a tragedy, phrases and idioms used habitually by the lower classes in the public streets,

he would rightly be reprimanded. . . . We sculptors cannot clothe our statues in modern costumes without deserving a similar reproach."

The sculptor's arguments prevailed, and except for the suggestion of a toga draped over his shoulder and a figleaf, Napoleon stands there in all his marble glory, holding in his right hand an orb surmounted by winged Victory and in his left, a staff of authority in place of a scepter. The head is idealized but recognizable; the body with the shifting of the weight toward one side points directly to Praxitelean models (see Fig. 50).

The reclining statue of *Pauline Bonaparte as Venus* (Fig. 422) is another example of the use of a Hellenistic model, for Canova, like David, had come under the sway of Winckelmann. While it is similar to David's *Madame Récamier* (Fig. 420), the statue conveys much less of the individuality of its subject than does the painting. Both Canova statues show how a sculptor, much more than a painter, was restricted in expression during this wave of classical enthusiasm.

While practically nothing of ancient painting was known to David, museums filled with well-

preserved ancient statues offered themselves to Canova. Although the painter was free to create a new style, the sculptor had to conform to existing models. Like a good academician, Canova advised his students on a "scrupulous adherence to rules" and against "arbitrary and capricious errors."

Deviation from the "rules" was possible, however, when it could be justified on rational grounds. In Canova's view, everything was defined by classical rules. Hence when he did a portrait of a contemporary figure, the body, its pose, and the drapery were taken directly from antique models, and the

423. Antonio Canova. *Napoleon*. 1802–10. Marble, height 11'8" (3.56 m). Wellington Museum, London (Crown copyright).

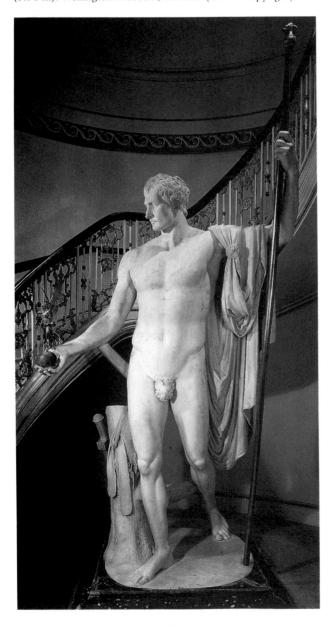

head was idealized just enough to fit the subject. In theory Canova accepted the Greek idea of art as an imitation of nature, but in practice his art became an imitation of art. For his observations of human nature, he was content to look about the Vatican and other Roman collections instead of studying people and human nature as such. Furthermore, his constant self-conscious striving to create objects of art too often led to artificial works. In the mind and hands of a greater artist, Canova's view of art might possibly have produced more significant results. In his own case, however, this adherence to ancient models had a definitely repressive effect.

Because of the great demand for his work, Canova employed a large number of assistants in his studio. His huge output, plus the use of some modern devices and methods that were unknown to Praxiteles, gave his workshop something of the aspect of a factory. Among other things, he used chemical solutions to achieve the extraordinary smoothness of his surface textures, and he employed a pointing machine to make exact copies of ancient sculptures. Despite murmurs from less successful sculptors, nothing in Canova's lifetime diminished his glittering reputation.

The British Parliament invited Canova to London to evaluate the Parthenon sculptures before purchasing them from Lord Elgin (see Figs. 44–47). One would have thought that, after feeling the full force of these originals, the Italian sculptor might have realized their superiority to his previous models. Instead, he smugly found in them the justification of his own life's work and seized the opportunity to point out how wrong his critics had been. He did show good judgment, however, in refusing to attempt a restoration. Canova also scored with his observations on the differences between the real Greek sculpture and the works designed for the Roman market.

MUSIC

Napoleon as Patron

Musicians in Paris were as active as the architects and painters; Napoleon's attempts to win over the French artists and those of the conquered countries extended into the field of music. "Among all the fine arts," he said, "music is the one which exercises the greatest influence upon the passions and is the one which the legislator should most encourage."

The production that most closely caught the spirit of the new Empire, however, was Spontini's opera *La Vestale (The Vestal Virgin)*. Appearing in 1807, at the height of Napoleon's military successes,

it had the necessary pomp and pageantry to whip public enthusiasm to a pitch of frenzy. It had the right Roman setting, and the spectacle of a vestal virgin's struggle between her desire for personal happiness and her vows of service to the state was sufficient to ensure more than a hundred performances in its first season in Paris. The plot stressed glory on the battlefield, and Spontini supplied the necessary triumphal marches. His music is full of the resounding brass and the trumpet's blare, singing in the grand style, and the sound of massive choruses. One of his contemporaries wrote that "his forte ["loud"] was a hurricane, his piano ["soft"] a breath, his sforzando ["sudden accent"] enough to wake the dead." It was none other than Hector Berlioz who attributed to him the invention of the "colossal crescendo."

Beethoven: The Heroic Ideal

Unknown to Napoleon, the essence of the heroic ideal had been captured in musical form in Austria, one of the countries he had conquered. Ludwig van Beethoven's Third Symphony, which the composer entitled the *Eroica*, or *Heroic*, was never heard by the man whose career had suggested it; nor was it played in Paris until 1828, a quarter of a century after it was composed. Yet a French writer of later times, Romain Rolland, could declare with the full weight of history on his side: "Here is an Austerlitz of music, the conquest of an empire. And Beethoven's has endured longer than Napoleon's."

The original idea for this mighty work was apparently made on a visit to Vienna by Marshal Bernadotte, one of Napoleon's generals turned diplomat. He casually suggested that Beethoven write a work honoring Consul Bonaparte. Beethoven accepted the challenge, and after a period of four years of inspired effort the colossal symphony appeared, bearing the desired dedication. But the year that the symphony was completed was the year in which Napoleon accepted the title of emperor. Beethoven, feeling that the former apostle of liberty had become both a traitor and a new tyrant, erased the name from the title page and inscribed it instead "to the memory of a great man."

That memory indeed had stirred Beethoven deeply, for from the days of his youth he had been a lifelong enthusiast for the ideals of liberty, equality, and fraternity. It was Napoleon's championing of these principles, his opposition to hereditary privilege, his will and ability to translate these ideals into action, that had moved Beethoven profoundly, as with so many other artists and writers of the time. The Third Symphony is not narrowly Napoleonic,

but more generally an elaboration of the heroism of one who, for a time at least, rallied the progressive and freedom-loving people of all nations around his standard.

The music Beethoven wrote for the theater was invariably based on themes involving the quest for individual liberty and the cause of popular freedom. In his only opera, *Fidelio*, he insisted on a story that would reflect high moral purpose and steadfast resolve. In the fluid forms of his instrumental compositions, however, these ideals of liberty, equality, and fraternity reached their most abstract and universal expression. Beethoven used the power of his art to convey the spirit of these great human declarations. Thus he illuminated the path of humanity toward its ultimate destiny of progress and perfectibility.

Through the *Eroica* Beethoven was giving tangible shape to the goals of a large part of humanity during those stirring times. In it he mirrored the titanic struggle between the opposing attitudes of sub mission and assertion, passivity and activity, acceptance and challenge. Through it he gave flesh to the word of the triumph of spirit over matter, will over the power of negation, and the victorious human drive against the forces of suppression.

Though the length of the symphony is unprecedented and the orchestra only somewhat expanded, Beethoven never fell into the trap that many of the French composers of the revolutionary period did when they equated colossal size with grandeur of expression. While the French revolutionists wrote their choruses for a thousand voices accompanied by cannons and three or four combined orchestras, Beethoven added just one horn to his usual brass section.

Beethoven clothed his ideas in rich folds of lustrous sound that grow out of the poetic idea itself. Furthermore, by raising the level of musical content and meaning, he succeeded in producing an organic work of art where others had failed. While the Third Symphony as a whole can be criticized on formal grounds and for a certain lack of unity in the four separate movements, the fiery spirit of creation when Beethoven was at the height of his mature powers has never been surpassed. The *Eroica* was as much a revolution in music as the American and French revolutions were in the fields of political thought and action.

THE PROMETHEAN IDEA. The Eroica might with equal justification be called the Promethean Symphony in honor of Prometheus, who had taken the divine fire from the hearth of the gods on Mount Olympus and brought it down to animate the bodies and souls of men and women and to release them

from the bonds of ignorance. For fire brings warmth and light, and with the light comes enlightenment. Prometheus was adopted as the prime symbol of the Enlightenment in philosophy and social thought as well as in poetry, art, and drama. He represented for Beethoven—as for the poet Shelley—"the type of the highest perfection of moral and intellectual nature impelled by the purest and truest motives to the best and noblest ends."

Gradually a musical idea associated with Prometheus began to take shape in Beethoven's notebooks. It first saw the light as a simple popular dance tune, then in 1801 as a prominent number in his full-length ballet *The Creatures of Prometheus*. In 1802 it was used as a theme for an extended set of piano variations. In its most exalted form it became, at last, the basic material for the great finale of the *Eroica*. Here it is transformed into a monumental set of orchestral variations that become a veritable musical arch of triumph through which the image of a liberated humanity joyously passes by in review.

Symphony No. 3 Ludwig van Beethoven (finale: *Allegro molto*, bars 76–83)

This last movement of the *Eroica* begins with a fiery plunging figure for strings, a motif taken from the ballet when Prometheus descends from Mount Olympus, torch in hand. Then follows the so-called skeletal theme—the basis for the entire finale—derived from the lowest line of the Promethean dance.

Starting on E-flat, it rises five tones to the dominant note of B-flat, descends an octave to the B-flat below, then returns to the original E-flat. In effect, this skeletal theme simply defines the tonal center of E-flat major with the empty upper and lower dominant limits of the tonality, or key center. This harmonic vacuum is gradually filled by the addition of a second, third, and fourth voice, while simultaneously the rhythmic divisions are quickened by similar subdivisions. Not until the 76th bar (left) is the Promethean melody joined to its previously heard skeletal bass.

The form of the finale is a series of variations unequal in length and strongly contrasted in style. What had before been a pleasant little dance tune now assumes the imposing shape of a triumphant anthem. Beethoven, by his additive process, is able to build this melody into the cumulative structure he needs for his victory finale.

Some variations are aristocratic in sound, while others are rough and ready. Compare, for example, the elegant sonorities of bars 175-197 in the Eroica with the boisterous band music heard in bars 211–255. A similar open-air episode to that heard in bars 211-255 occurs in the finale of the Ninth Symphony, where Beethoven inserts a popular "Turkish" march, scored in a striking manner for bassoons, horns, trombones, cymbals, triangle, and drums. Further contrasts in the Eroica finale can be heard in the fugal episodes (bars 117-174 and 226-348), which employ sophisticated contrapuntal devices, such as the inversion of the skeletal theme (277-280) and the sturdy German chorale (249-364) that begins at the point where the tempo is slackened to a more moderate poco andante ("a little slower").

All this vast variety of forms—dances, songs, fugues, chorales—is arranged sequentially in the manner of a procession that eventually leads up to the rousing triumphant climax heard in bars 381–395. At this point, Beethoven throws in all his orchestral forces, including the brasses and drums, to bring about the image of ultimate achievement of the heroic ideal. Afterward there remains only the quieter anticlimax (396–430), in which the whole awesome spectacle is contemplated retrospectively just before the whirlwind *presto* that brings the movement to a triumphant close.

EARLIER MOVEMENTS OF THE EROICA. The great opening movement is cast in **sonata form**, which might be described as a dramatic reconciliation of opposites, or, more technically, as a strategy of thematic and key relationships. Brought to perfection in the late 18th century by Haydn and Mozart, this balanced classical design, with its true Aristotelian beginning, middle, and end, unfolds with an opening section called an **exposition**. This is followed by a

central core, the *development*, and the movement then concludes with a recapitulation. Optionally a prologue, or introduction, and an epilogue, or coda, may be added. The exposition presents an abstract dramatic encounter between a protagonist consisting of related motifs, themes, or subjects within a principal key center (the tonic) and an antagonist composed of contrasting material in a different key center (the dominant, relative major or minor, and so on). Then follows the development, or working-out portion, in which the previously presented materials oppose or conflict and interact with one other. The subjects or themes may be broken up into fragments or segments, new tonal territories explored by modulating to new key centers close or remote, and themes combined in overlapping contrapuntal lines. Finally, the materials are reassembled in the recapitulation that reveals their altered character in a kind of dramatic reconciliation. Beethoven here projects a first movement on a heroic scale.

Each of the four movements in its way shattered precedent. The first is distinguished by its restless surging character and its enormous expansion of sonata form to include a development section of 245 bars. The mobilization of such forces, as well as the transformation of the coda into a terminal development of 140 measures, caused Romain Rolland to call it a "Grand Army of the soul, that will not stop until it has trampled on the whole earth."

A funeral march as the second movement of a symphony was another innovation, though Beethoven had included one in his earlier Piano Sonata, Op. 26, which bears the inscription "on the death of a hero." Its heroic proportions here, as well as its poetic conception as a glorification of the hero, link it with the first movement. While such a transformation scene is a fairly common idea for a painting, statue, poem, play, or opera, its use within the more abstract symphonic form is unique.

The effect of this funeral march is that of a glowing lamentation for the heroes who give up life itself so that the ideals for which they fought may live. It is, in this case, a collective rather than an individualized expression, though it emphasizes that every great human advance is accompanied by personal tragedy. The stately measured rhythms and muffled sonorities also reminded the listener of Beethoven's time that contemporary heroes, as well as such ancient ones as Socrates and Jesus, often suffered martyrdom at the hands of a society that did not understand them.

The title "Scherzo" over the third movement also appears for the first time in a formal symphony, though again it had been used earlier in piano sonatas and chamber music. Beethoven once more reveals himself a man of the revolutionary period by the substitution of this robust humor for the traditional minuet, but in such a grand design he hardly had any other alternative. Berlioz has referred to its energetic rhythms as a kind of play, "recalling that which the warriors of the *Iliad* celebrated round the tombs of their chiefs."

Then comes the great victory finale, which has already been described. The heroic image is later continued in the finales of the Fifth and Ninth symphonies. The amplification in these later works contributes to a more profound understanding of the earlier *Eroica*.

All three finales envision the emergence of a strong and free human society, and all three start with themes in the popular style of his time. In the *Eroica*, it is a modest little country dance; in the Fifth Symphony, a simple marching tune; and in the Ninth Symphony, an unpretentious hymn. All are built up to epic proportions. By the use of an immense variety of styles, episodic deviations, a wide range of keys, and shifting orchestral color, they become collective rather than individual expressions. Instead of being restricted to one side of life, they embrace a cross section of musical levels and reach out to include the entire human panorama.

THE ARCHEOLOGICAL IDEA

The Napoleonic era was a mixture of forward and backward tendencies. At the very time when the social hopes of the revolutionary period were about to be realized in democratic forms, Europe was confronted with a militant revival of ancient Roman imperial authority. The 18th-century individualism that had led to the struggle for freedom was engulfed in a 19th-century regimentation, or uniformity, disguised as a movement to maintain the hard-fought social gains. Revolutionary ideals were partially eclipsed by Napoleonic actualities; the desire for freedom collided with the need for order; the rights of individuals conflicted with the might of authority; and spiritual well-being was pitted against material considerations.

New scientific and technological advances competed for attention with revivals of ancient glories. Napoleon boasted of a new culture, yet he clothed it in a Roman toga. But the early 19th century was by no means unique in its revival of a bygone era. Virtually every period in Western art since Greco-Roman days has revived classical ideas and motifs in one way or another.

The thousand-year span of Greco-Roman civilization provided all future generations with a host of choices worthy of emulation. In the neoclassical

period, dramas, operas, or novels could be set in Athens, Sparta, the Alexandrian empire, the Roman republic, or the West and East Roman empires. Their characters could be lofty Olympian gods or rugged Roman heroes. Dramatists could choose the Roman playwright Seneca as their model, as did Quinault and Racine in the baroque period; or they could turn to the Athenians Sophocles or Euripides, as did Goethe and Shelley. Architects in the 17th century, such as Bernini and Perrault, built then-modern palaces that they decorated with classical motifs, while the neoclassicists Vignon, Percier, and Fontaine constructed almost precise models of Greek and Roman temples. Forms of government likewise ranged from the democratic republic to the autocratic empire. Aside from the shape and spirit it assumes, a revival is largely a matter of selection from a wide choice of models.

Each period has tended to choose from the past those elements that harmonized with its specific ideals and goals. Florentine Renaissance humanists, in their reaction to medieval scholastic thought and the traditional Church interpretation of Aristotle, turned to the pagan beauties of antiquity in general and to the philosophy of Plato in particular. The Renaissance revival of classicism, however, was confined to a few intellectuals and artists. Neoclassicism, on the other hand, was mirrored in forms of government, became the officially approved art style, and rested on a base of broad popular acceptance. Baroque classical interests reflected an aristocratic image of society and were restricted to courtly circles. Again, Louis XIV and his associates identified themselves with the gods of Mount Olympus, and their moral standards, like those of the ancient deities, were the ethics of a highly privileged class. Napoleonic neoclassicism, by contrast, was directed toward the middle class, which saw a comfortable image in the living standards of ancient Pompeii and Herculaneum but tempered luxury with the stricter moral standards of a revolutionary regime. The new interest in classical sculpture, architecture, and painting was also a bourgeois criticism of the artificiality and extravagance of courtly life as mirrored in the rococo. Without the moral overtones of this revived interest in the ancient world, the choice of conservative classical art forms would have been extremely odd for such a revolutionary period.

Faithfulness to Antique Models

The principal difference between early 19th-century artists and their predecessors was in the desire for faithfulness to antique models. Archeological correctness was now possible, owing to a more detailed

knowledge of the past. Winckelmann and his generation had made classical archeology a science, and the excavations at Pompeii and Herculaneum had provided the material and stimulus for authenticity.

For neoclassical success, a building had to be archeologically accurate. The Vendôme Column was planned as a replica of Trajan's Column, and the Arc du Carrousel preserved the proportions and shape of the Arch of Septimius Severus, even if reduced somewhat in size. When variations were made, as in the instance of the Arc de Triomphe and La Madeleine in Paris, the results were more interesting. The first two may be likened to a pair of competent academic theses, while the latter two approximate the livelier style of good historical novels.

Archeological correctness meant lifting an ancient building, which had been designed for quite a different purpose, out of its context, period, and century and putting it down bodily into another period where it had no practical reason for being. This

424. HORATIO GREENOUGH. *George Washington*. 1840. Marble, $11'4'' \times 8'6'' \times 6'10\frac{1}{2}''$ (3.46 \times 2.59 \times 2.1 m). National Museum of American Art, Smithsonian Institution, Washington, D.C.

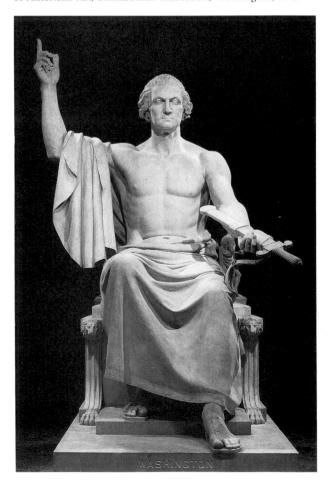

would never have occurred in the rational Enlightenment period. While Palladio, Mansart, and Wren had been concerned with adapting classical principles and motifs to the needs of their times, Vignon, Percier, and Fontaine were busy trying to fit activities of the Napoleonic period into ancient Greek and Roman molds.

Likewise, in the neoclassical style, a successful statue had to be accurate. And since so many antique models existed, the sculptors were limited in their creative freedom. A case in point is Horatio Greenough's monument of George Washington (Fig. 424), originally commissioned for the national Capitol building. The pose is that of the Olympian Zeus known from ancient Greek coins. The result is an overbearingly pompous posture quite out of keeping with the character of one of the founders of the American republic. Another error occurred when sculptors omitted carving the irises and pupils of the eyes and left them blank, because they did not know that the Greeks and Romans had painted in such details. The prevailing whiteness made their works resemble mortuary monuments, since they had overlooked the fact that the ancients had designed their statuary and friezes for the strong light and shadow of the open air and not for the dim interiors of museums. While Praxiteles and Michelangelo had succeeded in turning marble into flesh, Canova and Greenough converted the living flesh of their models into cold stone.

Enthusiasm for antiquity sometimes led David into similar situations. For the heads of figures in his early pictures he used ancient Roman portrait busts instead of live models. In the baroque period, when Poussin and Claude Lorrain painted Rome, they did so usually in terms of picturesque ancient ruins, but David painted archeological reconstructions. Madame Récamier was a 19th-century Parisian socialite, but David made her into a fancy-dress reincarnation of a Pompeian matron. David's reliance on lines and planes was often so strict that the effect of his paintings was almost as severe as that of relief sculpture. David was saved, however, from some of the major pitfalls of his architectural and sculptural colleagues because so few examples of ancient painting were known at the time. As a consequence, he was forced to divert his considerable talent as a painter to a new style.

In poetry, a similar motivation can be found in the reforms of the poet-hero of the Revolution, André Chénier. They were based on his studies of the Latin and Greek originals. For the forms of his odes and elegies, his pastoral idylls and epics, he drew directly on Homer, Pindar, Vergil, and Horace. "Let us upon new thoughts write antique verses," he had urged; and to a considerable degree his enthusiasm helped him carry out his announced objective.

Emancipation of Music

In this archeological era the musicians fared the best of all because they knew no examples surviving from antiquity to emulate. An opera, to be sure, could get some authenticity into its plot, scenery, and costumes; and such productions of 1807 as Persuis and Lesueur's *Le Triomphe de Trajan*, their *L'Inauguration du Temple de la Victoire*, and Spontini's *La Vestale* tried to make the grade in this respect. All this, however, was on the surface and could hardly be compared with the type of authenticity represented by the Vendôme Column or the Napoleonic arches of triumph.

Since the musicians had to develop their own style, the music of the period has overshadowed the other contemporary arts, and its vitality has given it a lasting general appeal. Just as the fussy rococo had brought about a countermovement in the prerevolutionary neoclassicism, so a reform in music had been carried out in the 18th century under Gluck. By reducing the number of characters in his operas, omitting complicated subplots, strengthening the role of the chorus, transferring much of the lyrical expression to the orchestra, writing simple unadorned melodies, and avoiding ornate coloratura cadenzas in the Italian style, Gluck had brought about a musical revolution similar to David's in painting and paved the way for a new style.

Gluck's ideas were based partially on a reinterpretation of Aristotle's *Poetics*. In his preface to *Alceste* (1767) he had stated that his music was designed to allow the drama to proceed "without interrupting the action or stifling it with a useless superfluity of ornaments." Echoing the words of Winckelmann, he added that the great principles of beauty were "simplicity, truth, and naturalness."

These principles found their ultimate expression in the sinewy music of Beethoven, who, by impatiently brushing aside ancient precedents and models, achieved an expressive style that was genuinely heroic and not merely theatrical.

MID-19TH CENTURY

	KEY EVENTS	ARCHITECTURE AND VISUAL ARTS	LITERATURE AND
		1726-1796 William Chambers ★ 1746-1828 Francisco Goya ▲ 1748-1813 James Wyatt ★	MUSIC 1717-1797 Horace Walpole ◆ 1749-1832 Johann Wolfgang von Goethe ◆
1750 -		1752-1835 John Nash ★ 1768-1826 Marie Guillemine Benoist ▲ 1771-1835 Antoine-Jean Gros ▲ 1774-1840 Caspar David Friedrich ▲	1766-1817 Germaine de Staël ◆ 1768-1848 Chateaubriand ◆ 1770-1850 William Wordsworth ◆ 1771-1832 Walter Scott ◆ 1772-1834 Samuel Coleridge ◆
1775 -		1775-1851 Joseph Mallord William Turner ▲ 1776-1837 John Constable ▲ 1780-1867 Jean-Auguste-Dominique Ingres ▲ 1784-1855 François Rude ● 1787-1843 Jean Pierre Cortot ● 1790-1853 François Christian Gau ★ 1791-1824 Théodore Géricault ▲ 1795-1860 Charles Barry ★ 1796-1875 Antoine-Louis Barye ● 1796-1875 Camille Corot ▲ 1798-1863 Eugène Delacroix ▲	1782-1840 Niccolò Paganini □ 1782-1871 Daniel F. E. Auber □ 1783-1842 Stendhal (Henri Beyle) ◆ 1784-1859 Louis Spohr □ 1786-1826 Carl Maria von Weber □ 1787-1874 François Guizot ◆ 1788-1824 George Gordon, Lord Byron ◆ 1788-1860 Arthur Schopenhauer ◆ 1791-1864 Giacomo Meyerbeer □ 1792-1822 Percy Bysshe Shelley ◆ 1795-1821 John Keats ◆ 1797-1856 Heinrich Heine ◆ 1799-1850 Honoré de Balzac ◆
1800 - 1825 -	1814 Fall of Napoleon. Restoration of the monarchy under Louis XVIII 1821 Napoleon died 1824 Louis XVIII succeeded by Charles X	1801-1848 Thomas Cole ▲ 1802-1878 Richard Upjohn ★ 1808-1879 Honoré Daumier ▲ 1812-1852 A. W. N. Pugin ▲ 1814-1875 François Millet ▲ 1814-1879 Eugène Viollet-le-Duc ★ 1817-1885 Théodore Ballu ★ 1818-1895 James Renwick ★ 1824-1881 George Street ★	1802-1870 Alexandre Dumas, Sr. ◆ 1802-1885 Victor Hugo ◆ 1803-1869 Hector Berlioz □ 1803-1870 Prosper Mérimée ◆ 1804-1876 George Sand ◆ 1809-1847 Felix Mendelssohn □ 1810-1849 Frédéric Chopin □ 1810-1856 Robert Schumann □ 1811-1872 Théophile Gautier ◆ 1811-1886 Franz Liszt □ 1813-1883 Richard Wagner □ 1813-1901 Giuseppe Verdi □ 1818-1893 Charles Gounod □
1023 -	1830 July Revolution overthrew old line of Bourbons. Louis Philippe began reign as limited monarch 1837-1901 Victoria, queen of England 1837 Commission for the Preservation of Historical Monuments founded by Louis Phillipe 1840 Guizot, French historian and statesman, became prime minister 1848 February Revolution overthrew Louis Phillippe's government. Second Republic proclaimed; Louis Napoleon, nephew of Napoleon I, elected president 1852 Louis Napleon elected emperor; reigned a Napoleon III abdicated after unsuccessful conclusion of Franco-Prussian War. Third Republic proclaimed		1833-1897 Johannes Brahms □ 1838-1875 Georges Bizet □

19

The Romantic Style

The watchword of the Age of Reason and the Enlightenment had been Descartes' declaration: "I think; therefore I am." The neoclassical painter David revealed a similar sentiment when he said: "Art should have no other guide than the torch of Reason." For the romantics Descartes' dictum became: "I feel; therefore I am." They also believed that the "heart has reasons that Reason does not know." So in the romantic rebellion, artists exalted emotion over intellect, mystery over reason, passion over restraint, freedom over rules, and the supremacy of the individual over that of the crowd.

The romantics felt the need for the artist to transcend the boundaries of logical thought and rise above the limitations imposed by reason. The excesses of the French Revolution had shown them the power of fanaticism and the important part chance played in human affairs. From their vantage point, the romanticists could look back upon the role intolerance played in the early days of the Revolution, the crimes committed in the name of liberty during the Reign of Terror, and the massacre of equality and fraternity under Napoleon's dictatorship. As science progressed, the universe seemed to grow more mysterious and less predictable. They also noted that such major minds as Kant, Voltaire, Swift, and Rousseau became increasingly skeptical of Enlightenment thinking and that they had all introduced many modifications that suggested new directions of philosophical inquiry.

In England, France, Germany, and the United States, the seeds of romanticism had been planted in the 18th century. The sensibility style had strongly stressed personal feelings in the novels, paintings, and music of the time (see pp. 426–32). The rebellious Storm and Stress movement had been built on breaking formal restraints and unleashing violent emotional outbursts (see p. 433). Burke's articulation of the power of the sublime and awesome aspects of nature to transcend the confines of beauty suggested uncharted territory for the arts to explore

(see p. 433). The early development of the Gothic novel (see p. 433) was destined to come to full fruition in the romantic works of Walter Scott, Victor Hugo, and Edgar Allan Poe. Rousseau's "back to nature" movement did not mean taking to the woods so much as it meant avolding too much intellectualizing and opening the mind instead to instinctive emotional experience. The romantic landscape painters, for their part, took Rousseau quite literally and looked for inspiration in unspoiled natural surroundings.

Romantic artists began to work in a greater variety of forms than before, while poets and musicians likewise revealed the breakdown of a comprehensive worldview by writing shorter works and generally revealing an inability to conceive or present their world as a systematic whole. Even when such a composer as Berlioz did write symphonies, the results were no longer the all-embracing universal structures of Beethoven but sequences of genre pieces strung together by a literary program or some recurrent motif that give them a semblance of unity.

New also was the idea that an artistic work was not a self-contained whole but something that shared many relationships internally as well as externally with other works of art. This idea began with the attempts by certain individual artists to overcome many of the arbitrary limitations and technical rules of their separate crafts. The literature of the period was filled with musical references, and musicians for their part were drawing on literature with full force for their program pieces. The architects were called upon to build dream castles out of the novels of Walpole, Scott, and Hugo; and it is difficult to think of Delacroix's painting or Berlioz's music without Vergil, Dante, Shakespeare, Goethe, and Byron coming to mind.

The effect on music was a host of new and hybrid forms, such as the program symphony and the symphonic poem. The tonal art had been associated from its beginning with words, and program music

was by no means an invention of the 19th century. No other period, however, built an entire style on this mixture.

There is also a considerable distinction between the setting of words to music, as in a song, or the musical dramatization of a play, as in an opera, and basing a purely instrumental form on the spirit of a poem or the sequential arrangements of episodes taken from a novel. Berlioz wrote overtures not only to operas but to such novels as Scott's Waverley and Rob Roy. Mendelssohn wrote Songs Without Words for the piano, leaving the imagination to supply the text, and Berlioz's Fantastic Symphony and Harold in Italy became operas without words. In such later works as the "dramatic symphony" Romeo and Juliet and the "dramatic legend" Damnation of Faust, both of which are scored for soloists and chorus as well as orchestra, he was, in effect, writing concert operas in which the costumes and scenery are left to the listener's imagination. This tendency continued until it reached a climax in Richard Wagner's music dramas, which he conceived as Gesamtkunstwerke, complete or total works of art.

The spirit of romanticism, however, cannot be captured in a single attitude. It included a variety of aesthetic approaches, stylistic tendencies, and divergent directions. One of these could be called *romantic realism*, when artists painted dramatizations of current events. Another was the medieval revival as opposed to the neoclassical emphasis on Greco-Roman antiquity. Still others were the emphasis on individualism and nationalism as well as the awakening to the exotic colors and fascinations of the Orient. Then came the romantic deification of nature in the work of the landscape poets and painters.

In England and Germany romanticism was mainly a movement of the intellectuals, poets, novelists, painters, and musicians. As the style gained momentum in France, however, it penetrated into wider social and political circles. Eventually the romantic movement became the motivating force that overthrew the reactionary branch of the Bourbon monarchy in the Romantic Revolution of 1830—and so became the official style of France.

THE ROMANTIC REVOLUTION

Well before the romantic Revolution of July 1830 new ideas were stirring the minds and imaginations of the intellectuals and artists of Paris. In 1827, as the new movement was spreading, Victor Hugo published his *Cromwell*, a drama with a preface that served as the manifesto of romanticism. François Guizot was lecturing at the Sorbonne on the early history of France. François Rude, destined to be the

principal sculptor of the period, returned from his Belgian exile. And the painter Eugène Delacroix wrote in his journal that when he went to the Odéon Theater to see Shakespeare's *Hamlet*, he met the writers Alexandre Dumas and Victor Hugo. The Ophelia in that production was Harriet Smithson, later to become the wife of the composer Hector Berlioz. Gérard de Nerval's translation of Goethe appeared that autumn and inspired Berlioz to compose *Eight Scenes from Faust*, which later reached popularity in the revision called the *Damnation of Faust*. Delacroix was already at work on his famous *Faust* lithographs to illustrate the 1828 French edition of Goethe's play.

All in all, Paris in the 1820s was an inspiring place and time, and when Théophile Gautier later came to write his history of romanticism, he looked back on his youthful years with nostalgia:

What a marvelous time. Walter Scott was then in the flower of his success; one was initiated into the mysteries of Goethe's Faust, which as Madame de Staël said, contained everything. One discovered Shakespeare, and the poems of Lord Byron: The Corsair; Lara; The Giaour; Manfred; Beppo; and Don Juan took us to the orient, which was not banal then as now. All was young, new, exotically colored, intoxicating, and strongly flavored. It turned our heads; it was as if we had entered into a strange new world.

Liberty Leading the People, 1830

Nowhere is there a better example of the mating of the artistic genius with the spirit of the time than in the life and work of Eugène Delacroix in the Paris of 1830. His Liberty Leading the People, 1830 brought those glorious July days to incandescent expression (Fig. 425). The canvas, in which he distilled the essence of that revolution, is dominated by the fiery allegorical figure of Liberty, here seen as the spirit of the French people whom she leads onward to triumph. No relaxed neoclassical goddess but a virile, energetic reincarnation of the spirit of 1789, she has muscular arms strong enough to hold with ease both a bayoneted rifle and the tricolored banner of the republic. Though bare-breasted, she betrays no sign of softness or sensuality, and her powerful legs stride over the street barricades as she leads her followers forward through the oncoming forces. While intended as a symbolic figure, she is treated by Delacroix as a living personality. Only the Phrygian cap and the near-classic profile, serene in the face of

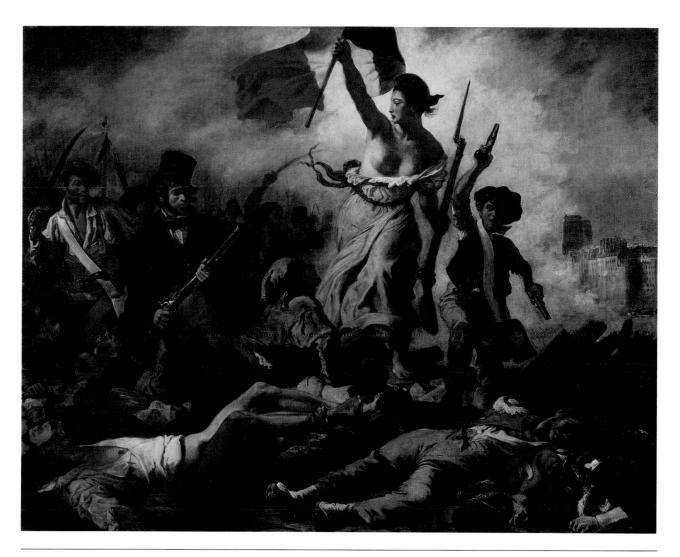

425. Eugène Delacroix. Liberty Leading the People, 1830. 1830. Oil on canvas, $8'6'' \times 10'10''$ (2.59 \times 3.3 m). Louvre, Paris.

danger, indicate her significance. She does not hover over the action on wings, as so many other artists depicted her; instead, with her feet on the ground, she is in the midst of the turmoil.

Liberty's followers include both impulsive students and battle-scarred soldiers who have heeded her call rather than that of their reactionary king. The boy on the right is recruited from the Paris streets. Though too young to understand the events, he is there, a pistol in each hand.

In the background are the remnants of the old guard from revolutionary days still carrying on the struggle. Two main social classes are represented—in the shadows on the extreme left, the man armed with a saber is obviously a working-class figure. In front of him toward the center the more prominent figure in the fashionable frock coat, top hat, and sideburns is a bourgeois gentleman who has grabbed his musket and joined in the general confusion. It

was his class that controlled the fighting and stamped its image on the new monarchy in the person of Louis Philippe, the "Citizen King."

Though the July Revolution was essentially a palace revolt replacing a reactionary Bourbon with his more liberal cousin, no aristocrats are represented as taking part. In the shadow below, the wounded and dying are strewn on the loose cobblestones looking toward Liberty, for she is both their inspiration and their reason for being. Through smoke at the right are the towers of Notre Dame.

Because of the contemporary frame of reference in which one recognizes the familiar shirts, blouses, trousers, rifles, pistols, and other 19th-century equipment, the picture sometimes has been called realistic. But because the spirit of the work rises above the event itself and because the artist has rendered feeling rather than actuality, the picture surely is in the romantic style. By infusing reality

with the charge of an electric emotional attitude, Delacroix raises his picture to the level of an idealized though highly personal expression. As a consequence, all who see this painting seem to be experiencing the Revolution of July 1830 for themselves.

More eloquent than any page in a history book, the canvas has captured the feeling as well as the facts that make up the incident. It is as if all the noise had roused Delacroix from his dreams of the past and, now suddenly wide awake, he has applied his expressive techniques consciously to one of the stirring happenings of his own time.

As always with Delacroix, color plays an important part in the communication of mood. Here, a striking instance of the use of color is seen in the way he takes the red, white, and blue of the banner (the symbol of patriotism) and merges them into the picture as a whole. The white central strip, signifying truth and purity, blends with the purifying smoke of battle. The blue, denoting freedom, matches the parts of the sky visible in the top corners through the smoke. The red in the flag high above balances the color of the blood of those below who have fallen for the ideal of liberty. Thus, the symbolism of the banner blends into the color scheme, and both combine with the dramatic lighting to define the emotional

range. All these, in turn, expand the patriotic theme into a formal pictorial unity of intensity. When the new bourgeois king purchased this picture in the name of the state during the Salon of 1831, the seal of official approval on the romantic style was further fortified.

Eugène Delacroix

It was characteristic of romantic painting that Delacroix, its leading representative, should look more to the fantasy of the literary world for the sources of his pictorial visions rather than to the world of everyday appearances. His choice of subjects as well as his treatment of them makes this immediately apparent. Such titles as the *Death of Sardanapalus, Mazeppa, Giaour and the Pasha*, and the *Shipwreck of Don Juan* all point to the germ motifs of these paintings in the poetic writings of Lord Byron. Delacroix's illustrations for Goethe's *Faust* (Figs. 426 and 427) won the complete admiration of the author himself, who felt that for clarity and depth of insight they could not be surpassed.

Delacroix's imagination had been haunted by *Faust* since he first saw it on the London stage. In fact, in a letter to a friend in Paris, he had com-

426. Eugène Delacroix. *Mephistopheles Flying*, illustration for Goethe's *Faust*. 1828. Lithograph, $10\frac{3}{4} \times 9''$ (27 × 23 cm). Metropolitan Museum of Art, New York (Rogers Fund, 1917).

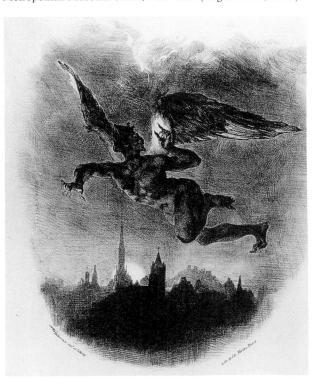

427. Eugène Delacroix. *Margaret in Church*, illustration for Goethe's *Faust*. Lithograph, $10\frac{1}{2} \times 8\frac{3}{4}$ " (27 × 22 cm). Metropolitan Museum of Art, New York (Rogers Fund, 1917).

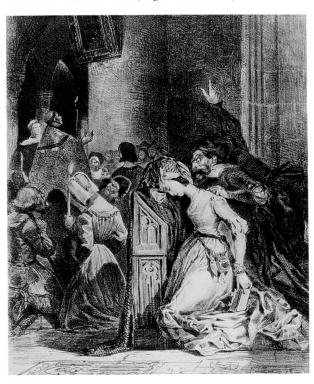

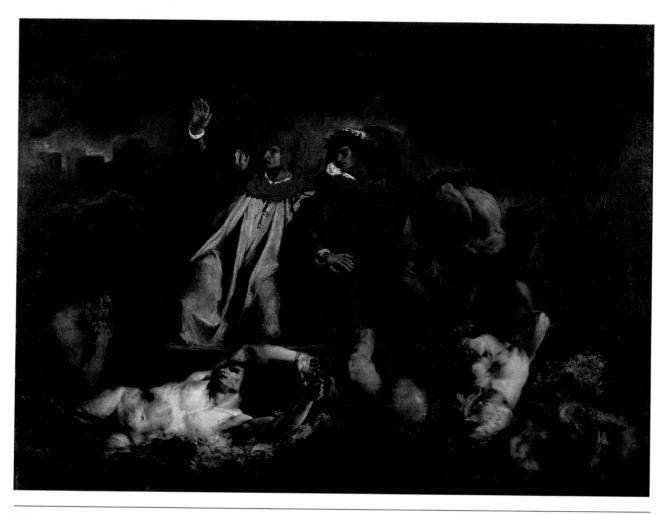

428. Eugène Delacroix. *Dante and Vergil in Hell.* 1822. Oil on canvas, $6'1\frac{1}{2}'' \times 7'10\frac{1}{2}''$ (1.87 × 2.4 m). Louvre, Paris.

mented particularly on its diabolical aspect. The lithographs, or prints, that eventually resulted show his mastery of illustration and prove Delacroix's proficiency in small works as well as large.

Despite his close kinship with Byron and Goethe, Delacroix was not always in sympathy with the work of his romantic Parisian contemporaries. In his diary he spoke of Meyerbeer's opera *Le Prophète* as "frightful" and referred to Berlioz and Hugo as those "so-called reformers." "The noise he makes is distracting," he wrote about Berlioz's music; "It is a heroic mess." Of all musicians he admired Mozart the most, and among his contemporaries only Chopin measured up to his standards of craftsmanship.

Delacroix's color technique was a means of dramatizing his emotional and highly charged subject matter. For him, color was dominant over design. As he declared, "gray is the enemy of all painting . . . let us banish from our palette all earth colors . . . the greater the opposition in color, the greater the brilliance." His admitted models in painting

were the heroic canvases of Rubens (see Figs. 374–376) and the dramatic pictures of Rembrandt, with their emphasis on the dynamics of light (see Figs. 349–352). Among his contemporaries he admired the mellow landscapes and subtle coloring of the English painter Constable (see Figs. 449 and 450).

Delacroix's own art was built on principles of color, light, and emotion rather than on line, drawing, and form. This is nowhere better illustrated than in his early masterpiece *Dante and Vergil in Hell* (Fig. 428), the first of his pictures to attract wide attention when it was exhibited in the Salon of 1822. The revival of Dante's *Divine Comedy* (see pp. 226–27) was another of the romantic literary enthusiasms. It was the *Inferno* part, with its emphasis on tales of the demonic and macabre as well as on the tortures of the damned amid hellfire and brimstone, that held the greatest appeal.

In *Dante and Vergil in Hell* Delacroix enters the realm of pathos. The central figure is that of Vergil. In the crimson robe of a medieval Florentine

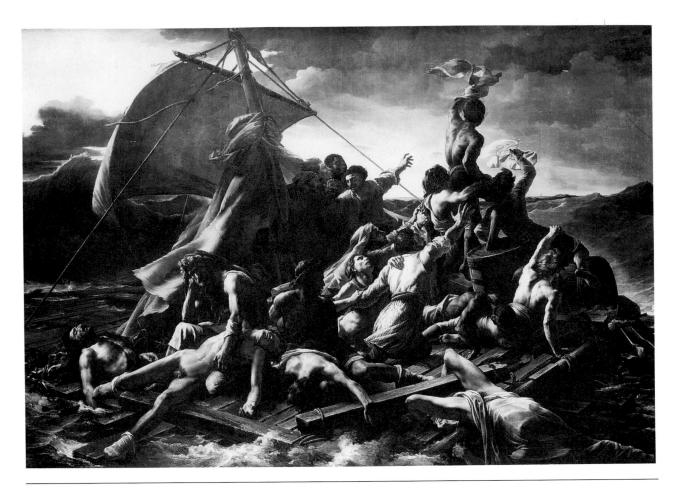

429. Théodore Géricault. Raft of the ''Medusa.'' 1819. Oil on canvas, $16' \times 23'6''$ (4.91 \times 7.16 m). Louvre, Paris.

crowned with the laurel wreath, he stands with dignified monumentality as a symbol of classic calm. On his left is Dante with a red hood on his head. In contrast to the serenity of his immortal companion, he is expressively human and emotionally involved with his grotesque and gruesome surroundings. He looks with terror on the damned who swirl all about him.

The wake of the boat is filled with the writhing forms of the condemned, who hope eternally to reach the opposite shore by trying to attach themselves to the craft. One attempts to climb aboard, and the gnashing teeth of another bite into the edge of the boat, but in vain as they are plunged into the dark waters. Distress and despair are everywhere. On the right is Phlegyas, the ghostly boatman, seen from the rear as he strains at the rudder to guide the boat across the River Styx to the flaming shores of the city of Dis, visible in the distant background between the clouds of sulfurous fumes.

When first exhibited, the picture brought down storms of protest and abuse on Delacroix's head, which helped immeasurably to bring the young artist to critical attention. One defender of David's academic tradition called it a "splattering of color"; another thought Delacroix had "combined all the parts of the work in view of one emotion." While its expressive intensity was novel then, the work now easily falls into place as part of the macabre aspect of the romantic style. Even the nude figures, as muscular as those of Michelangelo and Rubens, function here more as color masses than as forms modeled three-dimensionally. As Delacroix once declared, color *is* painting, and his development of a color palette capable of arousing specific emotional reactions from his viewers was destined to have a far-reaching effect on later painting.

Théodore Géricault

Delacroix's initial inspiration for the *Dante* picture was first fired by his association with his older contemporary, Théodore Géricault, whom he thought of as his master. While Géricault was painting his *Raft of the ''Medusa''* (Fig. 429), Delacroix observed the work in progress and posed for the dying youth lying

face down in the center foreground. The vast canvas created a sensation because its subject was a controversial topic of current interest. The French government frigate had foundered off the West African coast. The captain, a reactionary royalist, together with the officers, seized the lifeboats for themselves and cast the 149 hapless passengers and crew adrift on an improvised raft.

The event was a political scandal of major magnitude, and Géricault dramatized it with great passion and intensity. The superbly modeled figures were based on Géricault's studies of Michelangelo's nudes in Rome, not realistically as they would have appeared after twelve days of hunger, thirst, and exposure, when only fifteen survivors were finally rescued. The hectic scene is held together by the tight pyramidal composition with the line of interest rising from the lower left to the waving young sailor at the top. Shipwrecks, when human will proved powerless in confrontation with the awesome force of nature, were a favorite subject of romanticism in literature and art since the romanticists exalted the sublime over the merely beautiful. Géricault, however, did not deal so much with heroism as with the elemental animal will to survive. This powerful

430. Francisco Goya. *The Sleep of Reason Produces Monsters*, from *Los Caprichos*. 1796–98. Etching and aquatint. Museo del Prado, Madrid.

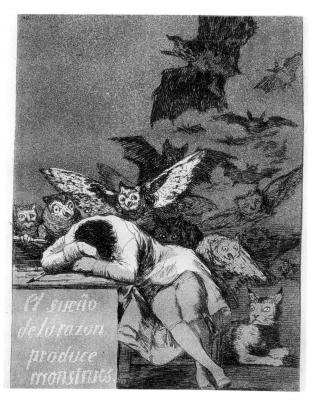

work soon became a political manifesto against the restored Bourbons. Among other forces, it led to their overthrow in the revolution of 1830.

Francisco Goya

In lonely eminence stands the towering figure of Francisco Goya. His lifetime spanned the years between 1746 and 1828, and his work defies conventional stylistic classification. During this tempestuous time his art reflected the conflicting crosscurrents of ideas, political upheavals, and stylistic trends. All were sifted through the keen eye of his powerful individuality. His early work in the Spanish royal tapestry studios mirrors the carefree, light-

431. Francisco Goya. *Saturn Devouring One of His Children*. 1820-23. Wall painting in oil detached on canvas, $4'9_8^{7''} \times 2'8_8^{8''}$ (1.46 \times .83 m). Museo del Prado, Madrid.

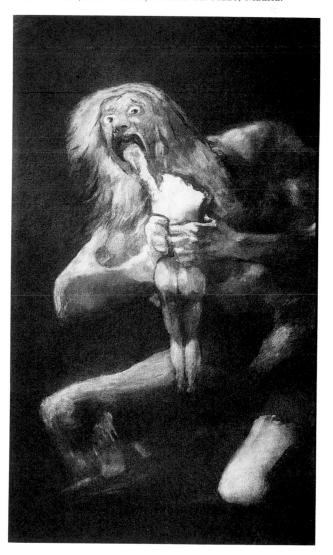

hearted attitudes of the aristocratic rococo. He also shared the Enlightenment opposition to religious fanaticism, social injustice, and senseless cruelty. But like so many others, his optimistic faith in the power of reason to solve human and artistic problems ended in deep disillusionment.

The first of his series of etchings entitled *Los Caprichos* (Fig. 430) bears the enigmatic inscription "The sleep of reason produces monsters." This can be read both as an endorsement of rationalism and as a warning that the surrender of reason can result in disorder and misery. Or it can be seen as a sign that the faith in reason to solve human problems had ended only in creating nightmares.

Goya parted company with the neoclassical ideal of "noble simplicity and quiet grandeur." His break with the usual neoclassical treatment of mythological subjects is revealed in the bitterness and horror of *Saturn Devouring One of his Children* (Fig.

431). In this painting, made late in life for his own dining room, Goya illustrates the blood and gore of ancient myths as an antidote to the glamour and glory of neoclassicism elsewhere.

Goya had witnessed the sufferings of his subjugated countrymen during Napoleon's invasion of Spain in 1808. His *Executions of the Third of May, 1808* (Fig. 432) was painted some years later, at the time Spain had regained its independence after Napoleon's downfall. Goya saw nothing of the positive aspects of warfare, only the desolation of his country and its accompanying misery and bloodshed. This is his answer to the heroic posturing of Napoleon's official painters. The stance of the French firing squad recalls that of the Horatii in David's famous picture (see Fig. 418). But the spectator's sympathy here is with the defenseless civilians, rounded up at random to avenge a guerrilla attack on the French forces the day before. The work is in the romantic realistic vein

432. Francisco Goya. Executions of the Third of May, 1808. 1814–15. Oil on canvas, 8'9" × 13'4" (2.67 × 4.06 m). Museo del Prado, Madrid

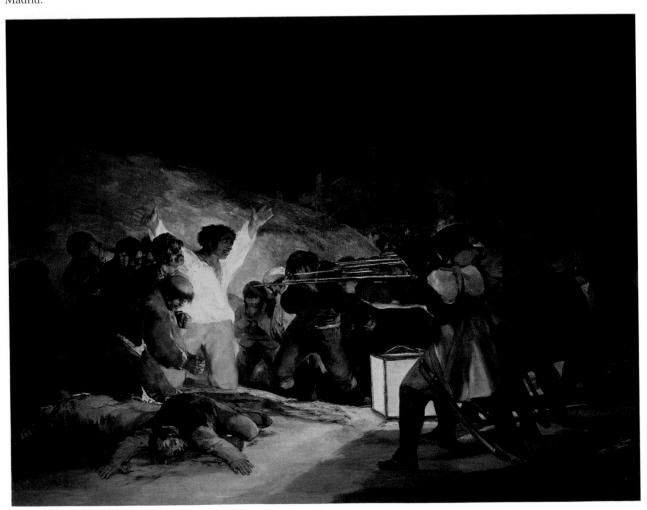

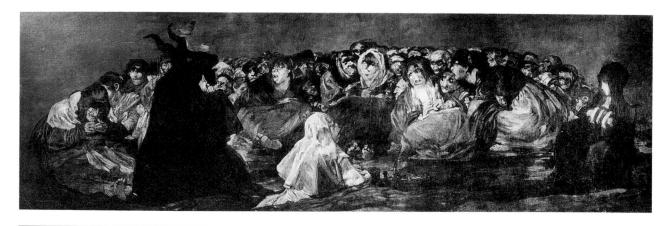

Francisco Goya. Witches' Sabbath. c. 1819–23. Oil on canvas, $4'7_8'' \times 14'4_2''$ (1.4 × 4.38 m). Museo del Prado, Madrid.

as with Delacroix and Géricault (Figs. 443 and 429), though it predates them by some years

Intended for public exhibit, the picture was to memorialize those who had lost their lives in the conflict. Despair and disillusionment are everywhere. From Goya's point of view the Enlightenment, represented by the lantern, was to have brought reason and order into society. Christianity, symbolized by the church in the background, the tonsured monk, and the crucifixionlike posture of the victim awaiting execution, should be leading to the brotherhood of man. The revolutionary ideals of liberty, equality, and fraternity have here become a mockery. All have failed. Only the artist's vision and power to expose human martyrdom emerge to create meaning and reassurance.

Goya's liberal sympathies, however, were once more briefly revived in his Allegory on the Adoption of the Constitution of 1812. This short-lived document declared the people sovereign and reduced the king to a figurehead. Still seeing nothing but brutality and misery around him, he then withdrew from public life. In the final paintings of his so-called "Black" period he explored the dark and terrifying world of the subconscious (Fig. 433). Evil was now no longer to be attributed to the devil but to humanity itself. The 19th century adopted him as a romantic, while 20th-century surrealists and expressionists saw him as one of their own.

François Rude

The Departure of the Volunteers of 1792 by François Rude (Fig. 434) is one of the dominating sculptural works of the romantic style. It achieved its stature by its impassioned expression and sustained heroic

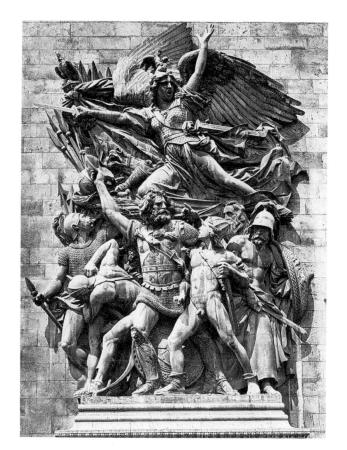

434 François Rude. Departure of the Volunteers of 1792 (La Marseillaise). 1833-36. Height 42' (12.8 m), width 26' (7.93 m). Right stone relief, Arc de Triomphe de l'Étoile, Paris.

mood. Its prominent location on one side of the Arc de Triomphe in Paris assured it the largest possible audience. Carved in the boldest high relief, the dimensions of the composition alone—rising to a height of 42 feet (12.8 meters) and spreading to a width of 26 feet (7.9 meters)—make it of truly colossal proportions. The conception and commission of this work date from the wave of patriotic emotion associated with the Revolution of July 1830 and the memories that stirred of earlier struggles for freedom. This source of inspiration was shared by both Delacroix and Rude, whose design certainly owes much to Delacroix's *Liberty Leading the People*. It took Delacroix only a year to get his painting before the public, but a sculptural work of these proportions took Rude six years to complete.

The scene shown is that of a band of volunteers rallying to the defense of the newly established French Republic when it was threatened by foreign invasion in 1792. The five determined figures in the foreground are uniting to meet the common danger and are receiving mutual inspiration from the winged figure of Bellona. This Roman goddess of war hovers over them, urging them onward with the singing of the *Marseillaise*. A fine rhythm is established by the compact grouping of the figures; it is quickened by the repetitive movement of their legs below. All combine to weld the composition together in a lively yet majestic march.

These representatives of the humanity so recently liberated by the French Revolution are self-motivated protectors of their newly hard-won liberty, equality, and fraternity. The full force and power of four of the mature volunteers contrasts with the potential strength of the finely carved nude figure of the idealistic youth. The waning ability of the old man behind him is such that he can only point out the direction to the others and wave them on. The surging power of ideals held in common urges the volunteers ever onward with driving force and momentum.

Because Rude designed the *Departure* for a Napoleonic arch of triumph, his motifs are of Roman origin. The soldiers are outfitted with Roman helmets and shields, though the coats of mail and weapons in the background recall those of the medieval period. The avoidance of any contemporary costumes and symbols in this representation of an event that had taken place less than a half-century before points to Rude's tendency to draw on the past for inspiration.

Popularly and quite properly called the "Marseillaise in stone," the Departure represents a most inventive sculptural use of a musical motif in suggesting the great revolutionary song, which serves to unify the patriotic spirit of the group. The anthem, with its stirring words "To arms, O citizens," was practically forgotten during the days of Napoleon's Empire, and under the Bourbon restoration it was,

of course, officially banned. Credit for its rediscovery and revival goes to the composer Berlioz. Stirred to patriotic frenzy by the events of July 1830, though avoiding direct participation, this eccentric genius contented himself with scoring the song for double chorus and orchestra, asking "all who have voices, a heart, and blood in their veins" to join in.

In a later work, *Joan of Arc Listening to the Voices* (Fig. 435), Rude combines emotionalism and medieval subject matter. Executed originally in 1845 for the gardens of the Luxembourg Palace, the life-size statue represents the Maid of Orleans in peasant costume with a suit of armor at her side. In this way the sculptor indicated both her rural origin and her heroic mission. The mystic element is suggested as she lifts her hand to her ear in order to hear the angelic voices that guide her. By trying to capture the intan-

435. François Rude. *Joan of Arc Listening to the Voices.* 1845. Marble life-size. Musée de Dijon.

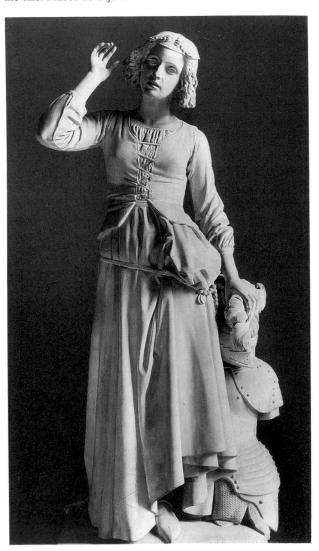

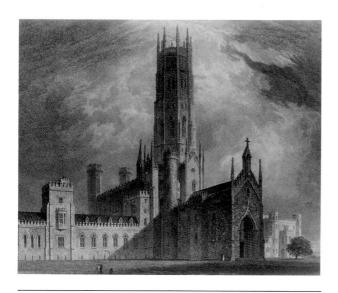

436.James Wyatt. Fonthill Abbey, Wiltshire (no longer standing). 1796–1807. Height of tower 278′ (84.73 m). Contemporary lithograph.

gible sounds of these heavenly voices as Joan listens with upraised head, Rude strains the marble medium to its expressive limits.

Rude, who had grown up in revolutionary times, was always thoroughly in sympathy with the liberal spirit. He accepted exile in Belgium in 1815 rather than live under a Bourbon ruler. Action was his aesthetic watchword. "The great thing for an artist," he once said, "is to do." Some critics find his Departure of the Volunteers of 1792 overcrowded, overloaded, and unbalanced. Others feel that this crowding and imbalance are justified by the subject of a concerted uprising of the masses and that unity is achieved by the direction of its movement. Clearly it shows no will toward classical calm. Its sheer energy makes a clean break with academic tradition. By thus liberating sculpture from many outworn clichés, Rude revealed himself as a true romanticist.

MEDIEVAL REVIVAL

Romantic architecture received its initial thrust from the popularity in the late 18th century of the so-called Gothic novels. Romances and plays of this type published in England were variously entitled: The Haunted Priory; The Horrid Mysteries; Banditti, or Love in a Labyrinth; Raymond and Agnes, or The Bleeding Nun of Lindenberg; and Horace Walpole's famous Castle of Otranto, subtitled A Gothic Tale.

The settings for these stories were large baronial halls or decayed abbeys, liberally equipped with mysterious trapdoors, sliding panels, creaking gates, animated suits of armor, and ghostly voices emanating from ancient tombs. Such scenes served as back-

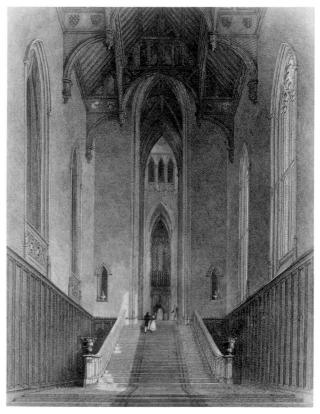

437.James Wyatt. Interior, Fonthill Abbey. Length 25' (7.62 m), width 35' (10.67 m). Contemporary lithograph.

drops for the injured innocence of fragile and helpless heroines and the fearless, if somewhat reckless, courage of dashing heroes. These tales played their part in the redefinition of the word *Gothic*—which Voltaire had called a fantastic compound of rudeness and filigree—into something more mystical, tinged with weirdness and bordering on the fantastic.

Gothic Revival in England and America

The imaginary castles of these novels first took on concrete form in England as the architectural whims of wealthy eccentrics. Walpole, the well-to-do son of a powerful prime minister, had indulged his fancy in a residence that gave its name to one aspect of the romantic style, "Strawberry Hill Gothick." William Beckford, whom Byron called "England's richest son," had the architect James Wyatt construct him a residence he called Fonthill Abbey (Fig. 436). Its huge central tower rose over a spacious interior hall that was approached by a massive staircase (Fig. 437). The rest of the interior was a maze of long drafty corridors that provided the wall space for the proprietor's pictures and tapestries as well as a suitable setting for his melancholy musings.

In his frenzy to have Fonthill Abbey completed, Beckford drove the workers day and night to the point where, in their haste, they neglected to provide an adequate foundation for the tower. Only a few years after its completion, the tower of Beckford's dream castle fell to the ground, taking most of the building with it. Since, however, ruins were greatly admired as residences at the time, this catastrophe only served to enhance the abbey's picturesque Gothic demeanor.

In the early 1820s Fonthill Abbey became so enormously popular that newspapers wrote of the "Fonthill mania." Up to five hundred visitors a day made the pilgrimage, particularly to see Beckford's spectacular landscaping, which had involved transplanting over a million trees to create an appropriate setting. The effect commanded the admiration of the painter Constable, who lived nearby, as well as that of such poets as Lord Byron and Edgar Allan Poe.

The Gothic novel in literature and the Gothic revival in architecture steadily gained momentum. Jane Austen's *Northanger Abbey*, a delicious satire on the movement, was published just as Sir Walter Scott's historical novels were bringing their author such huge acclaim. Scott's novels were translated

into French beginning about 1816. They, in turn, paved the way for the romances of Hugo and Dumas. These Gothic novels, plays, and operas also had their serious side, as they explored the social responsibilities and commitments of individuals to champion righteous causes.

The Gothic revival also had intellectual and political overtones. In England especially, it had received impetus in the opposition to Napoleon's attempt to establish a new Roman empire that would dominate the entire continent. The Gothic was then seen as an indigenous English style associated with the founding of universities at Oxford and Cambridge. In the political world it was linked with the establishment of parliamentary rule when the Magna Carta was signed in 1215. Hence when the new Houses of Parliament (Fig. 438) were designed by Charles Barry and A. W. N. Pugin and the New Law Courts by George Street, the Gothic style seemed most appropriate.

The medieval revival was also found in the United States. In New York the Gothic spires of Trinity Church rise among lower Broadway's skyscrapers. Two churches by Renwick furnish further examples—Grace Church (Fig. 439) and St. Patrick's

438. Charles Barry and A. W. N. Pugin. Houses of Parliament, London. 1840–60. Length 940' (286.51 m).

439. James Renwick. Grace Church, New York. 1845.

Cathedral, both dating from the mid-19th century. Many American colleges and universities, in their eagerness to be identified with ancient and honorable causes, were also built in the neomedieval style. And scattered throughout the country are half-timbered houses, castle residences, railroad stations, banks, and other public buildings that show the wide influence of the medieval revival on American architecture.

Gothic Revival in Germany and France

In Germany as early as 1772 the young poet Goethe, under the guidance of his trusted university guide Gottfried von Herder, was writing praise of the builder of the Strasbourg Cathedral, Erwin von Steinbach. The book, significantly, was entitled *Von Deutscher Baukunst (On German Architecture)*. Later, Goethe placed his drama on the medieval

Faust legend in a Gothic setting. In the 19th century, German literary interest in neomedievalism became the background for Wagner's operas *Tannhäuser*, *Lohengrin*, and *Parsifal*. The momentum of the romantic movements also led to the completion of the Cologne Cathedral after the discovery of the original plan, a project that had lapsed for several centuries (see p. 214).

Architectural energies in France at first were diverted toward the preservation of the many medieval monuments still in existence. Less than a year after the July Revolution, Victor Hugo had published his *Notre Dame de Paris* (known to the Englishspeaking world as *The Hunchback of Notre Dame*). The fact that the real hero of the novel is Paris's Gothic cathedral fanned into flames the popular enthusiasm for the restoration of churches, castles, and abbeys. Support for the reconstruction of Notre Dame was soon forthcoming in official circles from Guizot, the historian who was then prime minister. It was he who founded in 1837 the Commission for the Conservation of Historic Monuments.

In France, as previously in England and Germany, romantic architecture was associated with the upsurge of patriotic and nationalistic sentiment. It channeled French national energies into new flights of the imagination and provided French minds with an escape from dreams of Roman imperial glory that had become the nightmare of Napoleonic defeat.

The precise scholarship of the French academic mind found a ready outlet in the establishment of the new science of medieval archeology, which resulted in the restoration of such buildings as Sainte Chapelle and the Cathedral of Notre Dame in Paris. In his essay on medieval architecture, Eugène Viollet-le-Duc called attention to the engineering logic of medieval builders and demonstrated the organic unity of the Gothic structural system in which each stone played its part, and in which even the decorative details served useful purposes. Such belief that everything was necessary and nothing used merely for effect not only revised 19th-century architectural thought but also facilitated the 20th-century return to functional building.

As comparative latecomers on the medieval revival scene, the French architects were in no hurry to leave their reconstructions and design new buildings. Though the Church of Sainte Clotilde (Fig. 440) was planned at the same time that Victor Hugo, Delacroix, and Berlioz were producing their neomedieval works, not until 1846 could ground for it be broken. Designed by François Christian Gau, a native of Cologne but a naturalized French citizen, the project was completed after his death by Théodore Ballu. Although built principally of white

440. François-Christian Gau and Théodore Ballu. Ste. Clotilde, Paris. 1846–57. Width 105' (32 m), height 216' (65.84 m).

stone, Sainte Clotilde received the distinctive technical innovation of cast-iron girders added to the vaulting to assure strength and durability. The girders were disguised by blocks of stone, but the fact that a building of medieval design used materials developed by the 19th-century Industrial Revolution commanded considerable interest.

Based on Gothic models of the 14th century, the church has the usual features of a nave with side aisles, transept, choir, and apse with radiating chapels. The space of the richly ornamented façade is divided by four buttresses into three parts, each with an entrance portal. Those on the sides have tympanums showing in sculptured relief the martyrdom of Saint Valéry and the baptism of Clovis. The approaches to the portals have niches containing standing figures of the Merovingian saints associated with the earliest history of French nationhood after the fall of the Roman empire. The figures include Sainte Clotilde, Clovis' queen, and Sainte Geneviève, patroness of Paris.

The interior is lighted by a clerestory with as many as sixty stained-glass windows that carry out the iconographic scheme promised by the sculptures of the façade. The representations tell the legendary stories of Sainte Clotilde and some of her contemporaries, Saint Valéry, Saint Martin of Tours, and Saint Remi, as well as two of her children who were canonized, Saint Cloud and Sainte Bathilde. The choir is the setting for a large organ with a case elaborately carved in the Gothic manner. Here the composer César Franck presided from the year 1858 until his death in 1890, performing his compositions and famous improvisations.

When the Church of Sainte Clotilde is compared with such original Gothic monuments as the Cathedrals of Chartres (Fig. 182), Paris, and Rheims, it seems too consciously designed, overly symmetrical, and academically frigid. But when viewed in the context of its times and combined with the reflections of the medieval fervor of Victor Hugo, the emotionalism of Rude's sculpture, the expressive color of Delacroix's painting, and the fantastic imagery of Berlioz's music, it catches some rays of their glowing warmth. The church then becomes both their worthy architectural companion and an important incident in the unfolding of the romantic style.

Victor Hugo

Of the three great literary figures who influenced the writings of Victor Hugo at this time, Dante and Shakespeare were out of the past, and only his elder contemporary Goethe came from his own time. These three writers, as he states in the preface to Cromwell, pointed out the sources of the grotesque elements that were to be found everywhere, "in the air, water, earth, fire those myriads of intermediate creatures which we find alive in the popular traditions of the Middle Ages; it is the grotesque which impels the ghastly antics of the witches' revels, which gives Satan his horns, his cloven feet and his bat's wings. It is the grotesque, still the grotesque, which now casts into the Christian hell the frightful faces which the severe genius of Dante and Milton will evoke. . . ."

It was the *Inferno* section of Dante's *Divine Comedy* that inspired Hugo's poem of 1837. Written after a reading of Dante, as the title—*Après une lecture de Dante*—states, it closely parallels Delacroix's picture of Dante: "When the poet paints the image of hell," he wrote, "he paints that of his own life." Hugo sees Dante as surrounded by ghosts and specters, groping blindly through mysterious forests as weird forms

block his dark path. Lost amid thick fogs, with each step he hears lamentations and the faint sounds of the grinding of white teeth in the black night. All the vices and scourges such as vengeance, famine, ambition, pride, and avarice darken the scene still more. Further on, the souls of those who have tasted the poison of cowardice, fear, and treason mingle with the grimacing masks of those whom hatred has consumed. The only light amid this general gloom is the voice of the eternal artist, Vergil, who calls, "Continue onward."

In Petrarch, it was the Triumph of Death that Hugo admired; in Boccaccio, the vivid descriptions of the Black Plague; in Shakespeare, the macabre scenes from *Hamlet* and the boiling and bubbling of the witches' cauldron in *Macbeth*; and in Goethe's *Faust*, the descriptions of the Walpurgis Night. Collectively, these constitute a carnival of the macabre.

Hugo's transition to the new psychology is apparent as early as 1826. At this time he brought out a new edition of his Odes, to which he added fifteen ballades, with the fourteenth entitled "La Ronde du Sabbat," or "Rondo of the Witches' Sabbath." This new outlook he explains in his introduction. The odes, he writes, included his purely religious inspirations and personal expression, which were cast in classical meters. Those with the title of "ballad" have a more imaginative character than the odes and include pictorial fantasies, dreams, and legends of superstition. The latter came to him, he continues, under the inspiration of medieval troubadours, especially those rhapsodies of epic nature that were changed by minstrels to the accompaniment of their harps as they wandered from castle to castle.

"Witches' Sabbath" begins with a description of a Gothic church at midnight; the clock in the belfry tolls twelve, and the witching hour begins. Strange lights flash, the holy water begins to boil in the fonts. Shrieks and howls are heard as from all directions come those who answer Satan's call—ghosts, dragons, vampires, ghouls, monsters, and the souls of the damned from their fresh-emptied tombs. While Satan sings a Black Mass, an imp reads the Gospel, and the whole fantastic congregation performs a wild dance.

All in unison moving with swift-circling feet
While Satan keeps time with his crozier's beat,
And their steps shake the arches colossal and high,
Disturbing the dead in their tombs close by.

The last two lines, a refrain, are repeated after each of the ten verses, one of which will serve as an example.

From his tomb with sad moans Each false monk to his stall Glides, concealed in his pall, That robe fatal to all, Which burns into his bones. Now a black priest draws nigh, With a flame he doth fly On the altar on high He the crust fire enthrones.

The dawn whitens the arches colossal and gray,

And drives all the devilish revellers away;

The dead monks retire to their graves 'neath the halls,

And veil their cold faces behind their dark palls.

Both the technique and imagery of Hugo's ballad are related to the fantastic sections of *Faust*, and both poems, in turn, have a common ancestor in the witches' scene from Shakespeare's *Macbeth*. The similarity of metrical plan and black-magic imagery is unmistakable. One finds the same rhythmic language that is designed to charm the ear and stimulate the imagination rather than make logical sense, especially in the Walpurgis Night scene from *Faust*. The scene is filled with witches riding he-goats and giant owls; the earth crawls with salamanders and coiling snakes, while bats fly around and glittering fireflies provide the illumination. As Mephistopheles describes the ghostly dance, all manner of gruesome and awesome night creatures

. . . crowd and jostle, whirl, and flutter!
They whisper, babble, twirl, and
splutter!
They glimmer, sparkle, stink, and
flare—
A true witch-element! Beware!

The sources of Hugo's inspiration are thus clear, but while he must be counted among the masters of language and an outstanding literary figure, he was never a prime mover or noted for his originality. Highly skilled as a manipulator of symbols and a master of poetic forms, he was able to give clear expression to the changing voices of his time.

Yet, in spite of all this verbal facility and the uniformly high quality of his output, he never succeeded in producing a poetic masterpiece that stood out above all others. In his work all the ideas of his time are mirrored in his unparalleled use of language, and his voice is as typical as any within this period.

The brief but pungent reply of a modern critic sums it up. When asked whom he considered the greatest French poet of the 19th century, he answered, "Unfortunately, Victor Hugo."

Hector Berlioz

The salons of Paris during the days of the romantic dawn were populated with poets, playwrights, journalists, critics, architects, painters, sculptors, musicians, and utopian political reformers without number. Heinrich Heine, poet and journalist from north Germany, composers Chopin from Poland, Liszt from Hungary—all mixed freely with such homegrown artists and intellectuals as Victor Hugo, Théophile Gautier, Lamartine, Chateaubriand, de Musset, Dumas, George Sand, and others. Social philosophers like Lamennais, Proudhon, Auguste Comte, and Saint-Simon gave a political tinge to aesthetic debates.

In the supercharged atmosphere of the Paris salons Hector Berlioz must have appeared as an authentic apparition, embodying in the flesh the wildest romantic dreams and nightmares. One contemporary described him as a young man trembling with passion, whose large umbrella of hair projected like a movable awning over the beak of a bird of prey. The German composer Robert Schumann saw him as a "shaggy monster with ravenous eyes," his personality as that of a "raging bacchant," and spoke of his effect on the society of his times as "the terror of the Philistines." The suave and polished Felix Mendelssohn, on the other hand, found his French colleague merely exasperating, and he continually reproached Berlioz because, with all his strenuous efforts to go stark raving mad, he never once really succeeded.

In one striking personality, Berlioz combined qualities that made him a great composer, the ranking orchestral conductor of his day, a brilliant journalist, and an autobiographer. As a conductor, he was caricatured by the painter Gustave Doré as the mad musician (Fig. 441). At the first performance of one of his overtures, when the orchestra failed to give him the effect he demanded, he burst into tears, tore his hair, and fell sobbing on the kettledrums.

Berlioz's Memoirs are stylistically a literary

441.GUSTAVE DORÉ. Berlioz Conducting Massed Choirs. 19th-century caricature.

achievement of the first magnitude. From this lively source one gathers that Berlioz's development proceeded in a series of emotional shocks that he received from his first contacts with the literature and music of his time. One after the other, the fires of his explosive imagination were ignited by Goethe's Faust, which resulted in his opera the Damnation of Faust; by the poetry of Byron, which became the symphony for viola and orchestra Harold in Italy; by Shakespeare's tragedies, which inspired his Romeo and Juliet Symphony; and by Dante's Divine Comedy, which was the inspiration for his great Requiem.

Berlioz's autobiographical Fantastic Symphony, first performed in 1830, contains a complex of many ideas he gathered from the musical and literary atmosphere that surrounded him. Its subtitle, "Episode in the Life of an Artist," tells the listener that it is a program symphony based on a story. In the detailed programmatic notes he wrote for his work it is clear that he took the idea of poisoning by opium in the first movement, called "Reveries—Passions," from De Quincey's Confessions of an English Opium Eater, which had recently appeared.

The musical form of this movement, with its slow *Largo* introduction and the vigorous *Allegro agitato ed appassionato assai* continuation, is in the sym-

phonic tradition of Beethoven. Its principal claim to technical originality is the use of an *idée fixe*, or "fixed idea," by which Berlioz conveys the notion of his beloved, who is present and colors his every thought. The changing shape of the theme on its appearance in each of the five movements fulfills a dual purpose. It provides an appearance of unity in the sequence of mood pieces, and it expresses, by its mutations, the necessary dramatic progress.

In the succeeding movement, "A Ball," the hero beholds his beloved dancing a brilliant concert waltz in all the glamour and glitter of a great social occasion. The external and internal storms of the slow third movement, "Scene in the Country," bring out the benign and malignant aspects of nature as the hero seeks refuge and consolation in a true evocation of the romantic sublime.

Fantastic Symphony Hector Berlioz (*idée fixe*—"fixed idea," or leading melody)

In the "March to the Scaffold" he dreams of murdering his beloved and being condemned to death and led to the guillotine. The final bars of this fourth movement sound the fixed melodic idea in the piercing, high register of the clarinet. It is suddenly cut off as the blade falls. After a dull thud and roll of the drums, the crowd roars its bloodthirsty approval.

The symphony ends the diabolical "Dream of a Witches' Sabbath" as the exultant demonic forces claim the soul of the hero. The grisly scene here is both the climax and the unresolved end. This is the movement that most fully justifies the title *Fantastic*. It is divided into three distinct sections. The first is introductory, beginning with wild shrieks for the piccolo, flute, and oboe, accompanied by the ominous roll of the kettledrums in bars 7 and 8. This is echoed softly by the muted horns in bars 9 and 10 to suggest distance. After a repetition, the tempo changes from a leisurely *Larghetto* to a brisk *Allegro*, and the *idée fixe* is heard in bars 21 through 28.

Surely it is a novel notion that Berlioz's heroine, exemplified in previous versions of her theme as the embodiment of desirability, should now appear at the witches' sabbath. Was she a witch all along and disguised only in the hero's imagination in desirable human form? Or is this merely another manifestation of her "bewitching" power? The entrance at this point of his beloved on her broomstick, accompanied by a pandemonium of sulfurous sounds, is therefore somewhat unexpected. The hero, obviously Berlioz, gives a shriek of horror (29–39) as he listens to her modulate from the previously chaste C major to the more lurid key of E-flat. Her instrumental coloration, while still that of the pale-sounding clarinet, descends now in pitch to a new low and more sensuous register. After the shocking revelation, she executes a few capers and subsides for the moment as the introduction concludes with bar 101.

The second section of the final movement is labeled *Lontano* ("in the distance") and begins with the tolling of the chimes, recalling the opening lines of Hugo's ballad. After this signal for the unleashing of the infernal forces, the foreboding *Dies irae* is solemnly intoned, first by the brass instruments in octaves. In bars 127–146, it is in dotted half-notes. Next, in bars 147–157, the rhythm is quickened into dotted quarters. Then it becomes syncopated in triplet eighths (157–162) and ends with an abrupt upward swish of the C major scale.

With the appearance in off-beat syncopations and in such sacrilegious surroundings of this ancient Gothic liturgical melody, a solemn part of the old Roman Catholic requiem mass, Berlioz fulfills the promise of his program that he will compose a "burlesque parody" on the Dies irae (see pp. 223-25). Besides serving Berlioz as a symbol conjuring up all the fire-and-brimstone aspects of medieval Christianity, it also introduces at this point a form of macabre humor. This parody of a sacred melody caused considerable comment at the time. Schumann attributed it to romantic irony, one of the few forms of humor tolerated in a style practiced by artists who took life and themselves with deadly seriousness. Another explanation, however, seems more logical. It is to be found by applying a remark that Hugo made in the preface to Cromwell. "When Dante had finished his terrible Inferno," he wrote, "and naught remained save to give his work a name, the unerring instinct of his genius showed him that the multiform poem was an emanation of the drama, not of the epic; and on the front of that gigantic monument, he wrote with his pen of bronze: Divina Commedia." Thus, if Dante was justified in conceiving his Inferno as a comedy, though a divine one, then Berlioz could include the Dies irae in this context. Even the devil is conceded to be a clever theologian, and in Goethe's drama he is found in the sacred precincts of the church, whispering in Margaret's ear as she listens to the choir chant the Dies irae (Fig. 427).

The title of the third and final section of the fifth movement of Berlioz's symphony, which begins with bar 241, is "Rondo of the Witches' Sabbath," the neomedieval, bloodcurdling, Black-Mass ballad published by Victor Hugo in 1826 (see pp. 473–74). It is also the subject of one of Goya's paintings, Witches' Sabbath (Fig. 433). A dance fragment hinted at previously now becomes the "Rondo of the Sabbath" theme and a four-bar phrase forming a fugue subject. The first entrance is for the cellos and double basses (241–244). This is followed by the violas (248–251). Next enter the first violins, fortified by the bassoons (255–258). The final entrance is scored for woodwinds and horns.

These successive entries, each with a different instrumental combination, mark Berlioz's departure from the academic tradition of the linear fugue. Here he introduces the element of instrumental coloration into the usually austere fugal exposition. Other color combinations follow with melodic and chromatic variants of the subject in a fugal development that has won the composer wide admiration. It must be noted that when Berlioz is writing his wildest and most fantastic images, his mind is always fully in command. At the climax of such a work as this, he writes a fugue that neither violates the rules nor sacrifices his expressive intentions. As Berlioz himself expressed it: "One must do coolly the things that are most fiery."

After the fugue on the dance theme has come to its climax with the entire string section playing an extension of the subject (407–413), the *Dies irae* makes a reappearance, and the two themes are woven together with great skill from bar 414 to the end. Some of Berlioz's enthusiastic admirers have called this contrapuntal section a "double fugue." There is only one fugue, however, with the *Dies irae* melody running concurrently. With the final blood-curdling shrieks and flying images, a composer, quite probably for the first time in music history, has written a fugue that vividly fulfills its literal meaning—that is, a flight.

After the *Fantastic Symphony*, the use of the *Dies irae* became a symbol of the macabre, and it has been used countless times since. Liszt's *Totentanz* for piano and orchestra is a set of variations on it. It appears again in Gustav Mahler's Second Symphony and in some of Rachmaninoff's variations on a theme of Paganini. With this final movement, Berlioz also established a style that brought the demonic element—and a chain of harmonic and psychological dissonances—into music to stay. Both Moussorgsky's *Night on Bald Mountain* and Saint-Saëns's *Danse Macabre* are cut from the same cloth. One writer has even called this movement of Berlioz's the

first piece of Russian music. And in the music dramas of Richard Wagner, the influence of Berlioz's orchestration and his experiments in combining voices and orchestral music in dramatic symphonies and oratorios were all-pervasive.

The Wagnerian Synthesis

Wagner's art matured later than that of his younger contemporaries, and from his perspective he could survey the entire romantic scene and effect a synthesis of the romantic movement. Beethoven, he felt, had blazed a new trail in bringing vocal soloists and a chorus into his great Ninth Symphony, and his genius for motivic development was unparalleled. Schubert's union of poetry and instrumental music in the Lied, or art song, was on too small a scale. Weber had made a brave beginning toward establishing a national German opera, but it did not go far enough. Schumann's secret-society romanticism with its hidden meanings revealed only to the initiated was perhaps too refined and obscure, but the cult idea had a certain attraction. Paganini and Liszt had been sensational enough as virtuoso performers, but personal virtuosity was a perishable commodity. Chopin's urbane and polished style was restricted to the piano, but his chromatic harmony proved good grist for the Wagnerian mill. Liszt's programmatic symphonic poems, with their drama and thematic development, pointed in the right direction. Berlioz's original experiments in hybridizing the drama, symphony, and opera were to be very useful. When Wagner peered backward into history, the dramatic power and sweep of Shakespeare and the colossalbaroque qualities of Handel did not escape his notice. In Wagner's view, however, no approach was sufficiently successful in itself. Yet all contained enough vital elements to assure success if carefully selected, blended, and combined by him in the proper proportions. So Wagner projected a synthesis of all these tendencies wrapped up in a package he called the Gesamtkunstwerk—the complete work of art, including symphony, mythology, poetry, and drama. He then set forth on his aesthetic mission with religious fervor and messianic dedication.

This self-declared musico-dramatic successor to Shakespeare and Beethoven took most of his material from medieval sources. *Tannhäuser, Lohengrin,* and *Parsifal* came from the poetry and legends of the 13th-century minnesingers. *Tristan and Isolde* stems from a Gothic romance, while *The Ring of the Nibelung* derives from the early Germanic epic, the *Nibelungenlied* (see p. 168). *Die Meistersinger,* on the other hand, is set in Renaissance times. Wagner's mature music dramas are closer to the symphonic

idea than they are to Italian operatic conventions. The principal lyrical element is transferred to the orchestra, and the general effect is that of a vast symphonic poem, with visualized stage spectacle and vocalized running commentary on the orchestral action by the singers. Since the music of his mature operas runs on in an unbroken continuity, arias and recitatives effectively disappear as such, and only rarely is a self-contained aria introduced.

In lieu of aria, recitative, or ensemble numbers, the essential convention in Wagnerian music drama becomes the *leitmotifs*, or leading motifs. These terse aphoristic fragments may vary in length from a short phrase to a melody and are designed to characterize individuals, aspects of personality, abstract ideas, the singular properties of inanimate objects, and the like. The entities that can be so characterized are limited only by the composer's ability to conceive convincingly appropriate ideas. Wagner is astoundingly skillful in his capacity to create such musicaldramatic characterizations with minimal means. The forthright ringing sound of the leading motif for the invincible sword in the Ring cycle, for example, has a martial snap, buglelike melodic intervals, as well as the sharp, gleaming tone of the trumpet, all of which help convey the desired image (below). Contrast it now with the strange, mysterious harmonies that signify the helmet of invisibility (also below).

Ring of the Nibelung

RICHARD WAGNER

- (a. Invincible sword motif;
- b. Helmet of invisibility motif)

These motifs, moreover, are by no means static entities, and they undergo a constant symphonic development. The carefree 9/8 time of Siegfried's jaunty horn call [(a) in the example to the right] portrays the buoyant mood of the youthful hunter. But when this child of nature reaches manhood, the rhythm is transformed into that of a march with incisive off-beat accents (b). When Siegfried attains his true heroic stature, the same theme is amplified by full harmonies and reinforced by the whole brass choir and rolling drums (c). Finally, as the hero lies treacherously slain, the tempo slackens, and the theme is heard in the mournful minor key (d).

Ring of the Nibelung

RICHARD WAGNER

- (a. Young Siegfried;
- b. Mature Siegfried;
- c. Siegfried as hero;
- d. Siegfried's death)

With a fairly large number of such motifs to work with, the role of the orchestra as a participant in the drama is vastly enlarged. Furthermore, a motif sounded in the orchestra can recall an earlier event and clarify the root motivation behind a given action on the stage. In the Ring, which takes four evenings to complete, events of the first night (Das Rheingold) can be so recalled in the subsequent installments. Similarly, the orchestra can anticipate the future for the listener. At the end of the second evening (Die Walküre), for instance, when Wotan puts Brünnhilde to sleep on a mountain ringed with magic fire and the promise that only an intrepid and fearless mortal will awaken and claim her, the orchestra first announces (and Wotan then takes up) the motif subsequently to be associated with Siegfried as hero. Actually, at this point in the drama he is not yet born, but in the fatalistic predestination of mythology the prediction can safely be made. The orchestra, moreover, can interpret states of mind not yet explicit in overt action on stage. Thus when Siegmund and Sieglinde meet (Act I of Die Walküre), the orchestra makes clear that they are falling in love, though from their conversation they themselves seem as yet quite unaware of it. And finally the leading-motif system proves its efficacy at the end of the cycle in Die Götterdämmerung (The Twilight of the Gods). In Act III, when the mortally wounded Siegfried recalls his past and in the subsequent orchestral funeral oration, all the motifs previously associated with him pass by in biographical review: fate; his mother, Sieglinde; the heroism of his paternal ancestors, the Wälsungs; the sword; Siegfried's own theme; Siegfried as hero; and finally the women in his life, Brünnhilde and Gutrune. Such a procedure thus lends itself to biography in music and at the same time summarizes the entire dramatic cycle.

In Wagner all the intellectual trends, all the technical devices, and all the emotional directions of romanticism come together here. In addition to summing up the past and synthesizing the 19thcentury motivic system of writing, Wagner pushed the frontiers of Western harmony to their outermost limits. This sensuous seductive chromaticism, with its tangled web of motifs, never-ending chains of chordal progressions, and complex continuous counterpoints carried right through to the ecstasy of its rapturous conclusion, was destined to have profound effects on the future course of music. Recognizing the essential symphonic core of Wagner's writing, many of the post-Wagnerian composers subsequently dispensed with the stage business altogether and wrote their dramatic music in other mediums. Bruckner, Mahler, and the early Richard Strauss, for instance, translated the Wagnerian idioms into the program symphony and symphonic poem; César Franck into organ and orchestral works; Hugo Wolf into his songs for voice and piano; and Arnold Schoenberg into program chamber music such as his Verklärte Nacht (Transfigured Night) and orchestral song cycles such as his Gurrelieder (Songs of Gurre).

INDIVIDUALISM AND NATIONALISM

Romantic social and political thought viewed the status of people as individuals first and foremost and as members of society secondarily. The romantic period was also the age of the emancipation of the individual and the era of the great hero who attained such heights by personal efforts. Napoleon had stamped his image briefly on the age—as the corporal who became a general, as the bureaucrat who became emperor, as the individual who for a time completely dominated the European scene. He thus fired the ambitions of aspiring artists to conquer their own worlds in their poetry, painting, sculpture, architecture, and music.

Artists vied with each other for the top rung of the ladder in their respective fields. For sheer technique in letters it would be difficult to surpass Victor Hugo, who could write with mastery in any style. Viollet-le-Duc and other architects could duplicate any building in the history of architecture; and the names of such bravura composer-performers as the violinist Paganini and the pianist Liszt are legendary.

All this was, perhaps, a positive assertion of the diminishing self in the face of a growing organization of society under collective control. Each work of art was associated with the personality of a distinctive individual. It was no longer enough for an artist

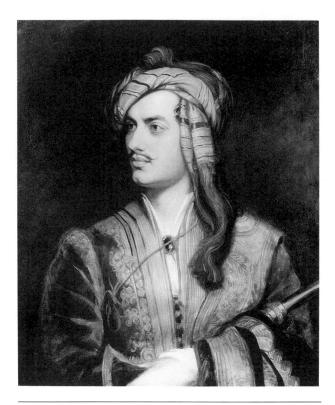

442. Thomas Phillips. *Lord Byron in Albanian Costume.* 1814. Oil on canvas, $29\frac{1}{2} \times 24\frac{1}{2}$ " (75 × 62 cm). National Portrait Gallery, London

to be merely the master of a craft, no matter how high the degree of skill. The artist had also to be a great personality, a prophet, a leader. It was consequently an age of autobiography, confessions, memoirs, portraiture, and the dramatic stroke. The preoccupation with living a "life" worthy of recording in biography took so much time that it became a real handicap to artistic production. More than in any other period there was an obligation to be a leading personality.

The place of the artist in society had been a matter of vital concern to such artists as David and Beethoven, who combined the moralistic fervor of revolutionary thought with a sense of social responsibility. David's championship of the cause of art in the French legislature and Beethoven's behavior toward his patrons as their social equal reveal both men as modern artists who placed the aristocracy of genius on a higher plane than that of birth.

The force of national identity also entered the picture. Chopin with his polonaises, and mazurkas, and his "Revolutionary" etude became the champion of Polish nationhood. Liszt with his Hungarian rhapsodies became the national hero of his native country. Giuseppe Verdi's operas, especially his *Nabucco*, became chapters in the book of Italian na-

tionalism. In *Nabucco* (Nebuchadnezzar) the plight of the children of Israel was a thinly disguised picture of Italy under foreign control. Its famous chorus became a revolutionary anthem, and the letters of Verdi's name an acronymic slogan for political union under one Italian king—Victor Emmanuel Red'Italia.

The great individual could no longer exist in a social or political vacuum. Byron, Delacroix, and others felt compelled to bend their energies and talents to the cause of liberating the oppressed Greek people from the Turkish tyrant's yoke.

Lord Byron's meteoric career in life and literature became at once the living symbol of romantic melancholy as well as the personification of freedom and political liberalism. He was idealized as a champion of oppressed peoples everywhere (Fig. 442). He first visited Athens in 1809 and immediately identified himself with the goals of Greek independence. On that first visit he translated the famous ancient Greek war song, giving it a contemporary twist by substituting Turkey for the old Persian enemy:

Sons of the Greeks! let us go In arms against the foe. . . .

Then manfully despising

The Turkish tyrant's yoke,

Let your country see you rising,

And all her chains are broke.

In a more melodious and lyrical vein he penned the lovely lines:

Maid of Athens, ere we part, Give, oh give me back my heart! Or, since that has left my breast, Keep it now and take the rest!

In 1823, while residing in Italy, Byron joined the London Greek Committee in furthering the cause of Greek independence. He then chartered the ship *Hercules*, financing the campaign partly with his own fortune, and sailed to Missolonghi in western Greece, where he died of a fever in 1824 while trying to bring the feuding factions together.

Eugène Delacroix was a constant reader of Byron. As he remarks in his journal, "To set fire to yourself, remember certain passages from Byron." His *Massacre at Chios* (Fig. 443) was inspired by one of the most gory episodes in that messy war. In a naval battle off the shores of Chios, the Greeks had set fire to the Turkish flagship, burning the crew and a detachment of soldiers to death. As an act of reprisal the Turks rounded up 20,000 completely in-

nocent bystanders on the island, burned their town, slaughtered most of them, and sold the rest into slavery. This senseless incident outraged all European countries. Delacroix's painting reflected this wave of indignation while it was still fresh.

The canvas is cast in the heroic mold, almost 14 feet (4.2 meters) high and more than 11 feet (3.3 meters) wide. All the foreground and middledistance figures are lifesize. The full title is Scenes of the Massacre at Chios: Greek Families Awaiting Death or Slavery. Théophile Gautier commented on the "feverish convulsive drawing and the violent coloring." These were the very qualities that inflamed Delacroix's critics, who dubbed it "The Massacre of Painting." Particularly apparent is the sensuous treatment of the women's bodies, especially the bound figure in the right middle ground. This softness strongly contrasts with the force, muscularity, and cruelty seen in the face and form of the Turkish cavalry officer. Eloquent also is the sense of defeat. apprehension, and despair written on the grandmotherly face of the woman in the foreground. The distant background contributes to the sense of doom with the smoking town and the threatening sky.

Whether an artist's self-image was phrased in classical terms as a Prometheus or in the medieval vocabulary as a knight championing the weak against the strong was not too important. Simply a geographical sounding board, local color, and a language suited to the creative medium were all that the artist needed. Some could find it in folk tales and ballads of a particular locale; others in collections and variations of Spanish epics, Scottish ballads, and German fairy tales; still others in the writing of Italian symphonies, Hungarian rhapsodies, and Polish mazurkas. In this light, nationalism, like the medieval revival, was a northern declaration of cultural independence from the Mediterranean tradition, tied up in the immediate sense in England and Germany with opposition to Napoleon. Berlioz's nationalism is expressed in a much more subtle way, but his operas without words, concert overtures, and music dramas were as distinct a departure from the prevailing Italian operatic tradition as were those of Weber in Germany.

EXOTICISM

The exotic perfumes of the Orient were wafted into the nostrils and fancies of romantic patrons, intellectuals, and artists. This was the time when European countries were building colonial empires. Spain had started with its vast holdings extending from the Americas to the Philippine Islands. England followed with the conquest of India and large parts of

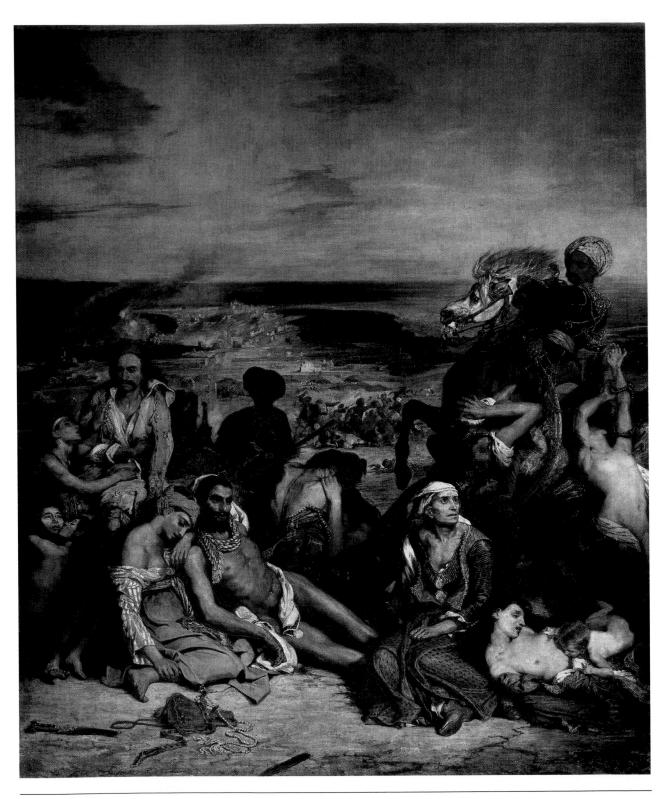

443. Eugène Delacroix. *Massacre at Chios.* 1824. Oil on canvas, $13'7'' \times 11'10''$ (4.19 \times 3.64 m). Louvre, Paris.

Africa. The French claimed Algeria and parts of central Africa. Shrewd business leaders opened up new foreign markets, while missionaries tried to bridge the gap between the Christian and pagan worlds. Artists captured the popular imagination with scenes of exotic mysteries associated with far-off lands and peoples. This is reflected in the striking *Portrait of a Black Woman* (Fig. 444) by Marie Guillemine Benoist. The masterly drawing, elegant painting, and sensitive humanity all point to the artist's status as a pupil of the great Jacques-Louis David.

"Enough of Greece and Rome: Th'exhausted store of either nation now can charm no more." So went the prologue of Arthur Murphy's play of 1759, *Orphans of China*. Thus the Oriental world was added to the imaginative repertory, and its changing image in one guise or another has been mirrored in the arts to the present day. Reflections of this early phase can be found in such operas as Gluck's *Unforeseen Meeting*, or *The Pilgrims to Mecca* (1764), and Mozart's *Abduction from the Seraglio* (1785), with its setting in a Turkish harem, and in William Beckford's Oriental novel *Vathek* (1786).

Kew Gardens, a public park in London, was studded with fanciful structures revealing a wide imaginative range. Some paths led to little rococo

444. MARIE GUILLEMINE BENOIST. *Portrait of a Black Woman.* 1800. Oil on canvas, $32 \times 25\frac{1}{2}$ " (81×65 cm). Louvre, Paris.

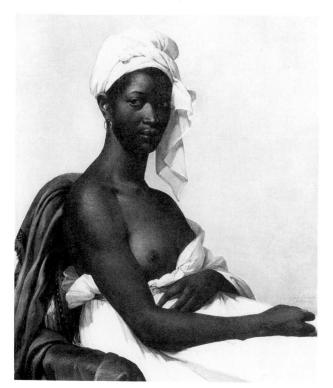

pavilions, others to Greek temples or Gothic chapels. Among them were a Moslem mosque, a Moorish palace, and a "house of Confucius." A pagoda, built by the Palladian architect William Chambers, is the only one of these fancies that has survived.

Only a short time later, Napoleon was fighting his Battle of the Pyramids (1798). In England, a tale entitled *Thalabor the Destroyer* (1799) by Robert Southey included chapters called "The Desert Circle" and "Life in an Arab Tent." Drawing rooms were hung with wallpapers depicting scenes of Mandarin China, and hostesses were pouring tea at Chinese Chippendale tables. The Prince Regent of England, like Kubla Khan in Coleridge's poem, did

445

JOHN NASH. Royal Pavilion, Brighton. 1815–21. Lithograph. Metropolitan Museum of Art, New York (Harris Brisbane Dick Fund, 1941).

446.

JOHN NASH. Dining Hall, Royal Pavilion, Brighton. 1815–21. Lithograph. Metropolitan Muscum of Art, New York (Harris Brisbane Dick Fund, 1941).

A stately pleasure-dome decree: Where Alph, the sacred river, ran

Through caverns measureless to man Down to the sunless sea.

Less poetically though no less fancifully, these lines described the Royal Pavilion (Fig. 445) the Prince Regent commissioned his architect to build at his favorite seaside resort of Brighton. John Nash, who had previously built an exotic country house

for a gentleman who had lived in India, came up with an Arabian Nights extravaganza in a style that was then referred to as "Indian Gothic." The exterior is an exotic fantasy of minarets and cupolas, pinnacles and pagodas, all constructed over cast-iron frames. A domed ceiling painted like a spreading palm tree covers the dining hall (Fig. 446). Completing the decor are water-lily chandeliers suspended from the cast-iron claws of scaly dragons, lotus-blossom lamps, Oriental lacquerware, and Chinese Chippendale furniture.

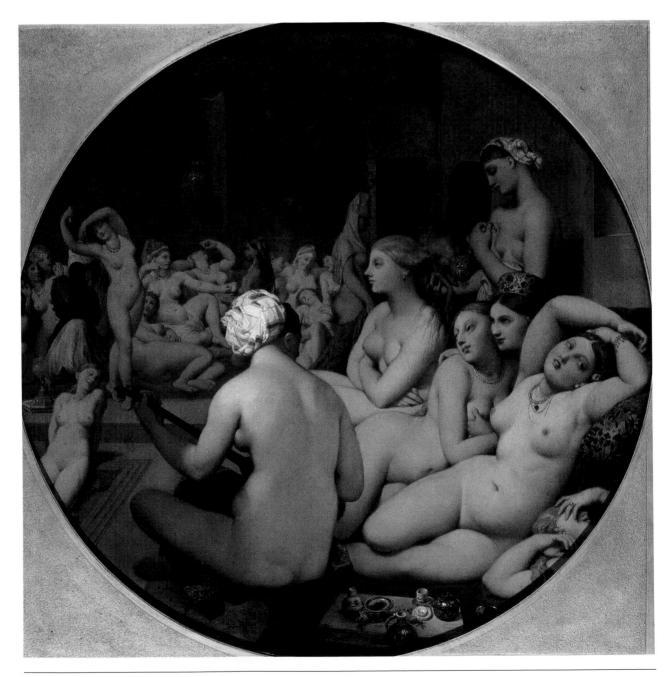

447. Jean Auguste Dominique Ingres. The Turkish Bath. c. 1852–63. Oil on canvas, diameter $42\frac{1}{2}$ " (108 cm). Louvre, Paris.

The colorful Japanese prints that found their way to Europe after Admiral Perry's voyage of 1852–54 had an important effect on painting. Gautier published a popular book called *L'Orient* in 1860, based on his travels. At this same time, Delacroix was painting one of his last pictures, *The Lion Hunt*, which vividly portrayed the violent struggle of men and horses against the unbridled ferocity of wild animals. Gounod's opera *The Queen of Sheba* was produced in 1862, at about the same time Ingres was finishing his fleshscape *The Turkish Bath* (Fig. 447).

The search for exotic settings eventually reached its climax in two of the greatest works of the lyrical stage—Verdi's Aïda, written in 1871 for the Cairo Opera in celebration of the opening of the Suez Canal, and Bizet's Carmen, which, based on a short story by Prosper Mérimée, was first performed in 1875. Toward the end of the century exoticism began to pall, and the realistic novelist Zola made fun of his romantic colleague Gautier because "he needed a camel and four dirty Bedouins to tickle his brains into creative activity."

BACK TO NATURE

Rousseau had already sounded the call of "back to nature" in the late 18th century. In so doing, he challenged the civilized, aristocratic image with his projection of the noble savage whose charm was achieved by shunning society and communing with nature.

For his own part, Rousseau was perfectly willing to be received in courtly circles, and his rustic little opera, *Le Devin du Village (The Village Soothsayer)*, was performed for Louis XVI at Versailles with great success. His ideas were partly responsible for the country cottage, complete with a dairy and mill, that Queen Marie Antoinette had built for herself amid the formal gardens of Versailles (Fig. 448).

The back-to-nature idea took root and became one of the more popular 19th-century escape mechanisms of city dwellers who dreamed of an idyllic country life that they had no intention of living. These people delighted, however, in reading poetry full of nature imagery as well as folk ballads and fairy tales. They hung landscapes by Corot and the now all-too-familiar peasant scenes of Millet on the walls of their apartments and townhouses. Beethoven's *Pastoral* Symphony and Wagner's "Forest Murmurs," as well as dozens of piano pieces and songs, sounded the proper rustic note in music.

Weber's opera *Der Freischütz*, which had been the success of the 1826 season in Paris, brought out some of the darker aspects of nature. In it, much is made of the sinister powers of the night, and the forces over which it rules are effectively presented in

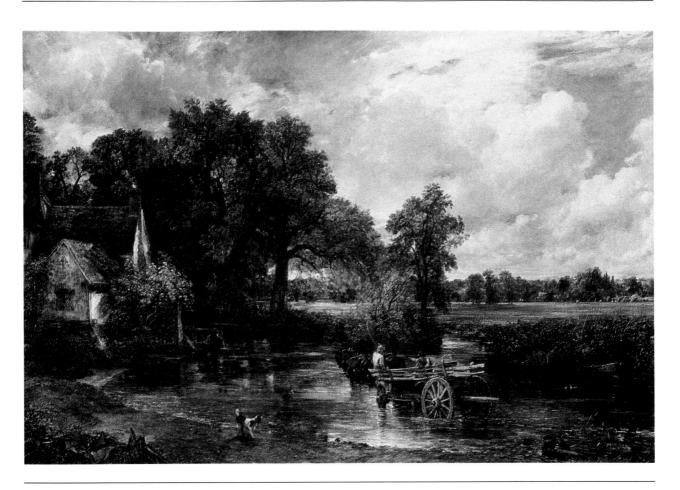

449. John Constable. *Hay Wain.* 1821. Oil on canvas, $4'2\frac{1}{2}'' \times 6'1''$ (1.28 × 1.85 m). National Gallery, London (reproduced by courtesy of the Trustees.).

the eerie "Wolf's Glen" scene. Nature, here, as well as in Goethe's *Faust*, exposed its terrifying as well as its inspiring aspects. Both works portrayed awesome elemental forces as well as powers of a magical and fantastic character.

Outstanding among landscapists was John Constable with his quiet studies of the English countryside such as *Hay Wain* (Fig. 449) and *Salisbury Cathedral from the Bishop's Garden* (Fig. 450). In comparison with the formal balance of the French landscapes by Claude Lorrain that Constable admired (see Fig. 379), the composition of *Salisbury Cathedral* is as relaxed and informal as an English garden.

Constable's major pictorial interests were in capturing unpredictable and fleeting changes of atmosphere; the infinitely varied intensities of light on clear, showery, or foggy days; sunshine filtered through translucent green leaves; and the changing reflections of the many-colored sky and passing

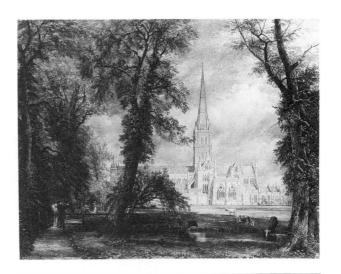

450. John Constable. *Salisbury Cathedral from the Bishop's Garden*. 1826. Oil on canvas, $35 \times 44_4^{17}$ (89 \times 112 cm). Frick Collection, New York.

clouds on water. To capture these effects Constable made numerous oil sketches in the open air and later finished his pictures in his studio. When his paintings were exhibited in Paris, their freshness, warmth, and spontaneity created a considerable stir. Delacroix admired Constable's bold use of color. His descriptive powers and technical innovations had an important influence on the impressionists.

In contrast to Constable's aim of accurate depiction of natural phenomena, the works of J. M. W. Turner, also English and a contemporary of Constable, were poetic invocations and emotionalized experiences tinged with a haunting romantic melancholy. In his early pictures Turner started with variations on the landscapes and seascapes of Claude Lorrain, whom he admired above all artists. His style, however, gradually turned away from the emphasis on history painting to more purely visual and painterly effects, while his grays and browns

yielded to soft, pastel hues and sparkling rainbow-like yellow and orange tonalities. As the titles of his paintings would imply, Turner sought to capture on canvas some of the elemental forces of nature—Snowstorm: Hannibal and His Army Crossing the Alps; Shade and Darkness: The Evening of the Deluge; Wreck of a Transport Ship; and Fire at Sea.

In one of Turner's late works, Rain, Steam, and Speed: The Great Western Railway (Fig. 451), the viewer feels the impact of headlong movement in the Edinburgh express as it crosses a bridge in a driving storm. The rabbit racing ahead of the crack train symbolizes both speed and the romantic's vision of modern technology as a threat to nature and the organic fundamentals of life. Amid the swirling, spiraling storm of wind and rain, the engine's firebox glows with hot, flamelike color that contrasts with the dark blue of the passenger cars and the flecks of light blue in the sky. Constable once criticized

451. Joseph Mallord William Turner. *Rain, Steam, and Speed: The Great Western Railway.* 1844. Oil on canvas, $35\frac{1}{2} \times 47\frac{5}{8}$ " (90 × 121 cm). National Gallery, London (reproduced by courtesy of the Trustees).

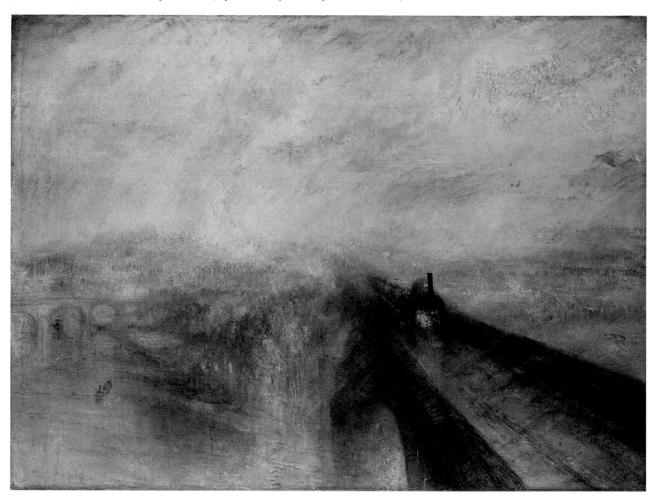

Turner for his "airy visions painted with tinted steam." But in retrospect, Turner's glowing canvases, many-colored light, and ethereal atmospheric effects proclaim him one of the most daring colorists in the history of painting. He pioneered the pathway leading to the use of light and color as a language for conveying mood and emotion.

In Germany the romantic landscape painters were more closely associated with poets and philosophers. Caspar David Friedrich's *The Wanderer above the Mist* (Fig. 452) depicts the image of man alone amid the awesome expanses of nature guided only by his inner light. Like the transcendental philosophers of the romantic period, Friedrich believed that God revealed himself in nature. Here the haunting space and mood of dark brooding melancholy recall the lovely lyric poetry of Wilhelm Müller as set in Franz Schubert's poignant and powerful song cycle *Die Winterreise* (Winter's Journey).

Thomas Cole was the leading landscapist of the Hudson River School. For him nature was the Bible. Through nature, he thought, one could discourse with God, and painting was the revelation of God's handiwork. The sweeping grandeur of the American society he portrayed was truly wild. But Cole's rug-

452. Caspar David Friedrich. *Wanderer above the Mist.* c. 1817–18. Oil on canvas, $29\frac{1}{2} \times 37\frac{17}{4}$ " (74.8 × 94.8 cm). Kunsthalle, Hamburg, West Germany.

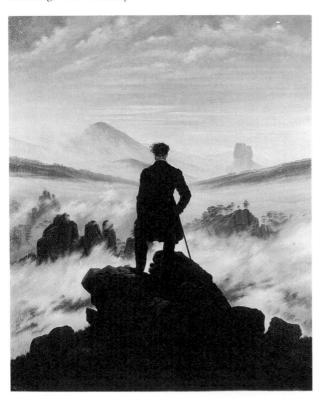

ged wilderness was far from the tame and familiar European countryside. In his pictures the viewer is drawn into the very heart of the pristine New York mountains, complete with craggy cliffs, fallen tree stumps, and gushing streams. Cole's vision is captured in his own words: "Seated on a pleasant knoll, the mind may travel far into futurity. Where the wolf roams, the plough shall glisten; on the gray crag shall rise temple and tower; mighty deeds shall be done in the pathless wilderness; and poets yet unborn shall sanctify the soil." In his *Last of the Mohicans* (Fig. 453) he paints a scene inspired by chapter 29 of James Fenimore Cooper's famous novel. Here is an American painting set in an American land-scape inspired by an American novel.

IDEAS: ROMANTIC HISTORICISM

History, in both the scholarly and popular sense, originated in the 19th century. The newly awakened interest in past periods and peoples began with archeological discoveries in Pompeii and Herculaneum and continued with French and British discoveries in Egypt. In the northern countries interest in medieval sagas, poetry, and romances found literary expression in fanciful Gothic novels. In architecture it took the form of building neo-Gothic castles and in reconstructing and preserving existing medieval abbeys, churches, and cathedrals. There were even architects who specialized in building picturesque ruins.

The dynamics of the revolutionary period with its social, political, and industrial upheavals, confronted artists with the image of a rapidly changing world. No longer were the arts produced only for a small, sophisticated group of aristocrats. Instead, they were addressed to a larger and more anonymous public, mainly middle class. Indeed, most of the artists of this period were themselves from the middle class. Discriminating taste, subtlety, and intellectual grasp of complex forms could not be expected in such audiences. Artists now had to charm, arouse, and astonish. An architect could no longer count on one patron for a single monumental project but had to cater to many clients with smaller buildings.

The concept of a divinely regulated universe controlled by a cosmic clockmaker was no longer valid in a world of constant change and evolving species. The romantic period once again had to recognize the drive of emotion and the force of fanaticism. Even the new scientific discoveries seemed to make the world more, rather than less, mysterious. Now it was necessary for the artist to go beyond logic and delve deeply into subconscious states of mind well beyond rational controls.

453. Thomas Cole. *The Last of the Mohicans.* 1827. Oil on canvas, $25 \times 37''$ (63×94 cm). New York State Historical Association, Cooperstown, New York.

Romanticism, then, is a blanket term covering a whole spectrum of social trends, individual attitudes, and artistic responses. The high degree of individualism ruled out a single stylistic direction. Personal hopes and fears, beliefs and feelings were mirrored in the work of each individual artist, and the consequences were profound and far-reaching. Above all, the romantic view included a sense of history. Creating imaginary places far apart from workaday situations proved a welcome refuge from the increasingly industrialized and mechanized world. It was now not sufficient for an artist to be a fine craftsman; it was necessary to become a great personality and champion of epic causes as well.

The increased ease of travel, the staking out of distant empires, and the interest in foreign lands and peoples added the exotic dimension to romantic thought. The industrial expansion reawakened a nostalgia for unspoiled nature and a redefining of the relationship of life and its natural surroundings. Artistic mediums were also brought closer together under romanticism, and painting and music became allied with literature for poetic allusions and pro-

grammatic interpretations. Color in the painting medium, as well as tone color in instrumentation, became increasingly important in the vocabulary of romanticism.

Sorting out these different trends, the mainstream of romantic ideas includes historicism as expressed in revivals of the past, a new awakening of individualism and nationalism, consciousness of an expanding world as seen in exoticism, a new appraisal of nature, and a closer alliance of art media and colorism.

A sense of history pervaded almost all aspects of thought and activity in the romantic movement. In France, England, and Germany, the medieval past in particular was associated with the foundations of nationhood. The French turned toward their beginnings in the preservation of their Gothic past in architecture, painting, and literature. In England the neo-Gothic Houses of Parliament recalled the origin of their constitution with the signing of the Magna Carta in 1215. In Germany memories of past grandeur pointed back to the Carolingian and Ottonian periods.

In such unstable and drastically changing times historical precedents were cited in all fields—social, political, economic, and aesthetic—to promote a feeling of continuity and stability. The philosophical and social systems of both Hegel and Marx were based on the dynamics of history and the evolving process of thesis, antithesis, and synthesis. Even scientific thinking looked backward to the origins and evolution of species. Meanwhile, the reading public turned the historical novels of Walter Scott, Victor Hugo, Alexandre Dumas, and James Fenimore Cooper into best-sellers. Medieval motifs and imagery animated the spirit of Goethe's *Faust*, Delacroix's paintings, and Berlioz's *Fantastic Symphony* and *Requiem*.

Contributing to this historical consciousness was the educational system, which divided architecture into polytechnical schools on the one hand and schools of fine arts on the other. Because engineers were educated in one school and architects in another, the construction techniques of building tended to be divorced from the stylistic aspects of architecture. When the fine-arts-educated architects did begin using cast iron and other industrial materials, it was to build dream castles and neomedieval cathedrals. Likewise, when musicians began to write for the improved horns and trombones of the 19th century, it was to sound the call of Judgment Day and introduce a rain of neomedieval fire and brimstone into their symphonies.

While willing to use the fruits of the Industrial Revolution as aids in the production and distribution of their artistic wares, the artists of the time were quite convinced that the new technologies were not making their world more beautiful. Thus the gulf between usefulness and beauty widened. Refusing to reconcile themselves to reality, the artists sought ever more fanciful ways to avoid the issue. Certainly they knew what was going on in their world. As intellectuals they were better educated and informed than similar groups in other times had been. However, "Any time but now, and any place but here" became one of the battle cries of romanticism. The vearning for past periods, whether ancient Greco-Roman or medieval, was expressed in the various revivals. The full significance of the Industrial Revolution remained for a later age to exploit.

Neoclassicism had been the earliest of the revivals of the past, and the passion for precision soon had divided it into separate Greek and Roman revival movements. Through historical novels and romantic imaginations, interest in medieval times was awakened; and as medieval scholars extended their studies, artists delved deeper into the Middle Ages. Revivals of Gothic, Romanesque, and Byzan-

tine styles followed next. The romantic love for times past was then expanded into admiration for the Renaissance and the baroque periods. The Library of Sainte Geneviève in Paris (see Figs. 462 and 463) and the Boston Public Library, in their exteriors at least, were revivals of Renaissance architecture. The Paris Opéra, begun in 1861, revived Louis XIV's Versailles. Wagner composed the opera *Rienzi* after a novel by the Englishman Bulwer-Lytton about a ruler of the Roman Renaissance. Mendelssohn rediscovered the greatness of Bach's choral music and in 1829 conducted the first performance of the *St. Matthew Passion* since the composer's death.

In retrospect, the 19th-century separation of the arts into classic and romantic camps has been resolved, because both are now seen as component parts of the same broader revival idea. The artists who lived on into the post-Napoleonic period drew their inspiration from Greco-Roman or medieval times with equal ease. John Nash, for example, built himself a neoclassical townhouse in London and a romantic Gothic castle in the country. Rude made statues of Roman nymphs and of Joan of Arc. Ingres painted the Apotheosis of Homer and later a picture of the Maid of Orleans. Keats wrote "Ode on a Grecian Urn" and also "The Eve of St. Agnes." Victor Hugo included neoclassical odes in the same volume with his medieval ballads. Berlioz admired Vergil as well as Dante and wrote The Trojans, an opera based on the Aeneid.

After neoclassicism and romanticism had run their courses, the revival idea led, in the later 19th century, to a broad *eclecticism*, or choosing at will from a variety of sources. In the arts this allowed an architect to build in any past style, a painter to do a portrait or historical canvas in the manner of Titian or Rubens, a poet to employ any form of metrical organization with ease, and a composer to pull out at will a Renaissance or baroque stop on the organ.

England and Germany both claimed the Gothic style as their own. To them it was a conscious departure from the Greco-Roman ideals of antiquity as well as their rebirth in the Renaissance, baroque, and neoclassical styles. In England especially, the Gothic revival was bound up closely with the wave of prosperity caused by a great industrial expansion, a glowing national pride, and a reaction against the Napoleonic empire that had threatened its own. The English clergy and their congregations demanded the turning away from Greco-Roman architectural forms as essentially pagan and the restoring of medieval liturgies that, in turn, needed appropriate architectural settings.

In Germany, the Gothic revival took the form of a vision of past national glory associated with Charlemagne, whom the Germans adopted as their national hero Karl der Grosse. The relative security and fame of Germany under the rule of the Holy Roman Empire had continued intermittently up to the reign in the 16th century of the Hapsburg Charles V, the last of the powerful emperors. The past thus played an important role in the 19thcentury revival of German power, based as it was on the memory of an empire dominated by the north. Stung into action by the abolition of the Holy Roman Empire under Napoleon, German nationalism fermented during the 19th century. It matured into the heady wine of Bismarck's statesmanship, the aroma of which reminded Teutonic experts of the heroic bouquet of such ancient vintages as Attila the Hun, Alaric, and Frederick Barbarossa.

From the Renaissance on through the aristocratic baroque tradition and the 18th century, French art was closely bound to traditional Greco-Roman forms. During the Revolution of 1789 and its aftermath, a wave of opposition to the Roman Catholic clergy's interference in public affairs led to the actual destruction of some medieval buildings to protest against Church influence and herald the new freedom. The neoclassicism of Napoleon's empire continued through the early years of the 19th century and, though weakened under the Bourbon restoration, had at least official approval right up to the Revolution of July 1830.

Underneath the political surface, however, the destruction of medieval monuments during the

French Revolution had indirectly stimulated certain groups to preserve parts of these works in museums. When the glories of their own medieval past were brought to the attention of some of the French at a time when the popular wave of neomedievalism was gathering momentum in England and Germany, there were bound to be consequences in France.

Very significantly, it was not until French national power had been thoroughly subdued under the coalition that defeated Napoleon in 1815 that the romantic style took a firm hold on the French mind and imagination. For the first time France began to look within and rediscover the roots of her nationhood in early medieval times. Even so, this interest in medievalism and romanticism lasted officially less than a generation—that is, between the revolutions of 1830 and 1848. Then, under the new emperor, Napoleon III, imperial ambitions rose once more, and a later phase of neoclassicism became the official style.

In retrospect, romanticism, in its many manifestations and various guises and disguises, has proved its durability. Successive styles—impressionism, expressionism, cubism—have come and gone. Romantic literature, however, continues to be read with pleasure and profit; romantic painting and architecture are admired; and romantic music in concert halls, opera houses, and on recordings is probably more widely popular today than it was in its own historical setting.

LATE 19TH CENTURY

	KEY EVENTS	ARCHITECTURE AND VISUAL ARTS	LITERATURE AND MUSIC
		1801-1865 Joseph Paxton ★ 1801-1875 Henri Labrouste ★ 1808-1879 Honoré Daumier ▲ 1809-1891 Georges Eugene Haussmann ★ 1819-1877 Gutave Courbet ▲ 1822-1899 Rosa Bonheur ▲	1799-1850 Honoré de Balzac ♦ 1809-1865 Pierre Joseph Proudhon ♦ 1812-1870 Charles Dickens ♦ 1813-1883 Richard Wagner □ 1818-1883 Karl Marx ♦ 1820-1903 Herbert Spencer ♦ 1821-1867 Charles Baudelaire ♦ 1821-1880 Gustave Flaubert ♦ 1821-1881 Fyodor Dostoyevsky ♦ 1822-1890 César Franck □
1825 - 1850 -	1830-1848 Louis Philippe, constitutional king of France 1837-1901 Victoria, queen of England 1848 February Revolution; Louis Philippe overthrown. Second French Republic proclaimed. Communist Manifesto issued by Marx and Engels	1825-1898 Charles Garnier ★ 1827-1875 Jean Baptiste Carpeaux ● 1832-1923 Gustave Eiffel ★ 1832-1883 Édouard Manet ▲ 1834-1903 James A. McNeill Whistler ▲ 1834-1917 Edgar Degas ▲ 1839-1906 Paul Cézanne ▲ 1840-1917 Auguste Rodin ● 1840-1926 Claude Monet ▲ 1841-1919 Pierre Auguste Renoir ▲ 1841-1895 Berthe Morisot ▲ 1844-1916 Thomas Eakins ▲ 1844-1926 Mary Cassatt ▲ 1848-1903 Paul Gauguin ▲	1828-1906 Henrik Ibsen ◆ 1828-1910 Leo Tolstoy ◆ 1833-1897 Johannes Brahms □ 1835-1921 Camille Saint-Saëns □ 1838-1875 Georges Bizet □ 1839 Daguerre and Niépce published findings on photography; daguerreotype process resulted 1840-1902 Émile Zola ◆ 1840-1893 Peter Tchaikovsky □ 1842-1912 Jules Massenet □ 1842-1912 Jules Massenet □ 1844-1900 Friedrich Nietzsche ◆ 1845-1924 Gabriel Fauré □
	1851 Louis Napoleon, president of Second Republic, became dictator by coup d'état 1852-1870 Louis Napoleon reigned as Emperor Napoleon III 1853 Admiral Perry opened Japan 1861 American Civil War began 1862 Bismarck became Prussian premier 1863 Abolition of slavery proclaimed in U. S. 1862-1886 Ludwig, king of Bavaria 1869 Suez Canal opened 1870-1871 Franco-Prussian War; Napoleon III abdicated; Third French Republic established; Germany united as empire	1851 Great Exhibition of All Nations in London; Crystal Palace by Paxton was one of buildings. 1852-1926 Antonio Gaudi ★ 1853-1890 Vincent Van Gogh ▲ 1858-1868 Bibliothèque Nationale built by Labrouste 1859-1891 Georges Seurat ▲ 1863-1944 Edvard Munch ▲ 1864-1901 Henri de Toulouse-Lautrec ▲ 1864-1927 Paul Sérusier ▲ 1889 La Grande Exposition Universelle held in Paris; Eiffel Tower was one of buildings 1874 First impressionist exhibit held	1850-1893 Guy de Maupassant ◆ 1856-1866 Physiological Optics published by Helmholtz (1821-94) 1857 Les Fleurs du Mal (Flowers of Evil) published by Baudelaire 1859 Origin of Species published by Darwin 1859-1941 Henri Bergson ◆ 1860-1956 Gustave Charpentier □ 1862-1918 Claude Debussy □ 1862-1949 Maurice Maeterlinck ◆ 1863 Life of Jesus published by Renan 1863 On the Sensation of Tone as a Physiological Basis for the Theory of Music published by Helmholtz 1870-1925 Pierre Louÿs ◆ 1871-1922 Marcel Proust ◆ 1871 Descent of Man published by Darwin
1875 -	1888 Wilhelm II, emperor of Germany 1889 Boer War between British and Dutch in South Africa begins		1875-1937 Maurice Ravel □ 1892 Pelléas et Mélisande by Maeterlinck presented in Paris 1896 Matter and Memory published by Bergson; Creative Evolution published in 1907 1902 Debussy's opera on Maeterlinck's Pelléas et Mélisande produced in Paris

20

Realism, Impressionism, and Symbolism

REALISM

Realism as a style was bound to occur as a reaction to romantic flights of fancy. A new world was waiting to be discovered in the rush of urban life, in the machines that revolutionized manufacturing, in the growth of industry, and in the facility of railway transportation. The growth of factories and the new machine-driven methods of production meant the shift from a farming to an industrial economy accompanied by the migration of large numbers of people from the country to the cities. Rapid changes were also taking place in the minds of the people, whose lives now moved at a faster pace, bringing about new social attitudes, new insights, and new adjustment problems.

Writers reveled in the rapidity of the printing presses, musicians marveled in the mechanical and acoustical improvements of their instruments, and painters delighted in the brilliant coloristic possibilities of synthetic chemical pigments. Low-cost reproductions such as lithographs and other print techniques made possible a wider distribution of pictures to a growing public. For the architects, such new materials as cast iron aided in the rapid construction of buildings. New manufacturing methods also yielded complicated decorative devices. Such ornamentation, formerly made painstakingly by hand, could now be produced in quantity quickly and cheaply to satisfy the demand for the practical and picturesque.

Not only did the application of scientific knowledge to industrial progress open many possibilities, but from the mid-19th century onward it raised many questions as well. Governments were seeking constitutional formulas that would strike a just balance between social rights and material progress. Religious denominations were trying to recon-

cile time-honored scriptural truths with the new scientific knowledge. Social theories explored the ways in which political liberalism could evolve side by side with traditional religious views. And philosophies attempted a new resolution between the fixed absolutes of idealism and the dynamic thought underlying the theories of evolution.

Architects, too, were wondering how their work could still remain in the realm of the fine arts and yet make use of the new materials and technological methods they now commanded. Sculptors such as Rodin were asking whether the traditional mythological and historical themes could be replaced by more contemporary subjects. The realistic and impressionistic painters were seeking a formula for incorporating into the accepted framework of pictorial art the new physical discoveries concerning the nature of light and its perception by the human eye.

Likewise, novelists such as Zola were trying to establish an alliance between scientific and literary methods. Poets and playwrights such as Mallarmé and Maeterlinck were looking for a middle ground between the realities of the revolutionary age and the traditional limitations of poetic expression. And such composers as Debussy tried to harmonize the new discoveries involving the physics of sound with accepted concepts of tonality and musical form.

Governments and rulers settled down from high-flown heroics and theatrical displays into the drab but necessary routine of bureaucratic officialdom. The energies of artists were diverted from historical and exotic subjects to everyday life and seemingly trivial occurrences. The novels of Balzac and Dickens were concerned with social comment and criticism, as was the art of Honoré Daumier. The people of Daumier's Paris live on in such genre works as *Third-Class Carriage* (Fig. 454), in which the

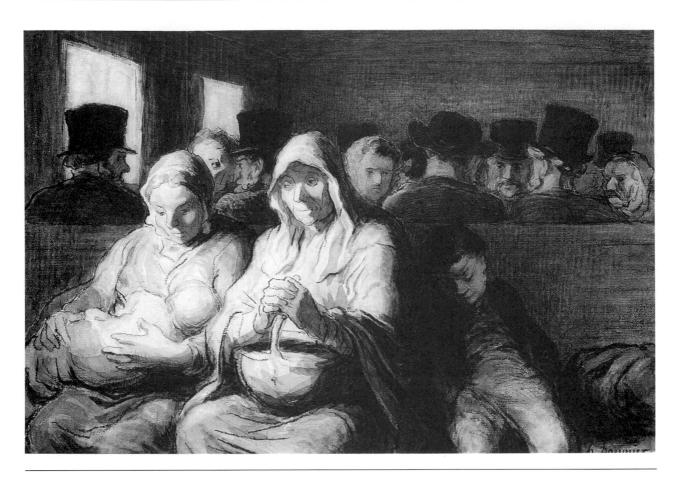

454. Honoré Daumier. *Third-Class Carriage.* c. 1862. Watercolor on paper, $8 \times 11\frac{5}{8}$ " (20 \times 30 cm). Walters Art Gallery, Baltimore.

artist's sense of social criticism is softened and his deep understanding and human compassion come to the fore. Ugliness, violence, and shock techniques, however, were intended to arouse but not to insult, offend, or alienate potential patrons.

Some artists, though, found life so disillusioning that art became the sole compensation for the miseries of their existence. These painters and poets eventually cut their ties with their potential middle-class patrons altogether. They retreated into a private world of art, where the painters produced pictures for a limited audience of other painters of similar persuasion and the poets wrote down their inspirations principally for the eyes and ears of other poets. Leading such insecure and underprivileged lives, artists often banded together in desperate little societies within society.

All these developments tended to turn artists toward the new world of the great city for their material and inspiration. The artificial replaced the natural, and urban entertainments eclipsed the delights of nature. The usual was dominant over the un-

usual, and the realistic here and now was in ascendance over the romantic there and then.

Painterly Realism

About the middle of the 19th century, the most important younger painters rejected romantic flights of the imagination and academic glorification of the heroic past. Those who styled themselves "realists" defined painting as a physical language and ruled out the metaphysical and invisible. The miracles of the 19th century, according to them, were mines, machines, and railroad trains.

COURBET. In the vanguard of the realists was Gustave Courbet. With a keen eye and a desire to record accurately what he saw about him, Courbet consciously set out to build an art on commonplace scenes. His painting was concerned with the present, not the past; with the momentary, not the permanent; with bodies, not souls; with the material, not the spiritual. His nudes were not nymphs or god-

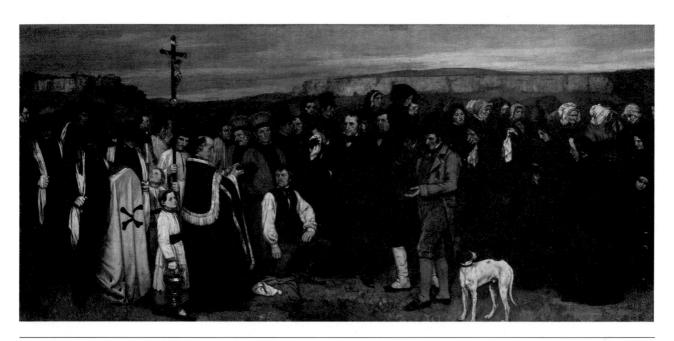

455. Gustave Courbet. *Burial at Ornans*. 1849. Oil on canvas, $10'3'' \times 20'10''$ (3.12 \times 6.35 m). Louvre, Paris.

desses but models who posed in his studio. When asked why he never painted angels, he replied, "Show me an angel and I'll paint one."

The villagers attending the *Burial at Ornans* (Fig. 455) are there out of a sense of duty. The priest routinely reads the committal service, and the gravedigger casually waits his turn to complete the job. No one betrays any great grief, and the skull and bone at the grave's edge add a realistic rather than a macabre touch. Courbet, however, sometimes became almost as passionate about the ugly as his predecessors had been about the beautiful. Both Courbet and Édouard Manet, who came under his influence, were sometimes seduced, despite themselves, into a strong emotional interest in their subject matter.

EAKINS. Realism found an American champion in the work of Thomas Eakins, who at first was as much interested in science as he was in art. His *Gross Clinic* (Fig. 456) was painted for the Jefferson Medical College in his native Philadelphia, where he himself had dissected cadavers in his student days. Here all his keen powers of observation are brought to bear in the operating theater, where several skilled surgeons are at work in a medical classroom. The obvious antecedent is Rembrandt's *Anatomy Lesson* (see Fig. 350). But Eakins's treatment has more immediacy and sharpness of focus. The light and

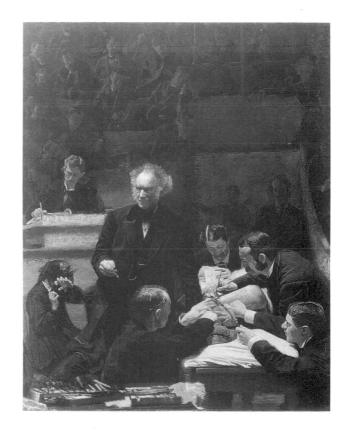

456. Thomas Eakins. *The Gross Clinic*. 1875. Oil on canvas, $8' \times 6'6''$ (2.44 \times 1.98 m). Jefferson Medical College, Philadelphia.

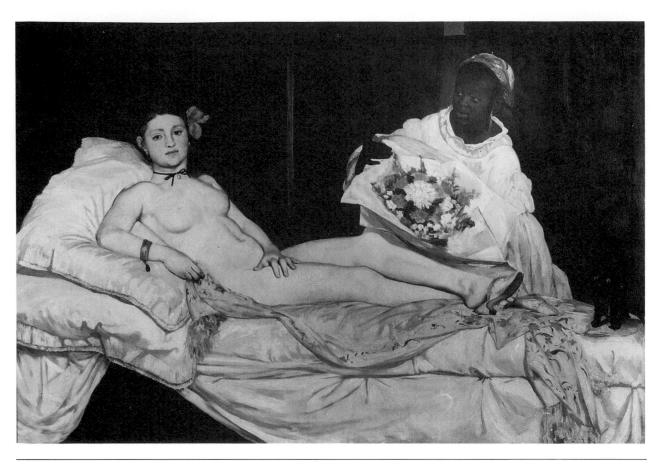

457. ÉDOUARD MANET. *Olympia*. 1863. Oil on canvas, $51\frac{1}{4} \times 74\frac{3}{4}$ " (130 × 190 cm). Musée de l'Impressionisme, Paris.

shade are more cameralike than Rembrandt's, but no less dramatic. The only touch of emotion is that of the mother of the patient, who holds her hands before her face in a convulsive gesture. There are no macabre touches of romanticism, only the calculated efficiency of the medical routine, with the noted surgeon Dr. Gross making his points while the students show various attitudes—close attention, indifference, or boredom. In other pictures Eakins captured the American love of sports with boat races, boxing matches, and hunting and shooting scenes. These and his penetrating portraits were all done with a relentless, sharp, realistic eye.

Manet. Back in Paris Édouard Manet had begun his career in the realistic style. His frank depiction of *Olympia* (Fig. 457) caused a major furor because it was recognized as a portrait of a well-known Paris courtesan of that name. Iconographically, the picture is in the Renaissance tradition of sleeping Venuses. However, this is no aloof goddess, but a successful member of the world's oldest profession.

Here, Manet portrays her, in Parisian parlance, as one of the "grand horizontals." Wide awake and looking very pleased with herself, she is surrounded with the attributes of success—flowers from a lover, a maid servant, and a cat to add a domestic touch.

Manet's realistic approach drew all manner of critical vituperation from the press and public. In his lifetime, his pictures achieved only notoriety and a type of scandalous success. One of his most ardent champions, however, was the writer of realistic sociological novels, Émile Zola, whose portrait appears on the cover of this book. Manet paints his friend and champion as a man of thought, seated at his desk and surrounded by the attributes of his trade together with allusions to the realistic movement in painting. On the wall are pictures within the picture—one of the Japanese prints that were so much admired for their bright colors and informal subjects of popular entertainments in theaters and teahouses, in this case an actor; and a self-quotation of Manet's own Olympia (Fig. 457), which is placed in front of Velásquez's masterpiece, Bacchus, or The Drinkers.

On the desk behind the quilled pen are the manuscript pages of Zola's monograph defending Manet's art, and it is here that Manet signs his painting. The fine composition is based on a series of rectangles foreshadowing the later cubist collages and the art of Mondrian (see Figs. 494, 495, and 500).

DEGAS. In the art of Edgar Degas the human figure is the focal center. Unlike Courbet and his contemporaries, Degas was uninterested in landscape. Beginning as a realist like his friend Manet, he eventually moved toward the lighter tonality and more brilliant color palette of the impressionists, particularly in his famous studies of ballet dancers. However, his deliberate approach, emphasis on line, and carefully constructed composition made his relationship to the impressionists a peripheral one.

Degas' command of line, meticulous drafts-manship, and accuracy of detail are all evident in the *Cotton Exchange at New Orleans* (Fig. 458). Degas' mother and her family were from New Orleans, and on an extended visit to his uncle and brothers who were in the cotton business there, he painted this

tightly knit composition in depth. "Everything attracts me here," he wrote back to a Paris friend. "I look at everything. . . ." Note the figures framed by the open windows and the way that all the other figures occupy an appointed place in relation to the receding planes. Each figure is also a portrait study in itself. Some are intent on inspecting the cotton; others are at their work; still others lounge in casual attitudes, awaiting developments. Degas' keen eye always seems to catch the exact moment that reveals individual character and personality whether the individual is a casual stroller in a park, a dancer executing arabesques, or a merchant at work.

Literary Realism

The literary dimension of realism is found in a host of major writers. The increasing level of education and rising literacy of the population created an everlarger readership. Many writing in the realistic vein found their inspiration in everyday events and real-life experiences. Honoré de Balzac created a complete fictional bourgeois world in his *Human Comedy*

458. Edgar Degas. Cotton Exchange at New Orleans. 1873. Oil on canvas, $28\frac{3}{8} \times 35\frac{3}{8}$ " (72 × 90 cm). Musée des Beaux-Arts, Pau, France.

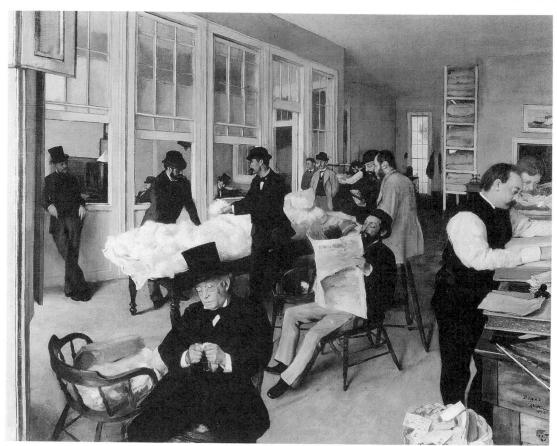

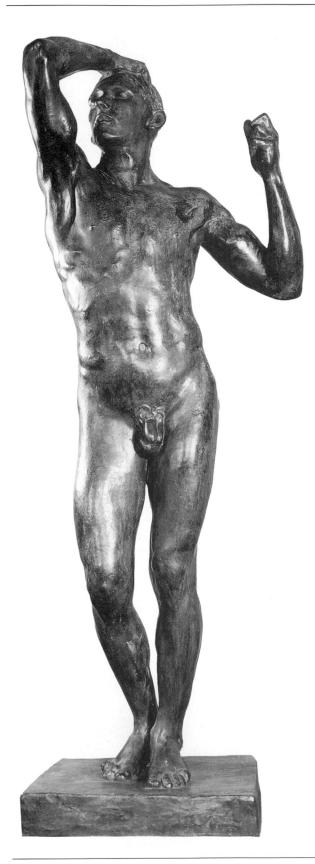

459. Auguste Rodin. *Age of Bronze.* 1876–77. Bronze, height 5'9" (1.8 m). Minneapolis Institute of Arts (John R. Van Derlip Fund).

that reflected the political and social trends of his time. Gustave Flaubert depicted Madam Bovary's struggles against the banalities of humdrum daily existence that drove her into a succession of ruinous tawdry affairs. In England Charles Dickens with his boundless humanity, exposed the plight of those condemned to debtor's prisons, the treatment of the poor in workhouses, and the exploitation of children in factories, always with wit and compassion. In Russia there was Fyodor Dostoyevsky, with his deep insights into the subconscious motivations of human behavior, his search for psychological truth in his characters, and the reasons for their alienation from society.

The novelist Émile Zola and the dramatist Henrik Ibsen allied themselves with sociology and wrote much as social workers might handle case histories. Zola, however, by temperament could not write without a passionate self-identification with the oppressed subjects of his novels. In the spirit of a reformer, he found it necessary to bring social sores out into the sunlight of public exposure in order to effect their cure. In Zola, the novelist's role resembled that of a social research worker, the novel a documentary case history.

Sculptural Realism: Rodin

Among the sculptural exhibits at the Paris Salon of 1877 was a statue of a nude youth entitled Age of Bronze (Fig. 459). Too lifelike, said the academic critics. Too good, thought his fellow sculptors as they started rumors that Auguste Rodin was trying to pass off a statue taken directly from plaster casts of a living model. In official quarters the gossip was given sufficient belief to cause the hasty withdrawal of the work. To refute one and all, Rodin had casts and photographs made of the model who had posed for him, and the following year, with official explanations and apologies, the Age of Bronze was again on exhibition. A short while later it was bought by the state for placement in the Luxembourg Gardens. Such was the gulf, however, between art and life, between a monument and a reality, that in academic circles a statue that looked too real, too lifelike or natural, was considered a disgrace.

Gates of Hell. Like his forward-looking contemporaries in other fields, Rodin had turned away from the heroic toward the natural. While he admired Gothic sculpture and wrote a book about French cathedrals, his work contains few sermons in stone. Though he admired Dante and drew most of his later subjects from an early project for the Gates of Hell (Fig. 460), his conceptions show little of the

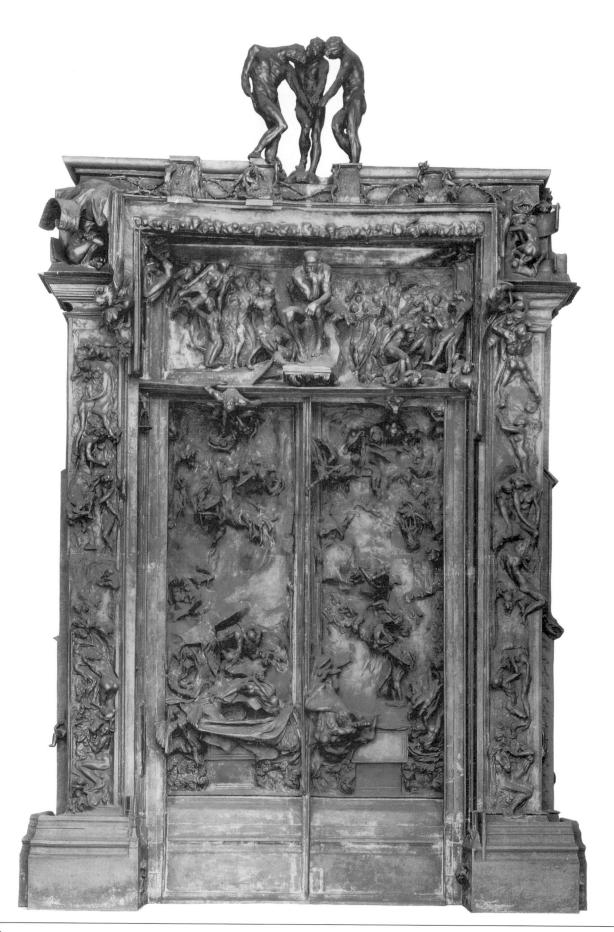

460.
Auguste Rodin. Gates of Hell. 1880–1917. Bronze, height 18' (5.49 m), width 12' (3.66 m), depth 2'9" (.84 m). Rodin Museum, Philadelphia (gift of Jules E. Mastbaum).

neomedieval hellfire and brimstone that motivated his romantic predecessors.

Intended as door panels for a projected building to house the Paris Museum of Decorative Arts, Rodin's gates had as their points of departure the portals of the Florence Baptistry, notably Ghiberti's Gates of Paradise (see p. 232) and the writhing nudes of Michelangelo's Last Judgment (see Fig. 322). The literary source was an odd combination of Dante and the symbolist poetry of Baudelaire. "Dante is not only a visionary but a sculptor," wrote Rodin. "His expression is lapidary in the good sense of the word." By "lapidary" Rodin implied that Dante's words and images were carved as if on stone. Above the doors broods the Michelangelesque figure of The Thinker—a man, not Christ, is here to judge. Rodin's figures are bodies, not souls; his damned suffer more from sensuous than spiritual longings.

Most details for the *Gates of Hell* were worked out between 1880 and 1887, except for readjustments that went on until 1917. *The Thinker*, Rodin's best-known work, and *Three Shades* (Fig. 460, top), *Adam*, and *Eve*, three of Rodin's later large-scale sculptures, were derived from the original germ of his inspiration for the *Gates of Hell*.

RODIN AND **HIS MATERIALS.** Not only did Rodin prefer the natural over the heroic, but he always acknowledged his material frankly, seeking neither to disguise it nor escape from it. In many of his works there is the feeling that his figures are just emerging out of their original state.

For Rodin, the process of forming supersedes that of form itself. The Hand of God (Fig. 461) exemplifies this, both in the method of execution and in the subject itself. Out of an indefinite mass of uncut stone, symbolic of the formless void, the hand of the Creator arises. Divine power over all things is suggested by the scale of the hand in relation to that of the human figures emerging from a lump of uncarved marble. The significance of the work was caught by the philosopher Henri Bergson, author of Creative Evolution, who called it "the fleeting moment of creation, which never stops." It is the implication that nothing is ever quite complete; that everything takes place in the flow of time; that matter is the womb, continuously giving birth; that creation is never-ending—in short, the acceptance of the theory and philosophy of evolution—which gives Rodin's conception it daring quality.

This is not, however, the mighty Michelangelesque struggle of mortals against their material bonds. Rather, it is a sensuous love of material as such, a reveling in the flesh or stone, and a desire to explore all its possibilities and potentialities. If Mi-

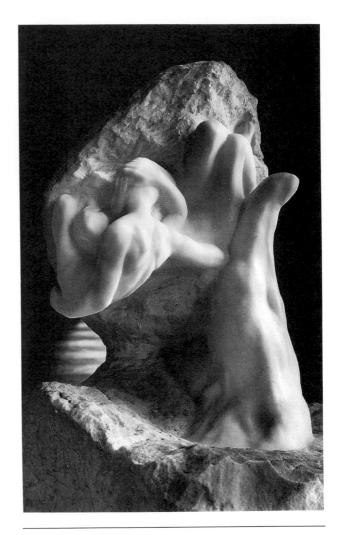

461. Auguste Rodin. *Hand of God.* 1889. Marble, height 29" (74 cm). Rodin Museum, Paris.

chelangelo left his figures incomplete and still dominated by their material medium, it was largely because circumstances prevented his finishing them. With Rodin, the incompleteness is a conscious and calculated part of his expressive design. Like the symbolist poets, the novelist Proust, and the dramatist Maeterlinck, Rodin went one step beyond mere description. For Rodin, as for his literary contemporaries, events were nothing in themselves. Only when conjured up later in memory did they acquire the necessary subjective coloration; and only then, paradoxically, could the artist treat them with the needed objective detachment.

Rodin always preferred to work from a memory image than directly from a model in the flesh. When he did work with a model, it was usually to make a quick sketch, a wash drawing, or an impression in wax or soft clay. He could then allow his figures to take plastic shape in this preliminary stage

at the moment of inspiration and thus to promote the feeling that they were products of improvisation. The process of transferring his figures into marble or bronze was left until the forms had been refined in memory and had assumed a more subjective and personal quality. Through memory and by looking inward, Rodin was able to give his compositions broader meaning; and by the addition of psychological depth, he gave his art substance and quality that raised it far above the world of appearances.

Architectural Realism

Throughout the 19th century there was a sharp division of thought about the work of an architect. Was the architect primarily an artist or a builder? A designer or an engineer? Should the architect be concerned more with decoration or with structure? Was the architect's place in a studio making drawings or in the field working with materials?

The champions of the viewpoint that the architect was primarily a fine artist achieved such facility that at practically a moment's notice they could produce on their drawing boards a design based on any known building from the past. Late in the century,

all the historical styles had been so carefully catalogued and documented that the range of choices was almost unlimited. What had begun as the revival of special periods now included them all.

The term for such a freedom of choice is eclecticism, and if a name is to be chosen for the architectural style of the period, this is the only one possible. The sole limitation on this eclecticism was the generally accepted appropriateness of the styles of certain periods to special situations. The classical was considered best for commemorative buildings and monuments, but "classicism" now could be anything from Mycenaean Greek to late imperial Roman. Medieval was the preference for churches, but this might mean Byzantine, Romanesque, early or late Gothic. For public buildings, Renaissance was thought to be the most suitable choice.

The industrial age, however, had produced new methods and materials that opened up novel possibilities. The potentialities of cast iron, for example, had been perceived by engineers and industrialists long before architects began to speculate on its creative applications to their art. The structural use of iron actually dates from the latter part of the 18th century, although at first it was found in bridges or

462. Henri Labrouste. Library of Ste. Geneviève, University of Paris (Sorbonne). 1843–50. Length 336' (102.41 m).

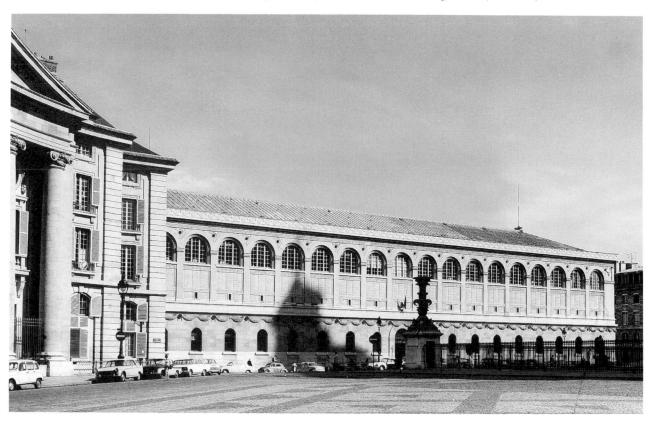

in cotton mills and other functional buildings, where it usually was combined with brick, stone, or timber or else used as a substitute for one or more of them. Nevertheless, the first steps toward a revolution in the art of building had been taken.

With the use of cast iron and steel, the 19th century was eventually to see the spanning of broader widths, the enclosure of more cubic space, and projections toward greater heights than had hitherto been thought possible. The new materials and structural principles were both a threat and a challenge to the traditional pictorially oriented designers, and the more they were used in building plans, the more progressive architecture became.

LABROUSTE'S LIBRARIES. It has already been noted how iron columns and girders had been used quite openly by John Nash in the exotic Royal Pavilion (see Figs. 445 and 446) at Brighton, marking one of the first instances of their use in a large residential building. In Paris, François Gau had used iron girders masked with stone facings to reinforce his Church of Sainte Clotilde (see Fig. 440).

Now Henri Labrouste, with an even more penetrating insight into the possibilities of the new material at his command, went one step farther in his Library of Sainte Geneviève (Fig. 462). A first glance at its exterior reveals simply a well-executed Renaissance-revival building—as such it is indebted to a 15th-century Italian church in Rimini designed by Alberti—with the usual festoons of garlands adorning the space above its row of windows. A closer inspection, however, shows that the ground floor is conceived as a solid space, while the bold arcade of windows above gives promise of light and air within. Since the building is a library, there is a working relationship between the closed storage space for the books below and the open reading room above. This is as far as the exterior goes toward a unity of means and ends, however. The stone on the outside gives no hint that the interior is constructed of iron.

By utilizing the strength of metal, Labrouste was able to replace the massive masonry ordinarily required for such a large reading room (Fig. 463) and at the same time provide for a maximum of open space and brilliant illumination. The room is vaulted with two series of arches made of cast iron, supported by tall, thin, fluted cast-iron columns, which form two parallel barrel vaults. An open leafy pattern related to the classical acanthus motif is used

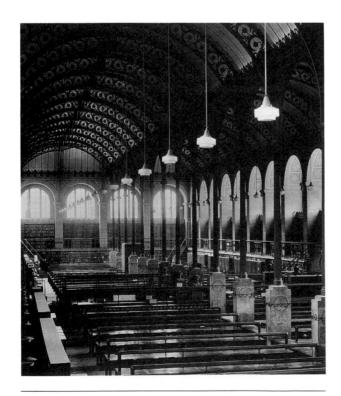

463. Henri Labrouste. Reading Room, Library of Ste. Geneviève, University of Paris (Sorbonne). 1843–50. Length 330′ (100.58 m), width 60′ (18.29 m), height 42′ (12.8 m).

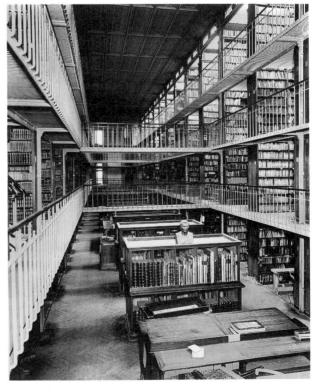

464. Henri Labrouste. Stacks, National Library, Paris. 1858–68.

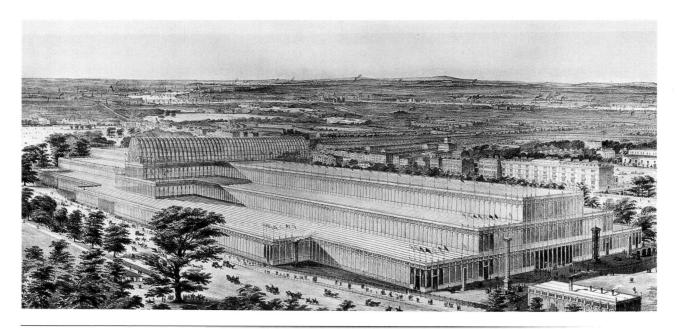

465. Joseph Paxton. Crystal Palace, London. 1851. Cast iron and glass, width 1851' (564.18 m). Lithograph.

as a decorative theme, and the vaults are supported by tall, thin, fluted Corinthian colonnettes, also made of iron. Labrouste thus managed his material so that he brought out its full structural possibilities. But by allowing his iron colonnettes to assume a form associated with carved stone, he compromised with tradition and let the expressive potentialities lag somewhat behind.

What Labrouste began in the Library of Sainte Geneviève he brought to a brilliant fulfillment in his later masterwork, the Bibliothèque Nationale, the National Library of France (Fig. 464). This storage space for books is conceived as the very heart of the library. It is now brought out into the open alongside the reading room itself. Though closed to the public, a full view of it is possible through a glass-enclosed archway. All superfluous ornamentation is omitted in favor of the function for which it was designed. Except for the bookcases and the glass ceiling, everything is of cast iron.

By dividing his space into five stories, four above and one below the ground level, Labrouste provided for the housing of about a million volumes. The floors are of open grillwork, which permits a free flow of light to reach all levels. Frequent stairways provide rapid communication between floors, and the strategically placed bridges allow freedom of access between the two wings. As a composition, they present a pleasing visual pattern of vertical and horizontal intersecting planes. In both these libraries, it is evident that Labrouste had taken a bold stride toward the realization of the potentialities of

the modern materials. His work as a whole is a contribution to the development of a new architecture.

PAXTON'S CRYSTAL PALACE. The same year that Labrouste was completing his first library, a new and original structure was going up in London that made no pretensions of being either a Roman bath or a Renaissance palace. The *London Times* referred to it as "Mr. Paxton's monstrous greenhouse"; and, to be sure, it was conceived and carried out by a landscape gardener skilled in the construction of conservatories and nurseries.

The occasion was the Great Exhibition of the Works of Industry of All Nations, where the latest mechanical inventions, as well as raw materials, were to be brought together with the finished products of industry. Machinery of all sorts was to take its place beside the manufactured arts and crafts that were being turned out by the new factories. The Crystal Palace (Fig. 465) that Joseph Paxton constructed to house the exposition was destined to eclipse the exhibits themselves and to occupy a unique place in the history of modern architecture. His light and airy structure was rectangular—408 feet (124 meters) wide and, with a neat bit of symbolism to coincide with the year of the exhibition, 1,851 feet (564.2 meters) long. It rose by means of a skeleton of cast-iron girders and wrought-iron trusses and supports, all bolted together with mathematical precision. Its walls and roof enclosed 33 million cubic feet (9.3 million cubic meters) of space.

The rapidity of the construction of the Crystal Palace was no less remarkable than its form. Previously, the whole structure had been accurately analyzed into a large number of prefabricated parts. So well planned was it that 18,000 panes of glass were put in place by 80 workers in one week. Begun at the end of September 1850, it was easily ready for the grand opening on May 1, 1851.

Contrary to expectations, the Crystal Place turned out to be a thing of surprising beauty and brilliance, as inexpensive in its construction as it was daring in its use of materials. No applied decoration of any sort marred the forthright character of the exterior. And while the iron columns of the interior paid lip service to their classical ancestors, the enormous scale made such details incidental.

At the inauguration ceremonies (Fig. 466), Albert, the prince consort, stood by a crystal fountain and restated the purpose of the exhibition: to present "a living picture of the point of development at which the whole of mankind had arrived, . . . and a new starting point from which all nations will be

able to direct their further exertions." Nothing seemed impossible to the machine age, and the engineers were indeed the prophets of the new order. Everything now seemed set for the Victorians to step out of their self-created pseudo-Gothic gloom into the new shining age of industrial prosperity. Paxton and his greenhouse, however, had to wait more than half a century before the architects caught up with them.

IMPRESSIONISM

The artists who followed Courbet sought for even greater closeness to nature in order to develop an art based on immediacy of expression. They took their easels outdoors and tried to do as much of their painting as possible on the spot rather than working in their studios from sketches. They were against painting a picture that carried any moral, any message, or any literary associations, and they cultivated indifference toward pictorial content.

466.Joseph Paxton. Foreign Pavilion, Crystal Palace, London. 1851. Color lithograph by J. Nash. From Dickenson's *Comprehensive Pictures of the Exhibition*, 1854.

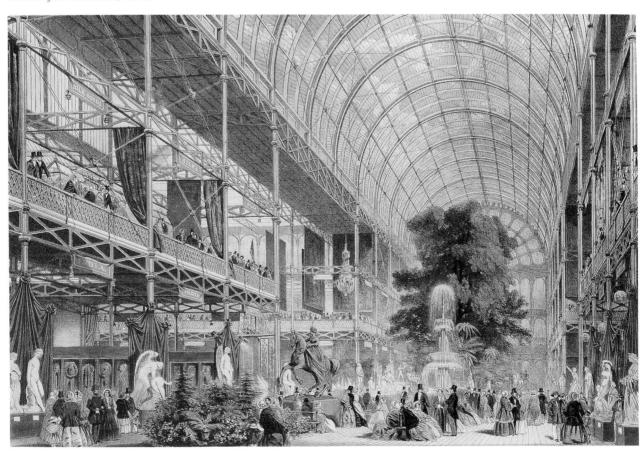

Optical realism was pursued to the point of separating visual experience from memory and avoiding any associations the mind normally calls into play. In 1874, Claude Monet exhibited a picture called *Impression—Sunrise*, which gave the new movement its name. At first, *impressionism* was picked up as a term of critical derision. The word has remained, and it does have a certain appropriateness, implying the unfinished, the incomplete, an affair of the moment, an act of instantaneous vision, a sensation rather than a perception.

Impressionist painters were well aware of the new discoveries in the science of optics, color theory, and the nature of light, and the new knowledge about the physiology of the eye. Joint researches of the painter Daguerre and the scientist Niépce on the making of photographic images on prepared metal

plates, which resulted in the *daguerreotype* process, had been published as early as 1839. The revelation that visual imagery was primarily dependent on extremely fine gradations of light intensities was bound to have an effect on painting. Physicists, including Helmholtz, made discoveries about the component prismatic parts of white light and pointed out that the sensation of color has more to do with a reaction in the retina of the eye than with objects themselves. The color wheel also demonstrated that two separate hues of a wheel at rest are fused by the eye into a third hue when the wheel is in rapid motion. And when all the colors of the spectrum are rotated, the eye sees them as tending toward white.

Painters also did some speculation of their own on the nature of the visual experience. Form and space, they reasoned, are not actually seen but im-

467. ÉDOUARD MANET. Rue Mosnier, Paris, Decorated with Flags on June 30, 1878. 1878. Oil on canvas, $25\frac{1}{2} \times 31\frac{1}{2}$ " (65 × 80 cm). The J. Paul Getty Museum, Malibu.

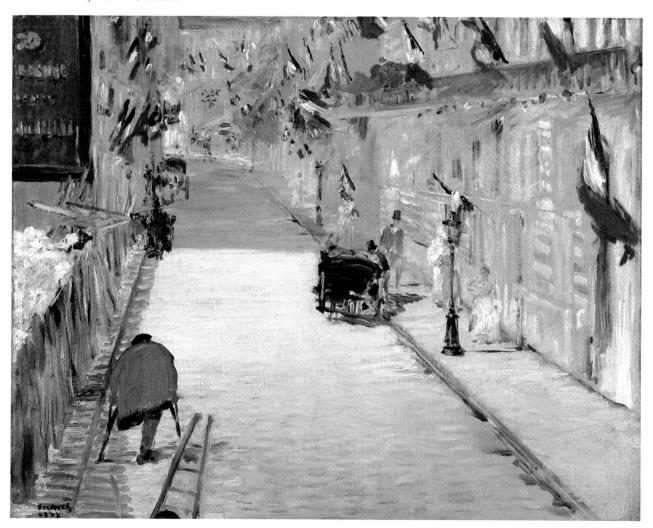

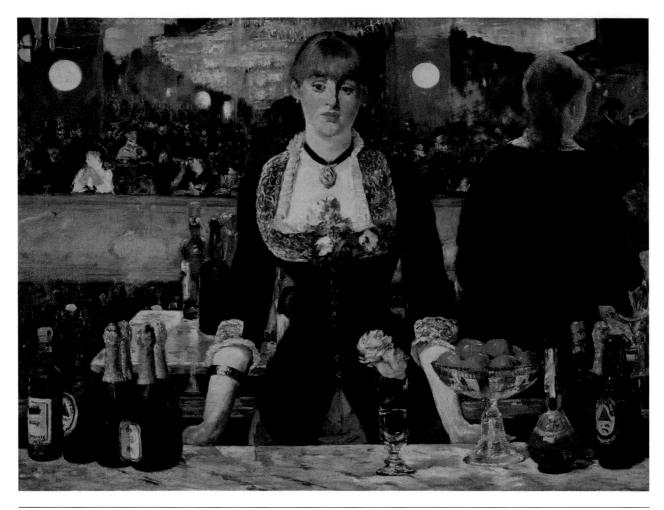

468. ÉDOUARD MANET. Bar at the Folies-Bergère. 1881–82. Oil on canvas, $3'1\frac{1}{2}'' \times 4'3''$ (.96 × 1.3 m). Courtauld Institute Galleries, London.

plied from varying intensities of light and color. Objects are not so much things in themselves as they are agents for the absorption and refraction of light. Hard outlines, indeed lines themselves, do not exist in nature. Shadows, they maintained, are not gray or black but tend to take on a color complementary to that of the objects that cast them. The concern of the painter, they concluded, should therefore be with light and color more than with objects and substances.

A painting, according to the impressionists, should consist of a breakdown of sunlight into its component parts, and brilliance should be achieved by the use of the primary colors that make up the spectrum. Instead of greens mixed by the painter on the palette, separate dabs of yellow and blue should be placed close together and the mixing left to the spectator's eye. What seems confusion at close range is clarified at the proper distance. By thus trying to increase the brightness of their canvases so as to con-

vey the illusion of sunlight sifted through a prism, they achieved a veritable carnival of color in which the eye seems to join in a dance of vibrating light intensities. As a result of this re-examination of their technical means, the impressionists discovered a new method of visual representation.

Manet. Manet's later work was in the impressionistic style with cityscapes constructed out of interrelated planes tinted with a rainbow of luminous color intensities (Fig. 467). His last large-scale work, Bar at the Folies-Bergère (Fig. 468), is a technical tour de force of major magnitude. At first glance the viewer would seem to be the customer the barmaid is waiting to serve, but her client apparently is the tophatted, goateed gentleman who is seen in mirror image behind the girl's reflection at the upper right. For correctness, the barmaid would have to stand almost sidewise to cast such a reflection, but with poetic license Manet lets her face forward. The com-

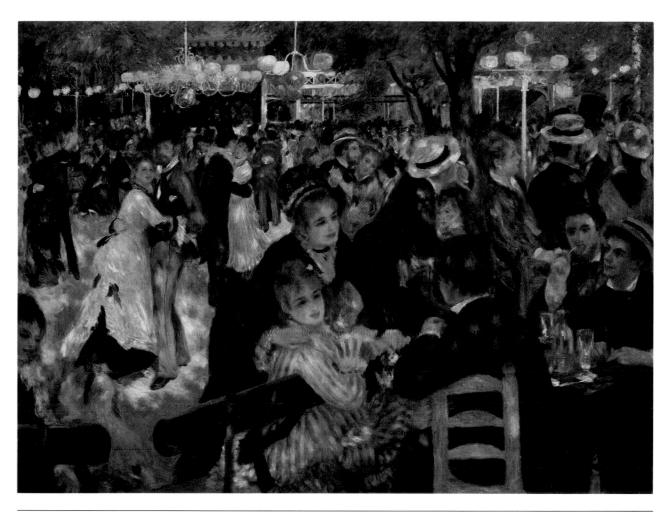

469. Pierre Auguste Renoir. La Moulin de la Galette à Montmarte. 1876. Oil on canvas, $4'3\frac{1}{2}'' \times 5'9''$ (1.31 × 1.75 m). Louvre, Paris.

position is tightly structured, with the double image of the patient waitress and the bottles of the stunningly painted still life in the foreground defining the vertical rising lines. The marble counter at the picture plane, its reflected image behind, and the mirrored ledge of the balcony take care of the horizontal balance.

The bohemian scene is bathed in glaring gaslight, glints of which are caught by the crystal chandeliers, assorted bottles, the vase and compote dish, and the balcony scene reflected in the shimmering expanse of the mirror. Except for the barmaid, all the figures are suggested rather than defined. With a few bold strokes Manet creates girls with opera glasses, ladies in colorful costumes, bearded men in stovepipe hats, and above all captures an evening's mood.

RENOIR. Auguste Renoir, like Manet, was interested in casual, lighthearted scenes. Even before Manet painted his *Bar at the Folies-Bergère*, Renoir

had done a similar scene set in a popular outdoor Paris café, *Le Moulin de la Galette* (Fig. 469), which had been shown first in the 1877 impressionist exhibit. The full force of impressionistic color is felt in the rainbow of brilliant lines, especially the variations of blue and the marvelous quality of filtered gaslight that Renoir had at his command. His obvious intention was to evoke the atmosphere of carefree gaiety and the whirling movement of dance as well as to revel in a world of color and light.

MONET. More than any other painter, Claude Monet was the central figure of impressionism. His picture *St. Lazare Train Station, The Normandy Train* (Fig. 470) is among his most typical works. The rendering of the humid atmosphere, the mixture of steam and smoke, the hazy sunlight filtering from the open background and transparent roof, and the contrast between the open spaces and the closed forms of the engines and railroad cars are the things

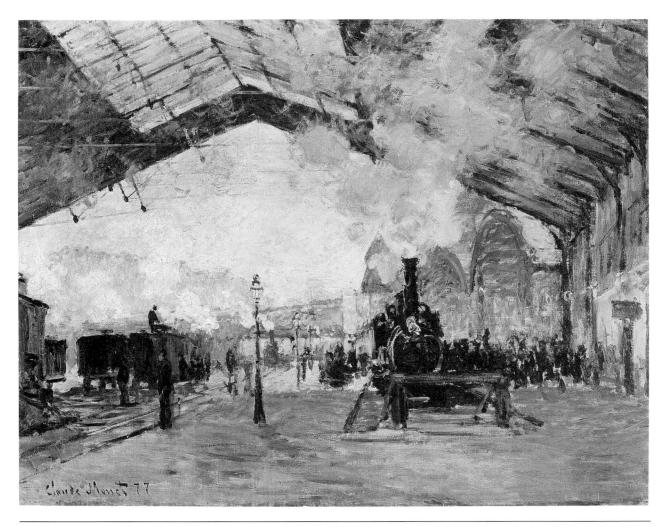

470. CLAUDE MONET. St. Lazare Train Station, The Normandy Train. 1877. Oil on canvas, $23\frac{1}{2} \times 31\frac{1}{2}$ " (60 × 80 cm). Art Institute of Chicago (Mr. and Mrs. Martin C. Ryerson Collection).

that concern him most. There is no hustle and bustle, no drama of arriving or departing people, no crowds or excitement, no interplay of people and machines as one might expect in such a setting. Instead, his figures merely file from the waiting room toward the train, and the working people go about their tasks in a matter-of-fact and unemotional way. The picture as it materializes therefore becomes an atmospheric study in blues and greens.

The full development of Monet's broken-color technique is seen more clearly in *Japanese Bridge at Giverny* (Fig. 471), painted in the garden of his home at Giverny. Here he breaks light up into a spectrum of bright colors that forms shimmering patterns in and around the leaves and lilies. Water imagery repeatedly recurs in impressionistic painting. Its surface reflections, the perpetual play of changing light, make water ideal to convey the insubstantial, impermanent nature of visual experience. Figure 471 is

one of many versions Monet painted of the same subject, and his method of work reveals that the objects he painted were of less concern than the light and atmosphere surrounding them.

In order to capture the moment he wanted, Monet would take up in a single day a succession of canvases—one showing the garden at dawn, another in full morning light, and a third in a late afternoon glow. The following morning he would take up the dawn scene where he had left off the day before and, when the light changed, set it aside for the next canvas, and so on. With scientific detachment, he tried to maintain the constancy of his subject matter by painting several versions of *Haystacks*, *Rouen Cathedral*, and *St. Lazare Train Station* in a series, so as to focus the interest on the variables of light and atmosphere. Each version varies according to the season, day, or hour. Monet might even be called the "weather man" of painting were it not

that, in spite of himself, his genuine involvement with nature usually overcame his objective detachment. As Cézanne once remarked: "Monet, he's only an eye, but my God, what an eye!"

Impressionism is clearly an art of urban people who see themselves in terms of a fast time pace, mounting tensions, and sudden change. Their fleeting lives are ruled by impermanent rather than permanent forces, and becoming is more real to them than being. Impressionistic painters purposely chose everyday subjects such as street scenes, children at play, and life in a night café. When they did go to the country, it was to the suburbs, in the manner of city folk on a

holiday. As a result, the general effect of impressionist painting is bright, cheerful, and lighthearted.

Impressionistic artists were intoxicated by light rather than life, and they saw the world as a myriad of mirrors that refracted a constantly changing kaleidoscope of color and varying intensities of light. They lived, therefore, in a visual world of reflections rather than substances, and one in which visual values replaced tactile ones.

To reproduce the fleeting atmospheric effects they desired, the impressionists had to work directly from nature. This led to a speeding up in the process of painting to a point where working with oils approached the more rapid technique of watercolor.

471. CLAUDE MONET. Japanese Bridge at Giverny. 1900. Oil on canvas, $35\frac{3}{8} \times 39\frac{3^{\prime\prime\prime}}{4}$ (89.9 × 101 cm). Art Institute of Chicago (Mr. and Mrs. Lewis Larned Coburn Memorial Collection).

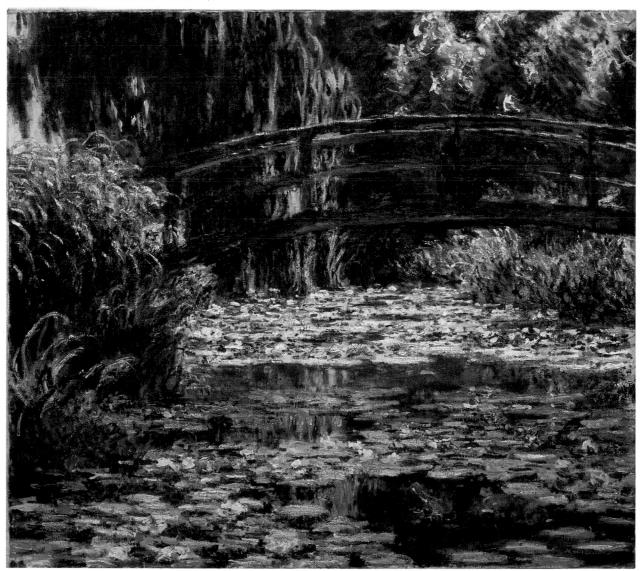

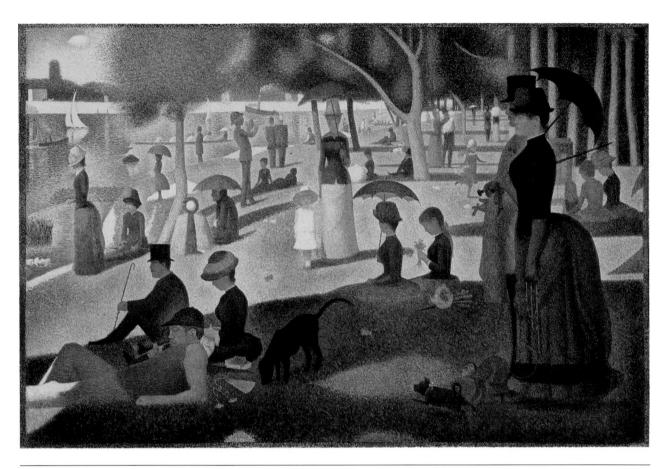

472. Georges Seurat. Sunday Afternoon on the Island of La Grande Jatte. 1884–86. Oil on canvas, $6'9'' \times 10'\frac{3''}{8}$ (2.06 × 3.05 m). Art Institute of Chicago (Helen Birch Bartlett Memorial Collection).

The criticism of hasty work and careless craftsmanship that the impressionists incurred from their contemporaries was sometimes quite justified. But when their intentions are fully taken into account, one finds no lack of technical skill on the part of the style's most important practitioners. They wanted their paintings to seem spontaneous and to have an improvised, fragmentary look. Beauty, like color, they felt, was in the eye of the beholder, not in the picture itself. They intended to paint not so much what is seen but how it is seen. Instead of formal composing, which implies a placing together, they sought to isolate one aspect of experience and explore it to the utmost. Their art therefore becomes one of analysis more than synthesis, sensation more than perception, sight more than insight. As such the cool objectivity of impressionism could be said to represent the triumph of technique over expression.

POSTIMPRESSIONISM

In their total immersion in the world of appearances, the impressionists consciously neglected the other dimensions of psychological depth and emotional involvement. As a consequence, they soon began to feel discontented under the arbitrary restrictions of such a limited theory. Nor were their audiences happy with the role of detached bystander they had been assigned. Both artist and spectator had, in effect, resigned the active role for that of the aloof observer of life.

In scarcely more than a dozen years after Monet had shown his *Impression—Sunrise*, the movement had lost its momentum. Even though no one painted an *Impression—Sunset* to commemorate the event, impressionism in its original form was at an end, to all intents and purposes, with the last impressionist exhibit in 1886. Many of the discoveries that had been made, however, survived in variously modified form in the work of the postimpressionist painters.

SEURAT AND CASSATT. Sunday Afternoon on the Island of La Grande Jatte (Fig. 472) by Georges Seurat shows how the impressionistic theory was carried to a logical, almost mathematical, conclusion. Light,

shadow, and color are still the major concerns, and the subject is also that of an urban scene, this time of a relaxed group of middle-class Parisians on a Sunday outing. Instead of informal, casual arrangements, however, everything here seems as set as an old-fashioned family portrait. Instead of misty, indistinct forms, such details as a bustle, a parasol, or a stovepipe hat are as stylized and geometrical as in a Renaissance fresco.

Unlike the impressionists, who improvised their pictures out-of-doors, Seurat carefully composed his large canvas in his studio over a period of years. Instead of hastily painted patches of broken color, Seurat worked out a system called *pointillism*. By this system thousands of dots of uniform size were applied to the canvas in such a calculated and painstaking way that the most subtle tints were brought under the painter's control. The picture,

moreover, was divided into areas, and graduating shades blended tonalities into a total unity.

The work of the American-born and American-trained artist Mary Cassatt shows a similar turning away from the fleeting atmospheric effects of impressionism to achieve a pictorial art based on fine drawing and carefully controlled composition. After moving to Paris, she exhibited with the impressionists from 1879 to 1886. In her later work, however, such paintings as her *Boating Party* (Fig. 473) reveal how she retained the brilliance of impressionistic hues but, like Seurat, was searching for a more enduring and personally sensitive format.

VAN **G**OGH AND **G**AUGUIN. It remained for the three great postimpressionist figures—Van Gogh, Gauguin, and Cézanne—to bring to fruition the full implications of the impressionistic breakthrough and

473. MARY CASSATT. *Boating Party.* 1893–94. Oil on canvas, $35\frac{1}{2} \times 46\frac{1}{8}''$ (90 × 117 cm). National Gallery of Art, Washington, D.C. (Chester Dale Collection, 1962).

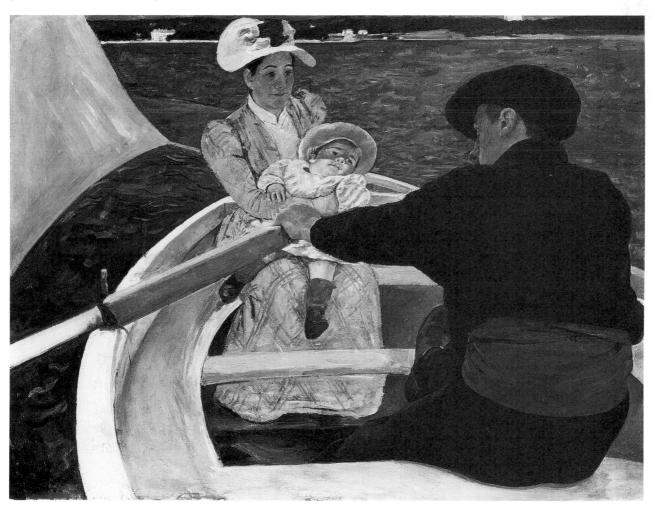

to translate it into a far more expressive language. They also directed impressionism away from the temporal and fugitive into the search for deeper meaning and universal values.

Vincent Van Gogh's *Starry Night* (Fig. 474) is an intensely personal testament. After studying for the ministry, Vincent became a pastor in a depressed Belgian coal-mining district. In the last decade of his tempestuous life, however, he found his true vocation in painting. His letters to his brother Theo tell of his burning desire to capture the spirit of life and his "terrible need of—shall I say the word—religion." A demonic worker, he threw himself into his art with the zeal of a medieval saint. *Starry Night*, one of his last pictures, reaches upward from the sleeping earth by way of the writhing, twisting, flamelike forms of the cypress tree, church steeple, and heaving hills to

merge with the incandescent sky where he finds his release and mystical union with the infinite. "We take a train to reach a city," he wrote, and "death to reach a star."

Paul Gauguin's *Mahana No Atua* (Fig. 475), or *Day of the God*, also shows how the brilliant color of the impressionists can be adapted to make quiet, two-dimensional decorative designs. In 1888 the mature Gauguin expressed his theory of the correspondence between natural form and artistic feeling when, during an outdoor painting session in Brittany, he interrogated and advised a younger colleague, Paul Sérusier, in the following way: "How do you see that tree? . . . Is it quite green? Then put on green, the finest green on your palette;—and that shadow, is it a bit blue? Don't be afraid to paint it as blue as possible."

474. VINCENT Van Gogh. *Starry Night*. 1889. Oil on canvas, $29 \times 36\frac{1}{2}$ " (74 × 93 cm). Museum of Modern Art, New York (Lillie P. Bliss Bequest).

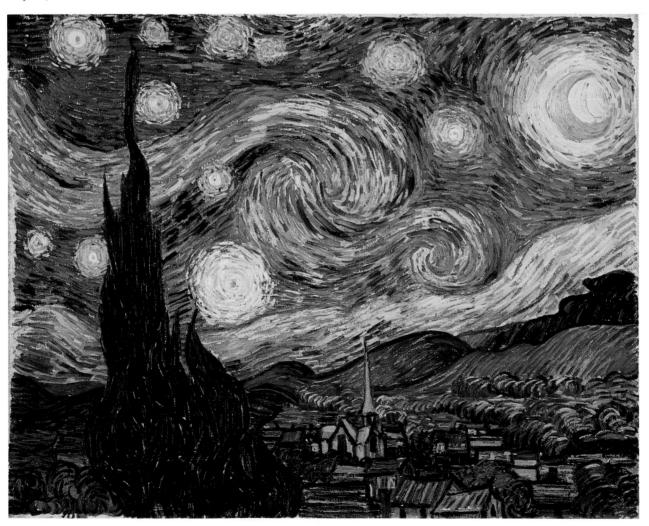

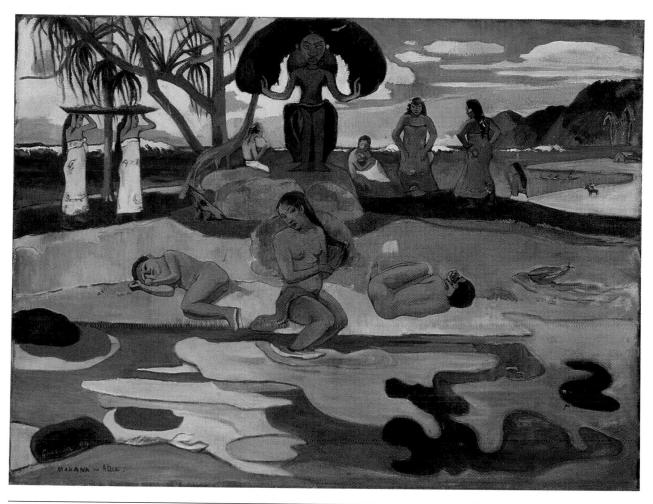

475.PAUL GAUGUIN. *Mahana No Atua (Day of the God)*. 1894. Oil on canvas, $27\frac{3}{8} \times 35\frac{5}{8}$ " (69.8 × 90.1 cm). Art Institute of Chicago (Helen Birch Bartlett Memorial Collection).

The process Gauguin recommended was that of synthesizing the facts of nature with the artist's own aesthetic intuition—the artist's sense of organizing lines, colors, shapes, and textures so as to have an intended effect. In an article published in 1890, Maurice Denis, a fellow student of Sérusier, formulated Gauguin's ideas into a formal statement that became fundamental to all understanding of modern art: "... a picture—before being a warhorse, a nude woman, or some sort of anecdote—is essentially a surface covered with colors arranged in a certain order." In other words, form and design, much more than actual subject matter, would have the greatest potential for investing a picture with expressive content. Because they were willing to distort the image of nature so as to make each painting express the artist's feelings, Gauguin and his associates paved the way toward expressionism in modern art.

CÉZANNE. In the 1870s Paul Cézanne was using the prismatic color palette of the impressionists, but he soon discovered the expressive limitations of the theory. His solution for some of the pictorial problems it posed became a turning point in the history of painting. For him, the superficial beauty of impressionism did not provide a firm enough base on which to build a significant art. The delight in the transitory tended too much to exclude permanent values.

Instead of severing connections with the past, Cézanne said that he wanted "to make of impressionism something solid like the art of the museums." Poussin was the old master he chose to follow, and his expressed desire was to recreate Poussin in the light of nature. The cultivation of instantaneous vision, according to Cézanne, ruled out the participation of too many other important faculties. His pictures, unlike those of the impressionists, were not

meant to be grasped immediately, and their meaning is never obvious. For Cézanne, painting should be not only an act of the eye but also of the mind. If painting aimed only at the senses, any deeper probing of human psychology would be eliminated. Light is important in itself, but it can also be used to achieve inner illumination. Color as such is paramount, but color is also a means of describing masses and volumes, revealing form, creating relationships, separating space into planes, and producing the illusion of projection and recession. Primary colors—red, yellow, and blue—produce brilliance, but careful mixtures can create a whole range of subtle effects.

Cézanne thus retained both light and color as the basis of his art, but not to the extent of eliminating the need for line and geometrical organization. Cézanne's interests are not so much in the specific as in the general. Analysis is necessary for simplification and to reduce a picture to its bare essentials, but the Cézanne composition and synthesis are still the primary processes of the pictorial art. His canvases therefore tend to be more austere than sensuous, more sinuous than lush. His pictures are dominated by order, repose, and a serene color harmony, yet they can rise to the very highest points of tension and grandeur.

The forms Cézanne chose were from his daily experience—apples, mountains, houses, trees—constants by which it is possible to measure the extent of his spiritual growth. "You must paint them to tame them," he once remarked. Mont Ste. Victoire,

476. Paul Cézanne. *Mont Ste. Victoire.* 1885–87. Oil on canvas, $25\frac{3}{8} \times 31\frac{7}{8}$ " (64 × 81 cm). Metropolitan Museum of Art, New York (bequest of Mrs. H. O. Havemeyer, 1924; the H. O. Havemeyer Collection).

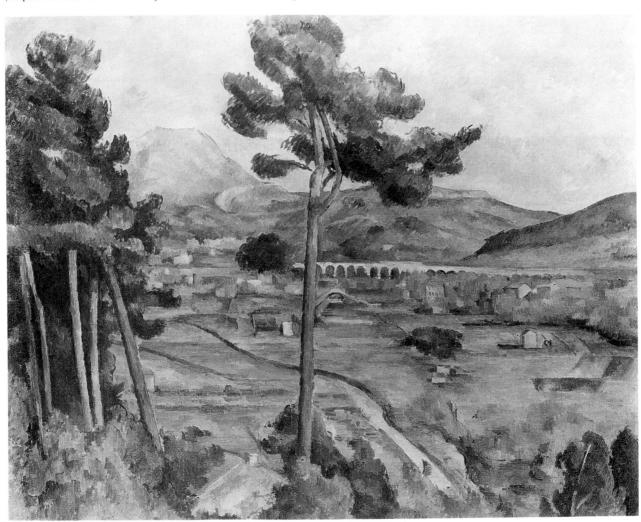

a rising rocky mass near his home in Aix-en-Provence, was for Cézanne a recurring motif, and it became a symbol of his ambitions.

The contrast of an early and a late version of Cézanne's favorite mountain provides an interesting index to his artistic growth. The first *Mont Ste. Victoire* (Fig. 476) dates from between 1885 and 1887. Another version (Fig. 477) was done between 1904 and 1906. Both are landscapes organized into a pattern of planes by means of color. Both show his way of achieving perspective not by converging lines but by intersecting and overlapping planes of color. In the first version, there is a complementary balance between the vertical rise of the trees and the horizontal line of the viaduct. In the second, these details are omitted, and a balance is achieved between the

dense green foliage of the lower foreground and the purple and light green jagged mass of the mountain in the background. In the earlier, the mountain descends in a series of gently sloping lines; in the later, it plunges steeply downward. In the former, such details as the road, houses, and shrubs are quickly recognizable. In the latter, all is reduced to the barest essentials, and only such formal contours as the cones, cubes, and slanting surfaces remain. Both pictures, however, are landscapes interpreted by the same highly individual temperament. Both show Cézanne's desire to mold nature into a meaningful pattern in order to unite the inanimate world of things and the animate world of the human mind.

In such a still life as *Basket of Apples* (Fig. 478), Cézanne works in a more intimate vein. The search

477. Paul Cézanne. *Mont Ste. Victoire*. 1904–06. Oil on canvas, $28\frac{7}{8} \times 36\frac{1}{4}$ " (73 × 92 cm). Philadelphia Museum of Art (George W. Elkins Collection).

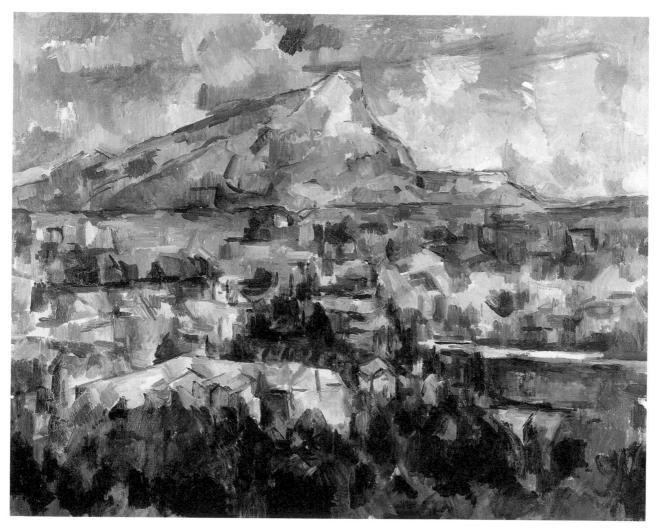

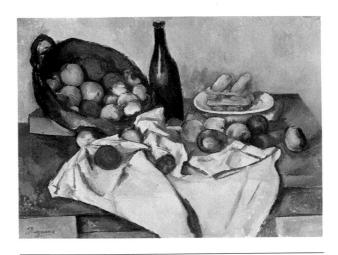

478. Paul Cézanne. *Basket of Apples*. 1890–94. Oil on canvas, $24\frac{3}{8} \times 31''$ (62.2 × 78.7 cm). Art Institute of Chicago (Helen Birch Bartlett Memorial Collection).

for pure formal values, however, still continues. In one of his letters, he remarked that nature reveals itself in the forms of the cylinder, the sphere, and the cone. Here his cylinders are the horizontally arranged biscuits, his spheres the apples, and his cone the vertically rising bottle. They are balanced in this case by the forward-tilting ellipse of the basket and the receding plane of the tabletop. An almost imperceptible feeling of diagonal motion is induced by the distribution of the fruit from the upper left to the lower right. This compositional momentum is brought to an equally imperceptible stop by means of the pear-shaped apple at the extreme right.

Cézanne brought a measure of form and stability into a visual world where everything was change and transition. If he succeeded only at times and failed at others, each result must be matched with the immensity of the task that he set for himself. Like all great masters, he realized in his mature years that he had made only a beginning, and he remarked that he would forever be the primitive of the method he himself discovered. This may be his historical position. And his art, in addition to being great in its own right, may be said to bridge impressionism and modern abstract painting.

SYMBOLISM

The art of the symbolist is one of the fleeting moment. Everything rushes past in an accelerated panorama, as if seen from a moving train. With the metaphor as a starting point, a symbolist prose poem flows by in a sequence of images that sweeps the

reader along on a swift current of words that scarcely leaves time to ponder their meaning.

Like the impressionistic painters, the symbolists reveled in sensory data, and, like the realistic novelists, they looked for their material among the seemingly trivial occurrences of daily life. But in their attempt to endow such happenings with profundity and deeper symbolism, they went one step beyond.

While the painters had found a new world in the physics of light and the novelists another new world in the social sciences, the symbolists looked to the new discoveries in psychology. By purposefully leaving their poetry in an inconclusive and fragmentary state, they were making use of the psychological mechanism of reasoning from part to whole. Since the poets did not define the whole, the reader's imagination was allowed full interpretive power.

Just as the impressionist painters had left the mixing of color to the eye of the observer and the relationship of the subject matter to the viewer's mind, so Mallarmé and the symbolists left the connection, order, and form of their verbal still lifes to be completed by the reader. They also found a new world to explore in "listening" to colors, "looking" at sounds, "savoring" perfumes, and in all such mixtures of separate sensations, known to psychology as *synesthesia*. This fusion of sensations by which the awakening of one sense impression sets up a chain reaction of others is vividly expressed in Baudelaire's "Correspondences," a poem from his *Flowers of Evil*.

Like those deep echoes that meet from afar

In a dark and profound harmony,
As vast as night and clarity,
So perfumes, colors, tones answer each other.

There are perfumes fresh as children's flesh,
Soft as oboes, green as meadows. . . .

By developing a hypersensitive tonal palette, Claude Debussy, like his symbolist colleagues, was able to sound a range of images from volatile perfumes (Sounds and Perfumes Turn on the Evening Air), fluid architecture (The Engulfed Cathedral), sparkling seascapes (La Mer), exotic festivities (Ibéria; Fêtes) to gaudy fireworks (Feux d'artifice). The symbolists pushed outward to the limits of perception in order to develop more delicate sensibilities and stimulate the capacities for new and peripheral experiences. They moved about in a twilight zone where sensation ends and thought begins. The very word symbolism, however, implies that the images are revela-

tions of something beyond sense data. And it is here that the symbolists parted company with the objectivity of the realists and impressionists.

Maeterlinck's Symbolist Drama

Maurice Maeterlinck made an interesting attempt to translate the aims of the symbolist poets into dramatic form. His *Pelléas et Mélisande*, a play first performed in 1892, brings about a synthesis of the material world and the world of the imagination. In it, he denies the importance of external events and explores the quiet vibrations of the soul. His symbols function as links between the visible and invisible, the momentary and the eternal. The tangible fragments of common experience, the seemingly trivial everyday occurrences furnish clues to the more decisive stuff of life.

"Beneath all human thoughts, volitions, passions, actions," wrote Maeterlinck in one of his essays, "there lies the vast ocean of the Unconscious, the unknown source of all that is good, true and beautiful. All that we know, think, feel, see and will are but bubbles on the surface of this vast sea." The sea, then, is the symbol of the absolute toward which all life is reaching, but which can never quite be grasped. What is seen and heard are only the ripples on the surface.

In his drama, the sea, the forest, the fountain, the bottomless well are the dramatis personae in a deeper sense than the human characters, who are but shadowy reflections of real people. In spite of the settings in which they appear, Maeterlinck's characters belong neither to the past nor to the future. They hover in an extended now. They seem to have no existence in space, no volume, but exist more as creatures of duration. So little is acted out that what plot there is seems to unfold within the characters. One overhears rather than hears the dialogue, and, in the ordinary sense, so little happens that a kind of dramatic vacuum is created which can be filled only by the imaginations of the spectators. Just as the eye must mix the colors in a impressionistic painting, so the observers' imaginations in a Maeterlinck play must connect the metaphors, must unite the tableaux (the frozen depiction of scenes) into a flow of images, must fill each pregnant pause with projections from their own experience, and must supply the emotional depth to its surface play of symbols.

Debussy's Lyric Drama

Maeterlinck's good fortune was to find a composer who could fill his silences with the necessary vague sounds, who could give voice to the "murmur of eternity on the horizon," and who could write the music that provided the link from dream to dream. It was, indeed, as if the music of Debussy had been created for the very purpose of providing the tonal envelope to enclose Maeterlinck's "ominous silence of the soul."

Debussy was able to make the sea sing "the mysterious chant of the infinite." In his score, the references to the ocean on which all the characters are floating toward their unknown destinies are handled with special sensitivity. In one guise or another, its waters are present in practically every scene, either in the fragmentary form of a spring in the forest, a well in a courtyard, a fountain in a park, or the stagnant pools of underground caverns.

This ever-present water imagery is used as the symbol of the flowing, fleeting nature of experience. As an unstable medium without form of its own, it becomes the means of capturing vague atmospheric effects and reflecting subtle changes of mood. The course of Mélisande's life is conveyed by means of

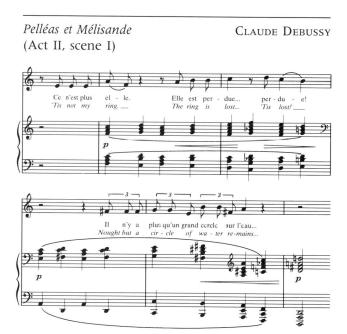

these changing waters. She comes from over the sea, is found by a dark pool in the forest, discovers her love for Pelléas at a fountain in the park, and as she dies, asks that the window be opened so that she can once more be with the sea.

Other symbols play their appointed parts. Mélisande weeps in the first scene over the loss of a golden crown, symbolic of her happier state of child-

hood innocence. Later, when she tosses her wedding ring up and down beside the fountain, she is taking her marriage vows lightly. When it falls into a bottomless well and disappears, it means that her marriage has dissolved. Only the circles on the surface of the water remain, subtly rendered by Debussy in the musical example on page 515. As the ripples expand, they foretell developments to come.

Debussy's style first took shape in the songs he wrote on texts by the symbolist poets, but Maeterlinck's drama provided him with the necessary lyric material to ripen it into maturity. Like those of the poets, his methods were in many ways the opposite of conventional operatic techniques. He followed Wagner in giving the orchestra the main task of carrying on the sequence of the drama. As a result, his work became more of a symphonic poem with running commentary by the singers than a conventional opera.

With characteristic poetic insight, Debussy saw that melody, in the sense of a set operatic aria, stopped rather than promoted the dramatic progress. "I wished—intended, in fact—that the action should never be arrested; that it should be continuous, uninterrupted," he commented. "Melody is, if I may say so, almost antilyric, and powerless to express the constant change of emotion or life. Melody is suitable only for song, which confirms a fixed sentiment."

In thus considering recitative as the most important element of the lyric drama, Debussy allies himself with his famous predecessors Lully and Rameau. But while their characters spoke in the stylized accents of baroque theatrical bombast, his speak in rhythmic flows of sound more closely approximating modern conversational French. "The characters in this drama endeavor to sing like real persons," the composer wrote; and by bringing their language closer to everyday speech and allowing the flow of dramatic action to proceed without interruption, his opera is far more plausible than is common in such a highly artificial medium. By using modes other than the traditional major and minor, Debussy's recitative takes on the flexible character of psalmodic chant. The rhythms are free, and the absence of regular accentuation allows the words to flow with elasticity.

Debussy's musical motifs parallel Maeterlinck's literary symbols and are often just broken fragments of melody. They suggest rather than define atmospheric effects or are associated with the mood of a character. While used with greater subtlety, they nevertheless are much closer to Wagner's system of leitmotifs than Debussy was willing to admit (see pp. 476–78).

The harmonic method Debussy uses likewise was well suited to rendering the ambiguities and obscurities of the symbolist poets. His key centers lose their boundaries; progressions move about freely in tonal space; everything is in a state of flux, always on its way but never quite arriving.

Debussy's sensitivity to the *timbre*, or distinctive quality, of sound borders on the uncanny. He thought of Mélisande's voice as "soft and silky," and thus the woodwinds dominate the orchestral coloration with their peculiarly poignant and penetrating quality. Above all, performers must know how to make this intangible music live and breath, how to render its rhythms with the proper elasticity, and how to fill its silences with meaning.

Debussy's evocation of Maeterlinck's pale, shadowy world is one of those rare instances of the indissoluble union of literature and music that makes it impossible for later generations to think of them as separate entities. Debussy worked on Pelléas over a period of ten years and was constantly worrying about the audience reaction to his fragile lyric drama. Maeterlinck's play had not been a success, and in a letter dated August 1894, Debussy anxiously asks a friend, "How will the world get along with these two poor little beings?" In an obvious reference to the popularity of Zola's writing, he goes on to express his hatred of "crowds, universal suffrage, and tricolored phrases." Contrary to Debussy's expectation, the opera ultimately was a success and is still performed. His elusive music proved its capacity to cast a spell over the most indifferent audiences.

IDEAS

Any interpretation of the complex interplay of forces that underlie and motivate the diverse tendencies of the latter part of the 19th century faces the usual danger of oversimplification. Two of the most prominent ideas, however, are chosen principally because they provide significant insights into the relationship of the several arts. These are the influence of the scientific method on the arts and the interpretation of experience in terms of time.

Alliance of Art and Science

Artists in all fields were aware of the extraordinary success of the scientific method. Realism and impressionism brought a new objective attitude into the arts, together with an emphasis on the technical side of the crafts and a tendency for artists to become specialists pursuing a single aspect of their media.

Architects began to look to engineers for the more advanced developments in building. A paint-

ing for an impressionist was a kind of experiment, an adventure in problem solving. Cézanne thought of each of his pictures as a type of visual-research problem. In sculpture, Rodin was seeking a new synthesis of matter and form. The literary realists were cultivating a scientific detachment in their writing and developing a technique that would enable them to record the details of their close observations of everyday life with accuracy and precision. Zola, by means of his experimental novel, introduced a modified social-scientific technique to fiction. In addition to his poetic dramas, Maeterlinck wrote popular nature studies such as The Life of the Bee and The Magic of the Stars. Debussy, for his part, spoke about some of his compositions as his "latest discoveries in musical chemistry."

Many of the actual discoveries of scientific research opened up new vistas in the various arts. Experiments in optical physics revealed secrets of light and color that printers could explore. New chemical syntheses provided brighter pigments for their canvases. Increased knowledge of the physiology of the eye and the psychology of perception led to a re-examination of how observers look at a picture and what they perceive. New metal alloys and processes of casting were a boon to sculptors. The theories of evolution gave Rodin some poetic ideas on how form emerges from matter, the animate from the inanimate. Helmholtz's On the Sensation of Tone as a Physiological Basis for the Theory of Music stirred Debussy and other composers to speculate on the relation of tone to overtone and consonance to dissonance in their harmonic techniques.

The impressionistic painters were convinced that pictures were made from lights and color, not line and form; the symbolists claimed that poetry was made with words, not ideas; and composers felt that music should be a play of varied sonorities rather than a means of evoking programmatic associations. By pursuing this general line of thought, artists made a number of discoveries. Monet revealed a new concept of light and color and their interdependence, Rodin an atmospheric extension of solid three-dimensional form. The symbolists found a new world of poetry; Debussy, a new concept of sound. Paxton and Eiffel, by incorporating light and air into their designs, achieved a new relationship of inner and outer space.

This mechanistic phase, however, could lead just so far, and artists were soon trying to push beyond it into paths that would lead to deeper psychological insights. Each of the postimpressionists was probing to find how the new discoveries could be used as a means of achieving new modes of expression. Cézanne's path led into a new concept of picto-

rial geometry that became an important anticipation of 20th-century abstract art and the point of departure for cubism. Maeterlinck attempted to humanize science and describe it in poetical terms. In his case, the result was a kind of animism that brought such inanimate objects as trees, stones, and fountains to life, gave them speech and a soul life of their own. In an essay "Intelligence of Flowers," he tried to establish more sympathetic ties between people and nature. In his stage fantasy, *The Bluebird*, Sugar and Bread are among the live characters. Cézanne also felt the living force of the objects he placed in his still lifes, and in a conversation with a friend remarked that there are people who say a sugar bowl has no soul, yet it changes every day.

The symbolists also tried to bring about a synthesis between the phenomenal world and that of the creative imagination. Their metaphors were material in the sense that they received expression through the senses, but they hinted at the existence of a more profound world of ideas and were definitely based on a view that life was something more than the sum of its molecular parts. Debussy, too, turned away form the physical elements of sound toward the deeper psychological implications of tonal symbolism.

Continuous Flux

The arts of the late 19th century were also bound together by their common tendency toward the interpretation of experience in terms of time. Progress was an idea that was carried over from the late 18th century. Material progress continued to be an indisputable fact; but also becoming apparent was the disassociation of the material from political, moral, spiritual, and aesthetic progress.

With industrialization came a specialization in which people were concerned more with fragments than with wholes. Industrial workers were rapidly forfeiting to the machine their place as the primary productive unit. With this loss of control came a corresponding shift from a rational worldview toward an increasingly irrational one. With industrialization also came a capitalistic economy in which the lives of workers were controlled by intangible forces beyond themselves.

Two centuries earlier, the baroque mind had been shaken by the Copernican revolution in which the notion of a fixed earth in the center of the universe was replaced by that of a satellite rotating around the sun. The late 19th-century mind was similarly rocked by the Darwinian and other evolutionary theories, which taught that creation was an ever-continuing process rather than an accom-

plished fact. As a result of such forces and ideas, the onward-and-upward notion of progress was revised downward to one of continuous flux and change.

The literary and visual realists concentrated on the momentary, the fragmentary, the everyday occurrence. Even when they planned their works in more comprehensive schemes, the effect was more that of a broad cross section than of a complete three-dimensional structure. For twenty years, Balzac worked on parts of his Human Comedy, Wagner on his Ring cycle, Rodin on his Gates of Hell, and Proust on his Remembrance of Things Past. None, however, is a systematic, organic, or logical whole or a single perfected masterpiece. Instead of having an all-embracing unity, they are easily broken down into a collection of fragments, motifs, genre scenes, scraps, and pieces. The late 19th century produced no grandiose metaphysical systems, such as those of Aguinas, Leibniz, Kant, or Hegel, each of whom tried to encompass all experience in one single universal structure.

Bergson's Theory of Time

The thinker who came the closest to making a clear picture of this turbulent age was the French philosopher Henri Bergson. His point of departure was a remark made by the pre-Socratic philosopher Heraclitus, who had said that one cannot step into the same river twice. Bergson cited Heraclitus in support of his theory that time was as more real than space, that the many were closer to experience than the one, and that becoming was closer to reality than being.

Bergson was critical of the intellect because it tended to reduce reality to immobility. He therefore ranked intuition as a higher faculty than reason, because through it the perception of the flow of duration was possible, and through it static, immobile quantitative facts were animated into the dynamic qualitative values of motion and change.

Existence, according to Bergson, is never static. Rather, it is a transition between states of being and between moments of duration. Experience is thus durational, "a series of qualitative changes, which melt into and permeate one another, without precise outlines. . . ."

Art for Bergson is a force that frees the soul and through which one can grasp "certain rhythms of life and breath," which compel the individual "to fall in with it, like passersby who join in a dance. Thus they compel us to set in motion, in the depth of our being, some secret chord which was only waiting to thrill." Convinced that reality is mobility, tendency, or "incipient change of direction," Bergson

thus felt that looking at or listening to a work of art is perceiving the mobile qualities of the objects or sounds presented. The aesthetic experience is essentially an experience in time and involves an "anticipation of movement" that permits the spectator or auditor in various ways "to grasp the future in the present." His theory of art is based on what he calls his "spiritualistic materialism," by which finely perceived material activity awakens spiritual echoes. All is based on the "uniqueness of the moment"; and perception of the flow of time is the same as an awareness of the pulsation of life, something that is quite apart from the mechanical or lifeless matter.

Past, present, and future, in Bergson's thought, are molded into an organic whole as "when we recall the notes of a tune melting, so to speak, into one another." Time, therefore, is "the continuous progress of the past, which gnaws into the future and which swells as it advances." But Bergson's concept of time is not clock time with its divisions into seconds, minutes, and hours; nor is it concerned with the usual groupings of past, present, and future. These are just arbitrary conveniences, like the points on a clock past which the hands move. Time cannot be measured in such a quantitative way; it is a quality, not a substance.

Bergson and the Arts

The application of Bergson's theory of time to the arts of the late 19th century can be very illuminating. The philosopher often cited the motion-picture as an example of what he meant by the perception of duration. The separate frames in a motion-picture film are still; but when the series is run through the projector, the mind melds them together in a continuous flow, and they appear to be animated and alive. So also are the separate colors on an impressionistic canvas, the separate metaphors in a symbolist poem, the separate scenes in a Maeterlinck play, the separate chords in a Debussy progression-all are molded by the mind into a continuum of time. In visual impressionism, the eye mixes the colors; in a symbolist poem, the mind supplies the connecting verbs for the so-called fragments; in a Maeterlinck play, the imagination gives the irrelevancies of speech and action a dramatic meaning; and in Debussy's music, the ear bridges over the pregnant silences.

In all the arts, this ceaseless flux leads toward the improvisatory, the consciously incomplete. Each work tries to be a product of inspiration rather than calculation. With the visual impressionists, all pictorial substance is broken down into an airy mixture of color sprays, fleeting shadows, and momentary

moods. Cézanne sometimes paints so thinly that parts of the canvas are actually bare, and at other times the texture is so thin as to be almost transparent. Rodin likewise leaves parts of the stone surrounding his figures uncut. And it is by no means an accident that some of the most important buildings of the time were open to the air and sky and were conceived as temporary exposition structures, such as the Crystal Palace, the Gallery of Machines, and the Eiffel Tower. In Pelléas et Mélisande, the characters are only outlined or sketched, and what they really feel has to be inferred by the spectator. The imagination actually supplies the emotional depth to what is but a surface play of forms. In all instances the audience, through perception, imagination, and memory, participates in the creative act.

The sense of creating for the moment is well illustrated in the sketches, color lithographs, posters, and paintings of Henri de Toulouse-Lautrec. Amid the surface play of flickering gaslight in *At the Moulin Rouge* (Fig. 479), the artist has captured with sure, deft strokes the mood and character of his subject,

which includes a self-portrait (the small bearded man in front of the tall top-hatted figure in the upper center).

Both the awareness of science and the accentuation of the flow of time became important means by which the arts at the end of the 19th century established the basis for the transition to the various modern styles. Cézanne has with justification been called the first great modern master. The functional architecture of Labrouste, Paxton, and Eiffel has become the foundation stone of contemporary architecture. Rodin's convex and concave surfaces and his preoccupation with the atmospheric problems of light and shadow have led to important new developments in sculpture. The fragmentary style of the symbolists anticipated the stream-of-consciousness and other techniques of modern literature. And Debussy's concept of relative rather than absolute tonality, together with his harmonic experimentation, pointed toward some of the significant musical developments of the 20th century.

479. Henri de Toulouse-Lautrec. At the Moulin Rouge. 1892. Oil on canvas, $4'\frac{3}{8}'' \times 4'7\frac{1}{2}''$ (1.23 × 1.4 m). Art Institute of Chicago (Helen Birch Barlett Memorial Collection).

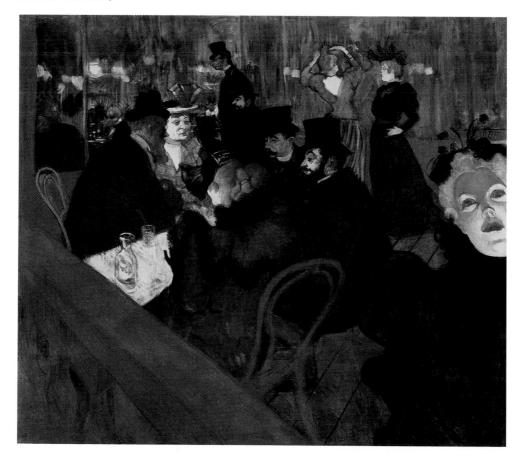

EARLY 20TH CENTURY

KEY EVENTS	ARCHITECTURE AND SCULPTURE	PAINTING	LITERATURE AND MUSIC
1891 Wainwright Building, St. Louis, first skyscraper. Motion- picture camera patented by Thomas Edison; sound recording developed 1903 Aviation age begun by Wright brothers 1905 Sigmund Freud formulated psycho- analysis. First motion- picture theater opened in Pittsburgh 1905-1916 Einstein developed theory of relativity 1908 Model T (touring car) introduced by Henry Ford 1909 Wireless radio developed by Marconi. Peary reached North Pole; 1911, Amundsen reached South Pole 1914-1918 World War I 1917 Russian revolution began 1922 Fascist revolution in Italy 1927 Lindbergh's solo flight across Atlantic 1928 First complete talking film 1929 New York stock market collapsed; Great Depression began 1930 Joseph Stalin became Russian dicator; 1934-1939 purged all opposition 1933 Nazi revolution in Germany. Adolf Hitler became Chancellor and dictator 1936-1939 Spanish Civil War. General Franco's dictatorship began 1939-1945 World War II 1946 Cold War began between the U.S.S.R. and Western powers	1838-1886 H. H. Richardson ★ 1856-1924 Louis Sullivan ★ 1861-1944 Aristide Maillol ● 1869-1959 Frank Lloyd Wright ★ 1870-1938 Ernst Barlach ● 1874-1954 Auguste Perret ★ 1876-1957 Constantin Brancusi ● 1882-1954 William van Alen ★ 1883-1969 Walter Gropius ★ 1886-1969 Ludwig Miës van der Rohe ★ 1887-1965 Le Corbusier (Charles Édouard Jeanneret- Gris) ★ 1887-1964 Alexander Archipenko ● 1887-1966 Jean (Hans) Arp ● 1890-1963 J. J. P. Oud ★ 1890-1966 Naum Gabo ● 1891-1973 Jacques Lipchitz ● 1898-1976 Alexander Calder ● 1898-1986 Henry Moore ● 1901-1966 Alberto Giacometti ●	1844-1910 Henri Rousseau (le Dovanier) 1863-1944 Edvard Munch 1866-1944 Wassily Kandinsky 1867-1956 Emil Nolde 1869-1954 Henri Matisse 1870-1954 John Marin 1871-1958 Giacomo Balla 1871-1958 Georges Rouault 1872-1944 Piet Mondrian 1879-1940 Paul Klee 1880-1916 Franz Marc 1880-1966 Hans Hofmann 1881-1955 Fernand Léger 1881-1955 Max Pechstein 1881-1973 Pablo Picasso 1882-1916 Umberto Boccioni 1882-1963 Georges Braque 1883-1949 José Clemente Orozco 1883-1966 Gino Severini 1884-1920 Amedeo Modigliani 1884-1950 Max Beckmann 1886-1957 Diego Rivera 1886-1980 Oskar Kokoschka 1887-1986 Marcel Duchamp 1887-1986 Georgia O'Keefe 1888-1978 Giorgio de Chirico 1889-1975 Thomas Hart Benton 1891-1976 Max Ernst 1892-1942 Grant Wood 1893-1959 George Grosz 1894-1964 Stuart Davis 1898-1967 Charles Burchfield 1898-1967 Charles Burchfield 1898-1967 Ben Shahn 1904-1989 Salvador Dali 1905 Expressionism begins; "fauve" exhibit in Paris, with paintings by Derain, Rouault, Matisse. Die Brücke ("Bridge") exhibit in Dresden; included paintings by Nolde, Kirchner (movement lasted until 1913) 1907-1914 Cubism developed in Paris by Braque and Picasso 1909-1915 Futurist movement in Italy 1911 Der Blaue Reiter ("Blue Rider") group formed in Munich with Kandinsky and Marc 191-1912 Chirico and Chagall exhibited protosurrealist pictures in Paris 1913 New York Armory Show brought controversial European art trends to U. S.; vogue for modern art began in America 1916-1922 Dadism founded in Zurich, Switzerland; spread quckly to Berlin, Paris, New York 1917 De Stijl magazine published in Holland; gave name to International Style with Mondrian, Gropius, Miës van der Rohe, Le Corbusier, Oud 1924 Surrealist manifesto published in Paris; movement later included	1842-1910 William James ◆ 1856-1939 Sigmund Freud ◆ 1856-1950 George Bernard Shaw ◆ 1858-1924 Giacomo Puccini □ 1869-1952 John Dewey ◆ 1860-1911 Gustav Mahler □ 1863-1938 Gabriele d'Annunzio ◆ 1864-1949 Richard Strauss □ 1866-1925 Erik Satie □ 1869-1951 André Gide ◆ 1871-1945 Paul Ambroise Valéry ◆ 1872-1915 Alexander Scriabin □ 1873-1943 Sergei Rachmaninoff □ 1874-1946 Gertrude Stein ◆ 1874-1951 Arnold Schoenberg □ 1875-1937 Maurice Ravel □ 1875-1937 Maurice Ravel □ 1876-1944 Filippo Tommaso Marinetti ◆ 1876-1946 Manuel de Falla □ 1878-1967 Carl Sandburg ◆ 1879-1936 Ottorino Respighi □ 1881-1945 Bela Bartók □ 1882-1941 James Joyce ◆ 1882-1971 Igor Stravinsky □ 1883-1945 Anton Webern □ 1885-1935 Alban Berg □ 1885-1935 Alban Berg □ 1885-1951 Sinclair Lewis ◆ 1885-1965 Edgar Varèse □ 1887-1962 Robinson Jeffers ◆ 1888-1963 Jean Cocteau ◆ 1899-1963 Jean Cocteau ◆ 1892-1974 Darius Milhaud □ 1895-1963 Paul Hindemith □ 1896-1966 André Breton ◆ 1897-1962 William Faulkner ◆ 1899-1963 Francis Poulenc □ 1899-1961 Ernest Hemingway ◆ 1899-1963 Francis Poulenc □ 1905-1980 Jean-Paul Sartre ◆ 1913-1960 Albert Camus ◆

21

Early Modern Styles

THE AGE OF ISMS AND SCHISMS

Wars, revolutions, social upheavals, displacement of peoples, computers, and automation—all have proceeded at such a pace that 20th-century men and women have difficulty keeping up with themselves. While new means of communication and transportation have shrunk the globe, the vast expansion of knowledge has made it impossible for the mind's eye to view the world as a whole.

The completion of the Industrial Revolution, the progress of electronic technology, and the necessity for specialization have further fragmented the vision. Clashes and discord are more usual than concord; disunity is ascendant over unity; discontinuity is more familiar than continuity; and a "multiverse" has replaced the universe. As we are bombarded on all sides by the mass media of television, radio, films, newspapers, and magazines, the quest for meaning and reality becomes ever more difficult. People must decide whether to conform or reform, suppress or express themselves, look within or without for enlightenment, and make yet another attempt to close the widening gap between the actual and the ideal.

The 19th century, somehow, had been able to contain the forces of liberty and authority, democracy and dictatorship, individualism and collectivism, free enterprise and economic monopoly, scientific advances and traditional religious beliefs, freedom of thought and anti-intellectual tendencies. The 20th century, however, saw these smoldering disputes break out into open conflict. The clashes of rival colonialisms were followed by revolutions in the wake of two world wars that brought communism to Russia, China, and Eastern Europe; Nazism to Germany and Austria; civil war, totalitarianism, and cold war to most of the world; and the rise of a host of new nations out of old colonial empires.

Revolutions and wars, however, are but one aspect of the human struggle; art movements are another. Above all the noise and confusion, the

voice of the present century can be heard, for pens and paintbrushes are as always weapons in the struggle.

Since the arts are forms of action, artists as well as social reformers and revolutionaries shout their battle cries, issue their manifestos, propose their cure-alls, and formulate their own isms and schisms. In the late 19th century such relatively simple aesthetic creeds as realism, naturalism, impressionism, and symbolism had their flocks of faithful followers. By comparison, the 20th century has become an angry Tower of Babel in which such gospels as constructivism, dynamism, neoplasticism, orphism, productivism, purism, supremacism, and vorticism have been proclaimed. On the other hand, cubism, dadaism, social realism, and surrealism proved themselves valid styles representing the early 20th century.

In approaching the art of the 20th century, one has much to keep in mind. Modern art, like the art of the past, must be understood in terms of its own frame of reference and what the artist is trying to do. Artists may intend to delight or irritate, to arouse or denounce, to exhort or castigate, to surprise or excite, to soothe or shock. They may be trying deliberately to achieve disorder rather than order, chaos rather than cosmos. The act of creating sometimes replaces the importance of the object created. Painters may plan their pictures as visual socks in the eye; composers may intend their music as assault and battery on the ear. Judging from the reactions to Picasso's early exhibits and the riot that greeted Stravinsky's Rite of Spring ballet, some artists have succeeded beyond their wildest expectations. Sheer shock values soon diminish, however, and artists have learned that they can blow Gabriel's trumpet of Judgment once, but not every day.

The tempo of change has been so swift that the 20th-century mind cannot keep pace with the scientists and artists. The span of time between innovations and their understanding and popular accept-

ance is often referred to as "cultural lag." Fashions, fads, and fancies succeeded each other with bewildering speed. This season's in group was next year's outcast. Alongside the passing trends, however, were the solid accomplishments of artists of major stature. The discoveries of Frank Lloyd Wright, Gropius, and Le Corbusier in architecture; of Picasso, Kandinsky, and Mondrian in painting; of Schoenberg and Stravinsky in music rank as major breakthroughs in the history of art. These artists now enjoy the status of old masters of modern art. The younger generation of artists, as well as their public, were then passing through a period of consolidation; they were extending the gains that had been made and preparing the ground for future discoveries.

Modern materials and methods opened up many new possibilities in the arts. Ferroconcrete, structural steel, glass, and laminated wood have taken their place alongside bricks and mortar, while cantilevering has joined the post and lintel. With the growth of cities, modern architects have had to construct facilities ranging from airline terminals, suspension bridges, and low-cost public housing to such entirely new capital cities as Brasilia and Chandigarh. Side by side with the steel-and-glass office buildings and urban-planning projects of the industrialized society, 20th-century architects have been called upon to build bold new churches and temples in daring designs.

Sculptors have discovered the use of the welding torch to replace the traditional hammer, chisel, and metal-casting methods (Fig. 480). Sophisticated metal alloys, Plexiglas, polyester resins, neon tubes, and plastics have superseded the older marble and bronze materials. Kinetic devices, powered by motors and programmed by computers, now bring actual motion to sculptural compositions, while formerly, except in cases of fountains, action could be implied only through muscular tension, a bodily stance, or directional orientation.

Painters have begun to work on Masonite and plastic surfaces as well as in mixed media. New synthetic paints, acrylics, and various textural additives have supplanted the earth pigments and natural oils used for centuries. And a new pictorial category of abstract and fantastic pictures has been added to the traditional classifications of history paintings, genre scenes, portraiture, landscape, and still life.

The graphic arts have been expanded to include many new media, among them silk-screen printing and color photography. The arbitrary distinction between the so-called major and minor arts, fine arts and crafts, beauty and utility has narrowed to the point where architect and engineer, sculptor and furniture designer, a cathedral and a suspension

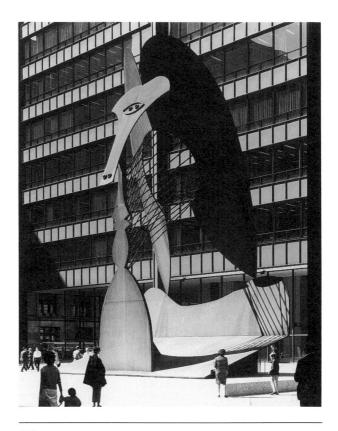

480.PABLO PICASSO. *Chicago Picasso*. 1967. Steel, height 50' (15.25 m). Civic Center Plaza, Chicago.

bridge—once thought to be poles apart—have been brought together in the modern unity of form and function. Drama has expanded from the live theater to include films and television, and new language concepts have been explored with words used as syllabic sounds in an abstract poetry.

As the picture of the first half of the 20th century became clearer, the battle for modern art was still being fiercely fought. Weapons such as provocative manifestos, verbal epithets, and critical thunderbolts were marshaled in the fray. There were also street demonstrations against museums and art galleries that refused the modernists recognition. The ultimate victory of modernism, however, had to wait until well after World War II.

EXPRESSIONISM AND ABSTRACTIONISM

Pablo Picasso's *Les Demoiselles d'Avignon* (Fig. 481) incorporate so many of the ideas of the early 20th century that it became a landmark of the modern-art movement. At the turn of the century Paris was alive with young artists, new notions, and stimulating exhibits. Picasso was impressed in turn by the great Cézanne retrospective of 1907; with a showing of

pre-Roman Iberian sculpture that, like most archaic art, represented the human body in angular geometrical patterns; and with expositions of African tribal sculpture. As a result, he began to reexamine his pictorial approach, turned away from representational conventions toward tighter geometrical controls, and began to acquire a collection of African sculpture that he so much admired.

Les Demoiselles d'Avignon had begun as an allegory. A man seated amid fruit and women was to have been Vice, while his opposite number entering on the left holding a skull in her hand was to have been Virtue. Under the new influences, however, the original plan was abandoned, and the picture developed in another direction by blending the figures, the background drapery, and the still life below

481. PABLO PICASSO. Les Demoiselles d'Avignon. 1907. Oil on canvas, $8' \times 7'8''$ (2.44 × 2.34 m). Museum of Modern Art, New York (Lillie P. Bliss Bequest).

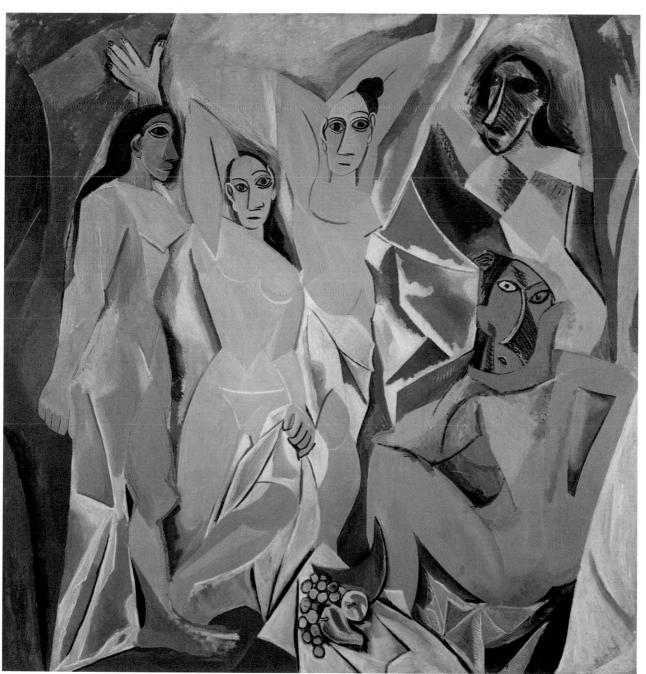

into an abstract design. The girl on the left who is pulling back some curtains became a series of overlapping planes and geometrically arranged contours. The head of the figure in the upper right resembles a mask from Etoumbi (Fig. 482) (at this time the colonial territory of the French Congo), while the head just below and the profile of the figure on the left also show African tribal influence. Picasso's preliminary drawings (Fig. 483) reveal his fascination with the oval-shaped heads, the long noses, small mouths, and angular bodies that characterize the sculpture of the Ivory Coast. The color, with its spectrumlike shading of bright hues one into another, contributes to the effect of an emotional crescendo, while the formal arrangement of the figures suggests the angular rhythms of a primitive dance.

Les Demoiselles is thus a pivotal picture. The heightened postimpressionistic colors, combined

482. Mask, Etoumbi region, People's Republic of the Congo. c. 1775. Wood, height 14" (36 cm). Musée Barbier-Müller, Geneva.

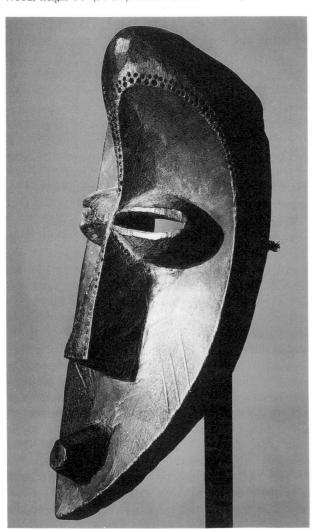

with the dynamism and energy of primitive art, make it a summary of the avant-garde Paris school of painting at the turn of the century. It also marks Picasso's intuitive invention of *cubism*, that most important step toward abstraction. When Georges Braque, one of the fauve painters, first saw *Les Demoiselles*, he perceived that both he and Picasso had been assimilating Cézanne's geometry of cones, spheres, and cylinders and his principles of construction. Over the next four years they worked out the rules of cubism.

In sorting out the developments in contemporary art, one has basically but two ways of looking at the world—from within or from without, subjectively or objectively, through emotion or through reason. These outlooks are by no means mutually exclusive, since mind is necessary for emotional awareness, and without emotional drive even the most rational proposition would be empty and devoid of meaning. For purposes of the present study the arts in which emotional considerations are dominant have been grouped under expressionism; those in which logical and analytical processes are uppermost are under abstractionism. Here a note of caution must be sounded, because all art is expressive to some degree, just as all art is abstract to a certain extent. Also, the abstract side of expressionism must

483. PABLO PICASSO. *Woman's Head.* 1907. Oil on canvas, $28\frac{7}{8} \times 23\frac{3}{4}^{m}$ (73 × 60 cm). Private collection.

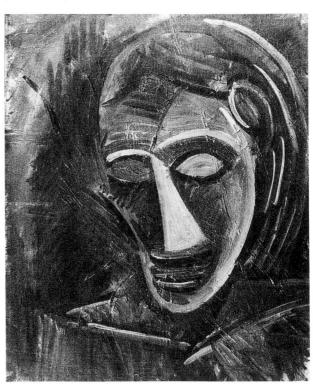

be taken into consideration just as much as the expressive side of abstraction. The difference drawn here is more a matter of degree than of kind.

Expressionism looks within to a world of emotional and psychological states rather than without to a fluid world of fleeting realism, as with impressionism. In their eagerness to develop a style with greater emotional force, the expressionist artists turned away from naturalism. With Van Gogh and Gauguin as their point of departure, these painters distorted outlines, applied strong colors, and exaggerated forms to convey their intentions (see Figs. 474 and 475). Expressionism in its limited sense applies to the pre-World War I period and to the German art movements known as Die Brücke (The Bridge) and Der Blaue Reiter (The Blue Rider). A broader definition, however, includes parallel developments in all major centers where artists were concerned primarily with the emotional approach to art and with their passionate involvement in all phases of life.

Expressionists are fully conscious of the visible world, but they leave behind the classical idea of art as an imitation of nature. They close their eyes to explore the mind, spirit, and imagination. They would agree with Goethe's saying that feeling is all, and they welcomed Freud's delving into the subconscious, which revealed a new world of emotion in the dark drives, hidden terrors, and mysterious motivations underlying human behavior. The expressionists are well aware that they inhabit a number of complex overlapping worlds, and they know too that there are worlds to be explored that are not seen by the eye and that are not subject to logic. The Norwegian artist Edvard Munch became one of the prophets of expressionism with such studies of stark human terror, haunting anxieties, and nightmarish fears as The Cry (Fig. 484). The lines radiating outward from the head of the screaming figure seem to continue the piercing cry in an organic pattern of shattering shock waves.

Expressionistic pictures are in psychological rather than natural focus. They describe intangible worlds with new techniques and new symbols, discordant colors and distorted shapes. The clashing dissonances of expressionistic music are intended to arouse rather than soothe the listener, and expressionistic literature startles the reader with revelations of neurotic, psychical, often psychotic states.

To describe their reactions to physical, psychical, and spiritual events, the expressionists alter, distort, and color their images according to the intensity of their feelings. Expressionism, then, may range from quiet nostalgic moods, through sudden shock reactions and hysterical outbursts, to screaming

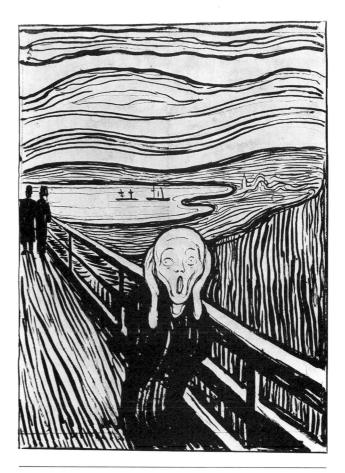

484. EDVARD MUNCH. *The Cry.* 1893. Lithograph on red paper, $14\frac{1}{2} \times 9_{8}^{7}$ (37 \times 25 cm). Museum of Fine Arts, Boston (William Francis Warren Fund).

nightmares. The results of such excursions into the subconscious may be quite uneven, but the artists' passport to these nether regions is nonetheless valid. Among others, expressionism has embraced such movements as neoprimitivism, dadaism, surrealism, and social realism.

Abstractionism implies analyzing, deriving, detaching, selecting, simplifying, and geometrizing, before distilling the essence from nature and sense experiences. The heat generated by the psychological and political revolutions of the 20th century was felt in expressionism, but the light of the new intellectual points of view is mirrored in abstractionism.

In previous centuries, a picture was a reflection, in one way or another, of the outside world. In 20th-century abstractionism, artists free themselves from the representational convention. Natural appearances play little part in their designs, which reduce a landscape to a system of geometrical shapes, patterns, lines, angles, and swirls of color. Choosing their pictorial content from nature, abstract artists eliminate the unimportant minor details of the ob-

served world and refine the haphazardness of nature and ordinary visual experience. Their imagination and invention are concentrated on pictorial mechanics and the arrangement of patterns, shapes, textures, and colors. From the semiabstract cubist art, in which objects are still discernible, abstractionism moves toward nonobjectivism, in which a work of art has no representational, literary, or associational meaning outside itself, and the picture becomes its own self-defining referent.

In the early years of the century, physicists were at work formulating a fundamental new view of the universe, which resulted in the concepts of space-time and relativity. In the arts, meanwhile, new ways of seeing and listening were also being worked out. In painting, for example, the cubist system of multiple visual viewpoints was explored, whereby several sides of an object could be presented at the same time. In sculpture, a new theory of volume was developed, whereby open holes or gaps in the surface suggested the interpenetration of several planes, and the existence of other sides and surfaces not immediately in view. In architecture, the international style, using steel and glass, incorporated in a structure the simultaneous experience of outer and inner space.

Similar developments occurred in literature and music, which found new ways of presenting materials in the time dimension. In literature, the stream-of-consciousness technique merged objective description and subjective flow of images. In music, the so-called atonal method of composition was formulated, by which fixed tonal centers were avoided in favor of a state of continuous flux and variation.

Such novel organizations of space and time demanded new ways of thinking about the world, new ways of looking at it, listening to it, and reading about it. Abstractionism includes such developments as cubism, futurism, the mechanical style, nonobjectivism, the twelve-tone method of musical composition, and the international style of architecture.

Neoprimitivism

As the first bonfire of 20th-century expressionism burst into flame, the spark that set fire to the movement called *neoprimitivism* was the 19th-century discovery of the native arts of the South Sea Islanders and the wood carvings of African tribes. As used here, neoprimitivism is limited to the conscious adaptations by sophisticated artists of authentic specimens of Oceanic, African, and other native art.

PAINTING. The first major artist to employ exotic patterns and motifs in woodcuts and paintings had

been Gauguin, and such pictures as his *Mahana No Atua* (Fig. 475), painted during his extended stay in Tahiti, clearly reflect the native influence. Examples of Polynesian handcraft, such as oars, arrows, and harpoons, had been collected by traders on their voyages and were shown in the Paris expositions of 1878 and 1889. Later, when expeditions went to the interior of Africa, wooden objects carved by members of black tribes were brought back for display. The ethnological museums, founded in Paris and Dresden to house these collections, commanded considerable interest among scholars, artists, and the general public. Books on African sculpture ap-

485. Amedeo Modigliani. *Head.* c. 1913. Stone, height $24_4^{3\prime\prime}$ (63 cm). Tate Gallery, London (reproduced by courtesy of the Trustees).

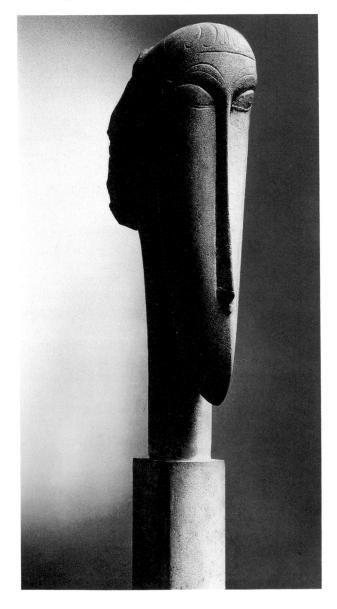

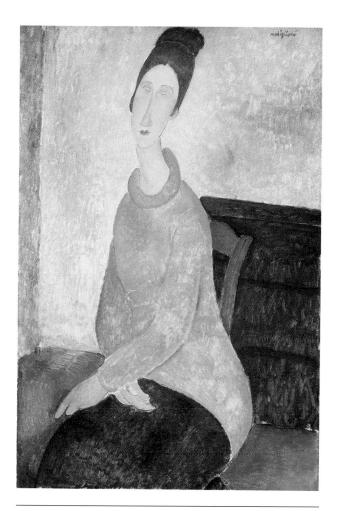

486. Amedeo Modigliani. *Yellow Sweater (Portrait of Mme. Hébuterne)*. 1919. Oil on canvas, $39\frac{8}{8} \times 25\frac{17}{2}$ " (100 × 65 cm). Solomon R. Guggenheim Museum, New York.

peared, and in 1890 James Frazer began publishing *The Golden Bough*, a twelve-volume digest of primitive customs, folklore, magical practices, and taboos.

African art, with its ingenious geometrical distortions of the human figure, its freedom from Western stereotypes and the academic tradition, promised a new beginning. Especially appealing was the animistic attitude of the tribal carvers, who divined the spirit of wood and stone and expressed it in the grains, textures, and shapes of their materials. German expressionists were fascinated by the strange, weird forms and nonintellectualism of African images. French artists, among them Matisse, found in these simplified geometrical forms a wealth of decorative motifs and an ample justification for their abstract designs.

SCULPTURE. The impact of native art also affected the course of 20th-century sculpture. When the young painter Modigliani came to Paris in 1906, he

fell so completely under the spell of African tribal sculpture that for a while he traded the brush for the chisel. One of these works, *Head* (Fig. 485), is in the same Ivory Coast style that Picasso had adopted. In his paintings, Modigliani later used similarly stylized oval faces and elongated shapes, such as those in *Yellow Sweater* (Fig. 486).

The elemental simplicity of Constantin Brancusi's sculpture has its inspiration in the power of native forms and the bold innovations of the fauve painters (pp. 529–31). Brancusi's objective was to free sculpture from everything nonessential and get down to ultimate essences. One egg-shaped marble piece, for instance, is called *Beginning of the World*. Like the neoprimitives, Brancusi accepts his materials for what they are—marble for its smoothness and roughness, metal for its hardness or softness. Whatever the material, he tries to understand its nature and fulfill its potentialities without forcing it to simulate something else. "What is real," Brancusi once remarked, "is not the external form, but the essence of things."

In his *Bird in Space* (Fig. 487) Brancusi is dealing with a bronze that has such a high copper content that it approaches the glossy brilliance of gold. By molding it into a graceful curvilinear form and giving it a high polish, he releases the metal medium into a form of energy. It is the abstraction of a movement, a feather in flight. Brancusi sometimes tried to increase the sense of motion in sculpture by placing his figures on slowly rotating turntables.

The influence of primitive sculptural forms is carried over into the later decades of the century in the work of Henry Moore. The other sources of Moore's powerful sculpture are prehistoric primordial forms, Stonehenge, ancient Etruscan tombs, pre-Columbian Mexican carvings, African and Oceanic art, the ways in which wind and water shape trees and erode boulders, and, above all, his own fertility of formal invention. "Truth to material," Moore once wrote, is "one of the first principles of art so clearly seen in primitive work. . . . The artist shows an instinctive understanding of his material, its right use and possibilities."

Moore's reclining figures are like mother earth or some fertility goddess of a forgotten cult. The curves and intricate windings rise above the human form and become a part of the heaving hills and plunging valleys of a rolling landscape. Many of Moore's figures are pierced by holes and hollows so that his sculpture has an interior as well as exterior existence. In his *Reclining Figure* (Fig. 488) the natural grain of the elmwood surface creates a pattern that suggests the ebb and flow of the tides as well as the action of wind and weather.

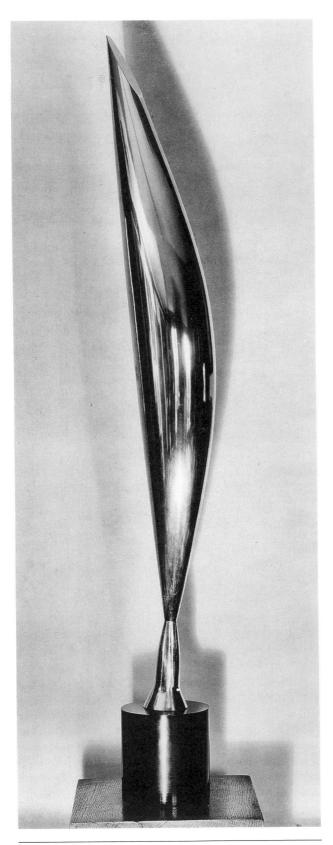

487. Constantin Brancusi. *Bird in Space*. 1925. Polished bronze, height $4'1_4^{3''}$ (1.26 m). Philadelphia Museum of Art (Louise and Walter Arensberg Collection).

Music. Knowledge of non-European musical systems had likewise increased rapidly during the late 19th century. The orchestrations of Debussy and Ravel had been influenced by the strange and exotic gong sounds of the gamelan orchestras from Java, which both composers had heard at the International Exposition of 1889. By far the strongest of these new influences, however, was American jazz music, which had its beginning in New Orleans and Chicago and which was heard in Europe through the traveling bands. In The Children's Corner (1908), Debussy included a number called "Golliwog's Cake Walk." The title refers to a stage dance developed from the American black minstrel show based on strutting steps and figures involving a high prance. A golliwog was a grotesque black doll popular in comic strips.

Igor Stravinsky, whose music reflects many style trends, achieved the neoprimitive musical counterpart of Picasso's *Demoiselles d'Avignon* in the ballet *Rite of Spring*, which he wrote in Paris for the Diaghilev company in 1913. Subtitled *Scenes from Pagan Russia*, the opening "Dance of the Adolescents" (below) uses repetitive rhythms and syncopated accents somewhat like those of American jazz. The sharply angular melodies, the complex textures created by multiple rhythms, the brutal accentuations, and the geometrical movements of the dancers are a masterly realization of the spirit of savagery.

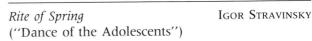

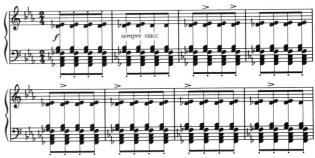

Jazz was born of the African-American union of the black people. They brought with them the African heritage of strong driving rhythms and choral singing. In America they encountered the Western harmonic and melodic traditions. This mixture of the memories of tribal ceremonies and more sophisticated musical conventions produced a music of such tremendous vitality that it swept all before it. Starting with the blues and ragtime in New Orleans, jazz

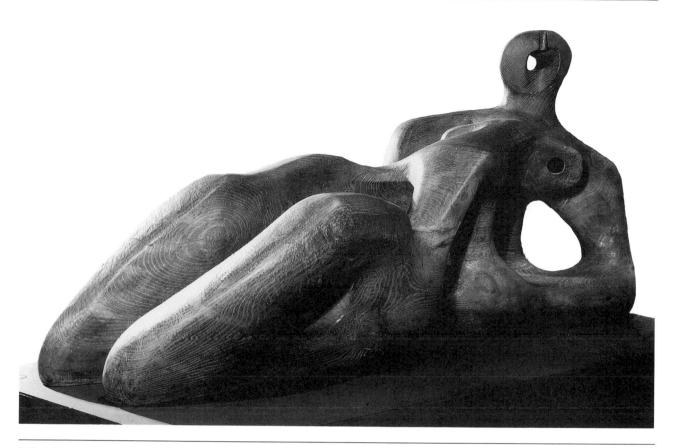

488. Henry Moore. *Reclining Figure*. 1939. Elmwood; height 3'1'', length 6'7'', depth 2'6'' ($9.1 \times 2 \times 7.6$ m). Detroit Institute of the Arts (gift of Dexter M. Ferry, Jr., Trustee Corporation).

spread to such centers as Chicago, St. Louis, and New York in the 1920s. With the various forms of rock, it now dominates popular music on both the national and international scenes. So rich a source of expression was soon recognized by major composers. In Paris, Debussy, Ravel, and Darius Milhaud worked elements of jazz into their compositions. In the United States, George Gershwin, Aaron Copland, and Leonard Bernstein based a major part of their output on it. Today jazz has become an art form in its own right. As such, it is not only one of the most important contributions blacks have made to the arts but also the unique American achievement in music.

Wild Beasts, The Bridge, Blue Rider, and Operatic Uproars

Expressionists deal with intensities of feeling rather than intensities of light. For them, the heat of creation supersedes the coldness of imitation. They present subjective reactions instead of representing objective realities and reassert the supremacy of the human imagination over the representation of nature. About the time Picasso was discovering tribal sculpture, other groups were championing expressionism in painting as a reaction to the cool atmospheric effects and objectivity of impressionism.

Van Gogh had pointed the way with his frenzied canvases, passionate pictorial outbursts, saturated colors, and evangelical fervor. Such a painting as *Starry Night* (Fig. 474), with the dark green flames of the cypress trees, rolling rhythms of the hills, and cosmic explosion of the Milky Way, was enough to set imaginations on fire. The barbaric splendor of Gauguin's color harmonies also was seized upon as a useful means for producing lively emotional responses. The expressionists also looked more distantly at the luminous colors of medieval stained glass and the imaginative inventiveness of Romanesque sculpture. Native arts of Polynesia and Africa played their parts here too.

FAUVISM. The violent color clashes and visual distortions of the French expressionistic painters in the Paris Salon of 1905 caused a sensation comparable to that of the first impressionist show. "Donatello in a cage of wild beasts [fauves]," commented a critic

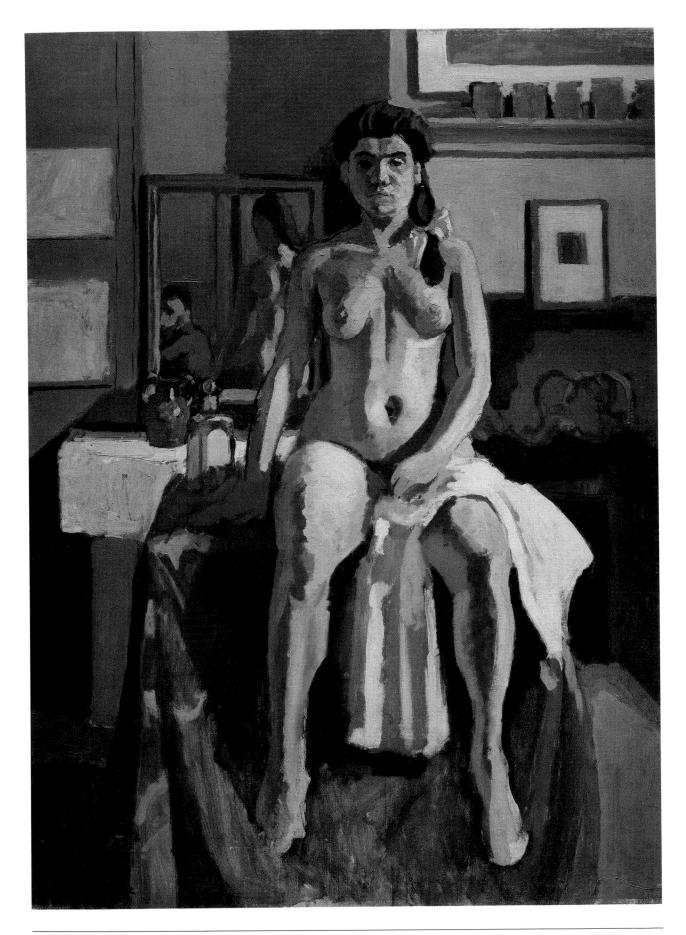

489. Henri Matisse. *Carmelina*. Oil on canvas, $32 \times 23_4^{4''}$ (81.3 \times 59 cm). Tompkins Collection, Museum of Fine Arts, Boston.

when he saw the paintings of Matisse and others grouped around a Renaissancelike statue. The early works of Matisse (Figs. 489 and 490), that most civilized of artists, were so classified, though in retrospect it is difficult to understand why. If there was ever anything "wild" about Matisse, it was his reveling in brilliant color for its own sake, his resourcefulness of invention, and his quality of Oriental splendor that made him a fauve—but a fauve quite without ferocity.

The Blue Window (Fig. 490), which he painted in 1911, shows his concern with formal aesthetic problems, vibrant color harmonies, and arabesquelike decorative motifs. The picture is composed as an abstract still-life study merging subtly into a stylized landscape. The hatpins in the cushion on the left unite with the empty vase behind them; the flowers in the other vase grow into the foliage and the roof of the painter's studio outside; the Oriental idol in the center leads the eye to the vertical division of the casement window, while the lines formed by the contours of the lamp continue with those of the tree trunk in the garden. The bedroom table and its objects are thus united with the trees and sky beyond, and the interior and exterior elements become parts of one design. Depth and recession are suggested only by a slight lessening of the color intensities. In this picture, Matisse approached his dream of an "art of balance, of purity and serenity devoid of depressing subject matter."

For Matisse, expressionism did not apply to the content of his canvases or to the communication of an emotional message but rather to the entire formal management of his pictorial pattern. "Expression to my way of thinking," he once remarked, "does not consist of the passion mirrored upon a human face or betrayed by a violent gesture. The whole arrangement of my picture is expressive. . . ."

DIE BRÜCKE AND DER BLAUE REITER MOVE-MENTS. German expressionism in the decade before World War I was mainly associated with two groups that developed simultaneously with the fauves: Die Brücke (The Bridge) and Der Blaue Reiter (The Blue Rider). The Bridge was a loose association of Dresden painters who took this name because they wished to form links with all artists of the expressionistic persuasion, as well as a bridge toward the future. They acknowledged their debt to Van Gogh and Gauguin, but most especially to the Norwegian Edvard Munch (Fig. 484).

Emil Nolde was among the most articulate members of Die Brücke, and *Dancing around the Golden Calf* (Fig. 491) was one of his many biblical subjects. Violent color dissonances of blood red and orange yellow plus distorted drawing carry his mes-

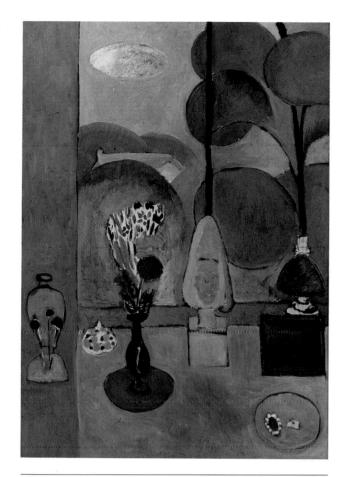

490. Henri Matisse. *Blue Window*. 1911. Oil on canvas, $4'3\frac{1}{2}'' \times 2'11\frac{5}{8}''$ (1.31 × .91 m). Museum of Modern Art, New York (Abby Aldrich Rockefeller Fund).

sage of the primitive fury and demoniac energies of his tormented dancers.

Der Blaue Reiter was the title of a painting by Kandinsky that became the manifesto of the southern German expressionist movement. It was also the name of a book, edited in 1912 by Franz Marc and Kandinsky, that reproduced paintings shown at a Munich exhibit of the previous year. The volume included works by some of the French fauves and Paul Klee, in addition to those by Marc and Kandinsky. The book also contained articles on modern art, while the Viennese composer Arnold Schoenberg contributed a chapter on parallel expressionistic developments in music. Marc's art, as seen in his Great Blue Horses (Fig. 492), is one of pulsating rhythms, curvilinear design, and lyrical movement.

Kandinsky was an international figure who first painted in his native Russia, worked in the post-impressionistic and fauve styles in Paris, and joined in founding the Blue Rider group in Munich. Works of his Blue Rider period, such as *Improvisation No. 30*

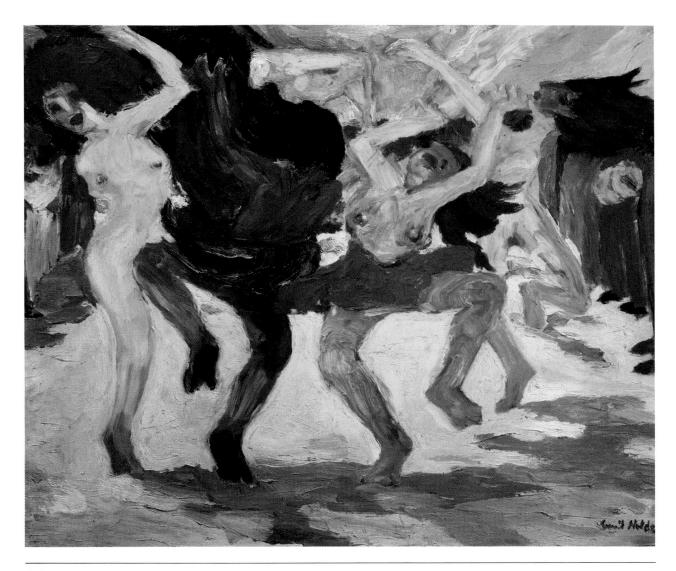

491. EMILE NOLDE. Dancing around the Golden Calf. 1910. Oil on canvas, $34\frac{3}{4} \times 39\frac{1}{2}''$ (88 × 100 cm). Staatsgalerie Moderner Kunst, Munich.

(on a Warlike Theme) (Fig. 493), still contained references to natural, human, and animal figures. In this instance, the artist mentions that he painted "subconsciously and in a state of strong tension" during 1913, when rumors of war were being heard. This, he added, explains the presence of the two cannons in the lower right and the explosive forms.

By eliminating objects and figures, dissolving material forms, and improvising according to his moods, Kandinsky reached the frontiers of nonobjective art and set the stage for the abstract expressionism of the 1940s and 1950s in which painting is "liberated" from nature (see pp. 566–73). His later work shows what he can express with lines, colors, and shapes. Commenting on his completely abstract paintings, Kandinsky stated that their content is

"what the spectator *lives* or *feels* while under the effect of the *form and color combinations* of the picture"—which may or may not coincide with what the artist had in mind when he painted it.

Kandinsky, who published poetry, plays, essays, and an autobiography, also recognized the affinity of his work to music. In his own words, he strove to reproduce on his canvases the "choir of colors which nature has so painfully thrust into my very soul" and believed that a painting should be "an exact replica of some inner emotion." Works that required "an evenly sustained pitch of inner emotional uplift sometimes lasting for days" he called "compositions." Spontaneous shorter works, sketches, and watercolors that "do not last the span of a longer creative period" he termed "improvisations."

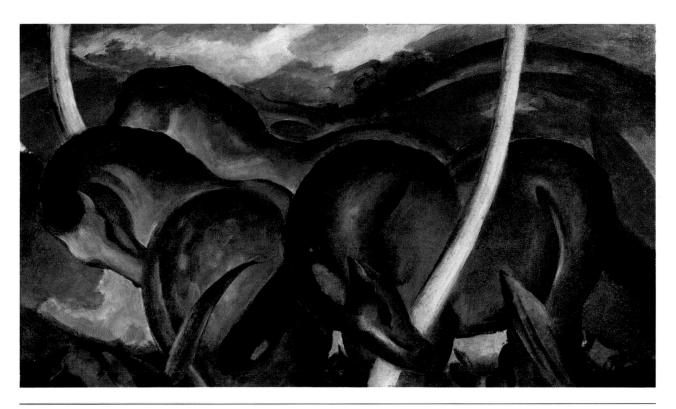

492. Franz Marc. *The Great Blue Horses.* 1911. Oil on canvas, $40 \times 63''$ (101.6×160 cm). Collection Walker Art Center, Minneapolis, Minn. (gift of the T. B. Walker Foundation, Gilbert M. Walker Fund, 1942).

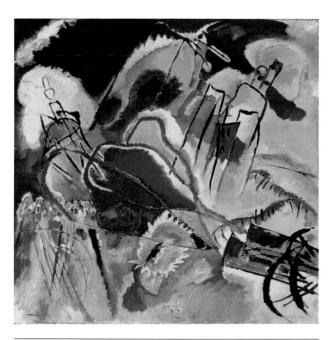

493.VASILY KANDINSKY. *Improvisation No. 30 (on a Warlike Theme).* 1913. Oil on canvas, 43¼" (110 cm) square. Art Institute of Chicago (Arthur Jerome Eddy Memorial Collection).

Musical Counterparts. Some of the earliest and most violent outbursts of musical expressionism are found in Richard Strauss's operas Salome (1905) and Elektra (1909), which he wrote in Munich while the Blue Rider movement was developing. Taking off from Richard Wagner's Tristan und Isolde, Salome's "love death" is an operatic voyage into the realm of abnormal psychology. In Salome, Strauss lures his listeners with sensuous sounds and a rainbow of radiant orchestral colors, then horrifies them with the gruesome spectacle of Salome's erotic soliloquy to the severed head of John the Baptist.

This simultaneous attraction and repulsion is bound to produce emotional excitement and elicit truly expressionistic reactions. The sensational nature of Oscar Wilde's play that Strauss adapted as his text, together with the famous "Dance of the Seven Veils," caused the opera to be banned in New York, Boston, and London. *Elektra* is a dramatically effective version of Aeschylus's tragedy (as adapted by Hugo van Hofmannsthal), filled with emotional climaxes, piercing shrieks, and lurid orchestral sounds.

Arnold Schoenberg's expressionistic song cycle *Pierrot Lunaire* (1912) explores the weird world of Freudian symbolism, and in his monodrama of 1913

Die glückliche Hand (The Lucky Hand) the dissonances of the musical score are reinforced by crescendos of colored psychedelic lights. Something of a high point is reached in Alban Berg's opera Wozzeck (1925), a musical dramatization of big-city low life in one scene of which beggars, drunkards, and street girls pursue the murderer as he vainly tries to escape from his surroundings and himself.

While Wagner had worked up his climaxes gradually and over a considerable period of time, generally starting low in pitch and volume and mounting upward in an extended melodic, harmonic, and dynamic crescendo, Schoenberg and Berg compressed the process. Their music became all climax, with the extremes of low and high, soft and loud following each other suddenly by leaps instead of in a gradual progression. With Wagner, dissonances existed in chains of sequences that eventually were resolved. With Schoenberg and Berg, dissonance exists for its own sake, with little or no relation to consonance or resolution.

Cubism

PAINTING. Just as the discovery of the rules of linear perspective had revolutionized painting in the Florentine Renaissance, so *cubism* brought about a new way of looking at things in the 20th century. First worked out in painting, the consequences of cubism were echoed directly in sculpture and architecture, and indirectly in literature and music. A strong shove in the direction of abstraction had come from the large retrospective exhibit of Cézanne's painting held in Paris in 1907, where the young painters who saw it were struck by the artist's pictorial architecture. In the catalogue, they noted a quotation from a letter in which Cézanne remarked that natural objects can be reduced to the forms of the cylinder, the sphere, and the cone. Art, they reasoned, is not an imitation of nature in the usual sense but an imposition upon nature of geometrical forms derived from the human mind. As a result, cubist painting became a play of planes and angles on a flat surface. Cézanne's famous sentence, it should be pointed out, never mentioned cubes at all. His cylinders, spheres, and cones are all rounded forms, presupposing curvilinear drawing; cubist drawing, on the contrary, is dominantly angular and rectilinear.

The Renaissance ideal had been the complete description of a pictorial situation from a single point of view; another vantage point would imply another picture. The cubist theory of vision took into account the breaking up and discontinuity of the contemporary worldview, in which objects are perceived more hastily in parts rather than more leisurely as wholes.

The world, as a consequence, was seen fragmentarily and simultaneously from many points of view rather than entirely from a single viewpoint. In Picasso's Demoiselles d'Avignon (Fig. 481), for instance, the faces of the second and third figures from the left are seen frontally while their noses appear in profile. Picasso and Braque, as the co-inventors of cubism, undertook a new definition of pictorial space in which objects were represented simultaneously from many visual angles, in wholes or in parts, opaque and transparent. Just as the Crystal Palace (Figs. 465 and 466) had pointed the way to interpenetration of the inner and outer aspects of architectural space, so the art of the cubists undertook to move inside as well as outside an object, below and above it, in and around it.

The cubists also were convinced that pictorial space, limited as it is by the two dimensions of the flat canvas, was something quite apart from natural space. From the Renaissance onward, the accepted procedure had been to produce the illusion of three-dimensionality by some form of linear perspective

494. GEORGES BRAQUE. *Oval Still Life (Le Violon)*. 1914. Oil on canvas, $36\frac{3}{8} \times 24\frac{37}{4}$ (92 × 63 cm). Galerie Beyeler, Basel.

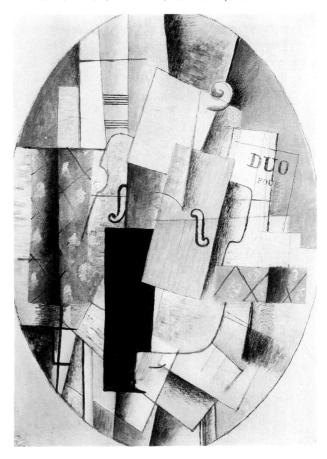

derived from the principles of Euclidean geometry. Cubist painters, however, approached their canvases as architects in order to construct their pictures. Instead of trying to create the illusion of depth, they built their pictures on the straight lines of the triangle and the T-square by which they defined the planes of their surfaces.

The expression of volume, as achieved by the modeling of objects in light and shade, was also modified by the cubists, and so was the tactile feeling and structural solidity of Renaissance painting. Instead of representing objects in the round, the cubists analyzed them into their basic geometrical forms, broke them up into a series of planes, then collected,

reassembled, and tilted them at will into a new but strictly pictorial pattern of interlocking, interpenetrating, and overlapping surfaces and planes.

Cubist color at the beginning was purposely confined to the rather neutral tones of gray, green, olive, and ochre. The emphasis was on design and texture, while unity was found in the picture itself rather than in the objects represented. The technique in its earliest stages can be observed in Figure 481 by the way Picasso renders the bodies of the figures on the extreme left and upper right.

Braque's *Oval Still Life* (Fig. 494) shows cubism in its more developed form, after the rules had been worked out. Typical is its use of natural objects as a

495. Pablo Picasso. *Three Musicians*. 1921. Oil on canvas, $6'7'' \times 7'3_4^{3''}$ (2.01 × 2.23 m). Museum of Modern Art, New York (Mrs. Simon Guggenheim Fund).

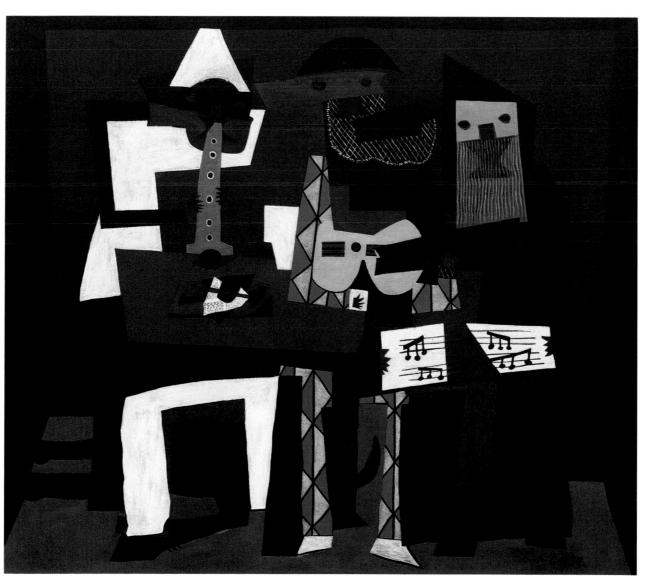

point of departure. Such still-life components as the table, violin, and sheet music are then broken up so that they can be reassembled in a design determined by the artist.

In their early doctrinaire stages, when the cubist painters were dogmatically trying to put their abstract doctrines into effect, cubist pictures tended to be rather cold, impersonal studies in abstract design. However, such modifications of this pure state as Picasso's *Three Musicians* (Fig. 495) began to appear. The flat, two-dimensional arrangement is retained, but the bright coloration gives the canvas a gaiety not found earlier. The three masked figures sitting at a table are the same commedia dell'arte figures that regularly recur on Picasso's canvases, cubist or otherwise; these come from his love of circus and theatrical performances in which clowns and other performers dress in festive carnival costumes. The figure on the left playing a clarinet is a Pierrot; the center one with the guitar is a Harlequin; while the more solemn monklike figure on the right holds a musical score.

496.PABLO PICASSO. *Woman's Head.* 1909. Bronze, height 16_4^{17} (41 cm). Albright-Knox Gallery, Buffalo (Edmund Hayes Fund, 1948)

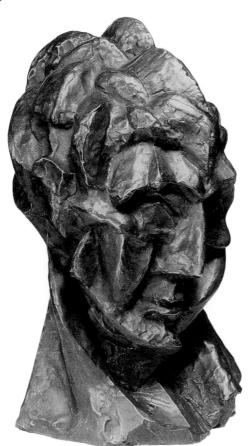

Sculpture. Picasso's *Woman's Head* (Fig. 496) is a translation of cubist principles into the three-dimensional medium of sculpture. It presents a geometrical analysis of the structure of the human face and emphasizes the most important planes and surfaces. By this process of disintegration, the head can be organized into a number of different facets, each of which can cast its own shadow and thus bring variety and a sense of movement to the composition.

The sculptures of Jacques Lipchitz are threedimensional adaptations of cubism in its mature

497.Jacques Lipchitz. *Man with Mandolin*. 1917. Stone, height 29¾ (76 cm). Yale University Art Gallery, New Haven (Collection Société Anonyme).

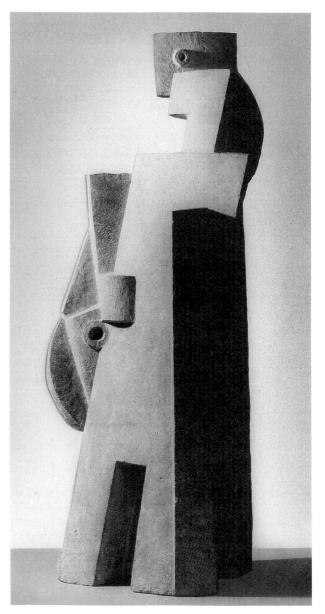

phase. The *Man with Mandolin* (Fig. 497) creates a repetitive pattern of rough stone textures, diagonal lines, tilted planes, irregular rectangles and triangles. Lipchitz breaks down the traditional distinction between solids and voids, convex and concave surfaces, the relationship between wholes and parts in an intricate interlocking design.

Music: Twelve-Tone System. The musical counterpart of this new concept of space is found in the breaking up of traditional tonality as well as in the search for new musical resources and mediums of expression. Stravinsky, as a strict follower of the principles of order, had said that "tonal elements become musical only by virtue of their being organized." The twelve-tone system of musical composition that Schoenberg evolved about 1915 was one of the stricter forms of tonal organization. As a point of departure he sets forth a basic row made up of the twelve different pitches of the chromatic scale. No tone may be repeated until the row is complete. This row can be played in normal order, upside down by melodic inversion, backward in retrograde motion, and upside down once more in retrograde inversion (see below). Furthermore, it can be presented successively in sequences or simultaneously as in the various styles of counterpoint. It can also be played in whole or in part simultaneously as a chord or tone cluster, or it can be played serially, one note after another as a melody.

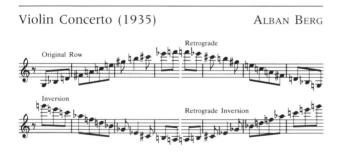

A row can be used as a unit, or it can be broken up into several shorter themes or motifs. It has been estimated that around half a billion different combinations are possible, which certainly is no limitation on its possibilities. The system provides the composer a wealth of material as well as a certain freedom within an orderly framework. The twelve-tone method has generally been referred to as *atonality* (that is, without tonality), but Schoenberg preferred to call it simply a method of composing with twelve tones that are related only with one another. Tonal-

ity is thus relative rather than absolute, since there is no single tonal center. Tonality in the usual sense, however, is not excluded; rather, the system encompasses tonality and rises above it.

One of the most accessible works in the twelve-tone repertory is Alban Berg's Violin Concerto of 1935 (below, left). The row is an ascending vertical series without repetition that can be followed easily by the attentive ear. Skillfully contrived, the first six tones contain the four triads of tonal music: notes one to three being the minor triad, two to four the augmented, three to five the major, four to six the diminished. A combination of four tones (one to four, two to five, and so on) forms types of seventh chords. The top four notes make a series of whole tones resembling the scale favored by Debussy. They are also the first notes of the chorale "Es ist genug" by J. S. Bach, which is quoted in full in the last part of the concerto. Berg's compositional space thus includes traditional tonality, harmony, and melody as his point of departure into the larger context of 12-tone atonality.

Futurism and the Mechanical Style

The movement known as *futurism* was begun in Italy under the leadership of the poet and dramatist Filippo Tommaso Marinetti before World War I. Agreeing with Nietzsche's remark that history was the process by which the dead bury the living, Marinetti declared in his *Manifesto* of 1909 that futurism was being founded to "deliver Italy from its plague of professors, archeologists, tourist guides and antique dealers."

The futurists wanted to destroy the museums, libraries, academies, and universities in order to make way for their particular wave of the future. "A roaring motorcar, which runs like a machine gun," they said, "is more beautiful than the winged Victory of Samothrace." Theirs was a vision of a state ruled by a mechanical superhuman mind, in which the people would be reduced to cogs in the gigantic wheel of a fully mechanized society.

Above all, the futurists projected an art for a fast-moving, machine-propelled age. They admired the motion, force, speed, and strength of mechanical forms, and in their pictures they wanted more than anything else to include the dynamic sensation of motion. A galloping horse, they said, has not four legs but twenty. Deriving his inspiration from automobiles, airplanes, trains, and machine guns, Severini painted *Armored Train* (Fig. 498), with its diagonal lines and plumes of smoke suggesting speed, while the gunfire adds the dimension of rapid action.

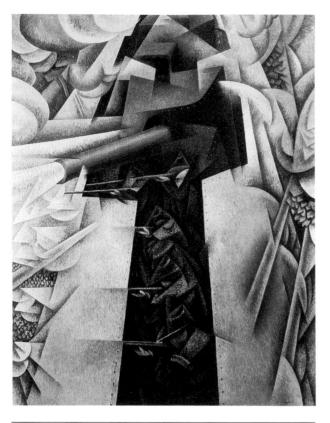

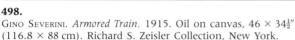

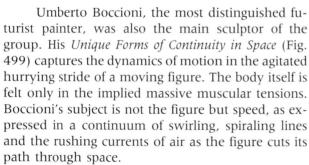

Futurism was influential chiefly for its formation of the "mechanical style." By taking ideas from both the cubists and the futurists, Fernand Léger developed a style in which precise and neat parts all fit into an appointed place, as in *The City* (Fig. 500). Léger loved crankshafts, cylinder blocks, and pistons—all painted in gleaming primary colors. Taking Cézanne's statement about cylinders, spheres, and cones more literally than did the cubists, he drew curved forms and modeled them in light and dark. His is a world without sentiment, populated by robots whose parts are pure geometrical shapes. Human forms are introduced only for their "plastic value" and remain "purposely inexpressive." In

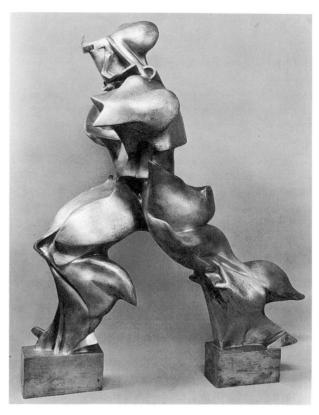

499. UMBERTO BOCCIONI. *Unique Forms of Continuity in Space.* 1913. Bronze (cast 1931), height $43\frac{7}{8}$ " (111 cm). Museum of Modern Art, New York (Lillie P. Bliss Bequest).

1924, Léger made an abstract film called *Ballet Mécanique*, in which machine forms replaced human beings and their activities.

THE MUSICAL DIMENSION. Stravinsky had composed a piece for player piano in 1917 entitled Étude for Pianola, and the French composer Arthur Honegger, using the normal symphony orchestra, gave voice in 1924 to the triumphant song of the machine in a work called Pacific 231. Its name is a reference to that year's model of an American locomotive. The piece was designed to evoke the sounds of the railroad, complete with the powerful grinding of the wheels and the penetrating shriek of the steam whistle.

Perhaps the most successful musical realization of the mechanical style is found in the works of Edgard Varèse. Technically trained in two fields, Varèse was as much a physicist as a musician, and the titles of his works sound as if they came from a laboratory: *Intègrales, Density 21.5* (the specific gravity of the platinum of the flute for which it was composed), and *Ionisation*. The last is constructed in a series of interlocking planes of sound that suggest, but are not directly imitative of, rhythms of modern city life.

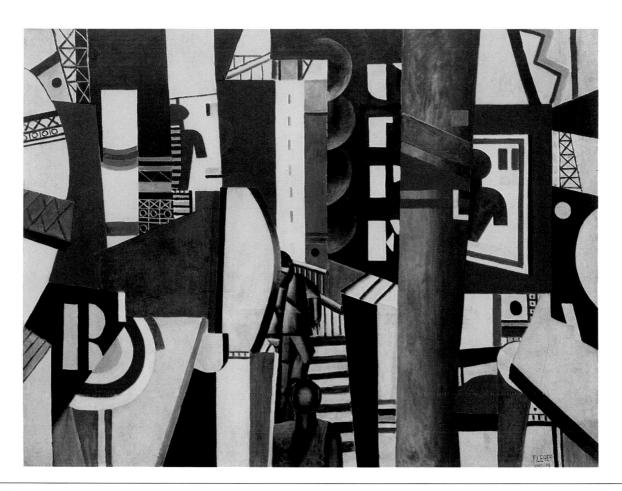

500. Fernand Léger. *The City.* 1919. Oil on canvas, $7'7'' \times 9'8\frac{1}{2}''$ (2.31 × 2.96 m). Philadelphia Museum of Art (A. E. Gallatin Collection).

Varèse's expressed aim was to build a music that would face the realities of the industrial world rather than try to escape from it.

Dadaism and Surrealism

In their Paris exhibits of 1911 and 1912, the Italian Giorgio de Chirico and the Russian Marc Chagall anticipated the development of surrealism. The term, in fact, was coined at that time by the French critic and playwright Guillaume Apollinaire to describe the dream fantasies, memory images, visual paradoxes, and assorted incongruities of their pictures. Chirico's dreamscape Melancholy and Mystery of a Street (Fig. 501) takes expressionism into an introspective world of free associations. "Everything," according to this artist, "has two aspects: the current aspect, which we see nearly always and which ordinary men see, and the ghostly and metaphysical aspect, which only rare individuals may see in moments of clairvoyance and metaphysical abstraction." His intention was to break down the barriers of childhood and adulthood, the sleeping and waking states, the unbelievable and the believable, the illogical and the logical, the fantastic and the familiar. Melancholy and Mystery of a Street is filled

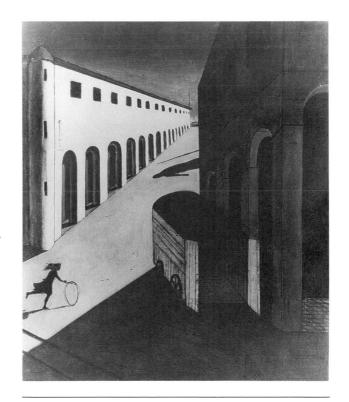

501. GEORGIO DE CHIRICO. *Melancholy and Mystery of a Street.* 1914. Oil on canvas, $33\frac{1}{2} \times 27\frac{1}{4}$ " (85 × 69 cm). Private collection.

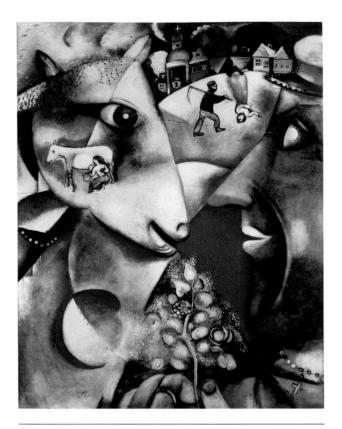

MARC CHAGALL. I and the Village. 1911. Oil on canvas, $6'3\frac{5}{8}'' \times 4'11\frac{5}{8}''$ (1.92 × 1.51 m). Museum of Moden Art, New York (Mrs. Simon Guggenheim Fund).

with an ominous silence and an all-pervading emptiness, made mysterious by deep perspective. Chirico's pictures are haunted by Freudian psychology and furnished with sundials casting long shadows, arcaded galleries, empty vans, factories, and strange statues.

I and the Village (Fig. 502) grows out of Chagall's memories of Russia. In one of his childhood reveries he remembered the ceiling of his parents' crowded cottage suddenly becoming transparent. "Clouds and blue stars penetrated, along with the smell of the fields, the stable, and the roads," he wrote, and "my head detaches itself gently from my body and weeps near the kitchen, where fish is being prepared." In I and the Village, as in a rainbow-hued dream, one image is superimposed on another, the houses are topsy-turvy, the farmer going to the fields is right side up, the peasant woman upside down, and the cow seems to be experiencing a contented reverie about a milkmaid.

DADAIST NONPICTURES. Dadaism was the product of the disillusionment, defeatism, and insane butchery of World War I. Anguished artists felt that the civilization that had brought about such horrors should be swept away and a new beginning made. To christen their movement, these artists chose quite at random a childish word out of the French dictionary—dada, a child's vocalization signifying a hobbyhorse.

Dadaism consequently was a nihilistic movement, particularly distrustful of order and reason, a challenge to polite society and the establishment, a protest against all prevailing styles in art. It was, in fact, anti-art in the then-accepted meaning of the term (Fig. 503). Dada artists worked out an ism to end all isms, painted nonpictures compounded of the contents of wastebaskets, concocted nonsense for the sake of nonsense, wrote manifestos against manifestos, and their political expression was anarchy. Their bitter humor and attack on respected institutions, however, helped to explode hypocritical pomposities. Also, by reducing the role of art to absurdity, they cleared the air for the experiments and

MARCEL DUCHAMP. L.H.O.O.Q. 1919. Rectified ready-made pencil on reproduction of Leonardo's Mona Lisa; $7\frac{3}{4} \times 4\frac{7}{8}$ " $(20 \times 12 \text{ cm})$. Private collection.

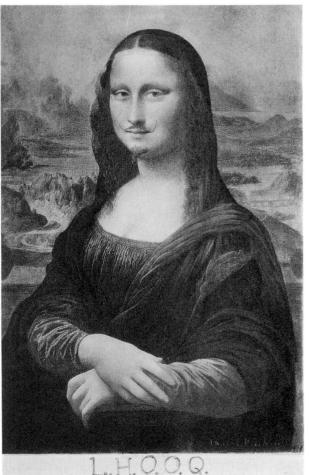

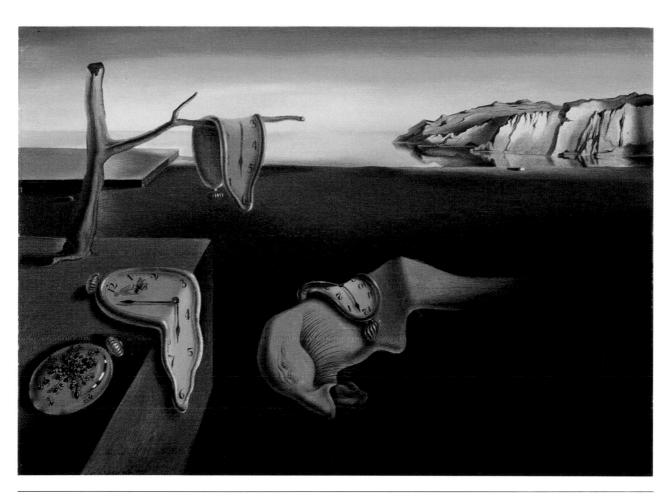

504. Salvador Dali. *The Persistence of Memory.* 1931. Oil on canvas, $9\frac{1}{2} \times 13''$ (24.1 × 33 cm). Museum of Modern Art, New York (anonymous gift).

innovations of the postwar period. A brief movement, dadaism was absorbed into surrealism, which has appropriately been dubbed the "dadaism of the successful."

PSYCHIC AUTOMATISM. The surrealist manifesto of 1924 proclaimed that the style was based on "pure psychic automatism by means of which one sets out to express, verbally, in writing or in any other manner, the real functioning of thought without any control by reason or any aesthetic or moral preoccupation." Surrealism, literally "superrealism," implies a greater reality underlying the world of appearances, an illogical, subconscious dream world beyond the logical, conscious, physical one. Members of the group believed in the superior reality of the dream to the waking state, of fantasy to reason, of the subconscious to the conscious. André Breton, author of the manifesto, also spoke of the "convulsive beauty" of dreams, and the surrealist poet Paul Éluard said, "a poem should be the debacle [ruination] of the intellectual."

The painter Salvador Dali associated himself with the group in 1929 and became one of its leading advocates. Symbols of various phobias, delusions, complexes, and other trappings of abnormal psychology are found in his pictures. Like Chirico and Chagall, Dali was haunted by the mystery of time, and his *Persistence of Memory* (Fig. 504) suggests images of evolutionary, geological, and archeological as well as dream time.

Today Paul Klee is generally accepted as one of the most significant pictorial talents of the 20th century. Such pictures as *Around the Fish* (Fig. 505) have caused many to dismiss him with a shrug, a scoff, or a smile. His disarming childlike innocence, however, is a highly deceptive simplicity and usually masks infinitely subtle meaning. His inventiveness outdoes even Picasso. He can delight the eye, tickle the fancy, or repel the observer with images straight out of nightmares. *Apparatus for Magnetic Treatment of Plants, Twittering Machine, A Cookie Picture, Moonplay, Idol for Housecats, Child Consecrated to Suffering, A Phantom Breaks Up*—so the titles run.

Klee's Around the Fish (Fig. 505) may at first seem like a garnished platter ready for the dinner table with a capricious collection of amusing objects surrounding it. This, however, is mere surface play in Klee's world of double meanings, myths, and metaphors. The fish from early Christian times has been a mystic symbol for Jesus. It refers to the Greek word for fish, ichthys, whose letters spell out Jesus Christ Son of God, Savior. The intricately interwoven patterns recall the lettering in medieval illuminated manuscripts. The crescent and full moon allude to the church calendar at Lent and Eastertide, the cross to Christ's crucifixion and death, the pink pennant to the banner that European children carry on Easter Day, while the sprigs in the jar tell of the coming spring.

Klee consciously set out to look at the world through the eyes of a child in order to achieve a spontaneity untroubled by reason. "I want to be as though newborn, knowing nothing," as he put it. With Klee, as with Freud and St. Paul, the child was

father of the man. By experimenting with hypnotic suggestion and *psychic automatism*, a technique that allowed the artist's hand to move spontaneously and at random, laying down on paper or canvas lines and patterns in no way formed by reason or logic, he gave his drawings the casual quality of doodles or the impulsiveness of improvisations. His mastery of line was so complete, however, that his work should never be confused with carelessness. By sticking mainly to small forms and to the techniques of watercolor and ink, pencil and crayon, he produced pictures with an element of genial humor that is notably missing in so much of modern art.

Joan Miró, like Klee, attempted an art of pure imagination existing outside logic or reason. In *Personages with Star* (Fig. 506) he used the technique of automatic drawing in a trancelike state and produced a painting that shows the influence of Kandinsky. While much of surrealism is preoccupied with the morbid and the abnormal, Miró lightens his fantasies with whimsy. His pictures have such titles

505. PAUL KLEE. Around the Fish. 1926. Oil on canvas, $18\frac{3}{8} \times 25\frac{1}{8}$ " (46.67 × 63.82 cm). Museum of Modern Art, New York.

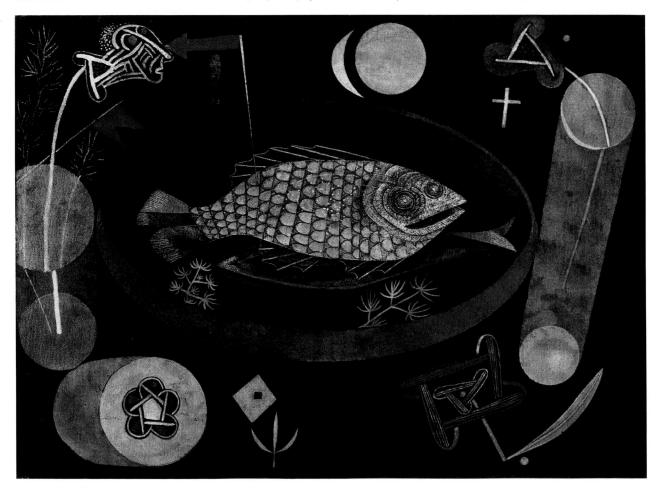

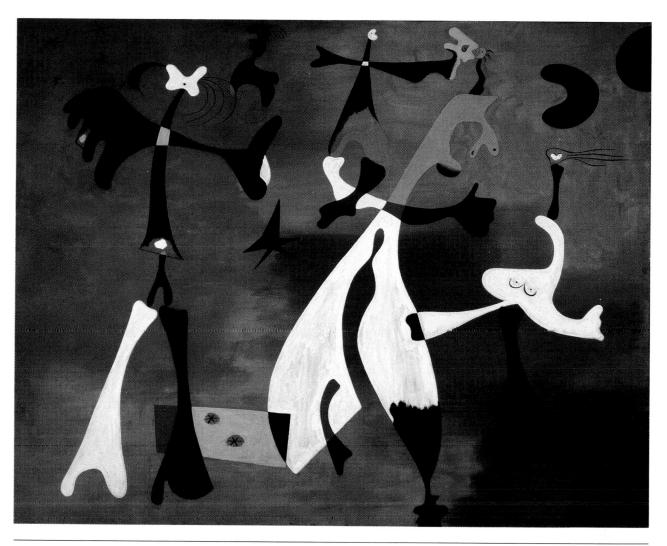

506.Joan Miró. *Personages with Star.* 1933. Oil on canvas, $6'6\frac{1}{4}'' \times 8'1\frac{1}{2}''$ (1.99 × 2.48 m). Art Institute of Chicago (gift of Mr. and Mrs. Maurice E. Culberg).

as *Persons Magnetized by the Stars Walking on the Music of a Furrowed Landscape*. They teem with abstract insects that buzz silently and geometrical worms that squirm statically.

Giacometti represents surrealism's sculptural dimension. In such a work as his *Palace at 4 A.M.* (Fig. 507) he uses a geometrical cagelike framework containing spectral and skeletal forms. The phantom figures in their interpenetrating open and closed spaces produce a haunting sensation of emptiness and human isolation.

LITERARY AND MUSICAL PARALLELS. Significant parallels to surrealism in the fields of literature and music can be cited. For instance, James Joyce and Gertrude Stein tried to establish a method for automatic writing as a way to tap the reservoir of the subconscious mind. The result was the stream-of-

consciousness technique, notably exemplified in James Joyce's *Ulysses* (1922). In this work Joyce deals with the thoughts, feelings, and spiritual states of his characters without regard to logical argument or chronological or narrative sequence. His style has the timelessness of dreams.

The more irreverent and humorous tendencies of surrealist painting have their musical parallels in such compositions as Erik Satie's three piano pieces of 1913. Entitled *Desiccated Embryos*, they have sarcastic expression marks, such as that which calls upon the pianist to play a melody "like a nightingale with a toothache." There is also the biting satire of Prokofiev's fairy-tale opera *The Love of Three Oranges* (1921) and the weird symbolism of Béla Bartók's legend-based opera *Bluebeard's Castle* (1918).

Paul Klee's world of childhood fantasy finds a charming lyrical counterpart in Maurice Ravel's

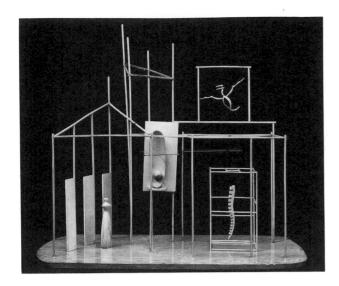

507. Alberto Giacometti. *Palace at 4 a.m.* 1932–33. Wood, glass, wire, and string; $25 \times 28\frac{1}{2} \times 15\frac{3}{4}$ " (64 × 72 × 40 cm). Museum of Modern Art, New York.

opera, *The Child and the Sorceries (L'Enfant et les Sortilèges)*, of 1925. In Colette's text, a child breaks some bric-a-brac and toys in a temper tantrum. In a dream sequence, the objects come to life to seek revenge. A Wedgwood teapot and a china cup, appropriately enough, carry on a conversation in broken English while dancing a fox trot; a little old man pops out of nowhere and sings multiplication tables and story problems with wrong answers; two cats sing a hilarious mewing duet; and all that is left of the torn picture of the fairy princess in the story book is "a golden hair and the debris of a dream." Ravel's clever orchestration adds whistles, wood blocks, and friction instruments such as cheese graters to the usual ones for a full range of effects.

Neoclassical Interlude

No century would be complete without its bow before the shrines of Greece and Rome. Just as the Renaissance and the 18th and 19th centuries did, so the early 20th century also had its neoclassicism. While works with classical references abound in the present century, the neoclassical movement came into sharpest focus in the 1920s. The comparative calm before the storm of World War I had been broken by the emotional extremes of pictorial expressionism and such neoprimitive outbursts as Stravinksy's *Rite of Spring*. In the aftermath of war, order and clarity seemed more important than violent expression.

In 1922, an adaptation of Sophocles' *Antigone* by Jean Cocteau was mounted in Paris. Picasso designed the scenery and masks, while the incidental music for harp and oboe was supplied by Arthur Honegger. An opera called *The Eumenides* by Darius Milhaud, based on Paul Claudel's translation of the tragedy by Aeschylus, was written in the same year. *Mercury* was the title of still another ballet brought out by the Diaghilev company in 1924, with music by Erik Satie and costumes and scenery by Picasso.

Three years later, Stravinsky completed his opera-oratorio *Oedipus Rex*. Diaghilev again was the producer, and Jean Cocteau's text, based on Sophocles' tragedy, was translated into Latin so that it would be in a "petrified" language and thus reduced to mere syllabic material. The motionless stance of the actors was intended to make them as static as Greek columns, and the chorus was placed behind a low relief where only their heads were visible. Such collaborative productions continued occasionally throughout the 1930s, when Stravinsky was found working with André Gide on a work for orchestra, chorus, and tenor called *Persephone* (1934).

508. PABLO PICASSO. *Three Graces*. 1924. Oil and charcoal on canvas, $6'6_8^{m} \times 4'11''$ (2 × 1.5 m). Collection the artist's estate.

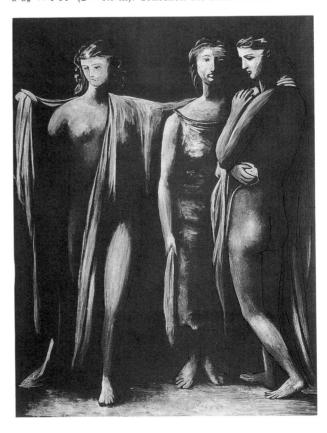

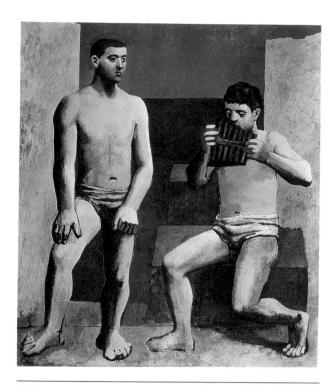

509. PABLO PICASSO. *Pipes of Pan.* 1923. Oil on canvas, $6'8^{1''}_{2} \times 5'8^{5''}_{8}$ (2.04 × 1.74 m). Collection the artist's estate.

PAINTING AND SCULPTURE. Picasso's pictures in the 1920s, such as the *Three Graces* (Fig. 508), also reflect this neoclassicism and are characterized by elegance of line, sculpturesque modeling of bodies, and reduction of pictorial elements to the barest essentials (compare Fig. 245). Others, like *Pipes of Pan* (Fig. 509), are beach scenes in which the figures appear statuesquely against geometrically organized backgrounds and chaste colors of white and blue.

While Picasso's painting took another turn after the *Three Graces*, his many book illustrations continued to show classical influences. Picasso had long admired the linear technique of Ingres (see Figs. 421 and 447) and the incisive carvings of Greco-Roman sculptors. Even in such an austere medium as etching, his illustrations for a new edition of Ovid's *Metamorphoses* (1930) and for Gilbert Seldes's version of Aristophanes' *Lysistrata* (1934) show his capacity for effective expression with minimal means (Fig. 510).

In the neoclassical interlude, the statues of Maillol and Despiau reassert the expressive importance of the nude figure, both in the round and in relief. Maillol's stable, calm figures are a welcome sight in an agitated century. His neoclassicism is creative not imitative, free not academic. The *Torso of Venus* (Fig. 511), with its Praxitelean curve and

stance (see Fig. 56), its antiquity and modernity, achieves a quiet monumentality that is both universal and timeless.

THE LITERARY DIMENSION. One of the most consistent patterns of contemporary literature, especially in France, is the reinterpretation of Greek myths in highly sophisticated terms as a subtle device for pointing out modern moralistic or political parallels. This tendency runs regularly through the works of André Gide, from his early *Prometheus Drops His Chains* (1899) to his autobiographical story *Theseus* (1946). It can also be found in Franz Werfel's antiwar play *The Trojan Women* (1914) and in Jean-Paul Sartre's *The Flies* (1943). The latter was staged in Paris during the Nazi occupation, and the reference to the plague of flies that sucked Orestes' blood in Aristophanes' bitter comedy could have escaped no one.

Pocts have sometimes found classical subjects a convenient way of leaving their works in a fragmentary state like antique ruins. Paul Ambroise Valéry's trilogy of 1922, for instance, contains a poem called

510. Pablo Picasso. *The Love of Jupiter and Semele,* Plate 6 for Ovid's *Metamorphoses* (Lausanne: Albert Skira, 1931). Etching, $12\frac{7}{8} \times 10\frac{1}{8}$ " (33 × 26 cm). Museum of Modern Art, New York (Louis E. Stern Collection).

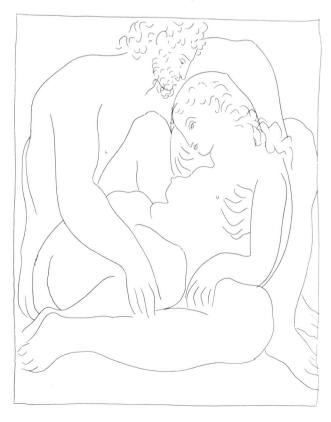

Fragments of Narcissus. T. S. Eliot's Sweeney Agonistes (1932), in which the grandeur of the past is contrasted with the drabness of the present, likewise is incomplete and bears the subtitle Fragments of an Aristophanic Melodrama. Freud's use of the names of characters from Greek literature—Oedipus, Electra, Narcissus—as symbols of recurrent subconscious drives also found its way into literature.

James Joyce's *Ulysses* (1922) uses classical mythology to give his ordinary, everyday characters universal significance. Originally, each of the eighteen chapters bore titles alluding to similar episodes

511. Arestide Maillol. *Torso of Venus*. 1925. Bronze, height 45" (114 cm). Courtesy Galerie Dina Vierny, Paris.

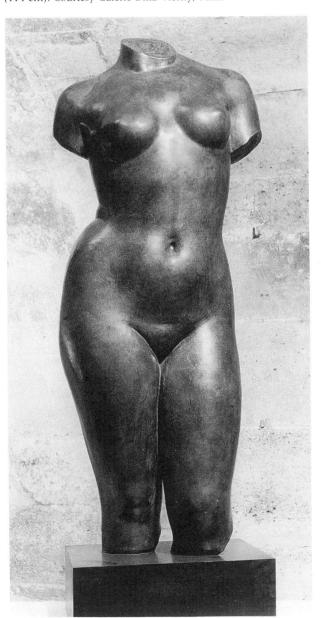

in Homer's *Odyssey*. The "Calypso" chapter refers to the goddess that Odysseus, or Ulysses, had lived with for seven years, just as Joyce's antihero Leopold Bloom had resided that long with Molly. In "Hades," Bloom is attending the funeral of a friend, an allusion to Ulysses' descent into the underworld. "Scylla and Charybdis," those hazardous rocks in the Straits of Messina that Ulysses had to navigate, is set in a library where Bloom and his friend Stephen Dedalus find similar pitfalls and contradictions in the books they consult. 'Sirens" takes place in a pub where the barmaids are singing bawdy ballads interspersed with popular opera arias. "Circe" is the brothel scene, in which the madam turns men into swine, rather like her mythical counterpart of old.

Such parallels with the heroic past serve to heighten the squalid picture of the present that the novel paints. The entire action of *Ulysses* occurs in Dublin in a single 24-hour period to preserve the classical unities of place, time, and action. The plot tells the tale of a wanderer who voyages through the treacherous terrors and temptations of Dublin's

512. Georges Rouault. *This will be the last time, little father!* Plate 36 of *Miserere* series. 1927. Aquatint, drypoint, and roulette over heliogravure, printed in black; $23\frac{8}{8} \times 17''$ (59 × 43 cm). Museum of Modern Art, New York (gift of the artist).

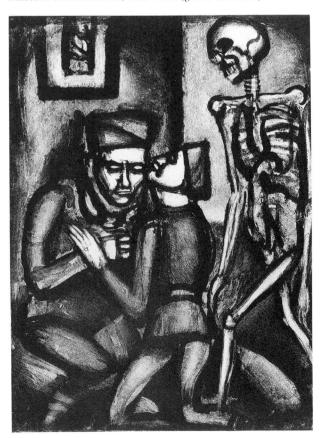

streets while on his way home to his wife and son. This becomes the modern counterpart of Odysseus's search for Penelope and Telemachus. In the larger sense, *Ulysses* is concerned with the eternal human search for the meaning of life.

Social Realism

Social realism represents the artist's protest against the intolerable conditions that beset humanity. In the tradition of Goya, Hogarth, and Daumier, many contemporary painters have championed the cause of the weak against the strong, the poor against the rich, the oppressed against their oppressors, of right-cousness against human folly. They have explored the dregs of society, the human rubbish of skid row, and the ugliness of the lower depths, thus proving that the paintbrush and the pen are often mightier than the sword.

This will he the last time, little father! (Fig. 512) is a print by Georges Rouault that depicts the heartbreaking farewell of a son as he leaves for war and almost certain death. Rouault's art is visionary, but his tragic clowns, comical lawyers, static acrobats, and active landscapes reveal his broad compassion and passionate protests against human exploitation and degradation. His pictures often mirror the grimacing masks of those who presume to sit in judgment on their fellows, and the insensitive faces of people in positions of power who are indifferent to human suffering. His series of a hundred etchings and aquatints for two projected portfolios entitled Miserere (Have Mercy on Us) and Guerre (War), with text by a literary friend, occupied him intermittently in the years following World War I. Though the portfolios as such were never published, 58 prints have been issued separately. The title page of the war volume in which Figure 512 was to have appeared reads "They Have Ruined Even the Ruins."

José Clemente Orozco, one of the Mexican muralists deeply involved in his country's revolution, identified himself with the struggle of the illiterate masses as they tried to break the chains of their landowning and capitalist exploiters. His grim satire

513. José Clemente Orozco. *Gods of the Modern World.* From the mural *Epic of American Civilization*, 1934. Fresco, panel $12' \times 9'11''$ (3.66 \times 3.02 m). Hood Museum of Art, Dartmouth College, Hanover, N.H. (by permission of the Trustees).

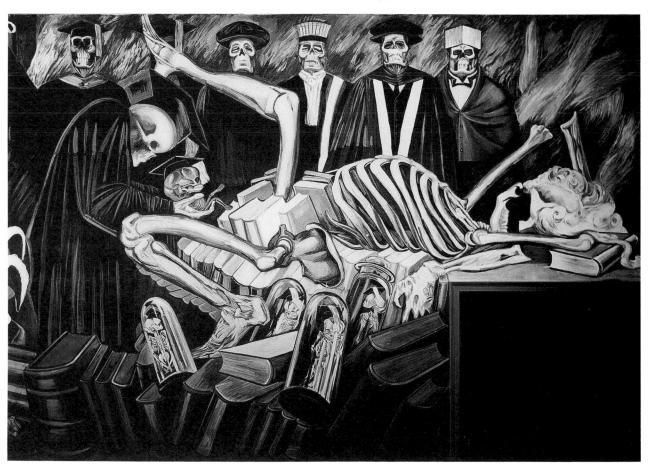

also extends to the academic community, as pictured in *Gods of the Modern World* (Fig. 513). This macabre comment on the sterility of higher education depicts a skeleton giving birth while one professor acts as a midwife and others witness the ghastly event.

In the United States artist Ben Shahn was an ardent champion of minority groups and the eloquent portrayer of the anonymous city dweller who has lost the sense of community identity. The stark setting and grim faces of *Miners' Wives* (Fig. 514) express the anxiety, fear, and desolation of the families of men connected with a hazardous occupation. Humanity's inhumanity is the general theme of many of his paintings, as Shahn pleads the cause of the victims of social injustice.

Bitter satires on the junglelike conditions of urban life and the dismal effects of mass media on the popular mind preoccupy the English painter Francis Bacon. In his *Painting* (Fig. 515), subtitled *The Butcher*, he speaks with the vocabulary of expressionism and surrealism as he depicts his nightmarish apparition. Less bitter but nonetheless poignantly expressive are Andrew Wyeth's muted

514. Ben Shahn. *Miners' Wives*. 1948. Egg tempera on panel, $4 \times 3'$ (1.22 \times .91 m). Philadelphia Museum of Art (gift of Wright S. Ludington).

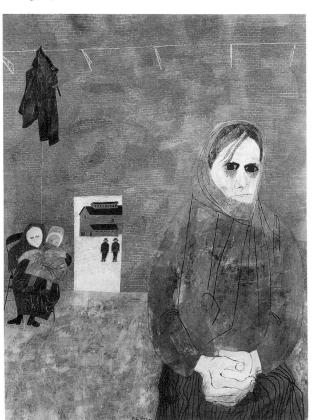

evocations of the social decay and unfulfilled aspirations of life on the American scene (Fig. 516).

Picasso's Guernica. Picasso's Guernica (Fig. 517) is at once the most monumental and comprehensive statement of social realism and a dramatic manifesto against the brutality of war. Picasso used a combination of expressionist and abstract techniques as a violent protest against a cruel and inhuman act by modern barbarians. What lighted the fuse of this pictorial explosion of death and terror was the first saturation air raid of the century. This horrible "experiment" by the German air force was carried out against the defenseless Basque town of Guernica and was an incident in General Francisco Franco's successful rebellion against the legally elected government of the Spanish Republic.

Picasso, a loyalist, was in Paris with the commission to paint a mural for the Spanish pavilion of the World's Fair of 1937. Just two days after the

515. Francis Bacon. *Painting (The Butcher)*. 1946. Oil and tempera on canvas, $6'6'' \times 4'4''$ (1.98 \times 1.32 m). Museum of Modern Art, New York (purchase).

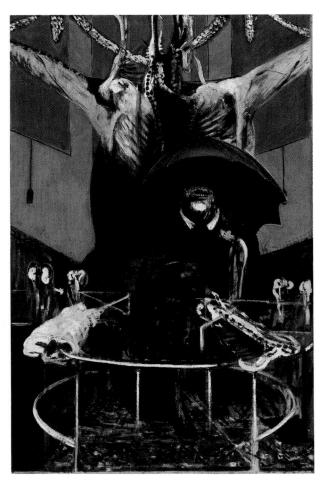

news of the bombing reached Paris, he began work. The huge canvas, accomplished in a matter of weeks, took up one wall of the Spanish pavilion, where it made an unforgettable impression on the thousands who saw it. The attention it attracted and

the measure of understanding given to it have been altogether in proportion to the value of Guernica as one of the century's most important paintings.

Guernica, a picture in the grand tradition of historical painting, is one of those rare incidents of the

516. ANDREW WYETH. Mother Archie's Church. 1945. Egg tempera on panel, 1'11" × 4' (.64 × 1.22 m). Addison Gallery of American Art, Phillips Academy, Andover, Mass.

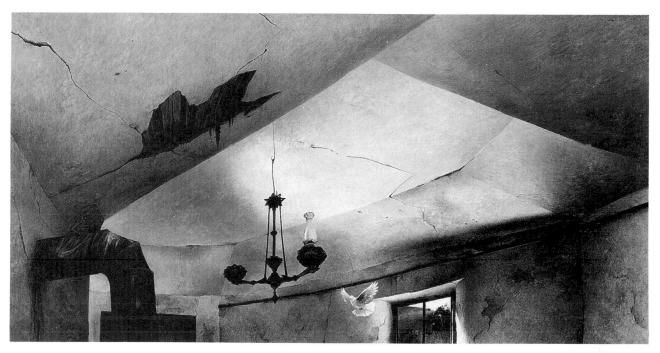

517. Pablo Picasso. Guernica. 1937. Oil on canvas, $11'5\frac{1}{2}'' \times 25'5\frac{3}{4}''$ (3.49 × 7.77 m). Museo del Prado, Madrid.

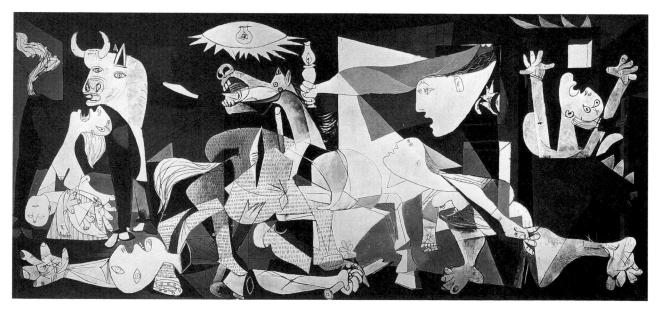

right artist painting the right picture at the right time. Its purpose was frankly propagandistic, its intent to horrify. But besides recalling the apocalyptic visions of Romanesque Last Judgments, it is a work of social protest in the manner of those 19th-century masters of irony, Goya and Daumier. The principal action begins in the lower right, where a woman dashes forward, her hands in an attitude of despair. The triangular composition then mounts to its apex at the point where the lamp, the horse's head, and the eye of day (with the electric bulb of night as its pupil) come together. From this climax, the viewer's eye moves downward to the head of the dismembered warrior at the lower left.

According to Picasso, Guernica is allegorical, and he explained some of the symbolism. The horse with the spear in its back, the inevitable victim of bullfights, signifies victimized humanity overwhelmed by brute force. The motif of the shrieking mouth is repeated in that of the screaming woman with her dead child at the left, the face of the soldier below, and the victim of the flames at the right. The bull, standing for brutality, is the only triumphant figure in this symbolic struggle between the forces of darkness and those of light, between barbarism and civilization. Above, an arm reaches forward to hold the lamp of truth over the whole gruesome scene. Amid the general havoc and gloom the artist sounds one soft note of optimism. Above the victim's severed arm and broken sword in the bottom center is a tiny plant in bloom to signify the force of renewal.

Guernica appeared at a time when many earlier pictorial experiments could be combined. It employs all the exaggerations, distortions, and shock techniques developed by expressionistic drawing, but it omits ghastly coloration in favor of the somber shades of mourning-black, white, gradations of gray, and a few touches of color. The abstract design, the overlapping planes on a two-dimensional surface, and the absence of modeling all derive from cubism. So also do the simultaneous principle of the day-and-night symbol; the head of the bull, which is seen both from the front and the side at the same time; and the sensation of inner and outer space by which the observer is at once both inside and outside the burning buildings. The elongation of the heads to express headlong motion coincides with the photography of movement made with stroboscopic light. The screaming, nightmarish subject matter is derived from that of expressionism.

Picasso painted so rapidly and with such large output that he often had difficulty resisting the temptations of his own ready technique. Consequently, much of his work is uneven. Here, however, after making a hundred sketches, he worked in a disciplined and selective manner that shows him in complete command of his medium. Thus, his successful synthesis in *Guernica* of so many of these divergent 20th-century techniques, as well as the vivid dramatization of his subject, has given powerful expression to the chaos and conflicts of this century.

Nonobjectivism

Abstractionism was worked out to its logical geometrical conclusion by Piet Mondrian just as expressionism had reached its point of pure abstraction in the work of Kandinsky. The pictures of these two artists are, of course, poles apart. Both artists, however, are *nonobjective* in that they are nonfigurative and nonrepresentational and that the pictorial content of their canvases bears no reference to recognizable objects or to anything outside the actual pictures. All subject matter, all associational meanings, are carefully avoided. The picture, with its lines, shapes, and colors, becomes its own referent.

Mondrian's art, like Kandinsky's, evolved gradually from the concrete to the abstract. In his early years, Mondrian painted landscapes and quiet interior scenes in the tradition of his native Holland, and his later style, though completely abstract, owes much to the cool geometrical precision of his great predecessor Vermeer (see Figs. 360–363). Mondrian might well have been describing his *New York City* (Fig. 518) when he wrote: "The new style will spring from the metropolis." He delighted in the crisscross patterns of city streets, architects' blueprints, gaunt steel skeletons of skyscrapers under construction, and simple faces of buildings of the international architectural style (see Figs. 525 and 526).

The new art, he continued, would not be individual, but collective, impersonal, and international. All references to the "primitive animal nature of man" should be rigidly excluded in order to reveal "true human nature" through an art of "balance, unity, and stability." This objective he strove to realize by using "only a single neutral form: the rectangular area in varying dimension." His colors are likewise abstract—black lines of various widths against white backgrounds, relieved occasionally by a primary color "climax"—red, blue or yellow—in as pure a state as possible.

In Mondrian's opinion, a work of art should be "constructed," and he approached a canvas with all the objectivity of a draftsman making a blueprint. The result of this pictorial engineering is the series of pure, two-dimensional studies of space for which he is best known. His visual patterns have a repose that

is based on a precise balance of horizontal and vertical elements, and they are clean to the point of being antiseptic. His pictures are far more complex than they may seem to the casual eye. They have had a great influence on modern design, especially of advertising layouts, posters, and rugs.

ARCHITECTURE

More than any of the other 20th-century arts, architecture has shown a great sense of responsibility and achieved a wide popular acceptance. A building, unlike a painting, has to stand up; unlike a sculp-

518. PIET MONDRIAN. New York City I. 1942. Oil on canvas, 12 × 10' (3.66 × 3.05 m). Sidney Janis Collection, New York.

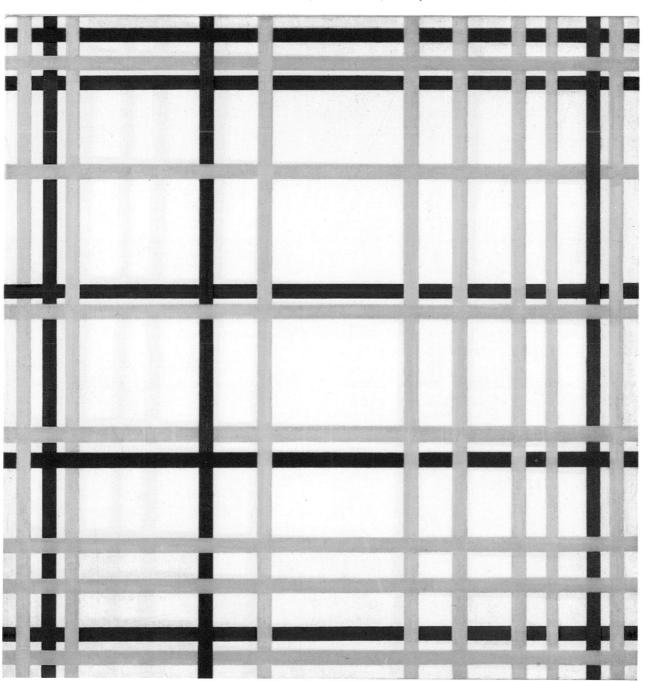

tural group, it must fulfill some practical purpose. Experimental architecture is possible, but the discipline of sound engineering kept architects from some of the wilder flights of fancy seen in painting, sculpture, literature, and music. Here the architect is no mere stonemason but an engineer of society, a philosopher, poet and idealist, and practical builder.

The needs of a complex, modern, urbanized society and the availability of new materials and structural methods have made a new architecture both possible and necessary. *Ferroconcrete*, cement reinforced by embedding wire mesh or iron rods in it, leads the procession of new materials. It has the strength of both steel and stone without their weaknesses or expense; it can span broader spaces than can marble and carry the weight of steel. The *cantilever*—the extension of a slab or beam horizontally into space beyond its supporting post—is an ancient

519. Louis Sullivan. Wainwright Building, St. Louis. 1890–91.

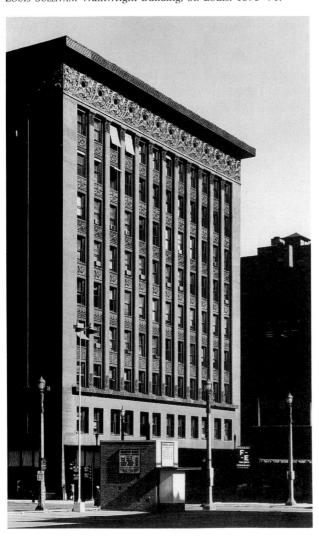

principle that had to await the development of ferro-concrete.

Frank Lloyd Wright on the one side and Walter Gropius with Le Corbusier on the other were the leaders of two opposing schools of architectural thought. Wright spoke as a romantic in terms of the union of nature and human beings that could be realized through his "organic architecture." Gropius and Corbusier were champions of the international style and its emphasis on building for the machine age.

Organic Architecture: Sullivan and Wright

Louis Sullivan's slogan "form follows function" is subject to a variety of interpretations, but the line of thought it provoked led to an important reevaluation of architectural forms in relation to human activities. It also led to a reexamination of basic architectural methods, materials, and purposes. Sullivan's disciple Frank Lloyd Wright and the architects iden-

520. Frank Lloyd Wright. Price Tower, Bartlesville, Okla. 1953.

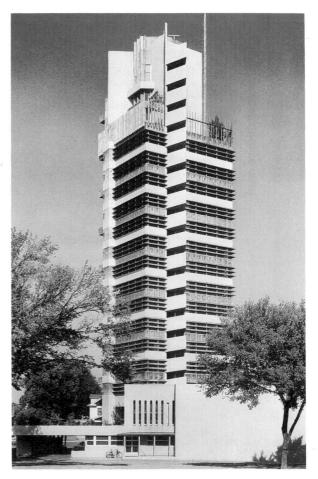

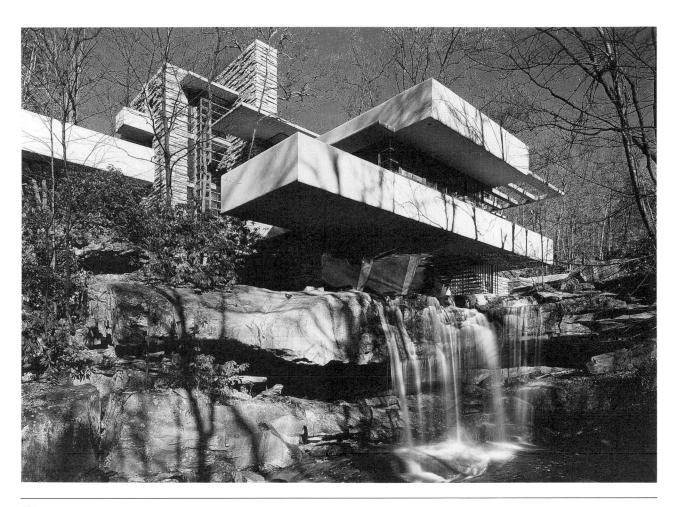

521. Frank Lloyd Wright. "Falling Water" (Kaufmann House), Bear Run, Pa. 1936–37. Reinforced concrete and stone: depth 64' (19.51 m), width 62' (18.9 m).

tified with the international style accepted the principles that stone should behave like stone, wood like wood, and steel like steel and that the design should be modified by the materials used. Both also pointed to the absurdity of people catching trains in Roman baths, working in Renaissance office buildings, banking money in Doric temples, living in Tudor houses, and going to Gothic churches. The criterion for a successful building was no longer what it looked like, but how well it fulfilled its purpose.

The skyscraper, among the earliest and boldest instances of modern architecture, was made possible by steel-skeleton construction and the elevator. It came out of the American Middle West as an answer to the need for commercial centralization. In the hands of Louis Sullivan, who put up the Wainwright Building in St. Louis in 1891 (Fig. 519), the skyscraper was a "proud and soaring thing," reflecting the pride of businesspeople in their work, as well as the curve and power of a technologically oriented society. The principal drawback to skyscrapers, however, is their contribution to congestion. From a

human standpoint, their value has thus far been less spectacular than their engineering.

Wright, picking up where Sullivan left off, saw both the advantages and the drawbacks of the sky-scraper. With characteristic romanticism, he spoke of his buildings in naturalistic terms. His eighteenstory skyscraper in Bartlesville, Oklahoma, has a "taproot" foundation, grows upward like a tree, with its floors and walls cantilevered outward like branches from its central trunk (Fig. 520).

Skyscrapers, Wright was convinced, did not belong in already-congested cities but out in the open, where they could breathe and have room to cast decent shadows. Wright's philosophy of architecture was that of a liberating force, and his creative freedom allowed for decorative motifs to grow organically out of his basic designs, the relations of masses to voids, the arrangement of windows and doors, the colors and grains of wood, and the textures of stone. Through his masterly interrelations, space for living and working comes to life and breathes.

The architect, according to Frank Lloyd Wright, is the poet who imagines the ideal life and fashions the forms, shapes, and spaces that guide men and women to live it. His organic architecture was based on the unity of site, structure, and decoration, and the early houses he built in and around Chicago were his first claim to fame. For him a dwelling had to be a home for the human spirit as well as for the human body. A house, he thought, should express warmth, protection, and seclusion. The heart of the home, according to Wright, is the hearth in the form of a central fireplace, and all the other rooms should be built around this. Interior space, moreover, should not confine but expand without interruption from the inside to the outside so as to bring people closer to nature.

"Falling Water" (Fig. 521), which Wright built for Edgar J. Kaufmann at Bear Run, Pennsylvania, is an expressive combination of reinforced concrete material, cantilevered construction, and a dramatic site. The house comes close to realizing Wright's ideal of a structure growing organically out of its site.

In this case, Wright's client loved the waterfall and wanted to live near it. "Falling Water" therefore embraces both the stream and the waterfall. Wright accomplished this by means of the cantilevered slabs that project from the rock embankment on which they rest and which carry the living space outward over the water itself. The ledge of natural rock under the water is paralleled by the concrete shelf above, while the jutting slab on top is placed at right angles to repeat the direction of the moving water. The site as well as the building is a series of terraces reaching outward from a stone core.

The interior of "Falling Water" is one large room opening out onto the terraces and porches. The horizontal planes of these porches, in turn, are balanced by the vertical volumes of the fireplace. The local stone used in this chimney mass is related both in color and texture to the natural rock of the river bank. The cantilevering here allows the several stories the independence to develop their own fluid floor plans. As on the outside, the inside space radiates around the central core, with advancing and receding areas promoting what Wright called the "freedom of interior and exterior occupation."

Art Deco

Before Wright's organic architecture and the bland functionalism of the international style became widely accepted, the dominant approach of the 1920s and 1930s was what these architects scornfully labeled "modernistic." In the 1990s this movement has become upgraded and is now called *art*

deco. The term derives from the title of a Paris exhibit of 1925, *Exposition des Arts Décoratifs*.

Art deco was a reflection of the jazz age of the roaring 1920s and the more sober 1930s when it was the dominant style, particularly in the United States. This was an art glorifying the machine and inspired by the speed of the automobile and airplane. It found expression in everything from soaring skyscrapers and luxury ocean liners to streamlined statuettes, overstuffed furniture, jukebox designs, radio cabinets, toasters, and other kitchen gadgetry. Art deco was motivated by the vibrant energy released at the end of World War I, a faith in mechanized modernity, and a joy in such new materials as glass, aluminum, polished steel, and chrome.

The most extravagant forms of art deco were found in the department stores and particularly in the movie houses of the period (Fig. 522). These "people's palaces" were the stuff dreams were made of. Here one found release from drudgery, boredom, and the humdrum activities of daily life. Audiences could revel in romances played by beautiful screen idols, hear the peals from the mighty Wurlitzer or-

522. TIMOTHY PFLUEGGER. Paramount Theater; Oakland, Calif. 1931 (restored).

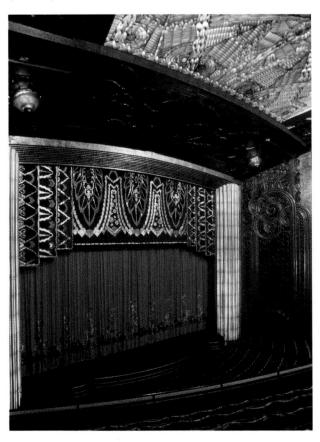

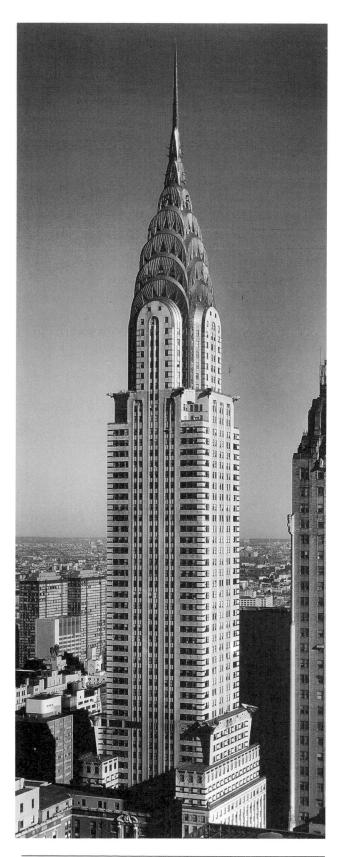

523. William Van Alen. Chrysler Building, New York. 1930. Height 1048' (319.43 m).

gans, and relax to the luxuriant sound of real symphony orchestras that rose up on stage elevators as they played hit tunes from Broadway musicals.

The architecture of these theaters was eclecticism gone wild—fantastic mixtures inspired by the *Arabian Nights*, Persian gardens, Egyptian temples, and Chinese pagodas. There were imaginary recreations of King Solomon's temple, Babylonian towers, Moslem mosques with minarets, and Mayan jungle pyramids. All were designed for spectacular entertainment in delightfully gaudy interior complete with spacious lobbies, winding staircases, grandiose murals, glittering chandeliers, banks of organ pipes, and a general profusion of ornamentation defying description.

There were also such less ornate and more enduring architectural masterpieces as the Chrysler Building (Fig. 523), long the symbol of New York City before the Empire State Building (also in art deco style) eclipsed it in height and size. It was finished in 1930 by its designer, William van Alen, who was called the "Ziegfeld of architecture." As the structure rises well over 1,000 feet (305 meters),

524. Chrysler building, elevator door.

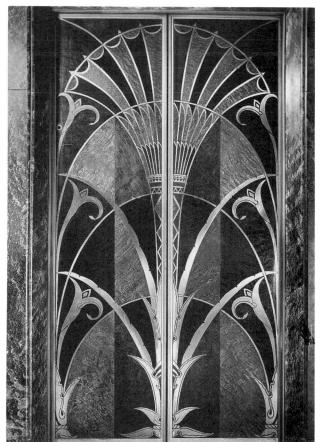

there is a pause at the thirtieth floor for a brick frieze featuring an abstract pattern that suggests automobiles with decorative hubcaps and huge winged radiator caps serving as gargoyles. The culmination of the structure is the familiar stainless-steel sunburst tower, with its overlapping projections pierced by sharply pointed triangular windows, which terminates in a soaring cadmium-plated spire.

The rich art deco interior is equally remarkable with its three-story entrance hall leading to a triangular lobby of African marble with stainless-steel trim. Each detail participates in this exuberant design from the elevator doors (Fig. 524) to the marble floors. Even the elevator cabs with their inlaid wood and intricately detailed geometric patterns become perfectly appointed small art deco rooms.

There is now no doubt that art deco was the universally popular style of the time. Hence the heated attacks and harsh criticism heaped upon it by Wright and the architects of the international style.

The major figures of this opposition—Wright, Gropius, Le Corbusier, and Miës van der Rohe—were also the leading intellectuals, social philosophers, and articulate critics for the attack. They fussed and fumed about what they saw as the bastard-modernistic approach. The international stylists insisted on a functional and structural architecture, free of decoration. They sniffed at art deco artists as embroiderers and lace makers and theorized that lack of decoration was a sign of spiritual strength. If there was to be decoration at all, it should not be applied to surfaces; rather, it must grow out of the materials and functions of the design itself.

Now, however, art deco has been favorably reappraised partly as a reaction to the endless spread of steel-and-glass boxes, nude buildings, and naked houses. Contemporary designers see that the urge for ornament is universal and cannot be repressed. They now ask, "Who is Walter Gropius to tell us that decoration is a crime and in bad taste?"

525. Walter Gropius. Bauhaus Machine Shop, Dessau, Germany. 1925–26. Length 167' (50.9 m), width 49' (14.94 m).

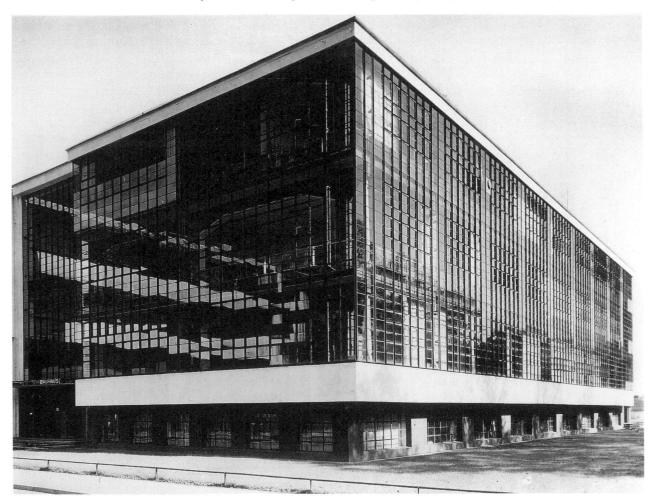

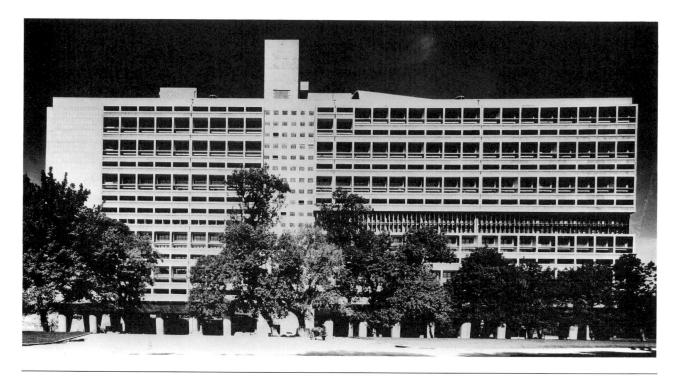

526. Le Corbusier. L'Unité d'Habitation, Marseilles. 1947–52. Length 550' (167.64 m), width 79' (24.08 m), height 184' (56.08 m)

International Style: Gropius and Le Corbusier

The international style crystallized in Germany with the work of Walter Gropius and Ludwig Miës van der Rohe, in France with Le Corbusier, and in the Netherlands with J. J. P. Oud. When Gropius was commissioned to reorganize a German art school after World War I, he renamed it the Bauhaus ("Building Institute") and made it a technical school of design with special emphasis on the industrial arts and the study of modern materials and methods. For the plant he brought together the complex of studios, machine shops, administrative offices, and professors' houses into a single masterly group of interlocking and interrelated cubes. Smaller units had bland Mondrian-like façades; others, like the Machine Shop (Fig. 525), were open structures with glass-curtain walls.

As a champion of the *international style*, Gropius started with the open box as the basic unit of space, varied its volume, and grouped several in a related pattern of cubes. The Machine Shop shows how the building is treated as an open volume rather than as a closed mass. By the method of cantilevering, Gropius allowed the building to project several feet outward over its supporting piers. The horizontal emphasis thus established is then carried out in the concrete base and repeated at the roof level.

Between the parallel lines of the base and roof hang the glass-curtain walls that bear no structural weight. The transparency permits details, such as the spiral staircase and the skeletal structure of the interior, to remain open and visible from the exterior. By thus allowing the interior and exterior of the building to be seen at the same time, Gropius achieved the architectural equivalent of the work of the cubist painters, who presented simultaneously the front view and profile of a human face or several sides of an object. The Bauhaus group proved to be some of the most influential buildings of its decade.

The Bauhaus exploration of materials and industrial processes led to many new approaches in printing, pottery, metalwork, weaving, and stagecraft. Students were taught never to forget the purposes their products were designed to serve. A chair, in other words, was made to sit in, a lamp to give efficient lighting. As a result, the Bauhaus became the fountainhead of the new industrial design. Such innovations as tubular steel chairs, indirect lighting fixtures, and streamlined appliances were accepted for mass production and are parts of every modern household today. In order to counterbalance the utilitarian side, however, Gropius added the painters Kandinsky, Klee, and Lyonel Feininger to his distinguished faculty to uphold the expressive and creative aspects of drawing and painting. Mondrian and the architect Miës van der Rohe also maintained close relations with the Bauhaus.

Le Corbusier, unlike Wright (who had a naturalistic approach), thought of houses variously, as machines for living, containers for families, extensions of public services. His commissions included a range from country villas to entire cities, private dwellings to apartment blocks, temporary exposition structures to pilgrimage churches. For him, architecture was the masterly and magnificent play of masses brought together in the light. Cubes, cones, spheres, cylinders, pyramids, he said, are the great primary forms that reveal themselves in sun and shadow. While Wright's buildings expressed harmony with nature. Le Corbusier raised his structures on piers to assert the "independence of things human." Wright rather tartly called Le Corbusier's cubistic buildings "boxes on stilts."

Le Corbusier's L'Unité d'Habitation (Union for Living) is an apartment house in Marseilles that brings together in a single structure a community of 1,600 persons with complete facilities for living, shopping, and recreation (Fig. 526). Remembering the dismal mass dwellings in Paris, which he called "disastrous architectural fortifications where thousands of families never see the sun," he set out to build apartments vibrating with color, light, and air.

To achieve his goal, Le Corbusier cantilevered a gigantic structure of rough-textured concrete over a double row of massive supports called *pylons*. The outside staircase is both functional and decorative in sculpturesque fashion. Set at an oblique angle to the horizontal axis, it relieves the rectangular masses with its rising motion.

The exterior is honeycombed with shallow balconies, which have sunbreaks tinted in many colors on the inner sides. These sunbreaks proved so effective in protecting the tall living rooms from the sun's glare that they have since become architectural clichés in warm climates. Each floor has duplex apartments served by a skip-stop elevator system. At the halfway point an entire floor is allotted to shops, while a day school for children, a gymnasium, and a theater are found at the roof level.

IDEAS: RELATIVISM

The only thing that is permanent is change. This seeming contradiction points at the very heart of 20th-century thought, whether expressed in philosophical, scientific, or aesthetic terms. No static absolute can provide a satisfactory view of the dynamic world of today. Even the age-old principles of mathematics can no longer be regarded as eternal truths but like art, as expressions relative to the time and place of their creations. So also the firmest articles of religious faiths and political doctrines are subject to

far more commentary and modification from time to time than their followers would care to admit.

The shift from a stable world order to the present dynamic view of the universe, which began with Copernicus and Galileo, has swept all before it. Those who believe in orderly progress toward a definable goal interpret this flux as some form of evolution. Those who accept it at face value, as most scientists do, believe simply in change. Both would agree with Nietzsche when he said that truth has never yet hung on the arm of an absolute; both must of necessity describe the world in relative terms.

In his observations of physical phenomena, Albert Einstein saw that, in a world where everything moves, any calculation or prediction, to be valid, must be based on the relative position of the observer. Newton's absolute space, which was immovable, and his absolute time, which flowed on uniformly—both of which were "unrelated to any outward circumstance"—had to be discarded and replaced by the theory of relativity. All space, in the modern view, is measured by mobility and change of relative position, and all time by the duration of movement in the space traveled across. The world becomes a space-time continuum; all matter, energy, and events are related in the four dimensions of space-time.

The study by anthropologists of the life and customs of primitive peoples has shown how ethical considerations are relative to tribal customs as well as to social and economic conditions. In Tibet, a woman may have several husbands because one man may be too poor to support a wife. In Africa, some tribes permit a rich man to have as many wives as he can afford. The pragmatic philosophers William James and John Dewey took a long look at history and a wide view of the world and concluded that when an idea is effective, it must be true; when it ceases to work, its truth is no longer valid and another solution must be discovered.

Such a relative world, in which all things appear differently to each person and each group, depending on educational, geographical, historical, ethnic, and psychological backgrounds, can be understood only in terms of many frames of reference. Any absolutism—such a totalitarian society as that of Plato's *Republic*, a modern police state, or a military dictatorship—insists on a maximum of conformity in order to assure the stability of government. A relativism—such as that of a modern democracy—allows for many different human images in a pluralistic society.

This relative world, moreover, is populated by men and women who see themselves in multiple images and express themselves in many different styles. In it can be found Marx's proletarian person, speaking in some form of social protest and bent on bringing about the ultimate triumph of the working classes and masses. Darwin's jungle people are there, beating on their neoprimitive tom-toms and speaking in existentialist vocabularies on the survival of the fittest. Nietzsche's *Übermensch*, or super being, who is determined to impose a mighty will on an unwilling world, has been thwarted in two brutal world wars.

The voices of Freud's psychological patients are heard, too, coming from couches and canvases as they try to share surrealistic nightmares with the world at large. Mechanical men and women, the spawn of the Industrial Revolution and the machine age, walk robotlike at large, thinking mechanistic thoughts in their electronic brains and expressing futuristic principles in their mechanical styles. There, too, is Einstein's relativist, who is drawing abstract pictures of the space-time world in slashing, angular lines that are organized by the many focal points of cubist perspective. Modern art as the mirror of this relativistic world therefore assumes multitudinous shapes in order to reflect the great number of diverse human images.

Small wonder, then, that this world, which has produced scientists who analyze and synthesize and physicists who work with fission and fusion, has also given birth to revolutionists who want to destroy a social order so as to reconstruct it in a different way. Warring nations hope to break down one international order so as to build up a new balance of power. Idol smashers feel compelled to destroy certain images people live by so that they can remake the world in their own image. And there are the artists who distort tangible objects so as to reshape them into forms that exist exclusively in their imaginations and on their canvases.

Relativism and the Arts

In this relative world, therefore, the cubists disintegrate the objects in their paintings so that they can reintegrate them in patterns of their own choosing. Since each picture creates its own spatial relationships, space is relative to the mind and mood of the painter rather than an absolute as it is in Euclidean geometry.

It is both impossible and undesirable to make any precise analogy between cubist principles and the mathematics of space-time. A relationship, however unsystematic it may be, can nevertheless be found in the cubist concept of several viewpoints existing at the same time and showing objects from many sides at once. By representing bodies at rest or in successive stages of motion, a futurist or mechanical-style picture sets up a space-time continuum of its own. Similarly, Giorgio de Chirico in *The Menacing Muses* (Fig. 527) places classical statues in a space bounded by a medieval castle, a contemporary factory, and a futuristic tower in order to create an image of time in which past, present, and future coexist in an extended now.

In music, the experience of dissonance is freed from its dependence on consonance, so that it demands neither preparation, anticipation, nor resolution. The absolutes of tonality, rhythmical regularity, and musical form have yielded to a host of tonal relativisms. Instead of a single meter, a modern musical score can use sequences composed of many meters in which a measure of 4/8 is succeeded by one of 7/8, then 2/8, 9/8, and so on. The same principle can be used simultaneously with several rhythms going on at the same time, as in Stravinsky's *Rite of Spring*. This is called *polyrhythm*.

Instead of organizing a work around a single key center, some composers have employed two tonalities simultaneously in the technique known as bitonality, while others have gone one step farther into polytonality. This, in turn, led to Schoenberg's method of composing with twelve tones that are related not to a central tonality but only to one another. Within the internal organization of the work. the sequence of tones known as the row can be played forward or backward, normally or upside down, simultaneously as in a chord, or fragmented into shorter motifs. A given note cannot be repeated until all the other tones are heard. The twelve-tone method emphasizes change and discourages repetition. Its ideal is constant variation creating a continual and perpetual state of tonal flux.

In Ulysses, James Joyce found his answer by making a simultaneous cross section of the life of a city. In this mazelike literary space-time continuum, all events, whether memories of the past or premonitions of the future, flow together into a kind of extended present. Dreamlike, there is no distinction between before and after. While the single day and night and city in which all takes place have some relation to the Greek unities of time, place, and action, there is no beginning, middle, or end to Joyce's structureless literary structure. Readers can begin at almost any place in the book, and the continuity will not be broken. The series of fleeting images are simply recorded, and the entrance to the dream world of free association of words and thoughts is left open for the reader to supply the transitions between moods, the union of the fragments, and thus create their own relative order. Its end is a conclusion in which nothing whatever is concluded.

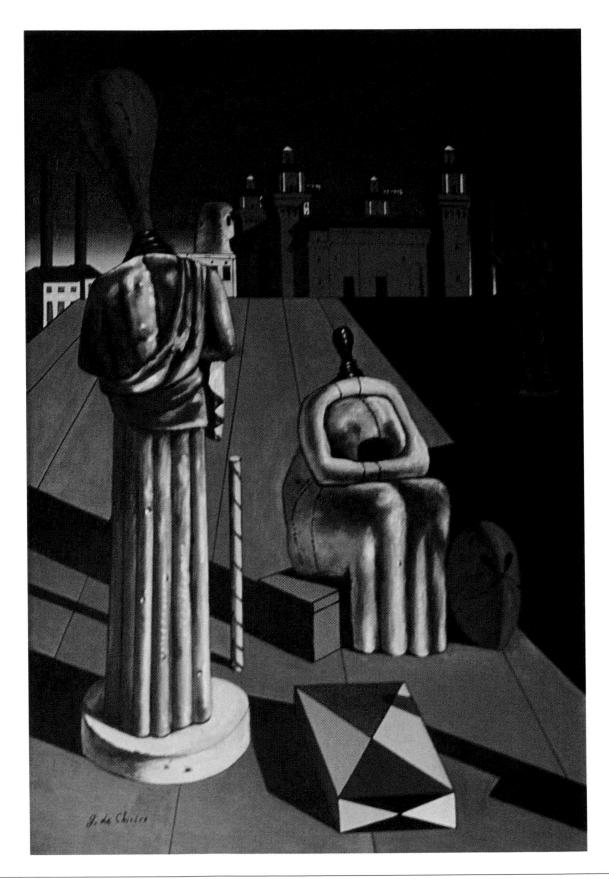

527. GIORGIO DE CHIRICO. *The Menacing Muses.* 1917. Oil on canvas, $37\frac{3}{4} \times 27\frac{70}{8}$ (96 \times 66 cm). Private collection.

Many of the forms of expressionism are also relative to the individual psychology of the artist, just as a Frank Lloyd Wright building is relative to the need of the human situation. Expressionism presupposes the free-associational techniques of psychological relativism. Somewhat like the romantic revolutionary of a century earlier, the expressionistic artist reasserts the primacy of the imagination over the intellect and takes flight from reality in order to find a superior reality in the world of mystery and fantasy. The tendency is anti-intellectual in the extreme, though the symbols and vocabulary evolve through highly rationalistic procedures. The emotional content poured on their canvases, pages, and musical scores derives from a particular human imagination and hence is relative to the infinite number of unsolved conflicts and suppressed passions of many different private worlds.

Historical relativism has provided the modern artist with an unparalleled number of choices of styles and techniques from the past as well as the present, and an anticipated future. The artist of the 20th century is the heir of all the ages. A Picasso exhibit or a Stravinsky concert can present a bewildering assortment of styles. Picasso drew inspiration from ancient Iberian sculpture, African masks, Romanesque wall frescoes, and medieval stained glass, as well as from contemporary sources. His paintings also include provocative variations on Velázquez's Las Meninas, Delacroix's Pietá, and other masterpieces that caught his eye. His mediums included pencil drawings, collages constructed of cloth and paper, ceramics, painted pottery, and woodcuts, as well as oils and watercolors. Sources for Stravinsky include the free rhythms of medieval plainchant, the dissonant counterpoint of the 14th century, the operas of Mozart, or the multiple rhythms of African music. To these masters historical relativism provided a complete freedom of choice without the necessity of sacrificing either their originality or their principles.

Philosophers of history, such as Spengler and Toynbee, through their sweeping historical panoramas have shown that the past still exists within the living present. From the point of view of historical relativity, then, tradition is usually a more potent factor than innovation. At all times—including the present—evolution has been a more powerful force in the process of change than has revolution.

Most 20th-century ideas and problems are variations on old themes that have challenged thinkers ever since the 5th century B.C. Those that in the past led to sharp dissonances have never been resolved. Instead, they have become outmoded, outgrown, temporarily forgotten; or they are bypassed, circumvented in one way or another, or made to assume new shapes and forms.

"Ideas have never conquered the world as ideas," Romain Rolland remarked in his novel Jean Christophe, "but only by the force they represent. They do not grip men by their intellectual contents but by the radiant vitality which is given off from them at certain periods in history. . . . The loftiest and most sublime idea remains ineffective until the day when it becomes contagious, not by its own merits, but by the merits of the groups of men in whom it becomes incarnate by the transfusion of their blood." Guildenstern in Tom Stoppard's play Rosenkrantz and Guildenstern Are Dead (1967) expresses the same thought in different words: "There were always questions. To exchange one set for another is no very great matter."

More important than the solutions or lack of them have been the emotional forces these notions have generated and the good fruits they have yielded. All the workable ideas eventually have been embodied in the buildings people erect to house their activities, the statues and pictures that reflect their human images, the words that express their innermost thoughts, and the music that gives voice to their strivings and aspirations in a world that is forever changing, forever in flux.

MID-20TH CENTURY

KEY EVENTS	ARCHITECTURE AND SCULPTURE 1867-1959 Frank Lloyd Wright ★ 1883-1969 Walter Gropius ★ 1887-1965 Le Corbusier ★ 1886-1969 Ludwig Miës van der Rohe ★ 1891-1979 Pier Luigi Nervi ★ 1892-1970 Richard Neutra ★ 1895-1983 R. Buckminster Fuller ★ 1898-1976 Alexander Calder ●		PAINTING 1880-1966 Hans Hofmann 1887-1968 Marcel Duchamp 1887-1986 Georgia O'Keeffe 1888-1976 Josef Albers		MUSIC 1873-1943 Sergei Rachmanov 1882-1971 Igor Stravinsky 1892-1974 Darius Milhaud 1896-1989 Virgil Thomson 1899-1963 Francis Poulenc	
1926-1927 First motion pictures synchronized with sound 1939-1945 World War II 1942 Nuclear fission, release of atomic energy achieved 1945 Atomic bomb developed United Nations organized New York City becomes international art, music center Commercial TV begun 1947-1950 UN headquarters established in New York 1948 LP recordings available 1950-1953 Korean War 1951 Electric power produced by nuclear energy 1957 First earth satellite launched into orbit by USSR; US satellite followed in 1958 1958 European Economic Community established Stereophonic sound recordings produced 1960 Laser technology developed New era in communication science begins 1961 First satellite with man put into orbit by USSR; US satellite with crew followed in 1962 1962 Telstar, American communications satellite, put into orbit 1964 Gulf of Tomkin Resolution escalates Vietnam War 1969 US astronauts on moon 1974 Completion of Skylab series photographing the solar system and surveying the resources of the earth 1976 U.S. spacecrafts transmitted pictures and data from Mars 1984 Personal and home computers widely available;	1902-1981 1903-1975 1904- 1906-1965 1906- 1910-1965 1914- 1917- 1918- 1918- 1922- 1924- 1925- 1928- 1928- 1928- 1931- 1933- 1933- 1935- 1936-1976 1937- 1945- 1958 UN in Pari Zehrfu Moore 1962-196 York C Perfort Owing Theate Opera Harris Max A Theate	S Louise Nevelson Marcel Breuer * Barbara Hepworth Isamu Noguchi David Smith Philip Johnson * Eero Saarinen * Nicolas Schöffer Bernard Rosenthal I. M. Pei * Joern Utzon * Ronald Bladen Joseph Beuys Howard Jones Anthony Caro Jean Tinguely Duane Hanson John Chamberlain Donald Judd Robert Smithson Sol LeWitt Robert Morris Mark di Suvero Richard Rogers * Carl André Christo Deva Hesse Renzo Piano * Richard Serra Joseph Kosuth ESCO building constructed by Breuer, Nervi, and sse, with art by Calder, Miro, Noguchi, Picasso, and others Lincoln Center built in New City; Library and Museum of ming Arts, by Skidmore, st, & Merrill; New York Stater t, by Johnson; Metropolitan House, by Wallace K. on; Philharmonic Hall, by bramowitz; Vivian Beaumont rt, by Saarien; paintings by Il, Johns, and others;	1903-1970 1903-1974 1904-1980 1905-1970 1908-1984 1909- 1910-1962 1912-1963 1913-1967 1915- 1922- 1923- 1923- 1923- 1924- 1924- 1925- 1928- 1929- 1930- 1930-1987 1931- 1933- 1944- 1941- 1941-	Jean Dubuffet Mark Rothko Adolph Gottlieb Arshile Gorky Willem de Kooning Clyfford Still Barnett Newman Lee Krasner Francis Bacon Franz Kline Jackson Pollock Morris Louis William Baziotes Ad Reinhardt Robert Motherwell Jules Olitski Richard Diebenkorn Roy Lichtenstein Ellsworth Kelly Larry Rivers George Segal Kenneth Noland Robert Rauschenberg Robert Indiana Helen Frankenthaler Claes Oldenburg Jasper Johns Andy Warhol Bridget Riley James Rosenquist Jim Dine Frank Stella Chuck Close John de Andrea	1911- 1912-	Aaron Copland Dimitri Shostakovich Oliver Messiaen Elliott Carter Samuel Barber Gian Carlo Menotti John Cage Benjamin Britten Witold Lutoslawski Milton Babbitt George Rochberg Pierre Boulez Hans Werner Henze Karlheinz Stockhausen George Crumb Krzysztof Penderecki

1900

Later Modern Styles

REVOLUTIONS AND EVOLUTIONS

The revolutionary spirit has continued in full force during the later part of the 20th century. Radical changes have come about in science, technology, politics, and economics as well as in the arts. Social relativity and the pluralistic society have replaced absolute values and uniformity. Anthropologists have confirmed the relativity of behavioral patterns and moral values in today's expanding world; psychologists have demonstrated the impossibility of clearly defining the normal and abnormal; artists have employed styles ranging from strict formalism to wide-ranging freedom, from imaginative abstraction to stark realism, and from detached objectivity to passionate expressionistic involvement.

Highly dramatic have been the developments in space exploration, electronic communications, increasingly sophisticated computer techniques, and robotics. The high-technology revolution has changed the human outlook and environment of the present era as much as did the Industrial Revolution some two centuries ago. The antennas and tentacles of the electronic media have heightened personal perceptions and psychologically extended the nervous systems of the present generation. Through electronic eyes people now watch the whole world, while the whole world is watching them. Through satellite transmitters and dishes capable of sending and receiving thousands of beams, communications have expanded dramatically. Information now reaches the four corners of the world, transcending national boundaries. News now reaches formerly closed societies with such facility that mandated censorship is nearly impossible to enforce. Equally dramatic is the effect of audio and video transmission on cultural developments, while vast numbers have been added to the potential audience. As a result the earth seems at times like a huge planetary city in which national and regional units function as provincial minorities within a vast global complex.

Thus far, however, the process of growth and expansion has generated more diversity than unity, more heat than light, as much conflict as understanding, and boundless possibilities for the future.

With its abstract-expressionists in the vanguard of painting and the partisans of the international style in the forefront of architecture, modernism thrived on opposition and controversy. Even after winning general acceptance, various modernist factions still vied with one another for supremacy. Other artists stirred up further strife with such offbeat styles as pop art, kinetic art, and conceptual art.

MODERNISM

The New York School

During the dark days of World War II, the United States continued to live up to its image as the melting pot of nations. But this time there was a meeting and merging not so much of peoples as of personages and personalities. Prior to the American entry into the war, the scientist Albert Einstein had come from Hitler's Germany, while Enrico Fermi arrived from Italy and Niels Bohr from Denmark. Together they succeeded in splitting the atom and ushering in the nuclear age. Formerly of the Bauhaus in Germany, the renowned international-style architects Walter Gropius and Miës van der Rohe began to teach and build in the United States, while Eliel Saarinen and his son Eero migrated from Finland to make their careers in the Northeast. Such literary figures as Thomas Mann and Aldous Huxley found southern California a congenial place to live and write. The composers Igor Stravinsky, Arnold Schoenberg, and Darius Milhaud were also working and teaching in California, while Paul Hindemith joined the music faculty of Yale University.

In this larger context history shows that all revolutions are really evolutions. Like tips of icebergs, only the more sensational aspects of revolutionary

change rise above the surface. The true essence of change is to be found in the greater, yet imperceptible, evolutionary portions that lie below. There the continuity of ethical and aesthetic concepts is to be found.

The second half of the 20th century, as will be seen, was to witness the triumph and acceptance of modern styles. Then as modernism began to recede into history, styles became increasingly fragmentary, while the postmodernist movement began to take shape. Modernism first and foremost was a style founded in opposition to the prevailing middleclass-establishment values. It was dissonant, controversial, shocking. For its part the establishment considered modernism scandalous and an offense to good taste, common sense, and the conventions of polite society. It was also considered subversive and threatening to the established order. However, when the arts of the modernists began to receive worldwide attention, acceptance eventually followed. Museums were founded to exhibit modernist works, and bourgeois society became collectors as modernist pictures rose in commercial value. In short, modernism in art, architecture, literature, and music became the new establishment. Its painters, writers, and composers were appointed as deans and professors in academies and universities. Its clichés now dominate commercial art, films, and the media.

A similar emigration from Europe was seen among painters and sculptors. The influential French dadaist Marcel Duchamp was already established in New York. Then came the outstanding nonobjective artist Piet Mondrian from Holland and the abstractionist Josef Albers, of the Bauhaus faculty, to open studios. When the war clouds darkened and the Nazis occupied France, leading figures of the School of Paris also found in New York a sanctuary where they could live and work. These included the sculptor Jacques Lipchitz and such painters as Léger, Chagall, and Max Ernst.

In the 1920s and 1930s aspiring young American artists and musicians had sailed for Paris in the wake of writers Gertrude Stein, Ernest Hemingway, and Henry Miller and composers Virgil Thomson and Aaron Copland. Now a reverse migration changed the posture of American artists toward their Continental colleagues. In the early 1940s they stood squarely in the center of things.

When such eminent minds combined forces with their American counterparts, they acted as catalytic agents that hurled the New York artists to the forefront. After 1945 and the war's end, some European artists returned to the Continent. The School of Paris, however, had lost its momentum, and most of the younger creative talents were to be found in New

York. Native artists were not free to effect their own creative synthesis of European and American styles.

For the first time in history an international style originated on the American scene. New York (Fig. 528) because the worldwide capital of art and music, the achievements of the New York School were felt throughout the world, and abstract expressionism took its place in the history of art alongside impressionism, cubism, expressionism, and surrealism. It became the true heir and logical successor in this great evolutionary sequence of styles.

While major architectural developments depended on the expansion of American commerce and industry, painting and poetry belonged to the dispossessed few. Theirs were the voices of angry young men and women who had been confronted with the specter of the Great Depression at the beginning of their careers and the horror of war as they matured.

At first they had been sustained as artists only through the grace of government-sponsored projects. To relieve mass unemployment, President Franklin D. Roosevelt's New Deal included artists and musicians among those aided by the Works Progress Administration (WPA). These programs brought artists, writers, and composers together in group enterprises that gave them a modest living.

As they worked together creating murals for public buildings, plays for regional theaters, and music for ballet productions and symphonic ensembles, American artists found themselves lifted out of their individual isolation and their alienation from society. They formed friendships, developed a sense of community, and discussed philosophies of life and art in a way that could be translated into action.

The Depression years had produced an atmosphere of radical politics among intellectuals and artists at a time when the basic structures of government and social institutions were scrutinized and questioned in the light of their apparent collapse. In this context art tended toward social realism and became an instrument of political propaganda for the exposure of poverty, hypocrisy, and injustice. It was to the credit of the abstract expressionists, who were nourished in this environment, that they sublimated their political revolt and transformed it into an aesthetic radicalism, the purpose of which was to reexamine the basic assumptions and conventions of the American heritage. Although the dominant theme of American art in the 1930s had been social realism (see Fig. 514), such artists as the sculptor David Smith and the painters Willem de Kooning and Arshile Gorky possessed the vision and the daring to explore the aesthetic and expressive potential offered by cubism, expressionism, and surrealism.

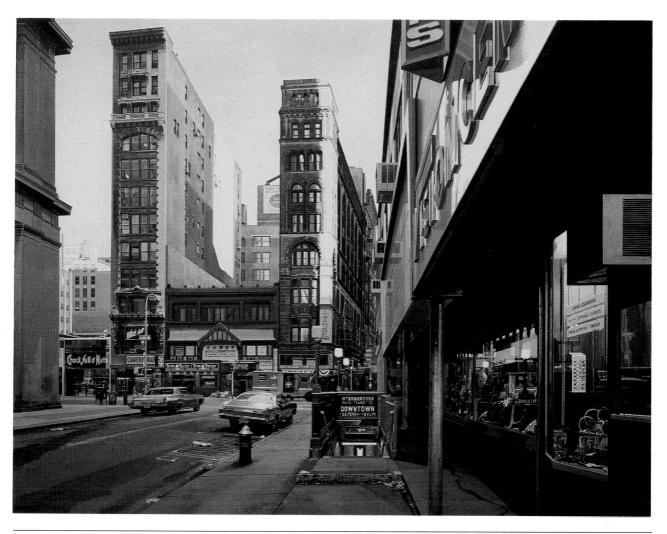

528. RICHARD ESTES. *Downtown*. 1978. Oil on canvas, $4 \times 5'$ (1.22 \times 1.52 m). Museen Moderner Kunst, Vienna. On loan from the Collection Peter Ludwig, Aachen, West Germany.

The designation *New York School* was first coined to distinguish the younger generation of American painters and sculptors from the School of Paris, the exceptional group of artists who lived and worked in Paris during the first four decades of the 20th century. Their brilliant innovations had made the French capital the center and symbol of achievement in modern art. At first only the abstract expressionists were thought to constitute the New York School, but the meaning of the term has been widened to embrace most of the styles whose development and acceptance have centered on New York since 1945.

Just as the School of Paris had embraced the Spaniards Picasso, Juan Gris, and Joan Miró, the Italians Modigliani and Chirico, and the Russian Chagall in addition to the Frenchmen Braque and Matisse, so also the New York School comprised an international group. The German master Hans Hofmann was already in his fifties when he established an art school on West 8th Street. The Dutchborn Willem de Kooning had moved to New York in the late 1920s, as had Mark Rothko from Russia by way of Portland, Oregon, and Arshile Gorky from Turkish Armenia. Jackson Pollock had been born in Wyoming and raised in California and Franz Kline in the coal-mining country of Pennsylvania, while Robert Motherwell hailed from San Francisco, Clyfford Still from Spokane, Washington, and the sculptor David Smith from Indiana. Barnett Newman and Lee Krasner were the native New Yorkers in the group.

Once WPA projects fell casualty to the wartime budget, the artists all found themselves living on the ragged edge of poverty, even desperation, in the bare lofts and cold-water flats of the Greenwich Village section of lower Manhattan off Washington Square. Richard Estes's realistic cityscape (Fig. 528) portrays this aspect. Theirs was not the prosperous, glittering New York of Wall Street, Madison Avenue, and the art galleries of the establishment on 57th Street. Alienation from American society, which they saw as a machine for brutality, was one of the common bonds linking their attitudes and giving them shape.

The focal point of these "loft rats" was the The Club, located at 35 East 8th Street, a local New York version of a Paris café where those who painted by day could talk to each other by night. In their vigorous arguments the artists often came to blows, but they shared a common unifying faith. They believed that art should be invested with powerful content and that the most potent means for giving expression to that content lay in the possibilities of abstraction in order to reduce shapes and forms to their essence.

In 1943 Newman, Rothko, and Adolph Gott-lieb—three member painters of the group—published a statement in the *New York Times* declaring that "there is no such thing as a good painting about nothing. . . . the subject is crucial and only that subject matter is valid which is tragic and timeless." At the same time, they asserted that the "impact of elemental truth" called for the "simple expression of the complex thought, and the importance of the large shape because it has the impact of the unequivocal."

Of an evening at The Club, Hans Hofmann could be heard discussing the doctrine of abstraction. A naturalist, or painter of physical life, he declared, could never become the creator of pictorial life. "You must give the most with the least," he taught, and "a work of art can never be the imitation of life but only . . . the generation of life." On a Friday night the avant-garde composer John Cage might give "A Lecture on Nothing" or sit before a keyboard for four and a half minutes of silence. W. H. Auden, the British-born poet who had settled in New York in 1939, would drop in to discuss his *Age of Anxiety* or give voice to some of the pessimistic existentialist reflections that occupied him in those days.

The Welsh poet Dylan Thomas came to read his lyrics, and the restless Allen Ginsberg, poetic voice of the "beat" generation, would put in an appearance from time to time. There he read his poem *Howl*, a hymn of defeat, a hell of despair. But like a Jackson Pollock web of interpenetrating lines (Fig. 532), *Howl* weaves a tapestry of images that captures the spirit of the seething metropolis:

- I saw the best minds of my generation destroyed by madness, starving hysterical naked, . . .
- who poverty and tatters and holloweyed and high sat up smoking in the supernatural darkness of coldwater flats floating across the tops of cities contemplating jazz, . . .
- who were expelled from the academies for crazy & publishing obscene odes on the windows of the skull. . . .
- . . . wine drunkenness over the roof tops, storefront boroughs of the teahead joyride neon blinking traffic light, sun and moon and tree vibrations in the roaring winter dusks of Brooklyn, ashcan rantings and kind king light of mind, . . .
- who sank all night in submarine light of Bickford's floated out and sat through the stale beer afternoon in desolate Fugazzi's, listening to the crack of doom on the hydrogen jukebox.
- who talked continuously seventy hours from park to pad to bar to Bellevue to museum to the Brooklyn Bridge,
- a lost battalion of platonic conversationalists jumping down the stoops off fire escapes off windowsills off Empire State out of the moon.*

Abstract Expressionism

While calling themselves *abstract-expressionists*, the artists of the New York School did not think of themselves as a group with common ideals. The most that can be said for the unity of the school was that its members shared a range of attitudes derived principally from the despair and anxiety of the times, from the opportunity for professional activity and cooperation afforded by the WPA, from the breakthrough in aesthetic form achieved by the cubists in their experiments with abstractions, and from the liberation of the subconscious attained among the surrealists using Freudian methods of analysis.

^{*}From Collected Poems 1947–1980 by Allen Ginsberg. Copyright © 1956, 1959 by Allen Ginsberg. Reprinted by permission of Harper & Row, Publishers, Inc.

All the abstract expressionists insisted on spontaneity, intensity of feeling, and a vast range of individual choices, materials, and situations. In practice, after all the talking, the goal of these American artists became the realization of an entirely new pictorial style, one synthesized from cubism and surrealism and fully equal to these in ambition and accomplishment. Within this spectrum each remained an individual, each had access to an infinite set of options, each strained in a personal direction.

As the critic Harold Rosenberg noted, each was "fatally aware that only what he constructs for himself will ever be real to him." Or, as William Baziotes said, "[my paintings] are my mirrors. They tell me what I am like at the moment." For the New York School as for the existentialist thinkers, painting was being in nonbeing. Jean-Paul Sartre expressed this view when he observed that "man first of all exists, encounters himself, surges up in the world—and defines himself afterward."

ORIGINS AND DERIVATIONS. From cubism the American artists learned the method of abstracting the essence from familiar shapes and forms. They also mastered the cubist techniques of analyzing and dissecting the subject matter of a painting in order to rearrange the parts into a satisfactory design for pictorial purposes. Like the cubists they frankly acknowledged the two-dimensionality and the shape of their canvases and made no attempt to create the illusion of deep space and fully rounded forms. As their teacher and guide Hans Hofmann put it, "The essence of pictorial space is flatness."

Surrealism also had a powerful effect on the New York group. European surrealists had discovered the free-association techniques of psychic automatism (see pp. 541–43), the spontaneous and random quality of which appealed greatly to the New York group. As one of the group expressed it: "I want to keep a balance just on the edge of awareness, the narrow rim between the conscious and the

529. Arshile Gorky. *The Liver Is the Cock's Comb.* 1944. Oil on canvas, $6' \times 8'2''$ (1.83 \times 2.49 m). Albright-Knox Art Gallery, Buffalo, N.Y. (gift of Seymour H. Knox, 1956).

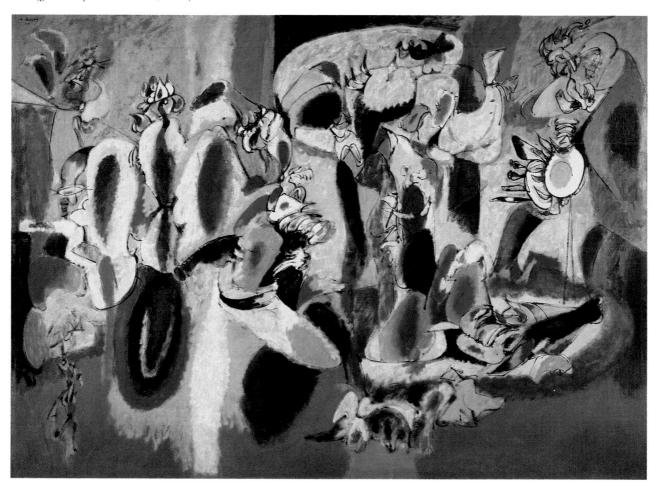

subconscious, a balance between expanding and contracting, silence and sound." Once psychic automatism had released a free flow of creativity, the artist could work over, revise, and realize from the doodling some designs of a more controlled sort. Arshile Gorky's nightmarish picture *The Liver Is the Cock's Comb* (Fig. 529) illustrates this heritage from surrealism. In his gruesome painting the artist conjures up fantastic images of skeletal shapes jostling imaginary creatures with sharp toothlike claws.

Psychic automatism gave priority to process, or the act of doing, over the logically worked-out conceptions of form. In effect, it reversed the order of previous notions of abstract art, which were based on intellectually preconceived ideas before starting a work. Once having accepted automatism as basic to the creative enterprise, the abstract expressionists converted it from the surrealist process of generating images to the act of painting itself. Thus they found a way of preserving freshness, of cultivating accidental dribbles and splashes for the evidence they offered of spontaneity and creative vigor.

Surrealism also pointed the way for the abstract expressionists to discover memory fragments of the innocent and primitive in modern men and women. Though long buried in the subconscious, such primordial memories were the source of the free, the instinctual, and the fantastic in the human imagination. Surrealism thus indicated a technique for liberating the images trapped in the subconscious and making them available to the conscious mind of the artist for use as the vehicles of the artist's expressive intent. Then the abstract expressionists attempted to come to grips with the elemental, the profound, and universal aspects of human emotion. For this they needed to develop a visual language of signs and symbols to depict the pictorial equivalents of human experience. In the process of artistic creation they sought the metaphors for the myths of universal genesis, as did Barnett Newman in Genesis— The Break (Fig. 530). The stark blacks and whites in this reconstruction of the primal creative force suggest God separating light from darkness, the essential from the trivial, bringing order out of chaos and form from the void. In this titanic struggle, it is as if a celestial body is taking shape out of nothingness.

The abstract expressionists' notion of painting as heroic gesture harks back to the sublime ideal of romanticism. Unlike the romantics, however, they sought to create a poetic art in purely pictorial terms.

ACTION PAINTING. Recognition of the abstract expressionists was slow in coming. Conservative art critics called their pictures "pots of paint flung in the face of the public." Even some of the avant-garde

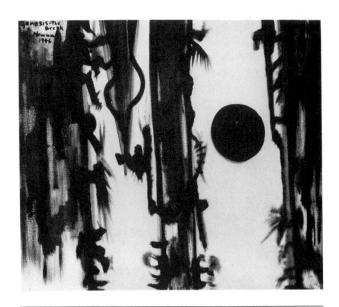

530. Barnett Newman. *Genesis—The Break.* 1946. Oil on canvas, $24 \times 27''$ (61 × 69 cm). © Dia Art Foundation, 1979.

commercial galleries hesitated to accept their paintings for exhibition. In 1943, however, Jackson Pollock's first one-man show in New York was an event that commanded international recognition and focused worldwide attention on himself and his fellow abstract expressionists. Pollocks's explosive canvases revealed a teeming vitality, frenetic energy, and creative invention that heralded a new era in painting. He was the original "action painter" who spread his enormous canvases on the floor so as to feel closer to his painting (Fig. 531).

With commercial paints, house-painting brushes, basting syringes, and sticks and trowels he performed a kind of ritualistic oily ballet dance as he dripped, squirted, dribbled, and flung. His "poured paintings," as they have been called, had no predetermined pattern. They are simply energy made visible, a kind of trancelike pictorial choreography in which the spectator is invited to join in the dance. With *Lucifer* (Fig. 532), the viewer is irresistibly drawn into a web of nervous rhythms pulsating with dynamic energy, a perpetual motion of lines and colors, as might be compounded of such elemental forces of nature as air, fire, and water.

Pollock was a master of curvilinear drawing. He developed the pouring techniques so that he could achieve a kind of improvisational continuity of extended overlapping lines in the process of painting. This cannot be done with the traditional way of handling the brush. In spite of the spontaneous and seemingly accidental quality, Pollock's battery of techniques is firmly controlled. He once insisted, "I

can control the flow of paint. There is no accident." The result is an amazingly complex web of interwoven lines, colors, and motifs similar in effect to musical counterpoint.

Neither Pollock nor his fellow abstract expressionists came as bursts from the blue, and no one was more aware of this than the painters themselves. Their stylistic synthesis, as previously discussed, had included elements derived from cubism, surrealism, and Kandinsky's passionate nonobjectivism. But

Jackson Pollock at work in his studio, 1950.

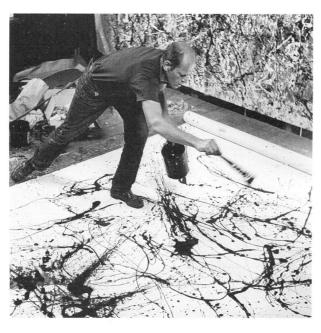

there is still larger and broader historical dimension. As early as 1756 the English writer Edmund Burke had published his essay on the *Philosophical Enquiry into the Origins of Our Ideas of the Sublime and the Beautiful*. Beauty in the 18th-century sense was based on order, clarity, balance, elegance, and proportion. The sublime, however, could include fearinspiring experiences; the magnificent, terrible, picturesque, and awesome; the horrendous forces of nature such as storms at sea and eruptions of volcanoes; and even the supernatural (see p. 433).

Around 1845, with the last pictures of the English painter J. M. W. Turner (see Fig. 451), one feels the same perpetual motion of blinding blizzards and wind-driven clouds, the same distillation of nature's most potent projections—energy, light, and motion—that characterize Pollock's paintings. As his contemporary the author William Hazlitt commented, Turner depicts "the elements of air, earth, and water. The artist delights to go back to the first chaos of the world or to that state of things when the waters were separating from the dry land, and light from darkness, but as yet no living thing nor tree bearing fruit was seen upon the face of the earth. All is without form and void."

The same thrust is carried into American art with the wider sweep of the romantic movement. Dating from about 1885, Albert Pinkham Ryder's *Jonah* (Fig. 533) seems to dissolve the material world into an ominous phosphorescent brightness. In his analysis of this picture, art historian Robert Rosenblum observes that Ryder's conception merges the "phenomena of sea, sky, moonlight with such awareness of their supernatural potential that he

532. Jackson Pollock. *Lucifer.* 1947. Oil, enamel, and aluminum paint on canvas; $3'5'' \times 6'9''$ (1.04 × 2.06 m). Collection Mr. and Mrs. Harry Anderson, Atherton, Calif.

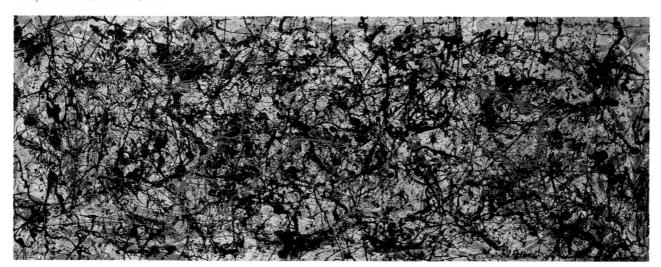

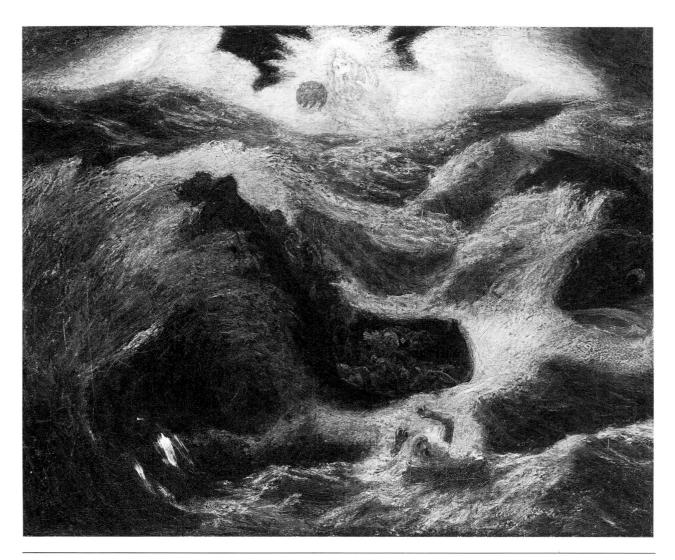

533. ALBERT PINKHAM RYDER. *Jonah.* c. 1885. Oil on canvas, $27\frac{1}{4} \times 34\frac{3^{\prime\prime\prime}}{8}$ (69.2 × 87.3 cm). National Museum of American Art, Smithsonian Institution, Washington, D.C. (gift of John Gallatly).

534. Franz Kline. *Pennsylvania*. 1954. Oil on canvas, $3'11'' \times 5'3''$ $(1.19 \times 1.6 \text{ m})$. Courtesy the artist's estate.

convinces us that a Biblical miracle could take place within the magical environment he usually creates in landscape alone."

Bringing together so many different and fundamentally opposite elements—cubism and surrealism, form and content, reason and emotion, control and freedom, line and color, drawing and painting, figure and ground, abstraction and expression—and doing it on such a heroic scale and without identifiable subject matter of any sort, Pollock achieved a balance so rare and exquisite that even he could not sustain the delicate poise for long. Eventually he chose to develop individually certain selected aspects of the totality present in his masterpieces. In just this way his followers carried modern art forward to new advances in aesthetic vision by basing their work on one feature or another of the complete statement

made by Pollock in his most fertile and triumphant period, from 1948 through 1950.

Fundamental as color was to many of the abstract-expressionist group, black runs like a leitmotif through much abstract-expressionist painting. Scientifically, black is the total absorption or absence of light, which is the medium of color. Thus, by reducing pigmentation to basic simplicity, black could be seen as a contribution to the quality of abstraction and as a speeding up of the painting process. For others, black played a symbolic role for moods of renunciation, grief, or despair.

Franz Kline, for instance, created huge angular black figures on white backgrounds. Many of his works seem like drawings blown up to the scale of large paintings. He reveled in the metallic skeletal forms so characteristic of the urban scene. *Pennsylvania* (Fig. 534) grows mysteriously in swift, sooty,

gestural strokes like the structural stresses of opposing forces in the skeletons of iron bridges, railway trestles, and locomotive engines of the artist's coalcountry origins. The image thus created is that of nostalgic, self-revealing memory.

Adolph Gottlieb and Lee Krasner, on the other hand, worked on a smaller scale and tried to preserve the sense of intimacy in their personal statements. Both devised their own sets of symbols and images that seem to communicate in a pictographic language akin to the picture writing of ancient hieroglyphs. In *Forgotten Dream* (Fig. 535) Gottlieb, using a cubist grid, invents a kind of preconscious or subconscious set of symbols in the manner of surrealist automatism. But while Egyptian hieroglyphs can be deciphered and medieval motifs looked up in a dictionary of symbols, the pictographs in these pictures have no referent other than the painting itself

535. Adolph Gottlieb. *Forgotten Dream.* 1946. Oil on canvas, $24 \times 30''$ (61.1×76.4 cm). Herbert F. Johnson Museum of Art, Cornell University, Ithaca, N.Y. (gift of Albert A. List).

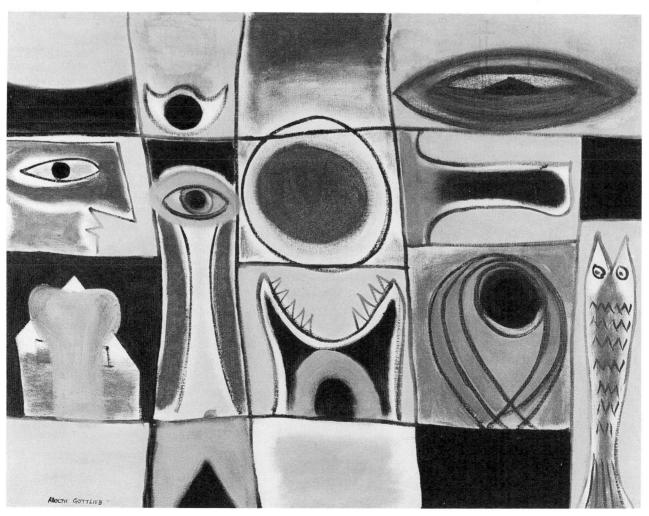

536. Lee Krasner. *Abstract No. 2.* 1948. Oil on canvas, $20\frac{1}{2} \times 23\frac{17}{4}$ (52 × 59 cm). Courtesy the artist.

or the subconscious mind of the artist himself. For her part, Krasner found her inspiration in Irish and Persian illuminated manuscripts. The study of Hebrew in her childhood, she says, also reinforced her concern and fascination with the curved lines of letter forms. Her *Abstract No. 2* (Fig. 536) is more abstract than Gottlieb's pictographs. As in a dream there is persistent repetition of an image with constant variations.

Color-Field Painting. Pollock and Kline are often regarded as the representatives of "gestural abstraction" within the New York group, while painters like Mark Rothko and Barnett Newman appear as "color abstractionists." A comparison of the Pollock and Kline works with Rothko's Green and Maroon (Fig. 537) or with Newman's Vir Heroicus Sublimis (Fig. 538) provides evidence of the reason for the distinction. Kline's Pennsylvania, with its blacks and whites, reproduces quite well on the printed page. To a lesser extent Pollock's Lucifer (Fig. 532), with its accent on line, would also survive in a black-and-white illustration. The works of Rothko and Newman, however, with their subtle and sensitive saturations—that is, purity, vividness, or intensity—of color would be lost and incomprehensible without their essential element. This fact emphasizes a fundamental division among the abstract expressionists, with the action painters appearing on one side and the color-field painters, or color abstractionists, on the other. The vigorous, muscular gestures of Pollock and Kline, for instance, have nothing to do with the delicate blending processes used by Rothko and Newman.

Rothko's *Green and Maroon* (Fig. 537) consists of several irregular rectangles floating in an atmospheric blue space. The rectangles are of unequal size with unstable contours and are painted in luminous hues brushed on with such delicacy that flickering light seems to radiate from the films of color. As the eye runs over the painterly edges of the rectangles, the delicate harmonies of the colors set off vibrations that make the shapes appear to breathe and shimmer within the color-suffused space.

Barnett Newman was also swept up in the tide of the heroic sublime. In his *Genesis—The Break* (Fig. 530) he had come to grips with the creative force itself with his contrasting blacks and whites symbolizing the emergence of light from darkness. He also carried abstraction still further into the forms of densities and saturations of a single color.

537. MARK ROTHKO. *Green and Maroon*. 1953. Oil on canvas, $7'6_4^{3''} \times 4'6_2^{1''}$ (2.31 × 1.38 m). Phillips Collection, Washington, D.C.

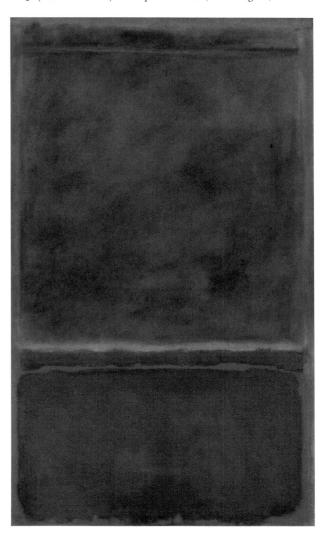

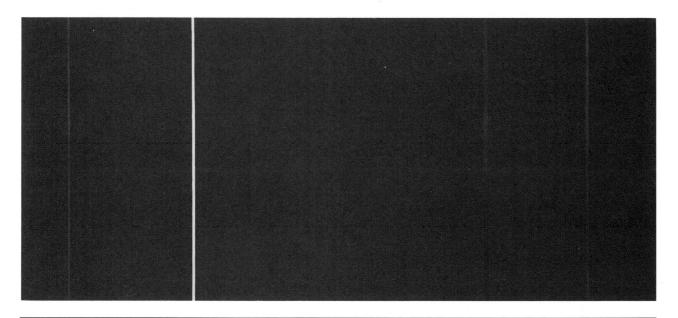

538. Barnett Newman. *Vir Heroicus Sublimis.* 1950–51. Oil on canvas, $7'11\frac{3''}{8} \times 17'9\frac{1}{4}''$ (2.42 × 5.42 m). Museum of Modern Art, New York (gift of Mr. and Mrs. Ben Heller).

Such pictures as Vir Heroicus Sublimis (Fig. 538), which might be translated as "Man, the Heroic Sublime," have but one vivid hue—in this case, red expanding horizontally with syncopated interruptions by lean vertical bands that seem to march across the huge canvas. Newman dazzles the eyes with sweeping color sensations. His vertical bands dominate his pictures with their nervous, vibrating contours. These "zips," as Newman called them, serve to "cut" the great field of absolute color and shock it into waves of visual energy that roll back and forth between the bands and the edges. This creates dynamic action in what otherwise seem a totally inert situation. These bands can also be read as abstract figures standing out against their color-field environment. In the way they parallel and echo the edges that fix the limit of Newman's canvases, they seem to be marking off pictures within pictures.

Both Pollock and Newman in their major pronouncements expanded the size of their paintings to immense proportions. They considered easel paintings of cabinet size to be a dying form. In their place they projected larger "portable murals" and environmental wall pictures so that the viewer could have a complete sense of involvement. Smaller canvases, they reasoned, were of necessity seen in relation to their setting with other objects in the room, the texture and color of the walls against which they were hung, and in conjunction with other pictures on the same and surrounding walls. Large-scale murals, on the other hand, are complete within

themselves since they make their own environment. Murals can be said to create space simply by occupying it, and in so doing they envelop the viewer.

Sculptural Dimension. The sculptor David Smith was subject to the same forces and circumstances that influenced the abstract-expressionist painters. He also associated intimately with the group, shared their goal of realizing new forms and a new style of abstraction and expression, and eventually became their sculptural counterpart. He began as a painting student at the Art Students League of New York but switched in the early 1930s to sculpture after seeing reproductions of works by Picasso and others using what then constituted an inventive new technique of joining and welding metal pieces and parts into abstract cubist assemblages (see Fig. 480). Smith was drawn to this technique in part because he had first learned it by working in automobile and locomotive factories where he had assembled and welded metal components.

Throughout his career Smith felt a great fascination for the basic quality of steel. "The metal," he wrote, "possesses little art history. What associations it has are those of this century: power, structure, movement, progress, suspension, destruction, brutality." Thus, Smith worked in the medium of constructed sculpture rather than in the traditional ones of carved stone and cast bronze. In order to accommodate a machine-shop studio large enough to construct works on an architectural scale plus ample

environment for their display, Smith moved to a farm at Bolton Landing in upstate New York. There, he could achieve not only the epic scale of the *Cubi* works (Fig. 539) but also the perspective to conceptualize them within a series of related materials and forms.

Some of Smith's constructions retain the rough blackness of iron; others have been painted bright hues, while in the *Cubi* series Smith scored the stain-

539. DAVID SMITH. *Cubi VI.* 1963. Stainless steel, height $9'10\frac{1}{2}''$ (3.21 m). Israel Museum, Jerusalem (donated by Mr. and Mrs. Meshulam Riklis).

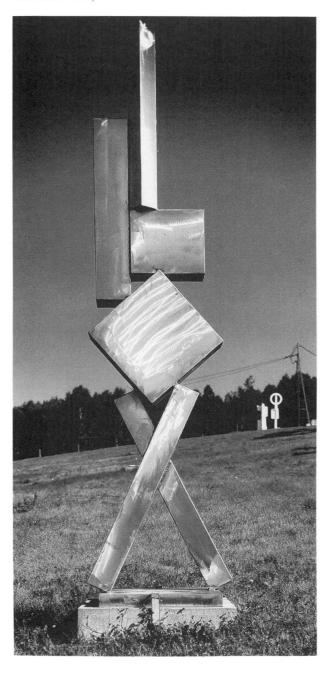

less-steel surfaces of the geometric volumes to make them flash, dazzle, and all but dissolve in refracted sunlight. The sense of lightness this creates seems a contradiction of the heavy, solid appearance of the monumental forms, the mass of them raised aloft by cylinders and balanced there in dynamic majesty.

A master draftsman who all his life drew from the model, Smith designed sculptures with such strong silhouettes and transparent interiors that they seem like "drawing-in-space"; in scale and proportion, they often relate to the human figure. The frontal views he designed also give many of the works a strong pictorial character. Smith possessed something of the surrealists' automatism in his astonishing ability to devise new forms. These frequently included standard industrial units or "found" objects from junkyards, which Smith transformed into artistic significance by making them integral with the whole of his design.

Smith's iron and steel constructions, like those in the *Cubi* series, create open and closed spaces that interpenetrate with their environment, defining space, volume, movement, and color as they stand silhouetted against trees, buildings, or sky. Seeing symbol in structure, Smith wrote: "When one chooses a couple of old iron rings from the hub of a wagon, they are circles, they are suns; they all have

540. Hans Hofmann. *Memoria in Aeternum*. 1962. Oil on canvas, $7' \times 6_8''$ (2.13 \times 1.83 m). Museum of Modern Art, New York (gift of the artist).

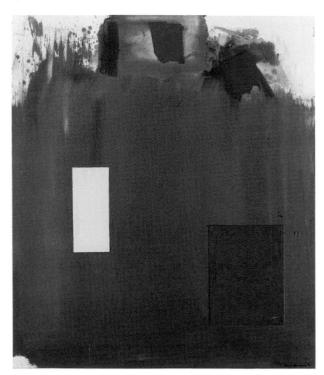

the same radius; they all perform the same Euclidean relationships."

Success eventually came to the "loft rats"; but after so much poverty, despair, and struggle, it seemed not a harbinger of the good life but the end of an epoch and the death of its heroes. Gorky committed suicide in 1948 and Pollock perished in an automobile accident in 1956, as did David Smith in 1965. Kline died in 1962, when he was fifty-one, and Rothko killed himself in his studio in 1970.

541. Helen Frankenthaler. *Formation*. 1963. Acrylic on canvas, $6'4'' \times 5'5''$ (1.93 × 1.65 m). Collection Alexis Gregory, New York.

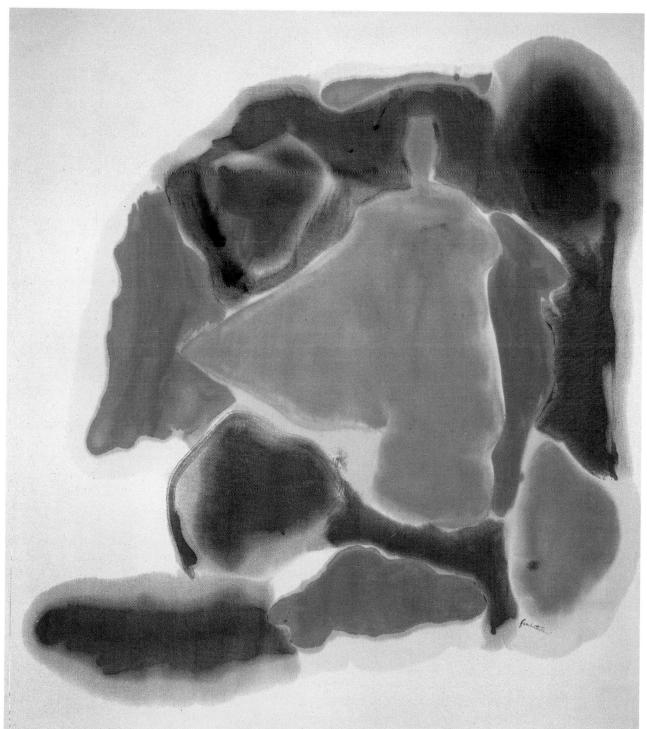

It was the years 1947–1953 that saw the movement experience its most intense activity and dialogue and achieve the highest quality in innovation as well as in production. As late as 1951, however, the artists' state was so desperate for the want of recognition that a group calling themselves "the irascible eight," which included Pollock, Kline, Rothko, Newman, de Kooning, Motherwell, Gottlieb, and Reinhardt, picketed the Museum of Modern Art to demand the establishment of a department of modern American art. In the same year, the Museum of Modern Art recognized the movement with an exhibition entitled "Abstract Painting and Sculpture in America."

Then about 1958 the prestige of the "heroic generation" soared when the museum circulated throughout Europe a comprehensive show of their work under the title "The New American Painting." This made abstract expressionism into an international style that transformed the character and appearance of new painting virtually all over the world.

In *Memoria in Aeternum* (Fig. 540), or *In Perpetual Memory*, Hans Hofmann, the old master of the style who survived many of his younger colleagues, paid tribute to the movement. Executed shortly after Kline's death, it is a melancholy picture of stark color contrasts, but one revealing the artist's astonishingly vigorous "push-pull" dynamic, a technique by which he caused painterly planes to achieve a daring structure of pictorial architecture.

Helen Frankenthaler extended the implications of Pollock's method and added yet another dimension to abstraction. She allows her colors—stained directly into raw canvas after the manner of Pollock—to assume free, shimmering shapes. She also follows Pollock in working on a canvas spread over the floor rather than set upon an easel or against a wall. *Formation* (Fig. 541) shows her technique of staining, dyeing, and washing the canvas with waves of various hues in the manner of a watercolor.

SERIALISM. Serialism was another modernist development that followed in the wake of abstract-expressionism. With *serialism* artistic enterprises are seen as aesthetic problems that admit of many different solutions. Such problems are pursued in a series, with each picture posing one possible solution. The lineage of serialism can be traced back to Monet, who in 1877 painted seven views of Paris's Old St. Lazare Railway Station (see Fig. 470). As he worked, the scene remained the same, but the atmosphere, light, steam, and color changed constantly, therefore appearing different in each painting. During the year 1891 Monet painted another series, the subject mat-

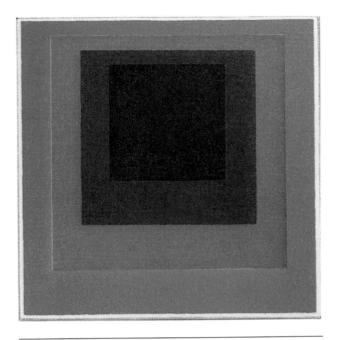

542.JOSEF ALBERS. *Homage to the Square: Floating*. 1957. Oil on canvas, 24" (60 cm) square. Yale University Art Gallery, New Haven (gift of Anni Albers and the Josef Albers Foundation, Inc.).

ter of which consisted of single and double haystacks in a field. On this occasion, he conceived the group as a whole so as to capture the variables of light and shadow, wind and weather, colors and hues, throughout the four seasons. Later, Monet rented a second-floor studio in Rouen, where he could face the intricately carved surface of the cathedral façade and paint it some twenty times.

Josef Albers, who had earlier worked in Germany with Kandinsky and Klee at the Bauhaus and later in New York, extended this idea into the realm of abstraction (Figs. 542 and 543). "In visual formation," this founder of modern serialization declared, "there is no final solution, therefore I work in series." Serialism, moreover, can be apprehended fully only when all units in a series are beheld together in a single room where they have a chance to reveal their relationships, where their reciprocal aspects can affect one another, and where their spacing against the surrounding walls plays a part as they form a continuum.

Serialism discards the idea of converging and compressing all ideas and elements into a single masterpiece. In serial painting there is no beginning, middle, or end, implying as this does the evolution and dramatic development of a single canvas. In the case of Monet, who can say which haystack or cathedral painting is the one and only great work? Se-

rialism also moves away from the balanced simultaneity of cubism and extends the experience of space into an unfolding continuum, or, to put it in mathematical terms, into sets of continuous, independent variables.

Serialism, then, is a process, not a finality. Constant variation is the order of the day as each picture changes in size, structure, geometry, and shape. Or the shape itself can become the constant, while the color saturations, the densities of the paint,

or the qualities of texture change. Or an element such as line can go through various vertical, horizontal, diagonal, or circular manipulations, always allowing for surprise or sport. An obvious analogy can be made with the theme-and-variation form in music. A more subtle one can be made with musical serialization, which emphasizes constant variation, as well as the process of thematic and rhythmic transformation, segmentation, fragmentation, and reassemblage and recombination of materials.

543.Josef Albers. *Homage to the Square*. 1964. Oil on canvas, 30" (75 cm) square. Yale University Art Gallery, New Haven (gift of Anni Albers and the Josef Albers Foundation, Inc.).

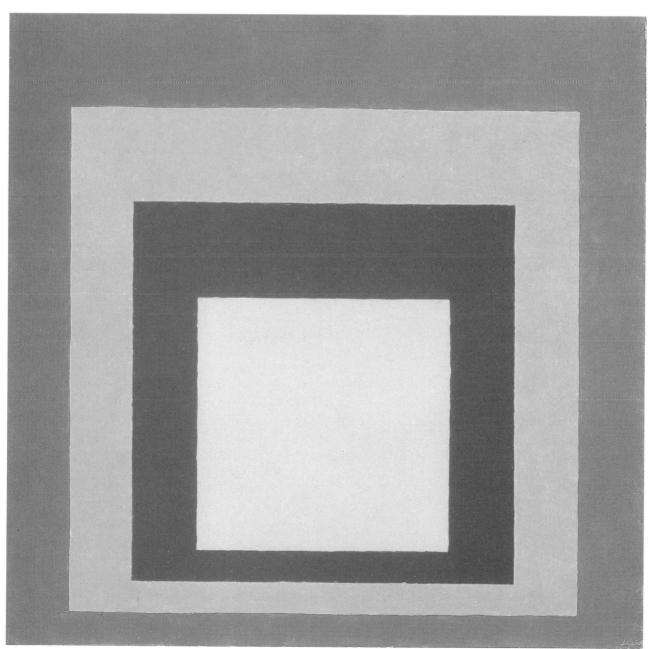

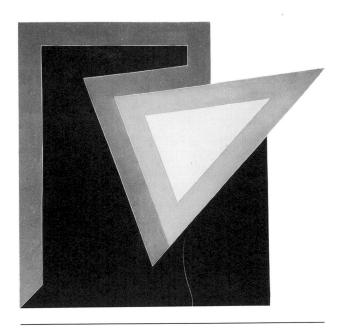

544. Frank Stella. *Tuftonboro I.* 1966. Fluorescent alkyd and epoxy paint on canvas, $8'3'' \times 9'1''$ (2.51 \times 2.77 m). Collection Mr. and Mrs. Victor W. Ganz, New York.

Frank Stella has also worked in the serialist vein and is a unique presence in the modern movement. In his *Tuftonboro* series he posed the question "Why do pictures have to be confined to any predetermined geometrical shape?" Everything is first reduced to the bare minimum of straight lines, severe geometrical forms, and strong colors. With *Tuftonboro I* (Fig. 544) the viewer is confronted with a slashing triangle that bursts the bonds of its rectangular base. The pictorial situation is reinforced by the black ground that contrasts strongly with the bright colors.

In *Singerli Variation IV* (Fig. 545) Stella projects a circular space with a complex interplay of advancing warm colors and receding cool tones as the curvilinear bands weave in and out, over and under. The picture recalls some of the heraldic banners and intricate interlaced lettering found in the pages of medieval illuminated manuscripts.

MINIMALISM. The implication behind *minimal art*, as the group in the 1960s called their work, is the reduction of sculpture to its irreducible minimum—

545.Frank Stella. *Singerli Variation IV.* 1968. Fluorescent acrylic on canvas, diameter 10' (3.05 m). Collection Mr. and Mrs. Burton Tremaine, Meriden, Conn.

546. Ronald Bladen. *X.* 1968. Painted wood for aluminum, $22 \times 26 \times 14'$ (6.71 \times 7.93 \times 4.27 m). Max Hutchinson Gallery, New York.

a form, outline, or shape. Minimal artists were more concerned with the way their pieces created, enhanced, or blended into their architectural or urban environment than with the autonomy of their sculptural works as objects. The minimalist point of departure can be found in David Smith's late Cubi series (Fig. 539) but, unlike Smith, the minimalists deemphasize personal involvement, expressive content, and hand welding in favor of fabricated impersonality. They also prefer "primary structures" (Figs. 546 and 547)—basic geometric volumes so simple as to be redundant—over the planes typical of cubist-derived sculpture (see Figs. 496 and 497). Materials tend to be the industrial ones of galvanized iron, aluminum, stainless steel, laminated wood, fiberglass, and plastics.

The minimalists also employ industrial methods, drawing up plans and specifications and making a small model in painted wood. This then is turned over to an industrial shop for final execution. Like architects, they project their schemes on a huge scale for public sites and must await patrons with the capital to finance such enterprises. Before Ronald Bladen could arrange for his massive *X* (Fig. 546) to be constructed in steel, he had it built in plywood for exhibition in a court at New York's Metropolitan Museum.

The minimalists shunned the conception of sculpture as an isolated object. Their productions do not sit on pedestals; rather, they rest on the floor,

547. ISAMU NOGUCHI. *Cube*. 1968. Painted welded steel and aluminum, height 28' (8.53 m). 140 Broadway, New York.

stand against a wall, are suspended from the ceiling, or occupy a whole room. Better yet, they take to the out-of-doors, like Isomu Noguchi's dramatically poised *Cube* (Fig. 547), where they merge with the surrounding architectural space and become part of the total environment.

Stylistic Fragments

Modern art had thrived on the very conflict and controversy it generated. Paradoxically, its eventual acceptance by the public brought about its disintegration into fragmentary styles that concentrated on isolated aspects of experience. The emotional intensity, heroic ambitions, and personal preoccupations of the abstract expressionists could no longer be sustained by the succeeding generation of artists. The arts then entered a period of fragmentation as painters and sculptors sought to bring art back down to earth. Their reactions looked to chance more than calculation, irreverence more than personal commitment, and generally lighter treatment. The styles they evolved included pop art; op, kinetic, and computer art; and conceptual art. Pop art reflected pros-

perity and consumer-society affluence. Optical art concentrated on the psychological aspects of vision. Kinetic and computer art explored the possibilities of new media. Conceptual artists felt that the idea behind a work of art was more important that its realization as an object, that process was greater than the product.

Pop Art. Pop art, with its use of everyday objects and familiar subjects that came from comic strips, the supermarket, and junkyards, had much in common with the earlier dada movement (see pp. 539–41). The original dadaism had been a bitter expression born out of the disillusionment with the governments and society that had brought on the slaughter of World War I. Like the political anarchists, these artists wanted to destroy accepted values in order to clear the way to reform. The new dadaists of the post—World War II period used the original vocabulary of the trivial and commonplace and assemblages of debris from attics and junkyards. Missing, however, was the bitterness in the older

fare, for both pop and the new dadaism were nourished by a joyous acceptance of modern materialism and the flood of commercial material from the mass media.

While the old dada had been a desperately serious movement, the new reveled in nonsense for its own sake. The artists' incongruous and unpredictable assemblages of random objects show a sense of wry humor. But they were now laughing with the world, not at it. As Robert Rauschenberg disarmingly remarked, he just wanted to live in the world, not reform it.

In Rauschenberg's *Monogram* (Fig. 548) it is apparent that pop art has allowed no boundary to separate art from life. Here is a hybrid form, an assemblage, or "combine painting," in which the artist has incorporated such randomly chosen objects as a stuffed angora ram encircled by an automobile tire and other bits of miscellaneous debris that spill out to challenge the ambiguous spaces of abstract expressionism and literally close the gap between art and life. Completing the three-dimensional collage

548. ROBERT RAUSCHENBERG. *Monogram*. 1955–59. Construction, $5'4\frac{1}{2}'' \times 3'6'' \times 5'3\frac{1}{4}''$ (1.64 × 1.07 × 1.61 m). Moderna Museet, Stockholm.

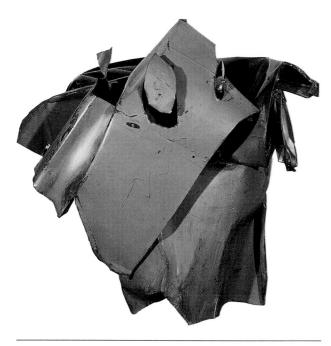

549. John Chamberlain. *Miss Lucy Pink*. 1963. Painted steel, $3'11'' \times 3'6'' \times 3'3''$ (1.19 × 1.07 × .99 m). Pace Gallery, New York.

are photographs, cut-out letters, and colors applied with the painterly abandon inherited from the first generation of abstract expressionists. The real irony at the heart of pop works like *Monogram* is that however trite, commercial, debased, and nostalgic the contents, they have been composed, interpreted, and transformed by the means and standards of a living pictorial tradition.

From Rauschenberg's assemblages it is only a short step into the domain of junk sculpture and "found art." John Chamberlain's *Miss Lucy Pink* (Fig. 549) uses the crushed and compressed sheets of an actual automobile chassis caught momentarily at a point in the cycle between its original function and the junkyard. Such art uses rusted machine discards, splintered wood, and industrial debris. It closely relates to the urban experience of throwaway materials in an age of rapid obsolescence.

With its accessible imagery, pop art at once celebrates and parodies the commonplaceness of a consumer society conspicuously dependent upon the supermarket, mass-media advertisements, bill-boards, and comic strips. The style was steadily accepted as "fun art" by an international public, grateful at last to discover something so commonplace, so much a part of everyday experience.

So extensively did pop art offer easily recognizable subjects to which all could relate that art itself has now entered the mass market and become merchandise for popular consumption. There are Andy

Warhol's still lifes filled with endlessly repeated soup cans and Coke bottles arranged as on supermarket shelves (Figure 550), as well as Jasper Johns's shooting-gallery targets, American-flag, and numbers series and Roy Lichtenstein's comic-strip paintings. Allen Ginsberg's perceptive poetry captures the spirit of this phase of pop art in "A Supermarket in California":

In my hungry fatigue, and shopping for images, I went into the neon fruit supermarket, dreaming of your enumerations!

What peaches and what penumbras! wives in the avocados, babies in the tomatoes! And you. García Lorca, what were you doing down by the watermelons? . . .

I wandered in and out of the brilliant stacks of cans following you, and followed in my imagination by the store detective.

We strode down the open corridors together in our solitary fancy tasting artichokes, possessing every frozen delicacy, and never passing the cashier.*

Rauschenberg and his fellow artists of pop and similar persuasions also joined in *happenings* comprising improvisation, chance, and random activities. Happenings constitute a multimedia package in which spontaneous, unplanned audience participation plays a part. These events must, of course, be prepared to the extent of choosing the place and assembling the materials and personnel.

In a typical happening the designers create an environment of sights, sounds, smells, movement, and action. Several musical ensembles may be used at random—one playing classical repertory, another vintage jazz, and still another rock music. Clips of various moving pictures in no particular order might be shown on one wall, slides projected in no discernible sequence onto a second, while on a third, psychedelic colors flash and twirl. Meanwhile, groups of dancers in bizarre costumes improvise steps and gestures, and athletes in track suits play games. Wind machines scatter confetti, a poet reads nonsense verse, a committed group stage a demonstration with placards and slogans, and an orator rants at the mob. As radio and television sets blare

^{*}From *Collected Poems 1947–1980* by Allen Ginsberg, Copyright © 1956, 1959 by Allen Ginsberg. Reprinted by permission of Harper & Row, Publishers, Inc.

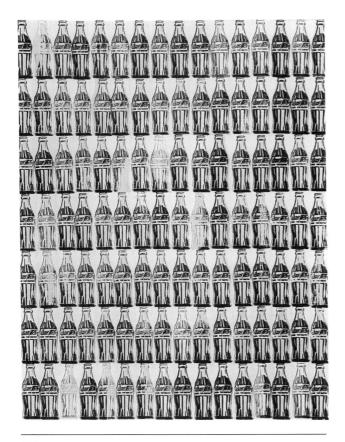

550. Andy Warhol. *Green Coca-Cola Bottles*. 1962. Oil on canvas, $6'10_4^{4''} \times 4'9''$ (2.1 × 1.45 m). Whitney Museum of American Art (gift of the Friends of the Whitney Museum).

and vacuum cleaners roar, members of the audience contribute spontaneously reactions. Some might describe such events as action paintings in living motion, other as contrived choas.

Though still maintaining an improvised appearance, a more permanent and solid dimension is supplied by Claes Oldenburg with his painted steel and aluminum *Geometric Mouse* (Fig. 551).

OP, KINETIC, AND COMPUTER ART. Op art, or *optical art,* is yet another attempt to come to grips with the nature of the visual experience. It could be described as a type of action painting, with the action taking place in the viewer's eye. Op artists have called their work, which developed out of geometrical abstraction and optical illusionism, "perpetual abstraction."

Bridget Riley's *Current* (Fig. 552) illustrates how stable lines seem to shift and deceive. Since it is impossible to apprehend the whole picture at one time, different responses are induced as the eye moves over partial sectors of the surface, so that the illusion of faster-slower and forward-backward movement occurs. The sense of perception is con-

fused as eye and brain signals get their wires crossed. The viewer then feels certain sensations varying from disorientation and discomfort to giddiness and exhilaration.

Optical artists are allied with mathematicians, physicists, and psychologists in their experimentations and explorations of optical phenomena. With op art, seeing is deceiving instead of believing. Like the impressionists, optical artists are concerned primarily with the work of art as an act of the eye. However, unlike the impressionists, they avoid all association with the outside world and concentrate on the way the eye and brain respond to optical data. By activating the responsive eye, by the impact on perception of color dissonances and the manipulation of geometrical patterns, op art has produced startling effects that amount to a new way of seeing.

Many artists of the 1960s and 1970s dematerialized their creations so that motion and colored light became the substance of the work of art. In this kinetic art sophisticated engineering and computer technology came into play. Leading the way earlier in the century were Marcel Duchamp with his primitive motorized works and Alexander Calder with his mobiles animated by air currents (see Fig. 566). Now with advancing electronic technology, light, action, and sound can be combined in time-space creations that are variously referred to as kinetic, serially programmed, or luministic art. These artists used computers to program their creations in motion, sound, and light. Some employed such terms as spatiodynamics and luminiodynamics to describe their alliance with science and engineering. Their machinelike constructs sported gleaming metallic rods whirling in fountainlike patterns and vibrating with strange sound effects. Other artists set up electromagnets that could be programmed to sustain metal objects in various patterns of attraction and repulsion.

In addition to its scientific and mathematical uses, the computer has long established itself as an aid in musical composition, kinetic sculpture, theatrical lighting, and choreography. With new graphic capabilities, supercomputers have succeeded in advancing from tools to full partnership in the creative process. These powerful instruments, which can product millions of mathematical computations per second, have entered the field of graphic arts. High degrees of brightness, wide ranges of color, acute definition of forms are now at the command of artists. Working with "electronic brushes," they have complete control in working with light instead of paint. All repetitive detail is eliminated. Images can be stored in and retrieved from memory banks, then altered and combined in electronic collages. Forms,

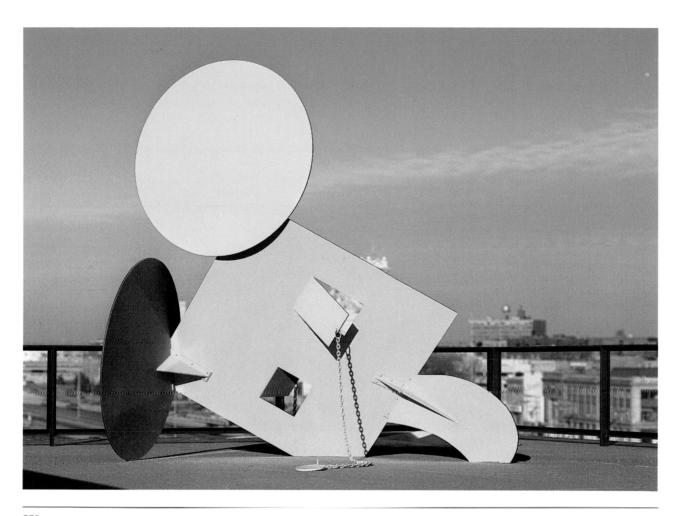

551. Claes Oldenburg. *Geometric Mouse, Scale A.* 1969–73. Steel, aluminum, automotive paint, $12 \times 15 \times 7'$ (3.66 \times 4.58 \times 2.14 m). Intended gift to Walker Art Center, Minneapolis, from Shirley and Miles Fiterman.

lines, shapes, colors, and light can all be manipulated at will. David Em, in his *Orejo* (Fig. 553), shows how a new world of fantasy is there to be explored. His pictures are evolved on the screen, then transferred to still photographs of moving animations on videotape. The potential of computer-generated imagery seems limitless.

Conceptual Art. As the term implies, conceptual art originates as an idea in the mind of the artist, materializes as a process, assumes whatever tangible shape it may, then disappears into memory or oblivion. The minimalists believed that what the artist produces is less important than the process that brings it into being. The conceptualists question the nature of art as an object that can be bought, sold, or placed in a museum except temporarily. Conceptual art has produced human body works, earth works, and works consisting of such curious materials as grease, cheesecloth, cornflakes, blocks of ice, or just plain dirt. Removing them from galleries has often meant much scrubbing, sweeping, and shoveling. All that remains is the debris of a dream, a memory experience, and documentary record in the form of

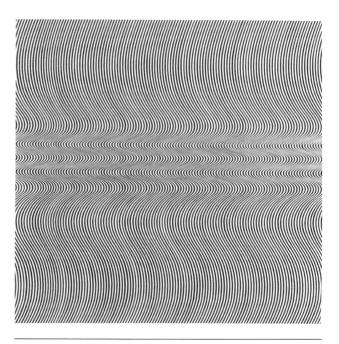

552. Bridget Riley. *Current.* 1964. Synthetic polymer paint on composition board. $4'10_8'''$ (1.48 m) square. Museum of Modern Art, New York (Phillip Johnson Fund).

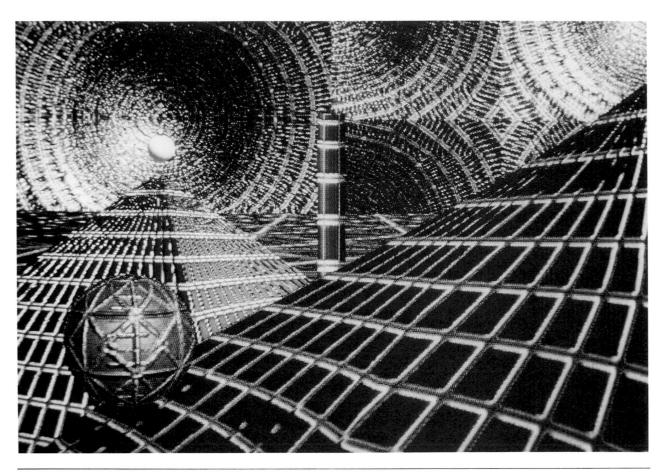

553. DAVID Em. *Orejo*. 1979. Photograph of computer-generated image.

videotapes or photographs. The art object itself, then, can only be found in a state of mind or in the activities involved.

Certain conceptualists like Christo do not offer objects for purchase and possession by collectors but as idea projects to be financed by patrons. Christo thinks on a stupendous scale, and his works include conceptions no one has ever thought of before. His projects show the effect of the imagination on the landscape and the sea. In 1971 his Valley Curtain stretched 1 million square feet (0.09 million square meters) of orange-colored fabric across the Grand Canyon. His Running Fence of 1976 strung more than 2,000 panels of white nylon cloth on steel poles and wire cables across 25 (40.25 kilometers) miles of California landscape. It rose up from the sea north of San Francisco and meandered over the farmlands like a white ribbon across the horizon only to disappear once more into the ocean.

For his *Surrounded Islands* of 1983 (Fig. 554) Christo assembled 6.5 million square feet (603,850 square meters) of pink woven polypropylene fabric and had it sewn into different patterns to enclose eleven islands in Biscayne Bay off Miami, Florida. As usual with Christo's works, the whole community became involved in the project. Environmental authorities had to be called in; marine biologists, ornithologists, and mammal experts were consulted; marine engineers and building contractors assisted in the preparations. Permits had to be obtained from governmental agencies, the governor and his cabinet debated the issue, local authorities had to approve, and a work force of 430 persons completed the installation. When the dream became a reality, the public beheld from the causeways, the land, the water, and the air a thing of beauty. The luminous pink fabric harmonizing with the green tropical vegetation of the verdant islands seemed like gigantic waterlilies. The average lifespan of Christo works is only about two weeks. When they are dismantled, however, their memory continues to live on as conversation pieces and in verbal descriptions, photographs, drawings, documentation, critical reactions, and tangible souvenirs.

On the European scene the most prominent conceptualist was Joseph Beuys, who produced

what he called social sculpture. "Art," he said, "is a basic metaphor for all social freedoms . . . it should be a true means, in daily life, to enter and transform the power fields of society." Among his tangible works is a gruesome reliquary box filled with mementos from the Auschwitz concentration camp. Another consists of a row of survival sleds equipped with blankets, canned rations, and flashlights, all being unloaded from the back of an actual Volkswagen minibus. More intangible was his 1965 happening entitled *How to Explain Pictures to a Dead Hare*. For this event at a Düsseldorf museum Beuys covered his head with honey and gold leaf and mumbled incoherently for three hours to a dead rabbit cradled in his arms. Both Christo and Beuys might be called manufacturers of dreams, some of which may seem more like nightmares.

Christo's and Beuys's transient productions typify the conceptual stance that a work of art is essentially an idea or process with or without tangible

554. Christo. *Surrounded Islands*. Biscayne Bay, Greater Miami, Florida. 1983. 6,500,000 sq ft (1,982,500 sq m) of floating pink woven polypropylene fabric.

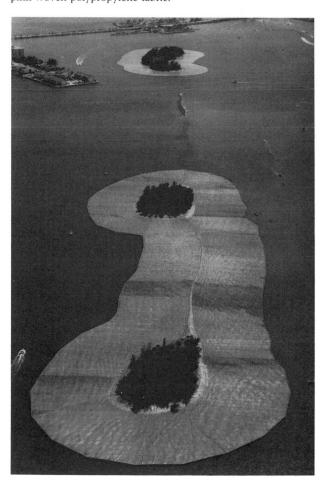

form. The movement came about partly as a reaction against the commercial art market and was an attempt to escape from the system whereby a work became a commodity, a collector's item with a price tag. The objective was to lead toward eliminating the work of art as a tangible object. But where does this leave the spectator? If there remains only an idea, very little communication can take place when there are no sounds or material media to convey it. As critic Clement Greenberg has pointed out, conceptualism is too much a feat of ideation and not enough of anything else.

Modern Musical Developments

Modern science and technology have provided composers and audiences with a whole new world of sound. Instead of vibrations resulting from strings or columns of air as with traditional instruments, sound waves could now be produced by electronic oscillations. With the invention and development of electronically generated sound, the use and alteration of everyday sound data by tape recorder, the random choices of musical happenings, the management of mathematical-musical formulas via the computer, and the psychedelic manifestations in mixed media, a whole host of novel possibilities became possible.

However, just because composers are inclined to experimentation does not necessarily mean that they are in the front of the procession, for experiments can lead to blind alleys and dead ends even more easily than to significant breakthroughs. And if such experiments do succeed in making major breakthroughs, the mere manipulation of new materials and ideas is not sufficient in itself to become the stuff of new art forms. For that takes the appearance and efforts of a master composer, one able to control the new resources and shape them into the forms of a new creative synthesis.

So whether a composer moves in the direction of rigidly controlled serialism, employs electronic computerization, or adopts the tried-and-true traditions of selective eclecticism, only time can tell which road leads to the future. Historical experience reveals that these seemingly new phenomena are actually variants and extensions of age-old principles and basic human urges. Viewed in this objective light, the events of the last part of the 20th century will in all likelihood exhibit about the same mixture of old, new, and experimental directions and of past, present, and future trends as those at any historical cross section of time.

One of the new instruments using electronically produced sounds is the synthesizer (Fig. 555).

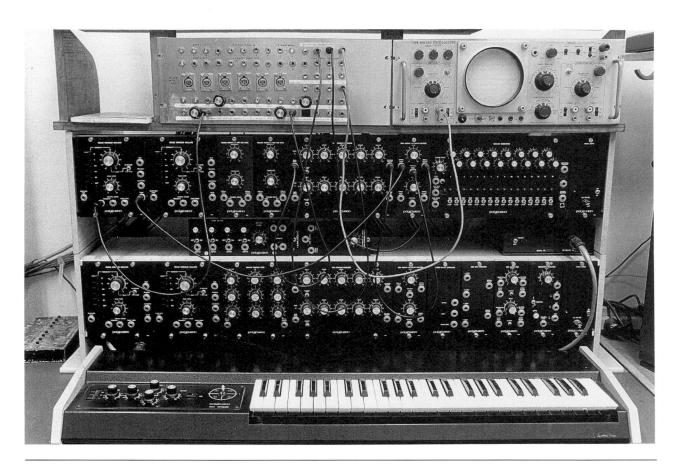

Synthesizer. Courtesy Syracuse University Photo Center, Syracuse, N.Y.

It can also be programmed in combination with the computer. By converting sound waves, with their elements of pitch, dynamics, duration, and tone color, into digits or a number of series, the synthesizer-computer can then be programmed to produce a tape. There are also portable synthesizers suitable for use in live performance.

Composers who have mastered the techniques of computerized sound generation can now dispense with conventional instruments and live musicians, if they wish, and use tapes or disks to distribute their works directly to the listener. The process of producing a musical work on tape is like that of the graphic arts, in which the artist creates a master plate of an etching or lithograph, then issues prints.

Whether the musical process is improvisatory, as with chance happenings, or rationally controlled, as with computerization, ample precedents in the musical past can be cited. Random fancy in the form of free improvisation is apparently as old as music itself. If the 20th-century composer seems to stress chance, the procedure is not essentially different from the vocal improvisations made in medieval times on old Gregorian tunes, an organist inventing variants on Protestant hymns, Bach writing out his

freely improvised toccatas and fantasies, or a virtuoso instrumentalist ad-libbing cadenzas in a classical concerto.

Freedom and strictness, however, are neither mutually nor musically exclusive, and the wise composer maintains both options separately or in combination. The work of Karlheinz Stockhausen and John Cage, both prominent figures on the international musical scene, reveal some of the possibilities of this mode of music making.

When today's mathematically minded composer turns to the computer, the process may differ in kind but not in spirit from certain musical methods of the past. The mathematical basis for music, for instance, has been known ever since Pythagoras discovered the ratios of the musical intervals in the late 6th century B.C. (see pp. 47–48). Some medieval composers accelerated or slowed down the note values of melodies and thereby expanded or contracted the rhythmic ratios of their motets (see p. 238). In his thirty variations on a theme, the famous ''Goldberg'' Variations, Bach in every third variation (the third, sixth, ninth, and so on) devised a series of canons, or exact imitations, from the unison, or same note, to the ninth.

In the earlier 20th century Schoenberg and Berg employed rigorous serial techniques: straightforward, in inversion, in retrograde, and in retrograde inversion (see p. 537). The musical thought of Milton Babbitt illustrates this approach.

Karlheinz Stockhausen. Now perhaps the outstanding representative of electronic composition, Karlheinz Stockhausen is one of a group associated with the Studio for Electronic Music, a subsidiary of the West German Radio at Cologne. Chance elements in his music are controlled so as to bring new forms into being—forms that grow out of the musical material.

Despite his invention of ingenious notational symbols for scoring electronic sounds, Stockhausen, in his more recent work, has parted company with a written score in favor of composing directly on tape. The genesis of such a composition is to fix the limits of the time dimension arbitrarily to, say, twenty or forty minutes and do perhaps a dozen "takes." Then the composer, like a film director, edits and chooses what will eventually become the final version.

For this style Stockhausen has evolved a complicated technique in which he may use players to produce short motifs, often in the extreme registers of their instruments. Also, in the manner of the theater of the absurd, the composer can call on them to improvise a sequence of grunts and groans, shrieks and squawks, hisses and sighs.

Each instrumentalist in such a composition session has a contact microphone connected to a central control panel. Here sits Stockhausen, like the conductor of old; but instead of a baton, he has a complex of electronic devices called "sinewave generators," "potentiometers," and "ring modulators." In a series of takes he develops the final composition. Developing, according to Stockhausen, means that the sounds are "spread, condensed, extended, shortened, differently colored, more or less articulated, transposed, modulated, multiplied, synchronized."

This approach is illustrated in *Opus 1970*. Each of the four players is provided with a previously prepared tape consisting of various fragments of Beethoven's piano sonatas, symphonies, the violin concerto, and some vocal music. The tapes play continuously, but the player may turn the loudspeakers up or down at will. All the while Stockhausen sits at his controls filtering, altering, changing the speed, blending the timbres, so as to achieve the effects and shapes he desires.

The listener's impression is that of an electronic soundscape in which Beethoven's music is reduced to fine particles, reassembled, and cubistically combined into a sequence of tantalizing, wispy frag-

ments. Occasionally the synthesizer may pick up a Beethovenian theme or line and carry on an inventive dialogue with it. Stockhausen says his intention is not to interpret, but "to hear familiar, old, performed musical material with new ears, to penetrate and transform it with a musical consciousness of today." To some, the result may sound like confusion confounded, a mixture of serenity and hysteria. For others it may accomplish what the composer hoped it would—that is, putting Beethoven's music in a new relationship with contemporary sound. At all events, it must be conceded that Stockhausen is a major musical mind, a composer of invention and ingenuity, a craftsman who manipulates and arranges his materials with a sure hand.

John Cage. From the 1930s through the 1980s, John Cage has invariably proved a provocative, often articulate leader for modernist avant-garde experimental developments. Nowadays he is most closely identified with the kind of chance techniques and musical happenings commonly referred to as aleatory music. The word "aleatory" derives from the Latin alea, meaning "dice," and John Cage believes in rolling the musical dice, tossing tonal coins, and accepting whatever comes up at random in the world of sound.

Cage's announced objective was to bring about a "revolution in the nature of musical experience." It could be said that the concern of earlier Western music with its reconciliation of the opposites of dissonance and consonance eventually led to the present liberation of dissonance. Should this be true, Cage shares with other modernist composers the problem of synthesizing musical sound and noise. An early 20th-century composer much admired by Cage is Erik Satie (see p. 543), who once declared himself ambitious to invent a music that would be like furniture—a music partaking of the noises of the environment, one capable of softening the sounds of knives and forks at dinner and of filling the silences in conversation.

Cage's revolt was against the extreme ordering and ultracontrolled conditions of such music as twelve-tone serialism, in which a precise reason exists for the placement of each note. So he conceived his own music as an experimental activity that creates conditions in which nothing is foreseen. He would free sounds from any preset formal continuity. Composer-critic Virgil Thomson found in Cage a "healthy lawlessness." To him, Cage engineered a "collage of noises" that produced a "homogenized chaos" carrying "no program, no plot, no reminders of the history of beauty, and no personal statement."

Cage's pieces avoid the conventional sense of a beginning or an end. At a given point one begins to hear sounds, and after a while they stop. By avoiding repetition, Cage causes his works to seem endlessly repetitious. Some listeners thus may agree with Virgil Thomson that there is no need for playing any of Cage's recordings for longer than five minutes, "since we know that it will not be going any deeper into an emotion already depicted as static. Nor will it be following nature's way by developing an organic structure."

MILTON BABBITT. Milton Babbitt's taking-off point was Schoenberg's twelve-tone method, but he extended serialism to include rhythm, dynamics, tone color, and speed, as well as pitch, harmony, and counterpoint. The computer is a natural instrument for Babbitt. He thinks with it and through it. With the computer, sounds can be superimposed; retrograde progressions become available by reversing the numbers; and all manner of speed changes, including rhythmic augmentation (expansion), diminution (contraction), and fluctuations (shifts) of tempo can be programmed.

The serialization of rhythm, for instance, involves ordering duration values in a graduated scale. Various rhythmic patterns and variants can then be programmed by multiplying or fractionalizing a proportional mathematical series. It could be a simple arithmetical progression such as 1, 2, 3, 4, 5, 6; or something more complex, like 1, 2, 3, 5, 8, 13. Dynamic values—levels of soft and loud, fade-outs and fade-ins—may also be rotated in serial sequences.

The digital synthesizer, in contrast to the limitations of conventional musical instruments, has the capability to control a limitless supply of musical and nonmusical sounds. With so vast a range of sonorities available to it, the computer can be programmed to perform as a composing machine. As such it can construct self-generated works or become the partner of a human composer.

Babbitt's *Vision and Prayer* (1961) for soprano and synthesizer merges the nonelectronic and electronic worlds of sound with a soprano singing live along with a tape produced by the computer. The text by Dylan Thomas is sung by the soprano in wide-skipping intervals, while the computer's tape deals with tone quality and the structure of the poem.

It is not surprising that Babbitt was attracted to a poem like Dylan Thomas's *Vision and Prayer*. It is a well-known anthology piece, an impressive vision that reads with a sense of verbal grandeur. Yet it is a serial poem, the length of the lines predetermined by the number of syllables that, according to the series, it must possess. The number series 1 to 9 yields on the printed page two visual designs, each with seventeen lines. The first design (for the first six stanzas) proceeds on the basis of one syllable for the first line, two for the second, three for the third, and so on up to nine syllables for the ninth line. The series then moves in retrograde. The tenth line has eight syllables, the eleventh has seven, and so on until at the seventeenth line one arrives again at a one-syllable word. This progression—1, 2, 3, 4, 5, 6, 7, 8, 9, 8, 7, 6, 5, 4, 3, 2, 1—yields a diamond-shaped stanza. For the second set of six stanzas, the syllables per line follow the progression 9, 8, 7, 6, 5, 4, 3, 2, 1, 2, 3, 4, 5, 6, 7, 8, 9, which produces on the page two triangles linked at their common apex (line 9). The first and last stanzas follow:

> Who Are you Who born is In the next room loud to my own That I can hear the womb Opening and the dark run Over the ghost and the dropped son Behind the wall thin as a wren's bone? In the birth bloody room unknown To the burn and turn of time And the heart print of man **Bows** no baptism But dark alone Blessing on The wild Child

I turn the corner of prayer and burn a blessing of the sudden Sun. In the name of the damned I would turn back and run hidden land To the But the loud sun Christens down The sky. Ι Am found. 0 let him Scald me and drown Me in his world's wound. His lightning answers my Cry. My voice burns in his hand. Now I am lost in the blinding One. The sun roars at the prayer's end.*

^{*}From *The Poems of Dylan Thomas*, copyright 1946 by New Directions Publishing Corporation, reprinted by permission of New Directions Publishing Corporation, J. M. Dent & Sons Ltd., and the Trustees for the Copyrights of the late Dylan Thomas.

Babbitt's aesthetic stance rests upon an appeal to intellectual rigor as the basis for the putting together (that is, the composing) of a piece of music. It is a view that makes no concession to immediate popular understanding. As he himself has said, "the composer's first obligation is to his art, to the evolution of music and the advancement of musical concepts."

Modern Architectural Developments

The shrill arguments between the pure functionalism of the international style and the more human scale of Frank Lloyd Wright's organic structures was muted in architectural developments after 1945. Both sides gave ground as they were confronted with environmental problems and increasing urbanization. Both also continued to build in the modernist tradition.

556.GORDON BUNSHAFT WITH SKIDMORE, OWINGS & MERRILL. Lever House, New York, 1952.

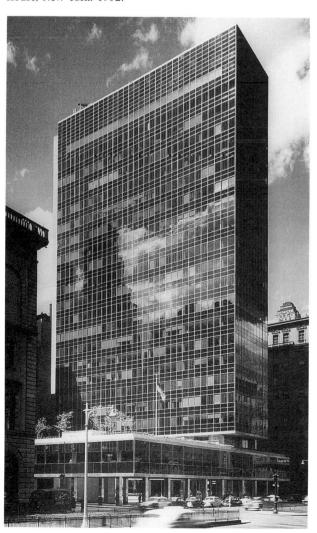

Gordon Bunshaft, Miës van der Rohe and Philip Johnson provided the continuity of the international style in two striking structures—Lever House (Fig. 556), designed by Bunshaft, is cantilevered outward beyond its structural supports to allow the great rise of translucent glass walls to reflect the city and sky with mirrorlike brightness. By omitting the ground floor and reducing the supporting steel shafts to a minimum, the architects created a small public garden and open passageway at the street level.

The Seagram Building (Fig. 557) has been called by its designers, Miës van der Rohe and Philip Johnson, the "Tower of Light." Open at the ground level, the building is supported by stilts, the functionalism of which is offset by outdoor pools and gardens sunk into a pink granite platform. The tower of smoky amber glass is cantilevered over bronze-

557.LUDWIG MIËS VAN DER ROHE AND PHILIP JOHNSON. SEAGRAM Building, New York. 1958. Ezra Stoller. © ESTO.

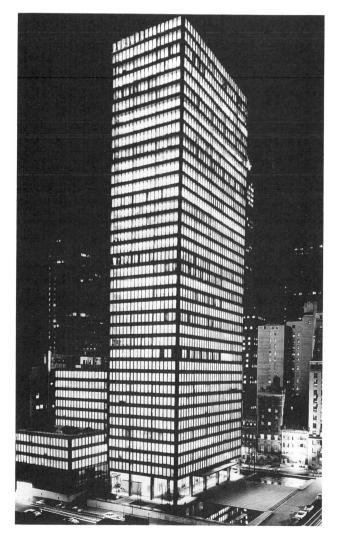

colored steel piers to impart airiness to the soaring mass. With a taste for the structurally spare, Miës van der Rohe went beyond mere practicality and delighted in the proportions of his buildings and reveled in the beauty of their materials. While baser metals would have been equally functional, the architect showed extreme sensitivity to the qualities and potentialities of his chosen materials. In the Seagram Building the bronze finish of the rising lines is alternately smooth and textured to provide a contrapuntal pattern.

In the closing years of his notable career, Frank Lloyd Wright finally received a commission to construct a building in his country's largest city—the Solomon R. Guggenheim Museum (Fig. 558), a gallery for abstract art. For Wright a museum should never be a group of boxlike compartments but a continuous flow of floor space in which the eye encounters no obstruction. To achieve this ideal, he designed a single round room of reinforced concrete 100 feet (30.5 meters) in diameter at the base, with a

hollow cylindrical core surmounted by a wire-glass dome 92 feet (28 meters) above ground (Fig. 559). Spiraling upward around the room, for a distance of a quarter of a mile (.4 kilometer), is an open six-story cantilevered ramp rising at a 3-percent grade and broadening from a width of 17 feet (5.2 meters) at its lowest level to almost 35 feet (10.7 meters) at the top.

Throngs of spectators can be accommodated without congestion as they move easily up or down the ramp. Visitors can take the elevator to the top level and wind downward at leisure, or they can start at the bottom and walk up. They can inspect part of the exhibit at close range and at eye level or view three levels simultaneously across the open room.

Le Corbusier. While Le Corbusier's "machines for living" still hummed and whirred, he did allow more color, poetry, and freedom to enter the designs of his later architecture. His pilgrimage church of

558.Frank Lloyd Wright. Solomon R. Guggenheim Museum, New York. 1957–59. Reinforced concrete; diameter at ground level 100′ (30.48 m), height of dome 92′ (28.04 m).

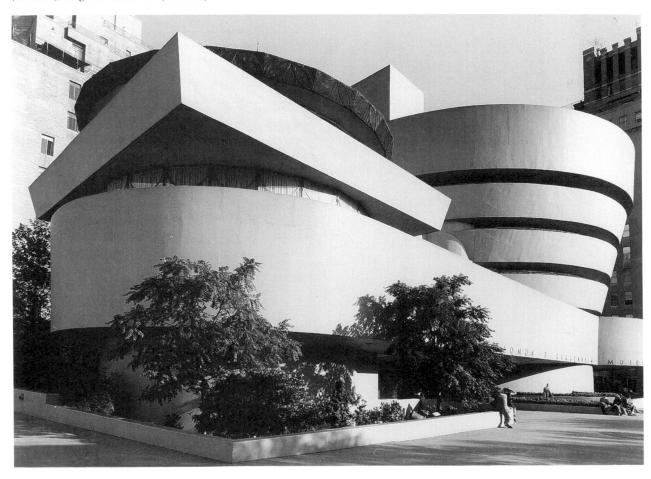

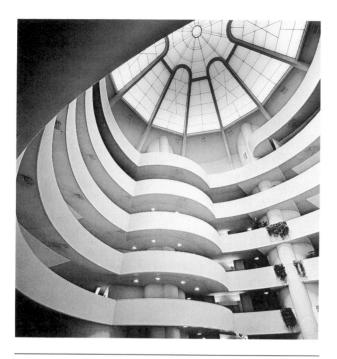

559. Frank Lloyd Wright. Interior, Solomon R. Guggenheim Museum. Ramp over $\frac{1}{4}$ mile (.4 km) long.

Notre-Dame-du-Haut at Ronchamp (Fig. 560), high up in the Vosges Mountains of southeastern France, is a delightful fantasy of free sculptural forms in ferroconcrete and stained glass. A prowlike roof harks back to the early Christian meaning of the word nave, which signified a "ship" steering its way through the stormy seas of life toward a haven of refuge.

The grandeur of the exterior of Ronchamp has the power to rival the splendid natural setting, but the interior (Fig. 561) offers the intimacy of the human scale. Years before, Le Corbusier and his associates had devised a proportional system based on 7.5 feet (2.2 meters), the approximate height attainable by an average man when standing with an arm raised. Using this dimension as a basic module, or unit of measure, the architect felt confident of achieving in his structures a scale suitable to human beings.

On the interior, the south wall (Fig. 561) may well be one of the great surfaces in the history of architecture. The pitch, curve, and massiveness of the wall suggest living strength and vitality. Its fine,

560. Le Corbusier. Notre-Dame-du-Haut, Ronchamp, France. View from southeast. 1950–55.

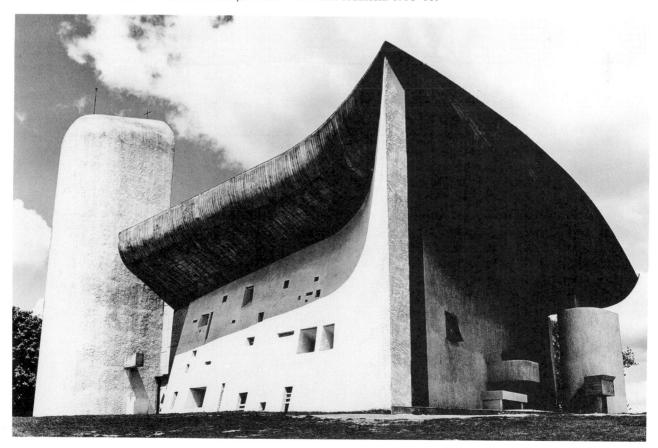

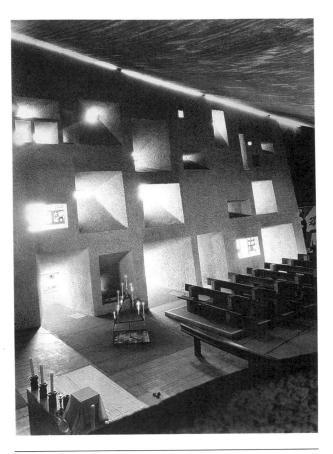

561. Le Corbusier. Interior south wall, Notre-Dame-du-Haut.

expressive beauty, however, derives from the inspired subtlety with which the openings have been coordinated through their differences, not only in scale, proportion, color, and decoration but also in the angles of their niches. Here and there on the stained glass has been painted the ancient prayer to the Virgin: *Je vous salute Marie, pleine de grâce* ("Hail Mary, full of grace"). At Ronchamp, Le Corbusier achieved an interior whose richness and complexity are functionally appropriate to the enactment of the rites of holy mystery.

SAARINEN AND UTZON. Eero Saarinen and Joern Utzon, in their imaginative solutions to modern architectural problems, achieved a working synthesis by providing for the functional needs of the many without sacrificing beauty of design and style.

For his Trans World Flight Center at Kennedy International Airport in New York (Fig. 562), Saarinen designed flowing concrete forms and dynamic stresses to convey the idea of flight while providing an airline terminal facility. Four large concrete shells resting on supports of abstract shape enclose an interior remarkable for its elastic space. The elegance and grace of its curvilinear contours qualify the Center as a massive piece of environmental sculpture as well as a functional architectural work. The image of a bird or plane can be seen with the outstretched wings. The structural supports sug-

562.EERO SAARINEN. Trans World Flight Center, Kennedy International Airport, New York. 1962. Ezra Stoller. © ESTO.

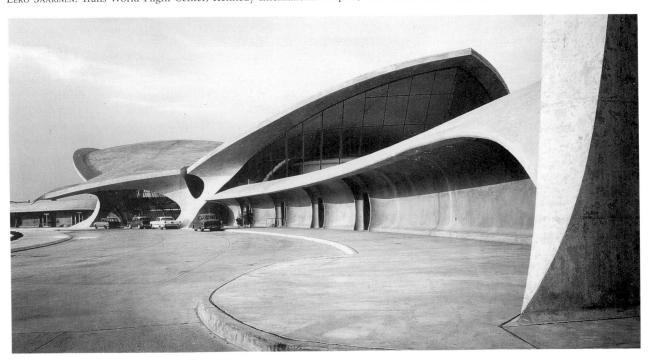

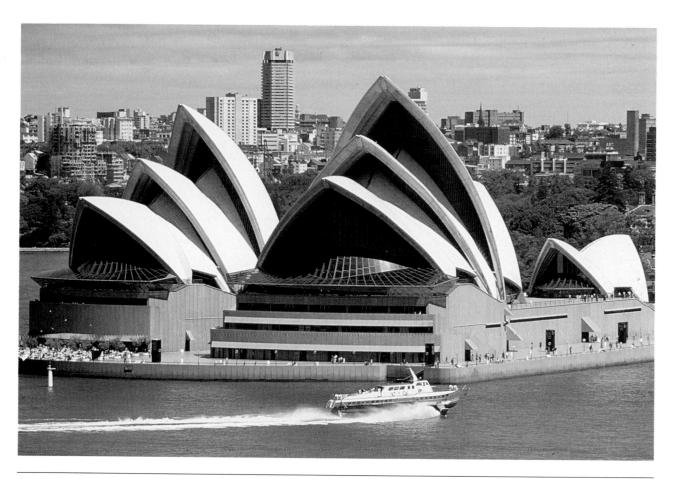

563. Joern Utzon. Sydney Opera House, 1959–72. Reinforced concrete; height of highest shell 200' (60.96 m).

gest the bird's wings, while the entrance overhang becomes the beak, serving at the same time as a waterspout. The whole effect is a metaphor of flight.

Three major buildings in the modern style have commanded international acclaim: the Sidney Opera House in Australia; the Pompidou National Center for Arts and Culture in Paris, commonly called Beaubourg; and the new East Building of the National Gallery in Washington, D.C. Each in turn functions as a cultural center with constantly ongoing activities.

Utzon's Sydney Opera House (Fig. 563) sits astride a point jutting out into Sydney Bay, one of the world's finest and busiest harbors. At first sight its unique shape looms up as a massive piece of outdoor sculpture. From some angles it suggests a group of interlocking shell formations, from others a group of great white sails skimming over the rippling water. An edifice of startling beauty, it has also risen to the status of a symbol for both Sydney and Australia, thus taking its place with the Eiffel Tower for Paris, the Empire State Building for New York, and the Gateway Arch for St. Louis.

Despite its accepted name, the Sydney Opera House is really a performing arts and recreation center. The complex includes three large auditoriums—the Concert Hall, the Opera Theater, and the Recording Studio—and two smaller halls, an exhibition space for art shows and trade exhibits, plus two restaurants. The activities it accommodates include orchestral and choral concerts; opera, ballet, and recital performances; jazz, pop, and folk concerts and variety shows; lectures and films; and conventions, meetings, and conferences.

The Danish-born Utzon won the international competition for the Sydney Opera House in 1957. His daring design, however, proved to be far ahead of the technology needed to construct it. It then took some twenty years to build, equip, and furnish. Mounting costs (well over \$100 million) and disputes with the government led to his resignation in 1966. The interior was finished off by a team of Australian architects.

The building was one of the most difficult construction jobs ever undertaken, calling for daring feats of structural technology. The immense poured-

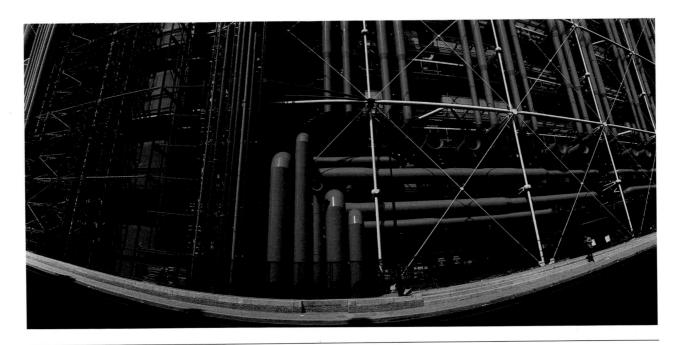

564. Renzo Piano and Richard Rogers. Georges Pompidou Center for Art and Culture (Beaubourg), Paris. 1977.

concrete foundation was first put in place over the natural sandstone bedrock of the site. Over this rise the three sets of roof vaults, or shells, of enormous size and bold curvature. If it had to be built from the ground up, the costs would have been astronomical. So a system of prefabricated units was devised by which precast segments made on the spot were hoisted into place by high tower cranes. The sections are held together by tensioned cables.

The Concert Hall and Opera Theater have rows of four shells each that form both the roof and the walls of the space they enclose. Covering the shells is a continuous skin of cream-and-white ceramic tiles. The mouths of the shells have two layers of thick amber-tinted glass to silence the harbor and traffic noises. They also serve as windows for the spacious interior lobbies, offering panoramic views.

Except for the elegance and quality of the materials and the free play of structural forms, there is no conscious attempt at decoration. In the tradition of Saarinen's Trans World Flight Center (Fig. 562) and Le Corbusier's church at Ronchamp (Fig. 560), the whole building becomes an ornament in itself, and the architect assumes the role of form giver. However, the form here does not follow the function. The high-pitched Gothic vaults, so effective on the exterior, proved disastrous acoustically. The various halls then had to have acoustic ceilings and wood-paneled walls to compensate. The building

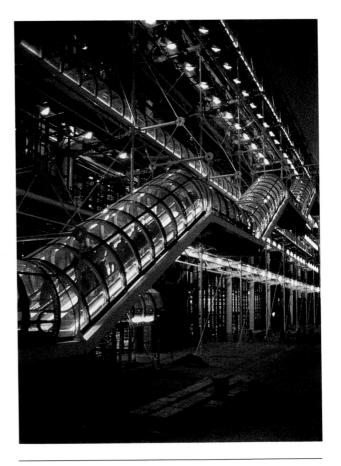

565. Georges Pompidou Center, night view of escalator side.

frankly is a return to the elitist concept of form for form's sake. Yet who is to quibble when the form is of such surpassing elegance and surprising beauty?

PIANO AND ROGERS. From its 1977 opening in Paris, the Pompidou National Center for Arts and Culture (Fig. 564) has been an instant popular success. The design by the Italian architect Renzo Piano and his British colleague Richard Rogers is both daring and functional. As a spectacle it has become the new Eiffel Tower, attracting Parisian locals as well as sightseers from the provinces and tourists from all countries by the millions. Beaubourg, as it is called from the plateau it occupies, is structurally an open glass box supported by steel-skeleton scaffolding. The first surprise is that it is all turned inside out. Things that normally are hidden in a basement or central core—building supports, heating and air conditioning ducts, freight elevators—are transferred to the outside, painted in strong colors, and made visible to all. The interior has no breakdown for separate rooms, no walls or supporting columns, only temporary partitions that can be shifted at will. The plumbing, in other words, becomes the facade, and the building's "guts" cover its skin.

The "boiler-room façade," as it has been called, achieves continuous action as freight elevators rise and fall and as people snake up and down the Plexiglas-enclosed escalators (Fig. 565). Kinetic architecture is one name for it, brutalism another. At any rate, the structure has produced lively controversy. This "let it all hang out" design is what Frank Lloyd Wright had characterized as indecent architectural exposure. Other critics point out that it has the aesthetics of an oil refinery. Establishment Parisians call it municipal assassination and consider it an affront to the historic grandeur of their city—just as they had protested in 1889 when the Eiffel Tower was built.

More sympathetically and enthusiastically, Beaubourg has been hailed as a science-fiction fantasy. With its bubble dome, transparent glass walls, whirring machinery, and spectacular lighting, it has been dubbed the first building of the space age. The stated purpose of Beaubourg was to move the cultural center of gravity away from New York and back to Paris. It was to be not only a museum, but also a center for the creating of art, music, drama, and films.

The complex contains the French National Museum of Modern Art, the largest collection of 20th-century painting and sculpture in existence; the Institute for Acoustical and Musical Research under the direction of composer-conductor Pierre

Boulez, a scientific laboratory where teams of engineers, acousticians, computer specialists, and theoreticians of all kinds will explore new approaches to sound and music; the Public Information Library that, for the first time in France, makes newspapers, periodicals, books, slides, musical cassettes, and videotapes available to all. In addition, there are an Industrial Arts Center, an experimental theater, a poetry gallery, a cinema, a sales area, various bars, and restaurants.

Beaubourg was conceived from the first as a people's palace that would break down the barriers between art and life, a cultural supermarket where both artists and visitors could get into the act. Its director has characterized it as "a creative, changing, multimedia, kinetic, cross-cultural presentation of the arts of our time." Together with the interior activities and lively exterior plaza where jugglers, fire eaters, and folksingers perform, it has become a perpetual happening. In this sense Beaubourg is the modern counterpart of the medieval cathedral. which was a museum of stained glass and sculpture. It also houses the serious pursuits of religious observances, musical performances, and university lectures, while the plaza serves as a marketplace and a theater for miracle plays, among other things.

I. M. Pei. The National Gallery's East Building in Washington, D.C., is a structure on a grand scale that has become one with the art it houses. The masterly interplay of geometrical unity and variety derives initially from the trapezoid-shaped site the building occupies. The architect, I. M. Pei, first divided the area diagonally into two triangular sections, one to house the art collection, the other for the newly established Center for Advanced Study in the Visual Arts, complete with a library and six-story reading room. The geometrical motifs are all taken from this basic division, and Pei's slashing shapes and startling diagonal accents combine high drama with dignified restraint.

Inside, the drama heightens as the space expands into a triangular court (Fig. 566) where tall trees alternate with the massive sculptures to provide a simultaneous indoor-outdoor feeling. Smaller alcoves branch out from this central hall to provide space for viewing art of more intimate dimensions. The large court is lavishly ornamented by works especially commissioned from the best-known, internationally accepted names on the contemporary scene. They include a Joan Miró tapestry, a Henry Moore bronze, and a splendid welded metal sculpture by Anthony Caro. All are scaled to harmonize with the space they occupy; this means they are

large. From the roof hangs what must be Alexander Calder's biggest and liveliest mobile (Fig. 566). The constant circular movement against the structure's sharp geometrical patterns provides a dramatic dimension of its own.

The massive scale, lofty posture, and pink granite exterior of the East Building harmonizes surprisingly well with the older, neoclassical Gallery opposite. The intention was to widen the scope of the National Gallery's activities. The older building will still house the superb historical collection of major masterpieces. The East Building can now concentrate on living masters, current art interests, special exhibits, and traveling shows. In its short lifetime since the 1978 opening, the building has already become a contemporary classic.

IDEAS

The Scientific Worldview

The state of scientific knowledge in any period of history is a mirror that reflects the way the people of that time understand their world. It also defines the range of possibilities and limitations of their potential for technological and philosophical achievements. The state of the arts of any era also points to the self-understanding of a particular society and its individuals in a given time and place. From their beginnings, the physical sciences have aimed at giving an exact picture of the material world. Scientists were at first convinced that the universe would be predictable if only all the data and knowledge could

566. I. M. Pei. East Wing, National Gallery of Art, Washington, D.C. 1978. Interior view of the triangular court with mobile by Alexander Calder.

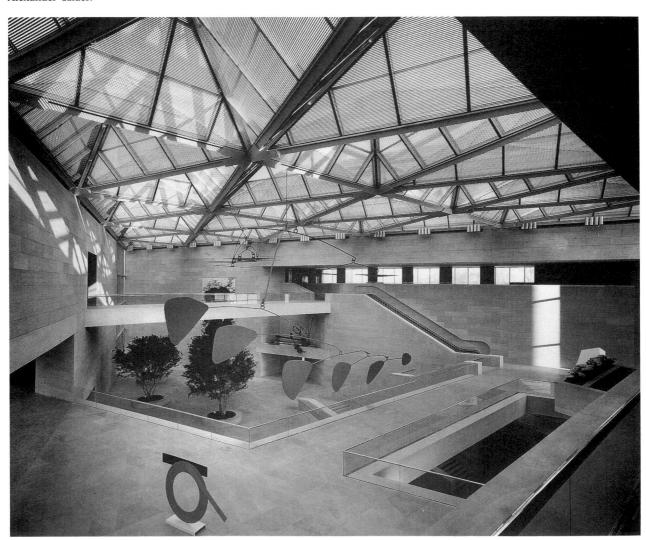

be gathered and collated. As more and more precise instruments were developed, however, more and more uncertainties came into view. As infinity was approached, the more elusive it became. Quantum physics has now demonstrated that there can be no absolute knowledge. There seems to be no way that scientists can predict the birth of a nova in outer galactic space or the exact motional patterns of electrons within the atom. Neither the Newtonian nor Einsteinian universes could guarantee certitude. Theoretical physics and mathematics consequently have become increasingly philosophically oriented.

The modern movement in art had been geared to the idea of scientific objectivity and invention. Artists thought that constant progress would lead to a bright technological future. Like science, modern art was experimental, concerned as it was with the invention of new facets and forms. Impressionists had been preoccupied with the science of optics, the cubists with dynamic geometry and Einsteinian relativity, the surrealists with Freudian psychological discoveries. Pop artists wholeheartedly embraced the processes and products of mass production and the consumer society; the minimalists delved in the methods and materials of the industrial world. In short, the modernist quest was for purity, predictability, and the clarity of an ordered world. Modernism specifically broke with the past in order to concentrate on a bright new future. The high point of modernism coincided with the time of space exploration and the lunar landing. Museums were then presenting computer-programmed cybernetic light shows. It seemed as if all the glories of modern technology had arrived. Human progress, modernists were convinced, would banish poverty, ignorance, and intolerance.

The postmodern period was to learn that in spite of computer technology, real life defies the precision of mathematical calculations. Modernist logic and optimism were no longer valid. Technology had led to the pollution of the earth's atmosphere and depletion of its natural resources. Space was rapidly becoming a junkyard. Socially, there was an everwidening breach between rich and poor, an increasing illiteracy rate as the population explosion continued, and a new wave of political terrorism. Since chaos seems to surround us, both scientists and artists have had to learn to live with it.

Most astronomers theorize that the multiverse surrounding the earth was produced by one or more cosmic explosions that yielded the solar system as a mere byproduct. Any order that is perceived becomes not a part of things out there but a mental construct that an individual mind may impose upon it.

Biochemists have speculated that life is also the result of one or more biological accidents. In a well-argued and challenging book entitled *Chance and Necessity* (1970), the Nobel Prize—winning biochemist Jacques Monod points out that eons ago, quite by chance, certain proteins and nucleic acids somehow combined to create metabolism and the reproduction of cells. As he remarks, "We would like to think ourselves necessary, inevitable, ordained from all eternity. All religions, nearly all philosophies, and even a part of science testify to the unwearying, heroic effort of mankind desperately denying his own contingency."

Human beings, then, face an environment that is oblivious to their hopes and fears, blind to their arts, deaf to their poetry and music. They stand alone in the immensity of a multiverse that is neither hostile nor friendly, but totally indifferent. Gone with the winds are the gods and original sin, gone are the heroes and villains, gone is the tribal fiction of a chosen people, gone are the determinism of heredity and environment, and equally gone are the preconceptions of the past.

Suddenly, all taboos, religious beliefs, moral codes, and traditional folkways have been swept away. Despite all the mythical, religious, and philosophical ideologies that have arisen over the ages to affirm the existence of cosmic eternal laws; despite the incredible growth of knowledge in all fields over the past centuries; despite all histories that unfold according to some evolutionary, necessary, and favorable plan that affirms the ascent of the human race—all that the sum total of human knowledge and experience can show is that human beings face an endless gulf, utter solitude, and total isolation.

So if we meet the challenge, we can look ourselves directly in the eye as does Gregory Gillespie in his penetrating self-portrait (see Fig. 572). We can make our own decisions freely and assume the responsibility for our own heritage and future directions. We alone control the meanings and values we choose to accept or reject. We are, in fact, right back at primeval chaos. Indeed, the great illusion is that we ever left it. Faced with an infinity of choices, we can create a new set of values, a new humanism, new expressions in the arts—new because these values are not imposed from on high, valid for all time and eternity, but because they are ours and ours alone. They constitute a new convenant in a new world in which we choose to live, move, and have our being. We are alone, we simply are. But being can mean that we can choose to be creative animals. The spiritual kingdom, the creative power, and the full glory are now to be discovered within ourselves.

LATE 20TH CENTURY

	KEY EVENTS	ARCHITECTURE AND VISUAL ARTS	LITERATURE AND MUSIC
			1889-1951 Ludwig Wittgenstein ◆
1900 -		1901-1974 Louis I. Kahn ★ 1903-1972 Joseph Cornell ● 1914-1988 Romare Bearden ▲	1901-1981 Jacques Lacan ◆ 1905-1980 Jean-Paul Sartre ◆ 1906-1989 Samuel Beckett ◆
1925 —		1925- Robert Venturi ★ 1925- Duane Hanson ● 1927- Philip Pearlstein ▲ 1927- Alfred Leslie ▲ 1931- Carlo Maria Mariani ▲ 1931- Denise Scott Brown ★ 1932- Richard Estes ▲ 1934- Michael Graves ★ 1935- Charles Moore ★ 1936- Gregory Gillespie ▲ 1937- David Hockney ▲ 1940- Chuck Close ▲ 1941- Thomas Hall Beebe ★ 1945- Anselm Kiefer ▲	1926-1984 Michel Foucault ◆ 1930- Jacques Derrida ◆ 1932- Umberto Eco ◆ 1934- Peter Maxwell Davies □ 1935- Terry Riley □ 1936- Steve Reich □ 1937- Philip Glass □ 1937- David del Tredici □ 1938- John Harbison □ 1947- John Adams □
1950 -		1951- Julian Schnabel ▲	
	1961 Berlin Wall constructed 1962 Second Vatican Council opens in Rome 1965 National Endowment for Arts and Humanities established 1969 U. S. astronauts on moon 1974 Mariner photographs Venus 1976 U. S. Episcopal churches approve ordination of women as priests and bishops. Vikings I, II explore Mars 1977 First manned test flight of U.S. space shuttle 1977 Complete genetic structure of living organism made 1979 Voyager explores Jupiter moons 1980 Electronic synthesizers available to composers, performers FAX extends electronic communications 1981 Voyager explores Uranus, its rings and moons 1989 Voyager explores Neptune and moons; Galileo launched to explore Jupiter and moons in 1995 Cold War ends Eastern European countries freed from Soviet control 1990 Berlin Wall comes down 1992 European Economic Community to create free market for people, goods,capital established	1351 Julian Schlinger 2	

Postmodern Styles

POSTMODERNISM

From the postmodern perspective, modern art has now become a period style, a historical fact. This does not mean that modernism is gone or forgotten just that it is no longer modern. What began as the tradition of the new has now become a new tradition. What was once a radical departure is now the accepted style. The hard-fought avant-garde revolution, with all its passion and fervor, has finally triumphed. Modernism first became the main guard: now it is the rear guard. Frank Lloyd Wright and Le Corbusier, Matisse and Picasso, Proust and Joyce, Schoenberg and Stravinsky are now old masters. The books and manifestos of modernism are now in rare-book rooms of libraries alongside the Renaissance treatises of Alberti and Palladio. The pictures of Arshile Gorky and Jackson Pollock now hang in major museums. The work of Alban Berg and Béla Bartók are found in the standard repertory of symphony orchestras. Abstract painters, atonal composers, and modern novelists are now professors in academies, conservatories, and universities.

Historically, from the mid-19th century onward "modern" art had always been that which departed from traditional practices, particularly the art that was taught in schools and academies and established institutions. Departing from academically approved norms and searching for the unconventional, the new was equated with a progress that signified the wave of the future. For more than a century avant-garde art stood for the ideal of aesthetic renewal and social renovation by challenging the entrenched beliefs of the establishment. Artists from Courbet on felt themselves precursors, moments between a defunct past and a future waiting to be born. Now that their future has arrived, it turns out to be a future that was.

Art that was popular and generally accepted from the mid-19th century on was considered conventional, reactionary, dull, and dreary by the thenmodernists of the realist and impressionist schools. The newly enriched middle class, however, wanted and supported work that showed excellence of craftsmanship. To them the art of the realists and impressionists looked unfinished and incomplete, hence of less worth to collectors. A rich English iron monger said in 1843 that he cared little about originality. "I love finish even to the minutest details. I know the time it takes, and that must be paid for." This, of course, described the state-supported, officially approved art of the academies and established institutions. The then-avant-garde artists proceeded to shock the establishment by inspired departures from the norms. In retrospect, their work is now recognized as the mainstream of the 19th and 20th centuries. Critical castigations and tirades against their art were predictable and a source of prestige for those involved. Immediate public acceptance would have been disastrous for their reputations. So the concept grew that art had to be ahead of its time by going contrary to established taste. It had to show signs of advancing toward the future, whatever that future might be.

Today, time has caught up with modern art, and the modernists' future is now behind them. In the postmodern period, modernism has joined other historical styles. The cool, impersonal, calculated abstractions of the international style and the dry mathematics of musical constructivism could not last indefinitely. The human equation was bound to make a reappearance at some point.

Modernism had tended to be elitist and exclusive, while postmodernism is more populist and inclusive. Modernism had reduced time to a perpetual present reality in order to concentrate on a projected future. *Postmodernism*, by contrast, takes the past into account and makes it an integral part of the present. Modernism had believed that a work of art was a self-contained entity that became its own referent. Postmodern criticism recognizes that a work of art can reflect many aspects of cultural, political,

and psychological experience. Modernism had become austere and its purity puritanical. Structure had become more important than substance. Its obsession with the new had led to novelty for novelty's own sake.

Postmodernism is concerned with a return to the world of reality, a new alliance with nature, a reappearance of objects as the eye sees them, a reappraisal of the human form for its expressive potential, a rediscovery of the past as seen through contemporary sophisticated eyes. Artists can now make living likenesses without apologies. Painters are free once more to re-explore the illusion of three dimensions on their canvases. Subject matter is back in style, and a picture can now be about something besides itself. Critics and historians can now discuss the life and times of artists and the social relevance of their works.

Postmodernism takes into account the ethnic and cultural diversity of today's pluralistic society. It also seeks to come to terms with the present-day contradictory and chaotic world by employing the vocabularies of complexity and ambiguity, paradox and irony, cynicism and whimsy. Architects, artists, writers, and musicians are reasserting the importance of history to provide a sense of human continuity. Liberation from modernism's pure utility and abstraction has led to a reassessment of meaning and metaphor, the mythical and poetical. Modernism's shock of the new has now become postmodernism's shock of the old. The past is once more a part of the living present. Stylistic pluralism has become the reflection of the pluralistic society.

POSTMODERN PAINTERLY AND SCULPTURAL DEVELOPMENTS

The New Realism

The new realism reaches into all categories except the fantastic inner world of dreams. For the modernists, realism had been anathema. Postmodernists, for their part, felt a strong need to come to terms with the real world once again. In his Reflections on Realism, the writer J. P. Stern remarked that realism is "the creative acknowledgment of the data of social life at a recognizable moment in history," a new concern with human beings in specific situations who, by force of circumstance, must make choices and decisions. Realism in various guises and disguises, however, has been around ever since the days of the cave artists. Realist easel painting, in fact, is one of the oldest and grandest traditions in American art. Old Models (Fig. 567) by one of the old masters of the style, William Harnett, gives testament to

this fact. In the 20th century, realism has been allpervasive by means of candid cameras, television, photojournalism, films, and theater.

The present generation of realist painters, however, refuses to yield naturalistic representational art to the photographers while at the same time it rejects the abstractionist notion that a picture has no referent beyond itself. The new realists are convinced that there is a world out there worth looking at and recording on canvas. This postabstractionist realism, however, does not shun the discoveries of the modern mode. It allows itself the choice of incorporating whatever devices may be relevant to its designs. The

567. WILLIAM HARNETT. *Old Models*. 1892. Oil on canvas, $4'6'' \times 2'4''$ (1.37 × .71 m). Museum of Fine Arts, Boston (Charles Henry

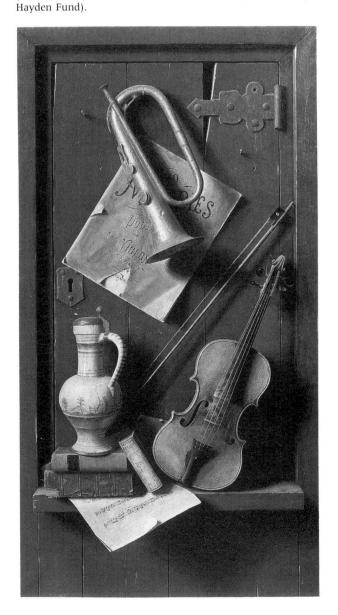

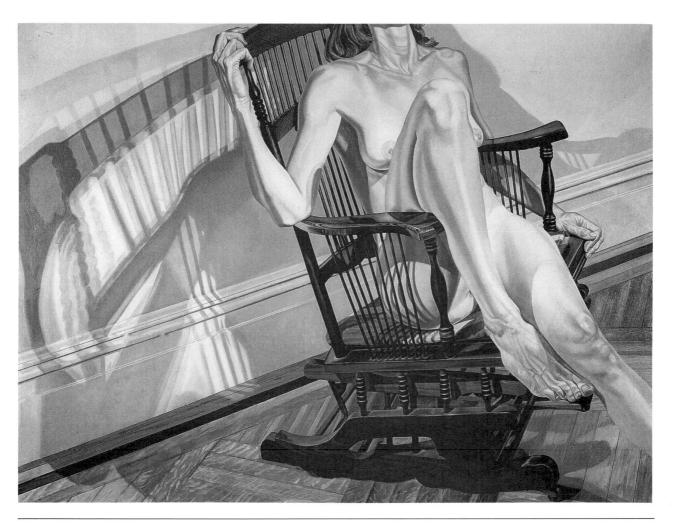

568. PHILIP PEARLSTEIN. *Female Model on Platform Rocker*. 1978. Oil on canvas, 72 × 96" (183 × 244 cm). Allan Frumkin Gallery, New York.

accent, in other words, is not on the subject or object portrayed, as in photography, or on the canvas as a flat surface, as in abstract art, but on the pictorial structure painted with all the refinements and sophistication possible.

PEARLSTEIN AND ESTES. It took both courage and self-confidence for an artist like Philip Pearlstein to paint the human figure (Fig. 568) in a style so long deplored and derided by abstractionist artists. He justifies his position persuasively:

I have made a contribution to humanism in 20th-century painting—I rescued the human figure from its tormented, agonized condition given it by the expressionistic artists, and the cubist dissectors and distorters of the figure, and at the other extreme I have rescued it from the

pornographers, and their easy exploitation of the figure for its sexual implications. I have presented the figure for itself, allowed it its own dignity as a form among other forms in nature.

In his unblinking, up-close presentation of human flesh as it actually is—not the cosmetic counterfeits traditionally offered by both romantic and academic image makers—Pearlstein seems a literalist of the most blatant sort. But the viewer capable of absorbing the candor of this imagery may well succeed in granting to the human body its "dignity as a form among other forms in nature." The artist advances this cause by adopting a keen but unemotional attitude toward his subject—the studio model—and by cropping faces and heads so as to depersonalize the body. Here the rocking chair and complex pattern of the floor and shadows contribute

569. Richard Estes. *Bus Window.* 1967–73. Oil on board, $6 \times 4'$ (1.83 \times 1.22 m). Allan Stone Gallery, New York.

a feeling of nervous movement to what is usually a static composition.

Pearlstein is a cool rationalist who reacted against the reckless passion and formlessness of the gestural painters. Too, each painting represents for him both an intricate problem in composition and the resolution the artist has been able to bring to it. To dramatize his pictorial space, Pearlstein usually tilts his view down so as to bring images and background planes forward and align his figures with the picture plane. The harsh studio light he uses allows for little softening play of shadow. This cold, bright, artificial light is part of Pearlstein's cultivated detachment toward his subjects and paintings. By way of compensation color is brought into play, and a rich blend of hues provides a wide range of light and dark contrasting tones.

In Richard Estes's cityscapes such as *Downtown* (Fig. 528) everything is sharply defined and crisply portrayed. They reveal an artist's reaction and commentary on the self-created urban environment people choose to live in. Through Estes's eyes people begin to see things they have not noticed before, and after they see Estes's pictures in a gallery, suddenly everything outside on the street begins to look to them like an Estes painting.

Estes works from photographs as raw material. as his urban landscapes would be impossible to paint on the street itself. He does his own photography and develops the color prints himself. For Downtown he took over seventy-five exposures of the general view and details in various lighting and weather conditions. In the studio he produced a photomontage, or pasteup of photographic details, as a kind of overall working model. In the process, the photographic images were redrawn, positions of buildings and objects got shifted around, and the process of selection and elimination came into play so as to tighten up and clarify the composition. As he remarked in an interview: "I can select what to do or not to do from what's in the photograph. I can add or subtract from it. Every time I do something, it's a choice . . . it's a selection from the various aspects of reality." Then with his cool assured craftsmanship the final stage emerges with brilliant clarity and crisp definition.

Reflections play a major role in both *Downtown* and *Bus Window* (Fig. 569). Like mirrors, they actually seem to double the pictorial space in a complex interplay of reality and reflection. By this means the viewer sees not only what occurs inside the picture plane with its recessions in depth but also what goes on in front of the picture. This adds another plane and dimension to the pictorial space. With the interplay of plate-glass refractions everything seems dou-

bled; for instance, one sees not only the interior of a building but its repetition with variants in mirrorimage reflections as well.

HANSON. Duane Hanson provides the sculptural dimension to the new realism. When seen in a gallery, his figures mix right in with the crowd, and one can hardly tell the spectators from the statues until some of them move on. Returning to the street after seeing a Duane Hanson show, one seems to see an animated Hanson statue in every passerby.

With marvelous directness, a sharp eye for minute detail, and an enormous love of the life he sees around him, Hanson portrays the people we all observe in everyday life. *Supermarket Shopper* (Fig. 570) is a humorous embodiment of conspicuous consumption. As the artist comments: "She began my satirical period. She is a symbol of the over-

570.

DUANE HANSON. *Supermarket Shopper*. 1970. Polyester resin and fiberglass polychromed in oil with clothing, steelcart, groceries; life-size. Courtesy O. K. Harris Works of Art, New York.

consuming housewife pushing a cart filled with every kind of imaginable item that she can buy in a supermarket...." The shopper's cart is piled up with TV dinners, prepared salads, cookies, cans of Coke, and other assorted junk foods. It all adds up to a devastating commentary on the conspicuous consumption in much of middle-class America. Instead of living, Hanson's shopper is just existing. Rich enough to afford all the products television commercials have sold her as symbols of the good life, she remains a spiritual pauper.

Hanson uses live models and makes a flexible mold of each section of the body—legs, torso, arms, and head in turn. Then the parts are assembled and shaped into the desired posture. Next, successive layers of flesh-colored polyester resin are poured into the negative mold, and it is reinforced with fiberglass. After the negative mold is removed, the positive mold is revealed, and the needed repairs are made. Then it is ready for painting and finishing. Such details as wigs, clothes, eyeglasses, and accessories are all real. The resulting figures are so natural that they do everything but walk and breathe. Han-

son's work, however, is far from waxlike image making. His figures are genuine human types shaped by their environment, caught up in the web of their ongoing social circumstances.

Hanson purposely picks ordinary, everyday people who live rather dull lives—working-class people, the downtrodden, the commonplace. As he comments, "I prefer to stay away from unusual looking people and try to produce a figure people can be confronted with in their everyday lives." Yet he lifts ordinary people to symbolic status. The honesty and intensity he puts into his work brings both the absurd and serious aspects of life into focus. Hanson obviously has a feeling of deep compassion and personal involvement in the lives of his fellow human beings. Through them he is criticizing the social circumstances that have brought them to their present plight. The range of his output spans social satire, the horrors of war, the forces that drive men and women to desperate acts. His most recent work, however, consists of penetrating studies of what urbanization, mechanization, and automation do to individual human beings.

571. Alfred Leslie. *View of the Oxbow on the Connecticut River as Seen from Mt. Holyoke.* 1971–72. Oil on canvas, $5'11'' \times 8'9_4^{1''}$ (1.82 × 2.7 m). Collection Peter Ludwig, Aachen, West Germany.

LESLIE AND GILLESPIE. In the postmodern search for continuity of the past, two traditional categories of painting have appeared with renewed vitality landscape and portraiture. In a series of paintings Alfred Leslie has taken his point of departure from the work of the romanticist of the Hudson River School, Thomas Cole (see p. 486). He has set up his easel at various views Cole had used and proceeded to realize modern versions of the same scenes. In Figure 571, for example, it is the so-called Oxbow, a bend in the Connecticut River as seen from Mt. Holyoke in Massachusetts. While Cole's interest was in creating melancholy moods with storms in the picturesque tradition, Leslie paints with a cool, exacting eye. Here the weather and atmosphere are stable, suggesting no emotional overtones. He also includes such antipicturesque details as an interstate superhighway slashing through the scene in the background.

Leslie, like many of his fellow realists, takes advantage of the latest developments of color photography to aid both the eye and the memory when he refines his composition back in the studio. Working from photographs, however, is far from new in the history of art. The 19th-century French landscapist Gustave Courbet found the camera an important aid in his studio. Later Paul Cézanne, who developed his great still-life paintings painstakingly over months and even years, used photographs of his carefully studied compositions as an invaluable record of his original intentions long after the apples, onlons, and flowers had decayed and faded away.

Portraiture is also one of the constants of art history. Gregory Gillespie's realistic self-portrait (Fig. 572) is a sensitive, probing image of self-analysis that can stand comparison with the work of any age. In his introspective gaze, he is following the age-old motto of Socrates, "Know thyself." For precedents one can look at similar self-revelations by Dürer (Fig. 279), Caravaggio, Rembrandt (Fig. 353–356), and Van Gogh. This is not the cool objectivity of Estes's photorealism, but rather a penetration into the depths of one's being in the eternal quest for self–knowledge.

All art begs the question "What is real?" Each generation of artists comes to grips with reality in one form or another. The impressionists saw reality in fleeting atmospheric effects. In the mid-19th century Courbet and Manet, who called themselves realists, found it in casual everyday subjects and in forest scenes. Leonardo da Vinci's reality is reflected in his meticulously accurate drawings of human anatomy, Michelangelo's in the powerful musculature of his heroic figures. The ancient Romans found reality in

572. Gregory Gillespie. *Self-Portrait (Torso)*. 1975. Oil and magna on wood, $30\frac{1}{2}\times24\frac{3''}{4}$ (77 × 63 cm). Collection Sydney and Frances Lewis.

their forthright, uncompromising portraits, the ancient Greeks in the mathematical proportions of their sculptured gods and goddesses, and the Cro-Magnon cave people in their carefully rendered naturalistic representations of the animals that roamed their primeval forests. Since defining reality seems a necessary struggle for artists of all periods, we appear to have come full circle, back to the beginning. As the sage of *Ecclesiastes* says, "What has been is that which shall be." So it is once again that today's readers, observers, and listeners must look to their writers, scientists, painters, and composers to answer the perennial question, "What is real?"

THE NEW HISTORICISM

New concepts of history have entered the present picture. The historical aspects of postmodernism embrace mythological allusions, idyllic landscapes, nostalgia for past golden ages, and thematic revivals of past styles. On the literary scene, one of the most articulate theorists of the postmodern worldview is Umberto Eco. In addition to his astute critical works, his inspired revival of the historical novel, *The Name of the Rose* (1980), has been acclaimed by both liter-

ary critics and the general public. Set in a monastery, the book's structure is a series of labyrinths within a labyrinth, stories within a story. The time is the 14th century, when the waning of the age of faith was accompanied by the dawning of an era of reason. The search is for the lost second part of Aristotle's Poetics, which deals with laughter and comedy, the whole being a crucial work marking Aristotle's break with Plato on the issue of the arts' freedom from moral censorship. Eco's book can be read on many levels ranging from that of a murder mystery novel with William of Baskerville (a disciple of the English scholastic philosopher Roger Bacon) enacting the part of the detective to that of an allegory in which the philosophical problems of the late Middle Ages become a metaphor for the postmodern world and a reminder that any history is always contemporary history. In an interview, Eco once defined postmodernism as "a visitation, frequently ironical and critical, of the forms of the past." Eco's love affair with history continues in his second novel, Foucault's Pendulum (1989). It is concerned, as he says, with a "yearning for mystery, for revelation, for illumination." In it one finds more mazes within mazes. Everything seems to be a symbol for something else, with the "something elses" standing for still something else.

Postmodern critical writings are studded with such terms as neomedieval, neorenaissance, neoexpressionism, neoabstract, and even neomodern. Some of the paintings of the 1980s bear such neoromantic titles as Path in the Wilderness, Aroused Shepherd Boy, Woman Riding the Beast, and Sigh of a Wave. In the neoclassical vein there are Aeneas, Daedalus, Tympanum, Dionysus' Kitchen, and Streets of Oedipus. Biblical subjects have also staged a return with The Expulsion, Jonah, The Angel and Jacob, and the Prodigal Son. Out of the whole spectrum, three painters exemplify some of these postmodern tendencies—the Italian neoclassicist Carlo Maria Mariani, the American neoexpressionist Julian Schnabel, and the black American neoabstractionist Romare Bearden.

Mariani, Schnabel, and Bearden. The Roman painter Mariani's ambition is to capture the classical spirit of the late 18th century. Therefore his art has a nostalgia for the elegance of a past golden age, which he seeks to capture in images relevant to the present. In the process he has created a partly historical and partly fictional School of Rome that originally had included the poet Goethe, the art historian Winckelmann, and the painters Raphael Mengs and Angelica Kauffmann. The latter was a

noted artist (see p. 441) who became Mariani's Muse, and her drawings and paintings are his admitted models. As a tribute, he has done a series of imaginary self-portraits of her.

Mariani believes that there is no absolute order to be found in the world as such, only in the world of art. He is concerned with the act of creation and the role of the artist in creativity. His mythological ideal is Prometheus, who stole the flame of life from the hearth of the gods. The protagonists of his pictorial dream dramas are all artists—gods, demigods, putti—with their palettes and brushes. His poets are crowned with laurel wreaths, his philosophers hold books, his artists their brushes.

His allegorical approach is seen in It Is Forbidden to Awaken the Gods (Fig. 573). Two Apollo-like figures are asleep. They are crowned with the laurel wreath signifying immortal fame, and their brushes identify them with art, since Apollo was the patron of the Muses. A drowsy Cupid is at their side, as is the broken head of a Venus. The huge hand with its commanding gesture is taken from a fragment of a colossal statue of a Roman emperor as Jupiter. The setting is like an empty stage flooded with a luminous glow that intensifies the deep shadows cast by the figures and the folds of their drapery. The flesh is softly and sensuously modeled. The meaning of Mariani's pictures is not immediately apparent, since the artist believes each viewer should become an active participant in the interpretive process. Interpretation is achieved by reading one's own reactions and reflections into the meaning of the picture. It is safe to say, however, that here one is looking at a dream of love and an allegory of the fulfillment of life in art.

Julian Schnabel's apocalyptic visions supply the neoexpressionistic aspect of postmodernism. His work emphasizes personal involvement and individuality as an affirmation of the social pluralism of this time. The human touch and a rediscovery of the many worlds of fantasy are also facets of the new expressionism. For his Death Takes a Holiday (Fig. 574) Schnabel reaches into the medieval past for his imagery. The mythic skeletal personification of death presides in a picture filled with kinetic energy, sweeping passion, and deep emotional involvement. For his surfaces he sometimes chooses velvet, as in this instance. At other times he constructs rough surfaces made up of broken pottery, animal skins, and chains. In his Exile, for instance, he juxtaposes such unlikely images as Caravaggio's Boy with Basket of Fruit and a portrait of the Ayatollah Khomeini, together with attached deer antlers and fragments of burnt logs, all to convey the chaos of dreams.

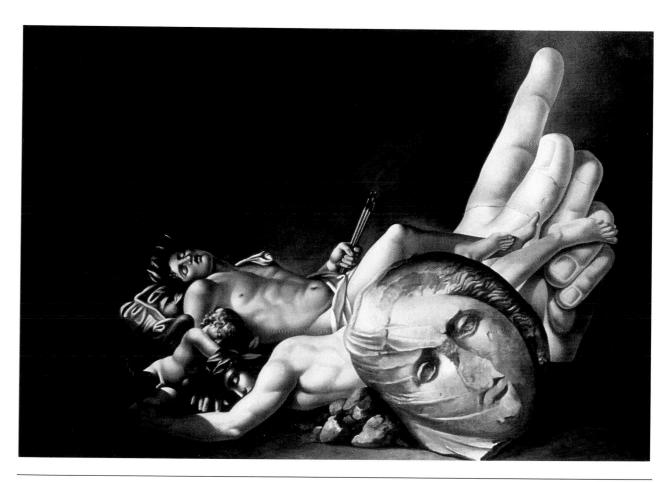

573. Carlo Maria Mariani. *It is Forbidden to Awaken the Gods.* 1984. Oil on canvas, $98 \times 78''$ (249 \times 188 cm). Courtesy of Hirschl Adler Modern Gallery, New York.

Romare Bearden's *Before the Dark* (Fig. 575) is a haunting image of American life. The work is like a celebration of a black family's ritual meal as its members gather for supper before sunset. A man sits at the head of the table pointing emphatically to the place where the standing woman should place the food on the checkered red tablecloth. Holding a cup

in her hand, a seated woman is opposite him. The guitar leaning against the table adds a musical touch. Above at the left the evening light streams in, while below a pitcher is placed on a stool. All is as formal as some religious rite. The whole composition conveys a sense of clarity and dignity to what is obviously a mundane daily occurrence. The rectangular

574. Julian Schnabel. *Death Takes a Holiday.* 1981. Oil on velvet, $7'6'' \times 7'$ (2.29 \times 2.14 m). Pace Gallery, New York.

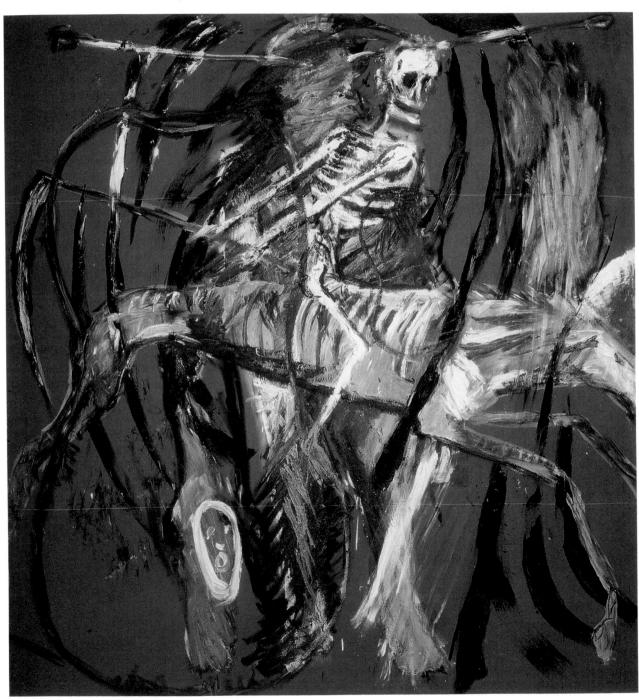

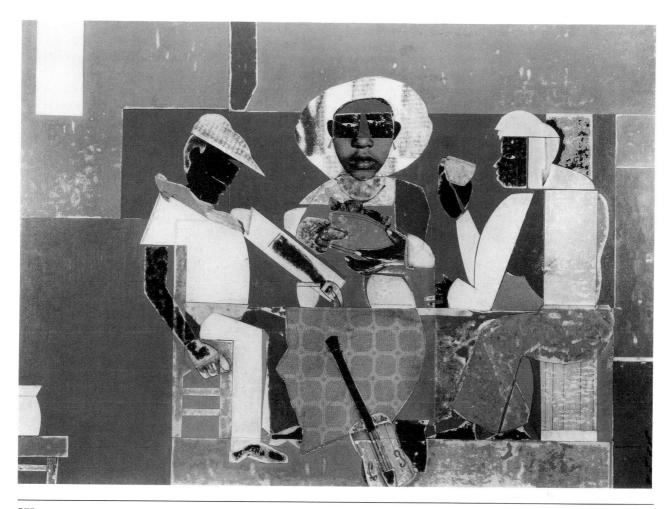

575. Romare Bearden. *Before the Dark.* 1971. Collage on cardboard, $18 \times 24''$ (45.7 × 61 cm). Studio Museum, New York.

background is stylized in the cubist manner; a feeling of mystery pervades the rendering of this quiet domestic scene.

Other notable Bearden works include a series of scenes based on the jazz of the Caribbean island of St. Martin and a black rendering of Homer's *Odyssey*. Bearden has succeeded in capturing a touching image of the American experience.

POSTMODERN MUSICAL DEVELOPMENTS

Like modernism in other fields, musical modernism was based on revolutionary ideas that became orthodoxy. Composers had retreated from contact with the general public and were concerned more with the complexities and potentialities of new musical resources and with music's inner structures than with its effect on the listener. The emphasis was on methods and techniques, organization and con-

struction. Everything had to be new and without immediate precedents.

On the postmodern musical scene, developments are similar to those in the visual arts. The new realists had rediscovered the integrity of the object. the expressivity of the human figure, and the validity of historical continuity. Just as postmodern painters have moved beyond the geometric calculations of cubism, so their musical counterparts have now veered away from the mathematical calculations of serial construction. Tonality is back in favor. Old critical categories of progression and retrogression, avant-garde and reactionary no longer apply. Even the atonal Schoenberg once remarked that there were still a lot of good pieces to be written in C major. And the postmodern tonalist David del Tredici countered that there are still many good pieces to be written with 12-tone rows. The historical dimension has also come into play in many obvious and subtle ways. Several major American composers have

looked to the Orient for the sensuous sounds of Balinese gamelan orchestras and the melodic fragrance, formulas, and persistent rhythms of Indian ragas.

The spectacular theater productions of Philip Glass and the dramatist Robert Wilson have been a postmodern success story. Their trilogy of portrait operas begins with Einstein on the Beach (1976) dramatizing the scientific dimension. Satyagraha features Gandhi's movement to promote racial equality in South Africa embodying the social aspect. Akhnaten, based on the Egyptian pharaoh who initiated monotheism, covers the religious aspect. History is represented by bringing dead languages to life. Archaic Hebrew, Egyptian hieroglyphics, classical Sanskrit, and Coptic are used to supply syllabic material for the lyrics, to free the audience from the need to follow the words, and to add a sense of mysterious ritual to the theatrical experience. The music of Glass is replete with the repetitive rhythmic cycles of Indian ragas, bland solfège formulas, scampering diatonic arpeggios, and long-held organ and pedal points that seem to have no beginnings nor ends. All are in major tonalities with almost no sense of development or modulation from one key to another. His sounds come from a combination of traditional and electronic instruments amplified to a high decibel level. All components are designed to provoke spellbinding, hypnotic effects that block out the conscious mind so as to release the inner awareness of the subconscious. All three operas typify the postmodern psychology of sensibility and involvement.

Two other American composers—Terry Riley and Steve Reich—have also ventured out of the Western tradition to capture the spirit and practices of Asia and Africa. Riley studied northern India's raga singing and combines Eastern feeling with the harmonic and contrapuntal techniques of the West. In his Shri Camel (1976), listeners are bathed in a flow of mesmerizing sounds. He uses electronic instruments, noting that this piece is scored for "a live orchestra of one person." While it is thoughtfully worked out, Shri Camel has the instant appeal of an improvisation. Steve Reich is at home with Western music but has also studied the drumming practices of West Africa, as well as Balinese gamelan playing. His Drumming (1971) is scored for voices, piccolo, and a battery of percussionists. Like African tribal music, it is endlessly repetitious, with progressively minute rhythmic variations.

The British composer Peter Maxwell Davies works on a far more sophisticated and esoteric level. A prolific writer, his works include symphonies, operas, songs, and song cycles, as well as chamber music for many unusual combinations. He has been intensely concerned with works of the Middle Ages

and Renaissance. Much of his music derives from medieval plainchant models on which he builds up complex contrapuntal structures. His *Ave Maris Stella* (*Hail, Star of the Sea*) of 1975 uses a plainchant modal melody of that name as a cantus firmus and ostinato device and then builds variants over it. The tune emerges straightforwardly in the final movement, for the flute. The work is a sextet, scored for a string quartet plus marimba and piano. It unfolds in a meditative, quiet manner, reminding the listener of the intricacies of a late Beethoven quartet.

In a more boisterous vein Davies writes a theater piece in the manner of a song cycle called *Eight Songs for a Mad King* (1969) for male voice and a motley ensemble in which each player is enclosed in a giant birdcage. They all watch and comment on the mad ravings of the vocalist. The latter might well go mad himself as he tries to meet the virtuoso demands made on his vocal mechanism.

Another showcase for Davies' parody is his symphonic piece, *St. Thomas Wake* (1969). The starting point is a 16th-century pavane that he burlesques with jazz idioms. He says it is based on "three levels of musical experience—that of the original 16th-century pavane 'St. Thomas Wake' as played on the harp, the level of the foxtrots derived from this, played by a foxtrot band, and the level of my 'real' music, also derived from the pavane, played by the symphony orchestra."

In America, John Adams has written a large-scale symphonic work called *Harmonielehre* (1985) that is rapidly taking a place in the orchestral repertory. The title is taken from Arnold Schoenberg's monumental treatise on harmony. The discourse was written in 1910, just as Schoenberg was making his radical breakthrough into atonality and 12-tone serialism. Reich points out that Schoenberg had dedicated his *Harmonielehre* to his mentor Gustav Mahler. "So I suppose that, on a far more modest level, my own *Harmonielehre* is dedicated to Schoenberg. The other shade of meaning in the title has to do with harmony in the larger sense, in the sense of spiritual and psychological harmony. The whole piece is about the quest for grace."

Unlike the later Schoenberg, Adams is a tonal composer. Since his music concentrates over long periods of time in a single key, the modulations come with startling force. As he notes, "What actually interests me is the relationship of one key to another—up a major or minor third, for example—the immense emotional power that's brought about by a modulation."

Adams's expressed intention is to devise a musical language that resonates with the past yet is geared to contemporary experience. The work is in

four parts, like a symphony with some programmatic associations. The first movement begins with throbbing E-minor chords and is like a singlemovement symphony in itself. The next part bears the title "The Anfortas Wound," an allusion to that king's search for the holy grail. In the quest, however, he is wounded like Tristan in Wagner's music drama, and the music broods on life and death. The third movement is a scherzo entitled "Meister Eckhart and Quackie," alluding to the medieval mysticist and the nickname of his young daughter. The buoyant mood conveys, as the composer describes it, the coming of grace, "the unmerited bestowal of blessing on man." The fourth and final movement then sets up a "tremendous harmonic struggle with different tonalities vying for dominance."

This look at modern and postmodern musical developments should be qualified by recalling that at the present stage of expanded horizons, "contemporary" music in the larger context is whatever today's classically minded audiences choose to listen to. Concert programs as well as recording collections reveal that Bach, Beethoven, and other major masters enjoy a greater following on the current scene than do Karlheinz Stockhausen, John Cage, and Milton Babbitt. The approach to recent developments in music leads in many directions. It is possible to feel secure in savoring tried-and-true classics. But modern listeners, like contemporary composers, can find adventure in exploring unfamiliar pathways.

POSTMODERN ARCHITECTURAL **DEVELOPMENTS**

The postmodern architectural approach was to reach beyond the functional efficiency of the international modern style with its steel-and-glass, high-rise boxes on stilts and glazed-in shopping malls. Modern architecture that was to have brought about the millennium had led to a disregard of natural, human, and environmental concerns. The result had culminated in sterility, endless repetition, and dehumanization. The international modernists had rejected any symbolic meaning in favor of pure functional efficiency. Postmodernists were quite willing to continue the technological breakthroughs of modernism, but they desired to add color, decoration, sculptural, and painterly embellishments that would give a structure some specific iconographical meaning. Postmodernists also choose to respond to the desires and needs of their pluralistic society. Architects have once again become the partners of painters, sculptors, and mosaicists. Decoration is not to be mere architectural embroidery but a basic part of the

larger architectural statement. Well-placed sculptural groups, frescoes, or mosaics can create points of interest in an overall design as well as give definition to exteriors and interiors that serve as symbols of human involvement. An unexpected turn here or a twist there can achieve an element of fantasy, warmth, and delight.

Kahn and Venturi

As heir to the romanticism of Frank Lloyd Wright, the Philadelphia architect Louis I. Kahn was one of the first to make a significant break with the international stylists. Kahn designed massive structures with the monumentality and grandeur of Gothic cathedrals and Egyptian temples. Indeed, they proclaim the drama the architect finds in the materials and processes of building. Kahn wanted his buildings to be "legible," and because they reveal how they were made, he believed they could be "read." Considered one of the great "form givers" of his time, Kahn looked to the knuckles, joints, and unfinished materials of his structures and there found the true basis of plastic richness and ornament.

Kahn's commission from the Salk Institute for Biological Studies at La Jolla, California (Fig. 576), gave him the opportunity to create a harmonious balance between the needs of laboratory scientists and a stimulating environment for their work. The special look of the building comes from the geometric slabs of concrete, the surfaces of which retain the pockmarks made by the plywood pouring forms. Embellishing this are plugs of lead that fill the tieholes left when the forms were removed. Kahn designed the structure to function but also to have a human quality. In the Salk Institute he provided an environment to engage its occupants to their full capacities for awareness.

Both Kahn and his former student and assistant Robert Venturi turned against the myth of hero architects like Le Corbusier, whose buildings stood sublimely aloof from all that surrounded them. Venturi's books—Complexity and Contradiction in Architecture, Learning from Las Vegas, and Learning from Levittown—suggest the challenge that these two architect-designers have put to modernist dogma. Venturi and his wife and partner, Denise Scott Brown, have noted that environment, more than monuments, is the reality of human experience. The Venturis declare that "the world can't wait for the architect to build his utopia, and the architect's concern ought not to be with what it ought to be but with what it is—and with how to help improve it now. This is a humbler role for architects than the modern movement has wanted to accept." Thus, the

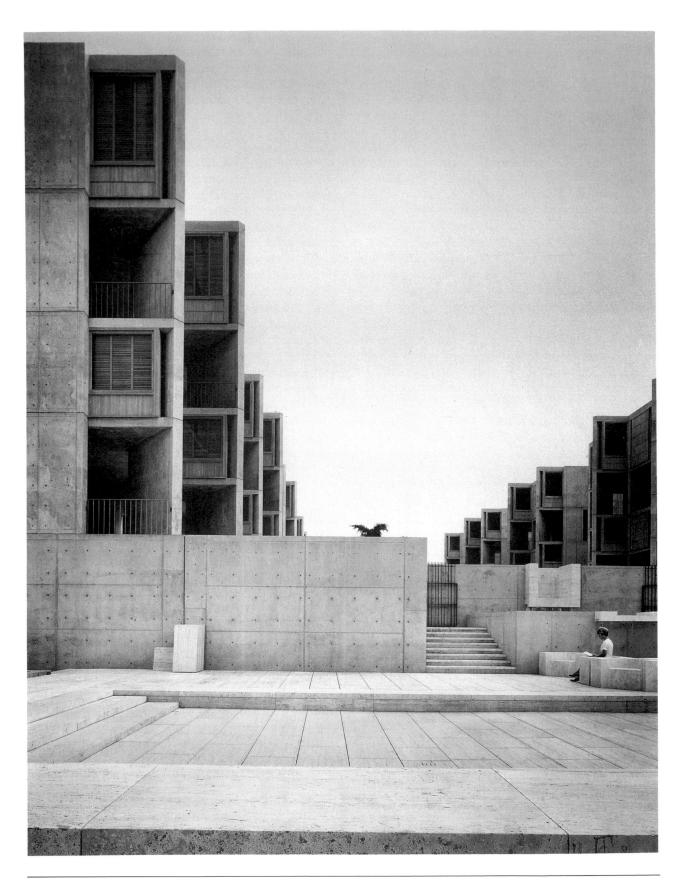

576.Louis I. Kahn. Salk Institute for Biological Studies, La Jolla, Calif. 1968.

Venturis have sought out the urban environment on its own terms, because it is there. And because it is there, they have studied the highway strip and the subdivision, to see why and how these despised features of the modern scene may have the vigor to make chaos work.

With insight and analysis, the Venturis have reasoned back through the history of style and symbolism. They have proposed a concept of a new architecture capable of responding to the speed and mobility of a society caught in the never-ending cycle of changing life-styles. Admirers of pop art, the Venturis accept the premise of the commonplace and of the cheap, efficient, and practical ways that mass culture serves its needs. But like the pop artists, they possess the education, wit, and irony to deal in paradox and perversity. The Venturis point out that having renounced decoration, modernist architects manipulate structural forms until the entire building takes on the quality of decorative sculpture. Using the theory of the building as a symbol, they cite as an example a building on the highway in the shape of a duck (the sales outlet for a duck farm)—and say they design "ducks" and "decorated sheds." The Venturis even think Main Street with its mixture of the old and new, its collection of drugstores, banks,

and fast-food stands, "is almost all right." The motto of Miës van der Rohe was "Less is more." The Venturis turn this inside out and assert "More is not less" and "Less is a bore."

Taking the label meant as an insult from an outraged modernist, the Venturis call their work "dumb and ordinary," all the while filtering the ordinary through their taste and knowledge until it becomes the extraordinary. A case in point is Guild House (Fig. 577), an apartment building sponsored by the Society of Friends to house elderly tenants who wanted to remain in the old neighborhood, a lower-middle-class district of Philadelphia.

With utmost candor, the building recalls "traditional Philadelphia row houses, or even tenement backs of Edwardian apartment houses." But all sorts of mannered elements—the emphatic façade; the notched shadow of the recessed entrance; the extreme left and right alignment of trimless, slightly overscaled but "standard" double-hung windows; the single, central arch form in an otherwise rectilinear design; the narrow white band running horizontally at the next-to-top story; the contrasting colors of the materials; the pop sign mounted like a movie marquee; and the purely decorative and nonfunctional wire rooftop sculpture formed like a television

577. Venturi, Rauch, and Scott Brown. Guild House, Philadelphia. 1965.

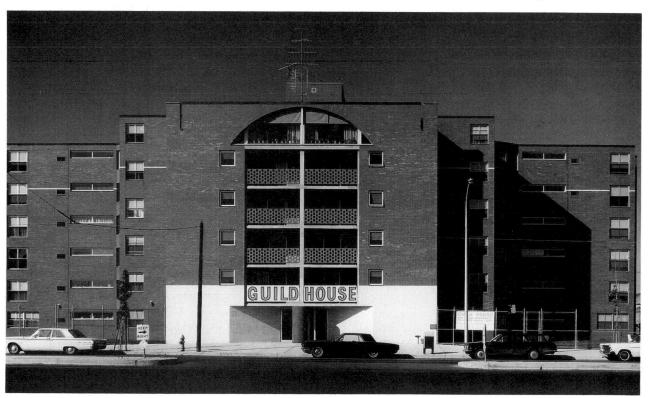

antenna—make it clear that a highly personal, idiosyncratic intelligence has been at work. The effect is to make the educated viewer feel compelled to look again, to discover why the commonplace seems so uncommon.

This is contradictory and complex, like life itself. However, in a time when construction costs make the dumb and ordinary inevitable, it may prove a valid response to the complex and contradictory needs of modern life.

Graves, Beebe, and Moore

Postmodern architects are once again concerned with meaning and symbolism. Their buildings now take human scale into account, and architectural ties with human expression and aspirations are being reaffirmed. It is recognized anew that structures do not stand alone but must have character and seek their place in the fuller context of society and the environment. As architectural critic Ada Huxtable wrote, neighborhoods are now "seen in terms of social identity, cultural continuity, and sense of place," and there is a "return to the basic understanding that architecture is much more than real estate, shelter, and good intentions." In the new architecture is also an expanded sense of history. For the first time, contemporary artists are becoming aware of the whole historical panorama in ways that are relevant to present-day living.

For a public office building in Portland, Oregon, Michael Graves has created a design of arresting interest (Fig. 578). Reacting to the endlessly repetitive glass, concrete, and steel box structures that compose the centers of all modern cities, he projects an architecture containing metaphorical allusions and spatial symbolism. His creations serve to delight the sophisticated taste without losing the common touch. In a kind of cumulative historical synthesis, the bright red massive pilasters and central keystone recall ancient Rome, while the fluttering fiberglass garlands allude to art deco. The skyscraper silhouette derives from the international style, but it is now treated historically. The original design was to have included a huge statue of Portlandia, a neo-Roman mythic invention for a goddess of modern commerce silhouetted diagonally across the façade. The general effect of the complex is that of a piece of gigantic sculpture in the manner of an assembly or collage, yet it has the stately grace and monumentality of an ancient temple.

When it came to building the nation's largest public library, Chicago's City Hall sponsored a com-

petition that was dubbed the "design war." The project is named the Harold Washington Center in honor of the city's first black mayor, and a jury representing various municipal constituencies was set up to make the final design choice. The need was for a building to shelve some 8 million books and documents on 72 miles of shelves with ample room for constant expansion. It also had to allow for microcomputers that would give readers instant access to every part of the main library and its more than 80 branches. The computers would also provide printouts on all manner of subjects to high schools and colleges, which could then receive deliveries of books and documents at their respective institutions.

The site is two large blocks in the middle of downtown Chicago in a historic core of office buildings with venerable façades. One submitted design was a modern steel-and-glass extravaganza conceived as a supermarket of information with reading rooms like glass porches projecting outward over the street. Another featured a transparent modern façade that floodlighted the interior and revealed the inner workings of the library to the man on the street. Still another had a high-tech interior with a twelve-story inner atrium with transparent elevators and escalators that let visitors float over the book stacks and reading rooms.

In the end, however, tradition won, and the panel chose Thomas Hall Beebe's design. For his precedent Beebe selected Labrouste's Library of Sainte Geneviève in Paris (see Figs. 462 and 463), the first modern library complex, with its open arcades that create natural lighting for the spacious reading room inside. Beebe's design thus creates a link between past and future. It also harmonizes with its existing architectural environment on State Street, with the open-arch construction of Louis Sullivan's nearby Auditorium Building and Chicago's Frank Lloyd Wright heritage. Beebe has taken human scale into account with an edifice that is both functional and flexible rather than futuristic. Without being massive, it has a historic look, a feeling of quiet grandeur. Above all, it has the authentic aspect of a library.

Charles Moore has designed for the Italian section of New Orleans near the Italo-American Institute, a nostalgic evocation of Renaissance Italy entitled Piazza d'Italia (Fig. 579). The site is circular, and the structure can be viewed from all sides. The classical orders are all represented. Their columns are constructed of curved steel sheets with neon lighting tubes curled around their collars. From every angle, the complex becomes an evocative piece of architectural fiction.

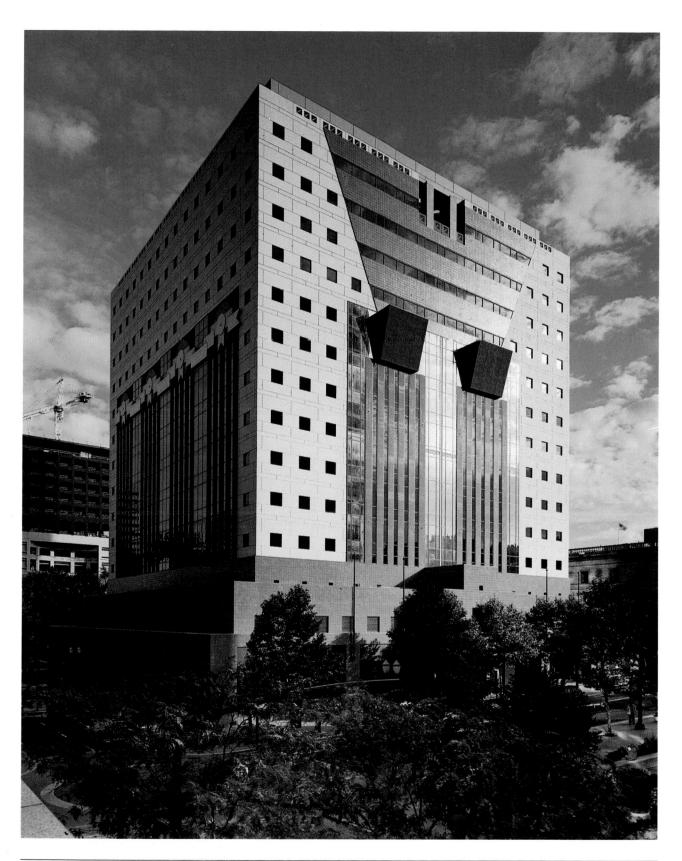

578. MICHAEL GRAVES. Portland Public Service Building, Portland, Oregon. 1980.

IDEAS: EXISTENTIALISM

One of the philosophical answers to fill the present-day vacuum is that of *existentialism*. The existential-were unconvinced by previous philosophical systems, especially that of Hegel, who seemed to have answers for all questions except the important ones: Who am I? What am I doing here? Where am I going? Bergson had already pointed out that the scientific method was a process of cold abstraction that failed to take personal experience into account. For the Enlightenment the motto had been "I think;

therefore I am," for the romanticists, "I feel; therefore I am." For the extentialists it became, "I exist; therefore I am." Thinking and feeling can be defined with some accuracy. But the matter of existing brings up as many questions as answers. As Shakespeare's Hamlet asked: "To be or not to be, that is the question." To affirm or deny? To believe or not to believe? To do or not to do? To be positive or negative?

All absolutes have now been swept away in the cosmic multiverse. Standing alone in the face of nothingness, each individual may create his or her own meaning for life. To work or play, to protest or

579.Perez Associates with Charles More, Ron Filson, Urban Innovations, Inc. Piazza d'Italia, New Orleans. 1976–79.

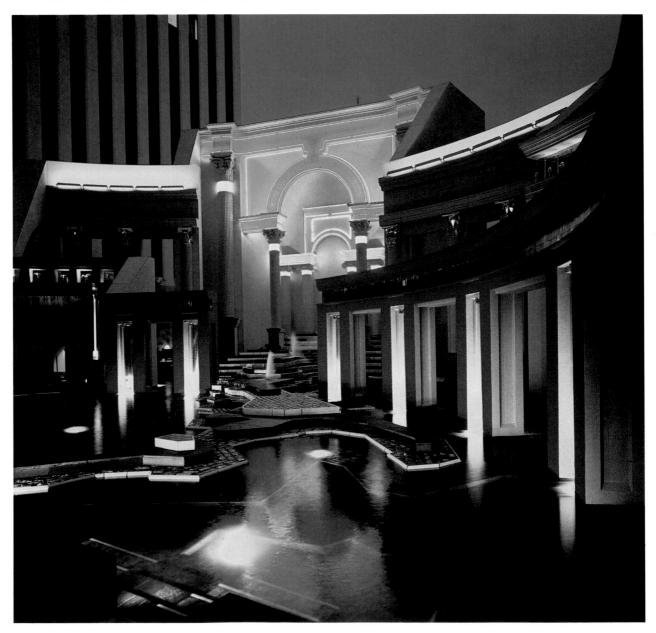

acquiesce, to love or hate, to notice or ignore, or to tend one's garden and let the world go by. For the French existentialist Jean-Paul Sartre, human existence was but a lighted candle in a vast darkness. When it flickers out, existence ceases. But Sartre took the affirmative view, and for him existence meant doing and the making of choices. The choices, however, are not casual but creative—those that lead to life commitments, positive forces in the face of the inevitable negation of death. Such a confrontation with extinction can be the greatest challenge to the affirmation of life. As expressed in the pursuit of knowledge and enjoyment of the arts, living on the brink makes each moment count. No one is more aware of this challenge than the artist. Whether the artist is a poet, painter, or composer, the will to create works that reveal the infinite possibilities in human attitudes, insights, and life-styles is irresistible. Art, in the view of the French philosopher André Malraux, has replaced religion as the last defense against death.

Sartre felt that human experience could best be expressed in myth and metaphor, in literature and art, rather than in formal argumentation. Novels, plays, art works, and music were for him better vehicles than philosophical treatises to translate abstractions into human terms. In Sartre's world existence precedes essence. That is, first one must exist, then project a self-image or define oneself through actions taken and works of art created. Human beings are condemned to be free; the only limit to their freedom is freedom itself.

One of the corollaries of Sartre's thought is the essential absurdity of life. As the notion of the absurd appears in existentialist art and drama, it takes on a very grim coloration. There is nothing lighthearted about it. Samuel Beckett's *Waiting for Godot* (a paraphrase of the existentialist philosopher Martin Heidegger's "waiting for God") is now a classic of contemporary theater. It unfolds in a series of inconsequential episodes that reveal the endless boredom and futility of life (Fig. 580). Godot, of course, never

580.Scene from Samuel Beckett's *Waiting for Godot*. Production by Roger Blin at the Théâtre de l'Odeon, Paris. 1961.

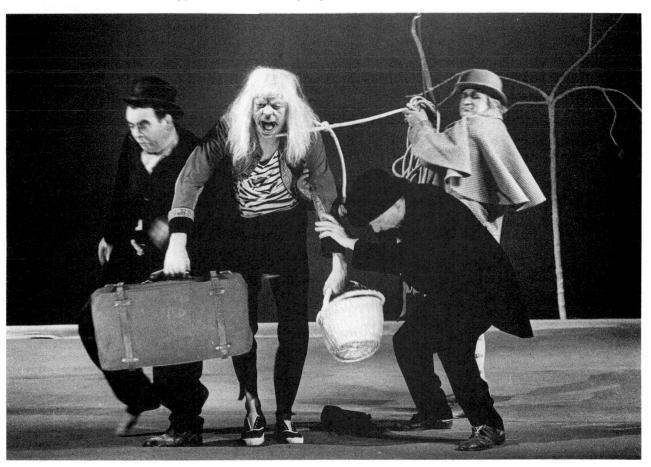

comes. *Waiting* is the watchword. Meanwhile the terse, brittle dialogue explores the nagging, niggling nuisances, trivialities, and irrelevancies of daily life:

VLADIMIR I get used to the muck as I go along.

Estragon [after prolonged reflection] Is that the

opposite?

VLADIMIR Question of temperament.

Estragon Of character.

VLADIMIR Nothing you can do about it.

ESTRAGON No use struggling.

VLADIMIR One is what one is.

ESTRAGON No use wriggling.

VLADIMIR The essential doesn't change.

ESTRAGON Nothing to be done.... ESTRAGON What do we do now?

VLADIMIR I don't know. ESTRAGON Let's go. VLADIMIR We can't. ESTRAGON Why not?

VLADIMIR We're waiting for Godot.*

For Sartre death is the ultimate absurdity. As Pozzo says about the human race in Beckett's play: "They give birth astride of a grave, the light gleams an instant, then it's night once more." Both Sartre and Beckett would agree with Leonardo da Vinci, who observed that just when he thought he was learning to live, he was only learning to die. Paradoxically, one cannot know life until confronted with death or experience affirmation until one encounters negation. All life, human or otherwise, has a death sentence hanging over it. There can be no sunshine without shadow, no light without darkness. In life there is always the imminent presence of death, in victory the specter of defeat; and every joy is haunted by sadness. Existentialism is essentially the ultimate humanism. For one must constantly ask: What does it mean to exist? What is human existence like? How does it feel to be human? In this world of infinite possibilities, any choice or action is of necessity not derived from, directed toward, or done for the sake of anything else. Everything can be, but nothing has to be or must be.

In the existentialist worldview, all works of art are creative acts in the face of nothingness. The artist can do something or nothing, become god or beast, Prometheus or Lucifer. Mythology becomes fact insofar as metaphor and fiction are products of the human imagination and because people have believed in them, acted upon them, written, built, carved, and composed because of them.

What is relevant for the contemporary audience and the modern artist is the great growth of knowledge about past and present, plus the easy access to the vast body of literature, art, and music across the ages. So with the many media at their command, with the tremendous extension in the span of human experience, with so many levels of taste and frames of reference, the artist and the modern audience have an unlimited number of choices.

These choices range from the traditional to the experimental, from the manipulation of mathematical formulas to chance and random happenings, from logical and cyclical wholes to fragmented reflections of a broken and distorted world. More concretely, they range from the historical repertory in recorded and live performances to acoustical jungles and electronic collages, from the revival of ancient media such as frescoes and mosaics to exploring Plexiglas and plastic fantasies, from static sculptures that rest securely on pedestals to mobiles and kinetic art in mechanical motion; from works in a single medium to multimedia mixtures of all the arts. So when it comes to "doing our own thing," the bewildering problem is that there are so many possible things to do and so many ways to do them.

POSTMODERN HORIZONS

In spite of the new historicism, postmodern art in all fields, including literature and music, is, of course, light years away from a return to the premodern past. Today no painter of whatever persuasion could possibly approach a canvas as if cubism and abstract expressionism had never happened. No composer could be unaware of the technical innovations of Schoenberg or Stravinsky. No writer could fail to take the works of James Joyce or Samuel Beckett into account. As the author John Barth observes, postmodern fiction is a synthesis of premodernist and modernist modes of writing. "My ideal postmodernist author," he says, "neither merely repudiates nor merely imitates either his twentieth-century modernist parents or his nineteenth-century premodernist grandparents. He has the first half of our century under his belt, but not on his back." Postmodern artists, writers, and composers have thus expanded their horizons to encompass the past as well as the present as they chart their future course.

Postmodernism, then, is a concept covering the range of art produced by and addressed to the present-day pluralistic society. Abstraction is still with us, as it has been from the beginning of time. Other constants in the history of art, however, are

^{*}Samuel Beckett, Waiting for Godot (New York: Grove Press, 1954), pp. 14, 31, 57.

now being rediscovered and brought into balance. The value of drawing and draftsmanship, a description of the objective world, the power of the human figure, and a sense of spirituality are now being reborn and reassessed. Thus in the present period of pluralism, all kinds of approaches to art have once more found space to coexist.

In the postmodern era all art past and present becomes contemporary by virtue of its living presence in the here and now. In the larger picture, 20th-century art is not only abstraction. Cubism and expressionism, aleatory and computerized music, and soaring structures of steel and glass are but a few within the wide range of available choices. For all the arts, over all ages of time, all reaches of space are now contemporary art. The Parthenon, Chartres Cathedral, the Sistine Chapel, the Guggenheim Museum, Lincoln Center, and the Trans World Flight Center, the paintings of Giotto, Rembrandt, and Picasso, the music of Bach, Wagner, and Stravinsky all exist in the expanded present. Ultimately it is up to the contemporary reader, viewer, and listener to choose whether to read Plato or Sartre, to look at Praxiteles' statues or at those of David Smith, to listen to plainchant or to Babbitt's computerized compositions. The outlines of the past, present, and future have become blurred, just as in cubist and abstract-expressionist painting, space has flattened out. In modern literature, music, and films time is experienced in a flowing continuum as in dreams. with flashes backward and forward. Foreground, middle ground, background; beginning, middle,

end; past, present, future—are all telescoped together. The new is also the old, and the old ever new.

Now that humanity can rekindle the fires of faith and reassert its creative forces, the arts become focal points in the act of reaffirmation. In the brave new world that stretches ahead, artists will find scope for their pictorial projections, modern architects will regard the needs of the pluralistic society as a renewed challenge to their powers, writers will discover many new avenues for communication in the media, and contemporary composers will revel in the possibilities of novel sounds.

This, then, is the exciting and exhilarating challenge of our time. For we can pursue the trivialities or sublimities of life, leap into the gaping void, wallow in the primordial ooze, or else create some mode of order in a world of arts and ideas. As the philosopher Nietzsche said in *So Spake Zarathustra*, you must have chaos in you to give birth to a dancing star: "I say unto you: you still have chaos in yourselves." So it becomes possible to foresee a shining creative future, a whole galaxy of dancing stars. For when we look at the world around us, the supply of chaos seems truly inexhaustible.

If any message comes through the mists and mazes of history, it is that we should never underestimate the power and creative capacity of the human mind. As long as the challenge is there, it is the eternal quest of the artist, scientist, or philosopher to envision the invisible, comprehend the incomprehensible, understand the unintelligible.

Glossary

Words in *italics* indicate terms defined elsewhere in the glossary. Consult the index for terms defined in the text and figures that illustrate them.

A

- **abacus** In an architectural *column*, the uppermost member of the *capital*; the slab upon which the *architrave* rests. See Fig. 31.
- **abstraction** In the *visual arts*, the essential rather than the particular, in certain instances even the *ideal*. The process of subordinating the real appearance of *forms* in nature to an *aesthetic* concept of form composed of *shapes*, *lines*, *colors*, *values*, etc. Also, the process of analyzing, simplifying, and distilling the essence from nature and sense experience. See *nonrepresentational* art.
- a cappella Italian for "in chapel style." Choral music without instrumental accompaniment
- **accompaniment** The music supporting soloist or group of performers; music subordinate to the *melody*.
- **acoustics** That having to do with the nature and character of sound.
- **acrylic, acrylic resin** A clear plastic used as a *vehicle* in paints and as a *casting* material in *sculpture*.
- **adagio** Italian for "slow"; in musical *composition* an instruction to the performer.
- aerial perspective See perspective.
- **aesthetic** Having to do with the pleasurable and beautiful as opposed to the useful, practical, scientific, etc. The distinctive vocabulary of a given *style*. An aesthetic response is the perception and enjoyment of a work of art.
- **aesthetics** A branch of philosophy having to do with the nature of beauty and art and its relations to human experience.
- agitato Italian for "agitated" or "restless." agora In ancient Greek cities, an open marketplace where the population could assemble and hold meetings.
- air A simple song, not to be confused with aria.
- **aisle** In church *architecture*, the longitudinal *spaces* situated parallel to the *nave* and *formed by walls, arcades*, and *colonnades*. See Fig. 122.
- **aleatory music** From the Latin for "dice," a music that is uncontrolled or left to chance. Whatever the elements introduced by the *composer*, their arrangement is left to the performer or to circumstance.
- **allegory** *Expression* by means of *symbols* to make a more effective generalization or moral commentary about human experience than could be achieved by direct or literal means.
- allegro Italian for "lively," "brisk," or "merry."
- altar Originally a stone slab or table where offerings were made or victims sacrificed; in the Christian era, a raised structure in a church at which the sacrament of the Holy

- Eucharist is consecrated; a center of worship and ritual.
- **altarpiece** A painted or *sculptured panel* placed above and behind an *altar* to inspire religious devotion.
- **alto** The lowest *range* of the female *voice*; also known as *contralto*. Too, the *line* in musical writing corresponding to the alto range, or an *instrument* with this range.
- **ambulatory** A covered passage for walking, found around the *apse* or *choir* of a church, in a *cloister*, or along the *peristyle* of an ancient Greek temple. See Fig. 148.
- andante Italian for "moderately slow."
- **animism** The belief that objects as well as living organisms are endowed with soul.
- **anthem** An inspirational *song*, usually nationalistic; a *choral* selection performed as part of a sacred service.
- **anthropomorphic** Human characteristics attributed to nonhuman things.
- **antiphony** Music in which two or more groups of *voices* or *instruments* alternate with one another
- **apotheosis** Deification, or the realization of divine status.
- apse A large nichelike space—usually semicircular in shape and domed or vaulted projecting from and extending the interior space of such architectural forms as Roman and Christian basilicas. Most often found at the eastern end of a church nave and serving to house the high altar. See Fig. 122.
- apsidal See apse.
- **arcade** A series of *arches supported* by *piers* or *columns;* passageway with arched roof.
- arch See Figs. 111, 187.
- **architectonic** Overall *design* and *composition*; that which has *structure*.
- architecture The science and art of building for human use, including design, construction, and decorative treatment.
- **architrave** In *post-and-lintel architecture*, the *lintel*, or lowest, division of the *entablature* that rests directly upon the *capitals* of *columns*. See Fig. 31.
- archivolt The molding that frames an arch.
 area Extent, range, or scope, having the character of space, whether two- or three-dimensional.
- aria An elaborate solo song (or duet) with instrumental accompaniment used usually in cantatas, oratorios, and operas. A da capo aria has the basic ternary form ABA. The first section (A) concludes on the tonic and is followed by the second section (B), which is contrasting in key and character. The singer then returns to the beginning (da capo), repeating the A section, usually with some improvisation. A continuo aria is an aria with continuo accompaniment.
- **arpeggio** The *notes* of a *chord* played successively rather than simultaneously, in either ascending or descending order and throughout one or more *octaves*.

- ars antiqua Latin for "the ancient art." A term used for the music of the 12th and 13th centuries, as opposed to the music of the 14th century, ars nova. Chief composers were Léonin and Pérotin; principal musical innovations were stabilization of meter and the advancement of polyphony from two-voice to three- or four-voice writing.
- ars nova Latin for "the new art." The title of an early 14th-century treatise by Philippe de Vitry, dealing with musical notation, which gave its name to the musical style of 14th-century France and Italy. Music of the ars nova (as opposed to the ars antiqua) has a more secular orientation, greater rhythmic complexity, independent part writing, and creativity.
- ars perfecta Latin for "the perfect art." A name used to describe the music of Josquin Desprez and other 15th-century Flemish composers.
- assemblage The technique of creating threedimensional works of art by combining a variety of elements—such as found objects into a unified *composition*.
- atmospheric perspective See perspective.
- **atonality** A type of music in which no particular *pitch* serves as the *tonic*, or *key*, *note*.
- **atrium** An open court constructed within or in relation to a building; found in Roman villas and in front of Christian churches built from late antiquity through Romanesque times. See Fig. 122.
- **augmentation** In music, a technique for slowing down a phrase or *theme* by increasing (usually doubling) its *note values*.
- **avant-garde** Vanguard or advance guard; a term used to designate innovators whose experimental art challenges the *values* of the *cultural* establishment or even those of the immediately preceding avantgarde *styles*.
- axis An imaginary line passing through a figure, building, or group of forms about which component elements are organized; their direction and focus actually establishes the axis.

B

- background In pictorial art, that part of the composition which appears to be behind forms represented as close to the viewer; the most distant of the three zones conceived in linear perspective to exist in deep space, beyond the foreground and middle ground. See perspective, relief.
- **balance** In *composition*, the equilibrium of opposing or interacting forces.
- **ballad** A narrative *song* usually set to relatively simple music.
- **ballet** A theatrical performance of artistic dance involving a plot or narrative sequence, costumes, scenery, and musical accompani-
- **balustrade** An architectural *form* that is a continuous row of abbreviated shafts (balus-

ters) surmounted by a handrail to make a low fence.

band A musical ensemble consisting of woodwind, brass, and percussion instruments, but no strings

bar See measure.

baritone The male vocal *range* between the high of the *tenor* and the low of the *bass*. **barrel vault** See Fig. 111.

basilica A rectangular-plan building, with an apse at one or both ends, originating in Roman secular architecture as a hall and early adopted as the form most suited to the needs of Christian architecture.

bas-relief See relief.

bass The lowest *range* of the male *voice*. Also, the lowest vocal or *instrumental line* in musical writing, or an instrument with the range to play these *notes*. The notes to the music in this range appear on a *staff* identified by a *bass clef* (9).

basso Italian for bass.

basso continuo See continuo.

bay In *architecture*, the *space* defined at four corners by the principal upright structural members, with the character of the space usually established by the need to sustain aloft the great weight of a *vault*. See Fig. 187.

beat In music, the unit for measuring time.
 binary form A basic two-part musical structure in which the second part differs from the first and both parts are usually repeated.

bitonality A musical technique in which melodies in two *tonalities* are played simultaneously

brass instruments The trumpet, French horn, trombone, and tuba, all of which have metal mouthpieces for blowing and a tube shape that flares into an opening like a bell.

buttress A *support*, usually an exterior projection of *masonry* or wood, for a *wall*, *arch*, or *vault*, that opposes the lateral *thrust* of these structural members. See Fig. 185.

\mathbf{C}

cadence A point of rest, pause, or conclusion in a musical *composition*; a strong, regular *rhythm* as in a march.

cadenza In music for solo *voice* or *instrument* a free or florid passage inserted by the *composer* or *improvised* by the performer, usually toward the end of a *aria* or *movement*, whose purpose is to display the performer's technical brilliance.

campanile In Italy, a bell tower, especially one that is freestanding, often next to but separate from a church building.

canon A body of principles, rules, standards, or norms; a criterion for establishing *measure*, *scale*, and *proportion*. In music, a type of strict *imitative counterpoint*, wherein the *melody* stated by one *voice* is imitated in its entirety by a second voice, which enters before the previous one has finished.

cantata Italian for music that is "sung," as opposed to music that is played, which in Italian goes by the term sonata. In the 17th-century sense of Bach, Scarlatti, and Handel, a multimovement composition for solo voices, chorus, and orchestra consisting of recitatives and arias for performance in church or chamber. Briefer than oratorio but, like oratorio,

differs from *opera* in being mainly nontheatrical.

cantilever In *architecture*, a *lintel* or beam that extends beyond its *supports*.

cantus firmus Latin for "fixed song," a preexisting *melody* that medieval and Renaissance *composers* used as the basis for *polyphotic* pieces in which they added new melodies above and/or below the cantus firmus.

canvas A fabric woven of cotton or linen and used as the *support* for *painting*. Also called *duck*, especially when made of cotton.

capital The upper member of a *column*, serving as transition from shaft to *lintel* or *architrave*. See Fig. 31.

caricature An amusing distortion or exaggeration of something so familiar it would be recognized even in the distortion.

cartoon A full-scale preparatory drawing for a pictorial composition, usually a large one such as a wall painting or a tapestry. Also a humorous drawing or caricature.

caryatid A *sculptured* female figure standing in the place of a *column*. See Fig. 35.

cast The molded replica made by the vasting process.

casting A process using plaster, clay, wax, or metal that, in a liquid form, is poured into a mold. When the liquid has solidified, the mold is removed, leaving a replica of the original work of art from which the mold was taken.

catharsis The cleansing or purification of the emotions through the experience of art, the result of which is spiritual release and renewal.

cathedra An episcopal throne, or throne for a bishop; also known by its Latin name *sedes* or ''see.''

cathedral The official church of a bishop containing his *cathedra*, or throne; a church that traditionally has been given *monumental* and magnificent architectural *form*.

cella An enclosed windowless chamber, the essential feature of a *classical* temple, in which the *cult* statue usually stood.

central plan In *architecture*, an organization in which *spaces* and structural elements are *ordered* around a central point.

ceramics Objects made of fired clay, such as pottery, tiles, vases, figurines, and building materials.

chamber music Music for small groups.

chamber opera An *opera* with a small cast and small orchestra designed for intimate surroundings rather than for a large opera house.

chanson de geste French for "song of heroic deeds"; an *epic* poem written in Old French during the 11th to 13th centuries and designed to be performed by *minstrels* and *jongleurs*.

chant A single liturgical melody for voice or chorus that is monophonic, unaccompanied, and in free rhythm. Various types are Byzantine, Gregorian, Ambrosian, Milanese, Visigothic (Mozarabic), Gallican.

chapel A small church or compartment within a church, castle, or palace containing an *altar* consecrated for ritual use.

chiaroscuro The art of *modeling* figures or objects in light and shade in order to get a

three-dimensional effect on a two-dimensional surface.

choir An organized group of singers or instrumentalists of the same class. In church architecture, the complex at the east end beyond the crossing, which could include apse, ambulatory, and radiating chapels.

choral That having to do with chorus.

chorale A *hymn* tune introduced in the German Protestant church by Martin Luther, who frequently wrote the texts and sometimes the *melodies*.

chorale prelude An organ piece based on a Protestant chorale, usually played before the congregation sings the chorale, or hymn.

chord Any combination of three or more tones sounded simultaneously.

chordal See chord.

chorus In ancient Greek drama, a group of singers and dancers commenting on the main action. In modern times, a *choir* or group of singers organized to perform in *concert* with one another. Music *composed* for a such a group.

chroma In *color*, the purity of a *hue*; synonymous with *intensity* and *saturation*.

chromatic From *chroma*; in the *visual arts*, that which has a full or broad *range* of *color*.

chromatic scale In Western music, the full set of *tones* or *pitches* available in an *octave*, or all the piano's white and black *notes* for an octave. The opposite of the *diatonic scale*, whose pitches would be sounded by the piano's white notes within an octave.

chromaticism Raised or lowered notes introduced into *diatonic* music, or used instead of the normal diatonic degrees of the *scale*, are called *chromatic notes*; chords involving their use are *chromatic chords*; harmony saturated with chromatic chords is *chromatic harmony*; and music overgrown with chromaticism is *chromatic music*. The *chromatic scale* is a twelve-note scale dividing the *octave* into twelve half-*tone* intervals—the seven diatonic tones plus the five altered degrees, as C, C-sharp, D, D-sharp, E, F, F-sharp, G, G-sharp, A, A-sharp, B.

civilization A *culture* in an advanced state of self-realization, thought to be characterized by marked efficiency and achievement in such realms as art, science, and letters, as well as in personal security and dignity.

classical All that relates to the *civilization* of Greece and Rome, and subsequent *stylistic* imitations of Western antiquity. *Classical* can also mean established excellence, whatever the period, *style*, or *form*.

clavecin French for "harpsichord."

clef French for "key"; in musical *composition*, a sign placed at the beginning of a *staff* to determine the placement of *notes*. See *bass*, *treble*.

clerestory A row of windows in the upper part of a *wall;* also, in church *architecture,* the upper portion of the interior walls pierced by windows for the admission of light. See Figs. 123. 185.

cloister A *monastic* establishment; more particularly, a covered passage, usually *arcaded*, at the side of or surrounding a courtyard within a monastery.

coda Italian for "tail"; a section at the end of a *movement* of a *composition* that serves as a

"summing up" by using previously heard thematic material. A short coda is often known as a codetta.

coffer In *architecture*, a recessed panel in a ceiling. Coffering can lighten both the actual and apparent weight of a massive ceiling and provide a decorative effect. See Fig. 110.

collage From "papiers collés," the French for "pasted papers"; a *composition* deriving from cubism and made by pasting together on a flat *surface* such originally unrelated materials as bits of newspaper, wallpaper, cloth, cigarette packages, and printed photographs.

colonnade A row of *columns* usually spanned or connected by *lintels*.

colonnette A small *column*, performing a decorative as well as a structural function.

color A perceived quality in direct light or in objects reflecting light that varies with the wavelength of the light energy, the brilliance of the light source, and the degree to which objects reflect or absorb the light energy falling on them. In paint, color is the light reflecting and -absorbing characteristic, which is a function of the *pigment* giving the paint its primary visual identity.

column A cylindrical post or *support* which often has three distinct parts: base, shaft, and *capital*.

comedy A light and amusing *play* or other literary work whose purpose is to arouse laughter in the beholder.

complementary colors Two contrasting hues that are found opposite each other on a color wheel, which hues neutralize one another when combined (such as red and green) and mutually intensify when placed adjacent to one another.

composer The writer of music or of musical *composition*.

Composite A *classical order* of temple *architecture* combining elements from *Ionic* and *Corinthian* orders, as the acanthus-leaf motif of the Corinthian order topped by the volutes of the Ionic. See Fig. 87.

composition An organization or arrangement imposed upon the component elements within an individual work of art.

compound pier In *architecture*, a *pier* with *columns* and *pilasters* bundled or clustered together, with each component usually corresponding to a member in the *ribs* and *vaults*.

compression In architecture, stress that results from two forces moving toward each other, as in dead weight or squeezing.

concert In music, artists performing together for an audience, or a single artist performing for an audience (a situation also known as a *recital*). Agreement or *harmony* among two or more factors.

concerting style A style that developed in 16th-century Venice by pitting *choirs, ensembles,* or soloists against each other in a variety of contrasting manners, as slow *tempo* vs. fast; *polyphony* vs. *homophony;* soft vs. loud.

concertino The small or solo *ensemble* in a *concerto grosso*.

concerto An *instrumental composition* featuring a soloist (violin, piano, cello, flute, etc.) pitted against a full *orchestra* and usually written in three *movements*.

concerto grosso An *orchestral composition* in which the *instruments* are divided into two

contrasting tonal bodies: a large (ripieno, or grosso) and a small (concertino) ensemble.

connoisseurship A discriminating knowledge of the qualities of art works and their *styles*.

consonance and dissonance Consonance occurs in an established tonal system when only the *tones* of that system are used. Use of a *note* outside the established tonal system creates a point of friction, or *dissonance*. Consonance thus achieves stability or repose, while dissonance causes tension and the feeling of motion toward a consonant resolution.

construction In *sculpture*, the process of making a *form* by assembling and joining a wide variety of materials, such as wood, cardboard, plastic, paper, and metal. See *assemblage*.

content See expressive content.

continuo (basso continuo) A contrapuntal concept favored by baroque composers. It is a continuous bass line defined sharply enough to function as a clearly distinguishable level within the musical complex. The continuo bass line is commonly played on a keyboard instrument by the left hand, while the right hand supplies filler parts improvisationally. Since numbers are often placed beneath the bass line to guide the player in realizing the filler parts, the continuo is also called figured bass. Because the continuo is also called figured bass instruments (lute, viola de gamba, cello, bassoon) usually supplement (or may substitute for) the keyboard.

continuo aria See aria

contralto Female voice part with low range; also called *alto*.

contrapposto The placement of the human figure in which one part is turned in a direction opposite that of the other (usually hips and legs one way, shoulders and chest another.)

contrapuntal The adjectival form of *counter-*

convention A formula, rule, or practice developed by artists to create a usage or *mode* that is individual to the artist, yet communicable to the *culture* of which he or she partakes. Conventions exist in both *form* and *subject matter*, and they constitute the vocabulary and syntax of the artist's language.

cool colors *Hues* generally in the blue, green, and violet section of the *spectrum*, Psychologically, cool colors tend to be calming and unemphatic; optically, they often appear to recede.

Corinthian The *classical order* of temple *architecture* characterized by slender fluted *columns* topped by highly carved, ornate *capitals* whose decorative *forms* derive from the acanthus leaf. See Fig. 38.

cornice Any horizontal architectural member projecting from the top of a *wall*; in *classical architecture* the crowning member of the *entablature*. See Fig. 31.

counterpoint The combination of two or more independent *melodic lines* into a single musical fabric; *polyphony*.

crescendo A continuous increase in loudness.

crossing In a cruciform church, the space formed by the intersection of nave and transent cross vault See Fig. 111.

cruciform Arranged or shaped like a cross.
crypt A vaulted chamber; wholly or partly underground, that usually houses a chapel and is found in a church under the choir.

cult A system of religious belief and its adherents.

culture The *values* and the system of their interrelationships that inform a society, motivate its behavior, and cause it to be functional to the general satisfaction of its members and to have a distinctive quality and character.

cuneiform The wedge-shaped characters of ancient writing in Mesopotamia, Assyria, and Persia.

D

da capo Italian for "from the beginning." Return to or repetition of the beginning.

da capo aria See aria.

daguerreotype An early form of photograph in which the image is produced on a silver-coated plate.

dance A *rhythmic* and patterned succession of bodily movements, usually performed to music.

decrescendo A progressive decrease in the level of loudness.

dentil From the French for "small tooth"; one of a series of small decorative blocks projecting just below the *cornice* of an *Ionic* or *Corinthian entablature*. See Fig. 74.

design A comprehensive scheme, plan, or conception. In *painting*, the pattern organization of a *composition*, usually seen in the arrangement of *lines* or the light-and-dark elements, rather than in *color*.

deus ex machina Latin for "a god from a machine"; a device in ancient Greek and Roman drama whereby a god is introduced by means of a crane to solve a plot that has thickened to such an extent that human solutions are impossible. Figuratively, any sudden and contrived solution to what appears to be an impossible situation.

development See sonata form.

diatonic The seven tones of a major (or minor) scale, corresponding to the piano's white keys in an octave. Diatonic chords are chords built of diatonic notes; harmonies composed mainly of such chords are diatonic harmonies. The opposite of chromatic.

diminuendo Diminishing in *intensity* or *dy-*

diminution Decreasing (usually halving) the *note values* of a phrase or section to achieve a quickening effect.

dissonance A discord or *interval* that creates a feeling of tension that demands resolution. See *consonance* and *dissonance*.

divertimento See serenade.

dome A hemispherical *vault*; theoretically, an *arch* rotated on its vertical *axis*. See Fig. 111.dominant The fifth *note* of a *diatonic scale*; a

chord built on the dominant.

Doric The oldest of the *classical styles* of temple *architecture*, characterized by simple, sturdy *columns* that rise without a base to an unornamented, cushionlike *capital*. See Fig. 31.

dramatis personae Actors or characters in a

- **drawing** A process of visualization by which an artist, using such *media* as pencil, chalk, or watercolor, delineates *shapes* and *forms* on a *surface*, typically paper or *canvas*.
- **duple meter** A marchlike *rhythm* based on two *beats* or some multiple thereof, as 2/8, 2/4, 4/4 time.
- **duplum** The second voice part counting upward from the *tenor* or *cantus firmus* in medieval *organum*.
- **dynamics** The various levels of loudness and softness of sounds and the increase and decrease of *intensities*.

E

- **echinus** The round cushionlike part of a Doric capital. See Fig. 31.
- **eclecticism** The practice of selecting from various sources, usually to form a new system or *style*.
- **elevation** An architectural *drawing* of the side of a building without *perspective* distortion. See Fig. 185.
- **empirical** Based on experiments, observation, and practical experience without regard to science and theory.
- **encaustic** A paint *medium* in which the *vehicle* is wax
- engaged column A columnlike form projecting from a wall and punctuating it visually. See Fig. 100.
- engraving A form of printmaking in which grooves cut into a metal plate are filled with ink and the plate pressed against absorbent paper after its surface has been wiped clean.
- **ensemble** A group of two or more musicians performing the same *composition*.
- **entablature** In *architecture*, that portion of a building between the *capitals* of the *columns* and the roof, including in *classical* architecture the *architrave*, *frieze*, *cornices*, and *pediment*. See Fig. 31.
- entasis The slight convex curving of classical columns to correct the optical illusion of concavity, which would result if the sides were left straight. See Fig. 31.
- epic A long narrative poem telling the tale of a hero.
- etching A form of printmaking requiring a metal plate coated with an acid-resistant wax, which is scratched to expose the metal to the bite of the acid. Lines eaten into the plate by the acid are subsequently filled with ink and transferred to paper after the surface of the plate has been wiped clean of excess ink.
- **ethos** Greek meaning "character." In art, that which gives a work *tone* or character and distinguishes it from other works. Also understood to mean the *ideal* or an ethical character.
- **Evangelist** One of the authors of the four *Gospels* in the Bible: Matthew, Mark, Luke, and John. Respectively, their *symbols* are an angel, a lion, an ox, and an eagle.
- exposition See sonata form.
- **expression** Having to do with those factors of *form* and *subject* that together give the work of art its *content* and meaning.
- **expressive content** The fusion of *form* and *subject* that gives art it meaning and significance.

F

- **façade** Usually the front of a building; also, the other sides when they are emphasized architecturally.
- **ferroconcrete** A building material composed of concrete with rods or webs of iron or steel imbedded in it. Also known as *reinforced concrete*.
- **finale** The final movement of a large instrumental composition; in opera, the ensemble terminating an act.
- **flat** A symbol (b) signifying that the *note* it precedes should be lowered by one half-step.
- **fluting** Vertical channeling, concave in shape, used principally on *columns* and *pilasters*.
- flying buttress A masonry support or segment of an arch that carries the thrust of a vault to a buttress positioned away from the main portion of the building; an important element of structure in the architecture of Gothic cathedrals. See Fig. 185.
- **foreground** In the *pictorial* arts, that part of the *composition* which appears to be closest to the viewer. See *middle ground, background,* and *picture plane*.
- **foreshortening** The effect of three-dimensionality made in two dimensions by basing *representation* on the principle of continuous decrease in size along the entire length of a *form* whose bulk is intended to be seen as receding in *space*.
- **form** In the *visual arts*, a *shape* or *mass*, or more comprehensively, the total arrangement of shapes, *structure*, and *expressiveness*. In music, the overall organization, structure, or *design* of a piece; the *ordering* in time of a *composition's* component sections. To give shape to something or achieve *style* in it.
- **format** In the *pictorial* arts, the *shape* (usually rectangular) of the *support* at its edges; also the encompassing *volume* of *space* in relation to which a *sculpture* or building seems to have its *formal order*.
- forte Italian for "loud"; fortissimo means "very loud"; fortississimo, "extremely loud."
- **French overture** A introductory *instrumental* piece first used at the 17th-century French courts and characteristically in two sections: a slow stately march with dotted *rhythms* in *duple meter* and a livelier mood with *fugal texture* and triple meter.
- **fresco** A process of *painting* on plaster, either wet or dry, wherein the *pigments* are mixed with water and become one with the plaster; a *medium* perfected during the Italian Renaissance
- **frieze** The central portion of the *entablature* between the *architrave* and the *cornice;* any horizontal decorative or *sculptural* band. See Fig. 31.

fugal See fugue.

fugue A *polyphonic composition* characterized primarily by the *imitative* treatment of a single *subject* or subject complex.

G

- **gallery** A long and narrow room or passage, such as that in the *nave walls* above the *aisles* of a church. See *triforium*.
- **genre** In the *pictorial* arts and *sculpture*, the casual *representation* of everyday life and sur-

- roundings. Also, a type, style, or category of art
- **geodesic** Architectural *structure* based on light, straight elements suspended together in a state of *tension*. Used mainly in the *design* and construction of *domes*.
- Gesamtkunstwerk German for a "complete," "total," or "consummate work of art"; a term coined in the late 19th century by Richard Wagner to characterize his *music dramas*, in which he brought about an alliance of all the arts—music, literature, theatre, and the *visual arts*—to realize a program of ideas.
- **glaze** In *oil painting*, a transparent film of paint laid over dried underpainting; in ceramics, a thin glassy coating fused to a clay body by firing in a kiln.
- **Gospels** Ascribed to Matthew, Mark, Luke, and John, the four biblical accounts of the birth, life, death, and resurrection of Jesus Christ. See *Evangelist*.
- **gouache** Watercolor made opaque by the addition of chalk.
- graphic Demonstration and description by visual means.
- **graphic arts** Vaguely related to the *linear* element, a term that identifies the *visual arts* of *drawing*, printmaking, typographic *design*, advertising design, and the technology of printing.
- **Greek cross** A cross in which all arms are the same length.
- Gregorian chant Liturgical music named for Pope Gregory I (590–604). Also known as plainsong, these chants are monophonic, unaccompanied melodies in free rhythm sung partly by soloists and partly by choir.

groin See Fig. 111.

groin vault See Fig. 111.

ground A coating, such as *priming* or *sizing*, applied to a *support* to prepare the *surface* for *painting*; also *background*.

ground bass See ostinato.

H

- harmonics High-pitched, otherworldly tones produced by touching the string of an instrument lightly with the finger so that it vibrates in segments rather than as a whole. Also called overtones.
- **harmony** The vertical or *chordal structure* of musical *composition;* the study of all relationships that can exist between simultaneously sounding *pitches* and the progressions of chords.
- **hedonism** The theory that pleasure is the principal goal and greatest good in life, a doctrine held by the Epicurean philosophers.
- **hierarchy** A system of persons or things that has higher and lower ranks.
- **hieroglyphic** A picture or a *symbol* of an object standing for a word, idea, or sound; developed by the ancient Egyptians into a system of writing.

high relief See relief.

homophonic See homophony.

- **homophony** Music in which a principal *melody* is supported by *accompaniment* in a *chordal* or *harmonic style*.
- **horizon line** A real or implied *line* across the *picture plane* parallel with its top and bottom

edges, which, like the horizon in nature, tends to fix the viewer's eye level and toward which in *linear perspective* all receding parallel lines seem to converge. See Fig. 250.

hubris Arrogance, as in a prideful act designed to supplant God with self.

hue The property of color that distinguishes one color from another as red, green, violet, etc. See saturation, value.

hymn A religious song meant to give praise and adoration.

hypostyle In Egyptian temple architecture, columns with a flat roof resting directly upon them to create a hall. See Fig. 13.

I

icon Greek for image, used to identify panel paintings made under Greek Orthodox influence that represent the image of a holy person—Christ, Mary, or a saint; such works often imbued with sanctity.

iconography In the pictorial arts and sculpture the meaning of the images and symbols depicted; subject matter.

ideal The representation of objects, individuals, and events according to a stylized, perfected, preconceived model; a kind of aesthetic distortion of perceived reality.

idealize See ideal.

idée fixe French for "fixed idea." Berlioz's name for a recurring melodic motif identified with the heroine in his Fantastic Symphony. In each movement the motif varies slightly to coincide with the musical and programmatic circumstances.

idol A representation or symbol of a deity used as an object of worship.

illusion See illusionism.

illusionism The attempt of artists to represent as completely as their formal means permit the visual phenomena of a palpably real world, even if imaginary, as in a scene of muscular and voluptuous bodies floating high in the sky.

image A representation of an object, an individual, or event. An image may also be an evocation of a state of being in representational or nonrepresentational art.

imagery In the visual arts, the particular subjects and objects chosen by an artist for depiction in a work, or, in the instance of totally abstract or nonrepresentational art, the particular forms and shapes with which the artist has composed a work.

imitation In musical composition, the successive restatement of a theme or motif in different voice parts of a contrapuntal complex. A canon is an example of strict imitation; modified forms occur by inversion, augmentation, and diminution.

impasto Paint laid on in richly textured quan-

improvisation On the spur of the moment, spontaneous musical composition for voice or an instrument. Also, in the performance of music, adding to the basic composition such decorative embellishments as chords and new melodies; a major aspect of baroque music and

incising Cutting into a surface with a sharp instrument.

instrument In music, a mechanism capable of generating the vibrations of musical sound.

See stringed instruments, woodwind instruments, brass instruments, and percussion instru-

instrumental See instrument.

instrumentation The practice by composers of organizing all instrumental possibilities for expression. It may also refer to the types and numbers of instruments used in a composition.

intensity In the visual arts, the relative purity or brilliance of a hue. In music, the relative softness or loudness of a tone.

interval In music, the distance between two notes as determined by pitch. A melodic interval occurs when two notes are sounded successively; a harmonic interval occurs when two notes sound simultaneously.

intervallic See interval.

intonazione Italian for "intonation." The 16th-century name for a prelude in which organists, by running their fingers rapidly over the keys and coming to a definite chordal cadence, established the pitch and mode for the choir prior to their singing a motet.

intrinsic Belonging to a thing by its very nature.

inversion In musical composition, a means of imitation by which the original ascending (or descending) voice is imitated by a descending (or ascending) voice at an equivalent intervallic distance.

Ionic One of the Greek classical styles of temple architecture, which developed in Ionia and Asia Minor and is distinguished by slender, fluted columns and capitals decorated with volutes or scrolls. See Fig. 31.

isocephaly In pictorial composition, figures arranged so that all heads align at the same level.

isorhythmic Polyphonic music in which the forms are compounded of sections unified by an identity of rhythmic relationships but not necessarily of melodic patterns.

J

jamb The upright piece forming the side of a doorway or window frame; on the portals of Romanesque and Gothic church architecture the place where sculptural decorations sometimes appear.

jazz An American music, originating in the black community early in the 20th century, in which players improvise on a melodic theme, expressing it in a highly personal way with syncopated rhythms and contrapuntal ensemble playing.

jongleur See minstrel.

K

key The pitch of the tonic (or tonal center within the tonality) established by the composer for a particular piece of music. It is the sum of all the musical relationships that can be perceived by constant comparison with a given pitch level. Also, a mechanism by which an instrument (piano, organ, clarinet, etc.) can be caused to sound.

keyboard The arrangement of keys on such instruments as the piano, spinet, and organ; therefore, "keyboard instruments."

keystone See Fig. 111.

L

lancet window A tall, narrow, pointed window used in Gothic architecture. See Fig. 185.

Ländler An Austrian peasant dance similar to a waltz and popular in the late 18th and early 19th centuries.

landscape In the pictorial arts, the representation of scenery in nature.

lantern tower A tower added above a dome to light the interior. See Fig. 222.

Latin cross A cross in which the vertical arm is longer than the horizontal arm, through whose midpoint it passes.

leading tone In music, the seventh degree of a major or minor scale; it pulls toward or "leads" to the tonic a half-step above.

legato Italian for "tied"; in music, the performance of notes in a smooth, continuous line; the opposite of staccato.

leitmotif German for "leading motif"; a melodic theme introduced by Richard Wagner into orchestral writing to characterize an individual, an idea, an inanimate object, etc., and developed to reflect transformations in the person, idea, or thing, recalling the past, prophesying the future, or explaining the present. lento Italian for "slow."

libretto (pl. libretti) Italian for "little book"; the text, words, or "book" of an opera, oratorio, or other musico-dramatic work.

Lied An art song in the German language. line A mark left in its path by a moving point, or anything, such as an edge, a boundary, or a horizon, that suggests such a mark; a succession of notes or ideas, as in a melodic line or a line of thought. The linear might be considered one-dimensional, as opposed to the spatial, which is either two- or three-dimensional.

linear See line.

linear perspective See perspective.

lintel In architecture, a structural member that spans an opening between posts or columns. See nost-and-lintel and Fig. 111.

lithography A printmaking process based upon the antipathy of grease and water. With a grease crayon or waxy liquid, a drawing is made on a slab of grained limestone or on a grained metal plate. The drawing is treated chemically so that each grain of the plate touched by the drawing medium can accept a greasy ink and each untouched grain can accept water and repel the ink. When the place has been wetted and charged with ink, an image in ink is retained that essentially reproduces the drawing. The printmaker then covers the plate with a sheet of paper and runs them both through a press, which offsets the drawing onto the sheet, thus producing the

liturgy A rite or body of rites prescribed for religious worship.

local color In romantic art and music, the use of ethnic or nationalistic folk idioms, scenes, dances, or poetry that depict picturesque set-

loggia A gallery open on one or more sides, sometimes with arches or with columns.

low relief See relief.

lyric Of or relating to the lyre, such as a song to be performed to lyre accompaniment. In a modern sense, that which is intensely personal, ecstatic, and exuberant, even poetic. Also (in the plural) words or verses written to be set to music. The lyric theater is that involving words and music, such as *opera* and musical *comedy*.

M

madrigal In the early 14th century, a secular two- or three-voice song with a fixed form: two or three verses set to the same music plus a concluding two-line ritornello with different music. The upper voices are usually in a florid style, with the lower notes written for longer values. In the 16th century, a secular four- or five-voice composition based on love poetry or lyrics, with no set form but highly imitative and often homophonic in passages.

major A type of diatonic scale in which halftones or semitones occur between the third and fourth, and seventh and eighth degrees of the scale (as opposed to the natural minor, in which the semitones occur between the second and third, and fifth and sixth degrees). A key or tonality based on such a scale.

masonry In architecture, stone or brickwork. mass In the visual arts, the act or implied physical bulk, weight, and density of threedimensional forms occupying real or suggested spatial depth. Also, the most solemn rite of the Catholic liturgy, consisting of both sung and spoken sections. It combines sections of the Ordinary (texts that do not change) in alternation with sections of the Proper (texts that vary for certain occasions or seasons). The sung sections of the Ordinary are Kyrie, Gloria, Credo, Sanctus, and Agnus Dei. The sung sections of the Proper are Introit, Gradual, Alleluia or Tract, Offertory, Communion, and Post-Communion. A cyclical mass contains sections of the Ordinary structurally coordinated by the presence of the same melody (i.e., cantus firmus) in the tenor. A polyphonic mass is the Ordinary set to music with two or more voice parts. The requiem mass is the mass for the dead.

matroneum Gallery for women in churches, especially those of the Byzantine style.

mausoleum A shrine or burial chapel.

measure A standard of comparison; in musical *composition*, a regular division of time, set off on the *staff* by vertical *bars*. In *rhythm* and *metrics*, "measured" means slow and stately.

medium (pl. **media**) In general, the process employed by the artist; in a more strict sense the binding substance or *binder* used to hold pigments together, such as linseed oil for *oil* paint. See *vehicle*.

melisma An extended sequence of *notes* sung to one syllable to text.

melismatic See melisma.

melodic See melody.

melody Single *tones* organized successively to create a musical *line*.

meter In poetry, the scheme of accented and unaccented *beats*. In music, the basic grouping of *beats* and accents into *measures*; e.g., the triple *meter* of a *waltz* is recognized by recurring patterns of three beats with an accent on the first beat.

metope Square slabs with or without sculpture that alternate with the *triglyphs* that form the *frieze* of a *Doric* temple. See Fig. 31.

metrical, metrics See meter.

mezzo Italian for "half," "middle," or "medium"; thus, *mezzoforte* means "medium loud," and *mezzo-soprano* means "middle soprano," or a female *voice* with a *range* between *soprano* and *contralto*.

middle ground In the pictorial arts, that part of the composition which appears to exist between the foreground and the background; the intermediate of the three zones of recession in linear perspective.

minnesingers German for "love singers"; German musicians of the aristocratic class who composed love songs in the medieval period. See *jongleur*, troubadours, trouvères.

minor In music, a type of diatonic scale in which the interval between the first and third notes or pitches contains three semitones (as opposed to four in a major scale). A key or tonality based on such a scale.

minstrel In the 12th and 13th centuries, a professional singing actor or mime in the service of a castle or wandering from town to town and from castle to castle. Also known as *jongleur*, and in an expanded meaning refers to *troubadours*, *trouvères*, and *minnesingers*.

minuet An elegant 17th-century French dance in moderate triple meter incorporated first into the suite and eventually into the sonata, symphony, or string quartet as the third movement. In the latter usage a minuet is in ternary form (ABA) employing a middle section called a trio, which is followed by a repeat of the minuet.

mobile A *constructed sculpture* whose components have been connected by joints to move by force of wind or motor.

mode A particular *form, style,* or manner. In music, the *ordering* of *pitches* into a *scale* pattern; also, a pattern of *rhythm*.

model See modeling.

modeling The *shaping* of three-dimensional *forms* in a soft material such as clay; also, the *representation* on a flat *surface* of three-dimensional forms by means of variations in the use of *color* properties.

modulation Movement from one *key* to another.

module A standardized two- or three-dimensional unit that is intended as a unit of *measure* in *architecture* or *sculpture*.

molto Italian for "much," meaning "very."
monastery A dwelling place where monks
live in a community for spiritual purposes.
monastic That having to do with monks and
monasteries.

monochrome A single *color* or the *value* variations of a single *hue*.

monophonic See monophony.

monophony Music in which one *voice* or a group of voices sings the same *melody*.

montage In the *visual arts*, a *composition* formed of pictures or portions of pictures previously photographed, painted, or drawn.

monumental A work of art or *architecture* that is grand, noble, timeless, and essentially simple in *composition* and execution, whatever its actual *size*.

mosaic A decorative surface for a floor or wall made of small pieces of glass, shell, ceramics, or stone set in cement or plaster. See Figs. 77, 124, 126.

motet A composition that developed in the 13th century when words *(mots)* were added

to the *duplum* (which became known as the *motetus*) of a *melismatic organum*. In the usual three-voice motets the *tenor* retained fragments of the original *plainchant melody*, and to each of the two upper voices new and different Latin texts were added. The 16th-century Renaissance motet is a four- or five-voice sacred *composition* developed by the Flemish composers and based on a Latin text. The musical *texture* is usually *polyphonic* with *imitation* between voices parts.

motif In music, a *melodic* or *rhythmic* fragment or *theme* capable of being developed into different and larger contexts. In the *visual arts*, the *subject* or idea of an art work, such as *still life* or *landscape*, or an individual feature of a subject or *form*, usually one that recurs or predominates in the *composition*.

movement A self-contained section of a larger piece of musical *composition*, such as a *symphony*.

mullions Vertical elements dividing windows into separate "lights" or glazed sections.

mural A painting on a wall, usually large in

mystical Having a spiritual meaning or reality that can be known only by intuition, insight, or similar subjective experience.

myth A legend or story that seems to express the worldview of a people or explain a practice or historical tradition.

N

narthex The porch or vestibule of a church. See Fig. 122.

natural In musical *composition*, a sign (ξ) meaning that, for the *note* to which it is attached, any previous indications of *sharp* (ξ) *or flat* (ξ) should be canceled.

nave The great central *space* in a church; in rectangular *plans* the space extending from the entrance to the *apse*, or to the *crossing* or *choir*, and usually flanked by *aisles*. See Fig. 122.

niche A hollow recess or indentation in a wall for a statue or other ornament.

nonobjective A synonym for nonrepresentational art, or art without recognizable subject matter.

nonrepresentational In the *visual arts*, works so abstract as to make no reference whatever to the world of persons, places, and the objects associated with them; art from which all identifiable *subject matter* has been eliminated.

notation The system and process for writing out music in characters and *symbols* so that it can be read for performance.

note A musical sound of a certain *pitch* and duration; the sign in written music for such a sound; a *key* on an *instrument* such as the piano or organ that when pressed makes a specific musical sound.

0

obbligato Italian for "obliged," meaning, in music, *parts* that must not be omitted; also, a decorative *line* of music meant to be heard as a foil to the main *melody*.

obelisk A tapering shaft of stone ending with a pyramidal top.

octave The *interval* from one *note* to the next of the same *pitch* name (as from C to C), either higher or lower, which is a span of eight *diatonic* notes.

oculus A round eyelike opening or window. See Fig. 110.

oeuvre French for "work"; the whole of an artist's production, or lifework.

oil painting The process of painting with a medium formed of ground colors held together with a binder of oil, usually linseed.

opera Theater in which music is the central dramatic agent. A typical opera involves a drama or play with scenery and acting with the text usually sung to the accompaniment of an orchestra. Various types exist: opera buffa (It.) is characterized by a light, simple plot with prominent comedic elements and spoken dialogue: opera seria (It.) normally employs recitative in place of spoken dialogue and involves a dramatic or serious plot; number operas employ a sequence of selfcontained musical "numbers" (arias, duets, choruses, etc.); music drama is the term used for Wagnerian operas, which substitute a continuous chain of music for musical numbers. See chamber opera.

opus Latin for "work"; in music a term used with a number to distinguish a particular composition or group of compositions within the chronology of the composer's total oeuvre or output.

oratorio A musical *composition* written for soloists, *chorus*, and *orchestra*, and usually based on a religious story or text. The latter may involve a plot or be purely meditative and nonnarrative. Oratorios are usually performed in concert halls or churches, without scenery, staging, or costumes.

orchestra In Greek theaters, the circular space before the proscenium used by the chorus. Also a group of instrumentalists, including string players, joined together to perform ensemble music.

orchestration The art and technique of arranging or *scoring* a musical *composition* for performance by the *instruments* of an *orchestra* or *hand*

order In classical architecture, a style represented by a characteristic design of the column and its entablature; see Doric, Ionic, Corinthian, and Composite. Also the arrangement imposed upon all elements within a composition; in addition, a harmonious arrangement. To arrange or organize something, give it order.

organic That which is living, such as plants; that which is integral to the whole; a system in which all parts are coordinated with one another.

organum From the 9th through the 13th centuries, the earliest *form* of *polyphonic* music, in which one or more *lines* of *melody* sound simultaneously along with the *plainsong*. In *parallel organum* (9th–10th centuries) an added *voice* runs exactly parallel and below the plainsong melody. In free organum (c. 1050–1150) the main melody occurs in the lower voice while the upper voice moves in a combination of parallel and contrary motion. In *melismatic* organum (c. 1150–1250) a few *notes* of the main chant or melody are prolonged and sustained in the lower

voice while the upper voice moves freely through the melismatic melody with numerous notes occurring for each note in the main chant. Two-part organum is known as organum duplum; three-part organum as organum triplum.

ostinato Italian for "obstinate," which in musical *composition* is the persistent repetition, usually in the *bass*, of a clearly defined musical figure or phrase, while other *parts* or *voices* change around and above it. Also called *basso ostinato* or *ground bass*.

overture *Instrumental* music written usually to precede an *opera*, *oratorio*, or *ballet*. It may be an entity unto itself or directly related to the music that follows. Also, a *concert piece* in one *movement*, often with an extramusical references.

P

painterly Painting in which the buttery substance of the medium and the gestural aspect of paint application constitute a principal aspect of the art's quality.

painting Traditionally, painting has been thought of as an art form in which colors are applied through a liquid medium to a flat surface, called a ground or support. A dry powder called pigment is the coloring agent in painters' colors, and, depending on the binding agent or binder used, pigments can produce such media of paint as oil, tempera, watercolor, fresco, encaustic, casein, and acrylic resin. These can be worked on such grounds or supports as paper, canvas, wood panel, and plaster. If the support has been given a preparatory coating by priming and sizing, the surface thus formed is considered to be the ground, which intervenes between the painting and its support.

palette A tray or *shaped planar surface* on which a painter mixes *colors*; also the characteristic *range* and combination of colors typical of a painter or a *style* of *painting*.

panel Any rigid, flat support for painting, such as wood, usually prepared, with a ground. Any flat, slablike surface, usually rectangular in shape.

pantheon Greek meaning all the gods of a people; a temple dedicated to them; a public building containing tombs or memorials of the illustrious dead.

parallel organum See organum.

part In musical *composition*, the writing for a single *instrument* or *voice* or a group of them; also, a section of a composition.

pathos Greek meaning the experience of emotion, grief, or passion. In art, an element that evokes pity or sympathy.

pediment In *architecture*, the triangular *space* or gable at the end of a building, *formed* in the *entablature* by the sloping roof and the *cornice*. See Fig. 31.

pendentive In *architecture*, a triangular segment of masonry whose plane is hemispherical, four of which can form a transition from a square to a circular base of a *dome*. See Fig. 130.

percussion instruments Drums, celesta, chimes, triangle, tambourine, castanets,

gongs, cymbals, glockenspiel, etc., all of which must be struck or shaken to make a musical sound.

performing arts The arts that have their full existence only in time and that to realize full existence must be played: music, *dance*, and drama.

peristyle A *colonnade* surrounding a temple or court.

perspective A pictorial technique for simulating on a flat, two-dimensional surface, or in a shallow space, the three-dimensional characteristics of volumetric forms and deep space. During the Renaissance in Italy, a quasimathematical scheme called linear perspective developed from the fact that parallel lines going in one direction away from the viewer must be seen as converging toward a single point on the horizon known as a vanishing point. (See Fig. 250.) Placed, in this system, at intervals along the assumed and converging parallels, objects are scaled in their sizes to diminish in relation to their distance from the picture plane. In northern Europe, at about the same time, painters developed a perspective system known long before to the Romans and the Chinese. Called atmospheric or aerial perspective, the system employed blurred outlines, loss of detail, alteration of hues toward the cool colors, and the diminution of color saturation and value contrast—all in proportion to the distance of the object from the viewer. See foreshortening.

piano Italian for "soft"; pianissimo (pp)
means "very soft"; pianississimo (ppp), "extremely soft."

pictorial That having to do with the flat arts of painting and drawing and, to a certain extent, with the art of low relief, in that its threedimensional subject matter and imagery are composed in relation to a flat rear plane that physically is parallel to and only slightly behind what would be a picture plane and whose edges constitute a frame or format of specific shape like that of a picture. Picture or pictorial space is that of the support, which is a flat surface defined by a specific shape, usually rectangular. To achieve here, at the picture plane on the support, the appearance of deep space, the artist must employ such illusionistic devices as modeling, foreshortening, and perspective so that, in a still life or landscape, for instance, objects and forms seem to rest firmly on a ground plane at intervals beginning in the foreground and moving through the middle ground to the background and beyond.

picture plane An imaginary vertical *plane* assumed to be at the front *surface* of a *painting*.

picturesque A pictorial situation that awakens thoughts of the *sublime*, magnificent, quaint, vivid, or rugged as opposed to the orderly, symmetrical, or beautiful.

pier A mass of masonry rising vertically to support an arch, vault, or other roofing member.See Figs. 111, 185.

pietà A devotional *image* of the sorrowing Virgin holding the dead Christ.

pigment Finely powdered coloring matter mixed or ground with various *vehicles* to *form* paint, crayons, etc.; also a term used loosely to mean *color* or paint. **pillar** Any vertical architectural member pier, column, or pilaster.

pitch A musical tone, or its relative highness or lowness as fixed by the frequency of the vibrations occurring per second within it.

pizzicato Italian for "plucked"; in musical composition an instruction to the performer to pluck the strings of an instrument instead of bowing.

plainsong From early medieval Christian worship, a type of sacred music or *liturgical* chant, monophonic in style and set to a Latin text. Sec Gregorian chant.

plan An architectural *drawing* that reveals in two dimensions the arrangement and distribution of interior *spaces* and *walls* as well as door and window openings, of a building as seen from above.

planar See plane.

plane A *surface* that is defined and measurable in two dimensions.

plastic That which is capable of receiving physical *form;* therefore, the *visual arts.* More narrowly, that which is pliant and malleable enough to be *modeled;* therefore, the material of *sculpture.*

plasticity The three-dimensional quality of a *form,* its roundness and apparent solidity; the capability of material for being *shaped, modeled,* and manipulated.

play A literary text consisting of dialogue composed to be acted out in dramatic form for the benefit of an audience.

player One who performs.

plot In literature, the plan or scheme of the story and its unfolding actions.

poco Italian for "little."

podium A platform, base, or pedestal for a building or a monument.

polychoral style *Compositions* in this style employ a *chorus* (with or without *orchestra*) divided into two or more groups that sing and play in alternation *(antiphonally)*. Venetian music at the end of the 16th century featured this style.

polychrome Several *colors* rather than one *(monochrome)*.

polymeter The use of different *metrical* units in successive *bars* of a *composition*.

polyphony A *texture* created by the interweaving of two or more *melodic* lines head simultaneously. *Counterpoint* is the technique used for composed polyphonic music.

polyrhythm Two or more *rhythms* combined in such a way that they are heard simultaneously, as the duple rhythm or two *beats* in the treble, triple rhythm or three beats in the *bass*.

polytonality Music in which two or more *keys* or *tonalities* are heard simultaneously.

portal An imposing door and the whole architectural *composition* surrounding it.

portico A porch with a roof supported by columns and usually with a entablature and a pediment.

post-and-lintel In architecture, a structural system employing two uprights or posts to support a member, the lintel or beam, that spans the *space* between the uprights. See Fig. 31.

prelude A musical composition designed to introduce the main body of a work—an opera; a separate concert piece for piano or orchestra, usually based on a single theme. See chorale prelude.

presto Italian for "fast."

primary colors Colors that in various combinations are capable of creating any other color or hue. In artists' pigments these are red, yellow, and blue; in natural or "white" light, they are red, green, and blue. See color, complementary colors.

prime To prepare a canvas or panel for painting by giving it a ground of white paint or one made with a gluey or resinous substance called sizing.

program music Broadly speaking, music that consciously imitates sound effects (bird calls, bells), describes natural or social events (thunderstorms, hunting scenes), or narrates a sequence of dramatic episodes derived from poetic and dramatic sources. In the 19th century, it refers principally to *instrumental* music based on a series of actions or a sequence of episodes designed to make narrative or dramatic sense, and declared by the composer to be subject to some sort of literary, *pictorial*, or philosophic interpretation.

proportion The relation, or ratio, of one part to another and of each part to the whole with regard to *size*, height, width, length, or depth.

proscenium From the Greek meaning "before the *skene*"; the proscenium *arch* is that which is set before the *stage space* and frames it in traditional theaters.

prosody The art of setting words to music. Also, a particular system or *style* of versification.

prototype An original *model*, archetype, or primary form from which other artists make copies or adaptations.

psalter A book of the psalms (*hymns*) found in the Bible.

pylon In Egyptian *architecture*, a monumental gateway shaped in profile like a truncated pyramid and leading to the forecourt of a temple.

R

range The extent and limitation of a series, such as the *notes* that a human *voice* is capable of singing, or a sequence or *values* from light to dark.

realism A mid-19th-century style of *painting* and *sculpture* based upon the belief that the subject matter of art and the methods of *representation* should be true to life without *stylization* or *idealization*.

recapitulation See sonata form.

recital See concert.

recitative In *opera, oratorio,* and *cantata,* a *form* of declamation that, although highly *stylized* and set to music, follows the *pitch* and *rhythms* of speech more than a *melodic line*. Recitative tends to serve a narrative function and often leads into an *aria* or connects arias and *ensembles*.

register A *range* (upper, middle, lower) within the capacity of the *voice*, human or *instrumental*.

reinforced concrete See ferroconcrete.

relief A *plane* that exists three-dimensionally as a projection from a *background*. Also, *sculpture* that is not freestanding but projects from a *surface* of which it is a part. When the projection is relatively slight, it is called *bas-relief* or *low relief*: when the projection is very pronounced, it is called *high relief*.

reliquary A small box, casket, or shrine for keeping sacred relics, usually made of and decorated with precious materials.

representation The depiction or illustration by the *graphic* means of the *visual arts* (*lines, values, colors,* etc.) of *forms* and *images* in such a way that the eye would perceive a correspondence between them and their sources in the real world of *empirical* experience.

representative style A type of *word painting* by which the descriptive *imagery* of the text is reflected in the *shape* and turn of the *melodic lines*

requiem See mass.

responsorial singing Alternate singing hetween a soloist and a group.

retrograde A term that indicates the employment of a *theme* or phrase in reverse order, starting on the last *note* of the *melody* and ending with the first.

rhythm In the *visual arts*, the regular repetition of a *form*. In music, all factors pertaining to temporal organization in music, including the comparative duration of *tones*, *meter*, and *tempo*.

rib In architecture, a slender arched support that in a vault system typically projects from the surface along the groins where semicircular vaults intersect each other. Ribs both reinforce the vaults and unify them aesthetically. See Fig. 183.

ribbed groin vault A *groin vault* reinforced with *ribs*. See Fig. 187.

ricercar An instrumental composition that developed in the 16th and 17th centuries as a counterpart to the vocal motet. It is characterized by the periodic recurrence of the first subject, and as each subsequent subject or subject complex appears, it ushers in a new section featuring contrapuntal imitations and variation techniques. The ricercar is the prototype of the later fugue.

ripieno The large *ensemble* in a *concerto grosso*.

ritardando In music, the gradual slowing of tempo.

ritornel, ritornello Italian for "refrain"; a recurrent passage in a *concerto, rondo, operatic* scene, etc.

rondo A musical *form* in which one main *theme* recurs to alternate with other themes, making a *structure* that can be diagrammed as ABACADA.

round A type of *canon* in which all *voices* enter at the *unison*.

rubato The fluctuation or variation of *tempo* within a bar or phrase without destroying the basic *meter*.

rusticate In *masonry* work, to build a wall of rough-hewn stone for bold *texture* and strong light-and-shade contrasts.

S

- **sanctuary** A consecrated, sacred, or holy place; in Christian *architecture*, that part of the building where the *altar* is placed; also a refuge.
- sarcophagus A stone coffin.
- **satire** A witty exposure of vice and folly, the purpose of which is to entertain and effect moral reform.
- **saturation** The purity, vividness, or *intensity* of a *color*.
- **scale** Relative or proportional *size*. In music, a succession of tones usually arranged in ascending or descending order and either a whole *tone* or a half-tone apart.
- scherzo Italian for "joke"; in sonatas, symphonies, and quartets, a movement substituted for the minuet and, like the minuet, composed in triple meter but at a faster tempo. Normally, the scherzo is linked with a trio in a sequence of scherzo, trio, and scherzo repeat.
- **score** The written version of music, with all *parts* indicated both separately and in relation to one another. To prepare music in written *form*.
- scriptorium In a medieval monastery, the workroom for the copying and illumination of manuscripts.
- **sculptural** That which is *plastic* or has to do with *sculpture*.
- sculpture A type of three-dimensional art in which *form* is created by subtractive or additive methods. In subtractive sculpture the form is found by removing (as in carving) material from a block or *mass*. In additive sculpture, the form is built up by *modeling* in clay, by *constructing* with materials as a carpenter or welder might, or by *assembling* such preexisting forms as found objects. Whatever the method, the final form can be *cast* in a material, such as bronze, that modifies from a liquid state to a hard and permanent one. Sculpture can be freestanding or *relief*.
- **section** An architectural *drawing* showing the side of a building without *perspective* distortion.
- **secular** Not religious, but relating to the worldly or temporal.
- **sequence** In musical *composition* the repetition of a *melody* or *motif* at different *pitch* levels. Historically, sequence refers to a musical style that first came into use in the 9th century by adding text syllabically to the long *melismas* on the final vowel of an alleluia. Eventually the melismas were elaborated or altered musically, and the sequences became highly developed as separate *compositions*. All but four were banished from the *liturgy* by the 16th-century Council of Trent.
- serenade, divertimento Instrumental compositions that originated in the 18th century for use at festive occasions, outdoor performances, or evening gatherings. Such works contain from two to six or more movements consisting of marches, dances, spritely allegros, and at least one andante. They are usually scored for woodwinds when intended for outdoor performance and for a combination of strings and woodwinds, or strings alone, for use indoors.
- **serial music** A collective term applied to 20th-century music that not only uses a *tone*

- row or series as its basic structural component, but also serializes *rhythms*, *timbres*, *dynamics*, etc. See *twelve-tone technique*.
- **sforzando (sforzato)** A strong *dynamic* accent.
- **sfumato** Italian for "smoked," a misty blending of light and dark tones to create soft edges and veiled effects. A type of *chiaroscuro*.
- shade, shaded See shading, value.
- **shading** The property of *color* that makes it seem light or dark. See *value*.
- **shape** A two-dimensional *area* or *plane* with distinguishable boundaries, such as a square or a circle, which can be *formed* whenever a *line* turns or meets, as in an S-shape or a T-shape
- **sharp** A sign (#) in musical *composition* instructing the performer to raise the *note* it precedes one half-step higher.
- **silhouette** A *form* as defined by its outline. **size** The physical magnitude of objects, *forms*, elements, and quantities. See *scale*; also *prime*.
- **skene** In the theaters of ancient Greece, which were open-air, the small building that provided for performances both a stage and a background. It is the root word for "scene" and "scenery."
- **sonata** Italian for "sounded"; in musical *composition*, an *instrumental* work usually written in three or four *movements*.
- sonata form A structural principle employed in a movement of instrumental music. It consists of three main divisions: the exposition, during which the musical materials of the movement are presented or "exposed" in the tonic key and a new key (the entire section is usually repeated); the development, in which the musical ideas of the exposition are worked out and explored in various keys to provide tension and contrast; and the recapitulation (reprise), which resolves the tension and contrast of the development by restating the exposition, but with all the themes in the tonic and usually with minor changes in orchestration or musical materials. A coda may be added in conclusion.
- **song** The simultaneous presentation of a literary text and a musical setting. The basic types are strophic, in which the *melody* is repeated over and over to different stanzas of the poem, and *through-composed*, in which the *melody* and *accompaniment* vary for each successive stanza.
- **song cycle** A group or series of *songs* sharing a common thought, theme, or musical treatment, and intended to be sung consecutively.
- soprano Vocal or *instrumental* register with the highest range. Soloists may be designated as coloratura soprano, a vocalist with great agility in the high register, capable of performing rapid, dazzling, *cadenza*like passages typical of 18th- and 19th-century *operatic arias;* dramatic soprano, a powerful and declamatory voice that extends downward to the *mezzo* region; or lyric soprano, a voice with light *texture*, considerable brilliance, and a capacity for sustained *melodic* singing.
- **space** A volume available for occupation by a form; an extent, measurable or infinite, that can be understood as an area or a distance capable of being used both negatively and positively.

- **spandrel** A triangular *space* above a *clerestory* window in a *barrel-vault* ceiling; also the *surface* between two *arches* in an *arcade*. See Fig. 184.
- **spatial, spatiality** That having to do with *space*.
- **spectrum** The full array of rainbow *colors* that appear when white light (sunlight) has been refracted into its component wavelengths by means of a transparent substance, such as a prism.
- squinch See Fig. 131.
- **staccato** Italian for "detached"; in musical composition an instruction to perform notes in a short and detached manner. The opposite of legato.
- **staff** The five horizontal *lines* and four intervening *spaces* on which musical *notation* can be written out. See *clef*, *bass*, *treble*.
- **stele** A stone slab carved in *relief* and set upright to commemorate a person or event.
- **stereotype** Something conforming to a fixed or general pattern.
- **still life** In the *pictorial* arts, an arrangement of inanimate objects—fruit, flowers, pottery, etc.—taken as the *subject* of a work of art.
- stoa In the agoras of ancient Greece, a building of one or two stories in the form of a colonnade or roofed porch providing space for a walkway and shops, offices, and storerooms.
- **stretcher** A wooden or metal framework upon which a painter's *canvas* can be stretched.
- stretto Literally, a narrowing or quickening process achieved by a faster tempo or diminution of the note values. In a fugue, stretto is the imitation of a subject in two or more voice parts in rapid succession so that the statements overlap, causing an increase of intensity.
- **string quartet** An *ensemble* of two violins, viola, and cello; a *composition* in *sonata form* written for such an ensemble.
- stringed instruments The violin, viola, violoncello (or cello), and double bass, all of which are equipped with strings capable of generating musical sound when either stroked with a bow or plucked.
- **structure** The compositional relationships in a work of art; a building or other constructed architectural unity; the operative framework that *supports* a building.
- style The terms form and style, "formal analysis" and "stylistic analysis" serve interchangeably in any discussion of the way artists work or the way their art works once it has been accomplished. Both form and style are concerned with those measurable aspects of art that caused the elements, principles, and materials to come together as a composition; but they are equally concerned with the expressive content of a work. They signify a sensitive, knowing, trained, and controlled shaping and ordering of ideas, feelings, elements, and materials. Style can be the identifying characteristic of the work of a single artist, of a group of artists, or of an entire society or culture.
- stylize To simplify or generalize forms found in nature for the purpose of increasing their aesthetic and expressive content.
- **stylobate** In Greek temple *architecture*, the upper step of the base that forms a platform for the *columns*. See Fig. 31.

subject In the visual arts, the identifiable object, incident, or situation represented. See iconography. In music, the theme or melody used as the basic element in the structure of a composition, as in a fugue.

subject matter See subject.

sublime The *representation* of the violent, wild, and awesome aspects of nature as opposed to beauty, which is based upon *symmetry*, *proportion*, and elegance.

suite In music, a collection of various movements without specific relationships in key or musical material. The music usually is dancelike, since suites before 1750 consisted almost invariably of four principal dance movements: the allemande, the courante, the sarabande, and the gigue. Often, simply excerpts from scores for ballet and opera.

summa An encyclopedic summation of a field of learning, particularly in theology or philosophy.

support In the *pictorial* arts, the physical material serving as a base for and sustaining a two-dimensional work of art, such as paper in the instance of *drawings* and prints, and *canvas* and board *panels* in *painting*. In *architecture*, a weight-bearing structural member.

surface The two-dimensional exterior *plane* of a *form* or object.

symbol A *form, image,* sign, or *subject* standing for something else; in the visual arts, often a visible suggestion of something invisible.

symmetry An arrangement or balanced *design* in which similar or identical elements have been organized in comparable *order* on either side of an *axis*.

symphonic poem, tone poem A term first applied by Liszt to a one-movement orchestral work of the late 19th century based on an extramusical idea (illustrative, literary, pictorial, etc.). The symphonic poem is a type of program music.

symphony An *orchestral composition* commonly written in three or four *movements*. In a typical symphony the first movement is fast and in *sonata form;* the second is slow and can be in sonata, *binary, ternary,* or *variation* form. The third movement (sometimes omitted) is a *minuet* (scherzo) and trio; the *finale,* usually in sonata or *rondo* form, is in a lively tempo.

syncopation Stressing a *beat* that normally should remain weak or unaccented.

synthesis The deduction of independent factors or entities into a compound that becomes a new, more complex whole.

T

tabernacle A receptacle for a holy or precious object; a container placed on the *altar* of a Catholic church to house the consecrated elements of the Eucharist.

taste The evidence of preference having to do with enjoyment and appreciation.

tempera A *painting* technique using as a *medium pigment* mixed with egg yolk, glue, or casein.

tempo In music, the pace or rate of speed at which the *notes* progress.

tenor The highest *range* of the male *voice*, or an *instrument* with this range. In medieval *or*-

ganum the voice that sustains the notes of the *chant* or *cantus firmus*. More generally, the *line* in musical writing corresponding to the tenor range.

tensile In *architecture, structure* that is capable of sustaining *tension*.

tension *Balance* among opposing forces; a state of unrest. In *architecture*, stress from two forces moving in opposite directions, like the pulling and stretching imposed on bridge cables.

ternary form A common three-part musical *structure* consisting of three self-contained sections, with the second specifically in contrast to the first and the third a repeat or modified repeat of the first: ABA or statement, contrast, restatement.

terra-cotta Italian meaning "baked earth"; baked clay used in ceramics, *sculpture*, and architectural decoration; also a reddishbrown *color* similar to fired red clay.

tetrachord A series of four notes. Two tetrachords in succession form a *scale* or *mode*.

texture In the *visual* or *plastic arts*, the tactile quality of a *surface* or the *representation* of that surface. In music, the relationship of the *me lodic* elements and the elements that accompany them, and the particular blend of sound these create

thematic See theme.

theme In music, a short *melodic* statement or an entire self-contained melody; *subject matter* to be treated in a *composition* through *development*, *imitation*, contrast, *variation*, expansion, juxtaposition, etc.

through-composed An *opera* with the whole of its text set to music; music that varies according to the needs of the text, instead of following a preconceived pattern of repeats and contrasts

thrust A strong continued pressure, as in the force moving sideways from one part of a *structure* against another.

timbre *Tone color,* or the particular quality of sound produced by a *voice* or an *instrument*.

toccata Italian for "touched"; music composed for keyboard instruments, written in a free style with running passages, chords, and sometimes imitative sections.

tonality See key.

tone In music, a *note*; that is, a sound of definite *pitch* and duration. In the *visual arts*, a general coloristic quality, as this might be expressed in a degree of *saturation* and *value*.

tone poem See symphonic poem.

tonic The first and principal *note* of a *key*, functioning as a place of rest or home base and acting as a point of departure and return.

tragedy A serious drama or other literary work in which conflict between a protagonist and a superior force (often fate) concludes in calamity for the protagonist, whose sorrow excites pity and terror in the beholder and produces *catharsis*.

transept In a *cruciform* church, the whole arm set at right angles to the *nave*, which makes the *crossing*. See Fig. 122.

treble In music, the higher *voices*, both human and *instrumental*, the *notes* to whose music appear on a *staff* identified by a treble $clef(\frac{\delta}{2})$.

triad In music, the simultaneous sounding of three *notes* to make a *chord* of only three

pitches built up in thirds from the root note.

triforium In church *architecture*, an *arcaded area* in the *nave wall* system that lies below the *clerestory* and above the *gallery*, if there is one, and the nave *arcade*. It can be open like a gallery or be sealed (blind). See Figs. 184, 185.

triglyph A slab divided by two vertical grooves into three bands. The panels that alternate with the *metopes* to form the *frieze* of a *Doric* temple. See Fig. 31.

triplum In the music of medieval *organum*, the third *voice part* counting upward from the *tenor* or *cantus firmus*.

triptych A painting consisting of three panels. A two-paneled painting is a diptych; a many-paneled one is a polyptych.

trompe-l'oeil French for "fool the eye"; a type of *representation* in *painting* in which the *illusion* of *form, space,* light, and *texture* has been so cunningly contrived as to convince observers that what they perceive is the actual *subject matter* and not a two-dimensional equivalent.

troubadours, trouvères French musicians of noble lineage who flourished in the 12th and 13th centuries composing secular songs dealing with chivalry, knighthood, the Crusades, woman, and historical subjects. *Troubadours* stemmed from southern France, trouvères from the north. Their German counterparts were the minnesingers.

trumeau A post or *pillar* placed in the center of a portal to help *support* the *lintel* above, especially in medieval *architecture*. See Fig. 193

tune A song or melody; a musical key; the correct pitch or tonality.

tunnel vault A barrel vault. See Fig. 111. twelve-tone technique A 20th-century method of composition devised by Schoenberg in which the seven diatonic and five chromatic tones are treated equally, so that no tonal center is apparent. Compositions are based on an arbitrary arrangement of these twelve tones. and their sequence is known as a tone row or series. The notes of a row must always be used in the established order but may be repeated or moved from one octave position to another. The row may also be used in inversion, retrograde form, retrograde inversion, or be transposed to any step of the chromatic scale. A series may also be arranged vertically to form chords.

tympanum In medieval architecture, the surface enclosed by a lintel and an arch over a doorway; in classical architecture, the recessed face of a pediment. See Fig. 151.

T

unison The "zero" interval that occurs when two voices or different instruments simultaneously play a note or melody at the same pitch.

unity The quality of similarity, shared identity, or consistency to be found among parts of a composition; a logical connection between separate elements in a work of art; the opposite of variety.

upbeat The *note* that occurs before the first accented *tone*.

V

value The property of color that makes it seem light or dark; shading. In music, the duration of a note. In general, the relative worth accorded to an idea, a concept, or an object.

vanishing point In linear perspective, that point on the horizon toward which parallel lines appear to converge and at which they seem to vanish. See Fig. 250.

variations A theme and variations is a musical form that consists of the statement of a melody or theme followed by various modifications of it.

variety Contrast and difference, the lack of sameness among separate elements in a composition; the opposite of unity.

vault A masonry or concrete roof constructed on the principles of an arch. See Fig. 111.
 vehicle The liquid in which pigments are dispersed to make paint. See medium.

verisimilitude The appearance of being true to the reality of the tangibly present world; in the visual arts, a kind of naturalism or realism. See illusionism, representation, trompe-l'oeil.

vibrato Fluctuation of pitch achieved by string

players through a shaking motion on the string. Vocalists often employ a similar wavering pitch to increase the emotional quality of their *tone*.

visual arts Those arts that appeal to the optical sense—*painting, sculpture, drawing,* printmaking, *architecture,* etc.

vivace Italian for "lively" or "vivacious."

voice The sound made by the human throat or by a musical *instrument*; the *part* in music written for that sound.

void A hollow or empty space.

volume Any three-dimensional quantity that is bounded or enclosed, whether solid or *void*.
 volutes Scroll-like spirals that characterize the *Ionic capital*. See Fig. 31.

votive From the Latin for "vow," an offering made to God or in his name in petition, in fulfillment of a vow, or in gratitude or devotion.

voussoir See Fig. 111.

W

wall In architecture, a planelike upright structure and surface capable of serving as a support, barrier, or enclosure. **waltz** A *dance* in moderate triple meter that developed from the Austrian *Ländler* in the early 19th century.

warm colors *Hues* in the red, yellow, orange, and sometimes violet sections of the *spectrum*. Psychologically, warm colors tend to excite and stimulate; optically, they appear to advance.

wind instruments See woodwind and brass instruments.

woodwind instruments The flute, oboe, English horn, clarinet, bass clarinet, bassoon, contrabassoon, and saxophone, all of which are pipes with holes in the side and can produce musical sound when blowing causes their columns of air to vibrate. Several of the woodwinds have mouthpieces fitted with reeds.

word painting See representative style.

Z

ziggurat A stepped pyramid in Mesopotamian architecture.

Index

arch, defined, 102

arch, triumphal, defined, 118

(Fig. 187); Babylonian, 7

arch-and-vault construction, 102

(Fig. 111), 188 (Fig. 185), 189

References are to page numbers, except for illustrations, which are also identified by figure numbers. Works have been listed under the names of their creatorscomposers, painters, poets, sculptors, etc. Architectural works and the paintings, sculptures, mosaics, etc. associated with them—in other words the visual arts not collected into museums—have additionally been listed under the cities where they are now to be found. The purpose of this feature is to serve the reader who may have the opportunity to travel and wish to use Arts € Ideas as a handbook-guide to the monuments it discusses. The Table of Contents should be consulted for further guidance to passages on periods, styles, media, and ideas Unless repeated in the text, the events, births, and deaths cited in the Chronologies at the opening of chapters have not been indexed. Many technical terms are included in the index with citations where they are defined in the text. For a more complete list of terms the reader should consult the Glossary, which commences on page 620.

Aachen, Germany, Charlemagne's (Imperial) Chapel, 141 (Fig. 145) abacus, 26, 28 (Fig. 31); defined, Abclard, **181**; Sic et Non, **204** absolutism, **387–389**, **393**, **412**– 413, 426 abstract expressionism, 563, 564, 565, 566-579, 618, 619 abstraction, defined, 52 abstractionism, 522, 524-526, 532, 534, 536, 548, 550, 563, 570, 576, 618-619 a cappella, defined, 281 academicism, **328**, **367**, **380**, **413**–**414**, **448**, **450**–**451**, **452**, **457**, 468, 471 acra, defined, 22 action painting, 568-572 Adam de la Halle, 172 Adam of St. Victor, 201 Adams, Henry, 178 Adams, John, Harmonielehre, 610 Aeschylus, 15, 24, 25, 45, 49, 57, **450**; Agamemnon, **44**; Electra, **533**; Eumenides, **543**; The Persians, **42**; The Suppliants, **48** Aesop, 165 Aeterne rerum Conditor (Hymn of St. Ambrose), 135 African art, 526, 527, 529, 561; mask from Etoumbi, 524 (Fig. 482) Age of Observation, **371, 384** Agesander. See Laocoön Group Agripentum, Sicily, 55, 83 airs, defined, 402 Aix-la-Chapelle. See Aachen, Germany Akhenaten. See Amenhotep IV

Albers, Josef, 564; Homage to the

Square, 577 (Fig. 543); Homage

to the Square: Floating, 576 Albert of England, 502 Alberti, Leone Battista, 260, 279, 314, 599; church in Rimini, Italy, of, 500; On Architecture. 237, 250, 265; On Painting, 237, 250, 265 Albertus Magnus, 181; Mariale. 193 Alcuin of York, 141 Aldine Press, 312 aleatory music, 587, 619 Alexander the Great, 21, 71–72, 76, 77, 253, 442; Pergamene bust of, 59 (Fig. 67)
Alfred the Great, 133 Altdorfer, Albrecht, Danube Landscape Near Regensburg, 309 (Fig. 289) Ambrose, St., and Ambrosian liturgy, 134-35 ambulatory, defined, **28, 146** Amenhotep III, Hypostyle Hall of, **9** (Fig. 13) Amenhotep IV, Hymn to Sun of. Amiens, France, 182; cathedral, 185, 188, 191 Amsterdam, Holland, 17th century, 367-370, 371; Jewish century, 307–370, 371, Jewish cemetery, 376 (Fig. 359), 377; Jewish ghetto, 374, 381; Oudekerk, 367, 377, 380 Angelico, Fra, 248–249, 261; Annunciation, 247 (Fig. 239), **248–249, 261;** frescoes of San Marco, 236 Anglican Church. See Church of England Anne of Cleves, **300** Anne of England, 411 Anthemias of Tralles, 126 (Fig. 133) antiquarianism: classical, 343; defined, 82; 15th century, 231; Napoleonic, 456-457; Renaissance, 233, 267, 273, 282, 306; romantic, 460 Antoninus Pius, 108 Antwerp, Belgium, 235, 281, 380, 394, 396 Apelles, Venus Anadyomene, 253 Aphrodite of Cnidos, 41, 42 (Fig. 56), 81 Aphrodite of Cyrene, **81** (Fig. 85) Apollo, **35, 46, 49, 50, 53, 57, 114, 275, 279, 389, 393, 394,** 402, 606; cult of, 73 Apollo Belvedere, 81 (Fig. 86), 267, 269, 443 Apollodorus, 25, 69 Apollodorus of Damascus, Basilica Ulpia, 89 (Fig. 94), 92 (Fig. 97); Forum of Trajan, 87, 88 (Figs. 92, 96); Roman baths of, 97; Trajan's Column, 89 (Fig. 94) Apollonaris, **117** apse, defined, 89, 117 apsidal chapels, defined, 146 Apuleius, Golden Ass, 104 Aquinas, St. Thomas, 181, 206, 226, 518; Summa theologiae, 193, 204, 207

Ara pacis Augustae. See Rome

arcade, defined, 118

(Fig. 11); Gothic, **188** (Figs. 185–188), **189**; Hellenistic, **63**; Roman, **21**, **97** (Fig. 103), **102** (Fig. 111); Romanesque, **146** (Fig. 149), arches, triumphal Roman, 271, 346 archetype, defined, 54 Archimedes, 81, 137, 279 architectonic, defined, 18-19 architrave, defined, **27** archivolts, defined, **149** Aretino, Pietro, **336** aria, defined, **402**; concerted aria, defined, 412; continuo aria, defined, **410**; da capo aria, defined, **410**; ostinato aria, defined, 410 Arian Christians, 114, 116, 117, 119, 120, 122, 134 Aristophanes, 24, 44; Lysistrata, 26, 545 Aristotle, 19, 21, 44, 56, 59, 81, 82, 204, 226, 228, 231, 259, 263, 278, 282, 456; Ethics, 279; Organon, 137; Poetics, 45-46, 53, 57, 457, 606; Politics, 49 Aristoxenus of Tarentum, **82** Arius of Alexander, **114**, **134** Arles, France, Abbey Church of St. Trophime, **144** (Fig. 147), 145, 149 Arnolfini, Giovanni, 291 ars perfecta, defined, 281, 325 art deco, 554-556, 614 asceticism, monastic Romanesque, 157 - 159Asopodorus of Philius, 108 Assisi, Italy, Basilica of St. Francis, **215**; Giotto frescoes, **217–219**; Martini's chapel, **209**; Upper Church, **216** (Fig. 209), 217 (Fig. 210), 219 (Fig. 212) Athena, 22, 31, 46, 49, 50, 53, 57, 60, 61, 63, 67, 68, 74, 75, 107, 193, 279; birth of, 34-35 (Fig. 43), 37, 38 Athena Lemnia, **41, 42** (Fig. 55) Athena Polis. See Pergamon, Turkey, subentries Athena Slaying Giant, 67 (Fig. 74) Athenaeus, 107-108 Athenodorus. See Lacocoön Group Athens, Greece, 109; Acropolis, 23 (Fig. 23), 25 (Figs. 25, 26), 26–33, 38, 60, 80, 87, 143; agora, **24** (Fig. 24), **26** (Fig. 27), **60, 77**; Delian League, **24, 38**; Erechtheum, **25** (Fig. 26), 30 (Fig. 33), 31 (Figs. 34, 35), **32** (Fig. 36), **87**; Hephaestum, **55–56**; Odeion of Herodes Atticus, **25** (Fig. 25); Panathenaea, **34–35**, **38**; Panathenaic Way, **26** (Fig. 27), 60; Parthenon, 19, 25 (Fig. 26), 26, 27 (Fig. 30), 28-29 (Fig. 30), **31, 33–39** (Figs. 39–47), **50, 56, 57, 619**; Parthenon marbles, **33–39** (Figs. 39–47); Propylaea, 25 (Fig. 26), 26, 27

(Figs. 28, 29), 30 (Fig. 33), 446; Temple of Athena Nike, 25 (Fig. 26), **26, 32** (Fig. 37); Temple of Olympian Zeus, **32**, 33 (Fig. 38); Theater of Dionysus, **25** (Fig. 25) atrium, defined, **118**Attalus I, **61**, **63**Attalus II, **71**, **82**Attalus III, **82** Attalus the Savior. See Attalus I Aucassin et Nicolette, 172 Auden, W. H., Age of Anxiety, 566 auditorium, defined, 43 Augustine, St., 138, 156; Confessions, 134-135; De Musica, 204 Augustus Caesar, Emperor, **87**, **94**, **104**, **105**, **109**; statue of, **85** (Fig. 88) aulos, defined, 73 Austen, Jane, Northanger Abbey, 470; Sense and Sensibility, 432 authoritarianism, early Christian, 136-137; medieval, 228 Autun, France, cathedral's *Last Judgment*, **159** (Fig. 163) Avignon, **209**, **281** ayre, defined, **303**

B Babbitt, Milton, 587, 611, 619; Vision and Prayer, 588 Babylon, 19; Hanging Gardens, 7; Ishtar Gate, **7** (Fig. 11); Musicians Playing at Ashurbanipal's Banquet, 7 (Fig. 10) Bacchus, 43, 321. See also Dionysus Bach, Johann Sebastian, 338, 380-383, 611, 619; B-minor Mass, 380, 383; Cantata No. 140, 382; Christmas Oratorio, 382; comparison of, with Handel, 410, 411, 415; "Es ist genug," 537; "Goldberg" Variations, 586; Passion oratorios, 382, 383; St. Matthew Passion, 382-383, 488; Wachet auf, ruft uns die Stimme (Sleepers Awake), 382 back-to-nature movement, romantic, 483-486, 487 Bacon, Francis (1561-1626), 404: Advancement of Learning. Bacon, Francis (1910-), Painting (The Butcher), 548 (Fig. 515) Ballu, Théodore, Church of Ste. Clotilde, 471-472 (Fig. 440) balustrade, defined, 313 Balzac, Honoré de, **491, 496**; Human Comedy, **495, 518** Bamberg, Germany, cathedral sculpture, 214 (Fig. 208), 215 Bamberg Rider, 214 (Fig. 208), 215 Barbarossa, Frederick, **489** Barberini, Maffeo. *See* Urban VIII, Pope barrel (tunnel) vault, defined, 102 (Fig. 111) Barry, Charles, Houses of Parliament, 470 (Fig. 478) Barth, John, 618

Bartlesville, Oklahoma, Price Tower, **552** (Fig. 520), **553** Bartók, Béla, **599**; *Bluebeard's* Castle, 543 basilica, defined, **88**; early Roman Christian structures, **117–122** (Figs. 119-127), 146, 156 bass, fixed, Gothic, 200 Battle of Issus, 71-72, 73 (Fig. 78) Baudelaire, Charles Pierre, "Correspondences" from Flowers of Evil, **496** Bauhaus, **556** (Fig. 525), **557,** 563, 564, 576 Bautista de Toledo, Juan, Escorial Palace, 354 (Fig. 336), 355 (Fig. 337) Bavaria, Upper, Wieskirche, 423, **424** (Fig. 396) bay, defined, 102, 146 (Fig. 111) Bayeux Cathedral, 166, 178 Bayeux Tapestry, 94, 164-168 (Figs. 168, 169), **169** (Fig. 170), 177, 178, 179 Baziotes, William, 567 Bear Run, Pennsylvania, "Falling Water," (Kauffmann House), 553 (Fig. 521), 554 Bearden, Romare, 606; Before the Dark, 608-609 (Fig. 575) Beaubourg. See Paris, Pompidou Center Beaumarchais, Pierre Augustin Caron, 435 Beauvais, France, 182; cathedral, 185, 188, 207 Becket, Thomas à, 213 Beckett, Samuel, Waiting for Godot, 617 (Fig. 580), 618 Beckford, William, 469, 470; Vathek, 481 Beebe, Thomas Hall, Harold Washington Center, 614 Beethoven, Ludwig van, 453-455, 457, 459, 475, 478, 611; Creatures of Prometheus, 454; Erocia (Third) Symphony, 453-**455;** Fidelio, **453;** Fifth Symphony, **455;** Ninth Symphony, **455**; *Pastoral* Symphony, **483** Bellini, Gentile, Brass Ensemble, 326 (Fig. 309); Procession in St. Mark's Square, 272 (Fig. 290), 317, 326 Bellini, Giovanni, Madonna and Child, 317 (Fig. 300); St. Jerome Reading, 317 (Fig. 299) Bellini, Jacopo, **317** Beneventum, Italy, Trajan's Arch, **83** (Fig. 87) Benoiste, Marie Guillemine, Portrait of a Black Woman, 481 (Fig. 444) Beowulf, 168 Berg, Alban, 599; Violin Concerto (1935), **537**; Wozzek, **534** Bergson, Henri, **518–519**, **616**; Creative Evolution, 498 Berlin, Germany, Brandenburg Gate. 446 Berlioz, Hector, 453, 455, 459, 463, 471, 472, 474-476, 468, 479; Damnation of Faust, 460, 474; Doré caricature of, 474 (Fig. 441); Fantastic Symphony, **460, 474–476, 488;** Eight Scenes from Faust, **460;** Harold in Italy, 460, 474; Memoirs, 474; Requiem, 474, 488; Romeo and Juliet, 460, 474; The Trojans, 488 Bernini, Gianlorenzo, 343, 345, **346, 365, 389, 390, 413, 463;** *Apollo and Daphne,* **393–394** (Fig. 372); Coronaro Chapel, 351, 352 (Fig. 334); Fountain of Four Rivers, 349, 351

(Fig. 333); Louis XIV bust, 393 (Fig. 371); St. Peter's Basilica, (Fig. 371), 81. Fetch Spasnica, colonnades, **268** (Fig. 254); St. Teresa in Ecstasy, **319**, **335**, **351**, **353** (Fig. 335), **393** Bernstein, Leonard, **529** Berry, Duke of, Book of Hours, 211, 212 (Fig. 205), 213 Berzé-la-Ville, Cluniac fresco (Christ in Glory), 153 (Fig. 156), 159 bestiaries, defined, 149 Beuys, Joseph, 585; How to Explain Pictures to a Dead Hare, Bible, early printings of, 233, 307-**308**; Gutenberg, **288**Birth of Athena, **34–35** (Fig. 43) bitonality, defined, 559 Bizet, Georges, Carmen, **483** Black Death, **219–223, 228, 231** Bladen, Ronald, X, 579 (Fig. 546) Blanche of Castile, 189, 194, 196 Der Blaue Reiter (Blue Rider) movement, 525, 531, 533 Blin, Roger, 617 Boccaccio, Giovanni, 231, 241; and Black Plague, 219, 473; Corbaccio, 219; Decameron, 219, 229 Boccioni, Umberto, Unique Forms of Continuity in Space, 538 (Fig. 499) Boethius, 134, 154, 194, 204, 226; The Consolation of Philosophy, 133, 137 Boffrand, Germain, Hôtel de Soubise, Salon de la Princess, **422** (Fig. 392) Bohr, Niels, **563** Boileau, Nicolas, 387, 391, 414, Bologna, Giovanni, 333-335; Rape of the Sabine Women, 335 (Fig. 317), 338; Winged Victory, **334** (Fig. 316), **335** Bonaparte, Pauline, **451** Bonaventura, St., 181 books, early printed, 288, 312, 343, 416 Borgo San Sepolcro, Palazzo Communale of, 252; Piero della Francesca's Resurrection for, **251** (Fig. 243) Borromeo, Carlo, **343** Borromini, Francesco, 343, 365, 423; San Carlo alle Quattro Fontane, 346, 347 (Figs. 326-328) Bosch, Hieronymus, 292-294; Garden of Earthly Delights, 293 (Fig. 276), Haywain, 294 Boston, Massachusetts, Public Library, **488**Botticelli, Sandro, **236, 241, 249,** 250-254, 257, 260, 261, 274, **283**; Adoration of the Magi, **251**, **252** (Fig. 244), **262**, **263**; Birth of Venus, **253**, **254** (Fig. 246), 283, 294; Primavera (Allegory of Spring), 252, 253 (Fig. 245), 283, 294, 545 Boucher, François, Toilet of Venus, **426** (Fig. 399), **441**, **446** Boulez, Pierre, **595** bourgeois. *See* domesticity, patronage of arts bourgeois drama, defined, 428 Bourges, France, 182; House of Jacques Coeur, 202, 203 (Fig. 198) Boyle, Robert, 414, 415 Bramante, Donato, **117, 267, 279, 406;** Tempietto, **282** (Fig. 270) Brancusi, Constantin, Beginning of

the World, 527; Bird in Space,

527, 528 (Fig. 487)

Braque, Georges, **524**, **534**, **565**; *Oval Still Life*, **535–536** Breton, André, **541** Brighton, England, Royal Pavilion, 481 (Figs. 445, 446), 482, 500 broken-pediment motif, defined, Bronzino, **329**; Allegory of Venus, **330**, **332** (Fig. 313), **333**, **338** Die Brücke (The Bridge) movement, 525, 531 Bruckner, Anton, 478 Bruegel, Pieter, the Elder, 294-295, 309; Peasant Wedding Feast, 294 (Fig. 277), 295, 301; Hunters in the Snow, 295 (Fig. 278) Bruges, Belgium, 288, 289, 291, 292, 296 Brunelleschi, Filippo, 240, 241-246, 250, 260, 261, 265, 279, 314; dome of Santa Maria del Fiore, 236-238 (Figs. 222 225), 261; Pazzi Chapel, 238, **239** (Figs. 226, 227), **240** (Fig. 228), **261**, **282**; Sacrifice of Isaac, 242 (Fig. 230) Bunshaft, Gordon, Lever House, 589 (Fig. 556) Bunyan, John, Pilgrim's Progress, Burke, Edmund, 433, 459; Philosophical Enquiry into the Origins of Our Ideas of the Sublime and the Beautiful, **569** Burkhardt, Jacob, 269 buttress, defined, 127 buttressing, 127, 128, 147, 148. See also flying buttresses Buxtehude, Dietrich, 338 Byrd, William, 281, 303 Byron, George Gordon, Lord, **459**, **460**, **462**, **469**, **470**, **474**; Phillips portrait of, 478 (Fig. 442), **479**; quoted, **479** Byzantium, **116**, **135**, **140** Caccini, Giulio, 325 cadenza, defined, 135 Caen, France, St. Étienne, **176** (Figs. 176, 177), **177–179**; St. Trinité, 176-179

Cage, John, 566, 586, 587-588, 611 Cagliari, Paolo. See Veronese, Paolo Calder, Alexander, 582; mobile, East Wing, National Gallery, **596** (Fig. 566) Callicrates, **25**; Parthenon, **27** (Fig. 30); Temple of Athena Nike, **32** (Fig. 37) Calvin, John, **308**, **327**, **367**, **416** Calvinism, 380, 381 Cambio, Arnolfo di, 236 (Fig. 222) Cambrai, France, 281 Cambridge, England, **211** Camillus, **441** canon, musical, defined, 39; defined as *oeuvre*, 281 Canon of Polyclitus, 39 Canova, Antonio, 457; Napoleon, **451, 452** (Fig. 423); Pauline Bonaparte as Venus, **451** (Fig. 422) cantata, 309, 382 Canterbury, England, cathedral, 209, 213 Canticle of the Sun (St. Francis), 223, 225, 226, 228 cantilever, defined, 552; and cantilevering, **552**, **553**, **554**, **557**, **558**, **589**

cantus firmus. 199 Capella Palatina (Charlemagne's Chapel), **141** (Fig. 145) capitals of columns, defined, 26; Byzantine, in San Vitale, 130 (Fig. 138); at Cluny Abbey Church, **154**, **155** (Figs. 157– 160), 156: Tuscan formation, 106; from Vézelay church, 150 (Figs. 152, 153), 152 Cappella Giulia (Julian Choir), Cappella Sistina (Sistine Choir), **267**, **268**, **280–281**, **345** Caravaggio, Michelangelo Merisi da, 605; Boy with Basket of Fruit, 606; Calling of St Matthew, 346-347, 348 (Fig. 329); Conversion of St Paul, 347-348, 349 (Fig. 330) Caro, Anthony, **595** Carraci family, **328** caryatids, 31 (Fig. 35); defined, 32 Casanova, Giacomo, 435 Cassatt, Mary, 508; Boating Party, 509 (Fig. 473) Cassiodorus, 119, 133, 134, 137, 143, 152 Castiglione, Baldassare, 265; Book of the Courtier, 263, 302 catacombs, Roman, **109**; early Christian paintings in, **93**, **113**, 114 (Fig. 115); sarcophagal uses. 123 catharsis, defined, **46** cathedra, defined, **132**; of Maximian, 132-133 (Fig. 141) cathedral schools, 191-192, 193, 199, 204 cathedrals, Gothic, 181, 182-185, 209-213, 214-215 Catherine of Russia, **422** Cato, **105** Catullus, **104** Cavalli, Francesco, **338, 401, 409** cave paintings, prehistoric, 2 (Fig. 1), 19, 605 Caxton, John, 288 cella, defined, 26 Cellini, Benvenuto, 327, 329, 333-335, 394; autobiography, 263, 333; Perseus with the Head of Medusa, 334 (Fig. 315) saltcellar of Francis I, 333 (Fig. 314) Cervantes, Saavedra, Miguel de, Don Quixote, 104, 362, 436 Cézanne, Paul, 507, 509, 511-514, 517, 519, 522, 524, 534, 538, 605; Basket of Apples, 428, **513, 514** (Fig. 478); Mont Ste, Victoire (1885–87), **512** (Fig. 476), 513; Mont Ste, Victoire (1904-1905), 513 (Fig. 477) chaconne, defined, 410 Chagall, Marc, 541, 564, 565; I and the Village, 540 (Fig. 502) Chalgrin, Jean François, 445, 446 chamber opera, defined, 409 Chamberlain, John, Miss Lucy Pink, **581** (Fig. 549) Chambers, William, 481 chambre group, and Vingt-quatre violons, 400, 401, 402 Chandigarh, India, 16 chanson de geste, defined, 168; example, 172 Chanson de Roland. See Song of Roland chantefable, defined, 172 chapelle, 400-401; defined, 402 Chardin, Jean-Baptiste-Siméon, Grace at Table, 428, 429 (Fig. 402); Still Life: Bowl of Plums, a Peach, and Water Pitcher, 428, 430 (Fig. 404)

Charioteer, from Delphi, 40 (Fig. 51) Charlemagne, 140-141, 169, 170, 173, 177, 178, 189, 489 Charles I of England, 362, 403, 416 Charles II of England, 387, 403, **404, 417** Charles V, Holy Roman Emperor, 286, 327, 333, 352, 254, 489 Charlottesville, Virginia, Monticello, 315; Rotunda, University of Virginia, 315, 446, **447** (Fig. 417) Chartres, France, cathedral, **182**, **183** (Fig. 180), **184** (Figs. 181, 182), 201, 203, 204, 205, 209, 211, 472, 619; architecture of, 185-190 (Figs. 183-188), 205 (Fig. 199); as shrine to the Virgin Mary, 183-184, 189, 191, 195; sculpture, 190-194 (Figs. 189-193), 228; stained glass, 189, 190, 194-199 (Figs. 194–196) Chartres, France, cathedral school, **191–192, 193, 199, 204** Chateaubriand, François René, Chaucer, Geoffrey, Canterbury Tales, 213; translation of Boethius, 133 Chenier, André, 457 Cheops, Pyramid of, 8-9 (Fig. 12) Chesterton, G. K., 229 chiaroscuro, defined, 329 Chicago, Illinois, Auditorium Building, 614; Chicago Picasso, 522 (Fig. 480); Harold Washington Center, 614; jazz, 528, 529 Chirico, Giorgio de, **541**, **565**; Melancholy and Mystery of a Street, **539** (Fig. 501), **540**; The Menacing Muses, **559**, **560** chivalry, code of, 206 choir: broken, 325, 328, 338; double, baroque, 417; Gothic, 189, 199-201 choleric, defined, 299 Chopin, Frédéric, 463, 474, 476; "Revolutionary" etude, 478 chorale prelude, defined, 382 chori spezzati, defined, 325 chorus: in English opera, 409-412, 415, 417; in French baroque opera, 402; in Greek drama, 48-49, 53-54, 57 Chrismon symbol, 129, 131, 132 Christ: representations of, as child (late medieval works), 213. 221, 222 (Fig. 215), 230, as Counter-Reformation avenger. 343; as Orpheus, 140 (Fig. 144), as shepherd, **114** (Fig. 115); —, by Caravaggio, 346, 348 (Fig. 329), by Dürer, 296 (Fig. 280), by Dutch Protestant, 369, by El Greco, 358, 359 (Fig. 342), 360 (Fig. 343), by Leonardo, **256** (Figs. 245, 246), **329**, by Michelangelo, 269, 270 (Fig. 257), 277 (Fig. 265), 345, by Rembrandt, 373 (Fig. 352), by Veronese, **324** (Fig. 308, 325; — , in catacomb art, **113,** 114 (Fig. 115), in early Christian art (Ravenna), 119-**122, 124,** in Florentine Renaissance art, 249 (Fig. 241), **250, 251** (Fig. 243), **252, 254, 255** (Figs. 247, 248), in *Ghent Altarpiece*, **289** (Fig. 273), **291,** in Marriage of Giovanni Arnolfini and Giovanna Cenami, 291 (Fig. 274), in Isenheim

Altarpiece, 298 (Fig. 282), 299 (Fig. 283), 300, in Royal Portal of Chartres Cathedral, 191 (Fig. 189), 192 (Fig. 190), 193, 194, in Sant' Apollinare Nuovo, 119 (Fig. 124), 125 (Fig. 125); — , Romanesque, **149**, **159** (Fig. 163); and Junius Bassus sarcophagus, 113-14, 115 (Fig. 115), and St. Francis of Assissi, 215; symbolism of, in Klee, 542 Christianity and early Christians, 111, 113, 114, 115–116 Christo, Running Fence, **584**; Surrounded Islands, **584**, **585** (Fig. 554); Valley Curtain, 584 Church of England, 327, 403, 406 Churriguera, José de, 355; altarpiece for San Esteban, 356 (Fig. 339) Churrigueresque style, defined, 355 Cicero, 104, 194, 226, 230, 441 Cimabue, Giovanni, 220-221, **229;** Madonna Enthroned, **222** (Fig. 215) Cimon, 24 citharoedus, defined, 134 cities: building and growth of, 111, in 18th century, 421, 439, Gothic, 202, in 19th century, 491, 492, 507, 509; and 20thcentury art, 538, 548, 550, 553 city and civil planning: Hellenistic, 80; Pergamon, 60, 62–63; Roman, 100–102, 105– 106, 108 (Fig. 114), 143; versailles as model for, 393; by Wren, 407-408 city-state, Florentine, 235-236 Claes, William, 369; Still Life with Oysters, Rum Glass and Silver *Cup*, **370** (Fig. 349) Classe, Italy, **119**, **120**; Sant' Apollinaire, **118–122** (Figs. 124– 127), 137, 138 (Fig. 142), 139 (Fig. 143); Sarcophagus of Archbishop Theodore, 132 (Fig. 140) classic, academic definition of, 414 classical unities. See unities, classical classicism: 18th-century Augustan English, 403; late medieval, 231; Renaissance, 233, 252, 282, 283, 288, 329; romantic, 486-489 Claudel, Paul, 544 Clement VII, Pope, 327 Cleophon, 53 clerestory, defined, 97 Clodion, Intoxication of Wine (Nymph and Satyr), 426, 428 (Fig. 401) cloister: at Cluny, 144-145; of Escorial Palace, 345 (Fig. 336); of St. Trophime, 144 (Fig. 147), 145; of St. Marco (Florence), 249; of Salisbury Cathedral, 211; of San Pietro in Montorio, 282; of Santa Croce (Florence), 239 (Fig. 226), 240 (Fig. 228) Clovio, Giulio, 360 Cluny, France: Abbey of, 143 (Fig. 146), 144, 182, 185, 187, 188, 199, 201, manuscripts, 152–153, metal works in, 152, murals, 153 (Fig. 156), music of, 153-156; Romanesque urban dwelling at, 164, 165 (Fig. 167); Third Abbey Church, 145, 146-150 (Figs. 148, 149), 153, 154, 155 (Figs. 157-160),

156, 161

Cocteau, Jean, Antigone, 544

coda, defined, 455 coffer, defined, 100 Cohen, J. M., Life of St. Teresa, Colbert, Jean-Baptiste, 389, 390, 413 Cole, Thomas, 605; Last of the Mohicans, **486**, **487** (Fig. 453) Coleridge, Samuel Taylor, "Kubla Khan," **481–482** Colette, The Child and the Sorceries, Cologne, Germany, cathedral, **214** colonnade, defined, **26** color-field painting, **572–573** columns: caryatids, **31** (Fig. 35), 32; Composite order, 106; Corinthian, 28 (Fig. 31), 32, 33 (Fig. 38), 89, 92 (Fig. 97); Doric, 26-31 (Fig. 35), 32, 55-56, 57; fluting, 29; Ionic, 30 (Fig. 33), 31-32 (Figs. 34, 37), 98; monumental, 87, 89 (Fig. 94), **93** (Fig. 98), **94** (Fig. 99); Tuscan, **98, 106** *comédie-ballet*, defined, **401** comedy, defined, 44 composition, defined, 17-18 compression, defined, 102 (Fig. 111) computer art, 579, 580, 582-583 computerized music, 619 Conant, Kenneth J., 118 (Fig. 121), 143, 146 (Fig. 149) conceptual art, **563**, **579**, **583**–**585** concertato, **325** concerto form, 325 concerto-grosso form, 341 concitato, defined, 327 concretion, defined, 52 Condorcet, Marie Jean, Progress of the Human Spirit, 438 Congregation of the Oratory (Oration Fathers), **341, 343** Congreve, William, **412** Constable, John, 470, 484-485; Hay Wain, 463, 484 (Fig. 449); Salisbury Cathedral from the Bishop's Garden, 463, 484 (Fig. 450) Constantine, 109, 115, 117, 279, 321; and Council of Nicaea, 114; and Edict of Milan, 113 Constantinople, 21, 100 (Fig. 135), **111, 115, 122, 126,** 129, 135, 137, 140, 143, 145, 181, 233 Contest of Apollo and Marsyas, 73 (Fig. 79), 74 continuo, defined, 380 contredanse, defined, 436 contrapuntal, defined, 199 conventions, defined, 16 Cooper, James Fenimore, **488**; Last of the Mohicans, **486** Copernicus, 341, 414, 415, 558; Revolution of the Celestial Bodies, 288; On the Revolution of the Planets in Their Orbits, 328 Copland, Aaron, 529, 564 Corday, Charlotte, 441 Cornaro family, chapel of, 352 (Fig. 334) Corneille, Pierre, **341**, **399**; *The* Cid, 413; Les Horaces, 448 cornice, defined, 28 (Fig. 31) cornu ("horn"), 103 Corot, Jean-Baptiste Camille, 446, 483 corporation pictures, Dutch, **369**, **371** (Fig. 350), **372** (Fig. 351), 385 Council of Nicaea, 114 Council of Trent, 291, 343, 345, 363

Counter-Reformation, 16, 327,

338, 341, 343-352, 400, 422;

church ceilings of, 416 (Fig. 391), 417; Spanish, 352, 354-363 courantes, 410 Courbet, 492, 495, 502, 599, 605; Burial at Ornans, 493 (Fig. 455) Coysevox, Antoine, equestrian relief of Louis XIV, 413 (Fig. 390) Cranach, Lucas, the Elder, 309; Luther as Augustinian Friar, 308 (Fig. 288) Crates of Mallus, 82 crèche, defined, 382 Crete, **12, 14;** Palace at Knossos, **13** (Fig. 18) Cro-Magnons, cave paintings of, 1, 2 (Fig. 1) Cromwell, Oliver, 213, 387, 403, cross (groin) vaulting, 97, defined, 102 (Fig. 111) cubism, 489, 495, 521, 524, 526, 534–537, 538, 557, 559, 564, 567, 569, 570, 571, 597, 609, 618, 619 cuirass, defined, 85 cuneiform, defined, 3 Cupid, **85**, **253**, **352**, **426**, **606** cupola, defined, 124, 236 Cyclades Islands, idol from, 13 (Flg. 19)

 \mathbf{D} dadaism, 521, 525, 539, 540-541, 564, 580 Daguerre, Louis-Jacques, 503 daguerreotype process, 503 Dali, Salvador, 448; The Persistence of Memory, 541 (Fig. 504) Dante Alighieri, 209, 229, 231, 241, 280, 450, 475, 488, 496, 498; Divine Comedy, 78, 205, 226-228, 336, 463-464, 472-474; Giotto portrait of, 227 (Fig. 220) d'Apulia, Nicola. See Pisano, Nicola Darius, 72 Darwin, Charles, 419, 559 Daumier, Honoré, 428; Third-Class Carriage, 491-492 (Fig. 454), 547, 550 David, Jacques-Louis, 446-450, 459, 464, 478, 481; Lictors Bringing Back to Brutus the Bodies of His Sons, 448 (Fig. 419), 449; Madame Recamier, 449 (Fig. 420), 451, 457; Oath of the Horatii, 447 (Fig. 418), 449, 466 Davies, Peter Maxwell: Ave Maris Stella, **610**; Eight Stars for a Mad King, **610**; St. Thomas Wake, 610 Debussy, Claude, 491, 517, 518, 519, 529, 537; The Children's Corner, 528; The Engulfed Cathedral, 514; Feux d'Artifice, 514; Ibéria: Fêtes, 514; La Mer, 514; Pelléas et Melisande, 515-516; Sounds and Perfumes Turn on the Evening Air, 514 Degas, Edgar, Cotton Exchange at New Orleans, 494 (Fig. 458) deism, 437-438 de Kooning, Willem, **564**, **565**, **576** Delacroix, Eugène, 459, 462-464, 467, 471, 472, 485, 488; Dante and Vergil in Hell, 463 (Fig. 428), 464, 472; Faust lithographs, **460**, **262** (Figs. 426, 427); *Liberty Leading the People*, 1830, **460–461**

(Fig. 425), 462, 468; Margaret

Delacroix, Eugène (cont.) in Church, 462 (Fig. 427) Massacre at Chios, 479, 480 (Fig. 443); Mephistopheles Flying, 462 (Fig. 426); Pietà, 561 Delian League, 24, 38 del Tredici, David, 609 Demeter, Persephone, and Iris, 36 (Fig. 44) demos, defined, 22 Denis, Maurice, 511 dentil range, defined, 65 DeQuincey, Thomas, Confessions of an English Opium Eater, 474 Derbyshire, England, Haddon Hall, 211 (Figs. 203, 204) descant, defined, 200 Descartes, René, 341, 367, 383, 415, 437, 459 Dessau, Germany, Bauhaus Machine Shop, **556** (Fig. 525) deus ex machina, defined, 43 development, defined, 455 Dewey, John, 558 Diaghilev, Sergei, ballet company, **528**; *Mercury* production, **544**; *Oedipus Rex* production, **544** diakonikon, defined, 123 Dickens, Charles, 428, 496 Diderot, François, 428, 431, 441, 446; Encyclopédie, 437; Natural Son, 428 Dies irae, 205, 223-225 (Thomas of Celano), 475, 476 Diocletian, baths of, 113 Dionysus, 36 (Fig. 45) Dionysius, 53 Dionysus, 43, 57, 63, 73 discantus, defined, 200 Discobolus (Discus Thrower), 40, **41** (Fig. 53), **50** dome, central type, on pendentives and squinches, 124 (Figs. 130, 131), **127, 128, 137**; defined, 102 (Fig. 111); of Florentine cathedral, 236 (Fig. 222), 237 (Figs. 224, 225), 238; Gothic, 186 (Fig. 183); of St. Peter's Basilica, 279-280 (Fig. 268) domesticity: and ancient Roman religion, 94, 96; and Bach, 383; Dutch Protestant, 369, 375, 383-385; and middle class, baroque period, 416; in Pergamon, 78 Donatello, 236, 237, 243-245, 246, 259, 261, 280, 289; David, 244 (Fig. 234), 245, 262; Lo Zuccone (The Prophet), **243** (Fig. 233), **245, 262**; Repentant Magdalene, **244** (Fig. 235), **245** Donatus, 194 Doré, Gustave, Berlioz Conducting Massed Choirs, 474 (Fig. 441) Doryphorus (Spear Bearer), 39 (Fig. 49), 40, 50 Dostoyevsky, Fyodor, 496 Douris, Instruction in Music and Grammar in an Attic School, 46, **47** (Fig. 60) Dowland, John, 286, 303; "I Saw My Lady Weepe," 302 (Fig. 285); "song in several parts," **380** Drake, Francis, 305 drama: church, mystery plays, 183; early Christian liturgical, 111, 140; French baroque, 341, 399, 403, 413, 448; Greek, 24, 42-46, 60-61, 65-67, 140; Roman, 104; Restoration, 408-409, 412; Storm-and-Stress. See Storm-and-Stress movement drum, defined, 29 Dryden, John, 56, 341, 403, 404, **408–409, 415;** Albion and Albanius, 409

dualism, Gothic, 201-203; medieval. 228 Duccio di Buoninsegna, "Rucellai Madonna," 221-222 (Fig. 216) Duchamp, Marcel, *L.H.O.O.Q.* **540** (Fig. 503), **564, 582** Dufay, Guillaume, 258, 261, 288, 302; dedicatory motet, Florentine cathedral, 237, 238 Dumas, Alexandre, 460, 470, 474, 488 duplum, defined, 199 Dürer, Albrecht, 286, 288, 296-299, 309; Four Apostles, 296, 297 (Fig. 281); Madonna and Child with a Multitude of Animals, 296 (Fig. 280); Self-Portrait, 296 (Fig. 279), 605 Dutch Reformed Church, 367-368 Dying Gaul, 62 (Fig. 69), 63-64, 68

E Eakins, Thomas, 494-495; Gross Clinic, 493 (Fig. 456), 494 earth goddesses: Earth, 31; Gaea, 67; Tellus, 86, 88 (Fig. 91) echinus, defined, 27 eclecticism, defined, **488** Eco, Umberto: *Foucault's* Pendulum, 606; The Name of the Rose, 605-606 Edict of Milan, 113 Edward VI, 300, 303 Edward the Confessor, 165; death of, 166 (Fig. 169), 178 Egypt, 486; ancient art and architecture, **8, 9, 13, 19**; Hypostyle Hall of Amenhotop III, **9** (Fig. 13); pyramids, **8** (Fig. 12), **9;** Sphinx, **8** (Fig. 12), Tutankhamen's throne, 10 (Fig. 15); tomb paintings, 10-11 (Figs. 15-17) Eiffel, Gustave, 517; Eiffel Tower, 519, 593 Einstein, Albert, 419, 558, 559, 563 Ekkehard and Uta, 214 (Fig. 207), electronic music, 585-586, 587 Elgin, Lord, and Parthenon marbles, 19, 452 Eliot, T. S., 105; Sweeney Agonistes, **546** Elizabeth I, **303, 327** Éluard, Paul, 541 Em, David, Orejo, 583, 584 (Fig. 553) empiricism, Hellenistic, 76, 81-82 enclosed-space structure, Roman, Enlightenment, the, 421, 432-433, 435, 437, 441, 454, 457, 459, 466, 467, 616 entablature, defined, 27, 28 (Fig. 31) entasis, defined, 29 Epic of Gilgamesh, 6 Epictetus, 77 Epicureanism: Hellenistic, 77, 81; Roman, **105**, **108** Epicurus, **77**, **81** epilogue, defined, 43 Erasmus, Colloquies and In Praise of Folly, 306–307 (Fig. 287) Erechtheum. See Athens Erechtheus, 24, 31 Ernst, Max, 564 Escorial, Spain: Escorial Palace, 354 (Fig. 336), 355 (Fig. 337); Martyrdom of St. Maurice and Theban Legion, 356, 357 (Fig. 340), 358

Este family, 327

Estes, Richard, 565, 601, 605; Bus Window, 602 (Fig. 569); Downtown, 564, 565 (Fig. 528), etching, defined, 373 ethos, defined, **73** Euclid, **56, 82, 194, 283** Eugene IV, Pope, 235, 237 Eugene, Prince of Savoy, 423 Eumenes II, **60**, **61**, **63**, **65**, **82** Euripides, 15, 24, 25, 57; The Bacchae, 42, 44, 45, 48; Orestes, 48 (Fig. 62) Evangelists, the, 133, 192 ex cathedra, defined, 132 exedrae, defined, 88 existentialism, 616-618 exodus, defined, 43 exoticism, romantic, 479, 480-483 exposition, defined, 454 expressionism, 467, 488, 522–525, 526, 527, 529, 531, 532, 533, 539, 548, 550, 561, 563, 564, 570, 619

Falconet, Étienne-Maurice, 426

Farinelli (countertenor), 429, 431

fauvism, **524**, **527**, **529**–**531**

ferroconcrete, defined, 552

façade, defined, 26

fasces, defined, 442

fealty, defined, 177

Fermi, Enrico, 563

Feininger, Lyonel, 557

feudalism, 111, 177-179, 205-206 Ficino, Marsilio, **252, 259, 283** fief, defined, 177 Fielding, Henry, 428; Tom Jones, Fiorentino, Rosso, Moses Defending the Daughters of Jethro, 328, 329 (Fig. 310) Flaubert, Gustave, 496 Florence, Italy: Baptistry, **161**, **236** (Fig. 222), **237**, **241**, **242** (Fig. 232), **245**, **296**; campanile (Giotto's tower), 236 (Fig. 222), 237 (Figs. 224, 225), 243 (Fig. 233), 245; cathedral dedication, 100; Church of Ognissanti, 222; guilds, 235, 241, 242; Medici-Riccardi Palace, 240, 241 (Fig. 229), 248 (Fig. 240), **249, 258, 261;** Monastery of San Marco, **236,** 261, Fra Angelico, Annunciation, **247** (Fig. 239), **248–249**; Pazzi Chapel, 238-240 (Figs. 226 228); St. Egidio, Portinari Chapel altarpiece, 292 (Fig. 275); San Lorenzo, 261; Santa Croce, 261; Santa Maria del Carmine, Masaccio frescoes for Brancacci Chapel of, **246**– 248 (Figs. 237, 238), 248, 261; Santa Maria del Fiore, 235, 236 (Figs. 222, 223), 258, Chapel of the Bargello, 226, 227 (Fig. 220); Santa Maria Novella, 221-222; Santa Trinità, 221, 222 (Fig. 215) flute, defined, 29 (columnar) flying buttress, 148, 188 (Fig. 185), 206 (Fig. 200) Folquet of Marseilles, 170 Fontaine, Pierre F. la, 413, 443, **456, 457;** Arc de Triomphe du Carrousel, **445** (Fig. 415); Vendôme Column, 446 (Fig. 416) foreshortening, defined, 261

forte, defined, 453

Fourment, Helena (Rubens), 397

Fragonard, Jean Honoré, 426: The Swing, 426, 427 (Fig. 400), 441 Francis I of France, 267, 327, 329, 394 Franck, César, 472, 478 Frankenthaler, Helen, Formation, **575** (Fig. 541), **576** Franklin, Benjamin, 432 Frazer, James, The Golden Bough, Frederick the Great, 422 Frescobaldi, Girolamo, 263 frescoes: of Black Plague at Campo Santo (Pisa), 223, 224 (Fig. 219); of Monastery of San Marco (Florence), 236; Florentine churches, 241, 246 (Fig. 237), **247** (Figs. 238, 239), **248** (Fig. 240), **249**; Giotto's, of life of St. Francis, **216–220** (Figs. 209–212), **227** (Fig. 220), 230, 231; Leonardo's Last Supper, 256, 257; Michelangelo's Last Judgment, 343, 344 (Fig. 322), 345; Sant' Ignazio (Rome), 349 (Fig. 332); of Santa Maria del Popolo (Rome), 267; Sistine Chapel (Rome), **273–278** Freud, **44**, **525**, **542**, **546**, **559**; Interpretation of Dreams, 45 Friedrich, Caspar David, The Wanderer above the Mist, 486 (Fig. 452) friezes: defined, 27; of Altar of Zeus (Pergamon), 65, 66-68 (Figs. 73, 74), 78, 79, 82; of Bramante's Tempietto, 282; of La Clérica (Salamanca), 355, **356** (Fig. 338); of Library of St. Mark (Venice), **313**; of Louvre (Paris), 390; of Parthenon (Athens), 28, 33 (Fig. 39), 34 (Figs. 40, 41), 45 (Figs. 42, 43), 121; of Sant' Apollinaire Nuovo (Ravenna), 119, 120-122; Trajan's Column, 92, 93. See also sculpture, narrative frottola, defined, 258 fugue, defined, 411 Fulbert, Bishop of Chartres, 194, Fuseli, Henry, 438; Ariadne Watching the Fight between Theseus and the Minotaur, 433,

G Gabrieli, Andrea, 338, 380; per voci e stromenti, Concerti . 325-326 Gabrieli, Giovanni, 328, 338-339, 380; Concerti . . per voci stromento, 325, 326 Galilei, Vincenzo, 325 Galileo, 55, 328, 414, 558 per voci e gallant style, defined, 421 Galla Placida, Empress, mausoleum of, 116, 117, 124 Gau, François Christian, Church of Ste. Clotilde, 471-472 (Fig. 440), **500** Gauguin, Paul, **509, 529, 531**; *Mahana No Atua*, **510, 511** (Fig. 475), 525, 526 Gaul and His Wife, 63 (Fig. 70), 64-65, 68, 399 Gautier, Théophile, **460**, **474**, **479**, **483**; *L'Orient*, **483** Gay, John, *Beggar's Opera*, **428** Gellée, Claude. See Lorrain, Claude genre scenes, 295, 309, 360, 362; defined, 369; Dutch, 369, 370, 428; 18th-century, 428

434 (Fig. 409) futurism, **537–538, 559**

history scenes, Dutch, 368-369,

Gentileschi, Artemesia, Judith Slaying Holofernes, 348-349 (Fig. 331) geometry: of Borromini's planning, 346, 347 (Figs. 327, 328); and cubism, 535, 609; dynamic, 597; and Gothic aesthetics, **204**; and Hellenic arts, **51–52**, **55–56**; and Hellenistic music theory, 82; of Pantheon, 56, 99-100; and Sistine Chapel frescoes, 274; and Uccello technique, 249 George I, 336 Gerbert of Rheims, 194 Géricault, Théodore, 464-465, **467**; Raft of the "Medusa," **464** (Fig. 429), **465** Gershwin, George, 529 Gesamtkunstwerk, defined, 460 Ghent, Belgium, 181; Cathedral of St. Bavo, Ghent Altarpiece, 289, 291 Gherardi, Antonio, Ávila Chapel cupola, **416** (Fig. 391) Ghiberti, Lorenzo, **241–246**, **257**, **259**; Baptistry doors, **237**, **241**, **242, 243** (Fig. 232); *Commentaries,* **241, 242, 260,** 263; Gates of Paradise, 498; Sacrifice of Isaac, 242 (Fig. 231) Ghirlandalo, 252, 274 Giacometti, Alberto, **543**; *Palace at 4 a.m.*, **544** (Fig. 507) Gibbon, Edward, **108**, **133**, **137**, **437**; *The Decline and Fall of the* Roman Empire, 86 Gibbons, Orlando, 417 Gibbs, James, St. Martin-in-the-Fields, 408 (Fig. 387) Gide, André: Persephone, 544; Prometheus Drops His Chains, 545; Theseus. 545 Gilgamesh. 6 Gillespie, Gregory, 597; Self-Portrait, 605 (Fig. 572) Ginsberg, Allen: *Howl*, **566**; "A Supermarket in California," **581** Giorgione del Castelfranco, 329; Concert Champétre, 318 (Fig. 301), 337; Tempest, 318, 319 (Fig. 302), 337 Giotto di Bondone, 209, 221, 229, 231, 241, 619; campanile (Florence), **236** (Fig. 222), **237** (Figs. 224, 225); frescoes of Basilica of St. Francis, 216 (Fig. 209), 217 (Fig. 210), 218 (Fig. 212), 219, 220, 227 (Fig. 220), **228**, **230** (Fig. 221); *Madonna Enthroned*, **222**, **223** (Fig. 217), *Portrait of Dante*, **226**, **227** (Fig. 220) Gislebertus, *Last Judgment*, Autun Cathedral, 159 (Fig. 163) Gisze, Georg, 286, 287 (Fig. 271) Giza, Egypt, Great Pyramid of Khufu, 8 (Fig. 12) Gladiatorial Contest, 103 (Fig. 112) Glareanus, 280 Glass, Philip, Akhnaten, 610; Einstein on the Beach, 210; Satyagraha, 610 Gluck, Christoph Willibald von, **410, 421;** Alceste, **457;** The Pilgrims to Mecca, **481;** Unforeseen Meeting, 481 glyph, defined, 28 Goethe, Johann Wolfgang von, 456, 459, 472, 525, 606; Faust, 283, 433, 435, 438, 460, 471, 473, 474, 475, 484, 488, Delacroix illustrations for, 462 (Figs. 426, 427), 463 Goldsmith, Oliver, 428; Vicar of Wakefield, 432

Gómez de Mora, Juan, La Clérica, 355, 356 (Fig. 338) Gonzaga family, 327 Good Shepherd, 130, 131 (Fig. 139) Gorky, Arshile, 565, 575, 599; The Liver Is the Cock's Comb, 567 (Fig. 529), 568 Goslar, Germany, Chapel of St. Ulrich and Imperial Palace, 163 (Fig. 165) Gospel book cover, England, 151 (Fig. 154), 152 Gothic novel, 459, 469, 470, 486 Gothic style: English, 209-213, 403: German, 214-215: Italian. 215-227; 19th-century revival of, 214, 460, 469-471, 471-Gottlieb, Adolph, 566, 571, 572, 576; Forgotten Dream, 571 (Fig. 535) Goubert drawing, 188 (Fig. 185) Gounod, Charles, The Queen of Sheba, 483 Goya, Francisco, **414**, **428**, **465**–**467**, **547**, **550**; *Allegory on the* Adoption of the Constitution, 467; Los Caprichos, 465 (Fig. 430), 466; Executions of the Third of May, 1808, 466 (Fig. 432); Saturn Devouring One of His Children, 465 (Fig. 431), 466; The Sleep of Reason Produces Monsters, **465** (Fig. 430) Gozzoli, Benozzo, **237**, **241**, **252**, 261; Journey of the Magi, 248 (Fig. 240), 249, 263 Grand Écurie, 401, 402 Graves, Michael, Portland Public Service Building, 614, 615 (Fig. 578) El Greco, 317, 319, 333, 338, 345–346, 354–360, 363, 365, 378, 398, 414, 416; Assumption of the Virgin, 358 (Fig. 341); Burial of Count Orgaz, 358, 359 (Fig. 342); Christ Driving the Money Changers from the Temple, 358, 360 (Fig. 343); Martyrdom of St. Maurice and Theban Legion, 356, 357 (Fig. 340), 358 Greenberg, Clement, 484 Greenough, Horatio, George Washington, 456 (Fig. 424), 457 Gregory the Great, Pope, 137, 140; Schola Cantorum of, 153 Greuze, Jean-Baptiste, 428; Village Bride, 431 (Fig. 407) Gris, Juan, 565 groin (cross) vault, defined, 102 (Fig. 111) Gropius, Walter, 522, 552, 557-558, 563; Bauhaus Machine Shop, 556 (Fig. 525) Grotius, Hugo, 367 ground bass, defined, 410 Grünewald, Matthias, 299-300; Crucifixion, 299 (Fig. 283), 300; Isenheim Altarpiece, 299-300; Nativity, 298 (Fig. 282), 299, 300 Gudea of Lagash, 4, 5 (Fig. 8) Guido of Arezzo, notational treatise of, 153-154 guilds: defined, 111; Dutch painters', 369; bakers of Chartres, window of, 196 (Fig. 194), dwelling places, Gothic, 202 (Fig. 197); Florentine, 235, 241, 242; of surgeons and physicians, Dutch, **371** (Fig. 350) Guizot, François, 460, 471 Gutenberg, Johannes, 233, 288 Guy of Amiens, 168, 169 gymnasiarch, defined, 74

Hadrian, Emperor, 86, 94, 99, 102, 103; tomb of, 108 (Fig. 114), 123 Hagia Sophia. See Istanbul, Turkey Haimon, Abbot, 185 Halicarnassus, Mausoleum, 76, 77 (Fig. 82) Hals, Frans, 375, 377, 385; Merry Lute Player, 369, 375, 376 (Fig. 357) Hammurabi, 5; Stele, 6 (Fig. 9) Handel, George Frideric, 338, 380, 410, 411-412, 415, 436, 476; compared with Bach, 410, 412, 415; Giulio Cesare, 411; Hudson portrait of, 411; Israel in Egypt, **411, 412**; Messiah. 411, 412; Semele, 411-412 Hanson, Duane, Supermarket Shopper, 603 (Fig. 570), 604 happenings, defined, 581 Hardouin-Mansart, Jules, 414, 415, 457; Versailles Palace, 390 (Fig. 367), 391, 392 (Fig. 369), 413 (Fig. 390) Harnett, William, Old Models, **600** (Fig. 567) Harold, King, King of England, **154, 166–167** (Fig. 168), **168,** 169, 177 harp, from Ur, 4 (Fig. 5, 6) Harrison and Abramowitz, Lincoln Center, 17 (Fig. 22) Harun-al-Rashid, 141 Harvey, William, 415 Haydn, Josef, 454 Hazlitt, William, 569 hedonism, defined, 77 Hegel, Georg Wilhelm Friedrich, 518 Hegemon the Thasian, 53 Hegeso stele, 51 (Fig. 64) Heidegger, Martin, 617 Heine, Heinrich, **474**, **488**, **616**Heinrich Frauenlob Directing a Minstrel Performance, 171 (Fig. 171) Helmholtz, Herman von, 503; On the Sensation of Tone as a Physiological Basis for the Theory of Music, 517 Hemingway, Ernest, 564 Henry IV of England, 145, 396 Henry VIII of England, 286, 300, 303, 306, 313, 327 Hephaistion mosaic, 71 (Fig. 76) Heraclitus, 304, 518 Herculaneum, Italy, 69, 70, 83, 449, 456, 486 Hercules Finding His Infant Son Telephus, **69, 70** (Fig. 75) Herder, Gottfried von, 433; Von Deutscher Bankunst. 471 Hermes, 53 Hermes and the Infant Dionysus,

39, 40 (Fig. 50), 81

Hero of Alexandria, 81

hexachord, defined, 314

high relief, defined, 33

Hezelo, Nave, Third Abbey

Herrera, Juan de, 363; Escorial

Palace, 354 (Fig. 336), 355

Church of Cluny, 145, 146

hierarchism, Romanesque, 159-

Hildebrandt, Lukas von, Belvedere

Palace, 423, 424 (Fig. 395)

Hindemith, Paul, 563; Mathis der

historicism: romantic, 486-489;

20th-century, 605-609

Herodotus, 51

(Fig. 337) Hesiod, **51**

(Fig. 149)

Maler, 300

160

Hodges, C. Walter, 304 Hoffmannstal, Hugo von, **533** Hofmann, Hans, **565**, **566**, **567**; Memoria in Aeternum, **574** (Fig. 540), 576 Hogarth, 428, 547; Countess's Levee, 429, 430 (Fig. 406); Harlot's Progress, **431**; Marriage à la Mode, **428**, **430** (Figs. 405, 406); Marriage Contract, **429**, **430** (Fig. 405); Rake's Progress, Holbein, Hans, the Younger, 286, 300, 306; Allegorical Portrait o Jean de Dinteville and Georges de Selve, 300, 301 (Fig. 284); Dance of Death, 307; drawing for In Praise of Folly, 307 (Fig. 287); Georg Gisze, Merchant, 287 (Fig. 271) Holt, Elizabeth G., Literary Sources of Art History, 324 Homer, 6, 31, 53, 283, 545; Iliad, 15, 450, 455; Odyssey, 24, 51, 69, 85, 104, 450, 545, 609 Honegger, Arthur, **544**; *Pacific* 231, **538** Honorius, Emperor, 115 de Hooch, Pieter, 377, 385; Mother and Child, 3'15, 3'16 (Fig. 358) Horace, 104, 283, 441, 457 hospice, defined, 145 Houdon, Jean Antoine: Voltaire, 431, 432 (Fig. 408), Washington statue, 432 Howard, Catherine, 300 Hudson River School, 486, 605 Hudson, Thomas, Handel portrait, 411 (Fig. 389) Hugh of Semur, 145, 148, 149, 153, 154, 156, 158 Hugo, Victor, **459**, **463**, **470**, **472**– **474**, **478**, **488**; Après une lecture de Dante, 472-473; Cromwell, 460, 472, 475; Notre Dame de Paris, 471; Odes, 473; "Rondo of the Witches' Sabbath," 473, humanism: Hellenic, 49-52; Renaissance, 231, 233, 258, 259-260, 263, 273, 279, 282-283, 288, 305, 367; Renaissance Christian, 306-309 humanitarianism, Franciscan, 229-Huquier engraving, 423 (Fig. 393) Huxley, Aldous, 78, 399, 563 Huygens, Constantijn, 367 hydraulus, defined, 103 hypostyle, defined, 9

I

Ibsen, Henrik, 496 iconography, defined, 124; Dutch modifications to, 369, 373-374; of Gothic cathedrals, 191-194; northern Renaissance, 299; Reformation, 309; Renaissance, **253, 254, 274**Ictinus, **25, 26, 27** (Fig. 30), **30** idealism, Hellenic, **52–54** idée fixe, defined, 475 ignudi, defined, 275 Île-de-France, 181–185, 199, 209 illuminated manuscripts, 152 (Fig. 155), **153** imperator, defined, **85** impressionism, 489, 502-508, 514, 516, 517, 521, 529, 531, 564, 597, 599 Index Expurgatorius, 343 individualism, Hellenistic, 75-78; and Reformation domesticity.

individualism, Hellenistic (cont.) 383: Renaissance, 258, 259. 261-265; romantic, 460, 478-Industrial Revolution, 419, 472, 488, 521, 559 Ingres, Jean-Auguste-Dominique, 451, 545; Apotheosis of Homer, **450** (Fig. 421), Joan of Arc, **488**; The Turkish Bath, **482** (Fig. 447), 483 Inquisition, 322, 324-325, 343, intercolumniation, defined, 26 international style, **526**, **550**, **552**, **553**, **554**, **556**, **557**–**558**, **563**, 589, 599, 614 intervals, musical, defined, 153 intonazione, defined, 325 "the irascible eight," 576 Irene, Empress, 189 Isaac, Heinrich, 258, 261, 268, 363, 380 Isidore of Seville, Etymologies, 149 Isidorus of Miletus, Hagia Sophia, **126** (Fig. 133) isocephaly, defined, 34 Israel and Israelites, 6-8 Istanbul, Hagia Sophia, 100, 126 (Figs. 133, 134), 127 (Fig. 135), 128, 130, 135, 137

Jacopone da Todi: Lauda, 226; Stabat Mater Dolorosa, 230 James, William, 448 James II of England, 303-304, 305, 404 jazz, 528-529, 554, 610 Jefferson, Thomas, 100, 432; Monticello, 315; Rotunda, University of Virginia, 446, 447 (Fig. 417) Jesuits. See Society of Jesus Jews, of 17th-century Amsterdam, 367, 374, 377; persecution of, in southern Europe, 367, 377. See also Inquisition John Chrysostom, St., 135 John of Holland, 286 John the Baptist, in Ghent Altarpiece, 289 (Fig. 273), 291; in Isenheim Altarpiece, 299 (Fig. 283), 300 John, King of England, 111 John XXII, Pope, 229 Johns, Jasper, 581 Johnson, Philip, Seagram Building, 589 (Fig. 557) Johnson, Robert, settings of "Full fathom five" and "Where the bee sucks," 305 Jones, Inigo, 408; Banqueting House, Whitehall, **315, 404** (Fig. 381), translation of Palladio, 338, 404 jongleur, defined, 169 Jonson, Ben, 305, 404 Josquin Desprez, 267, 283, 288, 302, 363, 380; Ave Maria motet, 280, 281; De profundis, 281 Joyce, James, 599, 618; Ulysses, 543, 546-547, 559 Julius Caesar, 85, 104 Julius II, Pope, 267, 268, 282; law code of, 273; Raphael portrait of, **269** (Fig. 265); tomb of, **271** (Fig. 258), **272**, **273**, 279 Junius Bassus, sarcophagus of, 94, 113, 116 (Fig. 116) Juno, 396 Jupiter, 396, 412, 606, 99, 104 Justina, Empress, 134 Justinian, 115, 117, 119, 122,

123, 126, 128 (Fig. 136), 129, 130, 132, 133, 135, 136, 137, 181; Digest of Laws, 129 Juvenal, 104

K

Ka, defined, 10 Kahn, Louis I., Salk Institute for Biological Studies, 611, 612 (Fig. 576) Kandinsky, Vasily, **522**, **531–532**, **533**, **542**, **550**, **557**, **569**, **576**; Der Blaue Reiter, 531; Improvisation No. 30 (on a Warlike Theme), 531-532, 533 (Fig. 493) Kant, Immanuel, 421, 438, 459. 518 Kauffmann, Angelica, 606: Cornelia Pointing to Her Children as Her Treasures, 441, 442 (Fig. 410) Keats, John, "Eve of St. Agnes," 488; "Ode on a Grecian Urn," 49, 488 keep, defined, 165 Kepler, Johannes, 55, 415, 417 keystone, defined, **102** (Fig. 111) Khafre, **9** kinetic art, 563, 579, 580, 582, King's Men, 304, 305 Klee, Paul, 531, 543, 557, 576; Apparatus for Magnetic Treatment of Plants, 541; Around the Fish, **541, 542** (Fig. 505); Child Consecrated to Suffering, **541**; A Cookie Picture, **541**; Idol for Housecats, 541; A Phantom Breaks Up, 541; Twittering Machine, 541 Kline, Franz, 565, 575, 576; Pennsylvania, 570 (Fig. 534), 571, 572 Knife Sharpener, 74, 75 (Fig. 81) Knights of Santiago, 362 Knox, Bernard, 45 Kore from Samos, 41, 42 (Fig. 54) Kouros from Sounion, 38 (Fig. 48), 39, 40, 53

L

519; Library of Ste. Geneviève, **499** (Fig. 462), **500** (Figs. 463,

464), 614; National Library

Krasner, Lee, 565, 571; Abstract

No. 2, 572 (Fig. 536)

Kritios Boy, 50 (Fig. 63), 51

(Bibliothéque Nationale), **500** (Fig. 464), **501** Lady chapel, defined, **189–190** laisse, defined, 178 La Jolla, California, Salk Institute for Biological Studies, 611, 612 (Fig. 576) Lamartine, Alphonse Marie Louis de, 474 Lamennais, Félicité Robert de, 474 lancet window, defined, 187 Ländler, defined, 436 landscape, **309**; Dutch love of, **369**, **370**, **377**, **385**, **417**; Lorrain's preference for, 399; Mondrian's, **550**; 19th-century romantic, 378, 459, 483, 484, 485, 486, 495; of Watteau, 426 Laocoön Group, 78, 79 (Fig. 83), 267, 271, 335, 394 Lapith and Centaur, 33 (Fig. 39) La Rochefoucauld, 78 Lassus, Orland, 281, 286, 302-303, 363

Last Judgments, 78, 119, 159, 223, 360, 550; Garden of Earthly Delights as, 294 laudati spirituali, defined, 225 lauds, 225 Lebrun, Charles, **387**, **389**, **392**, **414**; Versailles Palace, **391**, **392** (Fig. 369), **413** (Fig. 390) Le Corbusier, **16–17, 522, 552** 556, 599, 611; Notre-Dame-du-Haut, 591-592 (Figs. 560, 561), 594; L'Unité d'Habitation, 557 (Fig. 526), **558**Legend of the Three Companions, 217, 218 Léger, Fernand, 564, Ballet Mécanique, 538; The City, 538, **539** (Fig. 500) Leibniz, Gottfried von, 341, 415, 433, 518 Leif Eriksson, 168 Leipzig, Germany, St. Thomas's Lutheran Church, **381** leitmotif, defined, 477 Le Nôtre, Andre, plan of Gardens of Versailles, 392 (Fig. 370), 393 Leo X, Pope, 258, 267, 268, 281 Leonardo da Vinci, 246, 254-257, 260, 261, 265, 267, 279, **283**, **328**, **394**, **605**, **618**; Cartoon for *Madonna and Child* with St. Anne, 255 (Fig. 247); Last Supper, 256; Madonna and Child with St. Anne, 269, 329; Madonna of the Rocks, 255 (Fig. 248); Study of Human Proportions According to Vitruvius, 56 (Fig. 66); Study of St. Philip for The Last Supper, 256, 257 (Fig. 251) Léonin, Magnus liber organi, 199, Leslie, Alfred, 605; View of the Oxbow on the Connecticut River as Seen from Mt. Holyoke, 604 (Fig. 571), 605 Lessing, Gotthold E., Miss Sara Sampson, **428** Lesueur, Charles Alexander: L'Inauguration du Temple de la Victoire, 457; La Triomphe de Trajan, 457 Le Vau, Louis, Versailles Palace, 391 (Fig. 368), 402, (Fig. 380) Leyster, Judith, Self-Portrait, 369 (Fig. 348) liberal arts, seven, 192, 193 (Figs. 191, 192), 194, 203, 204, 300 Lichtenstein, Roy, **581** Lied, defined, **476** Limbourg Brothers, Duke of Berry's Book of Hours, 211, 212 (Fig. 205), 213 Limbourg, Paul de, self-portrait, 212, 213

Labrouste, Henri, 499, 500-501,

476

368

Locke, John, 437

loggia, defined, 336

Linear-B language, 14

and-lintel construction

lintel, defined, 26. See also post-

Lipchitz, Jacques, 564; Man with

Mandolin, 536 (Fig. 497), 537

Lippi, Fra Filippo, 236; altarpiece

(Nativity) for Medici-Riccardi

Liszt, Franz, 474, 478; Totentanz,

literacy, and early printed Bible,

Livy, 399; History of Rome, 104

London: **235**; Banqueting House, Whitehall, **315**, **404** (Fig. 381); British Museum, **446**; Crystal

Palace, **501**, **502** (Figs. 465,

466), 534; Globe Playhouse,

palace, 241, 249 (Fig. 241), 261

303, 304 (Fig. 286); Great Fire and Wren's plan for new city, 406, 407-408; Houses of Parliament, 470 (Fig. 438), 487; Kew Gardens, 481; King's Theatre, 408; under limited monarchy, 403-408; New Law Courts, 470; Old St. Paul's, 406; Palladium, 315; Parthenon sculptures, **452**; St. Martin-in-the-Fields, **408** (Fig. 387); St. Mary-le-Bow, **407** (Fig. 386), **408**; St. Paul's Cathedral, **100**, 404-407 (Fig. 383-385): Tower of London, 165, 173 (Fig. 172), 174 (Figs. 173, 174), 175-176, 177, 178, 179, St. John's Chapel of, 174, 175 (Fig. 175), 176; Westminster Abbey, 165; Wren's influence on skyline, Longhena, Baldassare, 326; Santa Maria della Salute, 339 (Fig. 321) Longinus, 450 Lope de Vega, 362 Lord Chamberlain's Men, 303 Lorenzetti brothers, of Siena, **221** Lorrain, Claude, **399–400, 457,** 484, 485; Disembarkation of Cleopatra at Tarsus, 399, 401 (Fig. 379) Louis VII, 181 Louis VIII, 194, 196 Louis IX (Saint Louis), 189, 194, 196, 206 Louis XIII, 396, 398, 413 Louis XIV, 338, 383, 387, 389, 390, 391, 412, 414, 416, 417, 421, 426, 428, 450, 456, 483, **488**; Bernini bust of, **393** (Fig. 371); Coysevox relief of, 413 (Fig. 390); and music, 400, 401; Rigaud portrait of, 388 (Fig. 365) Louis XVI, 432, 448 Louis XVIII, 445 Louis Philippe, **461** low relief, defined, **34** Loyola, St. Ignatius, **343, 349,** 352; Spiritual Exercises, 345, 364 Lucretius, 279, 283; On the Nature of Things, 104 Lully, Jean-Baptiste, 387, 401-403, 409, 410, 413, 414, 415, 516; Alceste, 402 (Fig. 380) luministic art, 582 Luther, Martin, 296, 298, 307-309. 327: Lucas Cranach portrait of, 308 (Fig. 288); A Mighty Fortress Is Our God, 309 Luxor, Egypt: Hypostyle Hall of Amenhotep III, 9 (Fig. 13)

M

Machiavelli, Niccolo, 263; History of Florence, 260; The Prince, 260 Maderno, Carlo, 117, 343; St. Peter's nave and façade, 268 (Fig. 254), 279, 280; Santa Maria della Vittoria, 351 Madrid, Spain, **352**, **354**, **355** madrigals, **225**, **301**, **302** (Fig. 285), 303, 325, 327, 345, Maeterlinck, Maurice, 491, 498, 515, 518; The Bluebird, 517; "Intelligence of Flowers," 517; The Life of the Bee, 517; The Magic of the Stars, 517; Pelléas et Mélisande, 515-516, 519 Magna Carta, 111, 206, 470, 487 Magnificat (Luke), 300 Mahler, Gustav, 478, 610; Second Symphony, 476

Maillol, Aristide, Torso of Venus, 545, 546 (Fig. 511) Mallarmé, Stéphane, **491, 514** Malraux, André, **615** Malton, Thomas, aquatint of St. Paul's Cathedral, 405 (Fig. 406) mandorla, defined, 153 Manet, Édouard, **492**, **494**–**495**, **504**–**505**, **605**; *Bar at the Folies*-Bergère, 504 (Fig. 468), 505: Olympia, 495 (Fig. 457), 496; Rue Mosnier, Paris, Decorated with Flags on June 30, 1878, 503 (Fig. 467) Manetti, biography of Brunelleschi, 238 Mann, Thomas, 563 mannerism, 319, 320, 327–336, 338, 343, 346, 348, 358, 433 Mansart. See Hardouin-Mansart, Mantegna, Andrea, 317 Mantua, Italy, 317, 325, 326, 327, 329; Palazzo del Tè, 335, 336 (Fig. 318) maps: Counter-Reformation Spain, **354**; Europe at Death of Theodoric, **526**; Europe c. 1140, **157;** Île-de-France, c. 1150–1300, **181;** Italy c. 1450, **262;** Northern Europe c. 1550, 285 Marc, Franz, Der Blaue Reiter, 531; The Great Blue Horses, 531, 533 (Fig. 492) Marcellinus, 103 Marcus Aurelius, equestrian statue of, **90** (Fig. 95), **93**, **103**, **108**; *Meditations*, **77**, **86**, **88** Maria Theresa of Austria, 421, 422 Mariani, Carlo Maria, 606; It Is Forbidden to Awaken the Gods, 607 (Fig. 573) Marie Antoinette, 443, 483. See also Mique. Marinetti, Filippo Tommaso, Manifesto (1909), 537 Mars (god), 99, 268, 321 Marseillaise, suppression of, and revival by Berlioz, 467 Marseilles, France, L'Unité d'Habitation, **557** (Fig. 526), 558 Marsyas, 74 (Fig. 80), 78 Martial, 104 Martini, Simone, 209, 221; Annunciation, 222, 224 (Fig. 218) Marx, Karl, 419, 488, 559 Mary Magdelene, 149, 292, 300; statue of, by Donatello, 244 (Fig. 235) Masaccio. 236, 246-248, 249. 250, 254, 261; Expulsion from the Garden, 246 (Fig. 237), 248; Tribute Money, 247 (Fig. 238), 248 Masolino, 261 masque, defined, 305 Matilda (Norman queen), 168-169, 176, 177 Matisse, Henri, 527, 530, 565, 599; Blue Window, 531 (Fig. 490); Carmelina, 428, 530 (Fig. 489) matroneum, defined, 126 Mausolus, Mausoleum of, 76, 77 (Fig. 82) Maximian, Archbishop, 123, 128 (Fig. 136), 129; cathedra of, 132, 133 (Fig. 141) Maximilian, Emperor, 302 Mazarin, Cardinal, 401 mechane, defined, 43 mechanical style, 537, 538, 539, Medici family, 16, 237, 247, 258, 261, 267, 274, 283, 289, 291,

292, 327, 337; Cosimo, 235-236, 240, 241, 249, 251, 252, 257, 261; Giovanni, 251; Giuliano, 249, 251; Leo, 268; Lorenzo (the Magnificent), 249, 251, 252, 257-258, 262-265, 268, 269, 282, 396; Maria (Queen Mother), 396; Piero, 249, 251, 252; Pierfrancesco di Lorenzo, 252. See also Leo X. Pope Medici-Riccardi palace. See Florence, Italy medieval revival, 19th-century, 214, 225, 460, 468, 469–478, 486, 487, 488 melancholic, defined, **299** Melancthon, **298** melismatic, defined, 135 melodrama, defined, 44 memento mori, 300, 369 (Fig. 349) Mendelssohn, Felix, 412, 474, 488; Songs Without Words, 460 Mengs, Raphael, 606 Mercury (god), 99, 253, 335, 336, 338, 402 Merimée, Prosper, 483 Mesomedes, 108 Mesopotamia: ancient art of, 3–8, 13, 19; harp from, 4 (Figs. 5, 6); literature of, 6; statues, 5 (Figs. 7, 8); ziggurats, 3 (Figs. 3, 4) Metastasio, Pietro, 422 metope, defined, 28 (Fig. 31) Mexico, City, Mexico: Cathedral, **365** (Fig. 346) Meyerbeer, Giacomo, *Le Prophète*, Michelangelo Buonarroti, 117, 237, 243, 246, 261, 263, 265, 320, 324, 325, 328, 335, 336, 351, 354, 360, 394, 398, 403, 406, 433, 457, 464, 465, 498, 605; "Boboli Captive," 271, 272 (Fig. 260); "Bound Slave," 271, 272 (Fig. 259); Bruges Madonna, 271; Creation o Adam, 277 (Fig. 265), 347; Creation of the Sun and Moon 275 (Fig. 263); David, 259, 260 (Fig. 252), 271, 273; Delphio Sibyl, **275**, **276** (Fig. 264); dome of St. Peter's, **268** (Fig. 254); God Dividing the Light from Darkness, 275 (Fig. 263), 277; Last Judgment, 274 (Fig. 262), 278, 329, 344 (Fig. 322), 345, 438, 496; Moses, 271, 272, 273 (Fig. 261), 283; Pietà, 269, 270 (Fig. 257), **271, 281;** *Pietàs*, **345;** St. Peter's, plan of, **346;** Sistine Chapel ceiling frescoes, 267, 269, 273, 274-278, 343, 344 (Fig. 322); sonnet, quoted, 272; Tomb of Julius II, 271 (Fig. 258), 272-273, 276, 277, 279 Michelozzo, 236, 237, 240, 241 (Fig. 229), **249** Miel, Jan, Urban VII Visiting Il Gesù, 345 (Fig. 325) Miës van der Rohe, Ludwig, 556, 557, 563, 613; Seagram 337, 363, 613; Seagram Building, 589 (Fig. 557), 590 Milan, Italy, 254, 327, 343; Sant' Ambrogio, 160–161 (Fig. 164); St. Ambrose of, 134–135; Santa Maria delle Grazie refectory, Last Supper of, 256 Milhaud, Darius, 529, 563; The Eumenides, 544 Miller, Henry, 564 Millet, Jean François, 483 Milton, John, 404

mimesis, defined, 50

Minerva (goddess), 268, 321, 396, 402-403 miniator, defined, **152** minimalism, **578–579** Minnesingers, defined, **172** Minoa, 12-14, 19; mural from Thera, 14 (Fig. 20) minstrel, defined, 170 minstrelsy, art of, 170-171 (Fig. 171), **172** Mique, Richard, Marie Antoinette's cottage, 483 (Fig. 448) Mira lege, 200, 201 Miró, Joan, 565, 595; Personages Magnetized by the Stars Walking on the Music of a Furrowed Landscape, **543**; Personages with Star, **543** (Fig. 506) Mnemosyne, 46 Mnesicles: Erechtheum, 30 (Fig. 33), 31 (Figs. 34, 35); Propylaea, 25, 26, 27 (Fig. 28) modernism, **599**, **600** modes: in Greek music, defined, 46-47; Mixolydian example, 48-49 Modigliani, Amadeo, 565; Head, **526** (Fig. 485), **527** module, defined, **39** Molière, 413, 414, 450; Le Bourgeois Gentilhomme, 401 molle, defined, 327 monastery, defined, 143 monastic orders: Benedictine, 143, 144; Carmelite, 343; Carthusian, 288; Cluniac, 229; Dominican, 236; 215, 216, 229, monasticism, 111 Mondrian, Piet, 495, 522, 550-551, 557, 564; New York City, **550, 551** (Fig. 518) Monet, Claude, **503, 505–507,** 517; Impression—Sunrise, 503; Japanese Bridge at Giverny, 506, **507** (Fig. 471); serial paintings, 506; St. Lazare Train Station, The Normandy Train, 505, 506 (Fig. 470) monochord, defined, 153 Monod, Jacques, Chance and Necessity, **597** monophonic, defined, **6** Monte, Philippe de, **281** Montesquieu, **437** Monteverdi, Claudio, 325, 326-327, 338, 339, 401, 409; Coronation of Poppea, 327; Eighth Book of Madrigals, 327; Orfeo, 326-327; Return of Ulysses, 327; Zefiro torno, 327 Moon Goddess's Horse, 37 (Fig. 47) Moore, Charles, Piazza d'Italia, 614, 616 (Fig. 579) Moore, Henry, 595; Reclining Figure, 527, 529 (Fig. 488) More, Thomas, 302, 307; Utopia, Morley, Robert, "It was a lover and his lasse," **305** mosaics: Byzantine and Roman, 118-122, 138, 140 (Figs. 124-126); at Chartres, 205 (Fig. 199); defined, 71; early Christian, 119-122, 135, 138; feudal, **165** (Fig. 166); from palace of Attalus II, **71** (Fig. 76) Moses, **51**; Michelangelo's statue of, 271, 272, 273 (Fig. 261) motet, defined, 200 Motherwell, Robert, 565, 576 Moussorgsky, Night on Bald Mountain, 476 Mozart, Wolfgang Amadeus, **410**, **421**, **424**, **433**, **435**–**437**, **454**, 463, 561; Abduction from the

Seraglio, 481; Don Giovanni, 428, 435-437, 438; Marriage of Figaro, 435, 437 Müller, Wilhelm, 486 mullions, defined, 195 Munch, Edvard, *The Cry*, 525 (Fig. 484), 531 Murillo, Bartolomé, 414; Immaculate Conception, 362 (Fig. 345), 363 Murphy, Arthur, Orphans of China, **481** Muses, **46, 49, 194, 378, 389,** 393, 606 musical instruments: in Bach settings, 382; baroque, 400, 401, 417; Dutch, 369, 380, 381 (Fig. 363); early Christian, **134**, **138**, **140** (Fig. 144); 18th-century, **425**, **426**, **436**; Egyptian, **12** (Fig. 17); feudal, **168**; Mesopotamian, **4** (Figs. 5, 6), **6**; 19th-century, **491**; northern Renaissance, 293, 294, 295, 300, 301, 302, 303; Phrygian, 73; Roman, 102, 103, 109; Roman Renaissance, 268; Renaissance, 261; 20th-century, 538, 544, 585, 586 (Fig. 555); Venetian organ, 325 musketeer pictures, Dutch, 372 Musset, Alfred de, 4/4 Mycenaea, 12, 14-15, 19; Lion Gate, 14, 15 (Fig. 21) Myron, 25, 40, 41, 50, 52, 82 mystery plays, 382 mysticism, baroque period, 416; Counter-Reformation, 363; early Christian, 137-140

Napoleon I, 19, 94, 442–446, 451–453, 455, 459, 466, 468, 470, 478, 479, 481, 489 Napoleon III. 489 narthex, defined, 117 Nash, John, 488; lithograph, Crystal Palace, 502 (Fig. 466); Royal Pavilion, Brighton, 481 (Figs. 445, 446), 500 national monarchies, rise of, 111, 205-206 nationalism, **383**; Protestant, **416**; romantic, **460**, **478–479**, **480**, 488-489 naturalism, 228-229, 233, 258-259, 260-261, 329, 346, 521 Naumburg, Germany, cathedral, 214 (Fig. 207), 215 nave, defined, 117 Nebuchadnezzar, 7 necking, defined, **27** Nefertiti, bust of, **9, 10** (Fig. 14) neoclassicism, 55; baroque, 456; Enlightenment and 18thcentury, 466, 488; Napoleonic, 446-450, 451, 455-456, 457; 20th-century, 449, 544-547 neomedievalism, 214, 460, 468, 469-478, 486, 487, 488, 489, 498 Neoplatonism, 236, 306, 343; Renaissance, 271-272, 274, 275, 276, 277, 278, 283 neoprimitivism, 525, 526-529, 559 Neri, Philip, **341, 343** Nero, **102, 104, 267** Nerval, Gérard de, 460 Neumann, Balthasar, Kaisersaal (Imperial Room), Bishop's Palace, Würzburg, **424** (Fig. 397) New Orleans, Louisiana: jazz, 528, 529; Piazza d'Italia, 614,

616 (Fig. 579)

New York City, 564; Chrysler Building, 555 (Figs. 523, 524), 556; The Club, 566; Empire State Building, 555, 593; Grace Church, 470, 471 (Fig. 439); Grand Central Terminal, 97; Guggenheim Museum, 590 (Fig. 558), 591 (Fig. 559), 619; Lever House, 589 (Fig. 556); Lincoln Center, 17 (Fig. 22), **619;** Low Memorial Library, Columbia University, **100**; Rockefeller Center, 17; Seagram Building, 589 (Fig. 557); St. Patrick's Cathedral, 470-471; Trans-World Flight Center, 592 (Fig. 562), 594, 619; Trinity Church, 470 New York School, **563–566**, **567** Newman, Barnett, **565**, **566**, **576**; Genesis-The Break, 568 (Fig. 530), 572; Vir Heroicus Sublimus, 572, 573 (Fig. 572) Newton, Isaac, 341, 414, 437, 438, 558; Principia, 415, 416 Nibelungenlied, 168, 476, 477, 518 Nicene Creed, 114 Nichomachus, 137 Nietzsche, Friedrich, 558, 559; So Spake Zarathustra, 619 Nîmes, France: Maison Carrée, 94 (Fig. 100), 446; Pont du Gard, 98, 99 (Fig. 106), 102, 109 Noguchi, Isamu, Cube, 579 (Fig. 547) Nolde, Emil, Dancing Around the Golden Calf, 531, 532 (Fig. 491) nominalists, late medieval, 228, 229 nonobjectivism, 526, 532, 550-551, 569 Norman Conquest, 164-168, 173 Notre Dame, defined, 189–190 Notre Dame de Belle Verrière (Our Lady of the Beautiful Window), 196, 197 (Fig. 195), 198 (Fig. 196) number theory, Gothic, 204-205

0

Oakland, California, Paramount Theater, **554** (Fig. 522) obbligato, defined, **383, 410** Oceanic arts, 526, 527, 528, 529 octastyle, defined, 28 octave, defined, 46 Octavian. See Augustus Caesar, Emperor oculus, defined, 100 Odo, Bishop of Bayeux, 165, 178 Odo of Cluny, **153**, **154** Odoacer, **114**, **115** oil on canvas technique, 315, 317 Old Market Woman, 80 (Fig. 84) Oldenburg, Claes, Geometric Mouse, Scale A, 582, 583 (Fig. 551) op art, 579, 580, 582 opera: 18th-century, **409–412**, **415**, **417**, **421**; French baroque, **401–403**; French, under Napoleon, 452-453; Mozartian, 435-437; 19th- and 20thcentury, 533, 534, 545-544, 610-611; romantic period, 460, 463, 474, 479, 481, 482, 483, 488; Venetian, public, 327, 328, 401, 409 Oration Fathers. See Congregation of the Oratory oratorio, 309; Handel's, Israel in Egypt, 411, 412, Messiah, 411, 412, Semele, 410-411 orchestra: French baroque court, 400; Greek theater, defined, 43

organ, Dutch, 380; Gothic, 200; hydraulic, see hydraulus organ point, defined, 200 organic architecture, 552–554, 589 organum duplum, defined and illustrated, 200, 201 Orozco, José Clemente, Gods of the Modern World, 547 (Fig. 513), **548** Orpheus, **47, 57, 138;** cult of, 123; reforms, 57 Orpheus Among the Thracians, 47 Ostrogoths, 114, 115, 116, 120-121, 122, 137, 143 otherworldliness, Romanesque, 158 Otto the Great, 141 Oud, J. J. P., 557 Ovid, 226, 253, 545; Art of Love, 104; Metamorphoses, 104, Picasso illustrations for, 545 (Fig. 510)

P

Oxford, England, 211

Pachelbel, Johann, 338

Padua, Italy, 209; Arena Chapel, Giotto frescoes, 218 (Fig. 211), 230 (Fig. 221) Paganini, Nicolò, 476, 489 Palermo, Italy, Palace of the Normans, 163; Dining Hall of Roger II, 164 (Fig. 166) Palestrina, Giovanni da, 281, 345, 363, 365 Palladio, Andrea, 313-315, 326, 328, 336, 337, 339, 403, 457, 599; Four Books of Architecture, 313, 315, 403, 404; Il Redentore, **314**, **315** (Figs. 295, 296), **316** (Fig. 297); Olympic Theater, **315**, **316** (Fig. 298); Villa Rotonda, 313, 314 (Figs. 293-294), 338, 346 Panathenaic Festival, 34, 35, 38 Pannini, Giovanni Paoli, Interior of the Pantheon, Rome, 101 parallel organum, defined, 156 Paris, France: Arc de Triomphe de l'Étoile, **467** (Fig. 434), **468**, **445–446**, **456**, **457**; Arc de Triomphe du Carrousel, 445 (Fig. 415), 456, 457; Chamber of Deputies, 443; early 19thcentury, 441-443; Eiffel Tower, **519, 593, 595**; Hôtel de Soubise, Salon de la Princesse, **422** (Fig. 392); Île-de-France, 181–185; Library of Ste. Geneviève, 488, 496 (Fig. 462); Louvre, 389 (Fig. 366), 390, 393, 398, 403, 406, 408, 450; Luxembourg Palace, 468, Rubens's Festival Gallery murals, 396, 398; La Madeleine, 443, 444 (Figs. 412, 413), 445 (Fig. 414), 456; Notre Dame, 181, 191, 441, 461, 471, 472, cathedral school of, 199–201; Opera, 488; Pantheon, 100; Place de la Concorde, 443 (Fig. 411); Place de Charles de Gaulle (Place de l'Étoile), 445; Pompidou Center (Beaubourg), **593, 594** (Figs. 564, 565), **595**; Ste. Clotilde, **471–472** (Fig. 440), **500**; Ste. Chapelle, **471**; St. Denis, 150, 181, 182 (Figs. 178, 179), 196, 199; Théâtre de l'Odion, 617; Tuileries Palace, **445**; University of (Sorbonne), **181**, **193**; Vendôme Column, 94, 446 (Fig. 416), 456, 457

Paris, School of, **564**, **565** Parmigianino, **327**, **329**; *Madonna* with the Long Neck, 330, 331 (Fig. 312) Parthenon marbles, in British Museum, 19. See also Athens, Greece Pascal, Blaise, **415**, **417** passacaglia, defined, **410** paten, defined, 130 pater familias, defined, 94 pater patriae, defined, 94 pathos, defined, 73-74 patronage of arts, 268-269, 329, 338, 341, 352, 354, 356, 360, 387, 389, 390, 393, 394, 396, 398; and Beethoven, 478; by Dutch middle class, 17thcentury, 368, 369, 370, 371, 384, 385; and 18th-century middle and upper classes, 421, 428, 431; English, 17th-century, 403, 407, 408, 411; of Medici family, **236, 249, 251, 252, 261– 262;** of Lorenzo de' Medici, 257-258; by Napoleon, 445, 446, 451, 452-455; 19thcentury, 486; 19th-century middle class, 492, 493; in northern Renaissance, 289, 295, 308; and urban Renaissance, 233, 246; 17th-century, 599 Pausanias, 69 Pauson, 53 Pax Romana, 85 Paxton, Joseph, 501-502, 517, 519; Crystal Palace, 501 (Fig. 465), 502 (Fig. 366) Pearlstein, Philip, 603; Female Model on Platform Rocker, 601 (Fig. 568) pediment, defined, 28 Pei, I. M., East Building, National Gallery, **595**, **596** (Fig. 566) pendentive, defined, **124** peplos, defined, 35 Percier, Charles, 356, 357, 443; Arc de Triomphe du Carrousel, **445** (Fig. 415); Vendôme Column, **446** (Fig. 416) Pergamon, Turkey, **24**; acropolis, **59**, **60**, **61** (Fig. 68), **63**, **80**, **143**; agora, **60**, **61** (Fig. 68); Altar of Zeus, **60**, **61** (Fig. 68), **63**, **64**, **65** (Fig. 72), **69**, **78**, **85**; architecture and sculpture, 80-81; Athena Precinct, 60-61, 63; Eumenaia festival, 75; library 61, 63; monument to Attalus I, 61, 63; mosaics, 71-72 (Figs. 76, 77); paintings, **69–71**; Panathenaea, **75**; royal residence, **61–63**; Temple of Athena Polias, **60**, **61** (Fig. 68); Temple of Trajan, 61 (Fig. 68), 62; theater, 61 (Fig. 68), 102, Pergamon Museum, Berlin, 63, 65 Peri, Jacopo, 325 Pericles, 16, 24, 26, 30, 38, 51, peristyle, defined, 28 Pérotin, 200, 201 Perrault, Claude, 390, 414, 415, 456; Louvre Palace, 389 (Fig. 366), 406 Persius, Louis Luc Loiseau de, L'Inauguration du Temple de la Victoire, **457**; La Triomphe de Trajan, **457** perspective: atmospheric, 246, 261, 417; linear, 229, 534, defined, 249; Pozzo's book on,

349; vanishing-point, 256

(Fig. 250) Perugino, **274** Peter Damian, St., 228 Petrarch, 209, 219, 223, 241, 312, 473; cycle of Triumphs, Petronius, Satyricon, 104 Pevsner, Nicholas, 213 Pfluegger, Timothy, Paramount Theater, **554** (Fig. 522) Phidias, **25, 33, 38, 49, 50, 82**; Athena Lemnia, **41, 42** (Fig. 55); Athena Promachus, 26, 31 Philadelphia, Pennsylvania, Guild House, **613** (Fig. 577)
Philip II of Spain, **294**, **352**, **354**, **355**, **356**, **358**, **387**, **412**, **416**Philip III, **354**Philip IV, **354**, **360**, **362** Philip Augustus of France, 181 Philip of Macedon, 59 Philip the Bold, Duke of Burgundy, 288 Philip the Good, Duke of Burgundy, 286, 289 Phillips, Thomas, Lord Byron in Albanian Costume, 478 (Fig. 442), 479 phlegmatic, defined, 299 photomontage, defined, 603 Phrygia, 72, 73 piano, defined, 453 Piano, Renzo; Georges Pompidou Center for Art and Culture, **593**, **594** (Figs. 564, 565), **595** Picasso, Pablo, **12**, **449**, **521–524**, 527, 529, 534, 541, 544, 545, 548–550, 561, 565, 573, 599, 619; Chicago Picasso, 522 (Fig. 480); Les Demoiselles d'Avignon, 522-523 (Fig. 481), 524, 528, 534; Guernica, 548, 549 (Fig. 517), 550; The Love of Jupiter and Semele, **545** (Fig. 510); Pipes of Pan, **545** (Fig. 509); Three Graces, 544 (Fig. 508), 545; Three Musicians, 534 (Fig. 495), 536; Woman's Head (bust), 536 (Fig. 496); Woman's Head (painting), 524 (Fig. 483) Pico della Mirandola, 249, 252, 253, 257, 258, 259; Oration, 260 pier, defined, 187 Piero della Francesca, 250; Resurrection, 251 (Fig. 243), 269 pilaster, defined, 98 pilgrimage churches, defined, 423 Pindar, 450, 457 Pinturicchio, Bernardino, 267 Pisa, Italy, 209; Baptistry, 220 (Fig. 213); Campo Santo frescoes, **223**, **224** (Fig. 219); cathedral, **161**, **221** (Fig. 214) Pisano, Andrea, 236 (Fig. 222), Pisano, Giovanni, 219, 220, 221 (Fig. 214) Pisano, Nicola, 219-220 (Fig. 213), 231, 259 plainchant, defined, 134 plainsong, defined, 134 plateresque style, defined, **355** Plato, 21, 22, 52, 57, 76, 81, 236, 252, 274, 275, 278, 436, 456, 605, 619; Laws, 259; Republic 46, 53, 54, 257, 259, 282, 306, 558; Symposium, 263, 283; Timaeus, 55, 56, 77, 204, 279, 283 Plautus, 104 Pliny the Elder, 71 Pliny the Younger, 134 Plotinus, Enneads, **252** Plutarch, **49, 379**; biography of Pericles, qtd., **24**; Parallel Lives, 441, 446 poco andante, defined, 454

podium, defined, 65, 94 Poe, Edgar Allan, 459 pointed arch, 189 (Fig. 187) pointillism, defined, 509 Poliziano, Angelo, **249**, **252**, **254**, **257**, **258**, **283** Pollaiuolo, Antonio, **245–246**, **259**, **260**, **261**; *Hercules* Strangling Antaeus, 245 (Fig. 236), 246 Pollock, Jackson, 565, 566, 568, 569 (Fig. 531), 570, 571, 573, 576, 599; Lucifer, 568, 569 (Fig. 532), 572 polychoral style, defined, 325 polychrome, defined, 107, 130 Polyclitus, 39, 50, 57; Canon of, qtd., 56 Polyclitus the Younger, Theater at Epidaurus, 43 (Fig. 58) Polydorus. See *Laocoön Group* Polygnotus, **25**, **53**, **69** polyphonic, defined, **156** polyphony: early forms, **154, 156**; Gothic, 200; of Île-de-France, 199; 16th-century, 302 polyptych, defined, 291 polyrhythm, defined, 559 polytonality, defined, 559 Pompadour, Mme. de, 426 Pompeii, Italy, 69, 71, 83, 449, 456, 486; House of the Faun, Battle of Issus, 73 (Fig. 78) Ponte, Lorenzo da, 435 Pontormo, Jacopo, 338; Joseph in Egypt, 329, 330 (Fig. 311) pop art, 563, 579, 580, 582, 613 Pope, Alexander, **341**Porcia and Cato, **94, 96** (Fig. 102)
Porta, Giacomo della, **343**; Il
Gesù, **345** (Figs. 323–325), **246**; St. Peter's dome, **268** (Fig. 254) portal, defined, 26 portico, defined, 26 Portinari, Tommaso, 292, altarpiece commissioned by, 292 (Fig. 275) Portland, Oregon, Public Service Building, **614**, **615** (Fig. 578) Portrait of a Roman Lady, **94**, **95** (Fig. 101) Poseidon, 31, 35, 38, 68 Poseidon and Apollo, 35 (Fig. 42) post, defined, 26 post-and-lintel construction, 21, 26, 56, 62-63 postimpressionism, 508-514, 517 postmodernism, 564, 597, 599–605, 606, 611–615, 618–619 Potsdam, Germany, Sans-souci, Poussin, 378, 398-399, 400, 402, 414, 416, 448, 457, 511; Et in Arcadia Ego, 399, 400 (Fig. 378); Rape of the Sabine Women, 398 (Fig. 377), 399 Pozzo, Andrea, 345, 465, 423: Saint Ignatius in Glory, 349, 350 (Fig. 332) Praxiteles, 39, 41, 74, 81, 259, **452, 457, 619;** Aphrodite of Cnidos, **42** (Fig. 56), **545;** Hermes and the Infant Dionysus, **40** (Fig. 50) presto, defined, 454 printing. See books, early printed Procopius, 129 Prokofiev, Love of Three Oranges, 543 prologue, defined, 43 Prometheus, 453, 454, 479, 545, 606, 618 Pronomos Painter, Audience Holding Their Masks, 44 (Fig. 59) prosody, defined, 46

protagonist, defined, 44 Protagoras, **49** prothesis, defined, **123** prototype, defined, 41 Proudhon, Pierre Joseph, 474 Proust, 498, 599; Remembrance of Things Past, 518 psalmody, antiphonal and responsorial, defined, 135 psychic automatism, 541–543, 567, 568 psychology of perception, 517, 518-519, 525 Ptolemy, **137, 194** Puget, Pierre, *Milo of Crotona*, **394** (Fig. 373) Pugin, A. W. N., Houses of Parliament, 470 (Fig. 438) punctus contra punctum, defined, Purcell, Henry, 403, 404, 408-411, 415, 416; Dido and Aeneas, 408-411, 417 putti, defined, 71 pylon, defined, 9 Pythagoras, 21, 47-48, 54, 55, 586; and music, at Chartres, 194; number theory, and early polyphony, 156; reforms of, 57 Pythios, Mausolus Mausoleum, 77 (Fig. 82)

quadrivium: at Chartres cathedral school, 204; defined, 200 quadruplum, 199; defined, 200 Quinault, Philippe, 403, 456 Quintilian, 103, 104

Rabelais, François, 307; Gargantua, 306; Pantagruel, 306 Rachmaninoff, Sergei, 476 Racine, Jean, 341, 391, 402, 403, 413, 414, 450, 456 raking cornice, defined, 28 Raleigh, Sir Walter, 305 Rameau, Jean Philippe, **421**, **516** Rameses II, colossi of, **9** (Fig. 13) Raphael, **260**, **261**, **267**, **274**, **278**– 279, 289, 328, 329, 354, 360, 394, 443, 450; Baldassare Castiglione, 263, 264 (Fig. 253); Julius II, 268, 269 (Fig. 255); Leo X with Two Cardinals, 268, 269 (Fig. 256); School of Athens, 278 (Fig. 266), 279 rationalism, baroque, 414-415, 437; Enlightenment-18thcentury, **433**, **437–439**; Greek, **415**; Hellenic, **54–57**, **81** Rauschenberg, Robert, Monogram, 580 (Fig. 548), 581 Ravel, Maurice, 528, 529, 543-544 (The Child and the Sorceries), 544 Ravenna, Italy, 21, 109, 114, 133, 140, 143, 221; Arian Baptistry, 124 (Fig. 129), Baptism of Christ and Procession of Twelve Apostles, 124 (Fig. 129); authoritarianism in, 136-137; Galla Placidia mausoleum, 116 (Figs. 117 118), 117, 124, Christ as the Good Shepherd in, 116 (Fig. 118), 117; mosaics at, 135; music at, 134–135; mysticism in, 137-140; Sant' Apollinaire Nuovo, 117, 118-122, 123, 124, 134, 137, 138,

Good Shepherd Separating the Sheep from the Goats, 119

(Fig. 124), Last Supper, **120** (Fig. 125), Procession of Virgin

Martyrs, 121 (Fig. 126); San

Vitale, 122 (Fig. 127), 123

(Fig. 128), 124, 125 (Fig. 132), 126, 128-130 (Fig. 138), 135, 137, 140, 141, Emperor Justinian and Courtiers, 128 (Fig. 136), Empress Theodora and Retinue, **129** (Fig. 137) realism, 521, 563; and Hellenic Greeks, 52-54; Hellenistic, 68, 76, 78–81; 19th-century, 491–502, 514, 516, 599, 605; postmodern, 600-605 reason, 18th-century definition of. recapitulation (symphonic), defined, 455 recitative, defined, 402 Reformation, **296**, **307–309**, **324**, **327**, **338**, **341**, **343**, **380**, **381** refrain, defined, **326** Reich, Steve, Drumming, 610 Reinhardt, Ad. 576 relativism, 558-561, 563, 597 Rembrandt van Rijn, 346, 367, 370-375, 377, 378, 380, 383, 414, 416, 417, 605, 619; Christ Healing the Sick (Hundred Guilder Print), 373 (Fig. 352); Dr. Tulp's Anatomy Lesson, 371 (Fig. 350), **372**, **493**, **494**; self-portraits, **374** (Figs. 353 [with Saskia], 354), **375** (Figs. 355, 356 ["Old"]); Sortie of Captain Banning Cocq's Company of the Civic Guard, 372 (Fig. 351), 373 Rembrandt, Saskia van Uylenburgh, 374 (Fig. 353) Rembrandt, Titus, 374, 375 Renoir, Pierre Auguste, La Moulin de la Galette à Montmartre, **505** (Fig. 469) Renwick, James, Grace Church, 470, 471 (Fig. 439) representative style (musical), defined, 327 Restoration, English, 403, 404 Rheims, 182; cathedral, 188, 191, 472; cathedral school. 193, 199 ribbed groin vault, illustrated, 189 (Fig. 187) ricercare, defined, 325 Richardson, Samuel, 428; Pamela, 432 Richelieu, Cardinal, 398, 412 Richmond, Virginia, state capitol, 446 Rigaud, Hyacinthe, Louis XIV. 387, 388 (Fig. 365) Riley, Bridget, Current, 582, 583 (Fig. 552) Riley, Terry, Shri Camel, 610 ritornel, 402 rococo style, defined, 422 Rodin, Auguste, **491**, **496–499**, **517**, **518**, **519**; *Adam*, **498**; *Age* of Bronze, **496** (Fig. 459); Eve, **498**; Gates of Hell, **496–497** (Fig. 460); Hand of God, 498 (Fig. 461); The Thinker, 438, 498; Three Shades, 498 Rogers, Richard, Pompidou Center (Beaubourg), **593**, **594** (Figs. 564, 565), **595** Roland legend, **163–164**, **168–** Rolland, Romain, 453, 455; Jean Christophe, 561 Romano, Giulio, 329, 335-336; Palazzo del Tè, 335, 336 (Fig. 318) romantic realism, defined, 460 romanticism, 214, 225, 378, 459, 460-469, 487, 489, 552, 568 Rome, Italy: aqueducts, 97-98; Ara pacis Augustae, **85, 86** (Fig. 89), *Imperial Procession*, **87** (Fig. 90), Tellus panel from, **88**

(Fig. 91), 104; Arch of

Septimius Severus. 445, 457: artistic sack of, by Napoleon, **442–443, 445;** Basilica Ulpia, 87, 88–89 (Fig. 94), 92 (Fig. 97), 96, 102, 106; Baths of Caracalla (Figs. 103–104), 97, 102; Baths of Diocletian, 97; Baths of Titus, 267; Castel Sant' Angelo, 327; civil engineering of, 143; Colosseum, 93, 97-98 (Fig. 105), 102, 106; Domus Aurea, 267; Forum of Trajan, 87-96 (Figs. 92-94, 96–99), **102, 106, 107;** Il Gesù, **345** (Figs. 323–325), **346, 349;** Imperial Baths, 96-97, 102; music of, in Renaissance, 268-269, 280-281, 325; Old St. Peter's basilica, 113, 117, 118 (Figs. 121, 122); Palazetto Zuccari, **336, 337** (Fig. 320); Pantheon, **98–100** (Figs. 107–110), **102, 106, 123, 124, 237,** 279, 283, 446; Piazza Navona, Fountain of Four Rivers, Fig 349, 351 (Fig. 333); Pons Aelius, 108; Portrait of a Roman Lady, 94, 95 (Fig. 101); St. Peter's Basilica, 100, 141, 185, 267, 269, 273, 280 (Figs. 267–269), **282, 343, 345, 354,** apse and dome, **268** (Fig. 254), **279, 280** (Fig. 268), 283, 404; Chair of St. Peter, 349; choirs, 267, 268; San Carlo alle Quattro Fontane, 346, 347 (Figs. 326-328); San Luigi dei Francesi, Calling of St. Matthew, 348 (Fig. 329); San Pietro in Montorio, Bramante's Tempietto, **282** (Fig. 270); San Pietro in Vincoli, tomb of Pope Julius II, 267, 271 (Fig. 258), 279; Sant' Ignazio, 345, 349, St Ignatius in Glory, 350 (Fig. 332); Santa Maria della Vittoria, Coronaro Chapel, **352** (Fig. 334), St. Teresa in Ecstasy, **353** (Fig. 335); Santa Maria del Popolo, **267**, Conversion of St. Paul, 349 (Fig. 330); Santa Maria in Trastevere, Avila Chapel cupola, 416 (Fig. 391); Sistine Chapel, 363, 619, Cappella Sistina, 267, 268, 280-**281**, **345**, Michelangelo's ceiling frescoes, **267**, **269**, **273**, **274**– 278 (Figs. 262-265), 343, 344 (Fig. 322); 16th-century sack of, by Charles V, 327, 333; Temple of Trajan, 94, 96; Trajan's Column, 87, 89, 92-93 (Figs. 98, 99), 107, 124, 231, 446, 456; the Vatican, 268 (Fig. 254), **443**, **452**, Pauline Chapel, **278**, Vatican Palace, **267**, Raphael murals in, **278** (Fig. 266), 279. See also Nîmes, France, Pont du Gard Ronchamps, France, Notre-Damedu-Haut, 590-592 (Figs. 560, 561), **594** Roosevelt, Franklin Delano, 564 Rosenberg, Harold, 567 Rosenblum, Robert, 569 Rothko, Mark, 565, 566, 575, 576; Green and Maroon, 572 (Fig. 537) Rouault, Georges: Guerre series, **547**; Misere series, **546**, **547**; This will be the last time, little father!, 546 (Fig. 512) Rouen, France, 182; cathedral, 191; Gothic half-timbered house, 202 (Fig. 197) Rousseau, Jean-Jacques, 402, 422, 433, 437, 438, 459; Le

Rousseau, Jean-Jacques (cont.) Devin du village, 483; Social Contract, 419, 438 Rubens, Peter Paul, 317, 319, 338, 348, 362, 378, 394, 396, 398, 400, 414, 416, 463, 464, 488; ceiling paintings, Banqueting House, Whitehall, 404 (Fig. 382); Garden of Love, **396** (Fig. 375), **425**, **426**; Henry IV Receiving the Portrait of Maria de Medici, **395** (Fig. 374), **396**; Rape of the Daughters of Leucippus, 397 (Fig. 376), 399 rubricator, defined, 152 Rude, François, 446, 460, 467-469, 472, 488; Departure of the Volunteers of 1792, 467, 469 Ruisdael, Jakob van, 367; The Cemetery, 376 (Fig. 359), 377– 378; Quay at Amsterdam, 320, 321 (Fig. 347), 377 Ryder, Albert Pinkham, Jonah, **569, 570** (Fig. 533)

S

Saarinen, Eero, 563, 592-595; Trans-World Flight Center, 592 (Fig. 563), 593 Saarinen, Eliel, 563 Sacchi, Andrea, Urban VII Visiting Il Gesù, 345 (Fig. 325) St. Louis, Missouri, Gateway Arch, **593**; Wainwright Building, **552** (Fig. 519), **553** St. Omer, France, Abbey of, Evangelistary, illuminated manuscript from, 152 (Fig. 155), 153 Saint-Saëns, Camille, Danse Macabre, 476 Saint-Simon (social philosopher), 474 Salamanca, Spain: Casa de las Conchas, **355**, **356** (Fig. 338); La Clérica, 355, 356 (Fig. 338), San Estaban, altarpiece, 356 (Fig. 339) Salisbury, England, cathedral, **209, 210** (Fig. 201), **211** (Fig. 202), **212–213** Sallust, 441 salons, 18th-century, 421, 422 (Fig. 392), 423 (Fig. 394); Parisian, romantic period, 474 Sand, George, 474 sanguine, defined, 299 Sansovino, Andrea, 267 Sansovino, Jacopo, 314, 326, 327, 354; Library of St. Mark, 312–313 (Fig. 292), 322, 336; Loggietta, 311 (Fig. 290), 322 Santiago de Compostela, Spain, shrine of the Apostle James, 145, 157, 160 Sanzio, Giovanni, 289 sarcophagus, defined, 109, 113 Sartre, Jean-Paul, 567, 615, 618, 619; Les Mouches (The Flies), 545 Satie, Erik, 544, 587; Dessicated Embryos, 543 satire, defined, 104 saturations, defined, 572 Savonarola, Girolamo, 283 Sayers, Dorothy L., 169 Scamozzi, Vincenzo, **339**; Olympic Theater, **315**; Procuratie Nuove, 336, 337 (Fig. 319) Scheidt, Samuel, Tablatura Nova, Schnabel, Julian: Death Takes a Holiday, 608 (Fig. 574); Exile,

606

Schoenberg, Arnold, **522**, **531**, **533–534**, **559**, **563**, **587**, **599**, **609**, **618**; Die Gluckische Hand, 534; Gurrelieder, 478; Pierrot Lunaire, 533; 12-tone system of music, 537, 559, 610; Verklärte Nacht, 478 scholastic synthesis, 203-207, scholasticism, 209, 228 scholasticism, 306, 343; defined, 203 School of Paris. See Paris, School Schubert, Franz, 476; Die Winterreise, 486 Schumann, Robert, 474, 475, 476 Schütz, Heinrich, 338; Christmas Story, 382; St. Matthew Passion, Scopas, school of (?), Dionysian Procession, 43 (Fig. 57) Scott, Sir Walter, 450, 470, 488; Rob Roy, **460**; Waverley, **460** Scott Brown, Denise, **611–614**; Guild House, Philadelphia, 613 (Fig. 577) scriptorium, defined, 152 sculpture, narrative, 92, 93-94, sedes, defined, 132 Seikilos, skolion of, 75 Seldes, Gilbert; Lysistrata, 545 Seneca, 77, 104, 441, 456 Sennacherib, relief from palace of, 7 (Fig. 10) sensibility, 421, 426-432, 438, 459 serialism, 576-578; in music, 585, 587, 588 Serusier, Paul, 510, 511 Seurat, Georges, Sunday Afternoon on the Island of La Grand Jatte, **508** (Fig. 472), **509** Severini, Gino, Armored Train, 537, 538 (Fig. 498) Seymour, Jane, 300 sforzando, defined, 453 sfumato, defined, 255 Shahn, Ben, 564; Miner's Wives, Shakespeare, William, **300**, **303**–**306**, **433**, **435**, **450**, **459**, **472**, **474**, **476**, **616**; *Comedy of Errors*, 104; Hamlet, 460, 473; Macbeth, 473; Merchant of Venice, 47; musical settings of songs of, 305; The Tempest, 305-306 Shelley, Percy Bysshe, 454, 456; Hellas, 57 Sicily, Italy. See Agrigentum; Palermo Siena, Italy, **209**, **219**, **220–21**; and Black Plague, 223 Simonides, 49 sinfonia, 325 Sixtus IV, Pope, 267, 274, 281 skene, defined, 43 skolion, defined, 75 skyscrapers, **553**, **554** Smith, David, **564**, **565**, **573–575**, **619**; *Cubi VI*, **574** (Fig. 539); Cubi series, 579 Smithson, Harriet, 460 social realism, 521, 525, 564 Society of Jesus (Jesuits), 343, 345, 346, 349, 352, 355, 364, 365, 416, 422 Socrates, 21, 24, 45, 46, 47, 49. 54, 57, 76, 81, 138, 259, 277, Sodoma, Il (Antonio de' Bazzi), solmization, defined, 154 Solon, 441 sonata form, defined, 454 Song of Roland, 163-164, 168-

170, 172, 177, 178, 179

Sosus, 71; Unswept Dining Room Floor, 72 (Fig. 77)
Souillac, France, Church of Notre
Dame, Isaiah, 158 (Fig. 161)
Southey, Robert, Thalabor the Destroyer, 481 Spengler, Oswald, 561 Spinoza, Baruch, 367, 383, 384 Spontini, Gasparo, La Vestale, 452-453, 457 Squarcialupi, Antonio, 237, 258, 261, 283 squinches, defined, 124 (Fig. 131) Staël, Mme. Anne-Louise-Germaine de, 460 stained glass windows, Gothic, 111, 187 (Fig. 184), 196, (Fig. 194), 197 (Fig. 195), 198 (Fig. 196), 206, 561 stasimon, defined, 48 Steen, Jan, Merry Family, 384 (Fig. 364), 385 Stein, Gertrude, **543**, **564** Steinbach, Erwin von, Strasbourg Cathedral, 471 stele, defined, 51 Stella, Frank: Singerli Variation IV, 578 (Fig. 545); Tuftonboro I, **578** (Fig. 544) Stern, J. P., Reflections on Realism, 600 stile antico, 325 stile moderno, 325 Still, Clifford, 565 Stockhausen, Karlheinz, 586, 611; Opus 1970, 587 Stoeffels, Hendrickje, 375 stoicism, **77, 81, 105, 108** Stoppard, Tom, Rosencrantz and Guildenstern Are Dead, 561 Storm-and-Stress movement, 421, 433, 459; drama, 435, 437, 438 Strauss, Richard, 478; Elektra, 533; Salome, 533 Stravinsky, Igor, **522**, **537**, **561**, **563**, **599**, **618**, **619**; Etude for Pianola, 538; Oedipus Rex, 544; Persephone, 544; Rite of Spring, 521, 528, 544, 559 stream-of-consciousness technique, 519, 526 Street, George, New Law Courts, London, 470 Stuart and Revett, Antiquities of Athens, 441 Sturm und Drang. See Storm-and-Stress movement style, defined, 18 stylobate, defined, 26, 28 (Fig. 31) sublime, the, 433, 459, 569 Suetonius, Lives of the Twelve Caesars, 104 Suger, Abbot, of St. Denis, **150**, **181**, **182** (Fig. 179), **196**, **199** Sullivan, Louis, **552–553**; Auditorium Building, 614; Wainwright Building, 552 (Fig. 519), 553 Sumer: art and architecture, 3-6; royal tombs, 4, 19; ziggurats of, 3 (Figs. 3, 4) summa, defined, 190 surrealism, 467, 521, 525, 539–540, 541, 564, 567, 568, 569, 570, 574, 597 288 (Fig. 272), 289 Sweelinck, Jan Pieterszoon, 338, 369–370, 380 Swift, Jonathan, 459; Gulliver's Travels, 428, 432 Sydney, Australia: Opera House, **593** (Fig. 563), **594–595**

Sophocles. 15, 24, 25, 49, 53, 57,

Rex, 44-45, 54

456; Antigone, **42**, **544**; Oedipus

syllabic hymn, defined, 135 symbolism, early Christian, 131, 132, 133, 138, 140, 542, 591; medieval, 233; 19th-century, including symbolistes, 498, 514– 515, 516, 517, 521; Romanesque, 149, 150, 158, 159 synesthesia, defined, 514 synthesizer, 585–586 (Fig. 555), 587, 588

T

Tacitus, 104, 441 Tallis, Thomas, 303 taste, 18th-century definitions and role of, 421, 438 Tate, Nahum, 409 Tellus, 86, 88 (Fig. 91), 104 tempus perfectum, defined, 205 tenebrism, 348 tenemos, defined, 65 tenor. See cantus firmus Terborch, Gerard, 385 Terence, **104**Teresa of Ávila, St., **343, 351, 353** (Fig. 335), 363, 364, 365; qtd., 352 ternary rhythm, defined, 205 terribilità, defined, 272 terza rima, 205 tesserae, defined, 71, 122 Theodora, Empress, 128, 129 (Fig. 137), 130 Theodore, Archbishop, sarcophagus of, 132 (Fig. 140) Theodoric, Emperor, 114, 115, 119, 121, 122, 124, 133, 134, 136, 137, 143; Palace of, 117 (Fig. 119), 118, 120 Theotocopoulos, Domenicos. See El Greco Theotocopoulos, Jorge Manuel, 358 thermae, defined, 97 Thomas, Dylan, 566, Vision and Prayer, 588 Thomas of Celano, Dies irae, 223, 225 Thomson, Virgil, 564, 587, 588 Thucydides, 51, 282 tibia (wind instrument), 104 Tiepolo, Giovanni Battista, ceiling mural, Kaisersaal, **424** (Fig. 397) timbre, defined, 516 Tintoretto, 319-321, 394, 397; Last Supper, 320 (Fig. 305); Marriage of Bacchus and Ariadne, 321, 322 (Fig. 306), 337; Paradise mural, 338
Titian, 318, 320, 321, 325, 326, 338, 354, 360, 394, 397, 488; Assumption of the Virgin, 319 (Fig. 303), 337, 358; Bacchus and Ariadne, 319, 320 (Fig. 304), 337 toccata, defined, 325 Toledo, Spain, San Tomé, Burial of Count Orgaz, 358, 359 (Fig. 342) tomb art, early Christian, 131-132; Egyptian, 10-12, 19 Toulouse, France, St. Sernin, 147 (Fig. 150) Toulouse-Lautrec, Henri de, At the Moulin Rouge, **519** (Fig. 479) Toynbee, Arnold, **561** traditionalism, Romanesque, 160-161 tragédie lyrique, defined, 401 tragedy, Aristotle's definition of, Traini, Francesco, Triumph of

Death, 223, 224 (Fig. 219)

Trajan, Emperor, 62, 63, 86, 87, 89, 91, 92, 94, 96, 97, 102 Tralles, Turkey, musical examples from ancient, 75 transept, defined, 118 triforium, defined, 118 triglyphs, defined, 28 (Fig. 31) triplum, defined and illustrated, 200 triptych, 292 triumphal arch. See arch, triumphal trivium, defined, 193 troubadour, defined, 170 trouvère, defined, 172 trumeau, defined, 194 tuba, classical Roman, 103 Tulp, Dr. Nicholas, 371 (Fig. 350) tunnel (barrel) vault, defined, 102 (Fig. 111) Turner, Joseph Mallord William, 486; Rain, Steam, and Speed: The Great Western Railway, 485 (Fig. 451), 569 turret, defined, 406 Tutankhamen, 9; throne of, 10 (Fig. 15); tomb art of, 19 Tuthmosis, Queen Nefertiti, 2, 10 (Fig. 14) tympanum, defined, 149

Uccello, Paolo, 237, 241; Battle of San Romano, 249, 250 (Fig. 242) Ugarit, Hurrian Cult Song from, 6 Ulm, Germany, cathedral, 213 (Fig. 206), 214 unities, classical (Aristotelian), 16, 37, 45, 52, 57, 92, 546, 559 universities, Dutch, 17th-century, **367, 371, 383, 384** University of Virginia, rotunda of, 100, 446, 447 (Fig. 417) uomo universale, defined, 265 Ur, music of, 6; harp soundbox from, 4 (Figs. 5, 6); royal tombs at, 19; ziggurat at, 3 (Figs. 3, 4) Urban II, Pope, 145 Urban VIII, Popc, 346 Uruk, 6; female head from, 4, 5 (Fig. 7) utilitarianism, Roman, 108-109 Utzon, Joern, 592-595; Sydney Opera House, 593 (Fig. 563), 594-595

Valéry, Paul Ambroise, 545; Fragments of Narcissus, 546 van Alen, William, 555, Chrysler Building, 555 (Figs. 523, 524), van der Goes, Hugo, 288; Portinari Altarpiece, 292 (Fig. 275) van Dyck, Hubert, Ghent Altarpiece, 289 (Fig. 273), 291 van Dyck, Jan, 286, 288, 289-291, 292, 317, 338, 414; Ghent Altarpiece, 289 (Fig. 273), 291; Marriage of Giovanni Arnolfini and Giovanna Cenami, 290 (Fig. 274), 291

van Gogh, Vincent, 414, 509-**510, 529, 605**; Starry Night, **510** (Fig. 474), **525** van Mander, Karel, Schilderboeck, 378 Varagine, Golden Legend, 292 Varése, Edgar, **538–539**; Ionisation, **538**; Integrales, Density 21.5, **538** Vasari, Giorgio, 263, 273, 328 Vatican Council, 134 Velázquez, Diego, 319, 360-363, **378, 414, 416;** *Bacchus (The Drinkers)*, **494;** *Las Meninas*, **362; 561;** *Water Carrier of* Seville, **360, 361** (Fig. 344) Veneziano, Domenico, **250** Venice, Italy: Doge's Palace, 312, 321, 338; Library of St. Mark, 312, 313 (Fig. 292), 336; Loggietta, 322; Procuratie Nuove, 336, 337; Il Redentore, 314, 315 (Figs. 295, 296), 316 (Fig. 297); St. Mark's Basilica, 311, 312 (Fig. 291), four horses, **445**, music of, **325–326**; St. Mark's Square, 272 (Fig. 290), 326; Santa Maria della Salute, 339 (Fig. 321) Venturi, Robert, 611-614; Complexity and Contradiction in Architecture, 611; Guild House, Philadelphia, 613 (Fig. 577) Learning from Las Vegas, 611; Learning from Levittown, 611 Venus, 85, 104, 252, 253, 254, 268, 283, 321, 333, 397, 410, 606 Venus of the Vatican, 267 Verdi, Giuseppe, Aida, 483; Nabucco, 478-479 Vergil, 226, 253, 399, 414, 416, 450, 457, 459, 463 (Fig. 125); Aeneid, 85, 104-105, 109, 231, 275, 488; Eclogues, 104; Georgics, 104; in Hugo, 473 Vermeer, Jan, 375, 377, 378-380, 385, 414, 416, 550; The Art of Painting, 378, 379 (Fig. 362); The Concert, 380, 381 (Fig. 363); Officer and Laughing Girl, 378 (Fig. 361); View of Delft, 377 (Fig. 360), 378 vernacular, defined, 201

Veronese, Paolo, 321-325, 326,

337, 338; Dream of St. Helen,

321, 327 (Fig. 307); Feast in the House of Levi, 322, 324

(Fig. 308), **325, 328;** testimony

before Inquisition, 322, 324-

Verrocchio, Andrea del, 245-246.

254, 259, 260, 261, 262-263

Versailles Palace, 389 (Fig. 267),

291 (Fig. 369), 403, 408, 416,

417, 421, 488; gardens of, 392

(Fig. 370), 274, Itali of Milro, 391, 392 (Fig. 369); Le Hameau, 483 (Fig. 448); Marble Court, 402 (Fig. 380); Salon de la Guerre, 413

Vesalius (Andries van Wesel),

Anatomy, 371, 384; On the

Structure of the Human Body, 298

(Fig. 390)

(Fig. 370), 294; Hall of Mirrors,

W Wagner, Richard, **460**, **476–478**, **516**, **534**, **611**, **619**; "Forest Murmurs," 483; Lohengrin, 471,

476; Die Meistersinger, 476;

vestibule, defined, 406

Luxury, 159 (Fig. 162)

294)

Vikings, 179

Villiers, Cardinal, 269

206 (Fig. 200), 207

virtù, defined, 265

volutes, defined, 32

Vyt, Jodoc, 289, 291

Vincent of Beauvais, 228;

Speculum majus, 191, 207

Viollet-le-Duc, Eugène, **149, 471, 478**; Gothic cathedral drawing,

Vitruvius, 39, 56, 100, 238, 243,

Voltry, Philippe de, Ars nova, 229 Voltaire, 421, 422, 437, 459, 469; Candide, 428, 433; Houdin bust of, 431, 432 (Fig. 408)

voussoir, defined, 102 (Fig. 111)

260, 283, 313, 328, 399

Vézelay, France, 170, 178; Abbey

Church of La Madeleine, 148

Vicenza, Italy, Olympic Theater,

315, 316 (Fig. 298); Villa Rotonda, **313–315** (Figs. 293,

Victoria, Tomás Luis de, 281, 365, 453. Offices for Holv Week, "O

Belvedere Palace, 422-423, 424

(Fig. 395); Hofburg Palace, 422,

423 (Fig. 394); Schönbrunn Palace, 422, 433 View of a Garden, 107 (Fig. 113) Vignola, Giacomo, 343; Il Gesù, 345 (Figs. 323–325), 346

Vignon, Pierre Alexandre, 444,

456, 457; La Madeleine, 444

(Figs. 412, 413), 445 (Fig. 414)

453; Offices for Holy Week, vos omnes' from, 363

Vienna, Austria, 421, 453;

(Fig. 151), **149–150** (Figs. 152, 153), **152, 159,** Demon of

Parsifal, 471, 476; Rienzi, 488; Ring of the Nibelung, 168, 476, 477, 518; Tannhäuser, 471, 476; Tristan and Isolde, 476, 533 Walpole, Horace, 459; Castle of Otranto, 469 Warhol, Andy, **581;** Green Coca-Cola Bottles. **582** (Fig. 550) Warka. See Uruk Warrior (Hellenic), 52-53 (Fig. 65) Wartburg Castle, 163 Washington, D.C., Capitol, **100**; city plan of, **393**; East Building, National Gallery, **593**, **595**–**596** (Fig. 566); Lincoln Memorial, 94; Union Station, 97; Washington Monument, 94; White House, 315 Washington, George, Greenough statue of, 456 (Fig. 424), 457; Houdon statue of, 432 Watteau, Antoine, **414**, **421**, **422**, **425–426**, **428**; *Garden of* Bacchus, 423 (Fig. 393); Gersaint's Signboard, 428, 429

(Fig. 398), 426 Weber, Carl Maria von, 476, 479; Der Freischütz, 483-484 Werfel, Franz, The Trojan Women, 545 Wesel, Andries van. See Vesalius White Tower. See London, England, Tower of Wilde, Oscar, 441-442, 533 Willaert, Adrian, 325 William the Conquerer, 164, 165, 168, 169 (Fig. 170), 173–174, 176, 177, 178, 179 William of Malmesbury, 169 William and Mary, **408**, **409**William of Orange, **408**Wilson, Robert: *Akhnaten*, **610**; Einstein on the Beach, 610; Satyagraha, 610 Winckelmann, Johann Joachim, **437**, **451**, **457**, **606**; *History of Ancient Art*, **441**, **446**, **457** Wind, Edgar, Pagan Mysteries of the Renaissance, 252 Wolf, Hugo, 478 Woman of Willendorf, 2, 3 (Fig. 2) Works Progress Administration (WPA), **564, 565, 566** Wren, Christopher, **338, 403, 414,** 415, 417; garden facade. Hampton Court Palace, 408, 409 (Fig. 388); plan for post-Fire London, 407-408; St. Mary-le-Bow, 407 (Fig. 386), 408; St. Paul's cathedral, 404-407 (Figs. 383-385) Wright, Frank Lloyd. **522**, **552**– **554**, **556**, **559**, **589**, **595**; "Falling Water," **553** (Fig. 521), **554**; Guggenheim Museum, **590** (Fig. 558), **591** (Fig. 559); Price Tower, **552** (Fig. 520), **553** Würzburg, Germany, Residenz (Bishop's Palace), Kaisersaal (Imperial Room), 422, 424 (Fig. 397) Wyatt, James, Fonthill Abbey,

(Fig. 402); Music Party, 425

X

Archie's Church, 549 (Fig. 516)

469 (Figs. 436, 437), **470** Wyeth, Andrew, **548**; *Mother*

Xavier, Francis, 343, 352

\mathbf{Z}

Zarlino, Gioseffo, 314, 338 Zeno, 77 Zeus, 36, 46, 49, 53, 55, 66, 67, 68, 79 Zeus (Poseidon?), 40, 41 (Fig. 52), 53 Zeus Hurling Thunderbolts, **65, 66** (Fig. 73), **67** ziggurat, defined, **3;** at Ur, **3** (Figs. 3, 4) Zimmermann, Dominikus, Wieskirche, 423, 424 (Fig. 396) Zola, Émile, **428**, **484**, **491**, **494**, **495**, **496**, **517** Zuccari, Federico, **335**; Palazetto Zuccari, **336**, **337** (Fig. 320)

Photo Credits

- Chapter 1: 1: Hans Hinz, Basel. 2: Hirmer Fotoarchiv, Munich. 6: University Museum, University of Pennsylvania. 12: D. M. Betancourt/Monkmeyer Press Photo. 13: Comstock. 15: Hirmer Fotoarchiv, Munich. 18: Erich Lessing/PhotoEdit. 19: Kimball Art Museum, Ft. Worth. 20: Art Resource Center, N.Y.
- **P.O. I:** National Museum, Athens, Art Resource Center, N.Y.
- Chapter 2: 23: M. Pillon/GNTO. The Rowland Company, New York. 28: Alison Frantz, Princeton. 30 & 33: Alison Frantz, Princeton. 34: Scala/Art Resource Center, N.Y. 35: Deutscher Kunstverlag, Munich. 37: U. Paparonnou, Athens. 40: Alison Frantz, Princeton. 44 & 45: Hirmer Fotoarchiv, Munich. 46 & 47: Hirmer Fotoarchiv, Munich. 49: Art Resource Center, N.Y. 56: Alinari/Art Resource Center, N.Y. 58: Art Resource Center, N.Y. 58: Art Resource Center, N.Y. 58: Art Resource Center, N.Y. 65: Art Resource Center, N.Y. 65: Art Resource Center, N.Y. 65: Art Resource Center, N.Y. 67: Art Resource Center, N.Y. 68: Art Resource Center, N.Y. 6
- Chapter 3: 67: Hirmer Fotoarchiv, Munich. 69: Scala/Art Resource Center, N.Y. 70: Hirmer Fotoarchiv, Munich. 75, 77, 78: Scala/Art Resource Center, N.Y. 79: Alinari/Art Resource Center, N.Y. 82: German Archeological Institute, Rome. 86: Art Resource Center, N.Y. 87: Alinari/Art Resource Center, N.Y. 87: Alinari/Art Resource Center, N.Y.
- Chapter 4: 88 & 89: Giraudon/Art Resource Center, N.Y. 90: Alinari/Art Resource Center, N.Y. 91: Fototeca Unione, Rome. 94: German Archeological Institute, Rome. 95: Scala/Art Resource Center, N.Y. 96 & 98: Alinari/Art Resource Center, N.Y. 100: CAISSE. 101: Erich Lessing/PhotoEdit. 103: Alinari/Art Resource Center. 106 & 108: Art Resource Center, N.Y. 107: Giraudon/Art Resource Center, N.Y. 113: Scala/Art Resource Center, N.Y. 114: Fototeca Unione, Rome.
- P.O. II: J. Pierpoint Morgan Library, N.Y.
- Chapter 5: 115 & 117: Art Resource Center, N.Y. 116: R. Moscioni/Art Resource Center, N.Y. 118: Erich Lessing/PhotoEdit. 119: Alinari/Art Resource Center, N.Y. 124: Erich Lessing/PhotoEdit. 125, 127, 129, 132: Alinari/Art Resource Center, N.Y. 126: Scala/Art Resource Center, N.Y. 133: Ara Gular, Istanbul. 136 & 137: Art Resource Center, N.Y. 140: Hirmer Fotoarchiv, Munich. 141 & 142: Art Resource Center, N.Y. 143: Scala/Art Resource Center, N.Y.
- Chapter 6: 146: The Medieval Academy of America, Cambridge, Mass. 147: CAISSE. 150: Roger Viollet, Paris. 175: A. F. Kersting, London. 176: Art Resource Center, N.Y. 177: Jean Roubier, Paris. 149: The Medieval Academy of America, Cambridge, Mass. 151: Art Resource Center, N.Y. 154 & 155: J. Pierpoint Morgan Library, N.Y. 156: CAISSE. 157–160: Courtesy of Dr. William Fleming. 161: CAISSE. 163: Marburg/Art Resource Center, N.Y. 164: Alinari/Art Resource Center, N.Y.
- Chapter 7: 165: Goslar Tourist Information, West Germany. 166: Scala/Art Resource Center, N.Y. 167–169: CAISSE. 170: Scala/Art Resource Center, N.Y. 171: Art Resource

- Center, N.Y. 172: Aerofilms Ltd. Borehamwood, England. 173: British Tourist Authority, London. 176: A. F. Kersting, London. 177 & 178: Jean Roubier, Paris.
- Chapter 8: 178: Art Resource Center, N.Y. 180 & 181: French Tourist Authority, New York. 183: Art Resource Center, N.Y. 186: CAISSE. 188: French Tourist Authority, New York. 189: Art Resource Center, N.Y. 190: CAISSE. 191 & 192: Éditions Houvet, Chartres, France. 193: ACT, Aero Foto, Paris. 194: Éditions Houvet, Chartres, France. 195: Wim Swaan. 196: CAISSE. 197: Bildarchiv Foto, Marburg/Art Resource Center, N.Y. 198: Art Resource Center, N.Y.
- Chapter 9: 201: A. F. Kersting, London. 203: Aerofilms Ltd. Borehamwood, England. 204: A. F. Kersting, London. 206 & 207: Helga Schmidt-Glassner, Stuttgart, West Germany. 208: Hirmer Fotoarchiv, Munich. 209: Instituto Centrale per il Catalogue la Documentazione, Rome. 210, 212–214: Alinari/Art Resource Center, N.Y. 211: Art Resource Center, N.Y. 215: Art Resource Center, N.Y. 216–218, 220: Art Resource Center, N.Y. 219: Alinari/Art Resource Center, N.Y. 221: Scala/Art Resource Center, N.Y. 221:
- Chapter 10: 222: Italian Government Travel Office, N.Y. 224 & 225: Courtesy of Dr. William Fleming. 226, 228–236: Alinari/Art Resource Center, N.Y. 237: Scala/Art Resource Center, N.Y. 238: Art Resource Center, N.Y. 240, 242–244: Scala/Art Resource Center, N.Y. 245: Art Resource Center, N.Y. 245: Art Resource Center, N.Y. 248: Lauros-Giraudon/Art Resource Center, N.Y. 248: Lauros-Giraudon/Art Resource Center, N.Y. 252, 253: Alinari/Art Resource Center, N.Y.
- Chapter 11: 254: Italian Tourist Office, N.Y. 256–258, 262–263: Alinari/Art Resource Center, N.Y. 259: CAISSE. 261: Scala/Art Resource Center, N.Y. 264 & 265: Nippon Television Network Corp., Tokyo, 266: Scala/Art Resource Center, N.Y. 270: Alinari/Art Resource Center, N.Y.
- Chapter 12: 271: Jorg P. Anders, Berlin. 272: Marburg/Art Resource Center, N.Y. 273: Giraudon/Art Resource Center, N.Y. 276: Scala/Art Resource Center, N.Y. 278: PhotoEdit. 279: MAS, Barcelona. 282: F. Bruckman, KG Verlag, Munich/Art Resource Center, N.Y. 283: Giraudon/Art Resource Center, N.Y. 284: Art Resource Center, N.Y. 286: The New York Public Library. 289: Staatsgemaldesammlungen, Munich.
- P.O. III: Art Resource Center, N.Y.
- Chapter 13: 290, 292, 293, 296–298: Art Resource Center, N.Y. 291: Wim Swaan, N.Y. 300, 303, 305, 306: Art Resource Center, N.Y. 308: Foto Rossi, 309, 310: Art Resource Center, N.Y. 312, 315: Alinari/Art Resource Center, N.Y. 313, 316, 317, 319: Art Resource Center, N.Y.
- **P.O. IV:** Prado, Madrid/MAS Barcelona. Art Resource Center, N.Y.
- Chapter 14: 322: Scala/Art Resource Center, N.Y. 323, 326, 328, 330, 335: Alinari/Art Resource Center, N.Y. 329, 332, 333, 340, 342: Scala/Art Resource Center, N.Y. 331: Art

- Resource Center, N.Y. 338 & 339: National Tourist Office of Spain, N.Y. 345: MAS Barcelona. 346: Murray Greenberg/Monkmeyer Press Photo.
- Chapter 15: 348: National Gallery of Art, Washington, D.C. 350, 360: Scala/Art Resource Center, N.Y.
- Chapter 16: 366: Giraudon/Art Resource Center, N.Y. 367–370, 373: CAISSE. 371, 372, 374: Alinari/Art Resource Center, N.Y. 375: Scala/Art Resource Center, N.Y. 376: Erich Lessing/PhotoEdit. 381, 382, 386–389: A. F. Kersting, London. 383: SEF/Art Resource Center, N.Y. 390: Art Resource Center, N.Y. 391: Alinari/Art Resource Center, N.Y.
- P.O. V: Louvre, Paris.
- Chapter 17: 392: Scala/Art Resource Center, N.Y. 394: Austrian State Tourist Office, N.Y. 396: Hirmer Fotoarchiv, Munich. 397: A. F. Kersting, London. 402: Art Resource Center, N.Y. 407: Art Resource Center, N.Y. 409: Yale Center for British Studies. New Haven, Conn.
- Chapter 18: 411: Aerofilms, Ltd. 412: H. Roger Viollet. 414 & 415: CAISSE/VAGA. 416: French Tourist Office, N.Y. 420:
- Chapter 19: 429: Alinari/Art Resource Center. 434: CAISSE. 438: Noel Habgood/Photo Researchers, Inc. 439: Gottscho.-Schleisner, Inc., Jamaica, N.Y. 440: H. Roger Viollet, Paris. 444: Giraudon/Art Resource Center, N.Y. 448: CAISSE. 449: Art Resource Center, N.Y.
- Chapter 20: 462, 464: CAISSE. 463: H. Roger Viollet, Paris 465: British Tourist Information Office, N.Y. 467: J. Paul Getty Museum, Malibu, Calif. 468: The Bridgeman Art, Library, London. 471: Art Institute of Chicago.
- Chapter 21: 480: Ezra Stoller, © ESTO. 489: Museum of Fine Arts, Boston, Tompkins Collection. 491: Art Resource Center, N.Y. 501: Mr. Wendall Cherry, Louisville, KY. 403: Mr. Alain Tarica, Paris. 519: Richard Nickel Archives, Chicago. 520: Wayne Andres, Grosse Pointe, Mich. 521: Hedrich Blessing, Chicago. 522: Paramount Theater of the Arts, Oakland, Calif. 523 & 524: Cervin Robinson, N.Y. 526: Lucien Herve, Paris.
- Chapter 22: 530: Lone Star Foundation, N.Y. 531, 536: Hans Namuth, N.Y. 534: Mrs. Elizabeth Ross Zogbaum, N.Y. 538: Eric Pollitzer, N.Y. 541: Malcolm Varon, N.Y. 544: Rudolph Burkhardt, N.Y. 545: Wadsworth Atheneum, N.Y. 547: © Beryl Goldberg, N.Y. 553: Mr. James Seligman, Los Angeles. 554: Wolfgang Volz/© Christo/C.V.J. Corp. 559: Robert E. Mates, N.Y. 560: George Holton/Photo Researchers, Inc. 561: Lucien Herve, Paris. 563: Australian Tourist Commission, N.Y. 564: 6565: Dimitri Kessel, Paris. 566: Norman McGrath, N.Y.
- Chapter 23: 569: Alan Stone Galleries, Inc., N.Y. 571: Allan Frumkin Gallery, N.Y. 573: Hirschl Adler Modern Gallery, N.Y. 575: Munson Williams Proctor Institute Museum of Art, Utica, New York. 578: Paschall-Taylor. 579: Norman McGrath, N.Y. 580: CAISSE.

\$		